Sāmarasya

Studies in
Indian Arts, Philosophy, and Interreligious Dialogue

Bettina Bäumer

Sāmarasya

Studies in
Indian Arts, Philosophy, and Interreligious Dialogue
— in Honour of Bettina Bäumer —

edited by
Sadananda Das
Ernst Fürlinger

D.K.Printworld (P) Ltd.
New Delhi

Cataloging in Publication Data — DK
 [Courtesy: D.K. Agencies (P) Ltd. <docinfo@dkagencies.com>]

Sāmarasya : studies in Indian arts, philosophy and interreligious
 dialogue : in honour of Bettina Bäumer / edited by
 Sadananda Das, Ernst Fürlinger.
 p. 29 cm.
 Bettina Bäumer, b. 1940, Austrian scholar of Indology and religious studies
 and former Director of Alice Boner Institute, Varanasi, India; contributed articles.
 Includes bibliographical references.
 Includes index.
 ISBN 8124603383

 1. Art, Indic. 2. Philosophy, Indic. 3. Cultural relations — Religious aspects.
 4. Cross-cultural studies — Religious studies. 5. Religions — Relations.
 I. Bäumer, Bettina, 1940- II. Das, Sadananda, 1969- III. Fürlinger, Ernst, 1962-

DDC 181.4 21

ISBN 81-246-0338-3
First published in India in 2005
© For Preface with Sadananda Das, Ernst Fürlinger.
 Copyright for individual articles, with the authors.

The views expressed in this volume are those of the authors, and are not necessarily
those of the editors or the publisher.

Published and Printed by:
D.K. Printworld (P) Ltd.
Regd. Office: 'Sri Kunj', F-52, Bali Nagar
New Delhi-110 015
Phones: (011) 2545-3975; 2546-6019; *Fax:* (011) 2546-5926
E-mail: dkprintworld@vsnl.net
Website: www.dkprintworld.com

मोहः शान्तो गुरुवरमुखाम्नायतत्त्वोपलम्भात्
मग्नं चेतः समरससमास्वादलोलं चिदब्धौ ।
भावव्रातः प्रशममगमत् निर्विकल्पे समाधौ
सिद्धाभासः स भवतु हि मे कोऽपि संवित् विकासः ॥

mohaḥ śānto guruvaramukhāmnāyatattvopalambhāt
magnaṁ cetaḥ samarasasamāsvādalolaṁ cidabdhau |
bhāvavrātaḥ praśamamagamat nirvikalpe samādhau
siddhābhāsaḥ sa bhavatu hi me ko'pi saṁvit vikāsaḥ ||

"My ignorance is removed, having received the ultimate reality
of the sacred texts from the mouth of my master.
My mind, eagerly desirous to taste the same flavour (*sāmarasya*)
of the ultimate consciousness, is merged in the ocean of it.
The multitude of thoughts has been subsumed
in that ultimate state of *samādhi*.
May I experience the manifestation of that awareness (*saṁvit*)
which is experienced by the perfect beings (*siddhas*)."

Swami Rāma Joo
(1852-1915)
the grandmaster of Swami Lakshman Joo

Contents

Editors' Preface xi

Acknowledgements xiv

Lokayātrā — A Pilgrimage in Two Cultures: xv
Photos and Biographical Essay

Bettina Bäumer — Achievements xxxv

SHARING OF EXPERIENCES

The Divine Master: Swami Lakshman Joo (1907-91) 3
 Sarla Kumar

Moments of Eternity: The Spiritual Core of Music 11
 Manju Sundaram

A Journey to Mount Kailash 17
 Bernard Imhasly

ESSAYS

Indian Philosophy and Spirituality

1. The Heart of Repose, The Repose of the Heart: A Phenomenological 27
 Analysis of the Concept of Viśrānti
 Arindam Chakrabarti

2. Bahurūpagarbhastotra: An Annotated Translation 37
 Hemendra Nath Chakravarty

3. On the Pārvaṇa Rites According to Abhinavagupta's Tantrāloka 49
 André Padoux

4. A Note on Santha Literature 57
 D. P. Pattanayak

5. The Significance of Tantra Rahasya 63
 Prabha Devi

6. Gandhi's Religious Ethics as Touchstone 67
 Joseph Prabhu

7. The Origins of Man 81
 Baidyanath Saraswati

8. A Commentary on the Opening Verses of the Tantrasāra of 89
 Abhinavagupta
 Alexis G.J.S. Sanderson

9. A New Theology of Bliss: 'Vedantization' of Tantra and 149
 'Tantrization' of AdvaitaVedānta in the Lalitātriśatibhāṣya
 Annette Wilke

Indian Arts and Aesthetics

10. Śiva in the Nineteenth-Century Banaras Lithographs 179
 Anjan Chakraverty

11. Relevance of Textual Sources in the Study of Temple Art 199
 Devangana Desai

12. The Goddess of the Island of Gems: An Early Eighteenth-Century 223
 Illustration of the Saundaryalaharī by a Mewari Master
 Eberhard Fischer

13. Concept and Representation of Time in Indian Visual Art 231
 Rai Anand Krishna

14. The Use of Primary Colours in the Nāṭyaśāstra 245
 Thomas Kintaert

15. Beginning of Śaiva-Siddhānta and its Expanding Space in Central India 275
 R. N. Misra

16. Guhāvāsī and Devarāja in Cambodia 307
 R. Nagaswamy

17. Myth of Renewal: Citrakāra Workshop Practices in Orissa 325
 Dinanath Pathy

18. Mountain, Myth, Monuments 337
Kapila Vatsyayan

Interreligious and Intercultural Dialogue

19. Trans-Religious Studies and Existential Interpretation 373
Karl Baier

20. An Ethics of Justice in a Cross-cultural Context 393
Michael von Brück

21. Interculturation of Religious Life: A Meditation 411
Francis X. D'Sa

22. The Doctrine of Recognition (Pratyabhijñā) and Interreligious Dialogue 431
John R. Dupuche

23. The Music of the Dharma 441
Mark Dyczkowski

24. Dialogue with Buddhism in the West: Concerning the Interreligious Meeting in a Secular Culture 457
Johann Figl

25. Hermann Hesse's Encounter with India: An Intercultural Appraisal 467
Annakutty V.K. Findeis

26. Self-knowledge — Space of Inwardness 479
Alois M. Haas

27. The Meaning of Nothingness for the Mystical Path in Johannes Tauler 521
Emmanuel Jungclaussen

28. Pūjā or the Exercise of Thankfulness 531
Rudolf zur Lippe

29. Between Similarity and Contrast: The Function of Comparisons in Interreligious Debates 541
Axel Michaels

30. To Bridge Identities 557
Bithika Mukerji

31. Does Unity of Minds lead to Religious Harmony? 561
Shivamurthy Shivacharya

32. The Drop of Water: An Intercultural Metaphor 567
 Raimon Panikkar

 Contributors 587

 Index 609

Editors' Preface

SĀMARASYA literally means 'that which is of or expresses the same, similar, equal (*sama*) flavour, juice, or essence (*rasa*)'. Why have we chosen this unusual word for the title of the Felicitation Volume of Dr. Bettina Bäumer?

It is one of the key terms of the non-dualistic Śaivism of Kashmir, a Hindu Tāntric tradition which she has been associated with, as both an academic and as a practitioner, for almost thirty years. The ontological context describes the undifferentiated state of Śiva and Śakti, the origin of all differentiation. In their mutual distinction within their non-difference, they serve as a definitive state of "the total absorption of two things or two states into one another, and if it is a question of two beings, both expressing the same desire to be united with the other" (L. Silburn). *Sāmarasya* denotes the highest spiritual state, where the essence (*rasa*) of the Divine is perceived as all-pervading, where Self and universe fuse into the One in perfect harmony.

This experience is similar to the highest aesthetic enjoyment (*rasa*), as Abhinavagupta, the great exponent of non-dualistic Śaivism, states clearly: The experience of *rasa* is "a resting (*viśrānti*) in one's essential nature (*saṁvit*), which . . . is pervaded by bliss (*ānanda*) and light (*prakāśa*), and is similar to the tasting (*āsvāda*) of the supreme *Brahman*." (*Abhinava- bhāratī* on *Nāṭyaśāstra* 6.31)

This is the core of Tāntric spirituality: the aesthetic, sensual experience can lead one to the highest state. To explore these connections of the aesthetic and mystical experience is one of the main concerns of Bettina Bäumer's work. In her life, the aesthetic and the mystic merge more and more into a single current.

It would also be tempting to apply the term *sāmarasya* to a description of the double religious affiliation of Bettina Bäumer. Then one would use a formula of inter-spiritual enthusiasm like: 'In her, the two religious streams of Christianity and Hinduism merge into each other'. But it is not so easy. This enthusiasm would ignore the fundamental distinctions of the exoteric dimensions of both religions — of the beliefs, doctrines, rituals, practices in Christian and Hindu traditions, the different cultural horizon and background of India and the West which form the cognition and experience of reality and which we cannot leave so easily.

The horizons do not fuse. Rather — to use Gadamer's famous phrase of the 'fusion of horizons' in a different way — one has to attain the open, empty 'sky' (*kha*), where the horizon expands without any limit. One has to attain that state of mind where it 'moves

in the open, unlimited sky' (*khecarī*, cf. *Parātrīśikā-Tantra*, *śl.* 1), where one attains the whole, undivided, integral state, the identity (*samatva*) with the Whole, the Divine: *khecarī-samatā* or *sāmarasya*. According to the Kashmirian *svatantraśivādvayavāda*, the 'doctrine of non-duality of the free (autonomous) Śiva' (Kṣemarāja: *Spandasaṁdoha*), this state is denoted as 'absolute freedom' (*svātantrya*), including the freedom from all limits of names, concepts, forms. It is only in this state that the borders of one's own cultural and religious horizon can be overcome — this is stated in the face of the denial of this possibility by the mainstream of postmodern philosophy. Of course, if one has entered this state — the dimension of timelessness, thoughtlessness — afterwards one will again return into the dimension of the duality, of the differences of religions. But one will view and experience this fact in a different way.

One systematic consequence of the Advaita experience for the Theology of Religions is, in our opinion, this: It has to overcome the struggle alternating between 'plurality' and 'unity', in order to be based on a more complex ontological model which is able to integrate the richness of the plurality of the world — including the manifold religious expressions — and the unity of reality. The Advaita 'experience', the state of this union itself, provides the structure of such an ontology, as we find with Abhinavagupta: the complete fusion (*sāmarasya*) of the manifoldness, plurality of reality (Śakti-dimension) with the fundamental unity of reality (Śiva-dimension), and at the same time even the transcendence of this fusion.

Like Thomas Merton, Abhishiktananda, Raimon Panikkar, Hugo Enomyia-Lassalle and others before her, Bettina Bäumer represents an interreligious dialogue which (in terms of Kashmir Śaivism) has this state of *sāmarasya*, of diving and dissolving in the divine *rasa* — pure joy, the essence of all — as its starting point, and which leads to a different perception of the exoteric dimension of the religions, of reality as a whole.

The three chapters of this book represent the main fields of the work of Bettina Bäumer:

1. Indian Philosophy and Spirituality,
2. Indian Arts and Aesthetics,
3. Interreligious Dialogue.

Her important contributions to all these areas express on the one hand the original integral vision of the Indian traditions and culture and the broadness of her interests and work, on the other hand, her privileged position of being in two cultures and religious traditions and in two academic worlds which she brings together in an authentic dialogue.

This Felicitation Volume is an expression of recognition of the work of Bettina Bäumer over the last forty years — as an eminent scholar, who entered deeply into Indian Culture and Spirituality, as one of the foremost expounders of non-dualistic Kashmir Śaivism, and as an important figure in the field of interreligious dialogue. It is a tribute to her outstanding work and personality. But at the same time it is an expression of friendship

— of our personal gratitude, respect and friendship to Bettina Bäumer, but first of all of the friendship and manifold relations between her and the authors of this volume. In this way the book reflects one of the many charismata of Bettina Bäumer, the charisma of friendship. It makes visible a fact which often escapes one's notice: that academic work and especially interreligious dialogue is based on friendship and personal relations. The broad range of contributors from four continents — Asia, Europe, Australia and North America — reflects her life and work in the last forty years: to build and to represent a bridge between India and the West, among the different intellectual, cultural and religious spheres.

So it is our hope that — like the work of her life — this book with its manifold voices from India and the West shall also contribute to the open exchange between the cultures, based on mutual respect and recognition, and to a 'Cultural Disarmament' (Raimon Panikkar), a 'disarmament' of the prevailing culture, the modern West. It should contribute to an overcoming of a destructive 'monoculturalism' (one single culture: the modern West and its values), 'mono-economism' (one single economic model: politically unleashed capitalism), 'monolingualism' (one single language: English), an absolute monism of power and other fundamentalisms of the 'single one' — in a *non-fundamentalist* way. It should contribute to the celebration of life in its manifoldness, of the whole, vibrating pluri-singular reality, essentially full of light, joy and beauty.

On this special occasion of Bettina Bäumer's 65th birthday we wish her many more years full of the *rasa* of joy and inspiration!

Sadananda Das
Ernst Fürlinger

Acknowledgements

The editors would like to thank the following personalities:

- Dr. Anjan Chakraverty (Varanasi) for his creative inspiration and practical support of the design of this book, especially of the cover;

- Sri Shashank N. Singh (Varanasi) who made available the painting for the cover of the book, in his well-known generosity;

- Assistant Professor Dr. Franz Wöhrer (University of Vienna), the translator of the complex article of Professor Alois M. Haas from German to English, for his precious contribution;

- the director of Bharat Kala Bhavan, Dr. T.K. Biswas, for permitting us to print paintings of their collection.

- Michael Ianuzielo (Montreal/Varanasi) and John Campbell (New York) for their committed and accurate language editing;

- David Peters (Vienna), Dr. Ulrich Winkler and Michael Bäumer (Salzburg) who helped us to find old and new photos of Bettina Bäumer;

- Pt. M.L. Kokiloo (Delhi) for providing us the motto for this volume;

- the publisher, Sri Susheel K. Mittal, for his cooperation, patience and encouragement;

- the authorities of the 'Alice Boner Institute' (Varanasi), for allowing us to use their facilities for the preparation of this volume;

- all contributors who were kind enough to accept our invitation.

Lokayātrā
A Pilgrimage in Two Cultures

Bettina Bäumer at the foot of Mt. Kailāsa,
Darchen, October 1998
(Photo: Susanne Ris).

Lokayātrā
A Pilgrimage in Two Cultures

ātmā mama bhavadbhaktisudhāpānayuvā'pi san
lokayātrārajorāgātpalitairiva dhūsaraḥ
"My hair has become grey
from the dust of my pilgrimage through this world,
but my soul is still young,
having drunk the nectar of your love."
— Utpaladeva: *Śivastotrāvalī* 1.2

BETTINA Bäumer was born on the twelfth of April, 1940 in Salzburg (Austria), the daughter of Professor Eduard Bäumer (1892-1977), a noted painter and professor of Visual Arts in Vienna, and Valerie Bäumer (née Feix, 1898-1982).

During Second World War the family was persecuted by the national-socialist regime in Austria. Her mother, being of Jewish origin, had to escape with her three children, Bettina, Angelica and Michael. The family hid in a village in the mountains, where they were protected by a Catholic priest, at the risk of his own life, till the end of the war in 1945.

From the age of ten she studied cello at the Academy of Music 'Mozarteum' in Salzburg. At the age of twelve, Bettina had a mountaineering accident, resulting in a protracted convalescence; she herself considers this to be the beginning of her spiritual quest. The parents had interests that included Indian spirituality, mainly Gandhi, Tagore and Krishnamurti, and in such alternative lifestyles as vegetarianism. Largely, it was the personality of her father, with his love of solitude, nature, silence, philosophy, mysticism, and his lifelong search for an authentic, radical life beyond the borders of conventions and common values, which influenced the direction of her life.[1] After high school, besides music she began to study philosophy and theology at the universities of Salzburg and Vienna.

1. See her intimate portrait of the father, the painter Eduard Bäumer: "Himmel — Erde — Meer: Die Spiritualität eines Malers", in: *Eduard Bäumer*, Salzburg: Verlag Galerie Welz, 1992, pp. 403-23.

In 1961, in the open, artistically-inclined environment of her parent's home, she met the Indian priest Raimon Panikkar (b. 1918 in Spain), who became one of the leading thinkers of interreligious dialogue. She was attracted by Indian philosophy and spirituality and, inspired by his personality, she decided to study Comparative Philosophy and Religious Studies with him in Rome (Italy). Having been brought up as a Protestant, she entered the Catholic Church in January 1963, at the time of the beginning of Vatican II, in a ceremony in the catacombs of Rome.

In Rome, Raimon Panikkar told her of the French Benedictine monk Henri Le Saux (of the Indian appellation Swami Abhishiktananda, 1910-73), and of his project, conceived with Abbé Jules Monchanin, of a Christian *āśrama* in Shantivanam near Kulitalai in south India, which was founded in 1950. She read Abhishiktananda's book, *Ermites du Saccidānanda* (1956) about his ideal of a Christian integration of the Hindu monastic tradition (*saṁnyāsa*) and his vision of a spiritual encounter between Christian and Hindu traditions. Fascinated by his ideas and lifestyle, she travelled to India for the first time in the autumn of 1963 via Bombay and met him in Shantivanam. His influence would inspire her towards a contemplative life in India, and he remained one of her ideals and role models in her approach to Hindu spirituality. During her first journey to India she met Indian philosophers like T.M.P. Mahadevan in Madras, and visited the Ashram of Ramana Maharshi in Tiruvannamalai. Abhishiktananda advised her to first finish her studies and thereafter return to India, which she did.

After completing her Ph.D. in philosophy in Munich (Germany) under the guidance of one of the most important Catholic theologians and philosophers in the twentieth century, Karl Rahner, she immediately returned to India with an exchange scholarship from the Government of India, and settled in Varanasi (north India). She chose Varanasi as it is a centre of traditional learning. Here she studied with Professor K. Sivaraman, her post-doctoral advisor at Banaras Hindu University, as well as with such traditional *paṇḍit*s as Ambika Datta Upadyaya, Ram Shankar Bhattacharya, and, for a short time, with M.M. Gopinath Kaviraj, as well as with scholars including P.Y. Deshpande and Thakur Jaideva Singh. She collaborated closely with Raimon Panikkar who was, at this time, also affiliated with the Banaras Hindu University. One result of this cooperation was the English translation and study of a selection of the Vedas published in 1977 under the title 'The Vedic Experience' by Raimon Panikkar.[2] With a brief interruption from 1975-79, when she worked as the assistant of Professor Gerhard Oberhammer at the Institute of Indology in Vienna and lecturer in Sanskrit, she has lived in Varanasi until the present day.

2. *The Vedic Experience. Mantramañjarī. An Anthology of the Vedas for Modern Man and Contemporary Celebration*, ed. and tr. with introduction and notes by Raimundo Panikkar, with the collaboration of N. Shanta, M. Rogers, B. Bäumer, M. Bidoli, London: Darton, Longman & Todd, 1977; 1st Indian edn.: Pondicherry: All India Books, 1983.

She herself translated the *Yogasūtras* of Patañjali (1976) which became the standard German translation of this important text, as well as a selection of the Upaniṣads (1986) into German.

Until his death in 1973, after a heart attack in Rishikesh, Bettina Bäumer was in close contact with Abhishiktananda who was a *guru* for her as well as a partner in dialogue, especially concerning the relationship between Hinduism and Christianity. After the death of this learned ascetic, Raimon Panikkar decided together with her to establish the 'Abhishiktananda Society',[3] which should look after the spiritual and theological heritage of Abhishiktananda, primarily in form of the publication of his writings.[4] Following the presidency of Panikkar, she has been the president of the Society since 1988. Under her direction the Society held three interreligious seminars:

- 'Mysticism: Śaiva and Christian' in Rajpur (Dehra Dun) in November 1990;[5]
- 'Śakti and Pneuma' in Bangalore in 1994;
- '*Śūnya, Pūrṇa, Plerôma*. Void and Fullness in the Buddhist, Hindu and Christian Traditions' in Sarnath in December 1999, with the participation of the XIVth Dalai Lama, Tenzin Gyatso.

These seminars, with their combination of academic lectures, discussions, silent meditation, recitation of scriptures of different traditions, human encounter and artistic performances, represent a model for interreligious gatherings which integrates the additional dimensions of an authentic religious dialogue.

In Varanasi, she collaborated with the Swiss sculptor and painter Alice Boner (1889-1981) who first came to India in 1929 and settled in Varanasi in 1936, becoming an important scholar and interpreter of Indian sculpture and temple architecture.[6] After her death, the 'Alice Boner Institute for Research on Fundamental Principles in Indian Art' was established in Varanasi by a Swiss foundation. In 1979 Bettina Bäumer was given the directorship of this new institute, a position which she kept until her retirement in 2000. In this context, she studied the temple architecture of Orissa as well as the Śilpa

3. Website: www.abhishiktananda.org

4. Selected titles of Swami Abhishiktananda: *Saccidananda: A Christian Approach to Advaita Experience* (1974); *The Further Shore* (1975); *The Secret of Arunachala* (1979); *Ascent to the Depth of the Heart. The Spiritual Diary (1948-73) of Swami Abhishiktananda* (1998).

5. Published as: Bettina Bäumer (ed.), *Mysticism in Shaivism and Christianity*, Delhi: D.K. Printworld, 1997.

6. Selected titles of Alice Boner: *Principles of Composition in Hindu Sculpture: Cave Temple Period*, Leiden: Brill, 1962; ed. (together with S. R. Śarmā) *Śilpa Prakāśa. Medieval Orissan Sanskrit Text on Temple Architecture* by Rāmacandra Mahāpātra Kaula Bhaṭṭāraka, Leiden 1966; rev. edn., Delhi, 2005; (together with Sadasiva Rath Sarma) *New Light on the Sun Temple of Koṇārka. Four Unpublished Mansucripts Relating to Construction, History and Ritual of this Temple*, Varanasi: Chowkhamba Sanskrit Series Office, 1972; (together with S.R. Sarma and B. Bäumer) *Vāstusūtra Upaniṣad. The Essence of Form in Sacred Art*, Delhi: Motilal Banarsidass, 1982; Georgette Boner, Luitgard Soni, and Jayandra Soni (eds.), *Alice Boner: Diaries. India 1934-1967*, Delhi: Motilal Banarsidass, 1993.

and Vāstuśāstras, some of which she translated from Sanskrit and published with illustrations. She did extensive fieldwork in Orissa in its artistic and religious traditions. From the inception of the 'Indira Gandhi National Center for the Arts' (IGNCA) in 1986 in Delhi, she collaborated with Dr. Kapila Vatsyayan, the academic director of this institution, in elaborating the programmes of a lexicon of fundamental concepts of Indian Arts (Kalātattvakośa) and of a series of texts on the Indian Arts (Kalāmūlaśāstra), and edited the first three volumes of Kalātattva-kośa (1988ff). She established the Varanasi branch of the IGNCA of which she remained the Honorary Coordinator from 1987 till 1995. In addition to all these academic activities, her office at Assi Ghat in Varanasi remains a fixed meeting point for scholars and students from all over the world, "always ready to offer intellectual and practical advice to all wandering Indologists in that which is the most terrible and sublime city of the world".[7]

Maybe it is the heritage of her parents, with their alternative lifestyle and vision, that she remains in contact with grassroots movements which struggle for a social reform, e.g., with Nirmala Deshpande, S. Sundaram and other representatives of the spirit of Gandhi in India. Important for her was also a long friendship with Agnes Kunze (1923-98), an outstanding social worker from Germany, who settled in 1961 in India to live and work in a leprosy colony, also establishing a weaving cooperative with cured leprosy patients in 1971[8]— a social activist, poet,[9] painter, passionate smoker (of tobacco) and spiritual person.

When Bettina Bäumer went to India, she had to abandon her beloved cello. It was a deferred gift from the Indian culture that she could later return to music, when she studied Indian classical music with Professor Prem Lata Sharma (1927-98), one of the most important Indian musicologists, at Banaras Hindu University. Since many years she has studied vocal music with her friend, the singer, teacher, and spiritual personality Smt. Manju Sundaram, as regularly as possible.

Bettina Bäumer's academic career brought her as a Lecturer to universities in India (Banaras Hindu University, 1972-74; Central Institute of Higher Tibetan Studies, Sarnath, 1985-87), as a Senior Research Fellow to Harvard (USA, 1994), as a Visiting Professor to Universities in Germany (Frankfurt, 1986), Austria (Vienna and Salzburg, between 1995 and 2003) and Switzerland (Bern, 1997-99). From 1982 till 1990 she was member of the 'Équipe de recherche' (research group) on Hinduism under the direction of André Padoux, at the 'Centre National de la Recherche Scientifique' (CNRS) in Paris. In recognition of

7. Gian Guiseppe Filippi, *Mṛtyu — Concept of Death in Indian Traditions*, tr. Antonio Rigopoulos (Reconstructing Indian History and Culture; 11), Delhi: D.K. Printworld, 1996, v-vi (preface).

8. K.K.M. Handweaving, 11 Nalapani Road, Dehra Dun — 248001, U.A., India. E-mail: kkmhandweaving@yahoo.com.in

9. Collections of poems of Agnes Kunze in German: *Verwobene Hoffnung*, Mainz: Grünewald, 1988; *Verdschungelter Glaube*, Eigenverlag: Verein Arbeitsgruppe 3. Welt Hard, 1998.

her manifold publications and scholarly work, she obtained the Qualification for Professorship (Habilitation) at the Institute for the Study of Religions, University of Vienna in 1997. It was surely a high point of her academic achievements when her contribution to the dialogue of religions and Religious Studies was awarded with a *Doctor honoris causa* from the University of Salzburg (Austria), Faculty of Catholic Theology, in 2002. Remarkably enough, she was the first woman to receive an honorary doctorate in the 380 years history of this Faculty.

As a Christian, she wanted to enter more deeply into Hindu spirituality and to proceed on her spiritual path for which, according to the Hindu view, a *guru* is essential, be he alive or already out of his body. She found him first in Śrī Ramaṇa Maharṣi (1879-1950), one of the greatest Indian sages in the twentieth century who, though she never met him during his life, was an important source of spiritual inspiration for her. In Varanasi she met Ānandamayī Mā (1896-1982) and heard Jiddu Krishnamurti whenever they visited Varanasi. But her search for an authentic *guru* (*sadguru*) was fulfilled when she met the last master (*ācārya*) of non-dualistic Kashmir Śaivism, the great *yogī* and *paṇḍit* Swami Lakshman Joo (1907-91), in 1986 in his *āśrama* near Srinagar. She received initiation (Śaiva *dīkṣā*) from him one year later.[10] It was this great master who opened for her the understanding of the texts and their spirituality.

Since then she has integrated her academic studies of non-dualistic Kashmir Śaivism, which she had first approached in 1977, and her personal practice in this spiritual lineage. She combines both an academic approach to Śaivism and a dialogue on the level of spiritual experience. As such, her approach to Śaivism exemplarily represents a new dimension of Religious Studies wherein the sharp distinction between an objective perspective from the 'outside' and a religious perspective from the 'inside' is overcome.

She has translated a selection of six chapters of *Tantrasāra* (1992) of the Kashmiri master Abhinavagupta (eleventh century), the main author of non-dualistic Śaivism, together with his *stotra*s. She has also translated into German one of the basic Tantras of this school of Śaivism, the *Vijñānabhairava* (2003), and has edited Swami Lakshman Joo's English commentary to the same *tantra* (2002), as well as Abhinavagupta's *Parātrīśikā-Vivaraṇa* with the English translation of Jaideva Singh (1988). A collection of her articles on Kashmir Śaivism was published in German in 2003. Every summer she teaches a text of this school in a retreat centre in the mountains of Salzburg, combined with meditation. In 1995 she founded the 'Trika Interreligious Trust' which organizes an annual international workshop on the non-dualistic Śaivism of Kashmir in Varanasi.[11] The Trust awards the 'Jaideva Singh Award' for merit in research and teaching Kashmir

10. See her personal report: 'How I met my Master', in: *Śraddhārcana*, ed. Prabha Devi, New Delhi: Paramarthika Charitable Trust, 1998, pp. 217-22.

11. Contact: Trika Interreligious Trust, 'Guptaganga', N-1/66, F-12 Nagawa, Samneghat, Varanasi-221005. E-mail: trika@sify.com.

Śaivism, for the first time in 2003 to Pandit H.N. Chakravarty (Varanasi), and in 2004 to Prabha Devi (Srinagar/New Delhi).

A significant expression of her religious orientation can be found in three of her numerous pilgrimages in India and Europe. One pilgrimage she undertook in 1962 from Assisi to Laverna (Italy), two major places in the life of the 'second Christ', Francis of Assisi (1182-1226), who represents a Christianity of poverty, non-violence and the experience of the unity of all beings. Between 1981 and 1984 she went on pilgrimages to the sources of Gaṅgā, and in 1998 to Kailash-Manasarovar, for the Śaivites the embodiment of Śiva, the most sacred mountain of the Hindus, Buddhists, Jainas and the followers of Bön.

A practitioner and member of a spiritual lineage of Śaivism, she has not abandoned her Christian origins, her deep interest in Christian mysticism and her love of the rite and spirituality of the Eastern Church, which is expressed in her relation to the Byzantine liturgy in the Benedictine Monastery in Niederaltaich (Bavaria) and her friendship with its former Abbott Emmanuel Jungclaussen.[12] In this way she is, like Swami Abhishiktananda and Raimon Panikkar before her, a bridge between the two religious worlds, or — more accurately and dynamically — an example of fording the river between the two shores, without any fixed connection. Diving into the depths of Reality, she enters the true meeting point of the spiritual traditions, in the 'cave of the heart'[13] — that dimension where all is silent, lonely and secret, and where all labels, names, images, forms, terms, and concepts find their end. Unlike Abhishiktananda, who was related to Advaita Vedānta, she is one of the pioneers of a Christian encounter with Hindu Tantrism (Kuṇḍalinī-Yoga). After centuries of misunderstanding, prejudices and apologetics by Western and Indian interpreters, Bettina Bäumer represents a recognition and discovery of the philosophical, theological and spiritual significance and richness of this stream of Hinduism, based on profound academic study, close contact with the Śaiva tradition in Kashmir and spiritual insight.

Ernst Fürlinger

12. See especially her lectures in Kyoto (Japan) in 1987, 'A Journey with the Unknown', published in: *Spirituality in Interfaith Dialogue*, ed. Tosh Arai, Wesley Ariarajah, Geneva: WCC Publications, 1989, pp. 36-41; and in Brussels (Belgium) *'Sivaite et chrétienne? Une expérience entre deux traditions religieuses'*, published in: Voies de l'Orient (Brussels) no. 82 (Janvier-Février-Mars 2002), pp. 2-8.

13. See Swami Abhishiktananda: *Hindu-Christian Meeting Point — within the cave of the heart* (orig. Paris 1965), tr. Sara Grant, Delhi: ISPCK, 1969, rev. edn. 1976. The Upaniṣadic motive of the 'cave' is an important theme in Bettina Bäumer's work; see her article: 'From Guhā to Ākāśa: The Mystical Cave in the Vedic and Śaiva Traditions', in: Kapila Vatsyayan (ed.), *Concepts of Space: Ancient and Modern*, New Delhi: Indira Gandhi National Centre for the Arts/Abhinav Publications, 1991, pp. 105-22.

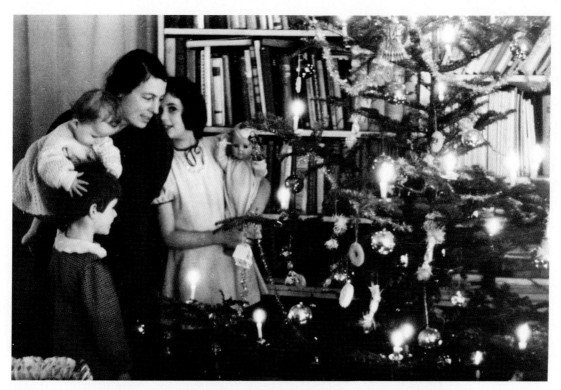

Pl. 1. Family at christmas 1940 (Photo: Eduard Bäumer).

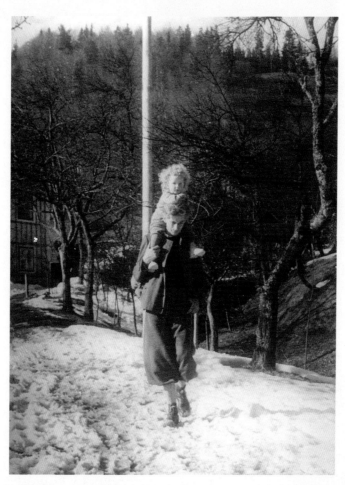

Pl. 2. Father and daughter, Salzburg countryside, *ca.* 1942.

Pl. 3. At the age of two - Salzburg 1942
(Photo: Eduard Bäumer).

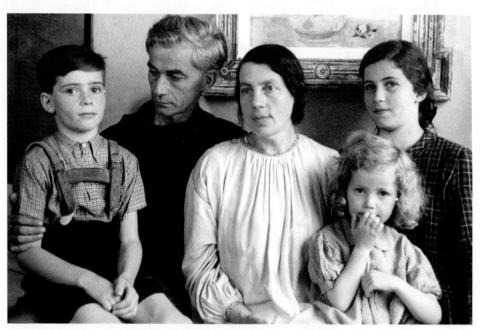

Pl. 4. The family in their house in Salzburg, 1943:
Michael, Eduard, Valerie, Bettina and Angelica Bäumer.

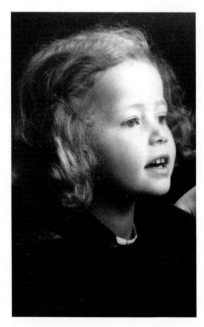

Pl. 5. At the age of five (Photo: Eduard Bäumer).

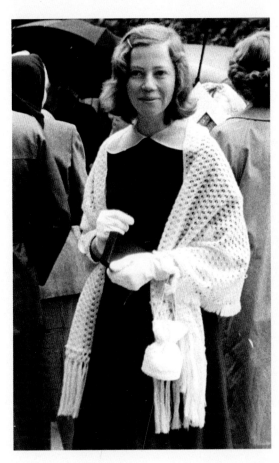

Pl. 6. Confirmation, 1955.

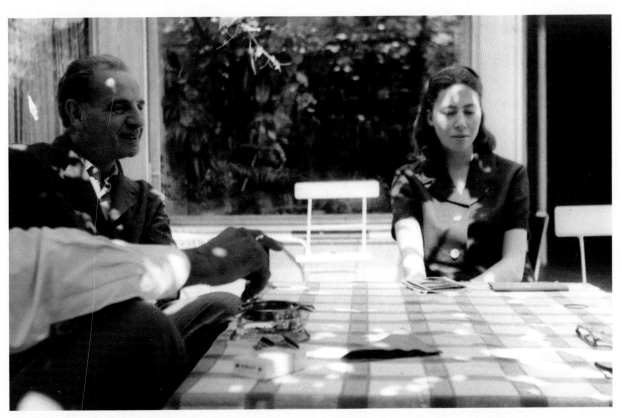

Pl. 7. With the philosopher Alfons Rosenberg, Salzburg, 1959.

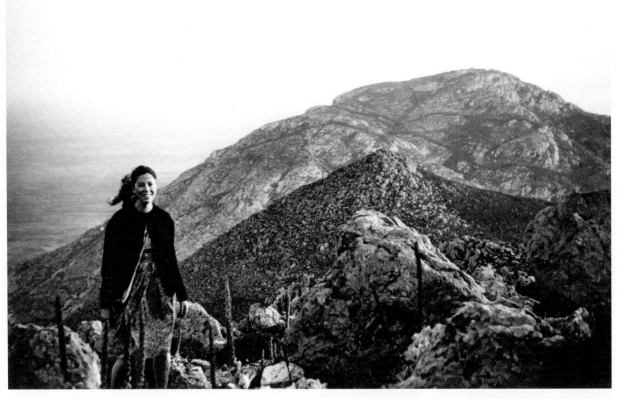

Pl. 8. Retreat at the Island of Patmos, Greece, Sept. 1964, after her first journey to India
(Photo: Roselyne Lombard).

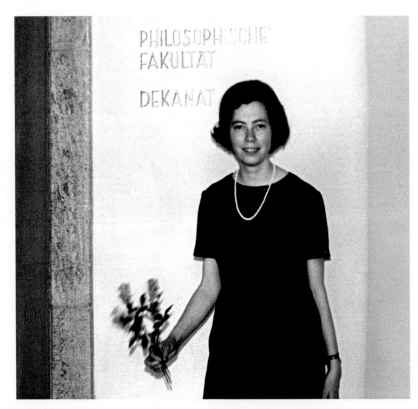

Pl. 9. Receiving her Doctorate (Ph.D.) at the University of Munich (Germany), June 1967.

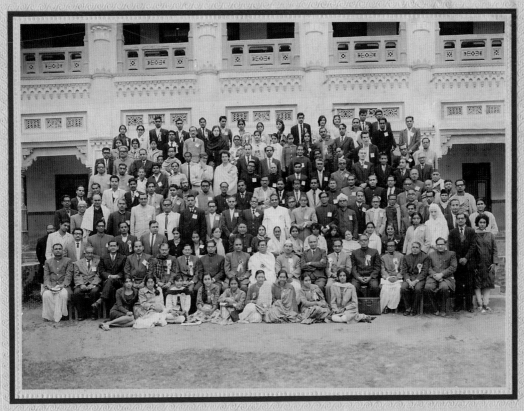

Indian Philosophical Congress
41st SESSION
BANARAS HINDU UNIVERSITY
DECEMBER, 1967

Ground :— , Km. Vijaya Shree Pandey, Devi Priya Sen, Miss Kanya Sen Gupta, Usha Kiran Jain, Pratima Gupta, Munni Kumari Agrawal.
Chairs :—Dr. R. K. Tripathi, Dr. B. G. Tiwari, , Prof. A. Jha (Treasurer), Dr. A. G. Javdeker (Jt. Secretary), Dr. N. K. Devaraja (Local Secretary) Prof. A. K. Mazoombar (General Secretary), Dr. T. R. V. Murty (Vice Chairman, Reception Committee), Dr. Kalidas Bhattacharya General President), Dr. B. L. Atrey, Prof. J. N. Chubb, Dr. Rajendra Prasad, Dr. R. C. Pandey (Sectional President), S. Chakravarty, G. C. Joshi, Dr. S. R. R. Bhandary (Treasurer Reception Committee), , Mrs. Srivashan,
1st Row Standing :— Nirmal Bardhan, S. P. Singh, P. K. Sen, G. V. Ratu, B. N. Tripathi, Dr. Shivraman, Miss S. Kaur, Dr. Uma Gupta, Dr. (Mrs.) S. Basu, R. K. Chaubey.
Miss Chhanda Biswas, Km. S. Tewari, Km. S. Tewari, Mrs Usha Pal, Mrs. D. Dutt, Mrs. V. W Abluwalia, Kum. S. H. Divetia, Mother Grant, S. C. Biswas, N. C. Padbi.
2nd Row Standing :—G. V. S L. Narasimharaju, , Pandit Y. D. Shastri, Dr. S. P. Singh, Dr. H. N. Joshi, H. N. Srivastava, Khwaja M. A. Hay (Dehli), Dr. J. A. Yajnik Prof. Umesh A. Yajnik Dr. S. Banerjee, , Prof. Bhupendranath, Dr. S. S. Sharma, Prof. G. S. Nair, , Prof. D. G. Shastri, , Dr. S. R. Sundaram Iyangar, Dr. K. N. Upadhyaya, Sri L. K. Aravakar,
Dr. A. K. Mukherjee, Prof. K. Baksi, Dr. G. C. Nayak.
3rd Row Standing :—Dr. L. N. Sharma, R. R. Pandey, Prof. S. Jha, Prof. R. R. Sahay, A. P. P. Tungesh, N. C. Padhi, Alan Unterman, Prof. D. N. Gandhi, Prof. M. Chakravarty, Dr. M. Prasad, Prof. J. P. Atreya, S. K. Johri, A. K. Chatterjee, Dr., Dr. B. K. La'. Dr. H. Maheshwari, Dr. K. C. Sogani, Dr. R. S. Mishra, Dr. K. S. Srivastava,
Dr. G. Ignatius,
4th Row Standing :— Dr. K. P. S. Choudhary, Prof. A. K. Verma, B. K. Pandey, , Nitin J. Vyas, R. G. Olsew, R. M. Reed, , M. B. Srinivasan, Prof. R. N. Mishra, Prof. B. S. Sanyal, Prof. D. M. Patel, J. C. Hindley.
5th Row Standing :—C. P. M. Namboodiri, R. R. Dravid Dr. Santosh Kumar, , A. Gupta, , Dr. S. M. Tewary, , Checko Valiaveetil, Dr. Francis J. Vadketh, Dr. S. Mookerjee, Dr. R. K. Mittal.
6th Row Standing :— P. Gupta, Sheshi Wahal, S. Sanyal, Tufani Ram, Dr. S. Azzopandi, Miss Dr. B. Bammer, S. Mazoombar, Miss Ira Chatterjee, Miss. S. Bose. Munni Gaur Nirmala Tandon, Tr. B. Singh, Dr. R. Panikkar.
7th Row Standing :— Asha Sharma, Asuna Banerjee, A. P. Chaurasia, D. R. Yadav, R. B. Dubey, Ballabh Tripathi, Manorama Garg, Vijay Shree, G. Hingorani, R. C. Singh, Miss Kanak Khanna, Miss Vasanti Bhandari, , R. Tewari, , Prof. N. C. V. Raval. (Khaneja studio, Varanasi - 5.

Pl. 10. Indian Philosophical Congress with T.R.V. Murty, K. Sivaraman,
Kalidas Bhattacharya, Sr. Sara Grant, Bithika Mukerji; Varanasi, December 1967
(second row from top, sixth from the left).

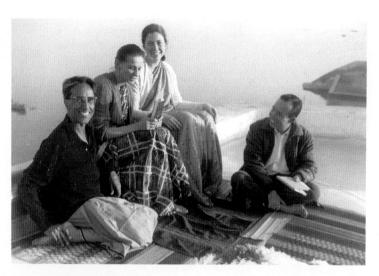

Pl. 11. With R. Panikkar, N. Shanta,
E. Aguilar on Panikkar's terrace,
Varanasi, 1968.

Pl. 12. With Swami Abhishiktananda, Varanasi, 1970.

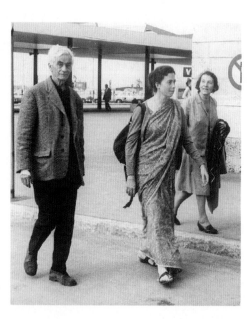

Pl. 13. Munich Airport, with parents, April 1970.

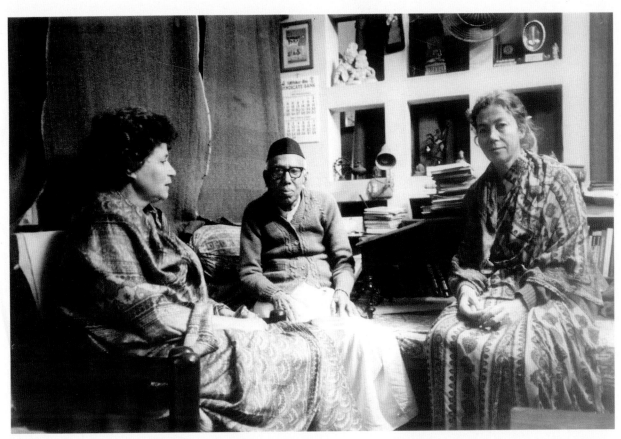

Pl. 14. With Jaideva Singh and sister Angelica Bäumer Varanasi, 1985 (Photo: David Peters).

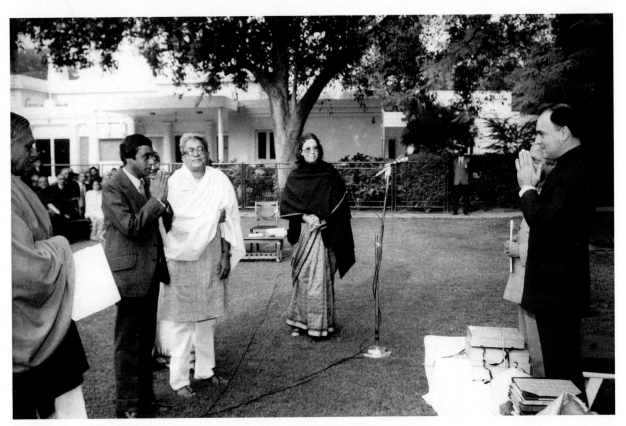

Pl. 15. Book release with Prime Minister Rajiv Gandhi, New Delhi, 1988.

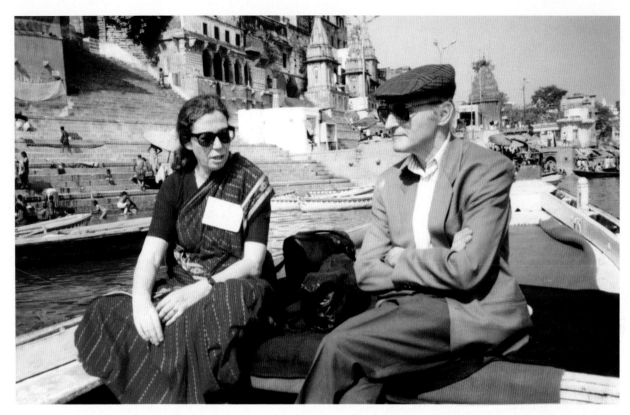

Pl. 16. With Austrian Ambassador, Dr. Christoph Cornaro, Varanasi, 1993.

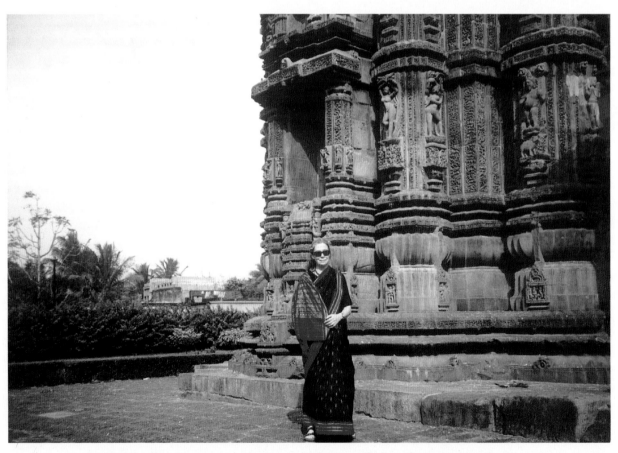

Pl. 17. Bhubaneswar, Rājārānī Temple (Photo: Sadananda Das).

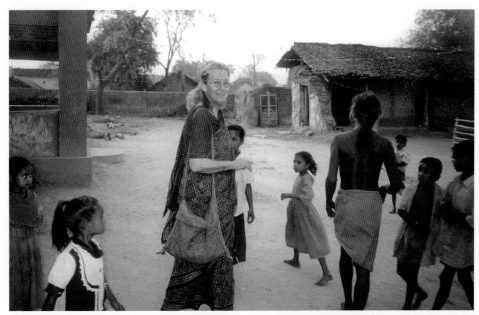

Pl. 18. Khaliapali, Orissa, in the Ashram of Bhima Bhoi, 2002.

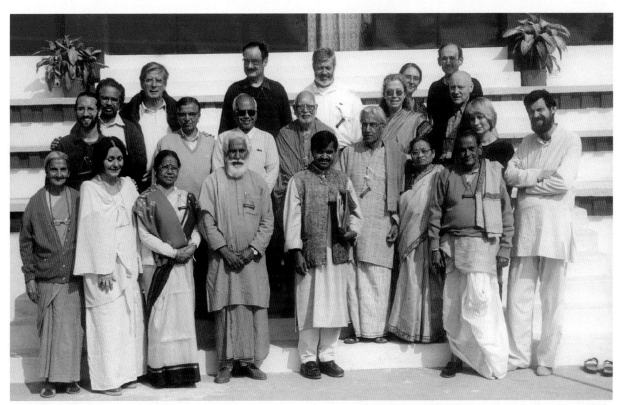

Pl. 19. Seminar on "Śūnya – Pūrṇa – Plerôma," part of the group, Sarnath, December 1999.
First row from left: Vandana Mataji, Milena Pavan, Rama Ghose, Swami Magni Ram Shastri,
Sadananda Das, Raimon Panikkar, Nirmala Deshpande, H.N. Chakravarty, Jacques Vigne.
Second row from left: N.N., M.L. Kokiloo, D.B. Sen Sharma, Swami Nityananda Giri,
Bettina Bäumer, Alois M. Haas, Paula Arvio.
Third row from left: Fr. Anthony Kalliath, Fr. Paddy Meagher, Roland Ris,
Rev. John Dupuche, Christiane Handl, Johann Figl.

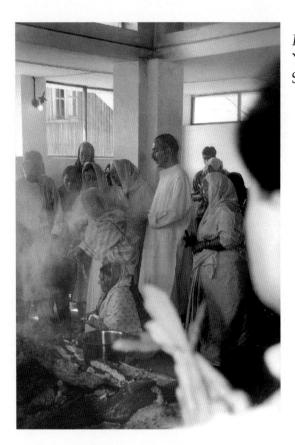

Pl. 20. Ishvar Ashram, Srinagar,
Yajña for Swami Lakshman Joo,
September 2003 (Photo: Ernst Fürlinger).

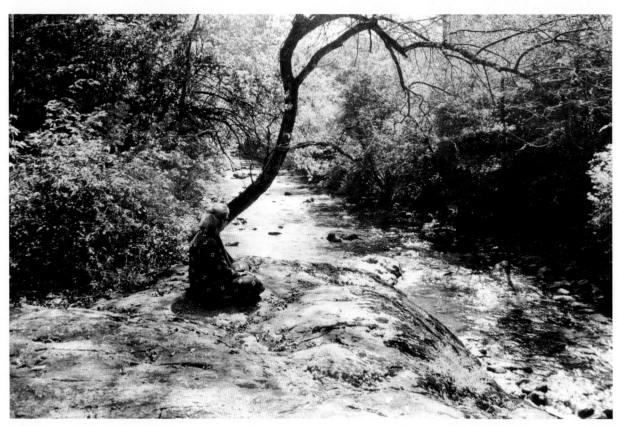

Pl. 21. Kashmir, Shankarpal (Rock of the Śivasūtras), September 2003.

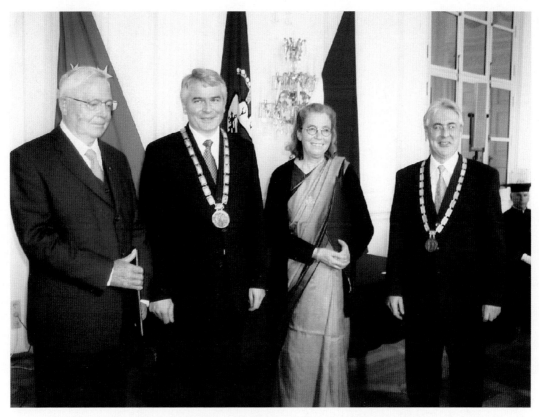

Pl. 22. Award Ceremony *Doctor honoris causa*,
University of Salzburg. From left: Prof. Otto Kaiser,
Prof. Heinrich Schmidinger (Vice-Chancellor), Dr. Bettina Bäumer,
Prof. Friedrich Schleinzer (Dean, Theological Faculty), (Photo: David Peters).

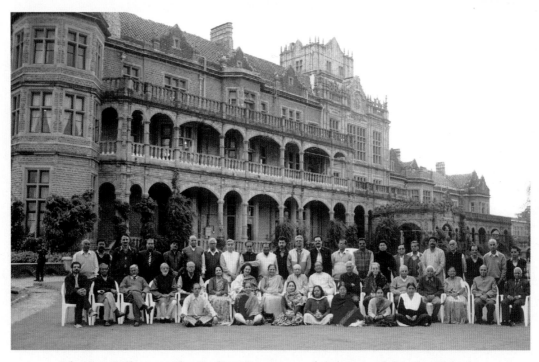

Pl. 23. Fellow at the Indian Institute of Advanced Study, Shimla,
with Chairman Prof. G. C. Pande and Director Prof. Bhuvan Chandel, October 2004.

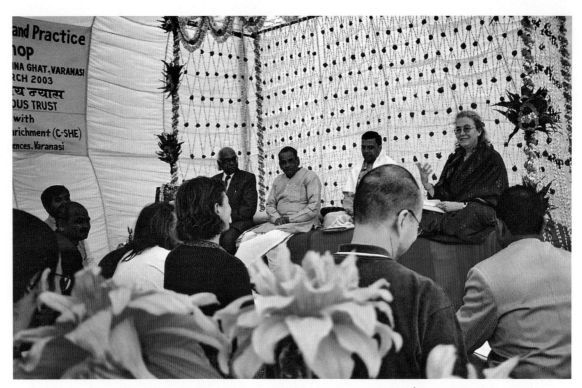

Pl. 24. International Workshop on Kashmir Śaivism,
organized by Trika Interreligious Trust, Varanasi, February 2003.
Opening Ceremony with Pt. Hemendra Nath Chakravarty, Pt. Kamalesh Jha
(Photo: Ernst Fürlinger).

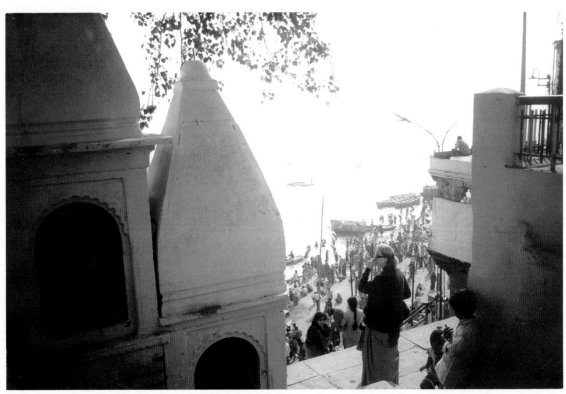

Pl. 25. Varanasi, Tulsī Ghāṭ, spring 2003 (Photo: Ernst Fürlinger).

Bettina Bäumer
Achievements

Academic Qualifications

1959	'Matura' (High School Leaving Certificate), Salzburg
1959-67	University studies in Philosophy, Religion, Indology (Sanskrit), Theology and Music at the Universities of Salzburg, Vienna, Zürich, Rome and Munich
1967	Dr. Phil. (Ph.D.) in Philosophy from the University of Munich, thesis on *Creation as Play: The Concept of Līlā in Hinduism, its Philosophical and Theological Significance.*
1967-71	Post-doctoral research in Indian philosophy and Sanskrit at Banaras Hindu University (Varanasi)
1997	Habilitation (Qualification for Professorship) at the Institute for the Study of Religions, University of Vienna
2002	Awarded *Dr. honoris causa* from the University of Salzburg (Austria), Faculty of Catholic Theology.

Scholarships Held

1961	Exchange Scholarship from University of Zürich
1964-67	Scholarship from the Bavarian State Government, Munich
1967-71	Reciprocal Scholarship from the Government of India
1994	Senior Research Fellowship, 'Center for Study of World Religions', Harvard University (USA)

Positions Held

1972-74	Lecturer in German, Banaras Hindu University (Varanasi)
1975-79	Assistant and Lecturer in Sanskrit, Institute of Indology, University of Vienna (Austria)
1979-2000	Research Director, 'Alice Boner Foundation for Research on Fundamental Principles in Indian Art', Varanasi
1982-90	Member of the 'Équipe de recherche' (research group) on Hinduism

under the direction of André Padoux, at the 'Centre National de la Recherche Scientifique' (CNRS), Paris

1985-87 Visiting Lecturer in German, 'Central Institute of Higher Tibetan Studies', Sarnath, Varanasi

1986 Visiting Professor at the University of Frankfurt (Germany), Summer Semester

1986-95 Honorary Coordinator, 'Indira Gandhi National Center for the Arts', Varanasi Office; since 1995 Honorary Consultant

1995, 1997, Professor in Religious Studies, University of Vienna (Summer Semester)
1999, 2001,
2002, 2003

1997-99 Visiting Professor and Head of the Department of Religious Studies, University of Bern (Switzerland)

2000, 2004 Visiting Professor, University of Salzburg (Summer Semester)

2000-02 Coordinator, Orissa Research Project ('Deutsche Forschungsgemeinschaft', Germany)

Oct/Nov 2003 Visiting Professor, Indian Institute of Advanced Study, Shimla

2004-05 Fellow, Indian Institute of Advanced Study, Shimla

1988 to present President of the 'Abhishiktananda Society' (Delhi)

Works Published

MONOGRAPHS

Schöpfung als Spiel. Der Begriff līlā im Hinduismus, seine philosophische und theologische Bedeutung, Philosophical dissertation, University of Munich, 1969.

Upanishaden: Befreiung zum Sein, Zürich: Benziger, 1986. Reprint as paperback: München: Heyne Taschenbücher, 1994. New edition: Upanishaden: Die heiligen Schriften Indiens meditieren, München: Kösel, 1998.

Abhinavagupta. Wege ins Licht. Texte des tantrischen Śivaismus aus Kaschmir, Zürich: Benziger, 1992.

Vijñāna Bhairava: Das göttliche Bewusstsein. 112 Weisen der mystischen Erfahrung im Shivaismus von Kashmir, Grafing: Edition Adyar, 2003.

Trika: Grundthemen des kaschmirischen Śivaismus, ed. Ernst Fürlinger (Salzburger Theologische Studien 21, interkulturell 1), Innsbruck/Wien: Tyrolia, 2003.

EDITED BOOKS

Patañjali: Die Wurzeln des Yoga. Die Yoga-Sūtren des Patañjali mit einem Kommentar von P.Y. Deshpande, München: O.W. Barth, 1976 (*German translation of the YS by Bettina Bäumer*).

Rūpa Pratirūpa. Alice Boner Commemoration Volume, New Delhi: Biblia Impex, 1982.

Abhinavagupta: *Parātrīśikā-Vivaraṇa. The Secret of Tāntric Mysticism*. English tr. with notes by Jaideva Singh, Delhi: Motilal Banarsidass, 1988, rpt.: 1996, 2000.

Kalātattvakośa. A Lexicon of Fundamental Concepts of the Indian Arts, vol. I: Pervasive Terms — *Vyāpti*, Delhi: Indira Gandhi National Center for the Arts/Motilal Banarsidass, 1988, rev. edn. 2001; vol. II: Concepts of Space and Time, Delhi: IGNCA, 1992; vol. III: Primal Elements — *Mahābhūta*, Delhi: IGNCA/Motilal Banarsidass, 1996.

Prakṛti. The Integral Vision, vol. 3: The Āgamic Tradition and the Arts, Delhi: Indira Gandhi National Center for the Arts/D.K. Printworld, 1995.

Mysticism in Śaivism and Christianity, New Delhi: D.K. Printworld, 1997.

Raimon Panikkar: Das Abenteuer Wirklichkeit. Gespräche über die geistige Transformation. Geführt mit Constantin von Barloewen und Axel Matthes, München: Matthes & Seitz, 2000.

CO-AUTHOR OF

The Vedic Experience. Mantramañjarī. An Anthology of the Vedas for Modern Man and Contemporary Celebration, ed. and tr. with introduction and notes by Raimundo Panikkar, with the collaboration of N. Shanta, M. Rogers, B. Bäumer, M. Bidoli, London: Darton, Longman & Todd, 1977; 1st Indian edn.: Pondicherry: All India Books, 1983.

Śilparatnakośa, A Glossary of Orissan Temple Architecture by Sthāpaka Nirañjana Mahāpātra, ed. and tr. in collaboration with Rajendra Prasad Das (Kalāmūlaśāstra Series; 16), Delhi: Indira Gandhi National Center for the Arts/Motilal Banarsidass, 1994.

Vāstusūtra Upaniṣad. The Essence of Form in Sacred Art by Alice Boner, Sadasiva Rath Sarma, Bettina Bäumer: Delhi: Motilal Banarsidass, 1982; 3rd rev. edn. 1996, 4th rev. edn., 2000.

Śilpa Prakāśa. Medieval Orissan Sanskrit Text on Temple Architecture by Rāmacandra Mahāpātra Kaula Bhaṭṭāraka. Introduction and Translation by Alice Boner and Sadāśiva Rath Śarmā (Leiden 1966), ed. together with Rajendra Prasad Das and Sadananda Das, Delhi: Indira Gandhi National Center for the Arts/Motilal Banarsidass, 2nd rev. edn., 2005.

(with Johannes Beltz), *Bhima Bhoi: Verses from the Void*, New Delhi: Oxford University Press, 2005.

(with John Dupuche), *Void and Fullness in the Buddhist, Hindu and Christian Traditions: Śūnya — Pūrṇa — Plerôma*, New Delhi: D.K. Printworld, 2005.

ARTICLES

1. 'Empirical Apperception of Time' (Appendix of Raimundo Panikkar: Time and History in the Tradition of India: Kāla and Karma), in: *Cultures and Time* (At the Crossroads of Cultures; 1) Paris: The Unesco Press, 1976, pp. 78-88.

2. 'Die Bedeutung der Tradition im Hinduismus': *Kairos* 20 (1978), pp. 218-33.

3. 'Die Unvermitteltheit der höchsten Erfahrung bei Abhinavagupta', in: Gerhard Oberhammer (ed.), *Transzendenzerfahrung, Vollzugshorizont des Heils*, Wien: Sammlung De Nobili, 1978, pp. 61-79.

4. 'Puruṣa and the Origin of Form', in: *Rūpa Pratirūpa*, pp. 27-34.

5. 'Einblicke in die indische Kunst: Das wissenschaftliche Werk von Alice Boner', in: Eberhard Fischer/Georgette Boner (eds.), *Alice Boner und die Kunst Indiens*, Zürich, 1982, pp. 71-91. In English: 'Insights into Indian Art. Alice Boner's Scholarly Work', in: *Alice Boner — Artist and Scholar*, Varanasi: Bharat Kala Bhavan, 1989, pp. 65-87.

6. 'Silpa-Sastra-Texte in Orissa', in: Eberhard Fischer, Sitakant Mahapatra, Dinanath Pathy (eds.), *Orissa. Kunst und Kultur in Nordost-Indien*, Zürich: Museum Rietberg, 1980, pp. 69-70.

7. 'Henri Le Saux — Abhishiktananda (1910-73)', in: Gerhard Ruhbach, Josef Sudbrack (eds.), *Große Mystiker. Leben und Wirken*, München: C.H. Beck, 1984, pp. 338-54.

8. 'The Divine Artist': *The Indian Theosophist*. Thakur Jaideva Singh Felicitation Number, vol. 82 (Oct.-Nov. 1985), nos. 10-11, pp. 79-86.

9. 'Pañjara et yantra: le diagramme de l'image sacrée', in : André Padoux (ed.), *Mantras et diagrammes rituels dans l'hindouisme*, ed. A. Padoux, Paris: Éditions du Centre National de la Recherche Scientifique, 1986, pp. 49-61.

10. 'Vena: A Mystical Hymn of the Atharvaveda', in: *Navonmeṣa. Mahāmahopādhyāya Gopinath Kaviraj Commemoration Volume*, IV: English, Mata Anandamayee Ashram, Varanasi, 1987, pp. 289-91.

11. 'Duḥkha und Ānanda: Zwei Grundansätze hinduistischer Lebenshaltung', in: *Von der Erkenntnis des Leides*, Wien: Picus, 1988, pp. 83-90.

12. 'Unmanifest and Manifest Form according to the Śaivāgamas', in: A.L. Dallapiccola (ed.), *Shastric Traditions in Indian Arts*, Stuttgart: South Asia Institute Heidelberg, 1989, pp. 339-49.

13. 'L'image divine: sa raison d'être et son effet selon la Vastusūtra Upaniṣad', in: André Padoux (ed.), *L'image divine. Culte et méditation dans l'hindouisme*, Paris: Éditions du Centre National de la Recherche Scientifique, 1990, pp. 143-49.

14. 'From Guhā to Ākāśa: The Mystical Cave in the Vedic and Śaiva Traditions', in: Kapila Vatsyayan (ed.), *Concepts of Space. Ancient and Modern*, New Delhi: Indira Gandhi National Center for the Arts/Abhinav Publications, 1991, pp. 105-22.

15. 'Can Diverse Religious Life-Worlds Be Shared?', in: T.S. Rukmani (ed.), *Religious Consciousness and Life-Worlds*, Shimla: Indian Institute of Advanced Study/Delhi: Indus Publishing Company, 1988, pp. 129-38.

16. 'A Journey with the Unknown', in: Tosh Arai, Wesley Ariarajah (eds.), *Spirituality in Interfaith Dialogue*, Geneva: World Council of Churches Publications, 1989, pp. 36-41.

17. 'The Guru in the Hindu Tradition': Studies in Formative Spirituality. *The Journal of Spiritual Formation*, vol. 11 (November 1990) no. 3, pp. 341-53.

18. 'Himmel — Erde — Meer: Die Spiritualität eines Malers', in: *Eduard Bäumer*, ed. by Hochschule für angewandte Kunst Wien, Salzburg: Verlag Galerie Welz, 1992, pp. 403-23.

19. 'The Play of the Three Worlds: The Trika Concept of Līlā', in: William Sax (ed.), *The Gods at Play. Līlā in South Asia*, New York/Oxford: Oxford University Press, 1995, pp. 35-49.

20. 'Vāc as Samvāda: Dialogue in the Context of Advaita Śaivāgamas', in: *La Parola creatrice in India e nel Medio Oriente. Atti del Seminario della Facoltā di Lettere dell"Universitā di Pisa, 29-31 maggio 1991* (Biblioteca di Filosofie e Religioni Comparate; 1) Pisa: Giardini, 1994, pp. 79-89.

21. 'Mudrā. Its Metaphysical Basis in Kashmir Śaivism', in: B.N. Saraswati, S.C. Malik, Madhu Khanna (eds.), *Art. The Integral Vision. A Volume of Essay in Felicitation of Kapila Vatsyayan*, New Delhi: D.K. Printworld, 1994, pp. 111-21.

22. The Rajarani Temple Re-identified': *India International Centre Quarterly* (Spring 1994), pp. 124-32.

23. 'Lines of Fire, Lines of Water: The Elements in Śilpaśāstra', in: *Prakṛti. The Integral Vision, vol. 3: The Āgamic Tradition and the Arts*, pp. 115-22. Spanish Translation: 'Lineas de fuego, lineas de agua. Los elementos en el *Śilpaśāstra'*, in: Chantal Maillard (ed.), *El Árbol de la vida. La Naturaleza en el Arte y las Tradiciones de la India*, Barcelona: editorial Kairós 2001, pp. 158-66.

24. The Relevance of Śilpa/Vāstuśāstra: *Gandhian Perspectives* (Varanasi), vol. 7 (spring 1994), no.1, pp. 23-28.

25. 'Sun, Consciousness and Time: The Way of Time and the Timeless in Kashmir Śaivism', in: Kapila Vatsyayan (ed.), *Concepts of Time. Ancient and Modern*, New Delhi: Indira Gandhi National Center for the Arts/Sterling Publishers, 1996, pp. 73-77.

26. 'Panikkar's Hermeneutic of Myth', in: Joseph Prabhu (ed.), *The Intercultural Challenge of Raimon Panikkar* (Faith Meets Faith) N.Y., Maryknoll: Orbis Books, 1996, pp. 165-76.

27. 'Aesthetics of Mysticism or Mysticism of Aesthetics? The Approach of Kashmir Śaivism', in: *Mysticism in Śaivism and Christianity*, pp. 329-49.

28. 'Reinkarnation und Karma in der religiösen Vorstellung des Hinduismus': *Religionen unterwegs* (Vienna), vol. 2 (May 1996) no. 2, pp. 10-16.

29. 'Universal Harmony: Samatā in Kashmir Śaivism', in: *Universal Responsibility. A Felicitation Volume in Honour of His Holiness the Fourteenth Dalai Lama, Tenzin Gyatso, on His Sixtieth Birthday*, ed. Ramesh Chandra Tewari, Krishna Nath, New Delhi: ANB Publishers, 1995, pp. 111-19.

30. 'The Way is the Goal. My Spiritual Journey between Christianity and Hinduism', in: Vandana Mataji (ed.), *Shabda Shakti Sangam*, Bangalore, 1995, pp. 267-69.

31. 'Disharmony — the Root of Evil in Kashmir Śaivism', in: Anand Amaladass (ed.), *The Problem of Evil*, Chennai: Satya Nilayam Publications, 1997, pp. 110-25.

32. 'A Few Methodological Remarks': *The Utkala Pradipa* (Bhubaneswar), vol. 2 (June 1998), no. 1, pp. 5-8.

33. 'Yoga and Art: An Indian Approach', in: B.N. Goswamy (ed.), *Indian Art: Forms, Concerns and Development in Historical Perspective*, New Delhi: Munshiram Manoharlal, 2000, pp. 77-90.

34. 'Vāyu: The Life-Breath of the World in the Hindu Tradition', in: Maya Burger, Peter Schreiner (eds.), *The Perception of the Elements in the Hindu Traditions* (Studia Religiosa Helvetica; 4/5) Bern *et al.*: Peter Lang, 1999, pp. 145-58.

35. 'Abhishiktananda and the Challenge of Hindu-Christian Experience': *MID Bulletin* 'Christ of the 21st Century'. Papers from the Contact Persons Workshop, no. 64 (May 2000), pp. 34-41.

36. 'Entsagung und Freiheit: Das Ideal des Sannyasa im Hinduismus': *Ordensnachrichten* 39 (2000), no. 6, pp. 25-35.

37. 'Micro-macrocosmic relationships in the Chandogya Upanisad': *Jñāna Pravāha Bulletin* (Varanasi) no. 4 (2000-2001), pp. 69-78.

38. 'Tāntrik Pandits in Varanasi: A Brief Survey', in: Axel Michaels (ed.), *The Pandit. Traditional Scholarship in India*, New Delhi: Manohar, 2001, pp. 99-103.

39. 'Sivaite et chrétienne? Une expérience entre deux traditions religieuses': *Voies de l'Orient* (Brussels) no. 82 (Janvier-Février-Mars 2002), pp. 2-8.

40. 'From Stone to God', in: R. Nagaswamy (ed.), *Foundations of Indian Art. Proceedings of the Chidambaram Seminar on Art and Religion, Feb. 2001*, Chennai: Tamil Arts Academy, 2002, pp. 28-37.

41. 'Beauty as Ānandaśakti in Kashmir Śaivism', in: Harsha V. Dehejia, Makarand Paranjape (eds.), *Saundarya. The Perception and Practice of Beauty in India*, New Delhi: Samvad India Foundation, 2003, pp. 35-43.

42. 'Gourou Hindou — disciple chrétienne': *Voies de l'Orient* No. 91 (Avril-Mai-Juin 2004), pp. 23-30.

43. 'Some Buddhist-Śaiva Concepts: Anuttara and Sunya': *The Indian Theosophist*, vol. 102 (October 2004) No. 10, pp. 308-21.

44. 'Meditation on Death', in: Baidyanath Saraswati (ed.), *Voice of Death. Traditional Thought and Modern Science*, Delhi: D.K. Printworld/Varanasi: N.K. Bose Memorial Foundation, 2005, pp. 23-35.

45. 'Konarka: Chariot of the Sun-God', in: Misra, R.N. (ed.), *Indian Arts: Peaks of Creativity*, Shimla: Indian Institute of Advanced Study, 2005.

ARTICLES IN DICTIONARIES AND ENCYCLOPAEDIAE

1. Lurker, Manfred (ed.), *Wörterbuch der Symbolik*, Stuttgart: Kröner, 1979. Articles: Avatara, Hinduismus, Shakti, Yoga.

2. *Kalātattvakośa. A Lexicon of Fundamental Concepts of the Indian Arts*, vol. 1, New Delhi: Indira Gandihi National Center for the Arts/Motilal Banarsidass, 1988. Articles: *Brahman, Puruṣa*. Vol. 2, New Delhi, 1992. Articles: *Nābhi in the Arts; Krama; Sandhi; Sūtra in the Visual Arts; Pūrna in the Arts*. Vol. 3, New Delhi, 1996. Articles: *Ap (Water), Vāyu (Wind)*. Vol. 5, New Delhi, 2002, Article: *Rekhā*.

3. *World Spirituality. An Encyclopaedic History of the Religious Quest. Vol. 7: Hindu Spirituality: Postclassical and Modern*, ed. K.R. Sundararajan/Bithika Mukerji, New York: The Crossroad Publishing Company, 1997.
 Articles: The Four Spiritual Ways (*upāya*) in the Kashmir Śaiva Tradition (3-22); The Spiritual Dimension of Indian Art (459-75).

4. *Handbuch Religionswissenschaft*, ed. Johann Figl, Innsbruck: Tyrolia, 2003. Articles: Hinduismus; Sakraler Raum und heilige Zeit; Gebet, Meditation, Mystik.

5. *Religion in Geschichte und Gegenwart. Handwörterbuch für Theologie und Religionswissenschaft*, Tübingen: Mohr/Siebeck, 4th edn. Article: Meditation/ Kontemplation: Indische Religionen.

OBITUARIES

1. 'Jaideva Singh — In Memoriam (1893-1986)', in: *Navonmeṣa. Mahāmahopādhyāya Gopinath Kaviraj Commemoration*. Vol. IV: English, Varanasi, 1987, pp. 449-50.

2. 'Swami Lakshman Joo: Sun of Kashmir Shaivism': *The Mountain Path* (Tiruvannamalai) vol. 30 (June 1993) nos.1-2; pp. 61-64.

3. 'Bahinji: Teacher, collaborator, friend', in: *The Alchemy of Love and Wisdom. As expressed through the holistic life and works of Prof. Prem Lata Sharma*, ed. Urmila Sharma, New Delhi: Radha Publications, 2002, pp. 587-90.

Sharing of Experiences

The Divine Master
Swami Lakshman Joo (1907-91)

Sarla Kumar

SWAMI Lakshman Joo (1907-91) was one of the twentieth-century incarnations of a long line of saints starting with *ṛṣi* (sage) Durvāsā. That such a godly personage revealed his extraordinary spiritual powers to uplift humanity reiterates the dictum of the *Bhagavad-Gītā*:

> *yadā yadā hī dharmasya glānir bhavati bhārata ।*
> *abhyutthānam adharmasya tadā'tmānaṁ sṛjāmyaham ॥*

> For whenever the law of righteousness withers away and lawlessness arises, then
> do I generate Myself (on earth). — *BhG* IV.7, tr. R.C. Zaehner

To those who were fortunate enough to have his *darśana* and initiation it was the culmination of the good deeds of countless births that bore fruition.

Ensconced in the hills and gardens of Nishat near Srinagar in Kashmir was the hermitage of this saint who did not renounce the world to wear ochre robes, yet he was more detached than any *saṁnyāsī*. *Siddha*s have proclaimed, 'Liberation is dependent on inner rather than outer renunciation.' True to the Śaiva tradition he did not look upon the world as *māyā* (delusion) but as a manifestation and extension of the Lord. *Māyā*, according to this unique system, is our inability to realize and perceive the divinity within us.

Swami Lakshman Joo was born in an affluent family on the 9th of May 1907. His father Pandit Narayan Das had a flourishing business of houseboat construction. Thus he inherited enough to be able to live simply and he never accepted any material gift from any devotee. But he gladly accepted a *bhajana* or flowers or fruits from loving devotees:

> *patraṁ puṣpaṁ phalaṁ toyaṁ yo me bhaktyā prayacchati ।*
> *tadahaṁ bhaktyupahṛtamaśnāmi prayatātmanaḥ ॥*

> Be it a leaf or flower or fruit or water that a zealous soul may offer Me with love's
> devotion, that do I (willingly) accept, for it was love that made the offering.
> — *BhG* IX.26, tr. R.C. Zaehner

Swamiji was a born *yogī* and a saint who lived in saintly discipline and showed no inclination towards worldly pursuits. The great Śaiva master Swami Ram used to live with Pt. Narayana Das and Araṇimal, Swamiji's parents, after he had lost his wife. When

Swami Lakshman Joo was born the great preceptor danced with joy saying, "I am Rama and now Lakshman is born." He placed him under the tutelage of his worthy disciple Swami Mehtab Kak when Swami Lakshman Joo was seven years old. Once at the age of six he was asked by Swami Ram to sit in meditation and concentrate on the tip of his nose. He describes the experience saying, "After five minutes I dived into a void that was greater than the greatest and fell down unconscious." He called God 'higher than highest', *Barebodh* in Kashmiri. He was formally initiated by Swami Mehtab Kak at the age of eighteen and reached the pinnacle of spiritual realization within six months. According to Swamiji this experience is so powerful that the embodied being cannot remain in it for more than a few seconds otherwise one would die. But having experienced it once the *yogī* remains in that divine state at all times.

Swamiji refused to marry and told his parents, "I am married to God." He wanted to live a life of seclusion and had asked his father to build him a separate house. But as his father kept postponing the prospect, Swamiji decided to leave home and went to live in a dense forest at Sādhu Gaṅgā near Baramula. In an interview with Alice Christensen Raukin[1] he reveals that here he got help from great masters and he once again experienced the ultimate, supreme God consciousness. In the meantime, his parents had learnt about his whereabouts and, with the help of Swami Mehtab Kak, they persuaded him to return. Now a house was built for him near his father's house. Here he immersed himself in meditation and the study of Kashmir Śaiva texts under the tutorship of Pandit Maheshwar Razdan. He studied Sanskrit grammar thoroughly and assumed the status of a scholar and saint. His ideal was Abhinavagupta, the tenth-century Śaiva master whose works he later interpreted for uplifting humanity. Apart from the *Śiva-Sūtras* of Vasugupta and *Vijñānabhairava* which are Āgamas (direct revelation by the Lord) he studied and later taught Abhinavagupta's *Tantrāloka*, Utpaladeva's *Śivastotrāvalī*, *Pañcastavī*, *Sāmbapañcāśikā*, *Mukundamālā*, *Parātrīśikā*, *Īśvarapratyabhijñā*, *Vātūlanāthasūtra*, etc. He published the exposition of Abhinavagupta's commentary on the *Bhagavad-Gītā* at the age of twenty-five. While he stressed the importance of the study of texts, he also asserted that they were not absolutely essential. The Lord only desires a devoted loving heart on whom grace is showered.

In 1934-35 his father built him a bungalow near Ishber village close to Nishat Gardens. This was in the midst of beautiful flowers and fruit trees. It became his hermitage and many devotees flocked to have his *darśana* and blessings. Here he was joined by *brahmacāriṇī* (female celibate) Śarikādevī, his most ardent and elevated disciple. Her father Jia Lal Sapore of Srinagar built her a house on the same premises and after some time the parents of both moved in with them. Swamiji lived here for almost twenty years in a state of godliness practising and teaching the mystical truth of Śaivism.

1. *Conversations with Swami Lakshman Joo, presented by Alice Christensen*. Three videotapes, American Yoga Association (Sarasota, Florida), 1989.

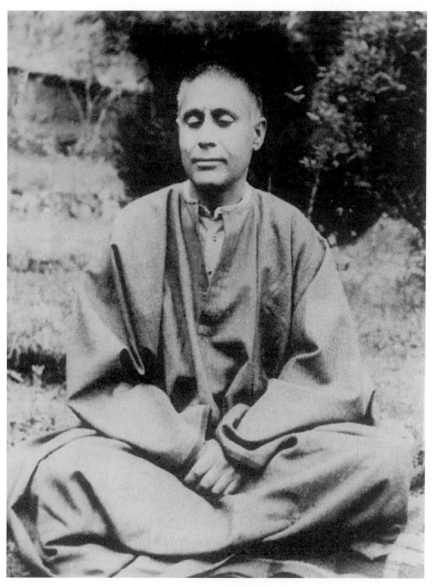

Swami Lakshman Joo

Swamiji made it clear on several occasions that Śaivism is not a religion but a universal thought meant for all humanity irrespective of caste, creed, gender or nationality. Devotees and disciples from various countries and religions experienced the divinity of his presence. A saintly fragrance, divine God-consciousness emanated from his being and the tortuous world was transformed into a magical, celestial, regenerative, spiritual place. Paul Reps in his book *Zen Flesh Zen Bones*, containing Zen stories, writes in 1957:

> Wandering in the ineffable beauty of Kashmir, above Srinagar I come upon the hermitage of Lakshmanjoo. It overlooks green rice fields, the gardens of Shalimar and Nishat Bagh, lakes fringed with lotus. Water streams down from a mountaintop. Here Lakshmanjoo — tall, full bodied, shining — welcomes me. He shares with me the ancient teaching from the *Vigyan Bhairava*, the *Sochanda Tantra* (. . .) and from *Mālinī Vijaya Tantra*. (. . .) It is an ancient teaching, (. . .) about the immanent experience. It represents 112 ways to open the invisible door of consciousness. I see Lakshmanjoo gives his life to its practice.[2]

Swamiji gave the gist of the means of entering divine consciousness, Śiva's reality beyond space, time, names and descriptions as taught by Lord Śiva to Devī for the benefit of humanity. It is the unique technique of centering, i.e. of experiencing the moment between two thoughts, two breaths, two movements and two desires. This moment is in essence the honey-filled focus of awareness and God consciousness. It is thinking towards the state of thoughtlessness where there is silence and ineffable joy. It is the technique of dissolving, being transformed, awakening, being one with the cosmic essence of being.

Swamiji had all the *siddhi*s (occult powers) but he rarely used them. He was sometimes seen at two places at the same time, he perceive derive one's thoughts and would clear doubts before one could frame a question. Devotees had the *darśana* of Śiva and Śakti in his body. Once I was facing a moment of extreme crisis and was terror-stricken. I stood looking out of the window fearful of the impending danger. Suddenly I had a vision. I lost all consciousness of my surroundings and stood engulfed by manifold shafts of light with Swamiji descending on each of them. I was dazed and spellbound. After some time when I regained normal consciousness I found the danger to have disappeared. I was simply wonderstruck and unable to speak. When I went to Srinagar and met Swamiji, I related my experience to him. He smiled and said ever so gently, "The Guru takes the form of Devī sometimes. You had a vision of the Devī." Śarikādevī and her brother Pt. Mohan Lal Sapore had the *darśana* of Swamiji as Lord Śiva sitting in a *ṭoṅgā* in front and Devījī seated at the back. She was distraught because after having experienced the highest bliss, that state was withdrawn by Swamiji. She could not reconcile to her situation even though Swamiji had assured her that she would regain that condition before leaving the body. After realizing that Swamiji was Lord Śiva himself she accepted his will. To his special

2. *Zen Flesh, Zen Bones.* Compiled by Paul Reps (1957), Harmondsworth: Penguin Books, 1971, rpt. 1986, p. 151 (introduction to short, summarized versions of the 112 *dhāraṇās* of *Vijñānabhairava*, considering it as the roots of Zen).

devotees he would say, "I am Bhairava," so one only needed to be with the *guru* to be with the Lord.

Swamiji's birthday was always a very special day when he would shower his blessings on his devotees. He would sit in *samādhi* (absorption in the Divine) all night and early in the morning would emerge like the morning sun to open the lotus of the hearts of those whom he had blessed. He was a picture of serenity immersed in divine bliss. Amidst the chanting of *śloka*s (verses) by Śarikādevī and Prabhā Devī, the gathered crowd of devotees would experience great joy as if one had had a vision of the Lord. Devotees sang songs in his praise and slowly he would sometimes open his eyes or smile to acknowledge their devotion. Then he would personally apply *tilaka* (a mark on the forehead) to each person present. People waited in long queues to re-dedicate themselves to the Master and receive his blessing. He performed the formal *pūjā* (worship) with a *paṇḍit* and then fed hundreds of people who had flocked to this festival of divine ecstasy. Instead of receiving presents he would give to each devotee a token of his love. These have been adoringly cherished and presented as a material proof of the *guru*'s grace.

Another very special day was the *yajña* (fire sacrifice) which Swamiji performed for his Master Swami Mehtab Kak. Flowers were gathered by the women, and each one examined to make sure there was no faded petal. The *sāmagrī* (materials for offering) for the *yajña* was prepared days in advance. The holy fire was lit and chanting continued for hours. At a special point a long chain of devotees was formed and each placed his or her hand on the shoulder of the person in front. One felt an electric current pass through one's very being as Swamiji emitted divine vibrations, which would travel along the chain. This was an occasion to be experienced for anyone to realize the great power of our Master. It was the only day when Swamiji would accept a token sum of money from those whom he had initiated. This was an act of passing his *guru*'s blessings to his devotees. Sometimes Swamiji would be in such ecstasy that he would dance like Lord Śiva. After the *yajña prasāda* would be distributed to hundreds of people.

Gurudeva reprimanded devotees he loved, whenever he found that their weaknesses were becoming an impediment in their spiritual evolution. Such remonstrance was once given to me publicly after a *yajña*. Like a fond father he also bestowed grace at the moment he showed his disapproval. By scolding in the presence of others he annihilated the ego. Through his gaze flowed immeasurable bliss and benediction. While seated in a crowd of hundreds of people his eyes would rest on the lucky devotee who sought his divine intervention with the Almighty. He could read one's thoughts like a book and before one could frame a question the answer was given.

Unlike many so-called holy men, *Gurudeva* did not shun female disciples because he was pure and incorruptible. Following Abhinavagupta, he was of the view that women are naturally endowed with spiritual power. He did not look upon women as objects of temptation. It was significant that two of his women disciples attained the highest spiritual

experience. They were Śarikādevī, a *bālabhrahmacāriṇī* (a woman who remained celibate from her childhood) who spent her entire life at her Master's feet, in his service. The other *siddhayoginī* was Lilian Silburn, a French devotee who lived under very austere conditions, often sleeping on the floor of the ancient Śiva temple at Gupta Gaṅgā near Swamiji's *āśrama*. She would sometimes hire a boat, anchored it near Īśvara *āśrama* and spent many years learning the Śaiva texts, which she translated into French, spending the major part of her time meditating. Later Lilian Silburn returned to France and, even though she became blind in her old age, she continued to uplift many French disciples in the Śaiva tradition.

Swamiji recognized a saint the moment he set eyes on him and treated him with great reverence. He went to Ramaṇa Maharṣi as a young man and received his blessings. They established a silent spiritual communication and when Swamiji returned he wrote a poem on his glory in Sanskrit.[3] On the other hand, when worldly people tried to see him, he shunned them and a persons' position was of no consequence to him. A few days before Indira Gandhi was shot she visited Īśvara *āśrama* and sought a meeting with Swamiji who knew what was in store for her in the next few days. He remained aloof and as she departed he did not give her *prasāda* (remnant of food offered to the deity). The Lord alone knows her *bhāva* (innermost thoughts) as she met him. Dr. Karan Singh, the son of the former *rājā* (king) of Kashmir, and his mother often visited Swamiji and he did not deny them his blessings.

It was not easy to be accepted as his disciple and he would test the sincerity and devotion of a seeker before showering his grace; when he granted me his grace it was not without the test of devotion. Three times he asked me to come for the benediction but when I arrived at the appointed place, he would not be there. But finally on the third occasion he blessed me. That experience is beyond words as it is seeped in an ocean of bliss and divinity. It is a moment of rapture, of magical power, of conveyance of the divine spark, of the awakening, a new beginning of life having an inexpressible meaning and direction. It is a transformation to an ethereal presence permeating one's very being, kindling a latent store of joy which is the gateway to infinitude and glory. To such a Master I offer a million *praṇāma*s (prostrated salutations).

3. Swami Lakshman Joo, 'Letter from a holy man': *The Malini* (January, 1996), pp. 4-5.

Moments of Eternity
The Spiritual Core of Music

Manju Sundaram

There is music in the sighing of a reed;
There is music in the gushing of a rill;
There is music in all things, if men had ears;
The earth is but the music of the spheres.
— George Gordon Byron

YES, it was the sheer resonance of the Vedic chants that impelled us — Bettinadi and me — to get to know each other, initially as a sensitive, receptive listener and a musician.

It was again pure and wholesome music, especially the strains of spiritual and devotional music, hymns and prayers that brought us very close to each other — now as individuals learning together and sharing together the beauty and joy of the musical recitations and renditions of hymns from the Vedas and the Upaniṣads; *stotra*s from various deeply spiritual and philosophical sacred Sanskrit texts. All these having the profound, eternal wisdom and truth enshrined in them; all the mysteries of the cosmic truths treasured in them. And, for the past almost two and a half decades, we have been co-travellers, fellow pilgrims on the most wonderful, meaningful and fruitful journey, the most energizing journey — leading towards no specific destination, but an endless journey — on which every step taken has been a sacred one, every moment — a destination in itself — so fulfilling and enriching.

I particularly recollect the days when we were graced with some beautiful experiences — while we were learning together the hymns from the *Śivastotrāvalī* of Utpaladeva and the *Anubhavanivedana* of Abhinavagupta. Bettinadi would explain to me beautifully the profound meaning of the text, helping me also to have the feel and fragrance of the words, and then I would just sing them. We really marvelled at the way things happened. One did not have to make efforts to compose the melody or set to tune the text. The words, the text found their own melodies. Those were the moments when the intuitive, creative faculties responded spontaneously to the melodic demands of the profound texts. Those perhaps were the moments when there blossomed this awareness of the complete harmony between and attunement of the text, the music and the creative energies of the musician. Ultimately the realization that all these are like the notes of the One Divine Melody.

We shared with wonder and delight, inexplicable joy and thrill, many of our experiences which inspired us to explore the mysterious realms of nature, the hidden aspects of nature; the mysteries, though perhaps beyond the range and reach of mind, nevertheless allow one a glimpse of, a fleeting glance at them when one surrenders to them. When there is complete, absolute, unconditioned surrender to the Divine. When thoughts cease to disturb, when intellect stops speculating, when the mind is silent; when one's whole being goes to a retreat, as it were. Then, in those moments of repose and vibrant silence one hears the voice of truth, the whispers of Truth. It comes on its own, one doesn't have to invite it. It unveils and reveals Itself, on its own — splashing and spreading the splendour, the fragrance everywhere. This glimpse at the indescribable phenomenon of nature inspires us to further explore and delve deeper and then understand that how music is the beautifully manifested symbol of the Universal Harmony; helps us to perceive, as per our own abilities, the truth that music perhaps is just the miniature symbol of the law, the order, the rhythm that governs and works through the whole universe. One is awakened to the truth that every little thing that one beholds or feels or perceives, every single note, every single tone that is struck help create the fundamental Harmony that pervades the universe. Then even the smallest and most trivial thing becomes significant; the simplest words become rich in meaning and every little moment turns into an ocean of eternity.

It is music that flows and fills the recesses of a longing heart, a vulnerably receptive heart with the melodies of eternal truth, goodness and beauty, breaking away all the barriers of time, space and age. And then, out of some inner compulsion, the mind's kaleidoscope starts weaving vivid and vibrant pictures of the days of yore and one breathes and lives the bygone days anew, afresh, once again.

* * *

On a warm, serene summer evening, a musician, a *sādhaka*, in a contemplative, creative mood, sings Rāga Gaurī — a beautiful *rāga* of evening twilight. His seven-year old daughter sits before him and listens with rapt attention. The father halts for a while. The child insists that he should continue. On asking, why, she replies, "because it sounds very nice and because while you sing, and whatever you sing makes me see and feel the Buddha's eyes opening!"

Does not the child's innocent utterance convey much more, much deeper and much beyond the literal meaning of the words? Was there not a communication, a communion with Him, through Sound, at a different plane altogether? Is this not a hint at the oneness of the child with the Energy? With the "hidden life vibrant in every atom"? Is this not a glimpse of the Divine in the child?

Madame Blavatsky, co-founder of the Theosophical Society, states in *The Secret Doctrine*:

> Sound is the most potent and effectual magic agent, and the first of the Keys
> which opens the door of communication between Mortals and the Immortals.

* * *

On 31st of December, the concluding session of the International Convention of the Theosophical Society at Adyar, Chennai, comes to a close with the chants of the excerpts from the Bhṛguvallī of the *Taittirīya Upaniṣad*. The session having been declared closed by the International President of the Society, the gathering starts dispersing. A lady approaches the singer along with an elderly gentleman, and says, "We are delegates from Russia and the leader of our delegation (pointing towards the gentleman) wants to say something to you." The gentleman says something in Russian language which the lady translates into English thus: "Although I did not understand or follow the meaning of what you chanted, not a word, not a syllable of it, but the very sound of it seems to have transformed my whole being!"

What really was it that touched him to the core? What was it that transformed his whole being? What was it that pierced through his heart and soul? Was it just the sound, or merely the words or the content? Or, was it the ethereal blend of all, the magic, the power of the Harmony of 'one life without and within' that filled to the brim the abyss so deep within his soul, his inner being?

The saint poet Kabīr, in one of his deeply philosophical poems, says:

> *sadguru ho mahārāja, mope sāiṁ raṅga ḍārā,*
> *śabada kī coṭa lagī mere mana meṁ, bedha gayā tana sārā,*
> *auṣadhi mūla kachū nahīṁ lāge, kyā kare baida bicārā ।*

> Great are Thou, O my Teacher! Thou hast bathed me in the Divine Colours of my Lord. Thy words of wisdom have pierced my whole being. No herb, no medicine and no healer now have a cure for it.

Yet another saint-poet Dharmadāsa expresses a similar thing as an ardent desire:

> *janama janama kā soyā re manavā, śabada kī māra jagā dījo re ।*

> Awaken me, O Lord! With the lashings of Thy words of wisdom, wake me up, I who has been in deep slumber birth after birth, life after life!

And the Bible says:

> In the beginning was the Word; and the Word was with God, and the Word was
> God. — *Jn* 1,1

* * *

It is an enchanting, cool evening of spring and we are at the bank of the river Gaṅgā. The sun has set but the grey and orange hues of dusk are still there in the sky. The river is just visible in the lingering twilight of the evening.

A programme of spiritual music has been organized in a nearby hall — small and cosy — having a very aesthetic and delicate decor. Among the audience are members of a delegation hailing from different European universities. The singer begins with chanting of the invocative hymns from the Vedas and the *śānti mantra*s of the Upaniṣads, followed by musical rendering of Ādi Śaṅkarācārya's *stotra*s such as the *Śiva-Mānasa-Pūjā*, the *Govindaśatakam*, the beautiful *Dakṣiṇāmūrti-Stotra* and so on. The concert concludes with rendering of a few devotional songs of Kabīr. A few minutes later, a tall, bearded gentleman comes to the musician, tears rolling down his cheeks which he neither hides nor wipes. He is hardly able to speak but manages to utter the words, between sobs, with much difficulty: "Look, what the music has done to me! I seem to have lost my self!"

What really has been done to him? What is it that has brought tears in his eyes? Is it the touch of the Master? Is it the resonance of the Chord struck within, unknowingly? Is it the melting of the inner regions in the warmth of the music? Or, is it the cry of the soul, caught, till now, in the meshes of the noisy world that feels the Presence and yearns for freedom to reach home?

> Music moves us and we know not why;
> We feel the tears but cannot trace the source;
> Is it the language of some other state, born
> of its memory? For, what can wake the soul's
> strong instinct of another world, like music?
> — Walter Savage Landor

In the same cosy, lovely hall, after a while, one happens to see a young lady, probably one of the members of the same delegation. She stands, leaning against one of the pillars there, all by herself. One sees an expression of exaltation and delight on her face. She beckons the organizer and also the musician and asks them: "Do you have words in your language which could describe exactly what is happening to me? Words which could express adequately how and what I feel at the moment?" And then without waiting for a response, she begins making some dance gestures then spreads and flaps her hands gently like a bird flapping its wings and soaring high into the skies. One can see the radiance of joy on her face and a feeling of gay abandon emanating from her being.

Music perhaps has unlocked for her the doors of that kingdom which is much higher, richer and full of Bliss. How beautifully Tagore puts it:

> Your voice, free bird, reaches my sleeping nest
> And my drowsy wings dream of a voyage
> To the light above the clouds.

Who really can express or describe, specify, classify or label the emotions that music evokes? It is neither a state of melancholy nor of joy; it is neither an expression of pain nor is it the expression of pleasure. It is not something personal, something that just affects an individual. It is a state that is uniquely, essentially and by its very nature, universal. It is

an emotion that takes into its grips, one and all. It is Ānanda, a state of sheer bliss, of inexplicable ecstasy. Ānanda it is that knows no boundaries, stands no barriers and sees no horizons. It is an endless surge of the creative energy, an expansion of the creative consciousness and that intense and compelling urge. Music or any creative art springs forth from Ānanda and also finds its destination in Ānanda. As Thakur Jaideva Singh in one of his lectures once said, that music is autonomous; music is for music, for itself; it has no motive. In the words of Tagore: "Love is an endless mystery, for it has nothing else to explain it." It spontaneously and naturally springs forth from Ānanda, it is an autonomous 'self expression' of Ānanda — Ānanda that has its own wondrous ways of expressing and manifesting itself.

How wonderful the phenomenon, the experience is, that music emerges from a place, from a certain point and in an instant permeates the whole atmosphere. The musician, sitting on the dais, sings and the music captures the hearts of hundreds of listeners, simultaneously, leaving no soul unstirred, no pair of eyes dry. It is like the river, the monsoon river that bursts the bank, when in spate, and floods the whole place, or the dense cloud, quiet one moment, but in the other bursts pouring itself heavily in showers to drench the earth. This is perhaps that state when, drowned in the bliss, one simply loses oneself to the cries of the soul. Heeding then, the whispers of the soul, all knowledge, all intellect and ego melt into an endless stream of melody — the melody of life, in the depths of which the singer, the listener, the thinker all are lost. Then what remains is music — with all its purity, all its sacredness and divinity.

It is here that one realizes how tremendous the impact of sound and music is on our psyche, what magical and magnetic power it has which transforms one's entire being, which changes one's whole approach towards life, gives an altogether new dimension and perception of life. It gives a new vision of harmony and unity in and of life. And once when a person is in the depths of music, a harmony is created deep within him and all of a sudden one finds openings into other realms and spheres of music. With his deepened sensitivity and enhanced receptivity he begins to hear music in all things. He begins to feel music in nature, he perceives music in a beautiful painting, in a piece of sculpture, in the idol in the shrine, in the carvings of everlasting beauty and most importantly harmony in human relationships. His whole being resonates with the harmony of the universe and it is in such deeply receptive moments that the great truths, the eternal cosmic truths unveil before him, unfold and reveal their divine splendour. It is in these moments when, though one does not understand the meaning, one breaths and one lives it; one exudes the fragrance of it. One's body, mind and soul all transform into a significant instrument in the orchestra of the divine harmony.

One no more carries the burden of life, one lives life to the full. One is now aware that the *śarīra vīṇā* he is endowed with is for the music of the Infinite and the Eternal. And once this happens then life is no more isolated from music, but life *is* music.

A Journey to Mount Kailash

Bernard Imhasly

IT was to be a spiritual journey, Bettina Bäumer had said. For many years she had wanted to go to Mount Kailash, and she wanted to share that experience with a handful of friends. And that is how the journey from Nepal into Tibet started — as a pilgrimage. From the beginning, however, we realized that it wasn't easy to be a pilgrim. It was the physical which occupied our minds with full force from day one — ill-fitting boots, bruised feet, the shortening of the breath, the cold. Not to speak of the logistics of daily unpacking and repacking, the pitching of tents, the ever-more elusive search for places to wash. The pilgrimage started as a trek, but not only for its labours, but its joys too: the little bells of the pack-animals, the laughter of the sherpas, the beauty of the landscape, the tingling intensity of bodily sensations, the joy of having crossed a pass or negotiated a narrow passage.

That was the first week. It was an excursion, a march, an expedition, a walk, a torture — each member of the group had a different reaction, depending on his or her stamina, depending on the day's itinerary. The landscape of Nepal added to it. At times quite similar to Switzerland, it was wilder, rougher, stonier. And, like the Alps, it carried the marks of civilization — villages, homesteads, tiny fields, watercourses, fountains. And on the trekking path there was a constant traffic of people — shepherds with their goats and sheep, porters carrying trading goods, baskets full of knives and scissors, or rolls of cotton fabric, young girls looking for firewood, children playing in mountain streams, old men, their bodies full of gout, sitting in front of their huts and waiting to die.

The change came as soon as we had crossed the Nyari Pass. Suddenly we saw a new landscape. The peaks retreated to the far horizons, losing their material hardness; the sharp contours of the valleys made way to wide ridge lines, swinging up and down like tectonic waves, huge mountain shoulders which sank down to a dry riverbed before ascending again to the snowline.

The landscape had made us into tourists, and it was the landscape which turned the tourists again into pilgrims. It wasn't a conscious decision, but we felt it. The proof came after a three-hour jeep drive from the border post of Puran to the Gurla Pass at 4900 meters. Suddenly a wide plain opened below us, the two Kailash lakes lying in its midst, and behind them the white cone of the holy mountain. That wasn't a tourist site anymore, an

exquisite photo object. Each of us stood next to the piles of stones, the prayer flags above the two Chörten, torn to rags by the wind. Some of us prostrated, oblivious of where they stood, oblivious of those around. Others closed their eyes and threw their arms around their thick down jackets. All were silent, listening to the wind, hissing and tearing at the flags.

The silence held, even after we had gone back to the cars, which glided down, first to open the sight of the Rakshas Lake, then of Mansarovar, the one turquoise, the other black. The pilgrimage had started, even though the daily routines — getting up, packing, rolling the tent — remained the same.

Our breath became shorter and shorter, migraines began to set in, heartburn. When we reached Darchen — the caravanserai where the circumambulation of Mount Kailash would begin and end — a Tibetan lady doctor took a pulse test of us all. While the group would travel to Tirthapuri, Toling and Tsaparang, four of us were recommended rest in Darchen. This would be a tougher form of hardship, for there was, apart from the small Tibetan Medical College, nothing besides a few houses. And there was, tougher than climbing a mountain, a huge pile of waste, where all the refuse, especially beer bottles, had been deposited for years, serving now as a public latrine, thanks to Chinese non-cooperation and Tibetan indifference. Meditate on a dung heap!

After Mansarovar and Mount Kailash, Tirthapuri is the third large pilgrimage place for Hindus and Buddhists. However, few people visited it at this time. A few Tibetans who had arrived on an old Chinese lorry were our only companions as we set out to the *parikramā* along the innumerable tiny stone heaps. From the top of the hill the monastery became visible below us, a long dam of prayer stones linking it to a small Gompa, with a huge prayer wheel inside.

From there, the journey to Tsaparang began as an endless drive through a wide plain before we passed through a Chinese military camp. Then the track rose to a pass when, upon reaching it, suddenly below us a mass of archaic sculptures of rock and sand rose. They were changing their colours, from yellow to lilac to black, from green to ochre into all shades of grey, depending on the play of sun and clouds. Beyond this moving canvas appeared the chains of the Himālayas, brilliant in their whiteness.

As we descended towards the Sutlej valley we dived headlong into this rough stony canvas. The narrow canyon was like a descent into an underworld. Suddenly we were surrounded by turrets and peaks and wide bands of slate, all chiselled and crenellated by the constant winds. The detritus of sand that had been blown away formed long pyramids at the bottom of these cragged sculptures, huge thick feet, cascading down in large waves not unlike the honeycomb *pagoḍā*s of an Orissan temple.

There was nothing but sand and stone, there was no vegetation, and the surrounding stillness was so total that each movement of a shoe or a piece of cloth reverberated like a shout. New turrets and cones and bulging clouds of stone kept rising before us, and it took

half an hour to finally spot the Sutlej river down below us, playing around large islands of sandbanks, waking us from this surrealist dream.

The journey to Tsaparang had been between clouds and brilliant bands of blue sky. However, when we started out on the Kora after our return to Darchen, the whole sky was washed and cloudless again. And as we turned north into the valley which skirts the western flank of the great mountain, the white snow cap of Kailash pierced the blue sky. For the next three days, the mountain would now become our guiding light, forever changing its appearance as we walked along its foot, and yet unmistakeable in its overpowering shape and presence. It was an unsettling experience at first: to walk along a sacred mountain whose sacredness lacked anything manmade. It was pure stone, pure space, yet it seemed to transcend its material nature like no sacred building ever could, merging nature and divinity, and leaving us suspended in their midst.

We came across a few Tibetan pilgrims here and there, some of them on yaks, others accompanying the stout and furry ponies, their harness yellow, red and blue ropes, strung along with beads and bells. There were no Hindu pilgrims. It was already late in the year, and the Lipu Lekh Pass from India to Tibet would by now be snowed in. Moreover, a catastrophe had occurred on this route just a few weeks before, when a pilgrims' camp, along with the small village next to it, was caught by a landslide and swept down into the Kālī river; over two hundred people were feared killed.

As our path slowly curved around the western flank it began to rise and become steeper. But the day's journey had been so smooth and steady that we had no difficulty reaching our camp site. Some of us were fresh enough to climb a little further, after seeing the wide gap opening beyond us which exposed the mountain right down to its roots. We wanted to look into this abyss. But we soon gave up, exhausted. We were now well above 5000 meters above sea-level, and every step became an act of will. As we wound our way back to camp, the sun had disappeared, and the temperature dropped instantly below freezing point. We quickly pitched our tents, downed our simple dinner and slipped into our double sleeping bags, fully dressed with gloves, cap and thick socks.

Driven into the tents by the cold, there was, however, an odd reluctance to surrender ourselves to the night. For night and sleep now became the tough part of the pilgrimage. Closed into a small tent, constantly short of breath, pursued by nightmares. During the day the conscious part of the pilgrimage played itself out: the *mantra* of step-after-step, the intense body sensations, the wide silent space around. Now, at night, the shadow side appeared, the unconscious which, for me, took the ever-recurring shape of losing the personal centre, crumbling before ever higher obstacles, the grinding down of the body ego into a boneless viscous mass, the crushing blow of the ever mounting challenge.

Every night now brought variations of these themes, and only when we had descended below 4000 metres altitude did these nightmares take shape, did they coagulate into concrete demands: carry unbearable loads! Hold up torrents of water! Help people in desperate

situations! Up here, however, there was no way one could get hold of these anxieties, except to trigger oneself out of sleep. But that was no solution, since the tent was too small to sit up, and the biting cold outside forbade any thought of taking a walk.

During the day's journey, when we would form small groups conversing between long silences, I talked about these nocturnal shadows with Bettina Bäumer. It helped me realize that they were not symptoms of depression, but a first glimpse into a process of ego destruction, which, if pursued diligently, would yield a new, transpersonal identity.

Only once did I go through the same process during the day's walking. It was the climb to Dolma La, the highest point in the Kora. A few of us, Bettina among them, chose to return before reaching this ridge behind Kailash. Thus they became Bön pilgrims, who circumambulate in the opposite direction. This way, they combined both the Buddhist and the pre-Buddhist tradition. For me too, the turning point came before reaching Dolma La. Shortly before that final climb the path passes through the Valley of Death. At first it looked like a huge field of garbage. Wherever the eye turned, there were clumps of cloth lying around, some still new, most torn into rags by the wind and the weather. It was the place where the pilgrims, in a symbolic gesture, shed their clothes, as they shed their egos in the moment of dying. I tripped into this death valley and was suddenly seized by an overpowering sensation of dying. There was nothing heroic about it, nothing of the dizziness of shedding the old ego in the moment of spiritual surrender. It was, instead, the sudden grip of total Aloneness, or rather Nothingness. Instead of a surrender by an act of will, everything dissolved — will, consciousness, devotion. My steps became unsteady and irregular, the breathing rhythm ceased, and I hardly could put one foot before the other. Death suddenly wasn't the comrade who taps my shoulder, but the aloneness of a body which shrinks to an extensionless point.

When I reached the top I was totally exhausted, much more so than my comrades, for many of whom the climb almost turned into an euphoric flight. I regained my balance only when I immersed myself in the sea of fluttering prayer flags which covered much of the narrow ridge. I wanted to drown in them and forget, but what I got instead was a fleeting moment of bliss. It helped me catch my step and breath, by putting myself into the framework of a ritual, tying my wife's Rajasthani shawl into the wind, bowing, in tears, before the mountain. Suddenly, there was a feeling of grace, and the departure from Dolma La became a rebirth. Running over a field of boulders, dancing from rock to rock, the two hours of descent felt like a freefall.

Once down in the plain, the walk became a re-conquest of space, of landscape. For two days we had only looked at the next step, the next stone in front of us. Now the eye started roving again and soaked in the vast expanse of nature before us. At times this massive landmass of Tibet almost became absolute, limitless, because of the absence of any physical points of reference. There were no trees, no houses, no people against which we could measure and limit this space, into which we could apply the yardstick of time. The distance

to the mouth of a valley ahead of us looked as if it could be crossed in half an hour. Two hours later we were still as far away as before.

This happened even when we were driving in our jeeps, which had picked us up in Darchen. Slowly, however, time and the political reality caught up with us again, as we were approaching the Kathmandu-Lhasa Friendship Highway. In the west we had seen nomads, in their yurts, grazing their yaks, or just walking somewhere in the plane, from nowhere to nowhere. Now we came across villages which had nothing Tibetan about them. Young Chinese stood in front of the shops, young soldiers walked along the dusty streets in their *opera buffa* uniforms. Only in front of the Karaoke and video shops could one spot some young Tibetans, or — in Sama — on the steps to the huge cinema hall. The air was full of Chinese film songs, interrupted by the staccato of military commands from somewhere behind the single line of shops. It was, we found later, a garrison, surrounded by walls and steel gates. Beyond them we glanced at long rows of an army depot, the pathways littered with old tyres and broken-down vehicles.

Only in Tholing on the Sutlej, before the Kora, had we seen a similarly depressing sight — Buddhist caves on the other side of the river, while our side was dominated by an eight-story watch tower. And in the bazaar we had seen brightly painted young Chinese women ambling along, watched by young Tibetans in Bavarian-type hunters' hats, a cigarette in the corner of their mouth, screechy bits of Western music in the cold air. Only in one tea shop had we seen the picture of the Dalai Lama, and only there the woman running the tea stall was willing to talk to us. For the Tibetans and Chinese milling about the momo stalls and video corners we might as well have been air.

It was a shock to come back to earth this way. Even nature, which had so powerfully taken possession of us, now turned into a meek and helpless victim. Just days before we had seen the Tsang Po as a young and impetuous stream, crystal clear, cold, sharp and pushing. Now, when we crossed it with a ferry just outside of Saga, the mighty river floated along, the water clouded, white tufts of foam swimming on top, the sure sign of industrial pollution.

The monasteries too provided little consolation. One saw that the Chinese had rebuilt many of them. Perhaps they wanted to show the world that they distanced themselves from the worst excesses of the Cultural Revolution. But did they? Most of those which we visited were either empty, or had a lonely monk as their only caretaker. And in Tsaparang we came across, right in the Prayer Hall, two Chinese men having a loud conversation — and smoking. What a contrast, we thought, to the monastery which we had passed two weeks earlier on the Nepalese side. Boys in monks' cassocks worked on the levelling of the large platform in front of the monastery. They formed a long human chain passing stones from hand to hand, laughing and singing *mantras*. Others were standing on ladders against the high walls of the big square building, filling the air slits with mud, in preparation for the coming winter. Inside, the warm air heavy with the smoke and smell of butter-

lamps, there was silence, and one could soak in the atmosphere of contemplation and prayer.

The rest of the journey did, surprisingly, provide a short and sweet ending. Travelling from Tingri — where we had a glimpse of far-away Chomolungma (Mount Everest) — we drove up to Kardung La. It was a straight road across a wide sloping plain, passing big herds of sheep. As the rising plateau began to level off there appeared, from behind the horizon, the peaks of the Himālaya, slowly like a huge stage prop, revealing their shimmering white slopes, from Shishma Panga in the West across the jagged lines to Gauri Shankar and Cho Oyu. When we reached the summit of the pass, we again stood silently, deafened by the whistling wind and the hammerlike flutter of the prayer flags. Right in front of us the rounded expanse of the Tibetan plain suddenly fell away and dropped into a narrow gorge, where the Sun Kosi had dug its way, breaking the massive mountain range. Our jeeps seemed to abandon themselves to the natural pull and, instead of following the curvaceous road, just went straight down the sandy slope. Soon we saw the first bushes, then the valley closed in and fir trees appeared on its flanks. Less than two hours after leaving behind the severe emptiness of the Tibetan plateau we were enveloped by ferns, moss and rocks, bamboo stalks, dripping crevaces and a roaring stream down below.

Zhangmu, our last nightly rest before crossing the border, had nothing left of Tibet and the pilgrimage, though we were still in China. The concrete buildings, perched precariously against the steep valley slope, had the look of get-rich-quick China. After dinner we offered our Sherpas a night out, and we all landed on the dance floor of a disco, where bored Chinese couples with expressionless faces moved around stiffly in a pair dance. It felt like salvation when we crossed the Kosī river the next morning, where we could sit down around a rough wooden table, order a *chai*, and soak in the chaos, noise and dirt of the subcontinent.

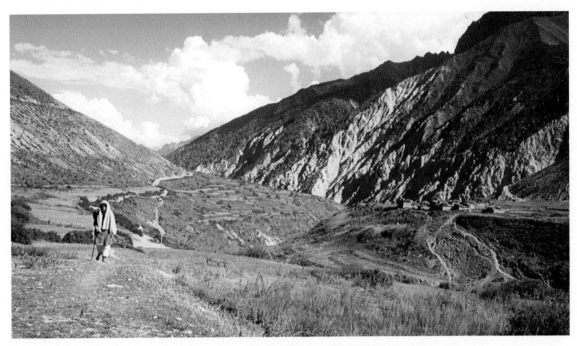

Pl. 1. On the pilgrimage to Kailash, 1998 (Photo: Susanne Ris).

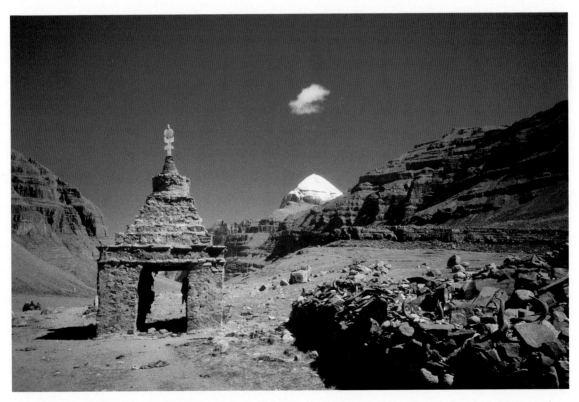

Pl. 2. Kailash, Parikrama, South-West (with Chörten). (Photo: Bettina Bäumer)

Indian Philosophy and Spirituality

1

The Heart of Repose, The Repose of the Heart
A Phenomenological Analysis of the Concept of Viśrānti

Arindam Chakrabarti

Repose

As a philosopher, Abhinavagupta was unique in many respects. One of his unique features was that he was more candidly autobiographical than most classical Indian philosophers. Not only does he address his future readers directly, sometimes, e.g., at the very end of *Īśvarapratyabhijñāvivṛtivimarśinī* (*ĪPVV* IV.4.10) — pointing out the futility of his own verbal descriptions, and appealing to the readers to engage in personal spiritual practice and experience directly Truth for themselves — *satyaṁ svayaṁ jñāsyatha* (almost like an early apostle of the European Enlightenment saying: "Think for yourself"), but he speaks to them in his own personal voice. We know next to nothing about the life or family of Kumārila, Śaṅkara, Vācaspati or Udayana from their own writing. But from the poetic and passionate descriptions, both in the 37th *āhnika* of *Tantrāloka*, as well as in the end of *Parātrīsikāvivaraṇa*, of his ancestors' migration from Antarvedī to the beautiful and holy valley of Kashmir on the banks of the incomparable river 'Vitastā' (Jhelum), his mother Vimalakalā's passing away during his infancy, his exceptional aunt Vatsalikā and her devotion to Śiva, his own cousin, brother, nephew and disciples, and, above all, of his teachers for different branches of learning, we get a fairly vibrant picture of his personality. In one of the invocation verses of *ĪPVV*, with his usual metaphorical flair, Abhinava describes the mature frame of mind with which he is now writing this second elaborate sub-commentary on a text on which he has already written a gloss:

> I have cleansed myself first by bathing fully in grammar; I have collected the flowers of discerning wisdom that grow in that wish-granting creeper of insightful imagination which grows out of the roots of good reasoning and worshipped the Lord of my heart with them; I have enjoyed the benefits of such beautiful great literature and poetry as can be compared with liquor made out of the essence of Ambrosia; and now, in the company of my beloved lady : discourse on divine non-duality, I am going to repose (*viśramyāmi*).

This verb *viśrāma* — to rest — is the root of that polymorphic philosophical term *viśrānti* which pervades Abhinava's writings on Epistemology, Metaphysics, Aesthetics, Phenomenology of Rituals and Rational Theology. Understanding this term, I submit, is

as central to understanding the triadic philosophy of recognition (*pratyabhijñā*), as comprehension of the more celebrated term *vimarśa* is recognized to be. *Vimarśa* (which, when romanized, is an anagram of the word 'Viśrama' — a fact Abhinavagupta would have enjoyed) has received some exegetical attention in English, but *viśrānti* has not. The purpose of this short paper is to start exploring the different aspects of the meaning and use of this term in Abhinavagupta's philosophy, and to forestall some possible misunderstandings of it in terms of the ordinary notions of resting, retiring, simple quiescence, or arresting of the movements of a tired mind.

Anyone who has wrestled with the complex argumentation, the mixing of esoteric meditation-techniques with conceptual logical subtlety, the relentless play of hermeneutic imagination, the amazing width of erudition, and incisiveness of psychological observations of *ĪPVV* would know that it is anything but the work of a tired retiring intellect. Abhinavagupta was, for sure, not 'giving his intellect a rest' and indulging in leisurely thinking merely mytical poetry in this incessantly polemical and intricately analytical commentary. It evinces, if anything, a mind which climbs up higher and higher flights of the endless stairs of thinking, *never knowing what it is to feel exhausted*, as Abhinava says himself in a remarkable verse in his commentary on the *Nāṭyaśāstra*:

> ūrdhvordham āruhya yadarthatattvam dhīḥ paśyati śrāntim avedayanti ।
> viveka-sopāna-paramparāṇām. — NŚ-AB Ch. VI

Perhaps that is the root of our key-term: *vigatā śrāntir yasmāt sā avasthā* — that state of being, from which all tiredness has vanished.

In an ecstatic crescendo of gradually deeper descriptions in *Tantrāloka*, *āhnika* VI (verses 9-13) Abhinavagupta passes from the empty nature of objectless clear sky of consciousness to its tendency to transform itself to an intentional awareness of objects and to fall on them in the form of a wavy brimming over of vibrating sentience and take concrete organic shape in the form of vital breath which finally rests in fullness as the light of omniscience in the heart of a *yogin* in rapture. In this climactic verse, following the basic Vedic-Tāntric common principle of "everything is of the nature of everything else," he equates repose with many other things:

> This is that power of vitality which stirs up all inner initiatives with desire, and it is known alternatively as '*Spanda*' (vibration), '*Sphurattā*' (exuberant self-manifestation), '*Viśrānti*' (repose), '*Jīva*' (life/or soul), '*Hṛt*' (heart), and '*Pratibhā*' (the light of creative intuition or omniscience). — *TĀ* VI.13

But these identities or equations are not very helpful in understanding the specific nuances of each of these concepts. Surely, when asked: "What is repose?" the answer: "Repose is nothing but *pratibhā* which is the heart," is not going to be illuminating at all. It is only after understanding the differences between these concepts and appreciating their individual significance that the equation or synthetic identification is going to be surprising and informative.

So, what is *viśrānti*, or 'repose,' as we shall translate it?

I think I can isolate at least seven different — but obviously interlinked — aspects to this key-concept from my limited exposure to the Kashmir Śaiva literature. These are:

1. Repose as ontological and epistemological terminus.

2. Repose as substance/self.

3. Repose as natural fulfilment, satisfaction, and therefore — fullness.

4. Repose as playful self-savouring creative leisure (thrilling tranquillity) of the feelings of the heart.

5. Repose as freedom.

6. Repose as a spiritual practical method for focusing attention to connectedness or the relational middle between subject and object and other binaries within any (intensely felt) sensation whatsoever, and thereby 'purifying' an object of sensation by immersing it in non-egoistic subjective awareness.

7. Repose as the greatest Goddess, beyond all temporal succession, in the heart. The Trivandrum edition of *Mahānayaprakāśa* reads:

viśrāntiḥ paramā devī kālopādhi-vivarjitā ।
savikalpavikalpānāṁ sarvāsāṁ saṁvidālayaḥ.— verse 57 *ullāsa* IX

I shall have space in this paper to discuss only the first three aspects in some depth. The textual support for the other four aspects is also very vast — I would wish to pick them up on a future occasion.

Terminus

To start with, the ontological sense of a stopping place or foundation of metaphysical explanations, where, as Wittgenstein put it (in his book *On Certainty*) "the spade turns." Subjective (but non-private) consciousness is that stopping place. In our inward search for roots we cannot dig beyond the nameless 'I' which Kant called the transcendental unity of apperception. Everything physical or mental, living or non-living, a thing or a process, that appears or manifests itself as an object of knowledge or is even missed as unfelt or mentioned as an object of ignorance, as something which is unapprehended (*anupalabdha*) at a particular time, ultimately rests on the light of consciousness. For, nothing is given unless it is given to an awareness. Nothing is noted as absent except as absent to an awareness. This is, of course, the underlying idealism of Abhinavagupta's *ābhāsa-vāda* or *saṁvedana-patha* (*asmin samvedana-pathe* cf. *ĪPV*: 1.1.4. vol 1, p. 78). But the arguments through which Utpala and Abhinava establish this foundational character of consciousness are not to be found, for instance, in Berkeley or Bradley. Instead of refuting the reality of relations or distinctions, as monists or idealists have usually done, Utpala establishes the undeniable objectivity and omnipresence of relations. And then Abhinava brings out how, to exist is to be related to something else, and to be related is to be recognized as mutually awaiting or "tending towards each other" by a recognizing

awareness. So, ultimately the foundation of all entities is relations and the foundation of all relations is a unifying or synthesizing consciousness. And this unifying consciousness has to take the form of a self-ascription which feels itself to be a single 'I', not just one objectifiable artificial knower-ego (*māyā-pramātā*) among other possible ego's, but an all encompassing I-awareness, in the light of which everything else is illuminated. In his gloss on verses 1 to 3, Abhinava not only quotes *Kaṭha Upaniṣad*:

> After His shining (*tam eva bhāntam anu. . .*), everything shines,
> It is by His light that all this is lit,

but he invites us to meditate creatively on the grammar of the Vedic expression: *taṁ bhāntam* (Him keeping-shining) which is derived by adding a *śatṛ* suffix to the verb *bhā* — 'to shine or manifest itself,' and then forming an accusative because of the dependency-particle *anu* meaning after. Depending upon the constantly spontaneously independently effulgent Self-Consciousness (*śatṛ* suffix signifies perpetually shining), by mimicking (*whom* does it mimic? the one which keeps shining. Hence accusative after the *bhā* + *śatṛ*), as it were, the agentive aspect of 'making' or 'creating' present in that Self, individual selves establish the relation of knower-and-known with objects which they then call 'this,' and then again 'this,' in an imposed temporal order. But if we start from the side of these — by themselves unconnected — objects, we cannot stop the analysis until we make these objects all "turn towards" and "rest in" (*ābhimukhyena viśrāntiṁ bhajante*), be objects *of* and *for* that great unifying ocean of sentience or self-awareness. That ocean *saṁvit-mahāsamudra* is the metaphysical end-point where all these beings, both external such as a blue colour or a blue substance, and internal such as a feeling of joy or pain, merge like so many rushing rivers meeting in an ocean (cf. *ĪPVV* vol. 1, pp. 350-56).

The idea is further simplified by this line of common sense reasoning. Take any object, a stone for instance. A stone exists. But it is not complete in itself. It pretends to be limited to itself and self-terminated (notice Utpala's expression *arthānāṁ sva-samāpinām* (*ĪPK* verse I.7.3). But it is nothing until it is related to other things, synthesized with its other time-slices and with what many people can see from many sides, with all its parts, phases, and glimpses. Yet: "how can there be synthesis or putting together of discreet self-terminated self-contained objects or cognitions" (*ĪPVV* vol. 1, p. 358), unless they figure in a judgement connecting it to other things or at least to a consciousness, of the form: "There is a stone here on the ground which need to be to the left of that other stone." Now this judgement needs support from a more foundational awareness: "It appears as if or feels like there is a stone here which I saw elsewhere earlier." And this "what it is like to feel as if there is a stone out there" needs an 'I' to which it has to feel some way. Until it comes to this 'I'-consciousness, no physical or mental, abstract or concrete, particular or general entity can come to rest or get a grounding in unquestionable existence.

Since this is not merely the Cartesian point that the self is the first certainty and the foundation-stone in rebuilding an edifice of knowledge once destroyed by methodical

scepticism, we must focus more on the "No object without relation, and no relation without a unifying I-consciousness" — aspect of this idea of ontological repose.

Let us try to follow Abhinava's 'argument from relations' in some more detail. When any two items are seen or mentioned together such as 'a man and a horse,' 'an apple-tree and an orange-tree,' they are thereby conjoined and related. And most strikingly, whenever we say even that this differs from that, the two distinct things are also shown to be related, for even distinction is a limiting case of relation. Unless the same continuous awareness registers two things together, they could not be registered as distinct. But to be related, the Kashmir Śaiva would add, is to be connected to the same consciousness which recognizes the relation, for an unrecognized relation is as good as non-existent. And consciousness can illuminate only what is essentially within the light of self-awareness. So everything that is other than other things is also unified with those things by participating in the same unifying awareness or Self. Thus the self becomes the ontological foundation or repose of physical phenomena such as a blue pot, or mental phenomena such as a happy feeling.

When a limited and individuated consciousness — a *māyā-pramātā* — distinguishes between any two things or any two people or between himself and another person, it actually weaves them together by the thread of that common subjective awareness which, as Abhinavagupta is fond of saying over and over again, finds its resting place in the 'I.' Not only do we need a unified self to assert the sameness between what was seen before and what is being touched now, even to assert the utter otherness between two objects, or to notice that a certain (remembered or expected) thing is now not seen we need to presuppose the identity of the self that sees them to be distinct hence related, which imagines what it would feel like if the object were seen and then fails to find that feeling.

Going along with the Buddhist opponent to some extent, the Śaiva philosopher admits that 'othering' or separation constitutes the very life of a manifold of self-cognizing intentional appearances: whatever appears to be its object must be distinguished from the awareness itself, and awareness itself is set apart from that object, one awareness is distinguished from another, and one appearing object from another such object. Indeed a cognition is called *pariccheda* (a demarcating grasp) because it consists in such tailoring from all sides (*paritaḥ chedanāt parichheda ucyate . . . IPVV* 1, III, 7). But each act of 'othering' or excluding is also an act of joining together. All our descriptions of and participations in actions depend upon our occupying the action-related roles which are classified as 'cases' (*kāraka*) in grammar. Thus we are always casting ourselves and our objects in the roles of nominative, accusative, instrumental, dative, ablative and locative, etc. But, through the door of these action-related roles, all that exists and happens in the world is interrelated because they are all related eventually to an observer's consciousness which registers these relations and is ready to carve them up into these semantic verb-centred categories: "This variegated conduct of common life is surely ruled by relation" (*sambandhādhīna eva citra iyaṁ lokayātrā, IPVV* vol. II, p. 49). And, as Abhinava notes in one of his flashy side-remarks: "since it is related it cannot be unconscious . . . the moment it gets into a relation, even the earth (clay) of the

pot becomes non-inert." (*yato'arthasya sambandhī tato na jaḍaḥ . . . tarhi sambandhamātreṇa mṛt api ghaṭasya iti ajaḍa syāt*; *ĪPVV* vol. 1, p. 241), nothing that is related to anything else can find its terminus anywhere outside consciousness, the ultimate relation-maker.

This is the sense in which the world of practice, the world of objects of knowledge, and the world of imagination ultimately come to rest in the subject of consciousness, the 'I-consciousnes.' It is a resting place because it is the final unifier. It is final because the series of illuminated-needing-an-illuminator or supported-awaiting-a-supporter comes to an end here. Everything is lit by this I-consciousness and this I-consciousness does not need to be lit by any further recognizer. No inquirer or justifier tries to question or justify the 'I.'

As has been recently discovered by Raffaele Torella, the *reductio-ad-absurdum* argument (*prasaṅga-prasaṅga-viparyāya*) which is behind this complex claim was fully laid out by Utpala himself in the, regrettably mostly lost, *Vivṛti*, where Utpala remarks:

> For cognitions never manifest themselves separately from it: though they may show a certain level of differentiation superimposed by the differentiation of their contents, yet, despite this delimitation due to spatio-temporal distinctions, they ultimately rest, to be sure, (*viśrāntir eva*) on their own nature consisting of a single and unitary consciousness (*eka-cit*).[1]

Here again we see Utpala using the key-term *viśrānti*.

Substance/Self

In commenting upon *ĪPK* (I.5.12), Abhinava remarks:

> That is called a substance, by resting in which, all sets of objects (entities meant by our referring terms) appear (shine) and are also used and wanted for serving practical purposes, and — if you don't get annoyed[2] — all this plethora of entities together making up a world out there objectively solid in itself, after all, find their repose (and substratum) only in consciousness, just as qualities and actions and events and other properties rest on a chief substance, hence this consciousness must be the chief Substance of all.

This idea of repose is a bit different from the idea of 'terminus of analysis.' Especially, Abhinava plays on the verb behind the common object-word: *artha* which means 'to be wanted.' When for a practical purposes, not just for art or fiction, someone wants a pot or a house, it has to be a substantial pot of clay or metal or stone, which can carry water, a real brick or wood or stone house which can give you shelter. Minus the substance or stuff, the clay, the stone, the wood, the metal, the mere form of a pot or the qualities of a house would not satisfy our *arthanā*, our wantings. Similarly, however accurately we may capture the physical being of an object unless it appears in experience, unless it is manifested in awareness, unless it rests under the shining all-pervading self-illuminating light of

1. This is a fragment of the original *Vivṛtti* that Torella has recovered edited and translated, on *ĪPK* (1.III.7).
2. This is a common rhetorical device to warn that something unpalatable to the materialist or realist is going to be said now.

consciousness, it is of no use to us. Hence, consciousness is the principal Substance of the universe, because in it all objects find themselves, and find their basis for being useful. So even when we are trying to think objectively (minus my own mind, as it were) what the object is in-itself, the object finds its self or substance in it being of some use to a conscious experience. Hence the self all things-in-themselves is that one Self which is the Great Lord that is I. Abhinava seems to be never tired of explaining this point from as many angles as possible with as many analogies and as many arguments and as many etymological analysis. He winds up the discussion here by saying:

> *tat anantadharmarāśi-viśrāma-bhitti-bhūtayaḥ* |
> *tasyāḥ (saṁvidaḥ) sa eva dharmaḥ caitanyam* ||

This consciousness is that property identical with that substantial consciousness that serves as the *resting foundation* of infinite multiplicity of all other properties.

Contentment/Fullness

In Abhinava's most favourite work *Mālinīvijayavārttika*, he makes this interesting remark: "What is called the bliss of this Lord is his repose in himself" (*svātmaviśrāntir eva asya devasya ānanda ucyate*). Elsewhere words such as *tṛpti* (satisfaction), *paritoṣa* (heart's content) are used to mean this same state of not thirsting any more, being content. The intentional outwardness of ordinary limited mental states, and the need to be illuminated and acknowledged by a mind found in ordinary limited knowable objects are all signs that these things do not rest in themselves, they depend on or hanker after something other than themselves. Yet a certain hint of satisfaction or temporary relief from yearning is found when a needy intentional awareness finds and feasts on the very object that it wanted and the object also finds its relatedness and recognition in that intentional awareness. This hint shows that at the meeting of knower and known, eater and the food, enjoyer and the relishable juice of artwork, consciousness finds a natural repose in itself. This expresses itself as a provisional completion of the cognitive, emotional, or aesthetic process, as a sense of satisfaction: *svābhāvikī ātmaniṣṭhā pūrṇatā*, a sense of not wanting anything besides anymore. When the self-consciousness finds such satisfaction within itself by projecting its own object, pretending to be distinct but related to it, and then rediscovering itself by denying that distinction in the renewed feeling: "It was I who have been shining through this thing over there which is also of the nature of illumination" and exploring the unending contentment of self-discovery, then it "considers all its roles of knower, instruments of knowledge, the known object — all of them to have been fulfilled, and does not want anything beyond" (*ahameva— prakāśātmanā prakāśe iti vimarśodaye sva-saṁvid eva pramātṛ-prameya-pramāṇādi kṛtārtham abhimanyate, na tu atiriktaṁ kāṁkṣati*", *ĪPV* vol. 1, p. 243). This sense of fulfilment and fullness is also called: 'Repose in the Reflective I-consciousness' (*aham-parāmarśa-viśrānti*).

This sense of not wanting anything else naturally leads to the other two senses of repose also, the sense in which to experience repose is to enjoy freedom — not depending

upon anything else (*ananyamukha prekṣitvam, ĪPV* vol. 1, p. 242).

The discussion of *rasa*, and especially of the *rasa* of peace or tranquillity, found in the *Abhinavabhāratī* on the 6th chapter of *Nāṭyaśāstra*, famously comments: "it is restlessness which is suffering." To the extent people, even in the world of entertainment and art, find their heart's repose in an intense undisturbed unobstructed (by such thoughts as "Is this factually real? When is it going to end? Hope this does not happen to me!") relishing of pure thick pathos or agony, even there they find bliss because, after all, such aesthetic savouring of a pure emotion is the embodiment of repose (*eka-ghana-saṁvit carvaṇe api loke asti lokasya hṛdaya-viśrāntir antarāyaśūnya viśrāntiśarīratvāt, aviśrānti rūpatā eva duḥkham*).

Thus, this idea of 'resting' (*viśrānti*) is not merely a metaphor for the metaphysical and epistemic structure-foundation relation. It also brings out the close link between cognition and emotion, between desire and knowledge, between consciousness and aesthetic rapture. A cognition or a presentation or representation or mental state 'rests' only where it finds complete satisfaction, where all its thirsts are quenched. And all cognitions find such a rest in the limitless Self alone, ultimately.

What Kind of Freedom is Repose?

Our modern and Western notion of positive freedom, that some affluent countries are now trying desperately to teach some other poorer traditional societies, is not at all consonant with the idea of repose. A certain measure of fidgety restlessness, now choosing one thing and then choosing something else, and a certain cultivated sense of dissatisfaction and discontent seems essential to this kind of freedom of choice. Just being unconstrained and independent is not enough, even for the typical Western idea of creative freedom. A free artist often indulges in extreme behaviour, cutting off his own ears or drinking himself to death or engaging in a duel, etc. From such a point of view, repose and contentment sounds like the very opposite of freedom of the spirit, an arresting of all activities and a death of all desires. How can we explain the idea of spontaneously self-renewing creative tranquillity, the idea of the heart's fullness and thirstlessness as an inexhaustible exhilaration of self-marvelling that does not require an absolute other to play with, but can be playful within oneself?

The answer to this worry comes from taking a harder look at Abhinava's description of *viśrānti*, this time, not as a metaphysical accomplished fact, but as something that we are instructed to perform as a meditational task. In the unjustly neglected text *Paryanta-Pañcāśikā*, which begins by consecrating the process of philosophical dialectic between proponent and opponent with identification of both parties and both views with Bhairava — the free-self-contracting self-expanding self-relishing Consciousness, Abhinava tells us how to 'purify' the impure objects and impure sensations and practices of ordinary life.

> To take externalized objects and immerse them into one's own innermost I-
> ness is purification. Impurity is nothing but the state when even though
> immersed, they do not bring repose to the heart. — verses 9-10

So the Śiva-consciousness also has its active power and its power of creating distinctions by contracting itself and then expanding itself, by denials and affirmations, by exclusions and inclusions, by revelling in entertaining options and imaginary possibilities. But true freedom is not reached until the world of things and ideas is wholly 'purified.' And secret instructions for this purification process is contained in a carefully shrouded language in the text *Vijñānabhairava* from where Abhinava likes to quote that crucial line: "what is special about the *yogin* is attention to the relation" (*sambandhe sāvadhānatā*, verse 106). Repose becomes freedom in every sense when the heart witnesses its own great power of creating and effacing differences and relishes the egoless 'middle' of that process of tasting any sensation or experience without getting fettered to either the taster or the tasted.

One subtle point about the exact nature of this freedom-in-repose could be best brought out by raising and answering a natural objection against Abhinavagupta's characterization of this restful subjectivity. The objection is that it suffers from an internal incoherence. It is described as the self-transcendence and limit-bursting nature of consciousness, when consciousness is contrasted with the inert which is self-confined and limited. Yet it is in virtue of the same repose that consciousness is said to be utterly independent of other things and self-contained. Which kind of freedom, then, does consciousness enjoy? The satisfied (bored?) finished and fulfilled kind or the ever-creative ever-uncompleted self-enhancing kind? That would be the worry.

The way to answer this objection would be to underline this double nature of repose. Unlike the insentient material object (whose materiality is ultimately illusory) which just sits there limited and finished in its own gross solidity — "*ātma-mātratāyām eva jadavat*," consciousness continually adds to itself, subtracts to itself, links back with previous states of consciousness in its search for synthesis (*samyojana, viyojana, anusamdhāna*) and reveals itself without waiting for any other entity. This lack of self-confinement and yet, lack of other-dependence makes it quietly climb itself, or self-climbing — to translate the beautiful synonym for "repose" that Utplaladeva chooses : "*ātmārohaṇam*"(*ātmani ca ārohaṇam viśramaṇā* — IPV I,4,4, Vol. 1, p. 168-69).

To translate a bit from Utpala's *ājadapramātṛsiddhi* :

> "The repose of the light in itself is called the supreme condition of the **I**.
> Because it is an absolute independence from every other being, it is autonomy,
> agency, and Lordship, in the primary sense" (APS 22cd–23)

This playful unfinishedness within any particular state of oneself has nothing to do with discontent or unrest. It is a perfectly tranquil will to divide and unite, to explore one's own infinite possibilities without waiting for anything external, a resting in freedom without any arresting of self-renewal. And, as a spiritual practice, one can tune in with this perpetually on-going process of Śiva consciousness by drowning all external objects into the inward **egoless I**. In this connection, Abhinava gives us a totally new grammatical

insight into interpreting the common expression for God : *"puruṣottama"* — usually interpreted as the Supreme Person — after which the 15th chapter of the *Bhāgavadgītā* is named. He points out that Kṛṣṇa himself breaks it up not as a superlative but as the grammatical first person *"uttamah puruṣah"* (*Gītā*, XV.17). So, consciouness, when it rests in its reflectively regained cosmic subjectivity of the all encompassing **I**, then it re-discovers its supreme divinity. This practice of drenching all objects into the reposeful self-relishing **I-that is all**, is called sacrifice, as *Mahānayaprakāśa* (Trivandrum, ed. by Shambasiva Shastri) remarks: *"sa yāgo yatra bhāvānām viśrāntih samanantaram"* (MNP, II.32).

While suggesting a cultivation of such quiet subjectifying repose in external objects as purification, both Abhinava and his later commentator Bhāskara warn against some common pitfalls. Some people may take the provisional resting place in ordinary sensual enjoyment — where also the Tāntric method encourages us to practice this "attention to the juncture of connection" — as the final resting place. If someone thinks that he is God because he has now become completely silent and lost himself totally in the sense-object — finding *samādhi* in sexual enjoyment, let us say, or has found repose in his greedy enjoyment of worldly consumable objects — he is merely deceiving himself and pretending to be fully content (*ye tvetena viṣayarasikā api paramātmaviśrāntim abhinayanti teṣām sva-vañcakatvam eva* — *Bhāskarī, ĪPV* vol. 1, p. 278).[3]

Real rest has to be found back within oneself, with no dependence on external objects. These other places of rest, such as practice of concentration on sense-objects, on the middle-of-sensory process, even on personal God or a deity, these are, Abhinava says, like midway-stops under a tree on the long journey to one's final destination in the village (*ĪPV* I.5.17).

When one finally comes home, the heart of all repose is recognized to be in the infinite sky in the middle of one's own heart. One's egoless 'I' can joyfully embrace all pleasures and sorrows, all victories and defeats, all things and beings without craving for anything at all. Such perfect rest is also the source of unlimited variations of joyous play of will and unconstrained love. From that love, we are told by Śruti and Āgama, all linguistic eloquence gushes forth, but it is itself an "unutterable" (*anuccārya*) state of speech where speech cannot go.

Let me end my hermeneutic tribute to the spiritual scholarship of Bettina Bäumer with a personal prayer of mine:

> *anupāyaika-labhyena dāsyaiśvaryeṇa madguroḥ |*
> *hṛd-viśrāma-vimarśāya śramo me yātvamoghatām ||*

With the wealth of servitude to my Guru, which is attainable only by means of 'no-means', I have tried to reflect on repose of the heart. May my exhaustion in understanding the nature of that state beyond exhaustion, not go in vain.

3. In *Bhāskarī* both on page 78 and page 278, we find one of the rarest mentions in Indian Philosophy, of the problem of self-deception — which is so widely discussed in Western thought.

2

Bahurūpagarbha Stotra
An Annotated Translation

Hemendra Nath Chakravarty

Introduction

Wɪᴛʜɪɴ the *stotra* (hymnal) literature of medieval India, the *Bahurūpagarbha Stotra* occupies a unique place. Apart from its literary value, it is deemed highly sacred and is kept hidden near one's heart, to be recited daily during the hour of one's spiritual activities.

In the *Svacchanda Tantra*, published in the 'Kashmir Series of Texts and Studies,' we find a glimpse of the same hymn in a slightly variant form, but the deity addressed there is not Bahurūpa but Svacchanda Bhairava. The similarity between the two is striking. Both of them have eighteen hands. Kṣemarāja infers why Bhairava should have eighteen hands thus: the Divine Lord, being the condensed unity of consciousness and bliss, has three main energies known as will, knowledge and action as His instruments (*karaṇarūpā*). As each of them has threefoldness, the number becomes nine, and as each in turn becomes twofold because of its manifestation of *parā* and *aparā* forms, it is eighteen-fold.

Thus, the commentator explains all the weapons of the Lord in a very meaningful way so that the worshipper may rise to the height of the sublimity of the Divine.

In the *Bahurūpagarbha Stotra* we do not find any description of Bhairavī, the consort. It simply mentions Svanibhadevī, similar to him, placed in his lap. But in *Svacchanda Tantra* (known as *Lalitasvacchanda*), her form is described not only as similar to Bhairava, but states something more. It adds that she is slightly dreadful and her voice is high-sounding, while her face appears satisfying. In this way we find a vivid description of both Bhairava and Bhairavī as well as the ritualistic procedure of worship.

Text

> *brahmādikāraṇātītaṁ svaśaktyānandanirbharam |*
> *namāmi parameśānaṁ svacchandaṁ vīranāyakam || 1 ||*

I pay my homage to the Great Lord Svacchanda,[1] the leader of Vīras,[2] who is

1. Svacchanda is the Supreme Lord.

2. *Vīras* are great heroic souls who have transcended the state of the bonded beings.

beyond the causes — such as Brahmā and the others[3] — and who is absolutely perfect in his bliss, one with his Śakti.

kailāsaśikharāsīnaṁ devadevaṁ jagadgurum |
papraccha praṇatā devī bhairavaṁ vigatāmayam || 2 ||

Having paid her obeisance, the Goddess questioned Bhairava, the God of gods and the Master of the Universe, who dwells on the peak of Kailāsa[4] and who is free from all impurities.

Śrīdevī uvāca:

prāyaścitteṣu sarveṣu samayollaṅghaneṣu ca |
mahābhayeṣu ghoreṣu tīvropadravabhūmiṣu ||

chidrasthāneṣu sarveṣu sadupāyaṁ vada prabho |
yenāyāsena rahito nirdoṣaśca bhavennaraḥ || 3-4 ||

Śrīdevī spoke:

Despite all sorts of atonements for transgressions of rules of conduct,[5] and despite all fears of the great, terrible forms, and despite all the desecrated states with all the states of defects, tell me the means, O Lord, by which a person effortlessly becomes free from faults.

Śrībhairava uvāca

śṛṇu devi paraṁ guhyaṁ rahasyaṁ paramādbhutam |
sarvapāpapraśamanaṁ sarvaduḥkhanivāraṇam || 5 ||

Bhairava spoke:

Hear, O Goddess, the supreme secret which is to be kept hidden, which is exceedingly wonderful; it pacifies all sins and removes all suffering.

prāyaścitteṣu sarveṣu tīvreṣvapi vimocanam |
sarvacchidrāpaharaṇaṁ sarvārtivinivārakam || 6 ||

It purifies all sorts of extreme atonements; it removes all sorts of faults[6] and it is the pacifier of all (inner) afflictions.

samayollaṅghane ghore japādeva vimocanam |
bhogamokṣapradaṁ devi sarvasiddhiphalapradam || 7 ||

One becomes free from all terrible transgressions against the rules of conduct only by means of the unbroken repetition of this *mantra*. (O Goddess,) it bestows liberation and enjoyment and gives the fruits of all (spiritual) perfections.

3. The *kāraṇas* are six: Brahmā, Viṣṇu, Īśvara, Rudra, Sadāśiva and Anāśrita Śiva, conceived as being located in six distinct locations of the pure body of the aspirant.

4. Kailāsa here means the top of the head, also known as *brahmarandhra*.

5. *Samayas* are the modes of conduct to be sincerely followed by the disciple after he receives initiation from the spiritual teacher.

6. *Chidra.*

śatajāpyena śuddhyanti mahāpātakino'pi ye |
tadardhaṁ pātakaṁ hanti tatpādenopapātakam || 8 ||

By 100 repetitions even great sins are purified; by half (i.e. 50 repetitions) (lesser) sins are removed; by a quarter (i.e. 25 repetitions) minor sins (are removed).

kāyikaṁ vācikaṁ caiva mānasaṁ sparśadoṣajam |
pramādādicchayā vāpi sakṛjjāpyena śuddhyati || 9 ||

By means of saying the *japa* once, all the mistakes of the body, word, mind or touch, performed by mistake or wilfully, are purified.

yāgārambhe ca yāgānte paṭhitavyaṁ prayatnataḥ |
nitye naimittike kāmye parasyāpyātmano'pi vā || 10 ||

It is to be recited carefully at the beginning and at the end of a sacrifice, and in daily rituals, occasional rituals, and in rituals performed for some desire, whether for one's own sake or for that of others.

niśchidrakaraṇaṁ proktaṁ svabhāvaparipūrakam |
dravyahīne mantrahīne jñānayogavivarjite || 11 ||

It is said to make (these rituals) faultless, and it completes (them), unto the perfection of their inner nature, even in the case of insufficiencies due to lack of materials, of *mantra*s, or in the absence of knowledge or *yoga*,

bhaktiśraddhāvirahite śuddhiśūnye viśeṣataḥ |
manovikṣepadoṣe ca vilome paśuvīkṣite || 12 ||

and in the case of lack of devotion or faith, especially in cases of impurity, and in the case of the flaw of mental distraction or in case of being seen by the uninitiated who are disrespectful.

vidhihīne pramāde ca japtavyaṁ sarvakarmasu |
nātaḥ parataro mantro nātaḥ paratarā stutiḥ || 13 ||

(This *stotra*) is to be recited in the case of being without the proper procedure (for ritual action) or when confused thereof, and in all (other ritual) actions (as well). There is neither *mantra* nor *stuti* higher than this.

nātaḥ paratarā kācitsamyakpratyaṅgirā priye |
iyaṁ samayavidyānāṁ rājarājeśvarīśvari || 14 ||

O dear One, there is no higher *Pratyaṅgirā* hymn[7] than this. O Goddess, this is the Great Queen of all the *Samaya vidyā*s.

paramāpyāyanaṁ devi bhairavasya prakīrtitam |
prīṇanaṁ sarvadevānāṁ sarvasaubhāgyavardhanam || 15 ||

stavarājamimaṁ puṇyaṁ śṛṇuṣvāvahitā priye |

7. A hymn that acts inimically towards an enemy, but favorably to the one who recites it.

O Goddess! This is said to be the supreme path of Bhairava. It is the path that brings delight to all the gods, and it increases all well-being. Listen with full attention, O Dear One, to this auspicious King of Hymns.

asya śrībahurūpabhaṭṭārakastotramantrasya, śrīvāmadevarṣiḥ |
anuṣṭup chandaḥ, śrībahurūpabhaṭṭārako devatā, ātmano vāṅmanaḥ
- kāyopārjita-pāpanivāraṇārthaṃ caturvargasiddhyarthaṃ pāṭhe viniyogaḥ.

Of this *Bahurūpabhaṭṭāraka stotramantra*, Vāmadeva is the *ṛṣi*, Anuṣṭup is the metre, Śrī Bahurūpabhaṭṭāraka is the deity, and the purpose of the recitations lies in removing the sins committed by way of word, mind and body and attending the fourfold goal.

atha dhyānam

vāme kheṭakapāśaśārṅgavilasaddaṇḍaṃ ca vīṇāntike,
bibhrāṇaṃ dhvajamudgarau svanibhadevyaṅkaṃ kuṭhāraṃ kare |
dakṣesyaṅkuśakandaleṣudamarūnvajratriśūlābhayān,
rudrasthaṃ śaravaktramindudhavalaṃ svacchandanāthaṃ stumaḥ ||

Dhyāna:

Shining in his left hands are a shield, a noose, a bow, a stick, a *vīṇā*, a small bell, a flag, a hammer, and an axe, and he holds the Devī on his lap. In his right hands he holds a sword, a goad, a stick of sugarcane, an arrow, a *ḍamaru*, a *vajra*, and a trident, and one hand is in *abhaya-mudrā*, the posture of assurance. We praise the five-faced Lord Svacchandanātha, white like the moon, who is standing on Rudra.

Aghora Gāyatrī:

oṃ bahurūpāya vidmahe koṭarākṣāya dhīmahi tanno'ghoraḥ pracodayāt |

OṂ "we know Bahurūpa, we meditate on Koṭarākṣa (whose eyes are sunken in); may Aghora inspire us!"

Mūlam:

oṃ aghorebhyo'tha ghorebhyo ghoraghoratarebhyaśca |
sarvataḥ śarva sarvebhyo namaste rudrarūpebhyaḥ ||

Mūlamantra:

OṂ Praise be to the forms of Rudra, Sarva, Śarva, Aghora, Ghora, and Ghoraghoratara.

Stotra:

oṃ namaḥ paramākāśaśāyine paramātmane |
śivāya parasaṃśāntanirānandapadāya te || 1 ||

OṂ Praise be to that Śiva, the Supreme Self, who is resting in Supreme Void, the Supremely Peaceful One, the abode of indescribable bliss;

avācyāyāprameyāya pramātre viśvahetave |
mahāsāmānyarūpāya sattāmātraikarūpiṇe || 2 ||

to the unutterable One, the immeasurable One, the Supreme Subject, the cause of the universe, who is in the great universal form, that one form which is the sole Existence.

ghoṣādidaśadhāśabdabījabhūtāya śambhave |
namaḥ śāntograghorādimantrasaṁrambhagarbhiṇe || 3 ||

Praise be to Śambhu who is the seed of speech in the ten forms of sound, and who holds in his womb the host of *mantras* which are peaceful, fierce and terrible.

revatīsaṁgavisrambhasamāśleṣavilāsine |
namaḥ samarasāsvādaparānandopabhogine || 4 ||

Praise be to him who is playful in the embrace of Revatī (Pārvatī) in the perfect intimacy of her company, to him who enjoys supreme bliss through harmonious union.

bhogapāṇe namastubhyaṁ yogīśaiḥ pūjitātmane |
dvayanirdalanodyogasamullāsitamūrtaye || 5 ||

Praise be to you in whose hands is enjoyment,[8] whose Self is worshipped by the great *yogīs*, to him whose form upsurges fully (blossoms) with the eagerness of totally obliterating duality.

tharatprasaravikṣobhavisṛṣṭākhilajantave |
namo māyāsvarūpāya sthāṇave parameṣṭhine || 6 ||

Praise be to Sthāṇu,[9] the Supreme,[10] whose nature consists of *māyā*,[11] who is pulsating with the agitation of creating the expansion of the entirety of living beings.

ghorasaṁsārasaṁbhogadāyine sthitikāriṇe |
kalādikṣitiparyantapāline vibhave namaḥ || 7 ||

Praise be to the all-pervading Lord, who is the bestower of experience of the terrible existence of the world, (and who is) the preserver and the protector of (all the *tattvas*) from *kalā* down to the Earth.[12]

rehaṇāya mahāmohadhvāntavidhvaṁsahetave |
hṛdayāmbhojasaṁkocabhedine śivabhānave || 8 ||

Praise be to the Śiva-sun who pierces the limitation of the heart-lotus and reveals it, (and who is) the cause of the destruction of the darkness of great confusion.

8. Or, "whose hands imitate the hood of a serpent." Also implied is the inseparability of Śiva (*bhoga*) and Śakti (*pāṇi*).

9. Śiva's name in Kurukṣetra is Sthāṇeśvara.

10. Parameṣṭhi Guru.

11. Creative power; the *māyā* referred to here is the *śakti* or the Divine.

12. I.e. impure creation; according to Trika doctrine, impure creation begins with *māyā* which is the cause of limitation.

bhogamokṣaphalaprāptirhetuyogavidhāyine |
namaḥ paramanirvāṇadāyine candramaulaye || 9 ||

Praise be to Candramaulī,[13] bestower of the supreme peace,[14] who is the cause of union, and who is the cause of the attainment of enjoyment and liberation.[15]

ghoṣāya sarvamantrāṇāṁ sarvavāṅmayamūrtaye |
namaḥ sarvāya śarvāya sarvapāśāpahāriṇe || 10 ||

Praise be to Sarva and Śarva,[16] the remover of all fetters, the embodiment of all scriptures, who is the sound of all *mantras*.[17]

ravaṇāya ravāntāya namaste rāvarāviṇe |
nityāya suprabuddhāya sarvāntaratamāya te || 11 ||

Praise be to you who screams, who is the end of sound, who is roaring, to the Eternal one, to the highly Awakened one, and who is the closest of all.

ghoṣāya paranādāntaścarāya khacarāya te |
namo vākpataye tubhyaṁ bhavāya bhavabhedine || 12 ||

Praise be to the Lord of speech, who is the sound and who moves at the end of sound, who is moving in the Void,[18] who is the World[19] and who is the one who destroys the world.

ramaṇāya ratīśāṅgadāhine citrakarmiṇe |
namaḥ śailasutābhartre viśvakartre mahātmane || 13 ||

Praise be to him who is full of delight in his play, who burns the husband of Rati,[20] who creates a wonderful multiplicity of things,[21] to the husband of the daughter of Himālaya, the creator of universe, the great Soul.

tamaḥpārapratiṣṭhāya sarvāntapadagāya te |
namaḥ samastatattvādhvavyāpine citsvarūpiṇe || 14 ||

13. The moon that decorates the head of Śiva is *amākalā*, the seventeenth, which neither waxes nor wanes, but rather continually replenishes the other 16 parts without losing its fullness.

14. *Nirvāṇa*.

15. Cf. *yasmin sarvaṁ yataḥ sarvaṁ yaḥ sarvaṁ sarvataśca yaḥ* |
yaśca sarvamayo nityaṁ tasmai sarvātmane namaḥ || — *Mahābhārata* (XII, 47, 54).

16. One who removes all sins.

17. Sound is stated to be of ten kinds; *ghoṣa* is one of them.

18. *Khacara = khecara*.

19. *Bhava* is Śiva in the form of water (*jalamūrti*). Cf. Abhinavagupta's *Abhinavabhāratī*, Ch. 2, *Maṅgalaśloka*:
saṁsāraṇāṭyajananadhātṛbījalatājuṣīm |
Jalamūrtiṁ śivāṁ patyuḥ sarasāṁ paryupāsmahe ||

20. I.e. Kāmadeva. This refers to the legend of the burning of Kāma, the god of love, by Śiva with the fire coming out from his third eye.

21. Or: "who is the painter of the universe".

Praise be to you, who is well-established beyond the darkness, who has reached the recess of everything, who pervades all the categories and paths, who is of the nature of consciousness.

revadvarāya rudrāya namaste rūparūpiṇe |
parāparaparispandamandirāya namo namaḥ ǁ 15 ǁ

Praise be to you, best at jumping,[22] to Rudra, the one who is the cause of all forms, who is the abode of the supreme and non-supreme vibrations.

bharitākhilaviśvāya yogigamyāya yogine |
namaḥ sarveśvareśāya mahāhaṃsāya śambhave ǁ 16 ǁ

Praise be to Śambhu who pervades the whole universe, who is attainable by *yogī*s and who is himself a *yogī*, the Lord of all gods, the great Haṃsa.[23]

carcyāya carcanīyāya carcakāya carāya te |
ravīndusandhisaṃsthāya mahācakreśa te namaḥ ǁ 17 ǁ

Praise be to you, Lord of the great *cakra*,[24] who is to be reflected and meditated upon, who is the agent of repeated discussion, who is (always) moving, who is established at the juncture of the sun and moon.[25]

sarvānusyūtarūpāya sarvācchādakaśaktaye |
sarvabhakṣāya śarvāya namaste sarvavedine ǁ 18 ǁ

Praise be to Śarva, the all-knowing, who is interwoven with everything, who covers everything in the form of energy, and who devours everything.

ramyāya vallabhākrāntadehārdhāya viyogine |
namaḥ prapannaduṣprāpyasaubhāgyaphaladāyine ǁ 19 ǁ

Praise be to the beautiful one, who is half of the body of his beloved[26] yet who is at the same time always unattached, who bestows the fruit of great fortune which is difficult to attain even through submission (to him).

tanmaheśāya tattvārthavedine bhavabhedine |
mahābhairavanāthāya bhaktigamyāya te namaḥ ǁ 20 ǁ

Praise be to you, O great Lord, who can be attained through devotion, the great Lord Bhairava, destroyer of worldly existence, the knower of the true reality.

śaktigarbhaprabodhāya śaraṇyāyāśarīriṇe |
śāntipuṣṭyādisādhyārthasādhakāya namo'stu te ǁ 21 ǁ

22. That is, who is expert at skipping over all the stages of experience, known as *vihaṅgama yoga*.
23. Cf. *Stavacintāmaṇi* (8). The great Lord is stated to be *haṃsa*, because it is He who dissolves within which has been created once. He is the author of *hāna*, destroying, and of *samādāna*; therefore, He is called *haṃsa*.
24. *Sahasrāra* or universal *cakra*.
25. *Iḍā* and *piṅgalā*.
26. The Ardhanārīśvara form of Śiva is referred here.

Praise be to you, who causes (one) in the womb of Śakti to awaken,[27] in whom refuge is to be taken, who is bodiless, who is the cause of attaining the goal of *śānti* and *puṣṭi*;[28]

ravatkuṇḍalinīgarbhaprabodhaprāptaśaktaye |
utsphoṭanāpaṭuprauḍhaparamākṣaramūrtaye || 22 ||

to him who has attained awakening from the coiled state of the energy, rising up with a hissing sound, and who is the very form of the Supreme *akṣara*,[29] the divine form of whose is highly efficient and has attained steadiness regarding this upsurge of everything.

samastavyasta saṅgrastaraśmijālodarātmane |
namastubhyaṁ mahāmīnarūpiṇe viśvagarbhiṇe || 23 ||

Praise be to you, who is in the form of a great fish in whose womb lies the universe in the form of totality and separateness, as if you have swallowed the net of all the rays and collected them inside your belly;[30]

revāraṇisamudbhūtavahnijvālāvabhāsine |
ghanībhūtavikalpātmaviśvabandhavilāpine || 24 ||

who is illuminated by the blazing fire arising from the fire-stick[31] collected from the bank of Revā river,[32] to him who removes all the bondage of the world consisting of solidified determinate thought.

bhoginīsyandanārūḍhiprauḍhimālabdhagarviṇe |
namaste sarvabhakṣyāya paramāmṛtalābhine || 25 ||

Praise be to you, who is elated after attaining perfection through been borne by the Serpent-chariot,[33] to you who consumes everything and who is eager to receive the supreme nectar.

naphakoṭisamāveśabharitākhilasṛṣṭaye |
namaḥ śaktiśarīrāya koṭidvitayasaṅgine || 26 ||

Praise be to you, who has filled the entire creation by entering within (the phonemes) from *ṇa* to *pha*,[34] whose body is Śakti and who is closely associated with these two extremes.

27. Or "who causes the womb of Śakti to awaken."
28. Rituals performed for peace are called *śānti* and nourishment is known as *puṣṭi*.
29. *Akṣara* is the indestructible *Brahman*, the Supreme. All the syllables are known as *akṣara* because they are the forms of energies of the Divine and inseparable from Him in essence.
30. Cf. *TĀ* (I.7): *macchandavibhuḥ*.
31. That is, the stick churned to create fire through friction.
32. The Narmadā.
33. The seven rays of the sun.
34. All the Sanskrit alphabets arranged differently from the order known as Mātṛkā. The order which begins with *ṇa* and ends in *pha* is known as Mālinī.

mahāmohamalākrāntajīvavargāvabodhine |
maheśvarāya jagatāṁ namaḥ kāraṇabandhave || 27 ||

Praise be to the great Lord of all the worlds, the friend of the Causes,[35] who is the cause of the awakening of the host of those worldly beings who have been overpowered by the impurity of great delusion.

stenonmūlanadakṣaikasmṛtaye viśvamūrtaye |
namaste'stu mahādevanāmne parasvadhātmane || 28 ||

Praise be to you, who is called the great God, who uproots all sorts of obstacles by your mere thought, to you who is of universal form, who is of the nature of supreme *svadhā*.[36]

rugdrāviṇe mahāvīryaruruvaṁśavināśine |
rudrāya drāvitāśeṣabandhanāya namo'stu te || 29 ||

Praise be to you, Rudra, who removes disease, who destroys the lineage of powerful Ruru demons,[37] who dissolves all sorts of bondage.

dravatpararasāsvādacarvaṇodyuktaśaktaye |
namastridaśapūjyāya sarvakāraṇahetave || 30 ||

Praise be to you, the Cause of all causes, who is worshipped by the gods,[38] whose energy is eager to enjoy the taste of the melting of the supreme nectar.

rūpātīta namastubhyaṁ namaste bahurūpiṇe |
tryambakāya tridhāmāntaścāriṇe citracakṣuṣe || 31 ||

Praise be to you, Bahurūpa, who transcends all forms, who is Tryambaka,[39] who moves in the core of three domains,[40] who has a strange eye.[41]

peśalopāyalabhyāya bhaktibhājāṁ mahātmanām |
durlabhāya malākrāntacetasāṁ tu namo namaḥ || 32 ||

Praise be to him, who is attained by the great-souled devotees through easy means, and yet who is difficult to attain for those whose minds are affected by impurities.

bhavapradāya duṣṭānāṁ bhavāya bhavabhedine |
bhavyānāṁ tanmayānāṁ tu sarvadāya namo namaḥ || 33 ||

35. The deities Brahmā, Viṣṇu, etc. See note 3 above.
36. The sound of oblation. *Svadhā* is uttered when anything is offered to the gods, while *svāhā* is said to the fire, to be carried to the gods indirectly.
37. *Ruru*: cf. *Rauravāgama*.
38. *Tridaśa* is a synonym of 'gods.'
39. Tryambaka (the Three-Mothered one, born from *Parā*, *Parāparā* and *Aparā*) is one of the names of Śiva, uttered with the prayer that He may bestow grace in such a way that one may transcend death and gain immortality.
40. Sun, moon, and fire.
41. His third eye.

Praise be to Bhava, who bestows worldly existence to the wicked, but to the noble souls who are totally absorbed in him, he destroys (all) worldly existence and bestows everything.

aṇūnāṁ muktaye ghoraghorasaṁsāradāyine |
ghorātighoramūḍhānāṁ tiraskartre namo namaḥ || 34 ||

Praise be to him who bestows liberation to limited souls, but gives terrible worldly existence to those who are deluded by the terrible *ghora* (*śakti*s).

sarvakāraṇakalāpakalpitollāsasaṅkulasamādhiviṣṭharām |
hārdakokanadasaṁsthitāmapi tāṁ praṇaumi śivavallabhāmajām || 35 ||

I pay homage to that unborn beloved of Śiva, who — although steadily abiding within the Heart-Lotus (of the practitioners) — sits on the *āsana* (of Śiva, who is) always full of delight in *samādhi* (this *āsana*), having emerged from all the Causes.[42]

sarvajantuhṛdayābjamaṇḍalodbhūtabhāvamadhupānalumpaṭām |
varṇabhedavibhavāntarasthitāṁ tāṁ praṇaumi śivavallabhāmajām || 36 ||

I pay homage to the unborn beloved of Śiva, who steadily abides in the glorious core of the realm of the various syllables, and who is eager to drink the honey which spurts up from the devotion within the lotus-heart of all worldly beings.

ityevaṁ stotrarājeśaṁ mahābhairavabhāṣitam |
yoginīnāṁ paraṁ sāraṁ na dadyādyasya kasyacit || 37 ||

Thus, is the excellent hymn spoken by the great Bhairava, which is the highest essence of the *yoginī*s.[43] This should not be given to anybody and everybody.

adīkṣite śaṭhe krūre niḥsatye śucivarjite |
nāstike ca khale mūrkhe pramatte viplute'lase ||

guruśāstrasadācāradūṣake kalahapriye |
nindake cumbhake kṣudre'samayajñe ca dāmbhike ||

dākṣiṇyarahite pāpe dharmahīne ca garvite |
bhaktiyukte pradātavyaṁ na deyaṁ paradīkṣite || 38-40 ||

It should not be given to the one who is not initiated, to the deceitful, to the cruel, to the liar, to the one who is untruthful, to the one who has no sense of purity, to the one who has no faith in (any) future life, to the mischievous, to the foolish, to the intoxicated, to the confused or to the sluggish, nor to the one who finds fault with the teacher, with *śāstra*s and with right conduct and who is quarrelsome, to the censorious, to the superficial, to the small-minded, to the opportunist or to the arrogant, to the one who is not liberal, to the sinful, to who is free from piety, or to the proud. It should be given to the one who is devoted but not to the one who has been initiated by others.

42. Cf. note 3.

43. *Yoginī*: one's own true nature is non-different from the self which abides steadily in the form of *śakti*.

paśūnāṁ sannidhau devi noccāryaṁ sarvathā kvacit ।
asyaiva smṛtimātreṇa vighnā naśyantyanekaśaḥ ॥ 41 ॥

O Goddess, this hymn should never be uttered before the bestial people. Only by keeping this hymn in mind shall all obstacles disappear:

guhyakā yātudhānāśca vetālā rākṣasādayaḥ ।
ḍākinyaśca piśācāśca krūrasattvāśca pūtanāḥ ॥

naśyanti sarve paṭhitastotrasyāsya prabhāvataḥ ।
khecarī bhūcarī caiva ḍākinī śākinī tathā ॥

ye cānye bahudhā bhūtā duṣṭasattvā bhayānakāḥ ।
vyādhidaurbhikṣadaurbhāgyamārimohaviṣādayaḥ ॥

gajavyāghrāśca ye ghorā palāyante diśo daśa ।
sarve duṣṭāḥ praṇaśyanti cetyājñā parameśvarī ॥ 42-45 ॥

॥ iti śrīlalitasvacchande bahurūpagarbhastotrarājaḥ sampūrṇaḥ ॥
॥ iti śivam ॥

Guhyaka, Yātudhāna,[44] Vetāla,[45] (attendants of Kubera), demons, Ḍākinīs, *piśācas*, evil-hearted beings, and the evil female spirits (*pūtanās*) who cause harm to newborn babies: all of them completely disappear through the influence of the recitation of the hymn. Those demons wandering above the sky and roaming on the earth, and the Ḍākinīs and Śākinīs and ghosts of various kinds and all the evil-hearted demons, very wicked and dreadful, (as well as) disease, famines, wretchedness, death, general absence of intellect, and dreadful animals like wild elephants and tigers flee in every direction. All wicked beings will disappear — this is the command of the great Lord.

The *Bahurūpagarbhastotrarāja*, contained in the *Śrīlalitasvacchanda*, ends here.

44. Evil spirits.
45. Living corpses.

3

On the Parvan Rites
According to Abhinavagupta's Tantrāloka[1]

André Padoux

AMONG the occasional or periodical obligatory (*naimittika*) rites to be performed by all Hindus are those to be carried out on the so-called *parva* or *parvan* days which are those of certain lunar *tithi*s, of solar *saṁkrānti*s, or of some other occasions. Though these rites are generally considered important, as shown by their prescription in the Purāṇas, Tantras and ritual *paddhati*s, not all traditions stress their importance equally. The Śaiva systems tend to emphasize them, and among non-dualist Śaivas the great Kashmirian master Abhinavagupta considers these rites to be of the greatest consequence, a position he sets out in detail in the 28th chapter of his *Tantrāloka* (*TĀ*),[2] and more briefly in chapter 20 of his *Tantrasāra*.[3] In fact, since these rites (and a few others) are both obligatory and necessary, Abhinavagupta would have preferred them to be classified as *nitya* rather than *naimittika*, though he follows the latter classification because it is traditionally accepted — hence their exposition in the 28th *āhnika* of the *TĀ*, which is dedicated to *naimittika* rites.

Though Abhinavagupta describes the *parvan* days as particular moments in astronomical or social time, he gives his own interpretation of the meaning of the term *parvan* and therefore of the significance of the *parvan* rites. He relates *parvan*, or *parva*, to the Sanskrit root *pṛ* with the suffix *van*, or to the root *parv*, both meaning to fill; this because *parvan*s are ritual occasions and actions which give fullness to consciousness: *svasaṁvitpūrṇa tālābhasamayaḥ parva bhaṇyate* (28.16b), a fullness obtained, he explains, because during the ritual, those who take part in the wheels of power (*cakracāriṇyaḥ*) formed by the ritual assembly (*melaka* or *melana*) of *siddha*s and *yoginī*s (that is, of male

1. Bettina Bäumer is one of those who have paid particular attention to the non-dualist Śaiva tradition of Kashmir, and who have toiled to make it known as widely as possible. Therefore it is fitting that I should dedicate to her this brief study of a passage from Abhinavagupta's *Tantrāloka*, not only as a contribution from a fellow-student of this same tradition, but also, and still more, as an affectionate token of our long friendship.

2. *The Tantrāloka of Abhinavagupta with the Commentary of Jayaratha* (KSTS, Srinagar, 1918-38, Reprint), ed. R.C. Dwivedi/Navjivan Rastogi, 8 vols., Delhi, *et al.*: Motilal Banarsidass, 1987.

3. *The Tantrasāra of Abhinavagupta*, ed. Pt. Mukunda Ram Shastri (KSTS ; 17) Srinagar, 1918.

and female participants) collectively transcend time. That this transcendence identifies them with the fullness of divine Consciousness is because, according to Abhinavagupta's conception of time, time has no intrinsic reality: is it based only on *prāṇa*, which itself rests in consciousness, that is, in God.[4] "The emissions and resorptions of the universe," says Abhinavagupta in *TĀ* (6.179b-181a), "have no other foundation than *prāṇa*, which rests on [human] consciousness, which itself rests in [divine] Consciousness, pure Conscience devoid of all objects. This pure Conscience is the Goddess, the supreme Mistress of the universe, the 38th *tattva*, the supreme all-transcending Heart (*evaṁ visṛṣṭipralayāḥ prāṇa ekatra niṣṭhitāḥ* ॥ *so'pi saṁvidi saṁvic ca cinmātre jñeyavarjite* ॥ *cinmātram eva devī ca sā parā parameśvarī* ॥ *aṣṭatriṁśaṁ ca tattattvaṁ hṛdayaṁ tat parāparam*)." In this system, only divine Consciousness is real. It is the essence and substratum of all that exists. Human actions merely divide this totality, obscuring or veiling the perfect omnipresent light. This being so, *parvan*s are days when the perfect Consciousness prevails in its fullness, and so ritual acts performed on those days tend to identify the officiating person with this time-transcending reality. So powerful is the identification reached on these occasions, says *TĀ* (28.19b-20a), that if an uninitiated person happened to enter the circle of *siddha*s and *yoginī*s while they were performing their ritual worship, he would immediately identify with (*tanmayībhavet*) the transcending state of mind of the initiated participants. During these moments of fullness, Abhinavagupta adds (28.23), the fullness of conscience of the participants is similar to Kāmadhenu: the rites performed bestow all that one can desire. We might well ask how an uninitiated person could be permitted to enter an esoteric, secret assembly. But, says Abhinavagupta (28.23-25), just as in a great feast all those who come in are welcome, similarly the *siddha*s and *yoginī*s, however eager they may be to reap the fruits of their ritual action, must not exclude those who, aware of their gathering, enter it. But in fact not everybody is free to enter: those attached to the ways of the world (*lokācāra*), says Abhinavagupta further on, must not be admitted: if such a person were to enter, the ritual action would have to be halted and taken up again at a later time. Even so, such a permissive attitude may well seem surprising. It is, however, philosophically grounded in the Trika's conception of consciousness as omnipresent (*sarvātmika*). In ordinary life (*lokācāre*), this consciousness is divided, 'contracted' (*saṁkucita*). But when, on *parvan* days, *siddha*s and *yoginī*s take part in such a Tāntric assembly (*melaka*) as the *cakrayāga/mūrtiyāga*, this common consciousness shines and expands (*vikasvara*), because the consciousnesses of all the participants mutually unite and reflect each other (*anyonyasaṁghaṭṭapratibimbād vikasvarā* — 28.374a): the flow of the vibrating rays (*ucchalannijaraśmyoghaḥ*) of consciousness of all the individual participants (all resting, in fact, in divine Consciousness), are mutually reflected as in so many mirrors and attain without effort (*ayatnataḥ*), a state of universal-ization, thus creating a condition akin to that of the divine omnipresent consciousness. The *TĀ* explains

4. Abhinavagupta's conception of time is expounded in chapter 6 of the *TĀ*; chapter 7 describes the apparition of the wheels of power (*cakrodaya*) and their role, together with that of *prāṇa*, in the quest for liberation.

this by saying that, in the same way, when many people are gathered to attend the performance of a play, a concert, or some other show, real aesthetic enjoyment is experienced only when the attention of the whole audience is concentrated on the show and all are absorbed in it collectively, not individually. One common (*ekatā*) state of consciousness then appears, full of peace and bliss (*pūrṇānandatvam*). The same mental state is to be obtained during the *melaka* or *cakrayāga* performed on the *parvan* days. This conception of a common transcendent state of consciousness resulting from intense collective participation in the performance of a ritual, a state to be compared to the aesthetic experience of a theatre audience, is, I believe, worth mentioning.

Apropos the performance of *naimittika* rites, and especially in the case of the *parvan* rites, Abhinavagupta sets out another original and interesting conception, which, like the preceding one, is grounded in his philosophy. On the *parvan* days, certain deities are to be worshipped, as we shall see. But what distinguishes these days, he says (28.188-192), is that these are the occasions when an adept must worship not only particular deities, but also everything that, "conscious or unconscious" (*cidacit*), indirectly or directly (*pāramparyeṇa sākṣād vā*), helps him to attain his goal, be it enjoyment or liberation (*bhogamokṣa*). This worship should thus also extend to the means used to perform it and, further still, to the means of the means to that end. That is, not only to the icon but also to the prescribed period of time, the ritual action, etc. (*tadupāyo'pi saṃpūjyo mūrtikālakriyādikaḥ*). But why should one worship these means and not just the deities themselves? The reason, Abhinavagupta explains (28.190-191), is that by their very nature (*upāyatvam*) the means engender the result (*upeyasūtisāmarthyam upāyatvam*). Therefore to identify with (*tanmayībhāva*) the means is the most direct way to reach the goal. The nearer the means is to the goal the more rapidly this will be attained; and what is nearer to the godhead than its worship (*arcana*)? Hence, the saving efficacy of the *parvan* rites. Of course, all worship in Tāntric or 'Tantricized' Hinduism tends to identify the worshipper with the deity being worshipped. To this however the *TĀ* adds a philosophical reason: a means is not only a means to an end. It is what causes that end. And for Abhinavagupta, whose philosophical stance is that of the *satkāryavāda*, the effect pre-exists in its cause. Therefore by the mere use of the proper time and of the various direct or indirect means for approaching a deity ritually, one already identifies, so to speak, with that deity. To this can be added another, more fundamental, reason, which Abhinavagupta puts forward in chapter 2 of the *TĀ* — namely that means and end (*upāya* and *upeya*) are indistinguishable. All outer means, he says, are "nothing else but the pure light, the innate essence of Śiva," *prakāśātmatāmātraṃ śivasyaiva nijaṃ vapuḥ* (2.15). This was stated in chapter 2, on *anupāya*, that is, in a mystical context. But metaphysically the notion is grounded in the *saṃvidadvayavāda*, the Trika doctrine of the non-duality of consciousness, for which "all is in all" (*sarvaṃ sarvātmakam*): the means as well as everything are always and eternally Śiva.

Another aspect of Abhinavagupta's conception of the means by which to approach the deity, and of the collective form this approach may take, appears in his description, in

this 28th chapter, of the role of the *guru* and of his family. The means or way (*upāya*) to the knowledge (*jñāna*) leading to liberation as well as to other rewards (*bhogamokṣopakāriṇaḥ*), he says (28.193), are the *śāstra*s and the *guru* who expounds and explains them. This account of the role of the *guru* is already to be found in *Śivasūtra* (2.6): *gurur upāya*. The *guru* is the *upāya*, the means to gain liberation, Kṣemarāja explains in his *Vimarśinī*, because he teaches the real meaning of the Śāstra, the efficacy of *mantra*s, etc. But here the role of transmitter of the divine is not limited to the *guru*, but extended to the "group formed by his wife, his brothers and sons and so forth" (*guroḥ patnī tathā bhrātā putra ityādiko gaṇaḥ*). This extension is possible, we are told, because the *guru* and his relatives and family are united not merely by a natural, physical bond, but also by an "accessory cognitive continuity" (*bodhopakārasantati*), since they are all grounded in the knowledge of Śiva (*śivajñānaniṣṭhitaḥ*). In this conception, the *guru*, identified as he is with the "sublime supramundane understanding or gnosis" (*asaṃsārocitodāratathāvijñāna*), is the cause (*kāraṇa*) of this divine presence, while his wife is his assistant (*sahakāriṇī*), his brothers and the other members of his group (*gaṇa*) being linked with him. This gnostic continuity is essential, adds Abhinavagupta (28.212), and is always to be worshipped and honoured (*mukhya eṣa tu santānaḥ pūjyo mānyaśca sarvadā*). The *TĀ* thus gives an unusually wide and rather unexpected interpretation of the Tāntric conception of the *guru* as divine.[5]

So, which are, according to Abhinavagupta, the *parva*-days? He says first (28.10-14) that they are of two sorts: *kula* and *akula*. The latter category he does not define. The former, the *kula* days, are those of the eight *yoginī*s Māheśī, Brāhmī, Kaumārī, Vaiṣṇavī, Aindrī, Vārāhī, Cāmuṇḍā and Yogeśī, each of whom is to be worshipped on two different *tithi*s. Further on (28.31-35), the *TĀ* classifies the *parvan*s differently: in six categories, *sāmānya*, *viśeṣa*, *sāmānya-sāmānya*, *sāmānya-viśeṣa*, *viśeṣa-sāmānya* and *viśeṣa-viśeṣa*. How these two classifications (which if combined, would include practically all the days of a lunar fortnight) are to be combined or distinguished in practice, is not explained. Abhinavagupta underlines the great importance of these days and the mandatory character of the performance of the *parva* rites: those who ignore the *parva*s, he says, do wrong and behave like animals (28.58-59). Such is the merit attached to them that, according to a *tantra* he quotes, if one has not done the *nitya* rite on some day, the performance of the *parva* worship acts as an atonement for the fault.

The ritual to be performed on *parva* days is the worship of the eight goddesses mentioned in *TĀ* (28.31-35). More specifically, the rite to be performed on such days is the *cakrayāga*, also called *anuyāga* or *mūrtiyāga*, which is, we are told, the most important (*mukhya*) of all the *nitya* or *naimittika* rites, and also among *kāmya* rites. The participants,

5. In the first chapter of the *TĀ* (1.236), Abhinavagupta states that the *guru* is one with his family or lineage (*svasantāna*). Commenting on this verse, Jayaratha explains that human differences being artificial or imaginary (*kālpanika*) the *guru*, fused in the divine Consciousness, is not to be differentiated from his *santāna*, which is made up of his own disciples and of the disciples of these disciples (*śiṣya-praśiṣya*), because they all shine (that is, exist) in unity with the Self: *ātmatvena ekasyaivāsya sphuraṇāt*.

male and female, must all be *jñānins* and *yogins* (*jñānī yogī ca puruṣaḥ strī vā*) for these are the best receptacles or supports (*pātram anuttaram*) of the ritual, their mere contact being a source of fullness (*tat saṁparkāt pūrṇatā syāt*): "A gift or any action in favour of a *jñānin* or a *yogin*," Abhinavagupta adds (28.64), "bestows as much merit as the sacrifice of the three worlds with all they contain."

"The master who knows that 'All that can be enjoyed is *māyā*, the enjoyer is Śiva and I am Him' knows the reality. He is looked upon as a god. When he enters the house all herbs dance!"[6] The *TĀ* (28.65-71) goes on to enumerate various other merits and virtues of such a master, referring for all this to the *Siddhayogeśvarīmatatantra*.[7]

There are according to *TĀ* (28.78-82) five forms of the *cakra-/mūrtiyāga* ritual. It can be solitary (*kevala*), when performed only by the *gurus*, or mixed (*miśra*), when performed by "*sādhakas* and so forth" (*sādhakādyaiḥ*): a rather vague description. Or it can be in pairs (*yāmala*), when the adepts perform it with feminine partners that can be either their wives (*sapatnīyogāt*) or a paid prostitute (*krayānīta-veśyāsaṁyogataḥ*). When it includes a union with 'energies' (*śaktisaṁyogāt*),[8] it is called *cakrayukta* and "produces all fruits desired (*sarvaphalapradaḥ*)." Finally there is the *vīrasaṅkara*, the sacrifice in which all participate (*sarvais tu sahito yāgaḥ*). Towards the end of the chapter (371-73), Abhinavagupta says that the union with a *yoginī* (*yoginīmelaka*) may be either violent or loving (*haṭhataḥ priyatas tathā*). He adds that when one unites with a female partner representing one of the eight *yoginīs* the union must take place on the *parvan* of that deity. The same rule applies when the master unites with a member of his own lineage 'or other' (*svasantānādi*) — the nature of this 'other' is not explained. It is worth noting here that Abhinavagupta's comparison, which I mentioned earlier, between the collective spiritual union attained during the *cakrayāga* and the collective aesthetic experience occurs apropos the union with the master's *santāna*, perhaps because this sort of collective state of mind may be more easily attained in a group linked both naturally and spiritually.

The *cakrayāga* or *mūrtiyāga* ritual is briefly described in *ślokas* 82b-111 of the chapter. The heroes and their energies (*vīra* and *śakti*) are to meet at night in a hidden or secret house (*rātrau gupte gṛhe*), calling each other by 'non-conventional' (*asaṁketa*), i.e. initiatic names and using a 'divine,' i.e. a secret, language (*devatāśabda*). These adepts constitute

6. *bhojyaṁ māyātmakaṁ sarvaṁ śivo bhoktā sa cāpy aham* |
 evaṁ yo vai vijānāti daiśikas tattvapāragaḥ ‖ 68 ‖
 taṁ dṛṣṭvā devamāyāntaṁ krīḍantyoṣadhayo gṛhe |

7. This Tantra (of the Vidyāpīṭha) is probably the oldest source of the Trika. Abhinavagupta appears to hold it in high esteem and quotes it often in the *Tantrāloka*. A short version of this text was edited in an (as yet unpublished) Oxford doctoral thesis by Judit Törzsök. This shorter version does not include any of the passages quoted in the *Tantrāloka*, which presumably refers to a much vaster work, unfortunately no longer available. The *Siddhayogeśvarīmata* deals with the pantheon and cult of female spirits (*yoginīs*) and *mantra*-goddesses.

8. A sexual union seems therefore not to take place in all forms of *cakrayāga*.

the wheel of the *cakrayajña*. If a whole 'wheel' of divine forms (*mūrti*) cannot be gathered, says the *TĀ*, the ritual may be performed with young girls (*kumārī*) provided they are under the age of puberty.

The *cakrayāga* is so-called because the participants are to be placed in a circle, the master, surrounded by his family or lineage, remaining in the centre. The other participants form three concentric rows, the outer one being for the lower initiates, the *samayin*s. Participants can also stay in a line, the master being always in the centre. All these circles or wheels (*cakra*) are to be worshipped (*pūjyāḥ*) successively (*cakrānusāreṇa*), beginning with the master and ending with the *samayin*s, with offerings of perfumes, incense, flowers, ointments and garments or pieces of cloth (*vāsa*), each participant being identified with a deity. These vary in number, from one, if Bhairava is worshipped as the 'Solitary Hero' (*ekavīra*), to sixty-four, which is the usual number of the *yoginī*s. These deities are thus considered as forming a wheel having from one to sixty-four rays or spokes (*ara*),[9] the rays being the deities to be worshipped. As *TĀ* (1.112) says, the power of the Lord radiates out as the thousand or innumerable rays of the cosmic wheel (*viśvacakra*).[10]

This being so, the worship is to be addressed, not to an icon, but to the participants in the *yāga*, beginning with the master and his family and lineage (*santāna*), then going on to "those who know the true nature of all" (*tattvavit*), then to the other participants and especially the female ones. Those worshipped in this way are described in the *Tantrasāra* as: "the master, a member of his group, one of his lineage, one who knows the truth, a virgin, one belonging to the lowest caste, a prostitute, a passionate woman or one who knows the essence [of this ritual]" (*guruḥ, tadvargyaḥ, sasantānaḥ, tattvavit, kanyā, antyā, veśyā, aruṇā tattvavedinī vā*):[11] a rather bizarre lot! The master worships first the main deity, the icon used for this purpose being a vase (*pātra*) placed on a support (*ādhāra*) and filled with liquor (*alisampūrṇa*).[12] The vessel is to be conceived of as being Sadāśiva, the liquor as the ambrosia of power (*śāktāmṛta*), i.e. as Śakti, and the enjoyer of the ambrosia as Śambhu, the Supreme Lord, Parameśvara. The master, "meditating the triad of man, Śakti and Śiva as intermingling" (*anuśaktiśivātmetthaṁ dhyātvā sammilitaṁ trayam — TĀ* 28.89), must now 'satisfy,' that is, make offerings (*tarpaṇam*) to all the rays of the wheel one after the other, i.e. to all the participants conceived of as deities, going first from himself, the *guru*, to the *samayin*s then, in reverse, from them to himself. He is to offer to the deities/participants various stimulating substances, including "meat, fish

9. The number of *yoginī*s varies. They are sometimes eight, sometimes many more, their number being sometimes said to be sixty-four crore, this enormous number expressing their all-pervasiveness as aspects of the power radiating from the supreme deity.

10. Lists of deities forming the rays of such wheels are given in *TĀ* (33).

11. *TS* p. 184.

12. *Ali*, which means a bee, is one of the conventional terms used in Tāntric texts to mean the alcoholic substance used as offering to the deity (*arghya*). Other terms are also used such, for instance, as *kāraṇa, hetu, vāmāmṛta*.

and so forth" (*māṁsamatsyādi*), using for this purpose either a vessel or his hands displaying a particular *mudrā*. The ritual ends with further offerings of perfumes and so forth to the participants, and the *dakṣiṇā*. In the *Tantrasāra*, Abhinavagupta concludes by saying that this sacrifice, the *mūrtiyāga*, is the most important of all the rites to be performed on the *parvan* days. Whoever performs it, even if he has not seen the *maṇḍala* (that is to say even if he is not initiated), obtains in one year all the rewards of a *putraka*,[13] and this even if he does not perform the mandatory daily (*nitya*) rituals. Which shows how important the *parvan* ritual is for Abhinavagupta, whose conception is based on the teaching of earlier *tantras*, but expanding it so as to give practically to this *naimittika* ritual more weight than to the obligatory daily (*nitya*) rites. This is an interesting aspect of the ritual, but one which does not seem to have survived in later Śaiva practice.[14]

13. The *putraka*, the 'spiritual son,' is the second degree of initiation, the *nirvāṇa dīkṣā*. A *putraka* may perform rituals, not the lowest initiate, the *samayin*, whose initiation is the *samaya dīkṣā*. The most thorough description of the various Śaiva initiations is that given in the third volume of the *Somaśambhupaddhati*, ed., fully annotated and tr. into French by Hélène Brunner (Pondicherry: Institut Français d'Indologie, 1977).

14. I wish to thank Barbara Bray who — as she did often — for her very kindly checking English of this paper.

4

A Note on Santha Literature

D. P. Pattanayak

THE *bhakti* movement, which took birth in the south and reached the north, flooded the whole country. As a consequence, Orissa, like the rest of India, experienced the twin waves of a religious as well as a literary revolution. In fact, the *santha* poets everywhere often speak the language of a revolutionary. This language is the result of their intense concern for the redemption of society. Their anger is not directed against any specific caste or class, any social group or religious sect. They pleaded for the welfare of all and raised their voice against moral decay and degeneration of personal honesty and ethical norms. Most of them experienced great personal tragedy, suffering, exploitation, ritual cruelty and various kinds of social decay. Their writings often become emotional and accuse society of decay and regional degeneration. Still their unwavering faith in man, their confidence in the welfare of mankind as a whole, and their love and compassion for humanity is apparent through their writings. As true revolutionaries they are the greatest lovers of fellow beings.

All the *santha* poets credit their poetic inspiration and insight to the grace of the Lord. Unlike the *Rīti* poets, who proclaim their identity or the identity of their patrons, the signature tune of these poets was their personal deities. Whether it is Kudal Saṅgama Deva or Channamalikārjuna, Jānakīvallabha Rāma or Aṇākāra Brahma, they proclaimed divine grace as the source of all creativity. Whenever their name was mentioned, adjectives such as 'sinner,' 'servant,' 'devoid of knowledge,' 'inconsequential idiot,' etc., are used to indicate their sense of humility and sublimation of ego. One of the fascinating dimensions of these personal deities is that they have the attributes of 'being everywhere' and 'being nowhere,' at the same time being full as well as void, being *saguṇa* as well as *nirguṇa*. The ultimate realities underlying all manifestations are achieved "not through external rights, prescribed code of conduct, pilgrimages or the worship of idols, but through devotion or *bhakti*."

Bhakti derives from a Sanskrit root *bhaj*, which has the meanings 'to divide, distribute, alert or apportion to,' as well as 'to serve, honour, revere, love and adore.' *Bhakti* is traced back to the Vedas and the Brāhmaṇas by enthusiastic scholars and is related to the *Bhagavad-Gītā* and the *Bhāgavata Purāṇa* in the classical period of Hinduism. The *bhakti* movement gathered momentum with Ālvars, who in ecstatic language wrote about their frenzied

emotional experience of love and union with Kṛṣṇa. Their influence spread northward and was responsible for a widespread popular form of Hinduism.

Bhakti is perceived in its nine-fold division (*navadhā-bhakti*). From another perspective its four-fold divisions are: (1) *Vātsalyabhāva-bhakti* — loving the deity as a parents love the child. This is usually associated with Kṛṣṇa. The anthology prepared by Sūrdās in Braja-bhāṣā is the most representative collection. (2) *Sakhyabhāva-bhakti* — as a friend loves his friend. The Kṛṣṇa-Sudāmā episode is representative of this. (3) *Dāsyabhāva-bhakti* — as a servant loves his master. Hanuman as depicted in Tulasīdāsa's *Rāmacaritamānasa* is the best representative of this kind of *bhakti*. (4) *Mādhuryabhāva-bhakti* — as a woman loves her paramour or husband. The relationship of the *gopīs* with Kṛṣṇa is the best representative of this *bhakti*. Besides, there is a fifth variety of *bhakti*, which is a synthesis of yogic and the Sufistic. The outstanding representative of this type is the poet-saint Kabīr, who disdained Hindu and Muslim theology alike, but was ultimately claimed by both the communities.

It is generally accepted that *bhakti* had its origin among the Dravidians in the south. But what is of importance is the fact that, in its onward march to the north, it was influenced by Buddhism, Nāthism and other regional manifestations of religion. Through the medium of Braja it travelled to the south. Even Ravindranath Tagore wrote his *Bhanu Singher Padāvalī* in Brajabolī. Recently, manuscripts have been discovered in which the language is Braja but the script is Telugu. In the border of Orissa and West Bengal people read *Bhāgavata* in Oriya language and in Bengali script.

The *santha* poets addressed the common man through use of language that was conversational and transparent. Unlike Ornate Literature of the period, which emphasized suggested meaning, they wrote a language which brought expression and meaning closer together. In modern literature, concealment of meaning plays a crucial role. Whether it is metaphorical use of language or manipulation of ambiguities, modern literary language conceals more than it reveals. The *santha* poets aimed at a direct communication of experience. The *Anubhava Mantap* created by Allama Prabhu has a spatial locus identified only in the union of minds.

The *santha* poets were champions of their mother tongues. Turning away from Sanskrit — which had by that time become exclusively the language of priests and *paṇḍitas* — they opened the gateway to knowledge by expressing their poetry in vernacular languages. Whether it is Hindi (*saṁskṛta kūpajala, bhāṣā bahatā nīra*),[1] Marāṭhī (*saṁskṛta bhāṣā devekeli tari prākṛta kay cora pasun ali*), Kannaḍa (*sulida baḷeya*), Tamil (*ariyan kaṇḍai tamilan kaṇḍai*), or Oriya (*saṁskṛta pārākṛta je beni samasari, kebaḷa gobinda rasa amīya mādhurī*),[2] their use of the vernacular language is an expression of revolt against Sanskrit and affirmation of

1. "Sanskrit is the water in the well, the language is the flowing water."
2. "Sanskrit and Prākṛt languages both are similar, only the essence of Govinda is sweet nectar."

regional languages. The story about the Tamil saints Appār and Sambandha is significant here. Both of them performed a miracle in the temple at Vidyāraṇya, where the front door was supposedly sealed by the four Vedas after they worshipped Lord Śiva. Appār sang a prayer of 44 lines written in Tamil and the front door flung open.

> The significance of the miracle seems to be that the Vedas in archaic Sanskrit tended to hide the knowledge of God from the many who could not read them. Hence, under inspiration, Sambandha requested a non-brahmin compeer of his in the realm of the spirit to remove the barrier through the instrumentality of hymn in Tamil.[3]

In fighting for their mother tongues they had to pass through ordeals. The Oriya *Bhāgavata* was termed *Teli-Bhāgavata*, 'The *Bhāgavata* of an oil man.' Ekanātha's *Bhāgavata Purāṇa* had to go through a test before it was accepted. The head of the monastery before whom Ekanātha appeared sat behind a curtain as he would not even look at the face of the man who had rendered the *Bhāgavata* into a Prākṛt language. Santha Tukarama was taken to task, since being a śūdra he did not have the right to read, preach and write *abhaṅga*s. His manuscripts, like that of Nāmadeva, were consigned to water but the Gods provided protection in both the cases.

Being lower caste, these devotees had great difficulty in entering into temples or in making offerings to the deities. The episode of Dāsiā Bāurī in Orissa in which Lord Jagannātha had to come out to accept his offerings, is well known. The story of Kanakadāsa in Karnataka where the Lord had to turn around to give *darśana* to his devotee is equally well-known. It is no coincidence that the medieval saints sprang from the lower order of societies, such as farmers, carpenters, tailors, gardeners, potters, goldsmiths, shopkeepers, and even shoe makers and *māhāra*s rather than from brāhmaṇas. They represent a protest against the caste-dominated society enmeshed in rites and ceremonies, self-mortifications and self-assertions, pilgrimage and penance. They are a protest against Sanskritization, which converted knowledge into hidden treasure and made it a preserve of the elite.

Perceiving the body as universe is attested in the *viśvarūpa darśana* of the *Bhagavad Gītā*. That the body is a temple, is recognized by many saints. Bāsava, the Kannaḍa Vīraśaiva saint, in one of his *vacana*s says, "The rich have built temples, what can I offer you? The two legs are pillars, the body is the temple and the head the golden cupola." The Oriya saints equated the body with the whole earth. The *piṇḍa brahmāṇḍa tattva* delineated by the *pañcaśakhā*s is the highest philosophical position, where all distinction of 'mine' and 'thine' is evaporated. Dnana Dev's reply to Chang Dev's blank letter in eighty-five *ovi*s known as *Chang Deva Prasashti* says, "Apart from name and form, we two are really the same. Be happy in the realization of this Supreme identity." The Marāṭhi saint poet Bahinā Bāī in an *abhaṅga* speaks of the temple of Marāṭhā mysticism:

3. Sachidanandam S. Pillai, 'The Shaiva Saints of South India,' in: *The Cultural Heritage of India*, ed. S. Radhakrishnan, vol. IV, Calcutta: Ramakrishna Mission Institute of Culture, 1982, p. 342.

The saints have shown their merciful favour. Jñāna Deva laid the foundation
and created the temple. His servant, Nāmadeva, built the wall surrounding
it. Ekanātha, the disciple of Janārdana, created its pillar in the form of the
commentary on the *Bhāgavata Purāṇa*. Tukārāma became its pinnacle. Now,
then, worship in the temple at your leisure, says Bahini, the flag above it
flutters in the wind. I have clearly described this temple.[4]

Orissa has a *santha* tradition beginning from Śūdramuni Sāralā Dāsa. Unlike the rest of
India, where the *santha* tradition or *bhakti* movement is affiliated to one god — Rāma,
Kṛṣṇa or Śiva — the śūdra tradition pays obeisance to many gods. Śūdramuni in his
invocations in the *Mahābhārata* has invoked, *gaṇe nārayaṇe rudre ambike bhāskare tathā*. There
is no mainstream. Like *kalau citrotpalā gaṅgā* ("in *kaliyuga* the river Citrotpalā is Gaṅgā"),
each stream is the mainstream. The *śūdra bhakti* of the Śūdramuni neither finds shelter
under one god nor does it get confused like the Vedic *ṛṣi's kasmai devāya haviṣā vidhema*
("What God shall we adore with our oblation?").[5] It takes every god and goddess as the
manifestation of the Supreme Being and therefore as objects of veneration.

The *pañcasakhā* developed this one step further. Acyutānanda claimed that he did not
want to be a brāhmaṇa, kṣatriya, not even a vaiśya, as he is proud of his śūdra tradition of
humility, the necessary condition for *bhakti* ingrained in this tradition. He even reinterpreted
the *Puruṣasūkta* of the *Ṛgveda* and said that the śūdra is the mouth of the *puruṣa*. His concept
of *śūnya* was not that of void, but of a *śūnya puruṣa*, who is both *saguṇa* and *nirguṇa*.
Jagannātha Dāsa, who was renamed Atibaḍi by Śrīcaitanya because of his devotional
fervour, had given the injunction that,

> *sakala vaiṣṇava pūjiba āpaṇā sūtra nachāḍiba,*

> Worship all sects, but remain steadfast in your chosen path.

This synthesis of Vaiṣṇavism, Buddhism, Yoga and Tantra in a single string of *bhakti* is
one of the signal contributions of *pañcasakhā*.

The śūdra *bhakta* Bhīmabhoi has sung, *e jīvana pache narke paḍithāu jagata uddhāra
heu* ('Let my life lie in the hell, let the world be redeemed').[6] *Bhakti* is never selfish. It is a
dedication of one's life for others, the others extending to the universe. It is a search for
personal salvation in the context of redemption of the universe.

All the *santha*s of Orissa have centred their philosophy as well as theology on
Jagannātha. As faiths like Vaiṣṇavism, Śaivism, Śāktism, Jainism, Buddhism, Yoga and
Tantra were assimilated in the cult of Jagannātha. It developed as an all-pervasive and
inclusive philosophy. Jagannātha was perceived as *Parama Brahman* as well as the
mahāśūnya. By synthesizing the opposites it became *loke vede ca prathita puruṣottamaḥ* ("He

4. Austin E. Abbot, *Bahina Bai*, p. 114 (Abhaṅg 229).

5. *ṚV* X.121.1. Tr. R. Panikkar (*The Vedic Experience* [London, 1977], Pondicherry: All India Books, 1983, p. 71).

6. *Stuticintāmaṇi* Bolī 27.7.

is well-known as the best among all the men in the world as well as in the Veda"). Jagannātha, who combines both the individual and universal consciousness, which is the *asaṅgohyayam puruṣaḥ* ("this person is without attachments," *Bṛhadāraṇyaka Upaniṣad*, IV.3.15) of the Upaniṣads and is the friendless withdrawn soul in our neighbourhood, has been the focal point of all the Oriya *santha*s. They have rendered the most concrete ideas, objects, and emotions in simple unadorned language, achieving unparalleled success in the amalgam of intellect and devotion.

The Significance of Tantra Rahasya

Prabha Devi

THE secret of the Tāntric doctrines is based on the tenet of self-consciousness. Tantra enables us to experience the supreme *śakti* (*parā-śakti*) in our practical, day-to-day life. The main aim of these scriptures is that the individual should experience and spontaneously realize the self in any state. The Tantras encourage us to seek and follow the *spanda* principle in order to achieve self-realization.

The doctrine of Tantra is completely at variance with all other schools of philosophy. It is noteworthy that the very five sense-organs which in other systems of thought are condemned and considered degrading and hence to be shunned, causing the individual's downfall, are regarded as the means of self-realization in the Tāntric scriptures. Although each experient is endowed with these five subtle elements (*pañca-tanmātras*) like smell, taste, sound, touch and form, it is, however, by not understanding their true subtle reality that one is ensnared by them becoming their victim. On the contrary, the tāntric *yogī* takes these subtle elements as a support and achieves the highest state of God consciousness. It has been said:

> *yena yena hi badhyante jantavo raudrakarmaṇāḥ* ।
> *so'pāyena tu tenaiva mucyate bhavabandhanāt* ॥

> Those sense objects, which lead the individual to fearful disaster, liberate the Śaivite *yogī* from bondage.

Now the question arises as to how and why the Śaivite *yogī* is not entrapped by these five subtle elements. The answer lies in the fact that the Śaivite *yogī* remains established at the 'source' of the enjoyment of these sense-organs. His aim is always directed to the subtle element of sound, form, smell, etc., and not the gross state. In other words, this *yogī* remains firmly established on the *paśyantī* state of speech without any thought construct, even while dealing with worldly affairs in the *madhymā* and *vaikharī* states.

In the same way, the *yogī*'s contact with the sense of touch and the object of touch, of any beautiful entity, through concentration becomes an experience of the subtlest energy of bliss, i.e. the beauty itself rather than the gross physical element. In this he easily becomes capable of self-realization. But it must be borne in mind that such a *yogī* has to be adept in

the search for the practical realization of *spanda*. By having the *darśana* (reverential appearance) of such *yogīs* worldly people are blessed:

> *darśanāt sparśanādvāpi vitatāt bhavasāgarāt* |
> *tārayiṣyanti yogīndrāḥ kulācārapratiṣṭhitāḥ* ||

> By having the *darśana* and the touch of these *yogīs* who are established in the *kaula* practice, one crosses the ocean of the world.
> — *Vimarśinī* under *Śsū* (III. 28)

By taking the support of form, the Tāntric *yogī* experiences the inner self. These *yogīs* take as their object of meditation some highly beautiful objects and by using this as a means, they experience the highest state of *nirvikalpa samādhi* (free from all thoughts and ideation). The following verse from the *Vijñānabhairava* illustrates the above-mentioned idea:

> *sthūla-rūpasya bhāvasya stabdhāṁ dṛṣṭiṁ nipātya ca* |
> *acireṇa nirādhāraṁ manaḥ kṛtvā śivaṁ vrajet* ||

> Fixing one's gaze without blinking on an external (beautiful) form, and making the mind supportless in a short time, one will attain Śiva.[1]
> — *VBh* (80)

In the same way these *yogīs* remain and enjoy the bliss of the self through experiencing pleasant tastes and smells. But the Tāntric *yogī* also realizes the bliss of self even while facing terrible sorrow and pain, without being affected by them. It is said in Somānanda's *Śivadṛṣṭi*:

> *duḥkhe'pi pravikāsena* |
> Even in sorrow the bliss of the self expands. — *ŚD* (V.9)

Abhinavagupta mentions in his *Parātrīśikā-Vivaraṇa*:

> *duḥkhe'pi eṣa eva camatkāraḥ* |
> Even in suffering the same wonder appears.[2]

The second important distinction of the Tantra doctrine is said to be the unrestricted flow of grace (*śaktipāta*). The grace of Śiva is always free, independent, neutral, it is not linked with effort — *sādhanā*. The recipient of this grace is beyond the limitation of status discrimination. The doctrine holds that a person ordinarily considered unworthy by pious people can be gratified by the grace of Śiva showered on him through His independent free will. On the other hand, a brāhmaṇa endowed with the four-fold means spends his entire life steeped in the customary limited forms. Taking this point of view into consideration, the *Mukat Tantra*, while disregarding differentiation, says:

1. *Vijñānabhairava: The Practice of Centring Awareness*. Comment. Swami Lakshman Joo, Varanasi: Indica, 2002, p. 93.

2. Abhinavagupta: *Parātrīśikā-Vivaraṇa, The Secret of Tantric Mysticism*. English tr. with notes and running exposition by Jaideva Singh, ed. Bettina Bäumer, Delhi: Motilal Banarsidass, 1988, Reprint, 2000, p. 16.

antyajāto'pi hīnāṅgaḥ sādhakaḥ sa ca mokṣabhāk |
ebhirguṇairviyuktātmā brāhmaṇo'pi na mokṣabhāk ||
dvijo māyīyatyājyastu mleccho grāhyo hyamāyikaḥ |

Anyone who may be maimed or is of a low caste but a true seeker (*sādhaka*) finds liberation. The brāhmaṇa who is unaware of the principles of Advaita is not worthy of liberation. One should shun the brāhmaṇa who is still caught in *māyā* and duality and embrace the low caste individual who has transcended these.

The third characteristic of the Tantras lies in the belief that knowledge must always be combined with *yoga* and awareness of it must be a guide on the path of salvation. Illogical knowledge has no significance. It is also said:

asadyuktivicārajñāḥ śuṣkatarkāvalambinaḥ |
bhramay atyeva tān māyāhyamokṣe mokṣalipsayā ||

Those who consider false and unreal knowledge, which is dry and logical remain entrapped in the web of *māyā* and remain in bondage unable to find liberation.

The truth lies in the fact that the insightful *yogī*, adept in *Trika-Rahasya* (the secret of *Trika*) tests all action on the touchstone of knowledge. The supreme goal of the *yogī* is to remain constantly aware while performing worldly action, transforming it into *sādhanā*. His aim is to get entry into the central point (*madhya-dhāma*). He undergoes any means or practice (*sādhanā*) fearlessly and joyfully to gain entry in the *madhya-dhāma* or central point. Truly, this God-conscious Śaiva *yogī* experiences the joy and bliss of the supreme in all actions. Abhinavagupta has said:

avikalpapathārūḍho yena yena pathā viśet |
dharāsadāśivāntena tena tena śivo bhavet ||

The one established on the thought free path, whichever path he takes from Sadāśiva to earth, becomes Śiva. — *TĀ* (I.211)

The fourth feature of the Tantra doctrine is that the whole universe is projected on the screen of the consciousness of the Lord through His own free will. Thus the image of the entire universe is reflected in the mirror of the Self. The following *sūtra* in *Pratyabhijñā-hṛdayam* illustrates this view:

svecchayā svabhittau viśvam unmīlayati |

By the power of her own will (alone), she (*citi*) unfolds the universe upon her own screen (i.e. in herself as the basis of the universe).[3] — *PHṛ* (2)

In the *Tantrāloka* Śrī Abhinavagupta says:

tena saṁvittimakure viśvamātmānamarpayat |
nāthasya vadate'muṣya vimalāṁ viśvarūpatām ||

3. *Pratyabhijñāhṛdayam. The Secret of Self-Recognition.* Sanskrit Text with English tr., notes and Introduction by Jaideva Singh (1963), Delhi: Motilal Banarsidass, 4th rev. edn. 1982, rpt. 1998, p. 51.

> Thus positing the universe which is Himself in the mirror of consciousness
> the Lord's pure cosmic nature is manifested. — *TĀ* (III.44)

The *Svacchandatantra* explains convincingly the means of entering that knowledge which is the ocean of nectar. In the chapter on the way of time (*kālādhvā*) the practice of exhaling and inhaling is dealt with in an insightful manner. The short duration of the fraction of a breath is conceptionalized as sixty years whereby the *yogī* transcends the limitation of time and enters the realm of timelessness. Utpaladeva has also mentioned this state in his *Śivastotrāvalī*:

> *na tadā na sadā na caikade tyapi sā yatra na kāladhīrbhavet* |
> *tadidaṁ bhavadīyadarśanaṁ na ca nityaṁ na ca kathyate'nyathā* ||

> Neither 'then' nor 'always' nor even 'once'.
> Where no perception of time exists, that very
> thing is your realization. And it can neither
> be called eternal nor anything else.[4] — *ŚSt* (XII.5)

Apart from the above, the state of time in the movement of breath corresponding to the summer and winter solstices, the solar eclipse, the lunar eclipse, the spring and autumn equinoxes is dealt with in great detail. The crux of the matter lies in the truth that Śaiva *yoga* is not practised in the morning and evening in a temple or by sitting and meditating in a particular place, in a set position. This is practised in every situation of one's own daily life, in every move and action of the body, in each *tuṭi* (fraction of breath) by remaining aware in God consciousness between the states of wakefulness and dreaming.

In the renowned *Vijñānabhairava* there is a beautiful exposition of 112 *dhāraṇā*s (means) which the seeker can make use of as the path to enter the *madhya-dhāma* (middle or central point).

Finally, on the basis of the following *śloka* by Abhinavagupta in his *Mālinīvijayavārtika* (II.151), it can be said that only that seeker who has received the grace (*śaktipāta*) of Lord Śiva has the capacity to tread this path:

> *ketakīkusumasaurabhe bhṛśaṁ bhṛṅga eva rasiko na makṣikā* |
> *bhairavīyaparamādvayārcane ko'pi rajyati maheśa coditaḥ** ||

> Only the bee enjoys the fragrance of the *ketakī* flower, not the fly; only that *yogī* can
> be immersed in the non-dual worship of Lord Śiva on whom He bestows His grace.

4. Constantina Rhodes Bailly, *Shaiva Devotional Songs of Kashmir*. A Translation and Study of Utpaladeva's *Śivastotrāvalī* (orig. Albany 1987), Indian edn., Delhi: Sri Satguru Publications, 1990, p. 71.

* *na bhedamohitaḥ*, variant reading in Kashmir Series of Texts and Studies no. XXXI, ed. by Pt. M.K. Shastri, Shrinagar, 1921.

6

Gandhi's Religious Ethics as Touchstone[*]

Joseph Prabhu

GANDHI was often called a saint among politicians. His saintly adherence to non-violence brought him comparisons to St. Francis of Assisi, St. Paul, and even to Christ.[1] And yet, when one thinks about it, that appellation bears a deep ambivalence. On the one hand, it would seem that politics with its power-mongering, amoral Machiavellianism, its valorization of expediency over principle, and of successful outcomes over scrupulous means is an unpromising avenue for saintliness. Thus, Bal Gangadhar Tilak among others warned Gandhi before he embarked on a political career in India, "Politics is a game of worldly people and not of *sādhus*."[2] Bringing politics into the spiritual realm invariably coarsens and corrupts it. On the other hand, introducing spirituality into the political arena would seem to betoken naïveté and ineffectiveness in an area driven by worldly passions and cunning. It is perhaps for these reasons that Christ himself appeared to be in favour of a dualism: "Give to Caesar what is Caesar's and to God what is God's."

[*] *Personal Note:* It is both a pleasure and an honour to contribute to this Festschrift for Bettina Bäumer. It is a pleasure because Bettina and I share a history that goes back almost 40 years. She had come from Austria as a young university student of philosophy to Varanasi to study Sanskrit and Indian religious philosophy. I was an undergraduate student of economic in Delhi University. We met initially in Delhi and then in other places in northern India at the camps organized by the All India Catholic University Federation (AICUF). The AICUF was in those days a vibrant student organization whose mission was to understand and live out the Christian gospel in relation to the divine Mystery and the needs of society. The chaplain of the Catholic Students' Union in Varanasi was Raimon Panikkar, who influenced us both in different ways. Bettina got to work closely with him on his Indian projects, a collaboration which bore fruit among many other books in *The Vedic Experience* and in the series of conversations edited as *Das Abenteuer Wirklichkeit*. I was more absorbed in Panikkar's attempt to relate Indian wisdom to world history and culture. Interestingly, that stimulus took us in geographically different directions. Bettina made her home in India and for many years spent all her time there. I by contrast have made my temporary home in the U.S. with frequent trips back to India. There is perhaps a certain complementarity in our respective efforts to promote interfaith and cross-cultural dialog. That is the pleasure I feel on this occasion. There is thus a certain appropriateness in my choice of Gandhi as a subject for this essay because he too achieved many of his insights in and through his cross-cultural journeys.

1. See among others Romain Rolland, *Mahatma Gandhi*, London, 1924 and C.F. Andrews, 'The Tribute of a Friend,' in: S. Radhakrishnan (ed.), *Mahatma Gandhi: Essays and Reflections on his Life and Work*, London: Allen and Unwin, 1949.

2. S.P. Aiyar, 'Gandhi, Gokhale, and the Moderates,' in: Sibnarayan Ray (ed.), *Gandhi, India, and the World: An International Symposium*, Philadelphia: Temple University Press, 1970, p. 103.

Gandhi, by contrast, without denying the distinction between the domain of Caesar and that of God, repudiates any rigid separation between the two. "To the hungry person God appears in the form of bread," he often said, a statement that he meant both literally and symbolically. He weakens the traditional dualism between religion and politics and attempts to fashion a non-dual relation between the two. In this new conception religion seen primarily, though not exclusively, in ethical terms connotes a reverence for truth and a service to life which do not stop at the door of the meditation room or the temple but spill over necessarily into the social sphere. Politics in turn is reconceptualized as public service on the largest possible scale and is, at least ideally, far removed from the factionalism, raw ambition, and power-games usually associated with it. It is this Gandhian notion of ethics which mediates the non-dual relationship between religion and politics. On the one hand, Gandhi makes ethics both personal and social, the core of religion, and on the other this ethicized religion seeks its fulfilment in the realm of politics seen as the arena for both the realization of truth and the greatest potential public service.

What I want to suggest in this essay is that the non-dual relationship that Gandhi sees between religion on the one hand and ethics and politics on the other gives his conceptions of all three domains a dialectical and fluid character, which allows for their progressive and mutual enrichment. But this dialectical mediation is not without the risks and dangers that any attempt at reconceptualization often carries. I shall divide this essay into three parts: first, I will provide an account of three key terms of Gandhi's religious ethics; second, I shall offer a few reflections on Gandhi's notion of *mokṣa* or spiritual liberation and its relation to *dharma*; and finally, I shall try to relate these Gandhian conceptions to our present-day situation.

Gandhi's Religious Ethics

Gandhi is a moralist through and through and yet it is difficult to write philosophically about his ethics. This is because Gandhi is fundamentally concerned with practice rather than with theory or abstract thought, and such philosophy as he used was meant to reveal its "truth" in the crucible of experience. Hence, the subtitle of his *Autobiography* — "the story of my experiments in truth." The experiments refer to the fact that the truth of concepts, values, and ideals is fulfilled only in practice. Prior to that practical fulfilment they remain spectral and abstract. Furthermore, Gandhi's ethics are inextricably tied up with his religion, which itself is unconventional. Though an avowed Hindu, he was a Hindu in a philosophical rather than a sectarian sense, and there was much Hindu ritual and practice that he subjected to critique. In accordance with this religio-philosophical ideal, his religion could be described as the life of the self attempting to realize itself as Self, and thus achieving *mokṣa* or spiritual liberation. But *karmayogī* that he was, Self-realization had to be expressed through work in the world and the details of daily life rather than through renunciation of the world. Gandhi's own ethics have a decidedly spiritual cast, but because he takes pains to express them in a neutral philosophical manner, he intends them to have general validity.

Thus, when he switches from affirming that God is Truth to saying that Truth is God, his rationale is that the latter is a more general statement which has resonance even for unbelievers:

> God is Truth, but God is many other things also. That is why I prefer to say that Truth is God . . . you may simply worship what you find to be the truth for Truth is known relatively. Only remember that Truth is one of the many qualities that we name. It is the living embodiment of God, it is the only Life and I identify Truth with fullest life and that is how it becomes a concrete thing for God is His whole creation, the whole Existence, and service of all that exists.[3]

This statement is a testament to Gandhi's innate sense of tolerance and inclusiveness, in that he believes that his ideals of truth and non-violence are accessible even to those who do not share his religious metaphysics. It is a feature of some moral statements that they can be differently interpreted and justified and yet be shown to have validity at different levels of understanding. Thus, the precept of honesty can be justified on the grounds of prudence ("honesty is the best policy"), or of promoting trust and social harmony in society (utilitarian), safeguarding one's own integrity and righteousness before the law (Kant), as duty owed to others as autonomous moral agents (Kant and some versions of Christianity), as a cosmic obligation (a dhārmic justification), to mention only some possibilities. Likewise, people may agree on certain human rights, even though they ground those rights quite differently. In a similar spirit, Gandhi wanted his teaching of non-violence to have the widest possible adherence. But if one wants to understand his own particular justification and interpretation of his ethical ideas, we cannot escape the religious metaphysics that serves as their ground and presupposition. James Hart captures this well when he writes:

> When the Vedāntic tradition holds that each self as Self, is profoundly and irreducibly non-objectifiable, it moves in the direction of holding that the truth of things and other selves has a form of causality other than that of material objects. The fundamental sense of oneself and the other which the commitment to Truth awakens is the incommensurability of selves with material, unselved, unbesouled objects. *Ahiṁsā* is the practice of a kind of transcendental reduction because it preserves this most basic truth. And being awakened to this most basic Truth, the truth about selves and meanings, is what provides the central importance of *ahiṁsā*.[4]

With these prefatory remarks I shall briefly analyse and comment on some of Gandhi's key ethical concepts.

Truth for Gandhi is not merely, or even primarily, the property of statements, though Gandhi does not deny the importance of factual truth or the correspondence between propositions and states of affairs in the world that either confirm or refute them. Rather, his multifaceted notion of truth emphasizes ontological, moral, and existential aspects.

3. M.K. Gandhi, *The Collected Works of Mahatma Gandhi*, 90 volumes, Publications Division, New Delhi, vol. 68, p. 81 (hereafter *CWMG*).

4. James Hart, Recent Works in Gandhi Studies: *Philosophy East and West*, vol. 44, #1 (January 1994), p. 156.

Ontologically, *satya* is derived from *Sat*, the self-existent essence, both the Is and the Ought of reality. It was this derivation that led Gandhi often to say, "Nothing exists in reality except Truth, everything else is illusion." Beyond the illusory temporal flux of phenomena lies the eternal Truth, what Gandhi also called Absolute Truth. We humans with our finite capacities can have access however only to relative truth, an assertion Gandhi uses to justify epistemological humility and tolerance. All our perceptions of truth are inevitably partial and therefore claims of cognitive absoluteness are both unwarranted and dangerous.

While the ontological aspect of truth points to a more objective notion, the moral and existential aspects move in the direction of a more subjective, almost Kierkegaardian, notion of truth as subjectivity, the deeply personal intuition of truth which can be experienced fully only through action. Raghavan Iyer brings out the duality between the subjective and objective aspects of truth:

> Gandhi could not regard truth either as solely the object of reason or as simply the product of human decision. For him (. . .) truth is nothing less than the splendor of reality and cannot be gained without an understanding of the Eternal Law of Nature, but when it is perceived and seized it must be acted upon. In this sense truth must be both discovered and created, found and enacted. . . . In this activist view of truth . . . it is not enough for thought to be based upon truth; the life of the thinker must express it, must represent it visibly in his actions.[5]

As already intimated, this idea of truth for Gandhi found its fullest expression in the field of politics, which, in accordance with his moral outlook, he regarded as the arena for doing good on the largest possible scale. The idea that Gandhi used to encapsulate this moral conception of politics was *satyāgraha*. This was conceived as a practical experiment to introduce truth and non-violence into the political field. Gandhi adopted this idea early in his political career when he chose *satyāgraha* as the name for his resistance movement against the repressive South African government. Explaining his decision, Gandhi wrote, "Truth [*satya*] implies love and firmness [*āgraha*] and therefore serves as a synonym for force. I thus began to call the Indian movement *satyāgraha*, that is to say, the force which is born of truth and love of non-violence."[6] The forceful and activist character of *satyāgraha* should correct a common misperception; namely that it denotes a passivity of resistance, a mere turning of the other cheek. Although Gandhi insisted that violence be met with love and understanding, the non-violent means chosen should not obscure the powerful end — that of establishing justice and truth. In fact, he is on record as saying that if the choice were between the passive acceptance of injustice and violent resistance to it, he would choose the latter. He was convinced, however, that non-violent resistance was superior to

5. Raghavan Iyer, *The Moral and Political Thought of Mahatma Gandhi*, Oxford: Oxford University Press, 1973, p. 154.

6. M. Gandhi, *Satyagraha in South Africa*, tr. V.G. Desai, S. Ganesa, Madras, 1938, p. 172.

both alternatives.

Satyāgraha begins with reasoning with one's opponent or adversary in an attempt to arrive at a just solution, recognizing that no party has a monopoly on the truth, or is wholly in the right. The purpose, therefore, is to work out a rational compromise that will be agreeable to both sides. It is only when such processes of reasoning, persuasion, and compromise have been tried and have proved unsuccessful that one adopts the direct action techniques of *satyāgraha*. *Satyāgraha* involves performing actions such as non-co-operation (strikes, boycotts, lockouts, fasts); civil disobedience (non-payment of taxes, disregard of specific laws or injunctions); publicizing one's cause through marches, rallies, picketing, and other forms of peaceful protest; and constructive programs (low-cost housing, education, health facilities, cooperative banks for the poor). A big part of such non-violent resistance is *tapas* or the willingness to suffer for one's cause. As Thomas Pantham puts it, "It is the assumption of *satyāgraha* that when reasoning fails to move the head, the argument of suffering by the *satyāgraha* helps move the heart of the oppressor or opponent. Self-suffering, moreover, is the truth-serving alternative to the truth-denying method of inflicting violence on others."[7]

Contained in this idea of *satyāgraha* is the question of means and ends, which for Gandhi are two sides of the same coin. Gandhi disagrees strongly with the conventional political idea that the ends justify the means. To the contrary, he held that immoral means taint and distorts potentially good ends, and to that extent he placed at least as much, if not more, emphasis on the means, which he described as ends in actions. "The means may be likened to a seed, the end to a tree; and there is just the same inviolable connection between the means and the end as there is between the seed and the tree."[8]

The forceful and activist character of *satyāgraha* leads naturally to the idea of non-violence. Gandhi is obviously invoking the Jain precept of *ahiṁsā*, or not causing deliberate injury or harm to any being, but Gandhi takes the precept far beyond its merely negative formulation to mean the largest love, the greatest charity. "If I am a follower of *ahiṁsā*, I must love my enemy or a stranger as I would love my wrong-doing father or son. This *ahiṁsā* necessarily includes truth and fearlessness."[9]

Ahiṁsā then is the deployment of moral force to persuade one's opponent or adversary. It differs from violence in that it respects the autonomy and dignity of the other, whereas violence does not. It differs from violence in the perpetual willingness to dialogue and negotiate with the other and, as far as is consistent with rightness, to come to a compromise. Given that one's grasp of the truth is at best partial, it is imperative to see

7. Thomas Pantham, 'Habermas's Practical Discourse and Gandhi's *Satyagraha*,' in: *Political Discourse: Exploration in Indian and Western Thought*, ed. Bhikhu Parekh and Thomas Pantham, New Delhi: Sage Publications, 1987, pp. 292-310.

8. *CWMG* vol. 10, p. 431.

9. Letter in: *Modern Review*, October 1916, quoted in R. Iyer, *Moral and Political Thought, op. cit.*, p. 180.

and appreciate the truth in the position of the other and to try and achieve a higher or dialectical reconciliation of conflicting ends. This negotiated compromise has the opposite effect of violence, which involves vanquishing and putting down one's opponent that inevitably sets up a cycle of resentment, ill will, and further violence.

Of course, Gandhi was not so naïve as to think that such moral persuasion would come about easily. He was all too aware that people who exercise power over others are not likely to give it up without some pressure being exerted. All the means of *satyāgraha* mentioned above should then be adopted as a way of morally coercing one's opponent to negotiate. It is true that coercion is being exerted, but it is a coercion that still respects the moral agency and dignity of the other, not least by the willingness to undergo self-suffering.

The strategy presupposes that the opponent does have a minimal openness to such moral appeal, a trait that Gandhi was willing to grant to most people. However, he also recognized that there are madmen and tyrants, rapists and aggressors who would not fall within that category. In those extreme cases Gandhi was willing to use physical force for the purpose of self-defense, as, for example, when he sanctioned the use of military force to drive back the Pakistani Army in what he considered to be the invasion of Kashmir in 1948. Less satisfactory was his response to Martin Buber, when the later skeptically asked Gandhi whether he thought that the Jews should use *satyāgraha* against Hitler.[10]

The three concepts I have discussed, *satya*, *satyāgraha*, and *ahiṁsā* might give us some idea of the texture of Gandhi's ethical thought. As mentioned earlier, the ideas of truth and non-violence are certainly to be found in the Jain, Buddhist, and Hindu traditions, but there is a big difference between Gandhi's conceptualization of these ideas and traditional ones. The high standards of moral and spiritual discipline that Gandhi invokes were traditionally part of the *sādhanā* of monks and saints, but decidedly not of people in political life. To the contrary, political thinkers like Manu and Kauṭilya sanctioned the use of physical force both for self-defense and for purposes of political order. Gandhi by contrast considerably softens the traditional dualism between ethics on the one hand, and religion and politics on the other. Instead, he attempts to forge a non-dual relationship between the two, where religion seen as reverence for and service to Life, necessarily leads to politics — the arena for the greatest potential public service; and where politics in turn is saved from power-mongering and the conflict of factional interests by the moral purification involved in religion at its best. It is very important to distinguish Gandhi's highly moral notions of both religion and politics from the ideological conceptions of them all too common in our time. Certainly the rise of religious

10. Martin Buber, J.L. Magnes, *Two Letters to Gandhi*, Jerusalem, Rubin Mass (April 1939), mentioned in Denis Dalton, *Mahatma Gandhi: Nonviolent Power in Action*, New York: Columbia University Press, 1993, p. 228. See also Gandhi's Exchanges with other Jews, which Dalton discusses on pp. 134-38.

fundamentalism and right wing religious groups would make any peace-loving person nervous about the marriage of religion and politics. It should be clear, however, from what I have written that the moral checks and balances that Gandhi exercised over religion and politics purified both domains and offered the world a far different and more noble conception of them that we have yet to measure up to.

Gandhi's Ethical Religion

The relation between *dharma* and *mokṣa* has been much debated in the Indian tradition. While it is generally agreed that the ideal of *mokṣa* trumps the claims of *dharma*, the exact relationship between the two ideals and the validity of *dharma* when seen from the perspective of *mokṣa* have been subjects of debate. On the one hand, *dharma* is seen as a means to the attainment of *mokṣa*, but from the perspective of *mokṣa*, *dharma* with its rigid clan/caste/family structure is often regarded as an obstacle to *mokṣa*. Orthodoxy often held that *dharma* had absolute validity even for the person who attained *mokṣa*; but there were — and are — many influential views that question this assertion. After all, *mokṣa* is a state of consciousness consequent upon seeing the true nature of things, while *dharma* belongs to the realm of action and will. Put otherwise, *dharma* upholds the established social-ethical order, whereas *mokṣa* is 'release' from this order in order to achieve self-realization, a free spiritual individuality that transcends the ethical realm.

For Gandhi, however, it is *dharma* that holds pride of place. While he does speak of *mokṣa*, it is the ethical worthiness for *mokṣa* rather than *mokṣa* in itself that he emphasized.

> I have come to the conclusion that no one can be called a *mukta* while he is still alive; one may be said at the most to have become fit for *mokṣa* . . . the necessity for deliverance remains so long as connection with the body remains.[11]

The parallel here with Kant is strong: just as Kant stresses the right over the good and virtue over happiness, Gandhi accents the quest for *mokṣa* rather than *mokṣa* itself. There is the same moral rigorism and accent on process rather than outcome. This is borne out among much other evidence by Gandhi's extraordinary wish to be reborn as an untouchable in order to serve the lowliest of the lowly. This flies in the face of all conventional ideas of *mokṣa* as release from the ethical demands of the social order to realize a free spiritual consciousness. Gandhi, like a *bodhisattva*, has no desire to be released from such demands. His frequent invocation of Advaita Vedānta is misleading — at least in its Śaṅkarite version: he is not much interested in attaining a higher state of consciousness where the veil of *māyā* might disappear. Rather, it is this world that he takes with full seriousness as the area in which we fulfil our dhārmic responsibilities.

In contrast to much of the Indian religious tradition that has a largely contemplative character, Gandhi's religion is strongly activist in nature. It is in practice rather than in thought or gnosis that the rightness or wrongness of beliefs is established. This activism

11. *CWMG* vol. 32, p. 136.

goes together with the decidedly ethical cast of his religion — the formation of right dispositions, attitudes, and relationships in relation to the demands of one's fellow men and women and of nature. It is only in and through such demands that a right relationship to God is established. Gandhi is in full agreement with St. John in believing that he who talks of loving God whom one does not see without loving one's neighbour whom one does see is a liar and a hypocrite.

John Maynard Keynes, the economist and philosopher, once distinguished between religion and ethics by saying that religion has to do with one's relation to oneself and the Ultimate, while ethics deals with one's relation to others and the penultimate. Gandhi would have thought that both sets of dualities in Keynes's account are misconceived — that of self and other and of the Ultimate and penultimate. Regarding the first, given his firm belief in the interconnectedness of all life and a relational view of the self, Gandhi would have strongly concurred with the sentiment of the English poet John Donne: "No man is an island complete in himself. . . . Every man's death diminishes me because I am a part of the whole . . . and therefore do not ask to know for whom the bell tolls, it tolls for thee." Regarding the second duality, that of the Ultimate and penultimate, while not denying the realm of the supernatural, Gandhi firmly believes that access to it is achievable primarily through the full embrace of the natural. It was in the faces of his fellow men and women, and in particular of the poor and oppressed, that Gandhi hoped to see God.

Four features of Gandhi's ethical religion may be commented on:

First, it is a solidly this-worldly affair. In a culture where cyclical views of time and a belief in *karma* and reincarnation often lead — mistakenly I would argue — to temporal indifference, Gandhi shares the Buddha's sense of urgency that it is in this life that we have to work out our salvation and that we have to do so in the fully-embraced present in whatever circumstances we may find ourselves. Gandhi was able to reconcile this sense of urgency usually associated with a linear view of "one life, one chance," with his belief in *karma* and reincarnation via the explanation that our present actions determine the nature of future rebirths. But he was not especially interested in speculating either about those rebirths or about any other world than this present one.

Second, as already pointed out, Gandhi's religion was social and corporate in its emphasis rather than individualistic. His idea of *swarāj* or moral self-governance was not the Kantian idea of autonomy with which it is sometimes mistakenly compared. While he certainly values the self-discipline involved in Kantian self-legislation, Gandhi had he been presented with a Kantian view, would almost certainly criticized its atomistic and insulated character — the sense that self-legislation is to be carried out free of social ties and local belonging. For Gandhi, by contrast, there was no question of being released from such ties, because it is such ties that constitute the warp and the woof of human existence, and to seek to be

free of them is to shirk our fundamental human responsibility. Ascent to the Divine and the Universal is to be achieved not by detaching oneself from the human and the particular, but rather by embracing them and seeking to make them worthy expressions of the Divine presence. Over and over again, and particularly in the commentary on the *Gītā*, Gandhi stresses the synthesis of two moral ideals, the outer one of social obligation and the inner one of renunciation and detachment. The goal then is renunciation not *of* action but *in* action, the true goal of *karma-yoga*, the path of selfless service.[12]

Third: In tune with his stress on this-worldliness and on particularistic ties is Gandhi's emphasis on the continuity of means and ends. Mention was made in the first section of the organic metaphors that Gandhi uses of seeds and trees and of root and branches to indicate how indissolubly linked means and ends are for him. In sharp contrast to those who emphasize ends and the success in achieving them whatever means one adopts, Gandhi accents the moral and existential priority of means. For one thing, ends lie in the future and the future is by definition not fully under our control. For another, there are also the unintended consequences of our actions and the actions of other agents than impinge on our own. Ends therefore lie beyond our reckoning; what we can and must focus on are means. But here too Gandhi distinguishes means seen purely instrumentally and means seen as expressive as goals. Seen as instruments means become a set of necessary and often tedious steps towards a goal, but it is the goal that commands our attention as for example when we perform an irksome job merely to earn some money. Seen as expressive, however, means become ends in action and even if one knows that one may not achieve the goal it does not really matter. Success is measured not in the actual achievement of the goal but in fidelity. Thus, Martin Luther King, Jr., Gandhi's famous disciple, delivered a well-known sermon the night before he was assassinated which echoes Gandhi's sentiments:

> Well, I don't know what will happen now. We've got some difficult days ahead. But it does not matter with me now. Because I've been to the mountain top . . . and I've seen the Promised Land. I may not get there with you. But . . . I'm happy tonight. I'm not worried about anything . . . my eyes have seen the glory of the coming of the Lord.[13]

Fourth: Gandhi's religion was holistic. Earlier, mention was made of how Gandhi saw religion leading naturally to politics and social service. Those who attended his prayer services were often struck by how smoothly Gandhi could interrupt

12. M. Gandhi, *The Gospel of Selfless Action or the Gita According to Gandhi*, Ahmedabad: Navjivan Publishing House, 1946.

13. Martin Luther King Jr., 'I See the Promised Land,' in: *A Testament of Hope: The Essential Writings of Martin Luther King Jr.*, San Francisco: Harper & Row, 1986, pp. 279-86.

and break away from pressing political matters and then take them up again spontaneously after prayers were recited. This holism provides a clue to the remarkably wide range of interests and concerns that attracted his attention: everything from theology to tooth care, conflict resolution to sanitation, political organization to endless experiments with his diet. Inner life and outer activity, self-development and service to others formed a seamless whole. Gandhi saw all of life as sacred and all of his own life as a prayer.

A Brief Evaluation

In the first part of this essay, I focused on Gandhi's religious ethics and in the second on his ethical religion in order to highlight the non-dual character of the relation between his ethics and his religion. I want in this final section to make a few brief comments first with reference to Indian traditions and then more broadly to the world at large.

First, within the Indian tradition, Gandhi's ethics as ethics represent the most substantial ethical contribution by an Indian in modern times. Ethics as a singular and coherent body of thought is not a field to which Indian thinkers on the whole have devoted much attention, at least as compared to other areas of philosophical and religious thought. This remains true in spite of the fact that much of the Indian philosophical and religious tradition has a definite value orientation and is centrally concerned with the practical ideals of *dharma* and *mokṣa* and with spelling out how other values and concerns stand in relation to them. This is a seeming paradox. For example, the late Bimal Matilal, one of India's most eminent philosophers, complained:

> Certainly there exists a lacuna in the tradition of Indian philosophy. Professional philosophers of India over the last 2000 years have been consistently concerned with problems of logic and epistemology, metaphysics and soteriology, and sometimes they have made very important contributions to the global heritage of philosophy. But except for some cursory comments and some insightful observations, the professional philosophers of India very seldom discussed what we call moral philosophy today.[14]

Instead, Indian thinkers incorporated moral considerations into various and sundry philosophical, literary, and theological texts in Sanskrit and the vernaculars without systematically elucidating the principles and norms that distinguish them as moral.

Now, Gandhi was neither a philosopher nor a systematic thinker, but rather a man of action. None the less, in the course of his life he was forced to face many ethical challenges and ponder several moral questions because, as already indicated, he was by disposition a moralist through and through. When non-Indian moral philosophers seek a contemporary Indian moral thinker to engage with Indian ethical reflection, it is

14. Bimal Matilal, 'Moral Dilemmas: Insights from Indian Epics,' in: *Collected Papers*, vol. 1, Delhi: Oxford University Press, 1999.

invariably Gandhi to whom they turn.

His contribution to religious thought is perhaps more contested. India's religious traditions are dominated by sages and mystics, and Gandhi was neither. Gandhi more accurately could be described as a deeply religious person who achieved great goodness. In any case, when we talk of religious *thought* it is the quality of reflection that is the relevant consideration. As a thinker, Gandhi offers us a model of ethical religion which is relatively rare in the Indian tradition. As already indicated, given the primary interest in *mokṣa* which is said to lie "beyond good and evil," there is in much of the tradition an ambivalence toward ethics. Both Tagore and Aurobindo, for example, were quite critical of Gandhi's moralism, even if Tagore muted his criticism in public. Tagore, schooled in the speculative magnificence of the Upaniṣads and admiring the aesthetic vitality and spirituality profundity of the classical Indian traditions, disagreed with Gandhi on practically every important political issue from *svadeśī* to mass civil disobedience, fasting to the spinning wheel, celibacy to technology. Underlying these disagreements was a fundamental difference in attitude and outlook. Tagore, the metaphysical poet, strongly disagreed with Gandhi's puritanism and (to him) stifling moralism. "Deliverance is not for me in renunciation. I feel the embrace of freedom in a thousand bonds of delight."[15]

Aurobindo was even more scathing in his criticism of Gandhi. For one thing, Aurobindo in his days of political activism has openly advocated violence when the occasion demanded it, and he found Gandhi's absolute stand on non-violence to be one-sided and limited. And when he gave up political activism for yogic experience, Aurobindo, with his quest for integral *yoga* and a kind of gnostic mysticism, considered Gandhi to be quite a pedestrian thinker, whose moral rigor, far from leading to spiritual freedom, more often than not led to self-alienation and a violence to oneself. For Aurobindo, Gandhi's ethical reflections belonged to a low stage of the development of mind and even at that low level was partial and exaggerated.[16]

Such sharp differences were due not only to differences in personality but also to their respective appropriations of the Indian tradition. Both Tagore and Aurobindo were mystically inclined thinkers, sympathetic to and appreciative of the speculative and metaphysical richness of the Vedas, Upaniṣads, and Indian philosophical traditions. Gandhi's knowledge of and sensitivity to ancient and classical Indian traditions was much narrower — he was attracted primarily to their moral and didactic aspects. This in a way facilitated his notorious interpretation of the *Gītā*, which many regard, with some justification, as idiosyncratic and hermeneutically arbitrary. The sources of his inspiration were the epics and the devotional saints of medieval Hinduism, with, of course, a deep

15. *Collected Poems and Plays of Rabindranath Tagore*, London: Allen and Unwin, 1958, p. 34. See also Sibnarayan Ray, 'Tagore-Gandhi Controversy,' in: *id.* (ed.), *Gandhi, India, and the World: An International Symposium*, Philadelphia: Temple University Press, 1970, pp. 119-41.

16. See Robert Mino, 'Sri Aurobindo's Dismissal of Gandhi and his Nonviolence,' in: Harold Coward (ed.), *Indian Critiques of Gandhi*, Albany: State University of New York Press, 2003.

Jain influence coming from his native Gujarat.

And yet in spite of this narrowness of focus and perhaps because of it, Gandhi produced a model of ethical religion that drew upon a neglected and relatively unappreciated strand of the Indian tradition — the path of *karma-yoga*, or spiritual realization through social action. Even though others like the Buddha had emphasized the connection between compassion for suffering humanity and spiritual integrity, it was Gandhi who took the Buddha's message in a new direction, namely into direct political activity. This was a radical move. In doing so, Gandhi hoped to achieve a dual transformation: on the one hand, he wished to purify politics by making moral and religious norms central to it, and, on the other, he hoped to purify religion by saving it from the dangers of self-absorption and narcissism. Modifying Christ's injunction slightly, only those who lose their life in socio-political service can hope to save it. Tagore, for all his disagreements with Gandhi, was perceptive enough to note this:

> The influence which emanated from his personality was ineffable, like music, like beauty. Its claim upon others was great because of its revelation of a spontaneous self-giving. (. . .) That is why, though his realm of activity lies in practical politics, people's minds have been struck by the analogy of his character with that of the great masters, whose spiritual inspiration comprehends and yet transcends all varied manifestations of humanity, and makes the face of worldliness turn to the light that comes from the eternal source of wisdom.[17]

This dialectical balance between morality, politics, and religion carries both great promise and significant risks. The danger of the spiritualization of politics, for many regarded as the realm of the possible, is that it idealizes human nature, sets impossible standards of behaviour, and ends up making the best an enemy of the good. As I am focusing in this essay more on the relation between religion and ethics, I shall not dwell further on the implications of Gandhi's moralism for politics.[18] In making moral standards foundational in all spheres, there is a danger of the *reduction* of religion to ethics, as, for example, in the moral philosophy of Kant. Gandhi avoids this danger by recognizing and invoking the transcendent elements of religions. He says, "So long as the seed of morality is not watered by religion, it cannot sprout (. . .) if we take out the essence of all moral laws, we shall find that the attempt to do good to mankind is the highest morality."[19] Far from reducing religion to ethics, Gandhi attempts to elevate ethics to religion, while at the same time providing checks and balances on religion and its possible corruption.

Mention of the possible corruption of religion brings into focus one of the great perils

17. Rabindranath Tagore, 'The Poet's Verdict,' in: S. Radhakrishnan (ed.), *Mahatma Gandhi, op. cit.,* p. 286.

18. I have dealt with the general question of politics and moral values in my on-line article of November 16, 2004, "Whose Morality? Which Christianity?" in: http://www.icujp.org.

19. M. Gandhi, *Ethical Religion (Niti Dharma)*, Madras, Ganesan, 1922, cited in R. Iyer, *Moral and Political Thought, op. cit.,* p. 48.

of our time — the emergence of the dark side of religion as it becomes ideological in nature. Charles Kimball has highlighted four signals of the debasement of religion which, while they have been perennial dangers, have emerged with particular force in recent times:

1. The insistence on the absoluteness of the truth claims in one's own tradition and the correlative demonizing and dehumanization of others who differ both within one's own tradition and those beyond.

2. The blind obedience to religious authorities who are thus given great power to make decisions that affect both the people of their particular traditions and those outside them.

3. The establishment of an ideal or messianic time bearing apocalyptic overtones, where destruction is seen as a prelude to some "final judgement."

4. The assertion that the ends justify all means, and where in the name of protecting the religion concerned or its interests, any means including violent ones are tolerated. This can sometimes lead to the waging of "holy wars" to achieve one's ends.[20]

Different forms of contemporary religion display some or all of these features in varying degrees, whether one is talking of ethnic tribalism, fundamentalism, or the rise of religious violence. In such a situation, it seems to me that Gandhi's unyielding insistence on moral self-examination and purification via the notions of truth, non-violence, and self-suffering (*tapasyā*), as a necessary corollary of any political engagement, is a much needed touchstone and corrective.

20. Charles Kimball, *When Religion Becomes Evil*, San Francisco: Harper Collins, 2002.

7

The Origins of Man

Baidyanath Saraswati

The Fourfold Pattern

IMAGES of reality are complex. But there are insightful perceptions reflected in scriptures and oral traditions. The understanding of reality comes from a partial representation of the gestures, hymns, melodies and intuitive visions. The Vedic hymns of origin share the mystical awareness.

> At first was neither Being nor Non-being
> There was not air nor yet sky beyond.
> What was its wrapping? Where? In whose
> Protection? Was Water there, unfathomable
> and deep? — *ṚV* (X.129.1)

To penetrate the mystery of the beginnings and to explain the immensity and the amazing harmony of the universe, another scripture says:

> In the beginning, to be sure, nothing existed, neither the heaven nor the earth, nor space in between. So nothing, having decided to be became spirit and said, "Let me be". He warmed himself further and from this heating was born fire. He warmed himself still further and from this heating was born light.
> — *Taittirīya Brāhmaṇa* (II. 2,9, 1-2)

From the discovery of this "nothingness," the sages moved further:

> The Word imperishable, is the First born of Truth, mother of the Veda and hub of immortality. May she come to us in happiness. In the sacrifice! May she, our protecting Goddess, be easy of entreaty! — *Taittirīya Brāhmaṇa* (II. 8, 8, 5)

Through the discovery of 'nothingness' and with the First born of Truth, the *puruṣa*, condition of reality, manifests itself. The first divine emanation proceeded. The *puruṣa*, the uncreated being, sacrifices himself, by dismembering himself and scatters around, the necessary number of portions, for the completion of the work of creation. He performs an act of self-immolation so that the universe may come into being.

> A thousand-headed is the Man,
> With a thousand eyes, a thousand feet;

Encompassing the Earth on all sides,
He exceeded it by ten fingers breadth.

The Man, indeed, is this all,
What has been and what is to be,
The Lord of the immortal spheres
Which he surpasses by consuming food.

Such is the measure of his might,
And greater still than this is Man.
All beings are a fourth of him,
Three fourths are the immortal in heaven.

Three fourths of Man ascended high,
One-fourth took birth again down here.
From this he shaped in all directions,
Into animate and inanimate things. — *ṚV* X .90, 1-4

Who is this Man? He is not man but only anthropomorphic. He is self-existing, uncreated Being (*puruṣa*). He is cosmotheandric. That is, he is at once cosmic, divine and human. He is the personal aspect of the whole of Reality.

What is this fourfoldness? Traditional thought makes reality intelligible by the archetypal pattern of fourfoldness.[1] The fourfold pattern exists universally and occurs on every level. From the four-footed *Brahman*, the ultimate Reality, or the four-faced Brahmā, the archetypal master of creation, a fourfold pattern of the cosmos is evolved. From the four-armed Viṣṇu, the master of preservation, the world exists. The four faces of Brahmā are aligned to the four directions to have a view of this created beauty in each direction. Four spirits represent the fourfold scheme of creation. The wishfulfilling cosmic Cow, the universal Nature, has four udders for streams of milk by which she supports the four kinds of creatures — sages, ancestors, gods and men. Four ages (*kṛta*, *tretā*, *dvāpara* and *kali*) signify temporal conditions typical of four categories of moral and spiritual orders representing the fourfold scheme of creation. The four Vedas symbolize the universal mind.

The Veda, as the form of *puruṣa*, is eternal. Even at the time of dissolution it exists in an unmanifest form. The Veda is *puruṣa* and *puruṣa* is the same as sacrifice. They refer to an identical principle, which is manifest as cosmos. From the sacrifice of *puruṣa* the whole universe is born. From his thousand (infinite) limbs come all things — both animate and inanimate — the creatures of the air, beasts of the forest and the village, the hymns and the melodies, the sacrificial formulas, horses, all creatures having teeth in either jaw, the breeds of cattle, sheep and goats, the four castes of men and the cosmic powers. The organic unity of creatures and creator is highlighted.

1. I am thankful to Kathleen Raine for drawing my attention to the relevance of Fourfoldness in European tradition: four gospels and four Apocalyptic Beasts (lion, eagle, ox and angel), representing these gospels; Blake's four: inspiration, reason, feeling and senses; four psychological types of C.G. Jung and so on.

His mouth became the *Brahman*; his arms
Became the warrior-prince, his legs
The common man who plies his trade,
The serving man was born from his feet.

The Moon was born from his mind; the Sun,
Came into being from his eyes;
From his mouth came Indra[2] and Agni,[3]
While from his breath the Wind was born.

From his navel issued the Air,
From his head unfurled the Sky,
The Earth from his feet, from his ear,
the four directions.
Thus have the worlds been organized. — *ṚV* (X. 90, 12-14)

Here the classification of organisms is based not in terms of kingdom, phylum and class. There is nothing like *homo sapiens*. Everything is clearly a limb of *puruṣa*. The limb refers to both structure and function, signifying unity and implying the manner in which all organ works in the maintenance of the organism as a whole.

Within the body there are power centres — the nodes of power of life energy. The four castes (*varṇa*) of men (brāhmaṇa, kṣatriya, vaiśya and śūdra) are linked to each power centre of the body of *puruṣa*:

Mouth	-	brāhmaṇa	(utterance of the primal creative sound)
Arms	-	kṣatriya	(protection from forces)
Legs	-	vaiśya	(movement of life)
Feet	-	śūdra	(fundamental starting power and ground of being)

Who can deny the power of mouth? Who can deny the power of feet? Who can deny the essentiality of arms and legs? Yet, these four represent not individual limbs of power but harmonies of the human world — the four castes of men.

The four castes form a conceptual model. They are idealized archetypes or aspects of existence here (the earth) and there (the sky). Four castes of planets: Jupiter and Venus are brāhmaṇa. The Sun and Mars are kṣatriya; the Moon and Mercury are vaiśya; and Saturn is śūdra. Of the signs of Zodiac, Pisces, Scorpio and Taurus are brāhmaṇa. Sagittarius, Aries and Leo are kṣatriya; Aquarius, Gemini and Libra are vaiśya; and Virgo, Capricorn and Cancer are śūdra. Four castes of soil: brāhmaṇa soil is white in colour; it smells like clarified butter and is astringent in taste. Kṣatriya soil is blood-red in colour; it smells like blood and is bitter in taste. Vaiśya soil is yellow in colour; it smells like alkaline earth and

2. Indra (Rain god) is one of the chief deities in the Vedic pantheon. Thunderbolt is his weapon. He possesses great powers and is described as the slayer of many demons.

3. Agni (Fire god) is one of the chief deities in the Vedic pantheon. He is described as the mouth of all the Vedic deities. Also identified with Vedic priests of all ranks.

is sour in taste. Śūdra soil is black in colour, it smells like faeces and has a taste like that of wine. Four castes of temples: depending on the division of the temple walls. The brāhmaṇa is characterized by 9, the kṣatriya by 7, the vaiśya by 5, and the śūdra by 3 *rathaka*s.[4] There are four castes of animals, plants and music. Among the animals, cow is brāhmaṇa, among the trees Banyan is brāhmaṇa, in music *dhrupada* is brāhmaṇa.

Thus, the four castes have been repeated or replicated on a variety of levels and in different modalities. The levels and modalities are hierarchical, and relations are hieratic. The sacred theory is that all realms are hierarchical or else chaotic. There are three universal qualities or elements (*guṇa*s) of which nature, or matter, is constituted. They are called *sattva*, potential consciousness; *rajas*, energetic, active, domineering; and *tamas*, coarse, inert, enveloping, darks. These qualities combine in various proportions to make up the universe and hence there is a potential difference among individuals and objects. In the hierarchy of *guṇa*, *sattva*, is placed at the top, because it is luminous and contrasted with *tamas* which is the lowest elements. The one who possesses *sattva guṇa* in abundance is called brāhmaṇa, the one with *rajas* is kṣatriya, and the one with *tamas* is vaiśya or śūdra. Caste determined by *guṇa* is the supreme identity of being (human, non-human); caste determined by social consideration may indicate an assumed position. Indian astrology bands each individual within a caste in accordance with the position of constellation at birth. This has nothing to do with his or her mundane social status.

The Vedic conception of human origins corresponds with the Australian aboriginal myth of origin of humanity. Australia is the oldest geological landmass and has the oldest animal species. The four races — black, white, yellow and red — correspond to the fourfold archetypal division of creation found in many ancient cultures. Native American, for instance, relates the four colours of their corn — white, yellow, black and red — to the four orientation of north, east, south and west and to the four races of men. Their entire cosmology is ordered by this colour division. The same archetypal pattern, based on the four colours and four directions, is found in Hindu cultures of India. This cosmological division also existed in ancient Egypt and continued in the philosophies of alchemy and astrology. The ancient Taoist philosophies of China and Japan order the entire universe around the same colours. The Australian aborigines divide their universe according to the colour of the four earth pigments: red ochre, yellow ochre, white pipe clay and black carbonic soils. Material science reveals the same fourfold pattern: The four elements basic to all organic substance — nitrogen, hydrogen, carbon and oxygen; the four universal fields of force — electromagnetism, gravity and the two nuclear fields; the four types of rocks that make up the earth's body — igneous, sedimentary, conglomerate, and metamorphic; and the four major tissues of the body — nerve, bone, blood, and the layered tissue (skin, fat, muscle). When a person visits the Chinese traditional healer the doctor will examine him according to the classical recipe of his medical texts known as the Four

4. Lit. projecting bay, central offset in plan and elevation.

Examinations. These consist of various ways of assessing the patient and will include visual, listening and smelling, asking and touching.

It may seem to be coincidence that modern astronomers have designated the four major phases in life-cycles of stars as black holes, red giants, white dwarfs, and yellow suns. However, their respective qualities are related to and consistent with other symbology of the four colours. Black, red, white, and yellow can be considered a signature for a fourfold relationship of universal qualities. This fourfold pattern of metamorphosis occurs on every level of manifestation — spatial, stellar, energetic, plant, animal and human. In the oldest form of African tribal dance, each step is repeated four times because "To be in this world is to be four in spirit and in body, like the four winds and the four legs of the animals". Fourfoldness is one of the archetypal patterns through which the foundations of the natural world are generated. Entering into these primary symmetries — or what the Australian aborigines call 'dreaming patterns' — in dance, music, image and thought allows one's being to join in the interrelatedness of seemingly separate phenomena. These types of thought are prevalent in many indigenous cultures and help explain why one goes further back in history and prehistory: the richer language is in metaphor and the greater utilization of geometry in art and design.

Many indigenous and ancient cosmology divide the natural world into a fourfold symmetrical order following the south, east, north and west orientations. These divisions include earth, air, water and fire, or black, yellow, white and red.

This is consistent with the other symbology of cosmological structures. For instance, the four-faced Brahmā, the archetypal Dean of creation enunciates the Vedic knowledge in a fourfold pattern or evolves the cosmos as a *svastika* with four angles of 90° each. The Brahmā's four faces are aligned to four directions. The mother Cow Virāj, in whose body all the divine powers abide, has four udders for streams of milk. The four cosmic ages, signifying the four categories of moral and spiritual orders, represent the fourfold scheme

of creation. The four-footed Brahmā has been conceived in terms of the four Vedas, the four castes of men and the fourfold scheme existing forever.

The Fivefold Order

The five-faced Śiva symbolizes the five material elements, the five oblations offered into five fires, the five sense-organs, the five casual sounds, the five categories of soul, and the five evolving modalities of the one Transcendent Reality.

The theory of the five elements is an unique contribution to human thought. Its basic assumption is, that, like the rest of the material world man is made up of five elements, which at death disintegrate and dissolve into nature. The elements have been spiritually identified and metaphysically debated for thousands of years. Traditions differ in respect of both identification and enumeration of elements. At the most general level, there are nine elements: earth, water, fire, air, sky, time, directions, mind and soul. Of these the first five are called *bhūta* and the last four *dravya*. The gross and subtle aspects of elements are recognized. Traditional vision leaps over the dichotomy. The reality of the subtler plane is said to be responsible for the grosser plane, and at a higher level of realization the distinction between the gross and the subtle gets totally obliterated.

The elements of nature (earth, water, fire, air, and sky) have a binding ability. Each element called *bhūta* has a form, a location, and a dependent relation with another element. The living forms of nature are self-originating, self-organizing and self-sustaining. The forms are pre-determined, and filled by perishable matter. Life is formless, self-existent and, essentially, indestructible. As soon as form and life come together the process of origination begins. Life activates matter that constitutes form, but in itself is not a material substance.

The elements constitute human and other form — both individually and collectively. Each major organ is said to have its own builder. Head and ears are associated with the sky, neck and chest with air, stomach with fire, and body with earth. The five fingers from the little finger to the thumb are associated, respectively, with earth, water, fire, air, and sky.

The elements are also known to have caused the origin of bio-social types. In south India, for instance, the ironsmiths relate themselves with earth, the carpenters with water, the coppersmiths with fire, the sculptors with air, the goldsmiths with sky. However, elements are intrinsically connected with one another, inasmuch as half in each belong to the selfsame substance and the other half made of the other elements at the rate of 1/8 of each of the other elements.

The binding-ability of elements is expressed in life-process. As the *Garbha Upaniṣad* (3) describes: One night after the union in a fertile period arises a nodule (*kalilam*); after seven nights, it changes into bubble (*budbud*); in half a month arises the embryo (*piṇḍa*); after one month it becomes solid (*kaṭhina*); when two months have passed the head appears; after

three months the formation of the feet is completed; at four months happily originates the fingers, the abdomen and the hips; at five months the back forms; after six months form the mouth, nose, eyes and ears, and after seven months the individual soul concludes the unifications. At eight months all the parts are complete.

Transposing the oral description of the elements of nature on the Upaniṣadic theory, it becomes clear that elements are associated with the intra-uterine formation of the major organs. The liquid stage from which the embryo arises is water. When the embryo becomes solid it is earth; the appearance of hollow head is sky; the formation of the moving feet is air; the origination of sex and abdomen is associated with heat of fire. This sequence of embryonic development roughly corresponds with the origin of the universe: from primeval water to earth and sky and from these to air and fire. It also supports the general theory of man as microcosm.

The Harmonic Principles

Traditional thought is based on harmonious thinking and harmonious living which the sages have revealed and the ordinary people have admired. Their perception of the beginning of the world from zero (nothingness) rules out any single factor (cosmic or divine) pervading the universe. It only signifies wholeness or infinity, as they understood in the first moment. The appearance of *puruṣa* marks the presence of the cosmic power that helps formation of relationship of all that exists. The fourfold pattern keeps everything in perfect balance. The fivefoldness of nature unfolds the mystery, explaining the structure and function of the world. The ancient thinkers knew that the universe is ever-growing and ever-changing, and that the heart of the world (energy) remains in constant motion.

The modern way of thinking is different. There is no direct parallel between traditional thinkers and modern thinkers. While the former consider cosmic principles more important and hence divine, the latter believes rather something different. The modernists consider man as the master of the universe, with a unique mind capable of destroying and recreating the universe at will.

Bibliography

Lawlor, Robert: *Voices of the First Day: Awakening in the Aboriginal Dreamtime*, Vermont: Inner Traditions International, 1991.

Panikkar, Raimundo: *The Vedic Experience: Mantra Mañjarī*, Berkeley: University of California Press, 1977.

Saraswati, Baidyanath: 'Tribal Cosmogony: Primal Vision of Man and Cosmos,' in: *Tribal Thought and Culture*, ed. Baidyanath Saraswati, New Delhi: Concept Publishing Company, 1991.

———, 'Cosmogonic Myths in Northeast India, Forces of Nature,' in: *Prakriti: The Integral Vision*, vol. I: Primal Elements: The Oral Tradition, ed. Baidyanath Saraswati, New Delhi: Indira Gandhi National Center for the Arts/D.K. Printworld, 1995, pp. 7-14.

———, 'Forms of Life in the World of Matter: Reflections on Tribal Cosmology,' in: *Prakriti: The Integral Vision*, vol. IV: The Nature of Matter, ed. Jayant V. Narlikar, New Delhi: Indira Gandhi National Center for the Arts/D.K. Printworld, 1995, pp. 91-96.

———, 'The Four Castes of Men': Temenos Academy Review (London), vol. III (2000).

8

A Commentary on the Opening Verses
of the Tantrasāra of Abhinavagupta

Alexis Sanderson

Verse 1

vimalakalāśrayābhinavasṛṣṭimahā jananī
bharitatanuś ca pañcamukhaguptarucir janakaḥ |

tadubhayayāmalasphuritabhāvavisargamayaṁ
hṛdayam anuttarāmṛtakulaṁ mama saṁsphuratāt ||

May my heart shine forth, embodying the bliss of the ultimate, [for it is] {one with the state of absolute potential made manifest in the fusion of these two, the 'Mother' grounded in pure representation, radiant in ever new genesis, and the 'Father,' all-enfolding [Bhairava], who maintains the light [of consciousness] through his five faces} / {*formed from the emissions produced through the fusion of these two, my mother Vimalā, whose greatest joy was in my birth, and my father [Nara]siṁhagupta, [when both were] all-embracing [in their union]]}.[1]

It is an ancient convention in India that a literary composition should begin with a form of words that promotes its success by dispelling the hindering powers (*vighnāḥ*) that strive to impede the completion of any pious endeavour.[2] Most commonly this auspicious beginning is a verse in which the author meditates on the deity of his personal devotion (*iṣṭadevatā*), either expressing his homage and adoration (*namaskāraḥ*) or praying for its favour and prospering influence (*āśīrvādaḥ*). The present verse, which precedes all but

1. For the function of the braces and typefaces in the translation of this verse see the second paragraph of the Appendix.

2. Already in the second century BC Patañjali declares (*Vyākaraṇamahābhāṣya*, vol. 1, p. 6, l.28-p. 7, l.2): *maṅgalika ācāryo mahataḥ śāstraughasya maṅgalārthaṁ siddhaśabdam āditaḥ prayuṅkte. maṅgalādīni hi śāstrāṇi prathante vīrapuruṣakāṇi bhavanty āyuṣmatpuruṣakāṇi ca* 'Intent on success, the master [Kātyāyana] begins with the [auspicious] word *siddha*-, in order to secure the success of this great mass of instruction, considering that works that begin with [words that promote] success (*maṅgalam*) become well-known and have authors who triumph and enjoy long life.' The word *maṅgalam*, which I have translated 'success,' denotes only the accomplishment of a goal which is sanctioned by the virtuous; see Kaiyaṭa ad loc.: *agarhitābhīṣṭasiddhir maṅgalam*. That which causes or promotes this success is termed a *maṅgalam* by extension (*upacāreṇa*).

one of Abhinavagupta's comprehensive works on the Trika,[3] exemplifies the second of these forms, being a prayer for enlightenment.[4]

In accomplishing this preparative function it also encapsulates the teaching that is to follow. For the fusion of the deities that it invokes is the Trika's ultimate reality; and it characterizes this fusion in terms that provide a brief but potent definition of that ultimate, namely, that it is, as we shall see, the undifferentiated essence of consciousness containing all reality, both inner and outer, in a state of absolute potential.[5] Indeed, it is precisely because the fusion of the deities is this ultimate that the verse could be believed to have the desired effect. For it expresses our author's immersing himself in his true identity and thereby achieving for a moment the state of enlightenment which alone can inspire and sustain a work that will expound the nature of that state and the means by which it may be realized. For the more sublime the goal of a pious endeavour the greater the resistance of the hindering powers; and when that goal is to bestow enlightenment through the recognition of ultimate reality, nothing less than the impression left by the direct experience of that reality can protect against distraction by the contrary impulses that will obscure it in the course of the conceptualization into which the author must descend for the benefit of his readers.

Abhinavagupta explains this doctrine of preparatory immersion (*samāveśaḥ*) in the course of his comments on the verse with which Utpaladeva, his teacher's teacher, opens his *Īśvarapratyabhijñāvivṛti*:[6]

> *te ca prakṣīṇamohasyāpi māyāsaṃskārāvinivṛttaśarīraprāṇaprabhṛtigatapra-*
> *mātṛbhāvasya pratyagātmanaḥ prabhaveyur apīcchāvighātāya, viśeṣataḥ*
> *samastalokam abhyuddhartuṃ parigṛhītodyamasya . . . yathoktaṃ "vighnāyuta-*
> *sahasraṃ tu parotsāhasamanvitam | praharanty aniśaṃ jantoḥ sadvastva-*
> *bhimukhasya ca | viśeṣato bhavāmbhodhisamuttaraṇakāriṇaḥ" ityādi . . . iti*
> *pratyagātmani śarīrādau tadrūpatātiraskāreṇāvanatirūpeṇa prathamasamaye*
> *parameśvarasvarūpotkarṣaparāmarśātmā samāveśaḥ . . . svīkāryaḥ. tatra hi sati*

3. *Mālinīvijayavārttika, Parātrīśikāvivaraṇa, Tantrāloka, Tantrasāra,* and *Tantroccaya*. Only the *Tantravaṭadhānikā* lacks it.

4. For these two forms of the verse for success (*maṅgalam*), the expression of homage and adoration (*namaskāraḥ*) and the benediction (*āśīrvādaḥ*) see Daṇḍin, *Kāvyādarśa* 1.14cd and Bhoja, *Sarasvatīkaṇṭhābharaṇa*, p. 123. The commentators, citing Daṇḍin, recognize a third category of verse for success, namely, that which is an 'indication of the subject-matter [to follow]' (*vastunirdeśaḥ*); but this is uncommon in religious works except as an incidental aspect of the other two. Where it does occur in a Śaiva text, it is argued that the sublimity of the subject is so great that the mere mention of it is sufficient to dispel all would-be hinderers; see Bhaṭṭa Rāmakaṇṭha on *Nareśvaraparīkṣā* 1.1.

5. *TĀV* vol. 1 (1), p.3, ll. 7-9, introducing this same verse in its occurrence at the head of the *Tantrāloka: iha khalu śāstrādāv alaukikāśīrvādamukhena vakṣyamāṇaṣaḍardhaśāstrārthagarbhīkāreṇa samuciteṣṭadevatāṃ śāstrakāraḥ parāmṛśati* 'Here, at the beginning of the treatise, the author directs his awareness to his appropriate chosen deity through an esoteric benediction that incorporates the teaching of the Trika that he will expound [in the course of the work].'

6. *ĪPVV* vol. 1, p. 18, ll. 3-5, . . . 9-12, . . . 14-16, . . . 18-23.

viśvam api svātmabhūtam abhinnasvatantrasaṁvinmātraparamārthaṁ bhavati.
iti kaḥ kasya kutra vighnaḥ. anantaraṁ tu granthakaraṇakāle yadyapi
pratyagātmaprādhānyam evānusaṁdheyam anyathā vaikharīparyantaprāpti-
nirvāhyaśāstraviracanānupapattes tathāpi tatsamāveśasaṁskāramahaujojājvalya-
mānanijaujaḥsamujjihāsitabhedagrahatayā na prabhavanti vighnāḥ.

7 *svarūpotkarṣa* em. : *svarūpotkarṣaṇa* KED **12** *samujjihāsita* em. : *samujjhāsita*
KED

[The hindering powers (*vighnāḥ*)[7]] are able to impede a person's will even if
he is free of delusion. For [while he remains in the world] the latent
impressions of differentiated reality continue to influence him, with the result
that he still projects the sense of self on to his body, vital energy, and [mind].
[And he is] all the more [vulnerable to these powers] if, [as in Utpaladeva's
case, the reason for his remaining in the world is that] he has decided to
strive to rescue mankind [from ignorance].[8] . . . This is supported by the
passage [of scripture] that begins "If a person undertakes a pious task,
countless hinderers assail him day and night, and with great determination,
especially if he is acting to rescue others from the ocean of incarnation. . . ."
So initially, [before composing the treatise,] one should suppress identification
with the body and the other levels of the individual self — this is the 'bowing
down' [that characterizes homage] — and so enter the state of immersion
(*samāveśaḥ*) in which one realizes the supremacy of the nature of Parameśvara.

7. These hinderers are defined by Abhinavagupta as follows in *ĪPVV*, vol. 1, p. 18, ll. 1-3: *ādhyātmikādayo*
 'navadhānadoṣādayas trividhā upaghātās tadadhiṣṭhātāraś ca devatāviśeṣāḥ 'The hinderers (*vighnāḥ*) [to be
 dispelled] are such as the defect of distraction, that is, all the three kinds of affliction, mental (*ādhyātmika-*),
 [material (*ādhibhautika-*)], and [supernatural (*ādhidaivika-*)], and the various gods that empower them.'
 Cf. Yogarāja, *Paramārthasāravivṛti*, p. 2, ll.1-2: . . . *-śaṅkātaṅkālasyasaṁśayādirūpavighnaugha-* 'the multitude
 of hinderers, namely, such [states of mind] as hesitation, uneasiness, laziness, and uncertainty';
 Śivadharmottara f. 125r5-7 (12.181c-183b) on the hinderers of meditation (*yogavighnāḥ*): *ālasyaṁ vyādhayas*
 *tīvrāḥ pramādastyāna*saṁśayaḥ* (em. : *saṁśayaḥ* Cod.) | *anavasthitacittatvam aśraddhā bhrāntidarśanam* |
 duḥkhāni daurmanasyaṁ ca viṣayeṣu ca locanā | *ity evamādikāḥ proktā yogavighnāḥ* 'Lassitude, serious
 illnesses, negligence, apathy, uncertainty, lack of concentration, lack of confidence, hallucinations,
 pains, melancholy, and distraction by sense-objects. Such as these are termed the hinderers of Yoga.'
 For the deities that embody them see, e.g., *Netratantra* 19.62c-64b, which refers to the 300,000 million
 hindering Vināyakas created by Śiva from his thumb, and the site-protectors (Kṣetrapālas) thought to
 hinder a Siddhi-seeker's practice if not placated that are mentioned and listed in the *Aghorīpañcaśataka*
 quoted in *Nityādisaṁgrahapaddhati*, ff. 44v1-45v2. In the latter passage see especially f. 44v3-4: *upapīṭhe*
 tu sandohe tathānye sarvatas sthitāḥ | *kṣetre kṣetre pure pure grāme grāme vasanti te* | *adhikāraṁ śivādiṣṭās te*
 pi kurvanti pālakāḥ | *vighnabhūtās surāṇāṁ ca vīrāṇāṁ siddhim icchatām* | *tapaścchidrāṇi kurvanti*
 dhvaṁsayanti tu pūjitāḥ 'Yet others are found everywhere, in Upapīṭhas and Sandohas. They dwell in
 every sacred place, town, and village. They exercise their office as protectors under the command of
 Śiva. As hinderers of gods and adepts seeking powers they cause fatal flaws in one's ascetic practice,
 but remove [these obstacles] if they are worshipped.'

8. Abhinavagupta alludes to the opening of Utpaladeva's *Īśvarapratyabhijñākārikā*: *kathañcid āsādya*
 maheśvarasya dāsyaṁ janasyāpy upakāram icchan | *samastasaṁpatsamavāptihetuṁ tatpratyabhijñām*
 upapādayāmi 'Having miraculously achieved the status of a slave of Śiva, and desiring to benefit
 mankind, I shall bring about his recognition, the cause of the attainment of all success.'

. . .[9] During this [immersion] the universe too is one with this true self, being nothing in its ultimate reality but undivided and autonomous consciousness. So [while the state continues] what can impede whom, and where? Thereafter, when one is producing the text, one has to focus on the individual self, since otherwise one would be incapable of composing the treatise, which can be accomplished only if it is brought down to the level of articulate speech. But [then] the hinderers have no power [to impede one], because one's inner force, which [now] blazes [more] intensely under the influence of the greater power of the impression of that state of immersion, has inspired one to abandon one's [earlier] faith in the state of differentiation.

The opening benediction, then, is to be read as testimony of the act of self-realization that enabled the work to proceed unhindered to its completion. But this is not its whole meaning. Both types of opening verse express immersion in the ultimate nature of the self, but whereas verses of homage and adoration (*namaskārah*) do so more or less directly, verses of benediction (*āśīrvādah*), such as this, do so only by implication. To the extent that they describe the deity they imply an act of immersion in its nature; but their explicit reference is to an act of prayer for a state that is yet to be accomplished (*sādhya-*). Furthermore, benedictory verses are always altruistic in intention. They are prayers that the deity act for the benefit of others, usually the audience or, more impersonally, the whole world or the virtuous.[10] Occasionally the author includes himself among the beneficiaries, but I know of no instance in which the beneficiary is the author alone.[11] Thus, though Abhinavagupta leaves the beneficiaries unstated in this verse, the force of convention conveys that he is praying either exclusively or inclusively for the enlightenment of others.[12] Which of these does he intend? Does he include himself among the beneficiaries? Or is he excluding himself, praying that we may attain the enlightenment that is already his? His exalted status in the tradition might be taken to support the latter reading. Yet I propose that it is the inclusive reading that he wished to

9. Any auspicious recital of a verse of homage (*namaskāraślokah*) must embody two aspects, humble devotion to the deity and sincere conviction of the deity's supremacy (*utkarṣah*), though only one or the other is usually explicit, the first with such expressions as *namāmi* 'I bow to . . .,' the second with such expressions as *jayati* or *vijayate* '. . . is supreme.' This principle is formulated by Utpaladeva in his *Īśvarapratyabhijñāvivrti*, in a passage quoted by Abhinavagupta in *ĪPVV* vol. 1, p. 8, ll, 12-13; see also *ĪPV*, vol. 1, pp. 6-8; and Maheśvarānanda, *Mahārthamañjarīparimala* p. 5, ll. 5-13.

10. Reference to the audience is the commonest form ("May the deity . . . you [*vah*]"). This is what we find, for example, in all but 14 of the 109 benedictory verses included in the anthology of Jalhaṇa (*Sūktimuktāvalī*, pp. 16-35), and in all but 5 of the 74 in that of Vallabhadeva (*Subhāṣitāvalī*, pp. 4-18). 'The world' (*jagat, jagatī*), 'the worlds' (*jaganti*) or 'the three worlds' (*trijagatī, trilokī*) are the next most frequent beneficiaries (7/109, 2/75). Once in Jalhaṇa's collection (2.24) they are 'the virtuous': . . . *asyatu satāṁ mohaṁ mahābhairavah* 'May Mahābhairava remove the delusion of the virtuous;' cf. the commentary on the Old Kashmiri *Mahānayaprakāśa*, p. 1, v.1: . . . *śāntā daśā . . . bhāsatāṁ satām* 'May the quiescent state . . . become manifest to the virtuous.'

11. The form is then 'May the deity . . . us (*nah*).' This occurs twice in Jalhaṇa's collection (2.58 and 2.91).

12. Non-mention of the beneficiaries is seen five times in Jalhaṇa's collection and thrice in Vallabhadeva's.

convey, namely, "May my heart shine forth in its fullness for us all." This accommodates the doctrine stated in the passage quoted above that even those who have achieved enlightenment must constantly reinforce it through acts of immersion (*samāveśaḥ*) while they remain in the body. If he thought this was necessary for the venerable Utpaladeva he would certainly have thought it necessary for himself. But more importantly, it is this alternative alone that accommodates what I take to be the natural implication of his silence, namely that the distinction between self and other is ultimately unreal, that self and other are merely the modes of appearance of the true self ("my heart") that expresses itself as all consciousness and its objects. The basis of this implication must be the alternative that includes both self and other. "My heart," then, is not Abhinavagupta's heart as opposed to that of others who are yet to be enlightened but rather the core of his being which is the core of all beings. Or we may say that "my heart," *mama hṛdayam*, is intended to mean "the heart of the 'I'," that is the innermost awareness (*vimarśaḥ*) that animates all manifestation (*prakāśaḥ*).[13] The same analysis will apply to the implied pronoun "us" in "May my heart shine forth in its fullness [for us all]." For within Abhinavagupta's Śaivism "we" can only mean the plurality of "I"s projected by and in the one "I."[14]

This, then, is the purpose of the verse. Through it Abhinavagupta expresses his own immersion in the true self as the precondition of successful exposition and at the same time prays for enlightenment, both for his own, that its prospering influence may sustain his work as he descends for our benefit into the unenlightened state of conceptual thought, and that we his audience may attain the same enlightenment in our turn, suggesting through the impersonality of the benediction that he and we are ultimately the one self, indeed that the deity and the beneficiaries of its favour are identical in the highest consciousness.

But the verse also exists to empower those who undertake to teach or study the work after its completion. We too are to contemplate its meaning in order to experience to the extent of our capacity the non-dual consciousness that alone can hold at bay the powers

13. Jayaratha recognizes the second of these meanings in his commentary on the verse as it occurs at the beginning of Abhinavagupta's *Tantrāloka* (*TĀV* vol. 1 [1], p. 4, ll. 1-2): *mamātmano hṛdayaṁ . . . tathyaṁ vastu* . . . 'the heart, i.e. the reality, of me, i.e. of the self'.

14. In support of the proposition that he includes himself among the beneficiaries one may cite the prayer for enlightenment that opens his commentary on the second section of Utpaladeva's *Īśvarapratyabhijñākārikā*. There too he prays inclusively, saying "May the glorious husband of Gaurī reveal the ultimate reality to us . . ." (*ĪPV* vol. 2, p. 1, v.1d: *. . . prakaṭayatu naḥ śrīmān gaurīpatiḥ sa ṛtaṁ param*). And in support of a non-dualistic interpretation of this inclusive prayer, namely, that "we" means "I" in the plural, the plurality of "I"s that are the aspects the one true "I," we may cite Bhāskarakaṇṭha's commentary on that prayer: 'May he reveal to us, that is, to the agents of awareness who being aspects of him are the object of limited "I" [-consciousness], the ultimate, all-containing reality that is his nature' (*Bhāskarī* vol. 2, p.1, ll. 20-21: *param ṛtaṁ nijasvarūpākhyaṁ pūrṇaṁ satyaṁ vastu naḥ svāṁśabhūtānāṁ parimitāhaṁviṣayāṇāṁ pramātṛṇāṁ prakaṭayatu . . .*).

that would have impeded Abhinavagupta's progress and will now try to impede ours as we attempt to follow him.[15] The reader is invited to re-activate the awareness that inspired and sustained the original act of composition, reading the verse as though it were his own, reaching towards his true identity and praying for the enlightenment of all others, both those who are his contemporaries and those that will follow. Thus the contemplation of the verse evokes not only the non-duality of consciousness in the timeless, metaphysical sense, but also the non-duality of the transmission of enlightenment through time from generation to generation. As Abhinavagupta says, the lineage is to be understood as a single state of being within which individual identities are incidental and irrelevant. This is the basis of the doctrine that the guru lineage and the deity are one and the same, and the justification of the injunction that the initiate must look upon the guru as the deity incarnate.[16]

Let us now consider more closely the terms in which the ultimate reality is expressed in the verse. The "heart" that Abhinavagupta contemplates and whose contemplation he invites, is his own consciousness in its ultimate, universe-enfolding nature as the non-dual essence of the union of Śiva and his innate power (*śaktiḥ*). This union is presented as the inseparability of the manifest (*prakāśaḥ*) and its representation (*vimarśaḥ*). Śiva, the manifest (*prakāśaḥ*), is consciousness as the constant and totality of manifestation seen without reference to its modes. Representation (*vimarśaḥ*), his power, is that by means of which this ever-manifest consciousness appears in those modes, representing itself variously as the differentiated reality of common experience (*bhedaḥ*) as the aesthetic synthesis of that plurality within the unity of self-awareness (*bhedābhedaḥ*), as non-duality (*abhedaḥ*) through the complete retraction of that plurality, and, ultimately, as the state

15. For the benefit of the *maṅgalam* to teachers (*vyākhyātāraḥ*) and students (*śrotāraḥ*) see Abhinavagupta's comments on the *Dhvanyāloka*'s opening verse in his *Dhvanyālokalocana* ad loc. Cf., in a Buddhist context, Karṇakagomin's comments in his -*ṭīkā* on the opening verse of Dharmakīrti's *Pramāṇavārttikavṛtti*. See also *Vyākaraṇamahābhāṣya* vol. 1, p. 7, l.2, in which Patañjali, continuing the passage quoted and translated above (n. 1), adds that the purpose of Kātyāyana's auspicious first word is also to promote the success of those who will study his work (*adhyetāraś ca siddhārthā yathā syur iti*).

16. *TĀ* 1.233-5b; *Mahārthamañjarīparimala* p. 95, l. 12-p. 96, l. 4: *tataś ca pūrṇasaṁvitsvabhāvā śrīgurupaṅktir iti tātparyārthaḥ. tata eṣāṁ *bahutvam etat (corr. : bahutvam. etat Ed.) tattvavṛttyā na saṁgacchate. kevalaṁ tattadupādhyupaśleṣavaśād aupacārikatayaivāṅgīkriyate yathaikam eva vastu darpaṇasalilatailādyādhārabhedāt tathā tathā pratibimbati. bahutvavacchariṭrādyuparāgo 'pi na bhedaprathām upapādayati yathoktaṁ mayaiva śrī-pādukodaye "tatra yat pūjyam asmākaṁ śaktīnāṁ maṇḍalaṁ mahat | svasvabhāvātmake śambhau tat kṛtsnaṁ paryavasyati | so 'pi deve gurau svātmany aikātmyam upagacchati" . . . iti* 'And so the gist is that the venerable line of [the Krama's] gurus is of the nature of all-containing awareness. Therefore their [apparent] plurality is not in accord with the way they are in reality. It is accepted only figuratively, by virtue of association with diverse adventitious conditions, just as a single thing casts a variety of reflections because of the difference between the surfaces [on which it appears], such as a mirror, water or oil. The fact that [the guru lineage] is affected by bodies and the like that are plural does not cause any [true] plurality to appear [here], as I myself have taught in [my] *Pādukodaya*: "The whole vast circle of powers that we are to worship there is in the final analysis the Śiva that constitutes the essence of the self. And he is one with the venerable guru and [the worshipper] himself".'

of absolute potential (*visargaḥ*) in the core of consciousness, the 'ultimate non-duality' (*paramādvayam, parādvaitam*) that contains all these modes in a timeless simultaneity.[17]

The essence of that union, the "heart," is the manifest represented in this mode of higher non-duality, the state in which the manifest and representation are perfectly fused in the undifferentiated but all-inclusive totality of absolute potential. This state of fusion constitutes the very essence of consciousness. It is ever present as the basis of all experience.

The "mother grounded in pure representation, radiant in ever-new genesis" is the power of representation itself.[18] It is pure, because though it manifests the factors of time, place, and form that delimit contracted consciousness it is not subject to them itself, being the inexhaustible freedom of consciousness to appear in any configuration or in none. The "father, all-enfolding [Bhairava]" is Śiva as the totality of this manifestation;[19] and his "five faces" are the five powers by virtue of which this manifestation is sustained: consciousness, bliss, will, cognition, and action.[20]

When these two are fused, that is to say, when their natural state of fusion becomes manifest in the process of immersion (*samāveśaḥ*), consciousness rests blissfully in itself alone, having withdrawn the modes of extroversion in which it appears to reach out towards what is other than itself. In terms of the modes of plurality, synthesis, and non-duality it shines forth here as the state of higher non-duality that knows itself as the ground and substance of all three; and in terms of the five powers of manifestation it shines forth as the first two, consciousness and bliss, or more exactly as consciousness blissful (*nirvṛtā*) through fusion with itself, the powers of will, cognition, and action having been withdrawn and dissolved within this state as their ground and source.

Saying that this reality embodies "the bliss (literally 'the nectar') of the ultimate"

17. This non-duality of the manifest is 'higher' (*parama-, para-*) in the sense that it does not exclude plurality; see *MVV* 1.108; 1.122-123 (*parādvaitam*); 1.615-631 (*paramādvayadṛṣṭiḥ* [1.631]); 1.982c (*paramādvaita-*); 1.1132 (*arthe paramādvayasundare*); 2.17c-19b (*paramādvayadṛṣṭiḥ* and *parādvaitam*); 2.151 (→ *TĀ* 4.275) (*bhairavīyaparamādvayārcanam*); 2.270; 2.329 (*paramādvayavijñānam*).

18. Cf. *TĀV* vol. 1 (1), p. 5, ll. 15-16, where Jayaratha, commenting on this same verse in its occurrence at the beginning of the *Tantrāloka*, takes *āśrayaḥ* 'ground' or 'basis' in the compound *vimakalāśrayā* to be equivalent to *svarūpam* 'nature,' 'identity': 'whose ground, i.e. identity, is'

19. I take *bharitatanuḥ* ("all-containing," lit. "whose form is full") to imply the name Bhairava, as intended to be understood as a semantic analysis (*nirvacanam*) of that name. For this analysis cf. *PTV* p. 266, l. 7 (KED p. 233): *bhairavātma bharitākāram; Vijñānabhairava* 15 (*bharitākārā bhairavī*) and 23 (*yāvasthā bharitākārā bhairavasyopalabhyate*); cf. *Ūrmikaulārṇava* f. 7v8-9 (1.157c-158b): **pāṇir* (corr. : *pāṇi* Cod.) *hastaṁ mahatyugraṁ bhairavaṁ vīranāyakam | bharitāvasthayā tasya bhairavī sā vidhīyate; Kulasāra* f. 55v: **bhairavaḥ* (corr. : *bhairava* Cod.) *| bharitaṁ tena cāśeṣaṁ; Chummāsaṁketaprakāśa* f. 7r6-7 (v. 98): *vyāpikā tu samākhyātā nirāvaraṇadharmiṇī | bhairavasyāmitālokabharitasya nirākṛteḥ*; and the unattributed quotation in *TĀV* vol. 1 (1), p. 143, l. 9: *bharaṇāt bharitasthitiḥ*.

20. See *TĀV* vol. 1 (1), p. 7, ll. 2-5 (ad loc.). The five powers are called faces through their equation with the five faces of iconic Bhairava, namely, Tatpuruṣa (E, front), Sadyojāta (W, rear), Vāmadeva (N, proper left), Aghora (S, proper right), and Īśāna (upper). For this equation see *MVV* 1.169c-171b; and Kṣemarāja, *SvTU* vol. 1 (2), p. 54, ll. 2-3.

(*anuttarāmṛtakulam*)[21] Abhinavagupta alludes to its definition in the alphabetic code which he will expound in the third chapter of this work. In those terms, the "ultimate" (*anuttaraḥ*) is the first sound, the short vowel *a*, and "bliss" (*ānandaḥ*) is the second, the long vowel *ā*, understood as the fusion of two short *a*-s. Of these two the first is the ultimate in the masculine gender (*anuttaraḥ*), Śiva as undifferentiated manifestation (*prakāśaḥ*); and the second is the ultimate in the feminine gender (*anuttarā*), the representation (*vimarśaḥ*) or creative intuition (*pratibhā*) of that ultimate, the innate urge of manifestation to represent itself as the universe. Abhinavagupta's "heart" is "bliss," the long *ā*, because it is the bliss of self-containment that arises when the ultimate and its power combine in a state of fusion (*yāmalam*, *saṁghaṭṭaḥ*), that is to say, when manifestation immersed in itself alone experiences infinite bliss in the relish of its state of absolute potential (*visargaḥ*). As evidence in favour of this interpretation of the heart I offer two passages from Abhinavagupta's earlier works on the *Mālinīvijayottara*: *Mālinīvijayavārttika* (1.15-23) and *Tantrāloka* (3.67-69). The first:

> *aniyantritasadbhāvād bhāvābhedaikabhāginaḥ* |
> *yat prāg jātaṁ mahājñānaṁ tad raśmibharavaibhavam* ||15||
> *tataṁ tādṛk svamāyīyaheyopādeyavarjitam* |
> *vitatībhāvanācitraraśmitāmātrabheditam* ||16||
> *abhimarśasvabhāvaṁ tad dhṛdayaṁ parameśituḥ* |
> *tatrāpi śaktyā satataṁ svātmamayyā maheśvaraḥ* ||17||
> *yadā saṁghaṭṭam āsādya samāpattiṁ parāṁ vrajet* |
> *tadāsya paramaṁ vaktraṁ visargaprasarāspadam* ||18||
> *anuttaravikāsodyajjagadānandasundaram* |
> *bhāvivaktrāvibhāgena bījaṁ sarvasya yat sthitam* ||19||
> *hṛtspandadṛkparāsāranirnāmormyādi tan matam* |
> *etat paraṁ trikaṁ pūrvaṁ sarvaśaktyavibhāgavat* ||20||
> *atra bhāvasamullāsaśaṅkāsaṁkocavicyutiḥ* |
> *svānandalīnatāmātramātricchākarmadṛktrayam* ||21||
> *tathā ca guravaḥ śaivadṛṣṭāv itthaṁ nyarūpayan* |
> *sa yadāste cidāhlādamātrānubhavatallayaḥ* ||22||
> *tadicchā tāvatī jñānaṁ tāvat tāvat kriyā hi sā* |
> *susūkṣmaśaktitritayasāmarasyena vartate* ||23||
> *cidrūpāhlādaparamas tadabhinno bhaved iti* |

15d *vaibhavam* J$_{1,2}$ Hanneder : *bhairavam* J$_1$ after correction, Ked **16a** *tataṁ* conj. Sanderson (in Hanneder) : *tatas* Ked

21. I analyse this as an exocentric compound with *kulam* in the meaning 'body' (*anuttarāmṛtaṁ kulaṁ śarīram asya*); cf. *TĀV* vol. 2 (3), p. 76, l. 7 glossing *akulaḥ*: *akāralakṣaṇaṁ kulaṁ śarīram asya*. For this meaning see the unidentified Kaula scripture cited in *TĀV* ad 29.4: *kulaṁ śarīram ity uktam*. For *amṛtam* and synonyms in the meaning 'bliss' (*ānandaḥ*) see, e.g., Kṣemarāja, *Śivastotrāvalīvivṛti* on 12.4b (*amṛtam ānandaḥ*); 12.6d (*sudhāsadanam ānandadhāma*); 12.17a (*amṛtasya paramānandasya*); 13.5a (*bhavadadvayāmṛtākhyātes tvadaikyānandāprathāyāḥ*).

The supreme awareness that has arisen before [all others] from the unlimited [ground] that contains all things in their pure non-duality is manifested all-pervading in the plenitude of its powers, sharing the nature of that ground, [still] free of the hierarchy of goals that it will appropriate [at lower levels], differentiated only inasmuch as the radiance it emits is diffracted in the process of its expansion. This, whose nature is the power of representation itself, is the heart (*hṛdayam*) of Śiva. In this state he attains the highest non-duality by experiencing intimate union with the power that is eternally one with his nature. When this occurs, the highest 'face' arises, the ground in which absolute potential (*visargaḥ*) flows.[22] It is the seed of the universe, beautiful with the all-embracing bliss (*jagadānandaḥ*) that surges up in the expansion of the ultimate, holding in non-duality all the 'faces' that will subsequently emerge. It is this that is meant [in the scriptures] by such terms as the Heart (*hṛt*), the Subtle Motion (*spandaḥ*), Apperception (*dṛk*), the All-embracing [power] (*parā*), the Essence (*sāram*), the Nameless (*nirnāma*), and the Wave (*ūrmiḥ*).[23] This is the ultimate triad [of the Trika], the prior [state] that holds all [other] powers within its unity. Here the contraction caused by the inhibition of consciousness through the emergence of [differentiated] entities has fallen away, and the three [powers] that are the conscious subject's (*mātṛ-*) will, cognition, and action have become nothing but that subject's state of immersion in his own bliss (*svānandalīnatā*).[24] The master [Somānanda] taught this, when he declared in his *Śivadṛṣṭi* (1.3-4), "When one rests immersed in the experience of the unmingled bliss of one's consciousness, then one's will, cognition, and action are no more [than that experience]. One exists as the fusion of these three powers in their subtlest from. At that time one is undivided, completely immersed in the bliss that is consciousness (*cidrūpāhlāda*)."

22. Abhinavagupta uses the term 'face' (*vaktram*) here because his context is an exposition of the process through which consciousness conceives and manifests the streams of Śaiva revelation, their emergence being traditionally associated with the five faces of Sadāśiva. These faces are equated in the *MVV* with aspects of Śiva's power, the streams being presented as the natural expressions of Śivahood in these aspects. The heart is the sixth or highest face; and as the embodiment of absolute potential it is seen as the source of the non-dualistic teachings of the Trika.

23. For other lists of such terms see, e.g., *Tantrasāra* p. 27: *tatra parameśvaraḥ pūrṇasaṁvitsvabhāvaḥ. pūrṇataivāsya śaktiḥ kulaṁ sāmarthyam ūrmir hṛdayaṁ sāraṁ spando vibhūtis triśikā kālī *karṣiṇī (corr. : karṣaṇī KED) caṇḍī vāṇī bhogo dṛk nityetyādibhir āgamabhāṣābhis tattadanvarthapravṛttābhir abhidhīyate* 'In that [practice] Parameśvara is all-containing consciousness. The Power that is his [consort] is nothing but this comprehensiveness. It is she that is meant by such scriptural terms as the Totality, Potential, the Wave, the Heart, the Essence, the Subtle Motion, Pervasive Glory, the Ruler of the Three [Goddesses], Kālī, the Retractor [of Time] ([Kālasaṁ]karṣiṇī), the Furious (Caṇḍī), the Word, Experience, Apperception, and the Eternal (Nityā)'; *TĀ* 3.69 (quoted below); *Spandasaṁdoha* p. 5, ll. 8-12; *Spandanirṇaya* p. 66, ll. 6-9.

24. Jayaratha, *TĀV* vol. 1 (1), p. 7, ll. 11-13, defines the 'ultimate triad' (*paraṁ trikum*) as the fusion of Śiva and Śakti (*śivaśaktisaṁghaṭṭaḥ*), i.e. we must presume, Śiva, Śakti, and their fusion (*a, a,* and *ā*). It is clear that he thinks this is what Abhinavagupta means here, because he cites these verses (*MVV* 1.17-20) immediately after the passage containing this definition (*TĀV* vol. 1 [1], p. 7, l. 15-p. 8, l. 5). However, the context indicates that the triad intended is rather that of the three powers will, knowledge, and action. Cf. *MVV* 1.391c-393.

The second:[25]

> *ittham viśvam idam nāthe bhairavīyacidambare |*
> *pratibimbam alam svacche na khalv anyaprasādatah* ||65 ||

> *ananyāpekṣitā yāsya viśvātmatvam prati prabhoh |*
> *tām parām pratibhām devīm samgirante hy anuttarām* ||66 ||

> *akulasyāsya devasya kulaprathanaśālinī |*
> *kaulikī sā parā śaktir aviyukto yayā prabhuh* ||67 ||

> *tayor yad yāmalam rūpam sa samghaṭṭa iti smṛtah |*
> *ānandaśaktih saivoktā yato viśvam visṛjyate* ||68 ||

> *parāparāt param tattvam saiṣā devī nigadyate |*
> *tat sāram tac ca hṛdayam sa visargah parah prabhuh* ||69 ||

So this universe is a reflection in the Lord, in the perfectly reflective void of Bhairava's consciousness, [and arises] under the influence of nothing outside [that consciousness]. This ability of the Lord to embody himself as the universe without drawing on anything outside [his own nature] is the supreme goddess that [our masters] call 'creativity' (*pratibhām*), 'the feminine ultimate' (*anuttarām*). It is the supreme Power of Universality (*kaulikī śaktih*), the ability of this (*asya*) deity (*devasya*) [Bhairava] {embodied in the sound *a* (*akulasya*)}[26] to manifest the universe (*kulaprathanaśālinī*) [though] {transcending it (*akulasya*)}, the power with which the Lord is ever one (*aviyukto yayā prabhuh*). The Power of Bliss (*ānandaśaktih*) [=*ā*] is the combination (*yāmalam rūpam*) of these two, the 'passionate embrace' (*samghaṭṭah*) out of which the universe is emitted [into consciousness]. This is the [ultimate] reality beyond both the universe-transcending and the universal (*parāparāt param tattvam*).[27] It is 'the Goddess' (*devī*) 'the Essence' (*sāram*) and 'the Heart.' It is the highest (*parah*), omnipotent (*prabhuh*) state of absolute potential (*visargah*).[28]

The heart that Abhinavagupta invokes as the source of inspiration and the goal to be realized is, then, the state of absolute potential (*visargah*) in which the three powers of will, cognition, and action, and the three modes of plurality, synthesis, and non-duality, are fused in blissful, all-embracing consciousness.

25. *TĀ* 3.65-69. Cf. the parallel passage in his earlier *MVV* (1.890-894).

26. I take the single word *akulasya* here to be intended to mean both 'other than the state of universality (*kulam*)' and 'having *a* as its body,' following Jayaratha ad loc., vol. 2 (3), p. 75, ll. 15-16 and p. 76, l. 7. Cf. *MVV* 1.890, where Abhinavagupta makes it clear that the 'ultimate' (*anuttarah*) as Bhairava is both the sound *a* and *akula-* in the first of these two meanings: *anuttarasyākārasya parabhairavarūpiṇah | akulasya parā yeyam kaulikī śaktir uttamā.*

27. Cf. *TĀV* ad loc., vol. 2, p. 82, ll. 9-10: *parād viśvottīrṇāc chaivād rūpād aparād viśvamayāc chāktād rūpāt param pūrṇam* 'Fuller (*pūrṇam* [← *param*]) than the higher [and] the lower, than the universe-transcending aspect proper to Śiva [and] the universe-embodying aspect proper to his power.'

28. The common sense of the term *visargah* is 'emission,' meaning either 'the action of emitting' or 'that which is emitted.' But in this higher *visargah* no process or object of emission is manifest. I have therefore abandoned the literal meaning of the term and translated it 'the state of absolute potential.'

His own birth from the union of his parents Vimalā[29] and Narasiṁhagupta[30] is now added to this statement through a second meaning evoked within the words that convey the primary sense. Information on his parents would be inappropriate in this context were is not that it is no ordinary act of procreation that Abhinavagupta brings to mind. It is rather the supramundane sexual union practised in the course of worship by those initiated in the higher, Kaula form of the Trika. For, as he will explain in chapter 22 of the *Tantrasāra*, at the climax of his treatise, the sexual act is practised there as a means of realizing precisely the state of absolute potential (*visargaḥ*) adumbrated in this opening verse.[31] This internal condition of immersion in the state of absolute potential, which differentiates this union from mundane copulation, is indicated by Abhinavagupta in the epithet all-embracing (*bharitatanuḥ*), which I take to indicate the state of inclusive universality that characterizes this absolute. Jayaratha is no doubt right to say that the epithet should be construed as referring to both Vimalā and Narasiṁhagupta, the precondition of Kaula union being that both should be immersed in awareness of themselves as Śiva and his consort (Śakti).[32]

By including this reference to Kaula union in his opening verse, he indicates the pre-eminence of the Kaula form of the Trika (*kulaprakriyā*, *kaulikī prakriyā*), which he sees as the most direct means of evoking the state of the heart and thereby attaining

29. *TĀV* vol. 1 (1), p. 13, ll. 1-3: *vimalābhidhānā iti. vimalā iti varṇakarṇakalā āśraya ālambanaṁ yasyāḥ sā *vimalābhidhānā* (em. : *vimalakalābhidhānā* KED) 'Having the sound-elements [*varṇakalāḥ*] *vi-*, *ma-*, and *la-* as her basis, support, i.e. called Vimalā.' The name Vimalakalā given by PANDEY (1963: 7) evidently follows KED's reading. My emendation is supported by the Kashmirian *Bhāskarī* on the opening verse of the *ĪPV* (vol. 1, p. 7, l. 15): *paramaśivaḥ: narasiṁhaguptākhyaḥ pitā. śaktiḥ: vimalākhyā mātā*; and the south-Indian *Īśvarapratyabhijñāvimarśinīvyākhyā*, f. 1r3-4 transcribed by the editor in *Bhāskarī*, vol. 2, p. 568: *śrīnarasiṁhaguptasahadharmacāriṇyāṁ śrīmatyāṁ vimalāyāṁ*.

Obviously Abhinavagupta refers to himself when he describes her as *abhinavasṛṣṭimahāḥ*, i.e. 'whose [greatest] joy was to give birth to Abhinava.' For this abbreviation of his name see also Kṣemarāja, *Śivastotrāvalī* p. 355, v. 3c; and *Gurunāthaparāmarśa* 7d, the first Pādas of 8-14, 16a, 17a, 24a.

30. In this reading — see *TĀV* vol. 1 (1), p. 13, l. 10-p. 14, l. 6 — the compound *pañcamukhaguptaruciḥ* ('who guards the manifest through his five faces') means 'illustrious (-*ruciḥ*) as Pañcamukhagupta,' i.e. 'so called' (*Tantrasāra*, ms. P₁, marginal gloss: *iti khyātaḥ*). Pañcamukhagupta equals Siṁhagupta, *pañcamukhaḥ* being a synonym of *siṁhaḥ* ('lion'); and Siṁhagupta is evidently an abbreviation of the name Narasiṁhagupta, which is given by Abhinavagupta as his father's in *TĀ* 37.54.

31. See *Tantrasāra* p. 202, l. 1-p. 203, l. 2 (← *TĀ* 29. 111c-127b).

32. *TĀV* vol. 1 (1), p. 14, ll. 6-11: *bharitatanur iti "śivaśaktyātmakaṁ rūpaṁ bhāvayec ca parasparam | na kuryān mānavīṁ buddhiṁ rāgamohādisaṁyutām | jñānabhāvanayā sarvaṁ kartavyaṁ sādhakottamaiḥ" ityādyuktyā dvayor api śivaśakti*samāveśamayatvānusaṁdhānasyeṣṭeḥ* (em. : *samāveśamayatvābhidhānasyeṣṭeḥ* KED) kākākṣinyāyena yojyam* 'The epithet "all-embracing" should be construed in accordance with the maxim of the crow's eye, [i.e. as looking to right and left simultaneously to qualify both what follows ('the father') and what precedes ('the mother' [*jananī*]),] because such scriptural texts as "They should meditate in each other on the nature that is Śiva and his power. They should not entertain human ideas [of each other] involving passion, delusion, and the rest. The highest adepts should do everything in the cultivation of enlightenment" require [both] to meditate on the state of oneness with immersion in Śiva and his power.'

enlightenment. Though the greater part of his text will be devoted to the more basic, Tantric form of the system (*tantraprakriyā*) — he will come to the Kaula rites only in the final chapter of the text — the whole exposition will be pervaded by Kaula principles. In short, it is a work on the Tantric and Kaula forms of the Trika from the standpoint of the latter.

More specifically, by claiming that he is himself the product of such a union he asserts that he is specially competent to instruct his readers in the nature and means of liberation. For he tells us elsewhere that the body of one conceived in such a union is the receptacle of enlightenment even before birth. That for which others must strive is his instinctively.[33] For the experience of the heart in Kaula union animates the united emissions of semen and menstrual blood which form the embryo.[34]

33. See *TĀV* vol. 1 (1), p. 14, l. 11-p. 15, l. 3 (continuing the passage quoted in the immediately preceding note): *tad evam evaṁvidhasiddhayoginīprāyapitṛmelakasamutthatayā "tādṛṁmelakākalitatanur yo bhaved garbhe | uktaḥ sa yoginībhūḥ svayam eva jñānabhājanaṁ *rudraḥ* (corr. [as quoted at *TĀ* 29.162b] : *bhaktaḥ* KED)" *ityuktanītyā svātmani niruttarapadādvayajñānapātratām abhidadhatā granthakṛtā nikhilaṣaḍardhaśāstra-sārasaṁgrahabhūtagranthakaraṇe 'py adhikāraḥ kaṭākṣīkṛtaḥ* 'Here, because [he tells us that] he is the product of such a union, that is to say, of the union of parents who were essentially a Siddha and a Yoginī, the author claims that he himself is a receptacle of the non-dual knowledge that is the ultimate goal. This is in accordance with what he has said [in *TĀ* 29.162c-163b]: "Anyone whose body has been formed from the bud of such a mingling, is termed 'born of a Yoginī' (*yoginībhūḥ*). He is automatically the receptacle of knowledge, [automatically] a Rudra." And in this way he conveys his fitness to compose a work that is a summary of the essence of all the Trika's scriptures.' Abhinavagupta confirms the statement quoted here by citing the *Vīrāvalikula* (*TĀ* 29.163cd): *śrīvīrāvaliśāstre bālo 'pi ca garbhago hi śivarūpaḥ* 'In the *Vīrāvaliśāstra* [it is said that] even [as] a child [he may be enlightened]. For he is identical with Śiva even in the womb.' Cf. *Parātrīśikā* 10: *etan nāyoginījāto nārudro labhate sphuṭam | hṛdayaṁ devadevasya sadyoyogavimokṣadam* 'One not born of a Yoginī, one who is not a Rudra, cannot, it is clear, attain this heart of the god of gods that bestows liberation through Yoga.'

34. According to the classical Indian medical theory conception takes place when, at the right time, semen (*śukram, retaḥ*) enters the womb (*garbhāśayaḥ*) and mingles there with menstrual blood (*raktam, rajaḥ, ārtavam*); see, e.g., *Bhāvaprakāśa, Garbhaprakaraṇa* 27-35; Bhaṭṭa Vāmadeva, *Janmamaraṇavicāra*, p. 8, l. 16-p. 10, l. 3.

 In the theory of Abhinavagupta and his followers it is not the pleasure of the man alone that is required for conception. The woman's sexual joy is also crucial. In *TĀ* 5.72 we read: *somasūryakalājāla-parasparanigharṣataḥ | agnīṣomātmake dhāmni visargānanda unmiṣet* 'Through the friction of all the elements of the moon and sun the bliss of emission will appear in the centre that embodies both moon and fire.' Jayaratha comments ad loc.: *"śucir nāmāgnir udbhūtaḥ saṁgharṣāt somasūryayor" ityādyuktayuktyā agnīṣomātmake madhyame dhāmny anupraveśena visargānanda unmiṣet. mukhyayā vṛttyā caramadhātuprakṣepātma paraṁ sāmarasyam udiyāt* 'The centre comprises both fire and moon, in the manner stated in such passages as "The fire called 'the pure' arose from the friction of the moon and the sun." Entering that centre causes the bliss of emission to occur. Literally speaking, there will arise the highest fusion that is the emission of the [seminal fluid (*śukram*) that] is the [seventh and] last of the vital elements [produced in the process of the transformation of nutrient fluid (*āhārarasaḥ, rasaḥ*) in the body].' This element is believed to be present in women too. Located throughout the body it decocts the nutrient fluid for the last time. The latter is now too pure to extrude any further impurity and breaks down into only two parts. One becomes the vital essence (*ojaḥ*), which likewise pervades the entire body, and the other becomes new semen in the case of men and both this and an eighth

→

It might be thought that in making this the object of his prayer Abhinavagupta has abandoned the convention that such verses should invoke the author's chosen deity (*iṣṭadevatā*). For it would appear that this heart is no deity at all, but at best the ground in which Bhairava and his power mingle and lose their separate identities. But the breach of convention is only apparent. For at the centre of Abhinavagupta's pantheon of contemplation and worship is a deity embodying this heart. He is merely leaving the reader to recognize it for himself: like the reality it personifies, it is pervasive but veiled.

The Maṇḍala that enthrones the Trika's deities and symbolizes their interrelation is a trident with a lotus above the cusp of each of its three prongs.[35] On these lotuses three goddesses are installed: Parā in the centre, Parāparā to her right, and Aparā to her left. In the Trika of the *Devyāyāmala*, however, there is a fourth goddess, Kālasaṃkarṣiṇī (the Destroyer of Time), who is installed above Parā as the ultimate ground. In the Trika of the *Mālinīvijayottara*, the explicit basis of the group of works to which the *Tantrasāra* belongs, there are only the three goddesses; but there are two forms of Parā, her common form and Mātṛsadbhāva ('The Essence of the Mother Goddesses' or, as the non-dualists preferred to gloss it, 'The Essence of the Conscious'), and Abhinavagupta, influenced by the *Devyāyāmala* and cognate traditions, took the second to be the *Devyāyāmala*'s fourth goddess under another name, that is to say, a higher aspect of Parā in which she subsumes her lower aspect along with Parāparā and Aparā.[36] Now the powers and modes are

→ element, the menstrual blood (*ārtavam*), in the case of women. Now in *TĀ* 29.119c-122b we are told that although in Kaula sexual union both partners simultaneously experience a state of emission that is both quiescent (inwardly focused) and active (through ejaculation) (*śāntoditātmakobhayarūpaparāmarśa-sāmyayoge 'pi* [121cd]) only the woman can conceive and that it is for this reason that she has been said to be 'one whose centre expands' (*praviskararamadhyapadā śaktiḥ śāstre tataḥ kathitā* [122ab]). Jayaratha (ad 29. 122c-123b) explains that the reason for men's inability to conceive is that they lack this expansion (*nṛṇāṃ hi madhyapadapravikāso nāstīty āśayaḥ*). The nature of this expansion is not clarified here but it is surely associated with the bliss of emission (*visargānandaḥ*) that was mentioned in this context in *TĀ* 5.72 cited above. Jayaratha comments on Abhinavagupta's remark in *TĀ* 29.122ab that women are distinguished from men by this natural power of expansion by quoting the following verse: *tiṣṭhet saṃvatsaraṃ pūrṇaṃ sādhako niyatavrataḥ | siddhir bhavati yā tasya sā dinaikena yoṣitām* 'The success that a strictly observant [male] practitioner can achieve in a whole year, can be achieved by women in a single day.' I propose that our authors believed that women are endowed by nature with the capacity to experience a sexual climax of much greater intensity than that accessible to men and held that this explains both their greater ability to experience in Kaula practice the blissful ascent through the central channel (*madhyadhāma, suṣumnā*) of the fire of the vital energy termed *udānaḥ* and their unique ability to conceive. The passage of the *Janmamaraṇavicāra* cited above contains a citation from the *Cillācakreśvaramata*, a post-Abhinavaguptan Śaiva scripture known to Jayaratha, that begins as follows, echoing *TĀ* 5.72 (*somasūryakalājālaparasparanigharṣataḥ | agnīṣomātmake dhāmni visargānanda unmiṣet*): *somasūryasollāsaparasparanigharṣaṇāt | jātavedasi saṃjāte madhyadhāmavikāsini | *vīryāruṇa*(em. : *vīrāruṇa* KED)*pariṇāmavaśād aṅkurasaṃbhavaḥ* 'The mutual friction of the expanding pleasure of the moon and the sun gives rise to a fire that causes the centre (*madhyadhāma*) to open up. This brings about a change in the [mingled] semen and menstrual blood, transforming them into the first state [of the embryo-to-be].'

35. For the outline of this Maṇḍala see Sanderson 1986, p. 171.

36. See Sanderson, 1986, pp. 192-194.

everywhere equated with the three goddesses. So the 'heart,' which is the fusion of those powers and modes,[37] is none other than this fourth goddess. And this equation, though tacit in the opening verse, is not so everywhere. For after identifying the state of bliss arising from the union of Bhairava and his power with 'the essence,' 'the heart,' and 'absolute potential' (*visargaḥ*), the passage of the *Tantrāloka* quoted above continues as follows:

> *devīyāmalaśāstre sā kathitā kālakarṣiṇī* |
> *mahāḍāmarake yāge śrīparāmastake tathā* ||70 ||
>
> *śrīpūrvaśāstre sā mātṛsadbhāvatvena varṇitā*

70c *śrīparāmastake* corr., as quoted in *TĀV* vol. 9 (15), p. 125, l. 12 : *śrīparā mastake* KED

It is called Kāla[saṁ]karṣiṇī in the *Devyāyāmalatantra*, in [the section on] the Great Ḍāmara Maṇḍala,[38] [where she is worshipped] above Parā; and it is called Mātṛsadbhāva in the *Mālinīvijayottaratantra*.

In locating reality at this point at which the three goddesses of the Trika and the triads they express are absorbed into the goddess Kālasaṁkarṣiṇī Abhinavagupta reveals an important key to his tradition's exegesis of the Trika, namely, that at its highest level its dynamics are none other than those of the Kaula Krama system followed by the practitioners of esoteric Kālī worship. For Kālasaṁkarṣiṇī has been imported into the Trika, or imposed on it, under the pervasive influence of that tradition. Abhinavagupta alludes to this Krama core of his Trika at vital points throughout his exposition of the system.[39]

Verse 2

> *vitatas tantrāloko vigāhituṁ naiva śakyate sarvaiḥ* |
> *ṛjuvacanaviracitam idaṁ tu tantrasāraṁ tataḥ śṛṇuta* ||

37. Cf. the opening benediction of the *ĪPVV* on which Abhinavagupta invokes 'the heart that is one with the three divine powers' (*śrīśaktitritayāviyogi hṛdayaṁ*).

38. *TĀ* 3.70-71b. For the term *yāgaḥ* in the meaning 'that on which [the deities] are worshipped' (*atrejyanta iti yāgaḥ*), that is to say, the Maṇḍala, see, e.g., *Mṛgendra, Kriyāpāda* 8.136; *TĀ* 31.43a, 46c-47a, and 53ab. For the use of the term [*mahā*]*ḍāmarayāgaḥ* to denote the variant of the trident Maṇḍala taught by the *Devyāyāmala* see *TĀ* 31.100ab. For the use of the term to denote the section of the work in which that Maṇḍala is taught see *TĀ* 15.335cd and Jayaratha on *TĀ* 3.70.

39. Cf. *TĀ* 33.30-31b, here equating the three goddesses with emission, stasis, and retraction: **parā parāparā* (corr. : *parāparā parā* KED) *cānyā sṛṣṭisthititirodhayaḥ* | *mātṛsadbhāvarūpā tu turyā viśrāntir ucyate* | *tac *cāprakāśam* (em. : *ca prakāśaṁ* KED) *vaktrasthaṁ sūcitaṁ tu pade pade* 'Parā, Parāparā, and Aparā are emission, stasis and retraction. But the scriptures teach a fourth, the state in which they come to rest. This is Mātṛsadbhāva. This [fourth level] is not explicit, being a matter for oral instruction. But I have alluded to it at every step.' Cf. *TĀV* vol. 1 (1), p. 150, ll. 3-4: *trikaṁ parādiśaktitrayābhidhāyakaṁ śāstram. kramaḥ catuṣṭayārthaḥ* 'The Trika is the doctrine that teaches the three Powers Parā, [Parāparā, and Aparā]. The Krama is the doctrine of the four [: emission, stasis, retraction, and the nameless].'

Not all are capable of mastering in depth my long *Tantrāloka*. Study, then, this *Tantrasāra*, which I have composed as a more straightforward [summary of the same subject].

The *Tantrāloka* (Light on the Tantras) is Abhinavagupta's most extensive work of Śaiva scriptural exegesis.[40] Entirely in verse it comprises nearly 6,000 stanzas; and these are succinct in style and technical in content. The *Tantrasāra* is about one sixth as long and is written in simple prose interspersed with verses that conveniently summarize the matter covered in each section. It also presents its subject more smoothly, sparing the student much of the philosophical arguments, digressions, elaborations, and accounts of alternative procedures that abound in the *Tantrāloka*.[41]

The title *Tantrasāra* could mean 'The Essence of the Tantras';[42] but the structure of the verse strongly suggests that -*sāra* here means not 'essence' but 'summary,' the summarized being the subject covered in the longer *Tantrāloka*. For Abhinavagupta states here that his *Tantrāloka* is both too difficult and too long for some and then recommends his *Tantrasāra* as the remedy, that is to say, as both a less complicated and a shorter treatment of the same subject. Either he could leave the reader to understand for himself that he is recommending the work for both these reasons, or he could make both reasons explicit. What he cannot do is to state one but not the other. This he would be doing unless we take the second, that of brevity, to be conveyed by the title itself, as I have indicated in the portion of my translation placed within parentheses. The title may be rendered, then, as 'A Shorter Exposition of the Tantras.'[43]

Having clarified the meaning of the element -*sāra* we may now consider the identity of the Tantras which the first part of the title identifies as the subject-matter of our work. Since Abhinavagupta refers here to the Tantras in general rather than to a more restricted

40. The Sanskrit also permits the translation 'Light of the Tantras.' Thus Raniero Gnoli published his translation of the work into Italian (1999) under the title *Luce dei Tantra*. Jayaratha gives both this and 'Light on the Tantras' as the meaning of the title in *TĀV* vol. 1 (1), p. 258, ll. 16-18: *tantrāloke tantrāṇāṁ pārameśvarāṇām āloka ivālokas tāny ālokayati prakāśayatīti vā* 'In the *Tantrāloka*, i.e. [in] this [work] which is, as it were, the light of the Tantras taught by Śiva, or which illuminates them.'

41. See the marginal annotations in *Tantrasāra* ms. P₁: (1) *sarvaiḥ akṛtatīkṣṇatarkaśāstrapariśramaiḥ* '[Not] all [are capable of mastering in depth my voluminous *Tantrāloka*], since [not all] have the [necessary] training in rigorous reasoning;' and (2) *tīkṣṇatarkahānyā ṛjutā* '[The *Tantrasāra*] is straightforward because it is free from rigorous reasoning.' The annotator echoes the opening words of Kṣemarāja's *Pratyabhijñāhṛdaya*, his simple outline of the philosophical and soteriological doctrines of Utpaladeva's *Īśvarapratyabhijñākārikā*, where he says that his purpose is to introduce the essence of that system to 'those of undeveloped intellect, who have not laboured in the rigorous discipline of reasoning' (*sukumāramatayo'kṛtatīkṣṇatarkaśāstrapariśramāḥ*).

42. Thus Raniero Gnoli entitled his Italian translation of the *Tantrasāra* (1990) *Essenza dei Tantra*.

43. This is how the title is understood by the glossator in *Tantrasāra* ms. P₁: *sāram arthākṣepeṇa vacanaṁ saṁkṣepaḥ* '-*sāra*, i.e. an exposition with the implication of [non-essential] topics, a summary.' The literal meaning of the second half of the verse is: 'But this *Tantrasāra* has been composed in straightforward language. Study it, therefore.'

group of texts, it would appear that he excludes only those whose exclusion could be taken for granted, that is to say, those that lie outside the boundary of his religion. The Tantras inside this boundary, that is to say, the Tantras that he recognized as valid instruction in the means of true salvation, might be thought to be those that teach the Trika. In that case the implied meaning of the title would be 'A Shorter Exposition of the Tantras of the Trika.'

However, his canon of fully valid Tantric revelation extends far beyond the confines of this system to embrace all the Śaiva Tantras, that is to say, all that have been propagated as the teaching of Śiva (*śivaśāsanam, śaivam*). For though he holds the major divisions of this Tantric Śaiva canon to be unequal in certain respects — he places the Trikatantras above the rest of the Bhairavatantras, and the Bhairavatantras above the Siddhāntatantras — he perceives them nonetheless as equal and united in this fundamental sense that all teach the means of true and definitive liberation, whereas all non-Śaiva Tantras and all non-Tantric scriptures, including those scriptures that advocate devotion to Śiva for the uninitiated,[44] offer goals that in reality are forms of bondage, being temporary states of reward, however exalted.[45] He explains this greater unity of Śaivism in the following passage of his *Mālinīvijayavārttika*:

44. I refer to such works as the earliest version of the *Skandapurāṇa*, recently edited by Bhaṭṭarāī, and the texts of the *Śivadharma* cycle (*Śivadharma, Śivadharmottara, Śivadharmasaṁgraha, Śivopaniṣad, Umāmaheśvarasaṁvāda*, [*Śivadharma-*]*Uttarottara, Vṛṣasārasaṁgraha*, and *Dharmaputrikā*), which, with the exception of the *Śivopaniṣad*, are still unedited. The *Śivopaniṣad*'s misleading name caused it to be included (and concealed) among the Śaivite Upaniṣads in *Un-Published Upanishads*, pp. 324-78. This literature concerns the religious practice of uninitiated, lay devotees (*śivabhaktaḥ, rudrabhaktaḥ, upāsakaḥ*).

45. The status of the pre-Tantric Śaivism of the various Pāśupata traditions was not a matter of universal agreement. According to our Kashmirian authors, following the authority of the *Niśvāsa* and the *Svacchanda*, the category of Śiva's teachings (*śivaśāsanam*) does include the scriptures of these traditions. It is accepted that they have the power to lead their followers to liberation at the reality-level of Īśvara. This is a lower liberation (*aparā muktiḥ*) than that attainable by those who have received full initiation (*nirvāṇadīkṣā* or *sādhakadīkṣā*) in any Śaiva Tantra; but it is a true liberation. For it lies within the pure universe, above the world-source (*māyā*). Once here a soul cannot fall back, and in time it will rise to the highest level. However, not all Pāśupatas were believed to reach the pure universe. The Pāñcārthika Pāśupatas, the Lākulas (also called Mahāvratas and Kālamukhas), and the Vaimalas are said to realize their scriptures' salvific potential, but the Mausulas and Kārukas are held to reach no further than the world-source, that is to say, the reality-level that is the upper limit of the impure universe. For though they follow valid scripture they have placed excessive emphasis on rites at the expense of gnosis. For this view of the Pāśupata systems, or elements of it, see *TĀ* 37.13c-15; *Niśvāsaguhya* 7.251c-252b (f. 67v2-3), 7.263c-264b (f. 67v6), 7.269 (f. 68r1-2); *Dīkṣottara* 18.123-125; *SvT* 10.1134-1135b, *SvTU* ad loc.; *SvT* 11.70-74, *SvTU* ad loc. A less generous view is found in the Saiddhāntika Paddhati of Somaśambhu and in the Saiddhāntika scripture *Sarvajñānottara*. According to the first the Pāśupatas reach no higher than the world-source and according to the second they reach not even this level, being 'liberated' in Time (*kālaḥ*), while other non-Tantric followers of Śaiva scripture, called Mahāvratas by the first and Somasiddhāntins by the second, are conceded true liberation by being assigned to the level Vidyā, just beneath Īśvara, in the pure universe; see *Somaśambhupaddhati* vol. 3, p. 553, verse 8ab; and *Sarvajñānottara* f. 37r2: *kevalārtha*vidaḥ* (em. : *vidiḥ* Cod.) *kālaṁ prāpnuvanti jitendriyāḥ*. For *kevalārthavit*

→

tena vaiṣṇavabauddhādiśāsanāntaraniṣṭhitāḥ ।
yathā samyaṅ na mucyante na tathā śaivasaṁskṛtāḥ ॥1.192 ॥

atimārgakramakulatrikasrotontarādiṣu ।
parameśānaśāstre tu ye samyag dīkṣitā narāḥ ॥193 ॥

teṣāṁ naivāpavargasya lābhe bhedo'sti kaścana ।
na caitadatirikto'pi mokṣopāyo'sti kaścana ॥194 ॥

kevalaṁ kvāpy anāyāsāj jīvanmuktikrameṇa ca ।
śīghram eva parā siddhir yathāsmaddarśaneṣv iti ॥195 ॥

kvāpi tattvāvalīyogaparipāṭīkramāc cirāt ।
tais taiḥ kriyākalāpaiś ca labhyate paramaṁ phalam ॥196 ॥

195a *anāyāsāj* conj. Sanderson (in Hanneder) : *anāyāsā* Codd.

So those initiated in Śaivism are truly liberated, and followers of other teachings, such as Vaiṣṇavism or Buddhism, are not. All individuals who have been properly initiated in the teachings of Śiva, whether in a Pāśupata system (*atimārgaḥ*), the Krama, the Kula, the Trika, or any other division, are equal in that all attain liberation. Nor is there any means of liberation outside these [teachings]. It is just that in some systems, such as ours, the ultimate perfection is achieved quickly and without struggle, through liberation in life, whereas elsewhere [in the Siddhānta and the Pāśupata systems] the supreme goal is reached slowly, through a course of graded meditations in which one ascends from one reality-level to the next, and by means of various complex rituals.

The *Tantrasāra*, then, is 'A Shorter Exposition of the [Śaiva] Tantras.' And this interpretation has the support of Jayaratha, who glosses the first element of the title *Tantrāloka* in the same way.[46]

But if the *Tantrasāra* is an exposition of the Śaiva Tantras, the sense in which it justifies its title is not immediately obvious. For, in fact, neither it nor the antecedent *Tantrāloka* deals directly with Śaiva Tantrism as a whole, either in general terms or by covering its various forms in sequence. Rather, both works are expositions of just one form of Śaivism, the Trika. In the introduction (*upodghātaḥ*) to his *Tantrāloka* our author writes:[47]

santi paddhatayaś citrāḥ srotobhedeṣu bhūyasā ।
anuttarasadardhārthakrame tv ekāpi nekṣyate ॥14 ॥

→ in the meaning Pāñcārthika consider the Tewar stone inscription of Gayākarṇa, Cedi Saṁvat 902 = AD 1151, *CII* 4: 58, verse 5c: *ācāryo 'dbhutakevalārthavacasāṁ pāñcārthiko yaḥ sudhīḥ*; and Viśuddhamuni, *Yamaprakaraṇa* 21d-22b: *viśuddhamuninālpakam । kevalārthāt samuddhṛtya yamaprakaraṇaṁ kṛtam.*

46. *TĀV* vol. 1 (1), p. 258, ll. 16-18: *tantrāloke tantrāṇāṁ pārameśvarāṇām āloka ivālokas tāny ālokayati prakāśayatīti vā.*

47. *TĀ* 1.14-15.

ity ahaṁ bahuśaḥ sadbhiḥ śiṣyasabrahmacāribhiḥ |
arthito racaye spaṣṭāṁ pūrṇārthāṁ prakriyām imām ‖15 ‖

Many different Guides are available for each of the [five Śaiva] streams, but
not one for the procedures of the Trika, the highest system of all (*anuttaraṣaḍ-
ardhārthakrame*).[48] So, at the repeated request of my pious pupils and co-initiates,
I am composing this clear and comprehensive exposition [of that system].

The *Tantrasāra*, then, is a shorter 'Guide to the Trika' (**trikapaddhatiḥ*). Indeed, it is
even more specialized than this. For as a Guide or Paddhati, it must be based on a single
work, and that, in this case, is the *Mālinīvijayottara*.[49]

How, the reader will ask, can Abhinavagupta claim to be expounding the Śiva Tantras
as a whole through the exegesis of a single Śaiva Tantra within one specialized division
of that canon? The answer is that he can do so because he holds — indeed in doing so he
asserts — that the scriptures of the Trika contain the essence that animates all the branches
of the Śaiva canon, indeed ultimately all religion, and that this essence appears in the
Mālinīvijayottara in its purest form. Thus:[50]

eka evāgamas tasmāl lutru laukikaśāstrataḥ |
prabhṛty ā vaiṣṇavād bauddhāc caivāt sarvaṁ hi niṣṭhitam ‖30 ‖

tasya yat tat paraṁ prāpyam dhāma tat trikaśabditam |
sarvāvibhedānucchedāt tad eva kulam ucyate ‖31 ‖

48. Raniero Gnoli has translated *anuttaraṣaḍardhārthakrame* 'for the school of the Unsurpassed, for the
 Trika, and for the Krama ('per la scuola del Senza Superiore, per il Trika e per il Krama' [1999: 6]). The
 Tantrāloka draws on the Krama; but by no means can it be considered a Paddhati of that system. As for
 the Anuttara ('the Unsurpassed'), i.e. the form of the Trika taught on the basis of the *Parātrīśikā*, its
 ritual procedures are altogether absent from the *Tantrāloka*. My understanding of the compound is
 also that of Jayaratha; see *TĀV* vol. 1 (1) p. 52, ll. 5-9: *prathamaślokapañcakāsūtrito 'nuttaraṣaḍardhārthakrama
 ity anena sākṣād abhihitaś ca trikārthas tāvad abhidheyaḥ* 'The subject [of the *Tantrāloka*] is the Trika, which
 has been implied by the five opening verses and expressly stated in the expression
 anuttaraṣaḍardhārthakrame [in 1.14c].'

49. *TĀ* 1. 17: *na tad astīha yan na śrīmālinīvijayottare* | *devadevena nirdiṣṭaṁ svaśabdenātha liṅgataḥ* 'There is
 nothing in this [*Tantrāloka*] that has not been taught by Śiva in the *Mālinīvijayottaratantra*, either
 explicitly or by implication.' Likewise, he refers to his *Tantrāloka* as a versified analytic commentary
 (*ślokavārttikam*) on the *Mālinīvijayottara*, calling the latter the *Ṣaḍardha*, i.e. the Trika[tantra], in *ĪPVV* vol.
 1, p. 33, l. 23: *śrīṣaḍardhaślokavārttike tantrāloke*.

 A Paddhati, literally a 'Guide,' is defined as follows by the Śaiva authority Bhaṭṭa Rāmakaṇṭha,
 Sārdhatriśatikālottaravṛtti p. 45, ll. 6-7: *paddhatiḥ pratiśāstraṁ vikṣiptasya śrutasya *tatsāmarthyākṣiptasya*
 (em. : *tatsāmarthyāt kṣiptasya* Bhatt) *ca mantratantrānuṣṭhānāya *saṁkṣepāt* (em. : *saṁkṣepa* Bhatt)
 **krameṇābhidhānaṁ* (em. : *krameṇābhidhānād* Bhatt) *yajurvedādau yajñasūtrādivat* 'For any scripture a
 Paddhati is a text that enables the performance of the rituals [of that scripture] along with the mantras
 [that accompany them] by succinctly arranging in the order [of performance] (i) the [instructions]
 explicitly stated [in that scripture but] dispersed in various places [throughout its length], and (ii)
 whatever [else] those explicit statements imply. An example is the *Yajñasūtra* in the case the [Kāṭhaka]
 Yajurveda.' On the relation between scriptures and Paddhatis see Sanderson 2005a, pp. 352-77.

50. *TĀ* 35.30-34.

yathordhvādharatābhākṣu dehāṅgeṣu vibhediṣu |
ekaṁ prāṇitam evaṁ syāt trikaṁ sarveṣu śāstrataḥ ||32 ||

śrīmatkālīkule coktaṁ pañcasrotovivarjitam |
daśāṣṭādaśabhedasya sāram etat prakīrtitam ||33 ||

puṣpe gandhas tile tailaṁ dehe jīvo jale 'mṛtam |
yathā tathaiva śāstrāṇāṁ kulam antaḥ pratiṣṭhitam ||34 ||

There is but one revelation (*āgamaḥ*) within which all [religion] is grounded, from the mundane [Vedic religion] to Vaiṣṇavism, Buddhism, and Śaivism. And the ground of that revelation, the ultimate goal [of religion], is the Trika. Because of its consistent non-duality it is also called the Kula. Just as there is one vital breath in [all] the limbs of the body, though each is distinct and lower or higher, so the Trika is present in all scriptures. And for this we have the authority of the *Kālīkula*: "It has been declared that this teaching transcends the five streams as the essence of the ten and eighteen [Siddhānta-tantras]. The Kula resides within the [Śaiva] scriptures like the scent in a flower, the oil in a sesame seed, the soul in the body, or the nectar of life in water."[51]

And:[52]

daśāṣṭādaśavasvaṣṭabhinnaṁ yac chāsanaṁ vibhoḥ |
tatsāraṁ trikaśāstraṁ hi tatsāraṁ mālinīmatam ||

The essence of the Lord's teaching in his ten and eighteen [Siddhāntatantras] and sixty-four [Bhairavatantras] is the Trika; and the essence of that is the *Mālinīvijayottara*.

This view of the relation between the Trika and the rest of Tantric Śaivism is, of course, a correlate of the metaphysical doctrine that the higher contains the lower until at the highest level everything is subsumed within the state of absolute potential invoked in our opening verse. Just as that state is the highest, all-containing reality, so in the parallel theory of revelation the Trikatantras are the purest expression of that state and the most immediate means by which it may be realized. As for the other branches of the Śaiva revelation, they are understood as expressions of that same state when it has undergone subtle differentiation through the projection into prominence of one or other of its hitherto latent powers.[53] By expounding the *Mālinīvijayottara*, then, Abhinavagupta can claim to be expounding the whole Śaiva revelation in its undifferentiated essence: whatever appears outside the Trika is merely the Trika inflected by a limiting context.

51. Cf. *Kālīkulapañcaśataka* f. 33r-v (2.35-38b): *etad rahasyaṁ paramaṁ kulaṁ jñātaṁ na kena cit | śaivād bāhyam idaṁ deva pañcasrotovinirgatam ||36 || daśāṣṭādaśabhedasya śaivasya parameśvara | antarlīnam idaṁ jñānaṁ na jñātaṁ tridaśeśvaraiḥ ||37 || sarvatra saṁsthitaṁ deva sugūḍhaṁ kulam uttamam | puṣpe gandha ivāsaktas tailaṁ yadvat tilādiṣu ||38 || tathaiva sarvaśāstrāṇāṁ kulam antaḥ pratiṣṭhitam.*

52. *TĀ* 1.18. See also *TĀ* 37.13c-26; *MVV* 1.391-399.

53. This is the point of *MVV* 1.15-399.

One might think that in a text based on such a vision of the canon it ought not to be necessary to look beyond the higher to the lower. Indeed it might seem improper to do so. The presence of Tantras other than those of the Trika ought, then, to be purely theoretical in the manner explained. In practice, however, Abhinavagupta does draw heavily on Śaiva Tantras outside his narrow focus, and in this way he gives his works something of the comprehensiveness promised by their titles. This is sometimes because he wishes to emphasize that certain doctrines are characteristic of the entire canon[54] and sometimes to confirm the non-dualistic perspective of the Trika by showing that it can be recognized even in texts far removed from this source, texts that those who recognize no higher authorities consider strictly dualistic. Abhinavagupta accepts that Śiva has taught dualism in these texts[55] but he seeks to assert his view of the canon by showing that Śiva has left traces even there of the non-dualistic awareness that he claims to be the source of all the Tantras and the explicit teaching of the highest.[56]

But there is another reason for his looking beyond the Trikatantras, and this is that the highest Tantras within the canon, though they are the most universal in terms of doctrine — their non-dualism subsumes and transcends the dualism of the lower scriptures —, are the least universal in the scope of their injunctions. For the canon is seen as a single complex utterance in which the instructions in the lower Tantras apply on the higher levels unless they are countermanded by more specific instructions. It follows that in order to translate the teachings of a text like the *Mālinīvijayottara* into action it is necessary to supplement it by reading in information from lower levels. The rule for such supplementation is that where the base text is concise or silent whatever is needed is to be drawn from the highest source possible. One is to look first to texts of the same class (*samāna-*), then to related texts (*samānakalpa-*) within the corpus of Bhairava-tantras, and finally, if that is necessary, to the altogether unrelated (*atyantāsamāna-*) Siddhāntatantras which form the lowest and most universally applicable level of injunction in the canon.

Jayaratha sets out the principle and illustrates its application with reference to *Mālinīvijayottara* 8.16. That verse instructs the initiate to make offerings to the deities who preside over the door to his shrine and then to cast in a flower over the threshold before he enters. Jayaratha explains that in order to act on this instruction the worshipper needs to know the names, order, and locations of the deities around the door, and also the ritual hand-gesture with which he is to accomplish the throwing of the flower. Since

54. See, e.g., *TĀ* 1.157-8, where Abhinavagupta points out that though the Śaiva canon (*parameśvaraśāstram*) distinguishes Śiva and his powers it does not consider them to be separable in the sense in which the property-holder (*dharmī*) and its properties (*dharmāḥ*) are separable for the Vaiśeṣikas.

55. See, e.g., *TĀ* 1.194 (*dvaitaśāstreṣu*); 1.224 (*dvaitaśāstre mataṅgādau*).

56. Thus, in the introduction (*upodghātaḥ*) to *TĀ* (1.22-106) see 59-62b ('*Kāmika*'); 62c-65 ('*Dīkṣottarādi;*' see *Dīkṣottara*, Paṭalas 2-3); 66 ('*Kāmika*'); 75-77 ('*Kiraṇa*'). Cf. *MVV* 1.196c-197b ('*Kālapāda*' = *Sārdhatriśarikālottara* 8.7d).

these details are nowhere to be found in the *Mālinīvijayottara* itself he must look beyond it, starting with the most closely related (*samāna-*) sources, that is to say, the other Tantras of the Trika. The names, order, and locations of the deities are encountered in the Trika's *Triśirobhairavatantra*. So for these he need look no further. But for the method of casting the flower he has to descend to the *Svacchandatantra*, a text outside the Trika but nonetheless of the same general type since it is a Bhairavatantra rather than a Siddhāntatantra. A passage in that text (2.26-27) informs the worshipper that he should throw the flower with the 'arrow gesture' (*nārācamudrā*); but it does not tell him how to make it. To supply this information Jayaratha turns to the *Anantavijaya*, a scripture which he assigns to the Siddhānta class and therefore places at the greatest possible distance within the canon from the text it is to supplement.[57]

In attempting to write a comprehensive Guide (Paddhati) to Tantric practice on the basis of the *Mālinīvijayottara* Abhinavagupta has indeed been obliged on several occasions

57. *TĀV* vol. 3 (4), p. 279, l. 12-p. 280, l. 17 ad *TĀ* 4.251cd (*nānyaśāstrasamuddiṣṭaṁ srotasy uktaṁ nije caret* 'He should not do within [the practice of] his own scripture anything that has been taught in another'): *apekṣāyāṁ punar utpannāyāṁ śāstrāntarād apekṣaṇīyam. anyathā hi tattaditikartavyatākālāpasyāparipūrtiḥ syāt. tathā hi śrīpūrvaśāstre* "*tatra dvārapatīn iṣṭvā mahāstreṇābhimantritam | puṣpaṁ vinikṣiped dhyātvā jvalad vighnapraśāntaye*" *ityādau dvārapatīnāṁ katham iṣṭir ity apekṣāyāṁ samānatantrāc chrītriśirobhairavāt* "*tato mūle uttarato nandirudraṁ ca jāhnavīm | mahākālaṁ sadaṁṣṭraṁ ca yamunāṁ caiva dakṣiṇe*" *ityādy apekṣaṇīyam. atraiva ca jvalat puṣpaṁ katham vinikṣiped ity apekṣāyāṁ samānatantre tatkṣepasya suspaṣṭam anabhidhānāt samānakalpāc chrīsvacchandaśāstrāt* "*bhairavāstraṁ samuccārya puṣpaṁ saṁgṛhya bhāvitaḥ | saptābhimantritam kṛtvā jvaladagniśikhākulam | nārācāstraprayogeṇa praviśed gṛhamadhyataḥ*" *ityādy apekṣaṇīyam. nārācāstrasya ca prayogaḥ kīdṛg ity apekṣāyāṁ samānakalpe 'pi śāstre tadanupalambhād atyantam asamānād anantavijayākhyāt siddhāntaśāstrād* "*uttānaṁ tu karaṁ kṛtvā tisro 'ṅgulyaḥ prasārayet | madhyamāṅguṣṭhakau lagnau cālayeta muhur muhuḥ | nārācaḥ kīrtito hy evam*" *ityādy apekṣaṇīyam* 'But [one's scripture] may lack certain necessary information. In that case one is bound to draw upon some other scripture, for otherwise it would be impossible to complete the full range of one's various obligations. To explain, the *Pūrvaśāstra* [*Mālinīvijayottara*] says: "Having worshipped the Door-Guardians there he should empower a flower by reciting the Great Weapon [mantra upon it] and after visualizing it burning he should cast it [into the shrine] to drive out [all] the impeders [that are in it]" (8.16). This and other [passages of the text] leave us in ignorance of how this worship [of the Door-Guardians] is to proceed. So we are obliged to supplement [our information] with such passages as the following from the *Triśirobhairava*, that being a text of the same kind (*samānatantrāt*): "Then at the base [of the door-posts] he should worship Nandirudra and Gaṅgā on the left, and fanged Mahākāla and Yamunā on the right." This same [verse of the *Mālinīvijayottara*] also leaves us needing to know how we are to throw in the burning flower. Since no text whose system is of the same kind gives clear instruction on its throwing we are constrained to draw upon such as the following from the scripture *Svacchanda*, a text of a similar kind (*samānakalpāt*): "After pronouncing the Bhairava Weapon [mantra] he should take a flower with tranquil mind and empower it with seven [utterances of that mantra visualizing that being imbued with the Weapon it is now] emitting flames of fire blazing in all directions. Employing the procedure of the arrow weapon he should enter the shrine." Since this does not tell us the nature of that procedure, and since that it is not to be found even in texts [such as this] that are [at least] similar, we must draw on a passage such as the following from a text of a completely different kind, the Saiddhāntika scripture *Anantavijaya*: "With his hand open with the palm up he should extend three fingers [the index, the ring-finger, and the little finger]. Joining the middle finger and the thumb he should move them [in and out] repeatedly [and then flick the flower forward by releasing the middle finger with force.]".'

to read in from the Siddhāntatantras not merely minor details such as those of the procedure of the arrow-gesture — system-neutral information of this kind he generally leaves his learned readers to supply for themselves as items in the basic lexicon of Saiddhāntika Śaivism — but whole rituals where these are elements of any complete Tantric system but have not been expounded in the *Mālinīvijayottara* or, it seems, in any text between that and the lowest level. For example, he draws on the *Dīkṣottara* for the procedure of initiation during the last rites (*antyeṣṭidīkṣā*)[58] and for the visualization of mantra-syllables (*varṇavidhiḥ*) during meditation,[59] and on that source and the *Kiraṇa* for abbreviated initiation (*saṁkṣiptadīkṣā*).[60]

Much of this reading in from below, whether tacitly expected of the reader or explicitly ruled, is in accordance with the intention of the *Mālinīvijayottara* itself. The sources Abhinavagupta chose for supplementation are no doubt those that were particularly important at these various levels in his time and region; and the author of the *Mālinīvijayottara* may well have looked out on a somewhat different terrain.[61] But whatever the case, it is probable that he would have had in mind some Trikatantras (notably the *Siddhayogeśvarīmata*), some Bhairavatantras, and a number of Siddhāntatantras, descending through these three categories in that order. We may be sure, however, that he did not have in mind a number of doctrinally crucial texts that Abhinavagupta locates in the immediate surroundings of the *Mālinīvijayottara*. For from these Abhinavagupta reads in elements that are fundamental to the innermost character of his Trika but have no basis in the *Mālinīvijayottara* itself. These are such features as non-dualism, that is to say, the doctrine that Śiva, his power, the world-source, and souls are the manifestations of a single dynamic essence (*[Trika]sāra*),[62] the centrality of Kaula non-dualistic practice (*advaitācāraḥ*) free of the inhibitions of convention (*niḥśaṅkācāraḥ*, *nirvikalpācāraḥ*) (*Mādhavakula*, *Sarvācāra/Sarvavīra[samāyoga]*, *Bhargaśikhā*, *Tilaka*, *Vīrāvalī*, *Niśisaṁcāra*, *Kramasadbhāva*, etc.),[63] the ideal of the translation of all

58. *TĀ* 24.4. The *Dīkṣottara* is part of the Saiddhāntika scripture *Niśvāsakārikā*.

59. *TĀ* 5. 148-151.

60. *TĀ* 18.11.

61. He may, for example, have made greater use of the *Svāyambhuvasūtrasaṁgraha*, since this appears to be the Saiddhāntika tantra with which the *Mālinīvijayottara* has most in common.

62. See *TĀ* 13.121-125. For the dualism of the *Mālinīvijayottara* see Sanderson 1992.

63. See *TĀ* 29.73c-75b, which paraphrases a passage from the *Mādhavakula* (*Jayadrathayāmala*, Ṣaṭka 4, f. 127v2-6) that distinguishes dualistic from non-dualistic practice (*advaitācāraḥ*). The *Mādhavakula* itself has much to say on the necessity of abandoning the inhibitions of dualistic observance, that is to say, observance that conforms to mundane (Vaidika) notions of the permitted and the forbidden. It clarifies what it means by non-dualistic practice and offerings by given lists of substances (*kuladravyāṇi*: onion, garlic, etc.), drinks (*kulapānāni*: urine [*śivāmbu*], beer [*surā*], blood, wine [*madyam*], melted human fat [*mahātailam*], the mingled sexual fluids [*kuṇḍagolodbhavam*], etc.), foods (*bhojanāni*: fish and various meats), and female consorts (*kulāṅganāḥ*: family members and women of untouchable castes) in the Kaula ritual; see *Jayadrathayāmala*, Ṣaṭka 4, ff. 128r2-130v3. For other of Abhinavagupta's sources on the transcendence of dualistic inhibition (*śaṅkā, grahaḥ*) see *TĀ* 12.16c-25 (*Bhargaśikhā, Sarvācāra,*

→

→ *Vīrāvalī, Niśisaṁcāra,* and *Krama*[*sadbhāva*]); *TĀ* 13.197-8 and *TĀV* ad loc. (*Niśisaṁcāra*); Sanderson 1985, pp. 211-212, n. 69 (*Kulagahvara, Niśisaṁcāra*); and *PTV* p. 266, l. 4-p. 267, l.7 (KED p. 234, l. 5-p. 236, l. 15) forcing 9c-10b (*caturdaśayutaṁ bhadre tithīsāntasamanvitam l tṛtīyaṁ brahma suśroṇi hṛdayaṁ bhairavātmanaḥ*) to refer to alcoholic liquor (*vāmāmṛtam, aliḥ*) and the five jewels or ambrosias (*ratnapañcakam, pañcāmṛtam*) of the Kaulas, that is, semen (*retaḥ, candanam*), menstrual blood (*puṣpam*), urine (*śivāmbu, dhārāmṛtam*), excrement (*viśvakṣāram, kṣāram, viśvabhasma, viśvanirgamaḥ, brahma, brahmā*), and phlegm (*nālājyam*): *catasro madhurakaṣāyatiktāmladaśā yasya madyasurāsavādes *tat **tithīsāntam**. ubhayavisargātma dravyaṁ **samanvitam** (corr. : *tat. tithīsāntam ubhayavisargātmadravyam. samanvitam* Gnoli: *tat tithīsāntam ubhayavisargātmadravyasamanvitaṁ* KED). *tadindriyadvayāntarvarti kusumaśabdavācyaṁ malam. tṛtīyaṁ brahma jagadindhanadāhaśeṣaṁ bhasma. **bhairavātma** bharitākāram āpyāyakam ambu. **hṛdayaṁ** ca *sarvendriyāntarvartirasāśyānatārūpam* (conj. : *sarvendriyāntarvati rasāśyānatobhayarūpaṁ* Gnoli, KED). *tad etāni dravyāṇi yathālābhaṁ bhedamalavilāpakāni. tathā hi dṛśyata evāyaṁ kramo yad iyaṁ saṁkocātmikā śaṅkaiva samullasantī rūḍhā phalaparyantā saṁsāra*jīrṇataror* (Gnoli's ms Ṅ : *bījataror* KED) *prathamāṅkurasūtiḥ. sā cāprabuddhān prati *sthitir* (KED : *śuddhāśuddhādīnāṁ sthitir* conj. Gnoli) *bhaved iti prabuddhaiḥ kalpitā. bālān prati ca *kalpyamāṇāpi* (conj. : *kalpyamāṇāpi ca* Gnoli, KED) *teṣāṁ rūḍhā vaicitryeṇaiva phalati. ata eva *vaicitryād* (conj. : *vaicitryakalpanād eva* Gnoli, KED) *sā bahuvidhā dharmādiśabdanirdeśyā pratiśāstraṁ pratideśaṁ cānyānyarūpā yathoktaṁ "glānir viluṇṭhikā dehe" iti. seyaṁ yadā jhaṭiti vigalitā bhavati tadā nirastapāśavayantraṇākalaṅko bhairavahṛdayānupraviṣṭo *bhavati. iti* (KED : *bhavatīti* Gnoli) *sarvathaitadabhyāse yatitavyam. śrītilakaśāstre 'yaṁ bhāvaḥ. śrībhargaśikhāyām apy uktam "vīravrataṁ cābhinanded yathāyogaṁ tathābhyased" ityādi. śrīsarvācāre 'pi "ajñānāc caṅkate mūḍhas tataḥ sṛṣṭiś ca saṁhṛtiḥ l mantrā varṇātmakāḥ sarve varṇāḥ sarve śivātmakāḥ l peyāpeyaṁ smṛtā āpo bhakṣyābhakṣyaṁ tu pārthivam l surupaṁ ca virūpaṁ ca tat sarvaṁ teja ucyate l spṛśyāspṛśyau smṛto vāyuś chidram ākāśa ucyate l naivedyaṁ ca nivedī ca naivedyaṁ *gṛhṇate ca ye* (em. Gnoli following citation in *TĀV* vol. 7, p. 106, l. 13: *gṛhyate ca yat* KED) l *sarvaṁ pañcātmakaṁ devi na tena rahitaṁ kvacit l icchāṁ utpādayed ātmā kathaṁ śaṅkā vidhīyate" iti. śrīvīrāvalīśāstre 'py ayam evābhiprāyaḥ. uktaṁ ca kramastotre "sarvārthasaṁkarṣaṇasaṁyamasya yamasya yantur jagato yamāya l vapur mahāgrāsavilāsarāgāt saṁkarṣayantīṁ praṇamāmi kālīm" iti. vyākhyātaṁ caitan mayā taṭṭīkāyām eva kramakelau vistarataḥ. ata eva ṣaḍardhaśāstreṣv eṣaiva kriyā prāyo niyantraṇārahitatvena pūjā. tatparipūraṇāyaiva sarvadravyālābhāt saṁvatsaramadhye catus trir dviḥ sakṛd vā pavitrakavidhir uktaḥ* '[The word] *tithīsāntam* [here refers to] wine, beer or similar liquors [It is described as *caturdaśa-*] since it has four conditions (*daśā*): sweet, astringent, bitter, and sour. The word *samanvitam* refers to the offering-substance (*dravyam*) that consists of the ejaculations of both [partners], the impurity known as "the flower" (*kusuma-*) in the two sexual organs. The expression "the third, Brahma" refers to the "ash" that is left from the [digestive] burning of the fuel that is the world [i.e. excrement (*viśvabhasma*)]. The term *bhairavātma* denotes the [world-]nourishing liquid, [called Bhairava because it is] all-containing (*bharitākāram*) [i.e. urine (*śivāmbu*)]. And the "heart" (*hṛdayam*) is the coagulation of the liquids found in all the sense-organs [i.e. phlegm (*śleṣmā, nālājyakam*)]. So whenever they are available [all] these substances [should be consumed] [to] dissolve the impurity that is plurality. I shall explain (*tathā hi*). We witness directly the following process. This inhibition (*śaṅkā*) is the state of the contraction [of consciousness that constitutes bondage]. Emerging and becoming established to the extent that it takes full effect it is the initial sprouting of the ancient tree of transmigration. It has been constructed (*kalpitā*) by the enlightened for [the benefit of] the unenlightened in order to provide them with a stable [social] order (*sthitir bhaved iti*). Although merely constructed it takes root and bears fruit in a variety of ways for these unenlightened persons. Precisely because of this diversity [inhibition] assumes different forms in each religion and region, being denoted by "duty" (*dharma-*) and a large number of other terms. Thus we are taught [in *Spandakārikā* 3.8a]: "The loss of joy (*glāniḥ*) [that is inhibition], which comes about when one identifies with the body, robs one [of one's essence]." Now, when this same [inhibition] is suddenly dissolved one throws off the contamination imposed by the restraints of the [religion] taught for the bound and enters the heart of Bhairava. Therefore one should strive in every way to cultivate this [dissolution]. This is the teaching of the *Tilaka*. The *Bhargaśikhā* too has told us: "He should venerate the observance of the Hero, [the follower of non-dualistic practice,] and he should practice it himself to the extent of his power." And

→

→ the *Sarvācāra* teaches: "The deluded is inhibited out of ignorance, and from that flow his births and deaths [in the cycle of transmigration]. [All] mantras are only sounds and all sounds are Śiva. [So why should one hesitate to utter those that are not Vedic?] It is ordained that all drinks permitted and forbidden are [to be seen equally as] [the element] Water, [all] foods permitted and forbidden as forms of [the element] Earth, [all visible things] whether beautiful or ugly as [forms of the element] Fire, all tangible things, whether one is or is not permitted [by the Veda] to touch them, as [the element] Air, and [every] aperture [of the body] as [the element] Ether. The food offered, the offerer, and those who receive it are all [to be seen] as those five [elements]. Nothing anywhere is other than those. The self may [therefore] generate desire [freely]. Why should it be inhibited [when it comes to performing these non-dualistic rites]?" The gist of the *Vīrāvalīśāstra* is the same. In the *Kramastotra* too we are told [with regard to Yamakālī]: "I bow to [that] Kālī who in the passion of her desire to accomplish the great resorption retracts the power (*vapuḥ*) of the tyrant Inhibition (*yamasya*) who impedes total withdrawal (*sarvārthasaṁkarṣaṇasaṁyamasya*) so diminishing man's [innate vitality] (*jagato yamāya*)." I have explained this [statement] at length in the *Kramakeli*, my commentary on that [hymn]. So it is that in the venerable teachings of the Trika the ritual is essentially this: to offer worship without the restraints [of inhibition]. Scripture instructs us to perform the ritual of the [offering of] Pavitraka [cords] four times, thrice, twice or once in the course of each year to compensate for [deficiencies in] this [worship] when not all the offering-substances are at hand.'

My interpretation of the first part of this passage as referring to the Kaula offerings known as the five jewels (*ratnapañcakam*) or ambrosias (*pañcāmṛtam*) and their identification rests upon the following passages: (1) *Kālīkulapañcaśataka* f. 61r (5.81ab) (quoted without attribution in *TĀV* vol. 11 [29], p. 16, l. 4), giving the first five of a list of twelve substances (5.81-82b) introduced by Jayaratha as "beginning with the five jewels" (*ratnapañcakādīni*): *reto harāmbu puṣpaṁ ca kṣāraṁ nālājyakaṁ tathā*; (2) *TĀV* vol. 11 [29], p. 130, ll 5-7, on the five jewels as body-products (*dehasthaś caruḥ*): *carv iti *ratnapañcakādyātmakam* (corr. : *ratnapañcādyātmakam* Cod.) *yad uktaṁ "dehasthaṁ tu caruṁ vakṣye yat surair api durlabham | śivāmbu reto raktaṁ ca nālājyaṁ viśvanirgamaḥ | ato vidhānapūrvaṁ tu dehasthaṁ grāhayec carum" iti*; (3) *Kālasaṁkarṣaṇīmata* f. 9r [4.4-5] in a list of sacramental substances (*caruḥ, carukam*): *uttamādhamamadhyañ ca palāṇḍu laśunan tathā | gṛñjanaṁ viśvakṣārañ ca harāmbu raudram eva ca | nālājyaṁ yonipuṣpañ ca mīnaṁ prākāśikaṁ carum | hālāhalam *surā* (em. following -*ṭippaṇaka* : *sura* Cod.) *śreṣṭhaṁ ṣoḍaśaite prakīrtitāḥ*; (4) *Kālasaṁkarṣaṇīmataṭippaṇaka* ad loc., f. 10v: commenting on *nālājyam*: *+ + amṛtaṁ kaṇṭhakūpe ca na tu śleṣman tu āharet*; (5) *Niśisaṁcāra* f. 7v1-3: *atyutkaṭaṁ *śivāmbuñ* (corr. : *sivammuñ* Cod.) *ca kuṇḍagolasamanvitam | alinā plāvitaṁ kṛtvā dakṣiṇāmṛtayojitam | narakaṁ pūrayitvā tu mantrajaptaṁ tu mantriṇā | *vāmāmṛtasamāyuktaṁ* (conj. : *dhārāmṛtasamāyuktaṁ* Cod.) *pibet pañcāmṛtaṁ param*; (6) *Ūrmikaulārṇava* f. 25v2-5 (3.75c-78), equating the five ambrosias (semen, phlegm, blood, *ambu* [urine], and *viśvakṣāram* [excrement]) with the five elements [ether, air, fire, water, and earth], the five Kāraṇas [(Sadā)śiva, Īśvara, Rudra, Viṣṇu, and Brahmā], and the Cakras of the Khecarīs, Gocarīs, Dikcarīs, Bhūcarīs, and Lāmāyoginīs respectively: *ādau retas tathākāśaṁ śivaṁ khecakram uttamam 76 dvitīyaṁ mārutaṁ śaktiḥ śleṣmā īśvaram ucyate | gocarīcakram evaṁ tu *tṛtīyaṁ* (corr.: *tṛtīye* Cod.) *dikcarīyakam 77 *tejo* (corr. : *teja* Cod.) *rudram iti proktaṁ raktam *agniḥ* (corr. : *agni* Cod.) *sapittakam | caturthaṁ viṣṇum ambuṁ ca sūryaṁ bhūcaricakragam 78 pañcamaṁ brahma candraṁ ca viśvakṣāraṁ kṣitiṁ tathā | lāmāyoginicakraṁ tu siddhapañcakulodbhavam*; (7) *Kubjikāmata* 25.223a: *kusumaṁ ca rajaṁ*; 25.224: *kādambarī prasannā ca parisruṁ madirā surā | vāmāmṛtam aliś caiva somapānaṁ madālasī*; 25.225ab: *dhārāmṛtaṁ śivāmbuṁ ca rati viṣṇu varuṇodbhavam*; 25.225c: *varco brahmā dvijanmā ca*; (8) *Picumata* f. 337r1: *sekaṁ śivāmbha mūtrañ ca*; (9) *JY Ṣaṭka* 4, f. 188r4-7 (*bhairavānanāvidhau bhūmikāvidhiḥ*, vv. 15-21b): *pañcaratnasudhā-sāradurdinaṁ ca pramuñcatī | suśuddhaṁ cāndram amṛtaṁ kalājālapariṣkṛtam 16 mahānandakaraṁ †citrya † pūrakam candanābhidham | tam ojam ojasāṁ sākṣāc chukram cāmṛtarūpiṇam 17 rasam atyadbhutaṁ bhūyaḥ bhūyaḥ kuṇḍalyāntarasaṁsthitam | *sarvāṅgāpūrakaṁ* (corr. : *sarvāgāpūrakaṁ* Cod.) *śubhraṁ *śivaṁ* (corr. : *śiva* Cod.) *sadasadātmakam 18 tataḥ parataraṁ bindor gālitaṁ cājyam uttamam | ghaṇṭācakra*srutaṁ* (em. : *mrutam* Cod.) *tac ca śāktaṁ syāc cakram uttamam 19 saṁhārotthaṁ caturthaṁ syāt sthūlaṁ sarvasrutaṁ mahat | taṁ śaktipiṇḍasaṁbhūtam ajarāmarapadātmakam 20 paramaṁ lavaṇaṁ nāma raktaṁ śivapadoditam |*

→

→ *sarvātmakaṁ sarvagataṁ mahāmāyāvipāṭanam* 21 *evaṁ sā pañcadhā devī galitā dravyarūpiṇī;* and (10) *JY Ṣaṭka* 4, f. 230v5-6 (*Mahālakṣmyādisiddhipaṭala*, vv. 34c-35): *brāhmaṇāṁś cālipānena kṣatriyāṁś ca śivāmbunā l vaiśyāṁś candanapānena śūdrān vai viśvabhasmanā l striyo vīrāṅgasaṁsparśād dīkṣayeta sumadhyame.*

The identity of two of the five jewels or ambrosias, semen and menstrual blood, is unproblematic since they are named uncryptically, the first in passages 1-2, 6, and 9 (*retaḥ, śukram*) and the second in 1 (*puṣpam*), 3 (*yonipuṣpam*), and 7 (*rajaḥ*). The mixture of the two, gathered after sexual intercourse, is termed *kuṇḍagolam*, as here in passage 5. This is the "flower" (*kusumam*) that Abhinavagupta identifies as consisting of the ejaculations of both sexual partners. That the remaining three should include urine and excrement is obvious enough, since all five jewels are products of the body (passage 2), and the natural surmise that of these *śivāmbu* 'the water that is Śiva' is urine is confirmed by passage 8. Abhinavagupta's interpretation of *bhairavātma* as "the water that is Bhairava" (*bhairavātma . . . ambu*) creates a synonymous expression. That excrement is intended by "the ash that is left from the burning of the fuel that is the world" found by Abhinavagupta in the term *brahma* is suggested by the fact that the digestive process that separates food into the nutrient liquid and waste was conceptualized as a process of burning in an intestinal fire (*jaṭharāgniḥ*); and it is confirmed by use of the expressions *brahma* and *viśvabhasma* in this sense in passages 6 and 10. Cf. 4's report that excrement (*varcaḥ*) is referred to as "Brahmā or the brahmin." I identify Abhinavagupta's "coagulation of the liquids found in all the sense-organs" with phlegm, because that description fits well with the last of the five jewels or ambrosias, termed *nālājyam* "the butter in the tube" in the esoteric jargon. That this is the latter's meaning follows from passage 6, in which it is identified under its ordinary name (*śleṣmā*), and from passage 9, which is surely referring to it when it speaks of the "butter (*ājyam*) that flows from the uvula (*ghaṇṭācakrasrutam*)." Passage 4 implies the same identification when, commenting esoterically on *nālājyam* it says + + *amṛtaṁ kaṇṭhakūpe ca na tu śleṣman tu āharet* 'He should consume nectar in this pit of his throat not phlegm.'

These offering substances are to be placed in a bowl of alcoholic liquor (*vāmāmṛtam*; see passage 7). Thus in passage 5: 'The mantra master should flood excrement, urine, mingled semen and menstrual blood, and phlegm with wine, fill [a chalice made from] a human skull (*narakam*) [with them] after empowering it with the mantras [of the Yāga], and then drink [this mixture of the] five nectars and *wine (conj.);' TĀ 29.10: *atra yāge ca yad dravyaṁ niṣiddhaṁ śāstrasaṁtatau l tad eva yojayed dhīmān vāmāmṛtapariplutam* 'In this worship the learned should employ precisely those substances that are outlawed in all the [Brahmanical] scriptures, flooding them first with alcoholic liquor'; and the commentary on the Old Kashmiri *Mahānayaprakāśa* p. 139, ll. 10-13, in which the worshipper is instructed to worship the deities of the Krama in a chalice filled with wine and smeared with the two jewels, probably semen and menstrual blood: *pātre . . . ratnadvayālabdhanyastaparāsavapūjitārghabharite* KED).

Wine and the jewels were also to be used in initiation, where they were known as *caruḥ/caru*, a term that in the exoteric context refers to rice, barley, and pulse boiled with butter and milk on fire taken from the Homa fire and fed to the candidates during initiation. The Trivandrum *Mahānayaprakāśa* gives "tasting the *caruḥ*" (*caruprāśanam*) as the action that bestows initiation in the Krama (2.5bcd): *caruprāśana*pūrvakam* (em. : *caruprāśanapūrvakaḥ* Ed.) l *guruṇā sampradāyasya bhājanaṁ kriyate paśuḥ* 'The guru makes a bound soul into a receptacle of the tradition by giving him the *caruḥ* to swallow'; and this is mentioned as an alternative method of initiation in the Kaula Trika in *TĀ* 29.198c-9b: *caro eva vā gurur dadyād vāmāmṛtapariplutam l niḥśaṅkaṁ grahaṇāc chaktigotro māyojjhito bhavet* 'Or the guru may simply give the [candidate] *caru* flooded with wine. If [the candidate] accepts it without inhibition he will enter the clan of the Goddess and be free of Māyā.' See Jayaratha's comment on this verse (passage 2): 'The *caru* is such as the five jewels, in accordance with the following passage of scripture: "I shall teach you the *caru* within the body that is hard to attain even for the gods: urine, semen, [menstrual] blood, phlegm, and excrement. Therefore [the guru] with due rites should give [the candidate this] *caruḥ* in the body to consume".' Similarly in passage 10, in the Krama-related 4th *Ṣaṭka* of the *Jayadrathayāmala* (on the Kashmirian provenance of *Ṣaṭka*s 2-4 see Sanderson 2005b, pp. 40-43):

→

external observance into a purely cognitive process of sudden enlightenment
(*Vīrāvalīkula*),[64] the convergence of the triads of the Trika into the goddess Kālasaṁkarṣiṇī
(*Devyāyāmala*),[65] and the accompanying superimposition of the categories of the tetradic
Krama (*Trikasadbhāva*).[66]

Since all these features, which are diagnostic of Abhinavagupta's Śaivism, are lacking
in the *Mālinīvijayottara*, one may ask why he chose to make it his base-text. Any of the
texts just mentioned would appear to have had a better claim; and the *Vīrāvalīkula* the
best claim of all, since sources recognized and quoted by Abhinavagupta place the
teaching of that Tantra at the very summit of the Trika's hierarchy of practice, and
locate the *Mālinīvijayottara* well below it as the basis of the most elementary level of the
system.[67] However, I propose that it was precisely because of this seemingly non-ultimate
character that Abhinavagupta made the *Mālinīvijayottara* the basis of his Paddhati. For
what characterizes it is not merely its lack of the higher doctrines and devotion to
Kālasaṁkarṣiṇī that constitute the core of Abhinavagupta's Trika — these can be read
in as implicit if the *Mālinīvijayottara* is the all-encompassing revelation — but also the
presence of elements which align it in the other direction with the Siddhāntatantras,
notably its system of the seven levels of conscious beings (*sapta pramātāraḥ*) and its
gradualist system of meditation (*yogaḥ*).[68] In these respects the text has a distinctly
Saiddhāntika tone; and indeed, unlike the higher, Kaula and Krama-influenced scriptures
of the Trika, it is cited by Saiddhāntika authors in the exegesis of their own scriptures.[69]

→ 'O fair-waisted one, [the guru] should initiate brāhmaṇas by giving them alcoholic liquor to drink,
 kṣatriyas by giving them urine, vaiśyas by giving them semen, śūdras by giving them excrement, and
 women by contact with the body of a male adept.'

64. See *TĀ* 4.89-91; 15.108c-109b; 29. 177-186b; 29.235; 29.271-277.

65. See *TĀ* 3.70; 15.335-8; 31.96-100. See Sanderson 1990, pp. 58-61.

66. See Sanderson 1986, pp. 197-98.

67. See *TĀ* 13.300c-302 with *TĀ* 22.40c-42b and the unattributed quotation in *TĀV* ad 13.302.

68. See *TĀV* vol. 7 (10), p. 7, l. 17-p. 8, l. 2, stating an objection to reference to this hierarchy of agents of
 consciousness in an exposition of the Trika: *nanv asmaddarśane naraśivaśaktyātmakam eva viśvam iti
 sarvatrodghoṣyate. tat katham iha siddhāntadarśanādisamucitaṁ pramātṛbhedam avalambyaitad uktam* 'Surely
 it is declared in all [sources] that it is the Individual, Śiva, and his Power that constitute the universe in
 our system. So how is it that he has made this statement, adopting the plurality of agents of
 consciousness proper to the doctrine of the Siddhānta and the like?' The *Mālinīvijoyottara* teaches its
 system of meditation on the reality-levels in 12.20-16.68. Abhinavagupta takes such gradualist
 meditation to be characteristic of the lower Tantras in *MVV* 1.195c-196b, quoted and translated above
 (p. 95).

69. See *Mṛgendravṛtti, Vidyāpāda* pp. 117 (3.31) and 123 (2.60ab); *Mṛgendravṛtti, Yogapāda* pp. 10 (17.18abc)
 and 35 (2.2-4c); *Mṛgendravṛtti, Kriyāpāda* p. 48 (7.27-29b) and 176 (11.29-32b); *Kiraṇavṛtti* on 1.22c-23b
 (1.18c-19b); and *Mataṅgapārameśvaravṛtti, Vidyāpāda* pp. 106, ll. 3-5 (1.18c-19b); and p. 109, ll. 13-14
 (2.60ab). There is also evidence that Sadyojyotis knew the text; see 1bc of his *Mokṣakārikā* on the
 Rauravasūtrasaṁgraha (← *MVUT* 1.17d-18a); 2b (← *MVUT* 1.25d); and cf. 73 with *MVUT* 1.18c-19b.
 Finally, a text quoted without attribution in his *Svāyambhuvavṛtti* (p. 73, ll. 8-9: "*yo hi yasmād guṇotkṛṣṭaḥ
 sa tasmād ūrdhvam*" *iti*) is identical with 2.60ab: *yo hi yasmād guṇotkṛṣṭaḥ sa tasmād *ūrdhvam iṣyate* (em.,
 following [i] *Mṛgendravṛtti, Vidyāpāda* p. 123, l. 14 [Kashmir and Devakoṭṭai eds.], [ii] *TĀV* vol. 5 [8], p.

 →

It appears, then, that the *Mālinīvijayottara* was the ideal matrix for an exposition of the Trika that aspired to encapsulate Tantric Śaivism as a whole, because it could be felt to subsume not only the highest texts such as the *Vīrāvalīkula*, with their transcendence of rites and grades, but also the religion of the lower levels. And this catholicity could be seen as the translation into practice of the 'higher non-dualism' (*paramādvayadṛṣṭiḥ*) which Abhinavagupta promotes as the ultimate truth, that is to say, a non-dualism which does not simply transcend dualities but includes them. In this perspective we might say that the *Vīrāvalīkula* is limited by the fact that its non-dualism is experienced negatively as the transcendence of all that flows, both reality and texts, from the ultimate consciousness it embodies, whereas the *Mālinīvijayottara* transcends this intolerance of the forms of Śaivism that are not pre-eminently cognitive, non-dualistic, and subitist, to accommodate all forms of the religion, to become, as Abhinavagupta describes the metaphysical teaching of the *Mālinīvijayottara*, the universal system that tolerates or favours all Śaiva systems.[70] He finds this view of the greater religion in the following passage of the *Mālinīvijayottara*'s 18th chapter:[71]

> *nātra śuddhir na cāśuddhir na bhakṣyādivicāraṇam |*
> *na dvaitaṁ nāpi cādvaitaṁ liṅgapūjādikaṁ na ca* ॥74॥

> *na cāpi tatparityāgo niṣparigrahatāpi vā |*
> *saparigrahatā vāpi jaṭābhasmādisaṁgrahaḥ* ॥75॥

> *tattyāgo na vratādīnāṁ carācaraṇaṁ ca yat |*
> *kṣetrādisaṁpraveśaś ca samayādiprapālanam* ॥76॥

> *parasvarūpaliṅgādi nāmagotrādikaṁ ca yat |*
> *nāsmin vidhīyate kiṁcin na cāpi pratiṣidhyate* ॥77॥

> *vihitaṁ sarvam evātra pratiṣiddham athāpi vā |*
> *kiṁ tv etad atra deveśi niyamena vidhīyate* ॥78॥

> *tattve cetaḥ sthirīkāryaṁ suprayatnena yoginā |*
> *tac ca yasya yathaiva syāt sa tathaiva samācaret* ॥79॥

79b suprayatnena Kᴇᴅ : suprasannena as quoted in *TĀ* 4.213c-219b

→ 23, l. 3, [iii] the reading of the Kashmirian MSS and most Grantha MSS at *Mataṅgapārameśvaravṛtti, Vidyāpāda* p. 109, ll. 14 : *ūrdhva iṣyate* Bhatt [*ibid.*] following two Grantha mss. : *ūrdhva ucyate* Kᴇᴅ, *TĀ* 9.310ab, *TĀV* vol. 2, p. 311, l. 9).

70. See *MVV* 1.631: *sarvānugrāhakaṁ pakṣam ālilambiṣase yadi | paramādvayadṛṣṭiṁ tat saṁśrayeḥ śaraṇaṁ mahat* 'If you wish to adopt the point of view that favours all others, you should take on the doctrine of higher non-duality, the ultimate refuge;' 1.693: *asmiṁs tu pakṣe sarveṣāṁ pravādānām api sthitiḥ | yuktā sarvaṁsahe pakṣe na kiṁcit kila duṣyati* 'In this position it is reasonable that all doctrines should have their place. In the position that tolerates all [positions] nothing is false;' 2.18cd: *parādvaitaṁ yad viśvānugrāhakaṁ* 'The higher non-duality that favours all.' Cf. *MVV* 1.133: *tataḥ pūrṇatayā sarvaṁsahabhairavadhāmani | pañcātmako 'yaṁ śāstrārthaḥ śāmbhavaḥ* 'So this fivefold Śaivism is located within the light of Bhairava, who, since he is all-encompassing, is all-accepting.'

71. *Mālinīvijayottara* 18.74-79 (quoted in *TĀ* 4.213c-219b).

In [the practice of] this [Tantra] there is neither [Veda-congruent] purity nor its absence; no concern for what may [or may not] be eaten [drunk, touched,] and so forth; neither dualistic observance nor its rejection; neither such [rituals] as *liṅga* worship nor their abandonment; neither [the rule of] owning nothing nor its opposite; neither such [features] as the wearing of matted locks and [the smearing of the body with] ashes nor their rejection. The adopting or avoidance of ascetic observances and the like, the visiting of *kṣetra*s and other [sacred sites], the observance of post-initiatory disciplines and so forth, and [distinctions between] such [features as] one's own and others' icons, insignia, [initiation-]names, [initiation-]lineages, and the like are neither enjoined nor prohibited in this [Tantra]. Everything [may be] enjoined or forbidden in [accordance with] this scripture. This alone is strictly ruled in it, O Empress of the Gods: that the meditator, striving with all his strength, should fix his awareness firmly on reality. He may adopt whatever form of practice enables him to achieve that.

In the *Tantrāloka* Abhinavagupta interprets this passage in just the spirit that I have proposed. He takes the *Mālinīvijayottara* to be propounding as its final position an enlightened Śaiva consciousness which enjoys a perfect freedom of practice by embracing and transcending all the Śaiva systems, both those that prescribe specific disciplines and, finally, a subitist Śaivism, which does not. By prescriptive Śaivism Abhinavagupta takes the *Mālinīvijayottara* to mean both the exoteric or common (*sāmānya-*) Śaivism of the Siddhāntatantras and a lower Kaula form within the Trika itself, which, though it throws off many of the externals of exoteric Śaivism, deploys its own limiting structures in their place. It follows that he took it to include by implication the various Śaiva systems between these two, that is to say, the Vāma and Dakṣiṇa (Bhairava) systems and, most importantly, the *Mālinīvijayottara*'s own non-Kaula form of Trika practice. The non-prescriptive Śaivism that Abhinavagupta takes the *Mālinīvijayottara* to have in mind, is a Trika system beyond even the Kaula level, but an essentialized, internalized reflex of that level. When these two Kaula levels, with discipline and without, are distinguished the first is termed the Kula and the second the Kaula or, less confusingly, the Mata. It is to this non-prescriptive level that the *Vīrāvalīkula* belongs. It is, then, the highest Tantra only in a penultimate sense, being transcended in the ultimate by the doctrine of the *Mālinīvijayottara*, which transcends both the uncomprising transcendence of the non-prescriptive Mata and the compromises of Śiva's consciousness represented by the various prescriptive systems from the lesser Kaula Trika to the gradualist Siddhānta. Thus, explaining the section of the passage that begins "[Here there are] neither such [rituals] as Liṅga worship nor their abandonment" he writes:

> *siddhānte liṅgapūjoktā viśvādhvamayatāvide* |
> *kulādiṣu niṣiddhāsau dehe viśvātmatāvide* ||256||
>
> *iha sarvātmake kasmāt tadvidhipratiṣedhane* |
> *niyamānupraveśena tādātmyapratipattaye* ||257||

jaṭādi kaule tyāgo'sya sukhopāyopadeśataḥ |
vratacaryā ca mantrārthatādātmyapratipattaye ||258 ||

tanniṣedhas tu mantrārthasārvātmyapratipattaye |
kṣetrapīṭhopapīṭheṣu praveśo vighnaśāntaye ||259 ||

mantrādyārādhakasyātha tallābhāyopadiśyate |
kṣetrādigamanābhāvavidhis tu svātmanas tathā ||260 ||

vaiśvarūpyeṇa pūrṇatvaṁ jñātum ity api varṇitam |
samayācārasadbhāvaḥ pālyatvenopadiśyate ||261 ||

bhedaprāṇatayā tattattyāgāt tattvaviśuddhaye |
samayādiniṣedhas tu mataśāstreṣu kathyate ||262 ||

nirmaryādaṁ svasaṁbodhaṁ saṁpūrṇaṁ buddhyatām iti |
parakīyam idaṁ rūpaṁ dhyeyam etat tu me nijam ||263 ||

śūlādi liṅgaṁ cānyasya kapālādi tu me nijam |
ādiśabdāt tapaścaryāvelātithyādi kathyate ||264 ||

nāma śaktiśivādyantam etasya mama nānyathā |
gotraṁ ca gurusaṁtāno maṭhikākulaśabditaḥ ||265 ||

śrīsaṁtatis tryambakākhyā tadardhāmardasaṁjñitā |
ittham ardhacatasro 'tra maṭhikāḥ śāṅkare krame ||266 ||

yugakrameṇa kūrmādyān mīnāntā siddhasaṁtatiḥ |
ādiśabdena ca gharaṁ pallī pīṭhopapīṭhakam ||267 ||

mudrā chummeti teṣāṁ ca vidhānaṁ svaparasthitam |
tādātmyapratipattyai hi svaṁ saṁtānaṁ samāśrayet ||268 ||

bhuñjīta pūjayec cakraṁ parasaṁtāninā na hi |
etac ca mataśāstreṣu niṣiddhaṁ khaṇḍanā yataḥ ||269 ||

akhaṇḍe 'pi pare tattve bhedenānena jāyate |
evaṁ kṣetrapraveśādi saṁtānaniyamāntataḥ ||270 ||

nāsmin vidhīyate tad dhi sākṣān naupayikaṁ śive |
na tasya ca niṣedho yan na tat tattvasya khaṇḍanam ||271 ||

viśvātmano hi nāthasya svasmin rūpe vikalpitau |
vidhir niṣedho vā śaktau na svarūpasya khaṇḍane ||272 ||

paratattvapraveśe tu yam eva nikaṭaṁ yadā |
upāyaṁ vetti sa grāhyas tadā tyājyo 'tha vā kva cit ||273 ||

na yantraṇātra kāryeti proktaṁ śrītrikaśāsane |
samatā sarvadevīnām ovallīmantravarṇayoḥ ||274 ||

āgamānāṁ gatīnāṁ ca sarvaṁ śivamayaṁ yataḥ ||275 ||

264a *śūlādi* conj. : *jvālādi* Kᴇᴅ **267a** *kūrmādyān* conj. : *kūrmādyā* Kᴇᴅ, supported

by *TĀV* ad loc. **271c** *niṣedho* corr. : *niṣodho* KED **274c** *sarvadevīnām* KED's MS *ka*, *TĀV* citing scripture ad loc. without attribution (*samatā sarvadevīnāṁ varṇānāṁ caiva sarvaśaḥ*) : *sarvadevānāṁ* KED

In the Siddhānta one is required to worship the *liṅga*, with the intention that one should come to see it as embodying the whole universe; but such [systems] as the Kaula forbid the *liṅga* cult, so that one may [progress to] realize this universality in [the microcosm of] one's own body.[72] [But] in this all-inclusive [teaching of the Trika] what reason could there be either for requiring the cult or for forbidding it?[73] [The lower Tantras prescribe the wearing of] matted locks, [ashes], and the like, so that by constantly adhering to these rules one may realize one's identity [with Śiva]. [But] the Kaula system forbids these [practices]; for it teaches a method that abjures all austerities.[74] [The non-

72. See, e.g., *MVUT* 18.2c-3b: *mṛcchailadhāturatnādibhavaṁ liṅgaṁ na pūjayet / yajed ādhyātmikaṁ liṅgaṁ Timirodghāṭana* 12.5ab: **liṅgaṁ* (corr. Vasudeva : *liṅga* Cod.) **svadehe* (corr. Vasudeva : *svedeheṣu* Cod.) *saṁpūjyaṁ*.

73. *TĀV* ad loc.: *iha punaḥ paramādvayarūpe trikadarśane tadvidhinā tanniṣedhena vā na kiṁcit prayojanam* 'But in this [system, that is to say, in the] Trika system with its higher non-duality, no purpose would be served either by enjoining or by forbidding it.' See *MVUT* 18.74d-75a: *liṅgapūjādikaṁ na ca | na cāpi tatparityāgo*.

74. Literally 'an easy method.' *TĀV* ad loc.: *kaule kuladarśane punar asya jaṭādibhasmādes tyāgo niṣedho vihita ity arthaḥ. yad uktam* "*jaṭābhasmādicihnaṁ ca dhvajaṁ kāpālikaṁ vratam | śūlaṁ khaṭvāṅgam atyugraṁ dhārayed yas tu bhūtale | na tasya saṁgamaṁ kuryāt karmaṇā manasā girā*" *iti. yato 'tra viṣayāsaṅge 'pi pārameśvarasvarūpāpatteḥ sukhenāyatnenopāyasyopadeśaḥ, yad uktam* "*pūrvair nirodhaḥ kathito vairāgyābhyāsayogataḥ | asmābhis tu nirodho'yam ayatnenopadiśyate*" 'He means that in the Kula system (*kuladarśane* ⟵ *kaule*) the prohibition (*niṣedhaḥ* ⟵ *tyāgaḥ*) of matted locks, ashes, and the rest is enjoined, as taught [in the scripture] "He should not associate in act, thought or speech with anyone who wears such insignia as matted locks and ashes, the banner, [the attributes of] the Kāpālika observance, the trident and the terrible skull-staff." For in this [system] is taught a method of realizing one's identity with Śiva easily, without effort, even while one is immersed in [the enjoyment of] the objects of the senses, as taught in [*Svabodhodayamañjarī* v. 12]: "The ancients taught cessation by means of the repeated practice of detachment. But I teach now that this cessation may come about effortlessly".'
Cf. *Kulasāra* ff. 82v-83r: *bhasmaṁ liṅgaṁ jaṭāṁ tyajya tyajya liṅgādikāṁ kriyāṁ | sadāguptena bhāvena gūḍha-*gocarasaṁsthitiḥ* (conj. : *gocasaṁsthitaḥ* Cod.); *Kulapañcāśikā* 3.17-21b (f. 4v3-5r1) collated with citations (T) (3.19 quoted by Kṣemarāja, *Śivasūtravimarśinī* ad 3.26 and *Netratantroddyota* vol. 1 p. 191; 20-21b quoted without attribution by Jayaratha on the present passage [*TĀV* vol. 3 (4), p. 287]): *yogavit kulamārgajñaḥ medhāvī *kulapūjakaḥ* (em. : *kurupūjakaḥ* Cod.) *| devī*bhaktaḥ* (em. : *bhakta* Cod.) *suguptātmā gurur ity abhidhīyate | yady api te trikāla*jñās* (em. : *jñā* Cod.) *trailokyākarṣaṇe kṣamāḥ | tathāpi saṁvṛtācārāḥ pālayanti *kulonnatim* (conj. : *kulodbhatī* Cod.) *| avyaktaliṅginaṁ dṛṣṭvā *saṁbhāṣanti* (corr. : *sambhāṣanti* Cod. : *saṁbhāṣante* T) *marīcayaḥ | liṅginaṁ nopasarpanti *atiguptā yataḥ priye* (corr. : *atiguptā yata priyet* Cod. : *atiguptatarā yataḥ* T) *| jaṭī muṇḍī śikhī *bhasmī* (Cod. : *daṇḍī* T) *mudrāpañcaka*bhūṣitaḥ* (T : *bhūṣitam* Cod.) *| vīratacaryā*samopeto* (corr. : *samopetam* Cod.) *yas tu *sevati* (corr. : *sevanti* Cod.) *maithunam | vīrapānarato devi mama *drohī* (T : *deha* Cod.) *maheśvari* (In place of 20-21b T has only two lines: *jaṭī bhasmī śikhī daṇḍī pañcamudrāvibhūṣitaḥ | pramādān maithunaṁ kṛtvā mama drohī maheśvari*) 'We call guru one who is a master of Yoga, a knower of the Kaula path, a wise worshipper of the Kula, a devotee of the Goddess, and completely concealed. Though [initiates] know the past, present, and future, though they can attract [any being] throughout the three worlds, yet they conceal their practice and so protect the status of the Kula. When the Yoginīs see one whose religious affiliation is hidden they

→

Kaula Tantras prescribe] the practice of [imitative] ascetic observance as the means of achieving identity with the [deity] denoted by [one's] mantra.[75] But [the Kaula Tantras] forbid this practice of impersonation, so that one may [progress to] realize that the [deity] denoted by the mantra is all-embodying. [The lower Tantras, both non-Kaula and Kaula, prescribe] entering holy places such as the Fields (*kṣetram*), Seats (*pīṭhaḥ*), and Secondary Seats (*upapīṭhaḥ*) as a means of overcoming obstacles [to the success of one's practice], or, in the case of an initiate engaged in mastering a particular mantra or [*vidyā*] (*mantrādyārādhakaḥ* [*sādhakaḥ*]), as the means of achieving that [mastery]. [But elsewhere, in Mata texts,] one is forbidden to visit holy places; and the purpose of this prohibition is to encourage the realization that one's self is embodied in everything and therefore all-embracing.[76] [In the same way, almost all Śaiva scriptures, both Kaula and non-Kaula] require that one adhere to various rules [once one has been initiated]. But Mata texts (*mataśāstrāṇi*) prohibit this, saying "One should realize one's own consciousness <unbounded>/<rule-free> (*nirmaryāda-*) and all-containing," intending to promote the realization of [non-dual] reality, on the basis that rules are dualistic by nature because they entail the exclusion of all kinds [of other actions]. [Likewise, both ordinary Kaula and non-Kaula Śaiva initiates] distinguish between different icons, seeing one as their own and others as alien, and between insignia, seeing such [insignia] as the trident (*śūlādi* [em.]) as those of others and those such as the

→ speak with him. They do no approach one who displays the external marks [of his religion], for they are extremely secret, O beloved. One who has sexual intercourse and enjoys the drink of [Kaula] heroes assaults me, O Goddess Maheśvarī, [if he does this] while engaged in the practice of ascetic observance, with matted locks, shaven head, [or celibate's] hairtuft, [smeared] with ashes, and adorned with the five insignia [of the Mahāvrata, namely, the necklace, earrings, bracelets, and topknot-'jewel' of human bone, and the Brahmanical thread of human hair].'

For the five insignia, i.e. the six minus ashes smeared on the body, see the following verse cited by Yāmunācārya, *Āgamaprāmāṇya*, pp. 46-47 (Y), edited here by collation with the closely related verse cited by Nirmalamaṇi as cited in *Somaśambhupaddhati* vol. 3, p. 681, n. 7 (N): *kaṇṭhikā (em. : karṇikā Y : kuṇḍikā N) kuṇḍalaṁ caiva *rucakaṁ (Y : uragaṁ N) ca *śikhāmaṇiḥ (N : śikhāmaṇiṁ Y) | bhasma (Y : keśa N) yajñopavītaṁ ca *mudrāṣaṭkaṁ pracakṣate (Y : mudrā ete mahāvratāḥ N) 'They teach that the six signs are (1) the necklace, (2) the earrings, (3) the bracelets, (4) the hair-jewel, (5) ashes, and (6) the sacred thread [made from human hair].' These six minus the ashes, are defined, but not numbered, in JY Ṣaṭka 1, f. 139r1-3, in the order earrings, bracelets, hair-jewel, sacred thread of human hair, and necklace: vīrāṇāṁ nṛpaśārdūla tantre 'smin bhairavārcite | śubhraśaṅkhe (1) prakartavye dvyaṅgule karṇike śubhe | *rucake (em. : caruke Cod.) (2) dvyaṅgule śaste turyaṅguṣṭhaḥ śikhāmaṇiḥ (3) | trivṛnnarakacotpannas tripañcasarikaḥ (4) samaḥ | kaṇṭhāj *ja(corr. : jaṅ Cod.)ghanasaṁsparśī śastaḥ pañcavato 'pi ca | suvṛttamaṇisaṁghā*ta(corr. : taḥ cod.)saṁghātaikāvalī (5) samā | dhāryā sādhakacandreṇa śeṣabhūtā tadiccha*yā (em. : gā Cod.).

75. The consecrated mantra-propitiator (*mantrārādhakaḥ*) takes on the appearance of the mantra-deity while seeking mastery over it. Thus one who propitiates Kālī dresses in women's clothing; see, e.g., *Kālīkulapañcaśataka* f. 58r (5.54abc): pūrvād ārabhya sarvās tāḥ pūjayed yoginandana | strīveṣadhārī bhūtvāsau; Ūrmikaulārṇava f. 16v4: strīveṣadhārako bhūtvā pūjākarmodyato guruḥ.

76. *TĀV* ad loc., quoting without attribution: nātaḥ kiṁcid apāsyaṁ prakṣeptavyaṁ ca nātra kiṁcid api | paripūrṇe saty ātmani kiṁ nu kṣetrādiparyaṭanaiḥ 'Nothing can be substracted from it and nothing can be added to it. Since the self is all-containing what is the point of pilgrimages to Fields and the rest?'

skull-bowl as their own.[77] And when the *Mālinīvijayottara* adds that there are yet other things that set one apart (*ādiśabdāt*) it has in mind such matters as penances, times of practice, and the lunar days [on which special worship is required, all of which are determined by the nature of the system one is following]. [And then there are initiatory names. For example, Kaulas think:] "This [person is a Saiddhāntika and so] has an initiation name that ends in -śakti, -śiva or [-gaṇa] [according to gender and caste], whereas I do not [but am identified] otherwise, [by a name chosen without reference to such distinctions]."[78] 'The clan' (*gotram*) [of which the *Mālinīvijayottara* speaks] is [a person's] teaching lineage, also known as his 'order' (*maṭhikā*) or 'descent' (*kulam*). In the Śaiva tradition there are three and a half such 'orders': the Śrīsaṃtāna, the Traiyambaka [saṃtāna], the Half-Traiyambaka[saṃtāna], and the Āmardaka[saṃtāna].[79] [In the Kaula Half-Traiyambaka order] there is

77. I have rejected KED's reading *jvālādi* 'such [insignia] as the flame' because there is no evidence that 'a flame' was ever a Śaiva insignium and because it is in any case implausible that it would have been, since the insignia in question are attributes carried by ascetics that enable those who see them to identify the tradition to which they belong.

78. Male initiates in the Siddhānta are given names ending in -śiva if they are born into one of the three regenerable caste-classes (brāhmaṇa, kṣatriya, and vaiśya) and ending in -gaṇa if they are born śūdras. All female initiates have names ending in -śakti; see *TĀV* ad loc. and *Mṛgendra, Kriyāpāda* 8.60c-61. Names in -śiva (/-śambhu) are frequently encountered, since they are given to brāhmaṇas, who dominated the authorship of texts and the positions that attracted the pious donations mentioned in inscriptions. For an example of a group of Saiddhāntikas with initiation-names in -śiva see the more than 95 images of named Śivācāryas in Dārāsuram (Hernault 1987, pp. 20-21, 31-35) from the twelfth century. The first part of the names is that of one of the deities in the retinue of Sadāśiva in the worship of the Siddhānta, i.e. the five face-Brahmas (Īśāna-, Aghora-, etc.), the six Subsidiaries (Netra-, Astra-, Śikhā-, etc.), the eight Vidyeśvaras (Sūkṣma-, Ananta-, etc.) or the four positive qualities of mind (*buddhidharmāḥ*) (Dharma-, Vairāgya-, Jñāna-, Aiśvarya-). As for the Mantrapīṭha division of the Bhairavatantras, the *Svacchandatantra*, its principal scripture, gives no information on the names to be given to those initiated into its Maṇḍala. Kṣemarāja, however, comments (*SvTU* vol. 2 [4], p. 25, ll. 1-5) that they should end in -śiva or -śakti according to gender. So the names should mark gender but not caste. But the *Kalādīkṣāpaddhati*, the Kashmirian guide to initiation based on this Tantra completed by Manodaguru in AD 1335/6 and subsequently enlarged, has regressed to the Saiddhāntika position, for it requires that śūdra men should be differentiated; see f. 77r78: *śūdraviṣaye amukagaṇaḥ* 'In the case of a śūdra [man the initiating guru should declare:] "N-gaṇa . . .".' According to the *Picumata*, the principal Yāmala- among the Bhairavatantras, men's names should end in -bhairava and women's names in -śakti (f. 171r4 . . . f. 172r1): *bhairave tu yadā puṣpaṃ patate . . . svacchandabhairavo nāma tadā tasya prajāyate | bhairavyāṃ tu yadā pātaḥ śaktibhairavasaṃjñakaḥ*; f. 172r4: *nārīṇāṃ tu yadā pātaḥ sthāneṣv eteṣu jāyate | tena gotreṇa tannāma śaktisaṃjñaṃ tadā bhavet*. In goddess-centred Bhairavatantras, such as the *JY*, all the initiated, regardless of gender, should have names ending in -śakti; see, e.g., Ṣaṭka 1, 18.82bc (f. 118v9-119r1): *puṣpapāte kṛte | sati śaktyante kalpite *nāmni* (em. : *dhāmni* Cod.). We are not told how one should be named when initiated into the non-Kaula Trika of the *Mālinīvijayottara*; but since this too is a Goddess-centred Bhairavatantra, one would expect names in -śakti. That is certainly what is prescribed in the Trika's *Tantrasadbhāva*, Paṭala 8, f. 45v4: *yasya mantrasya puṣpāṇi dṛśyante patitāni tu | tasya tatpūrvakaṃ nāma śaktyantaṃ parikalpayet*. In the Trika's Kaula system all names are gender-neutral and end in -bodhi, -prabhu, -yogin, -ānanda, -pāda, or -āvali, depending on the lineage (*ovalliḥ*); see *TĀ* 29.36abc on Saiddhāntika intiation name; also Sanderson 2005a, pp. 398-99 (n. 179).

79. For these orders see *TĀ* 36.11c-14: *tadā śrīkaṇṭhanāthājñāvaśāt siddhā avātaran 12 tryambakāmardakābhikhya-*

→

[also] the transmission of the Siddhas, one in each of the Ages, beginning with [Khagendra, the Siddha] before Kūrma (*kūrmādyāt* [em.]) and ending with Macchanda.[80] In addition there are the [six Kaula] 'hermitages' (*gharam*) and 'alms-houses' (*pallī-*), the major and minor Seats of the Goddess (*pīṭhopapīṭha-*), the hand-gestures (*mudrā*) and lineage signs (*chummā*).[81] To use these is again to distinguish between self and other. [A Kaula initiate needs to understand these matters because] he must keep to his own order in

→ *śrīnāthā advaye dvaye ǀ dvayādvaye ca nipuṇāḥ krameṇa śivaśāsane* 13 *ādyasya cānvayo jajñe dvitīyo duhitṛkramāt ǀ sa cārdhatryambakābhikhyaḥ saṁtānaḥ supratiṣṭhitaḥ* 14 *ataś cārdhacatasro 'tra maṭhikāḥ saṁtatikramāt ǀ śiṣyapraśiṣyair vistīrṇāḥ śataśākhaṁ vyavasthitaiḥ,* '[Finally the teaching was transmitted through a line of excellent human meditation masters but it was eventually lost.] Then three Siddhas took birth at the command of the Lord Śrīkaṇṭha. These were Tryambaka, Āmardaka, and Śrīnātha, and they were masters repectively of the non-dualistic, dualistic, and dualistic-cum-non-dualistic teachings of Śiva. An additional line derived from the daughter of the first. This was the well-established lineage known as the Half-Traiyambaka. Thus, through these lineages we have our three and a half orders, which have spread far and wide through pupils and pupils' pupils in countless branches.' In *TĀ* 37.60-61 our author tells us that in the Traiyambaka order his teacher was Lakṣmaṇagupta (preceded by Utpaladeva and Somānanda), in the Kaula Half-Traiyambaka Śambhunātha (preceded by Sumati), in the Āmardaka Vāmanātha, and in the Śrīsaṁtāna 'the son of Bhūtirāja.' In *TĀ* 36.15 he tells us that his *Tantrāloka* is imbued with the essence of the teaching of all of these orders.

Somānanda and Abhinavagupta tell us that the Traiyambaka was known as the Teramba in the vernacular; see *Śivadṛṣṭi* 7.121cd: *tryambakākhyā terambā deśabhāṣayā*; *ĪPVV* vol. 3, p. 402, l. 17: *traiyambakākhye lokaprasiddhyā terambādhidhāne* (corr. : *tairimbābhidhāne* KED) *gurusaṁtāne.* Cf. the Araṇipadra (Ranōd) Śaiva monastery inscription's description of four early (eighth-century) gurus of its lineage as presiding successively in Kadambaguhā, Śaṅkhamaṭhikā, Terambi, and Āmardakatīrtha respectively (*EI* 1: 40, ll. 7-14), and the Ranipur Jharial Inscription's reference to a guru Gaganaśiva originally of the Uttaraterambagṛha (*EI* 24: 32, ll. 1-2): *uttarateramvagṛhavinirggatagaganaśiva abhidhā* [. . .] *ācāryeṇa.* It seems likely that the Teramba order's connection with non-dualism and the Trika was a secondary development within an originally Saiddhāntika organization. The first Ṣaṭka of the *Jayadrathayāmala* gives a Tairambhā and Mahātairambhikā as the first two among eight orders (*maṭhikāḥ*) proper to the Śaivas of the Southern (Dakṣiṇa) Stream and an Uttaratairambhā among ten proper to those of the Northern (Vāma) Stream; see f. 187r7-8 (45.33cd): *maṭhikā cātra tairambhā mahātairambhikāparā*; f. 189r9-v1 (45.90-91b): *gambhīra*maṭhikā* (corr. : *madhikā* Cod.) . . . *tathā cottara-*tairambhā* (corr. : *tairimbhā* Cod.) *śalmalī daśamī smṛtā.* The Āmardaka Maṭha is associated with the sage Durvāsas as the origin of the Saiddhāntika lineage traced by Aghoraśivācārya in his *Gotrasaṁtati* found at the end of the *Mahotsavavidhi* pp. 419 et seq. The sage Durvāsas also figures in Somānanda's account of the Teramba lineage (*Śivadṛṣṭi* 7.108-122b). There Tryambakāditya, the first guru, is a son of Durvāsas, created mentally at the command of Śrīkaṇṭha to prevent the loss of the tradition.

80. KED's reading *kūrmādyā* is suspect because Kūrma[nātha] is not the first of the Siddhas of the Ages (*yugam*). He is the second, the first being Khagendranātha; see *TĀ* 29.29c; *Kālīkulapañcaśataka* 3.6-7: *khagendranātho vijjāmbā samāyātau kṛte yuge ǀ dvitīye kūrmanāthas tu maṅgalāmbāsamanvitaḥ ǀ tṛtīye meṣanāthas tu kāmamaṅgalayā saha ǀ caturthe mīnanāthas tu koṅkaṇāmbāsamāyutaḥ*; the commentary on the Old Kashmiri *Mahānayaprakāśa* p. 115, ll. 13-14: *śrīkhagendrakūrma*meṣa* (corr. : *śeṣa* KED) *macchandākhyayā catvāraḥ siddhā vyapadiśyante*; Arṇasiṁha, *Mahānayaprakāśa* 183c: *khagendrādyāḥ siddhavarāḥ.* Jayaratha sees the problem but resolves it by claiming that *-ādya-* 'first,' 'preceding' in *kūrmādyā* is intended to be understood twice (*tantreṇa*), i.e. as *kūrmādyādyā* 'the first of which (-*ādyā*) is he who was before Kūrma (*kūrmādya-*).' Doubting this explanation as artificial I have conjectured *kūrmādyān* '[beginning] from [the Siddha] who came before Kūrma.'

81. For these sets of six see *TĀ* 29.36-39 and the *Kulakrīḍāvatāra* quoted by Jayaratha ad loc.

order to achieve identity with [his deity]. He must never eat with a person
from an order other than his own, or worship an assembly [of Kaula initiates
and Yoginīs] which includes such people. But [all] these [common Kaula]
distinctions are rejected in [the higher Kaula] Mata texts on the grounds that
they introduce dualities into [the initiate's perception of] a reality that is
truly undivided. [The *Mālinīvijayottara* transcends this dichotomy between
the Mata texts and the rest by declaring that] none of this, from visiting holy
places to lineage restrictions, is enjoined or prohibited at this [highest level
of revelation]. It is not enjoined, because it is not in itself a guaranteed means
of access to Śiva; and it is not prohibited, because it can do nothing to diminish
that reality. For whereas the Lord is all-encompassing, injunction and
prohibition are merely differential constructions [freely manifested] within
his nature. They cannot compromise that nature itself. If one desires to
penetrate ultimate reality one has only to adopt whatever method one feels
to be most conducive in a given circumstance; and one may abandon that
method as one sees fit. There is no requirement here [that one follow a
particular system]. This has been taught in the following passage of Trika
scripture: "All goddesses, lineages (*ovallī*),[82] mantras, scriptures and methods
are equal. For all are Śiva."

Verse 3

śrīśambhunāthabhāskaracaraṇanipātaprabhāpagatasaṁkocam |
abhinavaguptahṛdambujam etad vicinuta maheśapūjanahetoḥ ॥

= *TĀ* 1.21 (T)

3b *prabhāpa* αKᴇᴅT: *prabhāva* αK₂B₁B₂JY . *saṁkocam* Gβ KᴇᴅT : *saṁkocanam*
P₂B₁B₂YJ

In order to worship Maheśvara [you have only to] examine the heart of
Abhinavagupta, this lotus whose petals were opened [forever] by the radiance
[that touched it] when he prostrated at the feet of the sun, [his guru]
Śambhunātha.[83]

82. These lineages denoted by the term *ovallī/ovalliḥ* are the six Kaula orders (Ānanda, Bodhi, Āvali,
 Prabhu, Pāda, and Yogin) taught in *TĀ* 29.32c-39. There we are told that Macchanda and his consort
 Kuṅkaṇāmbā (Koṅkaṇāmbā) had twelve sons, 'the princes' (*rājaputrāḥ*), that six of these were celibate
 (*ūrdhvaretasaḥ*) and so disqualified for the Kula, and that these six orders descended from the other six
 and their consorts. Jayaratha ad loc. glosses *ovallī* as 'stream of knowledge' (*ovallyo jñānapravāhāḥ*). The
 related term *oliḥ* is used in the same sense in the Kaula literatures of the worship of Tripurasundarī and
 Kubjikā; see, e.g., Jayaratha, *Vāmakeśvarīmatavivaraṇa* p. 14, l. 5: *olir ovalliḥ*. For the vernacular origin of
 these terms consider Hemacandra, *Deśīnāmamālā* 1.164b: *oālī asidos'olī* (autocommentary:) *oālī khaḍgadoṣaḥ
 paṅktiś ceti 'oālī* "a blemish in a sword" and "a line"'; cf. ibid. 1.151: *oggālo tathā oālo alpaṁ srotaḥ 'oggāla-
 and oāla-* "a small stream"'; cf. ibid. 1.148b: *olī kulaparivāṭī 'olī* "a family lineage"'; cf. in NIA Marāṭhī *ogaḷ*
 'streamlet'; Lahndā *ōl* 'hereditary custom;' Gujarātī *olⁱ* and Marāṭhī *oḷ* 'line'; Marāṭhī *oḷ, olī* 'streamlet,
 gutter'. For these NIA items see Turner 1966-71, s.v. *avagalati, avaghara-*, and *āvali-*.

83. The manuscripts of the *Tantrasāra* show two readings: (1) *-prabhāpagata-*, adopted in Kᴇᴅ and also seen
 in the occurrence of this same verse in the Kᴇᴅ of *TĀ*, and (2) *prabhāvagata-*. The second reading gives

→

ŚAMBHUNĀTHA

In the opening and closing verses of all his major Śaiva works Abhinavagupta acknowledges his gurus. But they are not the same gurus in each. Taking the works in the order in which they were composed we see that he acknowledges Śambhunātha, Bhūtirāja, and Lakṣmaṇagupta in the *Mālinīvijayavārttika*,[84] Maheśvara/Parameśvara in the *Parātrīśikāvivaraṇa*,[85] the first three and Maheśvara in

→ acceptable sense. We could translate: 'whose petals were opened [forever] (-*gatasaṁkocam*) by the power (-*prabhāva*-) of his falling (-*nipāta*-) at the feet (-*caraṇa*-) of the sun (-*bhāskara*-), [his guru] (Śambhunātha).' I have preferred the first reading because it adds to the force of the verse whereas the second does not, though the reference to radiance (the cause of the opening of the lotus) is not strictly necessary, as we can see from a closely parallel expression used by this author in *ĪPVV* vol. 3, p. 405, v. 2ab, where he describes himself as *nānāgurupravarapādanipātajātasaṁvitsaroruhavikāsaniveśitaśrīḥ* 'beautified by the expansion of the lotus of his awareness brought about by [his] falling at the feet of various outstanding teachers.' For there the expression of the cause of the expansion is left entirely to the power of suggestion, namely, that his teachers are being compared to the sun, which causes the petals of the day-lotus to open when its rays fall upon it.

84. *MVV* 1.2-7.

85. *PTV* p. 187 (KED p. 2), the 4th of the introductory verses: *jayaty anarghamahimā vipāśitapaśuvrajaḥ ǀ śrīmān ādyaguruḥ śambhur śrīkaṇṭhaḥ parameśvaraḥ* 'Victorious is Parameśvara, the venerable primal guru Śiva Śrīkaṇṭha [in human from], who, of incomparable greatness, has freed a multitude of bound souls from their bondage;' and p. 283 (KED p. 278), the 18th of the concluding verses: *parameśvaraḥ prapannaproddharaṇakṛpāprayuktaguruhṛdayaḥ ǀ śrīmān devaḥ śambhur mām iyati niyuktavāṁs tattve* 'Parameśvara, the venerable Lord Śiva himself employing the awareness of [that] guru in his compassionate desire to rescue his devotees, established me in this great reality [through initiation].' That this Parameśvara and Maheśvara are one and the same is made probable by the similarity in phrasing between these two verses and that in which the latter is acknowledged with Bhūtirāja in the *Tantrāloka* 1.9: *jayati gurur eka eva śrīśrīkaṇṭho bhuvi prathitaḥ ǀ tadaparamūrtir bhagavān maheśvaro bhūtirājaś ca* 'Victorious is the one guru, the glorious Śrīkaṇṭha manifest on earth, the venerable Maheśvara, his emanation, and Bhūtirāja [another].' And the following remark by Jayaratha ad loc. supports this conclusion: *maheśvara iti yaḥ śrīsaṁtatyardhatraiyambakākhyamaṭhikayor gurutayānenānyatroktaḥ parameśa iti īśa iti ca yad āha: bhaṭṭārikādibhūtyantaḥ śrīmān siddhodayakramaḥ ǀ bhaṭṭādiparameśāntaḥ śrīsantānodayakramaḥ ǀ śrīmān bhaṭṭādir īśāntaḥ paramo 'tha gurukramaḥ ǀ trikarūpas trikārthe me dhiyaṁ vardhayatāṁtarām* 'Maheśvara is the person whom he has mentioned elsewhere as his guru in the lineages (*maṭhikā* [see *TĀ* 4.265cd: *gotraṁ ca gurusaṁtāno maṭhikākulaśabditaḥ*]) of the Śrīsaṁtāna (Śrīnāthasaṁtāna) and the (Kaula-Trika) Half-Traiyambaka under the names Parameśa and Īśa: "May [my] threefold guru lineage fully expand my knowledge of the doctrine of the Trika: the glorious lineage of the venerable Siddhas from the Bhaṭṭārikā to Bhūti[rāja], the lineage of the venerable Śrīsaṁtāna from the Bhaṭṭa to Parameśa, and above them all the supreme sequence of gurus from the Bhaṭṭa to Īśa".' From *TĀ* 37.60cd we can infer that this Maheśvara who taught Abhinavagupta in the Śrīnāthasaṁtāna was the son of Bhūtirāja: *śrīnāthasaṁtatimahāmbaragharmakāntiḥ śrībhūtirājatanayaḥ svapitṛprasādaḥ* '[My] sun in the vast sky of the Śrīnāthasaṁtāna was the son of Bhūtirāja, who had received the favour [of initiation] from his father.' That this guru was an important figure in the early part of Abhinavagupta's career is confirmed by the closing verses of the latter's commentary on the *Bhagavadgītā*. There he tells us that he wrote this work while he was a pupil of the son of Bhūtirāja (*Bhagavadgītārthasaṁgraha*, p. 186, vv. 1c-2: *vipraḥ śrībhūtirājas tadanu samabhavat tasya sūnur mahātmā ǀ tenāmī sarvalokās tamasi nipatitāḥ proddhṛtā bhānuneva 2 taccaraṇakamalamadhupo bhagavadgītārthasaṁgrahaṁ vyadhād ǀ abhinavaguptaḥ saddvijaloṭakakṛtacodanāvaśataḥ* 'After him came Bhūtirāja. He had a noble son

→

the *Tantrāloka*,[86] Śambhunātha alone in the *Tantrasāra*, and Lakṣmaṇagupta alone in his philosophical commentaries on the *Īśvarapratyabhijñākārikā* of Utpaladeva and its auto-commentary (-*vivṛti*).[87]

These differences are not to be attributed to changes of allegiance over time. It is hardly probable that Abhinavagupta followed Śambhunātha in the period during which he composed the *Mālinīvijayavārttika*, dropped him in favour of Maheśvara before writing the *Parātrīśikāvivaraṇa*, returned to him before writing the *Tantrāloka* and *Tantrasāra*, and then dropped him again in favour of Lakṣmaṇagupta before writing his philosophical commentaries.[88] The differences are rather because it was our author's practice to do

→ who like the sun rescued all these people sunk in darkness. A bee at the lotuses of his feet [his pupil] Abhinavagupta has composed [this] *Bhagadvadgītārthasaṃgraha* induced by the exhortations of the brāhmaṇa Loṭaka.' That this is a very early work is apparent from its simple style, its narrow range of sources, and its author's modesty.

86. *TĀ* 1.9-11, 23, 16. Abhinavagupta also acknowledges his father Narasiṃhagupta, popularly known as Cukhala/Cukhalaka/Cukhulaka (*PTV* pp. 284-5 [KED p. 280], v. 12 [Cukhala]; *MVV* 1.5 [Cukhala]; *TĀ* 1.12 [Cukhulaka]; *TĀV* ad loc. [*cukhulaka iti lokaprasiddham asya nāmāntaram*]; 37.54 [Cukhalaka: *cukhalaketi jane prasiddhaś candrāvadātadhiṣaṇo narasiṃhaguptaḥ*]; *ĪPVV* vol. 3, p. 405, v.1 [Cukhulaka]). But it appears that he was Abhinavagupta's teacher only in the science of grammar (*vyākaraṇam*), with which he began his scholarly career before he moved on to Logic (*pramāṇaśāstram, tarkaśāstram*), Hermeneutics (*vākyaśāstram*), Poetics (*sāhityaśāstram*), and finally the study of the Śaiva scriptures; see *TĀ* 37.58a; *MVV* 1.5; *ĪPVV* vol. 3, pp. 405-6, vv. 2-5.

87. *ĪPV* vol. 1, p. 3, v. 4cd: *buddhvābhinavagupto 'haṃ śrīmallakṣmaṇaguptataḥ* '[I] having learned [the Pratyabhijñā] from the venerable Lakṣmaṇagupta'; *ĪPVV* vol. 1, p. 1, v. 2c (*śrīmallakṣmaṇa-guptadarśitapathaḥ śrīpratyabhijñāvidhau* '[I] who was guided on the path of the Pratyabhijñā by the venerable Lakṣmaṇagupta'; vol. 3, p. 406, v. 3cd: *śrīśāstrakṛdghaṭitalakṣmaṇaguptapādasatyopadarśita-śivādvayavādadṛptaḥ* 'proud master of the doctrine of Śivādvaya truly taught to me by the venerable Lakṣmaṇagupta, who was the product of [Utpaladeva], the author of [this] glorious Śāstra.'

88. That the *Parātrīśikāvivaraṇa* was written before the *Tantrāloka* is shown by *TĀ* 9.313. There Abhinavagupta says that he has explained at length his assertion that each reality-level contains all those above it in his treatise on the Anuttara (*anuttaraprakriyāyāṃ*), that is to say, in his treatise on the *Parātrīśikā*. For Anuttara in this sense see, e.g., *PTV* p. 282 (KED p. 276), 1. 26; *MVV* 1.917 (*ānuttaro yāgaḥ*); *MVV* 1.1120b (*ānuttaro nayaḥ*). The work to which he refers is his *Parātrīśikāvivaraṇa* and the passage in question is *PTV* p. 231, l. 28-p. 234, l. 13 (KED pp. 137-43). The priority of the *Parātrīśikāvivaraṇa* is also indicated by the fact that Abhinavagupta reports in that work that he writes for the benefit of his disciple Karṇa (p. 284, vv. 7-10 [KED pp. 279-80]), who, with Mandra, also requested the *Mālinīvijayavārttika* (1.11), whereas in the *Tantrāloka* he tells us (*TĀ* 37.65) that Karṇa is dead. The *Mālinīvijayavārttika* too was written before the *Tantrāloka* since the latter refers to the former's account of the Śaiva canon at 37.30 (*mayaitat srotasāṃ rūpam anuttarapadād dhruvāt | ārabhya vistareṇoktaṃ mālinīślokavārttike*). That the *Mālinīvijayavārttika* was written before the *Parātrīśikāvivaraṇa* is very strongly indicated by Abhinavagupta's statement in the latter (p. 198 [KED p.36], 1. 10) that he has already expounded at length in another work the subject of the state of absolute potential's 'non-circumscription by past and future' (*kālobhayāparicchedaḥ*). For this topic is treated at length in *Mālinīvijayavārttika*, 1.52-158 and nowhere else in his surviving works.

 That the Pratyabhijñā works were written after the exegesis of the *Mālinīvijayottara* is established by a citation from the *Tantrasāra* in *ĪPVV* vol. 2, p. 203, ll. 14-18 and by a reference to works 'such as the *Tantrāloka* and *Tantrasāra*' in *ĪPV* vol. 2, p. 214, 1.9.

homage only to the teacher or teachers who had contributed directly to his understanding of the subject-matter of the work in question. Thus just as Lakṣmaṇagupta was his sole source of instruction in the philosophical works of Utpaladeva, or the only teacher whose contribution to his understanding of them was direct or substantial enough to merit acknowledgement — he was, after all, Utpaladeva's pupil and successor in the lineage of the Traiyambaka order —, so it would seem from his special position in the *Parātrīśikāvivaraṇa* that Maheśvara was his sole teacher in the case of the *Parātrīśikā* and the Anuttara form of the Trika based upon it.[89] And if all four of the teachers mentioned here (Maheśvara, Bhūtirāja, Lakṣmaṇagupta, and Śambhunātha) are acknowledged by Abhinavagupta in the *Tantrāloka*, that is because each did indeed contribute to the work's contents, as more specific acknowledgements show in its course.

However, they did not contribute in equal measure. The least important of the four appears to have been Maheśvara. He is cited only once as the source of a particular teaching, and his accommodation in the opening verses is correspondingly unemphatic.[90]

Next in importance was probably Bhūtirāja. A guru in the lineage of the Krama that had descended from the Yoginī Maṅgalā through Jñānanetranātha, he initiated Abhinavagupta's father and Abhinavagupta himself in that system.[91] He may have

89. On the Anuttara form of the Trika, otherwise known as the Ekavīra or Parākrama, see Sanderson 1990, pp. 80-83.

90. In *TĀ* 3.90 Abhinavagupta identifies his teacher Maheśvara as the source of his explanation of the dynamics of the cycle of the Sanskrit syllabary (*mātṛkācakram*).

91. That he was a Krama master and the teacher of Abhinavagupta in this tradition is reported by an unidentified author on the lineages of the Krama quoted by Jayaratha as his contemporary (*adyatanaiḥ . . . yad uktaṁ*) (*TĀV* vol. 3 [4], p. 193, ll. 13-14): *śrībhūtirājanāmāpy ācāryaś cakrabhānuśiṣyo 'nyaḥ | abhinavaguptasya guror yasya hi kālīnaye gurutā* 'And there was another pupil of Cakrabhānu, called Bhūtirāja, who was the teacher of the teacher Abhinavagupta in the Kālī system.' There is also the evidence of a line in a verse from a lost work by Abhinavagupta quoted by Jayaratha in his comment on the opening verse of the *Tantrāloka* that acknowledges Bhūtirāja (*TĀV* vol. 1 [1] p. 29, l.3 [on *TĀ* 1.9]): *bhaṭṭārikādibhūtyantaḥ śrīmān siddhodayakramaḥ* 'the glorious lineage of the venerable Siddhas from the Bhaṭṭārikā to Bhūti[rāja].' The Bhaṭṭārikā here is surely the Yoginī Maṅgalā, the source of the Krama lineage that passed from her to Jñānanetranātha, since in the Kashmirian literature no Śaiva tradition other than the Krama is said to have originated from a woman. And in the *Tantrasāra* Abhinavagupta quotes an unidentified work by 'the venerable guru Bhūtirāja' or 'the venerable guru of Bhūtirāja' (i.e. Cakrabhānu) (*śrībhūtirājaguravaḥ*), which is evidently a work of the Krama since it gives a metaphysical semantic analysis of the name Kālī (p. 30, ll. 15-17: *kṣepāj jñānāc ca kālī kalanavaśatayātha . . . iti* 'as [my] venerable guru (or 'as the venerable guru of') Bhūtirāja has said: "Also she is [called] Kālī by virtue of [her derivation from] √*kal*, because she projects [*Dhātupāṭha* 9.68-69: kala vila kṣepe] and knows [*Dhātupāṭha* 9.322: kala gatau saṁkhyāne ca]")'; see also the quotation from Bhūtirāja on the nature of the goddess in *Mahārthamañjarīparimala* p. 122, l. 23.

From Bhūtirāja's guru Cakrabhānu the lineage goes back through Hrasvanātha (/Vāmana) and the Rājñī Keyūravatī to Jñānanetranātha, also called Śivānanda, who is said to have received the revelation from the Yoginī Maṅgalā in Uḍḍiyāna; see Arṇasiṁha, *Mahānayaprakāśa* 154-157 (edited in Sanderson 2001, p. 15, n. 14); and the commentary on 9.5 of the Old Kashmiri *Mahānayaprakāśa* (*haraśiru jina gaṅgi*

→

included Bhūtirāja's instruction in this domain among the grounds for his acknowledgement. But this is not apparent from the *Tantrāloka* itself. When Abhinavagupta acknowledges him in the course of the work it is not in Krama contexts but for teaching him the Saiddhāntika *brahmavidyā*, a text interspersed with mantras that is to be recited in the ear of the dying,[92] and a set of three Vidyā formulas for use in a radically simplified form of Kaula initiation and for recitation by initiates thereafter as

→ *avatārana* | *tā jānu maṅgala pīṭhadiśāna* | *sā mānavaughatristhānakulārana* | *bhānupāda aṣṭana śiṣyāna* 'As the Ganges descends to earth from the head of Śiva, so do all [the lineages of] the cardinal points of the Pīṭha [Uḍḍiyāna] from Maṅgalā. She was the friction-wood [that awakened the fire] of the three-staged Human Lineage [and] the venerable [Cakra]bhānu [who followed the last of these three,] was that of the eight Disciples': *śrīmaṅgalaiva pīṭhadiśām avatārapātraṁ yathā haraśiraḥ svarnadyāḥ. sā ca siddhaugharūpā *mānavaughe netrarājñīhrasvanātheti* (em. : *mānavaughanetrarājñī hrasvanātheti* KED) *trirūpasya kulasya ovalliviśeṣasyāraṇiḥ* (conj. : *trirūpasya kulāraṇiḥ kulasya ovalliviśeṣasyāraṇiḥ* KED) *trayāṇām agnīnām ivotpattisthānam. tataś ca mānavaughasyānte śiṣyaughāgranīr bhānupādaḥ aṣṭānām śiṣyānām prabhur yanmadhyād *rājñīśānyākhyā* (conj. [cf. Arṇasiṁha, *Mahānayaprakāśa* 158 on this female guru as a disciple of Cakrabhānu: *śrīmadīśānikākhyā yā pañcamudrāvibhūṣitā | akramakramasaṁtānakovidāṁ tāṁ namāmy aham*]: *rājñīśānākhyā* KED) *madantapāramparyanidānam* (corr. : *madantaṁ pāramparyanidānam* corr. KED : *sadantaṁpāramparyanidānam* KED's mss) 'It was Maṅgalā who was the source from which the [lineages of the] cardinal points of the Pīṭha [Uḍḍiyāna] descended, as the head of Śiva is [the source] of the Ganges. And she, [on her own] constituting the Siddha Lineage, was the friction-wood for the oustanding stream [of knowledge], the threefold descent consisting of [Jñāna]netra, [Keyūravatī] Rājñī, and Hrasvanātha, that constitutes the Human Lineage, as [the friction-wood] is the source of the three [Śrauta] fires. Then at the end of the Human Lineage came the venerable [Cakra]bhānu, the first of the Lineage of Disciples. He was the master of eight disciples. Among these was the Rājñī called Īśānī, the source of the lineage that ends [at present] in myself.'

The title 'Rājñī' ('queen'), which we see here attached to the names of the female gurus Keyūravatī and Īśānī, is not to be understood literally. It is more probable that it was current in Kashmir as a term for a female Śākta. The Kashmiri derivative *rōñ[u]* was used in this sense by the fourteenth-century Śaiva Yoginī Lallā (Lal Děd): *wŏth rainyā arcun sakhar | athē al-pal wakhur hěth* (Grierson and Barnett 1920, p. 32) 'Arise, O Rājñī (*rainyā*), and set out to make your worship, carrying wine, flesh and cakes in your hands.' In the second half of the eighteenth century the Kashmirian Bhāskarakaṇṭha renders the vocative *rainyā* in this verse with the Sanskrit *śāktikastri* 'O Śākta woman' (loc. cit.: *uttiṣṭha śāktikastri tvaṁ pūjayeśaṁ surādibhiḥ* 'Arise, O Śākta woman, [and] worship Śiva with wine and the rest'). In the same century Maṅgalā herself is termed Rājñī by Śivopādhyāya ad *Vijñānabhairava* 77 (p. 68, l. 13): *sarva*maṅgalā* (conj. : *maṅgala* KED) *maṅgalā rājñī bhagavatī*.

The evidence that Bhūtirāja was the initiator of Cukhulaka, the father of our author, is *ĪPVV* vol. 3, p. 405, v. 1: . . . *cukhulakaḥ śivamārganiṣṭhaḥ | śrībhūtirājavadanoditaśambhuśāstratattvāṁśuśātita-samastabhavāndhakāraḥ* '. . . Cukhuluka, devoted to the path of Śiva, the darkness of whose existence in bondage was completely dispelled by the rays of the essence of the teachings of Śiva that arose from the lips of Bhūtirāja.'

92. See *TĀ* 31.62c-91b. 31.62c-64b: *athocyate brahmavidyā sadyaḥpratyayadāyinī | śivaḥ śrībhūtirājo yām asmabhyaṁ pratyapādayat | sarveṣām eva bhūtānāṁ maraṇe samupasthite | yayā paṭhitayotkramya jīvo yāti nirañjanam* 'Next I shall tell you the *brahmavidyā* that grants immediate evidence [of its efficacity], [the *brahmavidyā*] that Śiva [incarnate as] Bhūtirāja has taught me. If it is recited when any creature dies its soul ascends [from the body through the cranial aperture] and attains the pure [state of release].' While giving the text, which comprises 12 verses in the Āryā metre exhorting the soul to rise from level to level within the body, Abhinavagupta notes its variant readings seen in the *Niḥśvāsa* and the *Mukuṭottara*, both Saiddhāntika scriptures.

a substitute for external worship.[93] Though Śākta in character, in that they invoke the Goddess,[94] nothing connects them specifically with the Krama. More probably they belong to the related tradition of the Śrīnāthasaṁtāna associated by Abhinavagupta with Bhūtirāja's son.[95]

93. *TĀ* 30.100-121b. See 30.120c-121b: *etad vidyātrayaṁ śrīmadbhūtirājo nyarūpayat | yaḥ sākṣād abhajac chrīmāñ chrīkaṇṭho mānuṣīṁ tanum* 'These three Vidyās were taught to me by the blessed Śrīkaṇṭha, who had assumed human form in our midst as the venerable Bhūtirāja.' The Kaula character of the initiation is evident in the fact that before the three Vidyās are installed in the person of the initiand one installs mantras that invoke Nāthas among whom are Śrīnātha (in first place) and Macchanda. The formation of the mantras (*TĀ* 30.103cd), i.e. HRĪṀ ŚRĪṀ + name + the honorific PĀDA, e.g., HRĪṀ ŚRĪṀ ŚRĪNĀTHAPĀDA, is Kaula, as are the names mentioned. Śrīnātha is venerated in the Kaula Krama system as the Siddha who revealed the scriptures; see *Kālīkulapañcaśataka* 2.12a: *vande śrīnāthapādābjau* 'I venerate the lotus-like feet of Śrīnātha;' 5.86c-87b: *yasmāc chrīnāthabhāṇḍāre cintāmaṇir iva sthitā | mayā tathaiva hṛdaye vidyeśī gopitā hare* 'O Śiva, I have concealed this great Vidyā in my heart in this way, because it is, as it were, the jewel that fufils all desires in the treasury of Śrīnātha;' and all the Paṭala colophons of the *Kālīkulapañcaśataka* and the *Kramasadbhāva*: . . . *śrīśrīnāthāvatārite* . . . 'in the . . . brought to the world by the venerable Śrīnātha.' In the Krama scripture *Devīdvyardhaśatikā* he is worshipped at the head of the lineage of gurus (f. 18v [226-227b]): *tatpṛṣṭhe pūjayed devi kālīṁ kālakṣayaṁkarīm | vaṭukaṁ ca gaṇādhyakṣaṁ śrīnāthaṁ śabarīṁ tathā | 227 anyāṁ ca gurupaṅktiṁ ca pūrvam eva krameṇa tu.* Macchanda (/ Matsyendranātha/Mīnātha) is venerated as the revealer of Kaulism in the current *Kali* Age in all its systems; see, e.g., *TĀ* 1.7 and commentary; *TĀ* 19.32cd; *Kālīkulapañcaśataka* 3.6-7.

94. The three Vidyās following *TĀV* ad 30.107-120b are: (1) OṀ HRĪṀ HŪṀ *siddhasādhani śabdabrahmasvarūpiṇi samastabandhanikṛntani bodhani śivasadbhāvajanani* SVĀHĀ, (2) A I ÑO YA RA LA VA A ṆA PHEṀ *mahāhāṭakeśvari kṣamasva pāpāntakārini pāpaṁ hana hana dhuna dhuna rudraśaktivaśāt* *SAḤ (conj: SAT KED), HRĪṀ *pare brahme caturvidye yogadhāriṇi ātme antarātme paramātme rudra*śakte (corr. : rudraśakti KED) rudradayite me pāpaṁ daha daha saumye sadāśive* HŪṀ PHAṬ SVĀHĀ.

95. We are told almost nothing about this order (*maṭhikā, saṁtānaḥ*) in our surviving literature, only (1) that it taught dualism-cum-non-dualism (*bhedābhedaḥ*) rather than the dualism of the [Saiddhāntika] Āmardaka order and the non-dualism of the [Trika's] Traiyambaka (Teramba) order and the Kaula Half-Traiyambaka order asociated with it (*TĀ* 36.11-13), and (2) that Abhinavagupta received instruction in it from 'the son of Bhūtirāja, who had received the favour [of initiation] from his father (*śrībhūtirājatanayaḥ svapitṛprasādaḥ*)' (*TĀ* 37.60cd). That the three Vidyās taught by Bhūtirāja should have come from the Śrīnātha order fits well with Abhinavagupta's report that his teacher in this order was Bhūtirāja's son, who had received initiation from his father. But it does not follow from it. My suggestion rests rather on the following circumstances. Firstly, the first of the Nāthas installed in the ritual of initiation in which these Vidyās are required is Śrīnātha (*TĀ* 30.102-3), which accords with the name of this order. Secondly, Abhinavagupta says when introducing this topic that he is going to explain (*kathyate*) the initiation (*dīkṣā*) which is *śrīsaṁtatyāgamoditā* . . . *hāṭakeśānapātālādhipacoditā* (*TĀ* 30.101). Now, that could mean 'which has been proclaimed in the scripture *Śrīsaṁtati*, taught by Hāṭakeśvara, the Lord of the Subterranean Paradises.' However, no such scripture is known. I prefer, therefore, to take *śrīsaṁtati-* to refer to the Śrīnātha order, i.e. 'which has been proclaimed in the scriptural tradition of the Śrīnātha order, taught by Hāṭakeśvara, the Lord of the Subterranean Paradises,' the abbreviation *śrīsaṁtatiḥ* being attested elsewhere (*TĀ* 4.266; *TĀV* ad 1.9 [see above, n. 85]).

We have seen evidence above that the Śrīnātha order followed a Śākta, Kaula tradition. As for the claim of Abhinavagupta that it professed a variety of dualism-cum-non-dualism, that is to say, the view that the divine reality is one and many according to whether it is in the state of resorption or emanation, we have no citations from that order's sources with which to test its accuracy. However, →

This leaves Lakṣmaṇagupta and Śambhunātha. As for the former, Utpaladeva's successor in the Traiyambaka order, we know that he wrote a commentary on the *Mālinīvijayottara*.[96] But it is unlikely that Abhinavagupta is acknowledging contributions to his understanding of problems in that Tantra when he mentions him in the opening verses of the *Tantrāloka*. For nowhere in the course of that work does he identify any such contribution.[97] It is much more probable that what he has in mind is his role as the teacher who expounded to him the philosophical writings of his guru Utpaladeva. Indeed in the closely related verses of acknowledgement in the *Mālinīvijayavārttika*, he makes clear, as he does not in the *Tantrāloka*, that he is doing homage to Lakṣmaṇagupta only in this capacity, as his 'teacher in the Pratyabhijñā.'[98]

In that case one may object that if it was Abhinavagupta's practice to acknowledge only those teachers who have clarified the work in hand, he ought not to have mentioned Lakṣmaṇagupta at all in these two works. But the objection is invalid, because Utpaladeva and Abhinavagupta, and no doubt Lakṣmaṇagupta between them, saw the Pratyabhijñā not as a discourse outside the Trika but as the systematic defence of philosophical principles revealed by Śiva within its scriptures. Nor is this hermeneutical focus altogether invisible in those works. It is particularly evident in the following passage of the *Īśvara-pratyabhijñākārikā* (1.5.10-14):

→ the Kashmirian Bhaṭṭa Rāmakaṇṭha (*c.* AD 950-1000) speaks of two kinds of Kaula non-dualism, one a doctrine of apparent transformation (*vivartaḥ*) and the other a doctrine of real transformation (*pariṇāmaḥ*); see *Mataṅgapārameśvaravṛtti, Vidyāpāda* p. 41, ll. 1-4, translated in Sanderson 1992, pp. 307-8, n. 91 (for 'merely transformation' there read 'merely apparent transformation'). It may be that the former represents the non-dualism of the Traiyambaka order (and the Kaula Half-Traiyambaka), the latter the dualism-cum-non-dualism (*bhedābhedavādaḥ*) ascribed to the Śrīnātha. It may well be that the Krama too saw itself as teaching some such dualism-cum-non-dualism and that this was widely seen as the characteristic of Śākta emanationist systems. In this connection consider the unattributed verse on the Krama lineage quoted by Jayaratha in *TĀV* vol. 3 (4), p. 195, ll. 5-8: *kramakulacatuṣṭayāśraya-bhedābhedopadeśato nāthaḥ* | *saptadaśaiva śiṣyān itthaṁ cakre savaṁśanirvaṁśān* 'Thus [Jñānanetra]nātha initiated exactly seventeen disciples, some of whom had successors, some not, in the dualism-cum-non-dualism that is based on the four states of embodiment in the [four] phases [of the cycle of Śakti].'

96. See *TĀV* vol. 11 (30), p. 184, ll. 12-14 (on *TĀ* 30.16a), where Jayaratha tells us that Lakṣmaṇagupta interpreted *dīptaiḥ* 'fiery' qualifying *kṣayaravalabījaiḥ* 'the seeds KṢA, YA, RA, VA, and LA' as *sarephaiḥ* 'with RA' (i.e. KṢRA, etc.). The reference is to his interpretation of *Mālinīvijayottara* 8.25c (*TĀ* 30. 16a). See also the next footnote.

97. Jayaratha claims that after stating Śambhunāthā's view of the procedure for the installation of mantras taught in *Mālinīvijayottara* 8.21-49 in *TĀ* 15.238-246 Abhinavagupta sets out Lakṣmaṇagupta's view in 15.247-252b. See *TĀV* vol. 9 (15), p. 122, l. 5: *śambhunātha iti śrīlakṣmaṇaguptamate hy anyathā nyāsavidhir ity āśayaḥ* 'His point in referring to Śambhunātha here is to convey that the procedure of installation is different in the view of Lakṣmaṇagupta;' *ibid.*, ll. 12-13 (introducing 15.247-8b): *śrīlakṣmaṇaguptaḥ punar etad anyathā vyācakhyāv ity āha* 'But Lakṣmaṇagupta has explained this differently. So [Abhinavagupta] says:' Perhaps this is correct. But Abhinavagupta makes no mention of Lakṣmaṇagupta here.

98. *MVV* 1.7 (*TĀ* 1.10), 1.8, 1.9-10 (→ *TĀ* 1.11). *MVV* 1.8bcd: . . . *pratyabhijñopadeśinaḥ* | *śrīmallakṣmaṇaguptasya guror vijayate vacaḥ* 'Supreme are the teachings of the venerable master Lakṣmaṇagupta, [my] teacher of the Pratyabhijñā. . . .'

svāminaś cātmasaṁsthasya bhāvajātasya bhāsanam |
asty eva na vinā tasmād icchāmarśaḥ pravartate ||10||

svabhāvam avabhāsasya vimarśaṁ vidur anyathā |
prakāśo 'rthoparakto'pi sphaṭikādijaḍopamaḥ ||11||

ātmāta eva caitanyaṁ citkriyācitikartṛtā- |
tātparyenoditas tena jaḍāt sa hi vilakṣaṇaḥ ||12||

citiḥ pratyavamarśātmā parā vāk svarasoditā |
svātantryam etan mukhyaṁ tad aiśvaryaṁ paramātmanaḥ ||13||

sā sphurattā mahāsattā deśakālāviśeṣiṇī |
saiṣā sāratayā proktā hṛdayaṁ parameṣṭhinaḥ ||14||

So it is indeed true that when the Lord manifests entities he is manifesting what already exists within himself. For [their becoming manifest requires that he be aware of them and desire manifestation; and] this consciousness of desire could not arise if they were not already within him. Those [who have mastered Śiva's teachings] know that the nature of any manifestation is representation (*vimarśaḥ*). If it were not, then manifestation (*prakāśaḥ*), even if it could take on the colour of an object, would be indistinguishable from insentient [entities] like crystals. This is why one's true identity (*ātmā*) has been defined as consciousness (*caitanyam*), that is to say, the act of awareness (*citikriyā*), or [rather] the state of being the agent of that act. It is this that distinguishes one from the insentient. The act of awareness is [silent, internal] representation, speech all-containing, spontaneously active. It is the true autonomy. It is the power of one's ultimate identity. It is this that is the 'tremor' [of consciousness] and the 'absolute being' which is unlimited as to place or time. It is this that is referred to as 'the Essence (*sāram*); and this is 'the Heart (*hṛdayam*)' of Parameśvara.

Up to the words "It is the power of one's ultimate identity" Utpaladeva speaks in this passage in terms which transcend association with particular Śaiva scriptures. But thereafter he demonstrates the scriptural basis of his system by indicating that the power of representation (*vimarśaḥ, citikriyā*) to which he refers is known, though under other names, in the Śaiva Tantras.[99] He does not tell us in his two commentaries exactly which

99. That Utpaladeva has the scriptures in mind when he says here that this power of representation (*vimarśaśaktiḥ*) is referred to as 'the Essence (*sāram*)' and 'the Heart (*hṛdayam*)' of Parameśvara is established by his auto-commentaries; see the *Vṛtti* ad loc. (*tatra tatrāgame* 'in various scriptures') and the *Vivṛti* ad loc., which, to judge from Abhinavagupta's *-vivṛtivimarśinī*, referred to 'scriptures and the like' (*āgamādiṣu*); see *ĪPVV* vol. 2, p. 199, ll. 4-5: *āgameṣu parameśvaraśāsaneṣu. ādigrahaṇād vedāntādau. muniprokteṣu siddhapraṇīteṣu gurunirūpiteṣu ca śāstreṣu* 'In the scriptures, i.e. in the teachings of Śiva. By "and the like" he means in the Upaniṣads and the like, [and] in treatises proclaimed by sages, authored by Siddhas or taught by teachers.' Abhinavagupta takes him to be referring beyond the scriptural literature notably to the works of Kallaṭa (*Spandakārikā*) and Somānanda (*Śivadṛṣṭi*).

scriptures he has in mind; but Abhinavagupta is no doubt true to Utpaladeva's intention when he cites the *Trikasāra* for the term 'essence' (*sāram*).[100]

For Abhinavagupta, then, the Pratyabhijñā expounds the philosophical basis of the *Mālinīvijayottara*'s teachings, so that Lakṣmaṇagupta's having trained him in that domain was sufficient reason for his acknowledgement in the *Tantrāloka* and *Mālinīvijayavārttika*, as well as in his commentaries on the Pratyabhijñā texts themselves.

So it appears through elimination that none but Śambhunātha can be said to have taught Abhinavagupta the Trika of the *Mālinīvijayottara* in the larger and more specific sense that accommodates the practical world of religion with its rituals, Yoga, and discipline; and this explains why he alone is acknowledged in the *Tantrasāra*, since that is a shorter exposition concerned with essentials and fundamentals.

Since Śambhunātha was Abhinavagupta's only teacher in the *Mālinīvijayottara* it follows that his instruction embraced both the Kaula and the non-Kaula forms of the system; and this comprehensiveness is confirmed by the range of the many acknowledgements that occur in the course of the *Tantrāloka*. Thus, when Abhinavagupta tells us that Śambhunātha was his guru in the Half-Traiyambaka, that is to say, in the order of the Kaula Trika, it must be understood that this implies that he was also a master of the non-Kaula system; and indeed he does once refer to him as a teacher in that domain.[101]

100. *IPVV* vol. 2, p. 204, ll. 17-20: *seyaṁ saptatriṁśī tattvakalā śuddhā ṣaṭtriṁśyāḥ paraṁ tattvam iti saṁbandhaḥ. iyatā sāratvaṁ nirṇītaṁ yad vitatya śrīviṣamadarśanasārasāstre nirūpitaṁ śaktilakṣaṇena* 'The syntax [of Utpaladeva's comment] is that it is this thirty-seventh, pure power of the reality-levels that is the ultimate reality-level beyond the thirty-sixth. This completes his analysis of the sense in which [the power of representation] is the 'essence,' a matter taught at length in the scripture *Trikadarśanasāra* in its definition of Power;' *ibid.*, p. 206, ll. 18-19: *anyatrāpi "yat sāram asya jagataḥ sā śaktir mālinī parā"* 'And in another source: "The essence of this universe is Mālinī, the power Parā".' The same line is quoted in *IPV* vol. 1, p. 211, ll. 7-9 as from the *Sāra* (*śrīsārasāstre*). Cf. *TĀ* 3.69c, quoted and translated above, where Abhinavagupta gives 'the essence' as one of the terms for the state of bliss. Jayaratha ad loc. says that the term is used in this sense in "such scriptures as the venerable *Sāra* (*sāram iti śrīsārabhaṭṭā-rakādyuktam*)." For Utpaladeva's term *sphurattā* 'the tremor' Abhinavagupta cites no scriptural authority. Taking it to be synonymous with *spandaḥ* he cites the *Spandakārikā* of Kallaṭa thereon (*IPVV* vol. 2, p. 199, ll. 6-11; *IPV* vol. 1, p. 209, ll. 3-11). For √*sphur* in this sense he cites Somānanda, *Śivadṛṣṭi* 1.2 (*IPVV* vol. 2, p. 299, ll. 15; *IPV* vol. 1, p. 209, ll. 4-5). He adds a line from the *Ūrmikaulārṇava*, not found in the surviving short recension of that work, which he takes to be referring to the power of representation when it speaks of "the wave of the waveless ocean of awareness" (*ūrmir eṣā vibodhābdher nistaraṅgasya kīrtitā*) (*IPVV* vol. 2, p. 199, l. 13; *TĀ* 4.184 and Jayaratha ad loc., who identifies the source [*TĀV* vol. 3 (4), p. 214, ll. 10-11]: *śrīmadūrmi*kaulādāv* [em. : *kīlāv* KED] *ūrmitvenāpi*). For *mahāsattā* 'absolute being' he cites the *Śrīrahasya* (*IPVV* vol. 2, p. 203, l. 5: *śaktiḥ . . . sattāmātrasvarūpiṇī*), an unattributed line which may or may not be scripture (*IPV* vol. 1, p. 211, l. 3: *mahāsattā mahādevī viśvajīvanam ucyate*), and the *Kakṣyāstotra* of Divākaravatsa (*IPVV* vol. 2, p. 203, ll. 8-9: *viśvasya sattā mahatīti soktā*). He does not cite a line in the surviving recension of the *Ūrmikaulārṇava* which refers to the highest power as both *sphurattā* and *mahāsattā*, exactly as in this line of Utpaladeva's (f. 14v4 [2.102ab]): *sā* *sphurattā* (corr. : *sphuraṁtā* Cod.) *mahāsattā khecarīṇāṁ susiddhidā*.

101. *TĀ* 6.88c-89b: *śrītraiyambakasaṁtānavitatāmbarabhāskaraḥ | dinarātrikramaṁ me śrīśambhur itthaṁ apaprathat* 'This procedure of day and night was revealed to me by Śambhu[nātha], who shines like the sun in the vast sky of the venerable Traiyambaka order.'

It was also to Śambhunātha that he attributed his enlightenment, as the present verse of the *Tantrasāra* makes clear. This special debt to Śambhunātha is more explicitly stated in the *Mālinīvijayavārttika* and *Tantrāloka*. In the first he writes (1.2-4):

> *yadīyabodhakiraṇair ullasadbhiḥ samantataḥ ǀ*
> *vikāsihṛdayāmbhojā vayaṁ sa jayatād guruḥ ǁ2 ǁ*
>
> *sābhimarśaṣaḍardhārthapañcasrotaḥsamujjvalān ǀ*
> *yaḥ prādān mahyam arthaughān daurgatyadalanavratān ǁ3 ǁ*
>
> *śrīmatsumatisaṁśuddhaḥ sadbhaktajanadakṣiṇaḥ ǀ*
> *śambhunāthaḥ prasanno me bhūyād vākpuṣpatoṣitaḥ ǁ4 ǁ*

' **2a** *saṁśuddhaḥ* em. : *saṁśuddha* KED

Glory to that master the rays of whose enlightenment shining forth in all directions have opened wide the lotus of my heart. May Śambhunātha be favourable to me, gratified by [this offering] of flowers in the form of words; for purified by the venerable Sumati and ever generous to the devotees of Śiva[102] he has transmitted to me a multitude of teachings directed to the destruction of [my] unliberated existence, teachings that shine [with the radiance of] the Trika and the five streams [of the lower Tantras], full of the awareness [that animates those scriptures].

And in the opening verses of the second he writes (1.13):

> *jayatāj jagaduddhṛtikṣamo 'sau bhagavatyā saha śambhunātha ekaḥ ǀ*
> *yadudīritaśāsanāṁśubhir me prakaṭo 'yaṁ gahano 'pi śāstramārgaḥ ǁ*

Glory to the unique Śambhunātha who with [his consort] Bhagavatī has the power to rescue the whole world [from its bondage]; for the rays of his instruction have illuminated this path of the scriptures for me, deeply hidden though it is.[103]

And, after following this verse with a statement of the need for a Paddhati to guide practice in the Trika, he adds (1.16):

> *śrībhaṭṭanāthacaraṇābjayugāt tathā śrībhaṭṭārikāṅghriyugalād gurusaṁtatir yā ǀ*
> *bodhānyapāśaviṣaṇut tadupāsanotthabodhojjvalo 'bhinavagupta idaṁ karoti ǁ*

102. Literally 'true devotees' (*sadbhakta-*). True devotees are those of Śiva, just as true gurus (*sadguruḥ*) are those consecrated in Śaivism, true scriptures (*sadāgamaḥ*) are those revealed by Śiva, and true reasoning (*sattarkaḥ*) is reasoning that proceeds within the limits established by those scriptures. See, e.g., *TĀ* 4.33-043b and Jayaratha ad loc.

103. According to Jayaratha ad loc. Bhagavatī was the name of Śambhunātha's *dūtī*, that is to say, the female partner consecrated for the performance of Kaula worship and the sexual intercourse it entails. Without such a partner, he explains, one cannot be qualified for Kaula practice (*TĀV* vol. 1 [1], p. 32, ll. 1-3): *kulaprakriyāyāṁ hi dūtīm antareṇa kvacid api karmaṇi nādhikāra iti* 'For in the Kaula system one is unqualified for any rite if one has no *dūtī.*' Cf. *JY Ṣaṭka* 4, f. 123r7 (*Kālikākulapūjānirṇayapaṭala*, v. 2ab): *sarvvato dūti karttavyā dūtihīno na siddhibhāk* 'It is altogether necessary to have a Dūtī. One without a Dūtī will not succeed.' This is quoted without attribution by Jayaratha ad *TĀ* 29.96, with corrected Sanskrit in the first Pāda: *kartavyā sarvato dūtir.*

Abhinavagupta fashions this [work] ablaze with the enlightenment that arose
[in him] through serving the order of teachers that annuls the poison of the
bondage of unawareness, the order [transmitted to him] from the lotus-feet
of the master [Śambhunātha] and his consort.[104]

Of Śambhunātha's life we know very little. But what we do know cautions us against
the assumption that the Śaivism expounded in these works was a specially Kashmirian
affair. For a verse quoted by Jayaratha from an unknown text by Abhinavagupta
associates Śambhunātha with Jālandhara, a centre of Śākta devotion in Kangra in the
northern Panjab,[105] and tells us that Sumatinātha, the guru of Śambhunātha,[106] was a

104. Here I follow Jayaratha ad loc. (*TĀV* vol. 1 [1], p. 34, ll. 15-16). However, it is possible that by
 Bhaṭṭanātha and Bhaṭṭārikā, the Lord and Lady, Abhinavagupta means the couple from which the
 Kaula lineage of the Trika was believed to have originated [in the Present Age (*kaliyugam*)], i.e.
 Macchandanātha and Koṅkaṇāmbā; see *TĀ* 1.7; 29.32cd. Macchandanātha's role as the Siddha of this
 age is attested in *TĀ* 4.267ab and in *TĀV* 1 (1), p. 24, l. 12, where introducing 1.7, in which Abhinavagupta
 prays for the favour of Macchanda, Jayaratha calls him the promulgator of the Kula and the 'Lord of
 the Fourth' (*tadavatārakaṁ turyanātham*). The 'fourth' here is evidently the fourth Age, the *kaliyugam*.

105. Lat. 32° 5' 14" N., long. 76° 14' 46" E, in Kangra town (in the Kangra District), formerly capital of the
 Katoch State; see Hunter 1886, vol. 7, pp. 429-30. For this and the many other Śākta sites in its
 pilgrimage orbit see the *Jālandharapīṭhadīpikā* of Prahlādānandācārya Kulāvadhūta. Pandey (1963: 12)
 wrongly asserts concerning Abhinavagupta: "There is, however, no doubt that he went to Jālandhara
 and learned Kaulika literature and practices from Śambhunātha." The statement from which he
 draws this unwarranted conclusion is only that Śambhunātha became well known from that Pīṭha
 (*TĀV* vol. 1 [1], p. 236, l. 9: *prasiddhim agamaj jālandharāt pīṭhataḥ*).

106. Here I disagree with Jayaratha. In *TĀV* vol. 1 (1), p. 235, l. 15-p. 236, l.2, he claims, following the
 opinion of unnamed 'experts in the lines of transmission' (*āyātikramavidaḥ*), that Sumatinātha was
 succeeded by one Somadeva and that it was the latter rather than Sumatinātha himself that taught
 Abhinavagupta's guru Śambhunātha: *sumatyantevāsina iti śrīsomadevādayaḥ. śrīsumatināthasya
 śrīsomadevaḥ śiṣyaḥ tasya śrīśambhunātha iti hy āyātikramavidaḥ* 'The "pupils of Sumati" [mentioned in
 1.213d] are Somadeva and others. For those who know the lines of transmission say that the pupil of
 Sumatinātha was Somadeva and that Śambhunātha was the pupil of the latter.' As internal evidence
 for this intermediary Jayaratha proceeds to cite *TĀ* 37.61: *śrīsomataḥ sakalavit kila śambhunāthaḥ*, where
 Abhinavagupta does indeed appear to refer to Śambhunātha as 'omniscient from [or after] Soma.'
 Soma, of course, could well be a *bhīmavat* abbreviation for Somadeva. Therefore, he argues, the places
 in which Abhinavagupta refers to Sumati as Śambhunātha's teacher (*TĀ* 5.41; *TĀ* 10.287; and a verse
 from an unknown work quoted in *TĀV* vol. 1 [1], p. 236, ll. 6-9) must be construed to be referring to
 him as his teacher's teacher (*paramagurvabhiprāyeṇa*), or, alternatively, as his teacher without reference
 to a particular position in the lineage, in accordance with the principle of *TĀ* 10.287 that one's whole
 lineage is to be seen non-dualistically as a single teacher (*TĀV* vol. 1 [1], p. 236, ll. 10-12). But it is
 altogether incredible that Abhinavagupta should have referred to his guru as the pupil of Sumatinātha
 in either of these senses. Jayaratha's or rather his source's conclusion that he did so rests solely on this
 one reference to Soma in *TĀ* 37.61. He offers no other evidence and would surely have done so if it
 had existed. I propose that the evidence of this single passage is illusory, the reference to Soma having
 arisen through a simple scribal error, in which the ablative *śrīsomataḥ* 'from the venerable Soma'
 entered in place of a nominative *śrīsaumataḥ*, qualifying *śambhunāthaḥ* in the meaning 'the venerable
 (*śrī*) pupil of Sumati (-*saumataḥ*)'. The reading *śrīsomataḥ* that produced the intermediary Soma[deva]
 is in any case syntactically awkward. In its place I propose a reading that is natural, that supposes a
 very minor error on the part of a scribe, post-consonantal *o* and *au* being commonly confused in both

 →

resident of 'the seat (*pīṭham*) of the Deccan',[107] by which he probably means Pūrṇagiri[108] or Kaulagiri (Kolhāpur).[109] That the Kaula Trika was prevalent in the Deccan at this time is confirmed by the Jain author of the prose romance *Yaśastilaka*. Written in Mysore around the middle of the tenth century and therefore probably during the life of Sumatinātha, it refers to the Kaula Trika more than once.[110] There is also the evidence of the *Ūrmikaulārṇava* in its 700 verse redaction. This work teaches a form of Krama Kaulism and was known, in another recension, to Abhinavagupta. It claims that as soon as it had

→ script and pronunciation, and that is consistent with the three other references to Śambhunātha as Sumati's successor.

107. *TĀV* vol. 1 (1), p. 236, ll. 7-10: *kaścid dakṣiṇabhūmipīṭhavasatiḥ śrīmān vibhur bhairavaḥ pañcasrotasi sātimārgavibhave śāstre vidhātā ca yaḥ | loke 'bhūt sumatis tataḥ samudabhūt tasyaiva śiṣyāgraṇīḥ śrīmāñ chambhur iti prasiddhim agamaj jālandharāt pīṭhataḥ* '[Incarnate] among men was the extraordinary (*kaścit*) [guru] Sumati, a glorious and all-powerful Bhairava who dwelt in [the sacred site that is] the seat [of the goddess] in the Deccan (*dakṣiṇabhūmipīṭhavasatiḥ*), an author of works (*vidhātā*) on Śaivism (*śāstre*) in its five streams and the glorious Kula (*sātimārgavibhave*). He was succeeded by his principal disciple, the glorious Śambhu[nātha], who achieved renown through [the power of the sacred site that is] the seat [of the goddess in] Jālandhara.'

108. The Kaulas speak of three seats (*pīṭhaḥ*) of the Goddess, namely, Uḍḍiyāna (in the Swat valley), Kāmarūpa (in Assam) and Pūrṇagiri, or, more commonly, four, namely, those and Jālandhara in Kangra. For the three see the *Niśisaṃcāra* paraphrased in *TĀ* 15.84-85 and quoted by Jayaratha ad loc. (*TĀV* vol. 9 [15], p. 48, ll. 4-9). For the more common set of four, with the addition of a fifth, the Mātaṅga Pīṭha, in the post-Trika system of the *Kulālikāmnāya* see the unattributed verse quoted in *Mahārthamañjarīparimala* p. 98, ll. 1-2 and Schoterman 1982, pp. 53-60 on *Ṣaṭsāhasrasaṃhitā* 1.36-49. There Pūrṇagiri is referred to by the name Sahya, i.e. the Sahyādri or Western Ghats. That Pūrṇagiri was in the Deccan is also indicated by the *Manthānabhairavatantra, Kumārīkhaṇḍa* f. 19r3-: *atha tṛtīyakaṃ vakṣye yathā bhavati tac chṛṇu | *kva cid* (corr. : kva ci Cod.) deśaṃ tathā ramyaṃ deśānām uttamaṃ nidhiḥ | diśādakṣiṇadigbhāge dakṣiṇāpathamaṇḍalaṃ | . . . bhairavās tatra pañcāśat pūrṇṇagiryāṃ samāgatāḥ.*

109. Lat. 16° 41' N., long. 74° 17' E. The identity of Kaulagiri, also called variously Kulādri, Kolagiri, Kollagiri, Kullagiri, Kolāgiri, and Kollāgiri, with Kolhāpur (Kolāpura, Kolāpurā) is indicated by the fact that the 700-verse *Ūrmikaulārṇava* refers to it as the abode of Mahālakṣmī (f. 27r4-5): *pīṭhāntaraṃ priye | kaulagiryabhidhānaṃ tu mahālakṣmīniketanam.* For the famous Mahālakṣmī temple of Kolhāpur see, e.g., Yazdani 1960, pp. 441-42 (Kollāpura-Mahālakṣmī). Indeed local tradition has it that Kolhāpur has grown up around the temple. In Kaula texts the site of Mahālakṣmī is generally -giri, as here. Thus in accounts of the eight Śākta *kṣetras* (Prayāga, Vārāṇasi, Kollagiri, Aṭṭahāsa, Jayantī, Caritra, Ekāmra, and Devīkoṭṭa (see, e.g., *Niśisaṃcāra* 4.10a: *kolāgiryā mahālakṣmī;* and *Kubjikāmata* 22.25c: *kolāgirye mahālakṣmīṃ*). But variants in which -pura or -purī takes the place of -giri do appear from time to time. Thus, in accounts of the same eight sites, see *Guhyasiddhi* f. 7v2: *kolāpuryāṃ;* and the Paddhati *Kālikākulakramārcana* f. 20v7-21r1: -*kollāpura-*. Kollāpura in the latter has been substituted for the form Kullagiri that appears in the *Mādhavakula* (*JY Ṣaṭka* 4, f. 124r1: *aṭṭahāsaṃ śikhāsthāne caritraṃ ca karandhrake | kullagiryā priye *karṇe* [corr. : karṇṇaṃ Cod.] *jayantyā* [corr. : jayaṃtya Cod.] cottarāyaṇe*), which the Paddhati reports that it is following here, and is Sanskritized as Kaulagiri in Abhinavagupta's version of the passage in *TĀ* 29.59-64 (59: *aṭṭahāsaṃ śikhāsthāne caritram ca karandhrake | śrutyoḥ kaulagiriṃ nāsārandhrayoś ca jayantikām*).

110. Somadeva, *Yaśastilaka*, pt. 1, p. 43, ll. 4-5: *sakalajanasādhāraṇe 'pi svadehe trikamatadīkṣitasyeva devabhūyenābhiniviśamānasya;* and pt. 2, p. 269, l. 14: *sarveṣu peyāpeyabhakṣyābhakṣyādiṣu niḥśaṅkacittād vṛttād iti kulācāryaḥ. tathā ca trikamatoktiḥ madirāmadameduravadanastarasarasaprapannahṛdayaḥ savyapārśvaniveśitaśaktiḥ śaktimudrāsanadharaḥ svayam umāmaheśvarāyamāṇaḥ kṛṣṇayā sarvāṇīśvaram ārādhayed iti.* The work was completed in AD 959 near Dharwar; see Handiqui 1949, pp. 3-4.

been revealed by Śrīnātha in Kāmarūpa it was carried by Siddhas to Kaulagiri, "the home of Mahālakṣmī," namely, Kolhāpur in Karṇāṭaka.[111]

Given the fervour of Abhinavagupta's acknowledgements of his indebtedness to Śambhunātha we are bound to ask to what extent his exposition of the *Mālinīvijayottara* is or is not original. The original is hard to establish: what appears so may have been drawn unacknowledged from sources now lost; and what is actually original may well have disguised itself in a system whose authority rests on the claim that its teachers merely clarify what the scriptures have already revealed. What we can do with certainty is to demonstrate that certain teachings are definitely not original, because Abhinavagupta himself has attributed them to Śambhunātha. These debts are numerous and in many cases fundamental to the character of his system. Here it must suffice to say that they include what is perhaps the most striking feature of Abhinavagupta's Trika, namely, the grounding of the three goddesses Parā, Parāparā, and Aparā in Kālasaṁkarṣiṇī and the widespread incorporation of allied Krama doctrine, notably that of the cycle of the twelve Kālīs who are the very core and signature of that Śākta system.[112] As for what may be original, it is noteworthy that he does not acknowledge Śambhunātha for the crucial interpretation of the passage of the eighteenth chapter of the *Mālinīvijayottara* quoted above, in which he finds the basis for the view that the Trika rises to an all-accommodating universality beyond its Kaula Mata levels. This doctrine

111. *Ūrmikaulārṇava* f. 26v8-27r5: *mahākaulārṇavoddhṛtam ǀ ūrmikaulārṇavaṁ guhyaṁ lakṣapādaṁ mahādbhutam ǀ nāmnā śrībhogahastākhyaṁ guhyakauleti gīyate ǀ *tasmād* (corr. *tasmā* Cod.) *dvādaśasāhasraṁ kaularājaṁ samuddharet ǀ pūrvaṣaṭka*dvayād* (corr. : *dvayā* Cod.) *devi ūrmikaulamahārṇavāt ǀ *saṁkṣepād* (corr. : *saṁkṣepā* Cod.) *uddhṛtaṁ devi idaṁ śāstrottamottamam ǀ sārdhatrīṇi sahasrāṇi mukhakauleti viśrutam ǀ tasmāt *sāraṁ* (corr. : *sāra* Cod.) *samuddhṛtya *guhyaṁ* (corr. : *guhya* Cod.) *saptaśatābhidham ǀ idaṁ rahasyaṁ paramaṁ khecarīvaktragocaram ǀ mahākṣetre kāmarūpe śrīnāthena prakāśitam ǀ saṁsthitaṁ tatra deveśi yoginīguhyaśāsanaṁ ǀ anyaṣaṭkadvayād bhadre mahākaulārṇavābhidham ǀ kula*madhyād* (corr. : *madhyā* Cod.) *daśaśataṁ bhogahastārṇaveti ca ǀ *tasmād* (corr. *tasmā* Cod.) *dvādaśasāhasrāt sāram etad udāhṛtam ǀ vyākhyātamātraṁ khecarair nītaṁ pīṭhāntaraṁ priye ǀ kaulagiryabhidhānaṁ tu mahālakṣmīniketanam* 'Extracted from the *Mahākaulārṇava* the secret *Ūrmikaulārṇava*, in a quarter of a lakh of verses [25,000, for 24,000], most wonderful, is called the *Bhogahasta* or the *Guhyakaula*. From that was extracted the *Kaularāja* in 12,000. From [these] first two six thousands of the *Ūrmikaulārṇava* this supreme teaching was extracted by abridgement, O Goddess, in 3,500 [verses], and known as the *Mukhakaula*. Śrīnātha extracted this 700 [redaction] from that as its concealed essence, the supreme secret within the oral tradition of the Yoginīs, and revealed it in Kāmarūpa. There, O Empress of the gods, this secret teaching of the Yoginīs remained. From the other two six thousands, known as the *Mahākaulārṇava*, O Virtuous one, the *Bhogahastārṇava* in 1000 [verses] was distilled. As soon as [the text of 700 verses] had been explained it was taken by Siddhas, O beloved, to another Seat, to the abode of Mahālakṣmī called Kaulagiri.' That it was the 700 rather than the 1000 that is to be understood as having been taken to Kaulagiri is evident from the chapter colophons, which refer to the work as follows: . . . *śrīmadūrmikaulārṇave mahāśāstre lakṣapādoddhṛte paramarahasye śrībhogahastakramāmnāye śrīkaulagiripīṭhavinirgate śrīmīnanāthāvatārite ṣaṭsatādhikaśate kulakaulanirṇaye*. . . . 'In the great scripture *Ūrmikaulārṇava* extracted from the 25,000, in the supremely secret *Bhogahasta* Krama system, in the 700 [verse redaction of that work] that came forth from the Kaulagiri Seat and was revealed by Mīnanātha, in the *Kulakaulanirṇaya* . . .'

112. See *TĀ* 5.41; 15.351c-352b; 29.95; 33.32cd.

may well have been elaborated by Abhinavagupta himself, along with its correlation with higher non-dualism in the metaphysical domain — a position which he bases on this same passage —, and the correlation of that non-dualism with the nature of the fourth goddess.

THE MEANING OF THE VERSE: DOING AND KNOWING

The heart of which Abhinavagupta speaks in this third verse is the all-encompassing consciousness invoked in his opening verse. He proclaims that he was that same consciousness contracted in the mode of unenlightened duality until Śambhunātha bestowed the initiation that culminated in his enlightenment. He now invites his readers to behold and scrutinize this state; and by using the demonstrative pronoun *etat* ('this') he indicates that it can be seen and scrutinized. It is perceptible in two senses. Firstly, it is embodied in the teaching set before his audience in this work — Abhinavagupta's state of enlightenment is his immersion in ultimate reality; that reality is the subject of the *Mālinīvijayottara*; and this *Tantrasāra* serves to reveal its meaning. Secondly, it is already eternally and everywhere present to all as the ground and substance of their consciousness. Through this double meaning he encompasses all three of the highest means of self-realization, namely, the study of revealed truth (*āgamaḥ*), reasoning in support of that truth (*yuktiḥ, sattarkaḥ*), and direct intuition (*svānubhavaḥ*), either the third alone or the third nurtured by the first and second.

But if liberation is a matter of self-knowledge what of the rituals of worship and other prescribed actions that are the greater part of salvific religion for the majority of Śaivas? He alludes to his position on this crucial matter when he says at the close of the verse that the purpose of gaining knowledge of ultimate reality is precisely to accomplish this duty of worship (*maheśapūjanahetoḥ*). By this he means two things: firstly that the worship required of initiates works only because it is a form of knowing, a contemplation of reality supported by encoding in symbolic action; and secondly, and more radically, that ritual actions are dispensable for those who can sustain that knowledge without their support, this self-knowing rather than its outer forms being the essence of the worship of a Maheśvara who is indeed none other than one's own innermost identity. This preeminence of knowledge over ritual sets the Trika's soteriology in stark opposition to that of the Saiddhāntika Śaiva tradition then dominant in Kashmir.[113] Having alluded to it at the end of the preliminary verses he proceeds in the preface that follows to expound it systematically as the theoretical basis of his entire exposition.

113. For the terms of the opposition between the Trika and the Siddhānta over the roles of knowledge and ritual action in the Śaiva's attainment of liberation see Sanderson 1995.

Appendix

Jayaratha's Interpretation of the First Verse

The exact meaning of the first verse is not yielded without effort. For Abhinavagupta has chosen to open his work with a conundrum based on paronomasia, the use of words in more than one sense (*śleṣaḥ*). To grasp the whole statement intended by the author one must read two meanings in some part of a verse; or read the whole verse in more than one meaning, so that one form of words is to be resolved into two or more disconnected whole statements. Such paranomasia, which is common in Sanskrit poetry, is usually penetrated without much difficulty with the help of the context and the conventions that restrict the field of expression. But here Abhinavagupta has chosen his vocabulary and phrasing in such a way that it is not easy to decide whether the paronomasia is pervasive or partial. Nor is it easy to determine which meanings are intended in which reading.

In the interpretation which I propose in my translation, the paronomasia is not pervasive — there is therefore only one statement — and it is deployed in the poetic figure *samāsoktiḥ* or 'concise expression.' There two meanings, one explicit and the other implicit, are conveyed by some or all of the terms that qualify the subject (in this case 'my heart . . . embodying the bliss of the ultimate'). Of the two the explicit meaning is the principal subject-matter (*prākaraṇika-*), and the implicit meaning the tangential (*aprākaraṇika-*).[114] I have marked the beginning and end of the two meanings by enclosing them between braces, put the explicit meaning before the implicit, marked the boundary between them with an oblique stroke, and set out the principal subject-matter in the roman and the subordinate in italic type.

Jayaratha, however, when he encounters this same verse at the beginning of the *Tantrāloka*, interprets it not as a single statement in which the paronomasia is limited to a part, but as three independent statements expressed concurrently by means of double paronomasia throughout the verse. The first and second express the view of the ultimate reality according to the Trika and Krama respectively. The third refers to Abhinavagupta's conception in the Kaula union of his parents. The three meanings he proposes, with his principal explanatory glosses within square brackets and explanatory insertions of my own in parentheses within them are as follows. I have added after each his summary of its point.

> Meaning 1 (Trika): May my heart (*mama hṛdayaṁ*) [the reality of the self (*ātmanas tathyaṁ vastu*)] expand (*vikasatāt* [← -*sphuratāt*]) fully (*samyak*[← *saṁ*]), embodying (*kulaṁ śarīraṁ yasya* [← *kulaṁ*]) the highest (*anuttara-*)

114. See *Alaṁkārasarvasva, Sūtra* 32; *Kāvyaprakāśa* 10.11ab.

and deathless (-*amṛta-*) [Amā, (the inexhaustible 'seventeenth lunar phase' [*saptadaśī kalā*], the power that nourishes the universe) (*amākhyakalāsvarūpaṁ*)], comprising the emission (-*visargamayaṁ*) [whose nature is the urge (of consciousness) to manifest itself externally (*bahirullilasiṣāsvabhāvaḥ*), spontaneously] manifested [*svata evollasitasattākaḥ* (← -*sphuritabhāva-*)] from the fusion (*saṁghaṭṭaḥ* [← -*yāmala-*]) of these two (*tadubhaya-*): the 'mother' (*jananī*), [the power of pure autonomy (*śuddhasvātantryaśaktirūpā*)] whose nature (*svarūpaṁ* [← -*āśrayā*]) is unlimited (*vigatā malā avacchedakā yasyāḥ* [← *vimala-*]) action (*kalā*), [the state of agency that is one with absolute representation (*paravimarśaikasvabhāvakartṛtālakṣaṇā*)], whose [all-encompassing] effulgence (*mahaḥ pāripūrṇa*lakṣaṇas* [em. : *lakṣaṇaṁ* KED] *tejaḥsphāro yasyāḥ* [← -*mahā*]) is in [the pure universe (*śuddhādhvamārge*) that constitutes] the primal (*ādyāyām* [← -*abhinava-*]) creation (-*sṛṣṭi-*), and the 'father' (*janakaḥ*), his nature (*svabhāvaḥ* [← -*tanuḥ*]) all-containing (*pāripūrṇyena pūritā* [← *bharita-*]), maintaining (*paripūritā prabandhenānuvartamānā* [← -*gupta-*]) his desire (*abhilāṣaḥ* [← -*ruciḥ*]) [to perform the five cosmic functions (*pañcakṛtyaviṣayaḥ*)] by grace of his five (*pañca-*) powers (*śaktibhiḥ* [← -*mukha-*]) [of consciousness, bliss, desire, cognition, and action (*cidānandecchājñānakriyātmabhiḥ*)].[115]

Summary: 'Thus in order to destroy the multitude of hinderers he has referred in this [meaning] to the Nameless, the 'ultimate triad' (*paraṁ trikam*) that is the fusion of Śiva and his Power, which because its nature is the flow of emission, is the seed of the world's diversity.'[116]

Meaning 2 (Krama): May there shine forth for me (*mama saṁsphuratāt* em. : *saṁsphuratāt* KED), [may I realize my identity with (*tādātmyenaikaḥ syām ity arthaḥ*),] the heart (*hṛdayam*) [that is the radiance of Kālasaṁkarṣiṇī pulsating in intimation of the whole cycle of powers from Sṛṣṭikālī onwards (*śrīsṛṣṭikālyādyakhilaśakticakrāsūtraṇena prasphuradrūpaṁ śrīkāla*saṁkarṣiṇīdhāma* [corr. : *saṁkarṣaṇīdhāma* KED])], the ultimate (*anuttara-*), [since emanation, stasis, and resorption are dissolved in it (*sṛṣṭyādīnāṁ atraiva layāt*)], the liquid ambrosia (-*amṛta-*) [that is the ecstatic relish of one's own identity (*svātmacamatkāraparamārthaṁ*)], the Nameless (*anākhyarūpaṁ* [← -*kulaṁ*]), that is one with (-*mayaṁ*) the diverse emanation (*vividhaḥ sargaḥ* [← -*visarga-*] [that constitutes the stasis (*sthityātmā*)] manifested (-*sphuritabhāva-*) from the mingling (*lolībhāvaḥ* [← -*yāmala-*], *tataḥ*) of the two [(flows of) emission and withdrawal (*tat . . . sṛṣṭisaṁhārātmakam ubhayam, tasya* [← -*tadubhaya-*], that is, from the mingling] of the 'mother' (*jananī*), [so called because she gives birth to the universe (*janayati viśvam iti*), that is to say, the Nameless Goddess Awareness (*anākhyaiva bhagavatī saṁvit*), Śiva's highest power that is the source of the

115.　Extracted from *TĀV* vol. 1 (1), p. 4, l. 1-p, 7, l.10.

116.　*TĀV* vol.1 (1), p. 7, ll. 11-13: *tad evam atra visargaprasarasvabhāvatvena jagadvaicitryabījabhūtaṁ śivaśaktisaṁ-ghaṭṭātmakaparatrikaśabdavācyam anākhyātmakaṁ vighnaughapradhvaṁsāya parāmṛṣṭam.* Jayaratha's source for the term 'ultimate triad' (*paraṁ trikam*) in this sense, i.e. the fusion of Śiva and his power, is *MVV* 1.15-20, a passage on the 'heart' of consciousness which very probably informed Abhinavagupta's composition of this verse, and certainly clarifies it.

cycles beginning with emission (*parā parameśvarī sṛṣṭyādicakrādyā*)], grounded in (*ālambanaṁ gatir yasyāḥ* [← *-āśraya*]) the pure (*vimala-*) phase (*-kalā-*) [that is the first (*ādibhūtā*) of the phases of the moon of consciousness (*cāndramasī*), and therefore full of the perfect nectar that nourishes the universe (*sakalajagadāpyāyakāriparāmṛtamayīty arthaḥ*)], the splendour (*mahas tejaḥ* [← *-mahā*]) [of her automony (*svātantryalakṣaṇam*) engaged in the ever-new (*abhinava-*), [ever-radiant (*sadā dyotamānāyāṁ*)] creation (*-sṛṣṭi-*) [that is her extroversion (*bahīrūpatāyāṁ*)], and the 'father' (*janakaḥ*), [the ultimate conscious subject corresponding to this state (*abhirūpaḥ paraḥ pramātā*)], who guards (*guptā . . pirarakṣitā* [← *-gupta-*] his radiance (← *-ruciḥ*) [by means of introversion (*svāvaṣṭambhabalena*), (maintained) by drawing in the various objects of awareness (*tattadviṣayāharaṇena*)] through the pathways (*mukhaiḥ . . . dvāraiḥ* [← *-mukha-*]) of the five (*pañcānāṁ* [← *-pañca-*]) [flow powers: Vāmeśvarī, (Khecarī, Dikcarī, Gocarī,) and (Bhūcarī) (*vāmeśvyādivāhaśaktīnāṁ*), that is to say, through the operations of sight and the other faculties of perception (*cakṣurādīndriyavṛttirūpaiḥ*)].[117]

Summary: 'In this [reading] the author refers to the supreme, nameless consciousness of Parameśvara, which manifests itself as the three sequences of emission (*sṛṣṭiḥ*), [stasis (*sthitiḥ*),] and [withdrawal (*saṁhāraḥ*)], yet is ever radiant beyond them, incorporating both [this] succession and the non-successsive [reality which pervades it].'[118]

Meaning 3 (Abhinavagupta's origin in Kaula union): May my heart (*mama hṛdayaṁ* [em. : *hṛdayaṁ* KED]), [the reality that is the rising of my inner vitality (*nijabalasamudbhūtilakṣaṇaṁ tattvaṁ*)] fully (*samyak* [← *-saṁ*]) expand (*vikasatāt* [← *-sphuratāt*]) [by penetrating the experience and understanding of all (*sarvasya . . . prakhyopākhyārohena*)]. Its source (*ākaro* [em. : *ākāro* KED] *yasya* [← *-kulaṁ*]) is the two highest (*utkṛṣṭe* [← *-anuttara-*]) Nectars (*-amṛta*), the Essences (*sāre*) [superior because their being contemplated in various ways, for example, as two deities, one white and the other red, differentiates them from the semen and (menstrual) blood of the uninitiated (*śvetāruṇātmadevatāmayatādyanusaṁdhānena paśuśukraśoṇitavailakṣaṇyād*)]; for it originated in (*prakṛtir yasya* [← *-mayam*]) the ejaculation (*kṣepaḥ* [← *-visarga-*]), [the outflow of the two bodily substances together termed Kuṇḍagola (*kuṇḍagolākhyadravyaviśeṣaniḥṣyandaḥ*), brought about] by (*tena*) the ecstasy (*sollāsaḥ . . . bhāvaḥ* [← *-sphuritabhāva-*]) of sexual union (experienced) in the Prior Worship (*ādyayāgādhirūḍhaṁ mithunaṁ, tasya* [← *-yāmala-*]) of (my) two (*tadubhayaṁ, tasya* [← *-tadubhaya-*]) [parents (*mātāpitṛlakṣaṇam*)],[119] (my) mother (*jananī*) [Vimalā (*vimalābhidhānā*)] 'whose base is the syllables *vi-ma-lā*' (*vimaletivarṇakalā āśraya ālambanaṁ yasyāḥ sā* [← *-vimalakalāśraya*]), for

117. Extracted from *TĀV* vol. 1 (1), p. 8, l. 7. 11, l. 10.

118. *TĀV* vol. 1 (1), p. 11, ll. 10-14: *atra granthakṛtā sṛṣṭyādikramatrayarūpatām avabhāsayanty api tadativartanena parisphurantī kramākramavapuḥ paraivānākhyā parameśvarī saṁvit parāmṛṣṭā.*

119. The term 'Prior Worship' (*ādiyāgaḥ, ādyayāgaḥ*) denotes the Kaula ritual of sexual union; see *TĀ* 29. 164; *JY Ṣaṭka* 4, f. 203v2-206r7 (*Ādyayāgavidhikramārthapūjāpaṭalaḥ*).

whom Abhinavagupta's (*abhinavaguptasya* [← -*abhinava*-]) birth (*janma* [← -*sṛṣṭi*-]) was the occasion of great rejoicing (*maha utsavo yasyāḥ* [← -*mahā*]), and my father (*janakaḥ*), famed far and wide (*dīptiḥ, sarvatra prathā, yasya* [← -*ruciḥ*]) [under the name (*saṃjñayā*)] [Narasiṃhagupta (-*pañcamukhagupta*-)], [both] replete (← *bharitatanuḥ*) [with their immersion in the state of identification with Śiva and Śakti].[120]

Summary: 'Here, because [he tells us that] he is the product of such a union, that is to say, of the union of parents who were essentially a Siddha and a Yoginī, the author claims that he himself is a receptacle of the non-dual knowledge that is the ultimate goal. This is in accordance with what he has said [in *Tantrāloka* 29.162c-163b]: "Anyone whose body has been formed from the bud of such a mingling, is termed 'born of a Yoginī' (*yoginībhūḥ*). He is automatically the receptacle of knowledge, [automatically] a Rudra." And in this way he conveys his fitness to compose a work which is a summary of the fundamentals of all the Trika's scriptures.'[121]

I follow Jayaratha in seeing the verse as referring not only to ultimate reality but also to the author's parentage and conception. For reasons set out above its character as a propitious benediction (*āśīrvādaḥ*) guarantees that the principal meaning is an invocation of that reality embodied in the fusion of Bhairava and the goddess; but the reader is prompted to look for a second meaning by the attenuation and abnormality of some of the qualifiers in this sense. The starting point from which he would begin to unravel this hidden meaning is, I propose, the word *janakaḥ* 'father.' While the goddess is not uncommonly addressed as the 'mother' (*jananī*, etc.) in this literature, Bhairava or Śiva is never addressed as 'the father' (*janakaḥ*, etc.). The meaning can be accommodated only by accepting an unconventional, metaphorical usage of the term. One looks, then, to see whether *janakaḥ* and *jananī* may not also be intended in their familiar sense of 'father' and 'mother' through paranomasia, and one's suspicion once alerted finds confirmation by discovering the names of both parents and their offspring buried in periphrasis and abbreviation: *vimalakalāśrayā* 'based in the phonemes *vi, ma,* and *la*' or 'based on [i.e. named after] the pure (*vimala*-) phase (-*kalā*)' for Vimalā, the author's mother, *pañcamukhagupta*- (Siṃhagupta) for Narasiṃhagupta, his father, and *abhinava*- for Abhinavagupta. The remaining second meanings then impose themselves as translated.

Apart from the fact that I co-ordinate this meaning with the principal I differ from Jayaratha here only in taking the expression *anuttarāmṛtakulam* as part of the section of the verse that is free of paranomasia, meaning 'the fusion of the ultimate and [its] nectar.' Jayaratha, as we have seen, also takes it in reference to Abhinavagupta's conception, in the meaning 'whose source is the two highest nectars.' I differ on this for two reasons. In the first place I take the verse as a single statement. In this interpretation the Sanskrit

120. Extracted from *TĀV* vol. 1 (1), p. 12, l. 2-p. 14, l. 11.

121. For the Sanskrit see above, n. 33.

reads well poetically only if the part with paranomasia and that without it are self-contained. In the order of my English translation, *anuttarāmṛtakulam* could be taken in two meanings without the two parts interlocking. One could simply move the first brace back to the point between 'May my heart shine forth' and 'embodying the bliss of the ultimate' and add the second meaning in the parallel position after the oblique stroke. But in the Sanskrit the words translated 'May my heart shine forth embodying the bliss of the ultimate' come not at the beginning of the verse but as the last of its four lines, and in an order of words which begins with the subject ('heart' [*hṛdayam*]) and ends with the verb ('may [it] shine forth' [*saṁsphuratāt*]), with the attribute in question and the possessive pronoun ('my' [*mama*]) between the two (*hṛdayam anuttarāmṛtakulaṁ mama saṁsphuratāt*). Consequently, if *anuttarāmṛtakulam* had two meanings the part with only one would be split in two by an additional element of paranomasia in the final line. If *anuttarāmṛtakulam* is not taken in more than one sense, as I propose, we have an aesthetically satisfactory and common pattern, in which a verse builds itself up to be resolved only at its end and at all once with the disclosure of the subject and verb. If we accept Jayaratha's view that *anuttarāmṛtakulam* has this additional meaning, so that paranomasia re-emerges after the subject (*hṛdayam*) has been disclosed, then the verse will shudder to a halt rather than glide smoothly to fulfilment. But there is a further reason for rejecting Jayaratha's interpretation. For if, as he claims, *anuttarāmṛtakulam* also refers to the semen and menstrual blood of Abhinavagupta's parents, the author will have clumsily repeated himself; for these two substances are none other than the 'emissions' (*visargaḥ*) mentioned earlier in the verse.

Once Jayaratha had decided that Abhinavagupta intended his verse to be read not as one statement but as several, he was bound to work out parallel meanings throughout. That he was mistaken in doing so is revealed by the awkwardness of the meaning he has assigned to *anuttarāmṛtakulam* in his third reading; but it is even more evident from the arbitrariness of the interpretations that provide two metaphysical readings, one in the language of the Trika and another in that of the Krama. I see only the first. One is pointed in the direction of the reference to the author's origin in Kaula worship by the terms 'mother' and 'father'; but there is nothing of this kind in the metaphysical reading to lead one from the principal doctrinal basis of the text to the Krama, no terms which are more at home in the latter and have to undergo interpretation to fit the former. The only basis I can see for the second meaning is the inclination of the exegete, Jayaratha or a predecessor, to read it in. The verse opens a work that weaves the Krama into the heart of the Trika. Since it encapsulates the teaching that is to follow, why should it not refer both to the Trika and the Krama? There is no reason why it should not and good reason why it might. All that is lacking is internal evidence that it did. And if this meaning is present even though it is not signalled, may there not be yet other meanings which can be read in the verse by a determined commentator? Jayaratha tells us that other possible readings had indeed been proposed, but that he has passed over them in silence for two

reasons. In the first place he fears their explanation would overburden his text. In the second he maintains that they do not contribute to the principal subject-matter.[122]

In other words the justification for his Krama reading is that it is possible and relevant, whereas these are possible but irrelevant or not directly relevant. This style of exegesis governed by possibility rather than probability is more appropriate to the texts of scripture, which as divine revelation are not thought to be tied to the semantic limits that restrain human beings when they attempt to convey their meaning to others in ordinary or poetic utterances. Whereas human statements are assumed to be unitary, however complex, a scriptural passage may be treated without apology as conveying simultaneously as many meanings as are possible within the limits set by the exegete's beliefs and the generous disciplines of traditional text-analysis.[123] In this regard one may bear in mind the enormous prestige of the *Tantrāloka* and the divine status that came to be attributed to its author.[124]

122. *TĀV* vol. 1 (1), p. 15 ll. 3-5: *atra ca saṁbhavanty api vyākhyāntarāṇi na kṛtāni granthagauravabhayāt prakṛtānupayogāc ca* 'Though yet other readings of this [verse] are possible they have not been given, for fear of overburdening the text, and because they do not serve the subject-matter [that is the immediate concern of this chapter].'

123. Perhaps the most striking example of this is the exegesis of the *Parātrīśikā* in Abhinavagupta's *PTV* (especially p. 193, l. 1-p. 197, l. 7 [KED pp. 19-32], giving sixteen semantic analyses of the word *anuttaram*, and p. 262, l. 16-p. 269, l. 11 (KED pp. 223-42), giving nine interpretations of v. 9 and sixteen meanings to the words *tṛtīyaṁ brahma* in that verse). By the disciplines of text-analysis I mean grammatical analysis (*vyutpattiḥ*) and semantic analysis (*nirvacanam*). Both provide the exegete with considerable room for manoeuvre. He need show only that the meaning he attributes to a sentence does not infringe the rules of grammar. It is not necessary to consider how far the expression of that meaning through those words conforms to normal usage, word-order and the like. It is enough that the meaning is not grammatically impossible. Semantic analysis is even more flexible. It enables an exegete to insert the meaning he seeks by deriving a word artificially from the meanings of verbal roots that resemble the sounds or syllables that compose it (*akṣaravarṇasāmānyāt*); see Kahrs 1998, p. 37, quoting Yāska: *akṣaravarṇasāmānyān nirbrūyāt* 'One may analyse on the basis of similarities of syllables or sounds.' Abhinavagupta echoes these words in *PTV* p. 268, l. 23-24 (KED p. 241): *tathā ca vedavyākaraṇe pārameśvareṣu *ca śāstreṣu* (conj. : *śāśtreṣu* Gnoli, KED) *mantradīkṣādiśabdeṣv akṣaravarṇasāmyān nirvacanam upapannam* 'In the explanation of the Veda and in [explaining] such words as *mantraḥ* and *dīkṣā* in the Śaiva scriptures it is proper to analyse meaning on the basis of similarity of sounds or syllables.'

124. See, e.g., *Īśvarapratyabhijñāvimarśinīvyākhyā* f. 1r1-6 (transcribed by the editor in *Bhāskarī*, vol. 2, p. 568): *iha viśvānujighṛkṣayā paramaśiva eva sakalabhūmaṇḍalottare śrīmacchārādādivyakrīḍāsane śrīkāśmīradeśe śrīnarasiṁhaguptasahadharmacāriṇyāṁ śrīmatyāṁ vimalāyāṁ līlayāvatīrya śrīmadabhinavaguptanātha iti prasiddhanāmadheyo* 'Out of his desire to favour mankind Paramaśiva himself freely descended into this [world taking birth] through Vimalā, the pious wife of Narasiṁhagupta, in the land of Kashmir, the celestial pleasure-seat of Śāradā, the blessed Goddess [of learning], the best [place] on the whole disc of the earth, [and was] known by the name Abhinavagupta;' and Madhurāja of Madurai, *Gurunāthaparāmarśa* 6cd: *jānvāsaktaika*hastasphuṭa*(em. : *hastaḥ sphuṭa* KED)*paramaśivajñānamudrākṣasūtro vāmaśrīpāṇipadmasphuritanakhamukhair vādayan nādavīṇām ǀ śrīkaṇṭheśāvatāraḥ paramakaruṇayā prāptakaśmīradeśaḥ ǀ śrīmān naḥ pātu sākṣād abhinavavapuṣā dakṣiṇāmūrtidevaḥ* 'May the glorious incarnation of Lord Śrīkaṇṭha, the divine Dakṣiṇāmūrti, who out of his supreme compassion came to the land of Kashmir in the form of Abhinavagupta, protect us, with one hand on his knee showing the

→

I hold, then, that Abhinavagupta, intended only one metaphysical reading, and that this, when embellished with the secondary, tangential reference to his origin, constitutes the whole meaning of the verse.[125]

Abbreviations

BORI	Bhandarkar Oriental Research Institute
CII	*Corpus Inscriptionum Indicarum*
conj.	My conjectural emendation
corr.	My correction
EI	*Epigraphia Indica*
em.	My emendation
IFI	Institut français d'Indologie
ĪPV	*Īśvarapratyabhijñāvimarśinī*
ĪPVV	*Īśvarapratyabhijñāvivṛtivimarśinī*
JY	*Jayadrathayāmala*
K_{ED}	The reading of the edition of the KSTS
KSTS	Kashmir Series of Texts and Studies
MVUT	*Mālinīvijayottara*

→ gesture of Śiva's supreme knowledge and [holding] a rosary, and playing the Nādavīṇā lute with the bright tips of the nails of his lotus-like venerable left hand.' This verse was taken by Pandey (1963: 21-22) as a "pen-picture" of Abhinavagupta. In fact, it presents him artificially, imposing the south-Indian iconography of the four-armed Dakṣiṇāmūrti Śiva in his musical aspect (*geyamūrtiḥ*), in which he shows the gesture of knowledge or exposition (*vyākhyānamudrā*), holds the Vīṇā and a rosary, and commonly has a hand resting upon his knee. He is seated surrounded by sages whom he is instructing, just as Abhinavagupta is described seated in the midst of all his pupils in v. 5ab of this composition (*āsīnaḥ kṣemarājaprabhṛtibhir akhilaiḥ sevitaḥ śiṣyavargaiḥ*). For the iconography of Dakṣiṇāmūrti, Śiva as the bestower of knowledge, see *Kāmikāgama* 2.51.1-9, 10-14, 21-25, 30-40, cited by Bhatt ad *Rauravāgama, Kriyāpāda* 35.287-292; *Dīptāgama* p. 688, ll. 8-13 (17.153c-156b) (also cited by Bhatt ad *Ajitāgama, Kriyāpāda* 36.254-255); *Kāraṇāgama* 2.174b-178, 187-190a, 193b-194a cited *ibid.*

That the *Īśvarapratyabhijñāvimarśinīvyākhyā* is south-Indian is strongly suggested by its citing sources that though rooted in the traditions of Kashmirian Śaiva non-dualism (1) were not known in Kashmir before modern times, (2) have been transmitted only in south-Indian manuscripts, and (3) have received commentaries only from and been cited only by authors who are south-Indian or who, like Bhāskararāya, had assimilated south-Indian traditions. A case in point is the *Parātriṁśikālaghuvṛtti* (cited in that work on p. 4, ll. 3-4; and p. 5, l. 6 and 17-18). This is attributed to Abhinavagupta by its colophon, and that attribution has been accepted without question by modern scholars. But there are good reasons to conclude that the attribution is spurious. In addition to the three criteria for doubt just stated it (4) shows a redaction of the *Parātrīśikā* (/*Parātriṁśikā*) that deviates from that adopted by Abhinavagupta in the *Parātrīśikāvivaraṇa*, a much longer commentary on this text that is certainly his, (5) deviates from the views and approach of that commentary, and (6) lacks the hallmarks of Abhinavagupta's style and, in my estimation, his intellectual brilliance.

125. I thank my pupil Isabelle Ratié, agrégée de philosophie, of the 5th Section (Sciences Religieuses) of the École Pratique des Hautes Études (Paris), for urging me to publish this after reading it in the form, revised and expanded here, in which I wrote it in 1995, also for commenting on my view of the poetics of the first verse, and for helping me to check the proofs.

MVV	*Mālinīvijayavārttika*
NAK	National Archives of Nepal, Kathmandu
NGMPP	Nepal-German Manuscript Preservation Project
PTV	*Parātrīśikāvivaraṇa*
SvT	*Svacchandatantra*
SvTU	*Svacchandatantroddyota*
TĀ	*Tantrāloka*
TĀV	*Tantrālokaviveka*

References

PRIMARY SOURCES: MANUSCRIPTS AND EDITIONS

Āgamaprāmāṇya of Yāmunācārya, ed. Rama Mishra Shastri. Reprint from *The Paṇḍit*, Benares, 1937.

Ajitāgama, ed. N.R. Bhatt. 3 vols. Publications de l'IFI No. 24. Pondicherry: IFI, 1964, 1967, 1991.

Alaṁkārasarvasva of Rājanaka Ruyyaka and Maṅkha with the commentary (*-vimarśinī*) of Rājānaka Jayaratha. See Dwivedī 1979.

Bhagadvadgītārthasaṁgraha of Abhinavagupta, ed. Rājānaka Lakṣmaṇa [Lakshman Raina]. Srinagar: Kashmir Pratap Steam Press, 1933.

Bhāskarī: Īśvarapratyabhijñāvimarśinī of Abhinavagupta with the commentary (*Bhāskarī*) of Bhāskarakaṇṭha. 2 vols., ed. K.R. Subrahmania Iyer and K.C. Pandey (vol. 1) and M.M. Narayana Shastri Khiste (Vol. 2). Allahabad: Superintendent, Printing and Stationery, United Provinces, 1938 and 1950.

Bhāvaprakāśa of Bhāvamiśra, ed. with a Hindī commentary (*Sarvāṅgasundarī*) by Lālacandraji Vaidya. 2 pts. 3rd. impression. Delhi: Motilal Banarsidass, 1968 and 1970.

Chummāsaṁketaprakāśa of Niṣkriyānandanātha. Berlin, Staatsbibliothek, Janert MS. 3771 (D. 112, Ka 387) (*Triṁśaccarcārahasya*). Paper; Śāradā. Also known as *Chummāsampradāyaprakāśa*.

The text comprises 105 aphorisms (*chummāḥ, chummāpadāni, saṁketapadāni*: from *liṅgu abhijñānu* to *ḍitto naṭṭo*) in a Sanskritized Old Kashmiri, with a verse frame-story and commentary in Sanskrit, interspersed with thirty verses in Old Kashmiri giving thirty 'oral instructions' (*kathāḥ, carcāḥ*), each labelled in Sanskrit (from the *pustakakathā* to the *gītikathā*).

Deśīnāmamālā of Hemacandra. See Pischel 1880.

Devīdvyardhaśatikā. NAK MS 1-242. NGMPP Reel No. A 161.12 Paper; Newari script.

Dhvanyāloka of Ānandavardhana with the commentaries (*-locana* and *-bālapriyā*) of Abhinavagupta and Rāmaśāraka, ed. Pattabhirama Shastri, Kashi Sanskrit Series 135. Benares: Jaya Krishna Das Hari Das Gupta, 1940.

Dīkṣottara. Institut français de Pondichéry MS. T. 17 (*Niśvāsakārikā*, pp. 795-1152). Paper transcript in Devanāgarī.

Dīptāgama. Institut français de Pondichéry MS. T. 507, pp. 533-1051. Paper transcript in Devanāgarī.

Guhyasiddhi. NAK MS No. 1163 NGMPP Reel No. A 150/39. Paper; Newari script.

Gurunāthaparāmarśa of Madhurāja, ed. P.N. Pushp. KSTS 85. Srinagar, 1960.

Īśvarapratyabhijñākārikā of Utpaladeva. See Torella 1994.

Īśvarapratyabhijñāvimarśinī of Abhinavagupta, ed. Mukund Ram Shastri, 2 vols. KSTS 22, 33. Bombay, 1918, 1921.

Īśvarapratyabhijñāvimarśinīvyākhyā (anonymous). Trivandrum MS 270 (*'Īśvarapratyabhijñāvyākhyāvyākhyā'*). Paper; Devanāgarī transcript.

Īśvarapratyabhijñāvivṛtivimarśinī of Abhinavagupta, ed. Madhusudan Kaul Shastri, 3 vols. KSTS 60, 62, 65. Bombay, 1938, 1941, 1943.

Jālandharapīṭhadīpikā of Prahlādānandācārya Kulāvadhūta. See Shastri 1983.

Janmamaraṇavicāra of Bhaṭṭa Vāmadeva, ed. Mukund Ram Shastri. KSTS 19, Bombay, 2018.

Jayadrathayāmala, Ṣaṭka 1. NAK MS 5-4650 NGMPP Reel B 122/7. Paper; Newari script.

Jayadrathayāmala, Ṣaṭka 4. NAK MS 1-1468. NGMPP Reel B 122/4. Paper; Newari script.

Kalādīkṣāvidhi of Manodaguru. BORI MS 157 of 1886-92, Paper; Śāradā.

Kālasaṃkarṣaṇīmata and *ṭippaṇaka*. Oxford, Bodleian Library MS Sansk. d. 39 (R). Palm-leaf; Newari script; AD 1391.

Kālikākulakramārcana of Vimalaprabodha. NAK MS 5-5188. NGMPP Reel No. A 148/10. Paper; Newari script.

Kālīkulapañcaśataka. NAK MS 5-358. NGMPP Reel No. B 30/26. Palm-leaf; Newari script.

Kāvyādarśa of Daṇḍin, ed. Rangacharya Raddi Shastri. 2nd edn. Poona: BORI, 1970.

Kāvyaprakāśa of Mammaṭa with the commentary of Śrīdhara, ed. Sivaprasad Bhattacharya. 2 vols. Calcutta Sanskrit College Research Series 7, 15. Calcutta, 1959, 1961.

Kiraṇavṛtti. See Goodall 1998.

Kubjikāmata: *The Kubjikāmatatantra. Kulālikāmnāya Version*, ed. T. Goudriaan and J.A. Schoterman. Leiden: Brill, 1988.

Kulapañcāśikā. NAK MS 1-1076. NGMPP Reel No. A 40/13. Palm-leaf, Kuṭila script, *c*. AD 1100-1200.

Kulasāra. NAK MS 4-137. Reel No. NGMPP 4/137. Palm-leaf, early Nāgarī. Read in a draft of an edition prepared by Dr. Somdev Vasudeva (Oxford).

Mahānayaprakāśa (Old Kashmiri) with a Sanskrit commentary (*-vivṛti*) by Rājānaka Śitikaṇṭha, ed. Mukund Ram Shastri, KSTS 21. Bombay, 1918.

Mahānayaprakāśa of Arṇasiṃha. In NAK MS 5-358. NGMPP Reel No. B 30/26 ('*Kālīkulapañcaśataka*').

Mahānayaprakāśa, ed. K. Sambashiva Shastri, Trivandrum Sanskrit Series 130, Citrodayamañjarī 19. Trivandrum, 1937.

Mahārthamañjarīparimala of Maheśvarānanda with the author's commentary (*-parimala*), ed. Vrajavallabha Dviveda. Yogatantra-Granthamālā 5. Varanasi: Research Institute, Varanaseya Sanskrit Vishvavidyalaya, 1972.

Mahotsavavidhi. Wrongly ascribed to Aghoraśivācārya's *Kriyākramadyotikā*, as its sixth part, but ending with Aghoraśivācārya's *Gotrasaṃtati*. Reprinted after resetting by the South India Arcaka Association, 1974, from the anonymous edition printed by Mayilai-Aḷakappa Mudaliyār, Madras (Cintātiripēṭṭai): Civañānapotayantracālai, 1910.

Mālinīvijayavārttika of Abhinavagupta, ed. Madhusudan Kaul Shastri. KSTS 31. Srinagar, 1931. See also Hanneder 1998.

Mālinīvijayottara, ed. Madhusudan Kaul Shastri. KSTS 37. Srinagar, 1922.

Manthānabhairavatantra, *Kumārīkhaṇḍa*. NGMPP Reel No. A 171/11.

Mataṅgapārameśvara, *Vidyāpāda*, with the commentary (*-vṛtti*) of Bhaṭṭa Rāmakaṇṭha, ed. N.R. Bhatt. Publications de l'IFI 66. Pondicherry: IFI, 1977; *Mataṅgapārameśvarāgama*, *Kriyāpāda*, *Yogapāda* and *Caryāpāda*, with the commentary (*-vṛtti*) of Bhatta Ramakantha up to *Kriyāpāda* 11.12b, ed. N.R. Bhatt, Publications de l'IFI 65. Pondicherry: IFI, 1982.

Mokṣakārikā of Sadyojyotis with the commentary (*-vṛtti*) of Bhaṭṭa Rāmakaṇṭha. In *Aṣṭaprakaraṇa*, ed. Krishnashastri, Devakoṭṭai: Śivāgamasiddhāntaparipālanasaṅgha, 1923.

Mṛgendra: *Mṛgendratantra*, *Vidyāpāda* and *Yogapāda*, with the commentary (*-vṛtti*) of Bhaṭṭa Nārāyaṇakaṇṭha, ed. Madhusudan Kaul Shastri, KSTS 50. Srinagar, 1930; *Mṛgendrāgama* (*Mṛgendratantra*), *Kriyāpāda* and incomplete *Caryāpada*, with the commentary (*-vṛtti*) of Bhatta Nārāyaṇakaṇṭha, ed. N.R. Bhatt. Publications de l'IFI 23. Pondicherry: IFI, 1962.

Nareśvaraparīkṣā of Sadyojyotis with the commentary (*-prakāśa*) of Bhaṭṭa Rāmakaṇṭha, ed. Madhusudan Kaul Shastri. KSTS 45. Srinagar, 1926.

Netratantra with the commentary (*Netroddyota*) of Kṣemarāja, ed. Madhusudan Kaul Shastri. KSTS 46, 59. Bombay, 1926, 1939.

Niśisaṁcāra. NAK MS 1-1606. Palm-leaf; Newari script.

Niśvāsaguhya. NAK MS 1-227, NGMPP Reel No. A 41/14 (*Niśvāsatattvasaṁhitā*), ff. 42r5-114v. Palm-leaf; Nepalese 'Licchavi' script; *c.* AD 900.

Nityādisaṁgrahapaddhati of Rājānaka Takṣakavarta, BORI MS. No. 76 of 1875-76 (*Bhṛṅgeśasaṁhitā*). Paper; Śāradā.

Paramārthasāra of Abhinavagupta with the commentary (*-vivṛti*) of Yogarāja, ed. Jagadisha Chandra Chatterji. KSTS 7. Srinagar, 1916.

Parātrīśikā with the commentary (*-vivaraṇa*) of Abhinavagupta. (1) See Gnoli 1985, (2) ed. Mukund Ram Shastri. KSTS 18. Srinagar, 1918.

Picumata (*Brahmayāmala*). NAK MS 3-370, NGMPP Reel No. A 42/6. Palm-leaf; early Newari script; AD 1052.

Pramāṇavārttika of Dharmakīrti with the author's commentary (*-svavṛtti*) and the subcommentary (*-ṭīkā*) of Karṇakagomin, ed. Rāhula Sāṁkṛtyāyana. Allahabad: Kitab Mahal, 1943. Reprinted by Rinsen Book Co., Kyoto, 1982.

Rauravāgama, ed. N.R. Bhatt, 3 vols. Publications de l'IFI 18. Pondicherry: IFI, 1961, 1972, and 1988.

Sarasvatīkaṇṭhābharaṇa of Bhoja, ed. Anundoram Barooah. Gauhati, 1961.

Sārdhatriśatikālottara with commentary (*-vṛtti*) of Bhaṭṭa Rāmakaṇṭha, ed. N.R. Bhatt. Publications de l'IFI 61. Pondicherry: IFI, 1979.

Sarvajñānottara. NAK MS 1-1693. NGMPP Reel No. A 43/12. Palm-leaf; early Nepalese 'Licchavi' script.

Ṣaṭsāhasrasaṁhitā. See Schoterman 1982.

Śivadharmottara, Wellcome Institute for the History of Medicine, London, Sanskrit MS δ 16 (ii), ff. 64-143. Paper transcript in Devanāgarī of a Nepalese palm-leaf manuscript.

Śivadṛṣṭi of Somānanda with the commentary (*-vivṛti*) of Utpaladeva (incomplete, up to 4.74), ed. Madhusudan Kaul Shastri. KSTS 54. Srinagar, 1934.

Śivastotrāvalī of Utpaladeva with the commentary (*-vivṛti*) of Kṣemarāja, ed. Rājānaka Lakṣmaṇa [Lakshman Raina]. Chowkhamba Sanskrit Series 15. Varanasi, 1964.

Śivasūtravimarśinī, ed. J.C. Chatterji. KSTS 1. Srinagar, 1911.

Śivopaniṣad. In *Un-Published Upanishads*, edited by the Pandits of Adyar Library under the supervision of C. Kunhan Raja. *Adyar Library Series 14*, Madras: Adyar Library and Research Centre, 1933.

Skandapurāṇa: *Skandapurāṇasya Ambikākhaṇḍaḥ*, ed. Kṛṣṇaprasāda Bhaṭṭarāī, Mahendraratnagranthamālā 2. Kathmandu: Mahendra Sanskrit University, 1988. See also Adriaensen, Bakker, and H. Isaacson, 1998.

Somaśambhupaddhati. See Brunner 1963-98.

Spandanirṇaya. See Kaul 1925.

Spandasaṁdoha of Kṣemarāja (commentary on *Spandakārika* 1.1), ed. Mukund Ram Shastri. KSTS 16. Bombay, 1917.

Subhāṣitāvalī of Vallabhadeva, ed. R.D. Karmarkar. Bombay Sanskrit and Prakrit Series 31. Bombay, 1961. Reprinted from the 1886 edition of Peter Peterson and Pandit Durgaprasada.

Sūktimuktāvalī of Jalhaṇa, ed. Embar Krishnamacharya. Gaekwad's Oriental Series 31. Baroda: Oriental Institute, 1938.

Svabodhodayamañjarī of Vāmanadatta, son of Harṣadatta. Banaras Hindu University Library, MS C. No. 4255.

Svacchandatantra with the commentary (*-uddyota*) of Kṣemarāja, ed. Madhusudan Kaul Shastri. KSTS 31, 38, 44, 48, 51, 53, 56. Bombay, 1921-35.

Svāyambhuvavṛtti. See Filliozat 1991.

Tantrāloka of Abhinavagupta with the commentary (*-viveka*) of Rājānaka Jayaratha, ed. Mukund Ram Shastri. KSTS 23, 28, 30, 35, 29, 41, 47, 59, 52, 57, 58. Bombay and Srinagar, 1918-38.

Tantrasadbhāva. NAK MS 5-445, NGMPP Reel No. A 44/2. Palm-leaf; early Newari script; AD 1096/97.

Tantrasāra of Abhinavagupta, ed. Mukund Ram Shastri. KSTS 17. Bombay, 1918.

 MSS: α = G (Madras, Government Oriental Research Institute and Manuscripts Library, MS No. 177706-B; palm-leaf; Grantha) and P_2 (BORI No. 145 of 1883-84; paper; Śāradā); β = P_1 (BORI MS No. 447 of 1875-76; paper; Śāradā) and P_3 (BORI MS No. 448 of 1875-76; paper; Kashmirian Devanāgarī); B_1 (Banaras Hindu University Library, MS C. No. 31; paper; Śāradā); B_2 (*ibid.*, C. No. 3866; paper; Śāradā); Y (Beinecke Rare Book and Manuscript Library, Yale University, Indic 32; paper; Śāradā); J (Jammu, Shri Raghunatha temple MSS. Library, No. 2333-2334; paper; Kashmirian Devanāgarī); K_1 (KED MS *ka*); K_2 (KED MS *ka*); K_3 (KED MS *ga*).

Tantravaṭadhānikā of Abhinavagupta, ed. Mukund Ram Shastri. KSTS 25. Bombay, 1918.

Tantroccaya of Abhinavagupta, ed. Raniero Gnoli and Raffaele Torella. In *Studi in onore di Luciano Petech*, ed. Paolo Daffinà, pp. 153-89. Studi Orientali publicati dal dipartimento di Studi Orientali 9. Rome: University di Roma "La Sapienza", 1990.

Timirodghāṭana. NGMPP Reel No. A 35/3, = A 1380/8. Palm-leaf; late Nepalese 'Licchavi' script. Read in a draft of an edition prepared by Dr. Somdev Vasudeva (Oxford).

Ūrmikaulārṇava. NAK MS 5-5207 (incomplete). Paper; Newari script.

Vāmakeśvarīmata with the commentary (*-vivaraṇa*) of Rājānaka Jayaratha, ed. Madhusudan Kaul Shastri. KSTS 66. Srinagar, 1945.

Vijñānabhairava with the commentary (*-uddyota*) of Kṣemarāja (on verses 1 to 23) completed by the commentary (*-vivṛti*) of Śivopādhyāya, ed. Mukund Ram Shastri. KSTS 8. Srinagar, 1918.

Vyākaraṇamahābhāṣya of Patañjali, ed. F. Kielhorn. 3rd edn. (1st edn., 1880; 2nd edn., 1892). Revised by K.V. Abhyankar. Poona: BORI, 1962-67.

Yamaprakaraṇa of Viśuddhamuni. Appendix 1 (pp. 24-25) in *Gaṇakārikā*, ed. C.D. Dalal. Gaekwad's Oriental Series 15. Baroda: Central Library, 1920.

Yaśastilaka of Somadevasūri with the commentary (*-vyākhyā*) of Śrutasāgarasūri, ed. Pandita Shivadatta Sharma and Kashinatha Sharma Parab. Kāvyamālā 70. Bombay: Nirnaya Sagara Press, 1901.

STUDIES AND TRANSLATIONS

Adriaensen, R., H.T. Bakker, and H. Isaacson. 1998. *The Skandapurāṇa. Volume 1. Adhyāyas 1-25. Critically Edited with Prolegomena and English Synopsis.* Supplement to Groningen Oriental Series. Groningen: Egbert Forsten.

Brunner, Hélène, ed. and trans. 1963, 1968, 1977, 1998. *Somaśambhupaddhati.* 4 vols. *Première Partie: Le rituel quotidien dans la tradition Śivaïte de l'Inde du Sud selon Somaśambhu; Deuxième Partie: Rituels occasionels dans la tradition Śivaïte de l'Inde du Sud selon Somaśambhu I: Pavitrārohaṇa, Damanapūjā et Prāyaścitta; Troisième Partie: Rituels occasionels dans la tradition Śivaïte de l'Inde du Sud selon Somaśambhu II: dīkṣā, abhiṣeka, vratoddhāra, antyeṣṭi, śrāddha; Quatrième Partie: rituels optionnels: pratiṣṭhā.* Publications de l'IFI 25. Pondicherry: IFI.

Dwivedī, Rewā Prasāda, ed., trans., and annot. 1979. *Alaṁkārasarvasva of Śrī Rājānaka Ruyyaka and Maṅkha with Vimarśinī of Jayaratha and with Hindī translation and explanation of both.* 2nd edn. Kashi Sanskrit Series 206. Varanasi: Chaukhamba Sanskrit Sansthan.

Filliozat, Pierre-Sylvain, ed. and trans. 1991. *Le Tantra de Svayambhū, vidyāpāda, avec le commentaire de Sadyojyotiḥ.* Geneva: Librairie Droz S.A.

Gnoli, Raniero, ed. and trans. 1985. *Il Commento di Abhinavagupta alla Parātriṁśikā (Parātriṁśikāvivaraṇa). Traduzione e Testo.* Serie Orientale Roma 58. Rome: Istituto Italiano per il Medio ed Estremo Oriente.

———, Trans. 1990. *Abhinavagupta, Essenza dei Tantra. (Tantrasāra).* 2 vols. 3rd edn. Turin: Boringhieri (1st edn., 1960).

———, Trans. 1999. *Abhinavagupta, Luce dei Tantra. (Tantrāloka).* Bibliotheca Orientale 4. Milano: Adelphi Edizzioni.

Goodall, Dominic, ed. and trans. 1998. *Bhaṭṭarāmakaṇṭhaviracitā kiraṇavṛttiḥ. Bhaṭṭa Rāmakaṇṭha's Commentary on*

the *Kiraṇatantra. Vol. 1: chapters 1-6. Critical Edition and Annotated Translation.* Publications du département d'Indologie 86.1. Pondicherry: Institut français de Pondichéry/École française d'Extrême-Orient.

Grierson, Sir George and Lionel D. Barnett, ed., trans., and annot. 1920. *Lallā-vākyāni or the Wise Sayings of Lal Děd, a Mystic Poetess of Ancient Kashmir. Edited with Translation, Notes, and a Vocabulary.* London: Royal Asiatic Society.

Handiqui, Krishna Kanta. 1949. *Yaśastilaka and Indian Culture or Somadeva's Yaśastilaka and Aspects of Jainism and Indian Thought and Culture in the Tenth Century.* Jīvarāja Jaina Granthamālā 2. Sholapur: Jaina Saṁskṛti Samrakshaka Sangha.

Hanneder, Jürgen. Ed. and trans. 1998. *Abhinavagupta's Philosophy of Revelation.* Mālinīślokavārttika I, 1-399. Groningen Oriental Series 14. Groningen: Egbert Forsten.

Hernault, Françoise. 1987. *Darasuram. Epigraphical Study, Étude Architecturale, Étude Iconographique,* Vol. 1: Text. Publications de l'École française d'Extrême-Orient. Mémoires Archéologiques XVI. Paris: École française d'Extrême-Orient.

Hunter, W.W. 1886. *The Imperial Gazetteer of India.* 2nd edn. London: Trübner.

Kahrs, Eivind. 1998. *Indian semantic analysis. The 'Nirvacana' tradition.* Cambridge: Cambridge University Press.

Kaul, Madhusūdan Śāstrī. Ed. and trans. 1925. *The Spandakārikās of Vasugupta with the Nirṇaya by Kṣemarāja, Edited with preface, introduction and English translation.* KSTS 42. Srinagar.

Pandey, Kanti Chandra. 1963. *Abhinavagupta. An Historical and Philosophical Study.* 2nd edn., revised and enlarged. Chowkhamba Sanskrit Series 1. Varanasi: Chowkhamba Sanskrit Series Office.

Pischel, R. 1880. *The Deśīnāmamālā edited with critical notes, a glossary, and a historical introduction. Pt. 1, Text and Critical Notes.* Bombay Sanskrit Series 17. Bombay: Government Central Book Depot.

Sanderson, Alexis. 1985. Purity and Power among the Brahmans of Kashmir. In *The Category of the Person. Anthropology, Philosophy, History,* eds. M. Carrithers, S. Collins and S. Lukes, pp. 190-216. Cambridge: Cambridge University Press.

———, 1986. Maṇḍala and Āgamic Identity in the Trika of Kashmir. In *Mantras et Diagrammes Rituelles dans l'Hindouisme,* ed. A. Padoux, pp. 169-214. Paris: Éditions du Centre National da la Recherche Scientifique.

———, 1990. The Visualization of the Deities of the Trika. In *L'Image Divine: Culte et Méditation dans l'Hindouisme,* ed. A. Padoux, pp. 31-88. Paris: Éditions du Centre National de la Recherche Scientifique.

———, 1992. The Doctrine of the Mālinīvijayottaratantra. In *Ritual and Speculation in Early Tantrism. Studies in Honour of André Padoux,* ed. T. Goudriaan, pp. 281-312. Albany: State University of New York Press.

———, 1995. Meaning in Tantric Ritual. In *Essais sur le Rituel III: Colloque du Centenaire de la Section des Sciences religieuses de l'École Pratique des Hautes Études,* eds. A.M. Blondeau and K. Schipper, pp. 15-95. Bibliothèque de l'École des Hautes Études, Sciences Religieuses. Louvain-Paris: Peeters.

———, 2001. History Through Textual Criticism in the Study of Śaivism, the Pañcarātra and the Buddhist Yoginītantras. In *Les sources et le temps. Sources and Time. A Colloquium, Pondicherry, 11-13 January 1997,* ed. François Grimal, pp. 1-47. Publications du département d'Indologie 91. Pondicherry: Institut français de Pondichéry/École française d'Extrême-Orient.

———, 2005a. The Śaiva Religion among the Khmers (Part 1). *Bulletin de l'École française d'Extrême-Orient* 90-91 (2003-2004), pp. 349-462.

———, 2005b. Religion and the State: Śaiva Officiants in the Territory of the King's Brahmanical Chaplain. *Indo-Iranian Journal* 47 (2004), In press.

Śāstrī, K. Sāmbaśiva. Ed. 1937-. *Descriptive Catalogue of Sanskrit Manuscripts in the Curator's Office Library, Trivandrum.* 10 vols. Trivandrum: Government of H.H. The Maharaja of Trivandrum.

Śāstrī, Pṛthurāma. Ed. and trans. 1983. *Jālandharapīṭhadīpikā bhāṣānuvādasahitā (A manual of pilgrimage to Jālandhara-pīṭha, Kangra, Jwālāmukhī, etc., and awakening of Kuṇḍalinī) Prahlādānandācaryakulāvadhāta-kṛtā.* Kangra: Yaśapāla-Sāhitya-Parishad.

Schoterman, J.A. Ed., trans., and annot. 1982. *The Saṭsāhasra Saṁhitā, Chapters 1-5.* Leiden: E.J.Brill.

Torella, Raffaele. Ed. and trans. 1994. *The Īśvarapratyabhijñākārikā of Utpaladeva with the Author's vṛtti. Critical Edition and Annotated Translation.* Serie Orientale Roma 71. Rome: Istituto Italiano per il Medio ed Estremo Oriente.

Turner, R.L. 1966-71. *A Comparative Dictionary of the Indo-Aryan Languages.* 3 vols. London: Oxford University Press.

Yazdani, G. Ed. 1960. *The Early History of the Deccan.* London, Bombay, New York: Oxford University Press.

9

A New Theology of Bliss
'Vedantization' of Tantra and 'Tantrization' of Advaita Vedānta in the Lalitātriśatibhāṣya

Annette Wilke

WHEN studying religious traditions we generally rely entirely on textual sources (usually written by an educated elite) and forget that it is human actors who determine and shape 'religion' and 'tradition.' The philological approach tends to ignore the living tradition and actual practice. Moreover, we are hardly aware that academic scholarship has its own share in the defining and selective processes. The first translations and the eagerness to discern origins have been decisive in shaping a normative academic 'canon' of sources. Regarding the vast amount of textual sources in India, studies on Veda and Upaniṣads were predominant in defining Hinduism. Śaṅkara's non-dual Vedānta was seen as a pinnacle of Indian philosophy, whereas Tantra did not attract much scholarly attention and was often judged in continuity with missionary discourses as debased and a deviation into magic. Were it not for the pioneering work of scholars like Bettina Bäumer, Tantra as a highly symbolic and ritualistic world orientation underlying all Śaivism, and notably the non-dual Tantra of Kashmir Śaivism and its philosophic mastermind Abhinavagupta, would be still unknown. Increasingly, there have also been studies on Śrīvidyā, the sophisticated cult of the Great Goddess Lalitā-Tripurasundarī, which owes much to 'Kashmir Śaivism' and is nowadays the most widespread Śākta Tantra in all of India. The *Lalitātriśatibhāṣya* (*LTBh*) I want to deal with, claims to be part of Śrīvidyā, too.[1] It is a learned commentary (*bhāṣya*) on the metric litany of three hundred names (*triśati*) dedicated to Lalitā Devī. This litany is much less well-known than Lalitā's thousand names (*Lalitāsahasranāma*), the recital of which is very popular in southern India, particularly Tamil Nadu, including among non-initiates, whereas the *Lalitātriśatī* is confined to initiates only.[2]

1. I was working on the *LTBh* during the time of my scholarship in Varanasi (1991-92) and express my thanks to Bettina Bäumer for her great hospitality and for introducing me to Panditji Hemendra Nath Chakravarty, with whom I had the chance to translate and discuss the text. Since 1992 I have extended my focus to field studies. The observations on present forms of Śrīvidyā presented below I have gathered from research in Varanasi, Tamil Nadu, Nepal, Sri Lanka and Tamil diaspora Hinduism in Germany.

2. In ritual settings the *āvali*-form (name in dative with *namaḥ*) is usually preferred to the metrical one. The

→

The *LTBh* commenting on this litany confronts us most directly with the problems outlined regarding the definition of traditions. It is a highly hybridized text of uncertain date ascribed to Śaṅkara and is included in the *Complete Works of Śrī Śaṅkarācārya*.[3] For academic scholars of the Śaṅkara tradition this alleged authorship is certainly curious and unhistorical — if they are aware of it at all — whereas for south Indian Smārtas, Śrīvidyā adepts and the Śaṅkarācāryas, the claim is only natural. A large number of Devī-Stotras are attributed to Śaṅkara,[4] notably the famous *Saundaryalaharī* which has inspired many commentaries. Southern Śrīvidyā practitioners consider Śaṅkara as an important authority of their cult. In their view, the great Advaita Vedānta philosopher was a Śrīvidyā initiate who brought about a major cult reform by installing the *śrīcakra* in Devī shrines and disseminating Śrīvidyā ideas and practises.[5] They consider the Śaṅkara *maṭha*s as their "unofficial nerve centres."[6]

This living tradition remains unnoticed or at best deliberately ignored by scholars of Śaṅkara's Vedānta and his later school, since it is not the 'real,' 'pure' Śaṅkara tradition. Scholars of non-dualistic Śaivism of Kashmir and Śākta Tantra, on the other hand, are well aware of the south Indian Śrīvidyā lore, but consider it a deviation from the 'original,' real Śrīvidyā. The original cult of Tripurasundarī is defined as Kashmiri late Kaula[7] and its purity and/or deviation is judged against the earliest Sanskrit sources available (which do not play a major role in today's Śrīvidyā any more): the ritualistic *Nityaṣoḍaśīkārṇava*, also called *Vāmakeśvarīmatatantra*, and the metaphysical *Yoginīhṛdaya*, which have been dated

→ Agastya association of both litanies indicates that they were composed in south India. In the colophons they are ascribed to the *Brahmāṇḍa Purāṇa*. The *Lalitātriśatī* contains the name Kāmakoṭinilayā (259), which may point to its composition in the Kanchi Śaṅkara Maṭha (called Kāmakoṭi). There are *LTBh* versions glossing *kāñcīpurapīṭham*.

3. Srirangam: Vani Vilas 1911, vol. 13, rpt. 1982 by Samata Books as vol. 5. There exist about fifty manuscripts of the *LTBh*, most of which mention Ādi Śaṅkara as the author (only four give no commentator, two ascribe the text to another author). The *LTBh* has also been edited separately by R. Anantakrishna Sastry (Bombay 1902), and by C. Sankara Rama Sastry (Madras 1949). There is a translation by Chaganti Suryanarayana Murthy (Madras: Ganesh & Co., 1967), which is unfortunately not always reliable. My rendering and analysis below draw on my own translations.

4. Besides Devī-Stotras, hymns to the other great Smārta deities found in *Bṛhatstotraratnākara* compilations are ascribed to Śaṅkara. He is also the alleged author of the *Prapañcasāra-Tantra*. The compiler of the *Śrīvidyārṇava-Tantra* pretends to be the great-grand-disciple of Śaṅkara and even the *Kulacūḍāmaṇi* (verse 3) mentions the Śaṅkara tradition. A *guruparamparā* was 'invented' starting with Śaṅkara's *parama gurus* Gauḍapāda and Govinda, and continued by his disciple Padmapāda (see S.K. Ramachandra Rao: *Śri Chakra*, Delhi: Satguru Publications, 1989, p. 4).

5. Annette Wilke, 'Śaṅkara and the Taming of Wild Goddesses,' in: Axel Michaels, Cornelia Vogelsanger, Annette Wilke (eds.), *Wild Goddesses in India and Nepal*, Bern: Peter Lang, 1996, pp. 123-78.

6. Sanjukta Gupta, Teun Goudriaan, Dirk J. Hoens, *Hindu Tantrism* (Handbuch der Orientalistik; II 7), Leiden: Brill, 1979, p. 28.

7. The Kashmir background has been worked out by Alexis Sanderson: 'Śaivism and the Tāntric Traditions,' in: Sutherland, Stewart a.o. (eds.), *The World's Religions*, London: Routledge, 1988, pp. 660-704, cp. particularly pp. 688ff., p. 704; André Padoux: *Le Coeur de la Yoginī : Yoginīhṛdaya avec le commentaire Dīpikā d'Amṛtānanda*, Paris: ed. Boccard, 1994, pp. 11, 41-46; and Madhu Khanna, *The Concept and Liturgy of the Śrīcakra based on Śivānanda's Trilogy* (doctoral thesis, Oxford, 1986).

between ninth and eleventh centuries AD and certainly give evidence of a strong Kashmir influence, although they may be of southern origin.[8] André Padoux expresses a common scholarly opinion remarking:

> The tradition, which developed early in south India, has remained active there. But, having been adopted by the Śaṅkarācārya of Śṛṅgerī and Kāñcīpuram, it evolved into a common form of non-dualist Śaivism, losing most of its Tāntric characteristics. Indeed, Vedantised, tracing its *guruparaṁparā* to Śaṅkara, instead of to the Tāntric founders of the tradition (who were probably from the north, possibly Kashmir), it has turned into an altogether different — a deviant and bowdlerised — form of the cult of Tripurasundarī.[9]

> The anti-Tāntric puritanical forms of the southern brand of the Śrīvidyā, so contrary to the original spirit of the system, are I believe, not attested before Lakṣmīdhara's time (fifteenth-sixteenth century).[10]

I do not want to deny that older forms of Śrīvidyā have been purely Kaula. Nor would I deny that serious changes concerning ritual, cosmology and metaphysics took place in south India as the *LTBh* also demonstrates. There are good reasons for judging the southern Śrīvidyā 'deviant,' 'bowdlerised' and 'anti-Tāntric.' Yet, my approach is somewhat different. I consider religion as a living body and a dynamic organism in constant flux. Accordingly, I would rather speak of re-interpretation and transformation. It is noteworthy that most Śrīvidyā manuscripts come from southern India. Concerning the living tradition, it is crucial to distinguish between a widespread Great Goddess theology or common form of non-dual Śaivism in which Śrīvidyā imagery became a public cultural memory on the one hand, and the lineages of southern initiates, to whom *śrīcakrapūjā* proper is restricted, on the other. The domesticated and popularized Śrīvidyā was tremendously successful. Its pervasive influence among a wider community of south Indian Śaiva-Smārtas led to a public display much different from the north where Śrīvidyā is kept very secret. In the south, the *śrīcakra* is present in all Devī temples and Lalitā-Tripurasundarī is one of the most popular deities. Many local goddesses are identified with her, first and foremost the famous Kāmākṣī of Kanchi. Śrīvidyā shaped a Great Goddess theology in which Tāntric, Purāṇic and Vedāntic traditions merged. I suspect that this is more than accidental. Śrīvidyā has been synthetic and inclusivist from its very beginnings.[11] It certainly belongs to later

8. The origins regarding time and place are still a matter of debate. Padoux (*Coeur, op. cit.*, p. 11, fn. 6) who locates the *Yoginīhṛdaya* in Kashmir, mentions Sanderson's opting for a south Indian origin. A "proto Śrīvidyā" emerging in Tamil Nadu around the seventh century has been postulated by Douglas R. Brooks, *Auspicious Wisdom. The Texts and Traditions of Śrīvidyā Śākta Tantrism in South India*, Albany: State University of New York Press, 1992, pp. 29f.

9. A. Padoux, *Coeur, op. cit.*, p. 7.

10. *Ibid.*, p. 8.

11. Its early forms overcode the 'Southern Transmission' (*dakṣiṇāmnāya*) of Kashmir Kaula Tantra and its youthful goddess Tripurasundarī, also called Kāmeśvarī, a goddess of love magic, with Krama, philosophical Pratyabhijñā and Trika cosmological speculations of the alphabet, but also incorporating *bhakti* and possibly southern Siddha traditions.

Tantra — a Tantra acceptable to brāhmaṇas and further developed by brāhmaṇas. Negotiating Tantra and Veda has been a major theme in this process and has given rise to different blends of Vedic and Tāntric. The Śrīvidyā's own claim to be the synthetic fifth 'Upper' or 'Supreme Transmission' (*ūrdhvāmnāya*), exceeding the quadruple Kaula fold, has proven true, since it indeed incorporated the pantheon of other systems in an inclusivist way. Such inclusion went as far as identifying the Śrīvidyā root *mantra* with the Veda, and *Para-Brahman* with the Śrīvidyā Goddess. This kind of merger is not only postulated by the *LTBh*, as I am going to show, but also by the Maharashtra (court) brāhmaṇa and Kaula Bhāskararāya, the most eminent Śrīvidyā philosopher who spent much of his life in Varanasi. He associates himself with the earliest Śrīvidyā sources as late as the seventeenth-eighteenth centuries,[12] and seeks at the same time a deliberate synthesis of Veda and Tantra.[13] His programme is clear right from the first verses of the *Varivasyārahasya*:

> The Great Radiance triumphs, at the sight of which nought else is seen. How then is it said in the Veda-s that all is known on Its being known? It has the Power (*Śakti*) of *Vimarśa*, which may be defined as inherent pulsation. It is the conjunction with that Power that Śiva creates, sustains and withdraws the world. She (*Śakti*) by whose transformation this creation in the form of objects (*arthas*), words (*śabdas*), plexuses (*cakras*) and bodies (*dehas*) exists, should of necessity be known by us.[14]

Bhāskararāya explains the Veda by Tantra. The *Chāndogya Upaniṣad* formula "by knowing which everything else is known" gives the catchword to unfold a Tāntric cosmology.[15] In consonance with the non-dualistic Śaivism of Kashmir, he has an utterly real and dynamic vision of the world as a direct manifestation and natural outflow of the divine play of Śiva (*prakāśa*) and Śakti (*vimarśa*). It is noteworthy that the *Yoginīhṛdaya* (2.73-77) already included Upaniṣad passages to explain the 'ultimate' meaning of the Śrīvidyā *mantra*. Bhāskararāya adds new meanings to construct a 'Vedic' or Smārta appearance[16] and adopts Mīmāṃsā

12. His *Setubandha* (AD 1733) comments on a portion of the *Vāmakeśvarīmatatantra*, while his *Varivasyārahasya* elaborates the *Yoginīhṛdaya*. For the Kaula background of the *Yoginīhṛdaya* (ritual consuming of alcohol and meat; anomistic behaviour of the liberated) see A. Padoux, *Coeur, op. cit.*, pp. 85, 89; for the Kaula background of Bhāskararāya see *Varivasyārahasya* 2.165 and other texts.

13. The brāhmaṇa Bhāskararāya does not seem to have had problems to be a 'Vaidika' and 'Tāntrika' at the same time, much like contemporary Nepali Śrīvidyā initiates, who perform (exoteric) Brāhmaṇical *pūjā* with Vedic *mantra*s as well as (esoteric) Tāntric *pūjā*. According to his biographers he had Brāhmaṇic and Tāntric initiation, and the long list of his works contains treatises on Veda and Vedic sciences (*Varivasyārahasya*, introduction, *op. cit.*, pp. xxx-xxxiii).

14. *Varivasyārahasya* (1.3-5), tr. S. Subrahmanya Sastri, Madras: Adyar, 1934, 6f.

15. Śaṅkara's exegesis of the *Chāndogya* passage was quite different. His key term was *sat*, '(pure) existence,' a term never used by Kashmiri authors. Śaṅkara identifies *sat* with the *ātman* abiding in everything and postulates: Only *sat* is real existence (comparable to clay in clay pots), whereas the world of plurality is merely "name and form," *nāma-rūpa* (like the clay pots) — an unessential and in the final analysis unreal (*mithyā*) adjunct (*upādhi*).

16. The six esoteric 'meanings' (*artha*) of the *Yoginīhṛdaya* (*Yoginīhṛdaya* 2.14-80; *Varivasyārahasya* 2.57ff., 64-147) are closely followed and framed by another nine, starting with *gāyatryārtha* (identity of Śrīvidyā and Vedic Gāyatrī) and ending with *mahāvākyārtha* (identity of Śrīvidyā and Upaniṣadic formula *tat tvam asi*).

methods, while remaining faithful to his lineage of the *Paraśurāmakalpasūtra* and the Maharashtra court background preserving Kaula forms.[17] Inversely, the orthodox celibate Śaṅkarācāryas adopting Śrīvidyā discarded Kaula sexo-yogic ritual to re-enact mimetically the blissful union of Śiva and Śakti, but kept the imagery as a suggestive metaphor, while remaining faithful to their own tradition regarding cosmogology. This is precisely the way the *LTBh* uses Tantra concepts as catchwords to unfold a philosophy of bliss and terms the world and its creation an *upādhi* or unreal adjunct. The Śaṅkarācāryas not only exercised a significant influence on Tamil Nadu Śrīvidyā initiates[18] but also influenced the Maharashtra lore. R. Krishnaswami Sastri, who introduces his family tradition in the lineage of Bhāskararāya's disciple Umānandanātha, declares: "In the realm of metaphysics Bhāskararāya was a convinced adherent and upholder of the Advaitavāda, promulgated by the great Śaṅkara,"[19] and a nineteenth-century commentator presents the *Paraśurāma-kalpasūtra* as a summary of the "Upāsanā-Kāṇḍa of the Veda."[20] Among southern initiates it is very common to understand Śrīvidyā ("Śākta Āgama") as the third or *upāsanā-kāṇḍa* completing the ritual part (*karma-kāṇḍa*) and speculative part (*jñāna-kāṇḍa*, the Upaniṣads) of the Mīmāṁsā. The *LTBh* author, too, conceptualizes the Veda as three-fold. None seems to conceive a major difference anymore between Śrīvidyā and Śaṅkara's Advaita Vedānta.

To speak of Śrīvidyā means to deal with a rather complex issue, not only in terms of its highly complicated ritual, its sophisticated metaphysical Great Goddess theology and its lineages of initiates who would not easily communicate with an outsider, but also in terms of its synthetic and inclusivist character, intracultural differences, regional varieties and historical transformations. It fascinated rulers, those of Nepal[21] and the Maharasthrian court, as well as ascetics and educated lay people. It is only natural that the different socio-cultural, regional and historical settings should have left their imprints on the Śrīvidyā cult, but Śrīvidyā equally changed the traditions with which it merged, most notably the

17. Bhāskararāya's father had associations with the Maharashtrian court. Bhāskararāya is said to have initiated all the Rājās of his time into the Śrīvidyā. His pupil Umānandanātha, who lived at the royal court in Tanjore, composed the work *Nityotsava* in AD 1745 to give easier access to the *Paraśurāmakalpasūtra*, a ritual compilation, which has been dated to the sixteenth century.

18. To what extent the Vedantization goes, can be seen in the Foreword to the *Saundaryalaharī* by Anna N. Subramanian, a well-known south Indian authority on Śrīvidyā (*Saundaryalaharī of Śrī Śaṅkarācārya*, tr. and commented upon by Swami Tapasyananda, Mylapore Madras: Ramakrishna Math, 1987, pp. ix-x). His view of reality (*saccidānanda, upādhi, neti neti, māyā*) is entirely shaped by Advaita Vedānta, as well as his Śakti image (*saguṇa Brahman: Brahman* with attributes or a "personal god" needed by those steeped in duality). Śrīvidyā and *kuṇḍalinī yoga* are according to him just another method. In ritual practice he was very vigorous until he died, performing *śrīcakrapūjā* daily for four hours, as I witnessed at his home in Chennai in 1991.

19. *Varivasyārahasya*, introduction, *op. cit.*, Madras, 1976, pp. xxvii and xxvi.

20. Lakṣmaṇa Rāṇade (AD 1888) quoted in the introduction of the *Paraśurāmakalpasūtra*, Madras 1923, rev. edn. Baroda: Oriental Institute (1950), 1979, p. xii.

21. See Jeffrey S. Lidke, *When the inside becomes outside. A Critique of the Western Discourse of Duality, based on an Analysis of Sādhana in the Trika-Kaula Śaivism of Abhinavagupta* (Ph. D. Thesis, University of California, Santa Barbara 1996).

Advaita Vedānta of the Śaṅkarācāryas. The Śrīvidyā's transformation in the south can be seen as a victory of the Śaṅkarācāryas in canalizing religious behaviour into orthodox tracks, but it was by no means a one-sided process. The ascetic abbots certainly changed Śrīvidyā considerably by 'purging' it completely of its Kaula traits, but in turn they also were ready to change their own cultural memory in a drastic way. The fact that today's Śaṅkarācāryas of Kanchipuram ritually worship Śiva and Śakti everyday, on a public platform in the Kāmakoṭi Maṭha, amply illustrates how much Śaṅkara's radically gnostic and anti-ritualistic Vedānta has transmuted in actual practice.[22] Reading the late Sri Chandrashekharendra Sarasvati's devotional speeches on the divine Mother and considering that even the northern *maṭha*s have adopted *śrīcakra* worship, one may ask whether it was Śrīvidyā or Śaṅkara who won the show. Rituals or combined methods (*karma-jñāna-sammuccaya*) and goddess veneration have little place in Śaṅkara's system.

Obviously, traditions are fluid. Such fluidity escapes (and breaks up) the academic 'canons.' This is one of the reasons why the *LTBh* did not arouse any scholarly interest until now. This commentary demonstrates the fluidity of traditions in a very extreme way. It is to my knowledge the most Vedāntized and least Tāntric Śrīvidyā version found in the textual tradition published so far. Internal and external evidence suggests that the *LTBh* is post-Śaṅkara and probably a rather recent text composed in one of the southern Śaṅkara *maṭha*s. I would agree with Brooks that it forms "an important link between Śaṅkarites and Śrīvidyā."[23] Neither the *Lalitātriśatī* nor the *LTBh* are referred to by Kashmir authors. Bhāskararāya knows the *Lalitātriśatī*[24] to which he even devotes a short commentary (*nāmaikadeśārtha*) in his *Varivasyārahasya* (2.111-113), but he does not refer to the *LTBh*. For its strong Vedāntic overcoding it has drawn ambivalent reactions even among south Indian initiates, but precisely for this very reason I consider it an interesting document. Its goddess image resembles greatly the one of the *Yoginīhṛdaya*, wherein the absolute (*parā*) aspect of the goddess is stressed, characterizing her as (all-knowing, integral) consciousness (*saṁvid*), incomparably beautiful and the highest bliss.[25] Yet it is revealing that the *LTBh* never uses the term *saṁvid*, but only *cid* (pure objectless), 'consciousness.' It equates the beautiful goddess not only with bliss (*ānanda*), but also frequently with the famous post-Śaṅkara formula *sac-cid-ānanda* (existence-consciousness-bliss) which is never used by Kashmir authors nor by Bhāskararāya. The *LTBh* commentator shares Bhāskararāya's aim of constructing a Veda-Tantra continuum, but the two authors do it in opposite ways: the latter from a Tāntric perspective and the former from a Vedāntic perspective. My major point, however, is that we find not just a transformation of Tantra but also a remarkable transformation and re-interpretation of Advaita Vedānta.

22. The Kāmākṣī temple of Kāñcī belonging to the *maṭha* follows its own Śrīvidyā *pūjā* manual: Durvāsā's *Saubhāgyacintāmaṇi*.

23. D.R. Brooks, *Auspicious Wisdom, op. cit.*, p. 45.

24. He refers several times to this litany as well as to the *ācārya's Saundaryalaharī* in his commentary on the *Lalitāsahasranāma*.

25. A. Padoux, *Coeur, op. cit.*, p. 71.

My initial questions in studying the *LTBh* have been: How do proponents of an entirely a-personal, anti-cosmic system like Śaṅkara's Vedānta deal with a system such as Śrīvidyā, in which a powerful goddess and an elaborate cosmology (represented as sonic cosmogony) are the very basis? What made it acceptable or even necessary for the celibate Śaṅkarācāryas to incorporate a ravishing female absolute into their theology? While the *LTBh* answers much of the first question, an extended contextual approach including empirical data will be necessary to venture an answer to the second question.

The Lalitātriśatī and the Lalitātriśatībhāṣya

The *Lalitātriśatī* litany forms an acrostic of the fifteen-syllabled Śrīvidyā root *mantra*, known as the *kādi*-version, and is therefore supposed to be a powerful *mantra* itself. Each of the fifteen syllables of the three *kūṭa*s (1) *Ka-E-Ī-La-Hrīṁ* (2) *Ha-Sa-Ka-Ha-La-Hrīṁ* (3) *Sa-Ka-La-Hrīṁ* is elaborated by twenty Goddess 'names' beginning with *ka* and continuing through the whole series (Kakārarūpā, Kalyāṇī, Kalyāṇaguṇaśālinī, . . .). Bhāskararāya was interested in this *mantra* part of the three hundred names (twenty times fifteen) and in numerical speculations. The author of the *LTBh* is interested in semantics and aesthetics. In both he elaborates a tendency found already in the litany which is an interesting and hybrid text itself. It reflects Kashmir theology in names such as Ekānandacidākṛti (25), Ekarasā (33) and Samarasā (222), as well as Advaita Vedānta in names such as Sarvavedānta-tātparyabhūmiḥ (224) and Saccidānandā (227). There are clusters of compound names starting with the same initial word that can be read as a compressed form of Śrīvidyā Great Goddess theology.[26] Very suggestive are also the names starting with *Hrīṁ*-: from the second *kūṭa* onwards they are highly poetic (205 ff.), conveying literally the *rasa* (taste) of the exceedingly charming Lalitā Devī.

The *LTBh* author — supposed to be Śaṅkara — hints several times at Indian aesthetics or *rasa* theories and has a pronounced *Hrīṁ*-theology, too. He uses a complicated *kāvya*-like style, which differs much from the lucid style in Śaṅkara's undebated works and yet seems to be programmatic for his aesthetic approach. His major aim is to expound a theology of bliss for which he quotes extensively from the Upaniṣads.[27] His most frequent and favoured terms are *ānanda* (bliss), *saccidānanda* (existence-consciousness-bliss), *upādhi*

26. In the first *kūṭa* (*vāgbhava-kūṭa*: *Ka-E-Ī-La-Hrīṁ*) we find 12 names beginning with *eka* ('one', suggestive of the Goddess's absolute nature and her single-minded worshippers); in the second (*kāmarāja-kūṭa*: *Ha-Sa-Ka-Ha-La-Hrīṁ*) 18 names beginning with *sarva* ('all', suggesting her cosmic nature and functions); and in the third (*śakti-kūṭa*: *Sa-Ka-La-Hrīṁ*) 16 names beginning with *kāmeś(var)a*- (suggestive of Kashmiri *kāmakalā* speculations around Śiva as "Lord (*īśvara*) of desire (*kāma*)" dallying with his Śakti Kāmeśvarī), and finally 19 names with *labdha* ('possessing, attained,' suggestive of her powers and the powers obtained by her worship). Also much of the other names highlight Śrīvidyā ritual, theology and metaphysics.

27. *LTBh* on names 1, 2, 4, 5, 17, 25, 26, 32f., 52, 60, 71, 99, 124, 151, 153, 162, 169, 187, 198f., 207, 227, 229, 278, 279-280. For commentaries related, stating her innate fullness, her being endowed with auspicious attributes, her conferring all possible forms of bliss and final liberation and her *bīja* Hrīṁ as ultimate source of bliss, see *LTBh* on names 3, 9, 58, 133, 144, 175, 179, 185, 211, 212, 216, 222, 240, 247f., 253, 256, 271, 282, 285, 292, 293, 300.

(limiting adjunct) and *tat tvam asi* (that you are). The Vedāntic differentiation between *saguṇa* and *nirguṇa* godhead (with and without attributes) or between imposed and natural quality markers (*taṭastha* and *svarūpa-lakṣaṇa*) is an often-reflected theme. There are some notes on *ajapājapa*, yogic *siddhi*s and *cakra*s (termed 'Yogaśāstra'), but there is little Mantraśāstra. Sonic speculations, Tāntric practises and *kuṇḍalinī yoga* are given little room.[28] Even important Śrīvidyā subjects like the fifteen-syllabled *mantra*, the *śrīyantra*, and the Mārtṛkā are rather casually skipped over and the Nityā and Āvaraṇa goddesses are not touched on at all.[29] The author seems to know little about Tantra,[30] but to be well-trained and versatile in Advaita Vedānta and its post-Śaṅkara sophisticated hermeneutics and scholastic debates.[31] Where Tantra and Kashmir Śaiva subject-matters are treated at all, they are quickly glossed over, given only as short secondary or third meanings, or else later Advaita Vedānta philosophy is superimposed on them.

However, even though Tantra is treated very marginally, it is not as simple as it looks at a first sight. Whereas some passages convey the impression that the author knows Tantra and Śaiva Āgama only by 'catch-words,' others are suggestive that he deliberately does not want to know too much. A closer look reveals an oscillating 'double entendre.' The short allusions to Śaiva-Śākta terminology and symbolism trigger off different associations for different readers. A reader conversant with 'Kashmir Śaivism' will be aware of a much larger semantic field than a Vedāntin whose attention is caught by the Vedānta overcoding.[32] Besides typical Advaita Vedānta terms such as *sat*, *saccidānanda*, *upādhi* and

28. The author tries some mantric morphology in the passages on *Hrīṁ*, all of which sound very like Smārta, e.g., the *H-R-Ī* denoting the *trimūrti*. Sonic cosmology is no theme at all, or else it is strongly Vedāntized like in name 262 where it is said that the Goddess became "by her own limitation of *māyā*" the word and its meaning, understood as the universe of name and form. For *kuṇḍalinī yoga* see name 1 (short mention), 197, 244 (a little longer with reference to 'Yogaśāstra'). Regarding 'Yogaśāstra' and yogic *siddhi*s see also names 28, 34, 47, 68, 71, 89, 188, 218, 299; for *ajapājapa* 142, 161f., 173; for the necessity to be initiated by a *guru* 3, 95, 97, 207, 220.; for a short hint to Kaula practices 36.

29. For all there is, see the short mentions in names 23, 244 (*mātṛkā*); 1, 12, 95-96, 181, 220, 258, 292, 300 (*mūlamantra, kādividyā, pañcadaśī*); 118 (*hādividyā*), 68 (*mudrā*), 46 (*pañcabrahma*), 27, 95, 259 (*śrīcakra*).

30. See for instance the explanations of major terms in name 7, 226 (*kalā*), 39 (*ekavīra*), 118 (*hādividyā*), 195 (*lajjā*), 197 (*kula, lakula*), 218 (*bījas* and linguistics), 244 (yogic *cakra*s), 248-50, 253f. (Kāmeśvara-Kāmeśvarī).

31. Post-Śaṅkaran terms are *saccidānanda, paramānanda* (highest bliss), *anubhava* (experience), *sākṣātkāra* (direct knowledge), *jīvanmukta* (living liberated), *āvaraṇa* and *vikṣepa* ('covering' and 'projecting' power of *māyā* in *LTBh* on name 54), as well as *saguṇa* and *nirguṇa Brahman* (*LTBh* on names 22, 218 a. o.), *mahāvākya* (8, 171, 228), *śravaṇa, manana* and *nididhyāsana* (43, 216). To later Vedānta belong the extensive *tat* and *tvam* discussions (24, 53 a.o.), the highly technical methodology concerning various forms of 'indicators' such as *taṭastha/svarūpa, jahad-ajahad/bhāgatyāga-lakṣaṇa* (24f., 69-72, 127, 173, 218, 262) and denotators of non-dual knowledge such as *sāmānyādhikaraṇa* (224), *vṛttivyāpti* (263) or *akhaṇḍākāravṛtti* (22, 222) as well as the various positions on the ontological status of the world (*pratibimba, pariṇāma, vivartavāda* and so on (22, 23, 34, 198, 203, 233, 249, 288, 292).

32. I realized this 'double entendre' while working with Pandit H.N. Chakravarty: whereas I tended to see merely the Vedāntic meaning and nothing really Tāntric (having previously studied Śaṅkara *bhāṣya*s and Advaita Vedānta treatises with the Vedāntācārya Swami Dayananda Sarasvati, my eyes were trained to see only the Vedāntic part), Panditji spotted a number of Kashmir Śaiva ideas.

māyā, not favoured by Kashmir authors, we find terms never used by Advaita Vedāntins but typical of the non-dualistic Śaivism of Kashmir, such as *samarasa*, 'equal flavour,' and major Kashmiri images such as the union of Śiva (denoting consciousness) and Śakti (denoting bliss).[33] There are a number of passages sounding like Tantra and presenting an osmosis of Tantra and Vedānta, for example: "Just as the same sweetness is running through all portions of sugarcane, the single flavour of *saccidānanda* is there in everything." How much the *LTBh* superimposes Advaita Vedānta on Tantra becomes amply manifest when one compares it with Kashmir Śaiva theology or with Bhāskararāya's *Varivasyārahasya*. Just how much the *LTBh* also changes the Advaita Vedānta through its excessive theology of bliss and its stress on the divine female becomes clear in a comparison with the *Pañcadaśī*.

Aesthetic Theology

The theology of the *LTBh* concentrates on the formula, "bliss absolute (*ānanda, paramānanda*) is the very nature (*svarūpa, svasvarūpa*) of the Goddess." This theme is like a thread running through the whole commentary and amounts to the statement: "she is the *rasa* of non-duality."[34] Being the highest *Brahman* (*Para-Brahman*), she pervades as existence-consciousness-bliss the high and the low equally like sweetness pervades a lump of jaggery; hence she is called Samarasā (222), 'Uniflavoured One.'

Being essentially formless and partless, a form and parts (*kalās*) are attributed to her for the sake of *upāsanā* or meditation (226). Even in her visible image (*mūrti*), Lalitā Devī appears as "condensed happiness" or "solidified bliss" (2-4); her smiling side glance conveys the *rasa* of mercifulness and sweetness (*karuṇa* and *mādhurya rasa*), her ornaments are indicators of the *rasa* of love (*śṛṅgāra rasa*); she has the sixty-four arts as her speech and this speech is exceedingly sweet; just like the pure-minded and the brāhmaṇas, she is fond of sweets; she delights in fine poetry and dance, including the "dance of the ignorant" who are occupied seeking pleasure and avoiding pain in their worldly play.[35] Being the very Self or inner ruler[36] and the non-dual *Brahman* in everything,[37] she is not only an uninvolved witness (*sākṣin*),[38] but very much part of the play: the universe is her manifestation (*sphurti*) and as inseparable from her as a cloth of cotton is inseparable from the cotton thread (139). She takes on a body by her own will, like clarified butter becoming

33. The "one single bliss" in which the Goddess is ever united with Parameśvara/Kāmeśvara is a theme (naturally) often re-appearing, since sixteen names of the litany start with Kāmeśvara (see *LTBh* on names 32-33, 50, 52, 56, 104, 118, 152 and the commentaries on the 'Kāmeśvara' names 243-58); the gloss on name 247 defines Kāmeśvara as the bliss of the realization of *Brahman saccidānanda*.

34. See *LTBh* 199 and the re-statements in 222 and 300 glossed above.

35. See *LTBh* on names 151, 153, 156, 172, 184, 199, 242 as well as 55 (she watches Śiva's dance of creation). The Śrīvidyā's ritual adoption of *rasa* theories is manifold and especially manifests itself in the musical compositions of Muttusvāmī Dīkṣitar.

36. *LTBh* on names 46, 123f., 198, 255 and others.

37. *LTBh* on names 130, 200, 222.

38. This term also belongs to the favourite ones (see glosses on 18, 48, 55, 140 and others).

solid (268). Her power being *māyā*, she creates everything autonomously out of her own desire,[39] deliberately she sustains everything (126) and destroys everything (127), she conceals or deludes,[40] and liberates[41] by her grace[42] and by being that very liberation herself.[43]

Thus she participates in the cosmic play as a "dancer in the theatre hall of *Hrīṁ*." Interpreting name 290 Hrīṁkārasthānanartakī in this way, the commentator states that *Hrīṁ* denotes the Goddess related to *māyā* and unrelated to *māyā*: her assuming purposefully variegated and changing forms *and* her being formless and changeless. Just as theatre and dance induce different degrees of intense delight or dullness due to the differences in the mental make-up of the audience, the Goddess and her activities are perceived differently depending on the degree of purity of mind. The *LTBh* ends with the statement (concerning name 300 Hrīṁkāraparasaukhyadā) that she bestows delight and all human ends to those steadily established in *Hrīṁ-japa*. Also the three gods Brahmā, Viṣṇu and Rudra (*trimūrti*) signified by the three individual *Hrīṁ* letters (of the *mantra* or H-R-Ī) receive the highest pleasure of equal flavour and balanced unification (*sāmarasyasukham ekībhāvānandam*) only from her. Likewise, she is the fruit resulting from the integral state of unbroken (partless) being-consciousness-bliss in which one realizes one's own nature as one with *Brahman* (*akhaṇḍasaccidānandabrahmasvarūpa*).

The Goddess's "uniflavouredness" is the "uniflavouredness" of one's own consciousness when free from the notion of duality. Like the Goddess who enjoys "the dance of the ignorant" (184) or the spectator in the theatre enjoys the play, one can attain an aesthetic experience of reality which transforms reality so that even grief is transmuted into pure delight. One realizes everything as a reflection of consciousness, which remains ever complete and unlimited, just as the sky does not become limited or manifold by its reflections in waterpots (22, 198, 292).

It is noteworthy that it was Abhinavagupta's aesthetic theory which postulated one single, unified flavoured *rasa* encompassing all aesthetic *rasa*s known in the traditional drama theories. In the non-dual merging of experiencer, experienced and experiencing which takes place in intense aesthetic delight, one tastes one's self-own fullness and bliss. Whereas Abhinavagupta thus correlates aesthetic and religious non-dual experience, the *LTBh* restricts aesthetics to spiritual issues. Although the author implies that an aesthetic appreciation of all of reality can be achieved by experiencing the one *rasa* or "unified flavour" of the Goddess/bliss, he carefully avoids any trace of sensualism. Even though he obviously appreciates poetics and fine arts, poetic pictures are in the final analysis but

39. *LTBh* on names 49, 125, 268, 274-76.

40. *LTBh* on names 54, 134, 196.

41. *LTBh* on names 9, 25, 99, 165.

42. *LTBh* on names 150, 153.

43. *LTBh* on names 162, 223, 220, 229.

a limited device to help a limited intellect grasp what is unconveyable by words (159). Accordingly much of the anthromorphic Goddess's names are interpreted allegorically.[44] The bewitching beauty of her body and her sexual inclination, expressed by name 17 Kamravigrahā, is taken to denote the entrancing qualities of Lalitā's image (*mūrti*) such as depth, forbearance and sweetness, and of course her very nature as embodiment of bliss (*ānandasvarūpa*). Like the *Yoginīhṛdaya*, the *LTBh* is primarily interested in the highest form of the Goddess which transcends the bodily level, but in contrast to the early Śrīvidyā text, Kaula rites and images are conspicuously absent.

Vedantization of Tantra

In Kaula Tantra *samarasa* is a technical term for the secret sexual union of male and female. According to the *LTBh*, the "one single taste" or "uniflavouredness" (*samarasa; sāmarasya*) of bliss, which is the most distinguishing characteristic of the Goddess, consists in having realized the intended meaning of the Upaniṣadic "Great Sentences" (*mahāvākya*) "I am *Brahman*" (*aham brahmāsmi*) or "that you are" (*tat tvam asi*). *Samarasa* is "the significance of the words *tat* and *tvam* when purified" from the *upādhi*s or limiting adjuncts, says *LTBh* (23), and *LTBh* (222) expounds the goddess name Samarasā accordingly: in the state of worldly existence it looks as though there are two *rasa*s which are entirely distinct (*bhinnarasavat*): namely omniscience belonging to the Lord (*īśvara*), denoted by *tat*, and partial knowledge belonging to the human individual (*jīva*), denoted by *tvam*. The Goddess is the common *rasa* of both. As such she is realized when, listening to the *mahāvākya*, an unbroken mental state (*akhaṇḍākāravṛtti*) occurs which is completely permeated (*vyāpta*) by the direct experience "I am *Brahman*." As uniflavoured unbroken taste being one's own consciousness-bliss, the Goddess pervades the Lord and the individual equally as a single *rasa*. She is the presiding deity of both (53):

> Īśādhidevatā: Īśa (=Īśvara), the Lord, implies here *jīva*, the individual, too. The Lord is signified by the word *tat*, having *māyā* as a limiting adjunct. Above (*adhi*) [transcending this qualified existence], abandoning these two characteristics there is the highest deity, luminously shining. This means: She is nothing but immutable consciousness (*cinmātra*), the real substance of the words *tat* and *tvam* being purified [from their limiting adjuncts].[45]

Experiencing her in "the form of one single bliss-consciousness," Ekānandacidākṛti (name 25), means liberation while living. In commenting on this name, the *LTBh* mixes Kashmir Śaiva and Vedānta vocabulary and philosophy:

44. Name 14 (Karpūravīṭisaurabhyakallolitakakuptaṭā) literally alluding to the Goddess chewing betel mixed with camphor, the fragrance of which floods the directions (an idea also found in the *Saundaryalaharī*), is taken to mean her sovereign might in ruling the universe; her bright red colour resembling *japā* flowers (name 155: Kāntidhūtajapāvalī) signifies her merely transcendental and utterly incomparable nature as blissful, illuminating consciousness; her arms being like the wish-fulfilling creeper (159: Kalpavallīsamabhujā) means that she has the power to grant desires according to past deeds.

45. *īśasyety upalakṣaṇaṁ jīvasyāpi īśasya tatpadavācyārthasya māyopādhikasya viśiṣṭasya adhi upari viśeṣaṇadvayasya parityāge devatā dyotamānā kūṭasthacinmātraśodhitatattvaṁ padārtharūpety arthaḥ |*

ekā, the one (f.) or most to be desired in form of liberation [is] *ānanda*, 'bliss', [denoting] happiness [and] *cid*, 'consciousness' [denoting] illuminative knowledge (*prakāśajñāna*). This bliss is consciousness. The blissful consciousness is one. This blissful consciousness is her form (*ākṛti*), her intrinsic own nature (*svarūpa*) and hence she is called 'She whose form is the one single bliss-consciousness.' She is thus characterised by existence, consciousness and bliss (*saccidānanda*) which are the nature of *Brahman* . . . [quotations from Bṛhadāraṇyaka Upaniṣad 3.9.28.7; Taittirīya Upaniṣad 3.6.1; Brahmasūtra 3.3.11]. . . . The innate nature of highest bliss is pure luminosity, characterised by illuminating (awareness) (*prakāśātmaka*). As such she is [experienced] by the possessor of the knowledge of the highest self in the state of liberation while living, or, she is in the form of the experience of that person as a direct perception.

Or [interpreted in another way]: some (rare) ones (*ekeṣāṁ*), the experiencers, the Yogis [taste] bliss directly, which is the goddess's own form and unveiled light (*nirāvaraṇaprakāśa*).

Or [interpreted in another way]: bliss is the consort of Śiva (Śakti); consciousness is Parameśvara [Śiva]. The two being one (*eka*), without difference of representation (*mūrtibhedarahite*), she has the form (*ākṛti*) of this [formless] blissful consciousness (*ānandacitau*).

Unto [this] Ekānandacidākṛti my salutations.[46]

In 'Kashmir Śaivism,' *samarasa* (*sāmarasya*) is closely related to Śakti. Śakti is Śiva's pulsating (self) reflecting awareness (*vimarśa*) and bliss (signified by the second letter *ā*), while Śiva is pure illumination (*prakāśa*) or consciousness, the supreme form of speech (signified by the first letter of the alphabet *a*). Creation of the universe (the alphabet solidified) is merely an externalization or self-manifestation of the internal dynamism ever-present in the divine I. It is typical that the *LTBh* commentator does not adopt the term *vimarśa*, but only *prakāśa*, relating it immediately to *sat* (existence) or *saccidānanda* (existence-consciousness-bliss). In (post-Śaṅkara) Advaita Vedānta, *saccidānanda* is the principal formula denoting the essential attributes (*svarūpa-lakṣaṇa/ā*) of *Brahman*,[47] whereas cosmological statements such as "that from which the universe springs forth" are considered indirect and unessential attributions

46. *ekānandacidākṛtiḥ | ekā mukhyā mokṣarūpatvena prāpitsitā | ānandaḥ sukham | cit caitanyaṁ prakāśajñānam | ānandaś cāsau cic ca ānandacit ekā cāsāv ānandacic ca ekānandacit ākṛtiḥ svarūpaṁ yasyāḥ sā | saccidānanda-brahmarūpalakṣaṇavatīty arthaḥ | 'vijñānam ānandaḥ brahma' 'ānando brahmeti vyajānāt' iti śruteḥ 'ānandādayaḥ pradhānasya' iti nyāyāc ca dīptisvarūpaprakāśātmakaparamānandasvarūpasya jīvanmuktyavasthāyāṁ paramātmajñānavatpuruṣānubhavarūpapratyakṣapramāṇagocaratvam asyā iti vā tathā | athavā ekeṣāṁ anubhāvikānāṁ yoginām ānandasākṣātkārarūpā ākṛtiḥ nirāvaraṇaprakāśarūpā yasyāḥ sā tathā | athavā ānandaḥ śivā cit parameśvaraḥ eke mūrtibhedarahite ānandacitau ākṛtir yasyāḥ sā tathā || oṁ ekānandacidākṛtaye namaḥ ||*

47. The name 227 Saccidānanda is defined in consonance with the Pūrva-Mīmāṁsā hermeneutics along with quotations from *Taittirīya Upaniṣad* as: "She is *sat*, *saccid*, and at the same time *ānanda*. *Sat* denotes that which is not negated by time; *cid* is self-luminous light; *ānanda* means utter delight . . . [various Upaniṣad quotations]. . . . They are the very nature of her, i.e. she is described by the characteristics of *svarūpa-lakṣaṇa* of *Brahman* as given by the Vedānta." The historical Śaṅkara did not yet use the formula *saccidānanda*. He preferred primarily *cit* along with *sat*, but did not have much to say about *ānanda*.

(*taṭastha-lakṣaṇa/ā*). It is characteristic of the *LTBh* that it glides constantly from 'bliss' and 'consciousness-bliss' to 'existence-consciousness-bliss.' While defining Śiva as consciousness and Śiva's spouse as bliss, Kashmir Śaiva imagery is used without quoting a source, whereas another gloss introduces the same imagery with the term *saccidānanda*, quoting a Smṛti:

> She is the limb and also half of the Lord (*īśvara*) whose nature is existence-consciousness-bliss and who is Śiva. The very nature of her body is blissfulness. She has this innate characteristic just like a body. 'Śiva is of the nature of existence and consciousness; his consort (Śivā) is directly composed of blissfulness' thus the Smṛti. . . . Or: the half portion of the Lord, namely of the letter 'Ha' is the *śaktibīja*. This is her form, her body consisting of *mantras*.[48]

In his typical way the commentator hints very briefly and rather ambiguously at a *mantra* issue. It is noteworthy that in Abhinavagupta's *Parātrīśikā* and in Jayaratha's *Tantrāloka* commentary the letter *Ha* signifies not only the condensed *visarga* (*ḥa* signifying the saturated bliss out of which the universe bursts forth), but also the spontaneous, utterly blissful cry of the female ritual partner in Tāntric sexual rites. The *LTBh* calls the letter *Ha śaktibīja* (seed (syllable) of Śakti). The author seems to refer to *Hrīṃ* (*ha + rī + bindu*), otherwise called *māyābīja*,[49] and to allude to the contention that *Hrīṃ* is made up of Śiva and Śakti letters.[50] It may also be noted that *Hrīṃ* does not play a major role in Kashmir Śaivism[51] or the *Yoginīhṛdaya*, whereas it is essential for later Śrīvidyā authors. Bhāskararāya speaks of *Hrīṃ* as *śaktibīja*, too. The term appears in his *mahāvākyārtha* of the root *mantra*. His treatment of the non-dual identity of the human self (*jīva*) and the absolute (*Brahman*) exposed by the Upaniṣadic *mahāvākya*s contrasts the *LTBh* in a revealing way:

> Although the letters *Ka*, *E* and *A* signify Brahmā, Viṣṇu and Rudra, they are to be understood in their secondary sense of Creation, Preservation and Destruction, which are the respective functions of those [Deities]. *Ī* signifies Īśvara and *Ḍa* implies Sadāśiva.[52] By these two [letters] are to be understood,

48. *LTBh* on Name 52 Īśvarārdhāṅgaśarīrā ("Her body is half and limb of Īśvara"): *īśvarasya saccidānandātmakasya śivasya ardhaṃ ca tat aṅgaṃ ca ardhāṅgam | ānandasvarūpatā śarīraṃ śarīravatsvarūpalakṣaṇaṃ yasyāḥ sā tathā | 'saccinmayaḥ śivaḥ sākṣāt tasyānandamayī śivā' iti smṛteḥ | athavā īśvarasyārdhāṅgaṃ vāmabhāgaḥ śarīraṃ mūrtir yasyāḥ sā | athavā īśvarasya hakārasya ardhāṅgaṃ śaktibījaṃ śarīraṃ mantrātmikā mūrtir yasyāḥ sā tathā | oṃ īśvarārdhāṅgaśarīrāyai namaḥ ||*

49. *LTBh* on names 203, 210, 293.

50. Verses 9-10 of the *phalaśruti* of the *Lalitātriśatī* state that the three *Ka* and the two *Ha* of the fifteen-syllabled *mantra* constitute the Śiva letters, while the *Hrīṃ* indicates the composite nature of Śiva and Śakti, and the rest of the letters (*E-Ī-La Sa La Sa La*) denote Śakti alone. The same idea is found in Lakṣmīdhara's commentary to *Saundaryalaharī* 32.

51. In the non-dualistic Śaivism of Kashmir the single seed-syllables *Sauḥ* and *Phaṭ* play a considerable role, whereas *Hrīṃ* is not a basal *mantra*. In the South *Hrīṃ* is known as "Gaurī-*mantra*" as well as *māyābīja*.

52. This is a further elaboration of *Varivasyārahasya* 2.134-136 which refers to the *saguṇārtha*: The fifteen seed syllables contain, according to this interpretation, the entire Veda — its ritualistic and its gnostic parts, the latter being indicated by the seed *Hrīṃ*. *Hrīṃ* denotes in this reading the (neuter, genderless) *Brahman* of the Upaniṣads, "praised" (*ī-la=īḷe*) in the three Vedas (three parts of the *mantra*) by the three great personal gods Brahmā, Viṣṇu and Rudra-Śiva (*ka-e*) who form the *trimūrti*.

secondarily, concealing (*tirodhāna*) and blessing (*anugraha*), the respective functions [of those two Deities]. *Ha Sa* is bliss, *Ka* is truth, *Ha* is infinity and *La* is knowledge. Having ascertained in this manner, the *Brahman*, through its Taṭastha- and Svarūpa-lakṣaṇas [indirect and direct qualities], [the *mantra*] establishes the identity [of the *Brahman*] with the Jīva-s by the third Group [in the following manner]: The term *Sa Ka La* refers to Jīva, as the latter has three Kalā-s: Jāgrat, Svapna and Suṣupti [waking, dream and deep-sleep]. *Hrīṁ*, the Śakti-bīja, denotes the *Brahman*. As there is apposition (*sāmānādhikaraṇya*) between the two, the pure things implied by them are identical.[53]

Bhāskararāya's *mahāvākyārtha* exposition is Mantraśāstra, but at the same time a hybrid text: He adopts Mantraśāstra methods (exegesis of the *mantra* phonemes) and Āgamic ideas (five-fold functions of Śiva, *tirodhāna* and *anugraha*) as well as Mīmāṁsā methods and technical terms of Advaita Vedānta authors (*taṭastha/svarūpa-lakṣaṇa*, three states, *sāmānādhikaraṇya*) to convey the state of non-duality which is placed in a cosmological context. It is typical of the *LTBh* author on the other hand, that his *mahāvākya* expositions are completely acosmic and very Vedāntic. In some of his cosmological statements, however, he definitely draws from Tantra and presents a hybrid osmosis of Vedānta and Śaiva-Śākta similar to Bhāskararāya. The gloss on name 54 Īśvarapreraṇākarī says that by being consciousness reflected in Īśvara (*īśvarasya bimbacaitanyasya svarūpā satī*), the Goddess sets the creation of the world in motion and commands all cosmic acts. By means of the powers will, knowledge and activity (*icchā-jñāna-kriyā-śakti* = the major powers of the Tāntric Śrīvidyā Goddess), the powers of veiling and projecting (*āvaraṇa and vikṣepa* = the powers of *māyā* according to post-Śaṅkara Vedānta) come into being and the Goddess assumes the form of reflected consciousness as her own. From the code words *āvaraṇa* and *vikṣepa*, we get on the one hand a completely Vedāntized and inverted re-interpretation of the Kashmir Śaiva symbolism of light (*prakāśa*) and reflection (*vimarśa*), or Śiva and Śakti, but also a transformation of Bhāskararāya's concealing (*tirodhāna*) and blessing (*anugraha*), on the other.

It is particularly noteworthy that both Bhāskararāya and the *LTBh* author take the synthetic syllable *Hrīṁ* to denote *Brahman*. Unlike Bhāskararāya, the *LTBh* calls *Hrīṁ māyābīja*[54] because it represents consciousness limited by *māyā*, but at the same time it postulates that *Hrīṁ* denotes and reveals the highest *Brahman* of the Veda and the ultimate human aim: *cidānanda/saccidānanda*.[55] The whole *mantra*, but particularly *Hrīṁ*, discloses the "ultimate awareness" (*paracaitanya*) which is "ultimate bliss" (*paramānandarūpa*) and Lalitā-Tripurasundarī's non-dual form as *saccidānanda* pervading everything as "inner ruler" and shining as the one Self in the world as "one and many," like the one moon reflected in the water of various vessels (292). To explain the relationship between the Goddess and the world, the *LTBh* draws from several theories dealing with the problem

53. *Varivasyārahasya* 2.141-145, transl. S. Subrahmanya Sastri, *op. cit.*, pp. 112f., 116.

54. See *LTBh* on names 84, 203, 210, 293 and others.

55. *LTBh* on names 89f., 98, 204f., 212, 286.

of one and many debated in the Śaṅkara school.[56] Its final position seems to be the Vivartavāda (203), but the Pratibimbavāda, or 'reflection theory,' of the Bhāmatī school plays a more crucial role, and the illustration of the water pot is used several times to show how the one consciousness (*ātmacaitanya, paracaitanya*) appears as though limited in the manifold existent beings from big elephants to little bugs (198).

Both Bhāskararāya and the *LTBh* author conceive the non-dual state of identity as the "single taste" of consciousness-bliss. In various passages of *Varivasyārahasya*, chap. 2, the idea returns that the *śaktibīja Hrīṁ* signifies (*Para-*) *Brahman* and the "single flavouredness" (*sāmarasya*) of consciousness-bliss.[57] However, the *LTBh* author reads the *samarasa* viewed through Śaṅkara and post-Śaṅkara *tat tvam asi* and *saccidānanda* hermeneutics, whereas Bhāskararāya conceives it to be rather like Kashmir Śaivism. The *LTBh* has an ambivalent attitude towards the love play of God and Goddess and its product, the world. In the gloss 164 it goes as far as saying that the breasts of the Goddess entice Śiva/Parameśvara to forget his own overlordship (*īśvaratva*), fulfilment (*āptakāmatva*) and eternal satisfaction (*nityatṛptattva*). Engrossed in her breasts, he is subjected to ignorance (*avidyā*) and looses his divine attributes by becoming the universe. According to gloss 253, she "deludes" herself by assuming a body of "we both husband and wife." Delusion (*moha*) is explained here in two ways: as seeing difference and as steady and total absorption due to the vision of the highest deity which is of the nature of supreme delight. Again, other passages are pure Advaita Vedānta: creation is but an imposed function and an accidental, indirect attribute (*taṭasthalakṣaṇa*) of the divine absolute; its real, natural characteristic (*svarūpalakṣaṇa*) is nothing but existence-consciousness-bliss.

The number of opposite responses suggest that *Varivasyārahasya* and *LTBh* react to each other. It is hard to decide which text was first, but the *LTBh can* be read as a reverse discourse of Bhāskararāya's *mahātattvārtha* and *mahāvākyārtha*, and in a limited sense even of the *sāmarasyārtha*. It replaces non-dual Kashmir Śaivism with non-dual Vedānta, the common denominator being self-luminosity and bliss. In the *LTBh*, the cosmogonic play becomes anti-cosmic delight; the merger with Śiva as the all-knowing (*saṁvid*) I being one with the world, appears as world-transcending non-dual knowledge of *tat* and *tvam*; the aesthetic delight is restricted to a spiritual level; the sexual merger is just one metaphor among others; instead of intoxication and rapture one seeks mind control and inner satisfaction. According to the *LTBh*, direct perception of the Goddess presupposes a controlled mind and body (*sādhanacatuṣṭaya*), and is attained by external and internal worship (*karma* and *upāsanā*) and listening to the Upaniṣadic *mahāvākyas* (228), their reflection and contemplation (*śravaṇa, manana, nididhyāsana*, 28). Worship encompasses *japa* of the Śrīvidyā Mantra and the single syllable *Hrīṁ*, as well as *yoga* and devotional acts such as hearing

56. Vivarta (203, 249), Pratibimba (22, 23, 198, 288, 292), Pariṇāma (rejected in 203, accepted in 209, discussed in 233), Satkārya (84) and Satkāraṇavāda (225).

57. *Varivasyārahasya* 2.119-120 ("the meaning of *Hrīṁ* is *Para-Brahman*, the result of the concord of Śiva and Śakti"), 2.134-136, 2.143-147.

the Goddess' glories and singing her praise (15, 124); the highest form of *bhakti* is to see her as one's own self (192). The primary form of devotion is the meditation of the non-difference of pure (utterly blissful) consciousness which negates an endowment with qualities (3, 5).

As in their metaphysics, the *LTBh* and *Varivasyārahasya* reflect significant differences in ritual practice, although both texts present a distinct *Hrīṁ* theology and regard *Hrīṁ* as a very special ritual device. In *Varivasyārahasya*, chap. 1, devoted to cosmological speculations and *yoga* aspects of the *mantra*, Bhāskararāya presents *Hrīṁ* as the most direct door to transcendental wisdom (1.49-51): by tracing its concrete sound back to the unstruck sound and cosmic consciousness which contains the universe in an extremely compressed form, one attains a sensual and bodily experience of eternity. Such contemplations (*bhāvanā*) on the *mantra* sounds are entirely missing in the *LTBh*, although *Hrīṁ* is termed the "most eminent seed" of Śrīvidyā (204: *śrīvidyārājabīja*) and regarded as different from other letters (287) owing to its "incomparable supremacy" (*niratiśayamahimnā*). The Goddess being *Brahman*[58] is *nirguṇa* (without attributes) as well as *saguṇa* (having attributes), and in both ways she can be meditated upon by the means of *Hrīṁ*.[59] *Hrīṁ-japa* and contemplation (*upāsanā*) confer the nectar of ultimate bliss.[60] The ritual is purely gnostic:

> Listening (*śravaṇa*) to the meaning of *Hrīṁ-bīja*, meditating on it (*manana*) and being absorbed in it (*nididhyāsana*) — by such constant practice making [the Goddess] a direct perception in form of self-evident light and bliss (*prakāśānanda*), she exalts her servants in all [respects].[61]

This is a completely Vedāntized way of speaking about *Hrīṁ-japa*. However, it is definitely not pure Advaita Vedānta. *Hrīṁ* replaces the *tat tvam asi* formula, and what is equally important is that it also confers powers — a very Tāntric idea. There is of course a non-Tāntric limit to it: whereas in Tantra the *mantra is* the deity by its powerful sonic character, the *LTBh* situates *Hrīṁ* in a scholarly discussion on signifier (*vācaka*) and signified (*vācya*).[62]

One of the most hybrid passages is gloss 23, commenting on the name Ekānekākṣarākṛtiḥ, "She is in the form of one and many syllables." It refers first to *māyā* who was defined in 22 (Ekākṣarī) as "most eminent" for being the *upādhi* of the Lord, and lastly to the Śrīvidyā *mantra*:

> The one (*eka*) indestructible (*akṣara*) [*māyā* without beginning and "indestructible" until the dawn of self-knowledge] denotes the ignorance (*ajñāna*) [consisting of] the predominance of pure light and intelligence (*śuddhasattva*) which is the limiting adjunct reflected (*pratibimba*) in the Lord (*īśvara*). The many (*aneka*) indestructibles denote the many forms of ignorance

58. *LTBh* on names 130, 200, 222.

59. *LTBh* on names 98, 204, 218.

60. *LTBh* on names 99, 206f., 211, 213, 292f.

61. *hrīṁkārabījārthaśravaṇamanananidhyāsananirantarābhyāsād aparokṣīkṛtasvayaṁprakāśānandarūpā satī svasevakān sarvotkarṣayatīti . . .* (*LTBh* on name 216).

62. Most *LTBh* passages on the *Hrīṁ*-names reflect this difference.

[consisting of] the predominance of impure light and intelligence which are the limiting adjuncts reflected in the individual beings (*jīva*) . . . [quotations from *Nṛ. T. Up.* 9 and *Śv. Up.* 4.10] . . . In them there are the forms (*ākṛti*) being particularised reflections of consciousness just like the [unlimited] sky is reflected and particularised by the [limited] water in the jar. She is that [awareness which appears as many forms].

. . . Or [interpreting it in another way]: 'e' and 'ka' (*eka*) — these two and the many (*aneka*) other letters (*akṣara*), joining all together, constitute the fifteen-syllabled root *mantra* (*mūlavidyā*). Her very own form (*ākṛti*) is that [root *mantra*]. By being a witness, having become one (*ekībhūtā*) whose [single] form (*ākṛti*) abides in many syllables (*anekākṣara*) and in many kinds of ignorance (*anekājñāna*) — as such is she whose own self has the nature of uniflavouredness which is the significance of the words *tat* (that) and *tvam* (you) when purified [from the ignorance or *upādhis*].[63]

The commentator acknowledges the *mantra* as the Goddess's very own form, but by paralleling its many syllables with the many forms of ignorance, the *mantra* is implicitly placed in the sphere of *māyā*. His final (Vedānta inspired) position is that the Goddess, whose nature is "uniflavouredness" (*sāmarasyātmaka*), is present as a uniform witness (*sākṣin*) in the *mantra* and in the world.

Tāntrization of Vedānta

Bliss has always been a major term in non-dual Tantra. Possibly under the growing influence and popularity of a 'brāhmaṇized' Tantra among Smārtas,[64] the Śaṅkara tradition started to emphasize bliss as important term, too. It is noteworthy that all the *LTBh*'s conversions of Tantra into Advaita Vedānta only radicalize a tendency of the later Śaṅkara tradition in which the Taittirīya formula *satyaṁ jñānam anantam* (true being, knowledge, infinity) is transmuted into the formula *saccidānanda*. With this formula, not yet used by Śaṅkara, "bliss" became a major term in well-known Vedānta treatises such as *Dṛg-Dṛśya-Viveka* or *Pañcadaśī*, which characterize the blissful non-dual knowledge as "unbroken singular flavour" (*akhaṇḍaikarasa*).[65] The intellectual

63. I am giving the full gloss below, since it also mentions briefly the Mātṛkā without, however, going into Tāntric ritual, *mātṛkānyāsa*, and the sonic cosmology connected with them: *ekānekākṣarākṛtiḥ | ekam īśvarapratibimbopādhitayā śuddhasattvapradhānam akṣaram ajñānam | anekāni malinasattvapradhānatayā jīvopādhibhūtāny akṣarāṇi ajñānāni 'māyā cāvidyā ca svayam eva bhavati' iti śruteḥ | ekam cānekāni ca ekānekāni tāni ca akṣarāṇi ca tāni tathā 'māyāṁ tu prakṛtim' iti śruteḥ | teṣu ākṛtayaḥ pratibimbāny avacchinnāni vā caitanyāni ghaṭasthodakāvacchinnapratibimbatākaśavad yasyāḥ sā tayā | athavā ekāni ca praṇavādyāni anekāni ca akārādik- ṣakārāntāni akṣarāṇi varṇāḥ ākṛtiḥ svarūpaṁ yasyāḥ sā mātṛkāsvarūpatvena vā 'akārādikṣakārāntā mātṛkety abhidhīyate' iti vacanāt | athavā e ca ka śca ekārakakārau tau cetarāṇy anekākṣarāṇi ca sarvaṁ militvā pañcadaśavarṇātmikā mūlavidyā ākṛtiḥ svarūpaṁ yasyāḥ sā | sākṣitayā ekībhūtā anekākṣareṣu anekājñāneṣu ākṛtiḥ svarūpaṁ śodhitatattvampadārthasāmarasyātmakaṁ yasyāḥ sā tathā || ekānekākṣarākṛtaye namaḥ ||*

64. Most of the *mantra* compilations of later Tantra are Smārta-oriented.

65. See *Dṛg-Dṛśya-Viveka* (particularly verses 14, 21f., 25, 26, 28, 29f.), in which the formula *saccidānanda* (as common determiner of everything existing) and the absorption in one's self-own bliss plays a decisive role. The *akhaṇḍaikarasa* of this non-dual, direct experience is the highest goal. *Ānanda* is defined in a →

background of the *LTBh* author is undoubtedly later Advaita Vedānta and its scholastic hermeneutics and debates. His *tat tvam asi* discussions presuppose Sadānanda's *Vedāntasāra*. Given these facts, there is nothing original in the commentary, yet it is innovative and unique. I am not aware of an equally strong emphasis on *ānanda* in other Advaita Vedānta texts. Not even the *Pañcadaśī's* five chapters on bliss express a similar theology and ideological framework, for they conceive bliss as devise for "dull" (*manda*) seekers who are not competent for rigorous study and discrimination (12.90). The *LTBh* associates *saguṇa-upāsanā* with less competent seekers, but never bliss. There is still a more important difference: its feminization of bliss. None of the Advaita Vedānta treatises would visualize bliss as a female absolute and the consort of Parameśvara. This difference is also reflected in the term *samarasa* used instead of the *akhaṇḍaikarasa* in the Vedāntic texts. The *LTBh* is not only a Vedantization of Tantra, but also a Tantrization of Vedānta.

The Great Goddess of the *LTBh* is first and foremost a metonym of bliss and liberating knowledge. Her proper name 'Lalitā' hardly appears, and also the term 'Śakti' is rarely used. Specialists on non-dual Tantra and Kashmir Śaivism will object that this Goddess image represents an empty bliss and not a real *ānanda* at all. *Ānanda* in their eyes is the I resting in its own fullness, without inside-outside boundaries, the complete merger of knower, known and knowing, and at the same time a dynamic throbbing full of energy, creativity and life. Their *ānanda* is like an ocean, containing all powers, including the power of consciousness. Power is the most decisive term. Non-dual experience means taking Śiva's form and participating in his autonomy, his energetic fullness and limitless power(s) which Śakti embodies. Knowledge is not the Vedāntic non-dual objectless awareness of the ever attributeless *Brahman*, but *saṁvid*, the 'integral vision' and complete fusion with the world. It is revealing that the *Yoginīhṛdaya* uses the terms *cid-ānanda* and *saṁvit-paramānanda* interchangeably. It may be objected from a Śaiva perspective that in the *LTBh* the Goddess and her names are reduced to *tat tvam asi*. Her power is thus no power at all, but a mere appearance. Instead of being Śakti, she is moulded by *māyā* — a term despised in Śaiva Tantra. The Advaita Vedāntins give poisoned sweetness by presenting an 'atheist,' impersonal, abstract doctrine and a powerless Goddess. Everything but *ānanda* or *saccidānanda* is an illusion.

Such reproaches touch on important differences. However, they do not do full justice to the *LTBh*. *Ānanda* means very much realizing the Self resting in its own fullness, the goddess is not at all powerless or a mere abstraction, the world is not seen as mere illusion and even the endowment with divine powers is not lacking completely. Besides constructing a Veda-Tantra continuum, one of the major aims is a refutation of atheist

→ very orthodox way as the *priyam* (the "loveable" aspect existing in all things). The *Pañcadaśī* devotes
 its last five chapters (11-15) to the term 'bliss' ("bliss of *Brahman*," "bliss of the self," "bliss of non-
 duality," "bliss of knowledge" and "bliss of objects"). For the term *akhaṇḍaikarasa* see 11.82, 11.96,
 11.124 (*ānandāsvāda*), 15.2, 15.31; for the self being pure illumination, absolute bliss and consciousness-
 bliss see 12.58 (*svaprakāśacidātmaka*), 12.72, 12.80, 15.2 (*paramānanda*), 12.76 (*cidānanda*).

doctrines and an apology for a theist perspective, as I am going to show. It is revealing to compare the *LTBh* with the *Pañcadaśī*: there we find the classical statement that *Brahman* is *saccidānanda* and the world mere *nāma-rūpa*, made up of "names and forms" (13.62) which have no real existence, being products of unreal, yet powerful *māyā*. Experiencing the fullness of *saccidānanda*, one ignores automatically name and form (13.80, 13.92, 13.103), and the more one ignores name and form and realizes that the world is unreal (*mithyā*), the more one experiences one's self-own bliss and the unbroken, non-dual flavour of *Brahman* (13.81, 13.105). *Māyā* is described as a mighty power (13.89f. *et al.*), but also as an illusion or jugglery, *(a)indrajāla* (13.10, 13.37). Non-existence (*asattā*), inertness (*jāḍya*) and misery (*duḥkha*) are her major characteristics (15.23). The author of the *LTBh* would hardly say a thing like that. He does not use the term *indrajāla*, although he often speaks of *māyā*. How could he not do so as a good Advaita Vedāntin? The selective way, however, by which he draws from Tantra *as well as* from Vedānta, leads to a transformation of both. His treatment of *māyā* resembles positive passages on *māyā* in the *Pañcadaśī* such as the following (13.13 and 13.15):

> Sages perceived that the self-luminous power [of *Brahman*] is concealed by its own qualities. The Supreme Power [of *Brahman*] is manifold, having the nature of activity, knowledge and strength. . . . 'With whatever power he sports, that [power] becomes his manifestation. O Rāma, the power of *Brahman* being consciousness is felt in the bodies [of all beings].[66]

Replace 'he' with 'she' and you get a major feature of the Goddess in the *LTBh*. She is not the pulsating power of Śiva, but she is not derogative illusionary *māyā* either. She is rather *Brahman* in a feminine form, with and without attributes, efficient and material cause at once. *Māyā* refers to ignorance and limiting adjuncts, but also to divine, autonomous creativity. The relationship between the Goddess and *māyā* is intriguingly complex: the Goddess is *māyā*, possesses *māyā*, has the attribute of *māyā*, manifests herself through *māyā* and is (deliberately) limited by *māyā*;[67] *māyā* is attributed to her (290); she is the basis of *māyā* and of the world, controlling *māyā* and wielding the cosmic functions;[68] she destroys the sinful products of *māyā* and dispels ignorance (31, 45); she is free of and beyond *māyā*.[69] The Goddess is thus herself the principle of plurality and limitation, and affected by it, in so far as everything existing and changing is her limited manifestation, but on the other hand she is also *saccidānanda*, and by her very own nature the changeless basis of *māyā* and beyond *māyā*. The major thesis seems to be summarized in the gloss of the "dancer in the theatre hall of *Hrīṁ*" (290). Combining in the Goddess image *saccidānanda Brahman* and productive *māyā*, the author re-constructs the powerful Śakti image of Śaiva-Śākta

66. *devātmaśaktiṁ svaguṇaiḥ nigūḍhāṁ munayo'vidan | parā'sya śaktiḥ vividhā kriyājñānabalātmikā ‖ yayollasati śaktyā'sau prakāśaṁ adhigacchati | cicchaktiḥ brahmaṇo rāma śarīreṣūpalabhyate ‖*

67. *LTBh* on names 22f., 33, 45, 84, 196-98, 203, 209-10, 262, 268.

68. *LTBh* on names 54, 69, 140, 183, 197, 210.

69. *LTBh* on names 40, 53, 137, 161, 210, 238, 290.

literature from an Advaita Vedānta perspective. By introducing the Goddess who integrates *Brahman* and *māyā* he goes a vast step beyond the *Pañcadaśī* and comes to a more positive appreciation of *māyā* and the world without ever losing sight of Advaita Vedānta essentials.

The Goddess of the *LTBh* is not powerless. She is the very pinnacle of all powers by possessing omniscience, ultimate lordship and all glories (gloss on 269 Labdhaiśvaryasamunnatiḥ). Her primary power is the knowledge of *Brahman* (*brahmavidyā*) or the "greatness of attainment of all glories without any limitations (*nirupādhika*)" (269). Due to *māyā* she has also cosmic power. *Māyā* positively re-stated is the all-knowing and omnipotent Lord (*īśvara*) as well as the great *trimūrti* (Brahmā, Viṣṇu, Rudra-Śiva) whose cosmic functions she controls by being their inherent nature.[70] Completely at variance with the *Pañcadaśī*, but recalling Śaiva-Śākta Tantra, according to the *LTBh* the Goddess is the cause of creation and destruction by projecting in herself the difference between male and female (*strīpuruṣātmanā kalpitabhedavaśāt*, 250). The Goddess becoming dual in the form of man and woman (husband and wife, God and Goddess) is a recurring theme.[71] The image is inspired by the south Indian iconology of Śiva-Ardhanārīśvara ('half man, half woman'), and infuses Advaita Vedānta concepts (projection theory) to unfold an Ardhanārīśvara theology which is yet another piece of Vedantization of Tantra and Tantrization of Vedānta. This theology may be expressed in Śaiva terms (the Goddess is half of Parameśvara's body) or in Śākta terms (the Goddess being ever united with the God is the divine androgyne), the final position being clearly Vedāntic: she projects herself into a dual form, remaining ever-fullness and absolute consciousness, her true nature being beyond gender. The commentator uses the Ardhanārīśvara image to explain his hermeneutics and a theology of *ca* ("and"): precisely because there are really no gender differences, one may use all (grammatical) genders, be they feminine, masculine or neuter, to refer to the highest reality, the intended meaning remaining the same (22). Without this hermeneutic key in mind, the *LTBh* is confusing, since most glosses vacillate between 'she' and 'it' (or even 'he'[72]), so that it is never clear whether the text is speaking of the Goddess or *Brahman*. The commentator thus establishes on a narrative level, too, what he communicates on a cognitive level: Goddess and *Brahman* are non-different. He hardly ever uses the personal name Lalitā-Tripurasundarī, but prefers the impersonal term Paradevatā ('highest deity').

Why should there be a Goddess at all and why the form of the Śrīvidyā goddess? These questions lead to another major point, the personal dimension, one of extreme importance, too. The author of the *LTBh* does not only stress the *nirguṇa*, but also the *saguṇa* goddess form. It should be noted that he interprets only some of the

70. *LTBh* on names 50, 92, 153, 239, 300.

71. *LTBh* on names 22, 32f., 52, 250, 253, 268, 277.

72. If characterized as "pinnacle of all powers" (269), she is often referred to as "he." "He" generally denotes Īśvara and Parameśvara, but also Śiva (1) and Viṣṇu-Nārāyaṇa (298) merging with whom one gains infinite powers and the final end of ultimate bliss.

anthropomorphic names allegorically, and takes others in their plain literal sense. This mixture seems to be deliberate and programmatic, parallellizing femininity, graciousness and bliss. The major emphasis is on the Goddess' exquisitely beautiful physical features,[73] to which also the definition of the name Lalitā, "Beauty of the Three (Worlds)" (*lalitaṁ triṣu sundaram*) alludes (62). Her extremely enchanting bodily form equals Kṛṣṇa, her male counterpart (154, 176), and puts to shame the brilliantly red Japā flowers (155). The emerging Great Goddess theology resembles strongly the one of the *Saundaryalaharī* ("Flood of Beauty"),[74] but also recalls south Indian Navarātri ritual and mythology[75] and the value system of Brāhmaṇic wifehood.[76] The theological rationale for stressing a real physical body with head and hands (6, 153) is discussed several times: the Goddess's bodily softness and beauty are "bliss solidified" (*ānandaghana*) to facilitate meditation (*saguṇa-upāsanā*) and the experience of her *rasa* (4, 151, 153) as mercifulness or "melting grace" (3, 179). For the needy ones with devotion she assumes the bodily form with attributes for bestowing her grace (39: *bhaktānugraha, saguṇavigrahavatī*; 153: *bhaktānugrahakavigrahavattā*). Merely remembering her names destroys the inauspicious and produces the auspicious even in dull persons (124f.). Although in the final analysis the auspicious features are limited adjuncts (*upādhi*) superimposed on her (2-3, 179), there is no harm in praising her with qualities, since without a form it is quite impossible to represent the deity in the intellect (153). Therefore, such forms should definitely be accepted and there is no necessity for an atheist doctrine (*anīśvaravāda*) (153). Thus the Goddess should be worshipped as the *mantra* deity surrounded by many accompanying deities (39). In the tender form of Śiva-Kāmeśvara's beloved, she grants all the four (Brāhmaṇical) goals of life to those who worship her with or without attributes (296).

73. She is ever young (272) and beautiful in every limb (130, 187, 273). She has a lustrous red complexion, wears red garments (66, 138, 180, 189), and is richly adorned (67, 76, 116, 160, 163-64, 199). Her hair defeats the rainclouds (150), her face is like the moon (149), her eyes like a lotus (7), her neck like a conch (157), her jarlike breasts like the forehead of an elephant (114, 147), her smooth hands put to shame tender leaves (158), her thighs are soft (148) and she moves like a swan (162). She dwells in the Kadamba forest (10) and loves Kadamba flowers (11).

74. A mere sideways glance from her makes the dull and ugly resemble the God of Love (name 13 = SL 13); by the movements of her eyebrows Viṣṇu performs his function (13 = SL 24); a mere glance from her eyes makes millions of universes spring up (16 = SL 56); the *trimūrti* are her devotees and make salutations to her (106, 153 = SL 30). She is Sarasvatī (110 = SL 17). Both texts describe her ravishing physical beauty with pictures from the poetic tradition (SL 42ff.) and use the term *samarasa* (SL 34).

75. She is Durgā in the form of Mahālakṣmī (109) and she is Sarasvatī (110). She slays demons like Mahiṣāsura (168) and Bhaṇḍa (111), and is served by the commander Hayārūḍhā (107), by Sarasvatī and Lakṣmī (63, 194), by the *trimūrti* (106) and by the guardians of the quarters (113, 117, 167).

76. Glosses on names 65 (she has the form of women), 50 (she has Kāmeśvara as her husband), 77 (she is the mother of Gaṇeśa), 124 (she is the source of happiness as women are), 13 (her sideways glance produces the sentiment of love), 163 (she has the signs of the married state), 182 (she is worshipped by women to secure their married state). First of all the intense mutual love relationship of the divine couple is stressed (33, 36, 56, 68, 104f., 115, 118, 145, 152, 164, 243-249, 251, 255f., 271). She chose her husband by her own free will (276), is a chaste and devoted wife (53, 54, 228), yet equal to him in attributes and powers (234, 257).

To prove the corporeality of *mantra* deities, the author refers to the "Devatādhikaraṇa" and to the Haimavatī episode of *Kenopaniṣad*, where the divine "Mountain Daughter" appears "with golden ornaments" (153). The first reference is noteworthy, because it alludes to Śaṅkara's *Brahmasūtra* commentary 1.3.26-33 which discusses yogic powers and embodied deities.[77] This *Brahmasūtrabhāṣya* passage certainly does not belong to the core matters of the usual Advaita Vedānta treatises, whereas it plays a major role in the *LTBh*. The commentary on Lalitā's names can be read as both: on the one hand as a feminization of the bliss exposed in Advaita Vedānta treatises such as the *Pañcadaśī*, and on the other hand as a sub-commentary on *Brahmasūtrabhāṣya* 1.3.26-33 in order to advocate *saguṇa-upāsanā*. This double feature is very important in the *Hrīṁ* passages as well. *Hrīṁ* is presented as 'Veda' and 'Upaniṣad,' making the unknown known.[78] Its repetition and meditation secures the realization of the *saguṇa* and *nirguṇa* forms (*taṭastha* and *svarūpa* qualities) of the highest deity.[79] While the individual sounds H-R-I symbolize *saguṇa* meanings,[80] when assuming the form of the single *bīja* *Hrīṁ* they denote Tripurasundarī's (one's own self's) non-dual *nirguṇa* form as consciousness-bliss. By means of his synthetic Goddess and *Hrīṁ* image, the author transmutes the strict distinction between knowledge and action upheld by Śaṅkara into an integrative continuity, while at the same time infusing Tantra with Śaṅkara's position.[81] He identifies Āgama and Veda and postulates, like modern south Indian Śrīvidyā adepts, that the Veda itself teaches *karma*, *jñāna* and *upāsanā*, revealing both the *saguṇa* and *nirguṇa* forms of the highest Goddess and the *Hrīṁ-mantra* which is the source of liberation and all powers.[82]

A New Theology

The main function of the *LTBh* seems to be *saguṇa* and *nirguṇa-upāsanā*. A tentative global perspective of the whole commentary reveals a programmatic sequence, which starts with formlessness (*nirguṇa*), proceeds through formfulness (*saguṇa*) and ends with the merger of formless and formed in the *samarasa* experience:

1. *kūṭa* (*vāgbhava*): focus on transcendence and *tat tvam asi* expositions. The *Hrīṁ* section is dominated by *vācya-vācaka-sambandha* discussions and explores single phonemes and composite form.

77. Some *LTBh* manuscripts have the addition "(Brahma)sūtrabhāṣyakāra" (*iti sūtrabhāṣyakārābhyāṁ pratiṣṭhāpitam*). This particular section of the *Brahmasūtrabhāṣya* also seems to be the immediate background of the Yoga discussions in the *LTBh* (see *BSBh* 1.3.33 and *LTBh* 28 using the same quotations). It is also noteworthy that in gloss 224 (*Sarvavedāntatātparyabhūmiḥ*), the commentator speaks as though he were the *Brahmasūtra* commentator himself: *tattu samanvayāt* (*BSBh* 1.1.4) *ityadhikaraṇe pratiṣṭāpitamityalamativistareṇa*.

78. *LTBh* on names 204, 287f., 291, 294.

79. *LTBh* on names 98, 218, 286, 292.

80. The symbolic meanings given (three *guṇas*, three cosmic functions, *trimūrti*, the three states waking, dreaming, deep-sleep) correspond to the Purāṇic Great Goddess theology as well as to Śrīvidyā, leaving out, however, the more Tantric associations such as Vāmā, Jyeṣṭā and Raudrī, etc.

81. On the one hand he claims that no ritual injunction applies to ever-present knowledge (224, 292, 294), while on the other hand he presents ritual actions and *upāsanā* as direct means to knowledge.

82. *LTBh* on names 223, 277, 283, 286, 294.

2. *kūṭa* (*kāmarāja*): focus on immanence and encompassing nature, the demon-slaying goddess, she being the fulfiller of all wishes and the pinnacle of female beauty. The *Hrīṁ* is qualified as *māyābīja* and the most eminent letter.

3. *kūṭa* (*śakti*): focus on *samarasa*, sense of the *mahāvākyas*, God-Goddess union (exposition of *kāmeśvara* names), the Goddess's possession of a form and her formless reflection in everything. *Hrīṁ* is characterized as her most important seat of manifestation and as the source of ultimate bliss. Its *japa* grants all four *puruṣārthas*, or (Brāhmaṇical) aims in life (300).

None of the concepts and descriptions found in the *LTBh* is original and innovative in itself. By the mere combination of Vedāntic and Tāntric ideas, however, something new emerges: externalized (Vedāntic) bliss and internalized (Tāntric) sensuality and corporeality visualized in the graceful Goddess and her "body of bliss." When I say 'new', I do not necessarily claim that the *LTBh* author is the originator of these concepts. He may well just be legitimating a tradition that already existed. I only want to claim that this tradition is 'original' and noteworthy even from a Tantra standpoint. It is of course a totally Brāhmaṇic female, but the stress on *saguṇa-upāsanā*, female deity and bliss, is at the same time an emotional inversion and a feminization of the highly abstract and male-dominated Śaṅkara tradition. There is a clear Advaita Vedānta perspective, but at the same time there are selective ways of dealing with this tradition, such as sanctioning the corporal female beauty by the *Brahmasūtrabhāṣya* and *Kenopaniṣad*. The *LTBh* is definitely not a mere Advaita Vedānta text, but rather Śākta Tantra seen through the Śaṅkara tradition. The result is a Tantra so much Brāhmaṇized that not much more is left than a mere skeleton and a Śrīvidyā totally acceptable to the most orthodox Smārta brāhmaṇas and Śaṅkarācāryas; but at the same time the *LTBh* 'invents' an Advaita Vedānta so feminized and Tāntricized that it is far away from Śaṅkara's historical commentaries and from works such as the *Pañcadaśī*.

Due to its extreme hybridity, the *LTBh* is judged ambiguously even by contemporary southern Śrīvidyā adepts. Some scholars also attribute the *Lalitātriśatī* litany to Śaṅkara and consider the *LTBh* as peak of secretness and depths,[83] while others see it as a help for less competent seekers,[84] and still others not only doubt Śaṅkara's authorship, but hold that the *LTBh* is of little interest because it "does not abound in Tāntric explanations, or in helpful insights into the cult of Lalitā."[85] In my own fieldwork I found the whole range of voices, too. Many Śrīvidyā *upāsakas* would consult the *Varivasyārahasya* and Avalon or the *Śrīvidyārṇava-Tantra*, but not the *LTBh*.

Such a divergent reception is hardly surprising. Unlike other texts such as the *Prapañcasāra*, which use Śaṅkara's name as an authority to communicate pure Tantra, the *LTBh* sounds like Advaita Vedānta in the guise of Śākta Tantra. Being so much overcoded

83. D.R. Brooks, *Auspicious Wisdom*, op. cit., p. 45.
84. Suryanarayana Murthy, introduction to his *LTBh* translation, Madras: Adyar, 1967, p. xxii.
85. S.K. Ramachandra Rao, *Lalitā-Kosha*, Bangalore: Kalpatharu Research Academy, 1991, p. 64.

with Advaita Vedānta, it is rather unprofitable from a Tantra perspective, whereas it is highly profitable and exciting for persons affiliated to the Śaṅkara tradition — primarily, I would suggest, to the Śaṅkarācāryas themselves. Whereas Bhāskararāya *looks* like a Smārta, the *LTBh* author *is* a Smārta apologist, probably even a Śaṅkarācārya or a monk belonging to the *maṭha*. The primary addressees seem to be *paramahaṁsa*s or renunciates of the highest order,[86] but also Smārtas who seek the four Brāhmaṇical aims of life (*puruṣārtha*), upholding *varṇāśrama dharma* and "the conduct prescribed in the Veda;" the Goddess for her part grants only those wishes "not contradicting the rules of morals."[87]

I started from the principle that religions are dynamic organisms, constantly re-shaped by those enacting them. I would add the assumption that in changing historical and social settings, religions also tend to change, and that such change is a sign of their vitality. With its excessive theology of bliss and its apology for a theist perspective, the *LTBh* partakes in and continues the highly synthetic and inclusivist character that Śrīvidyā has had from its very beginnings. Belonging to non-dual Tantra, the Śrīvidyā's merger with non-dual Advaita Vedānta may be ascertained as a natural symbiosis (as southern practitioners would postulate, though in different ways) or as the end of a competitive struggle which the Śaṅkara tradition had to face in the wake of the all-pervasive presence and attractiveness of Tāntric and *bhakti* movements (as I would tend to suggest as historian of religion). The *LTBh* is in fact a proof that the Śaṅkarācāryas became 'victims' of this attraction themselves. It sanctions this attraction in two ways: (a) by presenting an *ānanda* for monks, and (b) in defending the necessity of a *saguṇa* form. Its pronounced thesis that there are no grounds for an atheist doctrine may suggest that contesting debates took place in the *maṭha*(s). The Goddess as bliss personified, had to be proven with the entire vocabulary of scholarly Vedānta. The basic message, that Goddess and seeker converge in non-dual *saccidānanda*, had to be repeated endlessly over and over. For a reader trained in 'Kashmir Śaivism' and Tantra, the *LTBh* was and is perhaps rather tedious and boring, whereas for an educated Smārta and Advaita-Vedāntin it possibly was and is quite attractive and thrilling because of its novelty in presenting familiar ideas in a new garment. It may be delightful and emotionally pleasing to find the abstract *Brahman* replaced with a ravishing female beauty.

Text Pragmatics and Living Tradition

The legends claiming that Śaṅkara was an ardent goddess worshipper and Śrīvidyā initiate contain some historic truth. They seem to be a retrospective projection of the ritual practice of Śrīvidyā, which had become a regular feature in some south Indian temples and within the Śaṅkara *maṭha*s, the most orthodox centres of scholarship and gnostic contemplation. When today's Śaṅkarācāryas pay homage to the gentle Mother of the World, distribute *śrīcakra*s, promulgate *Lalitāsahasranāma* chanting and act as spiritual teachers for a large number of south Indian Śrīvidyā *upāsaka*s, it becomes most

86. *LTBh* on names 29, 162, 169, 173, 182, 266.
87. *LTBh* on names 240, 265-266, 277, 296, 300.

manifest how a legendary past translates into a non-legendary present. The Śaṅkarācāryas exercise considerable influence in spreading Śrīvidyā worship, and their role has in fact increased in modern times.

My initial question in studying the *LTBh* was about the text pragmatics, particularly about the motivational forces, which led the celibate Śaṅkaran monks to incorporate a beautiful, highly erotic and powerful goddess into their system. Judging by the strong Vedāntic and puritan overcoding of the *LTBh*, one may say that in fact they had nothing to lose and much to gain. They interpret the goddess in perfect consonance with their system. The goddess image helped to work out the *ānanda* aspect. The theology of bliss, which is thus gained is emotionally highly appealing — and intellectually satisfying. Equally important, however, are the cultural politics suggestive of a complex network of reasons. Judging by the living tradition, the female inversion presented not only an alternative non-dual discourse, which probably fulfilled psychological needs by providing emotional satisfaction, but also presented a Tāntric tradition acceptable to the orthodox *jagadgurus*, helping them to legitimize their own fascination and at the same time gain control over heterodox movements. It was a device for defeating the Tāntric opponents with their own weapons, and sanctioning and perpetuating domesticated Smārta-Śaiva Tantra practices. Last but not least, it helped to channel local goddess cults into a pan-Hindu scheme and to win influence and control over non-Brāhmaṇic folk traditions.

In Tamil Nadu, a 'right hand' or 'Samaya' Śrīvidyā, completely purged from Kaula traits and claimed to be 'Vedic,' has become the standard. This fact is attributed to Śaṅkara, and the *LTBh* is seen as the direct expression of a major cult reform. In this context, the *LTBh* ceases to be a harmless metaphysical treatise or spiritual guide to *saguṇa* and *nirguṇa-upāsanā*, but transmutes into an instrument of polemics as the following statements show:

> Generally people in the lower order of culture are devoted to the worship of Devī as Kālī . . . , a manifestation that inspires awe and dread and that breeds religious fanaticism (. . .). Devī as Lalitā is worshipped by the classes of Hindu society in the higher plane of culture. While the Kālī worship has come to be looked as *avaidic*, the Lalitā form has won recognition as *vaidic*, and the orthodox Hindu worships Devī as Lalitā (. . .). That the cult of Lalitā was different from the debased side of Hindu religion is evident from the well known tradition that the great Śaṅkarācārya wrote a commentary on the *Lalitā-triśatī*; and thus attached a special significance to the worship of Lalitā.[88]

> A curious feature of this commentary [*LTBh*] is that there is not the slightest support here for the Vāma or Kaulācāra. This seems to be deliberate because Śrī Bhagavadpāda is well-known for his cleansing the Hindu religion of its unhealthy appendages and establishing it in its pristine glory.[89]

88. Ramachandra Dikshitar, *The Lalitā Cult*, Delhi: Motilal Banarsidass, 1991 (original Madras, 1942), pp. 2-3. It is noteworthy that Ramachandra Rao, *op. cit.*, p. 6, makes similar claims for Bhāskararāya.

89. C. Suryanarayana Murthy, Introduction to *Śrī Lalithā Triśatī Bhāṣya, op. cit.*, p. xiv.

Such claims are far from being the opinion of single authors, but are fairly common among south Indian Śrīvidyā proponents, many of whom are not only Smārta brāhmaṇas, but also influenced by Neo-Vedānta reform movements.[90] In stressing the 'cleansing' effect of Śaṅkara, they draw from oral and written *Śaṅkaradigvijayas*, which narrate that Śaṅkara installed the *śrīcakra* in front of Kāmākṣī and other Devīs. Whereas the classical *Digvijayas* seem to suggest that this involved a transformation from the local to the universal, more recent ones narrate a transformation of ferocious wild goddesses into benign and gracious ones. In the same vein, contemporary authors continue 're-inventing' the traditional lore by projecting their own reformist spiritual ideals into it, without being aware how much their judgemental evaluation of vital parts of Hindu culture as 'unhealthy appendages,' 'debased side of Hinduism,' or a 'lower order of culture' owes to missionary and 'enlightened' Victorian colonial discourses. In continuity and indigenization of such puritan discourses, they claim that Śaṅkara initiated a major cult reform in southern India carried on by his successors, namely the establishment of a chaste Vedic (*vaidika*) goddess worship untainted by Tāntric elements (*tāntrika*) and the elimination of 'objectionable' practices such as oblations of blood, alcohol, human flesh and sexual rites. Thus it is believed that he established the cult of the gracious supreme Goddess in the south, whereas in north India bloody sacrifices (judged 'inhuman' and 'terrible') and heterodox rites (judged 'corrupt' and highly 'objectionable') continued. Two elements are particularly noteworthy: (a) the mixture of Tāntric and non-Brāhmaṇic folk (or tribal) practices under the common heading *avaidic*, and (b) the reconstruction of the ancient *saumya-ugra* dichotomy and of the traditionally developed Samaya-Kaula difference as a Veda-Tantra and south-north opposition. Against the background of such highly problematic simplifications of indigenous discourses continuing the orientalist constructions of Hinduism and their misjudgements of Tantra, it was a great scholarly achievement to recognize Tantra as a valid system of thought and to stress the original Kaula Śrīvidyā. In this light the southern Śrīvidyā is indeed a 'deviant,' 'bowdlerized' and 'anti-Tāntric' form. The term 'debased,' used by south Indian authors, turns against their own beliefs. It is a fact that the living southern tradition, notably the cultural politics of the Śaṅkarācāryas, partly overlap with the reformist polemics.

The transformation of local traditions by the Śaṅkarācāryas' Śrīvidyā version is far from being a mere literary *topos*. The Great Goddess theology was an ingenious device to universalise local goddesses and bring them into an orthodox fold. The transformation of non-brāhmaṇa practices in village India into Brāhmaṇic ones does not only belong to the past, but also to the present. The Śaṅkarācāryas use the *śrīcakra* and Śrīvidyā theology as missionary devices to spread a non-dual, spiritualized Smārta-Hinduism and to convert wild local goddesses receiving blood sacrifices into the gentle and universal Mother of the World who rejoices only in purely vegetarian food. Such 'purging' processes, exercised particularly by the Kanchi Śaṅkarācāryas, have extended as far as the most northern

90. See A. Wilke, 'Śaṅkara and the Taming of Wild Goddesses,' *op. cit.*

Himālayan regions.[91] For several decades the Kanchi tradition has a strong influence in Sri Lanka also,[92] where traditionally a strict Āgamic Śaiva Siddhānta was predominant, alongside non-Brāhmaṇic cults of powerful earthbound village deities.[93] In modern times — according to my Śaiva Siddhānta informants, since about 50 years ago — Śrīvidyā has become very fashionable among Sri Lankan brāhmaṇas who seek to connect with Kanchi. Nowadays, Śrīvidyā is all-pervasive in Jaffna and Colombo Devī temples, and *śrīcakrapūjā* (*āvaraṇapūjā*) is included in much of the public temple worship, usually performed on each day of a full moon. It goes hand-in-hand with temple festivals where vows of self-mutilation are executed. This practice was imported to Germany with the establishment of the Kāmākṣī temple of Hamm-Uentrop, which was started in the late 1980s and has grown to become the largest Hindu temple in continental Europe since the late 1990s.[94]

The recent strong presence of Śrīvidyā in Sri Lanka has not only changed the Sri Lankan religious landscape, but also the traditional form of southern Śrīvidyā. Public *śrīcakrapūjā* in the temple cult is a new development.[95] The combination of Śrīvidyā rites with vows from village India can be seen in Germany, but not in Kanchipuram. The Sri Lankan case and its extension in Germany substantiate my major thesis that religions are a living body in constant flux. They illustrate the ongoing influence of the Kanchi Śaṅkarācāryas in spreading Śrīvidyā and Smārta Hinduism, but equally illustrate that the adoption of Śrīvidyā is never only a one-way process.

91. For an example in the Garhwal area, see: A. Wilke, 'Śaṅkara and the Taming of Wild Goddesses,' *op. cit.*, p. 139, fn. 15. I received reports of a number similar incidents, the living tradition being, however, more complex and resistant: local traits often remain more important than the pan-Hindu overstructure, and even original practices — judged 'objectionable' from a purist standpoint — may be maintained side by side with the new cult. Concerning the whole Himālayan region, it is noteworthy that there is evidence of an early presence of Śrīvidyā, notably in Nepal, where it is very secret, so that it even escaped the attention of prominent scholars such as M. Slusser, G. Toffin and R. Levy. I noticed the pervasive presence of Śrīvidyā in Nepal from existing manuscripts and field studies during Navarātri, 1999. Besides esoteric rites unnoticed by outsiders, the last days of this festival include a large number of public animal sacrifices. Quite contrary to the southern tradition, the Nepali chronicle says that (a) Śaṅkarācārya established animal sacrifice and Tāntric worship in Nepal.

92. The information on contemporary Sri Lanka are based on interviews with Sri Lankan priests and lay informants performed during my field studies in Sri Lanka, and my own observations in Jaffna and Colombo Devī temples (May 2003), as well as on field studies in Tamil-Hindu Goddess temples in Germany and my interviews with their priests (since 1999).

93. Bryan Pfaffenberger, 'The Kataragama Pilgrimage': *Journal of Asian Studies* 38, 2 (1979), pp. 253-70, describes a deep gulf between Āgama orthodoxy (Brāhmaṇic priests, "invoked deities," high standards of purity) and folk practices ("self-born" deities, blood-sacrifices, trance possession, vows of self-infliction).

94. For details see the two articles by A. Wilke in: M. Baumann, B. Luchesi, A. Wilke (eds.), *Tempel und Tamilen in zweiter Heimat. Hindus aus Sri Lanka im deutschsprachigen und skandinavischen Raum*, Würzburg: Ergon, 2003, pp. 125-68; 189-222.

95. It can be discerned in some south Indian reform movements, such as the Chāyā-Pīṭha (near Trichy), too. In Sri Lanka, however, it has become a normal feature, which is further developed. In May 2003, the Śaivācārya head of the famous Nāgapūṣani temple released a book on *śrīcakrapūjā* along with *homa* during a festive function in a Veda Gurukulam of Jaffna. The book had been written particularly for the temple cult.

Indian Arts and Aesthetics

10

Śiva in the Nineteenth-Century Banaras Lithographs

Anjan Chakraverty

MONOCHROME lithography, mostly in the form of book illustration, is one of the lesser-known art forms of pre-modern Banaras.[1] According to the existing information,[2] at least two litho press were set-up in the city during eighteen thirties, namely, Banāras Añjuman Yantrālaya and Sarasasudhānidhi Press. In 1845, Govinda Raghunath Thatte, a Maharashtrian, under the initiative and patronage of a local aristocrat, Raja Shivaprasad, founded a lithographic press (*chāpākhānā*) at the Dūdha-Vināyaka mohallā for printing *Banāras Akhbār*, a bilingual weekly in Urdu and Hindi.[3] The printed script was Devanāgarī. In 1847, ceased, the publication of the journal but the press named after the aforesaid periodical continued to print books probably till 1854.[4] Among the available Sanskrit religious texts published by Thatte at his commercial establishment, the earliest one with an illustrated colophon bears the date *Saṁvat* 1910 (CE 1853).[5] Some fifty-odd lithographic presses[6] thriving in the second-half of the nineteenth and early decades of the twentieth centuries were busy producing the major bulk of lowly-priced hymnal and secular texts as also ritual books in Sanskrit and Avadhi, Brajabhāṣā

1. Cf. Anjan Chakraverty, 'Banaras Lithographs: An Art of the Bourgeoisie': *Nandan* (Visva-Bharati, Santiniketan), No. XIX (1999), pp. 38-48; *Ibid.*: 'Gods and Men, Demons and Violence — Nineteenth-Century Lithographs of Banaras': *Kala-Dirgha* (Lucknow), No. 2 (April 2001), pp. 39-43.

2. Cf. Swami Medhasananda, *Varanasi at the Crossroads. A Panoramic View of Early Modern Varanasi and the Story of its Transition*, Kolkata: The Ramakrishna Mission Institute of Culture 2002, ch. 14, pp. 643-44. The Litho printing was introduced in Lucknow in 1837.

3. Cf. Vasudha Dalmia, *The Nationalization of Hindu Traditions: Bhāratendu Hariścandra and Nineteenth-century Banaras*, Delhi *et al.*: Oxford University Press, 1997, p. 229; Medhasananda: *Varanasi, op. cit.*, p. 644 and pp. 650-51.

4. Cf. Medhasananda, *ibid.*; however, a dated pilgrim map of Banaras, "symbolic in conception rather than cartographic," was printed at Thatte's *chāpākhānā* as late as 1873.

5. Cf. A. Chakraverty, *Banaras Lithographs, op. cit.*, p. 39.

6. Lithographic printing press has been variously termed in the Banaras colophons and printery as *yantra, pasana-yantra, śīla-yantra, yantrālaya, mudrālaya, mudrā-yantra* and *chāpākhānā*; Medhasananda gives a list of some nineteen printing concerns, cf. Varanasi, *op. cit.*, pp. 644-45; I came across in colophons some twenty-six names of the litho printing press which were situated in various parts of the city.

and Hindi for the townsfolk with a certain literary-mindedness. In a short while, the litho-printed volumes designed both in *pothī* and codex format were destined to become an affordable substitute for the manuscript, illustrated as well as non-illustrated.[7] The increasing demand among the literate middle-class of the era for the low-priced visual-enriched printed text had a certain controlling influence on the publishers and, in order to have a lucrative business, they employed local painters, "who were as talented and obliging as they were plentiful." The litho illustrations, printed only in black ink, were marked by an emphatic linear crispness, ideal for quick multiples. The artists worked in a fluid style keyed to the contemporary cultural perceptions of the bourgeoisie and, in general, received a modest payment. The art of litho printing was a gift of the newly-introduced printing technology that, however, made a rather belated entry in Banaras.

The iconic-narrative pictorial language characteristic of Banaras lithographs can be best analysed against the popular ethos of the time and in comparison to other contemporary sister crafts sharing the common urban domain. In this context, one may particularly mention the art of wall painting and glass painting, done mostly by potters or *naqqash* and occasionally by the multimedia artists, and even, to a certain extent, miniature painting. In Banaras, as might have been the case in Lahore, Agra, Lucknow and Allahabad, the artist was responsible only for his monochrome brush drawings on pre-processed litho stones. Professional printers[8] were appointed by the publishers to take care of the elaborate stone processing as also actual printing. The name of the printer as well as the scribe was unfailingly mentioned in the colophons, whereas the names of painters were invariably dropped or went unrecorded. At times it is hard to distinguish whether the scribe and the illustrator were different or the same person due to the cryptically penned colophonic details.

Towards the second half of the nineteenth century, local artists of Banaras were finding it difficult to cope with a rather grim situation of financial despair. This happened primarily due to the decrease in patronage, extended mostly by the trading and warring aristocracy of the city, towards the artisan community in general. During *c.* 1880-83, a skilled miniaturist like Ustad Mulchand (locally called Ustad Mula) or *Musavvar* Mularam (active *c.* CE 1840-1900), whose forefathers learned the art from a painter of Mogul atelier, was compelled by the circumstances to serve the Brajachanda Yantrālaya, a printing

7. A large number of Rajasthani scribes belonging to the *Channyati* brāhmaṇa caste settled down in Banaras towards the late-sixteenth or early-seventeenth century. There was also a diaspora of Matheran artists and scribes who were commissioned by the local patrons to prepare manuscripts, both illustrated and non-illustrated, and occasionally, even *prajñaptipatras* or "letters of invitation" to welcome a Jaina monk to the city. In addition, there were also *Kāyastha* scribes, expert in *kitābat*, and itinerant Kashmiri (*paṇḍit*) *kātibs* and *musavvars* active in the profession of manuscript production. Cf. Ananda Krishna, *Banaras in the Early 19th Century*, Varanasi: Indica, 2003, p. 15; J.P. Losty, *The Art of the Book in India*, London, 1982, p. 145.

8. He had been described in local craftsman's parlance as *bhusi chāpne vālā* or 'the ink printer' and at times as simply *kārīgar* (the technician).

concern owned by Brajachanda, as an illustrator and lay-out designer of the litho texts.[9] Mulchand's illustrations are undeniably the aesthetically superb examples, matchless in their draughtsmanly precision. One may presume that a few other members of his family also took resort to this newly-emerging profession and expressed in a fairly analogous style, marked by a linear firmness. There were other publishers, both pre-dating and post-dating Brajachanda and having a mediocre aesthetic sense, who gladly employed bazaar painters to embellish their inexpensive litho texts with a surfeit of hastily-drawn illustrations. These painters worked within a restricted repertoire but had the virility of an urban folk mode, exemplified at its best in the potter's style of Banaras wall painting. Bhairo Pathak and Durga Misir, whose names appeared in a few colophons,[10] seem to have had mastery in this particular idiom. Interestingly, we do also come across the name of Thakurji Kashmiri, an itinerant Kashmiri *kātib*-cum-*musavvar*, in a dated (CE 1855) colophon of *Gaṅgālaharī*. Ananda Coomaraswamy was the first to publish the lithographed illustrations of Lucknow and Banaras in his seminal treatise *Rajput Painting* and, while evaluating their style, expressed his lament in the following passage:

> It can be hardly doubted that if printing had been introduced into India before the decadence of *Rājput* art, and had the early *Rājput* draughtsmen known how to cut their drawings on wood (as might easily have been the case by slight adaptation of the widely practised art of industrial block-cutting for cotton printing and embroidery), books of the highest aesthetic value might have been produced. We must look upon this possibility as an opportunity that was just missed.[11]

The sacred city of Kāśī, as has been described in myths, is the 'permanent earthly home' of Śiva. The *liṅga*, representing both the manifest and unmanifest lord, is being worshipped in the shrines that are numberless in the 'Forest of Bliss,' *Ānandavana* or *Ānandakānana*. In comparison, the anthropomorphic representations in stone are not many. The late-

9. Cf. Anjan Chakraverty, 'Ustad Mulchand as a Litho Artist,' in: *The Ananda-Vana of Indian Art. Dr. Anand Krishna Felicitation Volume*, ed. Naval Krishna, Manu Krishna, Varanasi: Indica, 2004, pp. 483-94.

10. Bhairo Pathak's name appears in a pilgrim map of Banaras dated CE 1897 printed at Satyanarayan Yantrālaya, situated in Man Mandir *mohallā*. The expression *likhitam* (lit. written) used in the map stands for 'drawn by' as there is no text except the captions added to various shrines and deities represented. There is also a note appearing in the map that reads: "We have (at our printing concern) pictures of Gods and officials and of Raja-Maharaja kept ready for sale. Those are available at Kanaihyalal das *Tasvir vale*, (situated) behind the Gopal Mandir, Banaras city." The note makes it also clear that Satyanarayan Yantrālaya specialized in printing, apart from pilgrim maps, single sheet display prints drawn by painters. Incidentally, a line drawing of "Rādhā and Kṛṣṇa under a tree" by Ustad Mulchand is inscribed in *Nāgarī* : *Likhatam Mulchand* (Coll: Bharat Kala Bhavan, Acc. No. 1511). Further, Bhairo Pathak's name appears in a *Rāmacaritamānasa* volume of CE 1881 printed at Mahtab Hind Chāpākhānā, situated in Augusta Kuṇḍa *mohallā*. The style of his illustrations is similar to the one used in the pilgrim map. A sleek volume of *Hanumān Bāhuka* (dated CE 1873) printed at Divakar Chāpākhānā, situated in Bhadaini, Kali Mahal, was written and illustrated by Durga Misir. For an authoritative interpretation of the term *likhitam* cf. B.N. Goswamy, *Nainsukh of Guler*, Zürich, 1997, p. 287 and pp. 106, 112, 226.

11. Ananda K. Coomaraswamy, *Rajput Painting*, London, 1916, part I, p. 75, figs. 8 and 9.

eighteenth and nineteenth-century bas-reliefs adorning the temple exteriors display a variety of Śiva's iconic forms, most commonly conceptualized as Maheśvara or Mahādeva, the Great God residing in his heavenly abode mount Kailāsa with Pārvatī. He was also depicted as Bhairava, the terrible, frightful one. Contemporary wall painters generously borrowed aspects of such popular iconography, though in a few existing examples one may notice the emphasis shifting from a purely iconic to the multi-hued narrative. Depiction of legend-inspired episodes, based on the delightful passages of Śaiva myths, did also require a change in compositional choices for elaborate wall paintings. Set in friezes, the murals became the visual counterparts of the sacred narratives, much closer to the heart of the common men. The legends of the Sanskrit Purāṇas retold in vernaculars by the local narrators (*kathāvācakas*) became the very basis of a grand oral tradition, a common legacy shared by the contemporary artists as well as patrons with equal verve.

Stylistically, and to a great extent iconographically, the depiction of "Śiva as Ardhanārīśvara" (*Pl.* 1) in the litho-printed volume of *Gaṅgālaharī* (dated 1855), is a rare specimen of Banaras lithography.[12] This unusual line drawing[13] by Thakurji Kashmiri represents a blend of Kashmiri and Avadhi idioms and one may guess that the artist might have worked in Lucknow for some time before he opted to work in Banaras. In the nineteenth century there was a major concentration of Kashmiri (*paṇḍit*) calligraphers in Lucknow who were engaged in the mass production of manuscripts.[14] They were seeking commissions mostly of a non-elitist nature and it seems plausible that a few such groups of *kātib mai musavvir* (scribes together with a painter) preferred to visit Banaras and, with some prior experience of working on litho stones, found employment in the newly-established printing firms. In addition to "Śiva Ardhanārīśvara" Thakurji drew two more illustrations for *Gaṅgālaharī*. For the opening folio of the text he made a drawing of "Gaṅgā on crocodile"[15] wearing a characteristic *tāj* crown, a popular headgear of contemporary Avadh, and on the obverse of "Śiva Ardhanārīśvara" he designed a rather conventional panel of "Gaṇeśa flanked by Riddhi and Siddhi."[16] The image of "Śiva Ardhanārīśvara," seated on a tiger skin and wreathed in snakes, has a syncretic iconography of Śiva and Śakti, symbolizing the twin principle of Agni and Soma permeating every life organism. Divided centrally into two halves, the figures of Śiva and Devī are set in two different directions, counter-enhanced by the circular protrusions

12. *Gaṅgālaharī* by Poet Jagannātha, pp. 17; approx. 18 x 9 cm; text in *Nāgarī*, five lines per folio; off-white *Sanganer* paper; dated *Saṁvat* 1912; Monday, dark fortnight of *Phālguna* (Feb-March), inscribed: *kalam* Thakurji Kashmiri *va chāpnevāle* Ramphal, printed at Shivacharan's Divakar Chāpākhānā, situated in Bhadaini, Kali Mahal. Private collection, Varanasi.

13. 13 x 15 cm.

14. Cf. Abdul Halim Sharar, *Lucknow: The last Phase of an Oriental Culture*, New Delhi, 2001, pp. 104-05; Karuna Goswamy, *Kashmiri Painting*, New Delhi, 1998, pp. 48-64.

15. 13 x 4.8 cm.

16. 13 x 5 cm.

jutting forth from the arch. The lines are less expressive and a plethora of harshly drawn details are features to be associated with the style of Kashmiri painters. Thakurji Kashmiri's mode of expression, however, remains an isolated example as in no other litho-illustrated volume from Banaras can we detect any continuity of this hybrid idiom.

As mentioned earlier, the painters belonging to the local school of painting also worked as litho artists in the second-half of nineteenth century and a profusely illustrated sleek booklet of *Hanumānbāhuka*,[17] a hymnal text composed by poet Tulasīdāsa, published in CE 1881 is by far the most outstanding example of their style. This is, however, the only inscribed document to prove Mularam *musavvar's* contribution to the art of Banaras lithography. The other known examples attributed to him are three more booklets and a pair of single-page display prints. He was well versed with the technical subtleties of miniature painting, and his style was inclined towards the late-Mogul, which he inherited from his predecessors, and also towards the localized Rajasthani idiom of the Jaipur tradition, which he imbibed by imitating the available examples of the school. As has been pointed out by scholars, he excelled in the genre of *dhyāna-citras* or iconic paintings of Hindu deities as per the hymnal invocations (*dhyāna*) found in the ritual texts.[18] Behind the sustained rivalry between Mula and the painters migrating as early as 1815 from Patna (and Danapur) there were more than one reason, the major being "the area of ivory painting."[19] These Patna artists of the Banaras court, who used to trace their ancestry to the Murshidabad school, were patronized by Raja Udit Narain Singh (1795-1835) and Raja Isvari Narain Singh (1835-89). Both the kings had a special liking for the newly-evolved 'cult of realism' characterizing the style of these Company painters. Before long, Mula succeeded in mastering the technique of painting on miniature ivory plaques with meticulous stippling and remarkable exactness in drawing as virtually no correction was possible afterwards. Such a discipline helped him during his career as a litho artist and in all the fifty-one illustrations of *Hanumānbāhuka* may be noticed a restrain and accuracy in the delineation of even the tiniest figures. "Śiva and Pārvatī on Nandi"[20] (*Pl.* 2) is a case in point. Framed in circles, majority of his illustrations look like miniature ivory panels worked in monochrome and in this particular example the drawing is micrometric, executed with an eye for every minute detail. In a similar fashion, the closing folio of this text was designed with a cluster of deities studded in small circular panels of

17. *Hanumānbāhuka* by Poet Tulasīdāsa, ff 10; 24.7 x 16 cm., biscuit-coloured map litho, 51 illustrations, text in *Nāgarī*, dated *Samvat* 1938, eighth day of the dark fortnight of *Māgha* (Jan-Feb), inscribed: *Musavvar* Mularam, *chāpnevāle* Bhajjan Ram, printed at Brajachanda Yantrālaya, situated in Teliyanala. Private Collection, Varanasi.

18. "With his unmatched fund of traditional knowledge of *dhyānas* (iconographical formulae) of Hindu deities," opines Prof. Ananda Krishna, "Ustad Moola had scarcely a competitor in this field" (Ananda Krishna: 'Company Painting at the Benaras Court,' in: *Indian Painting — Essays in Honour of K.J. Khandalavala*, ed. B.N. Goswamy, New Delhi, 1995, p. 245.

19. *Ibid.*

20. Size of the circular panel: diam. 2.3 cm., folio. 8, *Hanumānbāhuka*, dated 1881. Private collection, Varanasi.

unequal size. Mula's skill of iconic drawing is at its best in the representation of the "Sadāśiva and Pārvatī on a lotus seat attended by Brahmā and Viṣṇu" (*Pl.* 3).[21] In the two other smaller circular panels on the lower row appear Gaṇeśa and Kārttikeya (on the left) and Poet Tulasīdāsa (on the right), adoring the Great God. Except the one at the top, all the four faces of Śiva are in three-quarter profile; the posture is *padmāsana* and the only weapon the deity holds in his right upper hand is the axe (*paraśu*). Every single stroke is here meaningful and the compact clustering of figures overlapping each other partially lends an effect of dimension to the tiny composition in the roundel. On the folio three of the same booklet, Mula arranged four circular panels in a vertical fashion dividing the text format into two halves and in one such small panel he made an intricate drawing of "Śiva and Pārvatī blessing Poet Tulasī" (*Pl.* 4).[22] The celestial couple was shown under the holy fig tree and one is reminded of a description in Tulasīdāsa's *Rāmacaritamānasa* which might have been an inspiring one for the artist:

> On this mountain was an enormous *bar* tree, which no time nor seasons could rob of its beauty; ever stirred by soft, cool, fragrant breezes and a shade from the hottest sun; the great banyan (*baṭa*) tree famous in sacred song as Mahādeva's favourite haunt. Once on a time the lord had gone under it, and in an excess of delight spread with his own hands his tiger-skin on the ground and there sat at ease: his body as fair in hue as the jasmine or the moon, his arms of great length, a hermit's cloth wrapt about his loins, his feet like lotus blossoms, and his toe-nails like gleams of light, to dispel the darkness of faithful souls; his face more splendid than the moon in autumn; and his decorations, serpents and streaks of ashes.[23]

Tulasī, the composer of the hymnal text and the humble devotee, stands with folded hands and Mula portrayed him in a somewhat standardized configuration in as many as twelve different panels of *Hanumānbāhuka*. Such repeated depictions of the poet-sage, whose greater part of life was certainly spent at Banaras during the sixteenth and seventeenth century, is a pointer to the great admiration the artist had for the celebrated Vaiṣṇava writer and his *Manas*, a classic in vernacular. Gaṇeśa stands behind Śiva and Pārvatī waving the flywhisk and all his iconographical features including the three-quarter face were straightaway derived from the popular nineteenth-century Jaipur prototype.[24]

21. Size of the circular panel: diam. 4.5 cm., folio. 8a, *Hanumānbāhuka*, dated 1881. Private collection, Varanasi.

22. Size of the circular panel: diam. 4.6 cm., folio. 3, *Hanumānbāhuka*, dated 1881. Private collection, Varanasi.

23. *Eternal Ramayana — The Ramayana of Tulsi Das*, transl. F.S. Growse (1883), New Delhi, reprint 1983, p. 56.

24. Cf. Linda York Leach, *Mughal and Other Indian Paintings from the Chester Beatty Library*, vol. II, Dublin, 1995, cat. no. 10.32, pp. 988-89; Georgette Boner, *et. al.*: *Sammlung Alice Boner*, Zürich, 1994, cat. no. 166, p. 65.

Pl. 10.1: Śiva as Ardhanārīśvara,
by Thakurji Kashmiri (1855).

Pl. 10.2: Śiva and Pārvatī on Nandī,
by Mularam *Musavvar* (1881).

Pl. 10.3: Five-headed Śiva,
by Mularam *Musavvar* (1881).

Pl. 10.4: Śiva and Pārvatī
blessing Poet Tulsi,
by Mularam *Musavvar* (1881).

Pl. 10.5: Goddess Kālī attended
by *Yoginī*s (*c.* 1790-1800).

Pl. 10.6: Detail of *Pl.* 10.5.

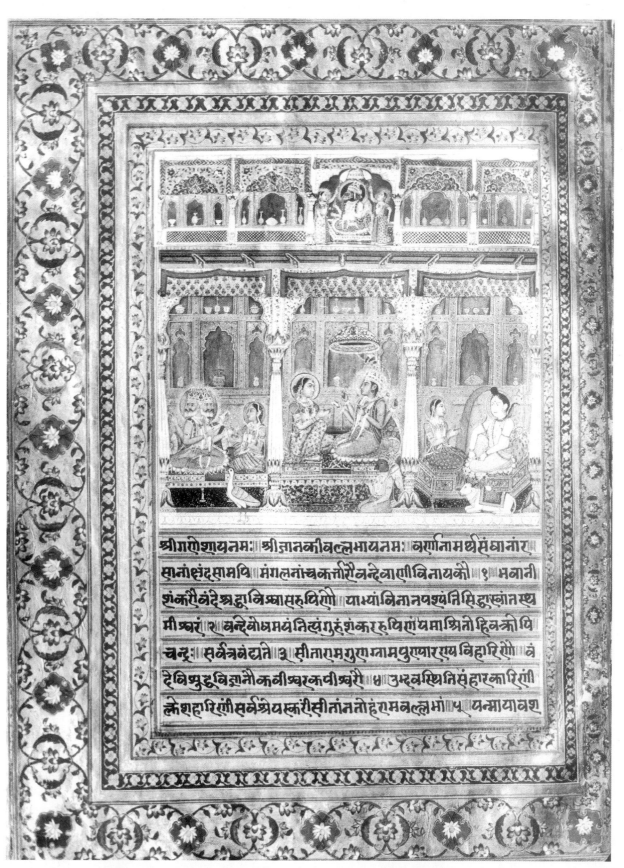

Pl. 10.7: Opening folio of *Rāmacaritamānasa* (1808).

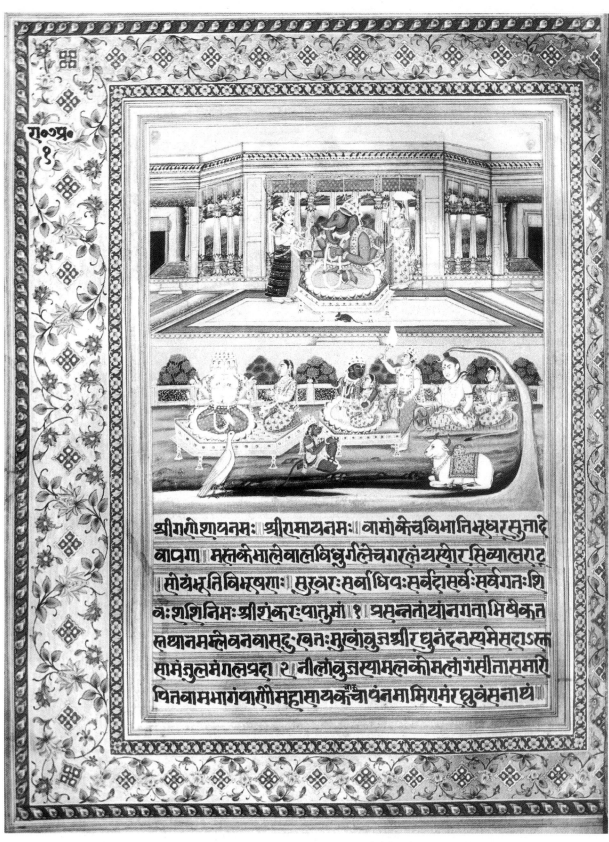

Pl. 10.8: Opening folio of Ayodhyā-Kāṇḍa, *Rāmacaritamānasa* (1808).

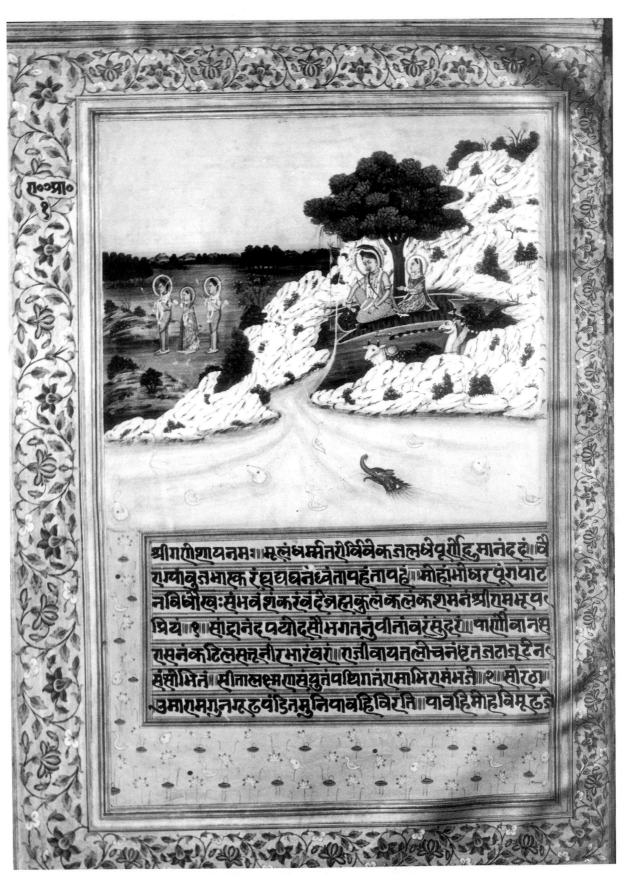

Pl. 10.9: Opening folio of Araṇya-Kāṇḍa, *Rāmacaritamānasa* (1808).

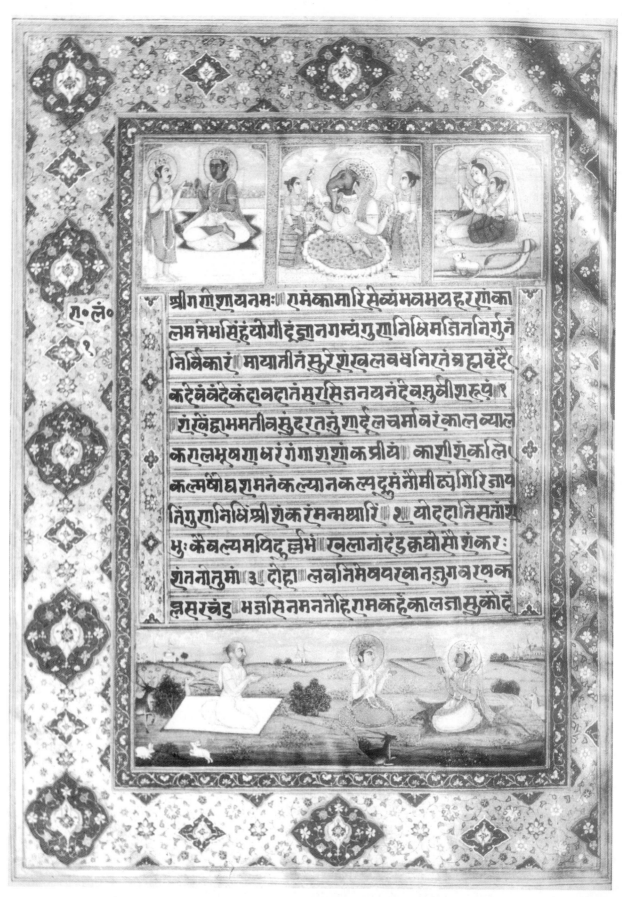

Pl. 10.10: Opening folio of Laṅkā-Kāṇḍa, *Rāmacaritamānasa* (1808).

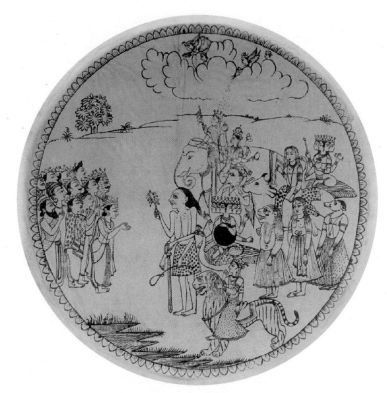

Pl. 10.11: Gods adoring Mātṛkās, Kālī,
Śivadūtī and Ambikā (*c.* 1880).

Pl. 10.12: Māheśvarī and Śivadūtī — detail of *Pl.* 10.11.

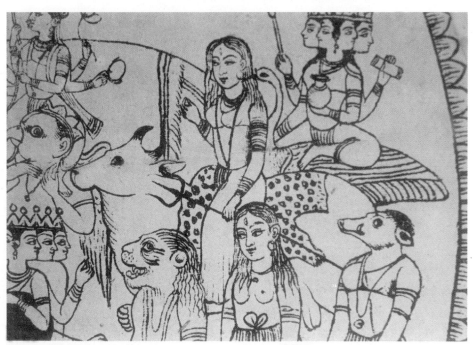

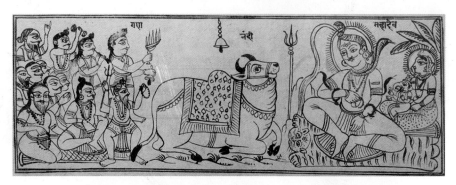

Pl. 10.13: End Pages — *Mahimnatilaka,* verso (1884).

Pl. 10.14: End Pages — *Mahimnatilaka,* recto (1884).

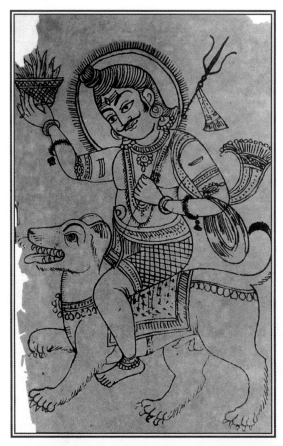

Pl. 10.15: Śiva as Baṭuka Bhairava (*c.* 1884).

In all the three tiny circular panels discussed above, Mula followed a certain common iconography for his Śiva images, lithe in proportion and ever-youthful, having no moustache. Twice the deity was depicted seated in *padmāsana* (Pls. 3 & 4), his matted hair tied into a bun at the top. The third eye is prominent in all the three drawings and in one (*Pl.* 4), a snake hugging around the neck forms a garland. The face rendered in two-thirds view has a contour taut and firm. This iconography Mula could master while working in his family guild where he seems to have copied and also interpreted afresh, some of the master drawings related to Śaiva theme by his fore-fathers. An illustrated folio[25] from an unidentified manuscript in *pothī* format (datable to *c.* 1790-1800) and attributed to Mula's fore-fathers by Professor Ananda Krishna may be cited here as one of the probable prototypes the former was familiar with. In one of the three arched niches of this folio was painted the image of "Goddess Kālī standing on Śiva, attended by a pair of indigo-hued *yoginīs*" (*Pl.* 5). Mula's grandfather Ustad Gval Sikkhi (*c.* 1760-1820) imbibed the late Mogul traits of his mentor Ustad Lalji *Musavvar* or Lalji Mall *Musavvar*[26] and passed it on to the subsequent generation who possibly painted this panel with "Kālī and Yoginīs." The dominant late-Mogul idiom[27] is easy to detect in the reclining figure of Śiva rendered with supple outlining and gentle touches of ashy wash, graded in terms of intensity to enhance the plasticity of the form (*Pl.* 6). The two-third view of Śiva's face, the serpent around his neck and the big earrings, a mark of his ascetic character, were the features Mula assimilated in his litho illustrations without any major alteration. Although he based his style on any such finished painting or master drawing in his family collection he dispensed with the tonal structuring on the litho stone with *tushe* and concentrated more on the linearization of form.

During late 1870s Ustad Mulchand was commissioned by Ramnath ji Vyas of Banaras, a devotee of Pitāmbara Devī and a *kathāvācaka* by profession, to work on two sets of

25. The horizontal folio has three cusped arches, each forming a niche. The central niche has a depiction of seated Gaṇeśa whereas the one on the right has a Kālī on Śiva attended by *yoginīs* and the one on the left has an eight-armed Devī seated on a *vyāla-siṁha* attended by a *bhairavī*. Painted in opaque watercolour on paper; size : 27.5 x 11.6 cm. Private collection.

26. Cf. A. Krishna, *Company Painting at the Benaras Court, op. cit.,* p. 245.

27. The other major examples of painting depicting Śiva (*Pls.* 7, 8, 9 & 10) in a localized Oudh idiom, considerably prosaic and lacking in all subtle nuances, belong to the *Rāmacaritamānasa* manuscript of 1865 *Vikram Saṁvat* (CE 1808) illustrated by a group of artists who came from Lucknow and possibly worked in Banaras for Raja Udit Narain Singh. The manuscript lying in the Royal library at Ramnagar Fort has five hundred and thirty-five illustrations, each having a decorative border of ornately conceived floral meanders or cartouches, apparently Islamic in spirit. In all the four paintings one might detect a somewhat standardized iconography of Śiva adorned with a set of familiar attributes which was not far removed from the archetypes handed down to Mula's ancestor by Lalji *Musavvar* of Delhi. Further, the Banaras version of the Oudh idiom and especially the painter's iconography of Śiva can be linked to a great extent to the style of two Lucknow painters, Udwat Singh (cf. T. Falk, M. Archer, *Indian Miniatures in the India Office Library*, London, 1981, cat. nos. 349 — iii & iv) and Ghulam Reza (*ibid.,* cat. nos. 350 — i, ii, iii, iv, v & vi), both employed by Richard Johnson during 1780s.

miniature painting for display in his private shrine. One of these sets was a series based
on *Devī Mahātmya* while the other consisted of illustrations of the tenth canto of *Bhāgavata
Purāṇa*, focusing on the deeds of young Kṛṣṇa. Mula's *Devī Mahātmya* series was
considerably influenced by an illustrated *Mārkaṇḍeya Purāṇa* (datable to *c.*1865)[28]
belonging to Mandi school and was then in the possession of the royal priest of Mandi
state residing in his neighbourhood, Raj Mandil *mohallā*. A single sheet display print[29]
from Brajachanda Yantrālaya with the depiction of "Gods adoring the Mātṛkās, Kālī,
Śivadūtī and Ambikā"[30] (*Pl.* 11) can be safely attributed to Mula on stylistic grounds.
Presumably, the drawing was executed during *c.* 1880, simultaneously or a little later
after the completion of the elaborate painting project of the Devī series. For the litho
version, Mula changed the vertically rising rectangular format of his painted Devī series
into a circular unit, the rim arrayed evenly with lotus petals. He divided the narrative
situation culled from the *Third Carita* of *Devī Mahātmya* into two units; on the right side
were composed the densely clustered Gods of Hindu Pantheon including Śiva. With
folded hands they adore and sing the glory of Ambikā, Kālī and Śivadūtī as also of seven
Mātṛkās having the "form, ornament and vehicle" of the gods from whose bodies they
sprang forth.[31] They all form a group on the left side of the composition while winged
celestial beings, appearing from hovering clouds, cause a rain of blossoms on them.

Mula, however, borrowed the basic pictorial raw material from the Mandi set which
he had a chance to look at repeatedly and respond to creatively. None the less, we notice
here an entirely divergent facet of his style in which the borrowed tradition of Pahari
masters was all too manifest and Jaipur idioms of Pratap Singh (1778-1803) and Savai
Jai Singh (1803-48) era as well as late-Mogul mannerisms were fused rather sparingly.
But, going beyond the physical structure he was keenly interested in depicting the subtle
sensations of the mind, leading the spectator to an invented realm of meanings. One
may notice again Mula's mastery in the genre of Tāntric *dhyāna* paintings when he
chose to conceptualize the iconic forms of two significant goddesses (*Pl.* 12) namely,
Maheśvarī and Śivadūtī, the former being the female *śakti* of Śiva[32] and the latter, the
śakti of the Great Goddess herself.[33] Mula's Maheśvarī with her matted hair spread loosely
on her shoulders, holds 'the best of tridents,' and rides the bull, the majestic vehicle of

28. The Mandi series is presently housed in 'Bharat Kala Bhavan,' Varanasi. Acc. No. 10871.

29. In all likelihood this print belonged to a series revolving around *Śaiva* or *Devī* theme. The only other
 known example, circular in format and of identical dimension, has a depiction of Śiva as
 Mahāmṛtyuñjaya with Amṛta (cf. the jacket cover). This also bears the details of the Brajachanda
 press. These display prints were substitutes of the *dhyāna citra*s, used in rituals as objects of worship.

30. "Gods adoring the Mātṛkās, Kālī, Śivadūtī and Ambikā," diameter of the central circular unit: 21.7
 cms., off white map litho. Private collection.

31. Cf. Thomas B. Coburn, *Devī Mahātmya: The Crystallization of the Goddess Tradition*, Delhi *et al.* 1984,
 Appendix A, pp. 313-16.

32. *Ibid.*, pp. 144-46

33. *Ibid.*, pp. 137-38.

Śiva. A leopard skin spread on the back of the bull is indicative of her ascetic character she shares with her consort. Her face in three-quarter carries a gentle expression, a subtle smile added with crisp strokes reminding one of Mula's refined line drawings.

Śivadūtī was shown in a benign stance, sensuous and agile, standing between Vārāhī and Nārasiṁhī. The mythic context of her birth laid down in *Devī Mahātmya* runs as follows:

> Then from the body of the Goddess came forth the very frightening *Śakti* of Caṇḍikā, gruesome (and) yelping (like) a hundred jackals (*śivaśataninādinī*).
>
> And she, the invincible one (*aparājitā*), spoke to Śiva, of smoky matted locks:
> O Lord, become a messenger to Śumbha and Niśumbha (saying)
> If you are desirous of battle because of pride in (your) strength,
> Then come (and) let my jackals (*śivā*) become satiated with your flesh.'
> Because Śiva himself was appointed as messenger by (this) goddess
> She has become, famous throughout the world as Śivadūtī (she who has Śiva as messenger).[34]

While portraying Śivadūtī, Mula paid attention to two iconic elements. Firstly, he wanted Śivadūtī to look different from Maheśvarī (composed in the print a little above the former) intrinsically and secondly, she should not look like a mere replica of the Mandi version.[35] Instead of the leopard skin, as shown in Pahari version she wears a pleated and unadorned loin with loose ends tucked at the front. The upper body with contours drawn tersely was shown bare. The earrings and armlets are the only ornaments she is wearing. The stiff strands of her matted hair, quite like a group of snakes, swirl down on her shoulders. Her glance is full of compassion and the smile is tinged with suppressed mirth. Belonging to a family devoted to the worship of Kālī, Mula could effortlessly delineate not only the structural complexities of the Devī iconography but, succeed in incorporating in this line drawing his intuitive understanding of the enriching philosophy behind the goddess tradition. In the history of Banaras lithography this single sheet print holds a unique position, matchless in its imagery. Sadly enough, none other artist from his family could continue with this esoteric tradition of *dhyāna citra*s and thus, gradually faded away one seminal facet of Banaras painting.

Mechanical reproduction of images in the lithographic technique opened up great possibilities for the enterprising publishers of Banaras. Litho prints, serving a mass market, were affordable and had a popular appeal much in tune with the taste-norms of the

34. *Ibid.*, p. 137; cf. also *The Mārkaṇḍeya Purāṇa*, transl. with notes by F. Eden Pargiter (Bibliotheca Indica), Calcutta: Asiatic Society, 1904, Reprint Delhi/Varanasi: Indological Book House, 1969, p. 503.

35. Considering family as the basis of Pahari style one may presume that the Mandi artist drew upon some Guler master drawing preserved in his family guild. For comparison one may refer to a Guler illustration of the same narrative situation belonging to a dated *Mārkaṇḍeya Purāṇa* series of CE 1781, cf. F.S. Aijazuddin, *Pahari Paintings and Sikh Portraits in the Lahore Museum*, London, 1977, cat. no. 41 (xxx), pl. 51 & p. 32.

middle-class gentry. As stated earlier, majority of the local publishers employed bazaar painters working in a listless style. Such litho illustrations do present an affinity to the contemporary wall paintings, especially in terms of the linear clarity and the way blank backgrounds, invariably white, were manipulated. *Rāmacaritamānasa* was one of the favourite vernacular texts of these publishers besides numerous Sanskrit prayer books. A litho edition of the *Śivamahimna Stava*[36] by Puṣpadanta having an end page illustrated on both the sides and bearing the date *Saṁvat* CE 1941/1884, may be referred to in this context as it typifies the bazaar style used in the portrayal of a Śaiva theme. Nevertheless, the anonymous artist conceived Śiva in a delightfully different iconic form, devoid of subtle connotation. Such an iconic form, much admired by the mass, was repeatedly used by a large number of artists expressing in this cliche-ridden monotonous style. On the obverse of the end page (*Pl.* 13) of *Mahimna Stava* booklet, Śiva was depicted as a middle-aged person with a heavy physiognomy; his matted locks secured in a knot bedecked with a snake. His garland and armlets remain entwined with snakes and he wears a *dhotī* with pleats arranged in an orderly way at the front. Inclined towards the right at a certain angle, his face in three-quarter profile would rouse a faint memory of the Jaipuri archetype while his moustache, alike the one noticeable in Kalighat *paṭas*[37] and nineteenth-century Bengal woodcuts[38] as also in the porcelain idols imported from Europe, add a definitive secular flavour. To the left of the horizontal folio, Mahādeva, Pārvatī and infant Gaṇeśa recline on a tigerskin, while at the centre a huge squatting Nandī wearing beaded ornaments and covered partly with a brocaded spread gazes fixedly towards his master. A group of twelve *gaṇa*s occupying the entire right corner adore the holy family; the one heading the group does the *āratī*; others play *ḍamaru* and *śahnāī*, dance or sing in chorus. The reverse side (*Pl.* 14) of the folio is explicitly decorative. The colophonic details in Devanāgarī were composed in a rectangle that was surrounded by four cartouches.[39] The two horizontal ones having almost identical depiction of Śiva

36. *Śivamahimna Stava* by Puṣpadanta; nineteenth-century explanatory notes appended to the text by Madhusūdana Sarasvatī, a disciple of *Parivrājakācārya* Viśveśvara Sarasvatī; ff 26; 37.3 x 15.1 cm.; cream-coloured *Sanganeri* paper; two illustrations on both sides of the end page; the colophon and the end page bears the date CE 1884. However, the colophon was completed on the fourth day of the bright half of Māgha (Jan-Feb) while the end page was finished on the eighth day of the dark fortnight of Caitra (March-April). The text was printed at Siddha Vināyaka Yantra (situated near Dhundiraja Ganesha) owned by Dauji Agnihotri. Private collection, Varanasi.

37. Cf. W.G. Archer, *Kalighat Drawings*, Mumbai, 1962, cover page; B.N. Mukherjee, *Kalighat Patas*, Calcutta, 1987, *Pl*s. I, III & IV.

38. Cf. A. Paul, *Woodcut Prints of Nineteenth Century Calcutta*, Calcutta, 1983, *Pl*s. 7, 8, 69 & 70.

39. Decorative devices of Islamic inspiration were used repeatedly by the Banaras litho artists on the colophon pages or covers. Such illustrators were essentially multi-media artists who derived motifs from a wide range of sources. A distinguished painter like Ustad Mulchand added to the back cover of *Hanumānbāhuka* a full-page panel decorated with *gul-o-bulbul*, an intrinsically Persian motif much in vogue with the eighteenth-nineteenth century *vaslisaz*. However, the process of assimilation was pretty unrelenting but it clearly reveals the continuity of a major tradition of the art of the book.

and Pārvatī on mount Kailāsa whereas the two set vertically were filled with bearded *gaṇa*s dancing to the music of *ḍamaru* and *siṅga*.[40] Floral ornaments were used as space-fillers in and around the cartouches, some of them belonging to the decorative repertoire of the contemporary brocade weavers of the city. These two immensely vigorous line drawings had innumerable descendants in the genre of popular wall paintings by the potters that very well survived up to the mid-twentieth century. "Śiva as Baṭuka Bhairava"[41] (*Pl.* 15) was solely modelled after the Śiva iconography of the *Mahimna* end page. The stylistic closeness would prompt one to date this single-sheet print close to the same year and further, attribute to the same anonymous illustrator or any member of his family guild.

A large number of litho prints depicting Śiva or Śiva as Bhairava may be listed and collectively they would represent iconic perceptions of an era experiencing quintessential change of direction.

40. A "C"-shaped, horn-type wind instrument.
41. Śiva as Baṭuka Bhairava, 24.3 × 14.5 cm, biscuit coloured map litho, *c.* 1884. Private collection.

11

Relevance of Textual Sources in the Study of Temple Art

Devangana Desai

An architect who has book knowledge but has neglected to apply that knowledge to any construction will faint when called upon to demonstrate his knowledge, 'like a cowardly warrior on a battlefield.'
On the other hand, one who is proficient as a builder but has not studied the *śāstra*s will prove to be a blind guide who leads his followers into a whirlpool.
— *Samarāṅgaṇa-sūtradhāra*, chapter 44

THIS quotation from the eleventh-century treatise on Vāstu (canons of architecture and allied arts), attributed to the scholar-emperor Bhojadeva of central India, suggests that there is not so much hiatus between text and practice in early India as we generally believe.* The text lays down that the architect should be proficient both in *śāstra* (text, theory) and *karma* (work, practice). At Bhojpur, near Bhopal, a temple built by this visionary king still preserves the artists' sketches carved in stone, a masonry ramp for transportation of stone blocks, and the work sites where the temple's components were being carved, throwing light on the mechanics of the temple's construction.[1]

Though we do get names of ancient preceptors of Vāstu codes such as Garga, Manu, Mārkaṇḍeya and others, canons on temple building were actually written down only from about fourth-fifth century CE when temples in dressed stone began to be constructed. From this time art-canons were incorporated as chapters in several religious and priestly treatises such as the *Matsya Purāṇa*, *Viṣṇudharmottara Purāṇa*, and the *Hayaśīrṣa-Pañcarātra*, as also in the astronomical treatise, *Bṛhat-Saṁhitā*. But significantly, until the tenth century we do not come across specifically written architectural texts. The specialized works on temple art, known as the Vāstuśāstras and Śilpaśāstras, were not written until

* A version of this paper was earlier presented at the workshop on "Value Systems in the Visual Arts of India and China," at the History of Art Department of the University of Sussex at Brighton, U.K., 22nd June, 2001.

1. Cf. M.N. Deshpande, 'The Śiva Temple at Bhojpur, Application of Samarāṅgaṇa-sūtradhāra': *Journal of the Asiatic Society of Bombay*, vol. 54-55 (1979-80), pp. 35ff; Kirit Mankodi, 'Scholar Emperor and a Funerary Temple, Eleventh Century Bhojpur,' in: *Royal Patrons and Great Temple Art*, Mumbai: Marg Publications, 1988, p. 66.

this time, except perhaps one or two examples such as the text called *Vāstutilaka* from western India. But from the tenth century onwards we have a large number of independent treatises on architecture and sculpture from different regions of India: Gujarat, Malwa (central India), Rajasthan, Orissa, Tamil Nadu and Kerala.[2]

By the tenth-eleventh century, the temple in India reached its perfection. This was the period of increased architectural activities and regional schools of art. The temple developed in its full-fledged evolved form with elaboration in its constituent parts. Some of the masterpieces of temple architecture were created in different regions of India in this period. The growing importance of the temple in the socio-religious life along with availability of liberal donations led to the expansion in the size of the temple by addition of new structures such as the hall for dance, hall for food offerings, and so on. Heights of temples also increased considerably. Ground plans too underwent a remarkable transformation and adopted various projections and recesses, creating extra space to accommodate the divine hierarchy — *parivāra-devatā*s (family divinities), *āvaraṇa-devatā*s (surrounding divinities), and so on.

In this period we get information about the importance of a special category of artist, called *sūtradhāra*, who was a master-architect controlling the *sūtra* (measurement cord) and the design of the temple. From about the ninth-tenth century he figured at the top of the hierarchical set-up of artists.[3] *Sūtradhāra*s are said to have written or compiled Vāstu texts, possibly at the behest of royal patrons. Regional competition and cultural rivalry could have led to compilation of a large number of Vāstu texts as also to the building of large-scale ambitious temples.

It is generally believed that theologians or brāhmaṇas compiled Vāstu texts and that builders and sculptors did not much use such texts in their actual practice. But there are several inscriptions from different regions of India recording proficiency of *sūtradhāra*s in constructional activities as well as in knowledge of Śilpaśāstras. There is epigraphical evidence to show that the architectural texts of Jaya and Aparājita were followed by artists in the western Indian temples in respect of various types of pillars.[4]

I have first hand information from western India that some of the Vāstu texts were composed by the Sompura architects. Certain instructions were orally transmitted and not put into writing. Recently, while talking to the practising architect Hariprasad Sompura, who has built over 30 temples, I learnt that he has in his possession handwritten 105 texts (some fragmentary) inherited from his family, including the *Vāstukaustubha*, written by Sūtradhāra Gaṇeśa, six generations before him. The Sompuras trace their

2. Cf. M.A. Dhaky, 'The Vāstuśāstras of Western India': *Journal of the Asiatic Society of Bombay*, vol. 71 (1996); Devangana Desai, *Social Dimensions of Art in Early India*. Presidential Address, Ancient India, Indian History Congress, 50th Session, Gorakhpur University, December, 1989.

3. Cf. R.N. Misra, *Ancient Artists and Art Activity*, Simla, 1975.

4. *Ibid.*, pp. 44ff; 72.

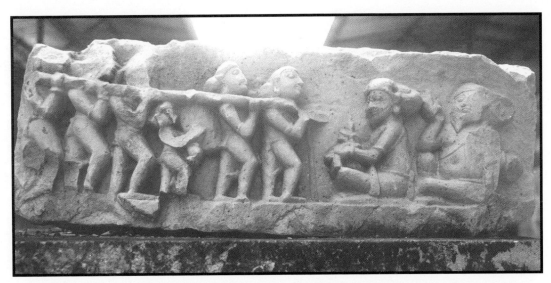

Pl. 11.1: Craftsmen, a writer, and a religious teacher with manuscript in hand.
Sculptured panel from ASI excavation of Bījamaṇḍala mound Khajurāho.

Pl. 11.2: Kandarīya Mahādeva temple, Khajurāho, about 1030.

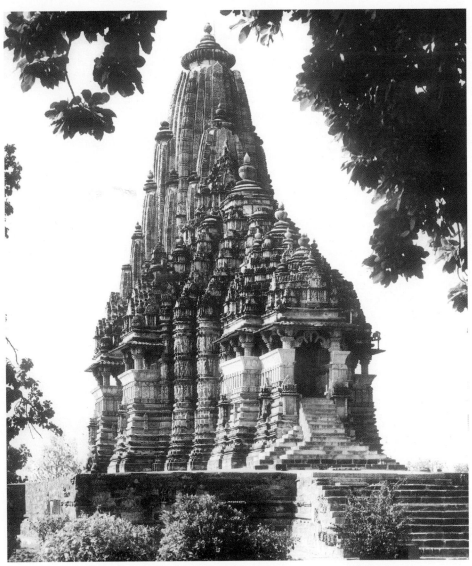

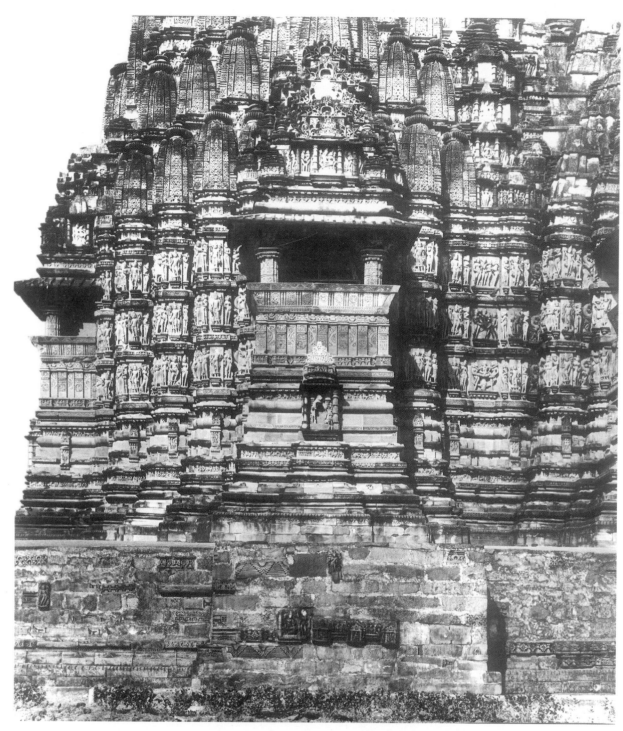

Pl. 11.3: Kandarīya Mahādeva temple, partial view from the south.

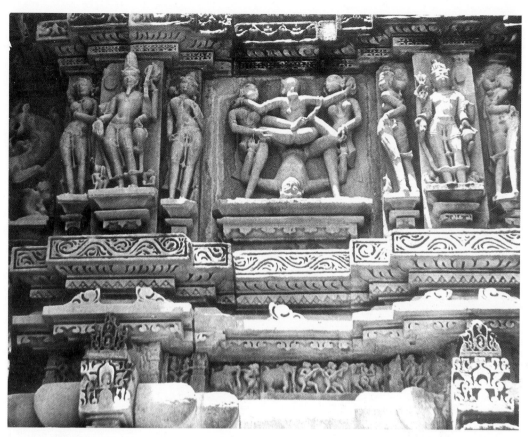

Pl. 11.4: Head-down pose, south juncture wall, Kandarīya Mahādeva temple.

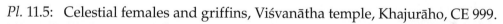

Pl. 11.5: Celestial females and griffins, Viśvanātha temple, Khajurāho, CE 999.

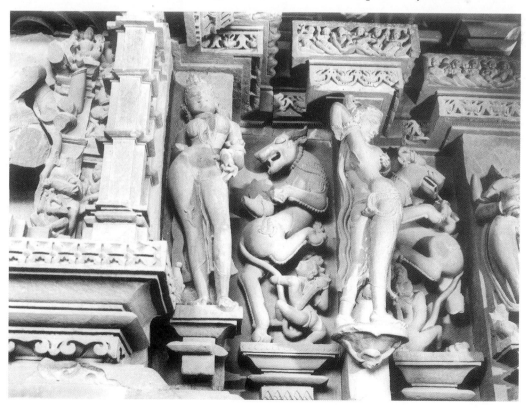

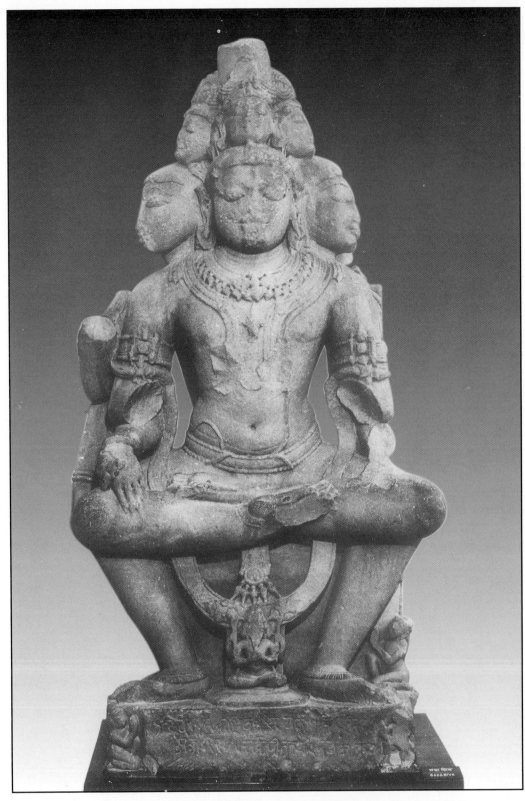

Pl. 11.6: Image of four-footed (Catuṣpāda) Sadāśiva,
ASI Museum, Khajuraho, eleventh century.

family connections to the scholar-architect Sūtradhāra Maṇḍana who wrote the well-known manuals on Vāstu and Śilpa in the fifteenth century. Their family history of 400 years, covering twelve generations, is available. Each generation adds to the existing knowledge of Vāstu texts. They generally consult *Aparājitapṛcchā* besides other texts such as *Kṣīrārṇava, Dīpārṇava, Vṛkṣārṇava,* and *Prāsādamaṇḍana.*

Similarly, in the context of south Indian temples, Ananda Coomaraswamy mentioned hereditary *śilpin*s and *sthapati*s of the Kammalar caste making use of the Śilpaśāstras, either in Sanskrit versions or vernacular abstracts.[5] In the first quarter of the twentieth century, historians of architecture, for instance, Henry Cousens and Jouveau-Dubreuil prepared their accounts of the development of temple architecture on technical information from living traditional craftsmen of western and southern India respectively.

In Orissa, also, the Śilpaśāstra tradition continues unbroken up to the present day. The setting up of *pañjara* (compositional diagram) is performed when carving out an image of a deity. Works by Alice Boner, Bettina Bäumer and others show the relation of Śilpaśāstras and existing monuments. Even today temple architects in Orissa quote verses from the *Śilparatnakośa* and other texts relating these to temple construction.[6]

Recent Research

Interpretative studies of texts by architectural historians in cooperation with traditional practising architects (*sthapati*s) have played an important part in identifying the terminology of various components of the temple from the plinth to the spire-finial, evolving a technical vocabulary of architectural forms. This has opened up an indigenous approach to the study of temples. As Pramod Chandra says:

> A new phase can be said to have begun in the analysis and understanding of Indian architecture . . . the texts, once shunned as inexplicable, are rapidly yielding their secrets; a careful and well-reasoned discussion on the basic systems of classification is occurring.[7]

The *Encyclopaedia of Indian Temple Architecture*, published by the American Institute of Indian Studies, gives a detailed description of architectural features of important temples within the regional/dynastic style. The temple is conceived and presented in the terminology of the Vāstuśāstras and Śilpaśāstras. Similarly, the work on Buddhist art by H. Sarkar, Debala Mitra and others shows the employment of the terminology from Buddhist texts. Textual scholarship has been combined with the knowledge of actual architectural and sculptural material in the research on Indian monuments.

5. Cf. Ananda K. Coomaraswamy, *History of Indian and Indonesian Art* (orig. London 1927), New York: Dover Publications, 1965, p. 125.

6. Cf. Bettina Bäumer, Rajendra Prasad Das (ed.): *Śilparatnakośa. A Glossary of Orissan Temple Architecture* by Sthāpaka Nirañjana Mahāpātra (Kalāmūlaśāstra Series; 16), introduction, Delhi: Indira Gandhi National Centre for the Arts, Motilal Banarsidass, 1994, pp. 1-3.

7. Pramod Chandra, *On the Study of Indian Art*, Harvard University Press, 1983, p. 35.

To give some idea of the research being done in the field, we may mention architectural historian Prof. M.A. Dhaky's analysis of Vāstu texts of western and central India on the basis of comparative architectural and sculptural material and in collaboration with practising temple architect Prabhashankar O. Sompura. He has scrutinized structural organization and formal details of at least 43 temples of western India (Gujarat and Rajasthan), offering a sound chronology, and presented drawings of their architectural parts in the terminology of the Vāstu texts of the region.[8]

The co-ordination of textual sources and field research is illustrated in Dhaky's masterly work on the ceilings (*vitānas*) of the temples of Gujarat with the help of eight Vāstu texts, which provides the structural and typological classification of ceilings, giving terminology for each minute decorative detail.[9] Referring to the ceilings of *maṇḍapas* (assembly halls), the text *Aparājitapṛcchā* gives 1113 varieties and assigns each class of ceiling to a particular deity, but field studies do not quite confirm these directions. In Hindu temples of medieval Gujarat, irrespective of the enshrined god, the Sabhāmārga and Nābhicanda orders of ceilings are employed. Dhaky voices the difficulties of this research, as the living tradition "faltered, if not totally failed, on this issue." For the knowledge of the construction of decorated ceilings had gone into oblivion since at least three centuries. The problem of the correct interpretation of these texts is one of the most difficult to handle. "The very nomenclature of its (ceiling's) components was unknown and today when the ancient canonical stanzas are coming to light after the centuries of obscurity, they speak in a language that is familiar and flowery but whose contents are sealed up in the iron chestes of slippery, often formidable, terms or bound up by the barriers of terse and pedantic phraseology." "Yet the texts are of immense value and it is solely with their aid that we can aspire today to probe through the mysteries of the *vitānas* (ceilings) and the minds of the ancient architects who shaped them."

Similarly, working on temples of the Bhūmija form (a temple form described in the texts *Samarāṅgaṇa-sūtradhāra* and *Aparājitapṛcchā* and identified by Stella Kramrisch), Krishna Deva has examined the extant temples in central India and Maharashtra along with textual material. He says: "The known examples follow the texts closely in the varieties of the plan and generally in composition and elevation, but differ in details of measurements and proportion." [10]

On the basis of field research, Michael Meister demonstrates that the 64-square (8 × 8) grid of the *Vāstupuruṣa-maṇḍala* (a magico-ritual diagram), prescribed in texts for temple architecture, was given practical application in developing ground plans for

8. Cf. M.A. Dhaky, 'The Genesis and Development of Maru-Gurjara Temple Architecture,' in: *Studies in Indian Temple Architecture*, ed. Pramod Chandra, New Delhi: AIIS, 1975.

9. Cf. J.M. Nanavati, M.A. Dhaky, 'The Ceilings in the Temples of Gujarat': *Bulletin of the Baroda Museum and Picture Gallery*, Baroda, vols. XVI-XVII (1963).

10. Krishna Deva, *Bhūmija Temples: Studies in Indian Temple Architecture*, New Delhi: AIIS, 1975, p. 91.

temples from the seventh to tenth centuries in north India. The constructional and aesthetic considerations altered the *maṇḍala's* utility as the architecture and ornament of the Hindu temple developed in the ninth century. An architect in making a design could manipulate the grid and the proportions derived from it. Meister says:

> It is not clear in India that all architects at work knew principles rather than simply the practice of architecture. Certainly not all temples standing accurately embody known principles in their construction. This study has found, however, that many temples do demonstrate some understanding of principles for applying the grid of the *Vāstu maṇḍala* to the plan of the temple.[11]

Recent studies of temples from the construction point of view by practising engineer R.P. Kulkarni[12] based on calculations and proportions of a variety of *śikhara*s (spires) given in Vāstu texts is worth noting. Similarly, Kirti Trivedi, Professor of Industrial Design, draws our attention to fractal elements in Hindu temples along with evidence from Vāstu texts.[13]

Some Limitations of Textual Sources

There are however, some limitations to the study of temples based on texts. The problem of terminology and nomenclature still remains to be solved as the texts of different regions like western India and Orissa use different terms and colloquial words. However, this problem can be surmounted by use of standardized terms as in the *Encyclopaedia of Indian Temple Architecture*. Also, there are hundreds of temples in Karnataka and Telangana regions, but no Vāstu texts have been found from there. So in studies on temples of these regions, the terms used are drawn from the relevant Sanskrit textual sources of Tamil Nadu and central and western India, as well as from inscriptions of these temples.

It seems likely that some of the encyclopedic Vāstu texts such as *Samarāṅgaṇa-sūtradhāra* and *Aparājitapṛcchā* were composed after the highly evolved types of temples they describe were constructed. Regarding the south Indian text *Mayamata*, Bruno Dagens remarks: "The theory of architecture we found in the *Mayamata* has been extrapolated from already existing monuments. In other terms, this Vāstuśāstra has been made according to some monuments and not vice versa."[14] But he clarifies that "the work is coherent," in spite of interpolations; these could be the result of an updating of the text. Dagens gives examples of the usefulness of the *Mayamata* to traditional architects. Similarly, there is inscriptional evidence indicating that the western Indian text *Vṛkṣārṇava*

11. Michael W. Meister, 'Maṇḍala and Practice in Nāgara Architecture in North India': *Journal of the American Oriental Society*, vol. 99, 2 (1979), p. 208.

12. Cf. R.P. Kulkarni, *Prāsāda-Śikhara* (Temple-Roof), Thane, 2000.

13. Cf. Kirti Trivedi, 'Hindu Temples: Models of a Fractal Universe': *Visual Computer* (1989), 5, pp. 243-58.

14. Bruno Dagens, 'Iconography in Śaivāgamas: description or prescription,' in: *Shastric Traditions in Indian Arts*, 2 vols., ed. Anna L. Dallapiccola, Wiesbaden/Stuttgart: Steiner, 1989, p. 151; *Mayamata*, tr. with introduction, New Delhi, 1985.

was composed after the construction of the Caturmukha temple at Ranakpur in CE 1449.[15]
Even so texts lay down guidelines for later generation of architects. This is also seen in
some of the Orissan texts such as the *Śilparatnakośa*, composed in CE 1620, more than five
hundred years after the construction of the great temples of Bhubaneswar, but which
guide the present-day *śilpī*s and *sthapati*s, as also researchers on temple art.

Again, texts continue to include canons of an early period, even when in actual
practice changes have taken place in temple rituals and requirements, due to changing
socio-cultural factors. The Indian temple is an evolving structure since the early centuries
of the era. But, to some extent, texts written in different periods do show the changed
scenario. Here we may mention that Stella Kramrisch has drawn attention to the
modifications in the proportionate measurements of the temple in the eleventh-century
text *Samarāṅgaṇa-sūtradhāra*. The pure proportions of the earlier texts were no longer
observed in the vertical dimension.[16]

Vāstu texts give instructions for construction of numerous types of temples, *maṇḍapa*s,
roofs, for instance, 15 types of temples, 27 types of *maṇḍapa*s, 25 types of *saṁvaraṇā* (bell-
stepped) roofs — for instance. Such instructions are 'in the nature of general programmes
from which different forms may be generated' and are guidelines for posterity. It is also
important to remember, as Kirti Trivedi says, that the system of measurement followed
by the Vāstuśāstras, called 'Tāla' system, does not depend on absolute dimensions, but
defines all dimensions as sets of relationships of proportions of component parts with
respect to the whole.[17] This system has the advantage that it is possible to work out the
proportions of parts irrespective of the overall size. Such an arrangement gives freedom
to artists. There is room for creativity and innovation. Otherwise, how can we get some
unique monuments and images?

Comparatively, the image-maker would be far more restricted than the temple builder.
For the efficacy of the icon made for worship, the sculptor has to follow the dimensions
and attributes laid down in *pratimā-lakṣaṇa* (characteristics of images) chapters in texts.
However, researchers do not find exact correspondence of image and iconographical
text, but sometimes have answers to their queries from literary or narrative texts. J.N.
Banerjea measured some representative Hindu medieval images in Calcutta museums
and while comparing these with the measurements prescribed in texts found "a fair
agreement between the respective data in the case of those images which are
comparatively well-executed ones."[18] Medieval India sees many new cults and their

15. Cf. M.A. Dhaky, *Genesis and Development of Maru-Gurjara Temple Architecture, op. cit.*, p. 126.

16. Cf. Stella Kramrisch, *The Hindu Temple*, 2 vols. (Calcutta 1946), rpt., 1976, p. 244.

17. Cf. K. Trivedi, *Hindu Temples, op. cit.*, p. 247.

18. J.N. Banerjea, *The Development of Hindu Iconography*, Calcutta: University of Calcutta, 2nd edn., 1956,
 pp. 621ff.

divinities. With the cult of sixty-four *yoginīs*, for instance, newer goddesses enter the fold with esoteric iconography. Texts in such cases follow, rather than precede, the image making.

Temples of Khajurāho and Textual Tradition

We will now examine the temples of Khajurāho in central India on which I have been working. This temple site flourished between CE 900 and 1150 under the Candella Rajput dynasty and has over 25 temples dedicated to the Hindu gods, namely Viṣṇu in his incarnations, Śiva, Sūrya, and the sixty-four *yoginīs*, and to the Jaina pontiffs. At this place, there are literally hundreds of sculptured divinities that hold manuscripts in hands. This is indicative of a strong textual tradition prevalent here. But no manuscripts have so far been discovered from the region. Yet we know that Khajurāho artist worked within the tradition of Viśvakarma Vāstu School; the inscription of the Viśvanātha temple of this site records the name of its master-architect (*sūtradhāra*) Chichha, and describes him as well-versed in Viśvakarma School.[19]

Khajurāho temples were constructed according to the Śāstric tradition of the central Indian Nāgara style of architecture. Though texts are not available in the Khajurāho region, those of the neighbouring regions of Mālwā and Gujarat such as *Samarāṅgaṇa-sūtradhāra*, composed in Mālwā between CE 1035-50, the *Vāstuvidyā*, composed in southern Rajasthan in the later part of the eleventh century, and the *Aparājitapṛcchā*, composed between 1150 and 1175, are helpful. These texts profess adherence to Viśvakarma.[20] Besides, the formal elements of the temples of central and western India have basic similarities.

In addition to architectural texts, the religious texts associated with the Viṣṇu and Śiva temples (Pañcarātra Vaiṣṇavism and Śaiva system respectively), have helped me in the identification and placement (*sthāna-nirṇaya*) of images in the temples. These texts deal not only with theology and Yoga but also with the building of temples, tanks and the making of images. In this connection it is interesting to note a recently excavated sculptural panel from the Bījamaṇḍala mound of Khajurāho that shows craftsmen carrying a stone on the left, a writer or scribe, and a bearded *ācārya* (religious teacher) with manuscript in his hand, as if giving instructions, depicted on the right (*Pl.* 1).

In understanding the cult of the esoteric god Vaikuṇṭha-Viṣṇu, whose image — brought to Khajurāho by the Candella king Yaśovarman in middle of the tenth century — was originally from Kashmir-Chamba region, the texts of that region were helpful. The sixth-seventh-century Kashmir texts, the *Jayākhyā-Saṃhitā* and the *Viṣṇudharmottara Purāṇa*, have *dhyāna-mantra*s (meditation formulae) of god Vaikuṇṭha. But we should

19. Cf. Devangana Desai, *The Religious Imagery of Khajurāho*, Mumbai, 1996, pp. 16-17.
20. Cf. M.A. Dhaky, 'The Vāstuśāstras of Western India': *Journal of the Asiatic Society of Bombay*, vol. 71 (1996).

not expect an exact correspondence of the text with the image, three hundred years after the texts were compiled and that too in a different region and different milieu. In the course of time new developments were included in the religious pantheon of central India. For instance, Buddha is included as an incarnation of Viṣṇu at Khajurāho, but he is not mentioned in the *Jayākhyā-Saṁhitā*. The only two Pañcarātra texts which mention Buddha as Viṣṇu's *avatāra*, are the *Hayaśīrṣa-Pañcarātra* and the *Nāradīya-Saṁhitā*. Also the *Viṣṇudharmottara* in its later chapter and the Purāṇas such as the *Matsya, Agni* and *Bhāgavata* name Buddha as Viṣṇu's *avatāra*. We must remember that in this period the Pañcarātra was disseminated through the popular medium of the Purāṇas and the Nārāyaṇīya section of the *Mahābhārata*.

So here we see that texts written in the sixth-seventh centuries such as the *Viṣṇudharmottara Purāṇa* of Kashmir region, and the *Hayaśīrṣa-Pañcarātra* and the *Agni Purāṇa*, said to be from eastern India, are helpful in interpreting the material of tenth-century central Indian temple. Similarly, it is not one text for one temple, but texts of different genre, both narrative (*Mahābhārata*, Purāṇas, Sanskrit literature) and non-narrative (Vāstuśāstras, Tantras, Āgamas) are useful in understanding imagery of a temple. Also the study of the allegorical play *Prabodhacandrodaya*, staged in the Candella court, was rewarding in understanding some of the sculptural depictions of the Lakṣmaṇa temple, dealt by me in a separate article.[21]

In this context I remember my dialogue with temple architect Hariprasad Sompura. I asked him which text he follows in building a temple. He was surprised at the question and said he consults several texts in building a temple. Why only one text for one temple?

Structural Aspects of Temples

Various components of the Khajurāho temples have been identified in terms of Vāstu texts. Stella Kramrisch points out the similarity in the rhythm of the unified plan of the Lakṣmaṇa temple and the schematic plan such as that of Prāsāda Vijayabhadra (drawn in her book, p. 250), following the *Samarāṅgaṇa-sūtradhāra*.[22]

Krishna Deva has employed terminology of Vāstu texts in his analysis of the Khajurāho temples. The mature Khajurāho temple stands on a high platform, *jagatī*, which is almost equal in height to the basement comprising of *pīṭha* (base with mouldings) and *vedībandha* (socle). The *śikhara* (spire) is twice or thrice the height of the *maṇḍovara*, which consists of the *jaṅghā* (wall) and basement. As Krishna Deva says:

> Each part of the edifice and its sub-part, down to the minutest mouldings,
> had certain set measures and proportions which were fixed either canonically

21. Cf. Devangana Desai, 'Sculptural Representation on the Lakshmana Temple of Khajurāho in the light of Prabodhachandrodaya': *Journal of the National Centre for the Performing Arts*, vol. XI, 3-4 (1982).

22. Cf. S. Kramrisch, *The Hindu Temple, op. cit.*, pp. 250, 255.

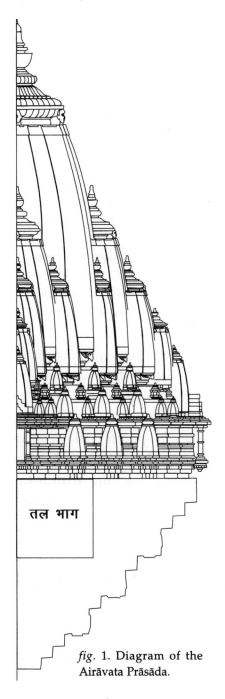

fig. 1. Diagram of the Airāvata Prāsāda.

तल भाग

or traditionally. The Khajurāho architect had a clear concept of well-tested, standard ratios and proportions.[23]

The Kandarīya Mahādeva temple (*Pl.* 2), so far the largest known temple on the site, has a lofty *śikhara* (spire) "decorated with graded and ascending series of smaller replicas of itself, totaling 84."[24] If we see the elaborate classification of the spires of the temples given in texts, the Kandarīya's *śikhara* seems to be of the Airāvata Prāsāda, which has 84 mini-*śikhara*s + the main *śikhara*. In fact, a diagram of the Airāvata Prāsāda (*fig.* 1) given in the text *Śilpa-Ratnākara*, compiled in 1939 by Narmadashankar Sompura from important Vāstu texts of western India, resembles the *śikhara* of the Kandarīya Mahādeva temple.[25]

Juncture Wall

On the basis of ground plans, the temples of Khajurāho can be broadly classified as (1) *sandhāra* temples with inner ambulatory (*fig.* 2), and (2) *nirandhāra* temples without inner ambulatory. I have noticed that the architects have distinguished the placement of erotic figures on the *sandhāra* and *nirandhāra* temples. On the juncture wall (*kapilī, sandhi-kṣetra*) of the former, they place erotic figures (*Pl.* 3), while on the juncture wall of the *nirandhāra* temples they place figures of divinities.[26]

When checking up Vāstu texts on the juncture wall, I found that no such placement of conjoint figures is mentioned on this architectural part. The texts give proportionate measurements of the juncture wall to the main shrine, but not sculptural figures to

23. Krishna Deva, *Temples of Khajurāho*, 2 vols., New Delhi: Archaeological Survey of India, 1990, pp. 18-20.

24. Krishna Deva, 'The Temples of Khajurāho in Central India': *Ancient India*, no. 15 (1959), p. 56.

25. R.P. Kulkarni, *Prāsāda-Śikhara*, *op. cit.*, p. 44. The number of mini-*śikhara*s varies in different temples. The Meru has totally 100 mini-*śikhara*s + the principal spire. Narmadashankar Sompura in his *Śilpa-Ratnākara*, compiled in 1939, presents diagrams of different temples and their *śikhara*s.

26. Cf. Devangana Desai, 'Placement and Significance of Erotic Sculptures at Khajurāho,' in: Michael W. Meister (ed.): *Discourses on Śiva. Proceedings of a Symposium on the Nature of Religious Imagery*, Philadelphia: University of Pennsylvania Press, 1984 (Indian edn.: Bombay: Vakils, Feffer & Simons, 1984), 143-55.

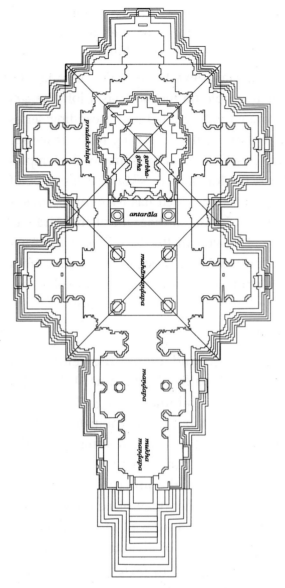

fig. 2. Plan of the sāndhāra temple
(Kandarīya Mahādeva), Khajurāho.

be placed on the junction. However, Michael Meister has observed such a depiction in actual practice. He says:

> The priest or architect at Chitor, searching for a scheme within which to place his images, saw the relation between his conjoint images of Śiva-Pārvatī and Śiva-Viṣṇu and the juncture between *prāsāda* and *maṇḍapa* in which to put them. Though no line of similar linkages on temple walls can be shown from the intervening period, architects at Khajurāho have struck on the same location faced with the need to give prominent place to scenes of ritual and physical union.[27]

At Khajurāho, architects considered the juncture of the hall for devotees and the sanctum of divinity, the juncture of phenomenal and transcendental worlds, an apt place to portray figures in conjunction (*sandhi*). It seems that architects, though working within the parameters of the traditional system, have not mechanically followed conventions, but have made an imaginative use of junctures to symbolize concepts.

There are two head-down postures on the juncture walls of the two Śiva temples — Viśvanātha and the Kandarīya

Mahādeva (*Pl.* 4). When drawing lines on their photographic reproductions, the geometry in their compositional scheme reminded me of the Kāmakalā Yantra of the Orissan text *Śilpa Prakāśa* (II, verses 498ff). According to the text, this was a protective *yantra*, the lines of which were to be concealed from non-initiates by placing erotic figures, which in turn, would give "delight to people." Based on this observation, we can say that the erotic figures and the *yantra* that they seem to conceal, were believed to magically protect the building against obstacles.[28]

27. Michael W. Meister, 'Juncture and Conjunction: Punning and Temple Architecture': *Artibus Asiae*, vol. XLI (1979).

28. Cf. Devangana Desai, *The Religious Imagery of Khajurāho, op. cit.*, p. 195.

Amorous figures are placed in the recesses of the *jaṅghā* (wall) in temples of Khajurāho, a tradition that distinguishes it from the temples of western India (Gujarat and Maharashtra) but has similarity with temples of the Orissan school (Bhubaneswar, Purī, and Koṇārka) of eastern India.[29]

Door of the Sanctum

According to Vāstu texts, the height of the door is supposed to be double than its width.[30] The Khajurāho temples conform to this rule as can be seen from the actual measurements of doorways of the temples.

The door in India is to be decorated with auspicious motifs to protect the building against evil influences. Since the sixth century CE the texts dealing with temple building recommend auspicious couples (*mithunas*), creepers and *gaṇas* to be depicted on doorjambs of temples. In Khajurāho temples, there are five, seven or nine *dvāraśākhās* (perpendicular parallel sections) on the doorjambs, carved with auspicious ornaments such as couples, *vyālas* (griffins), and creepers, as recommended in the texts. The door lintel represents the principal divinity in it central section (*lalāṭabimba*), and also the *grahas* (planetary divinities) and the *mātṛkās* (Mothers).

The religious texts prescribe *mantras* for worship of Gaṇeśa and Sarasvatī on the threshold, personified river goddesses Gaṅgā and Yamunā on the right and the left of the door, and followed by the *mantras* for worshipping the doorkeepers.[31] We see these figures represented on the doors of the Khajurāho temples.

There are certain typical depictions on doorjambs such as the incarnations of Viṣṇu in the Lakṣmaṇa temple (*fig.* 3), and the Seven Mothers and Gaṇeśa in the Duladeva Śiva temple. These depictions are recommended on doors in the Pañcarātra and Tāntric texts. The *Hayaśīrṣa-Pañcarātra* (Ādi Kāṇḍa, XIII, 25) of eastern India is among the rare texts that prescribe *avatāras* on doorjambs of a Viṣṇu temple. The Jaina temples (Ādinātha, Ghantai) have depictions of 16 auspicious dreams of the mother of Jina on the upper lintel, which is in accordance with Jaina Digambara tradition.

Sculptural Motifs

The depiction of *alaṅkāras* (ornaments) on temples was obligatory as these were considered to be auspicious and magico-defensive. The *alaṅkāras* such as couple (*mithuna*), serpent, full vase, creepers, griffin (*vyālas*), celestial female (*apsarā*, also called *surasundarī*), decorate temples in many regions of India. The *vyālas* are classified and 16 × 16 = 256 varieties

29. In my book *Erotic Sculpture of India. A Socio-Cultural Study* (1975), Delhi: Munshiram Manoharlal, 2nd edn. 1985, I have discussed the placement of erotic figures on temples according to regional schools of art.

30. Cf. T. Bhattacharyya, *A Study on Vāstuvidyā or Canons of Indian Architecture*, Patna, 1948, p. 238.

31. Cf. Devangana Desai, 'Location of Sculptures in the Architectural scheme of the Kandarīya Mahādeva Temple of Khajurāho: Śāstra and Practice,' in: *Shastric Traditions in Indian Arts, op. cit.,* p. 60.

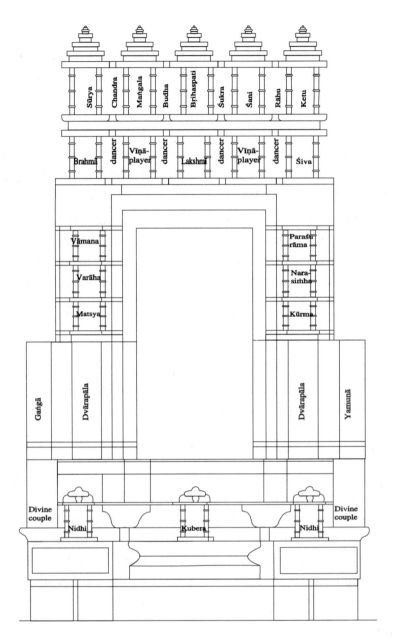

fig. 3. Diagram showing arrangement of the Door Divinities,
sanctum, Lakṣmaṇa temple.

are created by permutations and combinations in the *Aparājitapṛcchā*. This is helpful in
looking at the varieties of *vyālas* of Khajurāho temples with permutations and
combinations of heads and bodies of different animals and birds. However, the western
Indian texts as well as the eleventh-century temples of Gujarat region replace ascetics
(*munis*) for *vyālas*,[32] but Khajurāho temples, as also the Orissan temples, continue to
have *vyālas* in the recesses of the wall.

32. Cf. M.A. Dhaky, *The Vyāla Figures on the Medieval Temples of India*, Varanasi, 1965.

On an important theme of the *apsarā*, the Vāstu texts, including the Orissan *Śilpa Prakāśa*, and the western Indian *Kṣīrārṇava* give detailed classifications of 16 and 32 types respectively with their descriptions, such as Darpaṇā, holding a mirror, Nūpurapādikā, tying ankle-bells, Patralekhā, writing a letter, and so on, which help us to name some of the *apsarā*s at Khajurāho.[33] However, a noteworthy theme, much favourite of the Khajurāho artists, namely the female figure with a scorpion on her leg (*Pl. 5*), is not listed in any of these textual classifications of the *apsarā*.

Identification of Images

Textual studies helped me in identifying sculptural representations of the seven collective handsome divinities on the socle of the Lakṣmaṇa temple. A frog as the mount of one of these figures indicated the deity as planet Venus (in India male deity Śukra), as mentioned in Vāstu texts, and also seen in sculptural depiction of a slab found in the Khajurāho region (now in the Dhubela Museum).[34] This in turn helped me in further specifying the other six figures as planetary divinities. What becomes interesting to observe is that all these seven divinities, including the Sun god, are placed around this temple of Viṣṇu-Vaikuṇṭha. By this placement of the planetary divinities around the temple, the architect projects the temple as Mount Meru, the mythic mountain in the centre of the universe, around which the planets revolve.

Such identifications require knowledge of textual sources. Stylistic studies can help dating monuments but will not give this picture of the temple as Mount Meru or the temple as an ordered whole.

One of the remarkable icons of Khajurāho is Varāha — the Cosmic Boar. It bears on its massive animal body miniature carvings of more than 675 gods and goddesses of the Hindu pantheon. The depictions of the goddess Sarasvatī on its muzzle, Brahmā on its head, two Dikpālas (regents of space) on each of its four legs, and so on correspond to the stanzas in the religious texts, the Purāṇas and Pañcarātras.[35]

However, there are some unusual images, creations of Khajurāho artist-priests that defy identifications. One such image is the most magnificent and tallest image of Khajurāho enshrined in the Caturbhuja temple. Its identification as Dakṣiṇāmūrti Śiva as imparting knowledge, is not convincing.

Placement of Images

In a Hindu temple, the cardinal niches of the sanctum carry forth the presence of the central divinity to the exterior, and these generally represent the manifestations or incarnations of the main god of the sanctum, as explained by Stella Kramrisch in her

33. Cf. Devangana Desai, *The Religious Imagery of Khajurāho*, op. cit., p. 20.

34. D. Desai, *The Religious Imagery of Khajurāho*, op. cit., pp. 135-43.

35. *Ibid.*, pp. 64-69. Also Haripriya Rangarajan : *Varāha Images in Madhya Pradesh: An Iconographical Study*, Mumbai, 1997.

monumental work, *The Hindu Temple*. The architects of the Lakṣmaṇa and the Kandarīya
Mahādeva temples have meticulously programmed images on walls of the sanctum. On
the Lakṣmaṇa, there are 8 Dikpālas (regents of space), 8 Vasus (astral divinities), 12
vyālas, 12 Kṛṣṇa scenes, 24 *surasundarīs*, and Viṣṇu's incarnations in cardinal niches. On
the Kandarīya, there are 8 Dikpālas, 8 Vasus, 12 *vyālas*, 24 *mithunas* and 36 *surasundarīs*,
and Śiva's manifestations systematically placed on the three walls of the sanctum (*fig.*
4).

The sanctums of these temples resemble a *maṇḍala*, consecrated sacred space, which
is guarded on eight corners by the Dikpālas in eight directions. The positioning of Dikpālas
agrees well with the prescription of the *Aparājitapṛcchā* and other Vāstu texts. But the
significance can be understood from the ritual texts which advise the removal of obstacles
(*vighnas*) from eight directions and mentally invoking in their place Dikpālas to guard
against evils (*Īśānaśivagurudevapaddhati*, Kriyāpāda, XIII). The sanctum is to be conceived
as a *maṇḍala* in rituals. In the religious text *IGP*, after performing various rites, the aspirant
enters the *garbhagṛha-maṇḍala* (sanctum in the form of the *maṇḍala*).

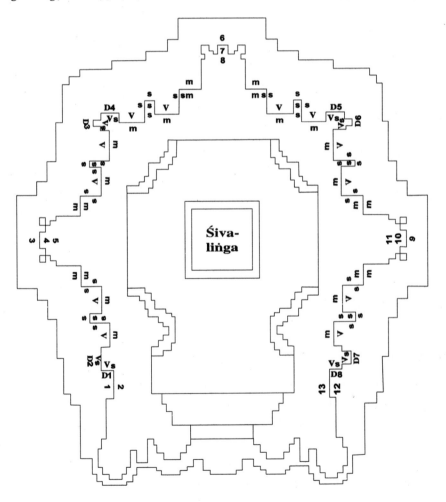

fig. 4. Placement of images on the sanctum wall, Kandarīya Mahādeva temple.

Concept and Image

There are two unique images of Śiva with four legs and six visible heads, topped by a *liṅga*, which is an iconography invented by Khajurāho artist, under the inspiration of Ācārya Ūrdhvaśiva who installed one of this unusual images (*Pl. 6*). The inscription on the pedestal of the image identifies it as Sadāśiva, the Eternal Śiva, considered to be manifest-unmanifest aspect of Śiva in religious texts. But its depiction is not according to any text, which assigns Sadāśiva five faces, though it is nearer the iconography prescribed in the fifteenth-century Vāstu text *Rūpamaṇḍana*,[36] compiled 300 years after the carving of the image. But this text too does not mention god's four feet.

It seems very likely that by showing the god four-footed (*catuṣpāda*), the artist-priest of Khajurāho is conveying, by way of a pun on the word (*pāda* = foot, part or quarter of a treatise), the concept of *catuṣpāda* (four parts) of the Śaivite system. We are reminded of the *Sarvadarśana-saṁgraha*, which describes different religious systems of India. This text defines the Śaiva system as "Catuṣpādam Mahā Tantram," meaning the Tantra treatise with four parts (*jñāna* or Knowledge, *kriyā* or Activities, *caryā* or Rituals, *yoga*). As I have shown elsewhere, Khajurāho artists — both sculptors and writers of inscriptions — were fond of expressing through puns and double-meaning language.[37]

The Temple as a Model of the Cosmos

When Coomaraswamy and Kramrisch interpreted the temple as a model of the cosmos, one thought that such statements were idealistic. But on actual analysis of iconic schemes of the Kandarīya Mahādeva and similar highly evolved temples, and also on the formal study of structures, we can say that such interpretation of the temple can be substantiated.

Khajurāho rose to prominence in India's history at a time when the temple had architecturally evolved into a mature structure. The architectural expansion of the temple was accompanied by conceptual developments in the religio-philosophical systems regarding the Supreme Being and its manifestations, the One and its many forms. A concept of far-reaching importance in the religious systems of the period was that of the emanation of cosmic elements from the Supreme Being in the process of creation of the universe, and their re-absorption to the primordial centre in the process of dissolution. There is a hierarchy of cosmic elements or divinities, one emanating from the previous one — as in a chain — from the Formless Supreme Being to the earth element in the evolution process and their return to the primordial centre in the process of dissolution.

I present here just a bare outline of the Śaiva emanatory scheme:[38]

36. R. Awashi, 'Two Unique Sadāśiva Images at Khajurāho': *Journal of Indian History*, vol. LIII (1961).

37. Cf. Devangana Desai: 'Puns and Intentional Language at Khajurāho,' in: *Kusumāñjali*, ed. M.S. Nagaraja Rao, Delhi, 1987.

38. Cf. T.A. Gopinatha Rao, *Elements of Hindu Iconography*, vol. II, Part ii, Madras 1914-16, pp. 361-96.

Supreme Being — \|	Niṣkala Śiva, undifferentiated formless entity
Parā-Śakti \|	emerges from his 1000th part
Ādi-Śakti \|	emerges from the 1000th part of the previous one
Icchā-Śakti \|	emerges from the 1000th part of the previous one
Jñāna-Śakti \|	emerges from the 1000th part of the previous one
Kriyā-Śakti \|	emerges from the 1000th part of the previous one
Sadāśiva \|	from the five *tattva*s (elements), which emerge from the tenth (*sakala-niṣkala*) part of each of the five Śaktis
Maheśa \|	emerges from the 1000th part of the fifth aspect of Sadāśiva
Rudra \|	emerges from the 1000th part of Maheśa
Viṣṇu \|	emerges from a crore part of Rudra
Brahmā	emerges from a crore part of Viṣṇu and so on.

It is significant to note that the medieval religious systems have used fractions in their presentation of the emanatory process. There is a chain of evolutes — each as a fraction or *aṁśa* of the previous one, and a diminutive *aṁśa* of the Ultimate Reality. There is a hierarchy of evolutes or manifestations, which helps us to see the hierarchy of divinities in relation to the principal enshrined god. The series of evolutes or divinities that emerged was bound to influence the hierarchy in the size and placement of images in temples.

While presenting the conceptual scheme of the Elephanta Cave of Śiva near Mumbai, Stella Kramrisch mentions the three levels of Śiva's presence in the cave:[39] (1) as the *liṅga* in the sanctum, symbolizing the unmanifest (*niṣkala*), formless Supreme Śiva; (2) the intermediary level of Sadāśiva, manifest-unmanifest (*sakala-niṣkala*), that relates formless to form; (3) the manifest (*sakala*) forms of Śiva as Maheśa — Dancer, *yogī*, Bridegroom, and so on. Doris Srinivasan in her article entitled "From Transcendency to Materiality: Para-Śiva, Sadāśiva and Maheśa in Indian Art" has cited visual representations of the doctrinal unfolding in temples of many regions of India by sixth to eighth centuries.[40]

It is in the centre of the *garbhagṛha* that the *liṅga* or emblem, conceived of as *niṣkala*, undifferentiated, is installed. The finial of the *śikhara* or spire is exactly above the *liṅga*

39. Cf. Stella Kramrisch, 'The Great Cave Temple of Śiva in Elephanta: Levels of Meaning and Their Form,' in: *Discourses on Śiva, op. cit.,* pp. 1-11. Also see Bettina Bäumer, 'Unmanifest and manifest forms according to the Śaivāgamas,' in: *Shastric Traditions in Indian Arts, op. cit.,* pp. 339-49.

40. Cf. Doris M. Srinivasan, 'From Transcendency to Materiality: Para Śiva, Sadāśiva and Maheśa in Indian Art': *Artibus Asiae,* vol. L, 1/2 (1990).

(*fig.* 5). The vertical line connecting the *liṅga* and the finial is the Cosmic Axis. The nucleus of the *garbhagṛha* is crucial like the *bindu* (point) at the centre of the *yantra*. It can be compared to a spider, which is linked to different parts in its web. The well-known simile of the *Brahman*, the Ultimate Reality, likened to a spider in the Upaniṣadic and Purāṇic literature helps us to understand the notion of the potential All-point.[41]

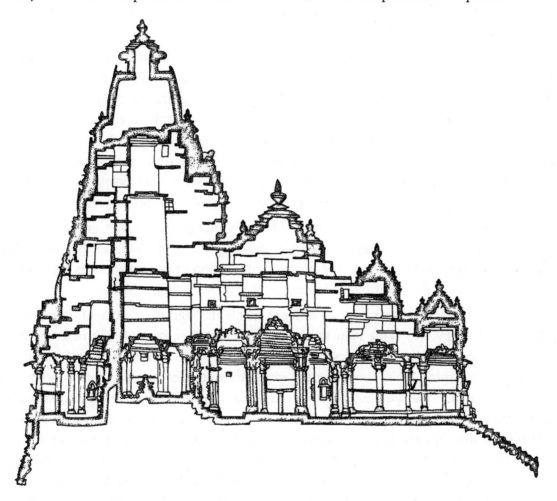

fig. 5. Kandarīya Mahādeva temple, elevation.

Expansion proceeds from the central point of the *garbhagṛha* on the horizontal and in all directions.[42] The unfoldment or evolution (*vistāra, prapañca*) from the central principle can be seen in the form of evolutes or manifested images, which are placed hierarchically in relation to the centre in some highly integrated and well-planned temples of medieval India.

In this context it is significant to mention that Richard Davis has examined various Śaiva rituals, in medieval texts and actual practice, as aids to worshippers in bridging

41. Cf. Madhu Khanna, *Yantra. The Tantric Symbol of Cosmic Unity,* London, 1979, p. 9; Betty Heimann: *Facets of Indian Thought,* London, 1964, p. 99.

the distance between the transcendent, formless, unmanifest Śiva and his graded manifes-
tations. He says that the temple is "an emanated structure, unfolding from its centre,
and space within the temple is organized as a concentric hierarchy, with the most exalted
areas located at or nearest the centre. To approach the preeminent deity in the *liṅga*, the
worshiper necessarily begins outside the temple walls and gradually approaches the
inner sanctum, moving from the periphery to the centre of the ritual space. Hence he
follows the order of reabsorption."[43]

The Kandarīya Mahādeva temple, architecturally one of the most magnificent temples
of India, is well planned in its iconic scheme. With the *liṅga*, described as the Primordial
pillar of the universe in a Candella inscription, in the centre of the sanctum, the centrifugal
movement radiates in the four cardinal directions of the temple in the form of images.
We see images of Sadāśiva (manifest-unmanifest), Maheśa's different forms (*līlā-mūrtis*),
and Rudra, Viṣṇu, Brahmā, and still lesser *aṁśas* or fractions in the rank of Śaiva
hierarchy. The hundreds of figures of standing Śiva, lesser in hierarchy, on the exterior
wall perform angelic functions in helping devotees to come nearer to Śiva.

The hierarchy of divinities in the texts of the Śaiva religious system[44] gives us an idea
of the 'status' of divinities that we see on different parts of the wall of the Kandarīya
Mahādeva temple of Khajurāho. The temple with its integrated imagery is an ordered
whole representing the doctrinal unfolding in its graded iconic scheme.

We have viewed the temple as an ordered whole through its placement of images in
relation to theology. The same view can be had from another angle. I refer here to Adam
Hardy, who looks at Indian temples "in terms of their formal composition and evolution,
and of their meaning." He says: "Formal structure and meaning are both rooted in a
world-view, which the temples, almost by definition, must reflect, being conceived as
microcosms or images of the universe." He discusses the "pattern" of centrifugal growth,
represented through architectural means. "All but the most basic forms of temple are
essentially composite, composed of interconnected aedicules, that is of multiple
representations of shrines or divine abodes. Just as a divinity has many aspects, a great
house for the god is made up of a collection of little houses, of various kinds and at
various levels of order, from primary components to sculpture-sheltering niches." He
says: "A particular kind of sequential chain, dependent upon embeddedness and
enshrinement, is characteristic in the temple dynamics, whereby one form gives birth to
another, which in turn puts forth another, and so on; a pattern closely paralleled by
theological/cosmological hierarchies."[45]

42. Cf. Stella Kramrisch, *The Hindu Temple*, op. cit., vol. I, pp. 167, 179.

43. Richard H. Davis, *Worshipping Śiva in Medieval India. Ritual in an Oscillating Universe* (orig. Princeton 1991), New Delhi, 2000, p. 69.

44. Cf. T.A. Gopinatha Rao, *Elements of Hindu Iconography*, op. cit., p. 370.

45. Adam Hardy, 'Form, Transformation and Meaning in Indian Temple Architecture,' in: *Paradigms of Indian Architecture*, ed. G.H.R. Tillotson, 1997, pp. 107ff; also *id.*: 'Time in Indian Temple Architecture,'

Hardy further says: "For those for whom the forms themselves are insufficient evidence that they embody manifestation, taking place through successive emanations, textual and iconographical evidence is at hand," and notably he refers to the eleventh-century western Indian Vāstu text of Viśvakarmā which states: "Let the five divinities — Brahmā, Viṣṇu, Rudra, Īśvara (Maheśa), and Sadāśiva — live in each *uraḥ-śṛṅga* (turret) on each *bhadra* offset."[46] As discussed above, the series of divinities invoked by the Vāstu text is the emanatory hierarchy of the Śaiva system.

I have attempted to present the cosmic order through the doctrinal unfolding in the iconic scheme — the centre and its many differentiated manifestations as seen in the Kandarīya Mahādeva temple of Khajurāho. And this can apply to any well-planned evolved temple of India.

On the basis of study of religious texts and a close observation of the iconic scheme of the temple, I would say that the Khajurāho architect is trying to express the essence of Indian philosophy in the grid and vocabulary of his time. Icons, which are but 'name and form' (*nāma-rūpa*) of the Formless, are not placed beyond the *śukanāsa* on the superstructure. Beyond this point we see "the ascent and descent and a renewed ascent" of a series of graded peaks, mini-spires, centering around the highest point, the finial, the Cosmic Axis, conveying the perennial rhythm of Creation, Dissolution and again Creation. Through the language of hierarchy and graded manifestations, the architect is conveying the truths of cosmological insight which today also strikes a note.[47]

Conclusion

If we do not insist on one-to-one correlation of text and image or text and architectural form, a study based on textual sources can be fruitful in developing an indigenous approach to temple arts evolving a technical vocabulary. Current research coordinating textual sources and actual architectural and sculptural material with the help of practising traditional architects has produced fruitful results. It does not seem likely that there was a sharp hiatus between text and practice in the field of temple architecture in India. Until recently, practising architects wrote manuals on temple design.

Though no text has been discovered from the medieval temple site of Khajurāho with its prolific building activity for a period of 250 years, textual sources of different regions help us in studying architectural features of the temples, iconography, and

→ in: *Concepts of Time, Ancient and Modern*, ed. Kapila Vatsyayan, New Delhi: Indira Gandhi National Center for the Arts/Sterling Publishers, 1996, pp. 354-72.

46. See my article 'The Structure of Time in the Kandarīya Mahādeva Temple of Khajurāho,' in: *Concepts of Time, op. cit*, p. 351, where I have cited the eleventh-century text *Vāstuśāstra* of Viśvakarmā from M.A. Dhaky, 'Prāsāda as Cosmos': *Brahmavidyā*, vol. XXXV, parts 3-4 (1971), pp. 216-17.

47. Cf. Devangana Desai, '*Temple as an Ordered Whole — The Iconic Scheme of the Kandarīya Mahādeva Temple of Khajurāho*,' Smt. Nabadurga Banerjee Endowment Lecture, delivered at the Asiatic Society of Bombay, April 1995, published in *The Journal of the Asiatic Society of Bombay*, vol. 70 (1995).

placement of images. Along with the Vāstu texts (*Samarāṅgaṇa-sūtradhāra,
Aparājitapṛcchā*) from central and western India, with which Khajurāho shares many
architectural features, those from eastern India (*Śilpa Prakāśa, Hayaśīrṣa-Pañcarātra*) also
throw light on placements of images. Staying within the tradition of the Viśvakarmā
School, the architects of Khajurāho have also created new images, new configurations
and iconic schemes which demonstrate that texts help in retaining tradition, but artists
could go beyond texts and make a creative use of motifs. The religious texts are of
considerable help in understanding the meaning of temple imagery — the hierarchical
manifestations of the unmanifest, the graded forms of the Formless — expressing the
temple as a model of cosmos. The Kandarīya Mahādeva, one of the highly evolved temples
of India, can be seen as enacting the drama of cosmic emanation and dissolution conveyed
in its iconic scheme, as well as in its formal structure.

Abbreviations

AIIS : American Institute of Indian Studies, Gurgaon.

ASI : Archaeological Survey of India, New Delhi.

The Goddess of the Island of Gems
An Early Eighteenth-Century Illustration of the Saundaryalaharī by a Mewari Master

Eberhard Fischer

WHEN I recently prepared a catalogue for an exhibition on "Goddesses, as depicted in Indian miniature paintings belonging to Museum Rietberg Zurich,"[1] I assembled a small but delicate group of four paintings from Rājasthānī and Pahārī workshops. They represent the Devī as seated on an outstretched Śiva as her couch that is in addition supported or guarded by four gods. Located inside a golden jewel-studded palace, this scene brings to mind the image of the Goddess residing on the island of Gems as expounded in the famous *Saundaryalaharī* verses. When I checked the relevant literature on Goddesses and their representation in Indian paintings, I was astonished to discover how little has been written over this specific and wonderful iconography of the Devī. In the catalogue of the major Devī exhibition shown in Washington,[2] for instance, not a single version of this image of the Goddess is included. Neither does this form of the Goddess appear in the anthology of hymns to the Devī,[3] that is otherwise illustrated with many outstanding miniatures, nor does for instance the recent book of Madhu B. Wangu do justice to the *Saundaryalaharī* verses and the paintings illustrating them.[4] Although the latter book has a reproduction of a fine but late Kashmiri version of this Goddess, the plate is titled "Bhairavī Aghoreśvarī," without reference to the *Saundaryalaharī* hymn. Only Annette Wilke reproduces a Goddess Śrīvidyā Lalitā as painted by the late Garhwal artist Mola Ram, painted clearly in the second half of the nineteenth century, but with correct references.[5] For a better understanding of the

1. Eberhard Fischer (in collaboration with B.N. Goswamy/Dinanath Pathy), *Göttinnen: Indische Bilder im Museum Rietberg*, Zürich: Museum Rietberg, 2005.

2. Vidya Dehejia, *Devī: The Great Goddess. Female Divinity in South Asian Art*. Published by the Arthur M. Sackler Gallery, Smithsonian Institution, Washington, Ahmedabad: Mapin/Munich: Prestel, 1999.

3. Usha P. Shastri and Nicole Ménant, *Hymnes à la Déesse*, Paris: Le Soleil Noir, 1980.

4. Madhu Bazaz Wangu, *Images of Indian Goddesses. Myths, Meaning and Models*, New Delhi: Abhinav Publications, 2003.

5. Annette Wilke, 'Śaṅkara and the Taming of Wild Goddesses,' in: Axel Michaels, *et al.* (ed.), *Wild Goddesses in India and Nepal*, Bern: Peter Lang, 1996, pp. 123-78, pl. 3.

eighteenth-century Indian painters' knowledge of the various divine forms of the Goddess it seems to me imperative to take into account whether they were acquainted with this great Śaiva text or not.

One of the finest Rājasthānī paintings, produced by an anonymous master at the royal Mewar court at Udaipur at the time of Mahārāṇā Saṅgrām Singh II around 1720/30, is a very large-size album page, representing the Goddess on the Island of Gems. The painting has a broad plain brownish-red album border with a five and a half lines inscription in Devanāgarī script, of which one-and-a-half spill onto the yellow top margin. This contains mainly the eighth *śloka* of the *Saundaryalaharī* text, and has additional commentaries in Rājasthānī *verso* and *recto*. It starts by saying that the *dhyāna* is of the Goddess Īśvarī, who is seated on Parama Śiva's lap. Then, with the words *sudhāsindhor-madhye suraviṭapivāṭīparivāte*, the eighth *śloka* start. B.N. Goswamy, who has read the inscription in 1987, summarized the final part of the inscription as such:

> Illuminated by rays, bright and dazzling, surrounded by moonlight, with lips red as the *bimba*-fruit and teeth gleaming, and creating a halo of light, you are the augmentor of everyone's belongings. With nails red like the petals of lotuses, tresses long and curly and decorating the head, you are worshipped by the gods including Brahmā himself, and honoured by praise sung of by the Kinnaris (celestial musicians) and made up of the 24 *tattva*s (evolvements of matter) which stand with folded hands in your presence.

The large pigment painting with thick layers of gold on paper (painting without borders 42.2 x 22.3 cm) was produced for the royal library at Udaipur where it was kept for a long time under an inventory number, written in red ink on the backside. When the painting was sold by the Mahārāṇā's heirs along with many other important paintings around 1970, it became part of an exhibition of Mewar paintings at Spinks & Sons Gallery in London in 1985, where my wife and I bought this miniature and gifted it immediately to the Rietberg Museum Zurich (Inventory 1985, no. RVI 939). This painting has been reproduced twice since then, first by myself in 1994 (where I mentioned that it was inspired by the *Saundaryalaharī* text) and then by Andrew Topsfield in his monumental monograph on Mewar painting, under the title "Śiva attended by deities. Illustration to the *Saundaryalaharī*, Udaipur, *c.* 1725-30. Museum Rietberg Zurich."[6]

The *Saundaryalaharī* or "Flood of Beauty" is one of the greatest Sanskrit texts of the ninth century, venerated by many Śaivas and Śāktas. As early as the thirteenth century it was assumed that the great Advaita Vedānta saint Śaṅkara was the author of this work — a tradition that was not questioned for centuries. In his text-critical edition, W. Norman Brown[7] however — and with him several Indian authorities like H.R.

6. Andrew Topsfield, 'Court Painting at Udaipur. Art under the Patronage of the Maharanas of Mewar,' *Artibus Asiae*; Suppl. 44, Zürich: Museum Rietberg, 2002, *fig.* 126.

7. W. Norman Brown, *The Saundaryalaharī or Flood of Beauty, Traditionally ascribed to Śaṅkarācārya*, Cambridge, Mass.: Harvard University Press, 1958.

Rangaswami Iyengar — inclined to the opinion that it was more likely that one of Śaṅkara's early followers composed these hundred *śloka*s in the praise of the Goddess, which then became famous under the great Śaiva teacher's name. But this controversial issue[8] is not of my immediate concern. What I would like to demonstrate here is that these wonderful *śloka*s were relevant and were well known to the Rājasthānī painters of the eighteenth century, when they developed their concept or vision of the Goddess.

In the second part of the *Saundaryalaharī* text (*śloka*s 42-91), the appearance of the Goddess as a "flood of beauty" is described in detail from her crown to the tips of her toes. She is, for instance, declared to be of reddish complexion, to have four arms equipped with bow and arrow, sling and elephant hook — attributes which she shares with Kāma, the god of love.[9] In addition, she is exalted as wonderful to look at with her long eyes "extending as far as her ears, with the eyelashes as feathering," her forehead shaped like a half-moon, her lips redder than coral or the *bimba* fruit, her breasts "perfectly formed as the temporal bosses on Gaṇeśa's elephant head," etc.[10] This text is much more than a poetical praise and theological eulogy of the Goddess as the primordial power. It contains both instructions on the forms of various *cakra*s for religious gains as well as hints for painters on how to visualize the supreme deity and her world.

Śloka 8, which is inscribed on the painting of the Mewar Master we are concerned with, is translated by Norman Brown as follows:

> In the midst of the Ocean of Nectar (where) covered with groves of heavenly wishing trees (is) the Isle of Gems, in the mansion of wishing jewels with its grove of *nīpa* trees, on a couch composed of (the four gods) *Śiva* (and the others), your seat a mattress which is *Paramaśiva* — some few lucky ones worship you, a flood of consciousness (*cit*) and bliss (*ānanda*).[11]

Subramanian renders the same *śloka* in English:

> A few blessed ones worship you, the Wave of Consciousness-bliss, located on the lap of the Supremely Auspicious One, on the couch of auspicious form in the residence of *Cintāmaṇi*, full of Kadamba trees, situated in the gem-island, surrounded by angelic trees amidst the ambrosial ocean.[12]

First of all, this *śloka* locates the residence of the Goddess: it is a wondrous site, an island of gems, situated in a lake of nectar with a marvellous palace built from supernatural jewels, and surrounded by trees that grow only in heaven. This setting presents an atmosphere of astonishment and awe, and includes typical determinants for this emotion such as "the sight of heavenly beings, . . . entry into a superior mansion, etc." These are

8. See also A. Wilke, 'Śaṅkara and the Taming of Wild Goddesses,' *op. cit.*, p. 125.

9. *Ibid.*, p. 127.

10. Cf. W.N. Brown, *Saundaryalaharī, op. cit.*, pp. 3-5.

11. *Ibid.*, p. 50.

12. V.K. Subramanian, *Saundaryalahari of Sankaracharya*, Delhi: Motilal Banarsidass, 1977, p. 5.

defined by the *Nāṭyaśāstra* as major elements to create *adbhuta*, the marvellous sentiment of the *rasa*-theory.[13] The Goddess resides in these wonderful surroundings, which provide a great challenge to a painter to visualize. In another verse, *śloka* 93, the palace of the Goddess is mentioned to be a *zenānā*-compartment, where she lives as the "*pardāh*-queen of Śiva, the victor over Tripura." That is one of the reasons why the Goddess is often called Tripurasundarī, a name not given to her in the *Saundaryalaharī*. It is because of her husband, the poet says, that the Goddess rarely makes an appearance and seldom shows herself or permits *darśana* to her devotees. She stays normally secluded in her palace behind strong walls.

The Mewar Master has superbly imagined and painted this island of gems with the magnificent palace. He was well-aware of the contemporary royal construction works carried out at the Jagmandir Lake Palace of Udaipur. Accordingly, he has painted a square lake-palace island surrounded by low walls and an arcade of columns in the shape of trees, with lofty pavilions in the four corners built not of stone, however, but out of pure gold. A variety of trees grow in the dazzling white courtyard around a magnificent high hall with an open-arched façade, a lapis-lazuli back wall (which has turned milky-grey due to age), and a ceiling covered by three golden cupolas. Inside this high structure is a smaller pavilion with an emerald green backdrop erected. All of this magnificent architecture is executed in the contemporary Rajput version of the late Mogul style (of *c.* AD 1700/25). But somehow, the two buildings and the site as such do not seem to be fixed firmly on the ground. Instead they appear like a celestial *vimāna*, a self-moving aerial boat-mansion that has come down from divine heights and has landed, though not anchored, on a lake, where lotuses grow and wild ducks dwell. The entire island seems to float on this water expanse with its many sharp-edged bays and rather flat shores. The painter imagined that the sun is rising to the left of this unearthly mansion, and that the sky and earth merge at the horizon in a very subtle way in early morning light.

The Goddess lives in this wondrous golden gem-palace, which is here, however, no pictorial visualization of the symbolic forms of the *śrīcakra*, as it is often interpreted by commentators.[14] The milky-blue lapis-lazuli backdrop of her palace remains typical for paintings from Mewar workshops of the following generations when depicting this mansion of the Goddess.

In a later verse, the *Saundaryalaharī* describes the composition of the couch or throne, on which the Goddess sits. *Śloka* 94, again in Brown's translation, begins: "Druhiṇa

13. Cf. B.N. Goswamy, *Essence of Indian Art*, San Francisco: Asian Art Museum, 1986, p. 213.

14. Cf. A. Wilke, 'Śaṅkara and the Taming of Wild Goddesses,' *op. cit.*, p. 127; Silvia Schwarz Linder: 'The Lady of the Island of Jewels and the Polarity of her Peaceful and Warring Aspects,' in: A. Michaels, *et al.* (ed.), *Wild Goddesses in India and Nepal*, *op. cit.*, pp. 105-22, here: 110.

(Brahmā), Hari (Viṣṇu), Rudra, and Īśvara, as servants, form your couch; (and) Śiva, (acts) as a counterfeit bedspread."

The Goddess, conceived as Śiva's wife (who keeps her, as we are already told in *pardāh*), sits on her husband's lap. Even though Śiva is "of a clear white sheen," his complexion has a reddish tint "from receiving the reflection" of the Goddess glowing red. In the Mewar Master's painting, Śiva has bent his head towards his wife, the Goddess, and keeps his left arm lovingly around her shoulder when addressing her, as shown by his right hand's pointing finger that is pointing up. Śiva is a handsome-looking young God, with a radiant halo around his head. Out of his tightly-drawn hair flows the sacred Gaṅgā over the crescent moon, hovering magically in front of his forehead. The God appears here in his *saumya*, graceful aspect, and richly bejewelled and clad in a golden *dhotī*. No snakes adorn him; no skulls or other ascetic equipment are shown with him. Here Śiva perfectly complements the shining and blissfully smiling Goddess, praised as the "flow of beauty." Smaller in size than her partner, the Goddess wears a crown, her hair falls around her face in "curly locks" as prescribed by the text. She is dressed in a red blouse, a petticoat and wears a translucent veil decorated with golden spots. The Goddess is four-armed, but as she is sharing an intimate moment with her husband, she carries no weapons. The God and the Goddess look into each other's eyes with deep feelings of mutual attachment.

The divine couple sit on a colossal light blue-grey tinted second Śiva, stretched out on the ground like "a counterfeit bedspread," as the poet says. This laying Śiva is not a corpse, even though he remains motionless, serving the Goddess. Dressed in a pink *dhotī*, he has folded his hands in front of his chest, his eyes are open as slits, he wears a necklace, arm- and wrist-bands as well as ear-rings. Once again this Śiva carries no trace of being an ascetic or mendicant.

The four gods mentioned in *śloka* 94 of the *Saundaryalaharī* as "servants" of the Goddess are depicted sitting at her feet, guarding the divine couple in the four cardinal directions: On the painting they are (from left to right) Indra, Brahmā, Śiva, and Viṣṇu. The colossal head of Śiva leans against Indra's hand and arm, whilst his feet are placed on Viṣṇu's lap. Indra is wearing a crown as befitting the ruler of the heavens, the four-headed Brahmā is white-bearded and holds the scriptures in his hands, Viṣṇu carries three of his emblems lotus, disc, and mace; his fourth arm with the conch is invisible. Śiva is depicted here as we normally see him in Mewar paintings, i.e. as an ascetic in a simple saffron-dyed *dhotī*, with his trident in one hand and snakes coiling around his arms.

What is truly outstanding in this painting is the emotion reflected from the faces of all the three Śivas; all of them are smiling as if the beauty of the Goddess enchants them. The Mewar Master renders superbly what the poet mentions in the last line of *śloka* 94 of the *Saundaryalaharī* text that Śiva "though he is the erotic sentiment incarnate, draws wonder from the eyes of the Goddess."

Most of the Rājasthānī paintings of the Goddess of the Jewel Island, which I know, show little more than the gem isle with its palace and the divine inhabitants. A few of those paintings do depict the *vāhanas*, the vehicles or animals of the four gods in front of the palace, complemented by celestial beings playing music and dancing. The Mewar Master, however, fills the foreground of his grand representation of the Goddess with her worshippers. They appear also in the works of a few later Pahārī painters, but in their paintings Gods are normally shown worshipping the Devī on one side, and ascetics and humans led by Nārada on the other. Unique to this painting by the Mewar Master is the peculiar fact that the depicted gods and groups of sages are not chosen at random, but represent specific thoughts expressed in the *Saundaryalaharī* verses.

To the right of the picture, assembled around god Brahmā is a group of two aristocratic-looking men, one of them still quite young, possibly a father and his son, a lady and an young brāhmaṇa praying with folded hands, or counting the *mālā* beads (rosaries) between their fingers. God Brahmā sits on a fully opened lotus and seems to advise them from three holy scriptures, which he holds in his hands. It is with this god's help that these humans hope to gain access to the Goddess. The four-headed Brahmā is the god of wisdom, sacrifice, and worship. And it is by no means accidental that above his head a lotus in the form of a *cakra* diagram appears, because the *Saundaryalaharī* text speaks eloquently of the *yantra* which are instruments to gain access to the Goddess. Especially the form and use of the *śrīcakra*, which also appears as a similarly fully opened flower, is treated in many verses.

Separated from these householders gathered around Brahmā is yet another, smaller group of two mendicants sitting next to a crowned, bejewelled, un-bearded, and light-complexioned person. This is Indra, the God of Heaven, "who performed hundred sacrifices . . . and attained (through that) incomparable magic power" (*Saundaryalaharī*, *śloka* 93). The bluish-grey, naked Śaiva ascetics with their matted hair tied on top of their heads and rosaries between their fingers listen attentively to what Indra teaches them on the doorsteps of the *zenānā* enclosure of the Goddess. Indra is in possession of the proper *mantra*s, which act like keys to her apartment, and which are concealed in the *Saundaryalaharī* verses. These *mantra*s (and *cakra*s) help to calm the devotee's senses, which is necessary, as *śloka* 93 proclaims, for all who aspire to "to gain the goal of doing worship," i.e. have a vision of the Goddess.

Pl. 12.1: The Goddess on the Island of Gems, Udaipur,
anonymous Mewari master, around 1720/30;
42.2 × 22.3 cm. Museum Rietberg, Zurich.

13

Concept and Representation of Time in Indian Visual Art[1]

Rai Anand Krishna

THE term *citrārpita* (cast in painting) is significant; Kālidāsa applies it in connection with King Dilīpa's encounter with the 'illusive' (*māyā*) lion in his *Raghuvaṁśam*.[2] As the king attempted to draw an arrow from his quiver he was surprised to discover that his fingers were glued (stuck), and thus he stood helpless, "as though cast in a painting."[3] He remained still till the spell was withdrawn. Ancient Indian literature is replete with similar references.

A variation on the same concept of interaction between movement and stillness is depicted by Kālidāsa's princely competitors for Indumatī's hand: They looked like the row of architecture on a 'kingsway,' at once illumined (activated) and alternatively drowned in darkness as the roving light travelled past.[4]

The concept of time in an art creation was taken up by the legendary Sanskrit grammarian of the second century BC, Patañjali. In reference to a stage-show he observes that concepts like 'past' and 'future' are inapplicable to art expression which always exists as 'presentness' (*vartamāna-kālatā*).[5] It is noteworthy that he calls it *vartamāna-*

1. Here is my warm and humble felicitation to Dr. Bettina Bäumer as a preliminary study, to start the discussion. I feel privileged to contribute to her felicitation volume. I heartily wish her a full hundred years of active and fruitful life.

2. *Raghuvaṁśam* (II.31), ed. by Acharya Reva Prasad Dvivedi, Varanasi, 1974.
 vāmetarastasya karaḥ praharturnakhaprabhābhūṣitakaṅkapatre |
 saktāṅguliḥ sāyakapuṅkha eva citrārpitārambha ivāvatasthe ||

3. *Citrārpita*: The term *arpita* is technical in painting and simply stands for 'painted.' Monier-Williams gives the basics as "fixed" and "engraved" besides "painted," cf. Monier-Williams: *A Sanskrit-English Dictionary* (1899), 1st Indian edn., Delhi, 1970, pp. 92f.

4. *Raghuvaṁśam* (VI.67), *op. cit.*
 sañcāriṇī dīpaśikheva rātrau yaṁ yaṁ vyatīyāya patimvarā sā |
 narendramārgāṭṭa iva prapede vivarṇabhāvaṁ sa sa bhūmipālaḥ ||

5. Commenting on Pāṇini Sūtra, *Hetumati ca* (III.1.26).

 On the other hand, a slow movement of event (i.e. time) can be illustrated through picturisation of the first drops of rainwater descending on young Pārvatī's front, while she was engaged in her *tapaścaryā*, before they "froze" after entering her navel. This image appears in the *Kumārasambhavam* of Kālidāsa

→

kālatā or the concept of 'presentness' and not *vartamāna* or the 'present' itself; that is, it is beyond our time-consciousness or in an abstracted form since the spectators experience the show (yesterday or before), in the present (tense) and shall continue to do so in the future again in the same manner (that is, in the present tense). This statement of Patañjali perhaps broadly corresponds with the 'frozen' moment in art or the 'time' beyond time.

We find another mode of temporality in such works as the rock-cut twin panels appearing at the cornice at the entrance of the Hīnayāna Buddhist *vihāra* at Bhājā (Maharashtra, second century BC).[6] This is the concept of a mythological past. In one of the scenes, the victorious charioteer drives on, crushing the bodies of the fallen demons, demon-guardians who in vain obstructed, his march. Perhaps the placement of these panels high up and the cloud-like enormous[7] leathery forms of the demons distinguish them from our world of experience to lead us to a mysterious world of mythology.

In contrast, the collaging of episodes within a single frame has been used by Indian sculptors and painters to show progression of time. Here we may refer to two panels from Bharhut railings (second century BC): the *Jetvana-ārāma* and the *Elāpatra Nāgarāja* episodes. In the former, the event is of the donor spreading gold coins over the ground to meet the demand of its greedy owner that is, to cover the entire space with gold coins as the price of the land, while the Buddha in his symbolic form of the *gandha-kuṭī* repeatedly appears on the scene. The finale is an assembly of semi-divines materializing on the horizon to celebrate the event, one of them in the whistle attitude which puts a full stop to the story. In the *Elāpatra Nāgarāja* scene, three episodes are knit together: the erring *Elāpatra* satiated with pleasures of life and unchallenged authority stands along with his family in full vanity. In the second episode, a wise brāhmaṇa warns the approaching Buddha against the impending danger. Finally, the wicked serpent's "change of heart" as he surrenders to the Master is depicted. These three events are accommodated in a single panel showing progression of events.

A morning setting is obliquely suggested in a bas-relief from Sāñcī *stūpa* no. 1 (late first century BC) showing one of the "War of Relics" episode. As the city gate is closed for defence reasons, a woman resident uses the side entrance to fetch water from the moat, indicating the early hours of the morning when womenfolk start fetching water for the

→ (V.24): "The first drops stayed for a while on her eye-lashes, dropped on the lower lip to be shattered and reduced to powder falling on her rising breast(s), gradually trickled down to (three) folds of her belly and thus entered her (deep) navel taking a long time"(*cireṇa nābhiṁ prathamodabindavaḥ*). In art context this is comparable with the *Pābujī Phaḍ* show (Rajasthan). Strangely we find another interpretation of this concept in a changed setting and with a different set of symbols in a matured Jahangir style painting (*ca.* 1620, see below) where the emperor sits over an hourglass . . . the sun and moon symbol in Indian context represent eternity, in Muslim tradition, effulgence. Hourglass stands for "measured time."

6. As ably identified by V.S. Agrawala as the legendary king Māndhātā's conquest over Uttara Kuru.

7. V.S. Agrawala, *Indian Art*, Varanasi, 1965, p. 191 and plates LXXXIII and LXXXIV.

day. It also suggests that the battle was stopped for the night following the tradition, and was resumed as the day broke. Similarly a night setting is available from one of the Bharhut reliefs, "Māyā Devī's Dream." In it, the would-be mother of Gautama, the Buddha, while sleeping has a vision of a white elephant entering her womb. Gāndhāra art apart, night scenes in mainstream Indian sculpture are practically unknown. Besides the drowsing female attendants and slumbering queen, a burning wick lamp is indicative of a night scene.

Representation of the hour of day draws attention to the sculptor's ingenuity. As sudden upsurge of the swollen stream is shown on a Sāñcī *stūpa* no. 1 panel by way of its raised surface, a rare instance in Indian sculpture of very high relief. Here a thicker stone block was harnessed to show in relief the flash flood. Alternatively, in the Mamallapuram rock-cut panel, a natural crevice in the middle was used to show the channel of the descending Gaṅgā stream. Formed by a storm-water downpour, it is a sight to see it activated. No wonder this natural phenomenon inspired the sculptor to realize, on such a grand scale, the *Gaṅgāvataraṇa* scene.

Here we find a brāhmaṇa or alternatively a *ṛṣi* looking at the sky with his arms raised and fingers locked, leaving an aperture to gaze at the high sun, thus indicating a noon time setting.[8] The austerity posture is clear in the Mamallapuram scene as the *ṛṣi* stands on one of his legs. Strangely the scene is caricatured at one of the lower registers where a cat stands mimicking the same austere (*tapasyā*) posture while the mice play around with impunity.

Suddenness is also shown in early and medieval Indian sculpture using representations of a *Vṛkṣadevatā*. A bas-relief from Bodh-Gayā (first century BC) shows a human arm flashing out of a tree-trunk offering a jugful of drinking water (though the recipient is not shown). Parallel to it is a reference in Kālidāsa's *Abhijñānaśākuntalam*.[9]

8. Heinrich Zimmer, *The Art of Indian Asia. Its Mythology and Transformations*, ed. Joseph Campbell, vol. II, New York: Pantheon, 1955, rpt. Delhi: Motilal Banarsidass, 2001, plates 272-73.

9. *Abhijñānaśākuntalam*, IV.4:
 ksaumaṁkenacidindupāṇḍu taruṇā maṅgalyamāviṣkṛtaṁ
 niṣṭhyutaścaraṇopabhogasulabho lākṣārasaḥ kenacit l
 anyebhyo vanadevatākaratalairāparvabhāgotthitair-
 dattānyābharaṇāni tatkiśalayodbhedapratidvandvibhiḥ ll
 Meghadūtam, I.26:
 nīcairākhyaṁ girimadhivasestatra viśrāmahetos-
 tvatsamparkāt pulakitamiva prauḍhapuṣpaiḥ kadambaiḥ l
 yaḥ paṇyastrīratiparimalodgāribhirnāgarāṇām
 uddāmāni prathayati śilāveśmabhiryauvanāni ll

 In the above references we find an electrifying experience. In the first instance, the contact is momentary (*kṣaṇa patrichita*. . .) while in the next there is the sudden burst of emotion.

 In the *kadamba* flowers, as though the forest had a 'hair raising' romantic experience, representations of instant reactions.

Two amorous scenes similarly show sudden arrest of motion; in both instances a partner holds the wrist of the other. The Sāñcī panel is sentimentally moving in its amorous content as the young man suddenly grasps his partner's wrist, interrupting her cooking (so that they could have some free moments together). Next is a popular theme well-known from the Ellorā rock-cut (and other) panels in which we find Lord Śiva and Pārvatī engaged in a *causara* (dice) game. As Pārvatī suddenly detects foul play, she interdicts Śiva by grasping his wrist.

Occasionally we find Śiva suddenly manifesting Himself in His anthropomorphic form, the *liṅgodbhava mūrtī* aspect. Even more dramatic is the *yamāri mūrtī* of Śiva, in which He rescues His devotee, Mārkaṇḍeya, from the clutches of death and thus immortalized him. Leaping out from the *liṅgam* in His human form, delivers a *triśūla* blow to Yamarāja (the Death god) who had appeared to take Mārkaṇḍeya's life while the latter was still engaged in his daily religious service to the Lord. In this, Śiva appears like a flash of lightening, immortalizing the devotee.

An Ajantā wall painting, showing Buddha's arrival to his forlorn wife and son, Yaśodharā and Rāhula's gate (AD 475-500) moves in the opposite direction in its time progression. A colossal figure of the Lord at the gate of an unostentatious architecture dwarfs the mother and son who stand in attendance, their craving eyes fixed on the visitor who is more of a symbol than a human figure. With little physical movement and with a blank look, he gently but non-chalantly turns his head in the direction of the "donors." This is how the scene is gradually allowed to freeze.

At this stage we might refer to some of the Indian paintings of later stages. Except for the gradual filtering down of the European paintings' influence first to Mogul court painting and then to the regional schools and sub-schools in localized forms, the night effect is not clearly stated in the length and breadth of Indian painting in its true sense. For example, the colours remain the same brilliant tones even in representation of night scenes in Rajput art. Even the eyes of the sleeping figures are wide open. A nocturnal setting is suggested with the introduction of a lamp or bodily gestures. Against this situation is an unusual painting showing an 'Elopement Scene at Night' (Bharat Kala Bhavan collection, *ca.* 1400) in the western Indian style of painting. The burning lamp and the drowsy guard below, indicate a night setting, but it is more eloquently stated by the ink-blue starry background.[10] Here the blue colour signifies the night which is one of the randomly used background colour in the general run of the western Indian style manuscript illustrations. Use of blue for the night, as seen here, shows a fresh evolution

10. Anand Krishna, (ed.), *Chhavi. Golden Jubilee Volume. Bharat Kala Bhavan 1920-70*, Varanasi, 1971, colour plate 3, p. 25. Parallel scenes from another *Chandayāna* illustrated manuscript (mixed western Indian style, Sultanate type, *ca.* 1500, Berlin Museum) for black dark night background on the same scene. Cf. Anand Krishna (ed.): *Chhavi-2. Rai Krishnadasa Felicitation Volume*, Varanasi: Bharat Kala Bhavan, 1981, figure 607.

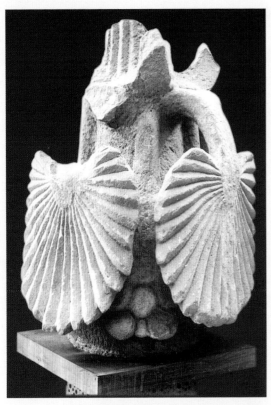

Pl. 13.1: Purchase of Jetavana,
Bharhut, second century BC.

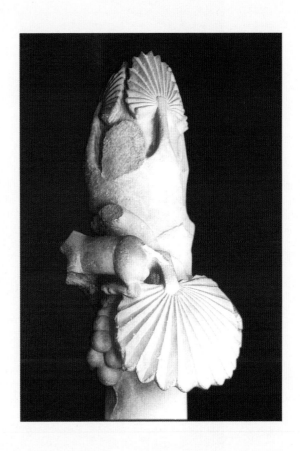

Pl. 13.2: King Erākapaṭṭa Pays
Homage to the Blessed One,
Bharhut, second century BC.

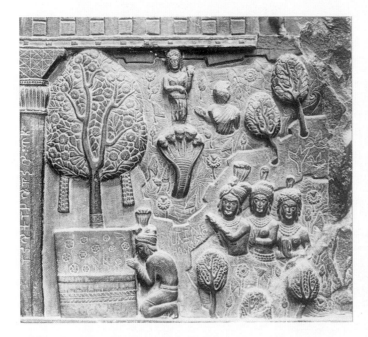

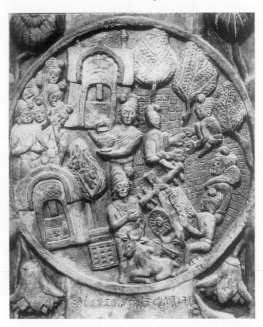

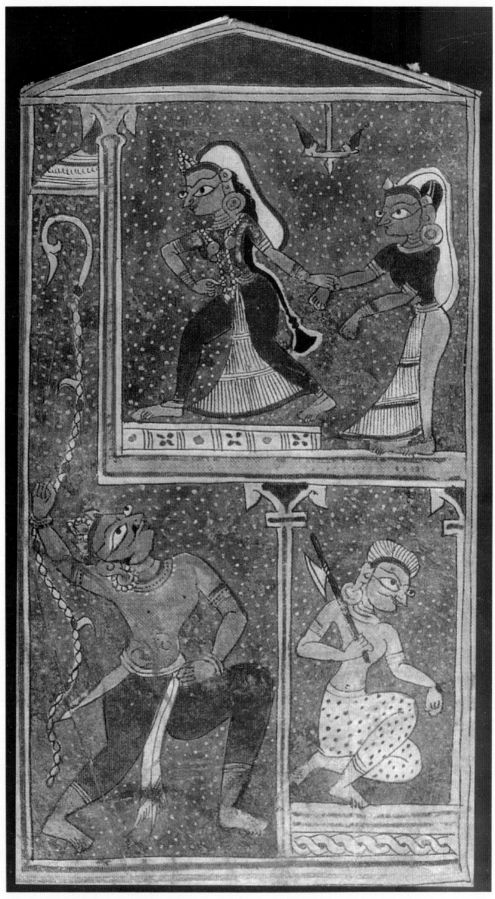

Pl. 13.3: The Heroine Elopes, Uttar Pradesh, *ca.* 1450-75.

Pl. 13.4: Raja Balwant Singh relaxing in front of a Fireplace,
ascribed to Nainsukh of Guler, *c.* 1755-60.

Pl. 13.5: Shaikh Phul in his Hermitage, by Bishndas, Mughal, *ca.* 1610.

Pl. 13.6: Jahangir Enthroned on a Hourglass, Album Painting *Peafowl*, ca. 1610.

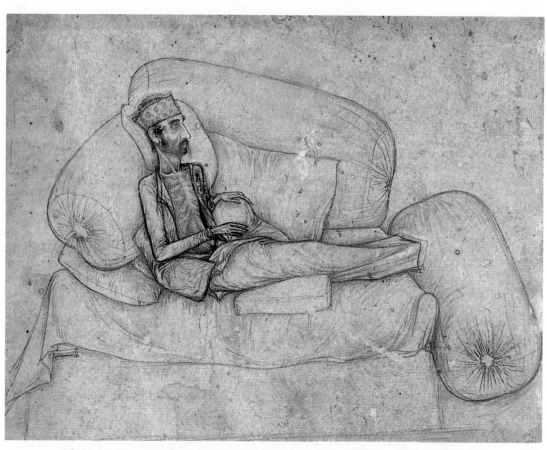

Pl. 13.7: Inayat Khan Dying, probably by Govardhan, Mughal, 1618.

of tradition and a more evolved colour-sense based on observation and personal understanding — possibly due to widening base of the style, induction of unorthodox themes and wider patronage — than its older cliched forms and expressions.

We have just referred above to European paintings' influence on night scenes and the unchanged colour tonality in spite of this influence. This phenomenon has lead to certain controversies in placing painted scenes in the night or daytime setting. I might take for example a "Portrait of Rājā Balwant Singh" (*ca.* 1760). Some Western and Indian scholars have explained it as a night scene, as the Rājā (noted for informal settings of his portraits) is preparing himself for going to bed while his favourite singer (most likely Lād Bāī) is singing his way to sleep.[11] According to this view, the Rājā is taking a cup for cleansing his mouth — a popular Western practice, as his laundry is stacked by his side. For a traditional Indian patron it would be a distant idea to have a portrait of himself with his laundry shown by his bed side. The absence of any lamp is also conspicuous.

Traditional Indian connoisseurs take it as an early morning setting in which the Rājā wakes up to the tune of music, is offered a cup following which he would rinse his fingers and dole the money bags (not the laundry!) out to the deserving, especially his brāhmaṇa favourites. One familiar with it would easily identify the money bags as *toḍā*s (standard bags of coins in 1000 or 2000 denominations) topped with an envelope (also noticed, when published), which could be a land grant-like gift. Thus the painter tries to glorify his patron's munificence, a sign of pious and high Hindu living. The Rājā, after doling out gifts, will inspect his royal horse; the syce (groom) in the corner reports himself for it. It was an ancient practice continued by the Rajputs to have a *darśana* of their elephants and horses before starting the day, which the Mogul emperors also followed. I have gone into this detail that in Indian painting the hour of the day is also determined by the activities of the actors. In another painting another Rājā is riding out, and his favourite singer girl accompanies him on a horse. The background-trees are pruned and the weeds, flowering. This shows the spring season when, in the Pahārī region to which the painting belongs, the locals chop the trees to use the land for cultivation, as the weeds burst forth into mustard colour flowers.[12]

In Rajput painting from Rajasthan and the Hills, the twilight setting is a popular device that influenced Mogul painting as well at least from the late Jahangir-Shahjahan period. The sky is illuminated by colourful clouds. This tradition goes back to the western Indian school, though there in a highly stylized manner. Some of the most picturesque examples of the heavy colourful clouds, are known from the Būndī-Koṭā paintings. In several examples, they do not necessarily represent the hour of the day but are simply employed as a motif. Another such motif is a combination of monsoon and springtime

11. B.N. Goswamy, Eberhard Fischer, 'Pahari Masters. Court Painters of Nothern India,' *Artibus Asiae* Supplementum XXXVIII, Zürich: Museum Rietberg, 1992, plate 125.

12. B.N. Goswamy, *Nainsukh of Guler*, Zürich, 1997, plate 25.

appearing simultaneously. Both idealized situation are familiar to us from our classical poetry and music.

The collage-like treatment of time in early Mogul school of painting is interesting. An independent study of this group is called for, out of such symbolic compositions from the Jahangir-Shahjahan period, where anachronistic inserts have been forced in earlier paintings to establish the interpolated pedigree. Alternately new compositions were evolved to establish direct linkages with remote but illustrious ancestors, ignoring the intermediary generations. Yet we find the 'present' well-depicted in the "Hermitage of Sheikh Phool" painting in Bharat Kala Bhavan.[13] This atmosphere of immediacy in the painting is supported by an inscription on the face of the painting by Jahangir himself. The other example already mentioned above, has the emperor Jahangir sitting over an hour glass, while figures like King James I of England and perhaps a Turkish Sultan wait upon him.[14] Ensemble Jahangir is shown here as 'Conqueror of Time' as well. A third painting (*c.* 1615-20) depicts him of thirty years of age, although it was painted about a quarter of century later. Here he holds a portrait of his father Akbar as he would have looked in *c.* 1620. Other symbols similarly confirm this later date of the painting. Thus we have a cocktail of dates, events and images to satisfy the patron's idiosyncrasies, or his repentance or devotion to his deceased parent against whom he had rebelled.[15]

Just to offer an instance of anachronism, I refer to a Malwa school painting from a *Rāmāyaṇa* series (*c.* 1640), wherein a matchlock is being fired among other sound producing devices, to awaken Kumbhakarṇa from his long slumber.[16] But this should be viewed from the point of the folk art influence where the present is usually mixed up with the past in its naivety.

Two paintings of the early Mogul School are noteworthy to represent the concept of death. Ignoring the chronological order of these examples, we first take up the 'Death of Inayat Khan' scene from the Jahangir period, known through its two versions. One is a line drawing in the Museum of Fine Arts, Boston (USA) which delivers the message more poignantly. The other coloured version is richer, yet the enigma of death is better conveyed by the dusky and colourless atmosphere of the line drawing of the void in which this emperor's favourite noble's existence hangs on a thread between life and death. The event finds a painful entry in the emperor's autobiography where with usual economy of details but with a detached sense of sadness the author exclaims: "Oh, to such a state of being a son of man can pass!" The noble is propped up against bolsters, his body reduced to skeleton and his eyes petrified amidst a haunting silence. He is more

13. A. Krishna (ed.), *Chhavi: Golden Jubilee Volume, op. cit.,* colour plate 18, p. 187.

14. Asok Kumar Das, *Mughal Painting During Jahangir's Time,* Calcutta, 1978, plate 63.

15. A. Krishna (ed.), *Chhavi: Golden Jubilee Volume, op. cit.,* figure 588.

16. A. Krishna, *Malwa Painting,* Varanasi, 1963, colour plate A.

dead than alive.[17]

The next painting is an illustrated leaf from the royal illustrated *Harivaṁśa Purāṇa* manuscript of Akbar period (*c.* 1590). It is not a work of one of the leading artists of the court yet deserves a special mention here as a singular painting: A colossal demon Prince ambushed by one of the forms of Viṣṇu lies flat on the battle-field awaiting arrival of his death. Life gradually saps out of him.

This is a typical Akbar period painting of the concluding decade of the sixteenth century. Our artist brilliantly expressed himself in picturising ebbying life stream of the fallen victim through his series of hands. The numerous outstretched palms hold a variety of weapons yet one cannot miss that each shows a subtle distinction, even in its grip or loosening of it. One can see a palm limp and dead, another in the process of becoming so, the next half-dead, to the next still alive yet not fully alive while suffering the pangs of the death process and so on. How a painter in this limited scope, like the one in the present scene, could convey the advent of death silently overtaking life is brilliantly illustrated here with a great deal of understanding and sympathy. Of course, other than the battle and *śikhara* scenes from the Rājpūt-Mogul period, there are hundreds of death and dying scenes from both the human and animal world, yet the above (Akbar school) painting has its unrivalled place in visualizing it. There is practically no philosophical message, yet what is striking in it is the close and unattached observation and expression of the gradual process of death or *kāla* which manifests itself more like a presence than a phenomenon.

Thus, we come to the end of the cycle where depiction of death does not stand at the end of the circle, for it must keep on going. And thus concluding, we once again come back to cosmic time, a Guler-Basohli school painting (*c.* 1730, Bharat Kala Bhavan collection)[18] showing "emergence of Hiraṇyagarbha" — the cosmic Golden Egg against the surging restless cosmic water or from turbulence to the primal elemental eternal. But *kāla* moves on and on and newer and newer horizons start appearing both in its conceptualization and visualization.

17. A.K. Das, *Mughal Painting*, *op. cit.*, plates 49 and 50; *Jahangir, Tuzuk-i-Jahangiri*, tr. A. Rogers, Delhi, 1964, pp. 43-44.

18. A. Krishna (ed.), *Chhavi: Golden Jubilee Volume*, *op. cit.*, illustration on the jacket.

14

The Use of Primary Colours
in the Nāṭyaśāstra[1]

Thomas Kintaert

THE *Nāṭyaśāstra* (NŚ), attributed to the sage Bharata, is known to be a seminal text in the fields of Indian theatre, dance, music, poetry, metrics, aesthetics, etc. It is the earliest extant scriptural source for many of these arts and sciences, regardless of whether one tends to date this text in the first centuries BC or AD. In the history of the visual arts it figures prominently as well, as it formulates a colour theory based on the primary colours. Of particular interest in this connection is the fact that different chapters of the NŚ describe the application of these colours in specific ritual contexts. The current study presents and interprets this application, incorporating relevant data on colours spread over the entire work.

The NŚ[2] takes up the topic of colour (*varṇa*)[3] in the chapter on *āhāryābhinaya* (NŚ 21) in connection with the actors' make-up (*aṅgavartana*, lit. 'application [of paint] on the body'),[4] which, together with their hairdo, etc., constitutes the 'preparation of the [actors']

1. The present article has resulted from the research for my PhD dissertation on the coordination of musical and scenic elements in the ritual preliminaries (*pūrvaraṅga*) to the ancient Indian drama. I gratefully acknowledge the generous support of the Austrian Academy of Sciences by granting a doctoral scholarship.

2. References to chapters and verses of the NŚ, if not specified, refer to NŚ 1934-92. The capital letters A and B after stanza numbers indicate the two verses of a stanza. This has been adopted from Mukund Lath, *A Study of Dattilam. A Treatise on the Sacred Music of Ancient India*, Delhi, 1978. Alternative readings, put between square brackets, are only provided when considered relevant for the topic at hand.

3. In the NŚ the use of the term *varṇa* is not restricted to its common meanings of 'colour,' 'social class,' 'syllable,' etc., but occurs furthermore in a technical sense in the field of music, referring to the four modes of producing vocal or instrumental sounds, i.e. in an ascending or descending order (*ārohin* and *avarohin*), staying on only one note (*sthāyin*), or in a wandering movement (*sañcārin*), i.e. a combination of *ārohin* and *avarohin* (see NŚ 29.4A-19A). Prem Lata Sharma points out the basic similarity between these different meanings of *varṇa* by stating that, "just as in language, letter or syllable is the primary unit, in the visual realm colour is the primary element, similarly in music, *varṇa* is the primary unit of melodic movement." (*Bṛhaddeśī of Śrī Mataṅga Muni*, Edited by Prem Lata Sharma, Assisted by Anil Bihari Beohar, vol. 1. [Kalāmūlaśāstra Series 8], Delhi, 1992, p. 182).

4. NŚ 21.78B-79A, 87A (see fn. 12). After giving the colours prescribed for the different characters in a

→

body' (*aṅgaracanā*).[5] The art of painting pictures, although not among the topics expounded in this text on the composite art of histrionics, is testified in a number of places. These few references to paintings and painters in the NŚ, even though of subsidiary relevance to the subject of this study, are now given for the sake of completeness.

1. Paintings and Painters in the NŚ

- In the chapter dealing with the construction of the theatre building, we find references to paintings (*citrakarman*) produced on the plastered and polished surface of walls, depicting men, women, 'acts caused by self-enjoyment'[6] and creepers.[7]

- The example of the metre *citralekhā* ('painting', 'portrait') contains a simile in which a woman, colourfully dressed and adorned with flowers, gems and other ornaments after having taken a bath, is compared to a picture.[8]

- The seventh of the ten arbitrators (*prāśnika*) enjoined to assess a play is a painter (*citrakṛt*). His or her specific duty consists in observing and evaluating the use of ornaments, dresses, make-up, etc. (*nepathya*) appearing in a performance.[9]

- In still another chapter the importance of songs in dramatic performances is highlighted by stating that, just as a picture without colour does not produce any

→ play the text concludes: *evaṁ kṛtvā yathānyāyaṁ mukhāṅgopāṅga*[*v.l.: aṅgopāṅgeṣu*]*vartanām* (NŚ 21.114A). I favour the alternative reading, as, in the NŚ, *upāṅga* already refers to the face (*mukha*) (Cf. NŚ 8.14A-B, according to which *aṅga* refers to the six body parts head, hands, chest, waist, hips and feet, while *upāṅga* stands for the eyes, eyebrows, nose, lips, cheeks and chin.). Paint is probably only applied on the uncovered body parts.

5. Cf. NŚ 21.5B, 77B, 161A. For its part, *aṅgaracanā* constitutes the third of the four subdivisions of *nepathya*, which latter stands here for the costumes, props, etc., of a play. This *nepathya* forms the subject-matter of the *āhārya* chapter (cf. NŚ 21.5A-B).

6. *caritam ātmabhogajam* (NŚ 2.85A). This appears to be a reference to amorous scenes. Cf. Ghosh 1951-61, vol. 1, p. 30.

7. NŚ 2.82B-85A. The verb *ā-likh* used here also appears in the nominal form *ālekhya* in the chapter on hand gestures as one of the things that can be represented with the single hand gesture (*asaṁyutahasta*) called *sandaṁśa* (NŚ 9.113A). This latter instance, however, might just as well refer to the act of writing, not necessarily to painting.

8. NŚ 15.118A-B:
 nānāratnāḍhyair bahubhir adhikaṁ bhūṣaṇair aṅgasaṁsthair
 nānāgandhāḍhyair madanajananair aṅgarāgaiś ca hṛdyaiḥ [*v.l.: vicitraiḥ*] |
 keśaiḥ snānāḍhyaiḥ [*v.l.: snānārdraiḥ*] *kusumabharitair vastrarāgaiś ca tais taiḥ*
 kānte saṁkṣepāt kim iha bahunā citralekheva [*v.l.: citramāleva*] *bhāsi* | | 118 | |

 Incidentally, *citralekha* also refers to the first of the twenty ways of playing drums (*vādyaprakāra*) (NŚ 34.191 [prose] & 210A-B, which correspond to 151 [prose] & 170A-B of the alternative reading of the same chapter).

9. NŚ 27.65A, 66B.

beauty, a play without songs cannot become delightful.[10]

- A painter (*citrakāra*), lastly, is mentioned as one of the members of the theatrical ensemble.[11] In view of the specific context in which colours are dealt with in the NŚ it is likely that the painter's main responsibility here lies in the application of the actors' make-up.

Having looked briefly at the painter and his art, let us now turn to his main tool: colours.

2. Primary and Derivative Colours in the NŚ

2.1. PRIMARY COLOURS

Of fundamental importance for the following elaborations is the theory of colours presented in NŚ 21.[12] There, four so-called 'self-arisen' or natural colours (*svabhāvajavarṇa*s, lit. 'colours caused by their own nature') are enumerated in the following sequence:

white (*sita*), dark blue (*nīla*), yellow (*pīta*) and red (*rakta*).

These — with the exception of white — constitute what we call primary colours. Before proceeding, it might be useful to elaborate a little on the specific nature of these colours. Generally in painting, the primary colours are blue, yellow and red.[13] While

10. NŚ 32.425A-B:
 yathā varṇād ṛte citraṁ na śobhotpādanaṁ bhavet |
 evam eva vinā gānaṁ nāṭyaṁ rāgaṁ na gacchati | |425| |

11. NŚ 35.37A (actually the 2nd verse of an *āryā* stanza): *citrajñaś citrakaro [...] |*

12. NŚ 21.78B-87A:
 sito nīlaś ca pītaś ca caturtho rakta eva ca | |78| |
 ete svabhāvajā varṇā yaiḥ kāryaṁ tv aṅgavartanam |
 saṁyogajāḥ punaś cānye upavarṇā bhavanti hi | |79| |
 tān ahaṁ saṁpravakṣyāmi yathākāryaṁ prayoktṛbhiḥ |
 sitanīlasamāyoge kāraṇḍava iti smṛtaḥ [v.l.: kāpota iti saṁjñitaḥ; kāpoto nāma jāyate; kāpotaka] | |80| |
 sitapītasamāyogāt pāṇḍuvarṇaḥ prakīrtitaḥ |
 sitaraktasamāyoge padmavarṇaḥ prakīrtitaḥ | |81| |
 pītanīlasamāyogād dharito nāma jāyate |
 nīlaraktasamāyogāt kaṣāyo nāma jāyate | |82| |
 raktapītasamāyogād gauravarṇa iti smṛtaḥ [v.l.: gaura ity abhidhīyate] |
 ete saṁyogajā varṇā hy upavarṇās tathāpare | |83| |
 tricaturvarṇasaṁyuktā bahavaḥ saṁprakīrtitāḥ |
 balastho yo bhaved varṇas tasya bhāgo bhavet tataḥ | |84| |
 durbalasya ca bhāgau dvau nīlaṁ muktvā pradāpayet |
 nīlasyaiko bhaved bhāgaś catvāro 'nye tu varṇake [v.l.: anyas tv ekaś ca niścitaḥ; anyasya tu smṛtāḥ] | |85| |
 balavān sarvavarṇānāṁ nīla eva prakīrtitaḥ |
 evaṁ varṇavidhiṁ jñātvā nānāsaṁyogasaṁśrayam | |86| |
 tataḥ kuryād yathāyogam aṅgānāṁ vartanam budhaḥ |

13. In painting with opaque paints the primary colours are more precisely ultramarine (the dark blue shade of lapis lazuli), yellow and carmine (the deep red of blood). Modern science has come up with

→

these colours cannot be arrived at by mixing other colours, the mixture of two or three primary ones in varying quantities produces all other colours. White, grey and black are sometimes not considered colours at all, or are labelled achromatic ('colourless') colours. Indeed, unlike 'chromatic' colours, they do not have a specific wavelength of their own, but become visible because of the incomplete (grey) or complete absorption (black) or reflection (white) of colour waves. Returning to the process of painting one notices that black can be attained or at least approximated by mixing all three primary colours. It is not, however, possible to obtain white by the combination of other colours and one is therefore compelled to use a separate white paint. The inclusion of white in the *NŚ*-list of primary colours therefore seems to reflect practical considerations.[14]

2.2. SECONDARY AND TERTIARY COLOURS

After presenting the four primary colours, the *NŚ* goes on to describe the secondary colours, called *saṃyogajavarṇa*s or 'colours produced by the fusion [of two primary colours],' and the tertiary colours, i.e. *upavarṇa*s or subordinate colours. The text first deals with the secondary colours, specifying by the mixture of which two primary ones they are created:[15]

- white and blue make light blue (*kāraṇḍava*, the colour of the *kāraṇḍa* duck [*v.l.*: *kāpota*; *kāpotaka*: pigeon colour])[16]

- white and yellow produce a pale yellow (*pāṇḍuvarṇa*)

- white and red combined, create pink (*padmavarṇa*, the colour of the Indian lotus, *Nelumbo nucifera*)

- yellow and blue account for green (*harita*)[17]

→ different shades, i.e. cyan (a turquoise shade of blue), yellow and magenta (a pinkish red), which are used, for instance, in modern colour printers. The commonly used acronym RGB on the other hand refers to the colours red, green and blue. These so-called additive primary colours — as opposed to the subtractive primary colours mentioned above — are put to use in the colour monitors of computers and television sets.

14. From now on, whenever primary colours are mentioned in this article, the colour white is included. In view of what will be said later on (see point 4.2.), it may well be that black is considered a shade of *nīla*, which would therefore include it in the group of primary colours as well.

15. One can observe that the enumeration of these secondary colours happens in a strict permutational way: To begin with, the first of the given list of primary colours is combined with the second, then with the third and at last with the fourth colour. Then the second colour is taken up, first united with the third and then with the fourth one. Finally, the third and fourth colours are fused.

16. Apparently, light blue and grey are not differentiated here. Cf. in this respect point 4.2.

17. The Monier-Williams (MW) dictionary provides the following meanings for *harita* as an adjective: "yellowish, pale yellow, fallow, pale red, pale, greenish and green." As a masculine noun it gives "yellowish (the colour)." The Apte dictionary gives the meanings green, tawny and even dark blue. The specification that *harita* is created from the fusion of yellow and blue however leaves no doubt that its meaning here is 'green.'

- blue and red create purple (*kaṣāya*)[18]
- red and yellow generate orange (*gauravarṇa*)[19]

The mixture of three or four colours, it is stated, produces many subordinate colours (*upavarṇa*), what we call tertiary colours. A rule is then formulated according to which one part of a strong (*balastha*) colour should be mixed with two parts of a weak (*durbala*) one. Blue constitutes an exception to this rule, as it is considered the strongest of all colours and should therefore be mixed with four parts of a weak colour.[20]

Besides its practical value as an aid in the mixture of paints, the concept of primary colours has a wide range of applications in the NŚ. In the following pages it will be examined in which specific contexts the *svabhāvajavarṇa*s are put to use.

3. Occurrences of the Primary Colours in the NŚ

3.1. COLOURED FOOD OFFERINGS IN THE CARDINAL DIRECTIONS

The second *adhyāya* of the NŚ, as has been mentioned before, deals with the construction of the theatre building.[21] In describing the erection of a rectangular (*vikṛṣṭa*) playhouse of the middle-sized variety — the ideal playhouse for mortals[22] — directives are first given regarding the selection of a suitable ground and the measuring of the outlines of the future building. After these preliminary procedures the foundation should be laid on an astronomically calculated auspicious day accompanied by the sound of different musical instruments. Then, at night, offerings consisting of fragrant substances, flowers, fruits and other kinds of food have to be placed in the ten directions,[23] accompanied by *mantra*s, according to the deities presiding over the respective regions.[24] Interestingly,

18. Again the resultant colour can be deduced from the mixture of its constituents. MW gives the meanings "red, dull red, yellowish red" for *kaṣāya* as an adjective and "a yellowish red colour" and "red, redness" for *kaṣāya* as a noun. Apte gives brown, red and dark red. — It has to be pointed out here that the Apte, Böhtlingk and MW Sanskrit dictionaries agree in assigning the meaning black to *nīla* besides dark blue (see point 4.2. and fn. 96), while the latter dictionary additionally gives the meaning dark green. The status of *nīla* as a *svabhāvajavarṇa* and the mention of the colours produced by mixing *nīla* with the three other primary colours however leaves no doubt about the colour expressed by *nīla* in the present context, i.e. blue or dark blue.

19. The Apte and MW dictionaries supply a variety of meanings of *gaura* ranging from 'white', 'yellowish', 'pale-red' to 'red(dish)'.

20. Neither the NŚ nor the AbhiBhā clarify what exactly is meant by strong and weak colours, i.e. whether they distinguish primary and secondary colours respectively, or certain colour characteristics like shade, etc.

21. Variously called *nāṭyaveśman*, *nāṭyagṛha*, *nāṭyamaṇḍapa* or *prekṣāgṛha*.

22. Cf. NŚ 2.7A-11B, 17A-B.

23. The four cardinal directions, the four intermediate ones, the nadir and the zenith. It is not specified which offerings are laid in the six last mentioned directions, nor in which places the offerings for the nadir and zenith should be placed. It should be kept in mind that ideally the theatre building is aligned along an east-west axis, the entrance facing the east (cf. NŚ 2.33A-35A; NŚ 13.11A-B; etc.).

24. NŚ 2.24A-41A.

the colour of the food offerings in the cardinal directions is specified, starting with the auspicious east and moving clockwise (*pradakṣiṇa*): White (*śukla*) food should be placed in the eastern direction, dark blue (*nīla*) food in the south, a yellow (*pīta*) oblation in the west and finally a red (*rakta*) one in the north.[25] Not only do the food offerings exhibit the four mentioned primary colours, but these appear moreover in the same order in which they are enumerated in the *āhāryādhyāya*.

3.2. COLOURED OFFERINGS AT THE FOUR CORNER PILLARS OF THE THEATRE BUILDING

A little further in the same chapter, the NŚ deals with the erection of the four supporting pillars (*stambha*) situated in the intermediate directions of the theatre building. The procedure demands that the architect fasts for three nights prior to the erection of the pillars,[26] which then takes place just after sunrise on an auspicious day.[27] Next, a variety of offerings,[28] again with specific colours, are made at each of the four pillars, which now bear the names of the four social classes (*varṇa*):[29] The offerings at the *brāhmaṇastambha* have to be of white colour (*śukla*),[30] those at the *kṣatriyastambha* should be red (*rakta*), the offerings at the *vaiśyastambha*, situated in the north-west, are yellow (*pīta*) and finally those at the north-eastern *śūdra* pillar should be rich in dark blue (*nīla*).[31] Although the location of the first two pillars is not specified, the position of the

25. NŚ 2.38B-41A:

 niśāyāṁ ca baliḥ kāryo nānābhojanasaṁyutaḥ | |38| |
 gandhapuṣpaphalopeto diśo daśa samāśritaḥ |
 pūrveṇa śuklānnayuto nīlānno dakṣiṇena ca | |39| |
 paścimena baliḥ pīto raktaś caivottareṇa tu |
 yādṛśaṁ diśi yasyāṁ tu daivataṁ parikalpitam | |40| |
 tādṛśas tatra dātavyo balir mantrapuraskṛtaḥ |

26. This seems to indicate that the architect stays awake during these nights, perhaps performing preliminary rituals for the erection of the corner pillars.

27. NŚ 2.44A-46A.

28. Cloths, garlands, unguents and different kinds of food are mentioned (see fn. 31, below). It is unclear whether the food items have the same colour as the other offerings, and whether only the food is presented to the brāhmaṇas or the other offerings as well.

29. Cf. NŚ 1.86A: *varṇāś catvāra evātha stambheṣu viniyojitāḥ |* It is clear that these deified *varṇas*, appointed by Brahman to protect the pillars, refer to the social classes. See also NŚ 3.6A, where the *varṇas* are invoked together with the other gods.

30. See also NŚ 2.50B in fn. 35.

31. NŚ 2.46B-50A:

 prathame brāhmaṇastambhe sarpissarṣapasaṁskṛtaḥ | |46| |
 sarvaśuklo vidhiḥ kāryo dadyāt pāyasam eva ca |
 tataś ca kṣatriyastambhe vastramālyānulepanam | |47| |
 sarvaṁ raktaṁ pradātavyaṁ dvijebhyaś ca guḍaudanam |
 vaiśyastambhe vidhiḥ kāryo digbhāge paścimottare | |48| |
 sarvaṁ pītaṁ pradātavyaṁ dvijebhyaś ca ghṛtaudanam |
 śūdrastambhe vidhiḥ kāryaḥ samyak pūrvottarāśraye | |49| |
 nīlaprāyaṁ prayatnena kṛsaraṁ ca dvijāśanam |

→

last two seems to imply that the *brāhmaṇastambha* stands in the south-eastern and the *kṣatriyastambha* in the south-western direction, so that one can get to all the pillars in a single clockwise round.[32] In this clockwise movement starting from the south-east the social classes associated with the four pillars appear hierarchically arranged in descending order. The colours of the oblations are once more the four primary colours, but this time they do not appear in the same order in which we met them so far. Whereas white once again stands first, we then get the sequence red-yellow-blue, not blue-yellow-red. I will come back to this issue later.[33]

3.3. METAL OFFERINGS AT THE CORNER PILLARS

Immediately after the offering of colourful substances a piece of metal[34] is put at the base of each of the four pillars. Maintaining the same order as before, the following metals are specified: *brāhmaṇastambha* — gold (*kanaka*), *kṣatriyastambha* — copper (*tāmra*), *vaiśyastambha* — silver (*rajata*), *śūdrastambha* — iron (*āyasa*). Finally, gold (*kāñcana*) is deposited at the base of all pillars, or, as per an alternative reading, at the base of the remaining pillars.[35] Let us now examine whether the choice of these metals could be influenced by their colour. The association of reddish copper with the kṣatriya pillar that

→　　Before these verses Ghosh gives the following stanza, inserted in some mss. (NŚ, 1956-67, p. 17, fn. 1 for vv. 46B-50A):

candanaṁ ca bhaved brāhmaṁ kṣātraṁ khādiram eva ca |
dhavākhyaṁ vaiśyavarṇaṁ syāc chūdraṁ sarvadrumaiḥ smṛtam | |

(The different reading of the second verse given in a fn. in NŚ, 1934-92, vol. 1, p. 58 seems to be corrupt: *dhāvākhyaṁ veśyavarṇaṁ syāc chatraṁ sarvadrumaiḥ smṛtam |*). Whether the colours of these types of wood correspond to the colours of the social classes associated with the respective pillars is not known to me. The material of the *śūdrastambha* in any case does not seem to be connected with a specific colour, as it is said to be made of all types of trees (*sarvadruma*).

32.　This view is also advocated by Abhinavagupta, who indicates the southeast as the direction of the first pillar (NŚ, 1934-92, vol. 1, p. 58: *prathamaṁ tv āgneyaḥ koṇaḥ;* cf. NŚ 3.26A: *pūrvadakṣiṇato vahnir niveśyaḥ*). The other theoretical possibility, i.e. the location of the brāhmaṇa pillar in the south-west and of the kṣatriya pillar in the south-east, would involve a leaving out of several pillars during the offerings in a clockwise (sw — ~~nw~~ — ~~ne~~ — se — ~~sw~~ — nw — ne) or anticlockwise progression (sw — se — ~~ne~~ — nw — ~~sw~~ — ~~se~~ — ne) or in an irregular combination of clockwise and anticlockwise movements. One would however expect any of these possibilities, if correct, to be enjoined in the text. Furthermore, it seems unlikely that the brāhmaṇa pillar would be situated in the southwest, so far removed from the auspicious eastern side of the playhouse.

33.　See point 4.3.

34.　In the case of the piece of gold it is specified as being in the form of an ear or neck ornament (see NŚ 2.51A, fn. 35, below).

35.　NŚ 2.50B-53A:

pūrvoktabrāhmaṇastambhe śuklamālyānulepane | |50| |
nikṣipet kanakaṁ mūle karṇā[v.l.: kaṇṭhā]bharaṇasaṁśrayam |
tāmraṁ cādhaḥ pradātavyaṁ stambhe kṣatriyasaṁjñake | |51| |
vaiśyastambhasya mūle tu rajataṁ sampradāpayet |
śūdrastambhasya mūle tu dadyāt āyasam eva ca | |52| |
sarveṣu [v.l.: śeṣeṣv] eva tu nikṣepyaṁ stambhamūleṣu kāñcanam |

has previously been venerated with red offerings is convincing in this regard. Although somewhat less obvious, the association of dark iron with the *śūdrastambha* that has been linked with the colour blue also might seem logical to a certain extent, particularly since black and grey are often not distinguished sharply from different shades of blue in Sanskrit.[36] Here, however, all similarities end. The colour white, associated with the brāhmaṇa pillar, would rather conform with the colour of silver, and the yellow colour of the offerings at the vaiśya pillar with the colour of gold, than the other way round. The colour of the employed metals consequently is not connected with the colour of the social classes. If it is intended to link the decreasing hierarchical order of the four *varṇa*s to the decreasing value of the four associated metals, then this would imply copper to be considered more precious than silver. The motivation behind the particular association of the four metals with the four corner pillars therefore remains unclear.[37]

3.4. GEMS ON THE STAGE FLOOR

Still later in the construction process the building of the stage (*raṅga*) is taken up. As a concluding ritual thereof different kinds of gems (*ratna*) are placed in the four directions of the perfectly flat *raṅgaśīrṣa* ('stage-head'):[38] Diamond (*vajra*) is laid in the east, the gem *vaiḍūrya* in the south, crystal or quartz (*sphaṭika*) in the west and coral (*pravāla*) in the north. At last, gold (*kanaka*) is deposited in the centre of the *raṅgaśīrṣa*.[39] If we compare the arrangement of these gems with the food offerings in NŚ 2.39B-40A we do not only notice the same clockwise movement starting from the east, but in addition find a more complete correspondence to the four primary colours than we had in the case of the metal offerings:

The association of the translucent 'colour' of diamond with the achromatic white is justifiable to some degree,[40] although a white pearl would probably have been a better

36. See point 4.2.

37. Even though an exact correlation between the colours associated with the four pillars and the colour of the four metals is wanting, a connection between the latter and the four primary colours cannot be excluded completely. — As part of a ritual act during a later phase of the construction work pieces of iron are deposited at the base of the four pillars of the *mattavāraṇī* (NŚ 2.63B-64A, 66B, 99A-B), an adjoining part of the stage whose exact nature is a matter of controversy (cf. NŚ, 1934-92, vol. 1, pp. 433-37; Panchal, Goverdhan: *The Theatres of Bharata and Some Aspects of Sanskrit Play-production*, Delhi, 1996, pp. 98-120). The fact that iron is associated with the śūdra *varṇa* on the one hand and with the *mattavāraṇī* pillars on the other hand is significant, as the latter are presided over by powerful *bhūtas*, *yakṣas*, *piśācas* and *guhyakas* (NŚ 1.91A-B), i.e. beings on the lower end of the hierarchical ladder.

38. NŚ 2.73B-74B:
 ratnāni cātra deyāni pūrve vajraṁ vicakṣaṇaiḥ | |73| |
 vaiḍūryaṁ dakṣiṇe pārśve sphaṭikaṁ paścime tathā |
 pravālam uttare caiva madhye tu kanakaṁ bhavet | |74| |

39. I will come back to this in point 4.1.

40. In analogy to water, the colour of which is often thought of as white (see fn. 143), the innate colour of colourless, transparent diamonds might have been considered to be white as well. The reflection of light on the polished facets of a cut diamond furthermore imparts a brilliant white appearance to the gem.

candidate had the main emphasis lain on the colour of the *ratnas*. It is likely that the choice fell on diamond to be linked with the positively connoted eastern direction, as it is the hardest and therefore most valuable of all gems.

The gem for the southern direction is *vaiḍūrya*. While this is considered to refer to a cat's-eye gem according to the Böhtlingk and Monier-Williams dictionaries, Apte, using the spelling *'vaidūrya'*, translates it with lapis lazuli, and Kangle, in his translation of *ArthŚ* 2.11.30, with beryl.[41] The term 'cat's-eye' refers to a light effect called chatoyancy that can be observed in some polished gems and as such is not related to any specific colour.[42] Mostly, cat's-eye gems refer to chrysoberyls possessing this characteristic, which have predominantly yellowish, greenish or brownish hues.[43] Beryls can equally appear in many shades among which greenish to light blue tones characterize the variety called aquamarine.[44] Lapis lazuli on the other hand has predominantly an intensive, dark blue colour.[45] The *ArthŚ* in its section on *ratnas* mentions a variety of colours for *vaiḍūrya*, from blue up to yellow and green, while the reference to 'the colour of water' (*udakavarṇa*) might indicate a highly translucent type of *vaiḍūrya*.[46] This would not seem to point to a lapis lazuli, rather to a beryl.[47] Whichever gem is referred to by the name *vaiḍūrya*, it is likely that its typical colour is dark blue, as is indicated in the 13th chapter of the *NŚ* by the mention of the mythological mountain range called Nīla, said to consist of *vaiḍūrya*.[48] In all probability it is therefore the colour blue that is linked here with the south, as it has been in *NŚ* 2.39B.

The *sphaṭika*, mentioned next, is placed on the western part of the stage floor. In the ritual described in point 3.1. the west was associated with the colour yellow. Can a *sphaṭika*, usually taken to mean a crystal or quartz, possibly possess this colour? This question has to be affirmed: While quartz exists in a variety of shades including yellow,[49]

41. Kangle, 1963, p. 113. See below, fn. 46.

42. Hall, 2002, p. 23.

43. *Ibid.*, pp. 108-09.

44. *Ibid.*, pp. 75-78.

45. *Ibid.*, p. 69.

46. *ArthŚ* 2.11.30: *vaiḍūrya utpalavarṇaḥ śirīṣapuṣpaka udakavarṇo vaṁśarāgaḥ śukapatravarṇaḥ puṣyarāgo gomūtrako gomedakaḥ.* Since water, as mentioned before, is associated with the colour white in other contexts (cf. fnn. 51, 52 & 143), it might be that the term *udakavarṇa* here describes a translucent gem of a whitish hue.

47. Both Buddruss and Winder arrive at a similar conclusion. See: Buddruss, Georg: 'Zum Lapis Lazuli in Indien. Einige philologische Anmerkungen,' in: *Studien zur Indologie und Iranistik 5-6. Festschrift Paul Thieme zur Vollendung des 75. Lebensjahres dargebracht von Schülern und Freunden*, Reinbek, 1980, pp. 3-26 (esp. pp. 5-6); Winder, Marianne: 'Vaiḍūrya,' in: Meulenbeld, G. Jan/Wujastyk, Dominik (eds.): *Studies on Indian Medical History. Indian Medical Tradition 5.* Repr. Delhi, 2001, pp. 85-94.

48. *NŚ* 13.31A: *nīle tu vaiḍūryamaye siddhā brahmarṣayas tathā* | Cf. also *MBh* 6.7.3A: *nīlaś ca vaiḍūryamayaḥ.* Although *nīla* might also mean black (more on this in point 4.2.), it is rather unlikely for *vaiḍūrya* to possess this colour.

49. Hall, 2002, pp. 82-87.

the colour of translucent rock crystal varies from colourless to yellowish.[50] A whitish or colourless appearance of *sphaṭika* is however documented in the *NŚ* itself. In the 32nd *adhyāya* the *sphaṭika* jewel (*sphaṭikamaṇi*) is mentioned thrice in verses exemplifying certain *dhruvā* metres. In the first example it is the moon that is compared to a bright white crystal,[51] while the other two verses speak of water with the brilliance of crystals.[52] It becomes clear that the colour of *sphaṭika* does not fit unequivocally into the scheme of primary colours related to the four cardinal regions that appears in the beginning of the second *adhyāya*.[53] One might reason that, due to the lack of a typical yellow gem, a yellowish crystal or quartz is chosen to be placed in the western part of the stage. Yet such an argumentation is highly conjectural.[54]

The last *ratna* mentioned is *pravāla*, coral. Among its differently coloured varieties it is the reddish coral that is used since millennia to manufacture jewellery.[55] Here again the northern direction in which *pravāla* is placed, coincides with the direction in which red coloured offerings were put before the actual construction of the theatre building was taken up.

3.5. CLOTHS ON THE JARJARA

Once the construction work completed, the stage of the theatre hall is consecrated with a series of rituals, the details of which are provided in the third *adhyāya* of the *NŚ*. As part of these rituals a *maṇḍala* is drawn on the stage floor in which the different deities are installed and worshipped with a variety of substances.[56] Then, a water-filled pitcher (*kumbha*) is placed in the centre of the stage — the region presided over by Brahman[57] — and a piece of gold put inside.[58] The veneration of all deities being completed, it is now the turn of the *jarjara* to be worshipped.

50. Hall, 2002, p. 81.

51. *sphaṭikamaṇiruciradhavalanibhaḥ* [. . .] *candro* (*NŚ* 32, Sanskrit rendition of Prakrit verse 264A). — Although the term *rucira* can mean 'saffron' as a neutre noun, and the feminine noun *rucirā* is documented as another name for the yellow pigment *gorocanā*, it is highly unlikely that *rucira* should have a similar meaning here, considering the comparison with the moon.

52. *sarasi jalaṁ* [. . .] *sphaṭikanibham* (*NŚ* 32, Sanskrit rendition of Prakrit verse 175A); *sphaṭikamaṇinikarasadṛśajale* (*ibid.*, Sanskrit rendition of Prakrit verse 267A).

53. See fn. 25, above.

54. Cf. however fn. 86.

55. Hall, 2002, p. 142. Cf. also *ArthŚ* 2.11.42, which mentions only red and pink coloured varieties of coral: *pravālam* [. . .] *raktaṁ padmarāgaṁ ca*. According to Kangle the term *vaivarṇika* in the same sentence does not stand for a colourless coral but refers to a specific variety of coral named after its place of origin (Kangle, 1963, p. 115).

56. *NŚ* 3.1A-71B.

57. Cf. *NŚ* 1.95A = *NŚ* 5.72B; *NŚ* 3.24A.

58. *NŚ* 3.72A-B.

The *jarjara* is a staff, 108 *aṅgula*s long,[59] which can consist of wood but is ideally made of bamboo.[60] In the latter case it should have four nodes (*granthi*), separating five segments (*parvan*),[61] which, on two occasions, are said to be protected by different deities: Brahman, together with all the classes of gods (*devagaṇa*), protects the upper segment, Śaṅkara/Hara the second one, Viṣṇu/Janārdana the third and Skanda/Kumāra the fourth, while the 'great serpents' (*mahānāga*) Śeṣa, Vāsuki and Takṣaka, the highest of the *pannaga*s, protect the fifth segment.[62] Furthermore, the *vajra*, most probably referring to Indra's weapon, is associated with the *jarjara* as a whole.[63] The evidently sacred nature of the *jarjara* has to be traced back to its myth of origin, which is narrated in the first *adhyāya* of the *NŚ*.[64] According to that story, Indra once seized his flagstaff, which had been erected and venerated during the festival dedicated to it (*dhvajamaha*, *mahendravijayotsava*), and crushed (*jarjarīkṛta*) the limbs of disturbing demons with it. As a result the other gods suggested that, from this moment onwards, the staff be called *jarjara*. The fact that the *jarjara* originated from the *indradhvaja*,[65] a representation of the *axis mundi*, as well as its close association with the centre of the stage,[66] seems to imply that the *jarjara* equally is a symbol of the sacred centre. This interpretation is consolidated by the mention of Brahman and the three *mahānāga*s as protecting the uppermost and lowest segment of the *jarjara* respectively. This corresponds closely with the *Mānavaśrautasūtra*, *Gobhilagṛhyasūtra* and the *Matsya Purāṇa*, which agree in naming Brahman as the guardian of the zenith and respectively identify Ananta, Vāsuki and Ananta/Śeṣa as protector of the nadir.[67] It therefore becomes highly probable that the *jarjara* indeed is a representation of the *axis mundi*.

In describing the veneration of the *jarjara* as part of the consecration of the stage, the

59. A little under seven feet or just above two metres if we take the *aṅgula* to be approximately three quarters of an inch (cf. Prasanna Kumar Acharya: *A Dictionary of Hindu Architecture. Treating of Sanskrit Architectural terms with illustrative quotations from Silpāsastras*[sic], *General Literature and Archaeological Records*. Manasara Series 1, Repr. Delhi, 1997, p. 5).

60. *NŚ* 21.174B-175B, 177A.

61. *NŚ* 21.177B.

62. *NŚ* 1.92B-94B; *NŚ* 3.79A-80B.

63. *NŚ* 1.92A; *NŚ* 3.78B.

64. *NŚ* 1.54A-75B (esp. 69Aff.).

65. Cf. in this regard *NŚ* 21.174A-B, 180A-B.

66. Cf. for example, the mention of Brahman as present in the centre of the stage (*NŚ* 1.95A) immediately after the description of the *jarjara* (*NŚ* 1.92A-94B), whose upper segment, moreover, is protected by Brahman. Cf. also the veneration of the *jarjara* after the placement of the piece of gold in the water vessel in the stage centre (*NŚ* 3.72A-73B). Unfortunately, it is not specified where exactly the *jarjara* is positioned while being worshipped.

67. Corinna Wessels-Mevissen: *The Gods of the Directions in Ancient India. Origin and Early Development in Art and Literature (until c. 1000 AD)*, Berlin, 2001, pp. 10, 14.

NŚ mentions cloth (*vastra*) of varying colour attached to its five segments:[68] A white (*śveta*) cloth is prescribed for the upper segment, a blue (*nīla*) one should be attached to the Rudra-segment below it, a yellow (*pīta*) cloth to the Viṣṇu-segment, a red (*rakta*) one to the segment protected by Skanda, and finally a multicoloured (*citra*) cloth to the lowest segment (*mūlaparvan*)[69] of the bamboo staff.[70] Here the four primary colours, this time arranged vertically, appear once more in the order encountered in the *āhārya* chapter.

3.6. EXPRESSION OF THE PRIMARY COLOURS BY MEANS OF THE CATURAHASTA

In an entirely different context, i.e. the description of hand gestures, we yet again encounter the *svabhāvajavarṇa*s. Among the variety of things that can be expressed by the single hand gesture (*asaṃyutahasta*) named *catura* the *NŚ* mentions 'different colours' (*nānāvarṇa*). Next it indicates how four particular colours, i.e. white (*sita*), red (*rakta*), yellow (*pīta*) and blue (*nīla*), can be specifically shown.[71] The information given is however of a general nature: To convey the colour white the hand showing the *catura* gesture should be held high (*ūrdhva*),[72] for showing red and yellow it should be moved in a circle (*maṇḍalakṛta*)[73] and for communicating the colour blue the hand should be 'rubbed' (*parimṛdita*), whatever this is supposed to mean.[74]

68. *NŚ* 3.74A-75A:

 śvetaṃ śirasi vastraṃ syān nīlaṃ raudre ca parvaṇi |
 viṣṇuparvaṇi vai pītaṃ raktaṃ skandasya parvaṇi | |74| |
 mṛda[v.l.: mūla; mūṣa]parvaṇi citraṃ tu deyaṃ vastraṃ hitārthinā |

69. The readings *mṛda-* and *mūṣaparvaṇi* (see fn. 68, above) do not seem to make any sense here.

70. Cf. this *citra* cloth of the bamboo segment protected by the three *mahānāga*s with the multi-coloured make-up (*nānāvarṇa*) prescribed for the theatrical representation of *pannaga*s, i.e. *nāga*s, in *NŚ* 21.103B (The term *nānāvarṇa*, however, could also indicate that a single but random colour is used for portraying a *nāga*. Vāsuki is furthermore assigned a dark [*śyāma*] colour in *NŚ* 21.99A. See table 1, at the end of this article.), as well as the colourful (*citra*) clothes assigned to *nāga*s, this time called *uraga*s, in *NŚ* 21.125A-B (see fn. 119). Cf. also *BṛSam* 35.1B-2A, which narrates the belief that the multicoloured rainbow originates from the breath of the *uraga*s, the progeny of the *nāga* Ananta (i.e. Śeṣa): [...] *indradhanuḥ | |1| | kecid anantakuloraganiḥśvāsodbhūtam āhur ācāryāḥ |*

71. *NŚ* 9.99B-100B:

 nānāvarṇāṃś ca tathā catureṇaivaṃ prayuñjīta | |99| |
 [sitam ūrdhvena tu kuryād raktaṃ pītaṃ [v.l.: pātaṃ] ca maṇḍalakṛtena |
 parimṛditena tu nīlaṃ [v.l.: līnāṃ] varṇāṃś catureṇa hastena [v.l.: varṇaṃ caturaṃ ca yuñjīta] | |]100| |

 Here the primary colours are mentioned in the same sequence in which they appear as part of the veneration of the four supporting pillars.

72. Cf. *ūrdhvasaṃstha*, the 2nd *hastaprakāra* (*NŚ* 9.220A; *AbhiBhā*: *ūrdhvaḥ śiraso 'py upari gacchan* [*NŚ*, 1934-92, vol. 2, p. 81]).

73. Cf. *maṇḍalagati*, the 6th *hastaprakāra* (*NŚ* 9.220B; *AbhiBhā*: *maṇḍalagateḥ sarvato bhramam* [*NŚ*, 1934-92, vol. 2, pp. 81-82]).

74. It is likely that Kavi has placed verses 100A-B between square brackets as they are not commented upon by Abhinavagupta in the extant *AbhiBhā*. Yet, as Ramaswami Sastri points out in his preface to the 2nd edn. of the 1st vol. of the *NŚ* (*NŚ*, 1934-92, vol. 1, p. 10), this "method was not satisfactory, nor was it successful especially because it has not been consistently followed throughout the book." It is possible, however, that this stanza is indeed an interpolation.

4. Analysis of the Ritual Application of the Primary Colours

The use of the *svabhāvaja* colours in the ritual contexts described above and their mention in the description of the *caturahasta* seem to point to a special importance attached to them. It has however to be mentioned that in none of the cited passages it has been specified that the colours used are *svabhāvajavarṇas*.[75] This information is only supplied by the *āhāryādhyāya*.[76] The withholding of this information in the passages dealing with the application of these colours is probably due to the fact that the NŚ has been conceived primarily as a handbook for the people involved in producing a play. Information of a more explanatory nature has most likely been passed on orally. Yet even without any further elucidation some rationale behind the ritual use of the primary colours emerges: As all existing colours originate from them and as such inhere in them, the four *svabhāvajavarṇas* represent the totality of all colours. Because of this they are associated with the four 'primary' or cardinal directions as well as with the four 'primary' or principal classes of Hindu society.[77] Furthermore, as none of the primary colours can be split up into other colours,[78] they, although being four in number, can be taken to represent the non-duality in the realm of colours.[79] The *jarjara*, standing for the generative, non-dual centre of the cosmos, consequently has the four primary colours associated to its different parts. The symbolism present here furthermore points to the fundamental identity of multiplicity, embodied by the *citra* cloth of the *jarjara*, and unity, represented by the *jarjara* staff itself.[80]

4.1. THE COSMOGRAPHY OF THE NŚ

The correlation of colours with the cardinal directions and the main social classes appears

75. Even Abhinavagupta is silent on this matter when commenting upon the relevant verses of the NŚ (NŚ, 1934-92, vol. 1, pp. 58-59, 63, 80; vol. 2, p. 50; vol. 3, pp. 137-39). It is however not unlikely that he was aware of the colours being used in these specific instances to be primary ones, but did not deem it necessary to point this out.

76. To be precise, the expression '*svabhāvajavarṇa*' occurs only in NŚ 21.79A (see fn. 12), which verse is even omitted in the Chowkhamba edition of the NŚ (see NŚ, 1956-67, vol. 1, p. 153, fnn. 13 & 14).

77. It is worth reminding here that the term *varṇa* denotes both social class and colour. Whether the appellation '*varṇa*' for class originated in the primary colours attributed to the four class divisions still has to be determined.

78. As we are concerned with painting, the dispersion of white light into its constituent spectral colours is not considered here.

79. Cf. in this regard the characterization of the colour *kasiṇas*, already mentioned in the Pali Canon (see fn. 148).

80. In this connection it is irrelevant whether the colours appearing on the *citra* cloth are all primary colours, derivative colours or a grouping of both, as in any case they must be a combination — either in form of a mixture or as a juxtaposition — of the primary colours on the cloths above it. — The symbolism of the *jarjara* is particularly helpful for our understanding of the seizing (*grahaṇa*) of the *jarjara* in the *pūrvaraṅga* ritual called *utthāpana* (see NŚ 5.75B-82A). There, the attainment of unity by the *sūtradhāra* is achieved simultaneously on various levels, both spacial (*jarjara*) and temporal (*sannipāta*). This topic, which is dealt with in detail in my dissertation, however cannot be considered here, as this would lead too far.

to be reflected in the cosmography current at the time of the *NŚ*. In several places the text reveals its Purāṇic world-view, which includes seven concentric islands (*saptadvīpa*) surrounded by as many oceans.[81] The central island Jambūdvīpa is for its part divided into nine regions (*varṣa*)[82] by mountain ranges. In the heart of the central *varṣa* Ilāvṛta lies the mountain Meru or Sumeru on whose summit reside the 33 gods (*trayastriṁśat*).[83] The Purāṇas give us more detailed information on the appearance of Meru. The four sides of this mountain exhibit, clockwise from the east, the colours white (*śveta*), yellow (*pīta*), black (the colour of a *bhṛṅgapatra*)[84] and red (*rakta*), which are connected with the brāhmaṇa, vaiśya, śūdra, and kṣatriya *varṇa* respectively.[85] Apart from the ambiguous colour assigned to the western side of Meru and the śūdra *varṇa*, the other three colours are primary colours. That the remaining colour should in all probability be dark blue will be explained in point 4.2. This association of the primary colours with the cardinal directions does not however coincide with the one encountered in the *NŚ*.[86] On the other hand, the *NŚ* and the Purāṇas agree with each other regarding the connection of colours with the four classes, again barring the colour blue.

Meru itself is often said to consist of gold.[87] Moreover, according to the *Bhāgavata* and the *Devībhāgavata Purāṇa* Brahman resides in the centre of Mount Meru's flat summit

81. Cf. *NŚ* 1.10B, 117B; *NŚ* 13.5B; *NŚ* 21.100B, 101B.

82. Cf. *NŚ* 13.21A-B; *NŚ* 21.101B-103A. According to the Purāṇas, the southernmost region Bhāratavarṣa, corresponding roughly with the South Asian subcontinent, is called *karmabhūmi*, as it is the only region in which people experience the results of their actions (*karman*). The other eight *varṣas* and six *dvīpas* are paradisiac regions whose inhabitants live like gods and are therefore called *bhogabhūmi*s, i.e. regions of enjoyment (Kirfel, 1920, pp. 58, 112). This agrees with the information given in the *NŚ* on the difference between Bhāratavarṣa and the other *varṣas* (*NŚ* 18.97A-100B).

83. *NŚ* 13.30B.

84. *bhṛṅgapatra*: the wing of a black bee or the leaf of Laurus cassia?; *v.l.*: *bhṛṅgipatra*: the leaf of the Indian fig-tree?

85. Kirfel, 1920, p. 93; Kirfel, 1954, p. 3*; *ibid.*, pp. 89-90, vv. 15A-19B; etc.

86. According to Nārāyaṇatīrtha's *Yogasiddhāntacandrikā*, a late commentary on Patañjali's *Yogasūtras*, Meru's four sides consist, clockwise from the east, of silver, beryl, crystal and gold (Kirfel, 1920, pp. 16*, 93). If 'beryl' here refers to a blue gem, then this association conforms more fully with the *NŚ*, which assigns the colours white, dark blue, yellow and red to the respective cardinal directions. Cf. also the following statement from Adrian Snodgrass, unfortunately given without any reference: "The colour of the face of Meru turned to our world of Jambudvīpa is made of sapphire and is blue. In India it is said that the blue colour of the sky is produced by the reflection of light from Meru." (Adrian Snodgrass, *The Symbolism of the Stupa*, Delhi, etc., 1992, p. 291, fn. 116). Jambudvīpa, another spelling for Jambūdvīpa, here refers to the southern continent of Buddhist cosmography (cf. Kirfel, 1920, pp. 183, 188). Regarding the colour of crystal, cf. point 3.4.

87. *kanakaparvata*, *kanakaprabha* (Kirfel, 1954, p. 7, v. 3B; *ibid.*, p. 95, v. 39A); *sauvarṇa* (*ibid.*, p. 89, v. 15A; *ibid.*, p. 95, v. 39B); etc. For the characterization of Meru as a 'golden mountain' (*kanakaparvata*), see also *MBh* 3.102.2A, 3.186.103B, 6.7.8B, 12.59.122B, 12.122.3A. The *Amarakośa* similarly includes Hemādri (lit. 'golden mountain') in its list of names for the world mountain (*AmKo* 1.1.50B: *meruḥ sumerur hemādri ratnasānuḥ surālayaḥ*).

in a perfectly square city, similarly consisting of gold.[88] Here we are reminded both of the piece of gold (*kanaka*) laid in the centre of the stage[89] after the construction of the *raṅgaśīrṣa*,[90] as well as of the piece of gold deposited in the water-filled *kumbha*[91] on the same spot during the consecration of the stage.[92]

Although the NŚ does not explicitly associate the primary colours with the four sides of the stage *maṇḍala*, it is highly probable that it presupposes such an association, as the cardinal regions of the theatre building and probably of the stage itself have already been correlated with these colours earlier.[93]

4.2. THE ASSOCIATION OF COLOURS WITH THE FOUR SOCIAL CLASSES

In most later texts the colours linked to the four social classes coincide with the ones associated with the class pillars in the NŚ, with the exception that the colour of the śūdra *varṇa*, is usually considered to be black. Frequently it is the word *kṛṣṇa* that is translated here. For this word the different dictionaries give the meanings black, dark and dark blue. Indeed, the colours black and blue or dark blue do not seem to be differentiated greatly in ancient Sanskrit literature.[94] In its section on colours the *Amarakośa* gives the following sequence of colours resembling *kṛṣṇa*: *nīla, asita, śyāma, kāla, śyāmala* and *mecaka*.[95] For all these words both the meanings black and dark blue are attested. Yet, as

88. Kirfel, 1920, p. 94. NŚ 18.98B mentions the earth (*bhūmi*) of the *varṣas* excepting Bhāratavarṣa to be golden (*kāñcanī*) as well, or, according to a *v.l.*, to consist of gold and gems (*hemaratnamayī*). Cf. in this regard fn. 82.

89. The stage centre is, as we have seen, linked with Brahman on different occasions. See fn. 57.

90. See fn. 38.

91. It is unclear whether this water vessel is in ἁ ny way related to the pitcher (*kamaṇḍalu*) named as an attribute of Brahman in an early description of his iconography (*BṛSam* 58.41A). Such a relation however seems not very likely, considering that the *kumbha* is broken later on as part of the consecration of the stage (NŚ 3.88B-90A).

92. See fn. 58.

93. See points 3.1. and 3.4.

94. The interesting topic of the socio-culturally determined perception of colours and its reflection in language cannot be dealt with here.

95. *AmKo* 1.5.14A: *kṛṣṇe nīlāsitaśyāmakālaśyāmalamecakāḥ* | As no further list of names signifying black or blue is given, it has to be concluded that both colours are equally represented here. Some of these colour names have been used interchangeably: Cf., as epithets of Śiva, Nīlakaṇṭha (NŚ 1.45A) and Asitakaṇṭha (56th unnumbered verse after NŚ 5.174B, part of an interpolated section), as well as the association of the *śūdravarṇa* first with *asita* in MBh 12.181.5B (the *v.l.* '*āsita*' is improbable in view of the colours attributed to the other classes in vv. 5A-B), and with *kṛṣṇa* in MBh 12.181.13B. In other contexts these colours meaning blue or black have been distinguished from each other: Cf. the association of *śyāma, kṛṣṇa* and *nīla* with different *rasas* in NŚ 6 (see fn. 121, below); the distinction between *kṛṣṇa* coloured and *śyāma* coloured earth, which are respectively unsuitable and suitable for the use as a paste (*lepana*) to be applied on drumheads in order to produce the desired sound (NŚ 34.129B-131A); the colours *śyāma* and *asita* used as the make-up of actors playing different roles (see table 1 at the end of this article). It is likely that the ambiguousness of the colour expressed by '*nīla*' has caused Ghosh to mistakenly translate the names of the *svabhāvajavarṇas* (i.e. *sita, nīla, pīta* and *rakta*) in the *āhārya* chapter with "black, blue, yellow and red" (Ghosh, 1951-61, vol. 1, p. 421).

nīla is said to be a *svabhāvajavarṇa* in the *NŚ*, it is clear that *nīla*, associated with the offerings to the śūdra pillar, must mean blue, not black. As it is highly probable that '*kṛṣṇa*' as the colour attributed to the śūdra class in other texts is intended to stand for a primary colour as well, it should ideally be translated with 'blue' or 'dark blue' in such contexts in order to identify it as a primary colour. The same goes for the colour, often translated with 'black,' that is attributed to one of the four sides of Meru.[96]

It is clear that the four colours attributed to the four classes do not refer to the skin colour of the people belonging to these classes. The *NŚ*, however, does associate class and complexion when it states that the colour of the make-up used to represent brāhmaṇas and kṣatriyas on stage should be fair (*gaura* [*v.l.: rakta*]), while it should be dark (*śyāma*) for the portrayal of vaiśyas and śūdras.[97]

4.3. THE HIERARCHY AMONG THE PRIMARY COLOURS

Now that the reason behind the particular application of the primary colours in the *NŚ* is somewhat clearer, let us take a closer look at the order in which these colours appear. The succession white-blue-yellow-red (i.e. w-b-y-r) is common to the exposition of the primary colours in *NŚ* 21, the offering of food in the cardinal directions in *NŚ* 2, perhaps the deposition of *ratnas* on the stage floor in the same *adhyāya* and finally the colours of the cloths attached to the *jarjara* in *NŚ* 3. A different arrangement, i.e. white-red-yellow-blue (w-r-y-b), appears in connection with the offerings at the four main pillars in the intermediate directions of the *nāṭyagṛha*.[98] In both cases a hierarchical order seems to be maintained, more obvious in the second sequence, with its specific association with the four social classes,[99] than in the first. In this first arrangement we only notice the

96. It should be noted that black paint frequently behaves in a way similar to blue paint. While the mixture of black with yellow should theoretically produce a darker yellow, what we actually get when mixing paints of these colours often is olive green. This is due to the fact that black paint is seldom purely black, but mostly consists of a mixture of pigments among which figures blue. If the same was true for some black paint commonly used in ancient India, then the observation of this fact might have contributed to the blurred distinction in Sanskrit literature between black and dark blue, as well as between grey and lighter shades of blue. For *nīla* in the sense of blue, cf. the references to the blue water lily, *nīlotpala* (e.g., *NŚ* 16.51A, 58A; *NŚ* 22.110B). As the colour of collyrium and smoke *mahānīla*, for which the dictionaries provide the meanings "dark blue" (Apte and MW) and "deep black" (MW), might stand for achromatic grey or black (*NŚ* 15.143A: *mahānīladhūmāñjanābhā*).

97. *NŚ* 21.113A-B (cf. table 1 at the end of this article).

98. The mention of the primary colours in connection with the *caturahasta* follows the same sequence. This is however not taken into account here, as it is questionable whether a strict hierarchy of the colours named is intended, especially since *rakta* and *pīta* are represented by means of the same movement of the *catura* gesture (cf. fn. 71 & 73). See however fn. 103, below.

99. A frequently encountered interpretation of the correlation between specific colours and the four classes is reflected in Ghosh, 1951-61, vol. 1, p. 25, fnn. 2-5 of vv. 46B-50A: "white — symbol of purity and learning, associated with the Brahmins. [. . .] red — symbol of energy and strength, associated with the Kṣatriyas. [. . .] yellow — symbol of wealth (gold) associated with the Vaiśyas. [. . .] blue — symbol of non-Aryan origin associated with the Śūdras.".

domination of white, bearing in mind the connection of this colour with the east. A decreasing hierarchical arrangement of the colours blue, yellow and red still has to be ascertained. Incidentally, it may be noticed that the order of the three colours following white agrees with the one appearing in the most splendid manifestation of colours in nature, the rainbow. There, from outside to inside, the colours red, yellow and blue are manifested with their respective mixtures between them.[100]

4.3.1. *White*

In both colour arrangements white takes the lead.[101] Its association with the important eastern region, the brāhmaṇa *varṇa*, the god Brahman,[102] the highest segment of the *jarjara*[103] and possibly the diamond indicates that this colour is regarded as possessing an exceptional quality. It therefore comes as no surprise that the *NŚ* on several occasions mentions the colour white in ritual contexts:

- The cord (*sūtra*) that is used to measure the ground plan of the theatre hall on the construction site is white (*śukla*).[104] The ritual nature of this measuring process, evinced among other things by the astrologically determined moment on which the measuring should take place, has to be attributed to the fact that it initiates the construction of the sacred *nāṭyagṛha*.[105] For the same reason the *sūtra* has to be handled with utmost care. The breaking of the cord while measuring will cause different kinds of disaster to occur, depending on where exactly it breaks.[106]

100. The colours of a rainbow are naturally ordered in accordance with their individual frequencies, from low (red) to high (purple). In the case of a double rainbow, the faded colours of the higher, secondary rainbow appear in reversed order, i.e. red as the innermost colour, etc.

101. White seems to have been traditionally regarded as the first colour. The section on colour names in the *Amarakośa* (*AmKo* 1.5.12B-17B) starts with white. Cf. also the reference in *NŚ* 14.108A to colours associated with classes of metres, where white (*śveta*) once again is placed first: *śvetādayas tathā varṇā vijñeyāś chandasām iha*। Ramakrishna Kavi elucidates with the following fn.: *gāyatrīprabhṛtijagatī-paryantānāṁ chandasāṁ — sitasāraṅgapiśaṅgakṛṣṇanīlalohitagaurā varṇāḥ* (*NŚ*, 1934-92, vol. 2, p. 246). While Kavi does not give any reference for this, Abhinavagupta mentions the *prātiśākhyas* and other texts in this context (*prātiśākhyādau* [*ibid.*]). Incidentally, the seven *chandases* from *gāyatrī* up to *jagatī*, referred to by Kavi, constitute the divine group (*divyagaṇa*) of metres (*vṛtta*) (*NŚ* 14.112B-114A).

102. Brahman, as we have seen, is the protector of the upper segment of the *jarjara*, characterized by a white coloured cloth (see point 3.5.).

103. It should be reminded in this regard that white is the only colour that, when expressed with the *caturahasta*, is shown with the hand held high (see point 3.6.).

104. *NŚ* 2.27B: *puṣyanakṣatrayogena* [*v.l.: yoge tu*] *śuklaṁ sūtraṁ prasārayet* [*v.l.: nidhāpayet*]। ।27। ।

105. The sacredness of the theatre building is apparent among other things from the elaborate rituals accompanying its construction and from the fact that it houses the stage *maṇḍala*.

106. *NŚ* 2.28A-31A. It is likely that the white colour of the measuring *sūtra* is due to white powder with which the rope is rubbed (cf. *AbhiBhā* : *śuklasūtratvaṁ* [*v.l.: śuklasūtraṁ*] *tāvat piṣṭarañjanādinā* [*NŚ*, 1934-92, vol. 1, p. 55, l. 7), as is presently done for instance in Tibetan Buddhism in order to leave visible marks on the surface on which a *maṇḍala* will be drawn, pulling the stretched string up a bit and letting it spring back. If so, white coloured powder still could have been chosen because of the ritual significance of white.

- For the construction of the stage blackish earth (*mṛttikā kṛṣṇā*) is used, which has to be ploughed so as to be able to remove gravel, grass, etc., from it. The two animals used for pulling the plough should possess a pure colour (*śuddhavarṇa*),[107] which in all probability implies the colour white.

- After having installed the deities and semi-divine beings in the compartments of the stage *maṇḍala* during the consecration of the stage, they are worshipped. One requirement is that the garlands and unguents used in the veneration of deities (*devatā*) should be white (*sita*), while red (*rakta*) ones are offered to the *gandharvas*, Vahni and Sūrya.[108]

- When choosing a proper bamboo stem for the fabrication of the *jarjara* several rules have to be observed, some of which are mentioned in *NŚ* 21. Apart from pointing out an astrological requirement (*puṣyanakṣatraja*),[109] it is specified that the soil on which the bamboo grows should be white in colour (*śvetabhūmi*).[110] In view of the sacred nature of the *jarjara* this might be another case in which white is prescribed in its role of a ritually pure colour. On the other hand, as we have seen above, dark (*kṛṣṇa*) earth has been used in connection with the stage, i.e. also in a ritual context, without any negative connotations. Furthermore, the earth on which the *nāṭyamaṇḍapa* is erected has to be either dark (*kṛṣṇā*) or light coloured (*gaurī*).[111] Hence the reference to whitish soil in connection with the *jarjara* might just as well be due to more practical concerns, indicating the type of soil ideal for the growth of the desired bamboo.

107. *NŚ* 2.70B (read '*śuddhavarṇau*' instead of '*śuddhavarṇo*').

108. *NŚ* 3.35A-B. Apart from Brahman, who occupies the centre of the stage *maṇḍala*, the main deities of the *NŚ* — Śiva, Nārāyaṇa [i.e. Viṣṇu], Mahendra [i.e. Indra] and Skanda — as well as Sarasvatī, Lakṣmī, etc., reside in the eastern part of the *maṇḍala* (*NŚ* 3.24A-25B). This region, as we have seen, is associated with the colour white. Vahni, i.e. Agni, and the *gandharvas* are installed in the south-eastern section of the *maṇḍala* (*NŚ* 3.26A-B). While this is the direction in which the *brāhmaṇastambha* is situated, venerated with white offerings, Abhinavagupta mentions the association of this region (*āgneya*) with the colour red (*rakta*) (*NŚ*, 1934-92, vol. 1, pp. 57-58; cf. also *BṛSam* 60.2B). If this colour association has to be adopted here as well, it has the appearance as if the colours used to venerate the deities in the present context are related to the position of these deities within the *maṇḍala* and the colours associated with the respective regions. Sūrya, worshipped with red substances, is situated in the eastern part of the *maṇḍala* according to *NŚ* 3.25A. However, several mss. place Bhānu (i.e. Sūrya) in the south-eastern section of the *maṇḍala* (*v.l.* of *NŚ* 3.26A), just like Agni and the *gandharvas*. Some of these mss. still place Sūrya, this time called Arka, in the eastern direction as well, while a ms. from Nepal does not (*v.l.* of *NŚ* 3.25A). This question still has to be examined more closely. As to the symbolic meaning of the colours white and red in the present context, cf. Ghosh, 1951-61, vol. 1, p. 37, fnn. 1-2 of stanza 34: "'White' here seems to be the symbol of purity and good grace. [. . .] 'Red' here seems to be the symbol of energy.". Cf. also fn. 99, above.

109. This might refer to the moment of the cutting of the bamboo, or, as Ghosh understands it, to its planting (Ghosh, 1951-61, vol. 1, p. 433).

110. *NŚ* 21.176A-B.

111. *NŚ* 2.25A-B.

- The theatrical 'orchestra' (*kutapa*) is situated on the western side of the stage. In the centre, his back to the wall and facing the east, the centre of the stage *maṇḍala* and the public, sits the player of the three *mṛdaṅga* drums (*mārdaṅgika, maurajika*).[112] Of particular interest here is the fact that, after these drums are made, they are venerated in three separate *maṇḍalas* drawn with fragrant cowdung, which are presided over by Brahman, Śaṅkara and Viṣṇu respectively. One of the items offered to Brahman and the *āliṅga* drum associated with him are white cloths (*śuklavāsas*).[113]

- While entering the stage during the ritual preliminaries (*pūrvaraṅga*) of a play the stage director (*sūtradhāra*) and the two *pāripārśvikas* assisting him share the following characteristics: All three of them, being initiated (*dīkṣita*) and ritually pure (*śuci*), assume the *vaiṣṇava* stance, express a look of wonder with their eyes (*adbhutādṛṣṭi*)[114] and wear white clothes (*śuddhavastra*).[115] The entering of the sacred space of the stage and the following actions — the first of which consists in the offering of two handfuls of flowers to Brahman in the centre of the stage[116] — are obviously ritual in nature. A similar situation is reported in connection with the already mentioned ritual worship of the three *mṛdaṅga* drums in three *maṇḍalas*. The person drawing these *maṇḍalas* and carrying out the subsequent veneration on an astronomically determined auspicious day is equally said to be pure (*śuci*) and dressed in white (*śuklavāsas*).[117] These two instances of white

112. *NŚ* 34, prose sentences between 214B & 216A (following Ghosh [*NŚ*, 1956-67, vol. 2, p. 172] I read '*dakṣiṇataḥ*' before '*pāṇavika*').

113. *NŚ* 34.279B (read '*datvā liṅge*' as '*datvāliṅge*'). Cf. the white coloured cloth attached to the upper part of the *jarjara*, said to be protected by Brahman. — In *NŚ* 34.280A-282B no specific colours are prescribed in connection with the subsequent adoration of the remaining two deities, although the mention of *raktakaudumbara* in connection with the offerings to the three-eyed Śiva (Tryambaka) in verse 281B might refer to some offerings made of reddish *udumbara* wood or to some other red coloured substances (the term *raktaka* can also stand for a red garment or one of several red coloured or red flowering plants, while *udumbara* can mean copper). The reading in the alternative version (*bhinnapāṭhakrama*) of this chapter, on the other hand, clearly states that red offerings and red cloths, among other things, have to be offered to the Śiva *maṇḍala* (*baliḥ kāryaḥ prayatnena rakto raktāmbaraiḥ saha*), while the Viṣṇu *maṇḍala* should be venerated with offerings among which are named yellow garlands, cloths and ointments (*sragvastrālepanaiḥ pītaiḥ*) (*NŚ* 34[alternative version].218B, 219B).

114. This specific glance, as its name reveals, is related to *adbhuta*, the sentiment of wonder and excitement (cf. *NŚ* 8.51A-B), and here seems to be an expression of the divine (*divya*) variety of *adbhuta*, which, according to *NŚ* 6.82A-B, is caused by the seeing of heavenly things (*divyadarśanaja*), in contrast to the *ānandaja* variety, produced by joy (*harṣa*). Cf. in this regard the long list of situations generating the *adbhutarasa*, in which figure among other things the seeing of celestial beings (*divyajanadarśana*) and the going to a temple (*devakulagamana*) (*NŚ* 6, 2nd prose sentence after 74B), which latter, in my opinion, corresponds to the stage *maṇḍala* approached and 'entered' by the *sūtradhāra* and his assistants.

115. *NŚ* 5.65A-67B.

116. *NŚ* 5.69B, 72A-B.

117. *NŚ* 34.274A-B, 275B:

→

clothes being worn on ritual occasions agree with the rule mentioned in the *āhārya* chapter according to which *śuddha* clothes should be worn by men and women when approaching deities, on auspicious occasions, while being engaged in penance, at the time of specific astronomical constellations, during wedding ceremonies and the performance of virtuous acts.[118] In dramatic representations white clothes characterize old brāhmaṇas, merchants, ministers, ascetics, people of the three upper social classes in general, etc. (*NŚ* 21.126A-127B). Even kings, who normally wear colourful (*citra*) dresses,[119] should exchange them for white ones during ceremonies performed to avert calamities.[120]

4.3.2. *Red*

In the first colour sequence (w-b-y-r) white is followed by blue or dark blue (*nīla*), in the second sequence (w-r-y-b) by red (*rakta*). Turning first to the latter series, the correlation of *rakta*, which as a neuter noun also means blood, with the kṣatriya *varṇa* is quite obvious. The *NŚ* provides more examples of the same nature:

- The colour associated with the furious sentiment (*raudrarasa*) is red (*rakta*).[121]

- Red eyes (*raktanayana*) are mentioned among the so-called consequents (*anubhāva*)

→ *citrāyām athavā haste śuklapakṣe śubhe 'hani* |
 upādhyāyaḥ śucir vidvān kulīno rogavarjitaḥ | | 274 | | [. . .]
 sopavāso 'lpakeśaś ca śuklavāsā dṛḍhavrataḥ | | 275 | |

118. *NŚ* 21.123A-124B:
 devābhigamane caiva maṅgale niyamasthite |
 tithinakṣatrayoge ca vivāhakaraṇe tathā | 123 | |
 dharmapravṛttaṁ yat karma striyo vā puruṣasya vā |
 veṣas teṣāṁ bhavec chuddho ye ca prāyatnikā narāḥ | 124 | |

119. *NŚ* 21.125A-B:
 devadānavayakṣāṇāṁ gandharvoragarakṣasām |
 nṛpāṇāṁ karkaśānāṁ [*v.l.: kāmukānām*] *ca citro veṣa* [*v.l.: vicitro 'tha*] *udāhṛtaḥ* | 125 | |
 See also v. 136A in fn. 120, below.

120. *NŚ* 21.136A-B:
 citro veṣas tu [*v.l.: vicitraveṣaḥ*] *kartavyo nṛpāṇāṁ nityam eva ca* |
 kevalas tu bhavec chuddho nakṣatrotpātamaṅgale | | 136 | |
 While dresses are said to be of three types, i.e. *śuddha*, *vicitra* (variegated) and *malina* (filthy) (*NŚ* 21.122A), it here becomes clear that *śuddha* in this context cannot simply mean pure or clean in contradistinction to *malina*, as this would imply *citra* clothes, also assigned to gods, etc. (see fn. 119), to be less clean. It can be presumed that *śuddha* clothes are meant to be white — as opposed to colourful (*vicitra*) clothes — and clean as well, as purely white clothes can hardly be imagined to be dirty.

121. *NŚ* 6.42B. The colour associations of the remaining seven *rasas* are: *śṛṅgāra* — *śyāma*; *hāsya* — *sita*; *karuṇa* — *kapota*; *vīra* — *gaura*; *bhayānaka* — *kṛṣṇa*; *bībhatsa* — *nīla*; *adbhuta* — *pīta* (*NŚ* 6.42A-43B). Here the choice of colours does not seem to have been led by the *svabhāvajavarṇas* but rather by psychological considerations. The fact that each of the four *rasa* groups consisting of a primary *rasa* (i.e. *śṛṅgāra*, *raudra*, *vīra* and *bībhatsa*) and its resultant *rasa* (i.e. *hāsya*, *karuṇa*, *adbhuta* and *bhayānaka* respectively) (see *NŚ* 6, 2nd prose sentence after 38B-41B) has a primary colour assigned to one of its two *rasas* might be a mere coincidence. — A natural red (*rakta*) facial colour (*mukharāga*), not applied by make-up, is furthermore an expression of the *raudra-*, *vīra-* and *karuṇarasas*, intoxication (*mada*), etc. (*NŚ* 8.162A, 164A).

of the *raudrarasa*.[122] Likewise, red, wide open eyes (*aruṇodvṛttatāraka*) appear as a feature of the *raudrīdṛṣṭi*[123] and are consequently mentioned in connection with angry humans — both men (*udvṛttaraktanetra*)[124] and women (*krodha-tāmrāyatākṣa*)[125] — and as a characteristic of demons for whom *raudra* is the natural emotion[126] (*raktodvṛttavilocana*,[127] *raktākṣa*[128]). In the 22nd chapter different types of character (*śīla*) of women are described, which often can be equally taken as characterizations of the beings they are named after. Accordingly, a woman of the *rākṣasa* type (*rākṣasaśīlā*), possessing an angry and jealous nature (*krodherṣyā*), is also said to have red eyes (*raktavistīrṇalocana*),[129] as does the excessively angry (*atikopanā*) woman of the *nāga* type (*tāmralocana*).[130]

- As we have already seen, the colour red is not only linked with the kṣatriya *varṇa* but, as the colour of the cloth on the fourth *jarjara* segment, also with Śiva's son Skanda, the god of war. Moreover, the only role for which red (*rakta*) paint has to be applied on the face and limbs of an actor is Aṅgāraka, the deified planet Mars,[131] which, according to the *Bṛhatsaṁhitā*, "presides over [. . .] warriors [. . .] red fruits and flowers, corals, army generals", etc.[132]

In the *NŚ* the colour red is mentioned a few times in ritual contexts as well, though not as prominently as white. The *pratisara* thread, fragrant substances, flowers and fruits used for honouring the deities while installing them in the *raṅgamaṇḍala* are all of red (*rakta*) colour,[133] while in the subsequent veneration of these deities, as we have observed before,[134] red garlands and unguents are used to worship the *gandharva*s, Vahni (i.e. Agni) and Sūrya.[135] Red offerings have also been used in the veneration of the Śiva

122. *NŚ* 6, 4th prose sentence after 63B.

123. *NŚ* 8.52A-B.

124. *NŚ* 25.54B-55A.

125. *NŚ* 15.94A.

126. *NŚ* 6, 6th-10th prose sentence after 63B.

127. *NŚ* 6, 12th prose sentence after 63B.

128. *NŚ* 12.52B.

129. *NŚ* 22.108A, 109A-B.

130. *NŚ* 22.110A-B, 111B. In *NŚ* 15.213A red eyes seem to be associated with the *śṛṅgārarasa*, but refer perhaps to a red make-up of the eyes (*raktamṛdupadmanetra*).

131. *NŚ* 21.98B (see table 1 at the end of this article).

132. *BṛSam* 16.13A-15B: *śastravartānām* [. . .] *raktaphalakusumavidrumacamūp[ānām]* [. . .] *vasudhāsuto 'dhipatiḥ* | | 15 | |

133. *NŚ* 3.19A-B:
 raktāḥ pratisarāḥ sūtraṁ [*v.l.: tatra; raktaṁ pratisarāsūtram*] *raktagandhāś ca pūjitāḥ* |
 raktāḥ sumanasaś caiva yac ca raktaṁ phalaṁ bhavet | | 19 | |

134. See point 4.3.1.

135. This does not implicitly refer to the colours of these divine and semi-divine beings. Cf. *NŚ* 21.97A, 98B, 103B (see table 1 at the end of this article), which mention the colour of the make-up applied on the

→

maṇḍala and the *ūrdhvaka* drum during the consecration of the latter.[136]

4.3.3. *Blue and Yellow*

Why the colour blue figures at the second place in the first colour sequence (w-b-y-r) is unclear. If its status as the strongest of all colours would play a role one would rather expect blue to start the ranking. While Śiva protects the *jarjara* segment characterized by a blue cloth, he, as we have just seen, is venerated with red substances during the consecration of the *mṛdaṅga* drums. Yellow, for its part, has only received greater importance in connection with the offerings to the *vaiṣṇavamaṇḍala* during the same ritual.[137]

Further references to blue and yellow in the *NŚ* did not provide any information on a hierarchical arrangement of these colours.[138]

5. The Use of the Primary Colours in the Make-up of Actors

The description of the primary colours in the *āhāryādhyāya* of the *NŚ* has been able to substantially broaden our understanding of the colour aspect of the rituals described in the first chapters of this text. Yet, the presentation of the theory of primary and derivative colours has been occasioned, as we have noticed earlier, by the subsequent description of the make-up applied on the faces and limbs of actors.[139] It is therefore worth examining whether the primary colours play any significant role in the choice of colours used in this make-up. Table 1, at the end of this article, lists the colours used in the portrayal of different roles, including variant readings. Let us analyze this information starting with the colour of gold. Gold has been associated with the stage centre and the brāhmaṇa *varṇa* in the *NŚ* and with Mount Meru in the *MBh* and several Purāṇas. As the colour of make-up, molten gold is associated with the deities Rudra (i.e. Śiva), Arka (i.e. Sūrya),[140]

→ actors portraying these beings: The *gandharvas* possess various colours (*nānāvarṇa*), Hutāśana (i.e. Agni) is yellow (*pīta*) and Arka (i.e. Sūrya) has the colour of molten gold (*tapanīyaprabhā*). Cf. also fn. 108, above.

136. See fn. 113.

137. *Ibid.* Yellow has already been associated with Viṣṇu in connection with the central cloth of the *jarjara* (see fn. 68).

138. A possible explanation for an assumed hierarchy in descending order of the series blue-yellow-red might be seen in the order of the colours appearing in a single rainbow (see point 4.3.). The fact that, among the colours blue, yellow and red, blue is situated closest to the centre of the circle partially manifested by the rainbow, could have accounted for this colour to be considered superior to yellow and red, which appear next in this order. Such an interpretation, however, is not found corroborated by textual evidence.

139. Abhinavagupta, commenting on *NŚ* 21.77A-B, contends that paint is only applied on male actors (*NŚ*, 1934-92, vol. 3, p. 121). This would imply that the role of an *apsaras* (see v. 96B in table 1, at the end of this article), as well as of the river goddess Gaṅgā (see v. 98A, *ibid.*) is enacted by a man.

140. This association is probably due to the golden appearance of the sun. Cf. *taptasuvarṇapiṇḍasamadehaḥ* [. . .] *divasakaraḥ* (*NŚ* 32, Sanskrit rendition of Prakrit verse 235A-B); *vidyotitakanakavapuḥ* [. . .] *divasakaraḥ* (*ibid.*, Sanskrit rendition of Prakrit verse 258B).

Druhiṇa (i.e. Brahman) and Skanda (i.e. Kumāra), and furthermore characterizes the people living on the six islands (*dvīpa*) surrounding Jambūdvīpa. The colour of gold is also associated with the people living in the northernmost *varṣa* of Jambūdvīpa, i.e. Uttarakuru. One could also translate the relevant verses to mean that, except for people living in Uttarakuru, those of the other *varṣa*s should have a golden complexion.[141] Yet, the fact that other colours are later on mentioned for the inhabitants of the *varṣa*s Bhadrāśva, Ketumāla and Bhāratavarṣa favours the first translation, which is moreover supported by a *v.l.* and the *AbhiBhā*.

White, the first of the primary colours, is associated with an even larger number of deities than gold. Some, like the deified moon (Soma), Jupiter (Bṛhaspati), Venus (Śukra),[142] groups of stars (*tārakāgaṇa*) and the snowy Himālaya range (Himavat) are visibly white in their physical manifestations. Water equally seems to have been connected with the colour white, as we have observed before.[143] This might have caused Varuṇa,[144] the oceans (*samudra*) and the river Gaṅgā to be represented by actors wearing white make-up. Among mortals, white paint is used to portray people living in the *varṣa* Bhadrāśva and according to some alternative readings also for inhabitants of Ketumāla.

Red (*rakta*) is, as has been noticed before, exclusively used for the representation of the god Mars.[145] As with the other heavenly objects mentioned above, it is probably the colour of the planet Mars, visible to the naked eye, which has lead to this association.

Yellow (*pīta*) is used to portray the deified planet Mercury (Budha) as well as the deified, 'oblation eating' sacrificial fire (Hutāśana, i.e. Agni). Once again the distinctive colour of these deities corresponds to the colour of their material counterparts.

The name given in the *NŚ* for the remaining primary colour dark blue, i.e. *nīla*, is conspicuously absent from the list of colours used to represent deities. It is only mentioned as the colour of people living in Ketumāla, or, according to an alternative reading, as one of three possible colours characterizing these people. However, after having mentioned gold, white, red and yellow as the colours of different deities the *NŚ* speaks of the colour *śyāma* for portraying the gods Nārāyaṇa (i.e. Viṣṇu), Nara and the *nāga* Vāsuki. In view

141. See, e.g., Ghosh, 1951-61, vol. 1, p. 424.

142. The planet Venus, known to us as the bright morning and evening star, is not only known by the name of Śukra, which literally means 'pure' or 'white' (cf. *śukla*), but also by the names of Śveta and Sita, both of which again denote 'white.'

143. See fnn. 51 & 52. This association of the colour white with water may well have had its origin in the knowledge of the latter's close affinity with snow and ice and/or in the observation of the white foam appearing when water is mixed with air (e.g., breaking waves, waterfalls).

144. In the *NŚ* Varuṇa has already become the god of waters (cf. *NŚ* 3.28B, 43A-B, 64A-B; *NŚ* 4.256B) and *lokapāla* of the western region (cf. *NŚ* 3.28B; *NŚ* 5.23A-B, 94A), although his Vedic association with the sky is still discernable in *NŚ* 1.85A, where he is related to the space (*ambara*, lit. 'sky,' 'atmosphere') of the greenroom (*nepathya*).

145. Here I disregard the *v.l.* of *NŚ* 21.113A which attributes *rakta* to people of the brāhmaṇa and kṣatriya *varṇa* as well.

of the vague distinction between Sanskrit names signifying black and dark blue, and bearing in mind the context of the exposition of the primary colours and the practical applications of the latter in the *NŚ*, it would seem likely that the term *śyāma* in the present context stands for dark blue, if it would not be for *śyāma* to be mentioned several times as the colour of certain inhabitants of Bhāratavarṣa as well: It is one of three possible colours of kings (*rājan*), the colour of people living in specific parts of Bhāratavarṣa like the Pāñcālas, etc., and generally the colour of people belonging to the two lowest social classes.

Only four more colours are mentioned:

- The colour *gaura*, which can stand for a white, yellowish or even light reddish hues and has been equated with orange in its role of a *saṁyogajavarṇa*, is attributed to *yakṣas*, *gandharvas* and generally to gods (*deva*), probably referring to the minor deities for whom no specific colour is indicated. It is furthermore mentioned as the colour of the natives of the remaining *varṣas*, implying the five *varṣas* excluding Uttarakuru, Bhadrāśva, Ketumāla and Bhāratavarṣa, also as one of three colours of inhabitants of Ketumāla as per an alternative reading, as one of the three colours kings (*rājan*) can possess, as the colour of mortal (*martya*) religious ascetics (*sukhin*), moreover as the predominant colour of people of the northern regions of Bhāratavarṣa and as the colour of brāhmaṇas and kṣatriyas.

- *asita*, i.e. dark blue or black, characterizes the appearance of *daityas*, *dānavas*, *rākṣasas*, *guhyakas*, *nagas* (i.e. deified mountains), *piśācas*, deified water (Jala) or Yama[146] and the deified atmosphere (Ākāśa). Among humans *asita* is the colour of people performing evil actions (*kukarmin*), people possessed by demons (*grahagrasta*), sick persons (*vyādhita*), persons doing penance (*tapaḥsthita*), people performing strenuous labour (*āyastakarmin*) and people of low birth (*kujāti*). It furthermore is the colour of ascetic (*tapaḥsthita*) seers (*ṛṣi*), as well as the predominant colour of people from southern parts of Bhāratavarṣa, etc.

- The colour of lotus (*padmavarṇa*) is said to be one more possible colour of kings (*rājan*).

- The colour of the *badara* plant is mentioned as the complexion of seers (*ṛṣi*), or, according to another reading, as the colour of, apparently personified, herbs (*oṣadhī*).

Ghosts (*bhūta*), *gandharvas*, *pannagas*, *vidyādharas*, the forefathers (*pitṛ*) and people equal to them (*samanara*) are characterized by make-up of various colours or perhaps a single random colour (*nānāvarṇa*). According to another reading, *nānāvarṇa* applies to ghosts, dwarfs (*vāmana*), beings with deformed faces (*vikṛtānana*) and those having the face of a boar (*varāha*), ram (*meṣa*), buffalo (*mahiṣa*) or deer (*mṛga*).

146. As water in various forms has already been associated with white, I favour the *v.l.* Yama here.

Regarding the application of the colour theory of the NŚ in the make-up conventions just mentioned one can observe the general tendency of secondary and tertiary colours as well as multiple or random colours (*nānāvarṇa*) to be attributed to demons, *yakṣas*, *gandharvas*, *pitṛs*, ghosts, etc., as well as to the inhabitants of Bhāratavarṣa. People living in the other, elysian *varṣas* and *dvīpas*[147] and above all the gods are however characterized by one of the primary colours or gold. This is however a generalization as, on the one hand, we have *gaura*, a derivative colour, being connected with gods (*deva*) in general and with people living in some paradisiac *varṣas*, and, on the other hand, there is the problematic nature of the attribution of *śyāma*, dealt with above. As to the association of *gaura* with gods and other benevolent beings, it could be that these, not being characterized by a specific primary colour of their own, are all chosen to be represented by the same light colour that is associated with the two highest social classes, religious ascetics, etc. It is noteworthy that Indra has not been named separately and therefore might have a *gaura* complexion as well. Regarding the question of *śyāma* one might consider the following thoughts: Just as, when moving from Bhāratavarṣa to the other eight *varṣas*, or, beyond Jambūdvīpa, to the six surrounding *dvīpas*, we leave behind known geography and enter the realm of idealized mythological space, in the same way the colours attributed to people of the different known regions and social classes within Bhāratavarṣa are most probably based on objective observation, while those ascribed to beings of the other regions of the ancient Hindu cosmography, and especially the ones attributed to the deities residing on Mount Meru, are idealized colours heavily loaded with symbolic connotations, i.e. the primary colours and gold. The colours mentioned for beings outside and inside of Bhāratavarṣa should therefore probably have to be interpreted in different ways. When referring to the make-up used to represent inhabitants of Bhāratavarṣa the terms *śyāma* and *asita* should perhaps be understood in their general sense of 'dark,' implying various dark brown hues, and should not be taken to mean black or dark blue. As the colour of certain deities on the other hand *śyāma* might denote dark blue. Being the colour of demons, etc., *asita* could perhaps stand for black. The whole matter is however far from clear, especially as the numerous alternative readings make it difficult to reconstruct the original text.

6. Conclusion

While many colour associations met with in the NŚ are culturally specific, the use of the primary colours of painting, i.e. a physical, universally valid phenomenon, allows people of different times and places to connect with its symbolism more easily. The unique quality of the primary colours makes intelligible the specific ritual use reserved for them in the NŚ. Their being uncaused, indivisible and, collectively, all-containing accounts for their association with the *axis mundi* of the ancient Indian cosmos, represented on the stage *maṇḍala* by the vertically positioned *jarjara*. In the Purāṇic cosmography, the axial

147. Cf. fn. 82.

world mountain Meru is equally characterized by these colours. Since all other colours are generated from the four primary ones, the latter represent the totality of colours. This explains their association, encountered in the NŚ and other texts, with the world quarters and the four social classes, each representing a four-fold division of their respective domain.

It is clear that the preliminary nature of the present study necessitates further research into the topics not or not adequately dealt with here.[148] The incorporation of information

148. Only a few additional points can be touched on at this point. In post-NŚ works dealing with the fine arts the theory of four primary colours has mostly been adopted, although some texts teach five primaries (C. Sivaramamurti, *The Painter in Ancient India*, Delhi 1978, p. 37). Cf. the two different lists of five primary colours given in the *Viṣṇudharmottara Purāṇa* (Parul Dave Mukherji, [ed.]: *The Citrasūtra of the Viṣṇudharmottara Purāṇa*. Critically ed. and tr. by Parul Dave Mukherji, Delhi, 2001, pp. 135, 150ff.).

A few stray examples might suffice to give a general idea of the broad range of contexts in which the four primary colours — the colour blue mostly termed *kṛṣṇa* and usually rendered with 'black' in translations — turn up: They appear for instance as the hues of the floors between the first four of the seven underworlds (*pātāla*) (Kirfel, 1920, pp. 143-44; Kirfel, 1954, p. 37 [v. 3A-B], 186 [vv. 13B-15A]). The floors of the remaining three *pātāla*s are said to consist of gravel (*śarkara*), stone (*śilā*) and gold (*kāñcana; sauvarṇa*) (*ibid.*). The primary colours connected with the social classes in descending hierarchical order, i.e. white, red, yellow and dark blue, furthermore characterize Viṣṇu in each of the four world ages, from the *kṛta-* to the *kaliyuga* (cf. Kirfel, 1920, pp. 91-92). In the *Agni Purāṇa* the same colours characterize the different body parts of Viṣṇu's mount Garuḍa, when the latter is described as a cosmic being, as well as the stones out of which statues of Viṣṇu-Vāsudeva should be sculptured (Marie-Thérèse de Mallmann, *Les Enseignements Iconographiques de l'Agni-Purana*. Annales du Musée Guimet. Bibliothèque d'Études 67, Paris, 1963, pp. 239-40). They appear as the colour of the feet of the throne of both Sūrya and Sadāśiva, as the colour of the latter's four hypostases, as the complexion of Śiva-Nīlakaṇṭha's four faces, etc. (*ibid.*). In the *BṛSam* the primary colours, mostly occurring in the copulative compound *sitaraktapītakṛṣṇa* and once more associated with the four social classes in descending order, are observed in sunspots, earth, diamonds, etc., as part of the art of divination (*BṛSam* 3.19B, 25A-B; 36.1A-B; 52.1A-B; 53.96A-B; 80.11A-B; cf. also *BṛSam* 35.8A & 86.77A-B).

Of high relevance for the interpretation of the religio-ritual application of the four primary colours is the role they play in Buddhist practice, already attested in the Pali Canon. There, ten objects of meditation are spoken of: the so-called 'totalities' (Pāli: *kasiṇa*, of uncertain derivation, probably from Sanskrit [Skt.] *kṛtsna*: all, whole, complete). The ten *kasiṇa*s consist of the six Buddhist elements (*dhātu*) and the four primary colours in the following order: *paṭhavī* (Skt. *pṛthivī*, earth), *āpo* (Skt. *āpaḥ*, water), *tejo* (Skt. *tejaḥ*, fire), *vāyo* (Skt. *vāyu*, air), *nīla* (Skt. *id.*, dark blue), *pīta* (Skt. *id.*, yellow), *lohita* (Skt. *id.*, red), *odāta* (probably Skt. *avadāta*, white), *ākāsa* (Skt. *ākāśa*, space, ether) and *viññāṇa* (Skt. *vijñāna*, consciousness). Each *kasiṇa* is considered to be omnipresent, non-dual and immeasurable, as follows from the following statement, repeated for each *kasiṇa*, e.g., for the *nīlakasiṇa*: *nīlakasiṇam eko sañjānāti uddhaṁ adho tiriyaṁ advayaṁ appamāṇaṁ* (*Dīghanikāya* xxxiii.3.3.(ii), in: J. Estlin Carpenter, [ed.]: *The Dīgha Nikāya*. Vol. III, London, 1911, p. 268 [cf. also *Dīghanikāya* xvi.3.29-32, in: T.W. Rhys Davids, {ed.} & Carpenter, J. Estlin {ed.}: *The Dīgha Nikāya*. Vol. II, London, 1903, pp. 110-11]; *Majjhimanikāya* II.3.7, in: Robert Chalmers [ed.]: *The Majjhima-Nikāya*. Vol. II, London, 1898, pp. 14-15 [cf. also pp. 13-14]; *Aṅguttaranikāya* xxv.1-2 & xxix.4, in: E. Hardy [ed.]: *The Aṅguttara-Nikāya*. Part V, Repr. London, 1958, pp. 46, 60 [cf. also xxvi.1-3 & xxix.5-6, *ibid.*, pp. 46-48, 60-62].), "One [. . .] contemplates the blue-kasiṇa [. . .] above, below, and across, undivided and immeasurable." (Bhikkhu Ñāṇamoli [tr.] & Bhikkhu Bodhi [ed.]: *The Middle Length Discourses of the Buddha. A New Translation of the Majjhima Nikāya*. Translated from the Pali. Original Translation by Bhikkhu Ñāṇamoli. Translation Edited and Revised

→

on colours spread over the entire NŚ as part of the methodology of this investigation has produced a huge amount of data. The assessment of this extensive material did not allow for each issue to be dealt with in an equally detailed manner, but has hopefully succeeded in offering a glimpse into the ritual use and theatrical application of some fundamental principles of art.

Table 1: Colours used in the make-up of actors in different roles
(NŚ 21.96B-113B)

1. divine and semi-divine beings		verse nos.
gaura	*devas, yakṣas & apsarases*	96B
tapanīyaprabhā	Rudra, Arka (i.e. Sūrya), Druhiṇa (i.e. Brahman), Skanda	97A
śveta [*v.l.: sita*]	Soma, Bṛhaspati, Śukra, Varuṇa, *tārakāgaṇas* [*v.l.:* Śiva; Arthendra], Samudra, Himavat, Gaṅgā, Bala [omitted in a *v.l.*]	97B-98A
rakta	Aṅgāraka	98B
pīta	Budha, Hutāśana	98B
śyāma [*v.l.: śyāmavarṇa*]	Nārāyaṇa, Nara, the *nāga* Vāsuki	99A
asita [*v.l.: śyāmavarṇa*]	*daityas, dānavas, rākṣasas, guhyakas, nagas, piśācas,* Jala [*v.l.:* Yama], Ākāśa	99B-100A

→ by Bhikkhu Bodhi, Boston, 1995, p. 640). The fact that the four colour *kasiṇa*s are identical with the four primary colours is significant and sheds new light on both concepts.

The religious and ritual use of the primary colours has been adopted by people beyond the Indian subcontinent as well. It remains to be seen, however, whether all of the following instances are directly related to the use of the primary colours in South Asia described above:

- In Bali the four primary colours and a mixture of these are associated with five ghosts and five gods (Willibald Kirfel, 'Zahlen- und Farbensymbole,' in: Saeculum 12 (1961) p. 243. = Robert Birwé (ed.): *Willibald Kirfel. Kleine Schriften*, Wiesbaden, 1976, p. 253). During a ritual related to the afterbirth of a child an offering is presented consisting of four heaps of rice, each possessing one of the primary colours, which are placed in the four cardinal directions, and a mixture of these four kinds of rice, deposited in the centre (*ibid.*).

- In Tibetan Buddhism the 'four great kings' (Skt. *caturmahārājan*; Tibetan: *rgyal po chen po zhi*, or simply *rgyal chen zhi*), guarding the cardinal directions and often painted on the walls on either side of the main entrance of a temple, each are characterized by one of the primary colours. Furthermore, in paintings depicting the Mahāyāna cosmography one comes upon representations of a square Mount Meru, its four sides exhibiting the four primary colours, one of which can be clearly distinguished as blue. The *kālacakramaṇḍala* attracts our interest for two reasons: On the one hand, its four sides, as well as the four faces and different body parts of its presiding deity Kālacakra exhibit the four primary colours. On the other hand, its very centre, when drawn with coloured sand, is made from five differently coloured circular layers, one above the other (cf. Barry Bryant, *The Wheel of Time Sand Mandala. Visual Scripture of Tibetan Buddhism*. In Cooperation with Namgyal Monastery, San Francisco, 1995, pp. 197-99), which reminds of the vertical arrangement of colourful cloths on the *jarjara*. The colours dark blue, yellow and red — in this order — are moreover frequently used in the brocade frames of religious scroll paintings (*thangka*), in the cloths wrapped around religious texts, etc.

2. other semi-divine and supernatural beings		
nānāvarṇa	*bhūtas, gandharvas, yakṣas* [omitted in a *v.l.*],[149] *pannagas, vidyādharas, pitṛs, samanaras* [*v.l.: samānava*] [instead of the above, *v.l.: bhūtas, vāmanas, vikṛtānanas, varāhameṣamahiṣamṛgavaktras*]	103B-104A

3. humans

3.1. humans living on the 6 *dvīpa*s surrounding Jambūdvīpa

niṣṭaptakanakaprabhā	people [living] on the six islands [surrounding Jambūdvīpa]	100B-101A

3.2. humans living on Jambūdvīpa

nānāvarṇa	people living in the *varṣa*s of Jambūdvīpa	101B-102A

3.2.1. humans living in the 8 *varṣa*s beyond Bhāratavarṣa

kanakaprabhā	people living in the *varṣa* Uttarakuru	102A
śveta	people living in the [eastern] *varṣa* Bhadrāśva	102B
nīla [*v.l.: śveta; nīla, śveta, gaura*]	people living in the [western] *varṣa* Ketumāla	103A
gaura [not present in the last *v.l.* given above]	people living in the remaining *varṣa*s [except Bhāratavarṣa]	103A

3.2.2. humans living in Bhāratavarṣa

padmavarṇa, gaura, śyāma	*rājan*s	105A
gaura	*sukhin*s	105B
asita	*kukarmins, grahagrastas, vyādhitas, tapaḥsthitas, āyastakarmins* & *kujātis*	106A-B
badaraprabhā [*v.l.: badaravarṇa*]	*ṛṣi*s [*v.l.: oṣadhī*]	107A
asita	*tapaḥsthitarṣis* [*v.l.: tapasvin*]	107B
(*prāyeṇa*) *asita*	Kirātas, Barbaras, Āndhras, Draviḍas, people from Kāśi [*v.l.: Kāñci*] and from Kosala [*v.l.: Kośala*], Pulindas, Dākṣiṇātyas	110A-B
(*prāyeṇa*) *gaura*	people living in the northern region like the Śakas [*v.l.: Śākas*], Yavanas, Pahlavas [*v.l.: Vāhikas*], Bāhlikas	111A-B
śyāma	Pañcālas, Śaurasenas [*v.l.: Śūrasenas*], Māhiṣas [*v.l.: Mahiṣas; Sakhasas*], Oḍramāgadhas, Aṅgas, Vaṅgas, Kaliṅgas	112A-B
gaura [*v.l.: rakta*]	brāhmaṇas, kṣatriyas	113A
śyāma	vaiśyas, śūdras	113B

149. I prefer this *v.l.*, as *yakṣa*s are already mentioned in v. 96B.

Bibliography and Abbreviations[150]

AbhiBhā	*Abhinavabhāratī*, Abhinavagupta. see: *NŚ*, 1934-92.
AmKo	Ramanathan, A.A. (ed.), *Amarakośa. With the Unpublished South Indian Commentaries* Amarapadavivṛti *of Liṅgayasūrin and the* Amarapadapārijāta *of Mallinātha*. Critically edited with Introduction by A.A. Ramanathan. Vol. 1. (The Adyar Library Series 101), Madras, 1971.
ArthŚ	Kangle, R.P. (ed.), *The Kauṭilīya Arthaśāstra*. Part 1. A Critical Edition with a Glossary, Bombay, 1960. see also: Kangle, 1963.
BṛSam	Bhat, M. Ramakrishna, *Varāhamihira's Bṛhat Saṁhitā with English Translation, Exhaustive Notes and Literary Comments*. 2 parts, Repr. Delhi, etc., 1992.
de Mallmann, 1963	de Mallmann, Marie-Thérèse, *Les Enseignements Iconographiques de l'Agni-Purana*, Paris, 1963.
Ghosh, 1951-61	Ghosh, Manomohan, *The Nāṭyaśāstra. A Treatise on Hindu Dramaturgy and Histrionics. Ascribed to Bharata-muni*. Completely translated for the first time from the original Sanskrit with an Introduction and Various Notes. 2 vols, Calcutta, 1951-61. see also: *NŚ*, 1956-67.
Hall, 2002	Hall, Cally, *Edelsteine. Naturführer*. Aus dem Englischen von Eva Dempewolf. Fotografien von Harry Tailor, s.l., 2002.
Kangle, 1963	Kangle, R.P., *The Kauṭilīya Arthaśāstra. Part 2. An English Translation with Critical and Explanatory Notes*, Bombay, 1963. see also: *ArthŚ*
Kirfel, 1920	Kirfel, W., *Die Kosmographie der Inder nach den Quellen dargestellt*. Mit 18 Tafeln, Bonn & Leipzig, 1920.
Kirfel, 1954	Kirfel, Willibald, *Das Purāṇa vom Weltgebäude (Bhuvanavinyāsa). Die kosmographischen Traktate der Purāṇa's. Versuch einer Textgeschichte*, Bonn, 1954.
MBh	*The Mahābhārata*. For the First Time Critically edited by Vishnu S. Sukthankar, S.K. Belvalkar, P.L. Vaidya with the Co-operation of Balasaheb Pant Pratinidhi [and others] and illustrated from ancient models by Balasaheb Pant Pratinidhi, Poona, 1927-66.
NŚ	*Nāṭyaśāstra*, Bharata when used in quotations, refers to *NŚ*, 1934-92.
NŚ, 1934-92	*Nāṭyaśāstra of Bharatamuni. With the Commentary Abhinavabhāratī by Abhinavaguptācārya*. Vol. 1(4th rev. edn.)-4, M. Ramakrishna Kavi (ed.), J.S. Pade (ed.), K.S. Ramaswami Sastri (ed.), K. Krishnamoorthy (ed.). [Gaekwad's Oriental Series 36, 68, 124, 145], Baroda, 1934-92.
NŚ, 1956-67	*The Nāṭyaśāstra ascribed to Bharata-muni*. Ed. with an Introduction and Various Readings from MSS. and printed texts by Manomohan Ghosh. 2 vols, Calcutta, 1956-67. see also: Ghosh, 1951-61.
v.l.	*varia lectio* (variant reading)

150. The abbreviations of titles of Sanskrit texts have been adopted from the Kalātattvakośa series of the Indira Gandhi National Centre for the Arts (IGNCA), New Delhi.

15

Beginning of Śaiva-Siddhānta and its Expanding Space in Central India

R.N. Misra

IN history, Śaivism is not necessarily a monolithic. It had different schools and sects and each of these had their respective doctrines and theology, which distinguished one from the other. These schools are variously listed in the Purāṇas and Āgamas.[1] Pathak identifies eight of them besides some other minor sub-sects. Those eight schools were Pāśupata, Kāpālika, Soma, Siddha, Kālānala, Miśra and Siddhānta.[2] Of these different Śaivite sects and schools, Śaiva-Siddhānta and its early history in northern Madhya Pradesh along with its expansion from seventh to tenth century forms the subject of this article.[3] The sect is well known in the context of eastern and central Madhya Pradesh and peninsular India.[4]

1. Cf. V.S. Pathak, *Śaiva Cults in Northern India*, Varanasi, 1960, pp. 3, 4.

2. *Ibid.*, pp. 4-57. Pathak has also mentioned certain sub-sects within this broad division.

3. The Śaiva-Siddhānta school has already received attention of V.V. Mirashi (ed.), *Inscriptions of the Kalachuri-Chedi Era (Corpus Inscriptionum Indicarum;* IV/1), Ootucmund, 1955, *intro.,* pp. cl-clix (quoted as: Mirashi, 1955); V.S. Pathak, *Śaiva Cults, op. cit.,* pp. 28-50; Rohan A. Dunuwila, *Śaiva Siddhānta Theology,* Delhi, 1985. In this paper the regions outside northern Madhya Pradesh have generally been left out unless reference to them became contextually necessary, but Śaivite history of the sites, established from seventh to tenth century, has been traced even beyond that bracket of time.

4. Cf. H.W. Schomerus, *Śaiva Siddhānta* (1912), Reprint, Delhi, 2000; R.A. Dunuwila, *Śaiva Siddhānta Theology, op. cit.;* T.M.P. Mahadevan, 'Śaiva Siddhānta,' in: Majumdar/Pusalkar (eds.), *Struggle for Empire,* Bombay, Reprint, 1966, pp. 445-49. The *Sarvadarśana Saṅgraha* of Madhvācārya contains authentic details of the sect. As the text was composed in south India where the school got firmly entrenched after its eclipse in north, the formulations about the system as contained in this text are in conformity with the final enunciations obtained in south. Cf. Uma Shankar Sharma (ed., tr.), *Sarvadarśana Sangraha of Madhavacarya,* Varanasi, 1984, pp. 274-97, for doctrinal precepts of the Śaiva-Siddhānta. For Śaiva-Siddhānta in eastern and central Madhya Pradesh, cf. Mirashi, 1955, *intro.,* pp. cl-clix.

 The Śaiva-Siddhānta has a fairly distinguished history in Tamilian tradition. It refers to 84 Śaiva ascetics including the *ācāryas* like Appāra, Jñāna Samabanda, Sundaramūrti and Maṇikkavāchaka (seventh-eighth century). It professes its foundations in twenty-eight Tantras which were believed to have been revealed by five-headed Śiva from his different mouths, e.g., Sadyojāta, Vāmadeva, Tatpuruṣa, Aghora and Īśāna. The *Aṣṭaprakāśas* are the chief works of the Siddhānta. They consist of five texts by Sadyojāta (*c.* AD 800) namely, *Nareśvara Parīkṣā, Rauravāgama Vṛtti, Tattva Saṁgraha, Tattvatraya,* and *Bhogakārikā* besides *Paramokṣanivāsa Kārikā, Nādakārikā* and *Ratnatraya.* The last three

→

The Śaiva-Siddhānta sect in central India is distinctly described in the epigraphs as 'Siddhānta' and its *ācārya*s or *muni*s as 'Siddhāntika.'[5] A succession of its teachers and their disciples (*śiṣya-praśiṣya paripāṭī*)[6] constituted its genealogies and these are expressed in terms of *siddha-santati*, 'offspring of the Siddhas,' *anvaya*, 'succession' or *vaṁśa*, 'lineage.'[7] But *santati* was not a term to denote biological descent. On the contrary, it signified spiritual descent of a well-known disciple from an erudite, senior, celibate and established *ācārya*. Later inscriptions, almost two centuries after the inception of the line, have attempted to re-construct a mythologized divine and ṛṣic descent of these ascetics. Suffice it to say here, that Kadambaguhādhivāsī (lit. 'denizen of a *kadamba* cave') was the first ascetic, human and historical, who started this line sometime around AD 675.[8] The history of Śaiva-Siddhānta in central India, or more precisely in northern Madhya Pradesh, thus seems to begin in *c.* AD 675. As for the source of its history, inscriptions issued either by its *ācārya*s or by the ruling princes who supported them or received their support form the basis of this study. The materials in these epigraphs are generally similar in content despite their disparate issuing authority,[9] whether princes or ascetics.

The sect had a long history and a widespread presence, first in northern, southern and central Madhya Pradesh (seventh to thirteenth century) and then on in Rajasthan

→ texts are ascribed respectively to Bhoja (eleventh century), Rāmakaṇṭha (*c.* AD 1100) and Śrīkaṇṭha (1125). To these may be added Aghoraśiva's commentary on *Tattva Prakāśikā* and the *Nādakārikā*. Cf. U.S. Sharma (ed.), *Sarvadarśana Saṁgraha, op. cit.,* p. 275.

5. Cf. Gurgi Stone Inscription of Kokalla II, in: Mirashi, 1955, p. 227, verse 3 (*Madhumatī dhāma Saiddhāntikānām*); p. 230, v. 40, *etān sāśanatvena dattavān siddhānta pāragāya*; or *siddhānteṣu maheśa eṣa niyata, Epigraphia Indica* (hereafter quoted as *EI*), vol. I., p. 358, v. 36.

6. *EI* vol. XXXI, p. 36, v.19.

7. *sā kadambaguhā mānyā yatrāsīt siddha santatiḥ*, or *śrīmān mādhumateya vitata kīrtiściraṁ vardhitā*, in Bilhari Stone Insc. of Yuvarājadeva II, in: Mirashi, 1955, p. 219, v. 48; p. 213, v. 55. The teacher-disciple succession is described in verses 43 to 58 of the inscription, the teachers having been designated as *munīśvara, munipuṅgava* or *guru* and disciples as *śiṣya*. The term *santati* (offspring) is mentioned in the Chandrehe Stone Insc. (cf. Mirashi, 1955, p. 227, v. 5). For *vaṁśa, ibid.,* p. 228, v. 19, *śrīmat mattamayūra vaṁśa tilako niḥśeṣa vidyānidhiḥ*.

8. Cf. V.S. Pathak, *Śaiva Cults, op. cit.,* p. 31.

9. The ascetics issued the Ranod, Chandrehe, Kadwaha and the Gwalior Museum inscriptions but others, including those of Bilhari, Gurgi, Jabalpur, Senkapat, Rajor and Karhad inscriptions among others, were royal charters. Some of the important inscriptions are as follows:

 1. Chandrehe Stone Inscription of Prabodhaśiva, Mirashi, 1955, pp. 200-01.

 2. Bilhari Stone Insc. of Yuvarājadeva II, *ibid.,* pp. 209-15.

 3. Gurgi Stone Insc. of Kokalla II, *ibid.,* pp. 227-30.

 4. Jabalpur Stone Insc. of Jayasiṁha, *ibid.,* pp. 333-36.

 5. Dhureti Plates of Trailokyamalla, *ibid.,* pp. 371-73.

 6. A Fragmentary Stone Insc. from Kadwaha, *EI* vol. XXXVIII, pp. 122-24.

 7. A Stone Insc. from Ranod, *EI* vol. I, pp. 354-61.

 8. Gwalior Museum Insc. of Pataṅgaśambhu (in Hindi), V.V. Mirashi, *Prachya Vidya Nibandhavali,* vol. IV, transl. Ajai Mitra Shastri, Bhopal, 1974 (quoted as: Mirashi 1974).

(AD 960), Orissa (tenth or eleventh century), Maharashtra (tenth or eleventh century), Andhra (thirteenth century) and Tamil Nadu (tenth to fourteenth century). There is also a reference to Aghoraśiva, an ascetic (of this sect) in an inscription (eighth-tenth century) from Jageshwar in the Uttaranchal region.[9A] The impact of the central Indian Siddhānta tradition is firmly indicated in this diaspora. For, excepting the instance of Jageshwar, everywhere else allegiance to central Indian monasteries (i.e. those in ancient Terambi, Madhumatī, Mattamayūra and Āmardaka, in Gwalior, Shivpuri and Guna districts of M.P.) is invoked in distant lands of Rajasthan, Chhattisgarh, Maharashtra, Andhra and Orissa. So, in essence, the history of Siddhānta in central India and beyond tends to turn substantially into an account of its expanding space, its material and conceptual boundaries and whatever they cordoned and transcended in the process.

The Siddhānta had a distinct philosophy. It was supposed to be a *mahātantra* (meta-system), conspicuous for its theology and doctrinal tenets. These tenets espoused a fundamental belief in three categories (*tripadārtha*) and four foundations (*catuṣpāda*) of the system.[10] The three categories consisted of *paśu*, *pati* and *pāśa* where the first is *jīva* (soul), the second Īśvara (Śiva) and the third, the bondage (*pāśa*) which binds the soul. The four foundations of the system consisted of *jñāna* (knowledge), *kriyā* (ritual practices), *yoga* (meditation) and *caryā* (discipline in doing the prescribed and avoiding the prohibited). Of these, *caryā* supposedly ensured attainment by *jīva* of *sālokya* (residence in the region of God); *kriyā* promised *sāmīpya* (nearness to God); *yoga* likewise led to attaining *sārūpya* (form of God); and *jñāna* to *sāyujya* (form of God), which amounts to liberation. In these formulations Siddhānta, in its developed form, enunciates a perpetual 'entitative difference between God and soul' but signifies a 'mystic union' between the two, thus propagating 'the unity in duality.'[11]

Rather than going into the philosophical aspects the Siddhānta doctrine, this paper seeks to specially emphasize on the expansion of the Siddhānta in northern Madhya Pradesh where it remained intact for more than five centuries as it grew unassailed in a non-competitive historical context of the land, people and culture of the region.[12] The details about the expanding landscape of the Siddhānta movement follow.

The Expanding Space of the Siddhānta: From Guhā to Diśaḥ and Urvī

The sacred topography of the Siddhānta movement is apparently interlaced with political, geographic and cultural content where spirituality is portrayed paramount, uncontested and complete. The Ranod inscription of Vyomaśiva written roughly two centuries after

9A. *EI* vol. XXXIV, p. 253, no. B-1; also p. 252, no. 16.

10. *tripadārthaṁ catuṣpādaḥ mahātantraṁ jagadguruḥ, sūtreṇaikena saṁkṣipya prāha* . . . , U.S. Sharma (ed.), *Sarvadarśana Saṁgraha*, *op. cit.*, p. 274.

11. T.M.P. Mahadevan, *Śaiva Siddhānta*, *op. cit.*, p. 455.

12. Cf. R.N. Misra, 'Religion in a Disorganised Milieu,' in Joseph T. O'Connell (ed.), *Organisational and Institutional Aspects of Indian Religious Movements*, Shimla, 1999.

the beginning of the ascetics' lineages, retrospectively describes the sect's progressively expanding space and its multiple branches (*vipula vardhita bhūriśākhaḥ*).[13] This may have reference to both conceptual and material spaces: conceptual in terms of its imagined sacred spaces and material in terms of the locations it occupied in strength. The inscriptions *inter alia* indicate this diaspora from *guhā*[14] (cave), *tapasthāna*[15] (locations for penance), *tapovana*[16] (penance forest) and *āśrama*[17] (hermitage), to vast territorial and spatial tracts. Such tracts are expressed hierarchically in terms of *tīrtha* (pilgrimage centres), *padra* (or *pada*) (a forest-tract settlement), *pattana* (township), *viṣaya* (district), *pradeśa* (region), *diśaḥ* (directions) and *urvī* (earth).[18]

The terms appropriately indicate material spaces incorporated into the movement to its advantage even as the claim implies its unhindered spread in territories it appropriated as it grew. Of those terms, *viṣaya* and *pradeśa*, though unnamed, have political connotations as, in other contexts, they imply administratively defined territorial and political units. *Pattana* implies a town; *tīrtha* has a religious and cultural import, while *padra* is a geographical unit in being a small settlement in (or, on the fringe of) a forest where distinctions between populated and solitary space is blurred. These limits seem to be transcended in *urvī* and *diśaḥ* implying an imagined, unlimited sway of the Siddhānta and the Siddhāntikas far beyond a narrow material landscape. This expansion is remarkable considering the fact that the locations of the ascetics in the beginning were limited to forests (*tapovana*) away from the populated settlements. The forest in these references is generally a place of penance, secluded, solitary, fit for a naturalistic and self-mortificatory living in meditation. In that classical imagery it evokes an exclusive sphere bereft of social, economic and other activities, which characterized life in a village or town. The forest thus stood as an antithesis of the village and the ascetics' total withdrawal into it signified his state of renunciation.[19]

Presumably unpretentious locations in the *vana* or *tapovana*, selected by ascetics for penance, seem to have developed later into habitats (*vasati*),[20] monasteries (*maṭha*,

13. *EI* vol. I, p. 355, v. 7; also v. 3.

14. For *guhā* as in 'Kadambaguhādhivāsī,' cf. *EI* vol. I, p. 355, v. 8; for *tīrtha*, cf. *EI* vol. I, v. 9; for *padra*, cf. ibid. p. 357, v. 29. It is mentioned as *pada* in a Kadwaha inscr., cf. *EI* vol. XXXVII, p. 122, v. 7. For *viṣaya*, *pradeśa* and *diśaḥ*, cf. *EI* vol. I, p. 357, v. 31. For *urvī* as in *urvīpati*, cf. ibid., v. 11; for *āśrama*, cf. ibid., v. 29.

15. Cf. Mirashi, 1955, p. 228, vv. 13-14: *yasya kāritavān muniḥ surasari tire tapaḥ sthānakaṁ*; or ibid., p. 200, v. 7, *sā śoṇanadasaṁgame bhramara śailamuletulaṁ. . . cakāra viditaṁ janairmunisakhaḥ praśāntāśrama . . . yaī kṛti*.

16. E. g. *āmardaka khyāti tapovana vinirgataī: EI* vol. XXXI, p. 36, line 14; or *EI* vol. I, p. 355, v. 15: *tapovanaṁ śreṣṭha maṭhaṁ vidhāya*. Also see note 13 above. For delimiting the boundary of *tapovana*, cf. R.A. Kangle (ed. and tr.), *The Kauṭilīya Arthaśāstra*, vol. I, Repr. 1986, p. 109.

17. *EI* vol. I, p. 357, v. 29.

18. See note 14 above.

19. For a detailed discussion on forest *vis-á-vis* village and man in it, cf. Charles Malamoud, *Cooking the World*, Oxford: Oxford University Press, 1998, pp. 74-91.

20. Cf. *EI* vol. I, p. 357, v. 31.

maṭhikā), pattana (township) or *tīrtha* (pilgrimage centre) endowed with fame and wealth and power too, unaided by the contemporary polity. The available evidence suggests that ruling princes entered the scene long after the ascetics had come into prominence. In this scheme of things the princes seem to have vied for a locus of their own on the fringes of the system to share the reflected glory of ascetics to their own advantage, not surprisingly they invoked ascetics' support by offering gifts and receiving initiation (*dīkṣā*) from them. Inscriptions, time and again, claim subservience of rulers to ascetics, as in the case of Prabodhaśiva, for instance. In the Chandrehe inscription it is said of him "his feet (were) rendered more resplendant by the (jewelled) crests of kings (who bowed to him) (*mahībhṛt mūrdhāgra praguṇatarapadaḥ*)."[21] Such unequivocal primacy of ascetics apparently distinguishes them from brāhmaṇa immigrants elsewhere who were settled in *agrahāra*s with land grants dispensed to them through royal charters. In contrast, what ascetics acquired is sometimes expressed in terms of a gift of the entire state (*naivedya yasmai nijarājya sāraṁ*).[22] Thus, patronage seems being thrust upon them by rulers in supplication. Such privileges descended upon them in their exclusive *vana* or *tapasthāna* where they were ensconced in secluded meditation. The ascent of the Siddhānta and the Siddhāntikas in these circumstances appears to have valorized the *vana*s (woodlands) relegating populated settlements to margins. It is a different matter that, even in their penchant in occupying forests, the ascetics professed to remain patronisingly linked to the community, i.e. *prāṇināṁ*[23] or *prajā*[24] in times of latters' distress. This protective role of ascetics must have enhanced their sway both among people and princes leading to their progressive empowerment and expansion much beyond the lived spaces of their presence.

The expanding sacred space of the Siddhānta movement was thus not limited only to territories; it included people as well. In term of territory its control extended from forests to distant lands incorporating, as was said earlier, *tīrtha, padra, pattana, viṣaya, pradeśa, urvī* and *diśaḥ* even as its centre remained anchored to the limited spaces like *tapasthāna, vasati* or *gurusthāna*. In regard to people, it incorporated in its fold a cross-section of society from people (*prajā, prāṇināṁ*) on one end, to the ruling princes on the other. In territorial expansion again, the movement did not remain spatially vague or couched in non-definitive territorial entities. It went on engulfing specific locations and their environs. Immigration[25] of the ascetics of particular *maṭha*s to the near or distant

21. Mirashi, 1955, p. 203, v. 12. The supplication of rulers to ascetics is in evidence in the instances of Avantivarman Cāḷukya, (*c.* AD 945-70) and others. For Prabodhaśiva, see also note 111 (concluding part).

22. *EI* vol. I, p. 357, v. 31.

23. *Ibid.*, p. 357, v. 31.

24. *Ibid.*, p. 356, v. 23, *uddhartuṁ vipadi prajāṁ*. Also *EI* vol. XXVII, p. 122, v. 5: *yattanubhṛtāṁ paritāpa śāntau.*
 . . .

25. For instance, the *ācārya*s of Āmardaka went to Senkapat and to other places, cf. *EI* vol. XXXI, p. 36, line 14; *EI* vol. XXXVI, p. 266, line 13-14. The latter refers to Sopuriya line of Āmardaka *ācārya*s.

places aided and strengthened its expansion even as it brought ever new regions under its control. The instances indicate that at first the core tended to extend towards peripheries in northern Madhya Pradesh, the cradle of the Śaiva-Siddhānta. Later, the principal centres (*tapasthāna*), so developed at Kadwaha (Mattamayūrapura), Terambi, Āmardaka and Madhumatī, persistently sent out their disciples to distant places. Branches of the central *maṭha* were thus founded at those distant places, leading to and resulting in a widely-distributed network of Siddhāntika *tapasthāna* and their ascetics (*sthānapatis*). The Ranod inscription[26] refers to several *maṭha* sites and their *ācārya*s together. It also indicates a rapid proliferation of the Siddhānta *tapasthāna* and their *sthānapatis*. Thus, Kadambaguhādhivāsī's Kadambaguhā (Kadwaha), Śaṅkhamaṭhikādhipati's *śaṅkha-maṭhikā* (at Surwaya), Terambipāla's Terambi (Terahi), Purandara's[27] Mattamayūrapura (Kadwaha) and Araṇipadra (Ranod) and Mādhumateya's Madhumatī (Mahua) in that order assumed significance with successive *ācārya*s from *c.* AD 675 to the ninth century. These sites are situated in Gwalior (e.g., Amrol), Shivpuri (e.g., Surwaya, Terahi and Mahua) and Guna (e.g., Kadwaha/Mattamayūrapura) districts of northern Madhya Pradesh.

The story of this expansion begins with Kadambaguhādhivāsī, the first ascetic of the line at Kadwaha bordering on Malwa. There is little information about this *muni* except for his celebrated descent. The Ranod inscription (vv. 7-8) mentions his ancestry from an ever-renowned ascetic lineage known universally: *sakala loka namasya mārtih indūpamah pratidinaṁ samudīyamānah*. But Kadambaguhā (Kadwaha), the seat of this *muni*, grew into a far-famed *tīrtha* of the Siddhāntikas in particular and the Śaivites in general. We will have more to say about Kadwaha later. It seems that Kadambaguhādhivāsī's eminent successors, instead of continuing at Kadambaguhā (Kadwaha), chose to move out and secure other locations for themselves. The expansion was rapid and perhaps aggressive, because the pontiffs seem to have been outgoing and adventurous, not necessarily given

26. Cf. *EI* vol. I, p. 355, vv. 8-9.

27. Avantivarmā of the Cāḷukya dynasty of Malwa is said to have gone to meet Purandara who was in penance at Upendrapura. For the dynasty, cf. Mirashi, 1955, *intro.*, pp. clv-clvi. After paying his respect to Purandara, the king gave away his entire kingdom to him (*naivedya yasmai nija rājyasāraṁ*) and received *dīkṣā* from him. Then he brought Purandara to Mattamayūra (*śrīmat pure mattamayūra nāmni*) and settled him in a monastery specially built for him (*sakārayāmāsa samṛddhibhājaṁ munirmaṭhaṁ sanmuniratna bhūmim*). Soon after, Purandara built another monastery at Araṇipadra (Ranod) and gave it over to his disciple Kavacaśiva (*punar dvitāyam . . . munīdro raṇipadra sanjñam tapovanaṁ śreṣṭha maṭhaṁ vidhāya*). This is the first instance of a ruler inviting a pontiff to his kingdom and settling him in *maṭha*. The practice of grant of land and villages and other properties to *maṭha* and its pontiffs became a common practice later on.

As for Upendrapura, it may be same as Ranod because of a pun in the name of Purandara (Indra), who may have been known as Upendra to distinguish him from Indra. His *tapasthāna* in Araṇipadra consequently will be Upendrapura, a hermitage or a forest settlement which he sanctified and which got designated after him. For the passages quoted above, cf. *EI* vol. I, p. 355, vv. 13-14. Also, R.N. Misra, 'Śaivite Monasteries, Pontiffs and Patronage in Central India,' *Journal of the Asiatic Society of Bombay*, N.S., vols. 64-66, (1993), pp. 108-24.

to sticking on to one and the same place forever. Some of the seats seem to have decayed in time but they were rejuvenated when a favourable opportunity arose again. Kadambaguhā was a classical example of this decline and resurrection. So was Araṇipadra. The fame of Kadambaguhā might have been temporarily eclipsed as other locations, e.g., Sarasvatīpattana, Terambi and Āmardaka, were invested by the second, third and fourth ascetic of the line following Kadambaguhādhivāsī.

The *tapovanas* eventually grew up as centres of the particular *sthānapatis* who, along with their disciples, occupied sprawling *tapasthāna* built there contemporaneously or even later as the circumstances permitted. In addition, Terambi, Āmardaka and Kadambaguhā sent out its scions to distant lands. For instance, from Terambi to Ranipur Jharial[28] in Orissa; from Āmardaka to Senkapat[29] in Chhattisgarh; from Āmardaka again to Karnataka[30] and Maharashtra besides Rajor[31] in Rajasthan. The ascetics of the Madhumatī branch similarly went to eastern Madhya Pradesh. One may see a pattern in this entire diaspora. In the beginning, each *muni* of the line seems to have selected a location for his penance and meditation. As the locations proliferated, they reorganized into the clusters of *tapasthāna* of Kadwaha, Terambi, Āmardaka and Madhumatī. The reorganization probably took place during Purandara's period (c. AD 825) but by then the pre-existing *tapasthāna* had also started branching out. New occupations occurred only when an ascetic from an existing centre either migrated on his own or was sent out. This duality of residence and immigration of ascetic seems to have spurred the proliferation and network of *maṭhas*.

In these movements marking a phenomenal increase in the number of *maṭhas*, there is a hint of competition and contest between the *sthānapatis* occupying particular *tapasthāna*. This is indicated in the attempt to construct an alternate genealogy different from that consisting of Kadambaguhādhivāsī, Śaṅkhamaṭhikādhipati, Tarambipāla, Āmardaka-tīrthanātha, Purandara, Kavacaśiva, Sadāśiva, Hṛdayaśiva and Vyomaśiva as set forth in the Ranod inscription.[32] Contrary to this genealogy, the Fragmentary Kadwaha Inscription[33] describes Purandara as descending from the mythical Vālakhilya

28. Cf. *EI* vol. XXIV, pp. 242-43.
29. Cf. *EI* vol. XXXI, p. 36, v. 16.
30. Cf. V.S. Pathak, *Śaiva Cults, op. cit.*, p. 30, fn. 3.
31. Cf. *EI* vol. III, p. 266, line 13.
32. Cf. *EI* vol. I, pp. 355-56, vv. 6-22.
33. Cf. *EI* vol. XXXVII, p. 122. The inscription refers to sages Vālakhilyas and then "speaks of Purandara as the first person probably of a lineage of Śivācāryas," Mirashi and Shastri, "A Fragmentary Stone Inscription from Kadwaha" (*EI* vol. XXXVII, p. 118). Purandara is said to have chosen Araṇipada like Śrīkaṇṭha chose *Dāruvana* for penance. The inscription also seems to refer to demise of Purandara who was a 'crest jewel' of the Śaivas. The name of his immediate disciple is lost; this person is however described a *bhuvanāśraya paṇḍita*. Then we have Dharmaśiva (who was a contemporary of Gobhaṭa) and then a reference to the death of a (Cāḷukya?) ruler of this place whereupon Dharmaśiva routed the army of foes; his death after victory is also mentioned. Dharmaśiva was succeeded by a disciple

→

sages with no one else in between. This is in contradiction to the version of the Ranod inscription. The contradiction in the genealogies of those two records and linking of Purandara with Vālakhilya sages in the Kadwaha record are deviations, which betray schism in the *maṭhas*. Unless Kadambaguhādhivāsī and his immediate successors are meant in the imagery of the Vālakhilyas, it would appear that the writer of the Kadwaha Fragmentary Inscription had a different perception about ascetic succession in the Siddhānta lineage. In any case, the Kadwaha inscription makes Purandara[34] the first historical personage at Kadwaha (after the mythical Vālakhilyas) and ignores his predecessors including Kadambaguhādhivāsī who are specifically enumerated in the Ranod record.

Such contestation and schism apart, it seems that by the ninth century the entire region extending from Amrol in Gwalior district to Kadwaha in Guna District had come under the sway of the Siddhānta movement. At least, till the emergence of Purandara, there is no evidence of rulers providing support in these developments. All the locations occupied by the *munis* before Purandara were established in *vanas* (forests) which suited their ascetic ways of life. It is remarkable because *vanas* were the exclusive spaces of the forest tribes (*āṭavikas*) like Śabaras, Pulindas, Seka, Aparaseka, Kacchapa, Bhadakana and Naras besides wild animals, *mlecchas* (barbarous people) and *taskaras* (robbers) who inhabited the lands in northern Madhya Pradesh from earlier time.

Each of these sites was appropriately secured with construction of a *maṭha* there. There seems to have been a method in this expansion as the initial boundaries of these sacred places were gradually extended to the vicinities. This was done by constructing temples,[35] paving roads and paths through forest and mountain and fording rivers and streams,[36] holding fairs and festivals[37] and in many other ways. These activities apparently

→ (name lost). This disciple gave *dīkṣā* to Harirāja. Thus, the ascetics' line of Kadwaha, excluding the Vālakhilya sages consisted of four ascetics from Purandara and included him too among the four. Counting backwards from the known date of Harirāja, viz., AD 984 and assigning 25 years to each sage, we may come to AD 909 as the date of Purandara's demise. In the same way we may come to *c.* AD 830 as the date of his birth, thus, allowing a ripe age of eighty years (or more) to him. This will advance his date and also that of his contemporary, Avantivarman Cāḷukya, who initially brought him to Mattamayūrapura (Kadwaha). The chronology needs a careful re-examination. But of significance here is the information that this Kadwaha inscription offers a genealogy that is different from the one found in Ranod inscription both before and after Purandara. And the variance suggests schism.

34. See note 27 above.

35. Cf. *EI* vol. I, p. 359, vv. 43-44. The inscription refers to construction of temples of Śiva and Pārvatī (*Śiva-yugma*), Umādevī, Nāṭyeśvara and Vināyaka by Vyomaśiva. Along with these temples he also laid a garden and excavated a *vāpī* (*ibid.*, pp. 43, 51).

36. Cf. Chandrehe Insc. of Prabodhaśiva (Mirashi, 1955, p. 203). Speaking about Prabodhaśiva, the inscription informs that "He by the process of excavation, breaking and ramming heaps of large stones . . . constructed a wonderful way through the mountain (and) across rivers and streams and also through forests and thickets. . . ."

brought the communities living around the forest closer to *maṭha*s and helped in expanding its boundaries or its sphere of influence.[38] The spots once appropriated were assiduously nurtured, even as their operational space got extended beyond the specific location of a *muni*'s anchorage.[39] Let us therefore briefly trace the Śaivite history of each site where the *maṭha*s came up in succession. It is conceded that these locations have other histories too either in conjunction with or independent of the Siddhānta. These points are taken up in passing below, even as the details help in delineating expansion and entrenchment of the Siddhānta in regions beyond the centre of its inception in northern Madhya Pradesh.

We start with Kadambaguhā, the site marking the inception of Śaiva-Siddhānta lineage. Apparently, the 'venerable Kadambaguhā'[40] came into reckoning when Kadambaguhādhivāsī occupied it and inaugurated a line of ascetics in *c.* AD 675. From then on, it remained in prominence for nearly a millennium up to VS 1587/AD 1529, notwithstanding occasional vicissitudes in its fortunes.[41] After AD 675 the site was rehabilitated by the Siddhāntikas and re-christened probably as Mattamayūrapura. This happened during the time of Purandara[42] (*c.* AD 825) who was fifth in descent in the line of sages starting with Kadambaguhādhivāsī. According to Ranod inscription, Purandara,

37. Cf. Bilhari Stone inscription of Yuvarājadeva II (Mirashi, 1955, p. 224), which refers to a fair where everyday, a bull made of beautiful wood was brought for the temple-god for performance of religious rites.

38. There are sometimes cases of *tapasthāna*s that decayed but those spots were soon renovated, re-invested and strengthened. This happened in the case of the *maṭha* at Araṇipadra, for instance. Here, the *maṭha* built by Purandara is said to have decayed and gone into a dark period in course of time (for reasons unknown). But Vyomaśiva restored its glory in the tenth century AD. Perhaps Kadambaguhā of Kadambaguhādhivāsī also suffered the same fate till Purandara restored it when he arrived there. For Ranod, cf. *EI* vol. I, p. 357, v. 29.

39. A location was first identified for its solitude as an exclusive *tīrtha* or a *tapasthāna* and invested by an ascetic who performed his penance there. Then that location was turned into a monastery and secured by the appointment of pontiffs from the same lineage at the site. This was the case with monasteries at Kadwaha, Ranod, Āmardaka, Terahi, etc.

40. Mirashi, 1955, p. 213, v. 48, *sā kadambaguhā mānyā*. Pathak (*Śaiva Cults, op. cit.,* p. 31) places Guhāvāsī in AD 675. He writes that the Chandrehe inscription of Prabodhśiva is dated in KS 724/AD 973. Prabodhaśiva is 12th from Guhāvāsī and hence, taking twenty-five years for one generation, Guhāvāsī may be placed in *c.* AD 675 and Rudraśambhu (same as Āmardakatīrthanātha) in AD 775.

41. Cf. Michael D. Willis, *Inscriptions of Gopakshetra*, 1996 (hereafter quoted as *MIG*), p. 22, inscr. of VS 1366. Four other local inscriptions refer to the *satī*s at Kadwaha, i.e. the wives respectively of a cobbler (*camār*) a milkman (*ahīr*), a *rāut* and a nameless person, who committed *satī* in VS 1451, 146 (?) 146 (?) and 1476, during the reigns of Mahmud Shah Tughlaq (AD 1413) and Dilawar Khan (1390 to 1405). Cf. *MIG* pp. 27-29.

42. See note 27 above. This succession after an interval of three generations between Kadambaguhādhivāsī and Purandara seems to have restored the primacy of the site where the Siddhānta sect originated, thanks to the former. Its sacredness continued to be reinforced by construction of temples here in quick succession within its immediate environs, between the ninth and twelfth centuries. Two of these temples survive within the enclosure of the local *maṭha*. Other temples are distributed around the

→

like his three other predecessors after Kadambaguhādhivāsī, did not begin at Kadambaguhā. Instead, he is said to have gained glory by performing penances in the *tapovana* (penance forest) at Araṇipadra (Ranod). Eventually, he revived the fame of Kadambaguhā (Mattamayūrapura, same as Kadwaha) on being reverently established there. Avantivarman Cālukya built a *maṭha* here for him (*sa kārayāmāsa samṛddhibhājaṁ munirmaṭhaṁ sanmuniratna bhūmiṁ*).[43] The ruler received *dīkṣā* (initiation) after offering his entire kingdom to him (*naivedya yasmai nijarājya sāraṁ*)[44] and thus redeemed himself, as it were (*svajanma sāphalyamavāpa bhūpaḥ*),[45] by bringing the sage to his land (*pura*). This land is now described not as Kadambaguhā but as Mattamayūrapura (*śrīmatpure mattamayūra nāmni*).[46] The line of sages descending from this *pura*,[47] *vaṁśa*[48] or *santati*[49] (clan) is described in a later record as 'purifying like the Gaṅgā.' Its other name, i.e. Kadambaguhā, seems to co-exist interchangeably with Mattamayūra in the Siddhānta genealogies for both of them are reckoned alternately in later inscriptions.[50] Purandara the sage of Mattamayūrapura/Kadwaha, on his part, became famous for being the preceptor of kings (*jagye gururbhūbhujāṁ*).[51]

Kadambaguhā thus seems to have been twice occupied, first by Kadambaguhādhivāsī in *c*. AD 675 and then again in *c*. AD 825 by Purandara (of his line) who came to be designated as Mattamayūranātha.[52] He laid a firm foundation of the line of Mattamayūra *maṭha* at Mattamayūrapura (Kadwaha); Ranod too had remained with him but subsequently he appointed his disciple Kavacaśiva[53] there. Kadwaha/Mattamayūrapura

→ village. The *maṭha* is a ninth-century construction that came up when Avantivarman Cālukya brought Purandara here. Other temples of Kadwaha are spread around the village singly or in pairs or in groups. These have survived despite several bloody battles at the site and assaults by "barbarians." Cf. *EI* vol. XXXVII, p. 120; *MIG* p. 22.

43. *EI* vol. I, p. 355, v. 14.

44. *Ibid.*, v. 13.

45. *Ibid.*

46. *Ibid.*, v. 14.

47. *Ibid.*

48. Cf. Mirashi, 1955, p. 228, v. 19.

49. *Ibid.*, p. 200.

50. *Ibid.* The verse begins with *mattamayūra santati* and Purandara, without referring to Kadambaguhādhivāsī. But the Bilhari stone inscription (Mirashi, 1955, p. 220, vv. 48 ff) refers to a line of sages of Kadambaguhā (*sā kadamba-guhā mānyā yatrāsīt siddha santati*). It speaks of Kadambaguhā "where there was a succession of sages in which line was Rudraśambhu (Āmardakatīrthanātha) who had Mattamayūranātha (Purandara) as his disciple. . . ." The Ranod inscription mentions Purandara as fifth in succession in this line starting from Kadambaguhādhivāsī. Thus Kadambaguhādhivāsī's reference as the progenitor of the line which included Mattamayūranātha helps in identifying Kadambaguhā with Mattamyūrapura.

51. Mirashi, 1955, p. 200, v. 4.

52. *Ibid.*, p. 213, v. 49.

53. Cf. *EI* vol. I, p. 355, v. 16.

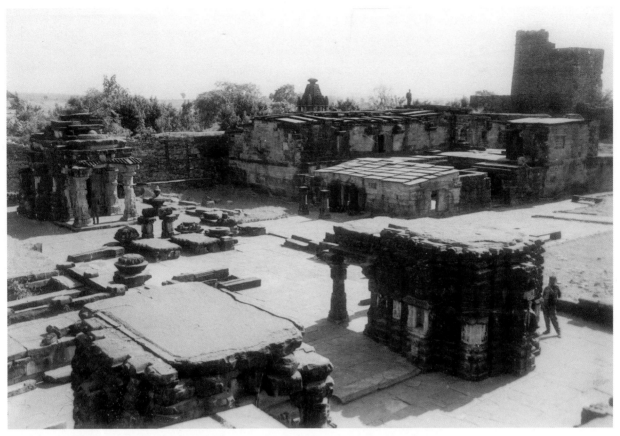

Pl. 15.1: *Maṭha* and temples (1-3), Surwaya.

Pl. 15.2: *Maṭha*: with a small *śikhara* to the left at the back, Surwaya.

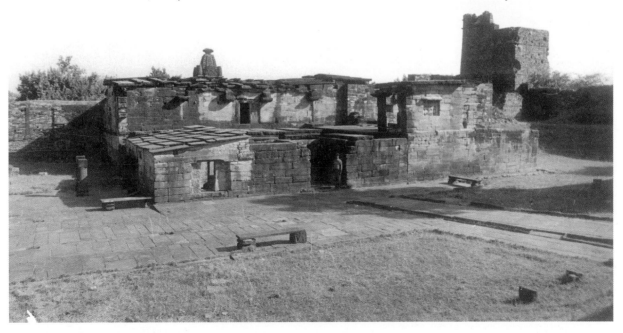

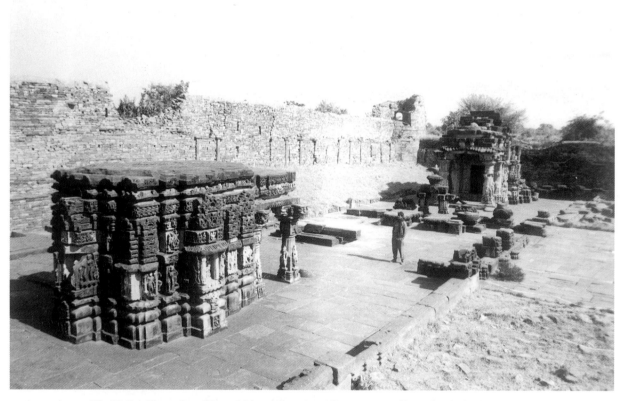

Pl. 15.3: Temples (1 and 2) with a fortification wall to the left, Surwaya.

Pl. 15.4: Śaivite ascetic on a
maṇḍapa-pillar, Surwaya.

Pl. 15.5: Śaivite ascetic on a
maṇḍapa-pillar, Surwaya.

Pl. 15.6: *Satī* pillar outside Mohajmata temple, Terahi.

thereafter flourished unabated and received attention of people, ascetics, pilgrims and rulers till the sixteenth century.[54] The local *maṭha* became strong and powerful. In early tenth century the then ascetic of the *maṭha* is seen to have joined a battle in support of his royal protégé. The ascetics' supremacy *vis-à-vis* state remained intact even afterwards. Royal patronage was offered to the *maṭha* on occasions but it was accepted reluctantly. Thus, we have an episode[55] about a Kadwaha ascetic and Harirāja, a Pratihāra ruler (tenth century AD). On being approached by Harirāja through a royal messenger, the ascetic is said to have asked of the messenger as to "who the ruler was?" (*āyuṣmān nṛpatiḥ ko ayaṁ iti papṛccha saṁyamī*).[56]

Harirāja, a *nṛpa cakravartī* unmindful of affront, sought and received initiation (*dīkṣā*) from the ascetic. At the end of the ceremony he gave some villages (*grāmāṇām*) as offering (*naivedya*) when the *muni* refused a gift of "rutting elephants."[57]

The genealogy of these sages as described in the Kadwaha record covers the period from *c.* AD 825-30 to 984. The Siddhāntikas and their *maṭha* continued to flourish even afterwards. A tenth-century image inscription here refers to *bhaṭṭāraka* Śrī Vakrasādhu who could be a Jain *sādhu* or a Śaivite sage, as the title *bhaṭṭāraka* occurs for a Śaivite pontiff elsewhere. Similarly, an eleventh-century record mentions a Siddhānta ascetic Īśvaraśiva and refers to the planting of a garden and building of a mansion during the reign of Bhīma, a Later Pratihāra ruler.[58] Yet another inscription of vs 1234, found on a slab in the *maṭha* at Kadwaha, mentions it as *go-surālaya* (an abode of cows and gods).[59] It also offers obeisance to Gaṇapati. Another inscription of vs 1450 found on a slab in a temple at Kadwaha refers to a gift by a Śaivite brāhmaṇa to another brāhmaṇa.[60]

Kadwaha seems to have developed into a centre of pilgrimage. The pilgrims' records by the score here from vs 1466 to vs 1587, refer to different pilgrims — brāhmaṇas, kāyastha, rāuts, a pilgrim from Ranthambhor and others — visiting this sacred place accompanied by members of their families. The last recorded instance of a Śaivite pilgrim visiting the site dates to the sixteenth century.[61] The 'barbarians' (*mlecchas*) did not dent the glory of Kadwaha as centre of pilgrimage despite nineteen assaults on it. To expiate

54. Cf. *MIG* pp. 28-31; 39; 43-45; 113.
55. Cf. *EI* vol. XXVII, p. 124, vv. 23-24.
56. *Ibid.*, v. 24.
57. *Ibid.*, p. 124, vv. 31-32.
58. Cf. *MIG* pp. 112 below; 113; a Kadwaha inscr. of vs 1162 in a temple contains names of some *ācāryas*. Other details are not known. Cf. *MIG* p. 7.
59. Cf. *MIG* p. 9. The inscription dated in vs 1234, indicates presence of cows as well as of gods in activities of the *maṭha*; *sura* implying either images of gods or the ascetics raised to the level of divinity.
60. Cf. *MIG* p. 27. The donor is mentioned as a devotee of Śiva.
61. Cf. *MIG* p. 113. It refers to *ṭhakkura* Majudeva, a devotee of Śiva in the script of sixteenth century. The inscription is engraved on one and the same slab that contains other records respectively of vs 1479 and vs 1504.

this, Bhūteśvara (AD 1316), an ascetic famous as *tapodhana* (wealthy in penance), performed penance and restored the *Śiva-liṅgam* of the chief shrine (*mūlāyatana*).[62]

Kadwaha did not remain untouched by the political events that kept happening while Śaivism flourished with the support of sages, rulers, pilgrims, devotees and people at large. The Cālukyas, Pratihāras and perhaps Yājvapālas, held sway over here in that order till the thirteenth century. They were followed by Alauddin Khalji (VS 1366), Mahmud Shah Tughlaq (VS 1451) of Delhi, Dilāwar Khan of Malwā [VS 146 (?)] and Sultan Mahmud Khalji (VS 1504). It became a *parganā* in VS 1403 when a *gumāshtā* named *mālika* Sahib Khan and two others namely *mālika*s Sahan and Khushdil were stationed here.[63] But the importance of Kadwaha as a pilgrimage centre remained intact at least till the sixteenth century, when a pilgrim is found to have recorded his visit. Kadwaha has a multi-faceted history, not limited merely to its Śaivite sanctity, its holy destinations and its centrality in the Śaiva-Siddhānta movement. These aspects of its history are significant in indicating an energetically promoted expansion of the Mattamayūra line of ascetics in territories that lay far beyond Kadwaha. It is seen that the branches of Mattamayūrapura *maṭha* eventually developed respectively at Raṇipadra (c. AD 825)[64] and at Madhumatī.[65] Yet another branch of Mattamayūra line came up at Karkaroni, somewhere in Koṅkaṇ region of Maharashtra in 1008-09. The Karkaroni line is mentioned as "sprung from the Mattamayūra *anvaya* (*śrī mattamayūra anvaya prasūta*)," "belonging to the fold of the Mattamayūra lineage (*śrīmān mattamayūra antargata karkaroni santāna*)."[66]

62. *Ibid.*, p. 22.
63. Cf. *MIG* pp. 14, 112, 31, 22, 27.
64. Cf. *EI* vol. I, p. 355, v. 15.
65. Cf. Mirashi, 1955, p. 202, vv. 5-6, where Śikhāśiva "the lord of Madhumatī" is described as a descendant of Purandara (II) of Mattamayūra.
66. Cf. *EI* vol. III, p. 301, lines 51-53. The Kharepatan Plates of Raṭṭarāja refer to Ambojaśiva who was the *ācārya* but "holy" Atreya rather than him was entrusted with property and the temple of Śiva-Avveśvara. It is a unique case where Atreya (not an *ācārya* but "holy" none the less) is entrusted with what in terms of property Ambojaśiva is divested of. In all other cases elsewhere the *ācārya*s exercised rights over temple or *maṭha* property. A distinction between temporal and administrative roles here is significant. Atreya was ordained by the royal grant to take care of (1) worshipping Śiva 'with five-fold offerings,' (2) keeping the shrine in proper repair and (3) providing food and raiments for ascetics (of the shrine), learned men, visitors and others' (*ibid.*, pp. 296-97).

The grants for the purpose were substantial and consisted of the following:

(1) Three villages,
(2) three other properties (e.g., *jīvaloka*, *chakantara* and *juhaka*),
(3) a *gaḍiyāna* (gold coin) from every vessel arriving from foreign land,
(4) a *dharaṇa* (a measure) of gold for every ship arriving from Kandamūlīya except Chemulya and Chandrapura,
(5) a family of oilmen, gardeners, potters and washermen,
(6) a *jagatīpura* inside the fort, and
(7) a piece of land formerly known as "the mare's ground" (*vadvābhuvaṁ*), for a garden (*ibid.*, pp. 300-01). →

Thus the Mattamayūra clan of ascetics, rising with Kadambaguhādhivāsī and from a small settlement of Mattamayūrapura (Kadwaha),[67] witnessed a phenomenal growth and expansion from the time of Purandara (AD 825) onwards. By the eleventh century it had established a fairly well-entrenched network of *mathas*. Chief among these were the ones at Ranod and Madhumatī (Mahua), and the latter's sub-branches in eastern Madhya Pradesh at Bilhari (Nauhaleśvara *matha*),[68] Maihar (Vaidyanātha *matha*),[69] Gurgi,[70] Chandrehe[71] and at Bherāghāṭ[72] (in Satna, Rewa, Sidhi and Jabalpur district of Madhya Pradesh). Even the other *mathas* of northern Madhya Pradesh representing the sub-branches became strong on their own. But Kadwaha (same as Mattamayūrapura) was the fountainhead of this movement, it being the central seat of the Siddhāntikas. That may perhaps explain the contesting claims in the later genealogies (mentioned above) about the primacy of Kadambaguhādhivāsī who was replaced by Purandara as the founder of the Siddhānta lineage. This alternate genealogy was constructed to elevate Purandara. In doing this, his descent from Kadambaguhādhivāsī was explicitly shrouded for, inscriptions from Kadwaha and elsewhere present him not as a successor but as the founder of the line and the first *sthānapati* at Mattamayūra (Kadwaha).

The pre-eminence of Kadwaha is not in doubt in the history of Siddhānta School of Śaivism. In course of somewhat less than a millennium from *c.* AD 675 to 1529 it witnessed much, e.g., well-endowed ascetics; construction of a sprawling *matha*, which became the hub of activities; construction of several groups of temples to the north, east and west of the village, inside the compound of the *matha* and on the bank of the river (in the area now known as Murayat: *mūlāyatana?*); a fortification in the fifteenth century; a battle (which saw an ascetic in action); 19 raids by 'barbarians' (fourteenth century) as also patronage of and to the rulers who requested and received *dīkṣā* from ascetics. The Delhi and Mandu *sultāns* attempted to alter its history, yet it continued to enjoy unmitigated glory as a place of pilgrimage. The pilgrims' records from VS 1466 to VS 1587 testify its sanctity that was reinforced by restoration in 1316 of its sacred places by Bhūteśvara. The Siddhāntika space here did not remain localised for ever to the *matha* alone: it spread out far and wide — to the vicinities which were embellished with several temples; to the distant places where people held it in veneration so much as to come here on pilgrimage. Its scions moved in strength to distant lands in Maharashtra, Rajasthan

67. Cf. *EI* vol. I, p. 355, v. 15.
68. Cf. Mirashi, 1955, p. 213, vv. 57-58.
69. *Ibid.*
70. *Ibid.*, p. 225 (Gurgi Stone Insc. of Kokalladeva), v. 7. The *matha* was established at 'enormous cost' (*ananta dhana pratiṣṭham*), by Yuvarājadeva I for Prabhāvaśiva. It seems to have been built at Gurgi near Rewa.
71. *Ibid.*, p. 232, v. 21, p. 203, v. 16.
72. *Ibid.*, pp. 336-39. This inscription refers to a pontiff's lineage with names starting from Vimalaśiva to Kīrtiśiva. There is no mention of *matha* in this inscription but reference to 'installing' a disciple by Vimalaśiva suggests existence of a monastery where succession must have been affected.

and eastern and central Madhya Pradesh where they (i.e. Mattamayūra-*santati*) found a strong foothold and brought further glory to the movement through a widespread network of *maṭhas* and their *ācāryas*. It had power, pelf and glory but above all its pre-eminence lay in its being the fountain of Siddhānta ascetics' diaspora on one hand and in asserting the unique phenomenon of woodland-based ascetics exercising their primacy over the land, people and state. *Tapovana* here seems to win over the populated settlements in substance. But in the final stages, as it grew it was lost to urbanism.

Siddhāntika monarchism was not limited to Kadwaha alone; other locations also played significant role in creating and strengthening the movement aided by the *maṭhas* that served as strongholds of the sages. While Kadwaha grew in prominence acquiring ever-new frontiers of material space in terms of territories its branches occupied other sites both in the near or distant regions, and their *ācāryas* too did not lag behind either in power or in glory. Forest tracts seem to have been their major attraction and they are found securing them without let. So, after Kadwaha, we go back to the immediate successor of Kadambaguhādhivāsī, i.e. Śaṅkhamaṭhikādhipati, 'the lord of Śaṅkhamaṭhikā,' who perhaps flourished at Surwaya (ancient Sarasvatīpattana). The *adhipati* part of his assumed name has an authoritarian tone. He seems to have occupied a small monastery (*maṭhikā*) at a site that eventually grew into a *pattana*.[73] An inscription in stone of vs 1341/AD 1285, of the time of Gopāladeva, a Yājvapāla ruler, refers to it as Sarasvatīpattana where Sārasvata brāhmaṇas worshipped Śiva: *śrutismṛtītihāsapurāṇa-vijña yajñapradhāna-śivasannidhāna*.[74] Śiva, Sarasvatī and goddess Mahāruṇḍā are invoked in another inscription from Surwaya dated in vs 1350/AD 1293.[75] The association of the Surwaya *maṭha* with Siddhānta asceticism is confirmed by life-size figures of ascetics carved on pillars of *maṇḍapa* in the temple built adjacent to the *maṭha*. Significantly, the innermost chamber of the *maṭha* containing a stone bed of the *munīndra* (lord of ascetics) has a *śikhara* exactly at the top, a feature seen only in this *maṭha* among all other Siddhāntika *maṭhas*. This seems to be in keeping with the ambience of lordship of the *adhipati* of this Śaṅkhamaṭhikā, which we so identify on the basis of graffiti in the shape of conches on stone-blocks of the *maṭha*.

No record of this *maṭha*'s contemporaneity with Śaṅkhamaṭhikādhipati (*c.* AD 700) is known so far. But it seems to have been built in late eighth or early ninth century. Garde[76] noticed two stages of its construction. He says that the original structure was built close to its north wall and later extensions representing the second stage were done on western side, probably in the tenth century, when it was enlarged and surmounted by two storeys

73. For *pattana* as 'township,' cf. D.C. Sircar, *Indian Epigraphical Glossary*, Delhi, 1966, sv. *pattana*, p. 246.

74. H.V. Trivedi, *Inscriptions of the Paramāras, Chandellas, Kachchhapaghātas and Two Minor Dynasties* (*Corpus Inscriptionum Indicarum*; VII/1-3), Delhi, A.S.I. 1978-91 (quoted as: CII); here: vol. VII/3 (1989), p. 593, v. 4.

75. *Ibid.*, p. 598, vv. 1-3.

76. Cf. M.B. Garde, *A Guide to Surwaya*, Gwalior, 1919, pp. 5-6.

and a *śikhara*. A fortification wall surrounding it came up before AD 1292 for, construction of a gate of the fort is mentioned in an inscription dated in vs 1350/AD 1292.[77] Since a gate could come up only after construction of fortification walls its fortified construction must have been complete before AD 1292. The inscription also refers to *rājñī* (queen) Salahanadevī and prince (*mahākumāra*) Sāhasamalla and it was noticed by Garde[78] "near the eastern gate in outer fort-wall." At present, the *maṭha* stands enclosed by "double line of fortification" with bastions and with a moat surrounding it. Patil dates this fortification to sixteenth-seventeenth century.[79] This date needs revision in view of the materials quoted above. It may be conceded that renovations and strengthening of fortification after its completion may have continued even later. The fortified enclosure at Surwaya now contains three temples (tenth to eleventh century) and inscriptions here refer to a well of vs 1341, another *vāpikā* of vs 1348, a *vāpī* and a garden of vs 1350. Some of these are still in place. The inscriptions from Surwaya also refer to brāhmaṇas, ṭhākuras, a *rāṇaka* of *lubdhaka* clan, *kāyastha*s (migrating from Mathura and settling down here) and masons as well as to the Yājvapāla rulers Gopāla and Gaṇapati, all within a chronological bracket of vs 1341 to vs 1772.[80] The *maṭha* at Surwaya has enough to celebrate its ancient glory but it has neither left a genealogy or a narrative of its activities. The name Sarasvatīpattana suggests that by AD 1285 it had turned into a township (*pattana*). The *maṭha* remained a landmark and it possibly obscured all else here. The woodland in its case seems to have transformed into a populated settlement then, but the history of the *maṭha* after the *munīndra* Śaṅkhamaṭhikādhipati is totally obscure. Terambipāla succeeded this ascetic not at Surwaya but at Terambi (Terahi).

Terambi (Terahi) has a battle-scarred history notwithstanding its occupation by Terambipāla (c. AD 725-50). In AD 903 it witnessed a bloody battle between *mahāsāmantādhipati* Guṇarāja, a Rāṣṭrakūṭa feudatory and Undabhaṭa, a feudatory of the Gurjara-Pratihāras.[81] In this battle the *koṭṭapāla* (governor of the fort) Caṇḍiyāna lost his life, fighting. The battle was fought on the banks of the river Madhuveṇī at Terahi; others besides Caṇḍiyāna, who died fighting included a *mahā-aśvapati* besides Allabhaṭṭa and Allajiyapa. The latter's wife Nanna committed *satī*.[82] The details indicate that Terahi

77. Cf. *MIG* p. 20.

78. M.B. Garde, *Guide, op. cit.*, p. 28.

79. Cf. D.R. Patil, *The Descriptive and Classified List of Archaeological Monuments in Madhya Bharat*, Gwalior, 1952, p. 131, no. 1608.

80. Cf. *MIG* pp. 18, 19, 20, 57, 61, 121.

81. Cf. K. Kielhorn, 'Two Inscriptions from Terahi' (1888), *Indian Antiquary*, vol. XVII, pp. 201-02 (Reprint).

82. *Ibid.*; also *MIG* p. 2. The second inscription refers to *sāmanta* and *aśvapati*. The name Allabhaṭṭa is interesting because one Alla, son of Vāyillabhaṭṭa of Varjara family of Gujarat is mentioned in an inscription from Gwalior. Cf. E. Hultzsch, 'The Inscriptions of the Vāyillabhaṭṭasvāmin temple at Gwalior' (1892), in: *EI* vol I, p. 154. Alla was contemporary of Ādivarāha (same as Mihira Bhoja, AD 836-85). The temple inscriptions of Gwalior are dated respectively in AD 875 and 876 while the battle took place in vs 960/AD 903. So the Allas repectively of Terahi and Gwalior may not be the same persons.

had a fort in early tenth century that has disappeared now. But the name Allabhaṭṭa is interesting because an Alla, son of Vāyillabhaṭṭa of Varjara family (*anvaya*) from Gujarat finds mention in an inscription of AD 875-76 from Gwalior. This Alla was contemporary of Ādivarāha (i.e. Mihirabhoja, a Gurjara-Pratihāra ruler). Terahi's fame lay in its being a distinguished centre of Siddhānta ascetics. The *maṭha* here was instrumental in despatching one of its *ācārya*s to a place in Orissa. Terambipāla, "the protector of Terambi" and a "conqueror of desire" like Śiva[83] (*pramathādhipasya tulam kāmajayaḥ*) may have been instrumental in this immigration. A Ranipur-Jharial inscription of tenth or eleventh century refers to Terambi as "Uttara Terambigṛha" (distinct from the southern Terambi which perhaps Ranipur was) from where immigrated the *ācārya* named Gaganaśiva (*uttare terambigṛha nirgata gaganaśivābhidhāna siddha ācārya . . .*).[84] Terambi now has a dilapidated *maṭha* besides two temples respectively of the ninth and eleventh century.

We move over now to Āmardaka (Amrol in Gwalior District), the next location in the series. It came into reckoning with the advent of Rudraśambhu[85] who is mentioned as Āmardakatīrthanātha in the Ranod inscription. His name reveals his status as the 'lord' (*nātha*) of the *tīrtha* that was Āmardaka. The name of the site suggests that as he took over this *tapovana*[86] it turned into a *tīrtha*. There is no previous history of the site's sacredness before Rudraśambhu but the forest tract of Āmardaka was found fit enough for penances by him (*bhūri tapaḥ tapo'pi satkhyātiḥ*).[87] Like his predecessors, he too seems to have opted for a sylvan, solitary and virgin territory in a woodland setting. This occupation came about in *c.* AD 775. The appropriation of Āmardaka forest was quick and its expansion rapid. This is borne out by immigration of its sages to Senkapat[88] in Chhattisgarh; to the *maṭha*s of Rajor and Chatraśiva in Rajasthan[89] and to Maharashtra

83. *EI* vol. I, p. 355, v. 9.

84. *EI* vol. XXXII, pp. 242-43.

85. Cf. Mirashi, 1955, p. 213, v. 48; V.S. Pathak, *Śaiva Cults, op. cit.*, p. 31.

86. Cf. *EI* vol. XXXI, p. 36, v. 16.

87. *EI* vol. I, p. 355, v. 9.

88. Cf. *EI* vol. XXXI, p. 36, v. 16ff. We are told that Sadyaḥśivācārya hailed from the 'penance grove' (*tapovana*) of Āmardaka. Sadāśivācārya was his disciple (vv. 17-18). The Śambhu temple was constructed (v. 13) (at Senkapat) which was turned over to Sadāśivācārya and his successors for "enjoying and partaking it" in perpetuity. For this, the *ācārya* received a grant of four *hala*-measures of black-soil land in Kodasima village and two *hala*s of land respectively in the Vināyaka village and in a locality called Lāṭa in Śrīparṇikagrāma. Cf. M.G. Dikshit, D.C. Sircar, 'Senkapat Inscription of the Temple of Śivagupta Balārjuna,' in *EI* vol. XXXI, p. 33. The ascetics were entrusted with the work of arranging *yāga* and *dīkṣā*, exposition of doctrine (*samayasya vyākhyā*) besides running a free feeding *sattra* every year on three specific occasions. The stay of the ascetics in the temple was made mandatory and they were instructed not to lend money for the sake of interest (*ibid.*).

89. Cf. *EI* vol. III, p. 266. It refers to Lacchukeśvara-Śiva temple and grants to it of a village Vyāghrapāṭaka along with its properties, e.g., grass in pasture land, *udraṅga*, rows of trees, water, *bhāga* and *mayūta* (?) income, shares of all sorts of grain, *khala-bhikṣā*, *prasthaka*, *skandhaka*, *mārgaṇaka*, fines including those on ten offenses, gifts, treasures, deposits and much more. The grant was made to meet expenses of

→

and Karnataka.[90] The immigrations to Rajasthan around *c.* AD 885 led to establishment there of two *matha*s — the 'Nityapramuditadeva' *matha* at Rajor and 'Gopāladevī-taḍāga-pallī' *matha* at Chatraśiva — each having *ācārya*s related to Āmardaka. These two *matha*s of Rajor and the vicinity reorganized themselves into the Sopuriya branch of the Siddhānta ascetics who were linked to and immigrated from Āmardaka (*āmardaka vinirgata sopuriya santati*).

The Karṇāṭa connection of the Āmardaka line is traced through Durvāsā, a mythical sage connected both with Āmardaka's Rudraśambhu and Karṇāṭaka's (Karhad in Satara district in Maharashtra) Gaganaśiva. The latter is said to have been the spiritual teacher of an Alūpa king.[91] This testifies to his Karnāṭaka connection. In the Karhad Plates of Kṛṣṇa III (AD 959), Gaganaśiva is described as the *sthānapati* (pontiff) of Valkaleśvara *matha* at Karhad. He belonged to the Karañjakheṭa branch (*karañjakheṭa santati*) of Āmardaka line and was a disciple of Īśvaraśiva whom he succeeded at Karṇāṭaka.[92] There is enough in these accounts to show the pace of expansion of Āmardaka branch of the Śaiva-Siddhānta ascetics outside the territory of its inception. Āmardaka turned into a *tīrtha* but its history is not recorded like that of Kadwaha. Today, the site has three temples of the eighth century.[93] A pilgrim's record of the eighth century is engraved on Rāmeśvara Mahādeva temple here. It mentions Bhāgacandra, a pilgrim.[94] In any case, Āmardaka came into prominence soon after its occupation by Rudraśambhu who established his reputation as 'chief of the sages' and as an 'object of veneration' (*vandyo rudraśambhu munīśvaraḥ*).[95] Rudraśambhu was succeeded by Purandara (Mattamayūra-nātha) but not at Āmardaka. The conspicuous rise of the Siddhānta during his times has been discussed above already. So we may pass on to Ranod.

→ bathing the god as also for different services. The administration of this grant was entrusted to Oṁkāraśivācārya, a disciple of Rūpaśivācārya who himself was a disciple of Śrīkaṇṭhācārya, All these formed the Sopuriya line of ascetics who descended from Āmardaka (Amrol). Of the two *matha*s, e.g., Nityapramuditadeva Maṭha at Rājyapura (Rajor, in former Alwar state of Rajasthan) and Gopāladevī Taḍāgapallī Maṭha at Chatraśiva (some place nearby), the latter was more ancient than the former. Counting three generations back from Oṁkāraśiva (AD 960), the beginning of the line at Rajor may be placed seventy five years earlier in *c.* AD 885 and that of the Chatraśiva sometimes before that date. It may therefore be concluded that *ācārya*s from Āmardaka (established in *c.* 775) came into prominence in Rajasthan by *c.* AD 850 first at Chatraśiva and then at Rājyapura.

90. Cf. V.S. Pathak, *Śaiva Cults, op. cit.*, p. 31.

91. *Ibid.*

92. Cf. *EI* vol. IV, 'Karhad Plates of Krishna III,' pp. 285-86, lines 58-66. Gaganaśiva of the record is described as: *karhāṭīya valkaleśvara sthānapati karañjakheṭa santati vinirgata īśānaśivācārya śiṣyāya mahātapasvine sakala śiva siddhānta pāragāya gaganaśivāya . . . sakalatapodhana.* Gaganaśiva was granted the village of Kankem along with trees, gardens and all produce, the fine on ten offences, etc.: *savṛkṣamālākulaḥ sadhānyahiraṇyadeyaḥ sadaṇḍadoṣādaśāparādhaḥ sarvotpattisahita ācandrārkanamasyo mayā dattaḥ.* The grant was for the maintenance of the ascetics who lived at the place.

93. Cf. R.D. Trivedi, *Temples of the Pratihara Period in Central India*, New Delhi, ASI, 1990, pp. 70, 86.

94. Cf. *MIG* p. 105.

95. Mirashi, 1955, p. 213, v. 48.

Ranod (also spelled as Ranaud, Rannod), originally Araṇipadra or Raṇipadra, was the *tapovana*[96] where Purandara rose to glory by performing penances before being invited to and lodged at Mattamayūrapura by Avantivarman Cālukya. Araṇipadra seems to be a compound of *araṇi* (a plant whose wood was particularly useful for igniting fire by friction) and *padra*[97] a "common land" (in a forest). It seems to have developed as Upendrapura[98] after Purandara established a *maṭha* here (*raṇipadra sanjña tapovanaṁ śreṣṭha maṭham vidhāya*, Ranod Insc., v. 15). It came to be venerated as a *gurusthāna* (seat of a teacher) and had an *āśrama* established originally by Purandara before his going over to Mattamayūrapura. It seems that the *maṭha* decayed in time (*viśīrṇa vidruta maṭha*) till Vyomaśiva[99] (c. AD 925) resurrected it. Vyomaśiva is described as having provided it with wealth, a granary, jewels, 'neighing horses' and 'roaring elephants.' He embellished the vicinity with a *vāpī* (tank) and temples dedicated to Śiva, Umā, Naṭeśa and Vināyaka.[100] The place seems to have become prominent like a *tīrtha* thronged by people on occasions. The pilgrims were accepted but were warned against planting trees on the bank of the *vāpī* and women among them were not permitted inside the premises of the *maṭha* in night.[101] The *maṭha* and its vicinities continued to flourish and expand. Pataṅgaśambhu who succeeded Vyomaśiva is said to have raised a Śiva temple 'white like moonlit sky' and 'lofty like the peaks of Kailāsa.' He pervasively acquired locations

96. Cf. Ranod Insc (*EI* p. 355, v. 15), it is again mentioned as a *tapovana* in Pataṅgaśambhu's inscription (Mirashi, 1974, p. 179, v. 12).

97. Ancient Malwa region was known for many *padras*, cf. H.V. Trivedi (ed.), *CII* vol. VII/1 (1991), pp. 153, 156. Araṇipadra is mentioned as Araṇipadam in the Kadwaha Fragmentary Stone Inscription. As such *pada* may signify the destination of a journey, e.g., *padyate gamyate'smin-padaḥ*.

98. Cf. footnote 27 above.

99. Cf. *EI* vol. I, pp. 355ff, vv. 20, 29, 30. Opinion differs on his identification. Pandit D. Sastrin (1928) identified him with Śivāditya Miśra, the author of the *Saptapadārthī* (*Lakṣaṇamālā*), a text on Vaiśeṣika philosophy. In this he was following the views of Pandit Nilakantha Sastri the editor of the *Śivādvaita-darpaṇa* who assumed that Śivāditya *ācārya* was accorded the name Vyomaśiva by his *guru* Siddhacaitanya Śivācārya, after his initiation and as such he occurs in the list of the ascetics of the Śaiva school founded by Vasava in Karnataka in c. AD 1200. According to Gaurinath Sastri, Vyomaśiva was fifth spiritual successor of Purandara (*mattamayūranātha*), "the founder of two *maṭhas*, one at Mattamayūrapura, probably identical with Ma-yu'lo referred to by I-t'sin, as in the neighbourhood of present Haridvara and the other at Ranipadra. . . ." Cf. Gaurinath Sastri (ed.), *Vyomaśivācāryaviracita Vyomavati*, 2 vols., Varanasi: Sampurnanand Sanskrit Vishvavidyalaya, 1983, vol. I, pp. ii-v; also pp. v-viii. Gaurinath Sastri places Purandara in AD 625-40, taking him to be a contemporary of Maukhari ruler Avantivarman who acceded the throne in AD 565. He regards Vyomaśiva as belonging to north-west because he mentions Pancapura (Pancakarpat, same as Pancagoda on the bank of Panjakora river, a tributary of Swat) and also Hirathaka, a term for persons from Herat. We however place Vyomaśiva in c. AD 925. That he was an *ācārya* of Śaiva-Siddhānta is clear from the Ranod inscription itself, which reads: *siddhānteṣu maheśa eṣa niyato . . .*' etc.

100. *Ibid.*, vv. 30, 44, 51-52. The succession of the ascetics after Purandara was as follows, Kavacaśiva, Sadāśiva Hṛdayaśiva (Harahāsa), Vyomaśiva and Pataṅgaśambhu, cf. Mirashi, 1974, pp. 179-82.

101. Cf. Mirashi, 1974, pp. 180-82, vv. 28; 29-37; 39-40: *maṭhanadevakulaṁ kūpastadāgānāṁ cha pañchakaṁ prākāro vāṭikā kārayeta*.

(*sthāna*) in Araṇipadra where he built a *maṭha*, two temples, wells, five *taḍāga*s (water tanks) and enclosed some of the structures with a *prākāra* (fortification wall). He also laid a garden.[102] The sacred topography of Araṇipadra from Purandara (c. AD 825) to Pataṅgaśambhu (c. AD 950) thus came to be defined by at least five temples, two *maṭha*s, six water-bodies, a walled enclosure, wells and a garden. In number, these appear to be far in excess of needs of the reclusive *muni*s and their disciples. It may therefore be surmised that these constructions catered to the needs of a large number of people who were attracted to the place. As they thronged to Araṇipadra, a need must have arisen to control them. As a result of controlling mechanism they were prohibited to sleep on beds or plant trees near the tank just as women were not allowed into the enclosure during night. Royal patronage was missing is these activities and Pataṅgaśambhu is specific in stating that he constructed the temple, etc., through the 'valour of his own arms' (*svabhujopārjita*). The inscription is silent about specificity of 'valour.' The sacred space in Araṇipadra in these references is seen on occasions as restricted to *gurusthāna, sthāna, āśrama, vasati* and *maṭha*. Then it is found enlarged pervasively to *tapovana, viṣaya, pradeśa, diśaḥ* and *urvī*. Together, they define the influence that the *maṭha*s, their *muni*s and Śaiva-Siddhānta generally wielded on people in vast territories. Today, most of the Ranod is reduced ruins and rubble apart from an ancient *maṭha* and a beautifully laid, ancient *vāpī* (tenth century) besides a tank (Gatlaika *talāo*) five wells, two mosques and three tombs of the seventeenth century.[103] Events kept on happening at Ranod from VS 1526 to VS 1805 and from Hizra (H) 732 to H 1204 in the reigns of Muhammad Bin Tughlaq (VS 1674), Shahjahan (H 1043), Aurangzeb (VS 1717, H 1073, 1088, 1098) and Shah Alam II (H 1204). In these events the Siddhānta stood sidelined and with the passage of time it disappeared from the site altogether, leaving behind only a *maṭha* and a *vāpī*.

102. Cf. *EI* vol. I, pp. 43, 51.

103. More than a score of inscriptions from Ranod from fifteenth to seventeenth century indicate a history of the site in which there is absolute silence about Śaiva-Siddhānta or its sages or even its activities. Ranod is mentioned as a *qasba* in VS 1720 and as a *parganā* in the Chanderi *sarkar* of *sūbā* Malwa in VS 1805. It remained in *faujdārī* and *amīnī* of Husayn Khan and *rāi* Mansukh in VS 1720, and others in VS 1724. The *quanungos* of VS 1720 and VS 1805 and its *caudharī* of VS 1720 are also known from records. During all these years it witnessed public works like, digging of wells, construction of *baodi*, including the *akhti-ki-baodi* in VS 1526, 1720, 1724, 1805 and Hizra (H) 1073; of mosques in H 732, 825, 1043, 1088, 1204 and one more (un-dated); of a Gate in H 1078. Inscriptions also refer to a *ṭhākura* of Ranod in VS 1720; to Ratnākara Deva of *gauḍa anvaya* who built a well and laid a garden in VS 1526; to the Jaina pontiffs of *mūlasaṁgha* and *Sarasvatīgaccha* in VS 1674; to the making of an image in VS 1674. In course of such activities Śaiva-Siddhānta withered away as a result of demographic, administrative and political changes in Ranod. It may have disappeared by the time of Muhammad Bin Tughlag or even before him, for nothing about it is found recorded after Pataṅgaśambhu (c. AD 950). For inscriptions from Ranod, cf. *MIG* pp. 36, 47, 50, 56-57, 63, 79, 84, 85, 92-96, 98, 99, 104, 119. The memory of Araṇipadra being a centre of Siddhānta Śaivism is however preserved in a MSS of *Prāyaścitta Samuccaya*, which refers to an *āśrama* of Śrī Raṇipatraka and to Lambakarṇa, a *muni* belonging to it. He is mentioned as *mattamayūra vaṁśaja*, belonging to the Raṇipatraka *āśrama*. In being the preceptor of Paramāra ruler Siyaka (AD 944-73) he may be similarly dated and that may take the Ranod line of the *mattamayūra santati* up to AD 973 after which the records are silent.

No account of the rise of the Siddhānta in northern Madhya Pradesh would be complete without reference to Madhumatī (Mahua, in Shivpuri district). Madhumatī has a unique position as it had come into prominence already in the seventh century with the construction of a *maṇḍapikā* dedicated to Śiva-Dhūrjaṭī.[104] Its rise is seen coinciding with the inception of Śaiva-Siddhānta at Kadwaha in time of Kadambaguhādhivāsī (*c.* AD 675). Madhumatī is situated about 10 km away to the north-east of Kadwaha and it is tempting to suggest that it could have been the site occupied by Kadambaguhādhivāsī whose name left its imprint on Kadwaha in the vicinity, while he repaired to Madhumatī. This suggestion may also conveniently resolve the occupation of Mattamayūrapura (Kadwaha) by Purandara later in *c.* AD 825. But Madhumatī does not find explicit mention as a seat of the Siddhāntikas till AD 973 when, recounting the past, the Chandrehe inscription[105] refers to the Mattamayūra clan and to Purandara and then on to his disciple Śikhāśiva, the *mādhumateya*. It would follow that Śikhāśiva derived his name from Madhumatī which was already in existence before Śikhāśiva. Madhumatī's glory is repeatedly sung in the Kalacuri inscriptions from eastern Madhya Pradesh even as they refer to the *muni*s of Madhumatī who were invited and settled in different monasteries built in that region for them. Prabhāvaśiva of Madhumatī, who was 'foremost among ascetics' and was 'revered by many kings' (*aneka nṛpa vandita*), was invited to his kingdom by Yuvarājadeva I (AD 915-45). His coming was a celebrated event and he is said to have 'sanctified the wanton woman that was the earth.'[106] A monastery was built at 'great cost' for him by Yuvarājadeva I probably at Gurgi (near Rewa) and he appropriately took charge of it.[107] His disciple Praśāntaśiva built a *siddha-sthāna* and a *tapa-sthāna* for ascetics respectively on the banks of Śoṇa and on the bank of Gaṅgā at Varanasi.[108]

104. Cf. S. Sankaranarayan, G. Bhattacharya: 'Mahua Inscription of Vatsarāja,' in: *EI* vol. XXXVII, pp. 52-56. This four-line inscription of five verses begins with an obeisance to Śiva in Siddhāntika terminology addressing him as *parama tattva*, *niṣkala* and *kālātman* who is the "cause of generation, sustenance and destruction of the *jagat*" (v. 1). It refers to the genealogy of Vatsarāja (of Avanti region). He built a 'beautiful' (*ramya*) stone *maṇḍapikā* (*śilā maṇḍapikā*) of Dhūrjaṭī for welfare of his parents and also for increasing *dhana*, *ratna* and *kośa*. Vatsarāja is significantly described as one whose person bore effulgence of *Brahma* and *Kṣatra*. His body was divided into those two parts by a *yajñopavīta* worn by him (v. 4). This *praśasti* was composed by *bhaṭṭa* Īśāna, son of *bhaṭṭa* Somāṅka. Īśāna hailed from Kānyakubja and he was a follower (*anugāmī*) of Vatsarāja (cf. *EI* vol. XXXVI, p. 55).

 The editors date this inscription to the middle of eighth century but others accept it as a seventh century record. As for Dhūrjaṭī, he is prayed elsewhere, in the Ranod inscr. (vv. 4, 34, 41) and again in the Chandrehe inscription (v. 8) which were issued by the *ācārya*s of the Siddhānta later. There could be some connection between the Dhūrjaṭīs of these records.

105. Cf. Mirashi, 1955, p. 200, vv. 4-5.

106. Cf. Mirashi, 1955, p. 200, v. 5.

107. *Ibid.*, p. 237, v. 7.

108. *Ibid.*, p. 232, vv. 13-14. He also built two temples, one probably at Gurgi near Rewa and the other at Chandrehe (Sidhi District, M.P.); his disciple built a *maṭha* at Chandrehe (*ibid.*, p. 201, v. 16).

Madhumatī continued to flourish despite these immigrations and more for, the Gurgi Stone Inscription of Kokalladeva II (last quarter of tenth century) underscores its eminence as follows:

> There is in this world Madhumatī, the abode of those who are versed in Śaiva Siddhānta, which contains excellent *ācārya*s of noble conduct; in which peacocks dance and shriek with joy at the untimely appearance of clouds caused by the uninterrupted mass of dark smoke of ever-kindled (sacrificial) fires; and which laughs at heavenly world with the mass of lustre of large and resplendent jewels set on the rows of its high mansions; — verse 3

> where appeared the first best ascetics whose minds were restrained by vows, (and) who taught the great and flawless doctrine of Śiva to their disciples; whose well-known fame, having the bright lustre of the nectar, even now whitens the universe, delighting the prosperous and learned men even as moonlight does the assemblage of night lotuses.

> — verse 4[109]

The Chandrehe inscription (AD 973) connects Madhumatī line of ascetics to Mattamayūra clan and its beginnings to Śikhāśiva, a disciple of Purandara,[110] designating the former as Madhumatīpati, 'the lord of Madhumatī.' But the Bilhari inscription of Yuvarājadeva II (c. AD 980-90) refers to a 'Mādhumateya' preceding Cūḍāśiva (same as Śikhāśiva). This Mādhumateya is identified with a Purandara (II) different from Purandara, the Mattamayūranātha.[111] After Purandara II and Cūḍāśiva in the line, came Hṛdayaśiva who, according to the Bilhari Stone Inscription (vv. 55-58) was the 'fame of Madhumatī lineage.' Lakṣmaṇarāja II, a Kalacuri ruler, invited him sending "precious presents (with) well-conducted messengers (who) brought him respectfully (and) in due form." The

109. *Ibid.*, p. 224, vv. 3-4, transl. p. 231.

110. *Ibid.*, p. 200, v. 4, transl. p. 202.

111. *Ibid.*, p. 213, vv. 53, 51-52; also, the genealogy worked out by Mirashi, 1955, *C.I.I.* vol. IV (1), *intro.*, p. cliv, where a succession is mentioned in which Purandara *alias* Mādhumateya is followed by Cūḍāśiva. The stone inscriptions from Chandrehe (vv. 4-6), Bilhari (vv. 52-55), and Gurgi (vv. 3-5) give a version of genealogy of Madhumatī ascetics, which is different from the one in the Bilhari insc. (v. 43). But the difference may be resolved by placing three ascetics namely Pavanaśiva, Śabdaśiva and Īśvaraśiva (of Bilhari insc. cv. 43) before Purandara II (c. AD 890) and his disciple Cūḍāśiva (same as Śikhāśiva: AD 915). The dates would thus tally with the reign of Yuvarājadeva I and his wife Nohalā (the Cāḷukya princess) (915-45), and their son Lakṣmaṇarāja II (AD 945-70) who were the Kalacuri rulers on whose invitation the ascetics of Madhumatī came to their kingdom. It seems that after Cūḍāśiva of Madhumatī the ascetics of this branch in Kalacuri region further divided into two lines. One of these lines extended from Prabhāvaśiva to Praśāntaśiva and Prabodhaśiva at Gurgi and Chandrehe. The other line had Hṛdayaśiva both at Nauhaleśvara and Vaidyanātha Maṭhas, and Aghoraśiva at Nauhaleśvara. Another Prabodhaśiva, who was a disciple of some *ācārya* (name lost), is mentioned in an inscription from Budhi Chanderi (Guna Distt.). He belonged to the lineage of Dharmaśambhu. Cf. *MIG* p. 4, inscr. dated VS 1100. Dharmaśambhu is mentioned in the Bilhari insc. (Mirashi, 1955, p. 220, v. 50) as a successor of Mattamayūranātha (same as Purandara). Obviously, there seem to have been two Prabodhaśivas, one at Chandrehe (AD 970) and the other in the vicinity of Kadwaha-Malwa, at Budhi Chanderi in VS 1100, at least a generation later.

king lodged him at Vaidyanātha *maṭha* whereupon he passed the charge of Nauhaleśvara *maṭha* (of Bilhari?) to his disciple Aghoraśiva.[112] It seems that Nauhaleśvara *maṭha* built by Nohalā for Īśvaraśiva, a sage from Madhumatī line, had become vacant which necessitated this rearrangement. Nohalā was the queen of Yuvarājadeva I (AD 915-45) and daughter of Avanivarman Cālukya (c. AD 900) who hailed from the Kadwaha-Mattamayūra region. The ascetics of that region were brought to the Kalacuri kingdom probably at the behest of this queen. This is the first instance of a woman, a queen in this instance, being instrumental in transplanting the Śaiva-Siddhānta and its pontiffs from Guna-Shivpuri region to the Kalacuri kingdom in eastern Madhya Pradesh with substantial grants to support them. Her husband Yuvarājadeva I and her son Lakṣmaṇarāja II supported her efforts in full measure, and followed her example in setting up *maṭha*s for the pontiffs who were invited from her homeland.[113] In this situation, Madhumatī turned into an inexhaustible source in providing several ascetics, e.g., Prabhāvaśiva at Gurgi (near Rewa); his successor Praśāntaśiva at Gurgi and Chandrehe; Hṛdayaśiva at Vaidyanātha *maṭha* (Maihar?) and Aghoraśiva at Nauhaleśvara *maṭha*. All this, while the parent *maṭha* at Madhumatī continued with those *muni*s who had stayed back.

Madhumatī witnessed construction of three temples. The earliest of those was dedicated to Śiva-Dhūrjaṭī (seventh century) and the other, also a Śaiva temple, was built in the eighth century. The third temple of the ninth century was dedicated to Cāmuṇḍā.[114] Madhumatī was also the site where woman committed *satī*. Two such instances are recorded there in the memorial stones respectively of VS 1688 and 1765. The story of expansion of Siddhānta Śaivism in northern M.P. concludes with Madhumatī. There might have been in the region certain other *maṭha*s perhaps at Keldhar in Shivpuri District where traces of fortification occur and at Gwalior at Gorkhi (the site of an ancient *golakī maṭha*?) but a conclusion about these is uncertain.

Two points need being underscored here; one, the irony that the sect which was once partial to women in disallowing their entry inside *maṭha* was, in course of time, substantially patronized by a woman, Nohalā, a Cālukya princess turned a Kalacuri queen. She proved to be instrumental in providing a foothold to Śaiva-Siddhānta in eastern Madhya Pradesh from where it went to Andhra with a renewed vigour after a distinguished history at *golakī maṭha* near Jabalpur. It is again ironical that the sacred sites of the *maṭha*s came to have a dubious distinction of being the places where time and again woman committed *satī*. The other point that needs stress is about the nature of

112. Cf. Mirashi, 1955, p. 213, v. 58: *munirbhūyo maṭhaṁ nauhaleśvaraṁ aghoraśivaśiṣyasya sādhuvṛttasya dattavān*. The Nauhaleśvara *maṭha* was very substantially provided with grants by Yuvarājadeva I and his wife Nohalā, the daughter of Avanivarman Cālukya.

113. Cf. Mirashi, 1955, *intro.*, pp. clv, clvi.

114. Cf. R.D. Trivedi, *Temples of Pratihara Period, op. cit.*, pp. 67-70; 119-21.

sites at Kadwaha, Surwaya, Terahi, Āmardaka (Amrol), Ranod and Madhumatī. Originally they figured as *tapovana;* some of these sites (e.g., Kadwaha and Ranod) turned into large settlements but the rest even today stand solitary. They are remotely placed and hard to reach. The ruins of *maṭha*s, as they stand today, are imposing.

II

This entire monastic movement grew up in the northern Madhya Pradesh spearheaded by its ascetics. The pontiffs' austere life given to extreme penance and reclusive ways is not in doubt, nor is so their extraordinary erudition. Inscriptions offer sufficient material on these aspects of the *muni*s. But these alone would not translate either into the empowerment of *muni*s or proliferation of their *maṭha*s. For that we must look for other reasons. In fact, the land and people of the region under review seem to afford explanation for ascetics' empowerment even as they betray non-competitive, political and social institutions in comparison. The rise of Siddhānta Śaivism may be viewed from this perspective.[115] Its rise indeed seems rooted in the hinterland (*tapovana*s) rather than in towns though towns ordinarily have both political and economic primacy. A comparison between town and hinterland may, in the situation, help in further ascertaining the point. First we may deal with towns in the region.

Two inscriptions from Gwalior (AD 875 and 876) provide some general idea about a typical town in northern Madhya Pradesh in the ninth century. According to the inscriptions, Gwalior (Gopāla-Kheṭaka, Gopālikera), the chief town of the region had a cluster of settlements around the fort. These consisted of general localities, e.g., Carcikā-Haṭṭikā, Nimbāditya-Haṭṭikā, Śrī Sarveśvarapura and Śrīvatsa-svāmīpura, representing the settlements of oilmen (*tailika*s). Two other settlements namely, Vyāghrakeṇḍikā and Jayapurāka were peasants' villages. The locality named Cūḍāpallikā and the hills of Gwalior were the habitats of the gardeners. A *sthāna* in the city was under the *sthānādhikṛta*. The fort was in the hands of a "warden of boundaries" (*maryādā dhurya*) and *koṭṭapāla*, i.e. Vaillabhaṭṭa and his son and successor Alla. These two served Mihirabhoja, the Gurjara-Pratihāra ruler of Kanauj. Inscriptions suggest that the town was administered by a board (*vāra*) run by the *sthānādhikṛta* (compare this with *sthānapati* Gaganaśiva of the Karhad Plates of Kṛṣṇa III, dated AD 959 and others like Śaṅkhamaṭhikādhipati, etc.), along with *śreṣṭhī, sārthavāha-pramukha, tailika-mahattara,* and *mālika-mahattara*. The primacy of traders is quite apparent in these arrangements.[116] As against this, the hinterland was in the hands of people who

115. Cf. R.N. Misra, 'Religion in a Disorganized Milieu,' in: Joseph T. O'Connell (ed.), *Organizational and Institutional Aspects of Indian Religious Movements*, Shimla: Indian Institute of Advanced Study, 1999, pp. 57-78; *id.,* 'Pontiffs' Empowerment in Central Indian Śaivite Monachism,' *Journal of Asiastic Society of Bombay,* N.S., vol. 72 (1997), pp. 72-86; *id.,* 'The Śaivite Monasteries, Pontiffs and Patronage in Central India,' *Journal of Asiatic Society of Bombay,* N.S., vol. 64-66, (1989-91), pp. 108-24.

116. As for Alla, he belonged to *Varjara (Banjara?* a nomadic tribe) *anvaya (EI* vol. I, p. 156, v. 2). Alla's →

descended from *Śabara, Pulinda, Seka, Aparaseka, Kacchapa, Bhadakana*s (as also robbers). These were pre-eminently the forest tribes — *āṭavika*s, in other words. Like the traditional *āṭavika*s described in the *Arthaśāstra* of Kauṭilya, these forest tribes were most probably fierce, belligerent, rebellious and mercenary. The term *bhaṭa* is commonly found used for warriors in the region. It seems to be generically applied to Gobhaṭa, Undabhaṭa, Dhūrbhaṭa, or even Vāyillabhaṭṭa and Allabhaṭṭa who, in a way, were warriors indeed. These were the persons who rose to the level of feudal chiefs under the Gurjara-Pratihāras.[117] Their brethren in the hinterland, the other *āṭavika-bhaṭa*s (warriors in forest), were not necessarily given to agricultural pursuits as the forests provided them subsistence and traders' caravans passing through their territory afforded them other commodities by plunder. Occasionally, they carried out cattle raids[118] in which lives were lost. As we shall see below, even armies on military expedition were not safe in the *āṭavika*s' territory. The movement through the wooded territory mattered for the traders and their caravans. But they found themselves vulnerable to these forest tribes, as the *bhaṭa*s controlled the hinterland. Only a compromise with them could have made the traders ply their trades, or rulers extend their sovereignty or even reach their desired destination.[119] In fact, trade was so brisk and traders so prosperous in the region that Hiuen Tsang (seventh century) ascribed vaiśya rulership to the Po-Li-Ye-To-Lo country (Pāriyātra region)[120] which apparently bordered on and included western and northern parts of Madhya Pradesh. In this entire scenario the northern Madhya Pradesh seems divided into towns and hinterland with towns dominated by traders and hinterland controlled by forest tribes till the emergence of the *muni*s and *maṭha*s of Śaiva-Siddhānta. The intractability of hinterland is in evidence time and again; for instance, in the time of the Kacchapaghāta

→ vocation as a warrior seems to be confirmed by his position as a *koṭṭapāla* and a 'warden of boundaries' at Gwalior in AD 876 (*Ibid.*, p. 156, line 2). He could be the grandfather of another Allabhaṭṭa who died fighting at Terahi in AD 903 (cf. *MIG* p. 2). This inscription is dated in VS 962. Forts are mentioned in the cases of both Gwalior and Terahi (for the latter, cf. *Indian Antiquary*, vol. XVII, p. 202). It thus appears that the feudal chiefs worked from fort to fort, as hinterland was generally votatile.

117. Cf. R.N. Misra, 'Religion in a Disorganized Milieu,' *op. cit.* (see fn. 115), pp. 60-66. Hiuen Tsang's description of Pāriyātra country gives a different picture about the neighbourhood of northern M.P. He says: "Grain is abundant here and late wheat. . . . The climate is warm and fiery; the people are resolute and fierce. They are not given to learning and are given to honour the heretics. The king is of the vaiśya caste; he is of a brave and impetuous nature and very warlike" (Samuel Beal [transl.]: *SI-YU-KI. Buddhist Records of the Western World*, Reprint, Delhi, 1969, p. 179).

118. For instance, an inscription from Devakani (Guna District) refers to Sahajanadeva in connection with some quarrel about cattle. His two wives committed *satī* on his death. The episode took place in VS 1387 and the record refers to the time of Muhammad Tughlag (cf. *MIG* p. 23). Memorial pillars from Shivpuri region and around, now deposited in Central Archaeological Museum, Gwalior depict herds of cows in decorative panels. These depictions may suggest demise of those heroes in cattle raids. For another warrior, cf. *MIG* p. 7, inscr. dated in VS 1177.

119. Harirāja, the Later Pratihāra ruler, contacted the Kadwaha *ācārya* through a messenger. So did Lakṣmaṇarāja in the case of Hṛdayaśiva who was approached through 'well-conducted messengers.'

120. Cf. S. Beal (transl.), *SI-YU-KI, op. cit.*, p. 179.

ruler Kīrtirāja (1015-35), when villagers are said to have seized the arms of the defeated Mālava army.[121] Then again in time of Kīrti Singh Tomar (1459-80) of Gwalior when the defeated army of Sultan Hussain Shah Sharqui was plundered[122] relentlessly. The menace of robbers too was real and rulers tried hard to emasculate them but with little success.[123] As we said earlier, cattle raids were common in the region and the latest instance of these is dated in vs 1387. We also have a reference from Narwar of a Vanavīra, 'valiant of the forest' (vs 1524): a *rāut* who had *jogī* Makaradhvaja as his preceptor.[124] The nature of land of northern Madhya Pradesh, divided as it was largely into deep forests and desiccated ravines (*kaccha*), provided an ideal habitat for the tribes or people, *āṭavika* in character. The first regional dynasty, the Kacchapaghātas emerged to power after exterminating the Kacchapas, which is suggested by their very name, i.e. Kacchapaghāta.[125] Political power in the region seems weak in these situations and hinterland, with its vast stretches, seems independent of political control. Even the Gurjara-Pratihāras could not alter the situations and hinterland seems to have remained independent of political control. So they drafted the *bhaṭas* into their polity, as is indicated by the names of Dhūrbhaṭa, Gobhaṭa, etc. Undabhaṭa (AD 903) among them was a *mahāsāmantādhipati* whose successor Dhūrbhaṭa is designated as *mahārājādhirāja* (AD 912-13) even as his Gurjara-Pratihāra overlord[126] held sway.

The entire northern Madhya Pradesh thus seems divided into towns (e.g., Gopālikera, Dobha and Padmāvatī) on one hand and vast expanse of hinterland on the other. In this division, the towns went into the hands of traders and the hinterland, invincible as it was, was controlled by the *bhaṭas* of the forest tribes which like the *bhadakana*s of yore (who lived in the natural rock shelters) occupied inaccessible forests. The *bhadakana*s of Shivpuri (second century BC) are mentioned in a clay seal also recently found in excavations at Adam near Nagpur (information kindly provided by Mr. Amarendra Nath, the excavator of Adam). Their connection with trade through Shivpuri region to ancient Vidarbha is thus proved beyond doubt. Entry into forests must have been risky till at least the *muni*s started occupying the *tapovana*s. Their life was steeped in austerities, a life that forests could endure and forest tribes would not contest. Their presence was not intrusive and they were bound to their hermitages. So, they could settle in the *tapovana*s uncontested by the people and tribes (*āṭavika*s). The *muni*s claim to have protected people

121. Cf. *Indian Antiquary*, vol. XV, p. 36, v. 10; also H.V. Trivedi (ed.), *CII* vol. 3 (1989), p. 542, v. 20.

122. Cf. B.D. Mishra, *Fort and Fortresses of Gwalior and its Hinterland*, Delhi, 1993, p. 140, quoting Habib and Nizami.

123. Cf. H.V. Trivedi (ed.), *CII* vol. VII, 3 (1989), p. 543, v. 20.

124. Cf. *MIG* p. 34.

125. H.V. Trivedi (ed.), *CII* vol. VII/3 (1989), p. 542, vv. 5-7, which describes Lakṣmaṇa, the first ruler of the Kacchapaghāta *vaṁśa* and his coming to power by force: *haṭhāt utpāṭya pṛthvībhṛtaḥ*. In the Dubkund inscription (*ibid.*, p. 532, v. 7). Yuvarāja is *Kacchapaghāta-vaṁśa-tilaka*.

126. Cf. *EI* vol. I, pp. 167, 169.

(*prajā; prāṇinām*) in times of distress to which reference has been already made above. Over a period of time the *maṭhas* succeeded in being beacons to the woodland communities because of their works of public utility, e.g., building temples, *vāpīs* and digging wells, fording rivers, holding festivals. They could also play the role of intermediaries between traders and forest tribes which they did. The *maṭhas* thus provided succour to visitors and safety to traders and perhaps even quartered them in times of need. They lent money to traders without charging interest.[127] The *maṭhas* wealth was substantial and included *dhana, dhānya, hiraṇya, ratna,* currency and even horses, elephants and cattle. With the passage of time they, in all likelihood, started employing cultivators to till their extensive land and artisans to build temples, *maṭhas* and other works. To the forest people and to the community they offered succour perhaps by dispensing medicine[128] and providing sustenance. It seems that they gained universal acceptance possibly as a result of their assumed role of mediation between woodlands and towns and between the *āṭavikas* and the traders. This would have opened doors for brisk trade in early medieval times in the region. It is seen that Siyadoni[129] in neighbourhood did develop into a market town. Having thus received acceptance, the *munis*, no wonder, were actively sought after by rulers for political and economic benefits. A later inscription[130] gives credit to a Śaiva pontiff for having brought virgin areas into revenue net of the ruler.

As of today, the *maṭhas* stand as fortified constructions at Ranod and Surwaya. At Ranod, the crenellations on the hind wall of the *maṭha* along with small tower (containing staircase inside) seem contemporary to Purandara (*c.* AD 825) with renovations done in times of Vyomaśiva (*c.* AD 925). The fortification of the *maṭha* at Surwaya was in place in AD 1292 but its beginnings may go back to the eighth century. A proximity of *maṭha* and a fort is in evidence at Terahi and at Kadwaha too.[131] As indicated earlier, we have the instance of an ascetic at Kadwaha who, out of pity for a local ruler, took up arms like Tripurāntaka and "conquered the whole army of foes by means of a bow and arrow acquired by his own miraculous powers."[132] (With *āṭavikas* on their side), routing the raiders was not impossible for them but that act however has clearly and pointedly a hint of militancy on the ascetics part. Other clues on this aspect of *munis* are also available. The presence of forts along with the *maṭhas* might indicate polity working in concert

127. Cf. *EI* vol. XXI, p. 36, v. 24: *vṛddhyarthaṁ arthaṁ āśrjadbhiḥ. . .*

128. Chandrehe inscription (Mirashi, 1955, p. 201, v. 14) confirms the knowledge of Prabodhaśiva about medicinal plants which grew around his *maṭha* and at which people are said to have looked with wonder.

129. Cf. *EI* vol. I, pp. 167-68; 172.

130. Vimalaśiva 'made even most distant people pay taxes,' cf. Mirashi, 1955, p. 339, v. 44.

131. The *koṭṭapāla* of Terahi is mentioned in a local inscription. Cf. *Indian Antiquary*, vol. XVII, p. 202. For Kadwaha fort, cf. *MIG* pp. 30, 31 where inscriptions of vs 1499 (two such) and vs 1504 are said be from "fort." If this 'fort' were not confused with the *maṭha*, it would indicate presence of a fort at Kadwaha where these inscriptions were noticed.

132. *EI* vol. XXXVII, p. 123, vv. 16-18.

with temporal power. The convergence of the two roles in sages is implicit in a later inscription where a *muni* is mentioned as *śastra-śāstra viśārada*, 'adept in learning as well as in weaponry.'[133] The *muni*s and the *maṭha*s in these references seem to have relegated political institutions to a subservient status. Not surprising therefore that in several instances, ruling kings are found supplicating to them. With forest tribes (generically the *āṭavika*s) under their control, rulers under supplication and traders protected, the *ācārya*s (*sthānapati*s), erudite in disposition and saintly in character paled others to a secondary status. This was perhaps possible in the Gopācala region where traditional *varṇa-jāti* model of social hierarchy seems absent till at least the eleventh century. Before AD 1092 brāhmaṇas find sporadic mention in the records of northern Madhya Pradesh at Tumain, Sesai and Mahua (seventh century). But a proper settlement of brāhmaṇas with a grant is in evidence for the first time in connection with a *brahmapurī* attached to Padmanātha temple at Gwalior in AD 1092. Similarly, a proper land grant to a brāhmaṇa (of a dubious *gotra* and *anvaya*) is seen in AD 1220.[134] As for kṣatriyas, a ninth century inscription from Gwalior refers to kṣatriya Memmaka, son of Devavarman, as a cultivator who tended his irrigated land in Jaipurāka locality of ancient Gwalior. Before that date, the Mahua inscription refers to Vatsarāja as combining the 'effulgence of *brahma* and *kṣatra* in his person (with the two) equally divided by his *yajñopavīta*.' Taken literally, this may mean neither a full brāhmaṇahood nor full kṣatriyahood for, the ruler's legitimacy seems to have rested in his *khaḍga* and in his being a *bhūpati*.[135] Others like *ṭhakkura*, *rājā*, *rāut*, *rāṇaka* — which are titles, assumed or conferred — are found in plenty in the inscriptions after the ninth century from the region. In comparison, *bhaṭa*s seem more conspicuous. For instance, we have the *bhaṭa*s, mentioned above, who served as feudatories of the Gurjara-Pratihāras. Or, other *bhaṭa*s who died fighting in a battle between the Yājvapāla Gopāla and Vīravarman Chandella on the banks of river Valuā at Bangla in Shivpuri district.[136]

133. Mirashi, 1955, p. 372, line 17.

134. Cf. R.N. Misra, 'Religion in a Disorganized Milieu,' *op. cit.* (see fn. 115), p. 60. Before this date, some brāhmaṇas who were brothers built a temple at Tumain (Guna district). *Dvija*s are mentioned in Mihirakula's inscription from Gwalior. At Sesai a brāhmaṇa mother immolated herself at the death of her sons. These are sporadic reference to brāhmaṇas in the region but the first of such settlers are noticed in Gwalior in AD 1092. This statement revises our earlier stand about the first mention of a *brāhmaṇa* in AD 1220. The statement was made in R.N. Misra, 'Religion in a Disorganized Milieu,' *op. cit.*, p. 60.

135. Cf. *EI* vol. XXXVII, p. 55, vv.3-4.

136. Cf. H.V. Trivedi (ed.), *CII* vol. VII, 3 (1989), p. 580, inscr. no. 163, lines 7-8: *yuyudhe turagārūḍho nihatya subhaṭān bahūn*. The warriors entertained a chivalrous idealism in being valiant. This is seen in a verse written on a memorial stone from Terahi. The verse reads as follows: *jitena labhate pṛthvī mṛtenā'pi surāṅganā, kṣaṇa vidhvaṁsinī kāyā, kā cintā maraṇe raṇe* (A.K. Singh, 'Some Hero Stone of Gwalior and their Inscriptions,' *Pragdhara*, Journal of U.P. State Archaeological Organisation (Lucknow), vol. 5 (1994-95), p. 140.

Thus, it seems likely that rise of the Siddhānta and empowerment[137] of its *ācārya*s as well as their unhindered expansion from the seventh to the tenth century in northern Madhya Pradesh, the land of its inception, happened due to the non-competitive nature of social and political institutions in the region during the period of its ascendancy, as well as the absence of an imperial authority and of conventional *varṇa*-oriented social hierarchy. The primacy of forests and its *bhaṭa*s in hinterland and of traders in town required an institution to mediate between them. In absence of a strong political and administrative authority, the *maṭha*s and their *ācārya*s emerged supreme to fill the vacuum, relegating all else into subservience while they grew in strength. They remained powerful and strong in the region, at least till the fourteenth century, after which new administrative, demographic and political changes and also the internal contradictions (e.g., from celibate *muni*s they turned into householders) made them redundant.

137. Cf. R.N. Misra, 'Pontiffs' Empowerment,' *op. cit.* (see fn. 115), pp. 72-86.

16

Guhāvāsī and Devarāja in Cambodia

R. Nagaswamy

Pāśupatas in Cambodia

AN inscription dated *śaka* 998 (1076 CE) from Ponken Kan in Cambodia mentions a teacher Śivasoma Muni, who is called Guhāvāsī. The relevant part of the inscription reads:[1]

> *śivasoma munir matimān mānyo yamīnām yamī guhāvāsī* |
> *bhagavadpāda āmaraṇād arjunajaṭilo piṅgavari* ||

> Śivasoma who was learned (*matimān*), much revered (*mānyo*), and a recluse amongst recluses (*yamīnām yamī*), was living in caves of the hill (*guhāvāsī*), wearing matted hair, from the death of Bhagavadpāda [probably his preceptor] (*āmaraṇād*).

The term *guhāvāsī* also occurs in the ninth *sūtra* of the text *Pāśupata-Sūtra*s of Lakulīśa.[2] The *sūtra* reads *śūnyāgāra guhāvāsī* referring to the practice of a *pāśupata-vrata* which stipulates that one should stay in a deserted dwelling or in caves of hills, observing the disciplines prescribed in the text. Evidence suggests that the Śivasoma Muni mentioned in the Cambodian inscription is an adherent of *pāśupata-vrata*. We note in this context that many of the *ācārya*s of Cambodia were specifically mentioned as Pāśupata *ācārya*s from the sixth century onwards. They served as *rājaguru*s and were responsible for many of the magnificent monumental temples in Cambodia.[3]

A brāhmaṇa named Vidyāpuṣpa, who served as an official under king Bhavavarman in the early seventh century and who consecrated a *śivaliṅga*, an image of Durgā and one of Śambhu-Viṣṇu seems to be the earliest to be mentioned as a Pāśupata *ācārya*. A highly learned man, a scholar in grammar, Vaiśeṣika, Nyāya and other traditional *darśana*s, he obtained from the king a *praṇālikā* for the God Siddheśa and had it consecrated

1. Cf. Adhir Chakravarti, *India and South East Asia Socio-Econo-Cultural Contacts*, Calcutta: Punthi Pustak, 1998, p. 267.

2. Cf. *Pāśupata-Sūtras*, with the commentary of Kauṇḍinya, ed. R.A. Sastri, Trivandrum: University of Travancore, 1940.

3. Cf. R.C. Majumdar, *Inscriptions of Kambuja*, Calcutta: The Asiatic Society, 1953. All the Cambodian inscriptions quoted in this article with numbers are from this book (quoted as: Majumdar).

on the Phnom Pra Vihar in Cambodia. He also built a temple of brick for the God Siddheśa:[4]

> *tasya pāśupatācāryaḥ vidyāpuṣpāhvayaḥ kaviḥ* |
> *śabda vaiśeṣika nyāya tattvārtha kṛta niścayaḥ* ||

He is probably identical with or related to Vidyābindu, son of Dhruva and grandson of Dhruva Puṇyakīrti, occurring in an inscription, dated *śaka* 546 found in Bayang.[5] He consecrated a pair of feet of Śiva and a cistern for the ablutions of the god on top of the mountain. Referring to his pious deed, the record refers to Paśupati-pāda (Pāśupata). His father Dhruva and his grandfather Dhruva Puṇyakīrti were obviously Pāśupatas, indicating, that the Śaiva *ācārya*s in Cambodia were Pāśupata followers from the very beginning of sixth century.

Another *ācārya* named Vidyāvṛkṣa consecrated a *śivaliṅga* named Kadambeśvara in *śaka* 549 (627 CE).[6] He was learned also in Buddhism in addition to grammar, Vaiśeṣika, Nyāya and Sāṃkhya. He was deeply devoted to Śiva and wanted to remain a Śaiva devotee, in every birth:

> *śabda vaiśeṣika nyāya sāṃkhya sugata adhvanām* |
> *dhurīyo likhita śāstra-aneka prahata buddhibhiḥ* ||
> *icchatā bhaktim īśāne sthiram janmani janmani* |
> *tenedaṃ sthāpitaṃ liṅgaṃ sthiraṃ śuddhābhisandhinā* ||

It is possible this Vidyāviśeṣa, who is mentioned close to Vidyāpuṣpa, was related to the latter. The ruling King, Īśānavarman, appointed a brāhmaṇa who is mentioned as Pāśupata to do worship in the temple built by Vidyāviśeṣa.

> *dvijaḥ pāśupato rājñaḥ adhikṛto devatārccane* |
> *idaṃ devakulaṃ bhoktum arhatyadbhuta saṃplavam* ||[7]

Kumārāmbā, a queen, built a brick temple, dedicated to Śiva as Vardhamānadeva, for the merit of King Nṛpādityadeva. The inscription extolling the greatness of the God Vardhamāneśvara describes him as Nṛtta-Bhairava, who danced forcefully swinging his thousand arms:

> *bhairava vibhrama calita bhuja sahasra vardhamāno yaḥ* |
> *śrī vardhamānadevaḥ mahita caraṇaḥ no-vyād* ||[8]

The inscription seems to be dated in the reign of king Īśānavarman in the seventh century. One Vaktra-Śiva excavated a cave (*guhā*) on the hill Bhadreśvara-*śaila* (the hill of Vat

4. Insc. No. 10.

5. Insc. No. 18.

6. The inscription is dated in the reign of Īśānavarman, and comes from Sambhor Prei Kuk. Insc. No. 16 (Majumdar, p. 22, verses 8-9).

7. Insc. No. 17.

8. Nui Ba Inscription of Nṛpāditya; Insc. No. 22 (Majumdar, p. 27).

Phu) for the meditation of ascetics and named it as the cave of Vaktra-guhā. The establishment of a *guhā* in the temple of Bhadreśvara for the ascetics to meditate should be viewed against the background of the Pāśupata system and to its guidelines for ascetics to resort to *guhā*s for meditation (*śūnyāgāra guhāvāsī*). The record belongs to seventh century.[9]

King Yaśovarman of Cambodia, who ascended the throne in 889 CE, was an extraordinary personality, who built three great *āśrama*s for the followers of Śaiva, Vaiṣṇava and Buddhist faiths. His Prei Perai stele inscription refers to the *āśrama*,[10] which he built for the Śaiva ascetics. This seems to distinguish Śaiva and Pāśupata systems as it states that Śaiva and Pāśupata *ācārya*s should be respected after the worship of Vedic brāhmaṇas (*viprah*).[11] Among them one who is a master of grammar (*vaiyākaraṇa*) should receive greater respect. A teacher, who is an expert in all the three subjects Śaiva, Pāśupata and grammar, should be considered superior in that *āśrama*:

> *śaivapāśupatācāryau pūjyau viprāt anantaram* |
> *tayoh ca vaiyākaraṇah pūjanīyo 'dhikaṁ bhavaet* ||
> *śaivapāśupatajñānaśabdaśāstravidāṁ varah* |
> *ācāryo 'dhyāpakah śreṣṭhah atra mānyo varāśrame* ||[12]

The Śaiva and Pāśupata are clearly distinguished in this record and may be taken to refer to the Siddhānta Śaiva. The record goes on to detail which of the ascetics can stay in the *āśrama*. This *āśrama* was incidentally called brāhmaṇa *āśrama*. Those who observe the injunctions for all the part of the day (*trisandhi*), who were of noble conduct, ever-engaged in study (*adhyayana*), who have turned away from married life, who have conquered their senses, who do not sleep in unknown places, who are steadfastly devoted to their chosen god alone, these people are eligible to stay in this brāhmaṇa *āśrama*. They should be provided with vessels containing sacred ashes for bathing, vessels containing ash for cleaning, begging vessels and the like. All these clearly indicate provisions made for Pāśupata ascetics.

The Pāśupata-Sūtras and the Commentary of Kauṇḍinya

It would be appropriate to recall what the *Pāśupata-Sūtras* are about:[13]

> The name Paśupati was a very ancient one, meaning God of *paśu*s. 'Paśu' means ignorant and worldly, from Brahmā, the highest, to the smallest insect. The *Pati* is the creator, preserver and destroyer of this universe and is the

9. Cf. Insc. No. 38.
10. Cf. Prasat Komnap Stele Inscription of Yaśovarman; Insc. No. 66 (Majumdar, p. 120); also Inscriptions No. 67 and 68.
11. Cf. Prei Prasat Stele Inscription, Insc. No. 68.
12. *Ibid.*, verses 60-61.
13. R.A. Sastri summarizes the school admirably, in his introduction to the *Pāśupata-Sūtras* (see footnote 2), a part of which is relevant in this context.

uplifter of all beings, irrespective of *karma*. The sole duty of a disciple is to undergo training and attain salvation. Their followers should possess full vitality, soundness of senses and purity. Unlike in other religions, blind, deaf, dumb, and diseased people and sinners are not allowed to take up initiation. The disciple should give up everything and spend their time within the premises of the temple to start with. In his commentary, the *Gaṇakārikā* on *Pāśupata-Sūtras*, Bhāsarvajña writes of their daily duties. Of course, the rules are very rigorous. After undergoing the first stage, the disciples had to follow still harder rules. They had to court disrespect from the public to show they had lost pride and other egotistical tendencies. The third stage gives them training to conquer their minds and senses. They had to shut themselves off from society and live in caves, not affected by cold, heat, sun, rain. After passing this stage they have to remain in cremation grounds with all their thoughts concentrated upon Paśupati. This is the fourth stage. The fifth stage is to meditate on one Supreme God without regard to their surroundings. The meditation must be without strict attributes. When one gets rid of misery, called *duḥkhānta*, one becomes immortal and lives in the presence of god Rudra alone. This is salvation. Plain living, without egoism and high thinking, till one casts away one's physical body is the central cult of Pāśupata system. Five stages are taught in this cult: (1) the recognition of *kāraṇa*, the cause, i.e. Pati, the Lord; (2) *kārya*, effect, i.e. egos (*jīvas*); (3) *yoga*, i.e. joining with the Lord; (4) *vidhi*, rules for practice and (5) the end of misery called *duḥkhānta*. These are called *pañcapadārthas* in this system. The disciples have to worship the Lord, by repeating mentally *mantras* of Sadyojāta to Sadāśiva, which occur in their main sacred works, fully realizing their meaning. No other religious ceremonies are allowed.[14]

Pāśupata system is essentially a Yoga system that defines *yoga* as "the union of soul with the supreme Lord" (*ātmeśvara saṁyogaḥ yogaḥ*), different from the definition provided by Patañjali's *Yoga-Sūtra*, which defines *yoga* as *citta vṛtti nirodhaḥ*, cessation of mental activities. The Pāśupata definition also indicates that each school of Indian thought modified the definition to suit their line of thought. Thus, Pāśupata call their system as Pāśupata-Yoga, while the Sāṁkhyas called their one Sāṁkhya-Yoga, while Patañjali's system was more precisely known as Pātañjala-Yoga. The *Pāśupata-Sūtras* call their school at the beginning, as "Pāśupata-yoga-vidhi," which means that the text deals with specific injunctions for the observances of the followers. The system is also known as Pāśupata Śāstra, Pāśupata Tantra, Pāśupata Grantha or Pāśupata Vidyā. The commentator Kauṇḍinya holds *śāstra*, *tantra*, *grantha* and *vidyā* as synonyms.[15] The system is called Pāśupatam because it was expounded by Paśupati and also because the school is centered on Paśupati, chosen by the aspirant. This was taught by the supreme Lord, Paśupati, who descended "out of play" in human form, to teach disciples like Indra, Kuśika and others. He appeared in Kāyāvataraṇa (in Gujarat) and reached Ujjayinī by foot. The

14. R.A. Sastri, *Pāśupata-Sūtras*, intro., pp. 8-9.

15. *Ibid.*, p. 2, Kauṇḍinya's commentary *tatra śāstraṁ tantraṁ, grantho vidyāca*.

Pāśupatas believed in terminating the suffering *duḥkhānta* by following the injunctions prescribed in this Yoga system. The observances prescribed are not optional but essentials (*vidhi*). The system recognizes three instruments of cognition: *pratyakṣa, anumāna,* and *āpta-vākya* (according to the commentator.) The system defines Āgama as the school of thought that has come down in succession of *guru-paramparā* from Maheśvara (*maheśvarāt gurupāramparya āgataṁ śāstram*). It deals with actions connected with the spiritual world. The other *pramāṇa*s like *upamāna, arthāpatti, asambhava* (mentioned as *sambhava abhāva*), *aitihāsa, pratibhā,* etc., fall within these *pramāṇa*s. It is Bhagavān who himself propels it to be achieved. The individual is the seeker. The cognition is called *saṁvit,* which is defined as deep intellectual analysis (*pramiti iti saṁvit; saṁvit samyak cintanam sambodha vidyā abhiyukteti arthaḥ*). It is also clear that this system and its texts are intended for brāhmaṇas who have chosen this path by abandoning their married life (after *gṛhasthāśrama*), after being tested by the *guru,* to follow this discipline.[16] This stage, embraced by the aspirant, is called the extreme path (*atyāśrama*). The followers have certain prescribed injunctions and are expected to strictly adhere to them. They have to smear their body with sacred ashes three times a day, and use ashes for cleaning their bodily limbs for purification; they do not use water for bathing or cleaning. The ash not only cleans but also indicates the observance of *Pāśupatavrata.* They should also wear, for increase of devotion, flowers that decorated earlier an image of Śiva. The other important observance is that the follower should wear a *liṅga* on his head, neck, or chest (*liṅga-dhārī*), which is considered as a symbol of Pāśupata-Yoga. In the same manner the householder, the *brahmacārī, vānaprastha,* and *saṁnyāsī* carry distinctive symbols. He should reside in temples in ground or high up in mountains in the shades of trees. He also laughs, sings, dances, gives out a screaming yell, salutes, and recites the names of the god (*hasita-gīta-nṛtta-ḍumḍumkāra-namaskāra-japya-upahāreṇa-upatiṣṭhet*). These are the initial stages of the adherents. The commentator Kauṇḍinya gives some interesting details about these practices. *Hasita* is loudly laughing. *Gīta*[17] means singing in the classical tradition prescribed in musical treatises, which would mean following appropriate tunes and beats (*rāga*s and *tāla*s found in Gāndharva Śāstra), the qualities of Maheśvara Śiva, his objects of possession, and his gracious actions. One could sing the Sanskrit songs or Prākṛt or the compositions in regional languages, composed either by oneself or those composed by others. The dance[18] (*nṛtta*) is to be performed as prescribed in the *Nāṭyaśāstra,* by the combined movements of hands and legs through outward, inward, upward, and downward and whirling sweeps in the *sabhā* of the Śiva temple. At the prescribed times,

16. *Ibid.,* p. 3.

17. *tatra hasitaṁ nāma yadetat kaṇṭhoṣṭha-puṭa-vispūrjanam aṭṭahāsa kriyate tad hasitam |*
gītamapi gāndharva śāstra samaya anabhiṣvaṅgena yatra bhagavat māheśvarasya sabhāyāṁ gauṇa dravyaja karmajāni nāmāni cintayante tat ||

18. *nṛttam api nāṭyaśāstra-samaya-anabhiṣvaṅgena hasta-pādānām utkṣepaṇam avakṣepaṇam |*
ākuñcanaṁ prasāra calanam anavasthānam ||
niyamakāle niyamārthaṁ geyasahakṛtaṁ prayoktavyam ||

the dance should be performed to the accompaniment of music. This should be followed by recitation and *dhyāna* (meditation).

All these worships are to be done in adoration of Mahādeva in his Dakṣiṇāmūrti form (*mahādevasya dakṣiṇāmūrteḥ*).[19] The earliest reference to Dakṣiṇāmūrti occurs in this text, which incidentally shows that Dakṣiṇāmūrti[20] is identical with the *Aghora* form of Śiva.

A detailed account of the *Pāśupata-Sūtras* is given by S.N. Dasgupta[21] and is not attempted here. A few other points that need to be recounted here are:

(a) The adherent should observe strict celibacy, and

(b) refrain from any food not offered to God Mahādeva.

(c) Drinking liquor and eating meat, etc., are strictly prohibited.

The Pāśupata follower is guided through five stages of practices that lead to the termination of worldly suffering. In the fifth and final stage the aspirant is advised to reside either in an abandoned residence or *guhā* in hills. The *sūtra* mentions it as *śūnyāgāra guhāvāsī*. The term *guhāvāsī* is employed in this observance as a *vidhi* (injunction). After this the aspirant attains Maheśvaratva and remains Śiva in "Śiva Sāyujya" that also goes by the name *kaivalya*. Interestingly the Pāśupatas name the fourfold aspirations of human beings as *dharma, artha, kāma* and *kaivalya*, the last being used in place of *mokṣa* found employed in other schools. The frequent references to Pāśupatas in Cambodian inscriptions should be viewed against this background.

Liṅga Purāṇa, a Pāśupata Purāṇa

It is known that the famous Purāṇic text *Liṅga Purāṇa* (*LP*) is a Pāśupata text.[22] It begins with an invocation to Rudra, Viṣṇu and Brahmā, which suggest that Paramātmā, the Supreme Being, combines in itself Rudra, Viṣṇu, and Brahmā. This emphasis on trinity reveals the approach of the Cambodian civilization, which invariably combines the

19. *Ibid.*, *sūtra* 9, *adhyāya* 1 of *Pāśupata-Sūtras*.

20. *ādityo diśo vibhajati, diśāśca mūrtiṁ vibhajanti.*
 mūrtiḥ nāma yadetad devasya dakṣiṇe pārśve sthitena udaṅmukhena upānte yad rūpam upalabhyate vṛṣadhvaja-śūlapāṇi-nandi mahākāla-ūrdhvaliṅgādi lakṣaṇam | yad vā laukikāḥ pratipadyante mahādevasya āyatanam iti tatra upastheyam ||
 By the specific use of the term *mahādevasya* in the *sūtra*, devotion towards other forms is prohibited in this system. Similarly the specific mention of the word Dakṣiṇāmūrti, east or west facing deities are not to be worshipped, says Kauṇḍinya in his commentary.

21. Cf. S.N. Dasgupta, *The History of Indian Philosophy*, vol. 5, Delhi: Motilal Banarsidass, 1975, reprint, pp. 130-49.

22. *Liṅga Purāṇa*, text with commentary, ed. by Jagadisa Sastri, Delhi: Motial Banarsidass, 1980 (quoted: *LP*). The first verse begins as:
 namo rudrāya haraye brahmaṇe paramātmane |
 pradhānapuruṣeśāya sargasthityantakāriṇe || ||

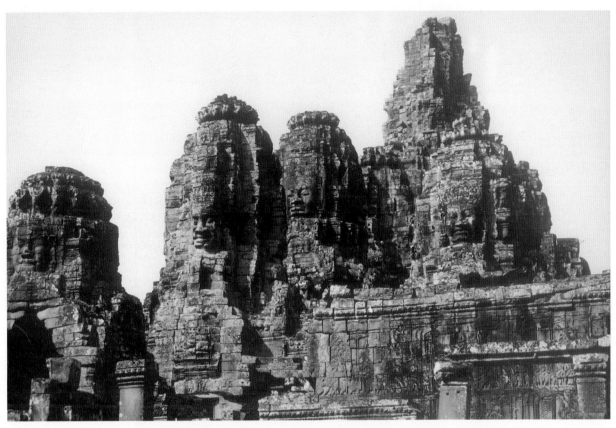

Pl. 16.1: *Śikhara*s of Bayon Temple, Cambodia, twelfth century.

Pl. 16.2: The Towers of Bayon Temple.

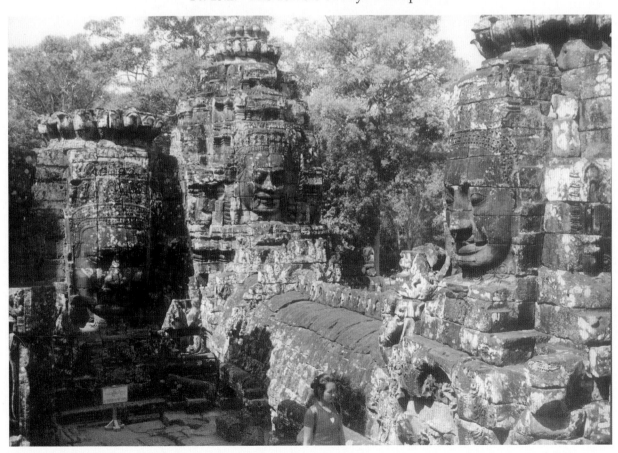

Pl. 16.3: Inscription on the door-jamb of the Bandaei Srei Temple, Cambodia.

Pl. 16.4: Inscribed slab, National Museum, Phnom Pen, Cambodia.

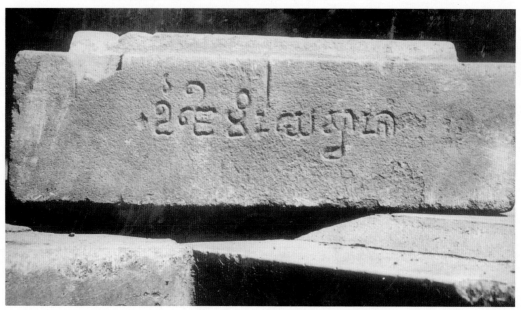

worship of Śiva, Viṣṇu, and Brahmā, from the earliest times to the mid-fourteenth century. This concept is emphasized again and again in the *Liṅga Purāṇa* at many places:[23]

> *jalabudbudavat tasmāt avatīrṇaḥ pitāmahaḥ |*
> *sa eva bhagavān rudrao viṣṇuḥ viśvagataḥ prabhuḥ ||*

The *LP* also details the *pañca mantras*, called Gāyatrī, consisting of Aghora, Tatpuruṣa, Vāmadeva, Sadyojāta and Īśāna hymns, preceded by Oṁkāra, known in the Śaiva-Siddhānta School as *pañca-brahma-mantras*. The *Pāśupata-Sūtras* of Lakulīśa consist of 168 *sūtras*, divided into five chapters, each chapter emphasizing one of the five hymns, *pañca mantras*, thus conforming to the *Liṅga Purāṇa*. The Pāśupata-Yoga is called Māheśvara-Yoga[24] enumerating the *ācārya* who came in the line of Yogāvatāra of Śiva. The *LP* mentions one *guhāvāsī* along with Lakulīśa, Gokarṇa, Gautama, Vaśiṣṭha, Kapila, Pañcaśikhā and others. The last four disciples to be mentioned are Kauśika, Garga, Mitra and Kauruṣya, who are known also from other sources. According to this Purāṇa, Rudra, who is Paśupati, taught this Pāśupata-Yoga. The followers of this school are called Yogeśvaras and Brahmavādins, pointing to the Vedāntic leaning of this school. It also explicitly states that by the term *yoga* this school denotes *nirvāṇa*, identical with *maheśapada*. There seems to be some subtle variation between the *Liṅga Purāṇa* and *Pāśupata-Sūtra* schools. This text almost seems to suggest that Lakulīśa took birth as a brāhmaṇa-*brahmacārī* in Kāyāvataraṇa, a *siddhakṣetra*, when Kṛṣṇa was born as the son of Vasudeva.[25] The four disciples Kauśika, Garga, Mitra and Kauruṣya are again mentioned at this stage.

Origin of Liṅga Worship

According to the *LP* the origin of *liṅga* worship originated with the appearance of a huge shaft of light, between Brahmā and Viṣṇu, when they were disputing who amongst them was great.[26] Narrating the appearance of Liṅgodbhava, the Purāṇa says that the luminous shaft burst forth with a thunderous sound *OM*, consisting of three syllables *A*, *U* and *M*, from which emanated the Vedas that appeared as a *ṛṣi*, from whom Viṣṇu learnt of the Supreme Being. The physical visualization of the Supreme proceeded from this primordial sound and so the Lord is said to be constituted by the syllables, words and hymns, as *vidyā-deha*. This is also known as *mantramūrti*, the hymnal image, in which five Vedic hymns — Aghora, Vāmadeva, Tatpuruṣa, Sadyojāta and Īśāna hymns — constitute the five basic *mantras*. When Viṣṇu visualized this form, he addressed the Supreme as Sūrya, Agni and Soma. He also addressed Him as Agni in the form of Rudra: *agnaye rudrarūpāya rudrāṇāṁ pataye namaḥ*. He is also addressed as one who has Vedas

23. *LP* p. 4, I.3.28[ab]-29[cd].
24. *LP* p. 7.
25. *Ibid.*, p. 25.
26. *Ibid.*, p. 20.

as his feet and a symbol of upward movement (i.e. by the study of Vedas one moves upwards to the highest state of knowledge), which is symbolized by the *liṅga: namaste śrutipādāya ūrdhva-liṅgāya liṅgine*.

An interesting term that appears again and again in the *LP* addressed to Śiva by Viṣṇu is Bhagavat (*namo bhagavate tubhyam*).[27] Another interesting passage shows Viṣṇu addressing Śiva as Viṣṇu thereby indicating that both Śiva and Viṣṇu are identical: *ātmane ṛṣaye tubhyaṁ svāmine viṣṇave namaḥ*.

Śiva is also called Hiraṇyagarbha. It is from the time of appearance of Liṅgodbhava that the worship of *liṅga* was established in the world:

> *tadāprabhṛti lokeṣu liṅgārccā supratiṣṭhitā |*
> *liṅgavedī mahādevī liṅgaṁ sākṣāt maheśvaraḥ ||* — LP I.19.15.

Kṣetrapāla is Pāśupata

The *LP* gradually unfolds the worship after detailing the worship of *liṅga* and its manifestations of Śiva, after which the Liṅgodbhava form is detailed and the origin of *liṅga*-worship is established. It is followed by another cycle of creation at the age of *padmakalpa*. After narrating the creation of Brahmā through the navel of Viṣṇu, Brahmā again started talking disparagingly about Śiva when in front of them appeared Kṣetrapāla, terrifying the whole world by his steps and throwing the ocean into the sky. Brahmā and Viṣṇu started praising this being with prayers, which has significant bearing on Cambodian inscriptions. This form is called Sūra, Devarāja, and Arimardana (valiant, King of Gods and Destroyer of enemies):[28] *sūraḥ devarājo arimardanaḥ*. He also is said to posses the head of a horse — Hayaśīrṣa, Brahmacārī, Havyavāhana, and is also identified with Nṛtta Bhairava who burst forth a terrifying laughter. Proceeding further the *LP* goes on to narrate the different manifestations, which Rudra took. In the seventeenth stage of the *kalpa*, Vyāsa took the form named Guhāvāsī and resided on the peak of Himālaya in a *siddhakṣetra* called Mahālaya. There he had sons who were *yogins* and *brahmavādins*. Finally, when Vyāsa was born as Dvaipāyana, and Kṛṣṇa as Vāsudeva, Śiva appeared as Lakulī. When a dead body was abandoned, Śiva entered the body and rose as a *brahmacārī* for the benefit of the world. The place is called a *siddhakṣetra* named Kāyāvatāra. He stayed in Meru Guhā with Viṣṇu and Brahmā. At that time he had four sons named as Kauśika, Garga, Mitra and Kauruṣya. These sons were great *yogins* and eminent scholars in the Vedas. They were called Pāśupatas and also *siddhas*, who smeared their body with sacred ashes, ever-engaged in the worship of *liṅga* both inwardly and outwardly. They resorted to this path with deep devotion to Śiva, mastering their senses with the aim of cutting the bondage of life. They were *ūrdhvaretas*, who attained

27. *LP* p. 18.

28. *kavacī paṭṭīśī khaḍgī dhanurhastaḥ paraśvadhī, aghasmaro 'anaghaḥ sūro devarājo 'arimardanaḥ* (I.21.81).

Māheśvara-Yoga and reached *Rudra-loka*. This *mārga* (path) bestowed realization of the self, called Pāśupata-Yoga.

The *LP* concludes this section with the statement: if one practices the *Pāśupatavrata* even for one day, he would achieve what could not be achieved through the Sāṃkhya or Pāñcarātra systems.

Dārukā-vana Episode, a Pāśupata Cult[29]

The *LP* seems to explain the Dārukā-vana episode of Śiva appearing as Bhikṣāṭana, in terms of the Pāśupata system. First Śiva appeared as a naked person with two arms, invitingly beautiful, making love-glances at the women of the *ṛṣis* who were captivated by his form and started following him addressing love-utterances. Śiva neither accepted nor rejected their advances. The sages got wild at this turn of events and started hurling abuses against the two-armed person, wandering naked in the forest. At this stage Śiva disappeared. The bewildered *ṛṣis* approached Brahmā who told them that they had failed to recognize the Supreme Lord who appeared before them as the naked man. They also lost all the merits they had acquired over all these years by abusing him. The sages came to their senses and started adoring the Supreme again. This first part of the Dārukā-vana story illustrates Śiva appearing as a Pāśupata-vratin in his first stage of yogic practice, without cloth (*vikṛta rūpa*), with ugly bodily features, making erotic advances towards women. These acts are prescribed in the first chapter of the *Pāśupata-Sūtras*. The same chapter also shows that these observances are resorted to by the Pāśupata-vratin to conquer his senses and to rise above praise or ridicule by inviting public revulsion. In this case he was praised by the wife of the *ṛṣis*, but received abuses from the *ṛṣis* and remained unmoved by both. The *Pāśupata-Sūtra* also mentions that when others abuse a Pāśupata-vratin, then they lose their religious merit, while the adherent of the *vrata* gains their *puṇya*. That happened in the case of the sages.

When the sages of the Dārukā-vana realized their folly and started worshipping Śiva intensely for one year, Śiva again appeared as a naked man for the second time, smeared with ashes all over his body, appearing in strange bodily features, holding a skull cup, laughing, at times singing, sometimes dancing *śṛṅgāra* dance, at times weeping and going to *āśrama*s again and again, begging food. This time the sages were on guard and realized it is the Supreme who has come and so started praising him.

The appearance of Śiva for the second time in the Dārukā-vana episode hasn't been properly focused upon by scholars. The words used by the *LP* clearly suggest the Pāśupata observances, vividly suggesting that the whole episode and the appearance of Śiva and his actions are visual representations of a Pāśupata-vratin as dealt with in the *Pāśupata-Sūtras*:

29. Cf. *LP* ch. 29.

> *devadāruvanaṁ prāptaḥ prasannaḥ parameśvaraḥ* |
> *bhasmapāṁsūpa digdhāṅgo nagno vikṛtalakṣaṇaḥ* ||
> *ulmukavyagrahastaśca raktapiṅgalalocanaḥ* |
> *kvacit ca hasati raudraṁ kvacit gāyati vismitaḥ* ||
> *kvacit nṛtyati śṛṅgāraṁ kvacit rauti muhur muhuḥ* |
> *āśrame hi aṭati bhaikṣaṁ yācate ca punaḥ punaḥ* ||[30]

These are exactly the same injunctions prescribed for a Pāśupata-vratin in the *sūtra* (*hasita gīta nṛtta dunduṅkāra japa dhyāna namaskāra upahāreṇa upatiṣṭhet*). One should note the use of the words *hasati, gāyati, nṛtyati, rauti*, etc., in the *LP*. Śiva illustrates himself the observance of *Pāśupata-vrata*, which is made explicit at the concluding part of this chapter in the *LP*. Śiva tells the *ṛṣis* that the adherents of Pāśupata who appear naked should not be ridiculed. They worship Mahādeva and attain *Rudraloka*. This *vrata* is also known as *vyakta liṅgī vrata*:

> *na nindyet yatinaṁ tasmāt digvāsasam anuttamam* |
> *bālonmattaviceṣṭhaṁ tu matparaṁ brhamavādinam* ||
> *mahādeva para nityaṁ caranto hi ūrdhvaretasaḥ* |
> *arccayanti mahādevaṁ vāṅmanaskāyasaṁyatāḥ* ||
> *rudralokam anuprāpya na nivartante te punaḥ* |
> *tasmāt etad vrataṁ divyaṁ avyaktaṁ vyaktaliṅginaḥ* |
> *bhasmavratāśca muṇḍāśca vratino viśvarūpiṇaḥ* || — *LP* I.33.5, 7, 8, 9ab.

The legend of Bhikṣāṭana is illustrative of Śiva himself enacting the efficacy of *Pāśupata-vrata* according to *LP*.[31]

Tripura-dāha is a Pāśupata Illustration

The *LP* also holds that legend connected with *tripura-dāha*, the destruction of the three cities of the *asuras*, illustrates the *Pāśupata-vrata*.[32] At the end of the destruction of the three cities, Brahmā tells that the *asuras* lost their lives and cities as they abandoned the worship of Mahādeva in the *liṅga*. The *devas* are all *paśus*; they should cast away their *paśutva* nature, observe *Pāśupata-vrata*, and worship Mahādeva in the *liṅga*.

It may be mentioned that the Cambodian inscriptions clearly show that the kings invariably installed *liṅga*s in different places. Though the names of the gods are given in the inscriptions, the importance of installing *liṅga*s is given prominence. Even in the Indian context one does not come across the emphasis on the *liṅga* as in Cambodia. This is clearly a result of the Pāśupata influence. It is the worship of Mahādeva in the *liṅga* that is important.

30. *LP* I.31.28-30.
31. *LP adhyāya* 71.
32. Cf. *LP* p. 88.

Devarāja

One of the most important facets of Cambodian culture is the institution of a special worship called Devarāja, that was started around 800 CE and which continued until 1050. Scholars have been debating the nature of this cult and its impact. It was introduced into Cambodia in the reign of Jayavarman II,[33] when he returned from Java and settled in Indrapura to rule. He shifted his capital successively to Hariharālaya, to Amarendrapura and then to Mahendra-parvata. In all these places, he had a *rājaguru* named Śivakaivalya, who followed the king wherever he went. Jayavarman, having heard that a brāhmaṇa named Hiraṇyadāman was an expert in a unique mystic ritual that would confer freedom of the king from foreign yoke and the king will become a *cakravartī* in his kingdom, invited Hiraṇyadāman to his kingdom to perform the ritual. Hiraṇyadāman agreed and came to Cambodia from Janapada, and at the request of the king he performed the ritual called *Vīṇāśikhā* and established the god Devarāja. The king was so pleased that he requested Hiraṇyadāman to teach the secrets of the ritual to his *rājaguru*, Śivakaivalya. Hiraṇyadāman agreed. Both the king and Hiraṇyadāman took an oath that no one else other than the members of the family of Śivakaivalya would do the worship of Devarāja. Hiraṇyadāman recited the entire text consisting of *Vīṇāśikhā*, *Sammohana*, *Nayottara* and *Śiraścheda*, so that the whole could be committed to writing. He later directed Śivakaivalya how to perform the rite. Śivakaivalya taught his family members how to do that worship of Devarāja. This took place some time in 803 CE. Nothing is heard about Hiraṇyadāman since then.

Śivakaivalya took the worship of Devarāja wherever the king went. Jayavarman returned to Hariharālaya to rule, and Śivakaivalya went with him taking the Devarāja with him. Śivakaivalya died at Hariharālaya, and after some time Jayavarman also died there. The complete list of kings who succeeded Jayavarman, the place where to they shifted their capital, and the family members who officiated as priests in the worship of Devarāja are recorded in detail in a long inscription of Sdok kak. A total of 13 kings are so listed till about 1050 CE and as many as eight *rājaguru*s, who officiated, are mentioned, and who continued to worship Devarāja. In addition, they built temples to Śiva, and installed *liṅga*s and arranged for their worship.

Identity of Devarāja[34]

Scholars had debated that the Devarāja Cult represented the deification of the dead kings of Cambodia and that the Cambodian temples with human faces on the towers are visual representations of this cult. However, the discovery and publication of the *Vīṇāśikhā* and *Śiraścheda Tantras* from a manuscript obtained from Nepal has given a better understanding of the subject. The text, assigned to the medieval period in Gauḍī

33. Cf. Sdok Kak Thom Stele Inscription of Udayādityavarman, Insc. No. 152.
34. See introduction to the above inscription in Majumdar.

script, consists of four parts: *Vīṇāśikhā, Nayottara, Sammohana* and *Śiraścheda*,[35] which are also mentioned in the Cambodian inscription. There is no doubt that the practices are the same as mentioned in the inscription.

It is seen from the text that the god worshipped was the central deity with four faces, seated on a lotus, with four ferocious goddesses portrayed as *śakti*s, each in a cardinal direction. The description as found in the text is as follows:

> The worship consists of adoration of five deities, Tumburu, Jayā, Vijayā, Jayantī (Ajitā) and Aparājitā. The main attention is the description of the five deities within a *maṇḍala*. The *maṇḍala* has the form of a lotus with four petals in the main directions of the sky. Tumburu resides in the centre (*karṇika*), surrounded by the others in the following manner: Tumburu in the center, Jayā in the east, Vijayā in the south, Jayantī in the west and Aparājitā in the north.

> Tumburu is described with four faces, eight arms, four bodies, three eyes, bearing a crown adorned with crescent Śiva's emblem, and bearing the *triśūla*, *gadā, pāśa*, and *aṅkuśa*, although only four of the eight hands are occupied by attributes. Tumburu is provided with royal apparel; he is called 'god of gods.' Jayā has the colour of the fruit *kṣīroda*; her sacred cord is a *vyāghra* (tiger); her mount is a corpse (*preta*); she has four faces and bears the *gadā* and the *kheṭaka*. Vijayā has the colour of the *dāḍima* flower and is provided with bow and arrow; she is fear-inspiring and consumes fish, meat and wine; her mount is an owl, an inauspicious animal. Jayantī has the yellow colour of pure gold, while her necklace and garment are also yellow; she bears a bell and *khaṭvāṅga* club; her mount is a horse. The colour of Aparājitā is black like collyrium and she wears a black garment; she stands on a divine chariot and bears, like Jayā, the *gadā* and *kheṭaka*; she emits a terrible roar. The secondary figures are Gāyatrī, Sāvitrī, Aṅkuśa and Astra.

In his brilliant analysis of the *Vīṇāśikhā Tantra*,[36] Teun Goudriaan has pointed out the different traits of the god Tumburu and the accompanying goddesses, so it is needless to go further into all these aspects. However a few significant points deserve recapitulation in the context of the present study.

"Tumburu is identified as a form of Śiva, usually four-headed."[37] Tumburu and Bhairava are enthroned in close association and surrounded by eight Mother Goddesses of ferocious appearance and activity.[38] Tumburu's worship counteracts demonic activities and sorcery and is conducive to victory for a ruler.[39] According to the *Tantrasāra* Tumburu

35. Cf. *The Vīṇāśikhā Tantra*, ed. and tr. Teun Goudriaan, Delhi: Motilal Banarsidass, 1985, intro., p. 8 (quoted: *VT*).

36. Cf. fn. 35.

37. *VT* p. 18.

38. *Ibid.*, p. 19.

39. *Ibid.*, p. 20.

appears as a Bhairava of four arms (not of four faces) and three eyes, wearing ascetic hair, seated upon a bull, within a lunar orbit and bearing the attributes *śūla, akṣamālā, pustaka, amṛtakalaśa*. His complexion and garments are white. Tumburu is four-faced according to one *mantra* given. The four sisters are called repeatedly *yakṣiṇīs*.[40]

God Tumburu is horse-headed and should resemble Sadāśiva with four bodies. He is seen as the manifestation of Śiva worshipped in the Tāntric tradition for the destruction of the enemies and acquisition of supreme ruling power. The context in which the ritual was performed makes it clear that Jayavarman who returned from Java wanted his enemy kings to be destroyed, and that he wanted himself to be bestowed with the power of emperor, *cakravartī*. Thus the Devarāja cult is not connected with the worship of the dead kings of Cambodia, but with the worship of ferocious deities, for the destruction of the enemies of the Cambodian king. The details of the rituals found in the text show that it was like a black magic, which confers the *siddha* of Devarāja to achieve the power of Indra. The title of the book called *Tantra* made scholars classify the text as within the non-Vedic system in the *vāmasrotas* category.

Rājasūya and Devarāja

In this connection two important points deserve to be mentioned. According to Vedic tradition, the king, desirous of victory and power like Indra, performs a Vedic sacrifice called *rājasūya*. Some of the rituals of *rājasūya* sacrifices have the same magical invocations, mainly for the destruction of the enemy kings and the like *rākṣasa*; this is clearly echoed in the Devarāja worship. It almost sounds like *rājasūya* sacrifice, substituted by image worship in place of sacrificial altar. It may be also pointed out that the *rājasūya*, an offering, is made to five deities, one male in the centre and four female goddesses, in four directions. The deities mentioned are Dhātā in the centre, and the four goddesses are Anumati, Kūhu, Rākā, and Sinīvālī, all considered as ferocious goddesses. In the *Vīṇāśikha Tantra*, leading to the *siddhi* of Devarāja, the central deity Tumburu, is a male, surrounded by Jayā, Vijayā, Ajitā and Aparājitā. Another point of interest is that these four goddesses are called sisters (*bhaginī*) as is the case of Anumati, Rākā, Kūhu and Sinīvālī.

The importance of a horse-headed god as a powerful deity is seen right from the time of the Vedas. The powerful Sūrya is called a horse-*vāji*. It seems that the God Tumburu with four faces especially with his horse face is a Vedic idea.

Tumburu and Kṣetrapāla

Finally we come to the *LP* which describes the appearance of Śiva as Kṣetrapāla (protector of the place). Among the names of Kṣetrapāla appear the names Devarāja, Hayaśīrṣa and Arimardana.[41] He is also called dancing Bhairava. The name Devarāja for Kṣetrapāla identical with Bhairava is very important. The following names appearing for Kṣetrapāla

40. *VT, ibid.*, p. 35.
41. *LP* I.21.

Bhairava found in the *LP* show the close identity of the Devarāja and Tumburu of the Devarāja cult of Cambodia, as detailed by Goudriaan, deserve special attention:

> *namaḥ kṣetrādhipataye bījine śūline namaḥ |*
> *prajāpatīnāṁ pataye siddhīnāṁ pataye namaḥ ||*
> *rakṣoghnāya viṣaghnāya śitikaṇṭhordhvamanyave |*
> *śmaśānaratinityāya namostū lmukadhāriṇe ||*
> *namo'stu nṛtyaśīlāya upanṛtyapriyāya ca |*
> *namo vikṛtaveṣāya krūrāya amarṣaṇāya ca ||*
> *pureśayo guhāvāsī khecaro rajanīcaraḥ |*
> *sūro devarājo arimardanaḥ ||*[42]

Kṣetrapāla (protector of the country and the place), Vijayin (conqueror), Prajāpati (protector of subjects), Siddhināṁ-pati (the lord of *siddhi*s), Rakṣoghna (destroyer of demons), Viṣaghna (remover of poison), *śmaśāna rati nityāya* (reveler of copulation in cemetery), *nṛtyaśīla* (fond of dance), *vikṛtaveśa* (with strange appearance), *krūra* (terrible), *pureśaya* (destroyer of cities), *guhāvāsī* (living in caves), *sūraḥ* (heroic), *devarāja* (god of the *deva*s).

As may be seen, all these names ascribed to Kṣetrapāla are equally applicable to Tumburu. We have also seen that Tumburu is identified with Bhairava in some texts quoted above. It is known that Bhairava can be a fierce deity and multi-headed, who can be invoked as Arimardana for the destruction of the enemy kings. In the worship of Tumburu for achieving the status of Devarāja, this concept might have played a vital role. Attention has been drawn to the description of Kṣetrapāla as Hayaśīrṣa. It may also be noted that the surrounding goddesses are called *yakṣiṇī*s. A number of impressive sculptures from Cambodia have come to light with horse faces, which are called Kalki or Hayagrīva and identified with Viṣṇu by scholars. In the light of the identification of Kṣetrapāla-Bhairava with Hayaśīrṣa and Devarāja it is likely that the sculptures with horse face represent Devarāja-Tumburu. We have also seen that the central deity in the *Rājasūya* is called Dhātā, identical with Brahmā with four faces. The appearance of Gāyatrī and Sāvitrī as accompanying deities in the worship of Tumburu in Devarāja worship also seems to suggest the impact of *Rājasūya* sacrifice. This aspect needs a detail study separately.

It may also pointed out that in the *Rājasūya* chapter, one of the *Kāṭhaka Saṁhitā* of the *Yajurveda* one gets the reference to four goddesses named Āgneyī, Vāruṇī, Rudrāṇī and Aindrī and are mentioned as part of the five deities worshipped in five directions (*pañca diśaḥ pañca devatāḥ*). Also in the chapter on *Rājasūya* sacrifice of the *Maitrāyaṇī Saṁhitā* a passage occurs mentioning the killing of Vṛtra by Indra. The Vedic passage says that the one who is anointed with *Rājasūya* sacrifice can destroy his enemies like the Vṛtra by Indra:

42. *LP* I.21.3ab, 20ab, 54ab, 60cd, 63ab, 69ab, 78ab, 81cd.

tato vai deva vṛtram aghnan |
vṛtraṁ khalu eṣa hanti yo rājasūyena abhisiñcate ||[43]

It is in this context that the four goddesses Āgneyī, Vāruṇī, Raudrī and Aindrī [44] are mentioned. There is also a reference to *Śiraścheda*, the head of Namuci which was cut-off. The word *Śiraścheda* used here is interesting. *Vīṇāśikhā* and *Śiraścheda* are clubbed together in the *Rājasūya* sacrifice, and that the text under consideration as *Vīṇāśikhā Śiraścheda* has the same title and function also deserves notice. Also we find the reference to four female goddesses in connection with the worships of five deities in the *Rājasūya* chapter of the *Maitrāyaṇī Saṁhitā*, where the central deity is called Dhātā and the four goddesses are called Anumatī, Rākā, Kūhu, and Sinīvālī — all wild goddesses. They are said to be sisters.[45]

The worship of Devarāja in the context of Jayavarman's return to Cambodia, and of his rule shaking the Javanese hold over the kingdom, and of his status raised to that of *cakravartī* as a result of the Devarāja worship, seems to suggest that there existed some reflection of the Vedic *Rājasūya* sacrifice.

However, this study suggests a perceptible shift in the nature of Śaiva faith in Cambodia. While the earlier inscriptions do not fail to emphasize the Pāśupata nature of the *ācārya*s of the kings (making direct reference to the term Pāśupata and other terms like *guhāvāsī* and also the practice mentioned in the *Pāśupata Sūtra* and the *Liṅga Purāṇa*), the later inscriptions point to a change. The Pāśupata system is not mentioned, or if mentioned there is only a feeble reflection. The great inscription mentioning the Devarāja Cult, listing the *rājaguru*s, does not mention any of the Pāśupata tenets. The faith in the Devarāja cult seemed to have eclipsed the Pāśupatas.

43. *te indra aicchan. hanāmenam iti, so 'abravīt sandhā vai me sahitam abhi drohayati, tam agniḥ abravīt ahameva tvetāḥ pāsyāmīti pṛthivyām, ahamantarikṣāt iti varuṇaḥ, ahaṁ diva iti rudraḥ, tato vai devāḥ vṛttram aghnan, vṛtram khalu vā eṣa hanti yo rājasūyena abhisiñcati tat vṛtraghnam eva etad.* (Yajurvedīya Maitrāyaṇīya Saṁhitā, ed. by Sripada Damodar Satvalekar, Svadhyaya Mandal, Paradi, *Rājasūya, adhyāya* 8, *prapāṭhaka* 3, *anuvāka* 4-5). Quoted:*YMS.*

44. *YMS: yat vahnī tena āgneyī; yad dhenuḥ sati dāntā tena vāruṇī; yad gauḥ tena raudrī; yat payaḥ tena aindrī; rūpaiḥ eva enām samardhayati.*

45. *YMS anuvāka* 5: *paśavaḥ chandāṁsī. gāyatrī anumati, triṣṭubh rākā, jagatī sinīvālī, kuhūḥ anuṣṭubh, dhātā vaṣaṭkāraḥ.*

17

Myth of Renewal
Citrakāra Workshop Practices in Orissa

Dinanath Pathy

THE researches initiated by Alice Boner and furthered by Bettina Bäumer are textual, with their roots in cultural studies. The other facet of cultural studies, which is more contemporary, has a bias towards art history. Both fields of study, the textual and art history, aim at contextuality. These researches are important because they weave a pattern between text and context. To be specific, Bettina Bäumer could start with Kashmir Śaivism but intrinsically link it to Orissan architecture and sculpture. I do not follow such a strict chronology to label the researches as ancient, but only because such kinds of studies are within the domain of ancient Indian History and Culture. The researches of all these scholars are internally connected and substantiated in approach, intent and methodology and are offshoots of art historical and archaeological protocol narratives and analytically descriptive. Bettina Bäumer has coated her intents with philosophical resonance.

Archaeology and history, no doubt, provide us with argumentative authenticity, but historical writing normally does not reflect artistic sensitivity and poetic feeling. There are, of course, histories written with literary cadence and personal concern. But the history books we generally come across in Orissa are the sum total of facts and figures that do not concern themselves with artistic experiences and appreciation of beauty in the realms of aesthetics. Art history is not the history about arts: it is written to understand and appreciate works of art and their artists, and so to lead one to rootedness.

My presentation is a part of my Jawaharlal Nehru Fellowship Project on *Art of Renewal: The work of Citrakāras in India with special reference to Orissa*. As I have already hinted, the new approach does not move from one art object to the other, from one temple sculpture or painting to another to frame up a historical chronology and relate them to dated dynasties; rather, it tries to link them to workshops and styles for a cultural appraisal.

Although the temples and the embellished sculptures therein are meant to be structurally permanent, the Indian mind is traditionally not geared to the idea of conservation and preservation that we have been trying to apply to our temples and monuments in recent years. Moreover, the images worshipped insides the temples and house shrines, and especially the murals in the interiors of living temples, were renewed

and replaced periodically. From several ancient inscriptions and later records we are aware that repair and maintenance of edifices and monuments were part of the emperor and king's duties and, in fact, several repairs have, over the course of time, become historical evidences. But the renewal as an artistic and ritualistic act is completely different from mundane repair and maintenance jobs which no doubt brought some virtues to the king. Renewal is to be equated with creation and is a symbol of both artistic and ritualistic tradition. Normally the kings preferred to build new temples, and they promulgated rituals and ceremonies concerning the propitiated images. Both the royalty, who were the patrons, and the priests, the ritualistic custodians of the temples, therefore wanted the worshippable images carved in wood and made of other perishable materials like clay and painted cloth. Such practices favoured art workshops, which remained busy being patronaged by the temples. Replacements and renewals recognized the ingenuity of the artists, respected their creativity and supported them by providing works. This was a great incentive for the workshops to thrive. Renewals and replacement anticipated rituals and ceremonies connected with immersion, installation and consecration.

There are textual prescriptions to such renewal practices. The following verse from *Bhuvanaprakāśa* mentions four types of images: 1. Painted images (*rekhā*), 2. Wooden images (*dārumayī*), 3. Metallic images (*dhātumayī*), and 4. Jewel or stone images (*maṇiśailamayī*).

> *mūrtiś caturvidhā proktā rekhādārumayī tathā* |
> *saumyā dhātumayī puṇyā maṇiśailamayottamā* ||[1]

These images are to be renewed at an interval of one, twelve, one thousand and ten thousand years respectively. Some texts add one more variety of images, which is the most short-lived. It is the clay image (*mṛnmayī pratimā*), which should be renewed every month.

This textual reference from the *Bhuvanaprakāśa* adds strength to our postulation that not only images of wood, clay and painted cloth, but even images made out of stone and metal are subject to renewal, making renewal mandatory for all kinds of images and bringing stone and metal workshops within the purview of our consideration.

As long as the intent and act of renewal is a demand based on material use and depreciation, renewal must be genuine or else it turns out to be mythical with ritualistic connotation. Immersion of palm-leaf manuscripts in water at an interval of roughly one hundred years for fear of spoilage or apprehending pollution at the hands of low-caste people is a mythical concept of renewal apart from saving the manuscripts from decay. It could be counter-argued that palm leaves might survive more than a hundred years

1. Quoted in G.C. Tripathi, 'Navakalevara. The Unique Ceremony of the Birth and Death of the Lord of the World,' in: *The Cult of Jagannath and the Regional Tradition of Orissa*, ed. Anncharlott Eschmann *et al.*, New Delhi: Manohar, 1978.

and these would not be polluted by people other than the family members who possessed them, even if they were retained beyond a period of mythically sanctioned time.

Navakalevara, or the renewal of the painted wooden images in the Puri Jagannātha temple, is a mixture of real and mythical intent. *Navakalevara* is not bound to take place every time when two *Āṣāḍha*s happen to occur in a year. It is an expensive affair and is performed only when necessary. There is also a sort of "small *navakalevara*" when the intercalary *Āṣāḍha*s recurs only after eight years — whenever the various coverings of the icons are only renovated and not necessarily the wooden structure.

In an act of renewal, it is always required to strike a balance between reality and myth. This is amply proved in the *navakalevara* ritual of the Jagannātha temple. The dream sequence in the temple of Maṅgalā in Kakatpur to examine *neem* trees for the images is a mythical proposition. In reality, a *daitā* and a priest armed with measuring tapes identify suitable trees, which are later dreamt in the Maṅgalā temple prescient. The mythical aspects sometimes take the upper hand and force devotees to fabricate facts in consonance with popular faiths. One of the characteristics of an appropriate tree is that is should have at its foot a few snake holes, or one should spot a few snakes creeping around its vicinity. To justify such a postulation, one of the publications on *navakalevara*, instead of being careful to paint/show a snake as if emerging from a hole, pasted a cut-out of the snake over the identified tree trunk, which did not create a semblance of reality, but rather was a wrongly-pasted collage to prove a point.

Renewals and replacements are an all-India phenomenon in which workshops dealing with image making and painting are involved. But renewals, whether genuine or mythical, involve workshop participation and serve the purpose of artistry and continuing tradition. I discuss the three most important motifs that are subjected to annual renewals. Elements of myth make the renewals more valid in the context of religion and faith. These motifs are of *Daṇḍanāṭa Kālīprabhā*, Maṅgalā of *osākoṭhi* and *Khudurukuṇi osā* and *anasarapaṭi* of Jagannātha temple.

Before embarking upon these three specific motifs for a brief appraisal of related tradition and artistry, I would like to refer to three interlinked studies, two undertaken by me in collaboration with Eberhard Fischer[2] and the third individually.[3] These three studies focus on classical mural tradition as in Kālikā Temple, folk mural tradition as in several temporary, semi-permanent and permanent village shrines, and tribal painting tradition of the Sauras. All three traditions are interlinked in their intent and approach

2. Eberhard Fischer, Dinanath Pathy, 'Drawings for the Renewal of Murals: Notes on Documents for Murals of the Kālikā Temple near Jayapur in the Koraput District, Orissa (India),' in: *Artibus Asiae* (Zurich), vol. LXII, no. 2 (2002); *id., Murals for Goddesses and Gods: The Tradition of Osakothi Ritual Painting in Orissa, India*, New Delhi: Indira Gandhi National Centre for the Arts/Zurich: Museum Rietberg, 1995.

3. Dinanath Pathy, *The Painted Icons: Wall Paintings of the Sauras of South Orissa*, New Delhi: Harman Publishing House/Bhubaneswar: Crafts Council of Orissa, 1996.

to renew and replace murals. The artists of these murals range from traditional *citrakāra*s to brāhmaṇas, farmers, gardeners, cowherds, untouchables and of course tribal Saura painters. Similarities of painting styles are evident in Kālikā temple and *oṣākoṭhi* because of their *citrakāra* workshops affiliations while *oṣākoṭhi* and *id-tal* drawings of Sauras have a kind of relation in formatting and specific figuration. Invoking a plethora of goddesses and gods for a group of worshippers by means of mural may thus have at least one root in the Saura tradition, and it is quite possible that *oṣākoṭhi* paintings looked very much like Saura *id-tal* pictograms a century ago. Evidently, there were stylistic developments, which in fact still continue. It is possible that the introduction of Brāhmaṇical goddesses and gods (like Maṅgalā, Durgā and Kālī) supported the trend to more realistic features of their complex iconography. Prototypes for detailed icons were available in Ganjam district: generations ago, *citrakāra* painters had settled in places like a Barapali, Mathura, Chikitigada and Dharakote and had produced early murals such as in Buguda or in Srikurmam (Andhra Pradesh). Unfortunately, very few murals dating to the nineteenth century still exist in Ganjam district. Therefore it is only possible to compare what was produced at that time by master *citrakāra*s for the temple and palaces with the work done by their descendants for a much less discerning clientele nearly a century later. But the available samples show the consistency of iconography and style over a period of at least three generations.

It is customary for Śaiva and Śākta participants in a procession to hold painted standards depicting Kālī. The tradition of carrying a banner of Kālī is in vogue with the *bhakta*s of *daṇḍanāṭa*. While Śiva in the form of a stone *liṅga* is taken in a wooden tray with the metal snake emblem, Kālī painted on a staff functions as the 'icon.' The painting is either a square or a rectangle in format held vertically with the help of a bamboo, its top, in a conical shape, resembles a house or shrine. The banner is treated as a shrine, remains covered with a cloth screen and is opened only at the time of offering of worship. A bunch of peacock feathers is tied at the top conical structure as a crown. Kālī is depicted as black-skinned naked goddess dancing violently on a prostrate Śiva. Painted four-handed, bejewelled with a garland of heads and limbs, a bleeding severed head in one hand and a bowl of blood in another is usually the most prominently seen icon. The peculiarity of this iconography is that the prostrating Śiva raises his organ till it enters Kālī and the expression on Kālī's face is one that of fearsomeness and excitement.

Throughout the year this icon is placed in the *ākhāḍā* (practising hall) and is offered regular worship. The devotees believe that this is a living icon with an invested *prāṇa*. After the annual procession and performances are over, the one in their procession inside the *ākhāḍā* shrine is immersed and a new one is inducted and placed in the shrine. The *prāṇa-pratiṣṭhā*, infusion of life force from the old to the newly painted banner, is brief but convincing. Both the old and the new are clubbed together with their painted surfaces touching intently for five to ten minutes, *mantra*s are uttered and the bangles from the old icon are removed and put around the new one.

A month before the beginning of the procession and performance, the leader of the group, the *adhikārī*, places order for a new painted Kālī icon with the local workshop. Sometimes the old and the disfigured banner, taken from the water after the ritualistic immersion, is given fresh layers of cloth and painted but in majority of cases it is a new icon that is replaced. With passing time and with each new painting, the style of workshop continues. There is hardly any change in colours, layout and iconography but with the demand of connoisseurs the colours become loud and garish.

Kālikā is the dark and terrible side of Durgā. The icons painted in Ganjam workshops are of Dakṣiṇakālī represented as wildly dancing on top of prostrate Śiva, who is sexually aroused.[4] On the murals, the best examples are Śrīkālikā temple of Jayapur, Dharakote palace shrine and the temporary *oṣākoṭhi* shrines.

Generally a workshop that produces icons for replacement and for temple murals, keeps a set of drawings for reference and tracing. From the Jayapur *citrakāra* workshop, we found a set of eight drawings, each measuring about 20.5 × 17 centimetres; although they have been pasted on printed paper, they are tattered and have turned yellow or even dark brown over the years, they are completely intact. The eight sketches of Kālī group corresponding the main eight aspects of Śiva are up to now available. In this set are the drawings of Māṇikaśrī (Māṇikeśvarī), Bhadrakālī, Mahākālī, Siddhakālī, Vijayakālī, Śmaśānakālī and a second Bhadrakālī. All these sketches are captioned at the top with colour suggestion helpful for transfer on to the multicoloured murals.

Kālī with her epithet as Dakṣiṇakālī could be related to the cult of Jagannātha (*śrīkṣetreṣu jagannātha svayaṁ dakṣiṇakālikā*) with the cult's strong affiliation with annual renewal and periodical *navakalevara*. Kālī is the denominator of time and the annual replacement in tune with sequencing time is a reminder.

Maṅgalāpaṭi, commonly related with the ritual of *Khudurukuṇi oṣā* or *Ta'poi*, has strong links with the maritime heritage on one hand and with the worship of Maṅgalā on the other by the virgin girls in hope of finding good and handsome husbands, quiet vogue in the coastal districts of Puri and Cuttack. This deity of auspiciousness appears at the centre of the *oṣākoṭhi* painted walls along with Śiva Naṭarāja in Ganjam district. Goddess Maṅgalā has different iconographic features aniconically in abstraction, taking the form of a pot, and is found in classical postures, wherein she, as a Vaiṣṇava deity, is always depicted enface, sitting in cross-legged *padmāsana* position, and four armed. Her body is coloured yellow and she wears a red or pink *sari* and a blouse. The goddess carries five pots; four in her four hands and the fifth one is placed on her head.

In Ganjam district, she is generally called Kākaṭapura Maṅgalā, the Maṅgalā of the temple of Kakatpur, or Bāṭamaṅgalā, the wayside Maṅgalā. Maṅgalā is popularly worshipped on Tuesday on the road. Most myths connected with her centre around the

4. Cf. Gosta Liebert, *Iconographic Dictionary of the Indian Religion*, Leiden: Brill, 1976, p. 119.

event of her (re-)installation in the mid-sexteenth century. This coincides historically with the first efforts to organise the *navakalevara* ritual for Lord Jagannātha, which began towards the end of sixteenth century. Legends record that the Goddess Maṅgalā was then worshipped in Orissa and in Siṃhaḷa *dvīpa* (Sri Lanka), and that a *sādhava* merchant by the name of Dadhivāmana brought her statue from Sri Lanka and installed her in Kakatpur.

In the *Maṅgalāpaṭi*, the four-handed Goddess sits in *padmāsana* with a raised sword in the right upper hand, unbecoming of a Vaiṣṇava deity. Here she is shown occupying a prominent centre with story sequences of *sādhava* brothers and *Ta'poi* tending goats, etc. The ritual of *Khudurukuṇi* has strong links with the maritime heritage on the one hand and worship of Maṅgalā on the other.

Citrakāra workshops in Ranpur, Nuapatna, Banki areas in Puri district and Mathura and Barapali in Ganjam district produce *Maṅgalāpaṭi*s, which are put to weekly worship by a congregation of unmarried girls, and at the end of the festival in the month of *Śrāvaṇa* (July/August), the *paṭi* is rolled up and immersed in the pond or river and is replaced by a new *paṭi* the next year. Nowadays the *paṭi* is being replaced by a painted clay image. The workshops of such images are located mostly in Bhubaneswar and Cuttack towns as well as in small towns all over the Cuttack district. The potters, with the decline of their profession in pot making, have shifted to making of clay images.

The *anasarapaṭi*s, temporarily replacing the painted wooden images of Jagannātha during the fourteen-day period of convalescence after the ritual bath in the month of June/July, are a prominent set of paintings put to renewal each year in the temple of Jagannātha at Puri and elsewhere in *gaḍajāta* areas. During the festival of *devasnāna pūrṇimā*, the wooden icons are ritually bathed; this results in the flaking of paint. The Gods are said to suffer from fever. A bamboo screen is erected in front of the icons, which then are removed from the bejewelled thrones and repainted. The devotees are not allowed to see the icons during this period; instead, three *anasarapaṭi*s of the deities are hung on the screen to be worshipped in place of the wooden images. The Gods in these paintings are shown four-armed with human bodies, and are quite different in shape from the famous wooden icons. The task of making *anasarapaṭi*s is assigned to three *citrakāra* workshops at Puri on a hereditary basis and the making of painting is known as *sevā*. This arrangement is codified and lends credence to workshop participation in the tradition of renewal at a highly classical temple like that of the Jagannātha temple. When painted on cloth, Jagannātha is renamed Nārāyaṇa in Puri and Nīlamādhava in southern Orissa, Balabhadra is known as Ananta Vāsudeva and Saṅkarṣaṇa respectively, and Subhadrā is called as Bhuvaneśvarī.

The *anasarapaṭi*s produced at *citrakāra* workshops all over Orissa are interestingly similar in iconography with little stylistic variations. During the painting of *anasarapaṭi*s, the *citrakāra* has to abide by strict rules; food is to be eaten in the afternoon only, the

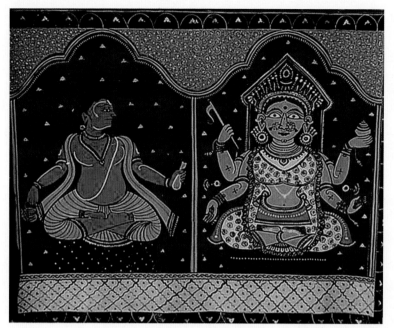

Pl. 17.1: Bhubaneśvarī paṭi, Puri region, contemporary, painting on cloth.

Pl. 17.2: Maṅgalā paṭi, Cuttack region, contemporary, painting on cloth.

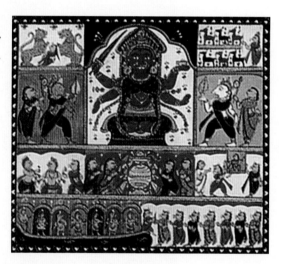

Pl. 17.3: Aṇasara paṭi of Balabhadra, Subhadrā and Jagannātha, paintings on cloth from the temple of Jagannātha, Puri. Photo: Eberhard Fischer.

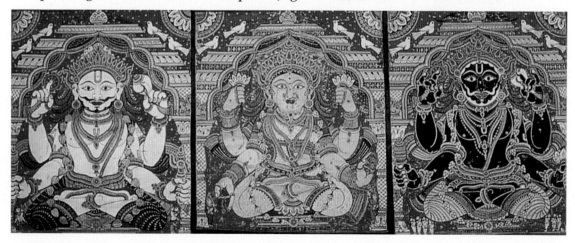

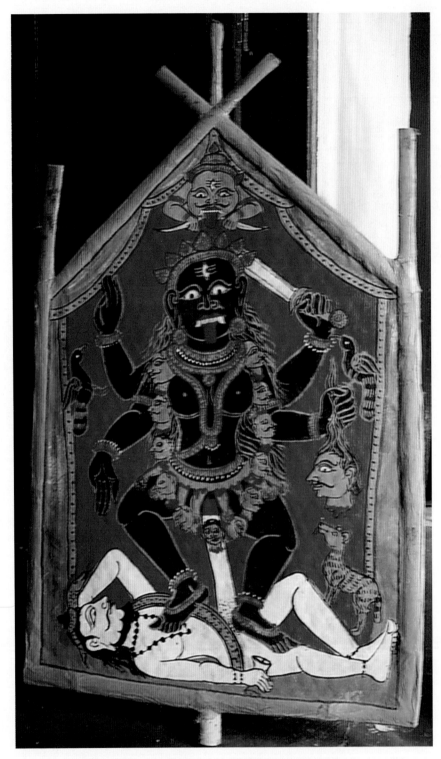

Pl. 17.4: Kālikāprabhā, Berhampur region,
painting on bamboo sheet, contemporary.

consumption of meat, alcohol, onion and garlic is forbidden, sleeping is permissible only on the ground, and celibacy is enforced. The finished paintings are infused with *prāṇa*, an investment of life performed with a *prāṇa-pratiṣṭhā* ceremony by a priest in the workshop. After a single-time use, they are buried in the temple complex, preserved in the temple stores and affiliated *maṭha*s, or sold to one of the devotees.

Besides these three most prominent replacement rituals, there is a wide network of renewals and replacements is Śākta shrines, particularly during *Navarātri* celebrations when *Durgāṣṭamīpaṭa*s painted on cloth-layered wooden planks are used in the rituals and immersed at the end of the festivals. In Vaiṣṇava shrines where wooden images of Rādhākrṣṇa and Rāma, Lakṣmaṇa and Sītā are worshipped, renewal is done annually or when necessary. The painting of Mahiṣamardinī Durgā with Aṣṭa Durgā is done in south Orissa in various *zamīndārī*s. Durgā is the protector of the fort; Durgā is the symbol of power and energy. Annually during the *navarātra* festival, an elaborate ritual is performed in these palace shrines as well as in temporary structures especially built for the purpose. This *Navarātri-pūjā* symbolizes the Sanskrit tradition both in the painting and ritual where the king and the upper-class brāhmaṇa priests are involved.

The Kālī banner and the image of Śiva combination keep on changing, a consideration with religious exigencies. To make the couple more compatible and to tune the alignment properly, both Śakti and Śiva were brought under the purview of the painting workshop. The *oṣākoṭhi* mural incorporates the images of Kālī, Durgā and other Śaktis as side-figures of Śiva-Naṭarāja. When Maṅgalā instead of Śiva-Naṭarāja takes the central stage, the images of Kālī and Durgā appear as side-figures. These interchanges are quite common and acceptable. It would appear that Śiva, Kālī, Durgā and Maṅgalā are the most important motifs, which keep alternating on the *oṣākoṭhi* mural.

The *Navarātri* classical tradition and the *oṣākoṭhi* folk tradition reflect two levels of artistic combinations and manifestations. While Śiva is totally absent as a focus without being subverted to Kālī in the painted panels related to *Navarātri-pūjā* (best exemplified in Śrīkālikā temple paintings), the *oṣākoṭhi* paintings, the product of the traditional *citrakāra* workshop, present Śiva as an important central motif. The workshops other than of the traditional *citrakāra*s bring Maṅgalā as the central image although Śiva is never a substitute to Maṅgalā. But strangely enough, we find an exclusive combination of Maṅgalā and Mahiṣamardinī in the Sonepur *Durgāṣṭamīpaṭa*. Again, Śiva is absent in *Durgāmādhavapaṭa*, where Jagannātha replaces Śiva.

We are tempted to refer to the trinity on the sculptural Koṇārka panel of the thirteenth century where the deities representing Virāja, Liṅgarāja and Jagannātha are projected. This trinity, considered as the most important deities of the time as a combined religious focus, helped the imperial power to thrive. With the change of religious affiliation and with the decline of Śaivism, Śiva was dropped from the panel and Mahiṣamardinī Durgā and Jagannātha remained to represent the concept with a different focus. This must

have happened in seventeenth-eighteenth century when Vaiṣṇavism was in ascendance in Orissa influencing the literary and visual forms of expressions. We believe that framing of Durgā with Jagannātha in a single painted format, exclusively for purposes of auspicious beginnings, must have been a twentieth-century idea.

We could see the possibilities of Kālī and Jagannātha clubbed together, Jagannātha in aniconic form and Kālī as Dakṣiṇakālī projecting the feministic manifestations and affiliations of Jagannātha. But, from the point of view of colour combinations, golden Durgā replaced Kālī to make a striking visual with the black aura of Jagannātha. I have strong convictions that in such combinations the innovativeness of the *citrakāra* workshops play definite roles, and that these ideas, no doubt, met the instant approval of the wise priests who came up with arguments to bestow textual sanction to such strange combinations.

As though to regain a lost splendour, Śiva temples imitated the flourishing Vaiṣṇava establishments. As a most recent practice, the newly painted entrance of the Liṅgarāja temple at Bhubaneswar could be cited. This is painted in the fashion of Puri Jagannātha temple entrance with bright colours. Twenty years back this was not in practice. In a small Śiva temple in the village Bhimapur in Ganjam district, two paintings are done on wooden boards, one for Śiva and the other for Pārvatī, that function as replacement icons when the enshrined *Śiva-liṅga* occasionally remains submerged under water. These two paintings also serve as *paṭuāra/parva mūrti*s and are renewed annually in the workshop of Lakshmikanta Mahapatra in Digapahandi. The Śiva and Pārvatī paintings iconographically resemble the *aṇasarapaṭi*s of Balabhadra and Subhadrā, though they are far inferior in artistic quality to the highly structured Jagannātha temple replacements. At the moment we have no other information of Śiva and his spouse being replaced as painted icons.

We have focused our discussion on these few paintings of the likes of Kālī, Maṅgalā, Mahiṣamardinī Durgā, Śiva, Pārvatī, and the *aṇasara* paintings of Nārāyaṇa (Nīlamādhava), Bhuvaneśvarī and Saṅkarṣaṇa (Ananta Vāsudeva) because of their similar painted features and classicism. Except for the paintings of Kālī and Mahiṣamardinī Durgā, which are action-oriented as dancing on a prostrate Śiva and killing the Mahiṣa demon, the rest of the paintings are like routine standard icons seated in *padmāsana* and sport emblems in their four hands. With minor variations in their emblems and change of workshop styles, the *aṇasara* painting of Saṅkarṣaṇa and Śiva of Bhimapur village will look identical. Similarly the images of Maṅgalā, Bhuvaneśvarī and Pārvatī can easily be alternated for one another. The Maṅgalā painting (*Ta'poi*) and the Bhuvaneśvarī *aṇasara* painting painted by Nuapatana/Tigiria workshop with frontal *mukuṭa* and a leaf-shaped green halo look similar. One is amazed to notice the manner the feet of the seated images are upturned like the fluttering wings of a bird on the Maṅgalā paintings of Sonepur and Tigiria workshops. Moreover, the Devī's bossoms as they contour and the hands as they emerge look quite similar.

While the renewals or replacements are demands of ritualistic traditions, the necessity arising out of material depreciation is not always being taken so seriously, and the formatting and style of replaceable paintings are decided by the painters or their workshop tradition. The renewal rituals with *prāṇa-pratiṣṭhā* and *visarjana* equated with birth and death lend a mysterious cadence and therefore tend to be mythical over the course of time. Mystification of the renewal and the replacement rituals in the Jagannātha temple at Puri are intense and offer no rationality. It seems that the paraphernalia that grew out of dire necessity to repair the wooden images spoiled during their removals and shifts from the temple and subsequent instalments in Puri temple overshadowed its basic purpose and became mythical with obviously created text to uphold such compulsions. This ritual was replicated with variations but with the same intent spread to Jagannātha temples all over Orissa. But *aṇasarapaṭi*s are not the sole representation of a renewable module that travelled from Puri to local temples: the renewal both as ritualistic and artistic practice existed much before with the focus on Śiva, Kālī, Durgā (and later Maṅgalā). An artistic format with an emphasis on Śiva and Śaktis existed in *citrakāra* workshops of south Orissa for which, except for the *Kālīprabhā* and *oṣākoṭhi* traditions, we have no historical and art historical evidence. It was easier to take on to a new tradition of *aṇasara* paintings that emerged and spread from Puri. A simple historical analysis of religious changes would lend weightage to our understanding as more authentic; nevertheless a whole set of mythical details and textual codifications and practices and overemphasis on the Jagannātha cult weigh heavy. But one should not forget that the strong tribal painting renewal tradition of the Sauras, as a ritualistic, artistic and mythical infrastructure, culturally support the south Orissan *oṣākoṭhi* and *citrakāra* workshop network. One should also not forget linkages of *daitāpati sevaka*s with Saura tribals who are responsible for replacement (*navakalevara* ceremony) at Puri, even though the *aṇasara* paintings are the product of *citrakāra* workshop. Several attempts have been made in favour of *citrakāra* workshops' networks with their centre at Puri and their spread, with the spread of Jagannātha temples, to regional pockets. However, our joint researches (with Eberhard Fischer) based on emerging art historical evidences and insights will prove that artistic traditions and their ensuing renewals centring Kālī, Śiva and Durgā are old enough to merit attention.

18

Mountain, Myth, Monuments

Kapila Vatsyayan

MOUNTAINS, as it is well known, occupy a significant place in the sacred geography of many cultural traditions of the ancient world. In some they are cosmic mountains and are perceived as the centre of the world, linking heaven and earth and anchoring the cardinal directions. In others they have been identified as places of revelation and vision, or as divine dwelling places. Even today, the Navajo imagine an "encircled mountain" around which stand four peaks. The Yorubas call out to the mountains; Kibo, the peak of Mount Kilimanjaro, is sacred for the Chhages of East Africa; the Moroccans refer to the great Atlas range as the pillar of heaven. Mount Fuji in Japan has always been considered as the link between heaven and earth.

In counter-distinction there is Mount Sinai as the most striking example of the mountain of revelation. Here Yahveh appeared to the Hebrews as a storm with fire and lightning or as a cloud that covered the peak. Yahveh also appeared directly when Moses and the elders ascended the mountain and saw the "god of Israel" (Ex. 24.10). It is believed that Mohammad heard the revealed word of the Koran at Mount Hira on the outskirts of Mecca. Even today pilgrims stand from noon to sunset on the ninth day of the Śajj pilgrimage at nearby Mount Arafat.

Mountains have been considered the dwelling place of the divine in several religious traditions. Mountain sanctuaries are equally important. Greek mythology is replete with references to them. The list is long and so are both the antiquity and the diversity of attitudes and approaches. Myths surround these real mountains or mountains of imagination. Mountains have inspired a vast body of literature, poetry, drama. Architecture attempts to replicate the mountain as in the ziggurats or the pyramids of Meso-America. However, despite the differences of attitude between the mountains as cosmic centres and those of revelation, there is no sense of either fright or revulsion, or a desire to conquer the mountain. The mountain was only not sacred for Luther who thought that the mountains scarred the surface of the earth with "warts and pockmarks" and signalled the fall and decay of nature, and for the writer Edward Burnet (sixteenth century), for whom mountains were the ruins of the post-diluvial world, a sign of chaos and fractured creation. The Romantics restored the balance somewhat. Now mountains

haunt, as in Wordsworth's Tintern Abbey, or become symbols of the ascension of the mind as in Shelley's powerful evocation of Mount Blanc.

These polarities of attitudes and responses are significant indicators of the fundamental notions of Man in Nature or Man and Nature or the disruption of the dialogue between the divine and the human.

In this essay I thought it would be pertinent to focus on sacred mountains, or the sacred mountain of mountains which has dominated the Indian imagination for millennia and is central to the world of myth and literature, architecture and sculpture, music and dance. It is a real mountain and a conceptual mountain. It is the fountainhead of the flowing waters of the rivers. It is pilgrimage and the journey to the unknown and boundless. It is perceptible but is in essence incomprehensible. There can be no question of ever imagining that this mountain could be conquered. There can only be a circumambulation of the mountain. The experience of the mountain is itself a revelation. It is a *darśana*, a vision. In the world of the mythic imagination it is the abode of the gods, particularly Śiva who performs his eternal dance here. In one aeon Satī is born here, who ultimately immolates herself; in another she is Umā, Gaurī or Pārvatī, who does penance to be united in marriage to Śiva. Kubera, the Lord of Treasures, guards the mountain slopes. Rāvaṇa travels in arrogance to shake the mountain but is humbled. Eventually he becomes a devotee and sacrifices nine of his heads to Śiva. Countless other myths surround the mountain. It is a sacred place in the three streams Hindu, Buddhist and Jaina, a consecrated *maṇḍala*. This is Kailāsa, the holy mountain, which inspires, beckons and calls people of all faiths. For the last two hundred years, many travellers, including those from the West, especially Hedin and Moorcraft, have tried to survey its physical contours, map its lakes and demystify the myth. However, the mystery remains for all those who have taken the pilgrimage and had a vision (*darśana*) of Mount Kailāsa and for all those for whom Kailāsa lives in the mind's eye.

The geological, physical material Mount Kailāsa is analogous to the primordial Mount Meru, the cosmic pillar of many cultures and religious traditions, which unites heaven and earth. But there was a moment even prior. Let us pause to recall the vision of the creation hymn of the *Ṛgveda*. Here is a profound insight into the mystery of reality, which could only be expressed through the language of poetry. It emerges from a deep mystical experience which is couched in a variety of images. The hymn is not speaking about origins; it is instead sharing a profound mystical awareness.

1. At first was neither Being nor Non-being
 There was not air nor yet sky beyond
 What was its wrapping? Where? In whose protection?
 Was water there, unfathomable and deep?

2. There was no death then, nor yet deathlessness
 Of night or day there was not any sign

The one breathed without breath, by its own impulse
Other than that was nothing else at all.

3. Who really knows? Who can presume to tell it?
Whence was it born? Whence issued creation?
Even the gods came after its emergence
Then who can tell from whence it came to be.
— Nāsadīya Sūkta, *ṚV* X.129
(Translation: Raimon Panikkar)

Through the series of questions the poet evokes the sense of the primordial mystery. There is a ungraspable but experiencable state of oneness and boundlessness. The symbol of the waters is important: the primordial water covers all, supports all. It has no form of its own, it is invisible and visible. It pervades everything, is the first condition of life. It is from the primordial waters that the mount Meru arises as *skambha* (cosmic pillar, *axis mundi*) in the *Atharvaveda*. Later, in Purāṇic mythology, the oceans and the waters are the abode of Viṣṇu. He lies supine on the coils of the snake of eternal time (*ādiśeṣa*). From his navel emerges the lotus, and on the lotus is Brahmā, the creator. It is this Lotus stalk which becomes the *meru* of other mythic images. Important amongst these are the references to the cosmic pillar in the context of the different incarnations of Viṣṇu. Viṣṇu represents the primordial waters: he emerges as fish (*matsya*) first. The fish both in poetic and visual imagery not only emerges from the waters, but also rests on a lotus plant, and the lotus stalk becomes a pillar. So also is the case with Viṣṇu's incarnation as a turtle. Now there is a disturbance in the oceans: a great churning takes place. Mandara, later to become Meru, is the pillar which is used as the churning rod. The gods and the titans (*devas* and *asuras*) churn the ocean in search for ambrosia (*amṛta*). The serpent Vāsukī (a symbol of eternal time) is used as the churning rope. Viṣṇu supports the *meru* (the churning rod) in the form of a turtle on his back. The image of the ocean and the primordial churning is sustained through many versions of the myth. Śiva enters the narrative as the one who drinks the poison and holds it in his throat. He is thus called Nīlakaṇtha. In many versions of the myth, the common feature is the disturbance in the ocean and the eventual churning out of essence and placing the vessel of ambrosia on the summit. The Mandara Meru, the rod, is both the instrument as also its measure. Its summit is beyond attribute.

Mount Kailāsa is the counterpart of the mythic Mandara and Mount Meru. It does not form a peak, and like Mount Meru rises heavenward as the seed cup of the world lotus. According to Hindu cosmology, four lotus-petal continents spread out from Mount Meru at the centre and, beyond them, the seven ring-shaped seas and further ring-shaped continents of the wider universe. Mount Meru is a *maṇḍala*, as is Kailāsa. The mythical Mount Meru and the physical Mount Kailāsa fuse into each other. Whether the presence of the Kailāsa gave rise to the myth or the myth was identified and located on Mount Kailāsa becomes insignificant, for there is the constant interplay of the real, tangible

and intangible — the geography and the myth. Each mutually empowers the other. Sacred geography of Hindu, Buddhist, and Jaina cosmology centres around Mount Kailāsa. Different interpretations are given to the physical phenomenon of the mountain, the cardinal directions and the river systems which emerge out of the mountain. However, there is an affinity, even a commonality of perception and comprehension. Mount Kailāsa is sacred to the three streams — Hindu, Buddhist and Jaina.

Mount Kailāsa is that supreme mountain amongst the Himālayan and trans-Himālayan ranges which has an unique personality. It is recognized as a vessel of cosmic power, a sacred centre of the world. It has transcendental power. It assumes different symbolic significance for the Hindu, Buddhist and Jaina. For the Hindus it is the seat of Śiva, for the Buddhists it symbolizes the gigantic *maṇḍala* of the Dhyānī Buddhas and *boddhisattva*s. The *Demchog Tantra*, the *maṇḍala* of Highest Bliss, has an elaborate description. Important in these descriptions is the account of the rivers. According to the Tibetan tradition, from the east of Kailāsa Mānasarovara flows the *Tamchog Khambab*. She flows from the horse's mouth. Another river *Lanchen Khambab* flows from the elephant's mouth in the west. In the north from the lion's mouth flows *Senge Khambab*. And from the south flows *Megcha Khambab*, i.e. the river from the peacock's mouth. These animals — the horse, elephant, lion and peacock — are the vehicles (*vāhana*s) of the Dhyānī Buddhas. The names of the rivers indicate that they are regarded as parts of a universal *maṇḍala*, of which Kailāsa is the centre. Parallel to it is the actual fact that the Brahmaputra, Sutlej, the Indus and Karnali or Gaṅgā have their source in the slopes of the Kailāsa or Mānasarovara. Amongst these, Indus and Brahmaputra embrace the entirety of the Himālayas and the whole of the Indian subcontinent like two gigantic arms. For the Jainas, Mount Kailāsa is identified with the highest part of the cosmolograph of the Jambudvīpa. It is also the locale of the celestial world in the Jaina conception of the universe as *loka* (or *loka-ākāśa*).

Sanskrit literature is replete with the imagery of Mount Meru and, later, Kailāsa. The latter, like Mount Meru, kisses the heavens. There are several references to Mount Kailāsa in the *Mahābhārata*. Often it is compared to the morning sun, or a ball of fire without smoke, immeasurable and unapproachable by men of manifold sins. It is to this mountain that the Pāṇḍavas take their last journey after the *Mahābhārata* war. It is on this mountain that Arjuna does his penance to receive the invincible weapon Pāśupata. Śiva tests him in the disguise of a hunter and finally reveals himself to bestow upon Arjuna his benediction.

In the *Rāmāyaṇa*, there are fleeting references to Mount Kailāsa. There is a beautiful description of the lake Mānasarovara which is full of symbolic message. It is said "when the earth of Mānasarovara touches anyone's body or when anyone bathes in the lake, he shall go to heaven (*svarga*). He who drinks its waters shall go to the abode of Śiva and shall be released from the sins of a hundred births. Its waters are like pearls." Elsewhere

in the same epic it is said that the lake was formed from the mind of Brahmā; there dwells Mahādeva.

Although the presence of mountains — the Himālayas, Meru and Kailāsa — is important in Vedic and epic literature, it is in the Purāṇas that the Himālayan ranges are thoroughly explored. There are lengthy and vivid descriptions of the geography, flora and fauna and the countless myths which surround them. Today, range upon range rises before us. Each range embodies the myth of Śiva. A vast panorama opens up of the several peaks which allude to the mythology of the celestial family. Near the pilgrimage centre Badrinātha there is Nīlakaṇṭha, the peak which reminds one of the myth of the churning of the ocean, and Kedāranātha, where the Pāṇḍavas stopped. The peak Triśula is the trident of Śiva, the consort of Śiva is Nandādevī. Her abode is extensive. At dawn, as the early sun rays touch the peaks, there is an unfolding of the primordial myths. As the sun rises, the peaks and the myths are once again shrouded in mystery. The process of unfoldment, revelation and mystery goes on incessantly. The experience is not physical; it is indeed mystical, full of mystery. It is from these ranges, both physically and metaphorically, that one travels towards Kailāsa confronting the lake of the dark waters Rākṣasatala (lake of the demons) to the pure serene waters of Mānasarovara, the lake of the mind where swans float and which has the purity of the pearl.

The Purāṇas explore the physical, mythical and psychical Himālaya repeatedly. Kailāsa is central although the other peaks, lakes and rivers are as significant. A vast sacred geography is created. Each place, river, lake, forest, mountain peak assumes a symbolic significance. The landscape encodes symbolic messages. Each natural form is imbued with supernatural significance, the ordinary, the mundane, is made extraordinary and sacred.

It is significant that the first major description of Kailāsa in the *Viṣṇu Purāṇa* is in distinction to Mount Meru and the Himālayas in general. The myth of the descent of the Gaṅgā is narrated here in detail. Later other versions follow. Other Purāṇas, *Vāyu*, *Śiva*, *Skanda* and *Kūrma*, devote considerable attention to Kailāsa and Mānasarovara. Each of these accounts reflects a deep insight into the mystery of the mountain; myths are told and retold with significant variations. The corpus is vast and extensive. A perusal of this material makes it clear that the mountains, lakes and rivers were no doubt real but their significance lay in their becoming homologues of psychic states of the human. If Kailāsa was the highest ascension to be seen from afar, circumambulated and not conquered, the rivers flowed out of this abode of undifferentiation to different directions, to nourish and nurture. They come from a source, a glacial level immeasurable, undefined but comprehensible by the mind. The two lakes Rākṣasatala (lake of the demons) and Mānasarovara (lake of the mind) were the pair in juxtaposition. Just as the Rākṣasatala, the lake of the dark water, had to be traversed before reaching the pure waters of Mānasarovara, so also the pilgrim's journey was from the dark and impure to the light

of pure consciousness. Mānasarovara is the lake of fertile creativity, serene and beautiful, nourishing. Kailāsa, its vision, is the ultimate fulfilment of desire, to be trans-desire.

At another level, the Purāṇas are replete with narratives of many myths surrounding the mountain and the peaks. In this space and place, there is the unfoldment of the several dramas which are played on the summit. The narratives of these myths are engaging as they are full of symbolic significance. All of the nature participates in this drama. The place is Mount Kailāsa, the *dramatis personae*, the entire pantheon of Hindu mythology. In one aeon the parent of Satī is Dakṣa, in another he is Himavat or Parvat (literally "mountain"), the father of Pārvatī. The rivers become the companions, sisters and rivals, especially Gaṅgā. The forests are the locks of Śiva, and there are a host of others from the smaller gnomes (the *gaṇas*) to Kubera, the guardian and door keeper, the Lord of Wealth and Treasures. Śiva and Pārvatī, in their eternal play (*līlā*), sometimes play dice, at others are universal parents.

Over the centuries, these myths and their diverse narratives and symbolism penetrated the Indian poets' imagination. For nearly two thousand years Kailāsa dominates the imagery of Indian poetry and drama. Each poet gives it a new meaning and significance. Towering amongst these is Kālidāsa, the writer of the famous *Abhijñāna-Śakuntalam*, which was to capture the attention of William Jones and Goethe. Little did either William Jones or Goethe realize that, apart from all the other surface romanticism of the play, it was a great invocation to Kailāsa and the eight-fold forms of Śiva. The body of Kālidāsa's work is saturated with the imagery of Kailāsa, the mountain, the lakes and rivers. He employs this imagery to create a multilayered texture to his deceptively simple poems and plays of love and separation and re-union, particularly the "Cloud Messenger" (*Meghadūta*) and *Abhijñāna-Śakuntalam*. The longer poem, an epic in its own right, is more explicitly situated in Kailāsa. *Kumārasambhavam* is the story of the birth of Kumāra or Kārttikeya who is born to vanquish the demon Tāraka.

The *Meghadūta* is built around the thin story of the Yakṣa who has fallen from grace and is exiled in Rāma's hill. It was here that Rāma also spent some time during his exile. Today the place is identified with Ramtek, a hilltop near Nagpur. The poet alludes but scantily into the reasons for the hero Yakṣa's exile. The reasons unstated are, however, full of significance. The story begins in Kailāsa and the lake Mānasarovara. Naturally, it is the abode of Śiva, and Kubera, the lord of riches and treasures, is the guardian doorkeeper of his ascetic master. The Yakṣa is given the duty to collect fresh lotuses from the golden pond (lake Mānasarovara). Kubera then offers them to Śiva. On a particularly auspicious day it is discovered that the lotuses were not fresh. Suddenly a bee captured in the lotus flies out and bites Kubera to let it be known that Yakṣa had gathered the flowers the evening before. He was passionately in love with his wife — in fact sick with passion — and so, to dally longer in the morning, he committed this act. The flowers could not be offered. As a punishment, Yakṣa is banished from Kailāsa to the South to Rāma's hill. It is here that the Yakṣa sights a raincloud. He addresses the cloud, entreats

it to become his messenger. There are no other characters, only allusions to the wife who is still in heavens in the city Alakā, and of course the presence of Śiva in Mount Kailāsa. The poet loads his short poem with innumerable allusions to a vast body of Indian mythology. Each verse, or for that matter phrase, opens up many worlds of mythic time and space. They are not confined to Śaiva mythology. Several other Gods, Kṛṣṇa included, enter into the seamless texture of imagery. Each stanza becomes a code for a polyvalence of meaning and significance. Several levels of contrasts and several dimensions of the journey of the soul are suggested. The cloud then becomes almost like mount Meru (the *axis mundi*), the mediator between the mundane and the sacred, the impure defiled and the pure, the real and the illusionary. The Yakṣa himself is not a specific person or character. The very name conjures up the images of the spirits of the waters and vegetation. The *yakṣa* and *yakṣiṇīs* constitute a very significant level of the Indian mythic imagination. *Yakṣa*, *yakṣiṇī*, and *apsaras* are born of the waters and are the spirits of nature. Indian Art — be it Buddhist, Hindu, Jaina — is replete with the personification of these nature spirits. A.K. Coomaraswamy has dwelt at length on them as water cosmology. Bharhut, Sanchi, Ajanta, Ellora, Khajuraho, Mount Abu are surrounded by these spirits in human form. They arise from the waters, become river Goddesses, they entwine trees, and are an aspect of our natural self — human, passionate and attached. The poet plays on the word, as much he employs the myth of Kubera, the Lord of the Treasures who guards the abode of Śiva, the detached *yogī*.

The Yakṣa tells the *megha* (cloud) that he will have to take a long journey. During the journey he will not only see different parts of India but also visit many cities and especially one temple dedicated to "Great Time" (Mahākāla). The cloud will also have to change his shape and form in space and time. The cloud then is the observer who overviews the vast expanse of human existence, but is also one who can enlarge and shrink to enter into inner spaces of the diverse experiences of the human mind. Sometimes the cloud will become the thunder of Śiva's drum, and at other times he will participate as a devotee in the worship of Śiva as cosmic time. The poem is more than a simple poem of longing and separation. Nor is it a poem merely full of some of the most evocative descriptions of nature. It is also not only a poem about the geography of India from Rāma's Hill to the Himālayas and Mount Kailāsa. It is also not only an account of the important urban centres such as Ujjain and the pilgrimage places such as the temple of Mahākāla. It is all these and more. Through the mythic allusions, the poet piles layers upon layers of meaning, different orders of time, and different dimensions of the inner journey of man from passionate bondage to the anticipation of an emancipated heaven of joy and bliss. The poet employs the myth of Kailāsa and of Śiva and the lake Mānasarovara to set-up a hierarchy of relationships between the terrestrial and the celestial, earth and heaven, and the intermediary spaces. The poem moves concurrently on the planes of the physical, psychical and spiritual. All levels are interfused through the narrative of the multiple myths.

At the very outset Yakṣa sees another auspicious day in *Āṣāḍha* (the rainy season) "a cloud embracing the crest of the hill." The strikingly-shaped cloud is like a sportive elephant bent down to bathe in a river bank. The Yakṣa entreats the cloud unmindful that his lovesick mind may itself be clouded. This mass of mists and light, winds and water becomes the *alter ego* of the Yakṣa, and his brother Yakṣa imagines the journey of the cloud to Kailāsa:

> And hearing your thunder — a sound sweet to their ears
> that can make Earth unfurl her mushroom parasols,
> regal swans longing for Mānasa-lake
> gathering tender lotus-shoots for the way
> will be your companion in the sky
> even up to Mountain Kailāsa peak.
> — *Meghadūta* 1 (Translation: Chandra Rajan)

When the cloud will come close to his journey, it will have a vision of Śiva in his multiple forms on those heights. Within three stanzas the poet traverses three orders of time and two major myths.

The first alludes to both Śiva as one who is adorned by the crescent moon. This takes us back to the story of the churning of the ocean. On that occasion Śiva took the crescent moon as it emerged from the waters and made it his hair ornament. He is then called Chandrasekhar. There is a faint suggestion to another myth. In an earlier aeon Satī was born of Dakṣa. Dakṣa did not invite Śiva, her husband, to the sacrifice. Satī visits her father uninvited and immolates herself in the fire. Śiva arrives, is angered and anguished. He carries the corpse of Satī on his shoulders. The movement of the world-order is halted, and there is chaos. Viṣṇu then cuts off parts of Satī, limb by limb. These limbs, wherever they fall, are the consecrated places of holy worship in India called Śaktipīṭhas. The *siddha*s and all others worship these holy spots.

Kālidāsa — with a perceptive insight — collapses these mighty myths into a few lines:

> Bending low in adoration, go round
> the rock bearing the footprint of the moon-crested Lord
> perpetually worshipped with offerings by Siddhas
> Looking upon it the body abandoned
> And sins shaken off the faithful gain
> the Eternal station of the Lord's attendants.
> — *Meghadūta* verse 56

And suddenly the tone changes to conjure up yet another manifestation of Śiva where the cloud will be participator:

> The wind breathing through hollow bamboos makes the sweet music
> Woodland nymphs sing with passion-filled voices

Of the victory over The Triple City
If your thunder rumbles in the glens like a drum
Would not the ensemble then be complete
For the dance drama of the Lord of Beings.
— *Meghadūta* verse 58

Śiva as the vanquisher of the three cities of gold, silver and iron is called Tripurāntaka. There were three cities in the sky, air and earth, of gold, silver and iron. The titans were the builders and naturally arrogant and destructive. A single spark from Śiva's third eye burnt all three to ashes. The metaphysical import of the myth is clear. The three cities are the three-fold darkness of human consciousness. The fire of the third eye of Śiva is that sudden spark of illumination. It is of this state of illumination that the woodland nymphs sing.

The poet not only alludes to the burning of the three cities, but takes the theme further in the last few lines, where he speaks of the enactment of the play of the burning of the Three Cities in Bharata's *Nāṭyaśāstra*. The *Nāṭyaśāstra* (second BC to second AD) refers to this presentation of this drama in Kailāsa before Śiva and Śakti. Thus there is the mythical event and also its enactment as the first play. The last reference takes us to the vast domain of Indian aesthetics.

And the poet continues with other images of Viṣṇu and his three strides but most powerfully of one which recalls the myth of Rāvaṇa's shaking the mountain Kailāsa:

And going on be Kailāsa's guest
mirror for goddesses — her ridges joints
cracked by ten faced Rāvaṇa's straining arms
filling all space the loftiness of his peaks
luminous as moon lotuses, seems
the tumultuous laughter piling up each day
of the parent of the Triple World.
— *Meghadūta* verse 60

While Rāvaṇa shakes the mountain Kailāsa, Pārvatī (Gaurī) holds Śiva's hand. Gaṅgā is also here "like a woman with her hair piled up," who bears masses of clouds shedding water in the rainy season (cf. verses 62 and 64).

Even from these few verses it will be clear that *Meghadūta* is a rich and tightly woven fabric of multiple myths and polyvalence of meaning. The poet vests the many levels of complexity through the motif of the cloud. Kailāsa is no longer the physical mountain of geography, it is the mythical space of the drama of the celestials and is the symbol of the ascension of the human from lower levels to higher levels of consciousness, from passion, attachment to emancipation.

In the other works of Kālidāsa also Kailāsa, the myths of Śiva and also Śiva in his iconic form occupy a central place.

The locale of the long poem, almost an epic of several cantos, *Kumārasambhavam* is situated in Kailāsa. The cosmic drama of the One uniting with his own self is enacted here. After Satī immolated herself in the sacrificial fire of her father Dakṣa in an earlier aeon, she is born again as the daughter of the Mountain (Parvat, Himavat). She falls in love with Śiva, who is deep in meditation, not to be disturbed. Gods are agitated because the world-order has again come to a standstill. They send Eros (Kāma, Madana), to pelt arrows at him so that the *yogī* ascetic would wake up to love. Śiva reduces Kāma to ashes. But the moment of burning Kāma to ashes is also ironically the moment of the ascetic *yogī* becoming a lover. Separately, Pārvatī resolves to do penance to attain her goal. Menā, her mother, dissuades her. Pārvatī is adamant. After arduous penance (*tapas*) in heat and cold, rain and thunder, there comes a moment when a mendicant appears before her. He lists all the disqualifications of Śiva and gives a vivid account of his unseemly visage and appearance. Pārvatī is firm in her resolve: she rebukes the visitor, spurns his advances. Well, he is none other than the Lord himself, disguised. He had come to test Pārvatī, in fact to seek her hand. A great marriage takes place. The snakes, the tiger skins and the garland of skulls and the ash are transformed into the most resplendent ornaments. His companions sing and dance. The bull Nandī rejoices. Śiva now is Kalyāṇasundaram. The world parents are united. Their abode is Kailāsa. Pārvatī is none other than his own energy (Śakti). Their eternal play (*līlā*) is remembered in countless ways as myths, dramas, songs, rituals and icons of Umā-Maheśvara, Śiva-Pārvatī, throughout India.

Kumārasambhavam is a re-narration of the myth. Many Purāṇas but especially *Śiva Purāṇa* gives a vivid, detailed account. Kālidāsa treats the subject with his characteristic power of containing complexity in a simple narrative structure. The cantos dealing with the Kāma (Eros) and Pārvatī's penance resonate with countless allusions of great significance. The poet lifts the narrative to great heights of metaphysics. The mythical becomes an instrument of exploring deep levels of consciousness.

The poem opens with an invocation to the Monarch of the Mountains Himālaya. The myth of the churning of the ocean is recounted. We are reminded of the measuring rod Mandara and Meru.

> There in the north is the Monarch of Mountains
> Himālaya named of divinity indwelling
> Plunging into the great oceans, east and west
> He stands as a rod taking the Earth's whole measure.

Here Kālidāsa introduces another image of "cave" or cave mountain, another motif of great significance in the Indian artistic and metaphysical traditions. Temples are mountains; they are also caves.

> That mountain fills the hollow bamboo stems with breezes he exhales through
> the cave mouths as if wishing to accompany with flutes note by note the high
> clear melodies of the fairies.

Metaphor upon metaphor is piled up throughout the poem especially in the first five cantos which are certainly the work of Kālidāsa. A fuller account of *Kumārasambhavam* demands a separate article. No justice can be done to it here by attempting to give details in a fragmentary manner. Suffice is to say that this poem is also about heaven and earth, of the terrestrial and celestial realms, of and about the three orders of space and time and the restitution of world order. The vanquishing of Tāraka by the son (not born, but created) Kārttikeya brings to completion another aeon. At a metaphysical plane the poem is a concretization through the poetic word of the concept of the timeless descending into time and space. It is through the language of metaphor that many metaphysical concepts come alive. Śiva is ungendered Ardhanārīśvara (the lord who is both male and female). He embodies the mystery of Being-becoming (*bhava-bhavānī*). He is imperishable (*akṣara*) (3.50), the world's form or universal form (*viśvamūrti*). The marriage of Śiva and Pārvatī is the union of the divine with itself. In essence *Kumārasambhavam* signifies the manifestation of a hierophany.

In the play *Abhijñāna-Śakuntalam*, Kālidāsa invokes Śiva in his form as the *aṣṭamūrti* (eight-fold form). This is a verbal icon. No longer is the myth narrated or characters appear. Instead the invocation and the final benediction, both dedicated to Śiva, frame the play. The seemingly simple romance of Śakuntalā and Duṣyanta is the explicit level. Scholars have interpreted it in recent years as the tension between tribal rural India and monarchy, the marginalized rural and the empowered state. It has also been interpreted in terms of gender imbalances. The sociological level is its surface value. Deeper, the poet is once again preoccupied with the journey from the terrestrial to the celestial. As in the *Meghadūta*, there are a series of contrasts within the world of nature. The title recognition of Śakuntalā offers a clue. Śakuntalā is nature pure and unsophisticated. She is, like the *yakṣa*, also a symbol of the water spirit who eventually travels through travails to the celestial abode of Hemakūṭa (Kailāsa). Her penance, even suffering, is of a different nature than that of Pārvatī's. However, separation, penance and ultimate union or in this case re-recognition is the theme. Śakuntalā in the hermitage is in lush secluded nature. Like the *yakṣiṇīs*, she entwines with the creepers, considers them her sisters. The bushes and the groves reverberate with the fragrance and sound of untainted innocence. Duṣyanta enters the hermitage riding a chariot, chasing a deer. The deer, antelope is no ordinary animal. The very image opens up another world of the primordial mythic moment. The allusion takes us back to the story of Dakṣa's sacrifice and Satī's immolating herself. The sacrifice itself had risen like an antelope. Śiva pierced the heart of the embodied sacrifice, who fled to heaven. In the myth it is the head of this deer that Śiva holds in one hand in his iconic form. Kālidāsa makes an oblique reference but leaves it at that.

Duṣyanta intrudes into this consecrated hermitage of original nature to hunt. As a consequence he does entrap Śakuntalā in bondage of attachment, but an attachment which has to be tested and purified. She has to travel to another realm. The motif of the

lost ring, the token of this attachment, his amnesia and eventual search for Śakuntalā are symbolic of the separate but interfused journeys of both. Śakuntalā ascends to Mārīca's hermitage in Hemakūṭa (Mount Kailāsa). This hermitage is in the heavens above. Now everything here is autumnal gold and rust. There are no water lilies, instead there are golden lotuses, reminiscent of the lotuses of Mānasarovara. The union of the two cannot take place on earth or terrestrial space, either of the secluded innocent *āśrama* or the gilded palace of the king, it has necessarily to be at the heights of mount Kailāsa in Hemakūṭa. The introductory benediction, as pointed out, is a verbal icon of the eight forms (manifestations) of Śiva.

The poet presents an image of Śiva thus:

> The First creation of the Creator
> That Bearer of oblations offered with Holy Rites
> That one who utters the Holy chants
> Those two that order Time
> That which extends, World Pervading
> In which sound flows impinging on the ear.
> That which is proclaimed the universal womb of seeds
> That which fills all forms that breathe
> with the breath of Life
> May the Supreme Lord of the Universe
> Who stands revealed in these eight forms
> perceptible preserve you.
>
> — Translation Chandra Rajan

An alternate translation by Barbara Stoler Miller runs thus:

> Water the creator's primordial element
> the fire bearing sacrifice, the priest
> the time dividing sun and moon
> ether filling the universe with sound
> What man call nature, the origin of all seeds,
> air that living creatures breathe
> may Śiva bless you with his eight manifested forms.

Both translations although with different emphasis allude to the five primal elements and the eight manifestations of Śiva. The play closes with the benediction.

> May the self existent Lord who unites in Himself (Śiva-Śakti)
> The dark and the light
> Whose infinite power pervades this universe
> annihilate forever the round of my births.

The epithets used for Śiva once again illumine a vision of Śiva in Kailāsa as re-united with itself (Himself). Śiva is *nīla-lohita*, i.e. the one with dark blue throat, but now also

radiant with rust glow, that is the glow of Śakti. If we follow the contours of the imagery from the invocation of the prologue to the final benediction, it is evident that the poet suggests in many subtle ways the eight-fold manifestation of Śiva. These meander through the text at the deeper implicit level. The iconic form of Śiva is always present.

It is characteristic of the Indian tradition that there are no absolute polarities. All opposites are perceived as complementaries or aspects of each other. The eight-fold forms of Śiva of the invocatory benediction are all aspects of the one, a-dual (beyond duality) and the final benediction as if closes the eight-fold lotus petals into the one and self-existent.

Perhaps it is not necessary to make any further comments on the preoccupation of the Indian mind in myth and literature with the vision of Kailāsa as the real mountain and the mountain of the mind and consciousness.

Kailāsa, Śiva and Pārvatī fill the pages of Indian poetry for centuries. Medieval Bhakti poetry reverberates with echoes of the mythology. The mythology is often reversed, or it becomes an aid to intense identification. Amongst this vast corpus there is the poetry of the medieval saint poets and poetesses of south India both of the Tamil and the Karnataka tradition. A.K. Ramanujam has recreated this most evocatively in several of his works, specially *Inner Landscape*. He recounts the lurking mythology of Kailāsa and Śiva in the poetry of *Basavanna*, and most of all *Mahadeviakka*. Going against all conventions, like Pārvatī, Mahadeviakka thinks of Śiva as her only husband. She pines for him, her heart is set on him. Unlike Pārvatī, she does not do penance. Instead, she sees him in her dream.

> Listen Sister listen,
> I had a dream
> I saw rise betel, palm leaf
> and coconut
> I saw an ascetic
> come to beg
> white teeth and small matted curls.
>
> I followed on his heels
> and held his hand
> he who goes breaking
> all bounds and beyond
> I saw the lord, white as jasmine
> And woke wide open.
> — *Mahadeviakka* 87 (Translation A.K. Ramanujam)

The ascetic is transformed as in Kālidāsa's *Kumārasambhavam* into the resplendent one. Mahadeviakka sees Śiva as he was at his wedding.

> Locks of shining red hair
> a crown of diamonds
> small beautiful teeth
> and eyes in a lighting face
> that lights up fourteen worlds
> I saw His glory
> and seeing I quell to-day
> the famine in my eyes
> — *Mahadeviakka* 68

Like Pārvatī, she is questioned "why should a woman want for her husband a man who destroys everything." The answer in Mahadeviakka's words is like Umā's answer, but different in tone.

> I love the Handsome One
> he has no death
> decay nor form
> no place or side
> no end nor birthmarks
> I love him O mother listen.
> I love the Beautiful one
> with no bond nor fear
> no clan no land
> no landmarks
> for his beauty.
> So my lord, white as jasmine, is my husband.
> Take these husbands who die
> decay and feed them
> to your kitchen fires.
> — *Mahadeviakka* 283

This is the Śiva without form and attributes *nirguṇa*. Mahadeviakka has dreams and visions of him.

> I saw the great one
> who plays at love
> with Śakti
> original to the world,
> I saw his stance
> And began to live.
> — *Mahadeviakka* 68

Śiva of Kailāsa lives in the poetry of the south India, he also lives and breathes in the poetry of Lalleśvarī, the saint poetess of Kashmir of the fourteenth century. Her longing for union is as intense.

Lalleśvarī's poems are an outpouring of her soul. Spiritual anguish is intense. She desperately searches for Śiva: yearns for union with him. He is cosmic consciousness who is within her own self. Her mystical experiences led her to a state where nothing but the awareness of the absolute, the one, remains. There is no duality, no Śiva or Śakti, nor word nor mind. She represents the quintessence of Kashmir Śaivism in the subtlest words of poetry. There are also nuances of the Buddhist doctrine of *śūnyatā*. For her the mystical state can be attained not through restraining sense-organs or penance or any other discipline. Instead the natural flow of devotion, trans sense and intellect, doctrine or dogma. Introspection, into the deep recesses of the cave of the heart is her calling. Her *guru* is inside. In her words,

> My guru asked me to do but one thing.
> To get still deeper in from the world without
> The words became my precept and command
> And that is how I do now naked dance.

For Kabīr, the weaver poet who transcended all boundaries of religion, caste, the wild geese/swans (*haṁsa*) in Mānasarovara become an image of the soul returning to its home.

> The swan has taken its flight
> To the lake beyond the mountains
> Why should it search for the pools
> or the ditches any more.

or again,

> In the celestial lake
> the swan has found
> its eternal home
> In utter abandon
> It floats
> Picking up pearls
> Tempted no more
> To fly off
> Elsewhere.

And without naming any God or deity he asks:

> O Kabir
> The Lord has created
> The entire universe
> Yet unattached to it
> He remains?

II

It will be recalled that in the *Meghadūta* the Yakṣa addresses the cloud, and says that "you will be the drum player in the enactment of the play of the victory of the three cities." Here it is pertinent to draw attention, even if altogether briefly, on the presence of the mountain and the cave and of Śiva in the origins and history of Indian aesthetics.

Bharata's *Nāṭyaśāstra* is saturated in the myths of Śiva at the implicit level. The dance of Śiva in his hundred and eight cadences of movement constitutes the subject of the fourth chapter called *Tāṇḍava Lakṣaṇam*. The playhouse itself was to resemble a mountain cave. The first plays enacted were those of the churning of the ocean and the victory of the Triple cities of gold, silver and iron. The theory of *rasa* posits eight principal states, comparable to the manifested forms of Śiva, wherein all merge in that one state of the formless and beyond form state of bliss and joy. This is state of the *ānanda tāṇḍava*, the dance of eternal bliss of Śiva; this is the final state of *ānanda* (bliss) of the aesthetic experience. This text also moves concurrently at the level of myth, theory and technique. Indeed, the myths become codes for explicating both theory and formal aspects of dramaturgy.

The text was interpreted and commented upon for centuries. Theoreticians and creative artists, poets, sculptors, musicians followed it in praxis. Kālidāsa's plays also exemplify the basic tenets. This makes the poems and the plays even more meaningful and polyvalent.

Amongst Bharata's commentators and interpreters, they were many. Each gave his special interpretation. Towering amongst these was Abhinavagupta who was a philosopher-mystic, deeply dedicated to a branch of Indian philosophy which we today recognize as non-dualistic Kashmir Śaivism. Aduality, non-duality is its core, but the complexities are many. In our context it is well to remember that Kailāsa and Śiva live as intensely in creative literature as in critical discourse. That is a subject which we cannot pursue here.

III

This is Kailāsa: mountain and myth of the creative imagination of the poet, dramatist and saint devotee and the aesthetician. Parallel and concurrent is the mountain, Kailāsa and the myth as recreated and replicated in monument, stone and brick, and in innumerable reliefs, stone sculpture, bronze images and in countless miniature paintings. The geographical canvas is vast, and the time extends from the earliest from the fifth century to the eighteenth century.

We had spoken of the Himālayan ranges, the mountain Kailāsa, in terms of both the actual landscape and the sacred geography of India. The two interpenetrate: one informs the other. The geological becomes the mythical and mythical becomes the geographical. Ecology and myth also fuse. Concurrent is the conception of the origin of the universe,

the cosmogony and the cosmological structure. The myth of the churning of the ocean, and of Viṣṇu as turtle upholding Meru, is primary. The cosmogony and its myth, the cosmology and its spatial and temporal schema of the universe, the actual topography with the mountain peaks, rivers, lakes are abstracted into the geometrical design of a *maṇḍala*. The mountain then is both lotus and rivers, the seven islands. The actual real mountain is imbued with attributes at different levels. There is symbolism of vegetation, and even lots of animals, of celestial beings. All signify ascension as well as descent. It is then a place of pilgrimage, a journey from the world of sense objects, desires, attachments, fear and darkness, to the lake of serenity of mind with swans and lotuses, and illuminating light. In the past and present these pilgrimages are undertaken as penance, purification in the hope of emancipation, from bondage. Cleansed and purified after the circumambulation and the experience of the vision of the mountain and the reliving, silently or otherwise, of the myths of Śiva and Pārvatī or Domchhok and his consort Dorje Phangmo who lives in the peak called Tijung near Kailāsa, remembering the journey of Ādinātha in the Jaina tradition, the pilgrim returns to the mundane terrestrial world, transformed.

Perhaps this experience of the real or imagined experience of the mountain Kailāsa, the pilgrimage and the myths told and retold, inspired architects, sculptors, painters to recreate the experience through architectural design, which would serve as an analogue to the mountain myth and the pilgrimage. Nothing else can explain the phenomenon of the repeated attempts in different parts of India, east, west, south and north, to replicate the mountain Kailāsa in architectural terms. The walls of the temple unfold the myths in visually spectacular dramatic forms. It would appear that Śiva, Pārvatī and a host of others are re-enacting the theatre of Kailāsa. Each niche has a different story to tell. In totality, there is cosmic drama retold. The monument becomes a symbol also for a pilgrimage, like the pilgrimage to the real mountain Kailāsa. The monument like the mountain connects earth and heaven, and is the beginning of spiritual journey to the divine.

Amongst the many examples of the architecture inspired by mountain, Meru, there is the outstanding example of Borobudur. It is Mount Meru and a *maṇḍala*. Paul Mus, more than anyone else, spent years to unravel the mystery of the mountain and the *maṇḍala*. This is the Buddhist articulation of the experience. The architectural plan, the shape and form, was developed meticulously to suggest a mountain, but also the ascension to *nirvāṇa* or *śūnyatā* through nine successive stages (*bhūmi*s). Borobudur as Meru and *maṇḍala* is yet another universe we cannot dwell upon. The ziggurats and the temples of Meso-America are comparable in conception but not in complexity.

In India, many attempts were made from the fifth century onwards to replicate or recreate Kailāsa in the architectural design of temples. One of the earliest of these attempts was the Kailāsanātha temple of Kanchipuram, dated fifth to seventh century AD. The dates, interestingly, enough are co-equal with those of Kālidāsa by some account. This is a magnificent structure where the entry into the temple is through a small gateway

(*gopuram*) of modest height. The courtyard serves as a circumambulatory path to the inner shrine, which is like a cave, a phrase we have come upon in the Purāṇas and in Kālidāsa. In the niches of the courtyard and in the outer walls are sculptures of massive proportions of Śiva in his many forms. The Kanchipuram Kailāsa temple is a masterpiece in design. It seems to replicate the journey to Kailāsa in a unique fashion which was later to become a standard pattern. Entering the temple through a modest gate, there is circumambulatory paths (*pradakṣiṇā* path). Along this path are sub-shrines. Each has a different story to tell. These are, as it were, the characters of the myths of Kailāsa. In the centre is a square sanctuary where Śiva resides in his aniconic form. Outside on the walls he emerges dancing in forceful energy. Some of these sculptures in high relief are of massive proportion.

Elsewhere in south India other attempts were made to recreate the shape and form of Kailāsa, especially in the temples of Pattadakal, Papanath and Virūpākṣa. Whatever the architectural style, the fundamental impulse was to recreate the experience of Kailāsa, and the other mountain peaks in mass and volume through human hands.

However, from amongst these several temples in all parts of India, north, south, east and west, there is one which is unique in conception and visualization, architectural schema and engineering skill. This is the Kailāsa temple of Ellora. I am not concerned here with the exact chronology or with issues of architectural antecedents. Important as these issues are for art history, here I would like to concentrate on the process of transforming the vision of the mountain and its myth into a monument. A superhuman effort was made to carve out a structural monument from a single piece of rock. The monument had to be both cave and mountain.

Cave shrines and rock-cut cave shrines of the Buddhists, Jainas, and Hindus are interspersed in the western coast of India. Bhaja, Karle, Ajanta and the complex of Ellora are outstanding examples. However, perhaps never before such an effort was made to isolate a monolithic block of two hundred and sixty-five feet long and one hundred and fifty feet wide to be carved into a temple. This was done by driving two parallel gorges on either side. This was then carved top to bottom, not structurally built from bottom to top. It is as if the architect first saw in his mind's eye the top of Kailāsa. This he does by translating the metaphor of the lotus, from petalled lotus with a pericarp. We almost begin here and then gradually travel down to the slopes of the mountains. The central sanctuary is massive in proportion, about 90 ft high. The central courtyard which now serves as the ground level measures 300 ft by 160 ft. This is the replication of Kailāsa the mountain, with its pillars, sub-shrines, aisles and gateways, etc.

Now let us begin the journey from the lower stages. You enter the temple through a gateway with a barrel-vaulted roof form, two free-standing monolithic columns and two elephants. As you enter, you meet the *yakṣīs*, the river goddesses and the *devī* in one corner. The myths and theme of the *yakṣīs* and river goddess is sustained. Gaṅgā, Yamunā,

Sarasvatī and Devī are present here, as they are in the myths and in the poems and plays of Kālidāsa. The free-standing monolithic columns are an architectural statement of the Mandara and the Meru, the rod of the myth of the churning of the ocean. The central sanctuary gives mass and volume to the conceptual mountain and replicates the form of the mountain Kailāsa. On the walls of the temple and in the sub-shrines and the auxiliary shrines, the narrative of the several myths is visually recreated.

Thus the architect employs both imagination and skill to translate the experience of the mountain, the myths and the metaphors of poetry into stone, volume and mass. Concurrently, the courtyard and the circumambulatory path serve as the symbolic pilgrimage to the mountain. Meaningfully the central shrine is placed on the second storey, at an elevation. As was to be expected, in the main shrine there is only a *lingam*. Outside are the different manifestation of Śiva, as also the tales from the two epics *Rāmāyaṇa* and *Mahābhārata*. A whole cosmos is created, which is in space and time, and outside it. The *lingam*, the free-standing column (*dhvaja stambha*) and the ascending pinnacle of the main shrine all serve as homologues. The courtyard and the circumambulatory path is the journey during the pilgrimage. The characters of the myths and the events are visual re-narration as reminders that the space and place of the temple is consecrated in another order of time.

Thus, while on the one hand the structure is separated from this world, it is also the mediator between earth and heaven. A precise conceptual and architectural schema is followed in respect of the sculptural reliefs. They are as if different scenes of a drama. Each takes the viewer to a different aeon. On the walls of the main shrine (*vimāna*), enclosing the central shrine (the womb-home *garbha-gṛhas*), are shallow shrines or niches. In the courtyard the enclosure of the Bull Nandī and the outer courtyard (*mahāmaṇḍapa*) is a dramatic, almost theatrical, presentation of myths from the epics. *Rāmāyaṇa* is on the south side and *Mahābhārata* to the north. The river goddess and *yakṣīs* occupy special places close to the entrance. Thus, each level and enclosure has an autonomy, and yet each is as essential part of the integral whole. The fact that the temple is dedicated to Śiva in his form as *mahāyogī* is established through the figure of Śiva as *mahāyogī* or Yogeśvara which is under the bridge, connecting the shrine of Nandī (the bull, Śiva's *alter ego*) and the *mahāmaṇḍapa*. On the walls, Śiva emerges in different forms as the slayer of the three cities, of gold, silver and iron. We will recall the reference to this in Kālidāsa's *Meghadūta*. There is a powerful depiction of the slaying of the blind demon Andhaka, who was none other than Śiva's own son. Once Pārvatī shut Śiva's eyes, all three, with her hands. From this unmindful act a blind son came into being. He was banished and became a powerful demon, but as usual in Indian myth, all demons do penance, ask for boons and receive them. Andhaka was no exception. He was invincible, except when he would lust for one like his mother. That is exactly what he did. When he beheld the beauty of Pārvatī, Śiva destroyed him, but in compassion made him as one of his companions. He is the emaciated Bhṛṅgī of Śiva's retine.

There are other myths of great power and import, but let us restrict ourselves to those we are already familiar with in Kālidāsa's poems and plays. The penance of Pārvatī and the subsequent grand marriage is a favourite in many caves of Ellora. In cave 21 (Rāmeśvara cave) there are two magnificent panels. One shows Śiva arriving as a mendicant and later revealing himself as Śiva. The panel is organized in a very complex manner with figures overlapping and the narrative not moving exactly sequentially. The retinue of Śiva's companions occupy the lower register. Facing the panel is the joyous celebration of the marriage of Śiva and Pārvatī. The wedding is taking place in Kailāsa, but it has all the grandeur of a royal wedding in a palace.

As we know, the heavenly couple lived in Kailāsa playing their eternal *līlā*. On one such occasion, Rāvaṇa arrived, roaming around the hills of Kailāsa. He was curious about this heavenly abode. Naturally, he was stopped by Kubera, the guardian of Kailāsa. Rāvaṇa was infuriated. He shook Kailāsa with all his might. Pārvatī was frightened. Śiva merely pressed the mountain with his big toe, and Rāvaṇa was trapped in a cavern. The myth of Rāvaṇa shaking mount Kailāsa is a great favourite with the sculptors of Ellora. There are several versions in cave 16 to cave 21, and in cave 29. Most important is a small panel in cave 16 where Rāvaṇa is symbolically represented as a devotee of Śiva. He offers nine of his ten heads to Śiva as a *liṅgam*. There are several versions of the myth. In one the guardian is not Kubera, but the bull Nandikeśvara. In this one Rāvaṇa is cursed that he will be born again only to be vanquished by monkeys. He is called Rāvaṇa because he cried when Śiva pressed his toe.

Of great significance, both ecologically and psychically, is the myth of descent of Gaṅgā. In one of Śiva's manifestations he is called Gaṅgādhara (the one who holds the Gaṅgā). This myth has many versions. Gaṅgā was one of the sisters of Pārvatī. She was also called Kuṭilā, crooked and short tempered. A third sister was the red one called Rāgiṇī.

In one version the myth runs as follows: It began with King Sagara, a just and mighty ruler, whose name means the ocean. After years of childlessness, the king retired to Mount Kailāsa with his two wives Keśinī and Sumatī. He practised austerities and prayed for a son. Finally his wish was granted by a sage called Bhṛgu. However, almost reminiscent of Greek mythology, the boon was full of riddles and irony. "You will beget many sons, your fame will be immeasurable. From one queen will be born one son and from the other 60,000." The king returned. In due time one son was born to the queen Keśinī. Sumatī, the other queen, brought forth a gourd with sixty thousand male seeds. In time with careful nursing they became boys.

Sagara now aspired to claim the title of the King of the Universe. Naturally, a horse sacrifice had to be arranged and a horse let loose to traverse the whole country unchallenged. Once this happened he claimed the title. Gods were jealous and fearful. They stole the horse and hid him in *ṛṣi* Kapila's *āśrama*. The sons came looking for the

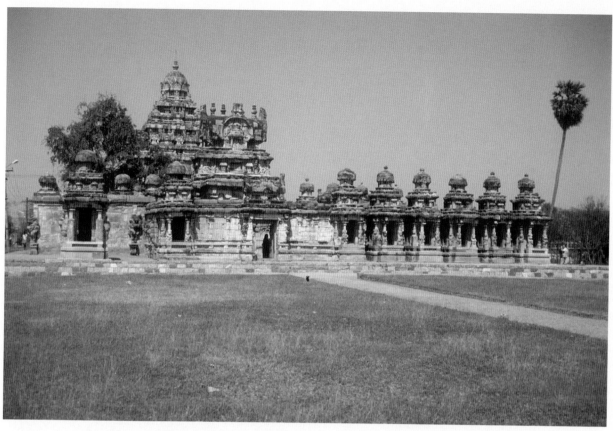

Pl. 18.1: Kailāsanātha, Kanchipuram, overview (Photo: David Peters).

Pl. 18.2: Kailāsanātha, Pradakṣiṇāpatha (Photo: David Peters).

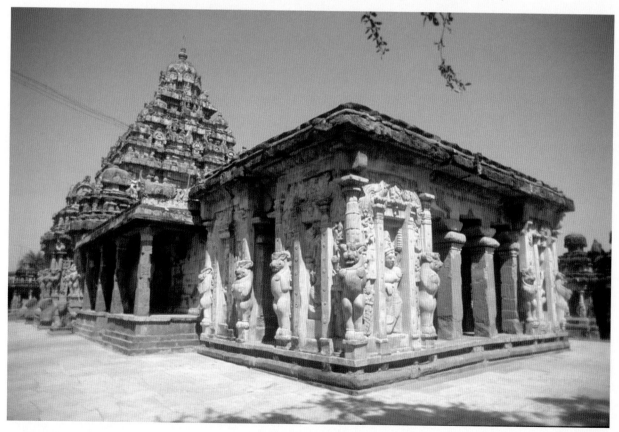

Pl. 18.3: Kailāsanātha, Pradakṣiṇāpatha (Photo: David Peters).

Pl. 18.4: Kailāsanātha, Śiva Ānandatāṇḍava (Photo: David Peters).

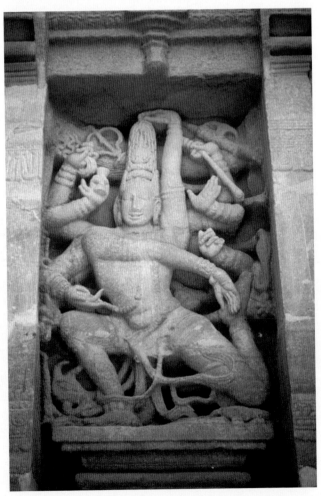

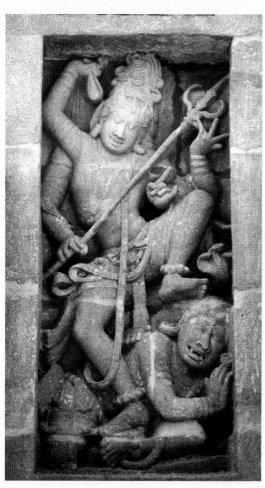

Pl. 18.5: Kailāsanātha, Śiva Kālāntaka
(Photo: David Peters).

Pl. 18.6: Kailāsanātha, Śiva Dakṣiṇāmūrti
(Photo: David Peters).

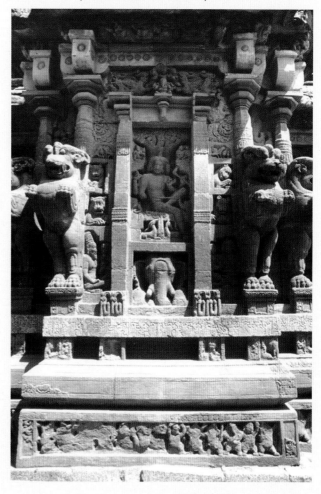

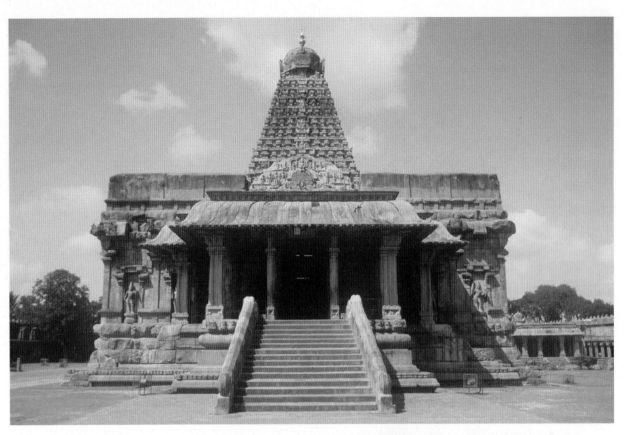

Pl. 18.7: Bṛhadīśvara, Thanjavur, front view with *śikhara* (Photo: David Peters).

Pl. 18.8: Bṛhadīśvara, Thanjavur, closer view of *śikhara* (Photo: David Peters).

Pl. 18.9: Bṛhadīśvara, Thanjavur, overview from the eastern side (Photo: David Peters).

Pl. 18.10: Bṛhadīśvara, Thanjavur, *liṅga* inside *garbhagṛha* (Photo: David Peters).

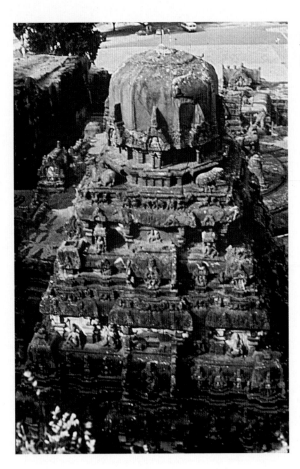

Pl. 18.11: Ellora, Kailāsanātha temple
(Photo: Archaeological Survey of India).

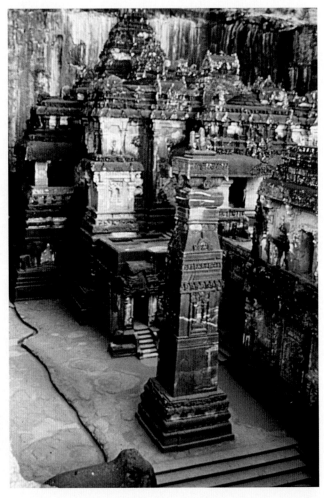

Pl. 18.12: Ellora, Kailāsanātha temple
(Photo: Archaeological Survey of India).

horse. They insulted the *ṛṣi* Kapila and were in turn reduced to ashes. The only redeeming feature of the curse was that the ashes of the sons would be purified only if Gaṅgā descended from heaven. Sagara died and so did the son and his grandson Aṁśumān and descendents. However, atonement was necessary. At last, Bhagīratha after a long lineage, became king. He was pious and dutiful. He was a single-minded seeker of truth. He said he would renounce kingdom to do penance so that Gaṅgā could come down from heaven. He stood on one leg for years and years. The gods were pleased, and Gaṅgā was persuaded to come down. She was the sister of Pārvatī called Kuṭilā (crooked). Haughty and proud, she agreed to descend but also threatened that she would cut asunder the earth, devastate all creation with her mighty force. Śiva intervened. She retorted "who is he to stop me. I shall sweep him away." And with her current circling the moon she rushed upon him.

Śiva was composed and unruffled. He caught the gushing river in his matted hair, dense as the forest of time coiled. Gaṅgā was enmeshed. She went round and round amidst his locks, could find no way. And at last tamed and bridled, she flowed as a beautiful river. Bhagīratha could purify the ashes of his ancestors. Śiva always hides her in his locks in his iconic form. Geographically the streams that make up the Gaṅgā resonate with this mythology: Alakanandā, recalling the heavenly city, Mandākinī and Bhāgīrathī. All three merge to form the Gaṅgā which flows from Haradvāra (door of Śiva) to the oceans again.

The myth has many versions. It is recreated, re-narrated in poetry, drama, sculpture in a variety of versions. There are several versions of the depiction of the myth in Indian sculpture. In a magnificent panel in Mahabalipuram, Mammallapuram, there is a depiction of the penance of Bhagīratha and the descent of the Gaṅgā. Of course, there is a difference of opinion amongst art historians. Some are of the view that the panel does not portray the descent of Gaṅgā; it is instead about the penance of Arjuna.

Be that as it may, in Ellora the artist treats the theme differently. No longer do we have the whole panorama of teeming life of vegetation, animals, flying *gandharvas* and *apsaras* and a Bhagīratha standing on one leg. Instead it is Gaṅgā and as the tamed one, who stands demurely next to Śiva. In course of time, Gaṅgā is incorporated into the iconography of Śiva. She is always hidden in his thick locks. The thick locks are the forest of the Himālayas and topsoil in ecological terms.

Kailāsa of Ellora was carved out of a single rock to be made into a mountain. Kanchipuram was constructed, and Elephanta rose from the ocean to become Kailāsa. It is not called Kailāsa, but it does replicate Kailāsa. The architectural layout and the alignment of the east-west and north-south axis, and the placement of the *liṅga* and the sculptures of the different forms of Śiva, is another architectural statement of great power and beauty.

This time it is not a monument carved out of rock. It is instead architecture and sculpture hollowed out from a rock which rises from the oceans. Śiva has been addressed several times as "Lord of the cave," especially in the poetry of the Vīraśaiva poets. Śiva dwells in the high mountain of the mind or the cave of the heart. In Elephanta the cave of the heart is as if scooped out of rock. As one climbs up the steep steps, there is the anticipation of reaching the mountain top. Once there, you are under the blue azure skies as canopy. There are no high towers, no sequentially laid out storeys or heights. There is no single entrance; instead, three entrances lead into the spacious cave. Two of these mark the axis of the temple. There is a hall with pillars but no façade. The two axes intersect in the temples hall. However, the innermost sanctuary is not situated here. Instead, it is to the west. There are sculptures of gigantic size all around. Most outstanding amongst these is the famous sculpture popularly called Trimūrti. In fact, it is a five-faced Śiva, as Stella Kramrisch has pointed out. The sculpture confronts the viewer who enters from the south. It is meant to be seen only from the front. Three heads are visible, the fourth hidden and the fifth head suggesting Śiva's transcendence is also concretely absent but in fact present. The total composition suggests the termination of a *liṅga*. So much has been written on this superb sculpture that it is not necessary to comment on it any further. However, for us, in the context of our theme of Mountain and myth, it is important to note that the architect of the sculptor was making an effort to create, within a cave, a mountain form which would be concurrently a mountain (Kailāsa) as a *liṅga*. The architect of Kailāsa at Ellora had established a column, a *liṅga* and a *śikhara* (high rising pinnacle) as analogues. The Elephanta artist hollows a cave, creates a metaphor of both mountain and Śiva in his five-fold form. The other colossal sculptures in the hall are a visual re-narration of the familiar myths. They are the manifested forms of Śiva, the *aṣṭamūrti* (eight-fold form) parallel to Kālidāsa's invocation.

Beginning clockwise from the western entrance, there is Umā-Maheśvara. We may now recall Śiva and Pārvatī's life in Kailāsa, and when Rāvaṇa shakes the mountain. The Elephanta artist breaks up the myth by placing Umā-Maheśvara on one side and Rāvaṇa on the other, that is the Rāvaṇa as the devotee. There are the other forms of the eight-fold Śiva: Śiva as bi-unity, male and female, Ardhanārīśvara, as the tamer of Gaṅgā (Gaṅgādhara), the marriage of Śiva and Pārvatī (Kalyāṇasuandaram). Facing Kalyāṇasundaram is the slayer of the blind demon Andhakāsura. The Lord of the dance (Naṭarāja) and Śiva the supreme *yogī* — Yogīśvara — complete the circle. Śiva as Sadāśiva, the eternal, and in his form as the embodiment of the five elements and the five activities of the world (*pañcaliṅgam*), are central to the conception though not placed centrally in architectural space. Śiva in Kailāsa, as experienced and visualized by the artists of Elephanta, is in essence transcendental. He is beyond measure and attribute, he is imperishable and impartable, he is beyond time. However, there is a phase, a state between the world and the state beyond thought and perception. This is the phase and state where he is with and without parts (*niṣkala* and *sakala*), in no time and in time. He

is unmanifest, but becomes manifest in his eight-fold form which Kālidāsa had invoked in the prologue of *Abhijñāna-Śākuntalam*. The cave of Elephanta is the architectural counterpart of the verbal icon expanded to gigantic proportions. The five-faced *linga* is also an icon of sound, for the five faces also represent primal sound. It is then called the icon of primal sound (*nādamūrti*) and *mantramūrti*, the image and icon of invocatory, consecrated chants. The subject of the icon of sound (*nādamūrti* and *mantramūrti*) encapsulates another dimension too deep and complex to be elucidated here.

The mountain Kailāsa and Śiva in his five activities and eight forms inspires others. The physical environment is not the actual caves and rocks arising from oceans. It is the plains of India. Amongst others, two major examples concretize through architectural structure the experience of the mountain and transform the myth into visual imagery. They make the temple a pilgrimage, analogous to the pilgrimage to Kailāsa.

The fact that the architects, i.e. the *śilpī*s, were filled with an emotional suffusion of Kailāsa, the mountain of the mind, is supported by a conversation quoted by A.K. Coomaraswamy with a traditional architect. The traditional architect from Tamil Nadu said to A.K. Coomaraswamy on August 6, 1925:

> It is commonly supposed that our ancient architecture is a laboured creation of men according to their respective fancies and abilities but our *Śaiva-āgama*s teach that the architecture of our temples is all *Kailāsabhavana*, that is of feelings and forms (*bhavana*) prevailing in Kailāsa which is on the summit of Mahāmeru far beyond the strata of existence known as *bhuvarloka svarloka*.[1]

Perhaps it was one of the ancestors of this traditional architect who conceived the great temple called Bṛhadīśvara in Tamil Nadu in the eleventh century. Again, much has been written lately on the temple as a political statement of power by the patron King Rāja Rāja Coḷa. Undoubtedly there were political and sociological imperatives and perhaps motivations, but there is a perennial value which long outlasts the temporally circumscribed and ephemeral rhetoric of power. The mountain of the imagination and the internal dedication to the feeling of Kailāsa, as the architect puts it, gives strength, beauty and proportion to this monument. It is a gem of architectural proportion and symmetry. The ground plan, the elevation plan, the sections: vertical horizontal and traverse, the placement of the sculptures on the outer and inner walls, from the plinth to the pinnacle, are precisely programmed. The architect translates each conception, metaphor and myth to architectural design and sculptural relief with unsurpassable meticulousness. Its neatness is matched by its staggering complexity of detail. There is a perfect juxtaposition of the inner and the outer, the earth and heaven. The Kailāsa of the Heaven is upward vertically, the presence of Śiva in his aniconic form as *linga* is inward in the womb house. His manifestations of the several playful forms occupy outer walls. Here he is special as the Lord of the south (Dakṣiṇāmūrti). The *linga* is vertically aligned

1. A.K. Coomaraswamy, *History of Indian and Indonesian Art* (1927), Dover, 1985, p. 125.

with an inner unseen pillar (*stambha*). It rises to the finial where a coping stone rests in the form of a lotus. Likewise there are many analogies on the horizontal plane. The ground plan comprises two perfect squares. The *sanctum sanatorum* is in the centre of the first square. The vertical structures are constructed here. Outside there is a large courtyard which serves as the circumambulatory path for the pilgrim/worshipper. The worshipper moves from the outer to the inner and also ascends from earth to heaven in the inner spaces of the temple. Unlike many other temples, the *śikhara vimāna*, i.e. pinnacle, can be reached through an inner staircase. Once on the heights right above the womb chamber, you suddenly see Śiva dancing in 108 modes. This is the space of ether, the last of the five elements, *ākāśa*. It is said that Śiva danced in the *paramākāśa*. This is also transcendence, transcendence imagined differently than in Ellora or Elephanta. There is a shared belief and a commonality of conception, but a totally different religious and artistic statement. The dance of Śiva is, at another level, the sculptural visualization of the descriptions of the 108 cadences (*karaṇas*) of the fourth chapter of the *Nāṭyaśāstra*. Geography, mountain, myth and aesthetic theories all coalesce.

Khajuraho in Madhya Pradesh is in the heart of central India. Its temples and particularly Kandariya Mahādeva, are today internationally famous. The temple matches the grandeur and precision of Bṛhadīśvara in Tamil Nadu. The two are almost contemporaneous. Both recreate Kailāsa the mountain and are dedicated to Śiva. However, their language of form is distinctively different. Known as Kandarīya Mahādeva, literally "the Lord of the Cave," this is now an attempt in a reverse order from Ellora. The mountain cave is not made into a temple, instead a cave-mountain is constructed out of stone. There are no circumambulatory paths, no subsidiary shrines of the kind in Kanchipuram, no courtyards. Instead, the architect creates the paradox of both ascension to a mountain through a series of platforms and entering into the compact space of a cave.

The temple is simultaneously replication of a cosmos, it is the cosmic Man (*puruṣa*) the mountain and the cave. The drama of the cosmos, as also the human drama of the emotions, of the states of love, valour, pathos and humour — is all played out on the outer walls. There is profusion as well as compactness. The *yakṣīs*, the *apsaras* appear in the most alluring forms, no longer as stately Gaṅgā and Yamunā. The others from the mythic world crowd the outer spaces, but all gradually recede as the pilgrim/viewer ascends upwards ready to enter the cave of the heart with the *liṅgam* in its austere isolation. This is the detached *yogī*. Far off in Kashmir, there is an actual cave and a natural *liṅgam* is formed. Pilgrimage takes place, culminating in the full moon when the snow *liṅgam* is formed only to dissolve again. Khajuraho is the counterpart in stone. So much has been written on the temple and so magnificently, from A.K. Coomaraswamy to Stella Kramrisch and now to Devangana Desai, that a word more need not be added. Nevertheless, the presence of the mountain in this monument can hardly be omitted from our account.

One could continue the journey to the temples inspired by Kailāsa and dedicated to Śiva in other parts of India, particularly to the Liṅgarāja temple of Orissa. Śiva, it is said, once fled from Kailāsa. In *Tretā-yuga* he was sick of the hypocrisy of the brāhmaṇas in Varanasi, where he resided as Kāśī Viśvanātha. He sought a retreat for himself, where he could again be the god with the blue throat. So he looked for the ocean where the churning took place and searched for a blue rock which would be his place, his Kailāsa near the oceans. He would then be the Lord of the three spaces, not only the killer of the three demonic cities. It is as the Lord of the three spheres that he is worshipped in the great temple of Liṅgarāja in Bhuvaneshwar. Here, near the ocean, another Kailāsa is created for the blue-throated god of the blue rock. This great temple is yet another articulation of the theme of Kailāsa and completes the circle.

In contrast, the Himālayas are the natural abode of the gods. Śiva moves freely in the mountains of Kashmir, Himachal, Uttar Pradesh and elsewhere. Kashmir has several large and small temples, which replicate Kailāsa from Narangnag to Śaṅkarācārya temple. Himachal Pradesh has as many, or more: Maṇi Maheśa, Gopeśvara and Mahādeva temple. The Uttar Pradesh hills have as many, especially Jageśvara. There, mountain shrines replicate in simpler ways the architectural mountain Kailāsa, but the myths of the gods are re-enacted by the humans in the annual celebrations. Ritual weddings are held, pilgrimages are undertaken, Pārvatī as Nanda weds and the gods travel from mountain tops to the valleys to meet. The drama of Kailāsa comes alive through the annual calendar. Ritual within the temple as in Bṛhadīśvara is an act of enlivenment of the divine. The ritual drama in the mountains is the human enactment of the divine. The human becomes the divine, and the gods of the shrines descend to valleys. As participant in these rituals there is the same process of cleansing purification and transformation as in the actual pilgrimage to Kailāsa and the mountain.

In the deep south, there are also sacred mountains, especially Sabarimalai and, of course, Arunachala, where the sage Ramaṇa Maharṣi lived. Each is consecrated space of both ritual and meditation, the journey upward and inward. Indeed Kailāsa and Arunācala are on the same axis undoubtedly. Ramaṇa calls out to the hill Arunachala:

> Glorious Mountain of Love, celebrated by Gautama, rule me with Thy gracious glance, O Arunachala!

> Dazzling Sun that swallowest up all the universe in Thy rays, with Thy Light open the lotus of my heart I pray, O Arunachala!

> Let me, Thy prey, surrender unto Thee and be consumed, and so have Peace, O Arunachala!

> I came to feed on Thee, but Thou hast fed on me; now there is Peace, O Arunachala!

> O Moon of Grace, with Thy (cool) rays as hands, open (within me) the ambrosial orifice and let my heart rejoice, O Arunachala!

Tear off these robes, expose me naked, then robe me with Thy Love, O Arunachala!

There (in the heart) rest quiet! Let the sea of joy surge, speech and feeling cease, O Arunachala!

O Pure One! If the five elements, the living beings and every manifest thing is nothing but Thy all-embracing Light, how then can I (alone) be separate from Thee? Since Thou shinest in the Heart, a single Expanse without duality, how then can I come forth distinct therefrom? Show Thyself planting Thy Lotus Feet upon the head of the ego as it emerges!

Kailāsa, we said in the beginning, is a *maṇḍala* or is conceived as one in the Buddhist tradition. Perhaps there could be no better way of concluding than to quote a poem of H.H. the Dalai Lama on Kailāsa:

With the deepest reverence
I bow in obeisance
To the infinite and eternal Buddha
The majestic monarch of the mountain
Who has risen
From the shoreless waters
Of wisdom and compassion,
He himself has nurtured
For limitless eons.

With the deepest reverence
I bow in obeisance
To towering thise
To magnificent Mount Kailāsa.

Glorified by seers of yore
As the very fountainhead
Of voice, of sound.

Mysterious, moonlit mount
One of only four and twenty sacred shrines
Consecrated by the Great Deity.

With the deepest reverence
I bow in obeisance
To towering thise
To magnificent Mount Kailāsa.

Reflected in the immaculate turquoise
Of the shoreless Mansarovar
Mystical mirror
Whose very vision can transform
All living beings it touches
With the radiance
Of a great new vision.

With the deepest reverence
I bow in obeisance
To towering thise
To magnificent Mount Kailāsa

Enveloped and surrounded
By divine environs
The merest thought of which
Brings boundless bliss
To body and mind.

Bubbling rivers that sparkle
With the eight qualities
Cooled and cleaned
By the lingering touch
The beatitude, the blessing
Of the beautiful breeze.

What better tribute?

Interreligious Dialogue

19

Trans-Religious Studies
and Existential Interpretation

Karl Baier

TRANS-RELIGIOUS processes form a promising area of research, which in the future will be subject to more attention, treatment, and reflection than is applied today. In the present article, I want to first exemplify the importance of this part of religious life by means of the history of Christianity, thereafter giving some thought to the category of the trans-religious and the definition of trans-religious studies. The second main part treats the adaptation of existential interpretation on the part of Buddhist thinkers of the Kyôto School, which made Bultmann's hermeneutics into one of the most important contemporary trans-religious methods.

Trans-religious Communication in the History of Christianity

In 1904, Josef Weiß wrote an article defending the *Religionsgeschichtliche Schule* against those misunderstandings that had arisen concerning its method.[1] In this context, he stressed that "*comparative* religious history is able and bound to display the migration of religious ideas from one religion into another."[2] In fact, Weiß and his colleagues were already going beyond the comparison of single religious phenomena, to which present-day comparative theology is often limited. They also stressed research and theological interpretation of the religious change brought about by communication between ancient Christianity and its religious surroundings. Historians of religion and many generations of exegetes have since convincingly elaborated the trans-religious character of both the First and the Second Testament. In the face of the considerable amount of influence originating from other religions, one might almost follow 1 Cor 4, 7, asking: "What have

1. The *Religionsgeschichtliche Schule* whose most important contributors included Wilhelm Bousset, Albert Eichhorn, Johannes Weiß and William Wrede was formed towards the end of the nineteenth century from a circle of Bible scholars and church historians at Göttingen. Its main focus was a historic comprehension of Christianity, especially of its originating from contemporary hellenistic sources.

2. Josef Weiß, review of 'W. Heitmüller, Im Namen Jesu,' *ThR* 7 (1904), p. 187, quoted by Elisabeth Hamacher, *Gershom Scholem und die vergleichende Religionswissenschaft*, Berlin/New York, 1999, p. 75 [stressing in the original].

you got that was not given to you?"[3] The communicative processes between different religions, underlying not only Christianity, but all three Abrahamitic religions and their Sacred Scriptures, find a continuation in their respective theologies. On a macro-historic level, the so-called Hellenization of Jewish, Christian, and Muslim theology is to be considered a model of trans-religious studies-formation.

With all due respect for the achievements of the *Religionsgeschichtliche Schule*, a noticeable tendency remains: that of treating Christianity and its theology as a finished entity, completely stabilized after its period of inter-religious formation. Thus Christianity seemed to be no longer open to relevant influence from other religions. There are many reasons for this. Most important of all appears to be the fact that from after antiquity until the twentieth century, there have not been any truly influential creative encounters of Christianity with other highly developed religions.[4] The influence of Germanic and Slavic religions especially during the period of migration meant no enrichment but a loss of standard, with the elaborate religious contents and forms of late antiquity now being interpreted following the archaic religiousness of these tribal societies.[5] In the Medieval Ages, no religious exchange was perceived us such, with the exception of the multi-religious societies of Spain and Sicily. Although the influence of Muslim theology was noteworthy even beyond Spain and other border areas, it was not resolved in a theological discourse, but only received in the context of the mediation and discussion of Greek philosophy. If not outright anathemized, the teachings of other religions were belittled to the level of "natural theology," inferior to Christianity as the only religion based on revelation (with the exception of Judaism, that already had occupied a precarious special status). The age of discoveries brought contact to evacuate non-European religions, yet modern euro-centrism, as well as the strife of Reformation and counter-reformation, have rather served to provincialize actual Christianity and its theology while spreading across the world. In defence against outside influence, certain European forms of Christianity were enforced as globally obligatory. Whatever did not fit the desired image was marginalized or extinguished.

As usual, with the loss of trans-religious inspiration, in the long run the quality of religious practice and theological reflection began to suffer. One can, following Hans Martin Barth, suppose that the exchange with other religions is a characteristic of religious strength. Religions that isolate themselves cut-off their own source of life in the attempt to preserve it untainted.[6] If the life of a religion flows without hindrance, transfers from

3. The same could count for Buddhism. See the pointed wording in Thich Nath Hanh, *Living Buddha, Living Christ*, London, 1996, p. 11: "Just as a flower is made only of non-flower elements, Buddhism is made only of non-Buddhist elements."

4. I hereby refer mainly to the history of Western Christianity. For the Christian East, however, there seems to be little difference.

5. See Arnold Angenendt, *Geschichte der Religiosität im Mittelalter*, Darmstadt, 1997, pp. 34-38.

6. Cf. Hans-Martin Barth, *Dogmatik. Evangelischer Glaube im Kontext der Weltreligionen. Ein Lehrbuch*, Gütersloh, 2001, p. 162.

other religions are simply taken for granted. Defence against outside influence is built up, especially when the future of a religious community is considered endangered on the part of its members, when paranoic or megalomaniac fantasies avoid seeing the positive elements of other religions, or when religious exchange is made impossible for mere reasons of political power strategies. It is thus generally a sign of weak religiosity. The strength of a religion, in fact, is not to be a closed entity, but rather to be able to receive influence from other religions, creatively processing them. Habitual defensiveness against trans-religious changes flattens and stiffens religious life.

Starting from the twentieth century, one can no longer by any means claim that the trans-religious development of Christianity is concluded. In the age of post-colonial discourse and globalization, the knowledge of the religions about one another is spread across the globe and has irreversibly seeped into the various religious communities. These are themselves often spread internationally and thus coexist with other religious groups and movements, in societies, which in many parts of the world now provide religious freedom. The hybridization of religion in the life and thought of those, whose spirituality is based on more than only one tradition, is spreading worldwide. On an academic level, comparative or intercultural philosophy and theology are being established as independent fields. For the Catholic Church, the opening towards non-Christian religions in *Vaticanum* II brought about the birth of complex inter-religious dialogues and diverse regional theologies consciously integrating non-Christian approaches of the respective geographical area. All these developments make indispensable a scientific approach researching on, and respectively contributing to, the shared history of religions in past and present times.

The wording Weiß used in the quote above, "migration of religious ideas from one religion into another" has certain weaknesses. The limitation to religious "ideas" is unsatisfying and furthermore it suggests the misunderstanding that the aforesaid ideas were rolling about like balls. Certainly though, in the concrete research of the *Religionsgeschichtliche Schule*, it was already known that immigration of religious phenomena normally changes the immigrating element and the religion of arrival. Trans-religious processes, especially when touching important experiences, topics, and practices, lead to a transformation of the recipients. Their religious identity is more or less newly constituted by a changing horizon of understanding. Trans-religious studies can contribute to a better understanding of such processes of change, allowing to approach them with less fear and hate, which often hinder the development of a peaceful and communicative coexistence.

What does "Trans-religious" Mean?

The category "trans-religious" is presently hardly used within or outside the scientific

disciplines.[7] Considering the rapid growth in publications on trans-cultural topics, it must be presumed that a more common use of the concept in the field of religious studies is soon to come. The term came into my mind when I was discussing the purpose of comparative and intercultural theology with my colleague and friend Roland Faber. Faber has by now published a first draft of trans-religious theology.[8] He especially stresses the category of transformation therein as the basis and aim of inter-religious dialogue by researching the mutability of religious traditions.[9] "Trans-religious" is for him applied to all processes of auto-transcendence of a religious tradition, be it by internal disputes or by encountering other traditions.

My main focus, also, is on creative reception, as emphasized by Faber. Yet, I believe that the other dimensions of trans-religious processes, such as the primary appropriation of external elements predating the creative insertion into the context of one's own religion (secondary appropriation), should also be taken into account. Since all 'small' borrowings, even if not leading to any far-reaching changes, can become important under certain circumstances, I would not elevate the momentum of transformation into the status of a norm. For trans-religious theology, a clear division from so-called syncretism is important, because syncretism still functions as a kind of four-letter word in theology. In the larger field of trans-religious studies, though, it would be a waste to exclude that broad and highly interesting area (however one may choose to define it) from research. Furthermore, I pledge for the limitation of the term to inter-religious phenomena, though conceiving the concept of the trans-religious in this field as amply as possible in order to live up to the abundance of empiric evidence.

The category then is not only applied to religious exchange on a highly theoretical level, but to any transfer of thought, outlook, norms, practices, rites, institutions, theological methods, etc., from one religion into another. Trans-religious processes begin with first contacts awakening the interest upon reception on the part of individuals or groups. After the initial phase, decontextualizations, translations and learning processes take place, introducing creative reception and integration into the new context

7. Presently one can find the term used mainly in three meanings: (1) for a way of thought or spirituality claiming to go beyond the existing religions ('trans' as 'transcendent'), as in the sense of a super-historic mystical experience considered the unique root of all religions; (2) for common threads going through all religions ('trans' as 'transsiberian'); (3) in the meaning I use, 'trans-' refers simply to the transfer between one religious tradition and one or more others. More detail to be found in the text.

8. Cf. Roland Faber, 'Der transreligiöse Diskurs. Zu einer Theologie transformativer Prozesse,' *Polylog* 9 (2003), pp. 65-94.

9. Faber's profiling of trans-religious discourse in the face of comparative theology reminds of the criticism of some representatives of cultural transfer research in reference to comparatistics. See the articles by Michel Espagne, 'Transferanalyse statt Vergleich. Interkulturalität in der sächsischen Regionalgeschichte,' and Jürgen Osterhammel, 'Transferanalyse und Vergleich im Fernverhältnis,' in: Hartmut Kaelble/Jürgen Schrieter (eds.), *Vergleich und Transfer. Komparatistik in den Sozial-, Geschichts-, und Kulturwissenschaften*, Frankfurt/M., 2003, pp. 419-38, resp., pp. 439-66.

(recontextualization). The reception, possibly along with failed and denied transfers, causes changes in the religion of arrival, respectively sometimes also in the religion of origin, and a rearrangement of what is received. Sometimes, trans-religious exchange is mutual and takes place in the form of dialogues or polylogues, often connected with conflicts. Finally, also the transfer's history of reception is part of the trans-religious field. Trans-religious processes thus form, all together, the kind of religious change achieved through exchange with other religions.

This change is a universal phenomenon linked to defence mechanisms. These are a topic of trans-religious studies as well as the various motives founding a positive interest in religious transfer. The defence mechanisms not only clearly show that religious transfers do not take place in un-ruled space, but also that they are rooted in a socio-political dynamic of forces, a fact which should be taken into consideration when conducting research on them.

Such research is undertaken by trans-religious studies as a form of interdisciplinary communication making trans-religious processes topic of a scientific discussion. This can be seen from different perspectives, depending on whether research is on the trans-religious field (perspective 1) and/or takes place within it, contributing to it (perspective 2). I propose to call studies from perspective 1 'religion transfer analysis,' following the more recent discipline of research on culture transfer.[10] It includes all scientific conceptualizations of trans-religious processes being made from a perspective of observation. Perspective 2, which could be called 'trans-religious theology' (in the wider sense, including, e.g., Buddhist theory developing in exchange with other religions), includes all theoretical attempts that are immediately part of trans-religious processes. Trans-religious theology is concerned with the truth of these processes and not just with sociological, psychological and historical dimensions of religious life. It further is marked by a commitment to certain religious traditions as well as to the consideration of other traditions.

From an observation perspective one can, for example, show how indigenous ancestral worship influences faith and theology of African churches, which problems arise therein, what can be learned thereby with regard to basic structures and possible laws of trans-religious processes (religion transfer analysis). Or one is immersed in the encounter, and

10. See Peter Burke, *Kultureller Austausch*, Frankfurt/M., 2000; Friedrich H. Tenbruck, 'Was war der Kulturvergleich, ehe es den Kulturvergleich gab?' in: Joachim Matthes (ed.), *Zwischen den Kulturen? Die Sozialwissenschaften vor dem Problem des Kulturvergleichs*, Göttingen, 1992, pp. 75-99. Research on cultural transfer stresses the changing effect of receptive processes, like the trans-religious studies treated in this article. For a definition see Christiane Eisenberg, 'Kulturtransfer als historischer Prozess. Ein Beitrag zur Komparatistik,' in: H. Kaelble/J. Schrieter (eds.), *Vergleich und Transfer, op. cit.*, pp. 399-417, here p. 399: "Research on cultural transfer scrutinizes exchange of cultures from different geographical and social groups, as well as their mutual penetration. In the centre of interest, there are not the expansion or the filters of the spreading, but the reception of the receiving party, considered as a creative act."

works, for example, at outlining an African Christology (trans-religious theology). Both forms of research are part of trans-religious studies and are founded, at different levels, on basic trans-religious experiences and learning processes.

Trans-religious studies finally turn to trans-religious discourse when its representatives engage in this form of research in a reflexive manner, that is, when they scrutinize its foundations, results, and problems in method and description, and when these are discussed critically. Trans-religious discourse thus forms the meta-level of trans-religious studies.[11]

The above-named perspectives of trans-religious studies can certainly also be executed by a single person, who would then be involved in a situation of trans-religious exchange, though at the same time reflecting scientifically on that situation as such, and who furthermore is grappling with general methodical questions. It does not seem very useful to play off these different aspects against one another. Just as useless is the attempt of constructing an opposition between trans-religious studies and religious comparatistics. Both procedures, comparison and transfer analysis, lead to meaningful results and can furthermore correct and enrich each other. In practised research they are often connected anyway.[12]

Religious Media in Trans-religious Use

A dimension of religion playing an important role in the trans-religious field is religious media, i.e. the various means used to represent and communicate religious messages and experience. These media are forms of oral or textual communication, practices such as meditation, prayer and cult performances, forms of religious art, but also processes of theoretical representation like styles of argumentation, methods of theological analysis and hermeneutics of sacred texts, and the like. Many of these media that arose within one religion can also become relevant for others, and they come into use after being adapted to the respective inner-religious situation. Hence, they become media with the ability of mediating between the religions. A practical trans-religious medium can be, for example, Zen meditation, introduced in Christianity in the twentieth century. This example shows well that media in the trans-religious field do not only serve as passive bearers of arbitrary messages. The question needs to be addressed, however, whether they are to be understood as part of the message, or whether, for example, certain forms of meditation *per se* transport Buddhist meanings, thereby perhaps being incompatible with Christian practise.

11. See R. Faber, 'Der transreligiöse Diskurs,' *op. cit.*, especially, p. 69.

12. For example, no religious transfer can be researched on without eventually comparing. On the other hand, comparative research must also take into account the possible transfers between the compared religions. See Helmut Kaelble, 'Die interdisziplinären Debatten über Vergleich und Transfer,' in: H. Kaelble/J. Schrieter (eds.), *Vergleich und Transfer, op. cit.*, pp. 469-93, especially pp. 471-80.

In this article, I would like to treat existential interpretation as an example of a trans-religious theoretical method of the twentieth century. It was originally not conceived to be trans-religious, but became so after being received and refounded by the philosophers of the Kyôto School. Methodically, my approach remains in the line of transfer analysis, as defined above. Yet, while writing, I seek to keep the trans-religious theologian in me from falling asleep, and I hope that a similar reaction can also be avoided among my readers.

Existential Interpretation

The disputes on Bultmann's programme of de-mythification were a predominant topic in the 1950s and 1960s.[13] The strengths and weaknesses of existential interpretation have by now been discussed in their completeness, and Bultmann has publicly found approval as a classic of modern theology.[14] His work is considered a successful attempt to unite exegesis, systematic theology, and philosophy. Not in its details, but as a principle of interpretation, existential interpretation has become part of the standard repertoire of Biblical hermeneutics, and has thus found its place in related manuals.[15] Before entering into the topic of its reception in Buddhism, I first want to make note of a few of its basic characteristics.

Bultmann's thought concerns the tradition of modern hermeneutics (Schleiermacher, Dilthey, and especially Heidegger), which goes beyond traditional hermeneutics and its canonized rules of interpretation.[16] To understand a text, this method of interpretation holds necessary an existential relationship of the interpreting party with what is being

13. Interreligious problems hardly played any role in this context. The few non-Western contributions, such as that of Raimon Panikkar, referring also to religions other than Christianity, failed to generate a separate discussion. The contribution of the Kyôto School, too, was hardly recognized. That is, among other factors, rooted in the fact that the relevant works were only published partially in German, and often only after the discussion had been finished. Relatively late, the first German monograph concerning the Kyôto school appears from the hand of a former follower of Bultmann: Fritz Buri, *Der Buddha-Christus als der Herr des wahren Selbst. Die Religionsphilosophie der Kyôto-Schule und das Christentum*, Bern/Stuttgart, 1982. Buri of course did observe the Bultmann reception by Kyôto School.

14. Literature on Bultmann is vast. For a good bibliographic overview, see *www.bautz.de/bbkl/b/bultmann_r.shtml*. Concerning the theology of Bultmann, see Günther Bornkamm, 'Die Theologie Rudolf Bultmanns in der neueren Diskussion,' *ThR* 29, (1963), pp. 33-141; G. Schmitthals, *Die Theologie Rudolf Bultmanns*, Tübingen ²1967; Bernd Jaspert, *Sackgassen im Streit um Rudolf Bultmann*, St. Ottilien, 1985; E. Gräßer, 'Notwendigkeit und Möglichkeiten heutiger Bultmannrezeption,' *ZThK* 91 (1994), pp. 272-84.

15. Thus, Manfred Oeming writes, "All in all, we believe the existential interpretation to be a highly useful instrument in linking differentiated historic analysis to a theological understanding that relates to the present time." Differently in Klaus Berger, *Hermeneutik des Neuen Testaments*, Tübingen/Basel, 1999, who considers existential analysis dispensable and tries to rehabilitate the mythical contents of the New Testament as such.

16. Cf. Rudolf Bultmann, 'Das Problem der Hermeneutik' (1950), in: *id.*, *Glauben und Verstehen. Gesammelte Aufsätze, Zweiter Band*, 5th edn., Tübingen, 1968, pp. 211-35.

communicated in the text. That counts, as Bultmann stresses, also for the Bible, predominantly treating the revelation of God and requesting a personal pre-understanding in this regard, which exists in question form prior to the explicit faith in God. "In human existence, an existential knowledge of God is alive as the question about 'contentment,' about 'happiness,' about the meaning and sense of world and history, as the question of the very truth of one's own being."[17] Since scientific exegesis must be aware of its leading preconceptions, first of all the question of authentic self-being (nowadays one may call it identity) must be proven by philosophical analysis to be a human trait. The aim of interpretation, and thus an understanding of the Bible, is reached when the understanding of being contained in it is clarified as an answer to the question about authentic existence.

This form of interpretation, besides the named hermeneutical reasons, mainly became necessary for Bultmann because the New Testament is filled with mythical images (good and evil spirits, miracles, expectation of the imminent end of the world, the Saviour descending from heaven, etc.) dating from ancient cosmology which is in his opinion, now no longer acceptable for modern mankind. They can no longer be taken literally in their substantial content, but must be questioned about the understanding of human existence, which they describe.

In philosophically analysing the meaning of being human, he stresses the use of adequate concepts, which should not be taken from the field of non-human being.[18] Thus, Bultmann attaches himself to a central theme of Heidegger's "Time and Being," which he generally follows in his anthropology.[19] Unlike all objective being, human existence is a being that is concerned with its own being and therefore "is to be responsible for itself and has to take hold of itself."[20] On the one hand this constitutes human freedom. On the other hand, it includes an openness towards the future, fate, and death, which means a profound loss of security. The plans for life — and life itself — can at any time be disturbed or ended, which is why being unavailable is a central characteristic of human existence. The inaccessibility of human existence evokes the basic mood of fear, and at the same time the tendency to flee the insecure by holding on to what is present and available.

17. Cf. R. Bultmann, 'Das Problem der Hermeneutik' *op. cit.*, p. 232.

18. Philosophical existential analysis is for Bultmann a science, "which talks about existence without objectivizing existence into worldly being." (R. Bultmann, 'Zum Problem der Entmythologisierung,' in: Hans Werner Bartsch [ed.], *Kerygma und Mythos. Ein theologisches Gespräch*, II. Band, Hamburg, 1965, pp. 179-208, p. 187)

19. The problematic of hypostatizing is found throughout the whole book, at the end of which once more is said: "Why does this hypostatizing so often gain power?" See Martin Heidegger: *Sein und Zeit*, 15th edn. Tübingen, 1979, p. 437. See Claude Ozankom: *Gott und Gegenstand. Martin Heideggers Objektivierungsverdikt und seine theologische Rezeption bei Rudolf Bultmann und Heinrich Ott*, Paderborn, 1994. Regarding Bultmann and Heidegger see among others Klaus Berger: *Exegese und Philosophie*, Stuttgart, 1986, pp. 127-76; Matthias Jung, *Das Denken des Seins und der Glaube an Gott. Zum Verhältnis von Philosophie und Theologie bei Martin Heidegger*, Würzburg, 1990, pp. 150-80.

20. R. Bultmann, *Zum Problem der Entmythologisierung, op. cit.*, p. 193.

The longing for security is also, for Bultmann, the basis of objectivizing thought in science, myth, and Christian dogmatics.[21] Science successfully conceptualizes the world as a flawlessly-ordered context of events by way of fixed laws, and makes the potentially available *actually* calculable. Thus, it represents a temptation of wanting to completely master the world and human existence. Myth knows about the unavailable and accepts that human life has its foundation in an incalculable, transcendent power; yet it projects that power into the field of the available. Myth "speaks of the unworldly in a worldly way and of the Gods in a human way."[22] Theology, too, is in danger of objectivizing the unavailable, in so far as it uses the language of affirming propositions, the truth of which seems to be independent of the existential relation to its content. Bultmann objects: "The affirmations of faith are no universal truths."[23] As dogmas, merely known and recognized in their being handed down, without relation to the concrete existential situation concerning man here and now, they lose their sense.[24]

Existential interpretation reads the Bible with the sketched anthropologic background and is thereby able to find the impulse it holds also for modern man. "The impulse consists in the word of God calling man from all his fear and self-made security to Him, and thus to his true existence — and thus also to freedom from the world, which he subdues by objectivizing thought in science, that in a way as to give it power over himself."[25] What Bultmann variably calls true existence, faith, Christian understanding of being, or freedom from the world, stands for a basic trust, for being able to open freely and without fear towards an insecure future. "Such a life becomes possible for the human being out of faith in God's 'mercy,' i.e. out of the trust that it is exactly that invisible, unknown, unavailable, which comes to man as love, brings him his future, which does not mean death for him, but life."[26] The ease arising from that implies an eschatological life as a new creature which is able to live in loving human togetherness.[27] It is a freedom from the world with trust in God, which at the same time is a new freedom towards the world.

Following a saying of his teacher Wilhelm Herrmann, which Bultmann repeatedly quotes, one cannot speak about how God is as such, but only what He does with regard

21. I thus pledge to not establish myth as the only adversary of existential interpretation, thus seeing it in the first place as a de-mythologizing, even if interpretation of myth is treated most widely in Bultmann.

22. Rudolf Bultmann, 'Neues Testament und Mythologie. Das Problem der Entmythologisierung der neutestamentlichen Verkündigung' (1941), in: H.W. Bartsch (ed.), *Kerygma und Mythos. Ein theologisches Gespräch*, vol. I, 5th ext. edn. Hamburg-Bergstedt, 1965, p. 22.

23. R. Bultmann, *Zum Problem der Entmythologisierung, op. cit.*, p. 197.

24. Regarding the existential interpretation of dogma, see especially Gotthold Hasenhüttl, *Glaube ohne Mythos*, vol. 1, Mainz, ²2001, especially pp. 85-88.

25. *Ibid.*, p. 188.

26. R. Bultmann, *Neues Testament und Mythologie, op. cit.*, p. 29.

27. *Ibid.*, p. 31.

to us.[28] That is why the activity of God, i.e. his being present as approaching, questioning, judging and blessing, forms the centre of his theology. Again, Bultmann puts the existential understanding of God's deeds in contrast with the mythical one. Myth displays them as objectively detectable events "interfering with the context of natural, historic, or psychological life, and bursting it, as a 'miracle.'"[29] For Bultmann, though, the beyondness of Divine action is safeguarded exactly by its not happening somewhere in between worldly events, but within them without touching their natural connection. It can be said that God is encountered always and everywhere, though being only discernible for the receptibility of faith. "I can understand an event concerning me in a perspective of faith as a gift or judgement of God, but I can also see it in its natural or historical context."[30] Such faith is an existential process of encounter, which can only remain alive if one sees oneself always anew as personally addressed by God, and if one consequently asks what God wants to tell her/him here and now.

An existence in faith is for Bultmann strictly dependent on the Christ event, whereas he himself feels this to be a delicate point, which does not easily fit into the general framework of his thought.

> Faith as obedient submission to God and as inner freedom from the world is only possible as faith in Christ. This is now the decisive question, whether this affirmation is a mythological remnant to be eliminated or demythologized by critical interpretation. It is to be questioned whether *the Christian under-standing of being can be executed without Christ*.[31]

The human nature shown in the New Testament is, on the one hand, not meant to be something mysterious or supernatural. Bultmann considers the Christian understanding of being as one that can very well be attained philosophically.[32] If it is so universally human, then the exclusive tie of this conception of being with Jesus Christ becomes questionable. Bultmann saves himself by moving the focus of the Christian message from the demonstration of the possibility of true existence to its realization. The core of the message of the NT was not the revelation of true human life, but the proclamation that man cannot free himself by his own power, instead having to rely on the liberating act of God. The Christ event functions as "the revelation of the love of God, which frees man from himself for himself by freeing him for a life of devotion in faith and love."[33]

28. See, e.g., R. Bultmann, *Zum Problem der Entmythologisierung, op. cit.*, p. 185.

29. See, e.g., R. Bultmann, *Zum Problem der Entmythologisierung, op. cit.*, p. 196.

30. See, e.g., *ibid.*, p. 197.

31. R. Bultmann, *Neues Testament und Mythologie, op. cit.*, p. 31 [stressing in the original].

32. Bultmann sees in the philosophy of Jaspers, Heidegger, and Kamlah successful attempts to elaborate the conception of man of the New Testament in a considerate and more consequent way (because without mythical remnants), without having to make recourse to revelation. See *ibid.*, pp. 32-34.

33. *Ibid.*, p. 39.

Bultmann then again exclusively links the presence of God's love in strict expressions to Jesus Christ. The New Testament was holding the knowledge that "man as such, man before and outside Christ, is not in his free being, not in life, but in death."[34] Without the mercy of Christ, the only adequate attitude towards life would be to despair over the possibility of true being.

Existential Interpretation within the Kyôto School

The conditions for a Buddhist reception of Bultmann among the representatives of the Kyôto School were favourable.[35] Since the Japanese Meiji Era universities of Western style were introduced as a result of the politics of opening towards the West. Philosophy existed as an academic discipline, at the beginning of which Western philosophy was more or less copied. The Kyôto School counts as the first truly autonomous modern school of Japanese philosophy, developing, against the backdrop of Japanese nationalism, the ambition of wanting to excel Western philosophy.[36] The respectively most recent developments in Europe were adopted, and a high interest developed in German philosophy, especially in Heidegger. Also, Protestant theology of the twentieth century was followed attentively, and reactions towards new trends and discussions therein took place swiftly.

Another reason for studying Bultmann was his claim to yield an interpretation of Christianity for the modern, technicized world. The cultural and religious crisis of identity brought about in Japan by modernization was one of the main problems of the Kyôto School. For its attempts to reformulate the Japanese (especially Buddhist) tradition in a language to be understood by modern Japan and the West, Bultmann was an interesting interlocutor, working on a similar problem of mediation on the Christian side.

Not lastly, there were also convergences regarding the way of thinking. With the founder Nishida, we thus find thoughts which favour the later reception of Bultmann. In his last great essay, "The Logic of place and a religious world view" (*Bashoteki ronri to shukyoteki sekaikan*, 1945), the "viewpoint on the 'I' from a perspective of objective logics or objectivization" is considered as the root of all error and as the foundation of the

34. *Ibid.*, p. 36.

35. The history of the influence of Bultmann in Japan is not confined to the Kyôto School. I will in the following not treat Japanese Christian theology (which in turn is partially influenced by the Kyôto school) nor the interesting attempt of the historian of religion Anesaki to transfer the difference of the historic Jesus and the kerygmatic Christ to Gautama Śākyamuni, that last in order to explain the *trikāya* doctrine. See Michael von Brück/Whalen Lai, *Buddhismus und Christentum. Geschichte, Konfrontation, Dialog*, München 1997, pp. 306-07.

36. For an introduction to the Kyôto school, see Thomas P. Kasulis, 'The Kyôto-School and the West. Review and Evaluation,' *The Eastern Buddhist*, New Series 15: 2 (1982); Ryôsuke Ohashi (ed.), *Die Philosophie der Kyôto-Schule. Texte und Eirführung*, Freiburg/München, 1990; Lydia Brüll, *Die japanische Philosophie. Eine Einführung*, Darmstadt, 1993, pp. 155-79. The state of research is presented by Rolf Elberfeld: *Kitarô Nishida (1870-1945). Moderne japanische Philosophie und die Frage nach der Interkulturalität*, Amsterdam/Atlanta, 1999, pp. 61-73.

original sin.[37] All errors concerning the relationship of God and man are to be founded in objectivizing, respectively object-logical thought.[38] This is already similar to the verdict of objectivization in Heidegger and Bultmann. It is unknown to me whether Nishida himself would have treated the writings of the early Bultmann. His reference to dialectic theology, however, has prepared the reception of the German theologian.

Moreover, parallels to Buddhist tradition were found in the elementary experiences of finitude which in Buddhism have always played a central role (keyword: suffering) and which just seemed to have been waiting to be treated through existential interpretation. The phenomenology of the nothing, to be found in Heidegger, could be critically continued using their own basic concept of the absolute nothing (*zettai mu*), which already is a result of the encounter between Buddhist and Western philosophy.

Nishitani Keiji

When the discussion on de-mythification had become the great topic of theology received in the entire world, Nishitani Keiji, who was the successor of Tanabe at the chair of philosophy in Kyôto, gave his respective views in an extensive article and in various parts of his main work.[39] Nishitani sees de-mythification as a fundamental problem of Christianity, which according to him was present therein from the very beginning. Already before Christianity, Greek philosophy would have tried to free itself from the mythological cosmology. Through contact with philosophy, a conflict would have arisen in early Christianity between faith, dominated by myth, and "reason awoken to self-confidence;" thus, the further history of faith and theology remained a history of that conflict.[40] "We may say that up to today, Christian theology is involved in this dilemma."[41] Bultmann

37. Cf. Kitarô Nishida, *Logik des Ortes. Der Anfang der modernen Philosophie in Japan*, tr. and ed. Rolf Elberfeld, Darmstadt, 1999, p. 238.

38. Cf. Kitarô Nishida, *Logik des Ortes. Der Anfang der modernen Philosophie in Japan*, tr. and ed. Rolf Elberfeld, Darmstadt, 1999, p. 242.

39. Cf. Keiji Nishitani, 'Eine buddhistische Stimme zur Entmythologisierung' (1961): *Zeitschrift für Religions- und Geistesgeschichte* 8 (1961) 244-62; 345-56; it appeared first under the title 'Der Buddhismus und das Christentum,' *Nachrichten der Gesellschaft für Natur-und Völkerkunde Ostasiens Hamburg*, Wiesbaden, 1960, 5-32; *id.,*: *Shukyō to wa nanika* (written 1954-61, published 1961), in English published as *Religion and Nothingness* (Nanzan Studies in Religion and Culture). Transl. Jan van Bragt, Berkeley/Los Angeles, 1982. My quotations refer to the English translation of Keiji Nishitani, *Religion and Nothingness*. Translated with an Introduction by Jan van Bragt, Berkeley/Los Angeles: University of California Press, 1983. Other works by Nishitani relating to existential interpretation which I do not refer here, are, by the same author, 'The "Problem of Myth",' *Religious Studies in Japan*, Tôkyô, 1959, pp. 50-61; by the same author, 'Die religiös-philosophische Existenz im Buddhismus,' in: *Sinn und Sein*, ed. Richard Wisser, Tübingen, 1960, pp. 381-89; 'Science and Zen,' *The Eastern Buddhist* 1: 1 (1965), pp. 79-108. Regarding the philosophy of Nishitani, see Taitetsu Unno (ed.), *The Religious Philosophy of Nishitani Keiji*, Berkeley, 1989; regarding Buddhist-Christian dialogue, Nishitani is further treated by Hans Waldenfels, *Absolutes Nichts. Zur Grundlegung des Dialogs zwischen Buddhismus und Christentum*, Freiburg, 1980.

40. *Ibid.*, p. 246.

41. *Ibid.*

was to have referred to the de-mythificating tendency of liberal theology, simultaneously projecting a way to revive the tradition of the Reformation.

Nishitani is impressed by the vitality of modern Christianity, shown in the intensity of the discussion on de-mythification. Contemporary Buddhism is in his opinion not vivid enough to hold such a debate. And yet he believes that Buddhist tradition can contribute something to it. "Where this active and extensive debate enters our field of vision, the presently lukewarm and ineffective Buddhism comes to memory as a kind of geological remnant from far-away times."[42] For Buddhism was to have already overcome the problem of de-mythification in its early days, thus opening a horizon distinguishing it from all other religions.

While thoroughly going through the criticism directed at Bultmann so far, he elaborates that the point is not the vagueness of his concept of myth, but the circumstance that by his critics "with all emphasis on the necessity of overcoming the mythological imagery, the use of mythological language is retained as inevitable."[43] A certain conservativism remains, the dilemma of which Bultmann had already pointed out in his counter-criticism. If myth were to be overcome by an interpretation bringing to light a new sense, then that sense could not be again expressed in mythical language, since that process would bring about the absurd consequence of de-mythification *ad infinitum*. Instead, Bultmann insists on the intention of myth having to be expressed in an entirely non-mythological way.

Nishitani tries to show the lack of completeness of that attempt, with Bultmann himself, judged by his very own conception of myth, falling back to mythical speech in relation to Jesus Christ. Though he was not thinking of him naïvely as a supernatural oracle, Bultmann would yet view him as a Divine event of salvation still having mythical structure as a historically unique *Verweltlichung* of the unworldly.[44] Thereby we return to the position of the critics of Bultmann claiming the inevitable character of myth. "Thus, it seems as though, in the area of Christian theology, a *dead end* is reached between the two opposed parties circling the problem of myth."[45]

Nishitani tries to confront this with a position from the Buddhist side, by which the "detachment from the form of myth in the religious field," up to now impossible in Christianity, "is to be executed completely."[46] He displays this form of radicalized de-

42. Cf. K. Nishitani, 'Eine buddhistische Stimme zur Entmythologisierung' *op. cit.*, p. 247.

43. *Ibid.*, p. 249.

44. On the other hand, R. Bultmann, *Neues Testament und Mythologie, op. cit.*, p. 48: "The beyondness of God is not made worldly as in the myth; but the paradox of the presence of the not-worldly God in history is claimed: 'The word became flesh.'" [stressing in the original] Bultmanns general treatment of the paradoxic presence of the transcendent in history is in harmony with the thought of Nishitani. Yet the historic unicity of that presence in Jesus Christ, which Bultmann claims, is for him reason enough to put Bultmann's Christology among the mythological imageries.

45. *Ibid.*, p. 253 [stressing in the original].

46. *Ibid.*

mythificating process using the interpretation of the doctrine of the virginal conception of Jesus Christ. The virginity of Mary was to refer to an unconditional, ultimate reality of each human, transcendent and at the same time united to concrete existence. "The invariable immaculateness (of man) transcends the immaculate or maculate psycho-physical being completely, yet it is not removed from that being in any way."[47] Both are truly two and truly one, or, as Nishitani also says in reference to the terminology of Nishida: They form an absolutely paradoxical (contradictory) self-identity.[48] In the words of Zen master Bankei, quoted by Nishitani: "We are unborn especially as bodily existing, especially in our being born by our parents."[49] At the background of such Zen-statements would be the Buddhist doctrine saying that all beings are originally of Buddha-nature. They are unmythical, because they do not make the Divine enter into the everyday world in an extraordinary event; rather, worldly everyday life is but the other side of transcendent purity. The breakthrough to the dimension of human being thus mentioned, and the self-understanding deriving from it, was to be an existential self-knowledge, running through all of human history like a vast river and manifesting especially in Buddhism. Attempts at that were also to be found in European history.[50]

In Christianity, birth from a virgin was to be limited to Jesus and considered a special case rooted in his Divinity. A consequent de-mythification was to only be possible when birth from a virgin and Divinity are expressions not linked to any distinct individual, but counting for everyone. In order to achieve that, transcendent reality would have to be thought not as crossing nature vertically, but as horizontal transcendence, being absolute negation (as complete otherness) and affirmation (as non-duality) of nature at the same time. Nishitani finds this not-nature as nature in the Mahāyāna Buddhist principle of formless void (*śūnyatā*, also translated as emptiness, nothingness), as an intangible last reality, being one with the formed being. "I believe that a fundamental and thorough de-mythification of all myths and an 'existential' interpretation of mythological imagery can only be possible in the breakthrough to the horizon of the absolute 'void' or the absolute 'nothing.'"[51]

47. On the other hand, R. Bultmann, *Neues Testament und Mythologie, op. cit.*, p. 257.

48. Jap. *zettai mujunteki jikodôitsu*. Rolf Elberfeld comments this fundamental concept of the Kyôto school, in K. Nishida, *Logik des Ortes, op. cit.*, p. 285: "Nishida uses this fixed formula since 1937. The absolutely contradictory self-identity of reality stands, for Nishida, in relation to the dialectic structure of the instant in a spatial and temporal way as the self-determination of the absolute nothing."

49. *Ibid.*, p. 261.

50. See *ibid.*, p. 260.

51. *Ibid.*, p. 350. Absolute nothing, in Japanese *zettai mu*, is a fundamental concept of the philosophy of Nishida. At the background, there is the Buddhist concept of emptiness or void, *śūnyatā*, but also the Platonic *chóra*. Absolute nothing represents the all-englobing, borderless place (*basho*), which transcends and gives space for the being and the relative nothing related to it, as well as all other polarities. Nishida already tried to build bridges to the Christian understanding of God from the thought of absolute nothing. See H. Waldenfels, *Absolutes Nichts, op. cit.*, pp. 55-64.

The conception of emptiness as absolute negation and affirmation of being at a first glance seems to be a metaphysical concept reminding of the christological two-nature doctrine, pictured here as absolutely contradictory self-identity of the absolute and finite, and extended to all humans, in fact to all being. But, trained with Bultmann, Nishitani displays the existential dimension of the absolute nothing much more clearly than Nishida. He thus thinks from emptiness as lived experience and not from a Hegelian idea of the absolute meant to imply *a priori* that the absolute were also to contain its own negation. The fundamental experience on which his interpretations are based is that of the movement into the foundationless nothing and out of it again. This is described as mystic dying and being reborn, in Zen Buddhist terms 'great death' and 'great enlightenment,' wherein are experienced the nihilation and the returning of all being. From this position, he develops an existential interpretation of Buddhism as well as of Christianity.

Despite the superiority of Buddhism concerning de-mythification, as postulated by Nishitani, he also sees mythical elements in it and demands a very central matter of Buddhist faith to be de-mythificated: the doctrine of rebirth. "The positive significance in myth will truly be revealed only through what Bultmann speaks of as *existentielle Entmythologisierung*. The same applies to the notion of transmigration."[52] He interprets the thought of reincarnation in a Bultmannian way, by taking from it the character of a doctrine describing objective facts, and showing the human self-understanding contained therein. The true meaning of this myth can "only be grasped when we interpret it so as to bring the content of that representation back to the home-ground of our existence in the present."[53] Existentially interpreted, *saṃsāra*, the cycle of rebirth, means for Nishitani an awareness of one's own being as "infinite finitude."[54] With this formula he intends finitude as a way of being which is caught within itself, wherein human existence is so tangled up as to never and in no place be capable of going beyond it. Where finitude, caught infinitely in itself, comes to be seen as such, a *nihilum*, a nothing, rises from the foundation of finite being and nihilates the being of man and with it the being of everything in the world. Nishitani sees the existential sense of the myth of reincarnation in this "nullification of all."[55] The experience of the *nihilum* (the nothing in the negative sense, an intermediate state on the way to the experience of emptiness), just like faithless existence in Bultmann, leads to despair. In Nishitani's view despair is understood as deepened awareness of existence, because in it, the abyss of the nothing emerges from the very source of being. Thus appears a depth, which normally we do not perceive. Despair is for him an issue of the dimension of transcendence, and shows the shape of being in the opening of nothingness.[56] *Nirvāṇa*, the liberation from the vain world, is a breaking out

52. K. Nishitani, *Religion and Nothingness, op. cit.*, p. 174.
53. *Ibid.*, p. 243.
54. *Ibid.*, p. 172.
55. See *ibid.*, p. 175.
56. See *ibid.*, p. 176.

of this being-toward-death and a turning to the true infinity as revealed in the innermost core of every existing human. For this liberation, the self must give up all high-handedness and become a place of receiving. "To take possession of infinity is for infinity to become reality as life; for it to be *really* lived. The 'Existenz' that connotes such a new life is nothing other than *nirvāṇa*, and such true infinity is *śūnyatā*."[57] Emptiness is not only the negation of *saṁsāra*, but at the same time affirms it, for it is the place where true finitude happens, no longer caught in itself, but open towards the infinite.

> *Śūnyatā* is the point at which we become manifest in our own suchness as concrete human beings, as individuals with both body and personality. And at the same time, it is the point at which everything around us becomes manifest in its own suchness. As noted before, it can also be spoken of as the point at which the words 'In the Great Death heaven and earth become new' can be simultaneously signify a rebirth of the self.[58]

The first chapter of Nishitani's *Religion and Nothingness* contains, in a nutshell, a coherent theological overall design of Christianity, from the starting point of the existentially interpreted *śūnyatā*, respecting practically every basic Christian doctrine. Here, I can only consider Nishitani's theology of Creation and his Christology. He again treats the conception of *creatio ex nihilo* not only as an expression of "metaphysical and theoretical reflection," but moreover as something concerning the truth of real things and the existence of everyone. The dogmatic expression becomes a question questioning the questioner her/himself, and that in the tough way of a Zen-Koan. He reaches this connection to the existential situation by referring the topic of creation to that of the presence of God, again not as a concept within one's mind, but as a presence by which "one is pressed from all sides for a decision, whether one faces a single atom, a grain of sand, or an earthworm."[59] In this respect Nishitani draws on the well-known passage in Augustine, according to which all things are declaring to be created by God.[60] Therein is included that they are not themselves God. We can, from this perspective, not encounter God anywhere in the world. Instead, everywhere we encounter the *nihilum*, a nothingness like an iron wall dividing everything from God. Therein, one meets simultaneously the vanity of all created being and the absolute negativity of God, his entire otherness, absence and transcendence. At the same time, creative divine force is found in everything, for He gives it being despite nothingness. The vanity of things and the absence of God in them is yet the place of His omnipresence, which bereaves us of any place, where we could live as independent self-existing beings. If we see the omnipresence of the absolutely transcendent God in this way, we immediately stand in front of the iron wall of God.

57. K. Nishitani, *Religion and Nothingness, op. cit.*, p. 177.

58. *Ibid.*, p. 90-91.

59. *Ibid.*, p. 38.

60. Augustine, *Confessions*, book 10, 6, 9 ff.

"One who has been able to come to faith may face it and walk through it."[61] The omnipresence of God then manifests as the overturning from absolute negativity to absolute positivity. "To entrust oneself to this *motif*, to let oneself be driven by it so as to die to the self and live in God, is what constitutes faith."[62]

Nishitani interprets the life of Jesus Christ as bodily revelation of that turnover from absolute negativity to absolute positivity, founded in God himself and forming the sense of creation.[63] Again, he composes the experience with Jesus by way of the existential "being-cornered," practised in Zen with the aim of the breakthrough to the void.

> The gospel proclamation that the Kingdom of God is at hand presses man to the decision to die and be born anew. The fact that the gospel of the Kingdom of God has an eschatological dimension signifies, from the existential standpoint, that the *motif* of conversion for man implied in divine omnipresence confronts man with an urgency that presses him to a decision on the spot: either eternal life or eternal death.[64]

Yet, not only Zen spirit underlies this passage. Down to the wording, parallels to Bultmann can be found. The fundamental difference between the latter and Nishitani consists in the fact that the call to conversion for Nishitani is already to be found in the omnipresence of God, as explained above, and the part of Jesus Christ only consists in manifesting this call with greater emphasis. As is to be expected, he does not speak of the passage from the old way of existing to the new as being possible through a love of God revealed only and exclusively in Jesus Christ. For Nishitani, Jesus does not have the character of being the last and final one to reveal God, and the only incarnation of the Logos in this world. For the appeal coming from Jesus Christ with his call for conversion and the revelation of the forgiving love of God are for him alive also in Zen Buddhism, respectively in Shin-Buddhism, and correspond to the fundamental structure of reality, which human existence is at all times subjected to.

Takeuchi Yoshinori

Also from the end of the 1950s onwards, Takeuchi Yoshinori, a student of Tanabe and confessing Shin-Buddhist, wrote a number of works in which he develops his Buddhist existentialism, using also existential interpretation in the style of Heidegger and

61. Augustine, *Confessions*, book 10, 6, 9 ff, p. 38.

62. *Ibid.*, p. 40.

63. Nishitani's Christology is closely connected to his kenotic trinitarian theology. See A. Münch, *Dimensionen der Leere. Gott als Nichts und Nichts als Gott im christlich-buddhistischen Dialog*, Münster, 1998, also Karl Baier, *Knōsis und Śūnyatā. Gott und Nichts im buddhistisch-christlichen Dialog*: Religionen unterwegs 1 (2003) pp. 4-9.

64. *Ibid.*, p. 40.

Bultmann.[65] From the part of the existentialist philosophers and theologians, Takeuchi sees a great help with the attempt to present original Buddhism in a new way, suitable for the Western way of thought.[66] He knew Bultmann personally and reports a conversation with him, in the course of which Bultmann praised the Zen classic "The ox and its herdsman" as a marvellous book coinciding with the Christian truth of man who has to forget the self to gain her/his true self. Takeuchi saw differences in the dialogue with Bultmann only concerning the relationship of truth and history in regard to salvation, and therefore, in effect, again concerning Christology.[67]

Gestures of superiority in the face of Christianity are absent with Takeuchi, just as he generally renounces to the reversed orientalism of his colleagues from Kyôto. With him, de-mythification becomes in the first line a pronouncedly critical treatment of his Buddhist tradition, sometimes consciously turning against authorized doctrines. He uses the existential interpretation as a skilful means to gain an existential understanding of the original teaching of the Buddha through relatively detailed analysis of the Pāli-canon, by which he can criticize later developments as aberrations.

At the beginning of the Buddhist path of salvation, there was to have been an existential internalization of finitude, which he, similar to Nishitani, explains by the experience of fear in the face of threatening non-being, by senselessness driving to despair, as by guilt and sin. Buddha would show the way to overcoming the attachment to the transient, leading on to the experience of the absolute and to mercy in relation to all mortal beings. But very early, this message was to have been forged by the objectivizing approach of early Buddhist schools. As examples for that, he refers to the doctrine of *anattā*, in so far as it replaces the originally intended experience of the nothingness of man with the conception of the self-being only a conglomerate of various psycho-physical functions; *kṣaṇikavāda*, the Abhidharma doctrine according to which all being consists of instantaneous events following one another in an ordered way; and finally the objectivizing view on the body in the *satipatthāna* meditation. *Pratītyasamutpāda*, the chain of caused formation, should also not be misunderstood as a chain of causes in an

65. Cf. Yoshinori Takeuchi, 'Buddhism and Existentialism. The Dialogue between Oriental and Occidental Thought,' in: W. Leibrecht (ed.), *Religion and Culture*, New York, 1959, pp. 291-318; *id.*, 'Das Problem der Eschatologie bei der Jôdo-Schule des japanischen Buddhismus und ihrer Beziehung zu seiner Heilslehre,' *Oriens Extremus* 8: 1 (1961), pp. 84-94; *id.*, 'Die Idee der Freiheit von und durch Kausalität im Ur-Buddhismus,' in: *Akten des XIV. Internationalen Kongresses für Philosophie in Wien, 2.-8. September 1968*, pp. 145-57; *id. Probleme der Versenkung im Ur-Buddhismus* (Beihefte der Zeitschrift für Religions- und Geistesgeschichte; 16), Leiden, 1972; *id.*, 'Shinran and Contemporary Thought,' *The Eastern Buddhist* 13: 2 (1980), pp. 26-45. A good overview on the work of Takeuchi is given by Buri, F., *Der Buddha-Christus, op. cit.*, pp. 255-83.

66. See Y. Takeuchi, *Probleme der Versenkung im Ur-Buddhismus, op. cit.*, p. 32.

67. Cf. Y. Takeuchi, *Shinran and Contemporary Thought, op. cit.*, pp. 40ff. For the Takeuchi/Bultmann conversation, see F. Buri, *Der Buddha-Christus, op. cit.*, pp. 277-80.

objectivized fashion.[68] "All of these ideas are products of objectivizing thought, entirely removed from the elucidation of existence by the interior force of transience, and thus taints the true sense of the transient and the 'not-I' up to the quantitative determination of discriminating thought."[69]

With Takeuchi, an influence of existentially interpreted Buddhism can be shown in Christian reception of Buddhism, and thus, the existential viewpoint serves as an interreligious medium also in backwards transfer. Heinrich Dumoulin, in his book *Encounter with Buddhism*, refers repeatedly to Takeuchi's *Problems of meditation in original Buddhism*. He entirely agrees with the criticism of the latter concerning the objectivizing position of some Abhidharma theories and Buddhist forms of meditation. "It is of decisive importance to keep the experience of transience an existential one, and not to draw it to the level of objectivizing thought."[70] For Dumoulin, the fundamental Buddhist experiences of suffering and liberation from it are an experience also made by Christians, which can be shared by all religious people.

> Both moments, ruin as well as the possibility of salvation, are connected in religious experience. Between the two, there is no relationship of cause and effect, [. . .], but they are the poles of the religious understanding of existence, present in the major world religions.[71]

The existential viewpoint, coming from Christian theology, returns to Christian theology by an existential understanding of Buddhism, developed in Japan. Dumoulin can, based on this trans-religious exchange, undertake the regress to existential understanding as medium of the encounter of the world religions.

Summary

The creative reception of existential interpretation at first directly influenced the way of thought of the Kyôto School. The reference to existential experience was in Nishida not methodically fundamental, though already present. Under the influence of Bultmann, dialectic patterns of thought are placed in the background. Nishitani and Takeuchi develop a form of existentialist mysticism which for them becomes the key of a new interpretation of Buddhism and Christianity. The Bultmann 'Rezeption' further allows the Japanese thinkers to connect to the present philosophical and theological discussion in the West and further to contribute the heritage of Buddhist tradition to this discourse. Buddhism, which according to the modernized Japanese intellectual mind of Nishitani at first appears fossilized, thus gains new life and is, with a lead in de-mythologizing, even positioned as a more modern form of religion in reference to Christianity. Nishitani as well as Takeuchi

68. Takeuchi interprets *pratītyasamutpāda* existentially as a "theory of conversion," leading to freedom from anguish and desires. See F. Buri, *Der Buddha-Christus, op. cit.*, pp. 261-62.

69. Y. Takeuchi, *Probleme der Versenkung im Urbuddhismus, op. cit.*, p. 28.

70. Heinrich Dumoulin, *Begegnung mit dem Buddhismus. Eine Einführung*, Freiburg, 1978, p. 34.

71. *Ibid.*, p. 39.

de-mythologize not against the anthropological horizon of Heideggerian analytics of being, but with the philosophy of the absolute nothing now conceived in a decisively existential way. This philosophy is linked to Heidegger, Bultmann, and Sartre through the *nihilum* as an intermediate phase, while aiming at deepening their analysis of being and nothingness.

Viewpoints on both religions are created, which simultaneously are at home in these traditions and beyond their borders. In Nishitani, the existential approach is mainly in the service of philosophical reflection on the human reality in its existential relation to transcendence. By the existential method he can take impulses from Buddhism and Christianity. On the other hand, he reinterprets them using his philosophy of *śūnyatā*. Takeuchi, rather, writes as a Buddhist "theologian" taking up the criticism of objectivizing thought to elaborate a new existential understanding of Buddhism, following the model of a "reform from the origin," and thus orienting it towards the most ancient Buddhism, though without denial of his own Shin-Buddhist roots.

Concerning Christology, in the portrayed religious dialogue no unity could be achieved between Bultmann and the Japanese interpreters on the basis of an existential interpretation. As for other points, an existentially interpreted Buddhism allows difficult areas in Buddhist-Christian dialogue, such as the doctrine of rebirth and *anattā*, to appear in a new light, consistent with Christian positions. Bultmann's positive statement regarding Zen Buddhism shows him as someone having been able to approach Buddhism on the basis of his own understanding of the (selfless) self-being. On the Buddhist side, on the other hand, new approaches to Christianity were opened. Related hermeneutics (in our case interdependent by transfer) obviously bring religions closer together.

As an interpretational key bringing common basic experiences to light, the existential interpretation has not yet fully employed its potential regarding inter-religious communication. If one decides to start from common anthropological structures such as basis of inter-religious understanding, existential interpretation offers itself as one of the elaborated and trans-religiously tested versions of this approach to further reflect upon.

20

The Ethics of Justice in a Cross-Cultural Context

Michael von Brück

THE central thesis of this paper is, primarily, that justice is neither a qualification of actions nor a political expediency, but is an existential reality. This reality is symbolized in different ways depending on religious experience and cultural conditioning. Underlying all concepts and ethics of justice is a dimension of basic insight that is beyond rational quantifying analysis.

The semantics of concepts of justice is different in various contexts and systems of meaning, i.e. in more general political and social contexts and in the rational discourse of philosophy. The general political term of justice is more confusing than helpful for a clear conceptualization; it might be treated more as a symbol in a mythological framework than a concept. In this context justice is defined in terms of what it is not, or metaphorically in differing categories: justice as impartiality, equality, etc. Thus, many programmatic formulae such as *International Movement for a Just World*[1] express a utopia over against the frustration with regard to social, economic and political conditions and call for action to establish a 'just world' without defining what the standard of this action must be in order to qualify as just and what *exactly* the notion of a 'just world' actually might mean conceptually. Certain political actions are condemned from a certain standpoint, but the very foundation of any standpoint remains controversial. 'Just' or 'unjust' are actions, which are determined according to the two standards of an Aristotelian *suum cuique* and the principle of treating equal cases in equal ways. Here, actions and their results as well as human freedom of action and the respective responsibility are the matter of discussion. The problem is how to establish criteria for what is regarded as being 'equal.'[2]

Therefore, I may suggest that justice could be discussed in two ways: as an agreement or result of negotiation and better insight that is worked out between partners in social processes, and/or as a reflection of the cosmic order, the divine will or any pre-established harmony that is not negotiable by human beings. Whereas the first assumption is reflected

1. As an example see the journal 'JUST Commentary. International Movement for a Just World,' Petaling Jaya, Selangor Darul Ehsan, Malaysia, since 2000.
2. A. de Jasay, *Justice and its Surroundings*, Indianapolis: Liberty Fund, 2002.

in the theories of Aristotle, Rousseau, John Rawls[3] and others, the second one seems to be one of the basic contents of any religious worldview. Rawls actually constructs his idea of justice as fairness in the line of the familiar theory of the social contract, following Locke, Rousseau and Kant. Accordingly, justice is the basic assumption which generates the condition for any further discourse in societies. It is an "original position," an "initial status," the "symmetry of everyone's relations to each other," which, of course, is neither an actual state of historical affairs nor a primitive condition of culture, but a purely hypothetical situation.[4] For Rawls, to think of justice requires the task to acknowledge interdependencies and mutual dependence of the different factors and actors in societies on the basis of reflexive reason. In religions, however, it is the *dharma*, the commandment of God, the *Tao* or the cosmic harmony or 'symmetry' of forces that is the root cause for justice in human relations.

In this essay I will not argue any of these positions mentioned above as such but maintain only that any discourse in this or that way depends on communication processes, i.e. language and actors. Actors have interests, which are mediated through claims. These claims may be compatible or not. However, in both cases they are part of the communication processes itself. And it is in communication that discourses materialize. Therefore, dialogue is the framework for any theory of justice, which may be inclined more to the first or the second position outlined above. Since today, due to economic, political and cultural circumstances, all discourses are linked to each other, it is in *cross-cultural* communication and dialogue that a theory of justice has to be worked out. The question is whether justice should be regarded as a precondition for dialogue or a wanted result of dialogue. The hypothesis I want to argue for is that justice is neither only a precondition nor only a result, but that it is the very process of dialogue itself that works out the parameter for what we could call 'justice.' This hypothesis, however, is based on a religious claim that justice reflects 'things as they are.' If this holds true, justice is more than a human invention or result of negotiation but rather the basis for a proper balance in the systemic interrelatedness of events, i.e. of the fact that things are as they are.

A further remark may be helpful to locate the following discussion in its philosophical context. Justice could be generally defined as a principle, which states that anybody should have or be given or be re-established in what is due to him/her. What is due, however, is a result of social agreement, at least in so far as it is mediated through processes of language. Aristotle's distinction of *iustitia distributiva and iustitia commutativa* also refers to a difference of general and particular justice that is mediated through processes

3. In his theory of justice Rawls follows in principle a communication model in as much as justice to him is "fairness" as a model for communication, which is established in a common act of choice with regard to the principles which determine the basic duties and rights and the distribution of goods (John Rawls, *A Theory of Justice*, Cambridge, Mass.: Harvard University Press, 1971, pp. 3ff.: 'Justice as Fairness').

4. Cf. J. Rawls, *Theory of Justice, op. cit.*, p. 12.

of communication, because both distributive justice and equalizing or compensating justice refer to actions of individuals linked in a community. Here, it is not important whether such a community is institutionally organized as a state or a church. However, it is obvious that under the present conditions, any distribution of values, goods, opportunities or means of communication is of cross-cultural importance.

First, it might be useful to revisit one of the more important normative texts on interreligious dialogue and relate its principles to the question of justice. At a remarkable Conference on Interreligious Dialogue in Chiang Mai 1977, the *World Council of Churches* (WCC) produced a paper which was adopted by the Central Committee of the Council in 1979 and recommended as "Guidelines on Dialogue" to the member churches. Chiang Mai 1977 proclaimed dialogue as a lifestyle (17), not mere discussion at conferences, and therefore dialogue was seen as a building of community across all kinds of social and cultural boundaries. Nothing has to be added today. "Dialogue," said the recent Revisiting Reflection on the Guidelines from 1977,[5] "must be a process of mutual empowerment, not a negotiation between parties" (18). In 1977, a similar insight was expressed in different words when the conference stated, that "dialogue is not reduction of living faiths and ideologies to a lowest common denominator (. . .) but the enabling of a true encounter between those spiritual insights and experiences which are only found at the deepest levels of human life" (chapter 22). In 1977 the formula was that dialogue is a "joyful affirmation of life against chaos," whereas the recent WCC document says: "It is a joyful affirmation of life for all." (20) Both statements are right, and the recent reading was certainly the general idea behind the Chiang Mai papers about a quarter of a century ago, and it is as much relevant today. Dialogue is to "dispel fears and suspicions between those who are seen to represent religious communities" (32). However, Chiang Mai 1977 was modest and aware that dialogue is not an instant means to resolve problems, but it needs patience and gradual build-up of mutual trust and friendship between partners in direct relationships, and only then dialogue "may in times of conflict prevent religion from being used as a weapon" (28). Not negotiation but empowerment. Negotiation is the art to find compromise between different interests; dialogue is to get empowered, because there is one interest that has been obscured over centuries and millennia time and again, *the interest for life, partnership, friendship, mutuality in view of our common origin in the Divine and our common destiny in an Ultimate Reality which we envision in different ways.*

However, we should not be naïve, because the divisions within humankind due to power struggles and injustice are too severe. As all our political and intellectual experience during the last two decades shows, this is not so much a theological problem, but a matter of economic, social and cultural conditions. Theologically we can debate and

5. See *Guidelines on Dialogue with People of Living Faiths and Ideologies*, Geneva: WCC, 1979; 'Guidelines for Dialogue and Relations with People of Other Religions. Taking Stock of 30 years of dialogue and revisiting the 1979 Guidelines,' *Current Dialogue*, vol. 40 (Dec 2002), pp. 16ff.

find commonalities, learn from them, and also affirm our different experiences and views, which cannot and need not be watered down by hybrid ideas which would not reflect any more the vital experiences of our traditions but only our own post-modern thinking structures. We can be different without loosing respect and friendship for each other. Different views are not prone to hatred and violence by themselves, but only if they are used as a tool to build up an armour against the other, a negative image or conscious devaluation of the other in order either to compensate for one's own actual weakness or to legitimate power used against the other in order to gain domination — an example has been colonial Christianity. Chiang Mai 1977 has been aware of this nexus between religion being misused as an ideology to legitimate violence and the vested economic and political interests of power and domination.

In these days we are even more conscious in this regard. It seems to me that today, as in 1977, the problem of justice is at the hub of cross-cultural relations. There is no clash of civilizations, but a struggle for economic, political and cultural justice on the one hand and the drive to even extend economic and cultural domination by the powerful on the other hand. The idea that it would be the civilizations or religions in themselves which are on the war path (Huntington's thesis) is only a means to deviate our attention from the real agenda. Unless we are clear about this brute fact, all interreligious dialogue is useless. But what is justice seen not only in terms of economic opportunities, but in terms of a religious realization?

Justice is the realization that living beings depend on each other for the very foundation of their lives. There never has been nor is there an independent individuality or cultural self-sufficiency. Especially in a cross-cultural context we not only need to be aware, but practice the mutual interdependency on all levels of life, i.e. with regard to body, mind and spirit. Thus, in short, my definition is:

Justice is equal opportunity for participation in all aspects of life, personal and social. I have to omit the question of distributive and punitive justice but will focus on what I call *participatory justice*.

Justice of the body means that there are equal opportunities and no exploitation within the physical and economic field. It also means that there is a right of the body to harmony and proper living conditions outside and inside the body, that is to say, in the social and the medical sphere.

Justice of the mind means that the plurality of cultural formations is a self-expression of human creativity. Cultural deprivation is an ethical crime against humanity. Certainly, cultures change, amalgamate, disintegrate, etc. These are organic processes of growth. But this is different from depriving whole peoples of the right to self-expression. A globalized uniform culture would be injustice, a horror and a sign of death. All religions should commit themselves to resist uniformity and domination but should seek cooperation and exchange.

Justice of the spirit means the dedication of all human life to a higher level of reality which some religious traditions call God, the Absolute, the Ultimate Reality. Life is not self-sufficient but expresses a deeper search for fulfilment in an experience of spiritual blessedness. We do experience and describe this level in most different ways. Justice of the Spirit means to acknowledge the richness, difference and inexpressibility of the Spirit so as to encounter one's own spiritual insights as well as those of others with joy, respect, reverence, awe.

Chapter 21 in the 1977 declaration of the WCC mentions four qualities or attitudes which should be the basis for dialogue, and it seems to me that their reaffirmation might be even more important today:

1. *Repentance*, because we have become aware how much religions have contributed to violence and hatred in the past, thus betraying the noble visions of the great founders;

2. *Humility*, in view of the ever-deeper richness we discover in our own and other traditions, so that we never have the truth but truth may have us, if we open ourselves and overcome judgemental prejudices;

3. *Joy*, because the community we have been able to build, the experience of dialogue over the last decades and the very chance of reflecting cultural traditions in the context of mutuality is a source for joy, friendship, interesting experiences of learning;

4. *Integrity*, which was defined as openness and exposure, the capacity to be wounded when realizing that we never live up to our faiths, that we need to reintegrate the depth we may discover in our own tradition through the eyes of the partner in dialogue, and the depths we may discover in other traditions, affirming both as an event of the presence of the Spirit which is the mystery of the One divine light. With this integrity we need to search and open ourselves and our own traditions for new truths and insights, and this is precisely the experience of many of us over the last decades.

Justice in the Context of the Plurality of Cultures

JUSTICE IN THE JUDEO-CHRISTIAN RELIGIOUS TRADITION

First, I want to take up the cross-cultural question of justice in the Judeo-Christian tradition versus loving kindness and compassion (*maitrī* and *karuṇā*) as the centre for Buddhist experience. I want to make two points in this regard:

(a) We need to recall that justice became a merely juridical term only in the Latin translation (*iustitia*) of the Hebrew and Greek concepts of *zedakah* and *dikaiosyne*. The Hebrew experience of the *zedakah* of God is much more than a juridical term of balancing out interests, actions and the results of action. Rather, the justice of the Hebrew God is his (or her) promise to be what he (she) is and to act according

to the divine promise to create and sustain life in all its multiplicity. From the creation to the idea of the covenant, this is the basic theological insight: in spite of all the ambiguity of life you can trust in God's all-encompassing benevolence as long as you — people and peoples! — remain in this benevolent interrelationship which God has set-up in history. Justice is God's truth and truthfulness ('*emeth*), and human beings are to respond to it. Jesus' interpretation of divine justice is a consistent sharpening of this Hebrew experience: What you do to these naked, hungry, imprisoned, lonely and downtrodden ones you have done to me (Mt 25). This is the Hebrew-Christian justice: Interrelatedness of the Ultimate Reality, which is personally close and yet incomprehensible and beyond any cognition, encompassing all the creatures on earth and in the cosmos. As long as the cosmos exists this divine promise of love, trust, truth and ultimate harmony will not perish. And where it is endangered, you are called to stand up against it prophetically, risking even your life.

I assume that this reading is not too far away from the Muslim experience as well, for in Islam it is so important to understand and proclaim God as just and merciful at the same time.

(b) Buddhist compassion (*karuṇā*) is based on wisdom (*prajñā*). Wisdom is the insight into the impermanence not only of things, but also of our concepts, ideas, thought. Things, including our ideas of justice, are part of an interrelated network, which appears in our perception and reflects in differentiating processes, including the processes of conceptualization. Thus, even the concept of justice is related to all other aspects of life, and compassion as a skilful means (*upāya*) to attain to wisdom is nothing else than to present the saving presence of Buddha-nature in all situations of suffering. What you have done to the downtrodden ones, you have done to the one Buddha-nature in all things, could have been said by the Buddha. However, he would not say "done to me," because this might imply an ego-awareness which the one who seeks *prajñā* needs to overcome. Thus, the Buddha would probably stress the intention in acting more than the act itself. But it could be disputed whether this is not also the point all Hebrew prophets make, including John the Baptist and Jesus.

To summarize: Justice in both traditions is not just an act of human good will or political expediency, but it is a response to reality as it is; it is resonating with the ultimate structure of reality, being in tune with God's will or interrelatedness (*pratītyasamutpāda*), respectively.

LANGUAGE

We need to be aware that any discourse concerning cross-cultural ethics is bound to use a specific language; in this case it is English. This determines the rules of the debate. We would play a different game if we were to talk in Chinese or German or Hindi. This is

not only a linguistic question, but a question of power — the language being used is the language of the one who determines the rules. We cannot avoid talking in one language, and for many historical and political reasons this is English. But we need to be aware of the problem, for here we deal already with a major difficulty of the cross-cultural discourse on ethics. The language problem is directly linked to the question of justice. And awareness might at least create the sensitivity in and among us, which is absolutely necessary for a dialogical partnership.

INDIVIDUALITY

Religion as stabilizing factor for social identity and as basis for ethical orientation is no matter of the past but a very important social factor in the present political situation worldwide. In fact, during the last twenty years or so, religions seem to become more relevant than at any other time during the earlier decades of the twentieth century. Thus, the well-known journal *India Today* (October 5, 1998) reported on the basis of a comprehensive survey that religion might be considered to be the "new opium of the young" (37), which would give the restless in the country stability and orientation in an unsettling world. The result of the investigation has it that it is precisely the youth who believe in God (94 per cent), that most young people pray (97 per cent) and that religions offer a substitute for the authority of the parents who would not be any more trustworthy as guides and resource for a value base. But, because of the broken authorities and the pluralistic options in modern societies, this kind of religious orientation tends to be not traditional, but selective, oriented towards spirituality and — even in India — it is quite individualized. This means that religious institutions which try to safeguard a certain unity (or even uniformity) for their coherence's sake tend to get weakened in the process of individual selective orientation on the pluralistic market of religious and non-religious options concerning values and orientation, a process which the Austro-American sociologist Peter L. Berger has called the "coercion for heresy," i.e. selective difference.

PLURALITY

Today there are no geographical areas left which would be closed culturally and religiously, i.e. there are no cultural spaces with clear boundaries or with a rather consistent cultural background which would be based on just one tradition. Rather, we have more or less mixed cultures, which are shaped by historical influences of different religions and various cultural systems. On the other hand, constructions of social identity as well as religious socializations are being established through influences from within and from without. The results of these developments are specific processes of amalgamation which do produce all the time structures of an ever-higher degree of complexity. Especially the modern means and ends of worldwide communication systems make it possible that different value systems, which may or may not have religious backgrounds, are communicated in rather uncoordinated ways. At the same time, ever more disparate religious, cultural and linguistic patterns of socialisation, i.e. social and

ethical values, are selectively mixed (consciously or unconsciously) and shape the pluralistic structures of our societies which, at the basis, are fundamentally oriented on a consumerism that is made possible by technological developments and political interests. However, 'religion' is not only a pattern of behaviour according to old traditions that would give stability in recourse of a coherently constructed past, but religion more and more seems to become an important force and factor in shaping the identities of individuals and groups in new ways.

Different language systems and cultures organize their perception of reality in remarkably different ways and construct different systems of categories. Therefore, we need meta-discourses on the conditions of cross-cultural communication which requires that not one model be a player and ruler at the same time. That is to say, *the rules of communication are to be created in the process of communication itself.* Such discourses will not only reveal the multiplicity of foundations of values in different cultures but will also show how the dialectic of *dissensus* and *consensus* is being shaped in a cross-cultural process of value-creation. To acknowledge this dynamic is to establish *the value of justice in the rules for the communication process itself.*

Classical Philosophical Issues in View of the Problem of a Global Ethics: Perception, Reality, Consciousness

PERCEPTION

During the 1960s the Club of Rome issued warnings concerning the limits of economic growth both in the ecological and social field. This has changed the perception of economic and cultural value structures on a worldwide scale, first in the developed countries, but later also in developing countries. However, today we know that what has been talked about was a limit of quantitative growth, whereas the question of qualitative growth has not been really tackled yet on the agenda of international organizations. The problem of quality, however, is a philosophical and ethical problem, because the categories of quality are mediated through cultural und religious values which are different in different areas of the world.

Human beings strive for realization of values and ideas on the basis of the difference of what should be and what is. Balancing out the difference is a matter of justice. Justice, therefore, is not one value among others, but it is the participatory right of all partners in the process of societies in balancing out all possible values.

In the context of today's historical experiences of globalization, there are new social diversifications which interpenetrate each other. This challenges traditional patterns of identity and value-orientation. As a result, one can observe on a worldwide scale the loss of social and emotional stability of groups and whole societies, which formerly were grounded in rather clearly-defined traditions. Here, the horizon or the space which human beings map out and work out through their historical perspectives and political actions

is being changed: *human beings live in a limited ecosphere which they form and by which they are being formed*. That is to say: *Human beings are both subject and object of their own economic and cultural acting*. They are actors and the result of their own actions. What follows is that human beings are fully responsible for their own well-being and their historical catastrophes respectively. This, it seems to me, is the real change in the perception of reality during the last few decades, and all religions and traditional cultures do need to adapt to this different situation. Cultural acting and economic acting appear to be in a much closer relationship than it has ever been recognized before: *Humans shape themselves in producing and in doing so they produce their own shaping*.

REALITY

Reality is not an ontological entity in itself which would exist apart from human consciousness. At least we cannot know anything apart from the modes and patterns of consciousness. Real is what we perceive as real. Our modes of perception, however, depend on patterns of values, which have been shaped by previous cultural behaviour. Human beings perceive as real primarily what is relevant, i.e. what influences human interests and survival positively or negatively. That is to say, reality is the result of interactive processes of perception between individual, society and the eco-spherical environment. Therefore, not only 'culture' but also 'nature' is a construct of the processes of culture, religion and politics, which are conditioned historically. Again, we have to add that in history we do not have a single culture or a single history, but different histories, which have produced different languages, religions and value-systems. Those cultures have interpenetrated each other in processes of mutual formation, but at times they also have stayed apart to some extent.

The other consequence of our reflection here is that the human being is not a stranger to nature but rather is a part of a net of communication in which is created what we call reality. The responsibility of humans, therefore, is an answer to their fate that, in being conscious of themselves, they are already a question to themselves, a question of their own existence. This insight has the consequence that the values through which we perceive reality are being created always anew in historical processes of change. But such processes both create themselves and at the same time presuppose themselves in a systemic way. What is real is determined by a social consensus on values. As we have demonstrated, this consensus depends on cross-cultural and interreligious processes of communication about the structures of perception.

These methodological reflections demonstrate that the real question is not so much which kind of reality we are living in, but which kind of reality we *want to* live in. To say it in other words: Which basic values are necessary so that we can limit the drive to unlimited economic growth in a limited system of resources in such a way that society still would be able to provide standards of living which enable humans to live in dignity; for instance, in providing enough jobs so that a certain minimal amount of social justice

is guaranteed? Is not a kind of "ascetic culture" (Carl Friedrich von Weizsäcker) necessary, at least necessary in ecological terms? But would such an "ascetic culture" make sense in economic terms? To answer these and similar questions, we have to be aware that 'dignity,' 'ascetic culture,' etc., are concepts which are culturally conditioned. Hence, since there are no unconditioned abstract terms which, once de-contextualized, could claim universal validity, there are also no abstract answers either.

CONSCIOUSNESS

The patterns of perception of reality are what we call consciousness. Yet, on the basis of what we have been discussing so far, it is clear that consciousness cannot be defined either as an individual entity or as a social one or as a global holistic system; rather, consciousness is a process of communication within the mental processes of the human being in exchange with other human beings and their environment. However, even the term 'environment' is not appropriate, for as we have seen, the reality which human beings do change and create is nature, but a nature of which the human being himself is part. In view of the basic principle that all phenomena in the world are interrelated (including economic, cultural and political processes)[6] we have to concede that a hierarchical model of structures of perception, structures of power, etc., has to give way to a more cooperative and systemic model of structures of communication.

It is the economic and cultural globalization as such that calls for a networking of political and intellectual processes of organization in which the polarization of individual and nation-states as well as the contradiction of nature and culture (and technology) is overcome. This would imply a change of consciousness, which would also bring about a radical change of many a traditional cultural/religious identity. Religions, as the traditional basis for social identities, are immediately challenged by this process of the change of structures of tradition because, under the conditions of modern plurality, the very matrix of shaping identities is being changed through simultaneous participation in different traditions, in different value systems and value communities. This has a bearing on our understanding of what religions are, what cultures are, what different languages are, and it would have tremendous implications for a different mediation of tradition and values. In other words, such an understanding would change our ways of handing down tradition; it would certainly have an effect on schools and universities.

Truth and the Religious Construction of Ethical Values

Ethical concepts depend on a community which accepts those concepts inter-subjectively. Thus, the community seems to be the presupposed basis for ethical values. On the other hand, a community is formed as a coherent structure only because of a specific identity. Identity, however, is shaped both by delimitation from other identities and by building

6. This, of course, is an application of the standard Buddhist concept of *pratītyasamutpāda* (interdependent co-arising), cf. Michael von Brück/Whalen Lai, *Buddhismus. Grundlagen, Geschichte, Praxis*, Gütersloh: Gütersloher Verlagshaus, 1998, pp. 99ff.

up structures of a world-view which is the basis of tradition, collective memory and a consistent structure of ethical rules. Therefore, it seems to be this set of assumptions and beliefs as collective memory which is the presupposed basis for any community. In other words, we cannot focus on either of the two factors without looking at the other factor at the same time: *Community comes into being because of a shared set of collective ideas, and those ideas live only in a specific community.*

Here we will focus only on one aspect of the complex matter, i.e. the problem of the consistency of a set of ethical values which seem to shape a certain culture, country, continent or tradition. In other words, we are to deal with the question of what makes ethical concepts convincing for a community to accept. Intellectual consistency or coherence could be interpreted as an application of the principle of justice in the field of cognition, in so far as different ideas and concepts are related to each other in a 'just,' i.e. balanced and non-contradictory way.

First of all we need to be aware that, in many traditional societies, basic patterns of ethical structure are being taken for granted just because they are part of the tradition. The implied philosophy here could be expressed in one sentence: *It is as it should be, for things are what they are precisely in being expressed that way.*

However, such unquestioned ideas, paradigms or sets of rules are taken for granted only as long as there is no alternative and no need for comparison and a selective process of acquiring the (ethical) tradition. As soon as a society is confronted with alternative models of living and different ethical rules, it needs to construct a new identity, for even a conscious foundation or philosophical reasoning for a certain standpoint is qualitatively new over against a tradition which had been taken for granted. As soon as there are competing ideas it is also (but not only) a matter of consistency to formulate a system of ethics which is convincing and acceptable to a society. Thus, the question of truth comes in.

TRUTH

What is truth? Here, we cannot go into the details of the philosophical problem of truth as it has been discussed in Western and other philosophical traditions.[7] It suffices to keep in mind that any discourse on this question needs to cultivate an awareness that the question itself is culturally conditioned: there is not one universal question of truth which might be answered in different material ways through cultural conditioning, but the very *structure* of the question of truth or the whole *concept* of truth is different in different cultures, both diachronically and 'diatopically.'

Thus, Indian Buddhism — and Vedāntic philosophy derived from it — developed the concept of *satyadvaya*, the two levels of being or truth (*satya*), viz., the conventional

7. I have discussed some basic methodological points concerning a cross-cultural debate on 'truth' in: Michael von Brück, 'Wahrheit und Toleranz im Dialog der Religionen,' *Dialog der Religionen* 1 (1993), pp. 3ff.

or relational level and the absolute or holistic level. This was modified in China where the model is not a hierarchy of levels but an organic harmony of the interplay of mutually dependent forces. This Chinese concept of 'truth' as the balanced harmony of mutually dependent forces or powers found its specific expressions in Confucianism, Taoism, Chinese, Buddhism, etc., but it was always there and is a distinct paradigm compared to the Indian model of hierarchies and levels.[8] Very different from the Indian and Chinese concept is the Greek and European model of truth. But even one culture develops different models of truth in the course of its history. So 'truth,' i.e. the construction and methodology of truth, is also subject to historical change.

Let us look briefly into the European tradition in order to substantiate the point. As has already been noted, both the notion of truth and the methodology to find truth are historically conditioned. What European history is concerned, I shall distinguish three models, which differ from the models of other cultures as I have just mentioned:

- an *onto-theological* model which lasted from the pre-Socratics until the Realists in the Middle Ages;

- a model centred on *subjectivity* which lasted from the Nominalists until German idealism;

- *language analysis* since the twentieth century.

Most thinkers of Greek Antiquity and the Christian tradition until Nominalism believed in an ontology which could express general notions about reality. Parmenides, Plato and Aristotle held the view of identity, continuity or at least of correspondence between being and thinking in the concept of *logos* or *nous*. Unchanging and 'true' structures as well as things could be known in their suchness. How? By participating in these eternal structures. That is to say: to attain the proper knowledge of reality is the basis of ethical quest and the foundation of certainty. A statement which has been proved true once was true for ever. Aristotle[9] holds that the relation of each being towards truth is the same as its relation to being as such. Therefore, the congruence of being and knowing makes possible the *theoria* of philosophy, i.e. the possibility of talking truth. In this line of thinking, Thomas Aquinas[10] defines truth as *adaequatio intellectus et rei.* This theory of correspondence has been developed and refined in different ways, but in any case it presupposes that without doubt the 'thing' or the matter as it is can appear to reason. Christian theology added, that the basis for the correspondence of the knowing and the known is nothing else than God. Would not the divine *logos* be present in human thinking, nothing could be known as true. Participation in truth is participation in the Divine. Hence, what became known as true was divine, beyond any doubt. However, in human history this participation in the Divine was made difficult (or nearly impossible) due to

8. Cf. M. von Brück/W. Lai, *Buddhismus und Christentum, op. cit.,* pp. 621ff.

9. Cf. Aristotle, *Metaphysics* 993 a 30.

10. Cf. Thomas Aquinas, *De veritate* q. 1,1.1; *Summa theol.* q.16, a.2 ad 2.

human freedom and striving for independence from God (the *hybris* of the Greeks) which Christianity called sin. The paradox is that humans, in using the freedom given by God, unavoidably deviate from God at the same time. And this is why human history is the struggle and fight for truth, for positions, claims and values. The paradox could be solved only by an act of highest freedom of God him/herself: self-sacrifice.

This structure of thinking was convincing as long as its foundations were generally accepted: the correspondence of divine and human *logos*, or the ontic order and the order of thinking. However, at the peak of the Middle Ages and especially during the Renaissance, the eternal divine order got a competing realm to deal with: the reality of matter, which was held to be 'objective,' that what could be known through senses and experiment. But even here we still have the basic structure of the old view: things change temporally, but in space they exist eternally; they change in time, but this change follows a course which is predictable as long as all the initial conditions would be known. Now it was the world that was limitless in time and space and thus 'the world' (or matter and nature) inherited what before were the characteristic marks of God. Therefore, even in this model, the traditional ontological structure remains the same: truth, once known, remains constant in a given system.

These ideas and ways of thinking were shattered by nominalism, by later sceptical theories and, in our century, by modern physics and neurosciences. Now, all notions, ideas and concepts which we are using are not any more grounded in a superhuman realm of ideas, but in the human mind. All we can think is a construction made by our own mind. That is, ideas do not refer to God or some immovable order beyond; but to the human being itself. Therefore, the foundation of truth can be sought only in human subjectivity — *cogito ergo sum*. Finally, there is not any more an assumption about a correspondence of being and thinking, but only the self-affirmation of the human subject. The climax of this development was Friedrich Nietzsche's nihilism, based on an anti-metaphysical drive, which tried to think the impossibility of the reality of truth (even if a conceptual 'truth' might not be avoidable). God beyond good and evil also meant God beyond truth and falsehood, i.e. God to Nietzsche was deceptive or deception. To bear uncertainty and pessimism was the human task, which only a "super-human" could shoulder. To Nietzsche it was the God of good and truth which had died, but he resurrected a God of blind will expressing himself in the chaos of reality. Whatever Nietzsche may have been suggesting here, it is obvious that even in destroying truth he needs to use and communicate in language, metaphor and argument to make his point — even the most radical criticism serves insight into 'truth,' notwithstanding truth here being defined as "falsehood, blindness, lie;" in other words: any anti-metaphysics depends on a metaphysical ground.[11]

11. There is a long and most interesting debate on Nietzsche's post-theological theology in the present philosophical and theological discourses. For a summary see W. Thiede, *"Wer aber kennt meinen Gott?" Friedrich Nietzsches "Theologie" als Geheimnis seiner Philosophie,'* Zeitschrift für Theologie und Kirche 98,4 (Dec. 2001), pp. 464-500, esp. p. 492.

To shorten a long philosophical development, we can summarize and comment on the consequences of this view: *Truth does not become subjective, but it rests on an intersubjective process of communication.*

Whatever this may mean for other fields of experience and thinking, here it suffices to note that this development led to the relativity of truth and the relativity of all criteria for truth, the relativity of values and the lack of an "ordering centre."[12] This had and has consequences for the search of identity — not only for the individual and its 'meaning of life,' but also for the coherence of societies. In other words, relativity means also plurality of truths and values, of ethical principles and ideas.

I cannot go here into a discussion of truth in different Asian traditions. Generally speaking, in Asia we do observe processes of pluralization as well, both in India and in China and elsewhere. But the consequences have not been the same as in Europe.

TRUTH AND LANGUAGE

Summarizing what has been discussed so far we can say: any concept of truth depends on language. All human language is metaphorical, i.e. the concepts of space, time, causality, matter, being, consciousness, truth and so on are metaphors which are mutually dependent and related to each other. They are not just descriptive, but imply reflections which depend on the social construction of a trans-individual communication of consciousness and contexts. Language (and concepts) not only communicates information about something given, but evokes images and motivation. Those motivations are communicated in structures of communication which form the matrix of a social pattern. This pattern is not a pre-stabilized harmony, but it is historically contingent and needs to be called a product of cultural processes.

Therefore, there is nothing like *the* Asian values (or even Indian or Chinese values) or *the* Christian European tradition, but there are complex *historical* processes, which construct precisely those concepts for the sake of social and political coherence of a given society. Expressed in a different way: *Tradition is not something given in the past, but a process of construction in the present.* And today, no doubt, it can be said that those processes — be it in India, China or Europe or elsewhere — follow pluralistic patterns.

Interreligious Discourse as a Foundation for Ethics

The world is being perceived as oneness or one world only under the conditions of some kind of mystical consciousness, as it has been expressed in different languages and cultures; however, on the level of rational thinking, there is certainly a struggling multiplicity of claims which prevents oneness from becoming a historical fact. However, in spite of their differences and competition, religions have also been aware of this oneness, as a possibility at least, in terms of religious politics such as eschatological ideals, messianic expectations or utopian constructions of a purpose toward an end in history. I would

12. Werner Heisenberg, *Wandlungen in den Grundlagen der Naturwissenschaft*, Stuttgart, 1959, p. 139

like to argue that due to economic, demographic and technological developments during the last century (especially the development in communication technology), this possibility has become a political imperative.

At the same time, however, we observe that conflicts are being nourished by interests and interest groups concerning nation, religion, trade and party politics. These conflicts reveal conflicts of identity and power. The debate on a global ethics is part of this game. On the one hand we can observe a process of conscientization which is connected with the demand for a "World-ethos,"[13] and several international organizations such as UNESCO are taking part in it. On the other hand, there are religious, political and economic interests fighting against such a process because groups and social/religious organizations are afraid of loosing their identity. This fear would not be without substance if there were a danger of the globalization of ethics in terms of centralization, centralized jurisdiction and a kind of dictatorship in world ethics, i.e. if the World-ethos would try to defy the reality of pluralism of ethical foundations. This, however, is not the case as long as the World-ethos is understood as a *project*, i.e. a dialogical process of discourse and communication. *World-ethos is not a number of sentences in a book, but an attitude of communication.* The rule is that all partners who are taking part have the same rights and status, and the possible consensus is being worked out in fair debate. This is what I call participatory justice. However, the hermeneutics of the debate will reveal the hidden identity and power-structures. Those hidden (economic and political) parameter need to be addressed.[14]

Religions do not exist independently of their social and political role. There are no simple and homogeneous religions, but always there are groups of interest and power within one religion, which have *different* ethical priorities. Take for instance the pope and a liberation theologian in the *favelas* of South America. They have the same religion and at the same time they have not, for they are bound by quite different interest groups in terms of power and economic influence. Or take a Śaṅkarācārya of a Hindu tradition (Advaita Vedānta) and the politicised masses who destroy the Babri Masjid at Ayodhya in order to execute certain political interests on the basis of a new construction of Hindu myth. Which one is 'truly' Hindu? There is no answer apart from the actual political interest structures, and any possible answer can only be the result of a process of communication and awareness of the groups involved.

Certainly, many religions know the principle of the 'Golden Rule.' Further, the union of the love of God and the love of the neighbour is by no means a principle of Christianity only. There are differences in the foundation and interpretation of the rule, but those

13. Cf. the debate on a 'World-ethos,' Hans Küng, *Projekt Weltethos*, München: Piper, 1990; Hans Küng/ Karl-Josef Kuschel (eds.), *Erklärungen zum Weltethos. Die Deklaration des Parlaments der Weltreligionen*, München: Piper, 1993.

14. Some details have been listed in: M. von Brück/W. Lai, *Buddhismus und Christentum*, op. cit., p. 642f.

differences do not always (and this is so in most cases) follow the demarcation line of what we call 'religion.' A consensus could be formulated which scholars from respective traditions might carefully work out on the basis of (their present) understanding of the tradition. Documents could be produced, and these documents might be important for oppressed minorities in those traditions whose leaders have signed the documents (compare the role of the Helsinki agreement for dissidents in Eastern Europe during the 1970s). However, any such consensus on an agenda of ethical principles would be insufficient for two reasons:

1. General views, which express ethical values based on an ethics of responsibility, will always be interpreted in a hermeneutical network of power interests. Any system of ethics is always broken by specific social structures, and it is only in those structures that a system of ethics can become reality. That is why those social structures have to be taken into account, not only for a later 'application' of ethical arguments but already in the process of their formulation and interpretation. *There is no ethics that could be formulated irregardless of the social matrix.*

2. The formulation of any general ethos or "World ethos" has an appropriate hermeneutical basis only on the basis of an *unconditioned* reasoning, that is, on the basis of a religious assumption which expresses the position of the subject that formulates a certain ethos. If this is so, ethical sentences have to be seen in context of the explicit or implicit religious world-view in its interpretation of self, world and the common good.

Here we have to conclude that a cross-cultural debate on ethics has to be aware that all dimensions of the human being, i.e. the economical, ecological, political and psychological aspects of communication, come into play in any communication between groups and peoples. *Those dimensions are fundamental for the process of understanding itself.*

Therefore the formulation of any general or cross-cultural ethics needs to take care of the political implications. Taking into account the present shape of the world, it is a matter of justice that the present *status quo*, which obviously is based on unjust international, social and economical as well as communicational structures, shall not be continued. This status might be quite acceptable from a European, American or Japanese perspective, but this is certainly not so from a Chinese, Indian or African perspective. Cross-cultural understanding and the cross-cultural debate on ethics is a discourse not free from structures of dominance (in German: not a "herrschaftsfreier Diskurs"). Therefore, the credibility of the ethical debate depends both on the ability of all partners to understand the diverging view of the other partner and on their willingness to share power.

To make it more clear: The cross-cultural ethical discourse is dependent on:

- economic relations between richer and poorer nations that are more just than they are now;

- the mutual recognition that one's own identity shall not be worked out at the expense of the other's identity;

- the insight that languages construct reality in different ways and that the partner's language is as valid as my own;

- the basic recognition that the partner has the same argumentative rights as I have;

- the insight that cultures (religions) are by no means monolithic but broken by social interest groups, i.e. the Confucian or the Christian values do not exist except as in forms differently interpreted. There are no single views and spokes-persons for a tradition, but discourses of different interests within a tradition. These multiple views should come into play when brought into the debate with multiple views in other cultures. In this way, the contradictions in each tradition are being revealed precisely by and in the cross-cultural debate on ethics.

Conclusions

1. Under cross-cultural conditions, any ethical discourse has to take into account that there are different constructions of reality and ethical discourses. All modern pluralistic societies are not the product of just one tradition alone, but of patterns of interference and mutuality of cultures.

2. In modern pluralistic societies, the basic religious problem which has consequences for the foundation of ethics is the following: If — in the jargon of the European Enlightenment thinkers — everybody shall be saved according to his/her own beliefs and value systems, it needs to be asked how any belief and value system is formed today. In traditional religions this happened:

 • by tradition,

 • by succession,

 • by discourse, especially when several traditions were at hand so that a conscious selection was required.

But modern religious socialization often lacks a critical acquisition of tradition, and instead of acquired knowledge people seek refuge in an uncritical claim of possession (of truth, God, authority of the *guru*, etc.).[15] On that basis it is difficult, if not impossible, to work out just rules for the pluralistic interreligious and ethical discourse. To work out those rules, however, is one of the most important and noble tasks today — for intellectuals in different cultures, for schools, universities, political organizations. What is necessary is a public and transparent discourse in which all groups who want to do so may

15. This attitude might be called fundamentalism depending on the usage of this rather unclear term.

participate. Justice means establishing global institutions which rule the globalized exchanges in just ways — the International Criminal Court is just a beginning. We do need an international juridical system that takes care of rules for global trade, exchange of money, etc., in the same way as there are legal restrictions on the flow of capital and economic enterprise in the countries with a socially-controlled market economy. But we also need rules for communication, and institutions which set and survey these rules. These institutions should be capable to impose legal sanctions, if necessary.

We need local and international institutions which foster this cross-cultural ethical discourse on a permanent basis so as to establish the rules and methodologies of the discourse in the making. This is a matter of justice, and if these rules are not established in terms of fair participation of all cultures concerned, justice cannot be established, because justice is a matter of equal distribution of opportunities, both in the economic and the cultural field.

21

Interculturation of Religious Life
A Meditation*

Francis X. D'Sa

RELIGIOUS life is generally understood as a lifestyle that Christians, especially Roman Catholics, lead in communities freely promising to live in poverty, chastity and obedience. Now that humankind is entering a new phase of consciousness where we realize that faith-communities have to speak and live in a way that they understand each other, I am experimenting with the idea of interpreting religious life in a manner that would be meaningful to other faith-communities in such a context.

Reality, Religion and Religious Life

Setting priorities is an important task for any group that is concerned with growth. This is especially true of a group that understands itself as being at the service of others, others who are in need.

But setting priorities is neither a simple nor a straightforward task. Here the point of departure is as important as the point of arrival. No amount of strategies will be of help, if heedless of our starting point we rush towards the goal. Indeed it is the starting point that will require careful examination and analysis. And by starting point I mean the presuppositions — the pre-sub-positions — with which we begin. Our presuppositions constitute the background of all our knowing, loving and acting. These 'shape' and 'form' us in every way. Hence, they need to be questioned and challenged and in some cases to be corrected and complemented. For, the background colours the foreground; what we see is essentially affected by the background.

One of the important constituents of our background is the understanding of reality, of 'God, World and Man'[1] that is operative in us. Our view of the world is involved in everything we do, decide and discuss. Once we have revised and articulated our approach to reality we can proceed to the re-vision of religion and religious life.

* Bettina Bäumer has been living religiously all her life long. This meditation is dedicated to her in gratitude for her reinterpretation of a religious life in today's context.

1. I shall employ 'Man' only in the context of 'God, World and Man.'

Reality and Religious Life

Our understanding of reality today is fragmented. We have matter and spirit, soul and body, subject and object, knower and known, sacred and secular, religion and politics, church and state, reason and understanding, religion and morality, God, World and Man, etc. We are fragmented beings. We cannot but think, love and act in a fragmented manner. Whatever we take up we distinguish, separate and break up; the tragedy is that we cannot put them together.

THE COSMIC, THE HUMAN AND THE DIVINE DIMENSIONS OF REALITY

To retrieve the unity of reality we have to return to a spontaneity that is founded on the unity of reality. We need a re-vision of reality, a new vision in the light of which we can experience reality.

Raimon Panikkar has put forward a vision which he calls by apparently awkward but in fact very significant expressions: 'theanthropocosmic' or 'cosmotheandric' where all the essential aspects of reality are unified: *theos, anthropos* and *cosmos*.[2] According to Panikkar, reality is basically trinitarian; it is tri-dimensional. It is constituted by 'materiality,' by 'consciousness' and by a certain kind of 'endlessness,' a sort of 'infinity.' Whatever we take, whether thing or thought, it has a perceptible or objectifiable aspect. Everything has to do with one or more of the senses. This is the material or cosmic dimension of reality.

Similarly, everything is related to consciousness in some way or the other. Whatever is objectifiable (and we said that every being is objectifiable) is so because of an objectifying consciousness. Without consciousness nothing would be objectifiable. This is the human or consciousness-dimension of reality.

Finally there is a depth-dimension to both the cosmic and the human dimensions. The cosmic aspect of reality can be objectified endlessly; there is no limit to the objectifiable-aspect. Similarly the human aspect can go on objectifying endlessly; it too has no limits. Both these dimensions are somehow 'unfinished;' they manifest a certain infinity. This is the mystery or depth-dimension of reality. If things did not have the depth-dimension they would cease to exist. Once you come to know a thing, you would come to know all about it, there would be nothing more to know about it. But our experience shows just the opposite. However much we may know a thing yet more remains to be known about it. This is the mystery of all things, of all reality.

Furthermore there is in the trinity of reality no higher and no lower. Every dimension is equally but differently important and indispensable. At the same time, every dimension is unique and cannot be reduced to the other. All are essentially interconnected, interdependent and interpenetrating; each is essentially unique and essentially constitutive

2. Cf. Raimon Panikkar, *The Cosmotheandric Experience. Emerging Religious Consciousness*, ed. Scott Eastham, New York: Orbis, 1993. Especially Part One, 'Colligite Fragmenta. For an Integration of Reality,' pp. 1-77.

of reality. That implies that all reality is constituted by these three dimensions. Every being has the dimensions of the cosmic, the human and the divine. Everything is interconnected with everything. With this we have a new understanding of God, World and Man. There is no God without world and Man; no world without God and Man, and no Man without God and world.

RELIGION AS THE SEARCH FOR ULTIMATE MEANING

With this background we can now proceed to inquire briefly about our understanding of religion. Religion is the search for and the mediation of meaning, ultimate meaning. Meaning must not be understood here as a sort of dictionary meaning but as the meaning of life-in-the-world. If reality is trinitarian, authentic meaning will accordingly have to be trinitarian too. Anything partial will always fall short of the trinitarian ideal of the Cosmic, the Human and the Divine. In other words, religion is the art and science of responding fully, that is, in a trinitarian fashion to the challenge of reality. All authentic living then is necessarily religious inasmuch as it is a holistic search for meaning at all levels.

In such an understanding of reality and religion, the distinction between the sacred and the profane is not possible. In the cosmotheandric vision all reality is sacred and hence the word profane does not occur in its dictionary. This is so because the Divine is a constitutive dimension of *all* reality. This implies that religion cannot be something that is added on to reality as a sort of afterthought. Religion is the search for the sacred in the real.

THE CHALLENGE OF RELIGIOUS LIFE TODAY

In the light of this the relevance of religious life has to be evaluated neither on the basis of the rich harvests of 'vocations' nor of the opposite. To state that religious life is more relevant in India than in Europe because of the increasing number of vocations would be tantamount to saying that a popular politician is more relevant than another who does not enjoy such popularity. Furthermore, it might be appropriate to recall that prophets were never very popular figures with their contemporaries. If we wish to understand the meaning and significance of religious life today, especially in India, we have to do so in the light of the challenges of our times and situations.

One major challenge of our times is of course the world-view of our times, a world-view embodied in the synthetic nature of our lifestyle and the analytic nature of our planning, in the reckless pursuit of profit and the meaningless variety of our products, in the devastation of nature and in the nature of devastation, in the power of politics and the politics of power, in our market forces and in our armed forces. The result is a world of a rich but powerful minority living on the powerless poor; a world of affluence and superabundance existing cheek by jowl with hunger and misery; and to crown it all, a world of material waste and spiritual meaninglessness.

What has religious life to say about such a world-view? In the face of such challenges can it go on being what it has always been, can it go on saying what it has always been saying, can it go on doing what it has always been doing? It is significant that the answers to these questions seem to be coming neither from religious leaders nor from religious communities but from secular movements like the ecologically conscious groups, those dedicated to peace and demilitarization, to justice and to the rights of children, women and of native peoples.

If religious life is to symbolize a counter-society, counter to possessiveness and profit, to domination and devastation, to materialism and manipulation, a society which incarnates the kingdom-values of freedom, fellowship and justice,[3] then it has to work out a self-understanding that responds to the needs of our times by questioning and re-interpreting the needs on a backdrop like the one we have articulated in our re-vision of reality. Response does not mean that we have to be uncritical of the presuppositions of the needs of our times or that we have to take them at their face value. Response means learning to read the signs of the times and to interpret them in a way that equips us to speak of good and evil, right and wrong in a language that does justice to reality, on the one hand, and that our contemporaries understand, on the other. Today, to speak of God as 'Creator' or as 'Divine Providence' may do justice to reality but it is not a language which our contemporaries will understand. Similarly to speak of God as 'Father' and 'Mother' may be intelligible to some groups but it may not do justice to today's complex understanding of reality. We need a language which can mediate between an authentic [understanding of a] tradition and a contemporary understanding of reality.

The Essence of the 'Christic' Experience

I begin by differentiating between 'Christian' and 'Christic' experiences. By Christian, I mean the historical and political aspects of the Christian traditions as they developed in the past ages and which tradition has interpreted with different stresses according to the problems of an age and its culture. By 'Christic' I refer to the mystery that revealed itself in the story of Jesus. All tradition and interpretation is at the service of this Christic aspect. No interpretation can ever fully or adequately encapsulate this mystery.

Few people realize the importance of tradition, its pervasive presence and power in our lives. Unfortunately for most people tradition means traditionalism. They tend to identify it with conservatism and obscurantism. In fact, the opposite is true. Tradition is the stream in which we are born, live, move and have our being. It is the light in which we challenge traditional customs, modes of interpretation and ways of behaviour. Without tradition we would be utterly lost. We would not be in a position to know where we are, what we are, much less to cope with where we are and what we are. A

3. See George M. Soares-Prabhu, 'The Jesus of Faith. A Christological Contribution to an Ecumenical Third World Spirituality,' in: *Theology of Liberation: An Indian Biblical Perspective*, ed. Francis X. D'Sa, Pune: Jnana-Deepa Vidyapeeth, 2001.

negative understanding of tradition has been emerging since the time of the enlightenment because reason has come to be endowed with a supremacy over understanding which it does not have and does not need. Reason has become the sole criterion for truth and the supreme arbitrator between right and wrong. Though we cannot now enter into this discussion it might not be out of place to add that in fact the ground of all reason is tradition. Reason is based on tradition, lives on tradition and indeed parasitically starts its own tradition in the mistaken belief that there is no need for any tradition because it connects tradition with authoritarianism.[4]

We have to distinguish between a living tradition and its caricature. A living tradition is that which gives life to its adherents, that on which they live whether they are aware of it or not. This is the ontological level, the level of being, living and reality. Its caricature is a fixed formulation, whether in language or in ritual or in customs, a formulation which is supposed to encapsulate it. It is a caricature because it is not possible to encapsulate any thing, much less a living being, in a formula. The real nature of tradition demands that we try to re-capture and re-interpret its essence for our times. I see the function of doctrines precisely in this context. Doctrines are contemporary efforts at discovering significant accesses to the essence of a tradition. Hence it is incumbent on every age and every culture to re-interpret the fundamentals in the form of relevant doctrines and not to take the doctrines of previous ages and cultures as the basis for re-interpretations.

Given the tremendous gap between the rich and the poor in our country, given the social and religious customs that are at the source, if not at the service, of discrimination of the socially, economically, culturally, sexually powerless groups, given the fact that the politics of religion are working hand in hand with the religion of politics, how do we understand the essence of the Christic experience, how do we formulate doctrines that are relevant for today?

Jesus was the first to dwell with the primal mystery, he was the first dweller, the real *Ādivāsī*. In the tribe he founded, everyone is chosen and no one is excluded. Indeed the tribe coheres together only when each individual learns to dwell with and experience acceptance of the primal Parent and thus becomes a person.

There is however a specific way of learning to dwell with and experience acceptance of the primal Parent: the way of complete *kenosis* (self-emptying) in the form of *diakonia* (service of others). If Jesus' experience of the supreme mystery animated and fulfilled him with the Spirit of total self-emptying and self-giving, we on our part can assimilate this experience only through the practice of self-emptying and self-giving.

4. Cf. Siegfried Wiedenhofer, 'Tradition,' in: *Geschichtliche Grundbegriffe. Historisches Lexikon zur politisch-sozialen Sprache in Deutschland*, hrsg. von Otto Brunner/Werner Conze/Reinhard Koselleck, Bd. 6, Stuttgart: Klett-Cotta, 1990, pp. 607-51.

Self-emptying and self-giving is the principle of the life of the world: the world lives because it is nourished on self-giving, or to use an Indian metaphor, on sacrifice or *yajña*.[5] Self-giving is the leaven which transforms bread into the bread of life, the recipe which changes a coming together of two or more in the name of Jesus into a Communion, the alchemic formula which turns human beings into brothers and sisters, and the Divine Mystery into *the* loving parent of all.[6]

Love then is the essence of Christic revelation. Love — that is, Christ's Spirit — makes a person go out to the other, to reach out to the other. Such love results in internal freedom from fear and anxiety and manifests itself in external commitment to the service of all.

I would like to express this in three biblical metaphors: washing of feet, breaking of bread and the feast of Pentecost.

WASHING OF FEET

Jesus' washing of his disciples' feet has been interpreted as a lesson in humility. That may perhaps be so but that cannot be the main or the only lesson.

> Do you know what I have done to you? You call me Teacher and Lord; and you are right, for so I am. If I then, your Lord and Teacher, have washed your feet, you also ought to wash one another's feet. For I have given you an example, that you also should do as I have done to you. — Jo 13. 12-15

The example is not merely of the one higher up bending down to wash the feet of the one lower down in the ladder of hierarchy! It also makes clear that Jesus' mission as Lord and Teacher consists in service. The true master is one who serves. Indeed, to dispel any misunderstanding in this regard he immediately adds in the next sentence: "Truly truly, I say to you, the servant is not greater than his master; nor is he who is sent greater than he who sent him" (Jo 13.16), thus applying to the servant the new understanding of master from the perspective of service. In Jesus' community the Lord does not lord it over the others but washes their feet; and a teacher teaches the importance of service mainly *by serving*.

5. Cf. Raimon Panikkar, *The Vedic Experience. Mantramañjarī. An Anthology of the Vedas for Modern Man and Contemporary Celebration*, London: Darton, Longman & Todd, 1977, p. 347: "If one had to choose a single word to express the quintessence of the Vedic Revelation, the word *yajña*, sacrifice, would perhaps be the most adequate." And later on p. 351: "By sacrifice Gods and Men collaborate, not only among themselves but also for the maintenance and very existence of the universe. Reality subsists, thanks to sacrifice. But this truly primordial sacrifice is not left to the whim of either Men or Gods; it has an internal structure and mode of operation, namely, *Rita*. Without *Rita* the Vedic sacrifice would degenerate into a manipulation of the whole cosmic order by Gods or Men, and we would fall into a hideous world of magic, as Men are sometimes prone to do."

6. See George M. Soares-Prabhu, 'The Synoptic Love-Commandment. The Dimensions of Love in the Teaching of Jesus,' in: *Theology of Liberation: An Indian Biblical Perspective* (Jnana-Deepa Vidyapeeth Theology Series; vol. 4), ed. F. X. D'Sa, Pune, 2001.

The significance of Jesus 'washing of his disciples' feet cannot be retrieved through a ritual washing of children's feet on Maundy Thursday. Its real significance is to be discovered in the fact that the first component of love is service. For us today the significance of Jesus' death on the cross is to be interpreted not so much through a theory of reparation wherein God needs to be placated and pacified (in our context such a God would indeed be, in the expression of S. Radhakrishnan, 'a sorry God'), but within the kerygmatic axis of service.

However it is very important that in a country like ours where, protestations notwithstanding, untouchability has played such a tragic role, washing of the feet of the 'last of the least' is surely needed to highlight both the plight of the marginalized and the unwillingness of the privileged many to redress their grievances. In this case washing of feet will mean identification with the cause of the voiceless and the helpless.

Having said this, the larger significance of this doctrine will have to be extended beyond the realm of the Human to the Cosmic. Service of creation is part of this mission. The sacrament of service is being actualized by people who are working for the displaced and the refugees, for the sick, the helpless and the aged, for prisoners, for human rights and women's rights, for non-formal education, for rural development, for political conscientization, for a just and human social order, etc. It is also significantly being realized by people who are engaged in caring for the earth, the air, the forests, the fish, the seas and the oceans, the beasts and the birds.

This idea of such a sacrament might sound strange. This is because our prevailing idea of sacrament needs re-vision. Our sacraments today are sectarian and privatized, perhaps even individualized; they certainly are churchy, but by no stretch of the imagination are they cosmic.

BREAKING OF BREAD

Again, Jesus' breaking of bread and sharing of the cup on the night before he died is significant as a symbolic summing up of his whole life. His testamentary words "This is my body which is for you. Do this in remembrance of me. . . . This cup is the new covenant in my blood. Do this, as often as you drink it, in remembrance of me" (1 Cor 11.24-25) constitute not only a manifesto but the hermeneutic key to the significance of his life, work and message.

Similarly, the fact that he took bread and wine is equally significant because they are the hermeneutic key to the meaning of the world. The world, like bread and wine, is a product of sharing and communion, and it lives on sharing and communion.

However, like everything in this world, bread is significant not in itself but inasmuch as it is meant for the "life of the world." Here we have the semantic axis of the world. "And the bread which I shall give for the life of the world is my flesh." (Jo 6.51) Jesus is indeed one who sustains the life of the world. The significance of Jesus consists in this: "This is my body which is for you! . . . This cup is the *new covenant* in my blood!"

And when we proclaim that Jesus is the way, the truth and the life we are proclaiming neither metaphysical theories nor apologetic doctrines *vis-à-vis* other religions. Way, truth and life are to be understood existentially, namely as realities which interpret our lives and make sense of them. Thus Jesus is truly the way to the true Parent, the way of washing of feet, breaking of bread and sharing of the cup of suffering and gladness. He is the truth that incarnates the source of all acceptance-and-belonging and who 'happens' (that is, be-comes manifest) along the way of service and selflessness. And finally, he is the life that emerges through the process of self-giving and self-emptying.

A Christian is called upon to build communities through service and sharing. Sharing presupposes service. For the precondition of communion is that we are willing to wash one another's feet. Bread becomes the bread of life only when it is kneaded in selflessness and baked in the oven of service. Of relevance in this context is Jesus' parabolic but nonetheless autobiographical saying of the grain of wheat.

Now sharing implies two things: sharing *with* others and sharing *in* their lives. For one shares what one has and what one is. It is in sharing that 'I' and 'You' without losing themselves are so purified that they discover their real unity in an originary 'We,' the originary community. The human being participates in a community that is constituted by the Human, the Cosmic and the Divine. This is the paradigm for all communities. Hence, it is not so much the formation of Christian communities as of trinitarian communities that is the real significance of breaking of bread. Every community, if it is to be genuine, has to become bread for other communities. This is the first and last criterion of community.

The sacrament of the breaking of bread is not a mere idea nor just an ideal; it is being realized wherever efforts at reconciliation are being undertaken and some kind of unity is being achieved on social, economic, ethnic, political and religious levels; that is, wherever communities are being formed without restrictions of caste, creed and race identities.

THE DESCENT OF THE SPIRIT

The way of service leads to and prepares for the breaking of the bread, namely, the building up of communities. This demands complete self-emptying in the form of suffering and death. Thus Jesus' death was the price of his way of life; but it was neither the end of the way nor the end of his life. His death was rather like that of the grain of wheat, a sharing in the humus of history and transforming it into salvation-history. The result was a completely new life, a totally new Spirit.

At the first feast of Pentecost the diversity of languages did not produce another Babel but a new universe of meaning where the salvific message was understood by everyone in one's mother tongue. This was the work of the Spirit of Jesus, the Spirit of understanding-and-acceptance which destroys insecurity and intolerance, pettiness and prejudice, narrow-mindedness and dogmatism.

How does she do this? In today's Babel of a world where conflicting claims about God, World and Man are being proclaimed, where one tradition tries to put down the other, where one political system aims at dominating the rest, where the one world is divided into different worlds according to caste, creed or colour, gender and material wealth, the Spirit of understanding-and-acceptance acts as the Hermeneut who builds bridges of mutual understanding.

Thus in the world of religion, she is leading us to the insight that the universe of Faith is the centre around which the pluriverse of belief revolves; in politics she is showing us that we have to hang together as a world community of united nations if we do not wish to hang separately as warring ethnic groups; in economics she is pointing out that the luxury of the rich countries is not primarily the fruit of their sweat but merely the pyramidal point resting on the exploited base of the powerless; in ecology (Panikkar with much reason substitutes it with 'eco-sophy') she is making us aware that material pollution is not unconnected with moral pollution that respects neither Mother Earth nor Father Heaven; through the peace movement she is revealing that training for peace, not preparing for war, is the best and most secure guarantor of peace and prosperity; through the human rights movement she is accusing not only the power-hungry who victimize the helpless but she is also grooming courageous prophets who stand up to tyrants; through the women's movements she is demanding a re-vision of our understanding of Man; through the movement for the preservation of wildlife she is condemning our wild way of going about with God's creation. In these and many other ways, the Spirit of understanding is spreading in all directions. This is indeed the beginning of the final feast of Pentecost.

The Spirit of Pentecost is the Spirit of acceptance-and-belonging; it is the Spirit that inspires and creates conditions that lead to acceptance-and-belonging. Viewed from our side, the final feast of Pentecost is to be interpreted not only as the crown and culmination of the way of service and sharing that heralds a new heaven, a new earth and a new humanity but also and much more as an invitation and challenge to collaborate in this enterprise of the Spirit.

THE ESSENCE OF AN INDIAN RELIGIOUS EXPERIENCE

In an approach analogous to the one I have taken with regard to the Christian doctrines, I would now like to proceed with the fundamentals of an Indian religious experience. I wish to formulate them in a similarly triune manner: *karma-yoga*, the path of renunciation leading to the welfare of all, *bhakti-yoga*, the path of communion with all beings, and *jñāna-yoga*, the path of discerning the distinction between wholeness and partiality. Though a section of Neo-Hinduism tries to separate these three *yogas*, they are, in my opinion, integral to a holistic understanding of a pluriformic *yoga*. I find this justified in my reading of the *Bhagavad-Gītā*.[7]

7. See for example my 'The Yogi as a Contemplative in Action,' *Studies in Formative Spirituality*, Journal of Spiritual Formation 11:3 (1990), pp. 289-302.

The gist of the *Gītā* concerns the fragmented and alienated nature of our being and how it can be opened up to all reality.[8] The *Gītā* is in fact a response to our one-sidedness in acting, willing and understanding. It is an answer to Man's search for wholeness which could be summed up in three moments: the wholeness of reality can be retrieved by one (a) who works selflessly for the welfare of all, (b) who without attachment loves all and (c) who thus is able to see all things in the Divine and the Divine in all things. Selfless work for the welfare of all is one approach: another approach is love for all and a third approach is that of seeing all things in the Divine and the Divine in all things. Implied in this process is a purification of the senses, of the heart and of one's vision. A holistic vision follows close on the heals of the purification of one's motives and of one's love.

This is the integral *yoga* of the *Gītā*. However we need to have a closer look at it.

To understand this *yoga* it is necessary to understand the cosmic dimension that is part of its world-view. The world and all that constitutes the realm of perception, of mind, memory and imagination — and not least of all, of the will and the understanding — is the world of change, the world of *prakṛti*. Here everything is interconnected with and interdependent upon everything. Every act in the world of change affects the whole of *prakṛti*, that is, the world of change.

It is important to grasp what is meant by an act: it refers not just to the physical act that affects the whole but also the motive that gave rise to it. A normal human action is the germination of a motive; when a motive germinates an action is born, irrespective of whether one is aware of the motive or not. They are two kinds of motives, those that bind and those that liberate. Those that bind can basically be reduced to what we understand by likes and dislikes, not just conscious likes and dislikes but more especially those which reside deep down in our being and exercise their power over us. Another name for them is attachment.

Attachment narrows our interests and restricts our horizon. It causes ontological blindness, the blindness that operates at the level of our being. Because of this we cannot perceive things as they are. We find ourselves in a world where attachment pervades everything and everybody. The result is that fundamentally our values are all pseudo-values because they are all reducible to likes and dislikes. Which means there is in us hardly a trace of any sensitivity to real values. The implication is that all our action at its

8. In this context see the interesting comment of Ken Wilber, *Sex, Ecology, Spirituality. The Spirit of Evolution*, Boston & London: Shambala, 1995, p. 4: "Central to these ecological approaches is the notion that our present environmental crisis is due primarily to a fractured worldview, a world-view that drastically separates mind and body, subject and object, culture and nature, thoughts and things, values and facts, spirit and matter, human and nonhuman; a worldview that is dualistic, mechanistic, atomistic, anthropocentric, and pathologically hierarchical — a world-view that, in short, erroneously separates humans from, and often unnecessarily elevates humans above, the rest of the fabric of reality, a broken worldview that alienates men and women from the intricate web of patterns and relationships that constitute the very nature of life and Earth and cosmos."

very roots is selfish, that all or love is really a camouflaged form of attachment and that what we believe to be true and right knowledge is projection of our common prejudices.

Basically then, *selfish interest* colours our action, pollutes our personal relationships and alienates us from reality, in the process incapacitating us from seeing things as they really are. Unable to experience our oneness with reality, much less to participate in it, our fragmented being seeks and runs after values that suit its situation of alienation, works out a self-understanding where God, World and Man form three separate identities, cultivates forms of religion where God is created in its own image and likeness, and in general takes refuge in rites and rituals where either some spiritual or material benefit is at the root of it. This is the world of self-deception that the *Gītā* tries to demolish through its pluriformic but trinitarian *yoga*.

KARMA-YOGA: THE YOGA OF RENUNCIATION

Karma-yoga is a sort of orbital movement sustained by the centripetal force of selflessness and the centrifugal force of service of all. Selflessness is not to be understood primarily as moral selflessness, wherein a person *resolves* to be selfless. Rather it is to be interpreted as ontological selflessness, that is, at the level of being, *freedom from* selfish motives and *freedom for* the welfare of all. The difference between moral and ontological freedom lies in this: whereas moral selflessness tries through an *effort of the will* to free itself from *wilfully* entertaining dubious motives, ontological selflessness is freedom from domination by likes and dislikes, and is a freedom which emerges through awareness of one's real nature. Because it operates at the core of one's being, it opens up one's being for the service of all.

This dual aspect of selflessness (freedom from likes and dislikes and freedom for the welfare of all) is renunciation (*saṁnyāsa*) in the fullest sense of the word. Renunciation is not mere detachment or indifference; like non-violence (*ahiṁsā*) it might sound negative (in English). Its negative meaning is intended to highlight its positive significance. Accordingly, a genuine *saṁnyāsī*, like a *bodhisattva*, stands at the threshold of ultimate freedom and works for the welfare of all. Another designation for a *saṁnyāsī* is *karma-yogī*. *Karma-yoga* enters the scene because the stress is on *karma*, 'action,' and 'commitment,' but not primarily on the 'external' aspects of commitment. What is stressed is the 'motive' aspect of action and commitment, that motive which effects internal freedom and external commitment to the welfare of all. A *karma-yogī* is one who is engaged in constantly purifying his/her motives, constantly in search of the pearl of great price, namely, the welfare of all.

BHAKTI-YOGA: THE YOGA OF COMMUNION

Important as it is to purify one's motives, this is not enough. Working for the welfare of all implies getting involved with things and persons whose welfare is the focus of the commitment. Hence there remains the equally important task of relating personally to the welfare of all. Working for such a goal, however noble, entails the danger of

domination and possession. *Bhakti-yoga* obviates this and goes a step further. It proposes the ideal: 'identify yourself with your neighbour,' an ideal that is homologous to the Christian ideal of 'love your neighbour as yourself.' The identification in question here does not imply a loss of personality, but the discovery of communion. For *bhakti-yoga* concerns itself with communion with all — more precisely, communion with the All.

Like *karma-yoga*, *bhakti-yoga* too is an orbital movement, but of a different kind. The similarity consists in that *bhakti-yoga* is also constituted by a centripetal and a centrifugal force. The former is called higher *bhakti* [*parā bhakti*] and the latter lower *bhakti* [*aparā bhakti*]. Higher *bhakti* is the pull from God, the pull that draws us to God; it is a pull that is at work at the very base of our being. Lower *bhakti* is our response to this pull. This attraction operates in every being and in the whole universe. To distinguish this pull from the push and pull of our likes and dislikes, and to discover it in *all* things (higher *bhakti*), and then to respond to it with all our being and all our love — *sarvabhāvena* — (lower *bhakti*) is communion in the fullest and best sense of the word *bhakti*.

Bhakti as communion presupposes renunciation as described above in terms of selfless commitment to the welfare of all, and discovers in this landscape the edifice of communion between the Absolute I and the finite Thou-s. *Bhakti* is not satisfied with the relationship of working for the welfare of all. Through *bhakti* this relationship is deepened on a different level by means of another more personal alliance consisting of love and devotion. *Bhakti* is thus not just love of human beings because it is not restricted to Man alone. It is a love that responds to God's love of Man in the Cosmos. Man, phenomenologically and historically speaking, is inextricably connected to the Cosmos. Anything that has to do with Man has necessarily to do with Man in the Cosmos.

This might best be illustrated through the example of the personal pronouns I, You, We and It. There is no I or You without a We; and no We is possible without an It. A We is possible within an It alone (the world); and only within a 'cosmified' We are I and You possible.

Applying this to *bhakti* on the ontological level, *bhakti* is the discovery of the communion between the finite You-s in this world, a communion centred around and nourished by divine love. It goes without saying that real *bhakti* is possible because of 'renunciation' in the form of selflessness that aims at the welfare of all.

JÑĀNA-YOGA: THE YOGA OF DISCERNMENT

Jñāna-yoga comprehends all levels of awareness and understanding, and extends from informative knowing through symbolic-personalistic language to transformative awareness. It begins at the stage of the body, proceeds to the mind-level, goes on then to the plane of the understanding and will, and lastly culminates in the ambiance of awareness. To put it simply, *jñāna-yoga* aims at an experience of discerning between change and non-change, being and becoming, body and spirit, time and timelessness. In other words, it helps reach the surpassing in what is passing, abiding continuity in change,

the eternal in the ephemeral. In other words, *jñāna-yoga* is the vehicle of wholeness which is the integration of polarities. It is the light of totality that is refracted through the pragmatic but deceptive prism of partiality. The abiding fruit of discernment is the illumination that separates the chaff of false-values from the wheat of authentic values, the wisdom that makes one build on the rock of being and not on the sand of becoming.

This *yoga* also has two stages — two levels, if you like — of conviction and discernment. Convictions (pre-understanding) have to be critiqued, corrected and qualified. This is done through the process of reasoning, reasoning out. Most of our knowledge, especially on the personal level, does not deserve the designation of knowledge because it is unfounded opinion. Hence, we have to question our presuppositions and to tread the path of reason cautiously so that our convictions are based in reality. The door to the house of faith is reason. If it would be folly to neglect this door, it would be a greater folly to take the door for the house.

We need to realize that reality has two aspects: being (non-change) and becoming (change). To arrive at such vital convictions belongs to the first stage of *jñāna-yoga*.

The second stage is a simpler though more difficult one. It consists in becoming aware of what such a conviction does to the innermost depths of our being. One makes a grave mistake if one were to take its mode of being as belonging merely to the cognitive level. A conviction, because it is a conviction (that is, a being captured/overcome, from latin *convictus*) affects us at a deep level. Unlike the first stage where the process of reasoning out is of the essence, the second stage is really a stage of discernment. Reasoning is never neutral; it is always partial and continuously changing according to the evidence. The most that reason, as the door to awareness, can do is to *lead* us to discernment, but it itself cannot enter. On the other hand, awareness, having no presuppositions (since it itself is what reason always presupposes), is always neutral and detached. Awareness is, in fact, real discernment.

Summarizing, we could say that to *karma-yoga*'s two aspects of selflessness and the welfare of all correspond *bhakti-yoga*'s aspects of divine pull and communion with all. In a similar manner *jñāna-yoga*'s two aspects of conviction and discernment correspond with these. To put it schematically:

karma-yoga	->	selflessness	<-> welfare of all
bhakti-yoga	->	divine pull	<-> communion with all
jñāna-yoga	->	convictions	<-> discerning the eternal in the ephemeral

Yoga is a protean word and means all things to all kinds of people. Among its valid meanings I would suggest belong integration, harmony and spirituality. The *yoga* that I have briefly sketched is holistic because it overcomes divisiveness and promotes integration at all levels, especially at the levels of commitment, communion and discernment.

Re-interpreting Religious Life

I take it that the need for revising our understanding of religious life in India is obvious within our interreligious and intercultural context. At any rate I shall not argue about it. In more than fifty years of religious life I have seen and gone through continual well-meaning changes, changes that have been more on the cosmetic than on the constitutive side. The re-thinking that I am engaged in is in the direction of interculturation between the Christian and the Hindu traditions. The basic re-vision that I am suggesting is to change gears *from an individualistic to a cosmotheandric approach*. Hence we would do well to understand poverty in the world of renunciation, to interpret chastity in the context of communion, and to comprehend obedience from within the universe of discernment.

The age of ghettos is over; whether we like it or not, we have no choice but to encounter universes of meaning other than our own. For those who profess to be Catholics (*kat 'holos*) this is an opportunity to actualize their catholicity. The world in which we Christians have appropriated poverty, chastity and obedience can be 'catholicized' through a fruitful encounter with the world of renunciation, communion and discernment. For only in and through such an encounter shall we be in a position to share and come to know and understand each other.

Whatever the historical origins and intentions of the vows of poverty, chastity and obedience, it seems to me that today they appear to focus on the individual, not on the person, on morality and not religion. Consequently our understanding of them tends to view them more from the moral and juridical side than the religious aspect. We need to move away from an individualistic interpretation towards a more personal, interpersonal, societal and cosmic level and so to a more holistic, that is, to a cosmotheandric universe of meaning. It is ironical that, whereas persons of good-will in science, politics and world-affairs are gradually seeking ever more widening horizons, we in the religious and theological world have become stuck to an individualistic and subjectivistic understanding of Man.

If we are suggesting an encounter with the Hindu world of meaning, the intention is neither to downgrade nor disqualify our vows nor to 'Hinduize' them but to highlight and articulate the processes of osmosis and symbiosis that have been taking place, especially in the last few decades. The purpose therefore is to discover the fundamental features, the common framework of Man in the world and from there to underscore the specificity of the different traditions.[9]

9. I am aware of the objection that my interpretation has to do with a 'big' tradition and that it has to do with Hinduism of the higher castes. I plead guilty but I suggest there is method in this madness. Not everything in such streams of Hinduism is negative, oppressive and dehumanizing. I submit that we have to search for liberative strands in these oppressive traditions and help them to retrieve the experience of wholeness that they once [might have] embodied.

UNDERSTANDING POVERTY IN THE CONTEXT OF RENUNCIATION: KARMA-YOGA

Originally, poverty was meant to free us from attachment to things that pass away in order to reach a state of inner freedom that would open us to the needs of our fellow human beings on the one side, and to the grace of the Divine on the other. But *alas*, today it has come to be closely linked with permission to acquire or possess, and its observance is spelt in terms of yearly budgets and monthly accounts. What is worse, it has concentrated on the individual and his or her moral character. Perhaps this is an exaggerated view but it still might contain a grain of truth.

Be that as it may, we have to make sure that the positive value of poverty is retained and, if possible, enhanced. In the world of the *Gītā* we saw how renunciation was basically a presupposition (in the form of selflessness) towards the goal of the welfare of all. Our understanding of poverty as detachment could very well be interpreted in a similar manner as renunciation of all attachment to 'finite' things and as encouragement to attach ourselves to the Divine Mystery[10] in order to work for the welfare of all. In that case, poverty would not merely mean the non-possession of things, but also detachment from passing things with a view to attaching ourselves to the Highest Good.

Poverty in the Indian sense of renunciation is much more comprehensive and goes beyond the economic and juridical order. Economic and juridical poverty are necessary as preconditions; they do not constitute the essence of renunciation. The essence consists in *inner freedom which generates external commitment*. It renounces because it brings freedom which inspires one to commit oneself to and engage in universal Welfare. If detachment is renunciation's point of departure, universal welfare is its vehicle and attachment to the Divine Mystery its point of arrival.

Thus, renunciation which encompasses the whole world of relationships but focuses on its cosmic dimension has a communitarian and cosmic understanding both in the process of detachment and in the person committed to detachment. The reason is that the renunciation of the person is taken to have a direct bearing on the welfare of all. *Renunciation is not merely an act of the individual person; it contains within itself the dynamics of world-welfare*. For renunciation (unlike our vow of poverty in our present Western Christian understanding) consists not so much in doing something more than what the 'ordinary Christian' does but in doing something which every person should be doing.

This way of interpreting poverty implies a *karma-yoga* spirituality, a spirituality which is founded on the *cosmic nature of all relationships and on the communitarian nature of person*. A *karma-yogī*, committed to the welfare of all, focuses on the cosmic dimension of reality. This kind of renunciation stresses detachment from all things in order to work for universal welfare. Poverty in such a context is not just a virtue of the individual; it is the proclamation of the interconnected nature of all reality on the one hand, and of

10. *Bhagavad-Gītā* 7.1.

commitment to work selflessly for the actualization of this interconnection on the other. It is, in short, a reminder of what each one is called to be: a *karma-yogī*.[11]

INTERPRETING CHASTITY IN THE WORLD OF COMMUNION: BHAKTI-YOGA

The vow of chastity, like our traditional interpretation of poverty, focuses on the individual's continence. Chastity too could be fruitfully understood from within a cosmotheandric vision of communion. We find ourselves in a world of personal relationships. The personal relationship is basically a discovery of the presence of the Ultimate Mystery in all things, especially in all persons, a presence which manifests itself through attraction. To respond to this attraction and through it to encounter the Divine Mystery, is to enter into communion. But to try to possess this divine pull is to be incapable of communing.

In the traditional way of looking at things, the vow of chastity focuses on the exclusion of sexual activity. Without giving up this aspect we could, with the help of *bhakti-yoga*, take this as the condition for communion with all things and persons. *Bhakti* is participation, communion.[12] Our chastity is only the preparation for, not the content of, communion. Chastity in the context of *bhakti* implies that our attention is on the presence and power of the Divine Mystery in flesh, flower and fruit. If renunciation is the first rung of the ladder leading to a healthy relationship to all beings, *bhakti* (as communion) is its final step. In this view, sexual chastity is part of our total renunciation of attachment to the realm of the finite.

However, *bhakti* is not just a romantic dream of an individual. It is a constitutive element of all, especially personal relationships. Things exist because of the Divine Presence in them and, because of it, they relate and get related. However, the Divine Presence in all things is not only gift and grace; it is also a task, a call to communion. For *bhakti* as communion requires that we no longer discriminate on the basis of caste, creed, colour or sex. There can be no real *bhakti* where division and discrimination exist. Communion presupposes community because communion is not a one-to-one relationship with individuals. Rather it is an ever widening concentric circle, a cosmotheandric WE embracing whatever and whoever comes its way.

Chastity in the world of communion could thus come to refer to the sharing of our being and our love with all beings, especially human beings. Moving away from fixation on sex we could focus on the goal of communion.

LOCATING OBEDIENCE IN THE UNIVERSE OF DISCERNMENT: JÑĀNA-YOGA

Obedience also has been seen in an individualistic manner as the relationship between

11. See my 'The Yogi as a Contemplative in Action,' *Studies in Formative Spirituality*, Journal of Spiritual Formation 11:3 (1990), pp. 289-302.

12. See my 'Zur Eigenart des Bhagavadgita-Theismus,' in: *Offenbarung als Heilserfahrung im Christentum, Hinduismus und Buddhismus* (Schriften zur großen Ökumene; 8), hg. W. Strolz und S. Ueda, Freiburg: Herder, 1980, pp. 97-126.

the superior and his or her subjects. The way it has been proposed and practised is, for today, far too subjectivistic and far too naive in believing that the will of God becomes manifest through the command of the superior. But all this came to be so because arguably obedience had its origins in a world where the notion of God and the idea of person and freedom were differently conceived. In a world where freedom is of the essence of person, God and person will be understood in a very different manner. Accordingly, the background for our re-interpretation of obedience is today's context of a human community slowly becoming aware of its cosmic responsibility.

The revolutionary changes in the means of communication have brought about the result that our world has shrunk to a global village. Human beings are becoming conscious of their closeness not only to one another but to the cosmos as well. Such closeness offers not only opportunities but is also fraught with dangers. On a global scale, the opportunities are in the line of cross-cultural sharing and interreligious communities. And the dangers are in the direction of more intensive exploitation of economically, politically and culturally helpless nations. On a personal level, there are opportunities of becoming world-citizens and interreligious persons. Here the dangers are eclecticism, instant-liberation and 'do-it-yourself religion' with help from religious supermarkets.

Here is the locus of obedience in the sense of discernment. We have to discern all-round growth from lopsided growth, between real growths of the person from the increase in possessions, between genuine international communities from multinational exploitative concerns. In essence, the discernment is between the freedom of the world of person and the *laissez faire* of individuals, between genuine community and groups masquerading as communities, between growth in material possessions and growth in service, sharing and significance.

In the mad rush for development of technology (more precisely technocracy) and its accompanying perquisites, there is need of people who can discern and point out where this rushing is leading humankind to: national selfishness and chauvinism, militarization and local, if not global, wars. Religious communities, who have renounced everything, will be the right people to call a spade a spade, to show the chinks in the technocratic armour. Such discernment, however, will not be the discernment done by individuals but by persons in communities.

In this context, obedience will mean obedience to the discernment done by communities; it will mean the actualization through creative means of the community's discernment. The background of obedience will be the discernment of a community vowed to renunciation; and the context of the community's discernment will be the problems and challenges of our times.

RE-VISION OF RELIGIOUS LIFE?

Where has our re-vision taken us? Firstly, it has led us from a world of individuals with individuals' concerns to a community of persons, conscious of their response-ability to

'world' concerns. Secondly, it makes clear that the content of this responsibility is cosmotheandric integration, that is, harmony at all levels. Concretely, it means that the search for the depth-dimension is at the level of personal growth, of national development and cosmic coordination. Thirdly, the vows are now to be seen as expressions of selfless commitment to the welfare of all, of communion with all beings, and of discernment with regard to the real and the apparent. Fourthly, it will prepare the way to the formation of interreligious and intercultural communities committed to universal welfare, cosmic communion and ongoing discernment of the dynamics in the social, scientific, economic, political and religious worlds.

Religious are those Commissioned to Work for World Concerns

The core of the commission to religious communities cannot be reduced to 'individual' perfection; rooted in a unifying awareness of God, World and Man, religious communities are called to be witnesses in their life-vision and their life-style to the cosmotheandric nature of all reality. In consonance with this, the vows also will have to take on a cosmotheandric *avatāra*.

TO WITNESS TO RENUNCIATION THROUGH WASHING OF FEET

Religious persons are commissioned to be witness to renunciation through the washing of feet. Our religious history, past and present, makes it imperative that we, the religious, be witness to renunciation of all hierarchical and oppressive systems with a view to working for a just and egalitarian society and thus for the welfare of all. Renunciation has to be portrayed and practised not as a kill-joy or a spoil-sport but as the life-support system of the whole world.

As religious persons, our first task, I suggest, is to assimilate the theory of renunciation and translate it into practice through the washing of feet. Their commission consists in selfless service for the welfare of all. Wherever there is need of service, the religious will be the first to be there because it is selfless concern for the welfare of all that inspires them. Today, world problems are being sorted and solved by people with vested interests, people who are concerned neither with selflessness nor with the welfare of the whole. Their solutions can only sow the seeds of new problems. Far too long have we been expecting too much where nothing much can be expected.

It is here that the religious have to step in and fill the lacuna by acquiring competence in different fields of public life. The religious will have to concentrate not on their private pastures but on the challenges of our times. With their vow of renunciation inspired by the vision of universal welfare, the religious could get involved in world concerns without hankering for power, personal gain or public honour. It is in public life that the religious are today called upon to give witness to the necessity of renunciation for peace and prosperity, environment, employment, women's empowerment, etc.

Thus a religious person will have to be first of all a real *karma-yogī*, involved in meeting challenges and solving problems but without attachment to the fruit of such labour. When we speak of *karma-yogī* the accent is not on *karma* but on *yogī*, that is, a person who is involved in action because it is part of the *yoga*-process. At the same time, it is not any action that the *yogī* is involved in but that action that leads to commonweal.

TO FORM COMMUNITIES WITH ALL BY BREAKING BREAD WITH ALL

If the goal of renunciation is not just a private practice of giving up possessions but is commitment to the welfare of all, the goal of communion is nothing less than giving up all forms of divisions and working for communion at different levels: communion with nature and communion with human beings. Renouncing 'mine' and 'thine,' the religious as *bhakta-yogīs* long to build communities wherever they go. The finale of such yearning, of course, is cosmotheandric communion. The search for oneness is in effect the search for the Divine Presence in all things which is the foundation of all communion.

At a time when the word 'love' is freely bandied about and its real content is gradually being emptied, those religious persons who vow to love all beings and to commune with them will be in a position to give witness to the true meaning of love and communion. As a 'contrast society' they constitute the real *magisterium* that discerns between authentic and inauthentic love, between love and lust, that is to say, between those for whom love is a passion and those for whom passion is love. Inasmuch as traditional religion and religious communities have failed it is the *bhakti-yogīs* alone who will be in a position to form communities where pluralism constitutes the form and communion the essence. Because they see and love the Divine Presence everywhere and at all times, they have no axe to grind and so are open to all persons and things.

TO DISCERN THE DESCENT OF THE SPIRIT IN THE EVENTS OF OUR AGE

One of the most important tasks of the religious will be to discern where the Spirit is at work. Neither politicians nor bureaucrats will be able to do this. The religious who have vowed to discern the working of the Spirit have the special assignment to promote understanding among diverse social, ethnic, language and religious groups. Because they are open to all, the religious as *jñāna-yogīs* will fearlessly speak out when religious traditions proclaim pseudo-values or politicize religious concerns for ulterior motives.[13] In a special way they will see to the interests of 'the least of the last.' For all this, prophetic courage and wisdom to speak for those who are helpless and voiceless will be required of them. *Jñāna-yoga* will amply equip them for this task.

Discerning the presence of the Spirit will mean critiquing the values incarnated in developmental and economic reforms, religious institutions, social reforms and political policies. Discernment will not mean primarily discerning private problems, but rather

13. In the last weeks of February 2004 the French Parliament has banned 'religious' symbols like headscarves in public school as not being in consonance with the secular nature of these schools.

the spirit at work in our times and our cultures. The opposite of discernment is calculation; it is the spirit that blinds us to real values, sets up profit and economic growth of a few as the pillars of universal progress, and so brings forth a world order bedevilled by division and dissension. The Spirit of the Lord, however, brings unity, equality, justice, joy, peace, prosperity, happiness and harmony.

Conclusion

Whether these reflections find assent or not, it is important to ensure that our search takes place at a fundamental level, at a level where changes in the world and world-order are occurring. For the question before us is this: is the axis of our renewal a new Heaven, a new Earth and a new Jerusalem, or a new church, a new congregation and a new constitution? To see the force of the question is to become aware of the force of our quest for renewal. Ultimately it boils down to what we are building our lives on: on the rock of hope or the sand of expectation? Hope springs from a world of mystery but expectation is generated by a world of mastery.[14] Will religious life inspired by a vision of wholeness become a symbol of hope, or will it merely be just another selfless but ineffective sign of expectations? This is the question before us.

14. See my 'The Challenge of our Times and the Response-Ability of Religious Life: Discerning the Challenges:' in: *In Christo. A Quarterly for Religious* 34:2 (1996), pp. 68-76; 34:3 (1996), pp. 133-42; pp. 203-12.

22

The Doctrine of Recognition (Pratyabhijñā) and Interreligious Dialogue

John R. Dupuche

Introduction

Of the many philosophical schools of Kashmir during its Golden Age, 'Kashmir Śaivism' in particular has attracted much interest in recent decades. Vasugupta (*c.* AD 875-925), its starting point, wrote down the *Śiva-Sūtra* and either he or his disciple, Kallaṭa, composed the *Spandakārikā*. Kallaṭa's disciple, Somānanda, wrote the *Śivadṛṣṭi*, the seminal work of what would eventually be called the Pratyabhijñā School. Somānanda's pupil, Utpaladeva, developed a classical formulation of the movement in his *Īśvarapratyabhijñā-kārikā* from which the Pratyabhijñā School takes its name. This work then received its greatest commentary, *Īśvarapratyabhijñā-vimarśinī*, at the hands of the 'grandson' of Utpaladeva, Abhinavagupta (*c.* AD 975-1025), the leading figure of non-dualistic 'Kashmir Śaivism.'

This paper will describe briefly some of the insights of the Doctrine of Recognition and show their value for the work of inter-religious dialogue. It is offered in tribute to Prof. Dr. Bettina Bäumer who has significantly contributed to the work of interreligious dialogue and who has experienced in herself the value both of Christianity and of 'Kashmir Śaivism.'

The Doctrine of Recognition (Pratyabhijñā)

The Doctrine of Recognition states, in a nutshell, that liberation (*mokṣa*) consists in the act of recognizing one's identity with Śiva. It is the liberation from the illusion (*māyā*) that I am fundamentally 'this individual,' essentially limited by time (*kāla*), necessity (*niyati*), forces (*kalā*) beyond my control, limited knowledge (*vidyā*) and attachment (*rāga*). Those five sheaths (*kañcuka*) conceal the essential reality that 'I am Śiva.'

Such a realization must be neither overestimated nor underestimated. It is not the individual in all his (or her) particularity who is Śiva — that would be megalomania. Nor can the individual say, 'I am really only this limited person.' One recognizes, rather, that one's essential reality is that of Śiva.

The emanation (*sṛṣṭi*) of the world proceeds from the Supreme Word and goes through various stages such as insight (*paśyantī*) through the as yet unformulated thought (*madhyamā*) to the verbal expression (*vaikharī*). Or, to use another set of terms, the highest level of the Supreme Word is beyond thought constructs (*nirvikalpa*) and is then expressed in thought (*vikalpa*) and finally in action of some sort (*kalpa*). This process of emanation leads to the formation of the objective world in all its illusion.

When frustrated by this basic illusion or stain (*mala*), the individual experiences desires and aversions, which in turn lead to unwise actions and so to the burdensome cycle of rebirth (*saṁsāra*).

However, by the grace (*anugraha*) of Śiva rather than by any act of his own, the individual recognizes his essential nature. The knowledge that 'I am Śiva,' or simply 'I am' (*aham*), is the Supreme Word (*paravāc*) and the resonance (*dhvani*) of supreme consciousness (*saṁvit*) of which every other word is a particular manifestation.

This grace of Śiva is disbursed in varying degrees at various times according to Śiva's own free choice, so that one person may be gifted with that profound insight even in the womb, while another may come to realization only after many lifetimes. Recognition may come as a blinding flash or gradually within the ordinary events of life, by reasoning or at the sight of the enlightened *guru*. No matter what the means, the result is the same and this alone counts.

Liberated-while-living (*jīvanmukta*), he recognizes not only that he is Śiva but also that all reality is an expression of His self. All is from Him, all is for Him, and nothing is foreign or alien. All is reconciled and unified in Him so that the *sādhaka* understands the variety of human history to be simply the many manifestations of His being. Behind such statements as 'I am Citra' or 'I am sixty-five years old' lies the primary statement 'I am' which resonates in all its freedom from contingency and in all its simple brilliance (*sphurattā*). He says, 'I am' and cannot say 'I am not.' He looks on every person and says 'You are my very self.' He hears himself in their every word. He understands that all is Śiva and perceives the Śiva-nature as the essence of every object and every person. There is a unity of heart (*sahṛdaya*) and of mind with all things and especially with those who have likewise come to the sense of their own Śivahood. In perceiving each other, these perceive their own self. Although experienced in different ways and in differing degrees, the Supreme Reality is constantly observed and appreciated.

The experience of recognition is described at the end of *Īśvarapratyabhijñā-kārikā*:

> *taistairapyupayācitairūpanatastanvyāḥ sthito'pyantike* ।
> *kānto lokasamāna evamaparijñāto na rantuṁ yathā* ॥
> *lokasyaiṣa tathānavekṣitaguṇaḥ svātmāpi viśveśvaro* ।
> *naivālaṁ nijavaibhavāya tadiyaṁ tatpratyabhijñoditā* ॥

> Just as an object of love, who has been brought to the presence of a slim lady by her various entreaties, cannot give her any pleasure — though he may

stand before her — so long as he is not recognized and, therefore, not distinguished from the common man, so the Self of all, which is the Lord of the world, cannot manifest its true glory so long as its essential nature is not recognized. — *ĪPK* IV.1.17

Abhinava comments as follows:

Suppose that the passion of love is aroused in a young lady by mere hearing of the excellences of a hero and that she — intensely desiring day and night to see him and with her heart completely out of control — sends messengers, writes love-letters, presenting her condition, and has her already slim body made slimmer still by pangs of separation. Now the hero unexpectedly turns up in response to her entreaties and stands before her. But she is not able to apprehend clearly his distinctive great qualities and consequently to her he is nothing more than an ordinary man. Under such circumstances, the perception of the object, though it actually takes place, does not give any satisfaction to the heart. Similarly, though the Lord of the Universe is ever-shining within as the very self. His shining does not make the heart full (of *ānanda*), because the self is not realized to be transcendental, and possessing the sup-reme Lordliness, characterized by unchecked freedom of thought and action. The Self, therefore, shines as do other ordinary objects, such as a jar etc.

But when she distinctly cognizes those excellences in him, either in consequence of a word from the messenger or of recognition of a characteristic or something else, her heart immediately blooms fully like a wonderful bud. And in consequence of repeated enjoyment of union, she experiences the rest of the heart in other forms also. Similarly, when transcendental Lordliness is fully recognized in the self, either as a result of preceptorial instruction or recognition of the powers of knowledge and action, then immediately in the very lifetime there is final emancipation, characterized by perfection. But if a person makes repeated efforts at merging himself in the Supreme, he attains mystic powers. Thus, it is the recognition of the Self which gives both the higher and the lower spiritual powers.[1]

Thus, recognition causes a sense of bliss (*ānanda*), which permeates the whole person in every way. Liberation does not mean abandoning the world but rather transmuting it. All is divine, all is sacred, every word is *mantra* and every action is ritual.

Bettina and Pratyabhijñā

Recognition is fundamental to understand Bettina's spiritual journey. She was received into the Catholic Church by Raimon Panikkar in Rome[2] in 1963 and afterwards travelled to India to meet Abhishiktananda. Many years later, after a long acquaintance with 'Kashmir Śaivism,' she journeyed to Srinagar and was initiated by Swami Lakshman Joo, the leading figure of this school. She describes the event as follows:

1. *Īśvarapratyabhijñāvimarśinī*, vol. 3, English tr. K.C. Pandey, Delhi: Motilal Banarsidass, 1986, pp. 230-31.
2. *Voies de l'Orient* (Janvier-Février-Mars 2002) no. 82, p.1.

On the day of my initiation, there were only a few people in the Ashram. He sent them all away and finally I was alone with my Master, in the *maṇḍapa*, in the garden. At that blessed moment he gave all his attention, and the indescribable happened. It was pure recognition (*pratyabhijñā*). No complicated ritual, no more testing, but the direct transmission in its total purity. Tears of joy and purification were flowing, the burden of so many lives was as if lifted, and I felt light — like a feather. He opened the door and removed all the obstacles, so that I could enter within — *samāveśa* [*sic*].[3]

The Terms 'Recognition' and 'Word' in the Bible

RECOGNITION

The New Testament has many words (δοκεω, γινωσκω, οιδα, αγνοεω and their cognates) to indicate knowledge. A few of them, in particular οιδα and γινωσκω, are occasionally translated into English as 'recognize.'

The verb οιδα is used in the scenes where "Mary did not recognize Jesus" (Jn 20.14) risen from the dead, or where "the disciples did not realise it was Jesus" (Jn 21.4).

In the phrase "did not recognize (επιγινωσκω)" (Mt 17.12) the prior knowledge comes from the writings of the Old Testament. In the phrase "Rhoda recognised (επιγινωσκω) Peter's voice" (Acts 12.14), prior knowledge comes from direct experience. The verb επιγινωσκω is used in similar fashion in Mk 6.54, Acts 3.10, 4.13, 27.29.

However, perhaps the most celebrated scene of recognition in the Public Life occurs at Caesarea Phillip (Mt 16.13-20). Others have seen Jesus but have not recognized him and think he is just John the Baptist or one of the ancient prophets but Peter acknowledges Jesus and proclaims, "You are the Christ, the Son of the living God." To this Jesus responds immediately, "Blessed are you, Simon son of John, for it was not flesh and blood that revealed this to you but my Father in heaven." Peter's recognition of Jesus comes from an inner knowledge already given by grace. The Christ standing before him coincides with the Christ already revealed in him.

The mutual act of recognition is expressed in John 10.14, "I know (γινωσκω) my sheep and mine know (γινωσκω) me." Or again, "They know his voice. They do not recognize (γινωσκω) the voice of strangers" (Jn 10.4-5).

The idea of recognition occurs also in the parables of the lost and found (sheep, coin, son) (Luke 15), in the frequent themes of promise and fulfilment (e.g., Acts 2.33), in the recommendation to seek and find (Luke 11.9) and in the work of the Spirit reminding the disciples (Jn 14.26). It is found supremely in the notion of faith, which is the knowledge of things only later understood (Heb 11.1).

3. B. Bäumer, 'How I met my Master,' in: *Śraddhārcana*, ed., Prabha Devi, New Delhi: Pāramārthika Cheritable Trust, 1998, pp. 217-22; here: 222. Bettina describes the essence of the event again in *Voies de l'Orient* (Janvier-Février-Mars 2002) no 82, p. 5: "Et ce n'était pas quelque chose d'étrange, d'inconnu, mais plutôt un acte de "reconnaissance" — ce terme même de la philosophie de l'école, *pratyabhijñā*, ce qui signifie reconnaissance de sa propre nature divine, ultime, libérée."

The major recognition scene after the Passion occurs on the road to Emmaus. At first something prevents the disciples from recognizing (επιγινωσκω, Lk 24.16) Jesus. After hearing his explanation of the Scriptures, which should have been enough for these "foolish men," "they recognize (επιγινωσκω) him at the breaking of the bread" (Lk 24.31). Whereupon they rush back to Jerusalem and joyfully tell the companions how they had recognized (επιγινωσκω) him in that way (Lk 24.35).

It would seem, therefore, that among the various verbs for knowledge in the New Testament the verb επιγινωσκω would best translate the Sanskrit word *pratyabhijñā*.

Just as the young woman, the "slim lady" of *Īśvarapratyabhijñā-kārikā* 4.1.17 has known her hero through the teaching of the preceptorial lines, so too the disciples understand the real nature of the Messiah as Jesus explains the Scriptures while walking on the road. Just as she does not recognize her hero even when he stands before her, so too the disciples do not recognize Jesus even as they listen to him. Just as she needs the moment of grace, so too the disciples need to see the most characteristic act — the breaking of the bread — in order to recognize the one who sits with them at table. Just as she is filled with bliss on recognising her suitor, so too the disciples are filled with joy and rush back to Jerusalem, their hearts burning, to break the good news.

The sight of the Christ has filled them with joy but not merely for reasons of friendship. They know that he fulfils the ancient hope of the people; he is all that was promised and all they are destined to be. He represents their true self. He is the outward sign of their inner reality, of their true nature where finally they find rest and where their journey reaches its goal. They know him as their very self. Therefore Paul can say, "I live or rather not I but Christ lives in me" (Gal 2.20). Paul's real self is not Saul born in Tarsus but the Christ. Paul is really the Christ; or rather it is the community of believers who are essentially the Christ. Paul had realized this on the road to Damascus when he heard Jesus' words, "Saul, Saul, why are you persecuting me" (Acts 9.4).

The act of recognition is a moment of identification (*tādātmya*) when the Christian becomes 'one body' with Jesus, not taking on the individual characteristics of the Nazarene, but acknowledging in himself the essence of Jesus expressed in the teachings, the signs and especially the events of the Paschal Mystery. It is the salvific moment.

Recognition implies faith and identity and is expressed communally in the sacraments of initiation where the outward signs correspond to the inner grace. The Christian is the Christ. Christ's self is the Christian's self. Indeed, there is one self. The idea of person does not involve dualistic separation but unity, for the experience of person implies identity of nature and identification in love. One is the other. One manifests the other.

WORD

The Prologue of the Gospel of John states that "through [the Word] (*logos*) all things came to be." The term 'Word' recalls the prophetic word, which commands either to

withhold or produce rain (I Kg 17.1), either to "tear up [or] . . . to plant" (cf. Jr 1.10) or to "make the whole of creation new" (Rev 21.5). Thus the act of creation — "Let there be light and there was light" (Gen 1.2) — is a prophetic word bringing about objective reality and is not the work of a demiurge producing order in the chaos of matter. Word is deed.[4] All things have the Word as their origin and source, not just in the past but continuously.

The 'Word,' however, refers primarily to that which existed before any projected reality so that the first sentence reads: "In the beginning was the Word, and the Word was with God, and the Word was God." The eternal Word is at the basis of the prophetic word and indeed of every human word, even the most banal. It both grounds and transcends them.

The Prologue of John starts with the eternal and with the prophetic, creative Word and goes on to speak of the incarnate Word. The one eternal Word, which is God (*theos*) and is turned towards God (*pros ton theon*), is indeed expressed in many diverse ways but "the Word was made flesh and dwelt amongst us" (Jn 1.14) and is fully expressed in the person of Jesus of Nazareth. The Gospel goes on to show how, in his works and words, this is the case. "We have seen his glory, as of the one full of grace and truth" (Jn 1.14). That same point is taken up in I Jn 1.1-4: "Something which has existed since the beginning, that we have heard, that we have seen with our own eyes; that we have watched and touched with our hands: the Word, who is life — this is our subject."

Recognition of the Word and Interreligious Dialogue

INTERRELIGIOUS DIALOGUE

Interreligious dialogue is sometimes divided into four categories:[5] the dialogue of life, where people of different faiths mingle and meet; the dialogue of cooperation, where they engage in common tasks; the dialogue of experts who explore their respective traditions in a more academic fashion; the dialogue of religious experience, where people share at the deepest level.

The fourth dialogue, that of experience, goes beyond the dialogue of daily life or of cooperation and its works, beyond the dialogue of experts and their many words, beyond categories and theologies to the deeper level of silence and stillness. It goes beyond words to the Word, to that illumination which is believed to have occurred in the interlocutor. It acknowledges that in them too the divine is alive and active.

The dialogue of experience presumes in the first instance that the participant has already a *logos*, for how can there be *dialogos* if the participant has nothing to contribute.

4. Goethe is well aware of this when he famously has Faust change the translation of the first sentence of the Gospel of John "Am Anfang war das Wort" to read "Am Anfang war die Tat."

5. 'The Attitude of the Church towards Followers of Other Religions,' in: Francesco Gioia (ed.), *Interreligious Dialogue. The Official Teaching of the Catholic Church (1963-95)*, Boston: Pauline Books, 1997, pp. 575-77.

Before any acknowledgement of another's *logos* there must be an awareness of one's own. It presumes that the participant possesses more than an academic knowledge and has personally experienced the essence of a tried and tested tradition.

There is also a presumption of truth in the other, which is not simply naïve, nor just a matter of good will. Only on that basis can the dialogue proceed.

THE RECOGNITION

It happens that on meeting members of another faith, a resonance (*dhvani*) begins to hum, a 'buzz': it is the vibration of the inarticulate Word. The interlocutors begin to recognize in each other the Supreme Word (*parāvāc*) from which all springs and of which rites and symbols are the valid but inevitably inadequate expression. My openness towards the interlocutor makes me perceive both his difference and our identity. The recognition occurs at a level beyond all thought constructs (*nirvikalpa*) and leads to a great joy (*ānanda*).

The meeting can at first seem bewildering because of the irreconcilable frameworks (*vikalpa*) of different religions. It can be disturbing because of the errors that may affect even the most developed traditions. If the interlocutors confuse the supreme Word with its inadequate expressions, they will remain at the surface and not discover the depths of their own tradition. On the other hand, if the expressions are rejected as irrelevant the dialogue will become unintelligent and merely sentimental.

The diversity is a fact. It also serves a purpose, for the diversity with its irreconcilable variety requires the person to go beyond mind and to discover the one Supreme Word, which stands as the source of all words (*vaikharī*).

The meeting of religions involves, therefore, a belief in one's own tradition and at least a readiness to acknowledge that the teaching of another tradition is in its essence an expression of the Word.

The meeting is the moment of recognition, for I recognize in the representatives of the other religion the Word that lies at the basis of my own. There is a perception of like by like, same by same.

It is also a moment of revelation since the Word perceived in the other shows all the more powerfully the Word present in myself. We bring each other into contact with the Word and are thus initiated into the Word. We evangelize each other. Furthermore, the other reveals me to myself, and brings me to myself just as he brings me to himself. His presence is a proclamation of myself to myself and vice versa. He reveals himself to me and by this fact he reveals myself to myself. He is the manifestation of my inmost self. I recognize him and recognize myself.

The recognition involves an acknowledgement of identity. The inmost self of the interlocutor is my very own self. We are essentially the one reality, the one Word, or to use the language of 'Kashmir Śaivism,' we are the one Śiva. I recognize myself in him

and his self in me. At the deepest level there is an identity of consciousness (*saṁvit*) and being such that silence and communion are the only adequate response.

The recognition does not take a person away from himself. Rather, it reveals his true self, forgotten for a while. It is the moment of identification when we become one body, one reality. He recognizes me as his very self, not so as to eliminate my personhood but to proclaim that he and I are one. The recognition eliminates the individual but not the person. Once the realization of identity has occurred the sense of separation and individualism disappears. It is a saving act.

It is not a question of a Christian becoming a Buddhist or of a Hindu becoming a Muslim. It is not a question of belonging to two or more religious systems, a double belonging (*double appartenance*),[6] but in recognizing that there is a common bond, a unity at depth.

As Bettina puts it in her brief account: in the presence of Swami Lakshman Joo she recognized her own self and came to know who she already was. Swami Lakshman Joo was not simply himself, entirely and authentically. He was also Bettina's self, for his self knew no bounds.

THE WORD MADE FLESH

According to Christian theology, what is true of Swami Lakshman Joo is supremely true of Jesus of Nazareth who knew life and death such as no religious figure has done. In Christian theology, the Supreme Word is made flesh at Bethlehem and is able to communicate most powerfully as flesh to flesh, human to human, the vulnerable to the vulnerable, but becomes fully himself, supremely Word made flesh, when he ceases to be limited flesh. The Christian faith holds that the moment of supreme revelation is found not in the words and works of Jesus in time but in the dislocation and meta-historical event of his death and resurrection. He is completely found outside of time or, equivalently, in the heart of everything.

For the Christian, the Good News does not mean opposing Christian truth and 'pagan error' but rather acknowledging in the interlocutor the presence of the Word who has been made flesh in history. Furthermore, the Word became flesh so that all flesh might become Word and all deities might be seen as Saviour.

We come here to a crucial point. Is Jesus, who belongs to no institution or race and belongs to everyone, uniquely the Word made flesh? Is Jesus of Nazareth, in his life, death and resurrection, fully and essentially and primarily the Word? Is the crucified one indeed the Chosen One? (Lk 23.35) This is a crucial question, which exceeds the limits of this paper.

6. C. Cornille, 'La dynamique de la double appartenance,' in: J. Scheuer/D. Gira, *Vivre de Plusieurs Religions*, Paris: Les Editions de l'Atelier, 2000, pp. 109-21.

Epilogue

For many people today, the figure of Jesus the Christ is unpalatable since they do not recognize themselves in him. He is presented as exclusive and excluding, separate and unattainable, a parody of himself.

While the Gospels portray Jesus in the flesh, according to St Paul "that is not how we know him now" (2 Cor 5.16). For the Christian, the meeting of people of different faiths will reveal the Word made flesh in ways that have hardly been imagined and will lead to a refreshing renewal of the perennial Christian teaching.

23

The Music of the Dharma

Mark Dyczkowski

WE Westerners who live or have lived in India for any length of time all know how it feels to go back to the West. Everything is the same and yet everything is radically different. It is like Alice's journey through the looking glass. We are on the 'other side.' It is, as Aldous Huxley said of the mescaline experience, like a journey to the 'antipodes of the mind' but, unfortunately, without 'the cleansing of the doors of perception.' Jung experienced this transition as a return to his own individualized Western consciousness after being immersed in the collective unconscious. According to Jung, as this unconscious exists from the beginning of all forms of consciousness, when we have a conscious experience of it, it feels as if we are travelling back into the past. The reverse happens when we go back to the West. It is like travelling forward into the future. And as the West values 'progress,' the West which is more 'advanced' is, as Jim Morrison of the Doors puts it, 'the best.'

We who have lived, or are living in India, must face this transition. Our fellows in the West keep telling us that this is an inevitable return to our roots. But instead of being a mystical journey to the Source, many of us experience it as a descent into the lower worlds of conflict, uncertainty, and alienation, attended constantly by the possibility of the loss of self-identity. In short, just as many of us from the West come to India to discover ourselves — for integration, the return to the West may lead to the opposite — disintegration.

We are faced with the hard fact that culture and the many values associated with it are relative. They depend on our human understanding and, above all, appreciation. We discover that people are spontaneously and unconsciously taught to appreciate the elements of their culture — its history, achievements, world-view, art and religion.

> Man lives, not directly and nakedly in nature like the animals, but within a mythological universe, a body of assumptions and beliefs developed from his existential concerns. Most of this is held unconsciously, which means that our imaginations may recognize elements of it, when presented in art or literature, without consciously understanding what it is that we recognize. Practically all that we can see of this body of concern is socially conditioned and culturally inherited. Below the cultural inheritance, there must be a

common psychological inheritance, otherwise forms of culture would not be intelligable to us. But I doubt if we can reach this common inheritance directly, by-passing the distinctive qualities in our specific culture. One of the practical functions of criticism, by which I mean the conscious organizing of a cultural tradition is, I think, to make us more aware of our mythological conditioning.[1]

It is always amusing to observe the music college teachers and students of Banaras Hindu University in Varanasi in north India listening to a performance of Western classical music. They clap between one movement and the other. They move their heads from side to side as they would when listening to the Indian equivalent, even though the rhythm is not at all perceptible to them. When asked a sincere opinion they simply say that it all seems to sound the same and we understand from their reply that they did not really appreciate the performance.

In situations such as this, when people feel that they should appreciate something they cannot or do not, they say 'I do not understand it,' wishing not to offend by their lack of appreciation. But in this case to know is to give value — whether positive or negative — while, conversely, ignorance is total failure to find any real value or even an absence of it. This is an example of how, despite our desire that it should be otherwise, our system of values is based more on feelings than on reason. This is quite obvious to those who have experienced the value of the art and ideas of various differing cultures. The music we like and appreciate is music which makes us feel something. The Truth we acknowledge, and a few rare souls are even prepared to die for, is the Truth we experience as being true. The Christian insists that there were people who saw the resurrected Christ, and the Hindu that the Self is known by knowledge, even though it is beyond mind. The whole of Buddhism is based on the Buddha's experience of enlightenment. The value of the Truth in all the self-evidence of undeniable experience is demonstrated by its effect. The Truth, a Christian feels deeply, will, as the Gospels put it, 'set you free.'

It is this reference to the 'other' that frees the feelings we have from solipsism. "This is not just how I feel, this is how it is." The music does not seem to be beautiful just to me, it is beautiful in itself. If you are like me and have dedicated your life as a Westerner to Indian music you know how frustrating this contrast can be. There is no way any of us will be convinced that the music seems beautiful just to us. It *is* beautiful in itself and those who don't experience it that way are 'mistaken.' Moreover, it is rich, fulfilling, devoid of any sense of its being incomplete. Again, there are 'objective' levels of attainment. We can clearly distinguish that some musicians are better than others. My personal preferences may vary to a degree, but there is agreement amongst many people about who are the best musicians. I know thereby that my feelings are not just my own. I share them with others, many others. In other words, I am experiencing a common object

1. Frye Northrop, *The Great Code: The Bible and Literature.* Quoted in: Anne Baring/Jules Cashford, *The Myth of the Goddess. Evolution of an Image*, London: Penguin, 1993.

with other people. The values I have are not just my own. But even so, these feelings are not shared by the whole of humanity — far from it!

May I dare to transpose all these observations to the field of religion? Religion is much more than music. It differs in many ways. For example, it has a substantial verbal content compared to music. Moreover, it relates to the whole of our life and not just to some particular moment. Religion has a soteriological dimension which music may also have but is not so immediately apparent. There are many more differences. And yet, the 'feeling' element is not so very different. The strange interplay between 'subjective' and 'objective' is also similar. There is also the hard fact that there are different religions and that those belonging to one usually cannot 'understand' or at least appreciate others.

One could add another feature, which is strangely analogous. The basis of Western and Indian music is radically different. The possibility of having a fixed drone for Indian music is the core of this difference. Much of Western music is based on modulation (the changing of the tonic — the 'base note of the drone') and harmony. Indian music has evolved to a fixed tonic. We can only make use of certain notes for any one *rāga*. To the Western music lover, who does not 'understand' Indian music — that is, who does not experience much through it — the music is 'primitive.' It possesses only a part of the features of the music he appreciates. It cannot take him 'all the way.' This is true also of his religion. He will be obsessed by the 'primitive' character of other religions in relation to his own. He will *feel* that they have not developed to the level of his own. They are, therefore, at best partial, provisional truths. As such, from one point of view, they are false. They are false because they pretend to be able to get you to the end of the path but cannot really do so. They are not false, however, if they are understood as stepping stones to the true religion, which is, of course, his own.

From a Buddhist's point of view, the central Truth of Christianity is provisional. This Truth is Christ. He, the Man and God, is the Truth, according to the Buddhist, if we accept that His true identity is realized once one has travelled beyond thought constructs. This is where the extinction — *nirvāṇa* — of craving, the ego and all painful finitude takes place. The Buddhist will insist that this must be the teaching of Jesus also, as it is of the Buddha, otherwise how could it be true? The Christian, for his part, may well sneer at the Buddhist teaching as instructing merely in transitoriness and all its consequences both at the ontological and epistemological levels and that there is still much more to realise, namely, Christ.

Finding myself often in the position of an observer, rather than a follower of just one religion, to me it seems evident that the problem is that every religion has something to offer which others do not have. Indeed, this something lies at the very core of that religion, for example, the Christ of the Christian and the Emptiness of the Buddhist. Christianity would not be Christianity without Christ and Buddhism would not be Buddhism without Emptiness. But, following this example, the 'something' of one religion cancels out the

other. If you try to supplement Christianity with Buddhism or vice versa you are creating an impossible mix, at least from the point of view of reason. As I write this I can almost hear the open-minded Christian or Buddhist protest. But the fact is that to make Buddhism fit with the Christianity of the Gospels, one would have to say that the Gospels do not contain all the teachings of Jesus and/or misrepresent them. The Christian would have to attribute a kind of transcendental 'No Mind' theism to Buddhism, which it has always considered to be a heretical misrepresentation of the Buddha's teaching.

Each major world religion is, for those who believe in it, complete. My personal opinion is that this is also objectively true. By 'objectively' I mean that it is not just an opinion, or a feeling of some people. If I were a perfect Buddhist, I would have reached the goal of human life. This is true if I were a perfect Christian, Muslim or devotee of Lord Kṛṣṇa. At the same time, however, no one religion is complete, in the sense that it does not see all of reality from every possible point of view. It sees reality completely from one point of view. This sounds like a criticism. One could develop it into an *apophansis*, which denies that there is any fully correct view at all, as all views are necessarily just one point of view. But I do not mean to do this. Each point of view of reality and the religious dimensions it implies, when fully developed, is complete. It explains everything fully and consistently, *as far as is possible.* Just as there is the mystical doctrine that every one thing is of the nature of all things (which explains how the body can be a microcosm), the same is true of every point of view. Each point of view contains all the others. But it does so in such a way that this phenomenon not only does not compromise its identity, but reinforces it. My body and the Whole of me is all things, this is why I am just as I am and am not anybody or anything else. When saying this I am speaking from a certain point of view. I can develop it to its fullest extent, given time and depth of insight so that this point of view can, as I have just said, contains all others *as far as possible.*

The limit of this possibility is the identity of this point of view. If I try to reach out beyond this limit, this point of view becomes a different point of view.

It is essential to add one other observation at this point, in order not to be misunderstood, although it renders the matter even more frustratingly complex. When we are talking about a world religion, we must do so with tremendous caution and, above all, great respect. This is not only because the world religions have involved millions of people over the centuries, amongst which some have been the greatest spiritual geniuses of humanity, but because they are never the products of just one or more peoples' reason or intuition. They are based on realization and revelation. It is absolutely essential to stress this fact. No religion is 'man-made' in the sense that someone or group of people have sat down to figure it out. Authentic religion is a product of insight into what is existent in itself, independent of our own ideas. It is a two-way process. Reality *as it is* becomes manifest — the *dharma*, as the Buddhist puts it, 'dawns.' God tells Moses on Mount Sinai that He is who He is. Jesus implicitly echoes His Father's affirmation when

He asks His disciples who they *think* He is to elicit the correct response, that He is God Himself made Man. This is the Truth, which is independent of his disciples' opinions and points of view. In short, at the core of each religion is the Truth, which is discovered. This discovery is a revelation, which sets the seeker free of all that is painful in any and every way forever.

Having said all this, we can return to the main line of our argument to support the thesis that each religion is one complete point of view. This uniqueness is not however, totally exclusive. One can illustrate this point by a phenomenon that has occurred in the development of Christianity. In general, the Semitic point of view within scripture does not allow for any discussion of Deity as consciousness. The Deity, in some sense or another, is a concrete (although, infinite), Person. It is not consciousness, which is thought to be abstract and impersonal.

As we all know, all three of the major Semitic religions, Judaism, Christianity and Islam, came into contact with Greek thought. The Greeks had developed many varied and elaborate concepts of the Absolute and consciousness. These ideas were, in many cases, based on experiences of Reality, and so were felt to be powerfully compelling, but represented a metaphysics at odds with the Semitic "host" religions into which they came to be assimilated. As with the other Semitic religions, this 'but' in the Christian context cut two ways. On the one hand, the Christian had to defend his Christian identity. His uniqueness as a Christian was, and is, based on the Uniqueness of Christ — the *apex unicum*. Accordingly, he fought Greek gnosticisms and Neo-Platonism tooth and nail as abhorrently heretical. At the same time, the Greeks had much to offer. Thus, through this contact, the Fathers of the Church evolved, amongst other things, a very elaborate doctrine of consciousness right from the first centuries of Christianity. The same happened in its own way in Judaism and later on in Islam.

Even a casual reading of the early Church Fathers would be surprising for most people. These early Christian contemplatives had developed an extremely elaborate psychology. In their solitude and silence, they observed the workings of the mind. They clearly understood that the gap between virtue and vice, man and God was the flux of thought. The devil, according to these mystics, is the distracting thought of things that are not God. Prayer is a means to concentrate on God and detachment from all else because it trains the mind. A mind which is one-pointed and attends to God is the vessel of God's grace. The Christian loves Christ and hence keeps his commandments to the degree in which his mind is, by God's grace, fixed on him. This is what it means to be in Christ, just as Christ is within God.

Anyone who has even a superficial knowledge of oriental religions can immediately notice that the methods to achieve this are all forms of theistic *yoga*. And *yoga*, or whatever you wish to call it, based on a concept of developing divine consciousness, does not, apparently, belong to the 'original' scriptural point of view. Thus, even though these

mystics are called, and considered to be, fathers of the Church, the Christian is warned to read them with caution!

To some Christians this seems unbelievably bigoted. They may even worry, as I do, that this attitude may lead to the intolerance and narrow-mindedness of fundamentalism. To these other Christians, however, it seems that they are preserving the integrity and identity of the Christian point of view. They are in fact operating according to the principles outlined above. Christ is all things to all men. At the same to time He is, and must be, *unicum.*

So are there any channels through which we of differing religions, differing cultures, and differing points of view can make contact? I wonder. Tolerance is certainly essential not just for a theoretician but for all of us. Most of the wars we wage against each other are due to our lack of tolerance. It is immensely tragic. One could well ask oneself whether religions have not done more harm than good. The slaughter in the name of religion is immense.

But tolerance can very easily be condescending. The Christian prays for the poor Jew, for the ignorant Muslims who do not know Christ. He may pray for the Jew in particular who is so near and yet so terribly far. The tolerant Hindu goes on repeating the hackneyed cliché that 'God is one,' the Buddhist that 'all is Void' — mere thought constructs, but good to the extent that they are religious.

For the past ten years I have been searching for 'loopholes' in the teachings of Jesus presented in the New Testament which allow for an opening out to other religions. Perhaps I should not be as surprised (I am tempted to say shocked) that they are very hard to find, if they exist. Those who have hardly studied the Gospels at all instinctively react to this fact, even without knowing how hard and fast it is, by saying that the Gospels are not the real message, or at least not all of it, of Jesus. Jesus cannot, they feel, have been as bigoted and narrow-minded as his saints seem to them to have been. But then his saints respond to these other people by questioning very seriously the depth of their faith. This is a measure of their understanding of the Good News of Jesus. The Good News is that the Messiah has come and that he is not only the Son of Man but also the Son of God and that He is the Truth. Every Christian should ask himself what Christ himself asked his closest disciples to consider 'who do you think I am?' And yet, even in the Gospels there are small openings to another world. Like the lame man who was lowered through the roof of a house where Jesus was preaching, there is an opening up and out from where he is, through which those who wish to can return back into Jesus. But this opening, like all the others we may find, is such that it closes with the ease with which it opens. It is like a valve that works both ways. It keeps the Christian in while allowing others in with him. At the same time it keeps those who are out, out.

The passage in question appears in two contrary versions in two Gospels. In one, the disciples question Jesus how they should react to an exorcist who is casting out devils in

Jesus' name but is not himself one of them. Jesus responds simply (and I would say sanely) by saying 'those who are not against me are for me.' This means that he can go on doing what he is doing, it is quite alright. In another Gospel, however, Jesus is reported to have said the opposite 'those who are not for me are against me.' Here the context is a dispute between himself and the Pharisees. In this context, the fact that they do not agree is not passive but active disagreement.

To my mind, this interesting variant in the two Gospels illustrates a number of important points. Firstly, it is essential to protect the Message from being just one amongst others. At the same time, it must be made accessible as much as possible. It must be both a narrow and a broad path. Narrow enough to exclude ambiguity on the absolute priority of Christ, and yet broad enough to include the whole of humanity, so that 'every knee may bend to His name.'

Is this real tolerance? Is this the real and complete message of Christ? Of course, nobody *knows* but then that is what faith is about, isn't it? Its object is God and His truth, which we don't yet fully know but *believe*. Someone may object that, in that case, we can all start interpreting the Gospels according to our own belief. Not at all. There is the Spirit of Truth, which will guide the Church when Jesus is no longer in the world and this Spirit of Truth is the soul of His Church who guides God's people, the Israel of the baptised. If all Christians knew the Truth there would be no need of the Church, the Spirit of Truth, or even the Gospels. But he does not *know*, he *believes*. Does this mean he can be mistaken? No, he would say, because what he has been told has been told to him by God Himself. But God Himself in the form of Jesus is reported as having said that "there are many more things that I could tell you." The remaining portion of the Truth (assuming for a moment that Truth is finite), will be told to the Christian by this same Spirit of Truth. Now, as Jesus is supposed to have lived an earthly life for barely 33 years, the Spirit of Truth, which is as much God as He is, should have been operating for a period of time which is over sixty times longer than Jesus. Those Christians who base their Christian faith on the Gospels base it on three years of Jesus' preaching as recalled by his disciples. These are the people who are the most certain of their having understood Christianity the best! They may read what great Christian saints have had to say afterwards but they do not need to comment or expound them. The Gospels contain everything!

It is hardly surprising that such Christians do not find anything of spiritual value in other religions when they find so little of it in their own! It is a strange pride of the uniqueness of Christ that nobody can have any voice of his own unless it is to echo Christ's words as reported in the Gospels.

But there is a great exception. This exception is embodied in the Epistles preserved as the Word of God. The fact of the matter is that no one who has had anything to say about the teachings of Christ after the middle of the second century of the Christian era

can be said to have uttered God's Word. To my mind, this Obscuration of God is as great a Mystery as His revelation some two thousand years ago!

These *human* endeavours on the part of some Christians is based on the sincere need to avoid mere human opinion and try to listen to the Word of God as it is and really try and understand what God is saying, not just what men may think he is saying. Hence, the distrust of thought, the seeming irrelevance of consciousness, and the constant struggle on the part of these Christians to stay away from what is not God's Word. All this would work if it were not for the basic human fact that people do experience what Christians call God outside of Christianity. Well then, someone may say, why not convert to that other religion? This does of course take place. But then the same 'problems' arise *mutatis mutandis* in that other context! So why bother? This is not a problem, some may say. But it is certainly is for many, because many people in this increasingly global village are having multi-religious experiences. They cannot accept, quite rightly in my view, that they should censor these experiences so that they can fit with those of the other members of the mono-religious community they may belong to. We who have these experiences are always the black sheep and must necessarily live liminal lives at the periphery of our religious community if it is a mono-religious one. We are not allowed to speak because we will inevitably say something which does not accord with doctrine. We must listen and, if we are truly multi-religious, experience deeply the truth of that religion.

I have not made a survey, but as far as I have been able to observe, such people basically belong to one religion and have experiences, and hence hold views, consonant with other ones. Thus, for example, there can be, and there are, Christian Hindus and Hindu Christians. These two people can be very different in their perspective and, I believe, this makes sense and is as it should be.

The Dangers and Advantages of Building Systems

When dialoguing with someone who holds particular religious beliefs, it is not only very bad method, but can also be extremely offensive, to tell him that his understanding of his own religion is incorrect. If a Christian feels more at ease with a particular dogma concerning the nature of the Eucharist rather than another, it would be very wrong for him to impose that view on a fellow Christian with which he is dialoguing. The same would of course be true for a Tantric Buddhist, for example, with regard to his conception of divine forms in relation to a Theravāda Buddhist. Attempts to change the views of those with whom one is dialoguing are in reality attempts at conversion. This is certainly not what any dialogue is about. It is also not a good basis for dialogue to think 'tolerantly' about the other person's religious convictions while thinking that they are mistaken. People who react in this way to other people's religious beliefs are not ready for an honest dialogue. The reasons for this are not only moral — the other participant is being treated as more stupid or misguided and hence inferior in his beliefs — but is also bad method. Why engage in dialogue at all if my own religion contains all the answers? If

one asks this question of a committed Christian, even one actively engaged in dialogue, the response is often a puzzled and embarrassed silence. For a Christian to say that he can learn something from a religion as fundamentally different as Buddhism or Hinduism seems to be an admission of a personal lack of faith. If Christ is all things to all men, He is amply sufficient. Well let's try making excuses for ourselves. Isn't Jesus reported to have said that there are many things he did not tell us two thousand years ago that will be revealed later in time? Perhaps the Gospels are not fair representations of what Jesus did say. We may try to distinguish theology from the Gospel. We may (and I believe this is the worst possible option, both in terms of method and honesty), make a whole new theology up for ourselves which is as we want it to be providing us with a set of beliefs which allow for dialogue without discomfort. I am not against new revelation and the system-building and theologizing which often accompanies it, if the result is yet another person or group with whom dialogue is possible. Each person has his own ideas, set of beliefs, cultural forms and norms to which he tries to adhere. If we move out of our Western culture we discover that they can be immensely varied. We notice that they are all as stringently impelling and meaningful to others as are our own. If we are open-minded and have the capacity to adapt, we further discover that we assimilate them also at times so much that they may become equally compelling and loaded with the sense of their reality and truth as they are for those of other cultures. Although some may think so, Western Hindus or Buddhists are not insincere, they are not playing a game.

The point I am trying to make is that, when engaging in dialogue, one must try simply to understand as fully as possible what the other person is saying. Conversely, I must try as best as I can to make myself understood without attempts at proselytization or putting myself in opposition in some way to my companions' beliefs. Those engaged in dialogue need not fear that this compromises their own beliefs or that it indicates that they are incomplete or that one's own faith is unsure. Dialogue is simply dialogue. It is both the means and the goal, so to speak. It is a means of perceiving the other as he or she is in his or her humanity. It is a vehicle of human contact and also a way of understanding one's own beliefs better.

Many Paths, Many Goals

The readers of this essay certainly know, and many may well agree with, what one could call a 'universalist' view of religion. It is one that says, amongst other things: "there are many paths but only one goal." Although this goal is often only vaguely defined and — in more ways than one — according to one's own personal taste and experience, it is a view which seems to have reason on its side. In fact, it virtually compels those who believe in it to believe it simply because, they say, it just could not be otherwise.

But what is this 'one goal'? Inevitably, we must search for words and concepts to fit what we intuitively feel must be right. But unless each of us starts from zero to build our

own conception of reality, we must fall back on one or more readymade ones. We try to get out of this predicament by making dogmatic statements of the sort "all religions are one because their goal is ultimately the same." Then in order to ensure the sameness of the goal we proceed to strip it of all possible distinctions from other religions.

We can try to do this in one of two ways. One way is to formulate dogmatic equations — 'the goals *appear* to be different but, in reality, they are the same.' I call this a 'dogmatic' view because nobody who has not reached the 'one goal' can actually know if this is true. It is, in other words, an object of belief, if not, indeed, faith. However, the frustrating fact of the matter is that this 'one goal' is just another goal amongst many ultimate destinations. Certainly, to be fair, one must concede the possibility that this is the 'true' goal. But then, if we assert that, or even if we quietly believe it in ourselves, we are, I am afraid, no longer treading on the universal way.

There is a second way, which, at first, seems more promising. One could call this 'the way of transcendence.' The goal is beyond our comprehension and formulations. It transcends our tiny intellects and its thought constructs. This position maintains that the path — any and every path to the one goal — is steeped in thought. The many paths are temporary fictions. They are of immense, indeed fundamental, importance, but they are merely means which, once reached the goal, can be discarded. Every great religion has this 'zero point.' All we need to do is search for those passages in any particular religious tradition which teach that God, the Goddess, Reality, the Absolute, or whatever else the one transcendent goal may be called, is beyond our conception and that the experience of it is, in relation to things of the world, 'empty.' There is nothing there.

But even this absence is not unique and unequivocal. It can be variously expressed, either positively — 'It is nothing because it is everything' or negatively — 'It is void of all phenomenal existence and conceptions.' Again, this can be because It is beyond everything as the really real compared to everything else which is relatively real, or else because Its existence is the Being and, hence, ultimate cause of all that exists. According to this view, the mystics are those people who have experience of the spiritual fullness and perfection of this 'emptiness,' which is the only 'real' and ultimate mystical experience. Whether the mystic is a Buddhist, Christian, Hindu, Muslim or Jain, he has this same ultimate experience.

Even so, the fact of the matter is that these people remain Buddhists, Christians, Hindus, Muslims or Jains after this experience. Indeed, it is this 'same' experience which fulfils them in their particular path. The truths they were taught concerning the Truth are perfectly and spontaneously confirmed. If not, the mystic must found a new path. As we all know, this does happen. But if this does not occur, the mystic does not usually become an apostate. He does not abandon his religion even if this experience may be explained to others and be experienced for oneself as somehow 'going beyond' one's own religion and, with it, all others. Rather, he will tend to accommodate this

transcendence into the views he has gone beyond. Indeed, every religion must have a transcendent dimension beyond words and established in reality. Religious truth is not merely the correctness of a mathematical operation or the correctness of a statement, it must be grounded in reality. Like an empirical fact, the ultimate Truth a religion preaches must be independent of knowledge of it, in the sense that it is as is whether known or not. But unlike an empirical fact (assuming for a moment that empirical facts are of this nature), it is also essentially (and not just incidentally) involved with those who experience it. This is even so if they experience it, as Buddhists put it, by a realization of their absence, at least in terms of what we generally consider to be our own and other peoples' presence. But although this may all be true, even in the 'ultimate' sense, the 'ultimate truth' cannot serve as an ontological or even metaphysical ground for the predication of an 'ultimate' oneness (or 'non-difference') between religions.

Let me come directly to the point. I submit that if we stop to consider for a moment, without prejudice, we find that each religion as an eschatological path differs from other paths because it suits a different goal. What we are aiming for compels us to find an appropriate way to attain it. And this way depends on what we are seeking to attain. If all the goals were really 'one,' the paths should also be 'one.' But this is simply not the case.

We may say that this is because different people have varying dispositions and/or levels of attainment and hence understanding. This way of looking at the path to liberation has been the hermeneutical key, which Buddhism (indeed even the Buddha himself) has used to open the locks of the seeming contradictions in its own diverse teachings. But this method presupposes that there is not only one goal but also only one path. As we progress, we should go from one religion to another, approaching as we do so the ultimate teaching which transmits in the purist way possible, in terms of human concepts, the doctrine concerning this 'zero point.' This may be true. But I find it hard to accept this view because this simply does not happen. The Christian mystic who has had been given the highest Christian revelation, namely, the mystery of the Trinity, does not become a Buddhist or Advaita Vedāntin. This is so even though he tells us about it in terms of cessation of all thought constructs, calls it a 'pure light' or the Godhead, which is the essence of God that transcends the 'personal God.' In fact, the Christian mystic emerges out of his 'zero point' experience to proclaim the Gospel of Jesus Christ. Similarly, the Buddhist preaches the truth of Dependent Origination and the doctrine of Voidness, which (as the Dalai Lama has expressly said many times) is not 'God,' although it stands at the summit of Buddhist spiritual endeavour.

So where do we go from here? One way is to take the path of the devotee and cling with passionate love and fidelity to one's own path, belief and the goal to which they point. Great world religions have been founded and developed by men willing to die for their beliefs. For them not all paths and goals are one — not at all! Another way for those who "know more" is to be honest and see what is in front of their noses: every major

religion is *radically* (that is, from it very root, which is the reality it preaches as ultimate is) different from every other. Then they can acquiesce in the ontological chasm that divides them in the pious silence of Unknowing and, illumined by the grace of their goal, see unity where it exists and accept the differences where they are. This frees one from the necessity of having to build new systems and preach new religions. If we do that, we create more diversity by proposing yet another goal and hence another ontological gap. And if we try to convert others to our own religion we transfer this gap into our daily life.

But while this is true of major religions, there is another religious phenomenon that we need to take into account. That is the proliferation of diversity within any one religion. The great Semitic religions try with varying degrees of success to restrain this phenomenon. Many bloody wars have been fought between Catholics and Protestants, Shiites and Sunnis, though they are Christians and Muslims. Certainly the reasons were political and social as much as religious; none the less, such conflicts are fired by the spirit of the people to affirm their version of the Truth. Indeed, if we examine any major religion closely we find that it breaks down into 'sects,' 'churches,' 'schools,' or 'traditions.' This is but natural. The cardinal example of the way a path may diversify is Hinduism. The paths there are so many that there are those who are of the opinion that Hinduism is more than one religion. Again, here the criterion which distinguishes a path or the branch of one is its goal. Vaiṣṇavites are those Hindus who are on the path to the attainment of the god Viṣṇu, and Śaivites, Śiva. Both are again subdivided into paths depending on their goal. Vaiṣṇavas may be followers of Kṛṣṇa or Rāma. Schools may be more or less dualist, etc. The same is the case with Śaivites. The development of a huge number of Tantric traditions from the middle of the first millennium onwards witnesses a phenomenal expansion of paths and goals. Here, as we would expect, we find countless examples of applied comparative religion. I shall quote the great Abhinavagupta. One of the finest minds India has produced, he expounded metaphysics and theology couched in such a highly sophisticated phenomenology that there are some who claim that it is not a religion. They mean that it is based on the 'scientific' principle of observation of cognition, which establishes by its very nature the existence of a dynamic, universal consciousness, which must be Śiva who is thus 'self-evident.' Here one may think is an insight so universal, so free of presuppositions that it affords a glimpse into the One Goal at the end of all paths. Indeed, Abhinava does claim that the Trikakula, the school of Śaivism he maintains is the highest, is the essence of all paths. However, he adopts the common method of placing each goal and its path on the rungs of a ladder. They are not equal:

> Thus there is only one tradition. On it everything is founded, from popular doctrines up to that of the Vaiṣṇavas, the Buddhists and the Śaivites. The supreme end of all of it is the reality called Trika. As it is present in everything and is undivided and uninterrupted it is known as Kula by name. Just as the

various parts of the body, superior and inferior, are divided one from the other, its life is none the less just one; similarly, Trika is present in all things, as scripture confirms. It is written in the *Kālīkulatantra*: 'Transcending the five currents (of scripture) this reality is said to be the essence of the ten and the eighteen divisions (i.e. the twenty-eight Siddhāntāgamas). Just as there is smell in a flower, oil in sesame, life in the body, nectar in water, similarly Kula is present in all things.' Thus, this tradition presents itself in various ways, in accord with the variety of perceivers. Belief is indeed only one even though it belongs to people of differing creeds, whether voteries of our doctrine or of that of others. The Sāṁkhya, Yoga, Pāñcarātra and the Veda should not, as the *Svacchandatantra* says, be censored as they (all) originate from Śiva.[2] These various traditions current in the world are but isolated fragments of a single tradition. They obscure and delude their devotees.[3]

Abhinava is always ready to point out that his tradition is superior to others. He quotes the *Svacchandatantra* as saying: "Those who preach the doctrines of Viṣṇu are all impelled by *Māyā* to wander (on a path) which is not that of liberation in their desire for liberation."[4] Pure Knowledge (*śuddhavidyā*) is divinely inspired, sound reasoning (*sattarka*) that leads one to adopt the right path which is, of course, that of Abhinava's Trika. Trika is superior to other schools not just because it leads to the highest goal but also because it is the best, most effective path to any stage along it. Thus, according to Abhinava, the *mantra*s of other Tantric schools require varying degrees of purification. "However, the *mantra*s based on the unsurpassable Trika are all, at every moment and in one place, the source of every good."[5] One could cite numerous other examples of how this path is no less exclusive, however much it integrates other paths and other goals into its own. This is because the great Abhinava is bound to apply a principle that I propose applies to all the so-called religions and 'popular doctrines' of the countless folk, tribal, and rural minor religions of the world. This is simply formulated in the equation 'the path is the goal.' The Jesus that Christians believe in proclaims that he is the Way and the Life. Kṛṣṇa is both the teacher and the source as well as end of his creation. The realization of the Self is the *Brahman*. The realization of Emptiness — that is, dependent origination — is the path and goal of Buddhism. Flattery and chastisement of ghosts and demons removes them by taking them into account each individually according to their specific identity and so on. All paths high and low — major ones and the minor ones they encompass — all have their own goals. These may be separate perceptions of the same goal from the point of view of those on branches of the same Path. Christian ecumenism is much more concerned with these people than interreligious dialogue for the simple reason that the goals of other religions is not that of participating in the relationship the Christ has with the Father.

2. *SvT* 5.44cd-5ab.

3. *TĀ* 35.30-37.

4. *SvT* 5.113b-114lab = *TĀ* 4.38.

5. *TĀ* 11.88; quoted in John Dupuche, *Abhinavagupta. The Kula Ritual as Elaborated in Chapter 29 of the Tantrāloka*, Delhi: Motilal Banarsidass, 2003, p. 83, fn. 38.

This view will seem outrageous to many who espouse the path of 'Many Paths, One Goal.' But need not be. Theirs is a wonderful and true path, as is their goal. Christians, Hindus, Muslims and even Jews may tread on this path as do those who, like the Bahai, have made their goal a multi-religious one. The fact of our human existence is that to assume any other positions and live by them you must be on a Path. This means that you must have a goal. Like the Buddhist Nāgārjuna you may suggest that, as they are relative, neither ultimately exist — they are both views — one maturing and the other its fullness. As a Christian, for example, you may suggest a 'beyond,' which is the central core of Deity and hence of all goals, what Agehananda Bharati, as a Hindu, called the "Zero-Point experience." But I suggest that if your path is Jesus or Kṛṣṇa you cannot simply kick them away from under your feet like one who does so to a ladder that has served as an aid to climb over a wall. The boat Buddha was tempted to abandon once he reached the other shore was so intimately connected to the goal he attained that, had he not come back to this shore on the same boat, none of us would have known anything about his attainment. Those who believe in many paths to one goal betray all the paths and every goal unless they choose one of them from which to view the others. Otherwise, if none of those available is appealing, they must make a new 'Multiple Path' to reach their 'Multiple Goal.' But this, inevitably, would be another path and a different goal.

There have been very few, if any, truly multi-religious, fully realised souls. The most famous example is Rāmakṛṣṇa, the nineteenth-century Bengali devotee of the goddess Kālī. His biography is full of wonderful stories of his experience of the highest or ultimate stages of many paths. Although a devotee of the Mother Kālī, directed by his teacher of the Advaita path he slashed her to pieces with the 'sword of discrimination' when she appeared before him and entered into such profound contemplation of the absolute *Brahman* that he could not be roused for months. There was a period when he loved Lord Kṛṣṇa so intensely he identified himself completely with Rādhā. Similarly, when he was a devotee of Lord Rāma, he was so identified with Hanumān that he lived in trees and even grew a tail. He even had a vision of Jesus. However, in each case Rāmakṛṣṇa reports that to prepare him for the new path and its goal, his mind was miraculously emptied of all his memories. Thus, his example confirms that practice conforms to theory — each goal is on its own separate path, so it is impossible to be on more than one path at a time and to have more than one goal. Otherwise you would have to be more than one person, which is not impossible, but far from psychologically integrating. Rāmakṛṣṇa was more 'open minded' than Abhinavagupta. He understood his experience to mean that the many paths and their many goals were all equally the result of the joyful sport of the Mother. She is Māyā — not the one who 'obscures and deludes' the devotees who are followers of the 'isolated fragments of a single tradition' but the Māyā who enlightens and inspires in myriad ways. She, the Mother of the Universe is, of course, Rāmakṛṣṇa's path and his goal.

Well then, are all religiously-committed people in different boats that pass each other in the night directed to different ports? No, that would be a view that would be anthropologically, psychologically, morally and, yes, also spiritually unsound. I do believe that all of humanity is actually on one great path and so has a single goal but that can only be indicated indirectly and in the most abstract of terms. The minute we try to formulate what it is, we fall into the aforementioned fallacies. Even so, one provisionally may say, that that path is that of spiritual development which leads to the most fully spiritually developed condition. Like the universal in a particular, this path is exemplified by every path as is its corresponding goal. After all every path is *the* path and every ultimate goal *the* goal. We may find similarities and differences between them. Both are equally essential if we are to compare two things. Although the complex totality of paths and goals cannot be reduced to one another or a common *tertium quid*, we may extract common empirically definable features. This works as long as we do not forget that they are not in context. We may apply the principles of apophatic 'transcendental logic.' Psychology, theories of mind, phenomenologies of perception, structural or deconstructional analysis of myths, legends and even theologies, anthropological, sociological, historical and even philological analysis are all open possibilities as tools for comparative study. We need not be reduced to patronizing moral considerations to justify the importance of interreligious dialogue. It can be part of many paths, or some of their branches and hence also a part of their goals. But we should not forget that we are not just comparing different paths — we are also comparing different goals.

Finally, I should stress that this position does not imply (although it may) that religions are purely human, cultural and psychological phenomena. Nor does the diversity of paths and goals mean that none of them are true or that those which are not one's own path and goal are false or incomplete (*pace* Abhinavagupta). I, at least, am not troubled by this immense diversity and it does not undermine my personal belief in my path and goal. Part of a heavenly choir, they can each can be heard, and one separately as well as together with others stir the sensitive soul to sublime heights of contemplation. There, he or she views her own path and goal and those of others like one who sits on the peak of a mountain.

24

Dialogue with Buddhism in the West
Concerning the Interreligious Encounter in a Secular Culture

Johann Figl

'Void' and 'Fullness' — Landmark Experiences of Interreligious Encounter

ONE of the essential qualities of the manifold scientific contributions and activities of Bettina Bäumer lies in the field of interreligious dialogue. In particular, she has contributed to the landmark encounter between Christianity and Hinduism, but at the same time she has given important impulses for the dialogue with Buddhism. In this context her important contributions were in actively organizing and realizing interreligious congresses in India and Europe. One, in my opinion, outstanding meeting was the retreat-seminar "*Śūnya — Pūrṇa — Plerôma*: Void and Fullness in the Buddhist, Hindu and Christian Traditions," organized in the name of the Abhishiktananda Society, which I myself was able to attend. It took place in Sarnath (India) in December 1999.

This five-day meeting with about thirty participants, scholars, Swāmīs and Rinpoches belonging to the different religions consisted not only of a theoretical analysis of these two basic terms 'Void' and 'Fullness,' but the lectures and discussions were embedded in a daily rhythm, which included a combination of meditation and prayer. Thereby, the interreligious dialogue wasn't merely a topic of the discussions, but was taken into practice. A look into the programme shows that about three hours — in addition to the lectures and discussions — were dedicated to meditation together, and also to longer recitations in Tibetan, Sanskrit, Greek or Pāli. The most important aspect of this meeting was, above all, that the Dalai Lama participated in the final session.

I learned much from the way of realization and the formulation of the topic of this conference, because the two leading concepts 'Fullness' and 'Emptiness' are essential spiritual experiences. 'Void' and 'Fullness' are not opposites, but Voidness is this Fullness itself. The terms represent two basic aspects of spiritual experience, two different expressions for the last Reality. But different religions are not simply divided among these two categories, but in every religion both are existing.

The essential subject 'Fullness and Void' also led to the insight that it is less advantageous to speak of 'Sameness' or 'Difference;' it would be, rather, fitting to use the

more dynamic terms 'Convergence' and 'Divergence.'[1] Because "every tradition has its own inner harmony and balance which ought to be respected."[2]

To me it seems that the above-mentioned inquiry — Void and Fullness — as well as the methodical reflections at this seminar lead the way ahead of interreligious dialogue, and both have a special relevance in a secular world. In this context I would like to focus this article on the encounter with Buddhism in the West. In the last century Buddhism became a lived and practised religion also in Europe and in the USA; though still a numerical minority, it is continuously growing. The dialogue between Christianity and Buddhism does not only occur in countries of Buddhist origin — although without any doubt these are and will be important for Western Buddhism — but it is also practised by the Buddhists living in a Christian surrounding. In many cases they are converts who turned away from Christianity (in a minor part from Judaism too) and turned towards Buddhism. If this dialogue should succeed, we have to realize the special aspects of Buddhism influenced by the West. In my opinion these specific motives and characteristics acknowledged in the Buddhist-Christian dialogue, in addition to the general aspects, which result from the structure and characteristic features of these two world religions.

In the following themes and characteristic features of Buddhism in the West shall be mentioned, to stress afterwards some ongoing aspects of interreligious dialogue under the conditions of secularity.

Themes and Features of Buddhism in the West

Two directions of discussions are included in this interim heading: First of all, Buddhism in the West means that this religion, which has existed in the east since long, can now also be found in different continents (Europe, USA, Australia).

Secondly the discussion directs towards whether it has its own *unique* features from Eastern Buddhism; i.e. if there is a specific *Western* Buddhism.

In the following I would like to focus on the second question and briefly outline the first, as I describe the stages of reception of Buddhism in Western culture, especially that of Europe.

There are three stages to be distinguished:

The first stage of perception of Eastern wisdom took place literarily, scientifically and philosophically mainly in the beginning of the nineteenth century. Romanticism, especially the brothers Schlegel, had been interested in the literature of Hinduism; Schopenhauer propagated his view of Buddhism as a nihilistic religion. Nietzsche in his late work *The Antichrist* (1888) placed Christianity in opposition to Buddhism, partly with approval. In

1. Cf. the report by Bettina Bäumer, *Setu. Bulletin of the Abhishiktananda Society*, No. 21, December 2000, pp. 4-9, especially p. 6.

2. Jacques Vigne, *How does a bridge between fullness and emptiness look like? Reflections after the Sarnath Seminar on Śūnya, Pūrṇa and* Plerôma, *ibid.*, pp. 11-16; quotation: p. 12.

the following decades many philosophers, artists and poets were fascinated by Buddhism.

A second stage, which represents a new form of presence of Buddhism in the West, is characterized by the appearance of wisdom teachers from the east in USA and Europe since the end of the nineteenth century. With the beginning of twentieth century, the first Buddhist and Hindu influenced communities were formed. Those were converts, most of them having grown up in the Christian religion who, in their searches, finally found the spiritual answer in the Eastern religions.

A third stage of the reception of eastern ideas in the West started in the 1960s of the twentieth century, when Eastern *gurus* contributed actively to the development of a religious sub-culture, in which meditative practices, in the context of an alternative lifestyle, had a great importance. This alternative-religious movement strengthened the interest in Buddhism as well, particularly in its meditative possibilities and richness. Initially, it were the Zen-courses that were popular. Since the middle/end of the 1970s, the new wave has been the establishment of Buddhist centres, largely Tibetan, which until the beginning of the 1990s gained more and more influence. In this way, Buddhism became a lived and practised religion in the Western countries.

After outlining these stages of the historical development of Buddhism in the West, we can proceed with the general question, that if there is a Western Buddhism, whether it has its *own* characteristics which distinguishes it from the forms of eastern Buddhism, i.e. specifically from the three traditional streams Theravāda, Mahāyāna, and Vajrayāna. Is there a 'fourth turning' of the wheel, as sometimes is said? And in which respect does and will this occur?

I would like to restrict myself to criteria of content and not to institutional ones; such institutional aspects, which result from the encounter with European culture, would for example be the organization of Buddhism as World-Buddhism. A modification of Buddhism in the West in recent times is a new relation between laymen and monks, and the fact that the Buddhism of immigrants and the Buddhism of Western followers are different, so both ethnically and sociologically we meet two different 'kinds' of Buddhism.[3]

From the perspective of content I see five characteristic features, all of which have a certain significance, but partly merge into each other. As keywords for these features I would like to mention:

1. autonomy,
2. rationality,
3. anti-dogmatism,
4. spirituality, and
5. therapeutic practises.

3. Cf. Eva Mullen, '*Tibetischer Buddhismus im Westen. Kreative Innovationen am Beispiel der tibetischen Gemeinde New York City*,' Zeitschrift für Missionswissenschaft und Religionswissenschaft 85 (2001), pp. 182-89.

I will start from historical examples; however, some features are persistent from a more distant past, and others are recent developments.

AUTONOMY

Within this term, the basic Buddhist concerns of 'freedom' and the relation to immanence is mentioned. Those Europeans who had converted to Buddhism since the end of the nineteenth century came from the secular culture of modernity, in which the principles of freedom of dogmas and freedom of choice were important, along with the experience of immanence. I would like to exemplify how this influenced the interpretation of Buddhism in the Western perspective on the basis of the work *A Buddhist Catechism: An Introduction to the Teaching of the Buddha Gotama*, by the German Buddhist Friedrich Zimmermann. He had published this book under the name Subhadra Bhikshu; it was first published in 1888 in Germany and then was translated into many other languages. Before that, H.S. Olcott created a Buddhist catechism which was published in 1881 in Colombo and appeared in German at Leipzig in 1887,[4] and which showed a very theosophical orientation. Zimmermann responded to this theosophical catechism with his own, which was based on sources in Pāli.[5]

One of the first questions in this catechism, regarding how someone becomes a Buddhist, is answered in this way: "By free determination. Not by birth, not by nationality nor race, not by consideration, baptism, or any other legally binding ceremony; for Buddhism possesses neither the power of a state religion, nor a hierarchy."[6] Here we can see also the basic idea of the free, autonomous decision which becomes more and more important.

Another question refers to the Buddha, and he is portrayed as the one who has experienced perfection, enlightenment and liberation in this very life.[7] So it refers to a message and an experience in *this* life and, at the same time, returns to *one's own effort*, whereby the independence of the individual is emphasized.

And upon the questions whether if Buddha was a God who manifested himself to humanity or if he was a messenger of God who came down to earth in order to bring salvation to men, in both cases the answer is a clear 'no.' In the explanation of the name of Buddha is emphasized, that he is

> The Awakened or the Enlightened One; it designates a being who by his own power
> has acquired the highest wisdom and moral perfection attainable by a living being.[8]

4. Cf. Heinz Bechert, 'Buddhist Revival in East and West,' in: Heinz Bechert/Richard Gombrich, *Buddhism in the Modern World*, London: Thames and Hudson Ltd., 1984, pp. 271-85; cf. especially 279f.

5. With this year 1888 and this work in Baumann's view a second phase of reception begins: Martin Baumann, *Deutsche Buddhisten: Geschichte und Gemeinschaften*, Marburg, 1993, p. 50.

6. Quoted after the English tr. C.T. Strauss, Kandy: Buddhist Publication Society, [2]1980 (*The Wheel Publication* Nr. 152/153/154), p. 1.

7. "He, who, of his own strength, attained perfection, enlightenment, and deliverance in this life" (*Buddhist Catechism, op. cit.*, p. 3).

8. *Ibid.*

In these aspects the autonomy, the freedom of choice, the independence, the individuality of man are in the centre. This is a new accentuation of Buddhism, but probably not a complete renewal of this religion, not a new turning of the wheel. Rather this description gives an accentuated answer on the questions and on the self-understanding of man, who is under the impact of the values of modern thinking.

RATIONALITY

In the case of rationality in the context of modernity it is evident that it is a very relevant dimension for the West. This argument is central for Western Buddhists from the beginning: that Buddhism is especially appropriate to the Western rational mentality. The early Buddhists of the Occident saw in Buddhism "a scientific religion of cognition," as Karl Seidenstücker says.[9] A reasonable religion was strived for, which also should be in agreement with natural sciences:

> Especially the presentation of Buddhism as 'religion of reason' made possible a clear
> distance to Christianity, which was felt to be dogmatic, and an orientation towards
> the values of enlightenment like reason and self-responsibility.[10]

If we try to interpret this motive we can say in general that the rational dimension of Buddhism is emphasized especially in respect to modernity. Buddhism was interpreted as "rational thought system," while especially referring to the fact that Buddha unlike other founders of religions did not "demand belief in his doctrine, but invited people to find out its truth by way of reason and religious practise and meditation." And in that sense one can say that Buddhism is "a religion of reason"[11] and it is therefore in an opposition against the religion of belief in dogmas, which are finally viewed as irrational.[12] Here we meet the phenomenon of a Buddhist modernism. Besides, since the end of the nineteenth century the concern was regarding a new interpretation of the Buddhist doctrine.

In a more recent book by a Singhalese Buddhist this line is also strongly emphasized. The learned monk Mahathera Piyadassi from Sri Lanka, whose works were published anew,[13] writes in the section "Buddhism of the Western World":

> We are indeed living in an age of science — an age where man inclined to accept the
> truth of anything only by observation and experiment rather than by mere belief.
> With the recent advances of science, man is becoming more and more rationalistic in
> his outlook and blind belief is fast disappearing. Whatever the critics of Buddhism
> may say, the dispassionate student of early Buddhism will realize that the basic

9. Cf. M. Baumann, *Deutsche Buddhisten, op. cit.*, p. 244.

10. *Ibid.*

11. The main work by the German Buddhist Georg Grimm (1868-1945) was: *The Doctrine of the Buddha: The Religion of Reason and Meditation* (first published 1915); there are a lot of editions and translations available. Only later the subtitle was enlarged by the editors after one of the last wishes of Georg Grimm to "The Religion of Reason and of Meditation" (preface [1975] by Max Hoppe in the edition Vienna, 1979, p. XI).

12. Cf. H. Bechert, *Buddhist Revival, op. cit.*, pp. 279f.

13. *The Spectrum of Buddhism. Writings of Piyadassi*, Taipeh, 1991 (quoted as Piyadassi: *Writings*).

principles of Buddhism are in harmony with the findings of science. The scientific outlook is emphasized in Buddhism when the Buddha says to the sceptic and the inquiring mind: 'This doctrine is to be examined, to be seen, and not merely believed.'[14]

This course of argumentation can be found in recent publications. In a work published in 2003, written for a wider group of interested people, Peter Riedl, president of the Austrian Buddhist community, says that the therein "described Buddhism (is) Western," and he states:

> Different from the religions of revelation Buddhism is a religion of cognition. It is all about a way of realization in which one must or should not believe in anything, not even that which Buddha was preaching. On the contrary, one can or should prove everything itself. In himself Buddha realized the truth; in oneself everyone can realize it again and again.[15]

Here the motive of rationality — Buddhism as a way of realization — is tied together with the first mentioned of autonomy, the independent examination of the religious truth; the background of both is the scientific main tendency of secular modernity.

ANTI-DOGMATISM (AGNOSTICISM)

Now I want to point to another direction, which goes, so to speak, to the limits of the possibilities of Western rationality, by calling the rational statement itself into question and arrives at an agnostic perspective, also regarding the basic truths of Buddhism such as the doctrine of reincarnation. The Buddhist Stephen Batchelor develops a "Buddhism for unbelievers."[16] He says regarding reincarnation that there are not only two alternatives, to belief it or not to belief it, but the third alternative would be to admit simply 'I don't know.'[17] Yet this is different from 'I refuse it.' The statement 'I don't know' concedes that there is an openness regarding the so-called metaphysical questions concerning after-death existence. This is in line with the statements of the Buddha who does not bring a philosophy but messages of salvation, and also the doctrine of *karma* and reincarnation belongs necessarily to this context of liberation and not into the context of metaphysical claims. So I think that even this rather radical approach does not leave behind the basic principles of Buddhism.

SPIRITUALITY

Ever since the encounter of Western philosophy with Eastern thought in the nineteenth century until present times, and in numerous publications, we can find the thesis that the West brings material prosperity, but in the end leads to a dissatisfaction of men, and the

14. Piyadassi, *Writings, op. cit.,* p. 401.

15. Peter Riedl, *Auf ins Nirvana. Gespräche über Buddhismus,* Wien, 2003, p. 13 and p. 33.

16. Stephen Batchelor, *Buddhism Without Beliefs: A Contemporary Guide to Awakening,* New York: Riverhead, 1997, UK edition, London: Bloomsbury, 1998.

17. *Ibid.*

Eastern religions were a necessary completion which provides inner nourishment and spiritual experience to men. From this point of view the main problem of western culture may be found in the sphere of the psychical, in the interiority, as the Buddhist teacher Piyadassi also writes: "The basic problems of the western world are psychological. The youth of this world are on the search for inner satisfaction."[18] Nevertheless, it has to be said that even the way of meditation, as it was passed on and is practised in the West, has a specific Western context and horizon of interest. Heinz Bechert says rightly that meditation traditions of modern Buddhism are taught in a new way:

> In this rather unorthodox way (. . .) meditation centres have been opened, where Buddhist lay followers can attend meditation classes and be instructed in practices hitherto reserved for specially selected and initiated monks.[19]

And consequently these experiences are made accessible for laymen too. Nevertheless, on no account can be said that this meditation is a total renewal or would add something completely unknown to Buddhism. It certainly contributed to the fact that the meditative aspect in particular is presented in a new and helpful form, particularly for the Western man who does not live as a nun or monk.

THERAPEUTIC PRACTICES

It was already mentioned that the spiritual offer of Buddhism has a therapeutic function for the Western man, who creates material prosperity under great stress, but was in danger that the meaning of life remains unanswered for him. Here it is not possible to deal with the numerous psychotherapeutic aspects and possibilities of application of Buddhism, like stress-clinics, ego-disassociation, etc.[20] Only one point, which seems to be a new focus within Buddhism, may be mentioned.

This novelty in the Buddhist history is the new interpretation of the Tāntric tradition, i.e. of the Vajrayāna-tradition, towards a sexual integration for couples. There are European and American workshops and groups where Tibetan monks offer the Tibetan Buddhist Tantra for the purpose of self-development and the development of one's own sexuality. Meditative techniques are used to revive the subtle energy to achieve the highest potential of intimacy of passion and of the spiritual connection.[21] Eva Mullen says rightly:

> Meaning and purpose of the sexual Tantras have always been a disputed topic in the Vajrayāna tradition. The purpose described herein — Tantra for the promotion of passion and intimacy — is, however, a historical novelty.[22]

18. Piyadassi, *Writings, op. cit.*, p. 400.

19. H. Bechert, *Buddhism in the Modern World, op. cit.*, p. 276.

20. Cf. M. Epstein, *Thoughts Without a Thinker*, New York, 1995, also the publications of Jack Kornfield (USA) and of the 'Insight Meditation Society' and the 'Spirit Rock Center,' e.g., Ch. Longacker, *Facing Death and Finding Hope*, New York, 1997.

21. Quoted after a description of a workshop by Eva Mullen, *'Tibetischer Buddhismus im Westen. Kreative Innovationen am Beispiel der tibetischen Gemeinde New York City,'* ZMR 85 (2001), pp. 182-89, esp. 184.

22. *Ibid.*, p. 184.

But even from a perspective seen from within Buddhism, this is not understood as a complete innovation.

Regarding the enumerated characteristics, it can be said that Buddhism gives an answer to the needs of the Western world, by showing that it has a great potential for innovation, by being open for modernity. In it modernism is not tinged with a negative flavour, but in it there was in fact a reception of modernity.

Is this modernistic Buddhism another Buddhism, a new one in the meaning of a fundamental change of certain points?

I do not think that one can say that, because the basic statements of Buddhism, the so-called 'essentials' which have the character of elementary concepts, are not questioned. It is a presentation of this religion of the East for Western men, but not a change of its essential contents. This would be the case if, for example, the *anatta*-doctrine would be questioned, as it was the case in the beginnings of Georg Grimm, the founder of the old-Buddhist community in Germany, or if one would question the doctrine of *karma* and reincarnation. But as far as I can see this is not the case for Buddhists in the West.

There might be a 'fourth turning' of the wheel in the future. Buddhists themselves see this possibility; but it is given that first of all one has to integrate the Eastern traditions appropriately. Lama Anagarika Govinda makes numerous considerations in his work *Lebendiger Buddhismus im Abendland* in this direction:

> We Buddhists in the occident have to learn from the historical schools of the east until we — without changing the essential content of the teaching — have found the appropriate expression and way for us (. . .). And so as up to now every country has contributed valuably to the enfolding of Buddhism, so also we in the west have to make our contribution for its further enfolding and to pervade it with fresh life blood, if the doctrine of the Eminent should put down roots here.[23]

Perspectives for the Interreligious Dialogue Under Secular Conditions

What can be learnt from the described situation? What does this situation mean for the Christian-Buddhist dialogue?

A primary fact to be kept in mind: this interreligious dialogue is not only a dialogue with the representatives of Buddhism from Asia, but has in the meanwhile became a dialogue as well between members of other religions and the Christians in the European countries, in America, in Australia. The communication with each other takes place before the background of living together with each other in the same country, the same community, in the same schools. Of course it takes also places in a situation of plurality of religions. It is often also a discussion with the modern seeking men of Western culture who are often alienated to their religion of origin. It is a dialogue with men who know the Christian belief more or less and had a history of experiences with it. So the interreligious dialogue with Buddhists starts in the Western countries *in situ*.

23. Lama Anagarika Govinda, *Lebendiger Buddhismus im Abendland*, Bern, *et al.*, 1989, p. 42, cf. 26f.

A second fact becomes clear from the above-mentioned aspects of Western Buddhism: it is shaped by the European culture, as it gives answers to the questions of men who feel obliged to the enlightenment and modern scientific-rational consciousness, an answer which is compatible with the postulates of modernity. Buddhism is thus not changed in its essential concerns, but gets a new accentuation in the West; the described features characterize it. The dialogue between Christianity and Buddhism will have to face these specific facts so that it leads to a better mutual understanding. The dimension of secularity can not be left aside; rather, the discussion is carried out in its horizon.

With that I come to a third point: the interreligious dialogue is therefore to expand beyond the encounter of religions to a meeting with the secular self-understanding of modernity. This is the common level of encounter which also contributes to such that the different religions acknowledge themselves as partners with equal rights. For the conception of equal rights and freedom of religion was the end result of a long path, which finally got a clear formulation in the human rights in the middle of the twentieth century. These are the secular prerequisites which are the conditions for an equal interreligious dialogue. Only the ethical principles of modernity create a horizon which in principle (not always in reality) starts from the equality of humans, also in regard to that of religious creeds. The premises of an autonomous modern self-understanding have led to a bearable living-together, first of all of the Christian faiths and then of the monotheistic religions, and finally made possible an openness for the encounter and dialogue of religions worldwide. The modern secular culture, which defines itself in relation to the traditional institutional-ized religions to a large extent as non-religious, contributes in this way decisively to the realization of the dialogue of these religions.

The outlined cultural and historical background is to be considered also, when we speak about spirituality in interreligious dialogue. Because not only both world religions bring up the topics of dialogue, but this happens always before the background of a secular, sometimes materialistic, but often religiously critical modernity, which is, so to speak, the silent third partner in the discussion.

The secular world was described in a radical way by atheistic critics of religion like Friedrich Nietzsche and others. His announcement of the 'Death of God' seems to be already dead itself in the perspective of the new religious search — but this is deceptive. Atheism, the absence, the silence of God, the "God-crisis" (J.B. Metz) — these affect also the form of spirituality today. The intellectual world which was brought about by the critics of religion is mentally present; the "Death of God" is not dead, but it seems to be changed into an inner moment of experience of modern self-understanding; so much that it is not necessary any more to mention the dying of god expressively.

Both religions are influenced by these cultural and philosophical developments in a different way, and they react on it in different ways — for the Buddhism in the West this has been shown in some respects.

If this whole cultural context is taken seriously, then the interreligious themes probably will be accentuated in a new way. For a dialogue under these conditions the retreat-seminar in Sarnath, mentioned in the beginning, and its topic "Void and Fullness" is a landmark model. Because, then, the present interreligious search for spirituality of the "Darkness of God" (M. Buber) faces 'Nothingness,' and in this way it can reach the experience of "Fullness". So to speak, it is the realization of the emptiness, of the dark night experienced by the mystics, the alienation of the soul, the absence of God, freely chosen by the German mystics Mechthild of Magdeburg. It is the night of "Nothing" experienced by Juan de la Cruz, which has an inner proximity to Nietzsche's message of the "Death of God."

The interreligious dialogue, especially with Buddhism in the West, is therefore to expand to a dialogue with the secular self-understanding and also with atheism which probably will have a new importance in the encounter between the non-theistic religion of Buddhism and the theism of Christianity.

Raimon Panikkar says appropriately: "The atheistic religion of Buddhism corresponds to the religious atheism of our time." And he sees in the contemporary atheism "a new, urgent phenomenon of first order."[24] Due to these circumstances it seems to me to be an important task in the present to give a greater emphasis to the topics of atheism and secularity. With regard to the interreligious dialogue the dimension of secularity has to be considered. The dialogue between the religions surely will be directed towards the central religious questions, such as those of the absolute and its existential and meditative experiences, the questions of salvation, of cult and prayer and so on. But these questions cannot be formulated and answered in the West without taking into account the self-understanding of a secular culture. The specific accentuations of important features which characterize Buddhism in the West make it necessary to consider, in the Christian-Buddhist dialogue, the dimension of secularity in this cultural region.

The indispensable dimension of spirituality, therefore, should be raised in its connection with autonomy and rationality and other characteristics of modern self-understanding. In this way, the dialogue enables not only the open meeting between the religions, but it could also contribute to a new determination of the relationship between religiosity and secularity, and thus help to overcome historically-grown barriers which are experienced despairingly by many peoples and sometimes lead to regrettable controversies.

Translation from German: Ernst Fürlinger/Michael Ianuzielo

24. Raimon Panikkar, *Gottes Schweigen. Die Antwort des Buddha für unsere Zeit*, München, 1992, p. 153 and p. 248.

25

Hermann Hesse's Encounter with India
An Intercultural Appraisal*

Annakutty V.K. Findeis

Introduction

HERMANN Hesse is one of the best known among the group of German authors who tried, influenced by the imagination of the Romantic period, to construct 'a passage to India' — a 'mental tunnel' to the east. The story of this mental crossing of the borders or this 'voyage to the orient' is often, in part, a story of a metaphorical and/or metaphysical passage to India.

In the process of the execution of such a journey, two moments or steps can be traced: first, the discovery or the designing of an idealized picture of India. Secondly, this ideal picture is then used as a building principle around which things are speculated. This literature itself functions thus as a passage to India which is often used as a 'passage to oneself.'

I would like to try and speak on the subject: 'Hermann Hesse's encounter with India' from a 'Rezeptions'-aesthetic perspective. In other words: this kind of 'Rezeption' is an Indian 'Rezeption.' I would like to concentrate only on a few works of Hermann Hesse which are significant. The main focus lies on Hesse's *Siddharta — eine indische Dichtung* (Siddhartha — an Indian poetic diction).

Literary Approximation of Self-Consciousness Through Reading

I would like to make a mention of a small and yet very important book by Hermann Hesse entitled *A Library of world literature*.[1] In this booklet, Hesse reveals his openness, his interest for inner development, his turning towards the cultural and intellectual wealth of all people and nations for the same. It is however worth noting Hesse's remarks on the concept of education, which reminds us of the German philosopher Kant's categorical imperative:

* Many may not know that Dr. Bettina Bäumer taught also German language and literature for some time at the Banaras Hindu University. It shows also different dimensions of her personality and talents. I had the good fortune to be her student in Banaras and also I was inspired by her to study Indology at the University of Vienna. As my teacher and a friend, my indebtedness to her is immense.

1. Hermann Hesse, 'Eine Bibliothek der Weltliteratur,' in: *id., Gesammelte Werke in zwölf Bänden*. Band 11 (GW XI). Schriften zur Literatur I (st 1600), Frankfurt a. M.: Suhrkamp, 1987, pp. 335-72.

"Real education is not education for achieving some goal, but it has [. . .] its meaning in itself."[2] In Hesse's 'world library,' one finds a collection of the 'world culture' in its historical breadth and depth.

In this context one must state that Hesse mediates India to his contemporaries as a country of wisdom and deep religiosity. He introduced India to the European world as a country of intellectuals, different religions, spiritual knowledge and wisdom. Thus we could say rightly that Hesse became a missionary for India and Indian or Asian 'Weltanschauung'[3] in Europe. Hesse studied India not only for himself, but rather he made his experience and his insights regarding India/Asia accessible for others as well. He reviewed regularly books on India. In this way, his approach to India and his image of India was mediated through his reading experience, besides through the family heritage of the direct Indian experience of his grandfather[4] and of his own parents, as the latter too lived for some time in Kerala — his mother could even speak Malayālam. All this, in some sense, accounts for his closeness to and his vision of India. For example, in 1912, a year after his so-called 'journey to India,' Hesse published his review of Leopold Schroeder's translation of the *Bhagavad-Gītā* as well as the discussion of Karl Eugen Neumann's translation of the "speeches of Buddha."[5]

The Indian Trip — Hesse's 'Passage to India'

Promoted by his publisher, S. Fischer, Hesse embarked on his journey to "India and Hinterindia" (Indo-China and Indonesia) in September of 1911. This trip, much alluded to in his later writings, indeed only lasted until his return to Gaienhofen in December of the same year — a period of only three months, including a lengthy time at sea. Apart from a few stops in Malaysia, Singapore and Sumatra, and a longer and more significant disembarkation at Ceylon (Sri Lanka), where he came into contact with Buddhist culture, his personal contact with Asian culture was rather limited; furthermore, he himself never set foot on Indian soil.

The impressions of this trip were delivered in a series of written sketches called *India* that binds all his experiences from his first passage through the Suez Canal to his concluding perceptions on his return journey.

2. *Ibid.*, p. 337.

3. Hesse's *Robert Aghion* shows that Hesse could explain himself in the literary forms of his relations to India also in a critical manner with the traditions of the relations between India and Europe, and with that he also could touch on a few family stories. The confrontations with the realities of south Asia mirror themselves in the records that are distinct from his travel experiences.

4. Dr. Hermann Gundert, Hesse's maternal grandfather, was active for more than twenty years as a missionary in south India. For chronological details see Konrad Pflug: 'Daten zu Leben und Werk von Hermann Gundert,' in: *Hermann Gundert : Brücke zwischen Indien und Europa*, ed. Albrecht Frenz, Ulm, 1993, 461-70. Cf. Annakutty V.K. Findeis, 'Hermann Gundert — der Magier und sein Erbe,' in: Albrecht Frenz (ed.), *Bote zwischen Ost und West*, Ulm, 1987.

5. H. Hesse, 'Indisches,' in: GW XII, pp. 20f, 24f.

His documentation of his travels can also be found in such texts as *Erinnerung an Indien* (Memories of India, 1916) and *Besuch aus Indien* (Visit from India, 1922).[6] The latter text contains some reflective essays in which he confesses that he has busied himself for more than half his life with "Indian and Chinese studies," and was accustomed to breathe "the aroma of Indian and Chinese poetry and piety" — but he has not yet found the "spirit" of India for which he was searching. Rather, as he admits, he must spend many more years searching for the "magic bridges" to that "revered" and "true East." To find its "hidden, timeless world of the values and the spirit"[7] meant for Hesse an ongoing process of learning until he had finished "with his search for India and the flight from Europe." Here the remarkable cue is the word "flight" that Hesse uses repeatedly in connection with his voyage to the east. Nevertheless in addition to that Hesse says: "it was however also an attempt, to obtain distance and overview."[8]

The yield of his so-called Indian journey is slight, in comparison with that which he hoped for of his "search of India." Hesse himself gives sober and filtered information about that; for example, in a letter to Conrad Haussmann towards the end of November 1911, he wrote on his journey:

> You might suppose that there is in me a certain intellectual tendency towards the Asian way, which was the result of my short trip to India. That is not so. I have been convinced for many years that the European spirit is in decline and needs a return to its Asian sources. I have honored Buddha for years and read Indian literature since my earliest youth.

And he adds in a letter to Alice Lenthold on the 26 July 1919: "To these thoughts and studies was my trip to India merely a very minor addition and illustration, nothing more."[9]

The "Respect for the Spirit of the East"

Hermann Hesse's own standpoint regarding the significance of his perception of India, opened up by his trip to Hinterindia and Ceylon, makes it clear that the journey satisfied neither his own expectations nor those of his readers. Nevertheless, in addition to his travel remembrances, there was a further impulse to work. Until this impulse had ripened into its literary fruitions, he had to undergo a passage of personal crises and therapeutic treatments, and a deepening engagement with the Asian spirit and culture was necessary for this fruition to occur. The positive result for Hesse, in the end, emerged as his increased openness towards the spiritual and intellectual orient:

6. For that also see the collection of texts in Hermann Hesse, *Aus Indien. Aufzeichnungen, Tagebücher, Gedichte, Betrachtungen und Erzählungen* (st 562). Re-edition expanded by Volker Michaels, Frankfurt a. M.: Suhrkamp, 1980.

7. H. Hesse, 'Besuch aus Indien' (1922), in: GW VI, pp. 294f. Cf. also: *Materialien zu Hesses Siddhartha*, Bd. 1, pp. 317-21; 'Aus Indien und über Indien,' *ibid.*, pp. 325-29.

8. GW X, p. 148.

9. Quoted from Hesse's Commentary, *ibid.*, p. 115.

When we spoke earlier, twenty years ago, about the 'spirit of the East,' we thought exclusively of India, of the Vedas, of Buddha, of the Bhagavad Gita. Now, while talking about the spirit of East Asia, we think just as much or more of China, of the Chinese art, of Lao-Tse, and Dschuang Dsi, also of Li Tai Pe.[10]

A few years later, in 1916, Hesse reflected on his direct encounter with the world of South and South-East Asia:

What remains is the experience of a dream visit to distant ancestors, a homecoming to the childhood fairytale condition of humanity, and a deep respect for the spirit of the East, that ever since came to me more closely in an Indian or Chinese form again and again and became my comforter and prophet.[11]

This language betrays that Hermann Hesse stands in the tradition of the romantic approach and interpretation of India (and Eastern Asia), which, since Johann Gottfried Herder's portrayal of the Kashmiris and the paradisiacal northern India, had put its mark upon German literature and, in part, also German philosophy. The dream visit and the fairy-tale like childhood conditions are, to an extent, an echo of Georg Wilhelm Friedrich Hegel's idea of India as a country of origin and as a cradle of humanity, in his evolutionary perception (understanding or interpretation) of the world history.[12] It also shows closeness to Arthur Schopenhauer, who sought and attained solace in the Upaniṣads, and who suggested to the Germans, during the difficult years of crisis of the nineteenth century, a wise and congenial way of living. All these evoke particular modes of *Rezeptionen*, hermeneutical approaches and longings towards the east.

Siddhartha — A Metaphorical-metaphysical Journey to India

Siddhartha, the most widely-known work of Hermann Hesse, was conceived during the years between 1919 and 1922. His creative activity was interrupted for some time, because Hesse found it difficult to bring the already begun work to a good and satisfying end. It will not be an exaggeration when *Siddhartha* is counted as one of the most read books of the twentieth century that have produced a "worldwide effect."[13]

If Goethe's *Dichtung und Wahrheit* (Poetic Diction and Reality) is a self-portrayal "in a half-poetic and a half-historical handling"[14] especially as a construction of the Self, so also Hesse's *Siddhartha* has a biographical tinge and literary form. It had a narrative

10. H. Hesse, 'Chronologische Betrachtung' (1921), in: GW X, p. 68. Cf. 'Bibliothek der Weltliteratur,' in: GW XI, pp. 368-70.

11. H. Hesse, 'Erinnerungen an Indien' (1916), in: GW VI, p. 289.

12. For Hegel's 'Rezeption' of India, cf. Wilhelm Halbfass, *India and Europe. An Essay in Understanding*, Albany: State University of New York Press, 1988, pp. 84-99.

13. Cf. *Hermann Hesses weltweite Wirkung. Internationale Rezeptionsgeschichte*, vols. I-III, ed. Martin Pfeiffer (1st 1927), Frankfurt a. M.: Suhrkamp, 1991.

14. J.W. v. Goethe, *Dichtung und Wahrheit*, ed. Klaus-Detlef Müller (Goethes Werke. Jubiläums-Ausgabe; 5). Darmstadt, 1998, p. 11 (preface, first part).

form and, at the same time, was an illustration of the search for and the finding of the Self. In the justifications of the title of his book, J.W. von Goethe provided the following understanding: "During the reflections and the realizations of the past, the imagination also works as a poetical ability, so that more results of life can be described as individual happenings."[15]

Similarly, Hesse's *Siddhartha* is a story of remembrances, selections, experiences, and imagination. To a certain extent, a re-reading or re-capturing of the past with its rich traditions establishes itself in the work. But one can also say that it is concerned here with a metaphorical/metaphysical poetic diction of his "passage to India" which, at the same time, is a "passage to oneself."[16]

Hesse's image of India — which is shown in *Siddhartha* — stretches with all its tensions between the Upaniṣads and the *Kāmasūtra*. Both stress, in their own way, the "secret teaching." In the Upaniṣads it is the "secret teaching of *ātman*," in the *Kāmasūtra* the love which stresses the physical love and also at the same time reveals the secrets of the body. Hesse seems to have trusted both these secret teachings. Thus, according to me, Hesse's *Siddhartha*, especially in the first part of the novel, addresses the tension of world renunciation and world affirmation, the polarity between unity and diversity, experience and theory or doctrine.

From the critical discussions with the past and the traditions, emerge different ways towards the liberation in the Indian context. Several alternatives are provided. The heterodox Buddhism rejecting the orthodoxy of Brāhmaṇism is one model for the spiritual solution of conflicts. Thus it's no wonder that the rebellious, protesting Hesse reveres Buddha in his perception of India, and yet quarrels with his very analytical teaching. This doctrinal portion is rejected towards the end of the first part of the novel. The dialectic between teaching and experience is shown by Hesse through a dialogical argument between Govinda and Siddhartha, the two important characters of the story. Thereby he always tries to point to the epiphanic event of the truth — to its experience.

We may not forget, that the two figures, from the "theory and teaching-tired" Siddhartha as well as in the "theory-believing and still not uncritical" Govinda, are, as poetical creations, themselves an alter-ego of Hesse himself. He hides himself behind the omniscient narrator.

We know from biographical reports that Hesse could not finish the story. As a reason for it he says: "Because a part of this story must show that I have also not experienced it up to the end myself."[17] The absence of the authentic 'experience' thus works impedingly.

15. *Lexikon der Weltliteratur, Band 3. Hauptwerke der Weltliteratur in Charakteristiken und Kurzinterpretationen. A-K.*, ed. by Gero von Wilpert *et al.*, Munich: Deutscher Taschenbuchverlag, 1997, p. 105.

16. The movement of search in *Siddhartha* can be seen with the reference to the work history of H. Hesse from the background by *Peter Camenzind* (1904) and *Demian* (1919), they however earn, motivingly and structurally, their own stamp through the new formations of the Hindu and especially the Buddhist traditions.

17. Letter to Georg Reinhardt.

The Gotama scene in the first part is also of importance. Here comes to the forefront the division and the conflict between theory and experience. The two *Samana*s, Siddhartha and Govinda, recognize the form of the Buddha. They take note of the "inner smile" (it seemed to laugh gently within) which suggests perfection. The conflicting attitudes towards the Buddha shown by the two characters must be taken note of for one to recognize the complexity of the image of India in Hesse's thinking. Siddhartha looks attentively at the holy form of Buddha, the very embodiment of the teaching; Govinda wants to acquire the teaching from Buddha's own mouth and he stays beside him. Siddhartha goes on his way further and he does not bind himself to the teachings of the Buddha.

As far as Hesse's image of India is concerned, here we get the impression that he rejects the conceptions of the world as illusion or transitory, and renunciation of the world, etc., as aspects of the teaching known to him. "Meaning and essence were not behind the things, but in them, in everything." He gains this world-affirming view, and in it also lie the dramatics and the dialectics of the form of the rest of the story. "I have been indeed awakened and been born today."

Through the role of Vasudeva, another important character of the novel, Hesse tries to present the meditative, simple life of a 'Wise one' in the Indian context. In the story he has the role of a boatman. The symbolic meaning of this motive is to be noted. Vasudeva is unique and stands out in the story because his role suggests the hidden qualities of a *guru* and indeed he functions as a *guru* for Siddhartha at the end.

The chapter prior to the last chapter of the book bears the title *OṀ* and is of particular importance. Here, Hesse tries to give once again the quintessence of the Indian religions and the quintessence of his search in the association with *oṁ* and Vasudeva. The experience of unity, the Advaita experience or the experience of non-duality — in other words, the unity of I and All — is central to the novel. Siddhartha learns to practice this unity in daily life. In the narrative we read of

> . . . a secret art [. . .] to think the thought of unity, to feel the unity and to be able to inhale the unity. This blossomed in him slowly, and radiated to him from the old childlike face of Vasudeva: harmony, knowledge about the eternal perfection of the world, the smile, and unity.[18]

The river, that can teach everything, symbolizes the stream of life and consciousness. This motive is also meaningful in the context of Indian religiosity. The river is holy; the water is *tīrtha* — a ford, a lace of crossing from one world or state of consciousness, to another. The life is understood as a pilgrimage, as a *tīrtha-yātrā*. This example shows how Hesse condenses terms and motives that originate from the Hindu world.

Here it seems to be appropriate to add a few remarks, on Hesse's *Siddhartha* from the perspective of an intercultural encounter. The starting point of his search is the individual crisis and the search for the truth and new values. It is an existential search for meaning.

18. H. Hesse, *Siddhartha*, *op.cit.*, p. 111.

In some sense, along with the critic of religion, a depreciation of values of both cultures also happens here. Hesse's representation of Siddhartha symbolizes — to use a post-modern term or paradigm — a culturally-hybridized human being; the text can be considered as the articulation of the well-read hybridism.

Hesse's readings of the texts of other cultures signal already a transcending of the polarization of the dichotomy between "own and foreign." The transformative value of the emancipation lies in the re-articulation and translation of the cultural elements, whereby the newly translated and recreated text belongs neither only to the self nor does it belong only to the foreign author. That translated text is the new moment of renewal that happens through the intermediary space of the inter-cultural event that resembles an epiphany, and evokes a moment of self-transformation. In this re-articulation of cultural texts, there also occurs an epistemological deconstruction. Is not Hesse referring to this deconstruction in his letter to Fritz Gundert in 1923:

> Naturally the Indian brahmanical (element) therein is only clothing, and in Siddhartha, not a Hindu but a human is meant. Of course, here "cloth" is more than a costume. From the Indian way and the Indian forms, I have come to know that which ought to have been for us our own native religion, but which was never so to me.[19]

This indicates a metaphorical transformation and the intellectual journey appears as a *parikramā* circling around one's self. Yet at a different place, Hesse admits:

> In spite of its milieu, Siddhartha is a very European book, and the Siddhartha doctrine emerges very much powerfully from the individual and it is taken very seriously in a way that has not been done by any Asian doctrine. As opposed to your nomenclature, I would like to say just the contrary: "Siddhartha" is the expression of my liberation from Indian thought. I have thought in the Indian way for twenty years, even though it only remains in my books between the lines, and I was a Buddhist at the age of thirty, although naturally not in the church sense. The way of my liberation from every dogma, also from the Indian, leads up to "Siddhartha" and naturally shall continue, if I remain alive.[20]

Although Hesse considers the text *Siddhartha* in his own way to be 'European,' it is clear that this adjective European has undergone a transformation. Similarly, the Indian has also seen a structural change and a transformation. We must pay attention to "the location of culture" (to use a term of Homi. K. Bhabha).[21]

How does Hesse see the process of this inter-cultural transformation and enrichment, the corrections and supplementations from the perspective of a searching human being? Answering a question by Berthli Kappeler, Hesse again indicates how one can sense the

19. According to: *Materialien zu H. Hesses "Siddhartha,"* vol. 1 (1st 129), Frankfurt a. M.: Suhrkamp, 1977, p. 183.
20. From the letter to Rudolf Schmidt, 18.1.1925. In: *ibid.,* p. 193.
21. Homi K. Bhabha, *The Location of Culture,* London and New York, 1994.

non-absoluteness of dogmas and theories and the boldness of the search for the truth. Once again, the following text points out the 'in-between' or the 'inter-space' of the inter-cultural and the epistemologically universal addressability of the cultural texts and values, something that transcends the cultural boundaries.

> I do not hold the Indian wisdom to be better than the Christian. I perceive it only as being slightly more spiritual, somewhat less intolerant,[22] something broader and free. It comes from the fact that in my youth, the Christian wisdom was forced on me in insufficient forms. It went exactly in the opposite way for the Indian Sunder Singh.[23] The Indian teaching was forced on him, he found the brilliant old religion in India to be distorted and deteriorated, like I found the Christian religion here, and he chose Christianity — that is, he did not choose it but he was simply convinced, filled and overpowered by the love-thought of Jesus, in the same way as I was by the thoughts of unity-thought of the Indians. For different people, different ways lead to God, into the center of the world.

At this search, Hesse naturally stresses the moment of the 'experience' as he continues: ". . . the one who yearns and tries to come closer to the essence of life, he experiences, whether in Christian or in any other robe, without fail, the reality of God or Life, if you like."[24] All this indicates a 'new location of cultures' in the discourse of interculturality and inter-religiosity, which can give new orientation in a positive way for today's globalized world. It signals, as Homi Bhabha underlines: "another territory of translation, another testimony of analytical argument, a different engagement in the politics of and around cultural domination."[25] In Hesse-*cum*-"Siddhartha" we have, thus, a model of well-read hybrids of the literary world. Besides, the hybridism noticeable herein is also biographically explainable, as we have already indicated earlier.

Result and Experience of the East-West Discourse (or of the Indian-German Dialogue)

At this point, I would like to refer once again to one of the central themes in the East-West discourse which might help us to understand *Siddhartha*. Experience, for example, is a central concept in poetics as well as in philosophy and religion; in various forms we encounter this problem of the dichotomy of theory and experience Also, "enlightenment" is an important term in the intercultural discourse. Here, one should closely consider the

22. Whether this is true today, that remains here placed.

23. The Sunder Singh mentioned by Hesse had created a lot of attention in the Western world as a *sādhu* and an evangelist (also with the famous religious scientist F. Heiler from Marburg). Since 1929 he is counted as missing in the Himalayas. Even today one considers him in the Christian Western circles, while he is less well-known in the West. Cf. A.J. Appasamy, *Sunder Singh. A Biography*, Madras, 1990 (reprint of the first edition 1958).

24. Cf. *Materialien, op. cit.*, pp. 180-81.

25. H.K. Bhabha, *Location of Culture, op. cit.*, p. 32.

understanding of "enlightenment" in Western and Eastern thought, and especially in the Indian cultural context. The concept of enlightenment in the Western context always includes the critique of religion — that is, the exclusion of formal religion. Furthermore, the Indian renaissance has been encouraged through the encounter with the West above all with the ideas of enlightenment of the eighteenth century. Aurobindo reflects on this encounter and shows its ambivalence:

> . . . even the new European influence, which was an influence intellectual, rationalistic, so often anti-religious and which drew so much of its idealism from the increasingly cosmopolitan, mundane and secularist thought of the eighteenth and nineteenth centuries, precipitated in India from the very first an attempt at religious reformation and lead actually to the creation of new religions. The instinct of the Indian mind was that, if a reconstruction of ideas and of society was to be attempted, it must start from a spiritual basis and take from the first a religious motive and form.[26]

Hesse's own representation of India is not only limited to the old Indian tradition and literature. He also reacts to an India that has experienced and gone through this renaissance. Hesse-*cum*-his *Siddhartha*, appears on the one hand to be critical which also reflects the Western mood of the times. Of course on the other hand, his Siddhartha is earnestly on a spiritual quest. The emphasis on spirituality (today as already in the nineteenth and twentieth centuries) we find in India within religion and philosophy. To quote Aurobindo once again: "But, principally, a real Indian philosophy can only be evolved out of spiritual experience and as the fruit of the spiritual awakening which all the religious movements of the past century have helped to generalize. . . ."[27] Still, Aurobindo understands "spirituality" in a wider and integral manner, when he says: "Spirituality is much wider than any particular religion. . ."[28] or "Spirituality is not necessarily exclusive, it can be and in its fullness must be all-inclusive."[29]

Aurobindo, one of the modern Indian thinkers with a European experience, does not negate intellectuality and rationality. In his integrated understanding of spirituality and experience, he also gives place to critical thinking. His own thought of the variety is in itself a proof for the unity of theory and experience. In his work *Reason and Beyond Reason*, he shows the possibilities and also the limits of reason.[30] And he points at the singularity of the Indian spirit,

> For the Indian mind is not only spiritual and ethical, but intellectual and artistic, [. . .] the Indian mind returns always towards some fusion of the

26. Sri Aurobindo, *The Renaissance in India* (1920), Pondicherry: Sri Aurobindo Ashram, 6th edn., 1966, reprint 1996, p. 31.

27. *Ibid.*, pp. 34-35.

28. *Ibid.*, p. 44.

29. *Ibid.*, p. 45.

30. Sri Aurobindo, *Reason and Beyond Reason*, Bombay, 1963.

knowledge it has gained and to a resulting harmony and balance in action and institution. . . .[31]

In the context of a dialogue or discourse between India and Europe, the above-mentioned concepts and views seem to play a role.

The danger always lies in the fact that one uses the categories such as rationality and irrationality, activity and passivity as alternatives or as opposites. I mean that people from Europe, tired of theory and activity, look towards India or Asia. They are led by the one-sided wish that India or Asia only stands for experience and passivity. Time and again one gets the impression, that Europe — in the past and also today to some extent — views the religious and cultural world of India or Asia as a corrective or alternative to itself. This follows from — according to me — an either/or logic, whereas in our life we require a not only/but also logic too. There is no question that Hesse, in his poetics and in his personal enterprises, had searched for 'experience.' We know from the biographical accounts, and also from the history of the origin or making of *Siddhartha*, that Hesse interrupted his work on the text during the chapter "by the river." "The loss of the alter-ego and the failure of authentic experience"[32] are shown to be the reasons that lead to this interruption. The maxims of his own experience played a big role with Hesse, especially in the case of *Siddhartha*.

Hesse's image of India concentrates naturally on the spiritual India. He too, like Herder, stands under the romantic influence and conceives an India which is meditative, passive, and peaceful, full of beauty and light. I would not like to doubt that there are these sides to India as well. But, then again, one has to search in India in order to find all these at once. Thus these trails of the picture of India, are one-sided and idealized, the result of a romantic imagination.

Hesse himself mentions that he has not only dealt with the classical India of the past but the modern India as well. He thanks Romain Rolland for this mediation: ". . . I thank him for one of my most valuable connections with modern India."[33] Besides Rolland, the important indologist Helmut von Glasenapp must be mentioned. Naturally, his reception of India is also dedicated to the spiritual India, and it is also not free from idealization. Yet Hesse is well-aware of the complexity and the contradictions, the elasticity, the integrative and working power of India, as we can understand from his biographical references.

Why is India perceived in this way? Does it agree with the self-understanding of an Indian man or woman? Since the neo-Hinduism of the nineteenth century, there has been an attempt in the Indian religious and philosophical context to put stress on

31. Sri Aurobindo, *Renaissance in India, op. cit.*, p. 14.

32. H. Hesse, *Siddhartha, op. cit.*, p. 118.

33. *Materialien, op. cit.*, p. 193.

"experience" in the sense of mystical experience. A good example is given by the renowned twentieth- century Indian philosopher, Sarvepalli Radhakrishnan, who taught for a few years in Oxford.[34] He reduces the Indian religions to "religions of experience"[35] and contrasts these with the prophetic and dogmatic religions of the west." The Western religions seem to emphasize, according to his view, that "the objective reality and the objective theoretical and institutional structures have a priority over the living dynamic of experience."

Hinduism, and especially Vedānta — as Radhakrishnan understands it — are open to that which is the basis for all the symbols: their living sources, their direct trans-symbolic experience; whereas, the other religions tend to lose the connection with this source. They allow the source to be buried under the dogma and the institutions.[36]

A wave of this thought, with its characteristic stress on the experience, and especially on the mystical experience, developed itself also in India. It led, in general, to the identification of the Indian religions with mysticism itself. The social, political, ethical and popular dimensions of the Indian religions lose importance against the mystical understanding and the secret of the teaching of wisdom. Hesse came in contact with many works and tendencies of neo-Hindu influence and knew about the impetus that followed from them.

The romanticizing and the idealizing of India by the German Indologists and poets also found its echo in India. To some extent this process helped Indian men and women towards building a self-identity, and also creating self-awakening.

The critique that is shown so far does not underestimate the value of his "Indian poetic diction" of *Siddhartha*. Where poetics or literature becomes the way for the search for truth, and at the same time discloses a place or experience, there the "passage to India" turns to be "passage to oneself."

34. In Oxford, Radhakrishnan had a professorship for Eastern religions and ethics from 1936-52. Representations and assessments of his philosophy can be found in: *The Philosophy of Sarvepalli Radhakrishnan*, ed. Paul Arthur Schilpp, Delhi, 1992 (reprint of the first edition 1952). Also see the comparative study of another important departer of poetry and thoughts between the East and West: Harendra Prasad Sinha, *Religious Philosophy of Tagore and Radhakrishnan. A Comparative and Analytical Study*, Delhi, 1994.

35. Cf. W. Halbfass, *India and Europe, op. cit.*, pp. 382-83.

36. According to W. Halbfass, *India and Europe, op. cit.*, p. 382.

26

Self-Knowledge—Space of Inwardness

Alois M. Haas

THE self as well as the awareness of the self, which is inevitably linked with it, and the awareness of its structure, are commonly assumed to be an insight established not before the early modern period of philosophy — a period that concerned itself especially with the problem of the subject.[1]

> Erst seit Descartes' Ansatz bei der Selbstgewissheit des sich wissenden Ichs als *fundamentum inconcossum* allen Wissens sei, so meint man, die interne Struktur des Wissens von sich selbst genauer analysiert worden, insbesondere in den idealistischen Selbstbewusstseinstheorien von Fichte, Schelling und Hegel, in deren Rahmen dann auch das Problem der Einheit des Selbstbewusstseins fundamentale Bedeutung gewinnt. Die vorneuzeitliche Philosophie gilt dagegen als einseitig ontologisch oder als objektivistisch am Seienden orientiert; die Probleme denkender Selbstbeziehung hätten ausserhalb ihres Horizonts gelegen.[2]

> [It has often been claimed that it was only in the wake of Descartes' premise of the certainty of the knowing ego, conceived as a *fundamentum inconcussum* of all knowledge, that the inner structure of self-knowledge had been analysed in greater detail, notably in the idealistic theories of self-consciousness by Fichte, Schelling and Hegel, in which context the problem of the unity of self-consciousness gained fundamental significance. Early modern philosophy, by contrast, is held to be orientated one-sidedly either towards ontology or towards the object and being; the problems of cognitive self-reflection, it is claimed, had been outside that horizon.]

This claim, however, has to do very little indeed, if anything at all, with historical fact, but it has very much to do with the endeavour of early modernism to set itself off against the previous age by claiming that its ideas are the achievements of its own originality. Any such claim has been contested (perhaps somewhat daringly) by top-ranking scholars (such as W. Schulz, K. Flasch, R. Imbach, B. Mojsisch),[3] who insist emphatically that the theories of the intellect by fourteenth-century mystics (Dietrich of Freiberg, Eckhart, Tauler, Seuse) can in fact be considered as the "antecedents of the modern idealist theories of productive

1. Cf. Jens Halfwassen, *Geist und Selbstbewusstsein. Studien zu Plotin und Numenios*, Mainz/Stuttgart, 1994. I have been inspired here by Halfwassen's ideas.

2. *Ibid.*, p. 5.

3. For the bibliographical dates of the studies by the authors referred to see *ibid.*, p. 5, note 2.

subjectivity."[4] And since these late medieval philosophers and theologians substantially relied on theorems of ancient classical philosophy and elaborated on them, it would seem reasonable not only to link the discovery of the inner world of the soul to Neoplatonism, which had a formative influence on German mysticism, but also to trace the problem of self-knowledge as conceived in the Late Middle Ages back to its very origins. Only on such a basis can the true range and significance of the reflections on the subject in pre-idealist philosophy be adequately outlined and assessed.

Over and beyond this, any other product of the thinking of mankind is interesting in this context in which the problem of self-awareness or self-knowledge is addressed, regardless of whether these philosophical reflections had a direct or indirect bearing on Western-occidental thinking or not. It is Indian thought in the first place that is of particular interest here.

Images of the Religious Journey and of the Path of the Soul

It is important to recognize — if one insists on historical correctness — that the problem of self-awareness became manifest for the first time in the context of man's practical quest for meaning. The key issue here was and continues to be the question of the meaning of human existence. Wherever philosophers pondered on the problem if and to what extent the individual can him/herself be the subject of the quest for the meaning of existence, religion, as an eminent source of meaning, has always been part of such reflections. What do we understand by 'religion'?

There is consensus amongst scholars today that the etymology of the word *religio* can not be established with absolute certainty.[5] There are in fact three possibilities of deriving the etymological root:

1. from *religere, relegere* — to reconsider something, to reflect once more on, or re-examine something mentally;
2. from *relinquere* — to leave, to separate from;
3. from *religare* — to bind, to be tied or knotted to.

Although the etymology of the last option here is philologically the least probable one, it applies best psychologically to what we actually mean by 'religion.' From ancient times it has been the ambition of religious man to approach the Divine in order to find peace and safety, ideally permanent, from the hazards of life, but ultimately also — with this spiritual aspiration culminating — to be united with the 'Numinous.'[6] Any attempt to be united

4. For the bibliographical dates of the studies by the authors referred to see *ibid.*, p. 5.

5. Cf. Jean Pépin: 'L'Itinéraire de l'âme vers Dieu selon Saint Bonaventure,' in: *id., Les deux approches du Christianisme*, Paris, 1961, pp. 205-73; passage referred to here, pp. 205-07 (quoted as Pépin).

6. On the concept of the 'numinous' see Rudolf Otto, *Das Heilige. Über das Irrationale in der Idee des Göttlichen und sein Verhältnis zum Rationalen* (1917), Munich, 1997; *id.: West-östliche Mystik. Vergleich und Unterscheidung zur Wesensdeutung*, 3rd edn., revised by Gustav Mensching, Munich, 1971; *id.: Das Gefühl des Überweltlichen (Sensus Numinis)*, Munich, 1932; the fact that Otto's exploration of the

→

with the Divine involves inevitably the transcending of a distance which is, *a priori*, beyond the human capacity of transcendence. The cliché-image to illustrate the struggle of man, tied to this world, aspiring to transcend it, springs from the spatial imagination: a long pathway or a strenuous journey. When the religious soul embarks upon the quest for the Divine, it also sets out into the unknown — it does not know where the journey will end, nor how to reach the destination which is infinitely distant. And since any journey of this kind may turn out to be a daring enterprise with an uncertain ending and with rather doubtful promise of success, the spiritual traveller is well-advised to resort to the accumulated experience of mankind in this venture. The spiritual pilgrim will not only desire to be directed, if possible, by a personal guide and to be allowed to make use of ready-made road maps and signposts set-up by travellers who have passed that path before, but he will also wish to proceed along a clearly structured itinerary, i.e. one that states clearly the schedule, the route and destinations and the time-table of the stops. The "pilgrims of the Absolute" (Léon Bloy) like other pilgrims to holy sites and shrines — all places where the encounter with the Numinous would seem to be particularly appropriate and promising — had itineraries of this kind at their disposal. These guidebooks provided, both literally as well as in a metaphoric-mystical sense, fingerposts indicating the direction towards the desired goal of the union with the Divine. These itineraries put particular emphasis on the adventurous nature of the journey with its many vicissitudes, hazards, severe hardships and unexpected occurrences, which may accompany the path across uncouth regions and which must be overcome, but they also referred to features of the inner journey, the changing condition of the traveller's soul, culminating in such practical advice as confining the daily stages to reasonable limits so that the pilgrim is neither overstrained nor entirely spared hardships. These spiritual itineraries had an "ascending dialectics,"[7] in which the scale of the ascent was often skilfully linked with a biographical conversion story.[8] This corresponds to Plotinus' notion of 'dialectics' in which dialectics is "the most valuable part of philosophy"[9] in that objects of thought and created things, the theoretical aspect and the pragmatic one, are methodologically transformed into a unity which may "lead us up to where we have to direct our pilgrimage."[10] The ascent has a dual structure: first, it progresses from the lower to the higher, the spiritual region, and secondly, it is a journey from the realm of the spirit to the outermost end of this place . . ., which then becomes the goal of the path when one has

→ 'numinous' has not lost in appeal to this very day is witnessed, for instance, by the studies of Carsten Colpe, *Über das Heilige. Versuch, seiner Verkennung kritisch vorzubeugen*, Frankfurt a. M., 1990, pp. 41ff., Wolfgang Gantke, *Der umstrittene Begriff des Heiligen. Eine Problemorientierte Religionswissenschaftliche Untersuchung*, Marburg, 1998, pp. 231ff., and Reinhold Esterbauer, *Anspruch und Entscheidung. Zu einer Phänomenologie des Heiligen*, Stuttgart, 2002 (cf. index).

7. Pépin, note 5, p. 207.

8. Cf. Karlheinz Ruhstorfer, *Konversionen. Eine Archäologie der Bestimmung des Menschen bei Foucault, Nietzsche, Augustinus und Paulus*, Paderborn, 2004, who considers the experience of 'conversion' as a crucial human experience up to the post-modernist period.

9. *Enn* I, 3, 14.

10. *Enn* I, 3, 1.

reached the summit of the spiritual world."[11] The ascent described allegorically by Gregory of Nyssa (335/40 - *c.* 400)[12] and Dionysios Areopagita (*c.* 500) is based on the biblical episode of Moses climbing Mount Sinai. This has become one of the most influential patterns for describing the spiritual journey in the history of Western mysticism. It was also taken up by John of the Cross in the image of the *mons contemplationis*. In this concept of the journey two aspects are combined: the unique sensory perception of the traveller, which is of great intensity; and it is linked to the pilgrim's experience of his own transformation, of his changing attitude to and experience of this world and of God. The ancient image of the 'way' suggests direction and guidance, inward growth, thinking and personal development. It is thus well suited to provide a pragmatic framework for the itinerary of the deep-experience of human existence.[13]

It is probably appropriate to add at this point that it is not necessarily always or exclusively the metaphor of travelling by which man's upward journey to the mystical union with God is illustrated. For there is the possibility of a direct experience of God, i.e. one that is not mediated by dialectics and does not depend on a conscious quest: it occurs in a spontaneous act in the state of ecstasy. It is a direct encounter with the Divine in the sense of Plotinus' *phygè mónou pros mónon*.[14] The metaphor of the journey into the interior of the soul would seem to apply to this kind of rhetoric, which, though spectacular spiritual experiences are not necessarily expected on the way, it does not relinquish the wish to achieve the state of union. Yet this is the Christian rhetoric of union, whereas the hermetic traditions focus much more radically on the spontaneous moment of spiritual elevation to the Divine. The following passage from the *Corpus Hermeticum* emphasizes this point — it even renders the more detailed model and rhetoric of the itinerary redundant:

> Befiehl deiner Seele nach Indien zu reisen, und schneller als dein Befehl wird sie dort sein. Befiehl ihr, dann zum Ozean zu gehen, und so wird sie wiederum in Kürze dort sein, nicht als ob sie von einem Ort zum anderen ginge, sondern als ob sie (längst) dort wäre. Befiehl ihr, auch in den Himmel hinaufzufliegen, und sie wird keine Flügel benötigen. Es wird ihr aber auch nichts im Wege sein, weder das Feuer der Sonne noch der Äther, nicht die Umdrehung (der Fixsterne), nicht die Körper der anderen Sterne. Durch alles wird sie sich einen Weg bahnen

11. *Enn* I, 3, 3.

12. Grégoire de Nysse, *La vie de Moïse*, Paris, 2000 (SC 1 bis); Gregory of Nyssa, *Der Aufstieg des Moses*, Freiburg i. Br., 1963; see also Thomas Böhm, *Theoria. Unendlichkeit. Aufstieg. Philosophische Implikationen zu DE VITA MOYSIS von Gregor von Nyssa*, Leiden, 1996.

13. Otfried Becker, *Das Bild des Weges und verwandte Vorstellungen im frühgriechischen Denken*, Berlin, 1937; Wolfgang Harms, *HOMO VIATOR IN BIVIO. Studien zur Bildlichkeit des Weges*, Munich, 1970; Richard Wisser, *Philosophische Wegweisung. Versionen und Perspektiven*, Würzburg, 1996; id.: *Vom Weg-Charakter philosophischen Denkens. Geschichtliche Kontexte und menschliche Kontakte*, Würzburg, 1998; Eleftheria Messimeri, *Wege-Bilder im altgriechischen Denken und ihre logisch-philosophische Relevanz* (Epistemata; 290), Würzburg, 2001.

14. *Enn* VI, 9, 11, 50; cf. also I, 6, 7, 8-10. On this see also René Arnou: *Le désir de Dieu dans la philosophie de Plotin*, Rome, ²1967, pp. 53f; Pierre Hadot: *Plotin ou la simplicité du regard*, Paris, ²1973, pp. 139ff; Jean Trouillard: *La Mystagogie de Proclos*, Paris, 1982, p. 28.

und bis zum äussersten Körper fliegen. Wenn du aber auch ihn ganz aufreissen wolltest und auch das anschauen, was ausserhalb ist, wenn es überhaupt etwas ausserhalb des Kosmos gibt — dann steht es dir frei. — Sieh, wie gross deine Kraft, wie gross deine Schnelligkeit ist. Und du sollst das können, Gott aber nicht? Auf diese Weise also begreife, dass Gott alles wie Gegenstände seines Denkens in sich hat: den Kosmos und sich selbst ganz und gar. Wenn du dich Gott nicht gleichmachst, kannst du Gott nicht erkennen. Denn Gleiches kann nur durch Gleiches erkannt werden. Vergrössere dich um eine unermessliche Grösse, lasse jede Körperlichkeit zurück, erhebe dich über alle Zeit, werde zum Aion, und du wirst Gott erkennen können. Nimm an, nichts sei dir unmöglich, und glaube, dass du unsterblich bist und alles begreifen kannst, jede Fertigkeit, jede Kenntnis, jeden Lebewesens Wesensart. Werde höher als jede Höhe, niedriger als jede Tiefe, erfasse in dir alle Sinneseindrücke zugleich, die es von dem Geschaffenen gibt: vom Feuer, vom Wasser, vom Trocknen, vom Feuchten, und denke, überall zugleich zu sein: auf der Erde, im Meer, im Himmel, vor der Geburt, im Mutterleib, ein junger Mann, ein alter Mensch, tot und nach dem Tode; und wenn du dies alles zugleich denken kannst: Zeiten, Räume, Dinge, Qualitäten, Quantitäten, kannst du Gott erkennen.[15]

[Command your soul to travel to India, and it will be there faster than your command. Command it afterwards to go to the Ocean, and again it will be there in a short time, not as if it went from one place to the other, but as if it had already been there. Command your soul to fly up to heaven and it will need no wings. Nor will it meet with any obstacles, neither the fire of the sun, nor the air, nor the circulation (fixed star), nor the matter of other stars. It will pave its way through anything and fly on until it arrives at the outermost body. But if you wanted to open up that body as well and see also what is beyond it — if there is anything at all outside the cosmos — you are free to do so. See how great your power and how quick your speed is. And you are expected to accomplish all that, but God is not? In this way you may comprehend that God encompasses everything like objects of his thinking: the cosmos and himself entirely. If you do not refashion yourself into the likeness of God you will not be able to know God. For likeness can only be known by likeness. Enlarge yourself by an immeasurable size, leave behind any corporality, transcend all time, be transformed into Aion and you will know any skill, any knowledge, and the essence of any creature. Grow higher than any altitude, lower than any depth, perceive all sense impressions that exist in creation simultaneously: fire, water, dryness, moisture, and assume to be everywhere at the same time: on the earth, in the sea, in heaven, before your birth in the womb, a young man, an old man, dead and after death; and when you are able to think of all that at the same time: times, spaces, things, qualities, quantities — then you may know God.]

As claimed in this passage, God cannot be reached unless man has assimilated to the uniquity

15. Cf. Pépin, note 5, p. 209f; *Corpus Hermeticum XI*, pp. 19f. (*Das Corpus Hermeticum Deutsch. Übersetzung, Darstellung und Kommentierung in drei Teilen*, ed. Carsten Colpe and Jens Holzhausen, Part 1, Stuttgart/Bad Cannstatt, 1997, pp. 134f.).

of God. This implies that a path or journey is not really relevant here. It is not before Meister Eckhart or Angelus Silesius that the daring mystical claim and "pious audacity" (to put it with Karl Barth) will be uttered again.[16] At the beginning a model of ascending dialectics prevails which makes use of various scales of different degrees and stages. The Christian scales of the ascent to God were above all inspired by the so-called graded psalms: these psalms, originally sung by the Jews when going up to Jerusalem from all regions of Palestine, were later adapted by Augustine in *Enarrationes in Psalmos*, but he removed the specific spatial context and furnished it with spiritual meaning. The following example sounds quite unlike the *Corpus Hermeticum* and its tendency to transcend the dimension of space:

> Bei seinem Aufstieg, wohin hat er seine Augen erhoben, wenn nicht zum Ziel, nach dem er sich ausstreckte und das er bei Aufstieg erreichen wollte? In der Tat steigt er von der Erde zum Himmel. Hier unten die Erde, die wir mit unsern Füssen stampfen — und hier oben der Himmel, den wir mit unsern Augen erblicken. Während unseres Aufstiegs singen wir: ". . . Zu Dir habe ich meine Augen erhoben, Du, der Du im Himmel wohnst" (Ps. 122,1). Wo aber ist die Leiter? Denn wir bemerken einen so gewaltigen Abstand zwischen Himmel und Erde! Ein gewaltiger Zwischenraum trennt sie. Dorthin wollen wir steigen, und wir finden keine Leiter. Könnte es sein, dass wir uns täuschen, wenn wir meinen, einen Aufstiegspsalm zu singen? Wir steigen zum Himmel, wenn wir über Gott meditieren, der uns im Herzen dazu disponiert hat. Was heisst das: aufsteigen im Herzen? Sich Gott nähern. Wer sich darum nicht kümmert, wird eher fallen als absteigen. Wer aber immer sich Ihm nähert, der steigt.[17]

> [At his ascent whereto has he lifted his eyes, if not at the goal at which he had stretched out and which he wanted to reach by this ascent? And indeed does he ascend from the earth to heaven? Here below is the earth, which we tread with our feet — and, there above is heaven, which we can see with our eyes. During our ascent we sing: "Unto thee lift I up mine eyes, O thou that dwellest in the heavens" (Ps 122,1). But where is the ladder? For we are aware of the enormous distance between heaven and earth! A gigantic space in between separates them. And we want to ascend there and do not find a ladder. Could it be that we have been mistaken if we think that we are singing a psalm of ascent? We rise up to heaven when we meditate on God, who has placed the disposition to do so into our hearts. What does this mean: to be lifted up within the heart? To get closer to God. Anyone who does not care about this, will fall rather than descend. However, whoever approaches God will ascend.]

The "ascent within the heart" referred to here alludes to Ps 83.6, which is again analysed by Augustine when he discusses the problem of ineffability in this concept of 'dialectics':

> Dieser Psalm (119) ist, wie sein Titel anzeigt, ein Graduallied (*canticum graduum*), auf Griechisch *anabathmon*. Die Stufen betreffen Ab- oder Aufstieg. Aber so,

16. Cf. Nicolaus Klimek, *Der Begriff 'Mystik' in der Theologie Karl Barths* (Konfessionskundliche und kontroverstheologische Studien 56), Paderborn, 1990, pp. 105-07.

17. *Enarr. in psalm.* 122, 3 (PL 37, p. 1631); quoted in Pépin, note 5, p. 211.

wie sie in diesen Psalmen gebraucht werden, bedeuten sie den Aufstieg. Verstehen wir sie also wie wenn wir zum Aufstieg bereit wären. Aber versuchen wir nicht, diesen mit den Füssen unseres Körpers zu unternehmen. Ein anderer Psalm (83.6) redet von 'Aufstiegen' (*ascensiones*). Aber diese Aufstiege wohin? *Im Herzen...* Was den Ausdruck 'Aufsteigen' betrifft, so ist es, wie wenn die menschliche Sprache hier versagen würde. Denn (das Wohin) dürfte nicht näher erklärt noch gedeutet werden können. Auch wenn man es nicht ausdrücken kann, sagt der Psalm doch: *am Ort, den er erstellt hat...* Wer wird es erfassen können, wo wir nach diesem Leben sein werden, wenn wir *im Herzen* aufgestiegen sind? Niemand. Hoffe also auf irgendeinen unsagbaren Aufenthalt im Glück, den für dich jener bereitet hat, der auch *Aufstiege in deinem Herzen bereitet hat.*[18]

[This Psalm (119) is, as indicated by its title, a song of degrees (*canticum graduum*), called *anabathmon* in Greek. The degrees are related to either ascent or descent. However, in the way these grades are used in these psalms they only refer to the ascent. We should thus understand them as if we were ready for the ascent. But we should not try to undertake the ascent with the feet of our body. Another psalm (83.6) speaks of 'ascents' (*ascensiones*). But to where go these ascents? *Within the heart.* ... As far as the term 'ascending' is concerned, it seems as if the human language will fail here. For (the 'where to') apparently can no longer be more specifically be explained nor interpreted. Even if one cannot express it, the psalm nevertheless says: *at the place, which he had prepared.* ... Who will be able to comprehend where we shall be after this life, when we have ascended *in the heart*? No one. Therefore what you a hope for is an ineffable sojourn in happiness which was prepared by the one who has also *prepared the ascents within your heart*.]

This discourse on ascent, however, turns out to be merely a propaedeutic of a religious experience of the self and of God. In this event the empirical ego experiences — and this is the crucial point — a radical "stretching" out into the infinity and endlessness of God; in other words: the ego is transformed in the process into the self. Experiential knowledge of God thus is becoming aware of one's own capacity to expand and stretch out unto the Infinite; and it is essentially a knowledge of the self in the light of its divine purpose and determination. This identity of the knowledge of self and God has shaped the mode of existence from the beginnings of man's thinking up to the postmodern era — and still does so today.

Self-knowledge and Inwardness as 'Existentials'

To achieve self-knowledge was already a familiar summons in classical antiquity (*gnothi sautón, nosce teipsum*),[19] which could not easily be equated with a mere ethical formula, such as: live as mindfully as possible, or act in a manner guided by conscience! The imperative is rather related to a clear existential instruction which did not just aim at the mortal condition

18. *Enarr. in psalm.* 119,1 (PL 37, pp. 1596-1597); quoted in Pépin, note 5, p. 211.

19. Pierre Courcelle: *Connais-toi toi-même de Socrate à Saint Bernard*, 3 vols, Paris, 1974-75; Christian Göbel, *Griechische Selbsterkenntnis. Platon — Parmenides — Stoa — Aristipp* (Ursprünge des Philosophierens; 3), Stuttgart, 2002.

of man: "Know thyself and be mindful of your mortality!," but (often in opposition to the former) also and in particular at man's kinship with and likeness to the Divine. Changing times resulted in changing interpretations of that imperative. The knowledge of man's miserable condition aside, the focus of the quest for self-knowledge could be shifted to the consciousness of man's greatness. Self-knowledge is never focused on what always remains the same, but is subject to different assumptions and conceptions of man at different times. However, the criteria for determining the notion of self-knowledge have something in common: they provide man with a dimension of inwardness in which self-awareness expands with increasing self-perception. And the inner space created in this way is clearly perceived as an "inward space" juxtaposed to the "outward man."[20] This was possible only because self-knowledge demanded to a certain degree the distancing of oneself from one's own ego — especially where the union with the One or the 'self' was intended. Without the awareness of the difference between the ego and the self, between shell and kernel, self-knowledge — understood in terms of transcending the ego and penetrating into the depths of the self — could not be attained.

In the following, a few positions in the history of self-knowledge and in the philosophical development regarding the notion of "the birth of the self" shall be discussed.[21] This is done in order to highlight the cultural-historical significance of these developments for the emergence of the notion of inwardness and its historical and anthropological relevance, and in order to emphasize the great importance of the 'invention of inward man'[22] to the

20. The 'Historische Anthropologie,' though a serious and formidable scholarly enterprise, refers only to the "animal in man," but is obviously ignorant of the aspect of "inwardness," both in subject-matter and terminology. Therefore it is imperative here to introduce the concept of the "inward man" into this discipline, which appears to be too heavily determined by the natural sciences. Cf. Christoph Wulf (ed.), *Vom Menschen. Handbuch Historische Anthropologie*, Weinheim and Basel, 1997, p. 89. Cf. Wulf, s.v. Seele, pp. 967-74. Page 973 summarizes the conception of contemporary anthropological research from an historical perspective, when it says: "Da Wissen und Verstehen der Seele an das Sprechen über die Seele gebunden ist, hat die Seele außerhalb der Sprache keinen Ort. Daher lautet die Frage nicht mehr, ob der Seele transzendente Bedingungen zugrunde liegen oder ob sie das Gesamt der menschlichen Innenwelt repräsentiere. Vielmehr richtet sich die Aufmerksamkeit eher darauf, wie sich die Seele in Diskursen konstituiert. Eine solche Perspektive führt zur Relativierung der über die Seele entwickelten Vorstellungen, Gedanken, Sichtweisen und Erkenntnisse. Dabei werden die Grenzen einzelner Disziplinen und Paradigmen übertreten und neue Weisen methodischer und inhaltlicher Strukturierung sichtbar gemacht." This may well be; however, this claim implies the exclusion of a wide range of perceptions, since the capacity of the soul is confined to speech and to objectifying perceptions, and thus ignores its potential of introspection.

21. Manfred Krüger, *Ichgeburt. Origenes und die Entstehung der christlichen Idee der Wiederverkörperung in der Denkbewegung von Pythagoras bis Lessing* (Philosophische Texte und Studien; 42), Hildesheim/Zürich/New York, 1996.

22. *Die Erfindung des inneren Menschen. Studien zur religiösen Anthropologie* (Studien zum Verstehen fremder Religionen; 6), ed. Jan Assmann, Gütersloh, 1993; *Schuld, Gewissen und Person. Studien zur Geschichte des inneren Menschen* (Studien zum Verstehen fremder Religionen; 9), ed. Jan Assmann and Theo Sundermeier, in cooperation with Henning Wrogemann, Gütersloh, 1997; *Rationalität und Innerlichkeit* (Philosophische Texte und Studien; 43), ed. Hanna-Barbara Gerl-Falkovitz, Nikolaus Lobkowicz, Fritz-Peter Hager, Thomas de Koninck and Horst Seidl, Hildesheim/Zürich/New York, 1997.

cultural history of man. It is clear that it is not the interpretation of the teachings that can be discussed first, but the historically documented statements relating to the gradual emergence of the notion of inwardness in the history of mankind, which is an essential part of our culture and civilization, and which played itself a crucial role in shaping the cultural heritage. The following topics will be at the centre of the following considerations: the tradition of Indian thought, ancient Greek thinking as represented by Plato and Plotinus and its reception by Christian philosophy and theology, in particular by Augustine, Bonaventure and Meister Eckhart in the Middle Ages, by Pascal in the early modern period, and, finally, in a secularized form, by the thinking at Goethe's time in Germany and the Romantics. These traditions and schools of thought were all concerned in one way or other, pointedly or perseveringly, with the conception of man's inwardness. Thus we may indeed speak of a history of fascination with inwardness.

India's Contribution to the Concept of 'The Inward Man'

It is astonishing that the earliest beginnings of man's thinking on inwardness should be found in Indian thought long before the pre-Christian era, and at least one century earlier than such thoughts emerge in ancient Greece and China;[23] but even there the underlying intentions point at a different direction: Chinese thinking starts with "human social and communal life," and Hellenic thinking with the "contemplation of the cosmos."[24] The so-called prose Upaniṣads (texts related to sitting-meditation) were composed in the late Vedic era, i.e. the Brāhmaṇa period following on the epoch of Vedic poetry (from about 900 to 700 BC); by the year of Buddha's death (483 BC) "the basic philosophical conceptions laid down in the older Upaniṣads had already been part of common knowledge amongst the ruling classes."[25]

One of these fundamental concepts is the notion of the relationship between *Brahman* and *ātman*, which derives from the "teaching on fire":[26]

> Das erhabene allgewaltige Brahmā, das das ganze Weltall durchdringt und beherrscht, davon ist meine Seele ein Teil, das bin ich selbst. Und diese Erkenntnis wirkte überwältigend und betäubend. Das höchste Wesen, das eigene Selbst, der Ātmā! Die alten Denker waren wie berauscht, als ihnen dieser Gedanke mit unmittelbarer Plötzlichkeit aufblitzte. Kein Wunder, dass ihm gegenüber alles

23. Georg Misch, Der *Weg in die Philosophie. Eine philosophische Fibel.* Erster Teil, Der Anfang (Sammlung Dalp; 72), Bern, ²1950, pp. 185-254, quotation p. 189.

24. *Ibid.*, p. 186.

25. *Ibid.*, p. 192. See also Axel Michaels, *Der Hinduismus. Geschichte und Gegenwart*, Munich, 1998, p. 48, table 1 (Religionsgeschichtliche Epochen) and p. 67, table 2 (Perioden der Literaturen der Hindu-Religionen), in which the older prose Upaniṣads (Bṛhadāraṇyaka Up., Chāndogya Up. and others) are dated *c.* 900 BC. Cf. also Helmuth von Glasenapp, *Die Literaturen Indiens*, Stuttgart, 1961, pp. 79-92, and Walter Ruben: *Die Philosophen der Upanishaden*, Berne, 1947, who dates the first generation of the philosophers of the Upaniṣads to the period of *c.* 700-670 BC (pp. 115ff.).

26. Erich Frauwallner, *Geschichte der indischen Philosophie.* I. Band: Die Philosophie des Veda und des Epos. Der Buddha und der Jina. Das Samkhya und das klassische Yoga-System, Salzburg, 1953, pp. 60-80, 72ff.

andere zurücktrat. Der Ātmā allein erschien als das einzig Wertvolle, frei von allen irdischen Beschränkungen und Unzulänglichkeiten, frei von allem Leid, in sich selbst ruhend, voll Wonne. Alles Irdische wurde ihm gegenüber als nichtig empfunden und man wendete sich gleichgültig von ihm ab, am nur den Ātmā zu suchen und zu erkennen.[27]

[My soul is part of the supreme omnipotent *Brahman*, permeating and governing the whole universe, and that I am myself. And this insight had an overwhelming and inebriating effect. The highest being, [identical with] the [individual] self, the *ātmā*! The ancient thinkers were almost inebriated when this thought flashed up in them at an instant. No wonder could compare to it; anything else was subordinate. *Ātmā* appeared to be the only thing that was truly valuable, free of any earthly limitations and deficiencies, free of any suffering, resting in itself, full of bliss. By contrast, everything in this world was considered futile and insignificant, and one turned away from it with indifference in order to seek and to know the *ātmā* alone.]

The affirmation of the *Brahman-Ātman* relation is persuasively expressed in one of the oldest texts:

Den Ātma möge man verehren. Denken ist sein Stoff, die Atemkräfte sein Leib, Licht seine Gestalt, der Weltraum sein Selbst. Sein Wollen ist wahr. Allwirkend ist er, allwünschend, allriechend, allschmeckend, das All durchdringend, wortlos, achtlos. Dieser mein Ātma im Innern des Herzens ist klein wie ein Reiskorn oder Gerstenkorn oder Hirsekorn oder eines Hirsekorns Kern, golden ist er, wie ein Licht ohne Rauch. Dieser mein Ātmā im Innern des Herzens ist grösser als die Erde, grösser als der Luftraum, grösser als der Himmel, grösser als diese Welten, allwirkend, allwünschend, allriechend, allschmeckend, das All durchdringend, wortlos, achtlos. Das ist mein Ātmā im Innern des Herzens, das ist das Brahmā. Zu ihm werde ich, wenn ich aus diesem Leben scheide, eingehen. Wem das zur Gewissheit ward, wahrlich, für den gibt es keinen Zweifel mehr. Also sprach Śāṇḍilya.[28]

[The *ātmā* is to be worshipped. Thinking is his substance, the forces of breath his body, light his shape, the universe his self. His willing is true. He is all-efficient, all-desiring, all-smelling, all-tasting, permeating the universe, wordless, inconspicuous. My *ātmā* inside my heart is small like a seed of rice or a grain of barley or millet, or the kernel of a grain of millet; he is golden like light without smoke. My *ātmā* within my heart is bigger than the earth, bigger than the sky, bigger than heaven, bigger than all these worlds, all-efficient, all-desiring, all-smelling, all-tasting, permeating the All, wordless, inconspicuous. This is my *ātmā* within the heart, this is *Brahman*. I will become *Brahman* when I depart from this life. Anyone who knows this with certainty, will truly no longer have any doubts. Thus spoke Śāṇḍilya.]

27. *Ibid.*, p. 72f.

28. *Śatapatha Brāhmaṇa*, X, 6, 3 and *Chāndogya Upaniṣad*, III, 14. As quoted in the abridged rendering of the text in Frauwallner, see note 26, 73 and 459, and note 33.

There is no contradiction when *ātman*, initially conceived as breath, is — according to a primeval belief in the soul — also conceived as a little man (*puruṣa*) — approximately the size of a thumb or just as big as a seed of rice or a seed of barley, who dwells in man's innermost heart.[29] This means that the external senses are in the literal sense regarded as mere tools or instruments of sense-perception, whereas the person, the 'I' or subject is the *ātman*, the self is that which truly perceives, listens and speaks. Thus the concept of *ātman* is best suited to be assigned a decisive role in Vedic philosophy. From the very special place held by *ātman*, in which all interests of life culminate, the thinking leads straight on to the universe, by which the self is incessantly inundated. "The I apprehends imaginatively as well as cognitively that (*Brahman*) and absorbs it."[30] In such an intense symbiosis it may happen that the self finally becomes identical with the universal Self (the *Brahman*) without being aware of it. There is a spontaneous oscillation between the awareness of the individual in *ātman* and that of the universal so that in the individual *ātman* the universal one becomes increasingly manifest.

In another text, the great Vedic teacher and founder of wisdom Yājñavalkya explains the exceptional role and function of the *ātman* to king Janaka of Videha, in the following words:

> Das ist dieser grosse, ungeborene, aus Erkennen bestehenden Ātmā in den Lebenskräften. Hier drinnen im Herzen ist Raum, darin ruht er, der Gebieter von Allem, der Herr von Allem, der Beherrscher von Allem. Er wird durch gutes Werk nicht grösser und durch böses nicht geringer. Er ist der Herr von Allem, der Beherrscher der Wesen, der Schirmherr der Wesen. Er ist der Damm, der diese Welten auseinander hält, damit sie nicht zusammenfallen. Ihn suchen die Brahmanen durch Vedastudium zu erkennen, durch Opfer, Spenden, Busse und Fasten. Wer ihn erkannt hat, wird ein Schweiger. Weil sie ihn als Stätte wünschen, verlassen die Wander-mönche ihr Heim. Darum begehrten die Alten, welche das Wissen besassen, nicht nach Nachkommenschaft, da sie dachten: 'Was sollen wir mit Nachkommenschaft anfangen, wir, deren Stätte der Ātmā ist?' Sie liessen daher ab vom Verlangen nach Söhnen, vom Verlangen nach Besitz und vom Verlangen nach einer Stätte und wanderten als Bettler umher. Das Verlangen nach Söhnen ist nämlich Verlangen nach Besitz, und das Verlangen nach Besitz ist Verlangen nach einer Stätte. Daher wird einer, der solches weiss, friedvoll, beherrscht, beruhigt, geduldig und gesammelt. Im Ātmā sieht er das Selbst. Alles sieht er für den Ātmā an. Das Übel überwältigt ihn nicht. Das Übel brennt ihn nicht. Er verbrennt jedes Übel. Frei von Übel, von Leidenschaft und von Zweifel wird er ein Brāhmaṇe, er, dessen Welt das Brahma ist.[31]

[This is the great, unborn *ātmā* within the forces of life that consists of knowing. Here inside the heart is space, and here he rests, the ruler of everything, Lord

29. Cf. Hermann Oldenberg, *Die Lehre der Upanishaden und die Anfänge des Buddhismus*, Göttingen, ²1923, pp. 45-47.

30. *Ibid.*, p. 46.

31. As quoted in Frauwallner, see note 26, pp. 73f. and 459, note 34 (*Bṛhadāraṇyaka Upaniṣad* IV, 4, 22-23).

of everything, governor of everything. He does not grow bigger by good works nor does he shrink by evil ones. He is Lord of everything, ruler over all creatures, protector of all beings. He is the supporting wall dividing these worlds so that they do not collapse. The brāhmaṇas endeavour to know him by the study of the Vedas, by sacrifice, alms, penitence and fasting. Anyone who has known him becomes a silent person. Itinerant monks leave their home because they wish to have him for their dwelling place. That is why the ancient people who were in possession of the knowledge did not desire to have offsprings, for they thought: 'What shall we do with descendants, we, whose place is the *ātmā*?' Thus they relinquished any desire for sons, the desire for property and the desire for a home and wandered about as mendicants. For the desire for sons is also a desire for possessions and the desire for possessions is the desire for a home. Therefore anyone who knows all that will become peace-loving, controlled, calm, patient and recollected. In the *ātmā* he recognizes the Self. Everything is identified with the *ātmā*. Evil does not affect him. Evil does not burn him. It is he who burns all evil. Devoid of evil, of passions and of doubt he becomes a Brahmin, he, whose world is the *Brahman*.]

What becomes clear from these statements is the conviction that the path to enlightenment leads from outside to the inside, from the multifarious external world of the *māyā* to the inner assimilation of *ātman* with the *Brahman*, the transpersonal, universal cosmic 'something' beyond all deities, which is also "the manifestation of the highest idea that one (the Indian people) has ever comprehended."[32] It is a path that moves like breath (the original meaning of *ātman*) from the outside to the inside. The concept of *ātman* was semantically expanded in the process: "The self, as an elementary, pre-scientific concept, which is not yet tainted by religious notions of the soul, the self was related to the unity of individual life as a whole, and it was not divided into body and soul."[33] This is clearly expressed in a passage from the *Kaṭha Upaniṣad* (4, 1):[34]

> The Creator made the senses outward-going:
> They go to the world of matter outside, not to the spirit within
> But a sage who sought immortality looked within himself and found his own Soul.

This kind of withdrawal into one's inner being is the beginning of self-knowledge, and this was already valid for the very first primeval man, who — according to the *Bṛhadāraṇyaka Upaniṣad* (*BU* 1, 4,1) — had to cope with the following insight:

> Am Anfang war diese Welt allein der Ātman, in Gestalt eines Menschen. Der blickte um sich: da sah er nichts andres als sich selbst. Da rief er zu Anfang aus: 'Das bin ich!' Daraus entstand der Name Ich. — Daher auch heutzutage, wenn einer angerufen wird, so sagt er zuerst: 'Das bin ich!' und dann erst nennt er

32. G. Misch, cf. note. 23, *ibid.*, p. 201.

33. *Ibid*, p. 202.

34. Juan Mascaro, *The Upanishads*, tr. from the Sanskrit with an introduction, Harmondsworth, 1965, pp. 61-62.

den andern Namen, welchen er trägt. — Weil er vor diesem allem alle Sünden vorher verbrannt hatte, darum heisst er pur-uṣ-a (der Mensch, der Geist). Wahrlich, es verbrennt den, welcher ihm vor zu sein begehrt, wer solches weiss.[35]

[In the beginning this world was solely *ātman* in the shape of man. This human being looked around and saw that there was nothing else but himself. There he first cried out: 'This am I!' From this derives the word 'I.' The same still applies today: if someone is addressed he/she will first say: 'This am I!' and he will tell his proper name only afterwards. Because he had burned (purged) all sin before, he is called *pur-uṣ-a* (the man, the spirit). Truly, he will be consumed by fire who desires to be the one who has such knowledge.]

With this advancement of the concept of *ātman*, everything was prepared

dass sich das grosse Ereignis vollziehen konnte: das Zusammenfallen der beiden Wesenheiten, die schon im Selbst des vom Brahman erfüllten Brahmanen verschmolzen, nun beide zu universeller Macht aufgestiegen waren: hier der alten Zauberkraft des heiligen Worts und der heiligen Kaste, dort der Idee des Ich, des Selbst. Die Schranken fielen. Nun fuhren die Denker, wenn sie vom Allwesen unter dem einen Namen zu sprechen angefangen hatten, mit dem andern fort. Wollten sie den Ātman beschreiben, sagten sie, dass er das Brahman ist. Wurde nach dem Brahman gefragt, erklärten sie es als den Ātman.[36]

[. . . for the big event to occur: the coincidence of the two beings, who had been fused already in the self of the *Brahman* filled with the *Brahman* and now risen to universal power: here the magic power of the holy word and of the sacred caste, there the notion of the I, the self. The borders were removed. The thinkers now continued, after they had begun to speak of the all encompassing being by the one name, to call it by the other name. When they wished to describe *ātman* they would say it was *Brahman*. When *Brahman* had been asked for, they explained it was *ātman*.]

The dimension of wideness, which the concept of *Brahman* attributed to the thinking on the Absolute, was united with that of depth in philosophical speculation, and that became manifest in the notion of *ātman* as inner space. Such an instance of the coincidence of opposites is not atypical of mystical writings and traditions. *Ātman*, identified with *Brahman*, thus becomes both the smallest and the biggest entity at the same time. And this was a very crucial turning point: man's self-reflection on the fullness of life within the self was linked with the speculation on the wholeness and all-oneness of creation and this resulted in the "coincidence of the two modes of being, which had already been made one in the self of the *Brahman* filled with *Brahman*, and both had thus been advanced to universal power."[37]

The double concepts of *Brahman* and *ātman* have been compared to Hegel's differentiation between *substance* and *subject*. If one concedes that each of the two pairs of concepts

35. Paul Deussen, *Sechzig Upanishads des Veda*. Aus dem Sanskrit übersetzt und mit Einleitungen und Anmerkungen, Leipzig, ²1905, pp. 392 f.

36. H. Oldenberg, see note 29, pp. 47f.

37. *Ibid.*, pp. 47f.

has resulted from a different historical context, such a comparison can be permitted. For, after all, the concept of the 'subject' acquired its idealistic-metaphysical sense[38] relatively late in the terminological history of Europe (commencing with Descartes' *Cogito, ergo sum* in the seventeenth century).[39] And it was much later that Hegel[40] opposed to the 'subject' the concept of 'substance,' whereas in Indian philosophy the idea of the separation between *ātman* and *Brahman* is associated with a rather archaic mode of thinking.

> In Indien vollzog sich die Vereinigung der beiden heterogenen Grundbegriffe *brahman* und *ātman* wie von selbst ohne gegensätzliche Spannungen. Das Ich wurde hier zum Prinzip der Philosophie erhoben, bevor der Begriff der Einzelseele des Individuums gewonnen war.[41]

> [In India the unification of the two heterogeneous key concepts of *Brahman* and *ātman* occurred almost automatically and without any opposing tensions. The self had become the principle of philosophy already before the concept of the individual soul and the individual person had been established.]

But even in India the discourse concerning the nature of *ātman* throughout history was not uncontroversial either, as is persuasively demonstrated in a recent study.[42] The texts of the Upaniṣads, however, clearly evoke the vivid impression of a process within the context of the philosophy of Vedānta,[43] in which the space of the inner self is discovered in ever-

38. Descartes' discovery of the *res cogitans* (Subjekt) versus *res extensa* is described by him in the following reflection: "Dann prüfte ich aufmerksam, *was* ich wäre, und sah dass ich mir vorstellen könnte, ich hätte keinen Körper. . . Ich erkannte daraus, dass ich eine Substanz sei, deren ganze Wesenheit (essence) oder Natur bloss im *Denken* bestehe und die zu ihrem Dasein weder eines Ortes bedürfe noch von einem materiellen Dinge abhänge . . ." (René Descartes, *Abhandlung über die Methode des richtigen Vernunftgebrauchs*, Stuttgart, 1984, pp. 31f.). On this aspect see also Annette M. Stross: *Ich-Identität zwischen Fiktion und Konstruktion*, Berlin, 1991, pp. 119-22.

39. Cf. Christian Link, *Subjektivität und Wahrheit. Die Grundlegung der neuzeitlichen Metaphysik durch Descartes*, Stuttgart, 1978; Paul Geyer, *Die Entdeckung des modernen Subjekts. Anthropologie von Descartes bis Rousseau* (mimesis; 29), Tübingen, 1997. For the historical aspect see Reto Luzius Fetz/Roland Hagenbüchle/Peter Schulz (eds.), *Geschichte und Vorgeschichte der modernen Subjektivität*, 2 vols, Berlin, 1998, cf. index of names; Richard van Dülmen (ed.), *Entdeckung des Ich. Die Geschichte der Individualisierung vom Mittelalter bis zur Gegenwart*, Cologne/Weimar/Vienna, 2001.

40. Joachim Ritter, *Subjektivität und industrielle Gesellschaft. Zu Hegels Theorie der Subjektivität*, in: id.: *Subjektivität* (BS; 379), Frankfurt a. M., 1989, pp. 11-35; cf. also Fetz/Hagenbüchle/Schulz, see note 38, index of names, s.v. 'Hegel.'

41. G. Misch, see note 23, p. 224.

42. Claus Oetke: *"Ich" und das Ich. Analytische Untersuchungen zur buddhistisch-brahmanischen ātmankontroverse*, (Alt- und Neu-Indische Studien; 33) Stuttgart, 1988, p. 1: "Die Frage nach der Existenz eines *ātman* ist ein Thema, mit dem sich indische philosophische Tradition fast während der gesamten Zeit ihres Bestehens auseinandergesetzt hat." ["The question concerning the existence of Atman is a topic that occupied the philosophical tradition of India almost throughout its entire history."]

43. Veda means 'knowledge,' i.e. the sacred, redeeming wisdom. In the plural the Vedas are a technical term for the collection of the four groups of texts: the *Ṛgveda* (the oldest collection of hymns), the *Sāmaveda* (collection of the tunes for the texts of the *Ṛgveda*), the *Yajurveda* (sacrificial speeches and psalms) and the *Atharvaveda* (magical prayers [against illnesses] and mystical prayers). Cf. Bettina

→

deepening dimensions, ultimately extending to cosmic dimensions so that the ultimate state of inwardness and self-identity (*ātman*) coincides with the divine *Brahman*. A frequently recurring sentence in the Upaniṣads is: *ya evaṁ veda sa eva bhavati* (who knows that it is so, will become so). This statement clearly indicates that what is meant is "knowledge by union" or "unifying knowledge."[44] On the basis of that knowledge nothing can be thought any more that would exclude the thinking subject, or vice versa: the person thinking can think nothing that would not be the cause for him to achieve existential union with the object thought of Self-knowledge in this context is not merely the objectifying knowledge of the spiritual structure of the individual self, but it is a knowledge of the self that transcends the individual self and aiming at the *unio mystica* (a hidden union) of the subjective self with the Universal Self. In this state, the knowledge of the sages of the Upaniṣads has ultimately transcended the inherent tendency of knowledge to be directed at something different, at an *other* (which necessarily remains the 'object' of thinking!) "which is the condition for the possibility of all our seeing, hearing, thinking and knowing":[45]

> Du kannst den Seher des Sehens nicht sehen,
> du kannst den Hörer des Hörens nicht hören,
> du kannst den Erkenner des Erkennens nicht erkennen,
> Dieses Selbst (*ātman*), das in allem ist, ist dein
> eigenes Selbst. Alles andere ist nur Ursache des Leidens.[46]

> [You cannot see the seer of seeing,
> you cannot hear the hearer of hearing,
> you cannot know the knower of knowing,
> this self (*ātman*) that is in all things, is your
> own self. Everything else is merely the cause of suffering.]

Elsewhere in the same Upaniṣad it says: "How can you know that by which one may know the whole Reality?"[47]

If, however, this trite method of objectifying the self, which is alone focused on the separation between subject and object, has to be rejected, for good reasons, then there remains only one path open to the thinking self: to turn inward to contemplate the self and its depth, and it is then that the experience of Advaita — the denial of duality and dualism — may become possible mystically, i.e. in a secret manner. In such a context the dissatisfaction springing from the division of the world into subject and object can no longer arise — provided that the self is indeed absorbed in a state of deep meditation of the kind described by Bettina Bäumer:

→ Bäumer's excellent introduction to the *Upaniṣads*: *Upanishaden. Die Heiligen Schriften Indiens meditieren.* Ed. and transl. from the Sanskrit and commented by Bettina Bäumer. With a preface by Raimon Panikkar, Munich, 1997, p. 27.

44. Bäumer, *ibid.*, p. 38.

45. *Ibid.*, p. 39.

46. *BU* III, 4, 2; quoted in Bäumer, *ibid.*

47. *BU* IV, 5, 15; quoted in Bäumer, *ibid.*, p. 40.

Der Begriff *ātman*, der wörtlich 'Selbst' heisst und auch einfach als Reflexivpronomen gebraucht wird, geht von der Innerlichkeit aus, von der Selbstreflexion und Suche nach dem tiefsten Grund im eigenen Ich. Er stützt sich weniger als die anderen Begriffe auf eine vedische Vorgeschichte und ist aus der Meditation und Versenkung der upanishadischen Seher entstanden. Doch hat er auch verschiedene Bedeutungen durchlaufen, die den Stufen der Suche nach dem eigentlichen Selbst des Menschen entsprechen: *ātman* bedeutet, vor allem in den älteren Upanishaden, oft einfach den Körper, oder die ganze leib-seelische Persönlichkeit, und wird immer mehr erweitert zu einer universalen, alles durchdringenden Immanenz. Das innerste Wesen des Menschen ist auch das innerste Wesen der Welt. Immer bleibt dabei der Aspekt der Innerlichkeit erhalten und der Namenlosigkeit, denn das *Selbst* kann nur immer das von jedem Menschen in seinem Innern Erfahrene sein.[48]

[The concept of *ātman*, which literally means 'self' and which is also used as a reflective pronoun, arises from inwardness, from self-reflection and from the quest for the innermost ground of the self. Unlike other concepts it is not so much based on antecedent Vedic history, but rather emerged from the meditation and contemplation of the Upaniṣadic seers. However, the term acquired various meanings in the course of its historical development, and these correspond to individual stages in man's quest for the true self: in the old Upaniṣads the word *ātman* often refers merely to the body, or else to the entire psycho-physical personality; its meaning, however, was increasingly expanded in the process until it finally signified a universal, all-permeating immanence. The innermost being of man is also the innermost being of the world. The aspects of inwardness and of namelessness are thus sustained throughout, because the *self* can only be that which is experienced individually in one's own inwardness.]

Gnothi Sauton and the Distinction between 'Inward' and 'Outward Man'

Surprisingly, no one to date has given a full account of what the dictum *In teipsum redi* (Augustine)[49] — which was handed down through the Middle Ages via Neoplatonism and Christianity — implies and what impact it may have had in terms of the cultural history, the history of civilization and the history of mentality. What is the effect of the inner mindfulness of man on and within man? What happens if man is required to examine his own self, i.e. to look into his soul by withdrawing into one's self in love and out of a desire for self-knowledge? Something was evidently revealed to the individual then, which should much later become manifest in the Romantics in a genuine culture of inwardness,[50] expressed

48. Bäumer, *ibid.*, pp. 41f.

49. Augustine, *De vera religione* XXXIX, 72, 202. See also Michael Schmaus: *Die psychologische Trinitätslehre des Heiligen Augustinus*, Münster/W., 1927, Reprinted: Münster/W., 1967, pp. 220-25; R. Berlinger, *Augustins dialogische Metaphysik*, Frankfurt a. M., 1962, pp. 154ff.; A. Maxsein, *Philosophia Cordis. Das Wesen der Personalität bei Augustinus*, Salzburg, O. J., (1966), pp. 35ff., 55ff.

50. Schelling and Fichte evidently follow Augustine to the very word in their demand to withdraw into one's self. Cf. M. Neumann: *Unterwegs zu den Inseln des Scheins. Kunstbegriff und literarische Form in der Romantik von Novalis bis Nietzsche*, Frankfurt a. M., 1991, pp. 66f. Novalis's famous *Blüthenstaub-*

→

by an idiom of its own and, linked with it, a focus on subjectivity. It is probably not too far-fetched to suggest that the emergence of the subject, i.e. the claim of modern man to be able to make autonomous decisions about himself, and to define both his personal aims in life as well as the aims of his generation or humanity at large, can be traced back to the incipient stage of introversion, when man began to withdraw to his inner self, the soul, conscience or inwardness.[51] Man's inclination to turn inward first gained momentum in late antiquity and has expressed itself more and more emphatically ever since. Classical antiquity, it is true, had also been conscious of the so-called "anxiety of man about himself,"[52] and it knew that self-knowledge was in important moral command as is manifest from the imperative of the Delphic *Gnothi seautón!*;[53] and the ancients also knew of course the "ideal of inner freedom."[54]

However, it is important to emphasize at the same time that, in classical antiquity, the anxiety about the self-resulted from the concrete and specific network of "power relationships" and "games of truth" (Michel Foucault),[55] which derive from the outward, social reality of man. Moreover, *Parrhesia* (openness, freedom of speech), i.e. an attempt to mediate between the subject and truth by uttering words of truth,[56] is also a form of self-knowledge. Here the command to "know yourself" is likewise connected with the demand that one must "take care of oneself," in order to be able to execute power justly and properly; that is to say, the appeal to attain self-knowledge is directed towards the outside. These exhortations to attain self-knowledge are aimed at practical aspects of existence such as dietetics, economics, erotic love, the carefully modelled pastoral life, housekeeping or the

→ *Fragment* (no. 16) indicates the direction of this path towards self-knowledge: ". . . ist denn das Weltall nicht in uns? Die Tiefen unsers Geistes kennen wir nicht. Nach Innen geht der geheimnisvolle Weg. In uns, oder nirgends ist die Ewigkeit mit ihren Welten, die Vergangenheit und die Zukunft" (*Schriften* II, 419) [. . . is not there eternal space within ourselves? We do not know the abysses of our mind. The mysterious path is directed inwards. Eternity and its worlds, the past and the future are within us, or nowhere at all.] Cf. Neumann, ibid., pp. 73-78, 81-85, 97-100, 103f., 110, 116-19, 128, 130, 134, 136, 139. See also A. Béguin: *Traumwelt und Romantik. Versuch über die romantische Seele in Deutschland und in der Dichtung Frankreichs*, ed. and with an afterword by P. Grotzer, Berne/Munich, 1972, pp. 248ff.; Otto-Friedrich Bollnow, Der 'Weg nach Innen' bei Novalis, in: *id., Unruhe und Geborgenheit im Weltbild neuerer Dichter*, Stuttgart, 1953, pp. 178-206; for the context of the spiritual history see: J. Brändle, *Das Problem der Innerlichkeit. Hamann - Herder - Goethe*, Berne, 1950.

51. For a survey of this "inward journey" from its beginnings in classical antiquity see F.W. Wodtke, *Studien zum Wortschatz der Innerlichkeit im Alt- und Mittelhochdeutschen*, Habil. Schr. Kiel, 1952 (masch.), pp. 6-33.

52. Michel Foucault, *Die Sorge um sich* (Sexualität und Wahrheit; 3), Frankfurt a. M., 1986.

53. Eliza Gregory Wilkins, *"Know Thyself" in Greek and Latin Literature*, Diss. Chicago, 1917; P. Courcelle, see note 19; C. Göbel, *Griechische Selbsterkenntnis. Platon — Parmenides — Stoa — Aristipp, op. cit.*

54. H. Gomperz, *Die Lebensauffassung der griechischen Philosophen und das Ideal der inneren Freiheit*, Jena, 1915.

55. Michel Foucault, *Freiheit und Selbstsorge. Interview 1984 und Vorlesung 1982*, ed. H. Becker *et al.*, Frankfurt a. M., 1993; *id., Das Wahrsprechen des Anderen. Zwei Vorlesungen von 1983/84*, ed. U. Reuter *et al.*, Frankfurt a. M., 1988.

56. Foucault, *Freiheit*, see note 55, 1993, pp. 57ff.

problem of love.[57] Self-knowledge is essentially an occupation with one's own self with the express purpose of providing insights for the proper direction of one's political, pedagogic and erotic behaviour, but which ultimately will also provide the "access . . . to truth in general."[58] And finally, there is the idealistic demand for "inner freedom" (Gomperz), "the condition of self-sufficient, free, inward contemplation,"[59] something that Aristotle considers to be an attribute of a hypothetical God, but not of man and real life.

In Christian anthropology, by contrast, the opposition between outward man and inward man is a central theme in Paul and has remained so, irrespective of the fact that Plato had already identified "the capacity of thinking" (*tò logistikòn tês psychês*) in the statement *toû anthrópou ho entòs ánthropos* (*Resp* IV 439d; IX 589a) with "moral inclination." This identification had been prepared by Plotinus (*Enn* V 1,10), Philon (*Plant* 42; *Congr* 97), the hermetical writings (Zosimos) and, had earlier been conceived in similar terms by the hellenistic Gnosis and mysticism.[60] The distinction between the inward and the outward man signifies, according to the apostle Paul (*Rom* 7, 22 and 2 *Cor* 4, 16), "the spiritual dimension in man, man himself, provided when endowed with consciousness, capable of thinking, willing and feeling. As a subject of moral judgement, man is susceptible to divine revelation, and can thus be governed and claimed by it."[61] "The term as used by Paul is to some extent always connoted with the idea of something hidden in man's inwardness and working secretly in man;" for Paul, the man within man is quite clearly seen as the one ". . . governed by God, and one 'becoming Christ within the Christian' (*Gl* 2, 20; 4, 19)."[62]

It was, no doubt, most significant that Christianity should react to the various conceptions of inwardness transmitted from classical antiquity, and finally adapt and adopt them with a dynamic energy inspired by the conviction that Christ must grow within man and that Christ is indeed the true inward man of man.[63] The Christian fathers partly adopted traditional aspects of Platonic and Neoplatonic anthropology. They combined the notions expressed in 2 *Cor* 4, 16 and *Rom* 7, 22 with the classical concepts in a manner that the inward man could find the Holy of Holies in the *hegemonikón*. This becomes evident from a passage in Clement of Alexandria (second century AD), which is still imbued with the thinking and idiom of Plato:

> Es scheint, dass die höchste aller Erkenntnisse die Erkenntnis seiner selbst ist. Denn derjenige, der sich selbst erkennt, erwirbt sich die Erkenntnis Gottes, und im Besitz dieser Erkenntnis wird er Gott ähnlich. . . Die Seele setzt sich indessen

57. *Ibid.*, p. 39.

58. Foucault, *Freiheit*, see note 55, 1993, p. 40.

59. Gomperz, see note 54, p. 273.

60. Theol. Wb. on the NT, vol. I, Stuttgart, 1933, p. 366 (J. Jeremias).

61. *Ibid.*, vol. II, p. 696 (Behm).

62. *Ibid.*, p. 696; cf. also Richard Reitzenstein: *Die hellenistischen Mysterienreligionen nach ihren Grundgedanken und Wirkungen*, Darmstadt, ⁴1966, pp. 354ff.

63. On Origen and Clemens of Alexandria see W. Völker, *Der wahre Gnostiker nach Clemens Alexandrinus*, Berlin, 1952, pp. 368f.

aus drei Teilen zusammen: Aus dem geistigen Teil, den man das Logistikón nennt. Das ist der innere Mensch, jener, der dem Menschen, den wir sehen, Befehle erteilt; ihm aber steht ein anderer vor, der ihn führt: Gott. Dann gibt es den zornmütigen Teil, der, weil tierisch, nahe bei der wutvollen Verrücktheit seinen Ort hat. Schliesslich gibt es an dritter Stelle den Seelenteil des Begehrens mit vielen wechselnden Formen, der vielfältiger als der Meergott Proteus sich mal so mal so verwandelt, zu verführen sucht, zum Ehebruch und zu Ausschweifung und verdorbenen Sitten anreizt.[64]

[It seems that the highest knowledge of all is the knowledge of one's self. For the one who knows himself also attains the knowledge of God, and being in possession of this knowledge, he attains the likeness to God. . . . The soul, however, is composed of three parts: first, the spiritual part called the *logistikón*. This is inward man, the one who gives orders to the man we actually see; inward man, however, is governed and directed by someone else: God. Second, there is the irascible part, which, because it is beastlike, is closely linked with rage and frenzy. Finally, there is the third part, the area of the soul encompassed by desire with its many multifarious and changing forms of manifestation, which is more variegated even than Proteus, the God of the Seas, who has no sooner transformed himself into one shape than he assumes a different one, and this is the part that tries to tempt and to allure man to adultery, debauchery and depraved morals.]

The inward man is thus called "the true man" by the Church Fathers as well, and is defined as the one created in the image and likeness of God (*Gen* 1, 27), and the one whose invisible soul is a temple in which God is to be 'erected' (apprehended).[65] For it is the soul alone that carries the image of God; the soul is *animus* or *nous*, and thus the *capax Dei*. This results in the division of man into a (mortal) body and an (immortal) soul. Origen (*c.* 185-254) compares the body to an armour and the self, the inward man, to the warrior dressed by it.[66] This manner of thinking is consonant with Platonic tradition which used the same comparison to illustrate that true man is identical with the soul. In early Christian thinking similar comparisons were used in which the body is viewed as the mere frame, shell, dress, slave or vessel for the soul. This notion suggests that true man is a spiritual being, hidden inside of that vessel, revealing himself to the outside world only through actions and behaviour.[67] Hence, true man is not what he appears to be, but is identified with his own invisible soul (St. Basil).[68]

64. Clément d'Aléxandrie, *Le Pédagogue*, Livre III, Paris, 1970, p. 13 (Päd. III, 1, 1); quoted in J. Pépin, *Idées grecques sur l'homme et sur Dieu*, Paris, 1971, p. 182. On the classical tripartite division of man by Plato into Epithymetikón, Thymoeidés and Logistikón cf. *ibid.*, p. 79.

65. Pépin, *ibid.*, pp. 184f.; A.G. Hamann, *L'homme image de Dieu. Essai d'une anthropologie chrétienne dans l'Eglise des cinq premiers siècles*, Paris, 1987.

66. Pépin, see note 64, *ibid.*, p. 178.

67. *Ibid.*, p. 179.

68. *Ibid.*, p. 186.

However, all these visual images are rather limitating, since they convey basically Platonic notions, ones, which — like the image of horse and horseman illustrating the hierarchical relationship between body and soul[69] — should never have been permitted to intrude upon Christian thinking in this marked poignancy. After all, Christianity does not in the least endorse the notion that the human body is merely temporal. Christian faith rather insists on the contrary — that man, at the resurrection on Judgement Day, will be called to eternal life, clothed in his transfigured body.[70] The Christian understanding of man is thus inextricably bound to corporality. For this reason an alternative model was developed by the Christian Fathers relatively early, and they adhered to it. Ireneus (second century) says it very clearly: "Perfect man is composed of three things: body/flesh, soul and spirit."[71] And this view accords with 1 Thess 5.23.[72] Any claim that reduces man to merely one of these three constituents, and which would still be considered to be the means of salvation, was thus vehemently rejected. The body is thus an integral part of the Resurrection. It is the entire human being, body and soul, that is redeemed by Christ.[73] Tertullian (*c.* 150-230), Justinus (second century) and Minucius Felix (second or third century), and many others following these theologians, insist vigorously that the body can never be excluded from the definition of man. In the course of history, the notion of inwardness, and hence of the inward man, gained increasingly in importance. Man continued to define himself more and more emphatically as a being distinguished by his innate spirituality; and the spiritual side of man was often understood and interpreted as 'man within man.'

The Middle Ages, which were confronted with a wide range of classical and early Christian teachings, and had to deal with many divergent approaches, and even a Renaissance[74] of classical spirituality, became as it were the main stage on which these conflicting interpretations of human existence were acted out. It goes without saying that

69. *Ibid.*, pp. 66f., 93.

70. C.W. Bynum, The *Resurrection of the Body in Western Christianity*, 200-1336, New York, 1995, pp. 21ff.

71. Pépin, see note 64, p. 168.

72. A.J. Festugière: 'La division corps-âme-ésprit de I Thess V, 23, et la philosophie grecque,' in: *id.*, *L'idéal religieux des Grecs et l'Evangile*, Paris, 1981, pp. 195-220.

73. Pépin, see note 64, pp. 169f.

74. See note 78 below and the following studies: Erna Patzelt: *Die karolingische Renaissance. Beiträge zur Geschichte der Kultur des frühen Mittelalters*, Wien, 1924; G. Paré/A. Brunet/P. Tremblay (eds), *La Renaissance du XIIe siècle*, Paris, 1933; Charles Homer Haskins (ed.), *The Renaissance of the Twelfth Century*, Cambridge, 1927, 1971; E. Panofsky, *Renaissance and Renaissances in Western Art*, Stockholm, 1960; Jean Leclercq: *Wissenschaft und Gottverlangen. Zur Mönchstheologie des Mittelalters*, Düsseldorf, 1963; Maurice de Gandillac/Édouard Jeauneau: *Entretiens sur la Renaissance du 12e siècle*, Paris, 1968; Marie-Dominique Chenu: *L'Éveil de la conscience dans la civilisation médiévale*, Montréal/Paris, 1969; Charles R. Young (ed.), *The Twelfth-Century Renaissance*, New York, 1969; Peter Weimar (ed.), *Die Renaissance der Wissenschaften im 12. Jahrhundert*, Zurich, 1981; Robert L. Benson/Giles Constable (eds.): *Renaissance and Renewal in the Twelfth Century*, Oxford, 1985; Tina Stiefel, *The Intellectual Revolution in Twelfth Century Europe*, New York, 1985; Sarah Spence, *Texts and the Self in Twelfth Century*, Cambridge, 1996; Jacques Verger: *La Renaissance du XIIe siècle*, Paris, 1996; Arnold Angenendt, *Geschichte der Religiosität im Mittelalter*, Darmstadt, 1997, subject index, s.v.

in this respect the Christian faith with its awareness of the dualism of man, inherited from classical antiquity, will inevitably favour conceptions affirming the spiritual nature of man, i.e. ones that deal primarily or preferably with the inward man. The following section will deal with this development, which continues to have a considerable impact on our existence today.

Medieval Self-Reflection

In his book *Weltfremdheit*, Peter Sloterdijk has lucidly pinpointed the historical event that initiated the Christian development towards inwardness. This was the "anchoritic revolution of the fourth century,"[75] i.e. the massive exodus of individuals into the deserts of Egypt and Syria motivated by the desire for a secluded, solitary life. It goes without saying that the perception of one's own inwardness is the consequence of a voluntarily chosen mode of existence in which all social contacts are suspended and all sensual pleasures and even discursive thinking is eroded; it is an attitude of radical denial in which the recluse is inexorably confronted with his own inwardness.[76] This path to God turned out to be the only option in a repressive culture and civilization granting to the individual only very limited living space. In this solitary environment the kind of person was formed that has continued to shape the cultural heritage to this very day. Sloterdijk has acknowledged this achievement very clearly and says it explicitly:

> Only in the desert the monarchy could be transformed into a new psychagogical law, and anything that in later history of European notions of the unity of the personality should become powerful, was partly prepared for in the Egyptian and Syrian deserts in the struggles for concentration on the one that is inevitable, struggles that had lasted for centuries. Monasticism is not merely semantically an effort of the individual solitary to qualify as the one of the heavenly ground of the world.[77]

In other words: the coenobite's concentration on his bliss and salvation depended on and was concurrent with introversion and self-contemplation; it was inevitable that the self-knowledge thus gained should have a formative and lasting effect on the individual.[78] The

75. Peter Sloterdijk, *Weltfremdheit*, Frankfurt a. M., 1993, p. 86.

76. M. Nédoncelle, 'Intériorité et vie spirituelle' : *DSp* VII, pp. 1889-1903.

77. Sloterdijk, see note 75, p. 87.

78. C. Morris, *The Discovery of the Individual. 1050-1200*, New York, 1979, pp. 64-107; T. Kobusch, *Die Entdeckung der Person. Metaphysik der Freiheit und modernes Menschenbild*, Freiburg, 1993, pp. 23-54. These two studies are not specifically focused on the monastic contribution to the formation of the individual person and the strengthening of man; the actual focus is the contribution of the Middle Ages to this process. It is rather astonishing, how much the contribution of the monastic traditions in general and that of the Middle Ages in particular, have been neglected in theologically orientated (Catholic) conceptions of anthropology (perhaps springing from a misconceived notion of modesty). Historical surveys often leap forward from the Church Fathers (including Augustine) to Thomas Aquinas and from there go on to modern approaches. A representative example, in lieu of many others, is A. Rizzacasa, 'Interiorità e interiorizzazione,' in: A. Rigobello, *Lessico della Persona umana*,

→

model of the inward *vs.* the outward man was finally adopted in the Middle Ages by various monastic spiritual traditions and became in practice a dynamic model of introversion. The path was directed inwards, since it was inside the heart that salvation came to pass.[79] Self-knowledge and knowledge of God[80] converged in the personal path to blessedness. This path proceeded from outside to inside and moved towards a particular goal.[81] The idea of progress developed here gained a dynamic which had a lasting impact on our civilization and still has and has become deeply engrained in the mentality of modern man.[82]

John Cassianus (*c.* 360-435)[83] introduced the monasticism of the Middle East to the West by founding a monastery and a nunnery at Marseille around 415. He describes the path that leads from outside to the inside very vividly in his writings: In the *Institutiones* he writes about the *external* form of monastic living, and in the *Collationes* (*c.* 426-29) he focuses on the inner spiritual life of exemplary anchorites and coenobites of Egypt. In this way he alerts the monks of the West to the benefits of introverted contemplation and to various forms of piety practised in Eastern monasticism. Apart from the practical active knowledge, there is a theoretical knowledge that is devoted to both the contemplation of divine things and the reading of Holy Scripture. The former yields insight and guidance in the monk's external combat against the eight cardinal sins (gluttony, lust, greed, anger, melancholy, *acedia*, vainglory and pride); it establishes rational grounds for physical asceticism and the coenobite's behaviour to the outside. The latter puts a special emphasis on the spirit, directing the monk on his thoughts, desires and emotions, on the purity of his heart and the growth in his spiritual life. Most of the passages dealing with 'the inward man' are devoted to the inner struggle against the evil thoughts of the heart. The spiritual combat of the monk is

→ Roma, 1986, pp. 157-76; cf. also L.F. Ladaria, *Antropologia Teologica*, Asti, 1995, pp. 131-34. For the given context of the twelfth century see E. Bertola: *Il problema della coscienza nella teologia monastica del XII secolo*, Padova, 1970; *ibid.*, 'Il socratismo cristiano nel XII secolo,' Rivista di Filosofia Neo-Scolastico 51 (1959), pp. 252-64; A. Maiorino Tuozzi, *La 'conoscenza di sé' nella scuola cisterciense*, Napoli, 1976. For an example demonstrating how the quest for self-knowledge can become a means to self-perception see Alanus von Lille, *Erkenne dich selbst!*, Stuttgart, 1989. On the early monastic tradition see F. Prinz, *Askese und Kultur. Vor- und frühbenediktinisches Mönchtum an der Wiege Europas*, Munich, 1980; A. de Vogüé, *Histoire littéraire du mouvement monastique dans l'antiquité*, 2 vols (to date), Paris, 1991-93.

79. J. Leveque/M. Nedoncelle, 'Interiorité' : *DSp* VII/2, pp. 1877-1903; M. Dupuy, 'Introversion,' *ibid.*, pp. 1904-18.

80. See the bibliography in the study of Courcelle, cf. note 19. See also A.M. Haas, *Nim din selbes war. Studien zur Lehre von der Selbsterkenntnis bei Meister Eckhart, Johannes Tauler und Heinrich Seuse*, Freiburg/Switzerland, 1971; and *id.*, *Geistliches Mittelalter*, Freiburg/Switzerland, 1981, pp. 3-27, 45-70; L. de Bazelaire, 'Connaissance de soi': *DSp* II/2, pp. 1511-43.

81. H. Blommestijn, 'Progrès-Progessants' : *DSp* XII, pp. 2383-2405.

82. It remains the task of the humanities to explore and to interpret the connection between the religious and the social conceptions of progress.

83. Cf. O. Chadwick, *John Cassian*, Cambridge, ²1979; A. Gianfrancesco, *La contemplation selon Jean Cassien. Aspects du monachisme ancien*, Université de Provence, 1989; M. Schneider, *Krisis. Zur theologischen Deutung von Glaubens- und Lebenskrisen. Ein Beitrag der theologischen Anthropologie*, Frankfurt a. M., 1993, pp. 8-62; and especially A. Solignac, 'Homme intérieur' : *DSp* VII/1, p. 655.

thus one with two front lines: one of which is directed to the outside, against the urges and temptations of the flesh, the other faces inwards and is turned against the destructive intrusion of thoughts. In this context Cassianus explicates a passage from the Gospel according to Matthew (5.39): ". . . whosoever shall smite thee on thy right cheek, turn to him the other also." The "other cheek" is, however, not the left one, but is interpreted allegorically by Cassianus signifying the inward man's affirmative acceptance of the blow received by the outward man.

The two other founders of Western mysticism, Ambrose (*c.* 340-97)[84] and Augustine (354-430),[85] though not monks themselves, emphatically assert and promote the monastic ideal. Through them introvertive mysticism was transferred to the profane world and the Christian laity. In other words: the kind of spirituality advocated by Cassianus and Augustine adheres to the common notion that the way to God consists, as a matter of principle, in turning inwards, since truth is hidden inside the depths of the self and can hardly be perceived from the outside. Truth dwells — as confessed by by Augustine — truly and actually in the inward man. This conviction is further endorsed by the ensuing intellectual developments of the Middle Ages. The notion of the inward man becomes the key issue in dealing with the world on all levels.

Before turning the attention to two developments which had a crucial impact on the Occident, I would like to refer to a thinker who developed in a striking manner the allegory of the inward and the outward man into a model of the anthropological self-determination of man. This is John Scottus, also called Eriugena (the Irishman) (*c.* 810-77).[86] He was the head of the school at the Court of Charles the Bold from about 847 onward and was surely the greatest man of learning in his time. In his work *Periphyseon* he deals, amongst other things, with the book Genesis.[87] He attempts in particular to read the word and the concept of 'paradise' allegorically. Thus paradise is nothing else but the perfect human being created in the image and likeness of God. The individual parts of paradise are defined in anthropological terms: the *land* stands for the body which has the capacity to be immortal,

84. Bernard McGinn, *Die Mystik im Abendland*, vol. 1: Ursprünge, Freiburg, 1994, pp. 292-312; Ruh, see note 87, cf. index of names.

85. *Ibid.*, pp. 330-80; Solignac, see note 83, pp. 655-58; W. Kersting, 'Noli foras ire, In te ipsum redi.' Augustinus über die Seele, in: G. Jüttemann/M. Sonntag./C. Wulf (eds.), *Die Seele. Ihre Geschichte im Abendland*, Weinheim, 1991, pp. 59-74; Ruh, see note 87, pp. 83-117.

86. On this see B. McGinn, *The Growth of Mysticism*, vol. II: The Presence of God: A History of Western Mystics, New York, 1994, pp. 80-118; Alois M. Haas, *Gott Leiden - Gott Lieben. Zur volkssprachlichen Mystik im Mittelalter*, Frankfurt a.M., 1989, pp. 241-63, 447-57. W. Otten, *The Anthropology of Johannes Scottus Eriugena*, Leiden, 1991, pp. 153ff., contains good summaries of the issues discussed in the following passages.

87. *Periphyseon*, Book IV, ch. 16 (*PL* 122, 822 A ff.). Johannes Scotus Eriugena, *Über die Einteilung der Natur*. Transl. L. Noack, Hamburg, 1983, pp. 113ff. On the 'Periphyseon' cf. Kurt Ruh, *Geschichte der abendländischen Mystik*, vol. I: *Die Grundlegung durch die Kirchenväter und die Mönchstheologie des 12. Jahrhunderts*, Munich, 1990, pp. 195-206. Cf. in particular R.R. Grimm, *Paradisus Coelestis - Paradisus Terrestris. Zur Auslegungsgeschichte des Paradieses im Abendland bis um 1200*, Munich, 1977, pp. 111-20.

the *water* represents the mind of the eternal body endowed with the capacity for knowledge, the *air* signifies man's rational mind illuminated by the rays of divine wisdom. The four virtues of wisdom, temperance, fortitude and justice correspond to the *four rivers of paradise* streaming forth from the "innermost crevices of mankind," which are understood to be the most secret pores of spiritual earth and which govern the actions and the behaviour of man in paradise. The two trees growing in paradise are the tree named "All" and the tree called "The Intelligible" or "Miscellaneous Things." Man is allowed to eat the fruits of the first tree, for it stands for the word and the wisdom of the father, Jesus Christ, who unites with man with his divinity. The second tree is the tree of the knowledge of good and evil. Adorned with apparent goodness it represents the evil implanted in the physical senses. Since the two trees are placed in the middle of paradise, they are also emblematic of the condition of man as a whole. Applying the allegorical exegesis to man, he is thought to encompass six "moments" or parts, three relating to outward man and three to inward man. The outward man consists of the *body*, made of substance, which is the lowest part; there is, secondly, the growing or prospering part, also called *the motion of life* and, thirdly, physical sensuality divided into the five senses. Together these three parts constitute 'outward man.'

'Inward man,' on the other hand, consists exclusively of the soul, which is also divided into three parts: the *inner sense*, which has the function to discern and to assess the perceptions transmitted by the five physical senses; secondly, *reason*, which investigates the causes of all created things and, finally thirdly, *mind* (*animus*), which governs the lower parts of human nature, looks into the surrounding world and into God. In this conception of man the three parts belonging to 'lower man' are transitory, whereas the three parts belonging to 'higher man' are intransitory, indissoluble and eternal. Viewed in cosmic dimensions, man is placed above nothingness extending below him, and looking upwards, he is placed below God. After these considerations Eriugena returns to the two trees and their central place in paradise: they are located right in the middle of the juncture where the material meets with the spiritual: the tree named "All" meets with the interior senses, the tree "Miscellaneous Things" touches the external senses. This provides the impetus for a dynamic process that moves from the outside to the inside (like in Augustine). And Eriugena uses almost exactly the same words as Augustine when he demands that every man should embark on this journey which will lead man to salvation:

> Denn im innern Menschen wohnt Wahrheit und alles Gute, welches das Wort Gottes, der eingeborene Sohn Gottes, unser Herr Jesus Christus ist, ausser welchem es kein Gut gibt, weil er selber alles Wahre und wesenhaft Gute und die Güte selber ist. Diesem steht als Gegentheil das Böse und die Bosheit entgegen. Und weil alles Böse weder in der Natur der Dinge bestandhaft gefunden wird, noch aus einer bestimmten natürlichen Ursache hervorgeht, sintemal es für sich betrachtet durchaus nichts als eine unvernünftige, verkehrte und unvollkommene Bewegung der Natur ist; so findet es in der ganzen Schöpfung keinen andern Sitz, als wo die Falschheit wohnt, deren eigentlicher

Sitz der leibliche Sinn ist.[88]

[For it is in the inward man that truth and all goodness dwells, which is the word of God, the only begotten son of God, our Lord Jesus Christ, outside whom there is no goodness, because he Himself is all truth and substantial goodness and benevolence. Opposed to Him is evil and malice. And since evil can neither be found as a substance in the nature of things, nor does it proceed from any specific natural cause, for it is, considered for itself, nothing but an irrational and perverse and imperfect motion of nature: therefore it has no place in the whole of creation except where falseness dwells. And the proper place of falseness is the corporal senses.]

However, when the learned philosopher illustrates human sensuality in the ensuing passages by the use of the symbolism of "the woman," it is no longer easy for us to follow him. Nevertheless, the important issue here is something else: the philosophical definition of man in terms of a being divided by contradictions with the self. Strictly speaking, only the 'higher man' can be called paradisaical, whereas the 'lower man' does by no means deserve such appellation. Elsewhere Eriugena's myth of man's genesis he states clearly:

Weil in jedem Menschen gewissermassen zwei Menschen verstanden werden, wenn der Apostel sagt, dass der äussere Mensch verderbe, der innere aber erneuert werde (2 Kor 4,16; Eph 4, 22-24); so wird mit Recht der nach dem Bilde Gottes gemachte innere Mensch im Paradiese gebildet, der äussere und vergängliche Mensch aber ausser und unter dem Paradiese aus dem Koth der Erde gemacht, und dieser wird dann genommen und in's Paradies gesetzt; denn hätte er in diesem sein Heil im Auge behalten und das göttliche Gebot bewahrt, so hätte er auch zur Würde seiner früheren Schöpfung nach dem Bilde Gottes gelangen können; weil er jedoch den göttlichen Geboten nicht gehorchen wollte, so verliess er nicht blos seinen Schöpfer, sondern auch die Würde des göttlichen Bildes und wurde darum in ein doppeltes Geschlecht, als Mann und Weib gespalten, welche Spaltung nicht von der Natur, sondern von der Sünde veranlasst worden ist.[89]

88. *PL* 122, 826A: In interiori enim homine habitat veritas et onna bonum, quod est Verbum Dei, Filius Dei unigenitus, Dominus noster Jesus Christus, extra quem nullum bonum est, quoniam ipse est omne verum et substantiale bonum et bonitas. Cui e contrario ex diversa parte malum et malitia opponitur. Et quia omne malum nec in natura rerum substantialiter invenitur, neque ex certa causa et naturali procedit; per se enim consideratum omnino nihil est praeter irrationabilem et perversum imperfectumque rationabilis naturae motum: nullam aliam in universa creatura sedem reperit, nisi ubi falsitas possidet. Propria autem falsitatis possessio est sensus corporeus.

89. *PL* 122, 817C, Quoniam in unoquoque homine duo quidam homines intelliguntur, dicente Apostolo, Exteriorem hominem corrumpi, interiorem vero renovari, merito interior, qui ad imaginem Dei factus est, in paradiso formatur, exterior vero et corruptibilis extra et infra paradisum de limo terrae fingitur; qui etiam apprehensus in paradiso ponitur, quoniam, si in ipso salutem suam operaretur, divinumque custodiret praeceptum, poterat etiam ad dignitatem superioris conditionis ad imaginem dei pervenire. Quoniam vero noluit divino obedire praecepto, non solum Creatorem suum, verum etiam dignitatem imaginis ejus deseruit. Ac per hoc in geminum sexum scissus est, in masculum videlicet et feminam: quae discissio non ex natura, sed ex vitio causam accepit.

[For in every single man there are, as it were, two beings, when the apostle says that the outward man may perish, yet the inward man is renewed (2 Cor. 4, 16; Eph 4, 22-24); thus the inward man was justly formed within paradise in the image of God, whereas the outward, corruptible man was made outside and below paradise from the dust of the ground, and was then taken and placed into paradise; if he had been mindful of his salvation there and heeded the divine commandment, he could have progressed to the dignity of his original creation in the image of God; but because he did not want to obey the divine commandments, he deserted not only his Creator but forfeited also the dignity of the divine image and was for that reason split up into two sexes, man and woman, a division that was not caused by nature but by sin.]

Therefore it should be the endeavour of man to restore the prelapsarian condition, in which he was neither divided by gender nor split within his personality. The path towards achieving that goal is retreating into the inward man, who is endowed with the image of God and may thus be a mediator on the way back to the pristine state. This notion is both ascetic and mystical, and it had a lasting impact on the subsequent views of man's inwardness in medieval monasticism and beyond — though it may not always be conceived in these explicit terms, but at least in terms of a model. And these considerations had a formative influence on processes and events of the sixteenth and seventeenth centuries related to religious issues.

A Short Glimpse at the Twelfth and Thirteenth Centuries

The period in which the dimension of inward man was turned to by both ascetic practices and mystical contemplation is largely identical with the climaxes of the Middle Ages. The twelfth century deserves to be thrown into full relief here, since it effected not only a considerable increase in the exploration of the human mind but it also brought about an unprecedented change in the European attitude of thinking in its turn towards more sensitive approaches to inwardness.

At a first glance the twelfth century appears to be a time of astonishing changes, in all of which extroversion, mobility and expansion are predominant characteristics.[90] For it was in the twelfth century that huge armies of knights-at-arms were sent to the east of the Mediterranean during the crusades, founding as conquerors colonial states on ancient oriental lands in Syria and Palestine; it was in the twelfth century that chivalric excursions led to the annexation of lands taken from Slavonic peoples; and it was in the same epoch that Emperor and Pope fought against each other in the 'dispute concerning investiture,' and it was in the twelfth century that there was a struggle for hegemony between the Guelphs and the Staufans; and that England and France were united into a *single* empire, and that individual states began to establish organized administration in the modern sense. All this gives evidence

90. P. Classen, 'Die geistesgeschichtliche Lage. Anstösse und Möglichkeiten,' in: *id.* (ed.), see note 74, pp. 11-32. See also the remaining contributions contained in this volume of collected essays, which provide a vivid picture of the mutability of the century.

of the immense effort taken and of the great intellectual abilities that made these enterprises and achievements possible. Nevertheless this period can, by reference to the spiritual renewal, be also called "the Renaissance of the twelfth century."[91]

The twelfth century is in many respects an exceptional epoch. It has been called by Heer "the first century of a new Europe."[92] And indeed, in the context of the history of the human intellect that importance of that century can hardly be overrated, and the dimensions of its impact can hardly be fully explored or assessed.[93] M.D. Chenu speaks of an "éveil de la conscience"[94] and he means by it the first signs in spiritual life of the emergence of an interest in human consciousness and self-consciousness — a collective effort that was aimed at a new comprehension of man's inwardness.[95] The key term in this context is the *ordo novus* which replaced the *ordo antiquus*.[96] The epithet *novus* was attached to all products of the inner quest for new forms and new content and became manifest in all areas of life, ranging from grammar to architecture, from urban movements for emancipation to a new understanding of history. In addition, there emerged a new sensibility in psychological and moral concerns, which had a crucial role to human consciousness and subjectivity. Man actually discovered himself as a subject. The subversive shock caused by this discovery of the subject can, for instance, be traced to the ethical teaching of Abaelard. He elaborated an ethics of intention, focusing on one's moral attitude, in which the moral value of our deeds and their judgement before God and other human beings are no longer assessed by objects that were deemed to be inherently good or evil, and to which our deeds are related, but by the degree of the inner affirmation or intention (*consensus, intentio*) underlying moral behaviour. Thus sin does not consist in the act of killing someone, but in the inner consensus preceding the actual deed. According to Abaelard, a sin is already committed if one *wants* to do a sinful deed, even if the act is not carried out afterwards. The traditional object-related ethics is thus replaced by an ethics hinged on the subject: "God does not judge our deeds in the first place but he rather judges the virtue and benevolence of our spirit, whereas the deed itself, regardless of whether it is motivated by a will to do good or evil, contributes

91. Haskins, see note 74; de Gandillac/Jeauneau (eds.), see note 74; C. Brooke, *The Twelfth Century Renaissance*, Norwich, 1969; C.R. Young (ed.), *The Twelfth-Century Renaissance, op. cit.*; R.L. Benson./G. Constable (eds.), *Renaissance and Renewal in the Twelfth Century, op. cit.*; P. Dronke (ed.), *Twelfth-Century Western Philosophy*, Cambridge, 1988.

92. Friedrich Heer, *Aufgang Europas. Eine Studie zu den Zusammenhängen zwischen politischer Religiosität, Frömmigkeitsstil und dem Werden Europas im 12. Jahrhundert*, Vienna, 1949, p. 15; B. Nelson, *Der Ursprung der Moderne. Vergleichende Studien zum Zivilisationsprozess*, Frankfurt a.M., 1977, pp. 140ff.

93. T. Stiefel, *The Intellectual Revolution in Twelfth Century Europe*, New York, 1985; P.S. Gold, *The Lady and the Virgin. Image, Attitude, and Experience in Twelfth Century France*, Chicago, 1985. See especially J. Paul, *Histoire intellectuelle de l'occident médiéval*, Paris, 1973, pp. 135-269; C.M. Radding, *A World Made by Men. Cognition and Society, 400-1200*, Chapel Hill, 1985, pp. 200ff.; R.C. Dales, *The Intellectual Life of Western Europe in the Middle Ages*, Leiden, 1992, pp. 147-209.

94. Chenu, see note 74.

95. Chenu, see note 74, pp. 10ff.; and Marie-Dominique Chenu: *La théologie au douzième siècle*, Paris, 1957.

96. Chenu, see note 74, pp. 14f.

nothing to our merit."[97] From this follows that the henchmen of Christ, who, according to
the scriptures, did not know what they were doing and who merely obeyed the orders of
their superiors, can and must be acquitted of any guilt in shedding Christ's blood
(consequences for the Third Reich!).[98] This formidable system of ethics of intention can
hardly be better exemplified than by the passion of Héloise, who was a faithful disciple of
Abaelard: Heloise is, as it were, the living proof of his moral teaching, even in situations, in
which Abaelard shrinks back from the ultimate consequences of his teaching. She explains
and confesses in a high spirited manner the holiness and truth of her love for Abaelard:
"My love is disinterested" (above all in the bond of marriage).[99] The complete surrender
goes so far as to accept being taken to a nunnery by Abaelard, so that he can be the absolute
master over her body and soul. From the convent she sends him passionate love letters, a
practice from which Abaelard tries to dissuade her sententiously and with great erudition.
And in this way she achieves the greatest victory over Abaelard that can be thought of,
even though it is also the most deplorable one. Abaelard's final resume from this experience
is summed up by in the following statement: "If you want to love God, do not love him as I
love Héloise, but in the way Héloise has loved me."[100] The nature and intensity of Héloise's
love can be compared to the love between Tristan and Isod.[101] On the level where intention
and disposition can do nothing but love, and do so irrespective of any obstacles and where
conscience obliges to love, and where, as a consequence, the remedies of the church (auricular
confession) are rendered ineffective, because the lovers cannot possibly weep over something
that they ardently desire in their heart of hearts. It was then that the old dictum by St.
Ambrose was revived and had a far-reaching impact: *Affectus tuus operi nomen imponit* — it
is your loving will that provides your action with a name and defines it.[102] The same applies
to another statement by the doctor of the church which evidently alludes to *Rom* 14.25:
Omne quod non est ex fide peccatum est. Ex fide, which means "with the most sincere faith and
in the best of all intentions." That is to say, one must follow the voice of conscience — and
this is the new discovery. One even has to obey one's *erring* conscience for it is likewise
binding and it would be a deadly sin not to do so. Even Innocence III, a pope who was

97. *Ibid.*, p. 19.

98. *Ibid.*, p. 20; Etienne Gilson: *Héloise et Abélard*, Paris, ²1948, p. 70.

99. Chenu, as note 74, p. 20; Gilson, as note 98, pp. 58-75, in particular pp. 66f., 69f.; A. Podlech: *Abaelard und Heloisa oder Die Theologie der Liebe*, Munich, 1990, pp. 258-69. These references do not suggest that I share the views expressed by these authors in the ongoing scholarly debate on the letters and the 'Historia calamitatum.' On this issue see P. von Moos: *Mittelalterforschung und Ideologiekritik. Der Gelehrtenstreit um Héloise*, Munich, 1974. On Abaelard's importance as a dialectic philosopher and mystic see Marie-Dominique Chenu, 'Abélard, le premier homme moderne,' in: *id., La parole de Dieu. I: La foi dans l'intelligence*, Paris, 1964, pp. 141-55, particularly p. 147.

100. Gilson, see note 98, quoted in Chenu, as note 74, p. 21 (unfortunately without page references).

101. G. Weber, *Gottfrieds von Strassburg Tristan und die Krise des Hochmittelalterlichen Weltbildes um 1200*, Stuttgart, 1953, vol. II, pp. 168ff. On the criticism of and for further studies on this conception of crisis see von Moos, as note 99, pp. 116f., issue 56.3.

102. Chenu, see note 74, pp. 28f (the following considerations are based on this passage).

renowned for anything but lenity in his ecclesiastical decisions, states with remarkable directness: *Quoniam omne quod non est ex fide peccatum est, et quidquid fit contra conscientiam aedificat ad gehennam . . . quam (persona) illa contra Deum non debeat in hoc judicio obedire, sed potius excommunicationem humiliter sustinere.*[103] Anything that is done without good intention is sin; and anything that is done contrary to one's conscience inevitably leads straight to hell. Therefore one should, rather, accept with meekness to be excommunicated by the church than act against one's conscience and thus against God.[104] This is truly an *ordo novus*, since fallible conscience is considered as morally binding. Doctrines of this kind must have had far-reaching repercussions and must have appealed enormously to the laity, not least because they had just begun to cautiously claim their rights. And, finally, the case of Tristan and Isod will have to be treated along the lines of this ideological and moral context.

Abaelard, however, represents only one side of the twelfth century. The opposite side is represented by Abaelard's great adversary Bernard of Clairvaux, who, in the end, was victorious over him.[105] If the twelfth century can be regarded as the century of the discovery of the occidental variety of love,[106] then Bernard supplied the modes of thinking and of behaviour, which — though originally conceived in spiritual and mystical terms — could also be transferred to the secular world. Bernard's erotic and psychological idiom in describing the relationship between the soul and God becomes the model of the measure of love in general. Even Gottfried of Strassburg took up that vocabulary in his description of the love between Tristan and Isod without apprehending any incompatibility or discrepancy with the subject of secular love. The rich variety of the psychological vocabulary in Bernard's love mysticism mirrors precisely the abundance of effects that love may have on the soul including the intuitive certainties provided by it. Everything is centred on the communion between the loving bride (soul) and her lover or bridegroom (God), culminating in the (ecstatic spiritual) inebriation of the nuptial union of the two, which instills complete *fiducia*, absolute loving trust, in man. "Love does not seek any other cause and no fruit other than itself. I love because I love, I love in order to love. What a great thing is love! It is possible for love to flow incessantly provided that it returns to its principle and origin and flows back to its source."[107] A direct consequence of this form of love mysticism is the immense extension of the human capacity of introversion. The self-acquired a dignity that had not been known in this way before. The self is "the image of God." The more God is united with the self, the

103. Decretales, c.13, X, II, p. 13, Friedberg II, 287; quoted in Chenu, see note 74, p. 29.

104. Chenu, see note 74, p. 29.

105. Cf. Jean Leclercq, 'Bernhard von Clairvaux' : *TRE* 5, pp. 644-51. On Bernard's conception of love see S. Gilson, *Die Mystik des heiligen Bernhard von Clairvaux*, Wittlich, 1936, pp. 98ff.; Otto Langer, 'Affekt und Ratio in der Mystik Bernhards von Clairvaux,' in: Dieter R. Bauer/Gotthard Fuchs (eds), *Bernhard von Clairvaux und der Beginn der Moderne*, Innsbruck-Wien, 1996, pp. 136-50; Assumpta M. Schenkl, 'Bernhard und die Entdeckung der Liebe,' *ibid.*, pp. 151-79.

106. Peter Dinzelbacher, '*Über die Entdeckung der Liebe im Hochmittelalter*': Saeculum 32 (1981) pp. 185-208.

107. Chenu, see note 74, p. 35 (*In Cant. Cant.*, sermo 83).

more intimately it becomes one with itself.[108] The circle of inwardness, in which God and man can become one, becomes complete: *A te proinde incipiat tua consideratio, non solum autem sed et in te finiatur.*[109] The paradox inherent in the ecstasy of love can be solved and explained in the following manner: the experience of the *excessus mentis*, which is the complete loss of selfhood, the loss of the *proprium*, involving also the nearly complete moral annihilation of the self, becomes in its highest point, in the condition of the perfect conformity of the one with the Other, absorbed in the absolute fullness of being. The description of the ecstasy of mystical union thus corresponds paradoxically with the ecstatic experience of profane love. Possessing God thus means possessing oneself. Uniting with the other in an act of love means being gratified with the fullness of being.[110]

It is quite exciting to observe how mysticism here achieves a descriptive analysis of human love and finally arrives at an analysis of the self and of man's actions. It appears that the romance of Tristan was, in its sentimental aspect, an element of the independent value of profane love, influenced by the Bernardian tradition of love-mysticism.[111] The profane consideration of the laity, which finds the way from the theoretical spiritual problem to the psychical reality of man in general, is both simple and brilliant: if love is, as stated by scripture, one and indivisible, human love cannot be separated from divine love. In fact, the one is related to the other. And it is indeed one of the great ventures of chivalric romance to explore the nature of the relationship between sacred and profane love, and to portray in fiction several options including Wolfram's theological conception of human love.

In 'Titurel' the omnipotence of love is celebrated in the presentation of the love between the children Sigune and Schionatulander:

> Owê, minne, waz touc/dîn kraft under kinder?
> wan einer der niht ougen/hât, der möht dich spüren, gienger blinder.
> minne, du bist alze manger slahte:
> gar alle schrîbær künden/nimêr volschrîben dîn art noch dîn ahte.
>
> Sît daz man den rehten/münch in der minne
> und och den [wâren] klôsenære/wol beswert, sint gehôrsam ir sinne,

108. On the doctrine of the image of God in the soul see the groundbreaking studies by R. Javelet, *Psychologie des auteurs spirituels du XIIe siècle*, Strasbourg, 1959; id., *Image et ressemblance au douzième siècle de S. Anselme à Alain de Lille*, 2 vols, Paris, 1967; St. Otto, *Gottes Ebenbildlichkeit. Überlegungen zur dogmatischen Anthropologie*, Munich, 1964; id., *Die Funktion des Bildbegriffs in der Theologie des 12. Jahrhunderts*, Münster/W., 1963; R. Cessario, *The Godly Image. Christ and Salvation in Catholic Thought from Anselm to Aquinas*, Petersham, 1990.

109. Quoted in Chenu, see note 74, p. 35 (source not indicated). For further relevant passages see Courcelle, see note 5, pp. 258-72; Etienne Gilson, *L'esprit de la philosophie médiévale*, Paris, 1948, pp. 214-33.

110. Cf. Chenu, see note 74, pp. 35f. On the terminological context of the emerging theme of inwardness see P. Miquel, *Le vocabulaire latin de l'expérience spirituelle dans la tradition monastique et canoniale de 1050 à 1250*, Paris, 1989, pp. 97-162.

111. D. Baumgartner, *Studien zu Individuum und Mystik im Tristan Gottfrieds von Strassburg*, Göppingen, 1978; K. Allgaier, *Der Einfluss Bernhards von Clairvaux auf Gottfried von Strassburg*, Berne, 1983.

daz si leistent mangiu dinc doch kûme.
minn twinget rîter under helm:/minne ist vil enge an ir rûme.

Diu minne hât begriffen/daz smal und daz breite.
minne hât ûf erde hûs:/[und] ze himel ist reine für got ir geleite.
minne ist allenthalben, wan ze helle.
diu starke minne erlamet an ir krefte,/ist zwîfel mit wanke ir geselle.[112]

[O woe, Love, what use/is your power in childhood?
And one who had no eyes,/even felt you behind his blindness.
Love why do you hide/in so many disguises:
when a writer's art can never/describe you in manner and in all your powers.

Even the righteous monk/is affected by love,
The recluse is bound by it,/and though both are obedient to their senses
Their daily routine is hard to maintain.
Love overwhelms the knight beneath his helmet,/love penetrates any narrow room,

Love has encompassed/the narrow and the wide.
Love has a house on earth/and it directs toward heaven alone towards God.
Love is everywhere, it only shuns the flames of hell.
Love is strong but its powers will slacken,/when wavering doubts are its companion.]

It is precisely the *aesthetic* option of the love test — as painted in a melancholy manner in 'Titurel' — that creates the basis for a fictional understanding of and an emotional disposition for the individual instance, for individuality, thus for the *casus* that can no longer be persuasively argued by casuistic theory. This corresponds in philosophy to the early manifestations of nominalism, which no longer accepts the claim to reality of the *genera*, the universals, as opposed to the individual things, but reverses the underlying assumptions: it is the universals that are mere names, whereas individual things are real. This turn of thought had a strong impact on religion. In Bernard, for instance, the spiritual ascent of man proceeds *per Christum hominem ad Christum deum*.[113] Thus the human dimension, the dimension of subjective experience, now attains, as it were, the status of empirical evidence in Christian spirituality. This also applies to the realm of profane love in which the natural power of attraction becomes an element of experience which transcends by far the merely sensual aspect of love.

112. Titurel I 49-51 (*Wolfram von Eschenbach*, ed. K. Lachmann, vol. 1: Lieder, Parzival and Titurel, Berlin, 1952, p. 397).

113. For a concise overview on this topic see J.R. Sommerfeldt, 'Bernard of Clairvaux: The Mystic and Society,' in: E.R. Elder (ed.), *The Spirituality of Western Christendom*, Kalamazoo, 1976, pp. 72-84; Bernardin Schellenberger, 'Bernhard von Clairvaux (1090-1153),' in: G. Ruhbach./J. Sudbrack (eds.), *Grosse Mystiker. Leben und Wirken*, Munich, 1984, pp. 107-21. On the context outlined here see W. Hiss, *Die Anthropologie Bernhards von Clairvaux*, Berlin, 1964, pp. 7-16; Ulrich Köpf, *Religiöse Erfahrung in der Theologie Bernhards von Clairvaux*, Tübingen, 1980, see index s.v. Jesus Christus. For an earlier reference cf. Gilson, see note 105, pp. 121ff.

Love is thus conceived in terms of a power underlying all relationships of man; but love is also thought of as a virtue, which is aimed at itself alone and nothing else, and which is prepared to accept any public disgrace, shame and social discrimination; what really matters is: love can only be satisfied by itself! Love is the basis of life, and it is love — sacred and profane — that from that period onward will supply the ultimate meaning of man's life. In the twelfth century no other theme was reflected on more perseveringly than that of love mediating between man and God.[114]

German Mysticism

In the so-called 'German Mysticism' of the fourteenth century, the typology of the inward and the outward man was enthusiastically taken up — most probably due to the influence of the many *De anima* and *De interiore homine* treatises of the twelfth century[115] — by the Dominican Meister Eckhart (*c.* 1260-1328)[116] and later by his disciples and fellow brethren Johannes Tauler (*c.* 1300 - 16 June, 1361)[117] and Heinrich Seuse (*c.* 1295-1366)[118] and it was

114. Cf. notes 74, 75, 105, 112, 113; Chenu, see note 74, p. 33f. See: E. Wechsler, *Das Kulturproblem des Minnesangs. Studien zur Vorgeschichte der Renaissance*, Halle/S., 1909; P. Rousselot, *Pour l'histoire du problème de l'amour au moyen Âge*, Paris, 1933; Z. Alszeghy, *Grundformen der Liebe. Die Theorie der Gottesliebe bei dem Hl. Bonaventura*, Rom, 1946; H. Pétré, *Caritas. Etude sur le vocabulaire latin de la charité*, Louvain, 1948; A. Nygren, *Eros und Agape. Gestaltwandlungen der christlichen Liebe*, Berlin, 1955; I. Singer, *The Nature of Love. 1: Plato to Luther*, Chicago, 1966, 1984, pp. 159ff.; J. Chydenius, *The Symbolism of Love in the Medieval Thought*, Helsinki, 1970; *id., Love and the Medieval Tradition*, Helsinki, 1977; W. van Hoecke./A. Welkenhuysen (eds.), *Love and Marriage in the Twelfth Century*, Leuven, 1981; H. Zeimentz, *Ehe nach der Lehre der Frühscholastik*, Düsseldorf, 1973, pp. 29-41 (on the background of the spiritual history and the history of the debate on the problem); H.E. Keller, *Wort und Fleisch. Körperallegorien, mystische Spiritualität und Dichtung des St. Trudperter Hoheliedes im Horizont der Inkarnation*, Berne, 1993, pp. 104-17 (early scholastic anthropology as the basis for the concepts of love). On this aspect see the contributions by K. Ruh, 'Geistliche Liebeslehren des 12. Jahrhunderts' : *PBB* 111 (1989), pp. 157-78; '*Amor deficiens* und *amor desiderii* in der Hoheliedauslegung Wilhelms von St. Thierry': *OGE* 63 (1989) pp. 70-88.

115. On the issue of the antecedents leading up to the twelfth century see I. Tolomio, *L'anima dell'uomo. Trattati sull'anima dal V al IX secolo*, Milano, 1979; I. Herwegen, *Kirche und Seele. Die Seelenhaltung des Mysterienkultes und ihr Wandel im Mittelalter*, Münster, 1928; G. Webb, *An Introduction to the Cistercian De anima*, London, 1961; L. Norpoth, *Der pseudo-augustinische Traktat: De spiritu et anima*, Cologne, 1971; B. McGinn, *Three Treatises on Man. A Cistercian Anthropology*, Kalamazu, 1977; on the continuation of this theme in the thirteenth century see A.C. Pegis, *St. Thomas and the Problem of the Soul in the Thirteenth Century*, Toronto, 1934. On the teaching on the inward man and his status by the Victorines see A. Mantanic, 'La hominis compositio tra la Scuola Vittorina e la prima Scuola Francescana,' in: C.A. Bernard (ed.), *L'antropologia de Maestri spirituali*, Milano, 1991, pp. 163-77; H.R. Schlette, *Die Nichtigkeit der Welt. Der philosophische Horizont des Hugo von St. Viktor*, Munich, 1961, pp. 50ff.; P. Sicard, *Hugues de Saint-Victor et son Ecole*, Bepols, 1991, pp. 27ff.; R. Baron, *Science et Sagesse chez Hugues de S. Victor*, Paris, 1977, pp. 160ff

116. Cf. A.M. Haas, *Meister Eckhart als normative Gestalt geistlichen Lebens*, 2nd revised edn. with additions, Einsiedeln, 1995; K. Ruh, Meister Eckhart *Theologe, Prediger, Mystiker*, Munich, ²1989; L. Sturlese, *Meister Eckhart. Ein Porträt*, Ratisbon, 1993.

117. L. Gnädinger, Johannes *Tauler. Lebenswelt und Mystische Lehre*, Munich, 1993.

118. Alois M. Haas, *Die Kunst rechter Gelassenheit. Themen und Schwerpunkte von Heinrich Seuses Mystik*, Berne, 1996.

developed into a practical mystical model of life.[119] Meister Eckhart's sermon *Vom edlen Menschen* (On noble man) is dedicated to this theme. In this sermon, written between 1308 and 1314, Eckhart refers to *Lk* 19.12, which relates the story of a nobleman who "went into a far country to receive for himself a kingdom" and to return again afterwards. Eckhart interprets this passage employing his very special technique of biblical exegesis. In taking this Gospel episode, Eckhart develops the allegory of the journey and elaborates it into a model for the anthropological description of mystical experience seen as the interaction of grace and nature.[120] In perfect man, nature and grace will co-operate in a way that results in a symbiosis of both. Since man is composed of body and spirit, Eckhart distinguishes between the outward and the inward man.[121] The flesh and the soul, i.e. sensuality and sensual perception, are the features of the old, outward, hostile and obsequious man. Contrasted to him is the inward man, who is much more worthy; he is the new, heavenly and young man, and the one who is genuinely noble and worthy. Whereas an evil mind is part of the outward man, the inward man is protected against evil by a guardian angel. In another instance, he employs the symbolism of gender: the inward man is Adam, or the male principle within the soul, the good tree that always bears good fruit. Another emblem is that of the field in which God has planted his image: it is the root of all wisdom, all the arts, all virtues, all goodness, and the seed of divine nature. Evil outward man, on the other hand, is compared to a weed[122] which will overgrow the divine seed when badly tended and that impedes its growth. The seed itself, however, can never be destroyed by any harm: *er glüejet und glenzet, liuhtet und brinnet und neiget sich âne underlâz ze gote* (DW 5,111, 20f.) [it glows and shines, is bright and burns and is turned without any intermission towards God]. By means of a spiritual pedagogic teaching derived from Augustine,[123] Eckhart illustrates that the inward man is prepared for the highest mystical experience of God by taking a path consisting of six stages or rungs. During this ascent, and concomitant with it, some inner growth is accomplished, which is the result of an intense process of introspection and introversion.[124] The six stages of spiritual growth are the following:

119. On this see H. Piesch, 'Der Aufstieg des Menschen zu Gott nach der Predigt "Vom edlen Menschen,"' in: U.M. Nix/R. Oechslin (eds.), *Meister Eckhart der Prediger. Festschrift zum Eckhart-Gedenkjahr*, Freiburg, 1960, pp. 167-99; M.M. Davy, *Die Wandlung des Inneren Menschen. Der Weg zum wahren Selbst*, Salzburg, 1986.

120. This feature of the sermon and its relationship to the Trostbuch of Eckhart is very well outlined by Piesch. See note 119 above.

121. The fact that Eckhart is to be placed here in the tradition of the Victorines is pointed out by Piesch, see note 119, pp. 177ff.

122. Meister Eckhart, *Deutsche Werke*, vol. 5 (*DW 5*), 110, 11; 111, 16. On this see Tauler's Vocabulary: Haas, see note 80, p. 103.

123. Augustine, *De vera religione*, c.26, n. 49; quoted in *DW 5*, 124, note 20; On this cf. Piesch, see note 119, p. 173; B. Studer, 'Il progresso spirituale secondo gli scritti antipelagiani di Sant'Agostino,' in: J. Driscoll, M. Sheridan (eds.), *Spiritual Progress. Studies in the Spirituality of Late Antiquitiy and Early Monasticism*, Roma, 1994, pp. 85-99.

124. Cf. Luigi Alici (ed.), *Interiorità e intenzionalità in S. Agostino*, Roma, 1990; R. Piccolomini (ed.), *Interiorità e intenzionalità nel 'De civitate Dei' di Sant'Agostino*, Roma, 1991; L. Alici, *et al.* (eds.), *Ripensare Agostino: Interiorità e intenzionalità*, Roma, 1993.

1. living a life in imitation of the saints
2. turning away from mankind and towards God (the Father)
3. the experience of sweetness and blessedness in God
4. the willingness to endure suffering and afflictions
5. living in inner peace and the abundant apprehension of wisdom supreme
6. 'un-learning' and re-education by God, understood as a process of being re-form-ed into the image of God; becoming a child of God, i.e. establishing the precondition for eternal life.

In addition, this programme of inward man's spiritual ascent is combined with a dynamic element in which the divine image in man is compared to a living well (an emblem derived from Origen), which is potentially always threatened by the danger of being covered with earth (even though the well underneath can never be destroyed). Another similitude employed here is the sun signifying the divine image in the soul; its radiance may be darkened at times either by an ailment of the eye or by external causes obscuring the sun, but the existence of the sun can never be denied. In order to uncover the divine image in the soul, man is required — like a sculptor or a wood-carver — to remove from it all redundant matter. The pure image of God thus becomes visible by a process of moving away from oneself. The biblical image of the departing and moving away from home thus signifies for Eckhart the turning away from the external world, the renunciation of other images (including imaginative pictures of God) in an endeavour to transcend beyond the individual self; in doing so man will become the son of God. And this is what really matters: the inward man must be transformed and overlaid by the son of God. By surrendering one's personality to God, the individual is transformed into a universal being, who is free to put on the second divine person, Jesus Christ, who himself encompassed universal man. The goal of this movement beyond the individual self — which is nothing else but an abstract image of man, purged from externals and endowed with the divine Presence effectively working in the divine seed — is the union with God: *in dem einen vindet man got, und ein muoz er werden, der got vinden sol* (ibid., 115, 5f.) [in the one man may find God, and anyone who is to find God must become one]. The condition for the possibility of becoming one with God is thus the overcoming of the *underscheid* (difference, *ibid.*), which — being the principle of multiplicity — would render the unitive experience impossible. Hence, follows the imperative: *Bis ein, daz dû got mügest vinden!* [Until you are one so that you may find God!, *ibid.*, 115, 8f.)]. Irrespective of its diversity, creation is permeated by God, who is the one and only principle of being. The departure from the outward man is thus exclusively motivated by the desire for the union with the one. In other words: union with the One in the inward man means aspiring for the transcendence of time and space and of discursive thinking. Even the awareness of nothing must be eroded so "that one finds solely pure life, being, truth and goodness" (*daz man dâ aleine vinde blôz leben, wesen, wârheit und güete, ibid.*, 116, 5f.). Finally, Eckhart addresses a special problem of mystical experience, i.e. the question if "the flower and core of blessedness (mystical experience) is that kind of knowledge in

which the spirit knows by intellectual cognition *that* it apprehends God" (*ibid.*, 116, 23-25). According to Eckhart the unveiled vision of God can for the time being not be extended to the cognitive awareness of this vision. For Eckhart, the act of recognizing that God has been apprehended and cognitively known is one step further, which he calls *herwider komen* (coming back, *ibid.*, 118, 23). This means the stage after the return of the self into earthly existence following on the unitive experience with God. Only after the unitive experience has ended man may recognize what has happened to him. The ultimate truth revealing itself in the inward man, however, is described in tautological terms at the end of this important sermon. It rules out any formal perception (of the Divine) within the horizon of human knowledge: *ein mit einem, ein von einem, ein in einem und in einem ein êwiclîche. Amen* [being one with one, made one by one, one in one and in (the) one eternally one. Amen, *ibid.*, 119, 6f].

The train of thought, moving in this sermon from the withdrawal into the self on to the departure from oneself and the path towards oneness and finally back again to the natural (earthly) condition, reveals that the inward man is indeed true man who is vouchsafed the union with God. German mysticism thus provides an inside view of man which advocates — against any constraints imposed on existence from outside — a concept of freedom which leaves all prerogatives to the man united with God.

Eckhart thus paved the way for Tauler and his rather pedagogical approach, and for Seuse and his rather psychological perspective. Introversion, turning inwards, is indispensable if outward man, who, in Tauler's view, is the man who has become entangled with external things and thus alienated from himself, wishes to attain the state of inwardness:

> der usser mensche werde broht in den innern menschen, do wurt der mensche ingenomen, do wurt alsolich wunder, alsoliche richeit geoffenbart.

> [The outward man is to be taken into the inward man; in this way man is encompassed by (the ground of his being). Great wonders and great riches will be revealed to him there.]
> — V 15; 71,16f.

In this constellation a very specific regulative function is attributed to the inward man with regard to the outward man and his proneness to indulge in sensual perceptions. The inward man watches over the external forces and instructs them in the proper way of acting. This necessarily incurs difficulties since man, corrupted by original sin and limited by his ontological condition (that is why man is regarded by Tauler as a 'nothing' in a double manner!), is prone to conceal his own inwardness where the true man dwells. Tauler takes up Eckhart's emblem of man featuring as a field overgrown with weeds, but he elaborates on it in a rather graphic manner. Man fails in his endeavour to delve into the 0inner ground of his being, where God is present, because the ground is hidden by thick layers of skin:

> do ist als manig dicke grúweliche hut úber gezogen, recht dick als ochsen stirnen,
> und die hant im sin innerkeit also verdeckt das Got noch er selber nút drin

enmag: es ist verwachsen.Wissent, etliche menschen múgent drissig oder vierzig
húte haben, dicker grober swarzer húte als beren húte. Wele sint dise hute? Das
ist ein ieklich ding do du dich mit willen zuo kerst, es si muotwillikeit an worten,
an werken, an gunst, an ungunst, hochmuetikeit, eigenwillikeit, beheglicheit
deheins dinges ane Got, hertmuetikeit, lichtvertikeit, unbehuotsamkeit der
wandelungen etc.

[Why, do you think, is it that man can in no way get into his own ground? It is
because a rather thick, repulsive skin is pulled over it, as thick indeed as the
forehead of an ox: and that skin conceals his inwardness to the extent that
neither God nor he himself can enter into it; the entrance is overgrown. And
you should know that several men may have thirty or even forty layers of that
skin, thick, rough and black like the hide of bears. What kinds of skins are
these? Any thing you turn to with your own free will: selfish words and works
to gain favour, or the urge to harm others by disfavour, pride, selfishness, or
the delight in any thing that has nothing to do with God, hardness of heart,
carelessness, reckless behaviour, and the like.]

— V 45; 195, 29-196, 3

In other words: The function of man's inner eye is obstructed by a coarse skin — signifying
the lapse into a blinkered worldly existence focused on creatures — which blinds man and
makes him deaf to the summons of God (V 45; 195,19ff.). This dismal condition calls for
radical psychoanalytical treatment which alone can clear the path from the outward to the
inward man; the keyword in this process is the combat between the inward and the outward
man; this combat wages until the outward man has been subjected to the control of the
inward man. This struggle of man against himself is nothing else but a "chasing of the
discord within one's own self":

Weles ist nu dis jagen? Nút anders denn das der indewendige mensche gerne
zuo Gotte were, so sin eigen stat ist, und tribet und jaget den ussewendigen
menschen, und der ussewendig mensche jaget einen andern weg und wil als
ussewendig zuo den nidern dingen, do sin eigen stat ist, alsus ist ein zweiunge
in disen.

[What kind of chase is this? It is one in which the inward man would like to be
directed unto God, where his actual place is, and towards whom he chases and
hunts down the outward man. However, the outward man chases away on a
different path; he wants to get outside to low things, which is his own homestead.
It is in this way that strife and discord are generated between the two.]
— V 9; 42, 27-31]

This combat is one between the outward man, who is corrupted by original sin, and the
inward man, who is redeemed within by Christ. In Tauler, as in Eckhart, the proportions
are clearly distributed: the outward man is orientated to the outside, the inward man is
orientated to the inside, where God is present in the affections and the ground of man's
being. Freedom is accomplished in the inward man alone.

In order to clarify the way and manner of the redemptive freedom, Tauler replaces the dual scheme of inward *vs.* outward man by a tripartite one, which enables him to illustrate the direction and the goal of his spiritual psychoanalysis and psychological guidance more clearly. Thus the extreme antithesis between outward and inward man is mitigated. Harking back on a Neo-Platonic philosopheme (derived most probably from Plotinus), Tauler elaborates a model of threefold man:

> der mensche ist rechte als ob er drú mensche si und ist doch ein mensche. Das eine das ist der uswendig vihelich sinneliche mensche; der ander das ist der vernúnftige mensche mit sinen vernúnftigen kreften der dritte mensche das ist das gemuete, das oberste teil der selen. Dis alles ist ein mensche.

> [Man can be seen as if he consisted of three human beings. The first one is the outward, beast-like, sensual man. The second is the rational man with his powers of the intellect. The third man consists of the affections, the highest part of the soul. All these together constitute one human being.]
> — V 64; 348, 21-25

The three men within the one human being form a hierarchy. The outward man must be controlled by cultivating the attitude of indifference, a process in which the man of reason gives the instructions and directions. However, the second man is also subjected to the order to sustain the attitude of "receptive indifference devoid of any complacency;" he is a "sojourner within his naked nothingness and surrenders and subjects himself to God, the Lord." On the basis of these preconditions the efficacy of the affections, the third man, can be taken for granted:

> Er wird al zemole ufgericht und blibet ungehindert und mag sich keren in sinen ursprung und in sin ungeschaffenheit, do er eweklich gewesen ist, und stet do sunder bilde und forme in rechter lidikeit; do git im got nach dem richtuom siner ere.

> [The third man is fully erected and remains so without any hindrance; and he may turn into his origin and into his state of non-being where he has eternally been. And there he stands devoid of any image and form in perfect emptiness ready to receive. Then God bestows on him gifts according to the riches of his virtue.]
> — V 67; 365, 30-343

One can say that the inward man has a double face here (as is clarified by Tauler elsewhere): the one is *ratio*, which encompasses the capacity of discursive thinking and thus operates with concepts related to the outside world. Complementary to it is the *intellectus*, intuitive knowledge, which operates by non-discursive thinking, beyond any categories; it perceives intuitively and has the capacity to experience God. The third man is thus radically open to God. The divine image and likeness is alive in him and effectively given. The affections are the dimension in man, in which — like in Eckhart's *vünkelîn* (spark) — the presence of God is apprehended, and where the likeness to God is affected. The affections encompass the

innermost man; reaching out to the innermost man incessantly is the obligation of the whole man. The ultimate aspiration is the gratuitous event of the mystical *inkêr* (in-coming):

> In disen obersten innewendigen menschen sol sich der mensche keren und legen mit dem fur das goetlich abgrúnde und gan sin selbes us, und gebe sich gevangen mit alme.

> [Man is to turn to this supreme inner man, and place himself together with him before the divine abyss and to transcend beyond himself and to be captured by all.]
>
> — 65; 357, 16-22

In this process of turning inward, man experiences what Augustine had described much earlier in the *Confessions* (*Conf* III, c. 6, n. 11): *Tu autem eras interior intimo meo et superior summo meo*. Tauler adopts this key concept of Christian mystical experience when he talks about the kingdom of God:

> das ist in dem innersten grunde, do Got der selen naher und inwendiger ist verrer wan si ir selber ist.

> [This is in the innermost ground, where God is much closer and much more inward to the soul than the soul is to itself.] — V 37; 144,6f

It is not possible to consider here whether a life devoted to the imitation of Christ is an inevitable precondition for this fundamental Christian experience. Tauler, however, clearly demands that a most intense devotion to the passion and the dying of the Saviour is an indispensable prerequisite for the union between man and God. By meditating on the passion, the awareness of man's inner conformity with Christ is evoked and endorsed, and it is only on the basis of this awareness that the union with the 'onefold' God becomes possible. However, if God grants a union between the primordial image of God and the human likeness, it will result in the deification of man within the innermost man:

> In disem wirt die sele alzemole gotvar, gotlich, gottig. si wirt alles das von gnaden das got ist von naturen, in der vereinunge mit gotte, in dem inver-sinkende in got, und wirt geholt úber sich in got. Also gotvar wirt sie do: were das si sich selber sehe, si sehe sich zemole fúr got. Oder wer si sehe, der sehe si in dem kleide, in der varwe, in der wise, in dem wesende gotz von gnaden, und wer selig in dem gesichte, wan got und si sint ein in diser vereinungen von gnaden und nút von naturen.

> [In this (event) the soul becomes like God, divine, godlike in kind. The soul becomes by grace what God is by nature in the union with God, in the immersion into God. And it is transported beyond itself into God. In this way it is transformed into the image of God: if it could see itself, it would believe it was God. Or else, whoever would see the soul, would perceive it by grace dressed in the very dress, the very appearance, mode and essence of God and would be blessed by this sight, for God and the soul are one in this union by grace albeit not by nature.] — V 37; 146,21-27

The works of Johannes Tauler demonstrate very clearly how mystical conceptions are combined with anthropological ones, the former clarifying and elucidating the latter. The scale of gradation of man starting from the outward man and ending in the innermost dimensions of inward man, where the fathomless ground flows over into the divine abyss, is a conception of inwardness which will be followed in the spiritual history for centuries to come. Its influence can be traced far down the Reformation period — it is especially reflected in Luther's division of man in the one who is outwardly enslaved and the other that is inwardly free (in his treatise on freedom) — and influenced various spiritual tendencies. But at this point the overview must be cut short. Certainly, Heinrich Seuse might have deserved to be discussed in some detail. He incorporated, after all, the philosophical-mystical teaching of Eckhart and the pedagogic-mystagogical teaching of Tauler into the conception of his own way of living, which he himself considered as a role model for subsequent generations — in his 'Vita' he even portrays himself as the saintly hero of a spiritual life! After an endeavour to achieve a spiritual form of living in the outward man, which occupied half of his lifetime, he eventually broke off the austere ascetic practices he had inflicted on his body and surrenders inwardly to the guidance of God and his chastisements. In Seuse, again, a turn from the outward to the inward man can be discerned — in this case it occurs on the level of a life that can be traced in concrete terms. This, however, leads straight into a new dimension — the realm of psychologically-orientated mystical introspection.

The Early Modern Period: Descartes and Pascal

In general, it can be said that the modern era, starting with Descartes, recognized that self-knowledge is the basis for all human knowledge and for self-determined moral behaviour. This is not particularly spectacular if these insights are compared to the philosophy of Vedānta, which had identified the knowledge of the world with self-knowledge as early as 800 BC. Even Descartes' claim that the only certainty is to doubt radically everything that maintains any claims to certainty has an equivalent in Indian philosophy in the radical claim that everything that man encounters as something 'real' is actually mere illusion: the 'veil of Māyā.' René Descartes (1596-1650) describes his 'discovery' in the *Discours de la Méthode* (IV, 1) in the following manner:

> Während ich so denken wollte, dass alles falsch sei, bemerkte ich sogleich, dass notwendig erforderlich war, dass ich, der es dachte, etwas sei. Da ich mir nun darüber klar wurde, dass diese Wahrheit: Ich denke, also bin ich, so fest und so sicher war, dass selbst die überspanntesten Annahmen der Skeptiker nicht imstande wären, sie zu erschüttern, so urteilte ich, dass ich sie unbedenklich als erstes Prinzip der von mir gesuchten Philosophie annehmen konnte.[125]

> [While I was thinking that everything might be false, I immediately realized that this necessarily implied that I, who thought so, must be something. In this way it became evident to me of the certainty of the following truth: 'I think,

125. Johannes Hirschberger, *Geschichte der Philosophie. II: Neuzeit und Gegenwart*, Freiburg, 1988, p. 93.

therefore I am,' this was so firm and certain that even the most far-fetched assumptions of sceptics could not shatter it, so I concluded that I could accept it without any reservations as the first principle of the philosophy I had been searching for.]

One should be clearly aware, however, that what is presented here in the semblance of a syllogistic reasoning is in fact an intuitive insight, if one wishes to assess the importance of this claim. It is important to add that in all the early versions of this famous dictum the 'ergo' is missing, and thus the stringency of the argument is weakened (in the sense of: *cogitans sum*). But even on the basis of this position Descartes is indeed "the father of modern philosophy" in that he advanced the tendency towards philosophical subjectivism and places it in a privileged position, when he asserts the primacy of the subject (inside) over the object (outside). Compared to the medieval realism of objects and ideas, Descartes' approach marks a clear shift in perspective away from the metaphysics of the Middle Ages towards epistemology, which became increasingly dominant (cf. Locke, Hume and Kant, and Neokantianism). It was evident to Descartes that the human mind (*res cogitans*) "can more easily be known than the body" (*res extensa*) (heading of the second meditation).

By way of summary one can say that Descartes, and with him the Early Modern Period, was the first to recognize (in the Western world) that self-knowledge is the starting point of all knowledge and the beginning of self-determined moral behaviour. Descartes tried to establish the ego as the ground of moral behaviour and in this way he endeavoured to move the thinking subject back to reason; not least because reason, to him, constitutes a model of reality within the context and confines of science. However, a reductive process of this kind inevitably bars the way to wisdom.

It was Blaise Pascal (1623-62) who starts with his enquiries at this juncture, opening with the question "Qu'est-ce que le moi?" His cumulative answer is illustrated by an example:

> "Was ist das *Ich*? — Kann ich sagen, dass jemand, der sich ans Fenster setzt, um die Vorübergehenden zu betrachten, sich dorthin setzt, um mich zu sehen, wenn ich zufällig vorübergehe? Nein, denn er denkt nicht im besonderen an mich. . . .[126]

> [What is the *I*? — Can I say that someone who sits down by the window in order to watch the passers-by, does so in order to see me, when I happen to pass by accidentally? No, because he does not think in particular of me. . . .]

What can be inferred from this consideration? It is the following: there is no knowledge of the I without the physical auto-experience of the same I. Pascal's I is a concrete being, whereas the Cartesian ego identifies itself by an abstract thought. One can advance the argument even further, if one contrasts the thoughts of the heart that are bound to the concrete I to the thoughts of reason, which encompass the universal aspect of a human

126. Blaise Pascal, *Schriften zur Religion*. Übertragen und eingeleitet von Hans Urs von Balthasar, Einsiedeln, 1982, p. 169, Nr. 306 [323].

being, whereas the heart is directed simultaneously to universal and individual things. And the same ego is to be hated if it is "unjust" by claiming to be at the centre of everything.[127] And this is unfortunately the normal state of affairs. But the cause why the "Moi" can become an object of hate resides in its own inwardness. The invisible part in us is at the same time the most real one of and in ourselves. For the centre of all perceptions is within the realm of the invisible. What in us is it then that perceives 'pleasure' (*le plaisir*) — is it the hand, the arm, the flesh or the blood? No, it must be something immaterial.[128] And this immaterial thing is the immateriality of the soul. The soul is made in the image of God; but, unfortunately, that image has become distorted. And this lapse into the realm of dissimilarity is the cause of both the misery and the grandeur of man.

Man, according to Pascal, is a chimera. What a novel thing, what a monster, what a chaos, a subject full of contradictions: man is the judge of all things and at the same time he is a dull earthworm! He is the place of truth and, yet, he is also the cesspool of ignorance and errors, he is both the splendour and the junk of the universe.[129] Assessments of this kind will render any anthropology null and void, if one likes to call it that way; but these descriptions are aimed at the identity of man, which is contradictory in itself and which is inside and, above all — in the sense of Augustine — encompassed in the innermost part by Christ, God incarnate — *Deus interior intimo meo*. For Pascal, the path to wisdom does not lead along the avenues of science, but along the pathway of holiness. This was the insight gained by Pascal at Port-Royal. The abstract sciences cannot contribute to advance the study of man, since they cannot approach moral wisdom. Though the principle that one should know oneself is definitely still valid with Pascal, he claims that true knowledge can never be attained by the positivistic sciences. And this is a statement by one of the greatest scientists of the seventeenth century.

The aporia remains. Pascal's demand that one must learn to know oneself is expressed in these words: "Je ne tiens qu'à connaître mon néant."[130] How shall I recognize myself as nothing, if nothing is true and nothing shall be and nothing is to be retained? Pascal's concept of the nothingness of man, however, must not be understood ontologically, but morally; it refers to the cause of the 'Disproportion de l'homme' (in the sense of Tauler who distinguishes between two kinds of nothingness in man). According to Pascal it is expressly the 'Moi en particulier,' i.e. the real and existing self that is capable of apprehending the metaphoric and the mystical sense of 'nothingness.' Thus self-knowledge in man's inwardness can, according to Pascal, in the end be accomplished only by the path of humility, which is at the same time the path of unconditional love.

* * *

127. B. Pascal, *Über die Religion und über einige andere Gegenstände*, tr. and ed. E. Wasmuth, Zurich, 1977, pp. 212f, no. 455.

128. Quoted in Hervé Pasqua, *Blaise Pascal. Penser de la grâce*, Paris, 2000, pp. 105-17, in this place p. 110.

129. Quoted *ibid.*, p. 113.

130. Quoted *ibid.*, p. 115.

I summarize: The medieval approaches to introspective self-knowledge and inwardness were outlined at the beginning, albeit in a rather cursory manner. At first, ancient Egyptian monasticism and its tendency to practise self-discipline in view of an inward (spiritual) conception of Christianity was referred to; then Augustine's tendency to explore man's inwardness was considered, followed by John Scottus and his mystical model of interpreting creation, in which the inward man is discovered and claimed to be the genuinely paradisiacal man, who is one with God. Finally, the two great mystical epochs of the Middle Ages were surveyed: the great upsurge of mysticism in the twelfth century that led to the discovery of both the secular and the profane love of the Passion, and the upsurge of mysticism in the fourteenth century, which resulted in a new conception of man's intellect: it is unfathomable and grounded in the abyss of God. It would not be difficult to trace these developments in man's quest for inwardness and self-knowledge further down in history: to the era of the Enlightenment in which the mystical tendencies of introversion become part of psychology (e.g., in pietistic circles and in the literature of introspection arising at that time), or to the time of Goethe and the Romantic period, in which the cult of subjective experience was cultivated and promoted by an elaborate system of inwardness. Inwardness is experienced as a spiritual inner space as juxtaposed to the outside world. The discrepancy — between the increasing orientation of man to the outside world, and attempts concomitant with that tendency to counteract these coercions from outside by liberating excursions into the inner self — is the condition of modern man and also applies to our existence. The tensions between these opposed poles in our lives cannot be entirely overcome, neither by an extreme focus on inwardness nor by an extreme fixation on the outside world. The graded mystical model advocating guidance from outside by reason, controlled by the prudent turn to inwardness, has, to my mind, a chance to succeed even today, for it avoids the limitations of one-sided approaches and suggests at the same time clear preferences for the shaping of one's life.

Translation from German: Dr. Franz Wöhrer

The Meaning of Nothingness
for the Mystical Path in Johannes Tauler

Emmanuel Jungclaussen

Why do we read Johannes Tauler again today?

IN any discussion of German mysticism, it must be said that, among the great writers, none has been read so much, or had such a broad influence, as Johannes Tauler (1300-60), — although some might contend that Heinrich Seuse's *A Small Book of Eternal Wisdom* (Büchlein der ewigen Weisheit) might rival this claim. Tauler's influence is due especially to the Latin translation of his work by the Carthusian monk Laurentius Surius which was published in 1548 in Cologne. It was through this translation that Johannes Tauler had influence throughout the Catholic domain — a notable example would be that of Juan de la Cruz (John of the Cross) and the Spanish mysticism in general.

Tauler was read almost even more fervently within the realm of Protestantism, from the young Luther up to the mystic Gerhard Tersteegen (1697-1769) whose lesser-known texts follow Tauler's, even unto their mode of expression. In fact, two Schlesian Protestants of the seventeenth century, Augustin Fuhrmann (1591-1644) and Johann Theodor von Tschesch (1595-1649), considered the mysticism of Tauler to be the "true Christian Catholic-Protestant religion," the common ground for a union of the churches. Furthermore, the nineteenth century saw a renewal of a recognition of Tauler, notably, originating from non-Catholic circles, albeit overshadowed by that of his teacher, Meister Eckhart. Any examination of the 'Wirkungsgeschichte' of Johannes Tauler demands a re-examination of his ecumenical importance; as this aspect of Tauler has been rather neglected, this reason may well now have some primary value for a contemporary re-reading. His ecumenical value must be understood in a broader sense than only of a Christian ecumenism, in that the ecumenism of mystical experience within the history of mankind — with regards to both the means of this experience and its end — is an essential part of interreligious dialogue, amongst the diverse yet corresponding means of mental absorption with the aim of a mystical experience.

Tauler himself stresses this ecumenism of the inner, mystical experience several times, when he talks about the Pagan masters, especially Proklos. He knew of Proklos (AC 410-85), the Neoplatonist indirectly through Dionysius Areopagita (about AC 500), the father

of the Christian theology of mysticism, and directly via the Latin translation by Wilhelm von Moerbeke in 1264.

Neoplatonism, especially that of Plotinus (AC 203-69), represents something like a bridge between the occident and India and therefore to the Eastern and far-Eastern non-Christian mystical experience. In any event, it is evident that Tauler would have appreciated the true Zen masters and the sincere Indian wise people as much as he did the Pagan masters. One must further say that his method of oral expression of the mystical experience, as also with his spiritual understanding of scripture in general, can only be properly appreciated against this background — without doubting in Tauler's non-heterodoxical Christianity, either. Because of its exceptional relation with praxis, the teaching of Tauler — that of a 'life master' — could be an important help for those who are concerned with the integration of Eastern ways of experience — in Zen, as well as in Yoga and its different varieties — into the Christian consciousness.

Otherwise, Tauler provides safe guidance to those who are searching within the Catholic and Protestant domains, within the Christian traditions, using these methods to journey to one's interior, today as at any time. Tauler is thereby very illuminating, due to his explanations of meditative and mystical experience, to understand paths of any denomination, Christian or otherwise. Because of the inner correspondence of such an experience and its verbal expression, especially in the mystical sermon, Tauler is still near to us (in the German-speaking countries) in a special way: his teaching strikes one with immediacy, in the German language (its middle-high German notwithstanding). Therefore it can reach us more easily and deeply than in the case of that which must travel through the difficult processes of translation of mystical texts from foreign languages.

How do we understand Tauler today?

Two preliminary remarks are necessary. First of all: Tauler hasn't left any written elaborated method or system of his way of absorption. Each of his sermons — which refer mostly to the gospels or lectures (Epistles) of the liturgical year according his particular understanding of scripture — contains the whole of his teaching, in each sermon from the vantage of a different point of view. Therefore, this selection of texts is a more or less subjective enterprise, especially concerning their inner structure, in spite of the attempt to clarify Tauler's main concern, which for the purpose of our examination is the meaning of Nothingness.

Tauler himself lived completely in the order and tradition of the Dominican monasteries of his time which he tried to revive through his sermons towards a true inner, mystical experience. The theological tradition of the great teachers of the church, like Augustine (354-430), Gregor the Great (540-604), Bernard of Clairvaux (1090-1153), Albertus Magnus (1193-1280) and Thomas Aquinas (1225-74) was a defining precursor to this spiritual order, in spite of Tauler's consciousness of the limits and dangers of a scholarly theological disputation. The Pagan and Christian masters of the mysticism of Tauler —

Proklos, Dionysius Areopagita and Meister Eckhart, on whose account he differs from the doctrine of Augustine and Thomas — have already been mentioned.

This leads us to the second preliminary remark: that Tauler is fully and completely a man of the Roman Catholic church whose hierarchically-ordered authority, doctrine, guidance and sanctity is above any doubt for him, as it is the secret body of Christ — which leads one to a dimension of interiorization and personal conscience where Authority and sacrament occasionally find their limit. But, with this, Tauler remains quite within the framework of the traditional doctrine of the Catholic church. His loyalty to the church doesn't hinder but rather encourages him to strongly criticize the exteriorization of the life of the church at his time. The many examples for this would go beyond the frame of this little work, which concerns interiorization, the discovery of the inner world.

Tauler encourages us to this discovery with his clear distinction of the 'inner' and the 'outer man.' If we look more carefully we nevertheless discover — according Plotinus — a 'threefold man:' the first is man who is bound by the senses, the second is bound by his intellect and the third is the highest hidden interior godlike, i.e. truly perfectly spiritual, man. Tauler assigns a controlling and correcting function to the man who is bound by reason for his turning to God, the man who proceeds from the 'beginning' to the 'perfected man.' The man bound by his senses should be freed from the disorder of the lower powers of the soul, those being 'desire' and 'anger.' But Tauler is aware of the limitations of the merely 'rational.' Finally, he is interested only in the perfected man who has entered into the namelessness of the innermost ground — the Kingdom of God in us — with all the powers of his soul collected in his 'Gemüt' (heart). This 'Ground' corresponds as a whole to the ineffable ground of being of the Divine Triple-Unity from which man is arisen as an image, or, more eloquently, has 'flown out' from it. Now, in his Ground the man finds the inner master, a 'pulling' and 'turning of self' towards God, as the Holy Spirit (who is mentioned more explicitly in Tauler than in Eckhart and Seuse). It is the Holy Spirit who transforms man and divinises him, back to his origin where the man was "God in God" eternally.

What is here described as purity (Lauterkeit), imagelessness (Bildlosigkeit) and formlessness (Weiselosigkeit),[1] etc., is near to that 'emptiness' which is understood as a characterization of the Absolute in Mahāyāna Buddhism, i.e. 'free from any

1. Translators' note: The use of the term "Weiselosigkeit" is already coined by Eckhart. 'Weise' (manner) means for him every kind of determination of being, according Aristotle's doctrine of categories. Everything which can be determined by categories (they being either substance or quality) has a certain manner of being, a specific form, and can be recognized with the help of images (*species*). Concerning human life, especially religious practice, 'Weise' means a certain way of life (to be married, to be a monk, etc.) or certain means to achieve salvation or religious recognition. God is without manner (weiselos), cannot be determined by categories of beings. To recognize him, to reach the state of the original union with the God without determination, manner and form, man must become himself like him: without manner, without determination, without form, empty (the translators would like to thank Dr. Karl Baier, University of Vienna, for his explanation).

determination.' The special function of the realization of one's own nothingness — in the nothingness of God — in Tauler's view is the most important characteristic of the way of the discovery of the inner world.

In this process of destruction, painful self-knowledge, and also fear — the 'being hunted,' as Tauler describes it repeatedly — has an essential function to enable the final mystic breakthrough as the "birth of God" in man finally. Love as crucial factor should also not be ignored.

Certainly, everything depends upon daily exercise. This daily practices includes not only the time of meditation, absorption, which is limited by Tauler with one hour in the night, i.e. in the early morning, but also includes work.

The daily exercise becomes concrete in a threefold way: first of all the meditation which starts from painful self-knowledge which becomes the direct confession before God. In the case of the 'beginning man,' the centre of meditation is Jesus Christ, the son of God, "so that his holy life and his great perfect virtue, his model, his teaching and his manifold suffering is lured out from ourselves, and our dark light is distinguished by his true essential light" (H 10). "One should grow accustomed to never losing the venerable suffering and loving model in the heart and to be careful not to give space to any foreign image." (H 57) Again Tauler says: "Nobody can excel the model of Jesus Christ." (H 15) Only then, after the purification of such a meditation, man is allowed to enter the way of a completely imageless trans-objective absorption as the short "wayless way;" in that place, there is no exact objectifying instruction, only the awakening call of the sermon.

Man, secondly, can find special help and support for his daily exercise in the sacrament of the altar, in the pious receiving of the Holy Communion. Tauler has devoted five of his eighty-four preserved sermons to this subject. But Tauler views the Eucharist in a wider frame: of a surrender of oneself to the transformation into the Trinitarian God.

Concerning the daily exercise, it shouldn't be ignored how important the adoration of Mary as the image of the perfected Human is for Tauler: "Nobody, my beloved, should rise so high in his exercises of devoutness in this life that he has not one free hour to offer to the loving mother of God an especially blissful praise and service and to request her in a loving manner to guide and pull and help us to reach her beloved child." (H 54) "Together with the Father she should become the 'Wiedergebärerin' (who is giving birth again) to all the limbs of the mystical body by leading it back into its origin." (H 55)

The following selection of Tauler's sermons especially takes into account the meaning of nothingness.

Sermon 51

Beloved! The great theologians and Masters of Reading debate whether recognition or love is more important and noble. But we want to speak about the Masters of Life. When we come into Heaven, we will certainly see the truth of all things. Our Lord said: 'Only one is necessary!' What is this one?

This One consists of that whereby you recognize your nothingness as being yours, whereby you recognize what you are and where you are within yourself. Because of this One you have caused the Lord so much fear that he has sweated blood. Because you did not want this One he cried out on the cross: 'My God, my God, why have you forsaken me!,' because this One, which is necessary, was totally abandoned by all men. Therefore, abandon everything now what I myself and all masters have taught to you, everything that they have said about effectiveness and contemplation, about elevated meditation, and learn this One alone, and thereby shall it become That for you: then you shall have laboured well.

There are some who speak about such great, reasonable, transcendent, transglorious things as if they have flown above all heavens, and still they haven't taken even one step out from themselves in the recognition of their own nothingness. They might have reached intellectual truth, but nobody can come to the living truth which truly is Truth without the way of nothingness.

The true diminution of oneself dives into the divine inner abyss of God. Here one loses oneself in complete and utter loss of one's Self: 'Deep is calling to deep by the roar of your cataracts.' (Ps 42.7) The created abyss draws inwards due to its depth; its depth and its realized nothingness draws the uncreated open abyss into itself; the one flows into the other, and a single one arises, *one* nothingness in the other.

This is the nothingness from which Saint Dionysius said that God is not of anything which can be named, understood or grasped: here the human spirit is completely surrendered to the divine; if God wants to annihilate it totally and if He could be annihilated in this union, he would do it out of love for this nothingness with which he is completely fused, because he knows, loves and feels nothing else than this One.

Beloved! Blessed are the eyes that come to see in this way! About them the Lord could say this word: 'Blessed are the eyes which see what you see!' Would that we all may become blessed owing to the true vision of our own nothingness. May God help us for this.

Sermon 77

Beloved! He who would only come to reach this ground of realization of his own nothingness, he would have found the next, shortest, straightest, safest way to the highest and deepest truth which you can reach on earth. To take this way none is too old or too weak, neither too stupid or too young, nor too poor or too rich. This way says: 'I am nothing!' Ah, what an inexpressible life lies in this 'I am nothing'!

Ah, nobody wants to take this way wherein you can look where you want. God forgive me! Really, we are and want and wanted always to be something, always one before the other. In this desire all men are so kept and bound, so that nobody wants to give himself. It would be easier for a man to do ten works than once to

give himself thoroughly. Every quarrel, every misery is about this.

From it all sorrow comes, all grievances. Therefore it is written that we are considered to be without God and grace, without love and virtue. Therefore we cannot find peace, neither from inside nor from out. This comes only because we want to be something. Ah, this being nothing, this would have whole, true, essential, eternal peace in every form, at every place, with every man, and it would be the most blissful, the safest, the noblest in this world, and yet none wants to strive for it, neither rich nor poor, neither young nor old.

Know this in truth: As long as you still have one drop of blood in your flesh or marrow in your bones without using it for the right detachment (Gelassenheit),[2] you thereby must not be so impudent to think yourself detached. You have to know: As long as you lack the very last ounce of true detachment, God will eternally stay far from you, and you will not experience the deepest and highest bliss in time and eternity.

The grain of wheat must die if it shall bring fruit. If it dies it will bring great fruit. Here a dying, a becoming nothing, an annihilation must happen, here an 'I am nothing!' must happen. In truth, here no wishing, no desiring, no requesting is sufficient, you must reach it with the exertion of your powers, you have to take pains over it, because what is free has no value.

Ah, beloved, turn to yourselves, and see how far and different you are from the loving image of our Lord Jesus Christ whose renunciation was bigger and more thorough than all the renunciation together which has been done by all the people in this time or will be done in future. Many people give themselves to God, but don't want to give themselves to the people. They want that God impels them but not mankind. No, one should give oneself like God wants it. And who wants to show you your nothingness — welcome him with great thankfulness and love; because he reminds you in truth what you are: nothing!

May God help us that we all reach this annihilation and thus dive into the divine being.

Sermon 54

When God wanted to create and make all things, he had nothing else before Him than the nothingness. From it only he created a something; he created all things from nothingness. Where God shall and will work in his particular way, he needs nothing more than nothingness. Nothingness is more qualified than everything that is, to experience the work of God in a passive way. Do you want to be always receptive for everything which God can and will give to his most chosen friends and work in them, in being and in life? Do you

2. Translators' note: The term 'Gelassenheit,' which is already important for Meister Eckhart, implies the meanings of 'detachment,' 'letting go,' 'equanimity.'

want that he overflows you with his gifts? Then apply yourself especially to understand that in truth you are nothing in your Ground. Because our selfishness and our lack of renunciation hinder God to fulfil his noble work in us.

Sermon 29[3]

You, however, should allow the Holy Trinity to be born in the center of your soul, not by the use of human reason, but in essence and truth; not in words, but in reality. It is the divine mystery we should seek, and how we are truly its Image; for this divine Image certainly dwells in our souls by nature, actually, truly, and distinctly, though of course not in as lofty a manner as it is in itself.

Above all, cherish this very sweet Image which dwells in you in such a blessed and unique manner. Nobody can express adequately its nobility, for God is in this Image, indeed He is the Image, in a way which surpasses all our powers of comprehension.

Scholars discuss this Image a great deal, trying to express in various natural ways its nature and essence. They all assert that it belongs to the highest faculties of our soul, which are memory, intellect, and will; that these faculties enable us to receive and enjoy the Blessed Trinity. This is indeed true, but it is the lowest degree of perception, leaving the mystery of the natural order. Saint Thomas says that the perfection of the Image lies in its activity, in the exercise of the faculties; that is, in the active memory, in the active intellect, and in the active will. Further than that Saint Thomas will not go.

Other theologians, however, state — and here we have something of far greater significance — that the Image of the Blessed Trinity rests in the most intimate, hidden, and inmost ground of the soul, where God is present essentially, actively, and substantially. Here God acts and exists and rejoices in Himself, and to separate God from this inmost ground would be as impossible as separating Him from Himself. This is God's eternal decree; He has ordained that He cannot and will not separate Himself. And thus in the depth of this ground the soul possesses everything by grace which God possesses by nature. In the measure in which man surrenders himself and turns to that inmost ground, grace is born in the highest way.

A Pagan master, Proclus, has this to say on the subject: 'As long as man is occupied with images inferior to himself, and as long as he does not go beyond them, it is unlikely that he will ever reach this depth. It will appear an illusion to really believe that this ground exists within us; we doubt that it can actually exist in us. Therefore,' he continues, 'if you wish to experience its existence, you must abandon all multiplicity and concentrate your attention on this one thing with the eyes of your intellect; and if you wish to rise higher, you must put aside all rational methods, for reason is now beneath you, and then you

3. Johannes Tauler, *Sermons*, tr. Maria Shrady, New York/Mahwah: Paulist Press, 1985, pp. 104ff.

may become united with the One.' And he calls this state a divine darkness: still, silent, at rest, and above all sense perception.

Beloved, it is a disgraceful thing that a Pagan philosopher understood and attained this truth, while we are so far from both. Our Lord expressed the same truth when he said: 'The kingdom of God is within us.' It is to be found in the inmost depth, beyond the activity of our faculties. And so we read in today's Gospel: 'We speak of what we know, and we bear witness to what we have seen; and our witness you do not receive.' Indeed, how could a person who lives merely by his senses receive this witness? To those who subscribe to such a way of life, that which is beyond the senses appears as an illusion. As Our Lord says: 'As the heavens are exalted above the earth, so are my ways exalted above your ways, and my thoughts above your thoughts.' And Our Lord says the same thing today: 'If I have spoken to you of earthly things and you believe not, how you will believe if I shall speak to you of heavenly things?' Recently I spoke to you about wounded love, and you said that you could not understand me, and yet we are dealing only with earthly things. How can you then expect to understand things spiritual and divine?

You are concerned with so many external affairs, always busy with one thing or another; this is not the witness of whom Our Lord said: 'We bear witness to what we have seen.' This witness is to be found in your inmost ground, beyond sensual images; within this ground the Heavenly Father begat His only-begotten Son, swifter a million times than the twinkling of an eye. And this happens in the swiftness of eternity that is forever new, in the inexplicable splendour of His Own Being. Whoever wishes to experience this must turn inward, far beyond his exterior and interior faculties, beyond all that the imagination has ever acquired from outside, so that he may sink and melt into that ground. Then the power of the Father will come and call the soul into Himself through His only-begotten Son, and as the Son is born of the Father and returns into Him, so man is born of the Father in the Son, and flows back into the Father through the Son, becoming one with Him. Thus Our Lord says: 'You will call me Father and will not cease to walk after me. This day have I begotten you, through and in my Son.' And now the Holy Spirit pours Himself out in inexpressible and overflowing love and joy, flooding and saturating the ground of the soul with His wondrous gifts. (. . .)

This, then, is the true witness: 'The Holy Spirit, testifying to our spirit that we are the children of God.' And thus we receive this testimony in our hearts, as it says in today's Gospel. (. . .)

And now, if you wish to contemplate the Holy Trinity within you, keep these three points in mind. First, keep God alone before your eyes. His honour, and not your own. Secondly, in all your works and exterior activities keep a close watch over yourself; be constantly mindful of your utter nothingness, and observe carefully what occupies you most. Thirdly, ignore what goes on around you: If it is not your business, do not pay attention to it; it will take care of itself. If things are good, let them be so; if they seem bad, do not

criticize and ask questions. Turn into the depths of your ground and remain there, so that you may hear the voice of the father Who calls you. He calls you to Himself and endows you with such riches that, if it were necessary, you could answer all the questions of the entire clergy in the Church; of such clarity and brilliance are the gifts God bestows upon His lovers.

And should you forget everything that has been said here, keep in mind these two little points: First, be truly humble, throughout your whole being, not only in mind and in outward conduct; think lowly of yourself, and see yourself honestly for what you are. And secondly, let the love you bear to God be a true one; not just what is usually understood by the term, which refers only to emotions, but a love that embraces God ardently. Such love is a far cry from what is usually meant by religious feeling, which is situated in the senses. What I mean here transcends all sensible experience; it is a gazing upon God with one's entire spirit, a being drawn by love, just as a runner is drawn, or an archer, who has a single goal before his eyes.

May the Blessed Trinity grant us to arrive at this inmost ground where its true image dwells. Amen.

Translation from German: Ernst Fürlinger/Michael Ianuzielo

28

Pūjā or the Exercise of Thankfulness

Rudolf zur Lippe

Pūjā is Care

PERHAPS no feeling has been so abandoned in the modern world like thankfulness. Conventional words of thankfulness are still being regularly exchanged. Spontaneous expression arises now and then when help, kindness, or ease interfere in the automatic structures of routine life. But normally the expression remains artificial and exaggerated, borrowed from the shelves of a theatrical repertoire. We are able to feel and express Thanks, apparently, only when we are on good ground.

No other dimension of our existence, maybe, is as abandoned in modern life as groundedness. Proudly we carry around the frame of our body instead of trusting the earth, or just the soil, to bear our weight. Military drill stresses the centre of our gravity so high up to the pride of the thorax that soldiers vanish or lose balance while standing at attention. Ballet dancers extend expression of their bodies into self-conscious arms and hands and touch the soil with their backs in fanciful curves; but their feet have unlearned to minister as the organ of human friendship with the earth. Feet have long since become the lowest part of the human apparatus for transport. The vision is about flying and practice is about controlled stability. Groundedness is the ever-moving experience of the upright humans to be centred on the earth that bears us.

Gravity provokes plants and animals to strive to remain upright. Modern men and women, even children, just use upright walking in order to position themselves or to overcome distance, either of them being defined in terms of a horizontal surface.

Thus, we have to accept our being heavy as a mere humiliation. The delightful experience of a sensibly weighing body and the forces that respond by keeping us erect is far from modern ideas about regular life. We seemingly gain independence from the performance of our body that is reduced to the useful and necessary purposes. Maybe, we even acquire the proud status of equilibrium under our own control, as we lose the sense of the beneficence of the earth bearing and of air raising us. In the Germanic scripture the basic experience of living upright is expressed in the rune *I*. Just a vertical line as a graph, which has an existential meaning of the greatest importance: connection betwixt earth and heaven.

Being grounded in this connection is the basic gift in the *conditio humana*. The very ground for feeling thankful every time we breath in, every time we set foot on the ground. To remind ourselves of this most elementary dimension of our lives, it may help to understand better the expressions 'worship' that usually comes up when an equivalent is sought for the Indian word *pūjā*. Underlying the many forms of *pūjā* in religion, we need to recognize the lively awareness of humans to live as the connection betwixt heaven and earth, that human consciousness is uniquely gifted to understand. Raising our arms we thus affirm the relationship. *Y* is, consequently, the symbol for *man*.

Worship

Now, there is more to *pūjā* than worship. In *pūjā* not only arms are raised, as sometimes they are so, but hands also take part in the exchange.

Flowers are grasped, taken to the temple, and deposited on the stand of the goddess. Milk and water are brought to the shrine to be spilled over *liṅgam* and *yoni*. The hands are joined and raised up together while the head is inclined in honour of the other, whether present in the very aura of the god or through another human being. While standing in the waters of mother Gaṅgā, the pilgrim reaches out with his or her hands for the holy liquid of liquids and offers it, returning the flow for the sake of a beloved being, much like we convey a kiss in the air to send it sailing toward the lover, the relative, the friend out of the reach of our embrace.

All of these gestures convey endearing respect. They may be called worship. But they evidently symbolize a more concrete relation that either is sought to be established or affirmed and renewed. *Pūjā* is not a mere ceremonial reverence. You *do pūjā*. *Pūjā* belongs in the category of doing. This becomes evident when a woman at Assī Ghāṭ in Varanasi brings a little light and water to a tree on the side of the street at the end of each day. Once, when I was invited to a *pūjā* for the planting of trees by volunteers in the jungle in Maharashtra, where deforestation has devastated the environment, I was struck by the coordination and unity of planting and *pūjā* — or praying as we would say. *Pūja* is care, more than worship.

At important temples and on special days we observe long queues of families with children and devotees purchasing the appropriate little basket of flowers that they carry in their hands until they enter the inner circles of the sanctuary. These flowers, handed over to temple servants with due piety, are taken by quick and efficient hands and thrown to the ground surrounding the statue, the mount Meru, or else a relic or image. Squeezed and molested by the pushing crowd, what came to my mind was labour for luck rather than veneration. Love's labour lost?

There is more to come by the other side of the sanctuary. Sometimes after another choreography approaches the shrine through the yards, you will receive, from other hands, a fresh basket with gifts that are impregnated with the presence of the goddess, together with blessed sweets. This you take home for yourself and your loved ones, charming

reminders of the encounter. But the very exchange happens in the moment — we might be blunt enough to say, when you get a short look at the image — no, when you are granted to receive the glance of the deity: *darśana*. To make sure the god or the goddess worshipped at this temple is aware of your desire to be blessed with his or her presence, on an ordinary day, you strike a bell above you. Children love to do so, sitting on their father's shoulders.

So far, it is very difficult for the observer from another culture to distinguish the ritualistic aspects from a less banal meaning. Only when you keep in mind what you have learned from the woman bringing water to the tree or from your studying the rituals of the Vedic tradition may you feel inclined to search for the ties that are renewed or created in the process achieved through the forms of the ritual. *Pūjā is about care.*

These deities are nothing absolute like the *pantocrator*, 'the Almighty,' sovereign over heaven and earth. Even the Hindu creator deities are themselves created. Their working, mighty as the forces of spirit and nature, only shares in the shaping and the dissolving of the forms of life. While the humans and other forms of life are in their hands, they themselves simply join in the *līlā* of the world. *Līlā* is interplay, an interpretation of what we might call evolution in just another melody and rhythm.

Worship describes the attitude of the Christian believer. He or she praises the Almighty for having created the world and submits his or her wishes to be, hopefully, included in his decision-making. In these monotheistic religions the destiny of the world is being taken care of exclusively and perfectly by this sovereign creator and ruler. The duties of the creatures are defined in their relationship with god whose commandments they have to obey. Fulfilling these duties they serve god and act towards the salvation of their own and individual soul. The Decalogue is composed of five commandments on the relations between man and god and five on the relations of man with man. The relationship between humans and the world or nature, consequently, have a derived status.

The Hindu genesis renders and inspires a completely different view. The history of the world is ever open to the unexpected. A god may be amazed by the outcome of his own creations. The world is not the execution of the creator's blueprint. Reality is the joint working of energies, gods and all other participants of creation. This interplay between the rules of the existing and the unknown that invites new evolutions or provokes revolution is *līlā*. An individual life history is regarded as *līlā*, exactly like genesis in total. In this ongoing process, *pūjā* is certainly worship in reverence to one particular of the gods and all of the creative energies. At the same time, it is also the symbolic expression for a proper participation. This aspect is certainly better perceived as care for the ongoing working of the world. Thankful we are to know that we are cared for and the expression of thankfulness is reciprocal. We respond with joy and we react with care.

Goethe's care for the phenomena, the world with us Here, I dare say that we may discover a common ground with what is perhaps the most advanced of occidental reactions to the dualistic consequences of monotheism: Goethe's 'natural sciences.'

We need to explain this concept in two main aspects. One is the role of nature in the human relation to transcendence. Goethe is known to have contested Newton's attitude toward the natural world with singular violence. Albrecht Schöne has even coined the quite aggressive title of a "Theology of colours" for his criticism. He interprets Goethe's assaults on "the ancient fortresse" of Newtonian dogma as para-religious fanaticism inspired by some pietistic experience in his youth. But I think the debate must be understood rather in reference to the position attacked.

Newton's laws of gravity and his explanation of the nature of light are the peak of mechanistic reconstruction of the material world. In Goethe's times, Newtonism was not only dominating the natural sciences. The earlier impact of Descartes, enhanced by Voltaire's reception of Newton's theory, exaggerated the strategies of reconstruction that were used for prediction and the projection of human purposes onto their schemes. This actually is the perspective about which Goethe felt almost fanatical. He knew precisely what his contemporaries, and ours, did not feel concerned with. Nature, the world of phenomena, was discarded by the purposive rationalistic explanation as a meeting ground for human imagination with the transcendent. But such encounters truly are what the experience of phenomena leads us to if we do not draw up walls of demarcation instead.

Phenomena do not have the ontological status of being, but their existence comes in to being in every new encounter. We do not observe what happens in the event of a rainbow, or simply of a spot of red, but we live together with it. We experience and perceive the phenomenon in correspondence with the very conditions of our proper nature. We are linked, in other words, with the natural phenomena by our own nature, in principle, and by the induced activity of our receptive senses and our consciousness, both cognitive and emotional.

Goethe was certainly capable of such a concept only because he has freed himself from the doctrines of monotheism. Western thought is eager to label such freedom of movement in thinking and feeling as pantheism. Goethe has been subjected to that theory all the more easily as he, as a matter of fact, felt much encouraged by the work of Spinoza, who may be referred to as a defender of pantheism. Goethe, however, did not just switch positions. His views are not of another, opposite ideology. He practices another approach, an approach somehow betwixt — if you want to define it in the regular terms, which were of very little interest to him. But his is not compromisingly betwixt, rather, it is an integrative one.

Engaging in the experience of nature, in all the possible attitudes and styles of awareness — from the casually remarked to the scientifically researched phenomenon — he defends the joy and richness of ever new encounters throughout our lives. Curiosity for ever-changing performances of what may be grasped, intellectually, as the same phenomenon; poetic reverence to the event that meets our sensibility and imagination; methodological insight into the interdependence of sameness and otherness, of diversity and comparability.

Thankful perception of reassuring accountability and amazement for the singularity of every actual presence.

> Drum ergreife ohne Säumnis
> Heilig öffentlich Geheimes.

> Never hesitate to get your way
> Holy secret on open display.

Goethe not only achieved distance from Christian theology and dogma. He equally left behind the occidental taste for an absolute that has dominated our theory of knowledge since early Greek philosophy and contaminates most of our everyday attitudes. It was not a dispute about philosophical systems that could have attracted his attention. He just laboured for free encounter with the holy in the medium of the phenomena of nature, in defence of possible experience of immanent transcendence.

> Willst du ins Unendliche schreiten
> geh nur im Endlichen nach allen Seiten.

> Thriving to pass on to the infinite
> Just walk all paths in the finite.

A Western Relative of an Eastern Style of Existence

Why do I think that an analogy may be discovered between the natural science of Goethe that is based on such convictions and the Indian tradition of *pūjā* as an expression of the Hindu genesis? Max Müller felt, "Indra is the concretion of the non-graspable as the abstraction of that which is not graspable" and: "Varuṇa was just an appellative title," an invocation for "the infinite within the finite." Of course, the distinction is clear. Vedic language is about deities; whereas natural science, including Goethe's, is about knowledge. But underneath the names and terms, these attitudes are closely related. No separation or even opposition is constructed dividing the finite from the infinite. While the Vedic religion is a tradition of knowledge about the world and ourselves within it, Goethe's research is based on grateful reverence for the manifestations, phenomena, together with a challenge for a full evolution of the individual in correspondence with this plentifully emerging world.

Goethe decided to cultivate these encounters for the awareness of the godly workings. Knowledge in such context is ethically embedded. The Vedic tradition, on the other side, carries a whole corpus of ecological, cosmological and other knowledge about "nature" from generation to generation. Certainly, the religious references of science remain quite general, vague. Tradition, religious tradition specifically, tends to limit further development of knowledge and its expanding application.

The idea of this analogy came to me one day in Calcutta. It was the great festivity for mother Kālī. Kapila Vatsyayan invited me to join her for the visit of the great temple. When we were allowed, after queuing with all the hundreds of devotees, to be in the

presence of the statue, first from the side, after another pilgrimage across the temple yards facing the black Kālī I was very astonished to see the fair body of beautiful Śiva trampled under her feet. But this episode follows very nicely the logic of Hindu mythology, which is, of course, permanent genesis. Kālī is not the creator; she is the creative principle and, therefore, the great dissolver of everything created. The created must give way for new creation. The venerated image in the centre of the sanctuary at Calcutta presents Kālī together with Śiva, her male counterpart and complementary force. He has accepted to be subjugated and dominated by her in order to calm an outrageous outbreak of fury. This is merely one episode, though an important one, in the relationship. Across the yards of the temple the enclosure is formed by a series of shrines in which the might of Śiva is celebrated in the most generous fashion. In six shrines, an open space under a dome protects a huge *liṅgam* of black stone on its *yoni*. Six shrines the believers enter, one after the other, to do *pūjā* spilling milk and water and offering pious attention to the ever changing presence of the god. The stone image is every time seemingly alike. But a widespread initiation makes the worshipper aware of the ever-heightened intensity of the spiritual presence through the symbolic stone.

I doubt whether the ordinary Hindu who pays his or her visit to the temple grasps in cognitive clarity the symbolic principles engendered in the whole of the architectural complex. They just step into the six shrines one after the other in due ritual. But through the act of *pūjā* everybody shares the performance of the underlying cosmology in sensual attentiveness. There are several polar fields of tension: centre and periphery, attributed to Kālī and Śiva, who both embody the creative and the destructive energies in an eternal interplay. Here, specifically, Śiva is the submissive compliment to the black mother in her ecstasy and, surrounding this centre, he is the glorious spiritual transcendence in the rhythmic cadence of the metamorphosis by the number of six. There is also the polarity of light and dark. Kālī the black over fair Śiva; the black *liṅgam*s evoking finally the ultimate manifestation of Śiva in the *liṅgam* of light that amazed even the other gods with such powerful intensity that they could not bear the very sight of it.

Polarity is the basic principle that Goethe discerns in his appreciation of nature. The colours appear in the interplay of light and darkness. They are phenomena emerging from the struggle of the complementary extremes. The leading principle in Goethe's under-standing of metamorphosis is that of intensification. A key example in the metamorphosis of plants becomes quite evident with the leaves as a first development and, thanks to a further pressure, the refined phenomenon of the flower with its petals and the arising organs of gender.

Could we wish for a more spiritually convincing, a more sensually evident presence of this principle of heightened intensity than in the sequence of the six *liṅgam*s? Maybe, you would object. Parallels in such principle concepts are very nice. But that is one thing, and practicing *pūjā*, on one side, and experiments in the research into nature, on the other side,

is quite another. Nevertheless, the importance of these principles is not a minor issue to begin with. And they certainly are as basic in Goethe's approach, an approach to the world altogether, as they come in a shocking surprise for the traditional western thought in general. This is exactly what J.P.S. Uberoi calls "the other mind of Europe: Goethe as a natural scientist." In these principles and in their impact on the ever-present awareness of man witnessing the phenomena in their most concrete aura a relationship with the world comes true that, somehow, is as active and as passive as *pūjā* suggests. This relationship is meant to heal the modern European separation of spirit and matter, of mind and flesh, overcoming the Western lack of awareness for the interplay of the manifest with the non-manifest.

There is all the receptivity that human beings develop as thankful members of creation. The skilful awareness for the phenomena that are given us to unfold is a service of consciousness, although somehow a secular discipline, in response to nature. Observing *pūjā* as an onlooker we may ignore, on that side, how much understanding of the workings of genesis is, perhaps implicitly for many, embedded in the attitude of the believer. Worship is, I believe, always thankful attentiveness, and as such it is not too bad a characterization for both attitudes, the exceptional Western and the regular Eastern one.

Now, it is true, that I have objected to worship as a translation for *pūjā* advancing the view that it expresses, together with veneration, also care. Care is an active participation in the workings of creation. The fact that in *pūjā*, in most cases, the humans partake only rather symbolically in the ongoing processes of the world does not diminish its active importance. On the contrary, the Hindu offers his or her contribution with hand, mind, and heart. The active aspect of participation is much less evident in Goethe's approach.

If we rightly claim that his phenomenology presents us with just another style of natural science, we have to admit that it is practised in search of knowledge. However, this style of research is different from the tradition of Bacon, Descartes and the "disclosure of the human genome" in two respects: one concerns the biography of the scholar; the other concerns the character of knowledge.

To be able to conceive of a phenomenon one needs to pursue what it sums up in the abstract throughout unaccounted concrete encounters. Such a pursuit is bound to educate the 'subject,' while the research advances on the side of 'the object.' The faculty to conceive is not acquired by theoretical deduction, only after a long history of interplay between amazing sensual revelations and conceptual speculation together. The resulting knowledge leads more to the possibly most appropriate awareness of the world than to skilled domination for instrumental purposes.

We are always free to use all of our achievements in order to manipulate our fellow beings, the elements or whatever. This is true already for a civilization based on *pūjā*. The story of the lion-man from the Upaniṣads is an example of cosmologic dimensions. But in Goethe's phenomenology, at least, a counterbalance against what he called the "velociferic"

is inbuilt into the production of knowledge. William Blake has coined the very formula for it: to acquire the quality to see ". . . a universe in a seed of sand."

I want to insist on these two, certainly very distinct views only up to this point. We can state that on either side aesthetics collect the substance for ethics, the joyful appreciation as the existential source for responsible relations of humans with the world with us. My argument is not about the classification of historic traditions. I am grateful for the convergence of two heritages that opens up an encouraging perspective for the present state of the world and the common global future.

Transcending Pūjā, Pūjā Transcendent

Some style or another of *pūjā* may become a common ground for human attitudes toward the common patrimony earth, whether we refer to it selfishly as 'environment,' that which is around us, or piously as 'creation,' leaving open the resulting question of a creator or several or none at all. Thankfulness translates itself into gestures of rewarding activity in the circumstances of everyday life. Such an exercise may prepare our minds to build up an endearing esteem for what bears our existence in the eloquent silence of co-existence. Scientific insight into the very conditions of survival, both of ourselves and the world we use and abuse, contributes to an awesome consciousness as does the love for the other. If science contributes the warning aspects of care, gratitude and love contribute the impulses for active reaction while theoretical knowledge plays the passive part.

Where both sides come together, the seeming opposites, science and worship, may discover that, in fact, they may form a complementary symmetry preparing a readiness for a finally encompassing consciousness.

But readiness is only a condition, not the actual attitude needed and, now, hopefully wanted. Two major obstacles still remain, or arise anew — shyness and resentment, on either side. May the rational scientific approach engage in sentimental commitment? May the believer betray the consecrated forms of tradition?

The dimensions of what is waiting for our care transgress absolutely all concepts known until our time. Most of the industrialized efforts in contemporary invention and production are invested to adept nature to human abuse, whether human nature or nature in general becomes their target. Progress is heading toward replacing, literally, earth altogether, from 'hydroculture' to projects for an exodus toward another planet. Science investigates living conditions on other planets; science fiction experiences with space stations. When planet Earth is transformed into junk let us drop it like the junk we have been throwing away everywhere until then. The old and manifold thrive of man to achieve immortality through disincarnation in diverse styles realizes its most ambitious pretension ever. Reality is being transformed into thin virtuality. Artificial intelligence and the total prosthesis shall do the job. Though this may forever remain a fantasy, there is nevertheless no part of the global world that does not get into the turmoil, whether under imposed pressure or by attraction, need, or greed.

Given this state of the world, a change in attentiveness will not in itself do the job. But such a change is the first and ultimate precondition. In order to develop attentiveness into attitude we want to accustom ourselves to some appropriate exercise. New forms of *pūjā*, or old ones if you are on friendly enough terms with them, can provide a medium between our incarnated existence and a symbolic order in which to expand groundedness anew. Of course, mere gestures cannot take the place of actual practice, social as well as individual. But I shall always remember the model given by the Chipco movement in the jungle of Maharashtra. To plant trees without a prayer accompanying the work in the ground engenders a lack of groundedness, even in otherwise efficient labour, because it does not arise out of a spirit of thankfulness and care as its manifest expression. In everyday modern life, on the other hand, I experience that much more often than not picking up litter from the surrounding world, washing the face of earth, is good enough a *pūjā* — for the time being.

> Alles prüfe der Mensch,
> sagen die Himmlischen,
> dass er, kräftig genähret,
> danken für alles lern
> und verstehe die Freiheit,
> aufzubrechen wohin er will.
> — Hölderlin

> May man prove all things,
> The celestials tell,
> So that he, forcefully nourished,
> To thanking learn for all
> And to understand the freedom,
> To break up where he is willing.

Between Similarity and Contrast
The Function of Comparisons in Interreligious Debates

Axel Michaels

The Logic of Comparisons in Interreligious Dialogues and Debates

IT is well known that the systematic interest in the history of religions is a discovery of the Enlightenment and Romanticism, as was once again demonstrated by Hans G. Kippenberg in his excellent book *Discovering Religious History in the Modern Age*.[1] This interest, programmatically propagated by F. Schleiermacher, created the first comparisons of religions that were not polemical. It is also a well-known fact that the science of religions (plural) commenced with Max Müller's study of religion (singular) which he developed from the comparative study of languages. His interest in comparing religions was basically a programme of discovering a

> new religion . . . for the whole world . . . firmly, founded on a belief on the One God, the same in the Vedas, the same in the Old, the same in the New Testament, the same in the Koran, the same also in the hearts of those who have no longer any Vedas or Upanishads or any Sacred Books whatever between themselves and their God.[2]

Thus, the method of comparing religions is a creation of modernity. Even the term *religion* is "solely the creation of the scholar's study. It is created for the scholar's analytic purposes by his imaginative acts of comparison and generalization. Religion has no independent existence apart from the academy."[3] Or, as Jonathan Z. Smith has put it elsewhere: "the enterprise of comparison . . . brings differences together solely within the space of the

1. Hans G. Kippenberg, *Discovering Religious History in the Modern Age*, Princeton: Princeton University Press, 2001.

2. Max F. Müller, *Bibliographical Essays*, New York: Scribners, 1884, pp. 80-81 (quoted from Luther, H. Martin: 'Comparison,' in : Willi Braun/Russell T. McCutcheon [eds.], *Guide to the Study of Religion*, London/New York: Cassell, 2000, pp. 45-56, here p. 52).

3. Jonathan Z. Smith, *Imagining Religion: From Babylon to Jonestown*, Chicago/London: The University of Chicago Press, 1982, p. xi.

scholar's mind. It is the individual scholar, for his or her own theoretical reasons, who imagines their cohabitation, without even requiring that they be consenting adults."[4]

Given the mass of religious data that were presented through the comparative study of religions, the units of comparison had to be construed as religious phenomena (G. van der Leeuw, M. Eliade, F. Heiler and other phenomenologists), ideal types (M. Weber), archetypes (C.G. Jung) or whatsoever. For, any stress on socio-cultural particularity and singularity, on contingency and specifity, did not allow for generalizations and, in a second step, comparisons,[5] and, in a third step, for the science of religions. The methodological question 'How to compare religions?,' thus, is itself based on a theological claim of — or at least common-sensical wish for — a unity of religions. The dilemma in comparisons is, therefore, evident: the method of comparison has the tendency to deny religious phenomena. What then remains is not the phenomenon but the religious world-view of the scholar of religious phenomenology. Singularities, then, more or less only serve for the illustration of theory.

However, other forms of comparing religions than the scientific ones have been the rule in the history of religions from its beginnings. There are, for instance, comparisons expressed in interreligious disputations and debates. It is this aspect that I want to stress focussing on public debates in South Asia.

Given the present desire for harmony in interreligious dialogues,[6] early interreligious debates were comparatively open with regard to their results and comparatively harsh in their mode. They often started or ended with bitter quarrels or polemics. The aim was not so much to create interreligious understanding as to separate religions from each other in order to maintain their distinctive character. The rigid representatives of religions did not want a dialogue, and the more tolerant ones did not need it. Comparing by contrasting was the preferred method in such contexts. For, "religions fight against each other, that is a fact."[7] Fortunately, verbal contests are the most inoffensive form of rivalry between religions which can be classified by separation, contest (from competitive games[8] to fierce fights), or mission.[9]

4. Jonathan Z. Smith, *Drudgery Divine: On the Comparison of Early Christianities and the Religions of Late Antiquity*, Chicago: University of Chicago Press/London: School of Oriental and African Studies, 1990, p. 115.

5. See also Fitz John Porter Poole, 'Metaphors and Maps: Towards Comparison in the Anthropology of Religion': *Journal of the American Academy of Religion* 54 (1986), pp. 411-57.

6. Ketut Waspada, *Harmonie als Problem des Dialogs. Zur Bedeutung einer zentralen religiösen Kategorie des Christentums mit dem Hinduismus auf Bali*, Frankfurt a. M. u.a.: Peter Lang, 1988.

7. Ugo Bianchi, 'Nach Marburg (Kleine Abhandlung über die Methode),' in: G. Lanczkowski (ed.), *Selbstverständnis und Wesen der Religionswissenschaft*, Darmstadt: Wissenschaftliche Buchgesellschaft, 1974, p. 214.

8. Johan Huizinga, *Homo Ludens. Vom Ursprung der Kultur im Spiel*, Reinbek: Rowohlt, 1956, p. 109 and pp. 119-32.

9. See Günter Lanczkowski, *Begegnung und Wandel der Religionen*, Düsseldorf/Cologne: Diederichs, 1971.

My hypothesis is that, generally speaking, religions use comparisons in such interreligious debates for showing the superiority of one's own faith or to prove the existence of a super-religion that combines the best of two or more religions. Logically seen, religions do not have any further option, since any comparison — including the scientific way of comparing religions — is trapped by the paradox that $a = a$ is a tautology and $a = b$ is a contradistinction. The material on interreligious debates in South Asia basically underpins this assumption even though it also presents a slightly different picture due to the inclusivistic character of Hinduism. I shall first outline some of the formal criteria and categories of debates, then provide some evidence from debates in nineteenth-century India and finally come back to more general conclusions.

Forms of Interreligious Disputes

In the Middle Ages of Europe and in the colonization process of North America, we encounter a number of famous religious disputations and debates (see *fig.* 1).[10]

- the Muslim-Christian dispute in Jerusalem (*ca.* 800)[11]
- the great debates between Christians and Jews in the thirteenth-fifteenth century, e.g., the forced disputation between Moses Nachmanides and Pablo Christiani in Barcelona (1263 AD)[12]
- Raimundus Lullus: see his *Libre del Gentil e los tres savis* (*ca.* 1271/72), *Liber Tartari et Christiani* (1285), or *Disputatio Raymundi christiani et Hamar saraceni* (1308)
- Markus Lombardus and the Judeo-Christian disputations of the Middle Ages[13]
- disputations between Native American aristocrats and Spanish apostles in the sixteenth century[14]
- several debates between Muslims and Christians in the Middle Ages[15]

fig. 1: **Religious disputes and debates in Abrahamic traditions**

10. See also Bernhard Lewis, *Religionsgespräche im Mittelalter*, Wiesbaden: Harrassowitz, 1992; Gerhard Müller (ed.), *Die Religionsgespräche der Reformationszeit*, Gütersloh: Mohn, 1980.

11. U. Berner, 'Zur Geschichte und Problematik des interreligiösen Dialoges,' in: Chr. Elsas et al. (eds.), *Tradition und Translation. Zum Problem der interkulturellen Übersetzbarkeit religiöser Phänomene [Festschrift C. Colpe]*, Berlin/New York: de Gruyter, 1994, pp. 391-405.

12. Robert Chazan, 'The Barcelona Disputation of 1263: Goals, Tactics, and Achievements,' in: B. Lewis/ F. Niewöhner (see below); Hans Georg Mutius, *Die christlich-jüdischen Zwangsdisputationen zu Barcelona. Nach dem hebräischen Protokoll des Moses Nachmanides*, Frankfurt a. M./Bern, 1982; Frank Ephraim Talmage (ed.), *Disputation and Dialogue. Readings in the Jewish-Christian Encounter*, New York, 1975.

13. Gabi Mund-Knoch, *Disputationsliteratur als Instrument antijüdischer Polemik. Leben und Werk des Marcus Lombardus, eines Grenzgängers zwischen Judentum und Christentum im Zeitalter des deutschen Humanismus* (Bibl. Germanica), Tübingen: Francke-Verlag, 1997; B. Lewis/ F. Niewöhner: *Religionsgespräche im Mittelalter*, Wiesbaden: Harrassowitz, 1992.

14. LaHontan, *Voyages du Baron de la Hontan dans l'Amerique septentrionale*, Amsterdam, 1705; W. Lehmann: *Sterbende Götter und christliche Heilsbotschaften. Wechselreden indianischer Vornehmer und spanischer Glaubensapostel in Mexiko 1524* (Quellenwerke zur alten Geschichte Amerikas), ed. G. Kutscher, Stuttgart, 1949; Hans Wissmann, *Die 'Colloquios' des Padre Fray Bernardino de Sahagún als religionsgeschichtliche Quelle* (Diss.); Heidelberg, 1977; id., *Sind doch die Götter auch gestorben: das Religionsgespräch der Franziskaner mit Azteken von 1524*, Gütersloh: Gerd Mohn, 1981.

15. Heribert Busse, *Die theologischen Beziehungen des Islams zu Judentum und Christentum*, Darmstadt: Wissenschaftliche Buchgesellschaft, 1988; B. Lewis/F. Niewöhner, *Religionsgespräche im Mittelalter*, op. cit.

In this list I have dismissed disputations which were just part of a literary genre, such as that of Petrus Venerabilis (*ca.* 1092-1156) and his *Dialogus inter Gentilem et Christianum* or that of Nicholas of Cusa, *De pace fidei* (1453), which are, to my knowledge, fictive dialogues, i.e. not based on a factual event. It seems that most debates and disputes were structured by certain categories regarding external circumstances, motives, procedure, and results (*fig.* 2)[16] that make up for the uniqueness and singularity of each debate. I propose the following classifications for an analysis of such debates:

(a) External circumstances:
- persons involved: teacher-student, real or fictive opponents, number of opponents or speakers
- duration
- place: public or private, inside or outside
- organizer, patron, donor, sponsor
- sources: written or oral reports, documents from one or both parties

(b) Motives, functions that caused the debate:
- demonstrating or proving the superiority of a certain faith
- strategy of raising the status of minorities
- proselytization
- game, competition, contest
- seeking or proclaiming religious or spiritual truth
- desire for harmony and universal understanding

(c) Forms and procedure:
- formal (e.g., *ars dialogica*[17]) or formless with, e.g., spontaneous interruptions
- situation: friendly, polemical, ironic, contesting, defensive, challenging; face-to-face situation, exhibition character
- forms of greetings and fare-well that indicate the atmosphere
- portion in the speaking time for the speakers
- chairman, referee
- common or separate textual grounds, knowledge of languages, language of the debate

(d) Results:
- winner and loser
- gaining or losing power or authority
- ridiculing or accepting the opponent's position
- proselytization
- uproar, tumult, protest

fig. 2: **Structures of religious debates**

16. E.W.B. Hess-Lüttich, 'Dialog und Gespräch,' in: P. Rusterholz/Maja Svilar (ed.), *Welt der Zeichen, Welt der Wirklichkeit*, Bern: Haupt, pp. 185-214; Claudia Schmölders (ed.), *Die Kunst des Gesprächs. Texte zur Geschichte der europäischen Konversationstheorie*, München: Deutscher Taschenbuch Verlag, 1979; Georg Simmel, *Soziologie. Untersuchungen über die Formen der Vergesellschaftung*, Berlin: Duncker, 6th edn., 1983 (chapter V: 'Der Streit,' pp. 186-255).

17. Uwe Gerber, *Disputatio als Sprache des Glaubens. Eine Einführung in das theologische Verständnis der Sprache an Hand einer entwicklungsgeschichtlichen Untersuchung der disputatio und ihres Sprachvollzugs*, Zurich, 1970.

Given this complexity, it is extremely difficult to compare debates from different religions and historical periods, held in different languages and regions. However, there are some common features. It seems that most public debates that took place within Abrahamic traditions can be summarized as follows. Since monotheistic religions are based on revelation, the truth of all religious propositions was already fixed before the debates started. In a way, all sides invariably claimed to have won the debate. The debate, thus, was not to question one's faith but to affirm it. There was no common target for the religious parties involved. On the contrary, it was the organizing party which generally (mis-)used the other party to prove their superiority. Such debates, therefore, did not aim at reaching any agreement or understanding in principal matters. Rarely was there a sensitive reaction towards other religions. The situation was generally asymmetric, i.e. the dialogue partners were not of equal position, qualification or education. As it were, the main purpose of the disputes was to draw clear border lines between the different religions, to defend one's religion and/or to proselytize. In short, comparing religions in debates of monotheistic religions had the clear aim of contrasting them.

The question for me — as an Indologist — is whether in South Asia the situation basically differs from that which is comparatively well known in the history of Abrahamic religions. This question is interesting because Hinduism, for instance, did not have any missionary attitude but a strong inclusivistic tendency so that the strategy of separating other religions and recognizing them as different is not likely to be successful. It is well known that Hinduism cannot be defined just on the basis of common rituals, paraphernalia (the sacred thread,[18] for instance), symbols,[19] insignias, vows, founders or forms of social organization (e.g., the caste system), and even less so on that of binding ideologies, doctrinal formulae, texts or forms of worship. To be sure, there is a breadth of historical development as well as social and regional divergence in the case of other large religious communities too, but Christianity, for instance, in all denominations takes recourse to one God, the Bible and the Cross, and Islam to Allah and the Koran. In India — and this is beyond dispute — one can note at most certain dominance on the part of Brāhmaṇical positions, but not any fundamental points in common. Thus the question remains whether such polytheistic religions show a different form of using comparisons in religious debates.

(Inter-)Religious Debates in South Asia

In contradistinction to what one would perhaps expect from the point just given, South Asia has a long tradition of religious debates. It started with the training of the Brāhmaṇical

18. Axel Michaels, *"Die Heilige Schnur und 'hinduistische' Askese,"*: Zeitschrift der Deutschen Morgenländischen Gesellschaft, vol. 144 (1994), pp. 330-44.

19. A. Michaels, 'The King and the Cow: On a Crucial Symbol of Hinduism,' in: D. Gellner et al. (eds.), *Nationalism and Ethnicity in a Hindu Kingdom: The Politics of Culture in Contemporary Nepal*, Amsterdam: Harwood Academic Publishers, 1997, pp. 79-100.

students of the Veda., i.e. *brahmodaya*.[20] In the highly antagonistic society of ancient India, verbal dexterity, such as skill in debates, was esteemed and admired. It involved using riddles, challenge and response, vehement expressions of hostility against rival ritual or theological views. The consequences are sometimes described as serious, for in such disputations one's head could be shattered if one lost the debate, as the Upaniṣads mention.[21]

Other famous examples are the polemical discussions against rival schools in Indian philosophy or a great number of sectarian debates, e.g., the Kabīr-Raidās debate.[22] Such *goṣṭhī*s and *śāstrārtha*s are a common feature of sectarian literature and a victory over religious leaders who are opponents is often to be found in hagiographical texts. Even in modern times, one sometimes encounters open-ended debates in meetings of *paṇḍits* (*paṇḍita sabhā*) on several topics. In such competitions prizes and trophies can be won, and many traditional scholars are always ready for a *'vāda* on the spot.' Assertion of personal authority through verbal dexterity still forms an integral part of Brāhmaṇical traditions; the same holds true for Tibetan Buddhism.[23]

However, these debates were, so to say, debates within a religion — if I may neglect in this context the above-mentioned difficulties unifying the various schools, traditions, denominations and sects under the heading Hinduism.[24] More interesting for the question of comparisons in interreligious debates are numerous debates between Buddhists, Muslims and Hindus (see the incomplete list in *fig. 3*).

> * the debate of Kamalaśīla and Hua Shang (792-94 AD) on Buddhahood in Tibet[25]
> * the disputation of the Jesuit Matteo Ricci and the Buddhist monk Aanhuai Xuelang (1599) in China[26]

20. Cf. F.B.J. Kuiper, 'The Ancient Aryan Verbal Contest' : *Indo-Iranian Journal* 4 (1960), pp. 217-81; Michael Witzel, 'The case of the shattered head,' in: *Studien zur Indologie und Iranistik*; 13/14 (Festschrift W. Rau), Reinbek, 1987, pp. 363-415; George Thompson, 'The Brahmodaya and Vedic Discourse' : *Journal of the American Oriental Society*, vol. 117.1 (1997), pp. 13-37.

21. *Chāndogya Upaniṣad* VIII.7ff., *Bṛhadāraṇyaka Upaniṣad* III.1ff., IV.23ff.; Hermann Oldenberg, *Die Lehre der Upanishaden und die Anfänge des Buddhismus*, Göttingen: Vandenhoeck & Ruprecht, 1915, pp. 160ff; Walter Ruben, 'Über die Debatten in den alten Upaniṣads,' Zeitschrift der Deutschen Morgenländischen Gesellschaft, N.F., vol. 9, pp. 238ff.

22. David Lorenzen, 'The Kabīr-Raidās-Debate,' in: *id., Formless God: Nirguni Texts from North India*, Albany, NY: State University of New York Press, 1996.

23. Daniel E. Perdue, *Debate in Tibetan Buddhism*, Ithaca, New York: Snow Lions Publications, 1992.

24. See A. Michaels, *Hinduism: Past and Present*, Princeton: Princeton University Press, 2004 (German ed., *Der Hinduismus. Geschichte und Gegenwart*, München: C.H. Beck, 1998), ch. 1.

25. F. Obermiller, *History of Buddhism (Bu'Ston's Text)*, vol. II, Heidelberg, 1931-32, pp. 188ff.; Juri N. Roerich [Roerich, G.], *The Blue Annals*, Calcutta, 1953; David Snellgrove, *Indo-Tibetan Buddhism*, London: Serindia, 1987, pp. 430ff.; G. Tucci, *Minor Buddhist Texts*, 3 vols., Roma, 1956-71, vol. II.

26. Iso Kern, *Buddhistische Kritik am Christentum im China des 17. Jahrhunderts*, Bern: Peter Lang, 1992; *id.*, 'Matteo Riccis Verhältnis zum Buddhismus': Monumenta Serica 36 (1984-5).

- Muslim-Hindu and Muslim-Christian debates initiated by Akbar the Great[27]
- Hindu-Christian controversies,[28] e.g., Hindu *paṇḍits* and Christian evangelists in the 1830s in Bombay[29] or Dayānanda Sarasvatī versus several missionaries in mid-nineteenth century in north and east India[30]
- Buddhist-Christian debates in Sri Lanka, e.g., the Buddhist monk Mohoṭṭivatte Guṇānanda versus the missionary David de Silva (1873)[31]
- Muslim-Christian controversies in India, e.g., Dr. Wazir Khan in Agra[32]
- debates on the relationship between Daoism and Buddhism in China[33]
- debates on Christianity and Buddhism in Japan[34] or Thailand[35]

fig. 3: Interreligious debates in South and East Asia

As mentioned, each debate has its own characteristics about which it is difficult, if not impossible, to generalize. Much depends, for instance, on the historical circumstances, but also on the quality and origin of the sources. As an example, I would like to briefly

27. S.A.A. Rizvi, *Religious and Intellectual History of the Muslims in Akabar's Reign*, Delhi: Munshiram Manoharlal, 1975, ch. 3.

28. John Brockington, *Hinduism and Christianity*, London: Macmillan, 1992; Wilhelm Halbfass, *India and Europe: An Essay in Understanding*, New York: State University of New York Press, 1988 (German ed., *Indien und Europa. Perspektiven ihrer geistigen Begegnung*, Basel, Stuttgart: Schwabe, 1981), ch. XIII.

29. Richard Fox Young, *Resistant Hinduism. Sanskrit Sources on Anti-christian Apologetics in Early Nineteenth-Century India*, Vienna: Institut für Indologie der Universität Wien, 1981.

30. Kenneth Jones, 'Swami Dayānanda Saraswatī's Critique of Christianity,' in: *id.*, (ed.), *Religious Controversy on British India, op. cit.*, pp. 52-76; *id.*, *Arya Dharm*, Berkeley: University of California Press, 1976; J.T.F. Jordens, *Dayānand Sarasvatī. His Life and Ideas*, London/Delhi, 1979; Hans-Joachim Klimkeit, *Der politische Hinduismus. Indische Denker zwischen religiöser Reform und politischem Erwachen*, Wiesbaden: Otto Harrassowitz, 1981; J. Lütt, *Hindu-Nationalismus in Uttar Pradesh 1867-1900* (Kieler Historische Studien; 9), Stuttgart, 1970; Y. Sahae, *Brahma Samaj and Arya Samaj. Ihre Entstehung und ihre Stellung zur Autorität der Heiligen Schriften* (Phil. Diss.), Bonn, 1964.

31. Heinz Bechert, *Buddhismus. Staat und Gesellschaft in den Ländern des Theravāda-Buddhismus*; Charles Malalgoda, *Buddhism in Sinhalese Society 1750-1900*, Berkeley, 1976; J. Muir, *Matiparīkṣā*, Allahabad, 1910 [in English]; J.M. Peebles (tr.), *The great debate. Buddhism and Christianity, being an oral debate held at Panadura between M. Gunanada and D. de Silva*, Colombo, 1955.

32. *Evangelisches Missionsmagazin*, vol. 34 (1849), pp. 162-67; vol. 39 (1854), pp. 72-80; Barbara Metcalf, *Islamic Revival in British India: Deoband 1860-1900*, Princeton, 1982; Avril Ann Powell, *Muslims and Missionaries in Pre-Mutiny India*, Surrey: Curzon Press, 1993; *id.*, 'Muslim-Hindu Confrontation, Dr. Wazir Khan in Nineteenth-century Agra,' in: Kenneth Jones (ed.), *Religious Controversy in British India*, New York: SUNY, 1992, pp. 77-92; Christine Schirrmacher, *Mit den Waffen des Gegners. Christlich-muslimische Kontroversen im 19. und 20. Jahrhundert*, Berlin, 1992; Gene R. Thursby, *Hindu-Muslim Relations in British India. A Study of Controversy, Conflict, and Communal Movements in Northern India 1923-28*, Leiden: Brill, 1975.

33. Helwig Schmidt-Glintzer, Thomas Jansen, 'Religionsdebatten und Machtkonflikte. Veränderungen in den Machtverhältnissen im chinesischen Mittelalter': Zeitschrift für Religionswissenschaft, vol. 2 (1993), pp. 50-90.

34. G. Scheerhammer S.J., *Die Disputationen des P. Cosme de Torres (S.J.) mit den Buddhisten in Yamaguchi im Jahre 1551*, (Mitteilungen der deutschen Gesellschaft für Natur- und Völkerkunde Ostasiens; 24, Teil A), Tokyo, 1929.

35. G. Lanczkowski, '*Das sogenannte Religionsgespräch des Königs Mongkut*': Saeculum, vol. 17 (1966), pp. 119-30.

draw your attention to Hindu-Christian debates in the nineteenth century in north India. As it were, neo-Hinduism showed in these debates two basic attitudes towards different religions: contrasting and separating them or identifying with them. However, it seems that in the public debates contrast was much more evident than in other encounters with Christianity.

Let me illustrate this with examples from the debates between Dayānanda Sarasvatī (1824-83) and Christian missionaries which took place in several north-Indian cities like Ajmer, Allahabad or Varanasi. Swami Dayānanda Sarasvatī was born in Tankara, a small town on the Kathiawar peninsula (Gujarat), as the son of a brāhmaṇa. Seeking liberation he ran away from his home in 1846, and soon after became a *saṁnyāsin*. He studied with a *guru* called Virajānanda Sarasvatī in Mathura. It was at this time that he became a reformer of Hinduism refuting almost all popular elements, i.e. idols, brāhmaṇa priests, pilgrimages, many socio-religious life-cycle rituals, and any scripture that was not in accordance with the Veda in its narrow sense. He also praised a formless god denying the Hindu conception of incarnations (*avatāra*). He proposed three forms of religious activities: *stuti* (hymns), *prārthanā* (prayer) and *upāsanā* (meditation). He rejected the caste system but believed in the *karma* doctrine. In 1875 he founded the influential 'Ārya Samāj,' a reformist movement, in Bombay. From 1863 until his death, Dayānanda Sarasvatī travelled widely through India preaching this new, purified form of Hinduism.

He participated in and organized several public debates (*śāstrārtha*) with missionaries and *paṇḍits*. In his early days he debated with *paṇḍits* in Sanskrit, later with the missionaries mostly in Hindī, but never in English. These disputations followed more or less fixed rules. Dayānanda Sarasvatī had learned how to arrange such debates in order to win them. For the debates were not a formless interchange of ideas or a joint strive for religious truth, but followed a prescribed style. They often took place in the city halls with a large audience and lasted several days and, once in a while, even nights. There was a patron and a trustworthy chairman who sometimes acted as a referee. The time available to the speakers was arranged. Everything was written down by impartial scribes and the account was often published afterwards with the signatures of chairman and participants. The topics were clearly defined. Quotations from authoritative texts were refuted by counter-quotations, and the use of grammar played a major role in the exegesis. Mostly there was a winner, with the decision sometimes being left to the audience. However, debates sometimes collapsed because the parties could not reach an agreement on topics or procedure.

All this happened in a context within which the British missionaries had brought new forms of proselytization to India, including the printing press by which a great number of tracts, pamphlets, journals, and books could be distributed, the hiring of paid representatives and professional debaters, the strong internal organization of various missions, aggressive campaigns of proselytization, and so forth. Dayānanda Sarasvatī's reaction was to a great extent an anti-colonial movement.

However, it is interesting that "in the biographical works one cannot find for the period before he reached Calcutta, i.e. before 1873, a single reference that indicates that the Swami had at that time even thought about Hinduism in 'national' terms, or in terms of comparison with other religions. He certainly had loudly proclaimed the excellence of the Vedic faith, but he had done this completely within the context of Hinduism itself."[36] It was in Calcutta that he was trained by public debates to think of Hinduism in relation to other religions, especially Islam and Christianity. Thus, before Dayānanda Sarasvatī was more or less forced to see himself as separated from another religion he did not recognize them as basically different. In this, he was following a significant pattern of Hindu reactions towards other religions which had been virtually ignored in the history of Brāhmaṇical traditions. After all, the first apologetic Sanskrit text against non-Indian religions, the *Matapariksāśiksā* (A Lesson for the [Author of] the *Matapariksā* [An Examination of Religions]), was published 1839; only the author was John Muir, a Scottish civil servant and Orientalist.[37] Given the impact of Buddhism, Islam and Christianity on the South Asian soil, the lack of extensive or important documents and texts relating to interreligious encounters is significant.

It therefore seems that comparisons in public debates contributed to the nationalization of religion, even sometimes creating a new syncretistic religion. Instead of the loyalty to family and communities such as kinship groups, caste, or village, the colonial appreciation for public and civil institutions was adopted by Indians and thus created a new form of nationalized religious identity. Even the assumption that there indeed was a religion called 'Hinduism' was a new phenomenon which to a great extent was established in opposition to the colonial understandings of what a religion looked like.[38] In the first census of the British administrators, Indians mostly mention their caste when asked to state their religion. As a consequence, the British administrative official and anthropologist Denzil Ibbetson decreed religious affiliation in the census of 1881 as follows: "Every native who was unable to define his creed, or described it by any other name than that of some recognized religion or of a sect of some such religion, was held to be and classed as a Hindu."[39]

In point of fact, the debates "were an important element in constituting fundamental changes in Indian social, political, and cultural life."[40] New religious leaders marked and claimed public space, new types of lay leaders rose to popularity, a transition from esoteric education based on a personal bond between teacher and pupil to a public and

36. J.T.F. Jordens, *Dayānand Sarasvatī, op. cit.*, p. 79.
37. See R.F. Young, *Resistant Hinduism, op. cit.*, for a detailed study of this text and controversy.
38. Barbara Daly Metcalf, 'Imagining Community: Polemical Debates in Colonial India,' in: K.W. Jones (ed.), *Religious Controversy in British India, op. cit.*, pp. 229-40.
39. Census 1881, Panjāb, p. 101.
40. B.D. Metcalf, 'Imagining Community,' *op. cit.*, p. 231.

impersonal form of education ensued, a shift occurred from familial contexts to urban settings, vernacular languages were used instead of Sanskrit, the previous language of the religious elite. These are among the enormous shifts in Indian society that could be mentioned here.

Dayānanda Sarasvatī's main work, the *Satyārtha Prakāśa* (The Light of Truth),[41] is an ideal expression of these changes. It contains a chapter with a discussion of Christianity and its errors. The form of this discussion is a dialogue between an unnamed Christian and himself, called "commentator" or "analyst". The chapter has been summarized by J.T.F. Jordens as follows:

> The thesis presented in this chapter is a very simple one: the claim of Christianity stands or falls with the Bible; the Bible is not the word of God; therefore, the Bible is not revelation and Christianity is not the true religion. To prove that the Bible is not God's word several arguments are used. The Bible is not universal, but particularistic and embedded in history. It contains a great number of statements that offend reason. By presenting a God who is limited by space and time, temperamental, deceitful, jealous, cruel, and a tawdry magician to boot, it contradicts the essential divine qualities. It also abounds in logical impossibilities, contradictions, and absurd miracles, and it displays a crude ignorance of scientific truth. Moreover, it contains many stories and precepts that are immoral, praising cruelty and deceit and encouraging sin. These are the basic arguments that are exemplified, page after page, in the many texts chosen from both Old and New Testaments.[42]

Dayānanda Sarasvatī had studied the Bible in its Sanskrit and Hindī translations, but he did not make any distinction between Judaism and Christianity since they both used the same authoritative text. He studied and compared religions on a competitive level, but with a familiar result: the other religion is declared as inferior, one's own as superior. In other words, the two religions compared in the thirteenth chapter of *Satyārtha Prakāśa*, i.e. Christianity and his purified Hinduism, are contrasted to an extent that they contradict each other on almost all levels. Again and again, it is sarcastically asserted that Christianity is worse than Hinduism.

A few examples for his way of comparing both religions must suffice:[43]

- *On heaven*: The Christian heaven is described as a problem of population control: "There will be only immigration, but no emigration." Heaven is ridiculed as a crowded city with smelling horses and dung.

41. Dayanand Sarasvati, *The Light of Truth*, tr. Ganga Prasad Upadhyaya, Allahabad, 1956 [English translation of *Satyārtha-Prakāśa*, Benares, 1869, reprint Ajmer: Vedic Yantralaya, 1947); see also the English translations of Durga Prasad, Delhi, 1970, and Chiranjiva Bharadwaja, New Delhi: Sarvadeshik Arya Pratinidhi Sabha, 1984.

42. J.T.F. Jordens, *Dayānand Saravatī: His Life and Ideal*, Delhi: Oxford University Press, 1978, p. 267.

43. See also K.W. Jones, 'Swami Dayānanda Saraswatī's Critique of Christianity,' *op. cit.*, pp. 54-56.

- *On the Last Supper*: The Last Supper (*prabhubhojan*) is declared as morally repugnant: "Disciples do not eat their *gurus*."[44]

- *On theodicy*: "Had the God of the Christians been an Omniscient Being, why would He have created this subtle serpent or Satan. But as He did create him, He alone is responsible for all evil deeds done by Satan for had He not created him evil (by nature), he would not have done evil deeds." (p. 594)

- *On circumcision*: "Had He approved of circumcision, He would not have made the foreskin at all in the beginning of creation." (p. 600)

- *On burial*: "(Christian = C.) It is not good to cremate those whom we love, while the burial of the dead is like laying them down to sleep; hence this mode of the disposal of the dead is good.

(Hindu = H.) If you love your dead, why don't you keep them in the house? Why do you even bury them? The soul you love leaves the body after death, what is the good of loving the dead decomposing body? But since you love it, why do you bury it under the ground? (. . .) Besides, how can it be an act of love on your part to throw earth, bricks, stones, lime, etc., on his eyes, mouth, chest and other parts of the body? (. . .)

C. - Even *cremation* gives rise to foul smell.

H. - Yes a little, if *cremation* be not conducted properly, but nothing compared with what takes place in other methods, such as the burial. (. . .)

- *On omnipotence*: Jesus lacks divine power because he is threatened with death.

- *On the creation of Man*: "If Woman was made of one rib taken out of Man, why are not all men short of one rib?" (p. 593)

- *On creation*: C. - Nothing but God existed before the beginning of creation.

H. - Where did this world then come from? Is the power of God a substance or an attribute? If it be a substance, there was then something besides God (before the creation of the world). On the other hand if it be an attribute, as no substance can come out of an attribute (the world could not have been produced out of it), as for instance, fire cannot proceed from light nor water from fluidity. Had God been the Material Cause of the World, the latter would have possessed all the attributes, nature, and characteristics of God, but such being not the case, it is certain that it was not produced out of God but out of the Material Cause the primordial matter in atomic condition. It behoves you therefore to believe that God is the Efficient Cause of the Universe as is recorded in the Vedas and other true *śāstras*. If, as held by the Christians, Adam's inward nature be that of the soul and his outward (appearance) that of man, why is not God's nature the same, because since Adam was made in the image of God the latter must necessarily be like Adam." (p. 592)

As these examples show, Dayānanda Sarasvatī mainly wanted to demonstrate the superiority of the Veda. He did not wish to discover anything in Christianity, nor did he want a neutral level. The Christian always lost. Unlike, for instance, Mahatma Gandhi, he did not want to point out similarities between both religions. He used the Bible simply to ridicule it demonstrating its inconsistencies, absurdities and oddities. He and others wanted to discredit their opponents in other religions and also Hindus who had converted to other religions.

However, in Hinduism one finds another and perhaps more typical reaction towards differing religions. This is the assertion that Christianity is derived from the Veda or that Hinduism encompasses all other religions. Such statements often refer to *Ṛgveda* (I.164.46) (Truth is one, sages call it by various names) followed by various quotations from the *Bhagavad-Gītā*.[45]

Even Dayānanda Sarasvatī articulated this idea, e.g., in "A Statement of my Beliefs" attached to the *Satyārtha Prakāśa*:

> I believe in a religion based on universal and all-embracing principles which have always been accepted as true by mankind, and will continue to command the allegiance of mankind in the ages to come. Hence it is that the religion in question is called *primeval eternal religion*, which means that it is above the hostility of all human creeds whatsoever. (. . .) I do not entertain the least idea of founding a new religion or sect. My sole aim is to believe in truth and help others to believe in it, to reject falsehood and help others to do the same. Had I been biased, I would have championed any one of the religions prevailing in India. But I have not done so. On the contrary, I do not approve of what is objectionable and false in the institutions of this or any other country, nor do I reject what is good and in harmony with the dictates of true religion, nor have I any desire to do so, since a contrary conduct is wholly unworthy of man.[46]

Dayānanda Sarasvatī's idea of all-comprehensiveness and the non-human, pre-historical origin of Hinduism as compared with Abrahamic religions was shared by many other influential reformists of Hinduism in nineteenth century India, e.g., Vishnubawa Brahmacari who was active in Bombay between 1850 and 1870. This form of comparing religions refrained from the method of contrast, but developed a specific form of inclusivism. After all, in Hinduism differing opinions rarely lead to exclusion from a religious community because there is no means for such a measure except dismissal from caste. Thus, the term sect is misleading in Hinduism. Indian terms such as *sampradāya*, *pantha*, *saṁgha*, *vāda* stress different paths, schools or communities rather than heterodox

44. See J.T.F. Jordens, *Dayānand Sarasvatī, op. cit.,* p. 68.

45. See, for instance, Gustav Mensching, *Tolerance and truth in religion,* Alabama: University of Alabama press, 1971, pp. 64-69.

46. *Satyārtha Prakāśa,* tr. Ch. Bharadwaja, *op. cit.,* p. 723.

movements. 'Sect' in a Hindu context should be understood as 'following' (from Lat. *sequi*) being applicable to particularistic Hindu communities under religious leaders. It is wrong, on the other hand, to take 'sect' in this context as denoting (in derivation from Lat. *secare*, 'cut-off, separate') dissident Indian minorities.[47] For a Hindu it was and still is possible to believe in the truth of several religions even if in his ritual practice it is different.

It was the Indologist Paul Hacker[48] who used the term 'inclusivism' for this approach of encompassing apparently differing religious positions to an extent that distinctions between religions are almost denied. He characterized it as a peculiar phenomenon of Hinduism. According to Hacker, the other religion is not perceived as another religion but declared as a part of one's own, often by recalling that the Veda is older than anything else. Differing positions are not accepted, denied or identified with one's own. There are no polemics against other religions because these are declared to be, in principal, identical with one's own religion.

Inclusivism may be seen as just another form of embracing differing religions, such as assimilation, acculturation, absorption, integration, or syncretism. In Hindu inclusivism, however, two or more elements of differing religions do not merge into a new form. On the contrary, the other element is not even recognized or perceived as different but thought of as one's own religion. It, thus, can be only partly compared with the *interpretatio Graeca or Romana* (see Tacitus: *Germania*, 43.4). Hindu inclusivism should also not be confused with tolerance even if neo-Hindus often claim that all religions are equal in essence and value, and declare Hinduism to be especially tolerant towards other religions. For, as Hacker aptly remarked, "the doctrine of equality of all religions turns out to be an assertion of the superiority of Hinduism."[49] Hindu inclusivism is, thus, a form of an universalistic approach towards religions which one finds, for example, by Radhakrishnan's statement: "The Vedānta is not a religion, but religion itself in its most universal and deepest significance."[50] — a statement which is based on his assertion that "every form of Hinduism is related to the common background of the Vedānta."[51]

For all the love of ordering and classifying, Hinduism often does not see religions in exclusionary terms. Hardly any battles are fought on the basis of differing opinions or on, for instance, the proper form of worshipping God (I leave out recent developments

47. W.H. McLeod, '*On the Word panth: A Problem of Terminology and Definition*': Contributions to Indian Sociology (N.S.), vol. 12 (1978), pp. 287-95.

48. Paul Hacker, 'Inklusivismus,' in: Gerhard Oberhammer (ed.), *Inklusivismus: Eine indische Denkform*, Vienna: Institut für Indologie der Universität Wien, 1983, pp. 11-28.

49. P. Hacker, 'Aspects of Neo-Hinduism as Contrasted with Surviving Traditional Hinduism,' in: Lambert Schmithausen (ed.), *Kleine Schriften*, Wiesbaden: Franz Steiner Verlag, 1978, pp. 580-608, here: p. 608.

50. Sarvepalli Radhakrishnan, *Hindu View of Life*, London, 1954, p. 23.

51. *Ibid.*, p. 22.

for which special reasons count). The various forms of religious belief and practice are regarded in essence as of equal value. One reason is that in Hinduism, the Ultimate often is perceived as a void that remains to be filled, and to which there are various interchangeable and basically equivalent paths, since otherwise it would not be the Supreme.[52] This Ultimate, whether the Veda, God or the Absolute (*Brahman*), can be expanded or compressed so that it embraces, or is contained in, almost everything. But it is precisely because these methods are characteristic of Hinduism that they cannot be reduced to a unique essence, a single trait, e.g., a holy book or the Veda. On the contrary, it is a speciality of Hinduism that it is also and to a great extent characterized by an identificational *habitus*[53] that does not ask for such clear-cut boundaries which are, as it seems, necessary for definitions and comparisons.

Summary and Conclusion

To sum up, interreligious debates and encounters have always played a major role in the history of religions. While a desire for achieving harmony via interreligious dialogue seems to be prominent in the present-day situation of religiosity, this was not always the case in the past where forceful, partly public, risky disputations and debates on religious matters have been integral to the history of religions. Being often political events, the results and influence of many public disputations were far-reaching.

A comparative analysis of such debates and disputations in South Asia shows that the long training in verbal debates (in India since Vedic times) and the predilection for performance in verbal contests contributed to the assertion of personal authority through verbal dexterity and to a special skill in the rhetoric. Although this oft-acclaimed skill helped Hindu theologians (i.e. the brāhmaṇas) in classifying religious topics, it mostly did not stimulate them to contrast religions as such. Interreligious debates did not necessarily broaden the understanding of the essential points or the fundamentals of the other religion but often built a part of an apologetic or polemic discourse. In most interreligious debates, religions were compared in order to demonstrate the superiority of one's own faith. In more indirect situations, however, a universalistic super-religion was often propagated. As it seems, contrasting comparisons were preferred in public debates whereas inclusivistic and identifying arguments dominated the dialogue in religious writings.

However, any comparison leaves, logically, only the options of either (open) contrast or (hidden) identity. It has to face the paradox that $a = b$ is a contradistinction, and $a = a$ is a tautology. Any comparative study of religions either leads to essentials and universals, or to contingency, singularity and specifity. The latter often raises the question of what it

52. See Madeleine Biardeau, *Hinduism. The Anthropology of a Civilization* (French Studies in South Asian Culture and Society; 3), Delhi: Oxford University Press, 1989 (1st edition Paris, 1981), p. 156.

53. See A. Michaels, *Der Hinduismus, op. cit.*, ch. VII.

all means. Comparisons, then, often simply serve as illustrations or examples, e.g., Eliade's collection of data isolated from its context. The first is often not scientific for it cannot be empirically proved, only construed. Comparisons, then, often serve for a simplification of the data, for a theoretical reduction *ad unum*. The science of religions, being basically a *comparative* science of religions, is trapped by this methodological tension between similarity and contrast arguments, or, as one could also phrase it, between theology on the one hand and history, philology or anthropology of religions on the other.

And yet, the differences in the forms and modes of contrasting and identifying religions can be extremely important and useful to understand. The case of Hinduism, for instance, has shown a special, inclusivistic form of encompassing oppositions and differences in which religious comparisons are almost impossible because whatever is different is declared as identical with one's own religion. It was predominantly by public debates that contrasting comparisons were introduced.

Finally, if it is true that one first has to separate (religion into religions) in order to be able to compare (them), then this approach is in itself almost a religious attitude. For why — on (this) earth — should religions be compared? From a universalistic and inclusivistic point of view, comparing religions means to break into pieces that which belongs together. From a dogmatic point of view, comparing religions means to underpin the differences — with the result that comparisons can only strengthen one's own faith. The scientific (religionswissenschaftliche) way of comparing religions is perhaps no exception to this dilemma of tautology and contradistinction. Given the fact that the history of the comparative science of religions has developed a number of extremely misleading theories such as evolutionism, naturalism, or animism, the modern method of constructing a meta-language as a *tertium comparationis* must also be regarded with suspicion. For it could well be just another universalistic or dogmatic form of asserting superiority of science over religion. Thus, comparisons may be a wonderful intellectual tool employed to classify, and, ultimately, perhaps understand religions, but they are easily misused if the historical, cultural, and religious background is not sufficiently considered. The problem remains that the more this is done, the less comparisons of religions work.

<center>

30

</center>

To Bridge Identities

Bithika Mukerji

> A healthy pluralism which used to be a characteristic of Hinduism is essential,
> but it should not be watered down to an indifferent secularism.
> — Bettina Bäumer[1]

THE last decades of the twentieth century saw the emergence of a global community. An emerging global consciousness is said to have been shaped by the interactions of primal traditions and axial age civilizations. This global intellect is now called upon to span the stretch of the entire historical experience. It is required to appreciate its roots, give due emphasis to the passing eras of greater awareness, and also envisage a future of new horizons.

During the same era, the global community actively participated in prestigious world conferences, promoting interreligious dialogues, expressing its concerns for our deteriorating environment, and recognizing a joint responsibility for the survival of man on this planet. Survival is increasingly becoming a key issue because violence has taken on new dimensions in our technological age. In the face of an unnerving proliferation of violence and terror, the euphoria regarding our progressive modern civilization is considerably tempered as we recognize that the spectacular achievements of science and technology have also brought the means of total annihilation much closer.

Had it been possible for the world religions to give some guidance to the manipulative powers of technocrats, perhaps some of the predicaments of rampant consumerism would not be with us now. Obviously this has not happened. On the contrary instead of promoting peace and goodwill on earth world religions seem to be a major source of divisive forces of massive proportions.

In this sense, the global intellect at the beginning of the twenty-first century is faced with the failure of religions. It is now poised on the brink of marginalizing all religions in the name of humanitarian secular values like justice and equality. Religions may survive as personal commitments, even to outre disciplines catering to passing fads and fancies.

The academic understanding of the word 'secular' is somewhat different from the present connotation given to it. Academically, it is used in opposition to the concept of

1. *Setu. Bulletin of the Abhishiktananda Society*, No. 18 (March 1997), p.3.

transcendence, a supra-human dimension of mystery, a realm of divine grace. Now it is used in the sense of moral uprightness with no support from religious dogma or creed. There is a paradox here. All religions are solidly based on moral codes. Without a cleansing of body, mind and intellect, no pilgrim may hope to traverse the razor's edge path to spiritual felicity. The tragic truth, however, is that in spite of codes, canons, sermons and laws recorded in all scriptures, human beings continue not to resist temptations toward evil deeds. This indeed is the twilight zone where all religions meet. Knowledge of what is desirable (*śreyas*) does not automatically translate itself into practice of the good. The history of religions all too easily prove that man is quite capable of putting the best of things to the worst of uses and still feel righteous about it.

Perhaps it would be a profitable occupation for the global intellect now to make an assessment of this transvaluation of all values taking place all around us. Religion, the treasure-house of man's aspirations for transcendence, the bridge by which he crosses over from mortality to immortality, stands neutralized. On the other hand, achievements which have added power to man's many talents are legion. 'Progress' may be translated to mean a proliferation of the means of enjoyment and comfortable living. There is, however, an obvious dark side to this onrush of plenitude. It is not for the benefit of all. Disparity is after all endemic to the marketing-based economic structure of our financial world. There are no bridges here to span the grave disparities between the very rich and the very poor. There is another not so obvious but significant lesson to be learned from our experience of modernity, namely, that man has not learned the secret of contentment or the ability to live at peace with himself.

The explanation for this anomaly is simple enough. Times change but man does not. The quality of human stuff has continued the same through many centuries without any appreciable change for the better or worse. Man has gained vast knowledge about the world but remains singularly ignorant regarding the age-old questions about personal identity, the meaning of his presence on earth and his destiny. Every field of study has a history which students can learn. In this area, however, each man's experience is unique to himself. He may not learn from another's experience the answers to questions which arise from his own inner being. One man's solution may not carry conviction to another. He cannot learn from history the reason why he is born or what his future is. It is only man who is seized with questions about the meaning of his short and apparently randomly situated life. The natural desire for happiness leads him on. The fragmented nature of joys in the world creates in him the desire for sustained and unalloyed happiness, a hankering for bliss, which will be fulfilment itself. Yearning for this abstract fulfilment causes an alienation which is at once the bane of his life as well as his glory because this is the gateway to spiritual truth.

Religion, therefore, primarily is a response, a revelation, a recognition of the quest for transcendence. Those who wish to jettison religion in favour of secular good deportment are unaware of man's deepest concern for freedom to be himself, that he is forever a pilgrim

in search of his own true identity. To be established in one's true nature is to be at peace with oneself. This truth lies beyond his own limited powers of understanding, neither can he will it to happen. He faces a new vista of mystery. Since the highest truth is preserved in concealment, there arises the need for the mediator, the teacher, the *guru*. In the teacher, the transcendent is made immanent. He is the visible, tangible proof of the viability of the search for Truth. It is he who can convince the seeker of the value of such texts:

> The knot of the heart is penetrated, all doubts are resolved, all bondages are destroyed, on seeing him who is here and beyond.
>
> — *Muṇḍakopaniṣad* II 2.8

The reality, called God (or by many other names) is at the core of the mystery indicated by scriptures and sacred writing. Religious wisdom is thus acquired by dialogues with the enlightened teacher. The compassionate teacher awaits the coming of the dedicated seeker. The all too powerful human will to power and discovery must be held in abeyance so that man is ready to listen to, heed the words being spoken. Humility is not a negation but an overcoming of the will. Since the will is the greatest divisive force in the world, it needs to be channelled into pathways of amity and goodwill. No religion has denied the importance of the world as the arena of action. This involvement if conducted in obedience to the norms of a serious religions commitment could be a gracious way of living in the world. Religion, alone then, would be a true guide for man. Truth is all-inclusive and unitive. It brooks no fragmentation. God's creation is many-splendoured and he is ever present with his creation. The manifestations of the infinite are also infinite, but this proliferation should not be evaluated as earlier, later, higher or lower, but rather a timely and suitable enrichment, a celebration of the ever-abiding presence of the divine in the sphere of the mundane. Teachers belonging to different traditions bear witness to this universal truth. They are the beacon lights for illuminating the darkness of ignorance. All those who can be called teachers belong to humanity. A bridge between two traditions is sometimes created by a great pilgrim in search of truth such as Swami Abhishiktananda. He demonstrates in full and with authority that although the linkages between traditions may appear tenuous and fragile, they are strong enough to be fully supportive for those who would attempt to make the journey to reach the goal. The search for and a commitment to unitive truth is the supreme bridge to join all diversities.

A very moot question is why the presence of many world religions be a matter of evangelism, conversions, martyrdoms, *jehad*s or plain atheism. Why should they be challenges or threats to each other? Is it not reasonable to think that Divine will itself has countenanced variety to be superimposed on unity. The global intellect of the twenty-first century would attain maturity if it could view the variety as manifestations of the one and only truth. To many, no doubt it may sound too simplistic a programme. It is true that a bland universalism, which slurs over the definitive characteristics of each devotional creed, can not be the answer. Man is born to a culture, a tradition, a country and at a particular time. All these factors shape his religions consciousness. When it comes to a commitment

to a religious way of life, his own is mostly — if not always — congenial or suitable for him. Religious consciousness can be called natural and responsible only when it realizes that there is no 'other' for it to assimilate, reject or destroy. The other is just another, as authentic a way of procedure as his own. If religions were not used or manipulated they would be recognized as so many pathways to spiritual felicity. In fact, all seekers could derive hope and sustenance from the devout man of another (not 'other') religion; this intercommunication would in turn strengthen each in his own faith.

It could be said that our post-modern world is in need of its religions as never before. We speak of religions here as they are meant to be; a mapping of the way to God-realization. Life in the world is the greatest imponderable. The present times are proceeding in their own accelerating pace stranding man at the crossroads.

This predicament may be stated differently. The commentators to sacred writings very often use this story to demonstrate the reality of human ignorance:

Ten men are obliged to swim across a river at night arriving at the other shore, they are concerned about the safety of all their companions. One man begins a tally but he forgets to count himself in. There are only nine men: There is great anguish at this loss. A compassionate passer-by, watches the men and is moved to pity although he knows there is no real cause for grief. He taps the shoulder of the man who is counting and says, "You are the tenth man (*daśamastvamasi*)."

There is great rejoicing at this recovery. The crucial words are 'compassionate passer-by' and 'recovery.' The story indicates that from within the circle of error (the theatre of activity of the world) there is no escape unless a tangential dimension opens up the possibility of recovery, which again in the ultimate analysis is not a new state but a finding of one's true identity.[2]

As stated earlier the highest truth is preserved for man as his divine inheritance by the religions as taught by the enlightened ones from age to age and country to country. The core of religious truth does not change with time, just as man's inherent nature does not. The divine is ever-present in the mundane. To be a human being is to qualify for receiving grace. In the practical world a quest may fail or succeed but in the dimension of transcendence, there is no question of seeking and not finding.

Religions are a value unto themselves. They, therefore need to be preserved. To be human, even to be humane is good enough but to relinquish the possibility of inheriting the unique treasure-trove of unalloyed bliss is thoughtless in the extreme. Religion is the only dimension of truth, which holds together humanity and divinity, mortality and immortality.

2. *Śaṅkarabhāṣya* on *Taittirīyopaniṣad*, II.1.

Does Unity of Minds Lead to Religious Harmony?

Shivamurthy Shivacharya

RECENTLY there was a National Youth Conference on the theme "Unity of Minds — A Pathway to Harmony of Religions." The theme of the conference selected by the organizers was quite interesting and of national importance. It obviously acknowledges conflicts between different religious groups and suggests that the unity of minds is one of the ways to bring about religious harmony. This further presupposes that the disunity of minds is at the root cause for disharmony of religions. If it is so, then the question arises: 'What is the cause for disunity of minds?' Unless we address the basic problems causing disunity of minds, we will not be able to achieve religious harmony. The situation is almost like what has been described in the Kannaḍa proverb: *huccu bidada horatu maduve aagoo haagilla; maduve aagada horatu huccu bido haagilla* (i.e. because he is a lunatic, no girl wants to marry him; since no girl wants to marry him, he has become a lunatic!). The boy is no doubt highly qualified and a good looking fellow. But how can you expect a girl to marry the boy who has gone mad? Similarly, unless the unity of minds is achieved, you cannot achieve religious harmony; unless the religious harmony is achieved, you cannot achieve unity of minds.

Ironically, the disunity of minds is to a greater extent caused by religions themselves in our daily life. We speak privately many things with persons of our own religion and stop talking abruptly, if someone of different religion suddenly enters. We feel uncomfortable to speak certain things in the presence of someone belonging to other religions even if he happens to be our best friend. If this disunity of minds is caused by religions, how can we achieve religious harmony? Is religion at fault then? Actually, the basic problem is not with the teachings of any religion, Hinduism, Christianity or Islam, but with the people not following the teachings of their respective religions. I am reminded of the following lines read somewhere: "When two philosophers or theologians meet, they argue. When two spiritual practitioners or mystics meet, they smile."

Religion, region and language play an important role in one's life and in the society we live. They influence our thoughts, our behaviours and our relationships with people around us. We identify ourselves with the religion to which we belong, with the region where we live, and with the language in which we speak. We feel proud of each one of

these. A villager in a far away country like Austria in Europe claims his village to be the best place in the world as he sings and rejoices in the following folksong in German:

Wohl ist die Welt so groß und weit
Und voller Sonnenschein
Das allerschönste Stück davon
Ist wohl die Heimat mein!

Surely, this world is very big and wide
And full of Sun's Light
But the best part of it
Is surely the place where I live!

The native speaker of Kannaḍa feels proud of his language by singing the following poems of the renowned national poet Kuvempu:

Bārisu kannaḍa ḍiṇḍimava
O karnāṭaka hridaya śiva!

kannaḍa ene kuṇidāḍuvudennede
kannaḍa ene kivi nimiruvudu!

Beat the drum of Kannaḍa
O God in the heart of Karnāṭaka!

My heart rejoices on hearing Kannaḍa
My ears stand up on hearing Kannaḍa!

The deep emotions recorded in these poems can be cherished by people all over the world towards their own hometown or language, be they German or Kannaḍiga. While hearing these songs, your heart unknowingly brings back to your memory those nostalgic experiences of your own hometown and of your own language, whether it is Tamil, Telugu, Malayālam or Hindi! There is nothing wrong in feeling proud of one's religion, region or language as long as you do not develop hatred towards people of other religion, region or language. But in our practical life, things are indeed quite different. Persons belonging to the same religious group or speaking the same language who are living in far away places, whom we seldom know or who may not be seen at all during our whole lifetime, receives more sympathy than our next door neighbour belonging to a different religious faith or speaking different language.

Religions in principle preach love for mankind and are meant for transforming our hearts and taming our minds with a view to realize the divine spirit within us. But in practice, religions have generated hatred and have become divisive forces and harmful to mankind. Day in and day out, we hear gruesome attacks and killings of hundreds of innocent lives in different parts of the globe — one such incident in the recent past being the brutal and barbarian attack by terrorists from Chechnya on a school in Russia where more than 200 innocent young children and teachers were killed. If the love for our own religion or region generates hatred towards the people of other religion, then the question

arises: 'What is the use of religion at all?' There is no wonder in what Dr. Ram Manohar Lohia once remarked: "Politics is a short-term religion; and religion is a long-term politics." To this, I have no hesitation to add that we, the religious leaders, have become more politicians than religious leaders and the politicians, in turn, have become more criminals than politicians. "Politics without principles is a crime!" once proclaimed Gandhiji. Religions are being misused and religious sentiments are exploited by politicians to usher into power.

The festival days have become a big headache to the police. What a shame that the religious festivals which are meant for rejoicing and gaining spiritual strength have turned out to be deadly warfare and street fights! Instead of becoming an expression of deep devotion to God, they have become an expression of religious chauvinism and hatred towards other communities. Religious practices are purely personal and should be observed for spiritual advancement (*ātmonnati*), killing one's own ego within, and not killing people around us. Religions were founded for finding peace in this life and in the life hereafter. But in practice, they have become the causes for unhappiness and unrest in the world. Religions should not be like attractive commercial ads in the market and religious institutions should not act like rival companies trying to popularize their own products!

As I wrote earlier, religions have become divisive forces. Recently in the month of April this year (2004), I had been to Australia and gave lectures at the La Trobe University in Melbourne. At the end of my lectures, I wanted to go to the washroom. As I walked down the corridors of the University, I was shocked and surprised to see two signboards in the washing area which read: "Male Muslim Washroom and Female Muslim Washroom!" So far I was under the impression that the washroom was the only place where everybody would go without any restrictions of religious affiliation. One can understand and appreciate providing separate wash rooms for men and women. But here is a University where separate wash rooms are provided for Muslims and non-Muslims. There must have been a demand from the Muslim community for providing such a facility which has been met with by the authorities of La Trobe University in Melbourne. The above signboards triggered off the thoughts in my mind that if a similar demand is made by the students of different communities in India, the Indian university buildings would be filled more by toilet blocks than by teaching blocks!

Religions were meant to overcome one's weakness but ironically they themselves have become one's weakness. To be religious does not mean just going to a temple, mosque or church. The younger generation of all religions all over the world in recent days are turning away from these shrines and do not care to observe religious practices. Though they are labelled as heretics or irreligious, I have often found them to be more religious in their daily life than a person regularly going to a temple or church. These youths observe certain principles of religion like feeling guilty inwardly if they make any mistake. On the contrary, people who appear to be religious least care for the lofty principles of religion and do not hesitate to do things prohibited by religion. Their religious activities are undoubtedly mechanical and restricted to *pūjā* rooms only. Once they come out of the *pūjā* room, they

indulge in doing all sorts of irreligious activities. They care more for materialistic values than for ethical or moral values! As a result, the religious symbols or signs they wear, to my mind, appear to be like gorgeous and fashionable ornaments or dress put on by an old lady who looks ugly! What is the use of red reins for an old horse? (*būḍhī ghoḍī, lāl lagām!*)

The primary aim of all religions is to make man happy both in this life and in the life hereafter. *Yato'bhyudaya niḥśreyasa siddhiḥ sa dharmaḥ* (True religion brings earthly happiness and heavenly paradise), says the *Vaiśeṣika-Sūtra*, a treatise on one of the six schools of Indian Philosophy. Religions propagate mutual trust, peaceful co-existence and humanism among people of the world. No religion preaches any violence to its followers. But there is no country in the world where there has been no violence or bloodshed in the name of religion or God. Basavaṇṇa who led a great socio-religious movement during the twelfth century AD in Karnataka (south India) strongly condemns the acts of violence in the name of religion. He stresses the need for being kind and gentle at heart towards all living beings, if one really wants to win the grace of God:

> *dayavillada dharmavadevudayyā*
> *dayave beku jagada prāṇigalellaralliyū*
> *dayave dharmada mūlavayyā*
> *kūḍala-sangayyanantalladollanayyā*

> What is the use of religion
> If it does not teach compassion?
> Be compassionate to all living beings in the world.
> Compassion is indeed the root of all religions.
> Lord Kūḍala Saṅgama
> Does not like it otherwise!

Many years ago, I had been to Costa Rica in Central America on the invitation of the University for Peace to give a talk at an International Conference on the theme "Religions Responding to Global Threats." One of the participants was a Rabbi from Israel who had an interesting incident to narrate. At the time of his departure from his country, he had met an old man his next door neighbour and told him that he was going to attend the Conference in Costa Rica on the theme "Religions Responding to Global Threats." The old man, who had some problem with his ears, mistook the theme of the Conference and immediately responded nodding his head: "Yes, Yes, Religions are the Global Threats!" Perhaps the old man is right and only we are mistaken!

Every country has got its own national territory with a definite geographical boundary separating the territory of other neighbouring countries. Apart from these political boundaries forming various nations, people have formed their own *invisible mental boundaries* based on religion, race, region, language and whatnot! These invisible mental boundaries are in a way stronger than the political boundaries. The political boundaries may change from time to time but not these mental boundaries, especially those based on religion, which we see growing stronger and stronger everyday.

If you go to Western countries, you will see young school children affiliated to one sports team or the other at the national level. Like the Cinema syndrome in India where boys and girls have their own favourite cine stars, the youths and even the adult people in the West have their own favourite sports team to support — as, for example, the rival baseball teams of New York's Yankees and Boston's Redsox in US. Once I had been to Netherlands leading a group of 150 disciples on a World Peace Tour. As we walked down the main street of Amsterdam, I found many Dutch people seated outside the restaurants sipping a glass of beer or apple juice with their ears glued to the radio/TV news. A football match between the Dutch team and the French team was going on in this famous city of flowers. The orange coloured dress of the Dutch players matched with the saffron colour of my dress. A group of Dutch fans looked at me curiously and jubilantly remarked: "Wow! You are supporting our team!" I just smiled at them and did not say anything. But one of our disciples jocularly replied to him: "You have the blessings of our Swamiji; your team will surely win!" After a while, the Dutch team really won the game. But to my dismay, some of our disciples lost their purses — and one of them even lost his passport — in the melee that ensued in their eagerness to grab the models of colourful footballs being freely distributed by the Dutch fans in their jubilation! What I intend to say here is: As long as you enjoy witnessing the sports and support your team, it is okay. But if your team loses the play and you resort to hooliganism — pelting stones, throwing rotten eggs and hand grenades, etc. — then the sports has no meaning. Similarly, religious fanatics have made their religions meaningless, chaotic and ruthless by their irreligious activities detrimental to the lofty principles of their religion. If the adherents of all religions make sincere efforts to understand their own religion in its proper perspective without any prejudice to other religions and try to practice its true teachings to kill the monstrous enemy within themselves, then the religious harmony is not far off to achieve. We should work together in that direction for peaceful co-existence and to save the humanity from all the brutalities committed in the name of religion and God and make this world an earthly paradise! Let me conclude with a poem which I wrote for a book on World Peace:

> *God is one, but His names are many*
> *Reality is one, but its ways are many*
> *Spirituality is one, but religions are many*
> *Humanity is one, but human beings are many*
>
> *There cannot be one religion for the whole world*
> *Religions are like flowers in a beautiful garden*
> *Every flower has got its own individual beauty*
> *Adding to the total beauty of the garden!*
>
> *Enjoy the beauty of the flower of your choice,*
> *While enjoying the beauty of the garden!*
> *Let not your choice be thrust on others*
> *Nor be it a cause for coercion and conflict!*

32

The Drop of Water
An Intercultural Metaphor*

Raimon Panikkar

Just as rivers flowing to the ocean
Merge in it, losing name and form,
So the wise Man, freed from name and form,
Attains the Supreme, divine Person.

— Muṇḍaka Upaniṣad III, 2, 8[1]

Nuestras vidas son los rios
que van a dar en la mar
que es el morir,
allí van los señoríos
prestos a se acabar
y consumir.

— *Jorge Manrique* Coplas

ACCORDING to the Veda, the Bible, and other sacred texts, water (the primordial element *par excellence*) precedes creation.[2] The myths of Babylon, Persia and India describe the primordial waters, and parallels can be found among the most widely divergent cultures from Greece to Africa.[3] Like life itself, water lies at the source of everything.[4] 'Living

* Bettina Bäumer is newly-born in India, and in spite of it has never neglected her first birth. Her life represents the harmony of two cultures, which haven't always understood each other. At a high point of her life some friends want to honor her by this Felicitation Volume. I am glad that I yet have the opportunity to present her my blessings. The following reflections are a new version of a study written some years before, 'L'eau et la mort,' in: Archivio di Filosofia (Istituto di studi filosofici) Roma, 1981.

1. *yathā nadyaḥ syandamānāḥ samudre'staṁ gacchanti nāmarūpe vihāya |*
 tathā vidvānnāmarūpādvimuktaḥ parātparaṁ puruṣam upaiti divyam ||
 Cf. *etiam* KaṭhU, IV, 14-15; BS, I, 4, 21 and also my commentaries in: *The Vedic Experience*, Delhi: Motilal Banarasidass, New edition, 2001, pp. 700-04.

2. Cf. *Gn* I, 2; ŚB IX, 1, 6, 1 (*āpo ha vā'idam agre*).

3. Cf. M. Eliade, *Traité d'histoire des religions*, Paris: Payot, 1970, §§ 60-61 and his bibliography on the subject, pp. 184-87; Ph. Rech: *Inbild des Kosmos*, Salzburg: O. Müller, 1966.

4. Cf. F. Baartmans, 'Āpaḥ,' *The Sacred Waters. An analysis of a primordial symbol in hindu myths*, Delhi: B.R. Publishing Co., 1990.

waters,' 'a spring of water welling up,' 'rivers of living water' are commonly found expressions in traditions all over the world.[5]

Water symbolizes life. Unlike individual plants or animals or human beings, water does not die. Water is one. Water moves and transforms as one water. The sea has the *stasis* of a fixed place and the *dynamis* of constant and seemingly immanent movement, at once always the same and ever-changing. Water is alive, it is the very source of life.[6] "Once upon a time," Ploutarchos tells us, "Man was without fire, but he was never without water."[7] In places where water is scarce or even non-existent, its absence renders the surrounding land barren, a "land of death."[8]

Numerous traditions attribute to water the power of purification and regeneration: one is born again into a new and higher life through the waters of baptism or of *abhiṣeka*. Water is necessary for purifying oneself[9] — before entering the temple, the mosque, etc.

Water, however, also possesses the power to drown, dissolve and destroy. We need only mention the almost universal myth of the flood, or point to the common experiences of farmers and sailors throughout the ages to illustrate this more perilous feature of water. Yet we should not hastily label this a paradox, and make the facile claim that the very source of life is also the cause of death. Life that is mortal is not 'pure' life, but is rather the life of beings whose capacity for life is limited. Death comes from being fragmented.[10] Our reflection on water and death pivots around this central point: death is a *constituent* element of life inasmuch as death is found in and among living beings, but death is not a *constitutive* attribute of life.[11]

Is life *qua* life mortal? There are two logical answers. If life is not primordial (if, for instance, life is the result of chemical development and biological evolution), then it is not inherently immortal. Life would then either be sheer chance, or an achievement that must

5. Cf. *Jn* IV, 10-11; VII, 37; *ŚB* IV, 4, 3, 15 (water is the elixir of immortality); etc.

6. In classical Greece, cadavers were called *alibantes*, those who have 'dried out,' those who have lost their water, their sap. Cf. Platon, *The Republic* 3 (387c), although modern etymology questions the accuracy of the classical interpretation of *alibos*. Cf. H. Frisk: *Griechisches etymologisches Wörterbuch*, Heidelberg: K. Winter 1954 *sub voce*. Some have thought, rather, of *oligos* with its connotation of frailty and impotence.

7. *Questiones convivial.* (2p 956a) The preceding text also refers to the dead as "without sap": "Water is useful in summer and winter, in health and illness, by day and at night. There is no situation in which we do not need it. For this reason, the dead are called *alibantes*, that is those who are no longer 'moist,' hence who are no longer alive."

8. The Rajasthan desert in India is called *marubhūmi*, i.e. the wild, uncultivated land (*bhūmi*), the land of death (*maru* — probably from the root *mṛ*, to die). The desert is described as *nirjana* (without living beings or without life) and *nirjala* (without water).

9. Cf. *ṚV* X, 9, 8.

10. We are reminded of Platon's arguments favoring the immortality of the soul by reason of its simplicity.

11. "Mejor que decir que los seres orgánicos mueren esencial y necesariamente, es sostener que se van constituyendo como seres mortales. La mortalidad, en suma, no es en ellos una propiedad constitutiva sino constituyente." J. Ferrater Mora, *El ser y la muerte. Bosquejo de una filosofía integracionista*, Madrid: Aguilar, 1962, p. 154.

be conquered again and again. This idea does not need to be exclusively tied to the theory of evolution; this is the function of sacrifice in the Veda, for example.

If, on the other hand, life is primordial (if life is the very principle of reality), then it is immortal by nature. This is a point of profound disagreement between those who believe in an absolute theory of evolution and those who believe in a living God. In the first case, life is the product or by-product of reality, whereas in the second, life is the very centre of reality. Echoing Aristotle, St Thomas said, *vita viventibus est esse*: "The life of living beings is their being." Now, this being is not static, but is rather a becoming, a 'not-yet-being,' since it is on the way to being — to be. Hence, this being is on the way to life, which is a risky process that can fail.[12] Ultimately, the problem is whether 'in the beginning' (*in principio*, en arch, *agre*) there was life and being or whether there was death and non-being?[13] Is life an epiphenomenon, or does life form the deepest core of reality? Can Man dare claim an immortality of a higher order than that of the sun, which has already 'lived out' most of its life, or than that of the stars, which are 'mortal' bodies whirling in sidereal space?[14] It is a disservice to feminism to yield to the mainly dialectic thinking of the males. How are we to understand expressions from many traditions that speak of the 'Lord of life,'[15] the 'Source of Being,'[16] the Father of him who is Life?[17] Do they mean that life is the most important product of reality, its 'first-born,' its primary manifestation, but not, perhaps, its ultimate mystery?

Putting these questions aside, let us try to understand how water, the symbol of life, can also bring about death. Supposing that a living being were given 'more' life than the life that is proper to it, this 'excess life' would, as it were, suffocate that creature's life. New life entails new being.[18] In this vein, the Abrahamic traditions contend that no one can see God — who is, by definition, pure life. Likewise, indic wisdom emphasizes that pure life

12. Cf. R. Panikkar: *El concepto de naturaleza. Analisis histórico y metafísico de un concepto*, 1951, 2nd edn., pp. 283-95, as well as the chapter on *"Life in vitro"* in my: *Ontonomía de la ciencia*, Madrid: Gredos, 1961, pp. 179-93.

13. Cf. the indic texts: "At first was neither being nor nonbeing" (ṚV X.129, 1); "In the beginning there was nothing here whatsoever. All this was swathed in Death — in hunger, for hunger indeed is death" (*BU* I, 2, 1); etc.

14. English language does not explicitly distinguish between gender and sex. Using this language as the modern *koinê*, the author does not subscribe to the north American modern usage and, conscious of the etymology of the words, gives not males the privilege of being Man, nor degrades females to the status of women. The masculine gender does not refer exclusively to males.

15. Cf. *AV* X, 7, 7 and also the conclusion in X, 7, 41.

16. Cf. my trinitarian interpretation in: R. Panikkar, *Trinität. Über das Zentrum menschlicher Erfahrung*, München: Kösel, 1993.

17. Cf. the affirmations of Christ as Life (*Jn* VI, 35-40; X, 28; XI, 25-26; XIV, 6) and God as his Father (*Jn* V, 18; X, 30; XVI, 28).

18. From this perspective, one could say that the Christian resurrection presupposes that Man already participates in a higher (divine) life; otherwise the resurrected one would not be the same person. Similarly,

requires pure being. Sunlight illuminates, but the glare of the sun can blind by excess of light just as much as darkness can by lack of light.

Water, the symbol of life, can also be the symbol of death, but in a different way. In and of itself, water *is* living and *is* the source of life, but it can also *bring* death. There exists a thin thread linking life and death — although strictly speaking, this link is not one of necessity. Let us reflect on the nature of this thread.

* * *

First of all, we must distinguish between death and non-life. We can experience death, but we cannot experience non-life. Non-life is a *concept* and exists only in a dialectical relationship with the *concept* of life. They are contradictories. Death, on the other hand, is not simply non-life or the inanimate. To be sure, we could define death as non-life, or vice versa, and this operation would be irrefutably logical, but it would not necessarily reflect reality. We might remark in passing that some religious philosophies see in the fact that we can think about death and life without totally experiencing either one is both an opening of the human being toward an ontological transcendence that goes beyond Man and an affirmation of human contingency.

Human life is often accompanied by certain experiences of death. When a loved one dies, it is as if part of our self has died. We also experience the death of love, ideals, goals and ideas that were previously part of our life. We justifiably speak of death as a personal and familiar experience. According to pure logic, although one cannot properly say 'I die' because there is no 'I' to say it, one may think that the 'I' dies. In short, certain experiences of death belong to us inasmuch as we are living beings. Our experience of life is impregnated with experiences of death.

Death occurs as a rupturing of life, as a point of discontinuity inexplicable in itself, but never simply as non-life. If a being is alive at moment *A*, it is difficult to see why it should not be alive at moment *B* unless some external element intervenes. This is the same law of inertia already formulated by Platon. Death requires a death-causing agent. Life does not die of itself, yet there is the universal human observation that conscious life also appears to include the consciousness of mortality. While death is certainly an *existential* partner of life, it is not necessarily an *essential* dimension of life.

Man has also conceived of a pure life, a life without death. Indeed, some experiences of life contain no reference to death. There are experiences of the present, the 'now.' As such, they have no durational dimension. Yet, we continue to live in time, and cannot believe in an open-ended duration in time, since we see that our fellow creatures die.

We can think about life and death, and in certain circumstances we can experience life without the intrusion of death. We can also experience death — not an absolute death, but rather, so to speak, a death tied to a life stronger than death. Nevertheless, the problem remains: can we experience a pure and absolute life while continuing to experience our being in time?

Further, although we can certainly *think* about non-life, we cannot *experience* it. The relation between life and death is not reducible to the relation between life and non-life, because in the final analysis, *the ultimate structure of reality is not necessarily dialectical.* We can say that non-life is the contradiction of life, whereas death is the opposite of life. Equating these two very different relations has, in my opinion, given rise to more than one misunderstanding. Non-life has nothing to do with death. Death, on the other hand, is related to life; it is its enemy. Non-life cannot touch life, but death deeply wounds life.

Can we find a parallel between the life-death relation and personal relationships? Are personal relationships constitutive or are they merely relations *de facto*, i.e. constituent and not constitutional relations? First of all, we can say that both of these relationships are dialogical relations and not simply dialectical ones. The 'I' of a person is opposed not only to a 'non-I' (as in a dialectical relation) but more importantly to a 'thou' (as in a dialogical relation). The 'thou' is neither 'I' nor 'non-I.'[19] This 'thou' is the 'thou' of the 'I.' The 'thou' exists in response to the 'I,' and the 'I' is 'I' only for a 'thou.' Neither exists without the other. Similarly, life is opposed not only by non-life, but also by death, which is neither life nor non-life. Life, which contradicts non-life, does not contradict death because life and death are related in a dialogical polarity. In a certain way, life seems to imply death.[20]

Here again we face two great avenues in the history of human thought: the monist or absolute monotheistic option and the a-dualistic or trinitarian option. The first great option, monism or rigid monotheism, declares that there can be an 'I' without a 'thou' and there can be life without death. In effect, monism says that reality is one, and that the 'thou' and death are mere appearance. Monotheism says that, *de facto*, a divine act has called both the 'thou' and death into being,[21] but this entails an act of divine grace that is neither *de iure* nor by necessity.

The second great option[22] tends to support the parallel we have drawn. A-dualism, or the trinitarian insight, claims that such a distinction (whether *de facto* or *de iure*) makes no sense in the realm of the ultimate. In this perspective, there is no 'I' without a 'thou,' nor any 'thou' without an 'I.' Similarly, the relationship between life and death is constitutive because the relationship is a constituting one, even if the present day modality of human death may change. If in the final analysis the life-death relationship is constitutive, life is a

Hindu *karma* implies a continuity of life deeper than that normally experienced by an individual.

19. The *proton pseudos* of German idealism, as well as all so-called modern thought (i.e. post-Descartes), bases its philosophical method on the dialectical opposition between the *Ich* and the *Nicht-Ich*, while neglecting the *Ich-Du* polarity, which Feuerbach had earlier explored, and which was later developed by M. Buber, F. Rosenzweig, F. Ebner and others.

20. Cf. for example, the "I die everyday" of I *Cor* XV, 31 and the once famous medieval chant, *media vita in morte sumus.*

21. Or as many Vedic texts say: In the beginning the I was alone, but the price of this solitude was ennui. The I was without joy and the desire for a second arose in him (cf. *ŚB* II, 4,1; *BU* I, 4, 1-3; *AU* I, 1, 1.).

22. Since we are limiting our comparisons in this study, we must exclude the dualist (pluralist) or polytheist option, which would defend the plurality and independence of every 'I' and 'thou.'

constant resurrection (from death). A-dualism would say that the relation of the 'thou' to the 'I,' like that of death and life, is real. The trinitarian idea would maintain that there is a complete interpenetration (a *circumincessio* or *perichôrêsis*) between the 'I' and the 'thou,' and that this relationship is sustained by death and resurrection.[23]

These two views of the life-death relationship raise another question: is the fact that death is constantly 'mixed' with life an accidental or natural phenomenon? As we have said, many traditions do not consider death a natural occurrence. Moreover, it is precisely pure life, one having no relation with death, that more than one religion calls God. From this perspective, theism would affirm the existence of life without death. Yet we do not intend to analyse the immortality of God or the Gods here. Rather, we are focused solely on the possible immortality of Man.

Have we not made a virtue of necessity, and deduced that human life must be mortal from the fact that death is inseparable form life?[24] Have not the traditional religions (except perhaps in their mystical expressions) been too hasty in relegating *real* life to *another* life, a life beyond death? Has not modern Man, in the East as well as in the West, continued this process by demythologizing the myth of a theological cosmology, in which the entire universe is sacred, only to substitute in its place the new myth of history, in which true life is projected into the future? Has not history been turned into cosmology so that the Western brand of modern anthropology might be inserted? Man no longer attains immortality in a cosmological setting (a different existence, whether in this world or in another one), but by virtue of his anthropological destiny (through fame and through a person's enduring influence on his society).[25]

These far-ranging considerations may serve as an introduction to our reflections on the metaphor of the drop of water, for they warn us of the danger of making monocultural assumptions when it comes to questions of human destiny. We cannot simply move from cosmology to cosmology, taking what we want from one and mixing it with another, while ignoring the less appealing or even contradictory aspects of both. This is true regarding both different cultures and the same culture at different stages of development. We must take into account, for instance, that heaven and hell no longer exist for a part of humanity, and that while Newtonian space has lost its metaphysical weight, historical time still retains its cosmological power. We will return to this after we have analysed a metaphor that straddles both space and time.

* * *

23. This would hold true in the intra-trinitarian realm as well as in a space-time economy. In Christianity, this is the place of the mystery of the Christ.

24. Today we speak of athanatology as the study of human immortality.

25. Significantly, the official ideology of communist countries uses history as the 'orthodox' expression of immortality. For example, one reads and hears everywhere expressions such as "A Hero of the People is immortal."

We are not planning to discuss the entire problematic on death, nor are we claiming that our metaphor is the 'best' for understanding the problem of human destiny. We are primarily trying to give a hermeneutic for this metaphor in such a way that does justice to those cultures and subcultures that use it. The study of any human problem includes not only what we think, but also what others think. Therefore, a valid discourse on death today cannot be an individual reflection, but must also contain what our ancestors have thought and felt when confronted with death. Death is not a pure, objectifiable 'fact,' for death includes all the perceptions that peoples — our forebears, our contemporaries, our children — have of death. Death 'is' what I think it is as well as what others think or have thought or will think it is. If these diverse experiences are foreign to us, they nevertheless belong to the very nature of death. The strength of our metaphor lies precisely in its relative universality. Because people of quite different cultures use this metaphor, it can reveal how death is seen and felt by them. Perhaps a hermeneutics of this metaphor will help to overcome a certain anxiety concerning death without, however, removing its mystery.

The destiny of the human individual has often been compared to the fate of a drop of water in the ocean.[26] What happens when a person dies? What happens when a drop of water falls into the sea? To be sure, the questions of mortality and immortality are meaningful only within a framework of our consciousness of human individuality. The living individual is mortal, not life. It is the same for a drop of water: the ocean does not die, but the drops of water that have fallen into the ocean disappear. In short, the individual, human or drop, dies. Death is a (primarily anthropological) problem that exists only for an individual. This is not to say, however, that our approach should be exclusively anthropological, or that we should ignore cosmology or theology. By so limiting our perspective, we would effectively cut ourselves off from a genuine understanding of other cultures. Nor are we suggesting that philosophical (read: cosmological) reflection about death has no place in religions or cultures that do not hypostasize consciousness in individuals.[27] What happens to the human 'drop of water' when it meets the infinite ocean

26. sGam.po.pa, the celebrated Tibetan monk of the twelfth century and the one-time disciple of Milarepa, composed *The Jewel-Ornament of Liberation*. This text later became the manual of the Kagyü-pa, which he organized. His work is an almost complete collection of all the buddhist sources. One text begins: "In the *Phags.pa bLo.gros mi.zad.pa'i mdo* (*Akṣakamatiparipṛcchāsūtra*) we read: 'Śāriputra, just as a single drop of water that falls into the vast ocean is not lost nor absorbed by the ocean until the end of time, so too the precepts concerning what is good and salutary that have transformed into illumination will never be exhausted until one becomes the quintessence of the awakening.'" Transl. H.V. Guenther, *The Jewel-Ornament of Liberation*, originally published in 1959 and again in Boulder, Co: Shambala, 1971, ch. XII, p. 160.

27. At the end of his chapter, "La mort cosmique Brahman et Nirvana," E. Morin writes: "Le refus de l'individualité, refus impossible dans la vie même et qui n'a plus de sens dans la mort, est á proprement parler l'escamotage du problème de la mort." *L'homme et la mort*, Paris: Seuil, 1970, p. 262. Obviously, the denial of individuality presupposes its prior existence. But it is one thing to deny individuality and quite another not to presuppose its existence as the only possible form of consciousness. A third attitude might consist of affirming the possibility of going beyond individual death.

of Brahmā, Dharmadhātu,[28] God, Nothingness, *nirvāṇa*, time or whatever name we give to the Ocean? What happens to Man when he dies?

By putting the question in this way, we first accept that death is inevitable and second, confine ourselves to explaining this fact without worrying whether or not death is constitutive to Man.[29] The radical question: "to be or not to be," as the *Kaṭhopaniṣad* poses it,[30] arises only when death confronts the individual as the problem of his own non-being. The question is: (my) being or (my) nothingness.

Various religious traditions have responded differently. Most modern interpretations of the Abrahamic traditions[31] place a great deal of importance on the individual, while the majority of Eastern religions are primarily interested in the totality.[32] In an ironic twist of fate, the question of individual immortality in the *Kaṭhopaniṣad*[33] was posed at a time that probably predates Platon. Of course, we are well aware that while the Indic answer does not negate the *ātman* (individual), it does counsel the recognition of one's identity with *Brahman*: *ātman brahma*.[34] Buddhism offers a completely different answer: there is no *ātman*.[35] Even more: Man's mistaken preoccupation with the *ātman* is the obstacle to real immortality (and *nirvāṇa*).[36]

* * *

Let us return to the drop of water. What happens when it falls into the sea? What happens to Man when he dies? Does he retain anything of his own or is he completely

28. Cf. sGam.po.pa, *op. cit.*, ch. XVII, p. 224.

29. Cf. Igor A. Caruso, *Die Trennung der Liebenden*, Bern/Stuttgart: Hans Huber, 1968, which offers a utopia made possible by going beyond death ("Aufhebung des Todes," p. 309), in a new modality of existing.

30. *asti nāsti* ("he is or he is not"), *KaṭhU*, I, 20.

31. I use this expression to denote not only the three great monotheistic religions but also humanism and Western-style marxism.

32. "Entre l'universel mythique (Nirvāṇa) et l'individual mythique (Salut), l'humanité choisit en masse le salut." E. Morin, *op. cit.*, p. 260. There is on the other hand, the striking fact that in practice every world-view pays more attention to the less developed aspects of its vision, while it takes other aspects for granted. For instance, the Abrahamic religions, which generally consider Man as *drop*, and hence presuppose human individuality as their point of departure, also emphasize collective salvation (of the people of Israel, of the Church, of the Umma), while the indic religions, which tend to identify Man with the *water*, also emphasize the complementary aspect of salvation as fundamentally individual: Man depends on his *karma*, he must rely on himself, he achieves his own liberation, etc. Likewise, we are aware of the widespread phenomenon that most prophets, regardless of their religion, tend to preach and emphasize precisely those aspects complementary to their own world-view: to individualistic people, they preach a common destiny, to aggressive people, non-violence, to traditions that have institutionalized injustice, justice, and so forth.

33. Cf. *The Vedic Experience*, *op. cit.*, pp. 563-71, where the situation of young Naciketas in the *KaṭhU* points toward a personalist solution, one that Yama, the God of death, later raises to an ontotheological level.

34. *Ibid.*, pp. 704-45. On the other hand, an identity between Man and Yahweh would be meaningless or sheer blasphemy.

35. Cf. however, the study of K. Bhattacharya, *L'ātman-brahman dans le Bouddhisme ancient*, Paris, 1973, which attempts to show that in the beginning, Buddhism did not deny the real *ātman*, i.e. the Upaniṣadic *ātman*.

absorbed by the Ocean of Being (or God or Nothingness)? Non-being *is* not. Can we not say the same about death? Death certainly *is*, but what is its ontological status? The Vedic tradition, as well as many others, would reply that death kills only what can be killed. If this is so, then death cannot kill 'what' we truly are. On the contrary, death discloses our true state. For this reason, the 'death' of an individual who has not burned all of its *karma* is only an intermediate state, because a person's real death frees her completely from *saṃsāra* (the cycle of existences). Similarly, we distinguish between death as the splashing of the human drop into the ocean "full of its lifespan" (*dīrgha-āyuṣ*) and an accidental, premature death (*akāla-mṛtyu*), which prevents growth and maturity.[37] The former implies the disappearance of the membrane surrounding the drop, while the latter evokes a more or less complete and unexpected evaporation of the water. Death as *dīrgha-āyuṣ* reveals the *Brahman* or *nirvāṇa* that we 'are,' it preserves everything that Man fundamentally 'is,' be that Soul, Nothingness, God, Being. . . . This does not die: *tat tvam asi*.[38] *You are that* which death has finally unveiled. Let us see what happens when a human drop of water dies, when it 'loses itself' in the sea.

Our answer depends on what we are: the drop of water or the water of the drop. What represents a human being: the drop or the water? What constitutes Man: his 'drop' or his 'water'? Is Man the quantitative difference between drops or the qualitative difference between waters?[39]

When the *drop* falls into the ocean, the surface tension that separates it from every other drop, the barrier that prevents total, profound communication and genuine communion certainly disappears. The drop no longer exists as drop. After falling into the ocean, this tiny separate drop of water, together with the time and space that individualized it, are no more. So too at death the individuality of Man is absorbed into *Brahman* or returns to its cosmic matrix or melts into God or is united with Him. The individual is annihilated, it ceases to exist, it is transformed into what it was (or was

36. Cf. H. v. Glasenapp, *Immortality and Salvation in Indian Religions*, Calcutta: Susil Gupta, 1963, p. v.

37. From this perspective, death is not inevitable; it is accidental, against nature. A person dies when he is abruptly or violently cut-off from life by an accident or an illness, before he has grown to maturity, begun a family, or accomplished his life's task in society. In this sense, an old man, a person who has reached the end of a long life, does not die. There is no breaking off from life, no interruption of its progress. The flame of life has finally consumed all the oil that nourished it, but continues to burn on in his children, his friends, his ideas and his achievements; cf. *The Vedic Experience, op. cit.*, 'Death and Dissolution,' pp. 553-612.

38. *CU*, VI, 8-14; 16, which permit the following extrapolation, because what the Upaniṣad really discloses is that we are a 'thou,' "That art *thou*." Cf. *The Vedic Experience, op. cit.*, pp. 747-58.

39. Cf. R. Panikkar, '*Singularity and Individuality. The Double Principle of Individuation*': Revue Internationale de Philosophie, Bruxelles, No. 111-12, Fasc 1-2 (1975), pp. 141-66. A scientific conception of the universe favours drops that are quantitatively (i.e. measurably) different, whereas a traditional understanding of the world emphasizes the qualitative differences in the water. It is difficult to see how one could defend a qualitative difference among drops (outside of the water) or a quantitative difference in the waters (outside of the drops themselves).

called to be) and so on. If Man is the drop, and if this drop falls into the sea, then this individual is truly dead. Death is ontological (obviously in terms of the being of the *drop*).

The *water* of the drop, however, does not suffer the same fate. It continues to be, it has lost nothing, it has not ceased to be what it was. The water of this drop is now in communion with the water of the entire ocean without having lost anything. Granted, it may have undergone some changes, but none of them has stripped the drop of its being as water. So too with Man, who realizes himself fully at death, who becomes what in reality he always was, although before death he was not (or did not appear to be) this real being in so far as he identified his being with his temporal past or his spatial parameters. Death breaks through the barrier of space and time, and perhaps also that of Man's limited consciousness. This change, however, cannot be so substantial or fundamental that we could speak of a mutation or of a different life. The water finds itself. Man realizes himself. *Vita mutatur, non tollitur!*[40] Death is phenomenal (obviously in terms of the *water* of the drop).

Our question is not yet answered: Is Man the *drop* of water or the *water* of the drop?

(a) *If Man is considered as drop*, namely as the superficial tension separating him from everything else, as an individual, a monad, then the human being indeed disappears with the individual's death, and death becomes a great tragedy against which Man must struggle with all his might.

We can describe two ways in which Man has undertaken this struggle: the first, what have traditionally been the concern of religion, the second, what is today called secularism.

The religious struggle postulates a more authentic and definitive life after death: the drop disappears in order to be born again, either as a crystallized and definitive drop in one of the many versions of eternal life, or as a new drop in an entirely new temporal life. Within the category of the traditional religions, we can further distinguish two types: one accepts a space-time unity on earth and resurrects the drop afterwards in some sort of eternal state. The other speaks in terms of a cosmic cycle of existence. The first posits a kind of mutation to a level that is absolutely higher than human existence. The second believes in a law of successive reincarnations, the law of *karma*. The latter type also believes that at a certain moment, which is the result of a more or less determined process, we can escape from the cycle of births and rebirths by attaining a pure transcendence similar to that sought by the first type of religion, but with a fundamental difference: in general, the former religions want to retain the 'drop' (individuality) on the 'other shore,' while the latter for the most part consider individuality as a characteristic of *saṁsāra*, the temporal order. Consequently, from this perspective, Man is considered to be a

40. As the latin liturgy for the dead chants: "Life changes, it does not disappear."

drop only during the span of his existence in this temporal universe. In fact, this type of religion has more in common with the attitude, described below, that considers Man to be the *water* of the drop.

The differences in these beliefs clearly show the ambivalence of every religious stance: everything depends on the belief of the believer. For example, belief in life after death can be consoling, positive and efficacious for those who profess it since, as they plod on through this "valley of tears," they take upon themselves responsibility for the entire universe, having in mind the better life to come. On the other hand, for those who do not believe in it, the idea of another world can be a destructive ideology and paralyse all human initiative. Or again, if the 'other' life is separated from 'this' life so that the former is independent from the 'works' of this world, the world is abandoned to its fate or, worse, left to those who would exploit it. In this case religion would indeed be an opiate that may perhaps assuage individual pain but in the long run perpetuates injustice.

In contrast to these answers, the so-called secular response proclaims that there is no 'other' life. An individual's only hope lies in improving the human condition as much as possible here and now. That death is considered a great scandal for its existence testifies to the fact that the project 'Man' has not yet been achieved. It is the one unavoidable fact that Man would like to deny and against which he must struggle in order to bring the human project one step closer to fulfilment. In fact, this secular struggle is motivated by what might properly be called a religious impulse, without which Man would be impotent, drugged by the opiates of egotism and non-action. In this sense, the struggle of secularism against death can be as genuinely religious as that of the 'formal' religions.[41]

Whether we label the struggle 'religious' of 'secular,' however, its chief concern is to save the *drop* of water, although 'drop' may imply a clan or a tribe or a chosen people, rather than a single individual. The basic attitude is clear: Man's destiny lies either in another world where human 'drops' are crystallized in a heavenly immortality or in this world, which is called to be transformed into paradise, although the generations who build this 'perfect society' must be sacrificed: "The workers will perish but the city will be built!"[42]

This response to death typifies the Abrahamic cultures, or more simply, Western civilization. Man is the drop.

41. This raises a semantic issue. Is the term 'religion' limited to one particular human attitude or is it rather a 'generic' label that admits many specific differences within an overall stance toward reality? Cf. my note, 'Have Religions the Monopoly on "Religion"': *Journal of Ecumenical Studies*, vol. XI, No. 3 (1974), pp. 515-17.

42. Note that this slogan could be applied to every branch of abrahamic religiosity: Judaism, Christianity, Islam, Marxism, Humanism.

(b) If *Man is considered to be the water of the drop*, then the human person can retain
her unique character after death. In a certain sense, the person is even more
unique than if she were the *drop*, for each drop is itself not by virtue of accidental
differences or superficial tension, nor because of spatio-temporal limitations, but
because every portion of water is *other* — unique. The distinction is ontic, not
epistemic. In other words, what distinguishes the drop is the water itself, not its
membrane or its situation in time or its place. The *water* of each drop is identified
by its identity with itself (identification by means of identity), whereas in (a) the
first instance, the *drop* is identified by differentiating it from all other drops
(identification by means of difference).[43] To say that a human being is the water,
moreover, does not mean that its being encompasses *all* water, only that it *is*
(real) inasmuch as it is water.

This belief has given rise to a great temptation, one similar to the drugging effect of
religion mentioned above. It consists of a kind of monolithic monism that cripples human
creativity: if my 'drop' is real only as water and not equally as the water of *my* drop,
what could it mean to "work out your salvation with diligence"?[44] To be sure, we must
be careful not to confuse monism with a-dualism. Monism results when thought stifles
reality, it reduces the real to a concept or an idea. A-dualism, on the other hand, maintains
the two (Being and Thought) in a creative polarity: it holds that the water of each drop
cannot be identified with any concept of 'water.' This distinction is important since the
water of each drop is precisely the water of each drop, and not the water of an abstract
concept of water. If we speak in conceptual terms, then the water of *my* drop must equal
the concept of 'water' of someone else's drop. But this conceptual interpretation does
not mean that these drops are identical as real *water*, rather it refers to some kind of
univocal concept of water. The quantitative formula H_2O certainly applies to water in
terms of its chemical composition but reality is also qualitative. Water is hot or cold, fresh
or salty, metallic or sulfurous. Not only does each water taste different, the water of
every drop actually differs from all other water *as water* (and not solely as drop).
Ultimately, when we say water, we imply all waters because in reality, water cannot be
labeled singular or plural, One or Many. The world is not reducible to quantity, nor for
that matter is it reducible to substance.

The temptation lies in giving up our immediate apprehension of the *symbol* by
substituting the *concept* of water and then declaring that the differences among the various
drops of water are only accidental or sheer illusion. Since Being is supposed to be one,
beings are defined as real in terms of an unambiguous *concept* of water, so any differences
must be ascribed to pure appearance lacking any foundation in reality: the drops would

43. Cf. R. Panikkar, *Kultmysterium in Hinduismus und Christentum*, Freiburg: Alber, 1964 *passim*.

44. According to tradition, these are the Buddha's last words.

not be real at all, only the ocean. Matter differentiates the drops, said the Scholastic, but this 'matter' is not the 'water.'

We are trying to discover what happens to Man when he dies and what happens to the water of the drop when it is united (or reunited) with the ocean. Certainly, many things change or disappear. The question is whether something of each drop perdures, or even better, persists after death. Whatever persists would have the stamp of reality, for persistence implies more than simply to perdure. Existence is the diastole of beings in centrifugal motion, it is the universe in expansion. Existence constitutes time. Being can perdure solely through the inertia of existence. Persistence, on the other hand, is the systole of beings in centripetal movement, it is the universe in concentration, returning to its centre, its 'sistence' beyond the barrier of death.

What persists? What changes? A philosophical elucubration might answer by speaking of primary and secondary qualities, or of accidents and substance, or of beings and their attributes. Our concern, however, is the nature of the reality that is revealed at the threshold of death. Here we use death in its widest, most general sense as the cessation of everything that can cease to be, as the elimination of the drop and everything that prevents it from being and acting as water. Whatever crosses this threshold is being, or at least possesses immortality.

How would we characterize this 'something'? What is 'immortality'? As we have said, we cannot speak a single language that is valid at once for every culture. Buddhism, for example, does not recognize a substantial 'something' that persists or changes. But even here our metaphor is useful: the drops of water would be part of a torrential rainfall in which the water that falls is in equilibrium with the water that is continually being formed into drops. When these fall as rain, they disappear as drops, and so on. . . . Nothing perdures: only perpetual changes in an unending momentariness. The radical relativity (*pratītyasamutpāda*) of reality persists.

An *ātmavādic* perspective offers another approach. It distinguishes between the ultimate I, the *aham*, the final source of action that some traditions call the divine or God or *Brahman*, and the psychological *ego* (*ahaṁkāra*), the conscious or unconscious origin of individual action, the individual soul (*jīva*). Simplifying a bit, we could say that the *I* is immortal and the *ego* is mortal. Immortality is achieved by purifying the *ego*, for it is precisely this purification that enables us to realize 'our' *I*. Or, returning to our metaphor, we attain immortality by becoming aware that we are water rather than drop, by choosing not to harden the wall that separates us, by achieving a victory over egotism, by realizing

45. Cf. *ŚB* II, 2, 2, 8.

46. Cf. *ŚB* II, 2, 2, 9-14; II, 4, 2, 1.

47. *antaraṁ mṛtyor amṛtam* (*ŚB* X, 5, 2, 4).

48. *CU* VI, 11, 3.

that our true 'personality,' or real 'nature' lies in the water that we are. Clearly, immortality is a sort of a conquest. In the beginning, so the *Brahman* says, even the Gods were mortal.[45] They became immortal and invincible only as a result of their fervent concentration and sacrifice.[46] "In death there is immortality."[47] Another text says, "Life does not die."[48] The conquest of death consists of discovering, in the double sense of *gnôsis* and realization of 'our' *I*, the true *I* that is unique for each of us because it is One without a second (*ekam evādvitīyam*).[49] At the same time, it means the death of our *ego*, which gives us the false impression that we possess as private property something we do not, indeed cannot own. On the contrary, it is 'this' alone that can possess us.

Now, a Buddhist would certainly not speak in these terms. He could, however subscribe to what we are saying by interpreting the nature of the water and the 'I' in a non-substantivist sense: both the water and the 'I' would be the symbols of a natural dynamism without an underlying permanent substance.

Our metaphor permits yet another consideration. Even if we realize that we *are* water, we must continue to become water, again and again, for we are water indeed, but a water that is not fully liberated, a water that can vanish because it lacks 'weight' or 'gravity' or, one might say, maturity. The drop can fail to grow and do not fall into the sea. It can simply disappear before it has had time to rejoin the ocean. The result is what some would call hell: a miscarriage, a rent in the fabric of reality, a drop of water that has evaporated. As St. Thomas says, carrying St. Augustine's idea of evil as *privatio* to its logical conclusion: *Peccatores in quantum peccatores non sunt.*[50] This failure to grow or mature has also gone under the name of transmigration.[51] Water that is still burdened with all its idiosyncrasies as a drop remains in the atmosphere, in the temporal world. This drop does not attain liberation, does not 'lose' itself in *Brahman*. Instead, it must continue its peregrinations under different guises: its water becomes part of other drops until these drops realize that they are water. The drop 'dies' but its water, which in one life 'dried up' by reason of the human vanities of an inauthentic existence, is not totally lost but becomes sublimated and continues on its way to realization. Indeed, following Śaṅkara, it is the water that actually 'transmigrates': "There is in reality no transmigrating soul different from the Lord."[52]

49. *CU* VI, 2, 1.

50. *Sum. Theol.* I, q. 20, a.2, ad 4.

51. Here we are not trying to compare these two notions, we are only describing their phenomenological link from one point of view.

52. Or: "The Lord is the sole transmigrator," *Brahma-Sūtra-Bhāṣya* I, 1, 5, tr. G. Thibaut. Cf. my article, 'La loi du karma et la dimension historique de l'homme,' in: *La théologie de l'histoire. Herméneutique et eschatology*, Colloquium de l'Istituto di Filosofia, Roma, ed. E. Castelli, Paris: Aubier, 1971, pp. 205-30.

53. Cf. *KaivU* 2, which says that only by renunciation can one attain eternal life; cf. also *BU* III, 5; *MaitU* VI, 28; as well *Mt* XIX, 21, 29; *Mk* X, 29-30; *Lk* XVIII, 28-30; *Jn* XII, 24-25.

54. Cf. *BG* V, 2-3; *Lk* VI, 35; XIV, 13-14; *Mt* VI, 3.

What is death? The loss of the *ego*, which may disappear in order to fall into nothingness or in order to transmigrate into other drops. Alternatively, the *ego* may die in order to effect a passage to the 'I.' Here, death is the discovery of the living water. The drop grows until its membrane bursts open like the petals of a flower, and the drop falls into the infinite ocean, without losing itself as water. In a word, the *ego* dies in order for the *I* to live in us,[53] which is why many spiritual discipline teach disinterested action,[54] the renunciation of the fruits of action,[55] 'holy indifference' (to things and events) and liberation from the chains that bind us to the inauthentic. Likewise, if the one who acts is not purified, his actions will also be impure.[56]

We are so accustomed to identify the second perspective (Man as the *water* of the drop) with indic spiritualities, that it might be worthwhile to direct our attention to a striking text of St. Francis de Sales. We notice that Francis uses water as a symbol to express the reality of the creature as well as that of the creator. In a chapter entitled "De l'écolement ou liquefaction de l'âme en Dieu" (On the liquidization of the soul of God), we find: ". . . si une goutte d'eau élémentaire jetée dans un ocean d'eau naffe, était vivant et qu'elle pût parler et dire l'état auquel elle serait, ne crierait-elle pas de grande joie: O mortels, je vis vraiment, mais je ne vis pas moi-même, ainsi cet ocean vit en moi et ma vie est caché en cet abîme." (If one elementary drop of water thrown in the ocean drowns, was alive and could speak and tell about the state it is in, would it not cry in great joy: O mortals, I live really, but I do not live myself, but that ocean lives in me and my life is hidden in this abyss.) [57]

The chapter begins with the words: "Les choses humides and liquides reçoivent aisément les figures et limites qu'on leur veut donner" (The humid and liquid things receive easily the forms and limits one wants to give them.) [taoist reminiscences?]. For this reason, we must possess "un coeur fondue and liquéfié" (a dissolved and liquid heart). So too, God says, "I will take out your flesh the heart of stone"[58] and likewise David confesses that his heart is "like wax, it is melted within my breast."[59] St. Francis continues in the same vein, using biblical images of water[60] to speak about the soul that "sort par cet écoulement sacré et fluidité sainte, et se quitte soi-même, non seulement pour s'unir au Bienaimé, mais pour se mêler toute et se détremper avec lui" (comes out from this sacred

55. Cf. *BG* VI, 1; *Lk* XVII, 7-10.

56. For this reason, neither *"quid hoc ad aeternitatem?"* (How is this (work, action) beneficial for eternal life?) nor *naiṣkarmya* (disinterested action) can be used by an egotist to justify individualistic salvation.

57. *Oeuvres* (ed., A. Ravier/R. Devos), Paris: Gallimard, 1969, p. 646.

58. *Ezek* XXXVI, 26.

59. *Ps* XXI, 15.

60. *Num* XX, 8; *Cant* I, 3; V, 6; VIII, 6.

61. We note that the ocean of divinity has the savory epithet "eau de naffe," that is, scented water, perfumed by orange blossoms.

62. *Gal* II, 20.

flow and holy fluidity, abandons herself, not only to be united to the Beloved, but in order to merge entirely and be dissolved in Him) — "engloutie en son Dieu" (enveloped in her God).

Concluding the chapter, he cites the metaphor of the drop.[61] The text is clear: the drop of water is and exists as water, its life is the life of the ocean. Here St. Francis is referring to texts of St. Paul: "It is no longer I who live, but Christ who lives in me,"[62] and "your life is hidden with Christ in God."[63] Lest there be any doubt regarding his interpretation, Francis, the Bishop of Geneva ends by saying: "L'âme écoulée en Dieu ne meurt pas; car, comme pourrait-elle mourir d'être abimée en la vie? Mais elle vit sans vivre en elle-même, parce que, comme les étoiles sans perdre leur lumiére ne luissent plus en la présence du soleil, aussi l'âme, sans perdre sa vie, ne vit plus étant melée avec Dieu, ains Dieu vit en elle." (The soul that flows in God dies not, for how could it die after sinking into life? But it lives without living in itself, for, as the stars cease to shine in the presence of the sun yet they lose not their light, so the soul, without losing its life, having merged with God lives not but rather it is God that in this way lives in it.)

Our interest in these excerpts lies not so much in their discourse on the absorption of Man in God, a classic theme in Eastern as well as Western mysticism, as in their use of the metaphor of water, and even that of the drop. Both symbols are clearly intercultural.

We have seen the *drop* of water transformed into immortality, and we have seen the *water* of the drop grow to a point where the drop bursts and falls, like a ripe fruit, into the sea. Let me conclude with some further reflections on the metaphor.

First, the need for a hermeneutic that does justice to intercultural problems. If we approach a different philosophical system using our own categories, we cannot help but misunderstand that system. If, in addition, our categories are foreign to the system we are examining, the misunderstanding will persist. Finding homeomorphic categories is a philosophical imperative of our times. In this study, I have attempted to show that these categories cannot be concepts but must be symbols and further, that metaphor can play an important role.[64] Our example has shown that far from expressing only a monistic concept of reality, the metaphor of the drop of water has more than one meaning even within a single culture. This is as it should be, for we are not seeking the uniformity of a single melody but a symphonic harmony.

Second, death is always "*sub specie individualitatis*": only an individual being dies. Moreover, consciousness of death is linked to consciousness of one's individuality. An entire species cannot experience death at once (although we know that species as such are

63. *Col* III, 3.

64. For a general study of metaphor, cf. P. Ricoeur, *La Métaphore vive*, Paris: Seuil, 1978.

65. Indeed, a *novum* of our times is the awareness that the extinction of the *human* species lies in the realm of possibility, and perhaps even of probability.

mortal and do become extinct). This is true at every level: death means the death of an individual, but this 'individual' can be a single-celled virus within our body, or the species of mammoths, or even our own species.[65] The individual could also be the drop of water or the water of the drop. . . .

We experience death as the death of a part of ourselves that is smaller than the totality of our being: the death of a finger, an arm, an ideal, a love, a belief. We cannot experience the death of all our being.[66] It is only when the *aham* as *ātman* emerges and the *ego* is reduced to but a part of ourselves that the *ego* can die. Without the realization of the *ātman*, the death of the *ego* would amount to suicide, since its death would mean the absolute death of the human individual.[67]

To express this in psychological terms, we could examine the modern preoccupation with death. The many studies on this subject provide ample proof of this obsession on the part of Western Man, the intellectuals in particular.[68] With the rare exception of a very few monographs on a non-Western culture, however, Man is treated in all these studies as the drop, not as the water; as an individual in itself and not as the bearer of life. Man thinks of himself as the owner of life rather than its agent and, in a certain sense, its steward.[69] Man is threated above all an individual and death means *its* (individual) death. In this framework, philosophical reflection regarding death cannot go beyond psychology, since the ultimate subject is the human *psychê*. Perhaps the ancient greek distinction between *bios* and *zôê*, i.e. between individual (biological) life and essential (zoological) life would be helpful here.[70] Is it possible to separate these two 'kinds' of life? When the individual *bios* discovers the *zôê* of totality, it does not lose its personality.[71]

66. Whence the importance of the symbolism of the heart in so many cultures and religions. As the person's center, the heart *cannot* die without all of reality disappearing.

67. Another example would be the famous (or infamous) distinction between 'Welt-bejahenden und -verneinenden Religionen.' The question is whether one is denying a world that is positive (real) or negative (unreal).

68. Cf. the 23 page bibliography of J. Wittkowski in his *Tod und Sterben. Ergebnisse der Thanatopsychologie* (UTB; 766), Heidelberg: Quelle und Meyer, 1978. As a *curiosum*, we note that although the first part of the book is entitled, "Angst vor Tod und Sterben" and each page has five to ten footnotes, nowhere do we find the name of M. Heidegger. Obviously, Wittkowski's book deals only with psychology.

69. Cf. the 3,806 titles on this subject in *Death, Grief and Bereavement. A Bibliography (1845-1975)*, compiled by R. Fulton, New York: Arno Press, 1977.

70. Cf. K. Kerényi in his "Introduction" to: *Dionysos*, New Haven: Bollingen Series, 1977.

71. It is good to recall that the *aiona zôê* of the Evangelist is not a perdurable *bios*; cf. *Jn* IV, 14; XII, 50; XVII, 2-3.

72. Cf. F.E. Reynolds, E.H. Waugh, *Religious Encounters with Death: Insights from History and Anthropology of Religion*, University Park and London: Pennsylvania State University Press, 1977.

73. Cf. R. Panikkar, 'Die Zeit des Todes, der Tod der Zeit: Eine indische Betrachtung,' in: *Der Tod in den Weltkulturen und Weltreligionen* (hg. C. von Barloewen) Frankfurt: Insel, 2000, pp. 340-53, where I introduce two basic attitudes toward death: life in front of us ('Sein zum Tode') and life behind us (the more one lives, the further away from death one goes).

Third, we find ourselves today in an intercultural world. We should not examine any problem from only one perspective or be satisfied by an answer given by a single culture.[72]

It is clear that the people of the world do not understand or 'live' death in the same way.[73] Moreover, the double fact that thousands of humans die everyday of unnatural deaths and that all of humanity faces the very real possibility of its collective death makes the problem even more acute. As we have said, the study of death has today become almost fashionable; however, the roots of our concern lie deeper than the current philosophical interest, which for the most part owes its existence to the repression of consciousness of death in the modern West.[74] It may be that our acute awareness also has something to do with the unconscious instinct of a humanity on the way to extinction.

An intercultural problem already mentioned can serve as an example of what I am saying here. Does the historical death of Man on this planet mean the absolute end of conscious life? It certainly does for those who 'live' in the myth of history; but it does not for those who 'live' in the myth of another cosmology. It is not easy to understand one myth if we cannot transcend our own myth. We can, however, agree that much of the contemporary world is preoccupied with the possibility of just such a cataclysm while others, hardly aware of the decline of the human race, are much less affected by it. If human life is a purely anthropological phenomenon, then a major nuclear catastrophe would mean the end of life. If, on the other hand, human life is part of a cosmic phenomenon, then a large-scale nuclear disaster on our planet would only be yet another in a series of explosions among the stars. The life we bear will continue in some other form on some other 'world.' With this in mind, it may be possible to instill a drop of cosmic hope in the first group and encourage a little historical responsibility in the second. Perhaps the metaphor of the drop has something to contribute here even if we do not believe in the myth of the other. Can we not transmythicize it into a more familiar symbol?[75]

A *fourth* lesson, is that the value of this metaphor is very limited in our modern world. Clearly, the idea of individual immortality in some 'other world' is problematic for many today, but the heading towards an earthly paradise is even more doubtful. On the other hand, belief in immortality is not only a source of consolation for some people, it also inspires heroic virtue. Furthermore, the secular alternative can itself be a noble ideal and trigger a complete devotion. In both cases, the *ego* is surpassed and the person is realized without requiring the immortality of the individual.

Likewise, if one posits an immortality that goes beyond the individual, whether on a vertical or on a horizontal plane, similar difficulties arise for modern Man. Nevertheless,

74. As an example, cf. R. Huntington, P. Metcalf, *Celebrations of Death. The Anthropology of Mortuary Ritual,* New York: Cambridge University Press, 1979.

75. Cf. R. Panikkar, 'La demitologizzazione nell'incontro tra Cristianesimo e Induismo,' in: *Il problema della demitizzazione,* ed. E. Castelli, Padova: Cedam, 1961.

belief in the immortality or even the divinity of one's most intimate core can lead to the realization of the person.

Are these two approaches mutually exclusive or could they be complementary? Some would say that we are mortal drops of immortal water. Others would ask if we cannot achieve a mutual fecundation in such a way that we not only aspire to immortality as water, but attain it as drop; and not only as a drop metamorphosed in another world but one retaining the living membrane of a drop of this earth.[76] Could not *bios* and *zôê* belong together? We are back where we started. . . .

Fifth, and last, a lesson in humility, having in mind its etymological connotation of harmony and union with nature. In our metaphor, the life of Man is homologous both to the drop and to the water, that is to say, to natural phenomena. Human destiny has been compared to at least one phase of the natural cycle. Not wishing to abuse the metaphor, we have not suggested further comparisons by evoking the rising of the ocean's water to heaven and descent of the clouds over the earth in the form of rain drops that feed the fields and rivers. . . . I would only say this: the destiny of human life is linked to the destiny of natural life. Once we reach our 'ocean,' who can say that we are not the essence or life of this ocean? More simply: we participate in the destiny of the water of the entire universe. Man, the World and the Divine share a common destiny and they are linked by a fundamental *religio*, the constitutive *dharma* of the universe.

76. A typical example of a modern Christian is the lovely work of J.M. Ballarín: *Pregària al vent*, Montserrat: Publicationes de l'Abadia, 2nd edn., 1979. "Vull dir que ni al cel no ens desfarem com un bolado místic en l'oceā de l'infinit" (p. 82). The identical image of the ocean!

Contributors

DR. KARL BAIER: born in 1954 in Landshut (Bavaria); studied ethnology and philosophy at the University of Vienna (Austria); graduation with a philosophical dissertation on Romano Guardini (1987). Afterwards study of catholic theology (M.A. 1993 in Religious Studies), which he completed with a work on the 'Rezeption' of Yoga in the West, from the Greek Antique to the 1930s of the twentieth century (published in 1998). From 1987 assistant at the Institute of Christian Philosophy, University of Vienna; since 1999 Assistant Professor. 1992 Yoga teacher Diploma at the Ramamani Iyengar Memorial Yoga Institute in Pune. In 1997 he taught a Postgraduate Course on "Main Trends in Phenomenology" at Jnana-Deepa Vidyapeeth (Institute of Philosophy and Religion) in Pune. Currently he is the academic director of the new Postgraduate Masters-Course "Spiritual Theology and Interreligious Process" (University Salzburg/Bildungshaus St. Virgil Salzburg). Since 2004 he is member of the editorial board of *Polylog*, a Journal for Intercultural Philosophy. An expert for German mysticism (especially Meister Eckhart, Nicolaus Cusanus), phenomenology and the history of Yoga in the West, Yoga teacher and lover of contemporary music (e.g., John Cage), he lives in Vienna. [**address**: Universitaet Wien, Institut für christliche Philosophie, Freyung 6/2/8, 1010 Wien, Austria, **E-mail**: <karl.baier@univie.ac.at>]

Selected publications: *Yoga auf dem Weg nach Westen. Beiträge zur Rezeptionsgeschichte*, Würzburg, 1998; *Wort-Ereignis Stille. Schöpfung bei Meister Eckhart*, Texing, 1997; *Ortschaften des Erwachens*, Obergrafendorf, 2000.

DR. MICHAEL VON BRÜCK: born in 1949 in Dresden (Germany); studied Evangelical Theology, Comparative Linguistics and Sanskrit at the University of Rostock, 1975 graduation (Dr. theol.) in Systematic Theology with a dissertation on "Possibilities and Limits of a Theology of Religions (Karl Barth and Rudolf Otto)." 1976-77 stipend of the 'World Council of Churches' in India and Japan; study of Indian Philosophy and Religion at the University of Madras (Prof. T.M.P. Mahadevan), also Yoga at Krishnamacharya Yoga Mandiram (Madras) as well as Zen-Buddhism in Japan (Tenryu-ji under Prof. Takashi Hirata Roshi and Prof. Keiji Nishitani and others). 1978 lectures at Faculty of Philosophy, University of Groningen *et al.*; 1979 ordination (pastor of Ev.-luth. Church of Saxony); 1982 habilitation in Systematic Theology ("Advaita and Trinity. Indian and Christian Experience of God in Dialogue of Religions"). 1981-85 Visiting Professor at Gurukul Lutheran Theological College in Madras. 1980 Lectures at the Centre for the Study of World Religions in Harvard (USA), at University of California Santa Barbara *et al.*; 1983-85 study of Mahayana Buddhism at Gaden Mahayana Monastic University (Karnataka) and Dharamsala, and of Tibetan Buddhism in Ladakh, Zanskar, and Sikkim. 1983-1984 Visiting Professor at University of Hawaii. 1985-87 assistant at Ecumenical Institute, University of Tübingen (Dir. Hans Küng). 1988-91 Professor of Comparative Religion, University of Regensburg. Since 1991 Professor (Chair) of Religious Studies, Theological

Faculty, University of Munich, 1997-99 Dean. Since 1998 Chair of the Interdisciplinary Religious Studies Program at University of Munich. [**address:** Universität München - FB Evangelische Theologie, Institut für Missions- und Religionswissenschaft, Schellingstraße 3/IV, 80799 München, Germany, **E-mail:** <MvBrueck@lrz.uni-muenchen.de>]

Selected publications: *Einheit der Wirklichkeit*, Munich 1986 (transl. *The Unity of reality. God, God-Experience and Meditation in the Hindu-Christian Dialogue*, New York 1991); *Denn wir sind Menschen voller Hoffnung. Gespräche mit dem XIV. Dalai Lama*, Munich 1988; *Weisheit der Leere. Sutra-Texte des indischen Mahayana-Buddhismus* (transl., commentary), Zurich 1989; *Bhagavad Gita* (transl., commentary), Munich 1993; (with Whalen Lai) *Buddhismus und Christentum. Geschichte, Konfrontation, Dialog*, Munich 1997 (transl. *Christianity and Buddhism*, Maryknoll, 2001); *Buddhismus. Grundlagen, Geschichte, Praxis*, Gütersloh, 1998; *Religion und Politik im Tibetischen Buddhismus*, Munich, 1999; *Wie können wir leben? Religion und Spiritualität in einer Welt ohne Maß*, Munich, 2002; *Zen. Geschichte und Praxis*, Munich, 2004.

D<small>R</small>. A<small>RINDAM</small> C<small>HAKRABARTI</small>: completed his B.A. in 1976 and M.A. in Philosophy (specialization in Formal and Philosophical Logic) in 1978 from Calcutta University; took his doctorate from Oxford University in 1982 with the dissertation "Empty Terms and Fictional Discourse" (supervisors: Sir Peter Strawson, Michael Dummett). Having been educated as an analytic philosopher of language at Oxford, he spent several years studying traditional Indian logic (Navya-Nyāya) and metaphysics. 1984-86 Lecturer at the Department of Philosophy, University of Calcutta, 1986-88 Associate Professor at 'The Asiatic Society of Calcutta,' 1988-90 Post-Doctoral Jacobson Fellow and Tutor at University College London, 1990-92 Visiting Assistant Professor at Department of Philosophy, University of Washington, Seattle, 1990-93 Adjunct Professor at Department of History and Philosophy, Montana State University, Bozeman, MT, 1993-98 Professor at the Department of Philosophy, University of Delhi. Since 1997 he is Professor at the Department of Philosophy, University of Hawai'i at Manoa, from 2000 to 2002 Director of the Center for South Asian Studies. He has held the Spalding Visiting Fellowship at Wolfson Co Oxford, the Institute of Advanced Study in the Humanities Fellowship at Edinburgh University, and he was Visiting Fellow at Trinity College, Cambridge. Alongside his academic career, he lived as a Hindu *sādhu* (Ramanuja order) for twelve years and was the cook of the *āśrama* in Varanasi (see, e.g., his lectures on "Good Food: Ethics of Eating" and "Eating Beauty: Aesthetics of Eating" in July 1998, University of Hawai'i). He worked as a philosophical translator from English to Sanskrit and Sanskrit to English for the encounter of Indian *paṇḍits* and Western philosophers (*Samvad: A Dialogue between two traditions*, ed. by Daya Krishna/Mukund Lath/M. P. Rege, Delhi, 1991). Since 1996 he has studied texts of non-dualistic Kashmir Śaivism, especially Pratyabhijña-School. In 2003 October he delivered the three MM. Gopinath Memorial Lectures at BHU on Abhinavagupta's Metaphysics of Consciousness. Currently he works on the integration of the Western analytical philosophy and the tradition of Indian logic, and on following book projects: *Moral Psychology. Normative and Epistemic Dimensions of Emotions and Feelings; The Name of God and The Speech Act of Prayer.* [**address:** University of Hawai'i, Department of Philosophy, 2530 Dole Street, Sakamaki Hall C-305, Honolulu, HI 96822, **E-mail:** <arindam@hawaii.edu>]

Selected publications: *Mane Bishoyok Darshonik Shamoshya*, Calcutta, 1982 (in Bengali; theme: Theory of Meaning); ed. (with Bimal Matilal): *Knowing from Words* (synthese Library Series) Dordrecht/Boston 1993; ed.: *Epistemology, Meaning and Metaphysics After Matilal*, Shimla (Anthology); *Denying Existence* (Synthese Library Series), Dordrecht/Boston, 1997; ed. (with Vrinda Dalmiya): *Blackwell's Source Book of Indian Philosophy*, London, 2005; *Universals, Concepts, and Qualities: New Essays on the Meaning of Predicates*, London, 2005; (with Roy Perrett) *Introduction to Indian Philosophy*, Cambridge, 2006.

PT. HEMENDRA NATH CHAKRAVARTY: born in 1918 in the village Kalihati, district Mymensingh (now in Bangladesh), as the son of Tarka Nath Chakravarty, an Āyurvedic physician. His family was initiated in the Kaulika tradition and were worshippers of Dakṣiṇa Kālī (right hand tantrism). Matriculated at the village high school in 1935; studied Sanskrit for one year, afterwards (1937-38) Sāṁkhya at Balānanda Brahmacharyasram in Deoghar (Bihar). In Aug. 1939 he came to Varanasi, where his uncle had a house, and studied Nyāya under Pt. Vibhuti Bibushana Bhattacharya, with the purpose to study afterwards Āyurvedic texts properly. Graduation in 1944 (Nyāya Tīrtha) and 1945 (Tarka Tīrtha) from Calcutta Government Sanskrit Association. Afterwards he worked as a teacher in a junior high school. He studied English privately (1947 Intermediate, 1950 B.A.) to find a better job. In 1954 appointed at Bengali Tola Intermediate College in Varanasi as a teacher of English, history and political science. In 1958 he met the famous pandit and Yogī Mahāmahopādhyāya Gopinath Kaviraj and began to study with him, beginning with Kṣemarāja's *Pratyabhijñāhṛdaya* and Patañjali's *Yogasūtras*. He remained closely associated with Kaviraj till his death in 1976 and was his right hand especially concerning the numerous publications of Gopinath Kaviraj. Like Kaviraj himself he also was related to the Ashram of Anandamayi Ma in Varanasi. He edited the sayings of Anandamayi Ma together with the commentary by G. Kaviraj in Bengali. After his retirement in 1978 at the college he taught at the Kanyapeeth of the Ashram, mainly English. From 1987 to 1995 he was Chief *paṇḍit* in the *Kalātattvakośa* project of Indira Gandhi National Centre for the Arts, Varanasi Branch, at this time directed by Dr. Bettina Bäumer (articles on *bīja*, *bindu*, *nābhi*, *cakra*, etc.). Beginning in 1972 till now he teaches students and works with scholars from abroad (in the past, e.g., with A.M. Breuinin, M. Dyczkowski, L.M. Finn, D.P. Lawrence, J. Gengnagel, J. Dupuche, A. Wilke), mainly in the field of Hindu Tantrism, especially non-dualistic Kashmir Śaivism. At present he is working on a revision of his English translation of Abhinavagupta's *Tantrasāra*, which will be published from Rudra-Press (USA). In 2003 he received the first Thakur Jaideva Singh Award for merit in the field of studying and teaching non-dualistic Kashmir Śaivism from Trika Interreligious Trust (Varanasi). Lives in Varanasi. [address: Plot No. 29, Vijay Nagar Colony, Bhelupur, Varanasi - 221005, India, E-mail: <ananyarup@satyam.net.in>]

Selected publications: *Tantrasāra by Abhinava Guptācārya* [with Hindi Translation, Notes and introduction in English] Varanasi 1986; ed. (with Jaideva Singh/G. Mukhopadhyaya: *Navonmeṣa. M.M. Gopinath Kaviraj Smṛti Granth* (2 vols.), Varanasi 1987.

DR. ANJAN CHAKRAVERTY: born in 1958 in Varanasi; B.A. (1978) and M.A. (1981) in Painting; PhD. with a dissertation on "Landscapes in Indian Miniature Painting" (1989, Banaras Hindu

University). Associate Professor, Faculty of Visual Arts, BHU. He shares his time between teaching art history and painting. Lives in Varanasi. [**address:** 11-B, Kamaccha, Varanasi - 221010, India]

Selected publications: *Indian Miniature Painting*, Delhi, 1996; *Sacred Buddhist Painting*, Delhi, 1998; *Lithographs of 19th Century Banaras*, Shantiniketan, 2000; *Ali Hasan: the Master Naqshaband of Banaras Brocades*, Delhi, 2002.

DR. SADANANDA DAS: born in 1969 in Tulasipur (Orissa); studied Sanskrit at University of Poona (M.A. 1991); PhD. in Sanskrit in 2002 with a thesis on "Vedic Theories of Creation with special reference to the Atharvaveda" (supervisor: Professor V.N. Jha). From 1993 to 1996 he worked as a Junior Research Fellow at Indira Gandhi National Centre for the Arts, Varanasi Branch; in 1997 he was appointed as a Research Assistant in Alice Boner Institute Varanasi, at this time directed by Dr. Bettina Bäumer, since 2003 as a Research Officer. In this function he has assisted her in editing *Śilparatnakośa: A Glossary of Orissan Temple Architecture* (1994), *Kalātattvakośa* (1996), and *Vāstusūtra Upaniṣad* (4th edn. 2000). At present he is editing and translating *Saudhikāgama*, an unpublished Sanskrit Text on Temple Architecture, Iconography and Town Planning from Orissa. His specialization is the teaching of Spoken Sanskrit; he taught numerous courses in India, from 1986 to 1989 under the auspices of Lokabhasha Prachara Samiti (Puri). Since 1996 he taught several courses on spoken Sanskrit and Sanskrit Language for beginners in Europe, e.g., University of Tübingen (Germany) in 1996, University of Bern (Switzerland) from October 1997 to June 1998, University of Lausanne (Switzerland) in 1999, 2000 and 2004, University of Florence (Italy) in 2003 (Advanced Summer School). Since 2000 he teaches the annual Summer School on Spoken Sanskrit at South Asia Institute, University of Heidelberg (Germany). Since spring 2005 he is Lecturer in Sanskrit at University of Leipzig, Germany. [**address:** N-1/66, F-12, Samneghat, Nagawa, Varanasi - 221005, India, **E-mail:** <sadanandadas@sify.com>]

Selected publications: *Subhāṣita-Mañjarī* [a Selection of hundred Subhāṣitas from Sanskrit Literature with English translation], Allahabad, 2001; rev. edn. 2004; ed. (with B. Bäumer/ R.P. Das), *Śilpa Prakāśa. Medieval Orissan Sanskrit Text on Temple Architecture*, rev. edn. Delhi, 2005.

DR. DEVANGANA DESAI: born in Mumbai; M.A. in Sociology (1979), PhD. 1970, University of Mumbai (published: *Erotic Sculpture of India. A Socio-Cultural Study*, 1975; 2nd edn. Delhi 1985). 1979-81 Homi Bhabha Fellowship, 1983-91 Chairperson of the Museum Society of Bombay. She is one of the foremost art historians in India and the leading expert for the famous temples in Khajurāho (see, e.g., her article 'Khajuraho' for the *Encyclopaedia Britannica*, edn. 2001). Since 1999 Vice-President of the Asiatic Society of Mumbai, editor of its Journal since 1992. Since 1999 she is Visiting Professor at University of Mumbai (Post-Graduate Diploma in Indian Aesthetics), since 2002 member of the Indian Council of Historical Research, Delhi. Editor of 'Monumental Legacy Series' on the World Heritage Sites in Indian (Oxford University Press). She was invited for lectures at Cleveland Museum of Art, University of Chicago, University of Vermont, the Asian Art Museum San Francisco, University of Sussex

at Brighton (UK), British Museum London, University of Berkeley, Rubin Museum of Art in New York. For her contribution to Indian Art, she was awarded the Silver Medal of the Asiatic Society of Bombay, and the prestigious Dadabhai Naoroji Memorial Prize. Currently she is researching on "Khajuraho Sculptures in Museums (remains of Lost Temples of Khajuraho)" for the Project for Indian Cultural Studies, Franco-Indian Research, Mumbai. Lives in Mumbai. [**address**: Shanti 1/30, 19 Pedder Road, Mumbai - 400026, India, **E-mail**: <devangana@vsnl.com>]

Selected publications: ed., *Pandit Bhagvanlal Indraji Memorial Volume* (Journal of the Asiatic Society of Bombay 1985); *The Religious Imagery of Khajuraho*, Mumbai, 1996; ed. (with V.M. Kulkarni): H.D. Velankar, Compiler. *A Descriptive Catalogue of Sanskrit and Prakrit Manuscripts in the Collection of the Asiatic Society of Bombay. Pandit Bhagvanlal Indraji Memorial Volume*, Bombay, 2nd edn. 1998; *Khajuraho* (Monumental Legacy) New Delhi, 2000.

PRABHA DEVI: born in 1924 in Srinagar. Her eldest brother, Jawahar Lal was married to Gunavati, the elder sister of Swami Lakshman Joo, the master of nondualistic Kashmir Śaivism; as a child she was often taken to him. At the age of ten years Swami Lakshman Joo taught her many verses of Abhinavagupta's *Tantrāloka*. She studied Hindi at the Punjab University and in Jammu, also Sanskrit and Hindi with her brother-in-law Professor Jialal Kaul. A year after the death of her young husband, Moti Lal Mattoo, in 1944 she decided to shift to the Sharika ashram of Swami Lakshman Joo in Ishbar (Srinagar), where she lived till 1962, afterwards in the new Ishwar Ashram, 1.5 km below the old Ashram, together with Sharika Devi, her cousin (the daughter of her brother Jawahar lal). Prabha Devi became a disciple of Swami Lakshman Joo who taught her several scriptures; she translated many texts and their commentaries into Hindi, e.g., *Kramanayapradīpikā* (1959); *Parāpraveśikā* (1973), *Sāmbapañcāśikā* (1976), *Paramārthasāra* (1977), *Pañcastavī* (1987) and Abhinavagupta's commentary on the *Bhagavad-Gītā* (1987). Swami Lakshman Joo lived in the *āśrama* together only with Sharika Devi, Prabha Devi and a helper, Gopinath. At the end of the 1990s almost all the Hindus migrated from Kashmir due to cross-border terrorism. She continues to live in the *āśrama* after the death of Sharika Devi and Swami Lakshman Joo in 1991 (information provided by Śri Pramod Sharma, Pinjore). [**address**: C/o Mr. Sudhir Sopore, 584 Sector 14, Faridabad, Haryana, India]

DR. FRANCIS X. D'SA: born in 1936 in Gokak Falls, Belgaum district, Maharashtra (India); entered the Society of Jesus in 1953; studied philosophy from 1957-60 in Pune at the *Pontificium Athenaeum* (Jnana-Deepa Vidyapeeth, Pontifical Institute of Philosophy and Religion). From 1964-68 he studied Catholic Theology at the University of Innsbruck (Austria); 1973 graduation (Dr. Phil.) at the University of Vienna; since 1973 working as a lecturer in Indian Religions and Theology of Religion at the Jnana-Deepa Vidyapeeth, Pune. He founded the Institute for the Study of Religion for research in Hindu traditions and promotion of interreligious dialogue in Pune. From 1975 regular visiting professor at the University of Innsbruck (Austria) and at the University of Fribourg (Switzerland). Guest professor in cross-cultural theology at the University of Frankfurt (Germany) and at the University of Salzburg (Austria). In India he has lectured among others at the Radakrishnan Institute for Advanced Study in

Philosophy (University of Madras) and *Satya Nilayam*, Institute for Philosophy and Culture (Chennai). Since 2003 he is Visiting Professor of Missiology and Dialogue of Religions at University of Würzburg (Germany). He founded several social projects in India, e.g., MAHER for the education and rehabilitation of abused women and their children. [**address:** Institute for the Study of Religion, Pune - 411014, India, **E-mail:** <dsaisr@giaspn01.vsnl.net.in>]

Selected publications: *Einführung in die Bhagawadgita*, Darmstadt, 1977; *Shabdapramanyam in Shabara and Kumarila. Towards a Study of the Mimamsa Experience of Language*, Vienna, 1980; *Gott, der Dreieine und All-Ganze. Vorwort zur Begegnung zwischen Christentum und Hinduismus*, Düsseldorf, 1987 (Italian translation: Brescia 1996); ed. (with R. Mesquita): *Hermeneutics of Encounter. Essays in Honour of Gerhard Oberhammer on the Occasion of his 65th Birthday*, Vienna, 1994; *The Song of the Wind. The Cosmic Vision of Jesus of Nazareth*, Mumbai, 1999; ed.: *The Dharma of Jesus. Interdisciplinary Essays in Memory of George M. Soares-Prabhu, S.J.*, Gujarat Sahitya Prakash, 1997; ed. (with I. Padinjarekuttu/J. Parappally): *The World as Sacrament. Interdisciplinary Bridge-Building of the Sacred and the Secular. Essays in Honour of Josef Neuner on the occasion of his 90ᵗʰ Birthday*, Pune, 1998; ed.: *Theology of Liberation: An Indian Biblical Perspective. Collected Writings of George M. Soares-Prabhu, S.J.*, vol. 4, Pune, 2001; *The Dharma of Jesus. Selections from George M. Soares-Prabhu's Writings*, Maryknoll, NY, 2003.

REV. DR. JOHN R. DUPUCHE: born in 1940 in Melbourne (Australia), to French parents who had come to Australia on business and who were prevented from returning to France by the outbreak of the Second World War. On leaving secondary school he entered the Jesuit order and completed an undergraduate degree in Scholastic Philosophy. Later, at Melbourne University he obtained an Honours Degree in French and German and a Masters degree in French. He completed a double degree in theology at Catholic Theological College and at the Melbourne College of Divinity; was ordained priest in 1974. He taught theology for many years at what is now the Australian Catholic University where he was head of the Religious Education Department. Doctorate in Sanskrit with a dissertation on chapter 29 of Abhinavagupta's *Tantrāloka*. Member of the Ecumenical and Interfaith Commission of the Archdiocese of Melbourne and of the Australian Commission of Monastic Interreligious Dialogue (MID). Chair of the Victorian Council of Churches Faith and Order Commission. Honorary Research Associate at the Centre for Studies in Religion and Theology at Monash University. He has recently established an interfaith household together with Swami Sannyasananda, a *yogī* of the Satyananda lineage, and the Venerable Lobsang Tendar, a Buddhist Gyuto monk from Tibet. Lives in Melbourne. [**address:** 542 Balcombe Road, Black Rock 3193, Australia, **E-mail:** <jrdupuche@pacific.net.au>]

Selected publication: *Abhinavagupta. The Kula Ritual As Elaborated in Chapter 29 of the Tantrāloka*, Delhi, 2003.

DR. MARK DYCZKOWSKI: born in London in 1951. He came to India in 1969. After completing his B.A. and M.A. degrees in Indian Philosophy and Religion at Banaras Hindu University, he returned to England in 1975 for his doctoral work which he carried out in the University of Oxford (supervisor: Richard Gombrich). He returned to Varanasi in 1979 as a

Commonwealth Scholar, for a second doctorate from Banaras Hindu University. In 1985 he joined Sampurnananda Sanskrit University (Varanasi) as a scholar for the degree of Vacaspati (D. Lit) and was affiliated with it for a project to edit *Manthānabhairavatantra*. He published a trilogy of books to the Spanda School of Kashmir Śaivism: *The Doctrine of Vibration* (1987), *The Aphorisms of Śiva* (1992) and *The Stanzas on Vibration* (1992). Since 1995 he is affiliated with Indira Gandhi National Center for the Arts. He is one of the leading experts in the field of Hindu Tantrism, especially for the earliest textual basis to have survived of the Trika system. Besides his academic work, he is an excellent sitar-player, trained in north Indian classical music by Omir Bhattacarya, a student of Ashik Ali Khan, and Dr. Gangrade, former head of the Music College of Banaras Hindu University. Since 1994 he has learned from the renowned sitarist Buddhaditya Mukherjee. Lives in Varanasi. [**address:** B-14/ 65, Narad Ghat, Varanasi - 221001, India, **E-mail**: <markvns@satyam.net.in>]

Selected publications: *The Doctrine of Vibration. An Analysis of the Doctrines and Practices of Kashmir Śaivism*, Albany, 1987, Indian edn. Delhi, 1989; *The Canon of the Śaivāgama and the Kubjikā Tantras of the Western Kaula Tradition*, Albany, 1988, Indian edn. Delhi, 1989; *The Aphorisms of Śiva: The Śiva Sūtra with Bhāskara's Commentary*, Albany, 1992, Indian edn. Varanasi, 1998; *The Stanzas on Vibration: The Spandakārikā with four Commentaries*, Albany, 1992, Indian edn. Varanasi, 1994; *A Journey in the World of the Tantras*, Varanasi, 2004.

DR. JOHANN FIGL: born in 1945; he studied at the universities of Innsbruck (M.A. theol.), Tübingen (Dr. theol.) and Vienna (Dr. Phil.) and worked as a lecturer at the Theological Highschool in Linz (Austria); habilitation at the University Vienna in 1983. 1995-99 Dean of the Theological Faculty, University of Vienna. At present Head of the Institute of Religious Studies, University of Vienna. Founding President of the Austrian Society of Religious Studies. Main fields of research: religions under the condition of modernity, atheism (especially Friedrich Nietzsche), secularism, new religions and new religious movements, Buddhism in the west, history and theory of Religious Studies. [**address:** University of Vienna, Institut für Religionswissenschaft, Freyung 6, 1010 Wien, Austria, **E-mail**: <johann.figl.@univie.ac.at.>]

Selected publications: *Die Mitte der Religionen. Idee und Praxis universalreligiöser Bewegungen*, Darmstadt, 1993; ed. (with H.-D. Klein): *Der Begriff der Seele in der Religionswissenschaft*, Würzburg, 2002; ed.: *Handbuch Religionswissenschaft. Religionen und ihre zentrale Themen*, Innsbruck/Göttingen, 2003.

DR. ANNAKUTTY V.K. FINDEIS: studied at the Centre of Advanced Studies in Philosophy, Banaras Hindu University (M.A. Philosophy, 1970) and from 1975-79 German Studies at the University of Salzburg (Austria) and Indology at University of Vienna. PhD. in Modern German Literature (*Das Unausgesprochene und das Unaussprechliche. Zum Problem des Schweigens in den Gedichten von Paul Celan*, University of Salzburg, 1979). 1973-79 appointed Lecturer in German at Banaras Hindu University, Arts Faculty; 1979-88 Reader in German, Department of Germanistic Studies; 1988-93 Professor and Head of the Department of Foreign Languages, University of Mumbai; 1993-2001 Professor and Head of the Department of German/Russia, University of Mumbai. Presently Visiting Professor, Department of German, University of

Mumbai; Visiting Professor, Indological Department, University Bonn. She is member of the International Association of Intercultural Philosophy and of the Philosophical Society of Mumbai, since 2002 member of the International Hermann Hesse-Society. Since 1995 she is member of the Executive Committee of the International Organization of German Studies. She is a scholar as well as a poet; her poems in German are published in "Im Tempel der Worte" (Bielefeld, 1984). Lives in Mumbai. [**address:** Readers Quarters 12-C-1, Vidyanagari (Kalina) Campus, University of Mumbai, Santacruz East, Mumbai - 400098, India, **E-mail**: <annakuttyf@hotmail.com>]

Selected publications: Grimms Märchen. Ausgewählte Märchen in Hindi, Varanasi, 1985/86: (ed.) *Interkulturelle Literaturwissenschaft* (Bombay Studien; 1) Bielefeld, 1991.

DR. EBERHARD FISCHER: born in 1941 in Berlin, University Studies at Tübingen, Munich and Basel, PhD. 1965 in Cultural Anthropology; 1965/66 teaching documentation of crafts at National Institute of Design, Ahmedabad; 1966/68 assistant University of Frankfurt a.M. and University of Heidelberg; 1968/71 Representative in India, South Asia Institute, University of Heidelberg, collaboration with Calico Museum of Textiles, Ahmedabad, and Tribal Research and Training Institute, Ahmedabad; 1972-98 Director of Museum Rietberg Zurich; since 1998 till now Senior Director and Curator of Indian Art at Museum Rietberg Zurich. Honorary Secretary General of Swiss Liechtenstein Foundation for Archaeological Research Abroad (SLSA) and President Alice Boner Foundation in Zurich; Publisher of *Artibus Asiae*, an international journal for Asian art. [**address:** Kurfirstenstrasse 1, 8002 Zürich, Switzerland, **E-mail**: <e.b.fischer@bluewin.ch>]

Selected publications: (with Haku Shah) *Rural Craftsmen and their Work*, Ahmedabad, 1970; (with Alfred Bühler) *Patola of Gujarat* (two vols.), Basel, 1979; (with Jyotindra Jain) Jaina Iconography, vol. 1 and 2, Leiden, 1977; ed. (with Dinanath Pathy and Sitakant Mahapatra) *Orissa. Art and Culture* (in German), Zurich, 1980; (with Jyotindra Jain and Haku Shah) *Temple-cloths for Mothergoddesses in India* (in German), Zurich, 1982; (with Hans Himmelheber) *The Art of the Dan*, Zurich, 1984; (with Lorenz Homberger) *The Art of the Guro* (in German), Zurich, 1985; (with B. N. Goswamy) *Pahari Masters. Court Painters of Northern India*, Zurich, 1992; (with Dinanath Pathy) *Murals for Goddesses and Gods. The Tradition of Osakothi Ritual Paintings in Orissa*, Zurich and New Delhi, 1996; (with V. C. Ohri and Vijay Sharma) The Wooden Temple of Devi-Kothi in Chamba District, H.P., Zurich, 2003.

DR. ERNST FÜRLINGER: born in 1962 in Linz (Austria); studied catholic theology at the University of Salzburg; M.A. in 1991. Since 1991 Co-Editor of the series "solidarisch leben" (to live in solidarity), published by Pustet Salzburg (e.g., German edition of R. Panikkar's *The Cosmotheandric Experience* and of H. Daly's *Beyond Growth: The Economics of Sustainable Development*). From 1991 to 2001 he was appointed director of studies at Bildungshaus St. Virgil Salzburg, an institution for education of adults, responsible for the departments Political Education and Interreligious Dialogue (e.g., one-year Courses on Buddhism, Hinduism, Islam, cooperation with Socially Engaged Buddhism). In 1995 Co-Founder of the Austrian Anti-Poverty Network; representing the network, he received the Bruno Kreisky-Award

for Human Rights in 1995. In 1999 awarded by the Government of Salzburg for education of adults. Since 2001 he has lived in Varanasi, preparing his PhD. thesis (University of Vienna, Religious Studies) in the field of non-dualistic Kashmir Śaivism (supervisor: Dr. Bettina Bäumer). 2003 Certificate Course in Sanskrit (Faculty of Sanskrit Learning and Theology, Banaras Hindu University). Since 2002 he has studied with Pt. H. N. Chakravarty. Since 2005 Research Affiliate, Special Centre for Sanskrit Studies, JNU, New Delhi. Lives in Delhi. [**address**: 92-A/3, 2nd Floor, Prateek Market, Munirka, New Delhi - 110 067, **E-mail:** <ernst_fuerlinger@web.de>]

Selected publications: ed. (with F. Nuscheler): *Weniger Menschen durch weniger Armut? Bevölkerungswachstum, globale Krise und ethische Herausforderung*, Salzburg, 1994; ed. (with H. Embacher/J. Mautner): *Salzburg : Blicke*, Salzburg, 1999; ed., tr.: *Bettina Bäumer: Trika. Grundthemen des kaschmirischen Śivaismus*, Innsbruck, 2003, 2nd edn. 2004.

Dr. Alois Maria Haas: born in 1934 in Zurich, studied German studies, philosophy and history in Zürich, Berlin, Paris, München; 1963 graduation (Dr. Phil.) in Zürich. 1969 habilitation in German studies, University of Zurich. 1969-71 Associate Professor at McGill University in Montreal. From 1971 till 1999 professor of the history of German literature from the beginnings till 1700, University of Zurich; 1978 Dr. theol. *honoris causa* University Freiburg, i.e. 1988/89 Fellow at the Wissenschaftskolleg Berlin (Center of Advanced Study). 1989-2000 President of the Swiss Paracelsus Society, since 2000 Honorary President. 1979 and 1996 awarded by the regional Government and the city of Zurich. President of the Hans Urs von Balthasar Foundation. He is one of the leading experts in the field of German mysticism, especially Meister Eckhart, and of the theory of mysticism. [**address**: Bergstrasse 11, 8142 Uitikon Waldegg, Switzerland, **E-mail**: <alois.haas@solnet.ch>]

Selected publications: *Nim din selbes war. Studien zur Lehre von der Selbsterkenntnis bei Meister Eckhart, Johannes Tauler und Heinrich Seuse*, Freiburg (Switzerland), 1971; *Meister Eckhart als normative Gestalt geistlichen Lebens*, 1979, rev. edn. Einsiedeln, 1995; *Sermo mysticus. Studien zur Theologie und Sprache der deutschen Mystik*, 1979; *Geistliches Mittelalter*, Freiburg (Switzerland), 1984; *Gott Leiden-Gott Lieben. Zur volkssprachlichen Mystik im Mittelalter*, Frankfurt a.M., 1989; *Die Kunst rechter Gelassenheit. Themen und Schwerpunkte von Heinrich Seuses Mystik*, Berne, 1996.

Michael Ianuzielo: (translator of the articles of E. Jungclaussen and J. Figl; language proofreading): born in Montreal in 1973; studied Pure and Applied Sciences before finishing his B.A. Honours in Religious Studies at McGill University Montreal in 1995. After manual labour and social activism he came to Varanasi in 2000 and completed his M.A. in Indian Philosophy and Religion at Banaras Hindu University. Since then he has been studying Sanskrit in Varanasi and stone sculpture in Mahabalipuram. [**address**: Assi Ghat, Varanasi - 221005, India, **E-mail**: <miguelitoji@yahoo.com>]

Dr. Bernard Imhasly: born in 1946 in Sierre (Switzerland); 1958-66 Boarding School in Einsiedeln; 1968 married to Rashna Gandhy, one daughter (Anisha, b. 1972). 1966-72 studies in Linguistics and Anthropology at the University of Zurich; PhD 1972. 1973-78 Lecturer at

the University of Zurich; publication of three books on Linguistics and Anthropology: "Das Problem der Kreativität in der Modernen Linguistik," "Einführung in die Linguistic," Modernisierungsprobleme in Bangladesch" (with Peter Müller and Hans Grambach). 1978 he joined the Swiss Foreign Service, 1979-80 Press Attaché, Embassy of Switzerland in London. 1980-84 Desk Officer for South & South-East Asia, Department of External Economic Affairs, Ministry of Economy in Berne (Switzerland). 1984-88 Counsellor, Swiss Embassy in New Delhi. 1988-89 Dy. Head, Middle East Division, Ministry of External Affairs, Berne. 1989-91 Consultant for Swiss Companies in India. From 1991 to date Correspondent for NZZ (Zurich), taz (Berlin) and Die Presse (Vienna) in South Asia, based in New Delhi. [**address:** B - 34 Sarvodaya Enclave, New Delhi - 110017, India, **E-mail:** <NZZDEL@dm.begasoft.ch>]

EMMANUEL JUNGCLAUSSEN: born in 1927, monk of the Benedictine monastery Niederaltaich (Bavaria), former abbot of this monastery in which he lived also many years within the Byzantine rite. He is a pioneer of the 'Prayer of the Heart' in the West and has edited the first complete German version of the classical religious text of the Eastern Church "The Way of a Pilgrim." His own spiritual path was inspired by a stay in Japan and his encounter with Zen. In the Ecumenical Institute of the monastery Niederaltaich, he is engaged in ecumenical and interreligious encounters and teaches the spiritual exercise of the Prayer of the Heart. [**address:** Abtei Niederaltaich, 94557 Niederaltaich, Germany, c/o **E-mail:** <mbrand@abtei-niederaltaich.de>]

Selected publications: (ed.) *Aufrichtige Erzählungen eines russischen Pilgers*, Freiburg, 18th edn. 2000; *Der Meister in dir. Entdeckung der inneren Welt nach Johannes Tauler*, Freiburg/Basel/ Wien, 1975; *In den Spuren der Meister*, Freiburg, 1992; *Schritte in die innere Welt*, 2 vols., Göttingen, 1997; *Unterweisung im Herzensgebet*, St. Ottilien, 1999; *Das Jesusgebet*, Regensburg, 2001.

DR. THOMAS KINTAERT: born in 1972 in Brussels (Belgium); 1990-2000 study of indology at the University of Vienna, graduation (M.A.) with the thesis "Die Prinzipien der rituellen Rhythmik der altindischen Kunstmusik, anhand des *tāla*-Abschnitts des Dattilam." 1996 marriage with Thsering Doma Bhutia. Since 2000 work on a doctoral dissertation on the coordination of temporal and spacial elements in the *pūrvaraṅga* rituals of the ancient Indian drama, financed from 2000 to 2003 by a doctoral grant from the Austrian Academy of Sciences. Lives in Vienna. [**address:** Spallartgasse 26-28/4/4, 1140 Wien, Austria, **E-mail:** <a9003065@unet.univie.ac.at>]

DR. RAI ANAND KRISHNA: born in 1925 as the son of *Padmavibhushana* Rai Krishnadasa, a writer, expert in Indian art and patron of numerous artist and scholars, who founded the famous museum Bharat Kala Bhavan at Banaras Hindu University (BHU) based on the collection of his grandfather Patani Mall. In the 1950s Ananda Krishna started a printing Press in Varanasi and became the editor of *Kala Nidhi*, the quarterly journal of Bharat Kala Bhavan. From 1953 he attended the Master Course in Ancient Indian History, Culture and Archaeology at BHU (M.A.); PhD. in 1962 with a doctoral work "A Survey of Rajasthani Paintings." Afterwards he became a lecturer at the Department of History of Art at BHU,

later reader and professor. He was visiting lecturer at the University of Michigan and Honorary Joint-Director of Bharat Kala Bhavan as well as Chairman of the Uttar Pradesh Lalit Kala State Academy (1984-86) and 1985 Dean of the Faculty of Humanities, BHU. Lives in Varanasi. [**address**: Amethi Kothi, N 1/55, Nagawa, Varanasi - 221005, India]

Selected publications: *Malwa Painting*, Varanasi, 1963; ed.: *Chhavi. Golden Jubilee Volume. Bharat Kala Bhavan 1920-1970*, Varanasi, 1975; ed.: *Chhavi-2. Rai Krishnadasa Felicitation Volume*, Varanasi, 1981; ed.: *Svantah Sukhay*, 1990 [anthology of Hindi Poetry]; *Banaras in the Early 19th Century. Riverfront Panorama*, Varanasi, 2003.

DR. SARLA KUMAR: born in 1929 in Lahore; at the time of Partition she had passed out of Kinniard College with an Intermediate degree, and the family shifted to Delhi, at this time reeling under most brutal communal riots. From 1951-58 she lived in Europe, where her husband was posted. After their return to India in 1958 she could renew her academic pursuits and joined the college of Jesus and Mary in Shimla in order to graduate and to obtain her degree in teaching. She then taught in the Loreto Convent in Shimla for three years and at St Colombas School in Delhi for seven years. She got her Master's degree in English literature in 1972 from Punjab University. Then she taught for 16 years in Delhi University colleges: Lady Shri Ram College, Miranda House and finally at the College of Vocational Studies where she got a permanent placement as Lecturer in English. In 1978 she applied for study leave and got her PhD. in 1981 with a doctoral work on Doris Lessing and Mary McCarthy; as a reader she continued teaching till the age of 60. After her retirement she learned Indian Classical Music for ten years, also Sanskrit, to be able to study the original texts of non-dualistic Kashmir Śaivism.

In 1969 she came in contact with Swami Lakshman Joo via her sister, who lived near his ashram in Srinagar, and her life acquired a new direction. Till his death in 1991 she was in close contact with him. Together with Bettina Bäumer she edited his commentary to *Vijñāna Bhairava* (*Vijñāna Bhairava. The Practice of Centring Awarenesss. Commentary by Swami Lakshman Joo*, Varanasi: Indica, 2002). [**address**: F-23, Hauz Khas Enclave, New Delhi - 110016, India]

DR. RUDOLF ZUR LIPPE: born in 1937 in Berlin (Germany), studied economy and public law in Bonn and Göttingen, afterwards history in Heidelberg and Paris. From 1969 he studied the history of the body in the modern age under Theodor W. Adorno, 1973 *venia legendi* for social philosophy and aesthetics at the University of Frankfurt; since 1974 Professor of Aesthetics at Carl von Ossietzky University Oldenburg. In 1981/82 Fellow at the Wissenschaftkolleg Berlin. In 1989 he initiated the 'Karl Jaspers Vorlesungen zu Fragen der Zeit' with intercultural visiting professors. From 1960 disciple of Karlfried Graf Dürckheim; cooperation with Hugo Kükelhaus. From 1997 Professor of 'Philosophy of Life Forms' at the private university Witten (Germany). Editor of the journal *Poiesis*. Lives in Hude (Germany). [**address**: Gutschaus/Kloster, 27798 Hude, Germany, **E-mail**: <Beate_Lukas@web.de>]

Selected publications: *Naturbeherrschung am Menschen*, 2 vols., Frankfurt, 1974; *Entfaltung der Sinne. Ein Erfahrungsfeld* (together with H. Kükelhaus), Frankfurt, 1982, new edition 1997; *Am eigenen Leibe. Zur Ökonomie des Lebens*, Bodenheim, 1983; *Der schöne Schein. Existenzielle*

Ästhetik, Bern, 1988; *Kultur der Stille. Karlfried Graf Dürckheim. Ein Lehrer des Zen im Westen,* Aachen, 1996.

DR. AXEL MICHAELS: born in 1949, is both a scholar of Indology and Religious Studies. He studied indology, sociology, philosophy, and law at Munich, Freiburg, Varanasi and Hamburg University. He worked as a research assistant at the universities of Münster and Kiel (Germany). From 1981-83 he was Director of the Nepal Research Centre (Kathmandu), 1986 Spalding Visiting Fellow, Wolfson College Oxford, 1992-96 Professor of Religious Studies at University of Bern (Switzerland). Since 1996 he has been Professor of Classical Indology at South Asia Institute, University of Heidelberg. In 2001 elected the Speaker of the Collaborative Research Centre "The Dynamics of Ritual." [**address:** Institut für Klassische Indologie, Südasien Institut, Im Neuenheimer Feld 330, 69120 Heidelberg, Germany, **E-mail:** <Axel.Michaels@urz.uni-heidelberg.de>]

Selected publications: *Ritual und Gesellschaft in Indien,* Frankfurt a.M., 1986; (with N. Gutschow) *Benares,* Cologne, 1993; ed.: *Klassiker der Religionswissenschaft: Friedrich Schleiermacher bis Mircea Eliade,* Munich, 1997; *Der Hinduismus: Geschichte und Gegenwart,* Munich, 1998 (tr. *Hinduism. Past and Present,* Princeton, 2004); (with U. Luz) *Jesus oder Buddha,* Munich, 2003; *Die Kunst des einfachen Lebens. Eine Kulturgeschichte der Askese,* Munich, 2004.

DR. R. N. MISRA: born in 1939, M.A. at Banaras Hindu University (1959), PhD. (Sagar, Madhya Pradesh, 1968). 1959-76 Lecturer, Department of Ancient Indian History, Culture and Archaeology, University of Saugar; 1976-80 Reader and Head, 1980-85 Professor at the School of Studies in Ancient Indian History, Culture and Archaeology, Jiwaji University, Gwalior. 1985-86 Professor at the Department of Ancient History, Culture and Archaeology, University of Allahabad. 1986-2001 Professor and Head at the School of Studies in AIHCA, Jiwaji University, Gwalior. Since 2002 Fellow at the Indian Institute of Advanced Study (IIAS) in Shimla. In 1986 he participated in the seminar on Shastric traditions in Indian Arts, South Asia Institute, University Heidelberg. For his book *Bharatiya Murtikala* he received the National award from the Rajbhasha Department of the Government of Bihar (1981/82) and the *anushansha* award from Uttar Pradesh Hindi Samsthan (1979/80). Currently he edits the bi-annual journal *Studies in Humanities and Social Sciences* of the Inter-University Centre at IIAS. [**address:** N-448, Aashiana, Lucknow - 226012, India, **E-mail:** <misrajibhai@yahoo.co.nz>]

Selected publications: *Bharhut* [in Hindi], Bhopal, 1971; *Ancient Artist and Art Activity,* Shimla, 1975; *Bharatiya Murtikala,* New Delhi, 1978, rev. edn. 2002; *Yaksha Cult and Iconography,* Delhi, 1981; *Sculptures of Dahakl and Daksina Kosala,* New Delhi, 1987; *Prācīna bhāratīya samāj, artha-vyavasthā aur dharma,* Bhopal, 1994; ed.: *Outlines of Indian Arts: Peaks of Creativity,* Shimla, 2005.

DR. BITHIKA MUKERJI: born in 1924 in Allahabad, studied philosophy at Allahabad University (PhD. 1954) and at McMasters University Hamilton, Canada (PhD. 1981). In 1972 she went to Geneva for one year, to lead a seminar on Hinduism and Christianity. She was Reader of Philosophy at Banaras Hindu University from 1957 to 1984. From her childhood she was closely associated with one of the most outstanding religious personalities in modern times,

the Bengali mystic Sri Anandamayi Ma (1896-1982). Already the author of the authoritative biography of Sri Ma, *A Bird on the Wing* (1964; rev. edn., Delhi, 1998), she published a personal memoir *My Days with Sri Ma Anandamayi* (Varanasi, 2002). Lives in Allahabad. [**address:** Sri Anandamayi Colony, 31, George Town, Allahabad - 211002, India]

Selected publications: *Neo-Vedānta and Modernity*, Varanasi, 1983; *The Hindu Tradition*, New York, 1988; ed. (with K.R. Sundararajan): *Hindu Spirituality. Postclassical and Modern* (World Spirituality; 7), New York, 1997.

Dr. R. Nagaswamy: born in 1930; studied Sanskrit language and literature (MA., University of Madras), afterwards arts and archaeology (PhD., University of Poona). Later he got a special training in archaeological excavation and conservation of ancient monuments. 1959-62 curator for art and archaeology, Government Museum Madras; 1963-65 Asst. Special Officer for Archaeology, Government of Tamilnadu; 1966-88 first Director of Archaeology, Government of Tamilnadu. He was director of the Epigraphy Programme of the "Ecole Française d'Extrême Orient", Pondicherry and consultant of the Government of India for the UNESCO documentation of cultural heritage. He held the Presidency of the "Dr. U.V. Swaminatha Iyer Manuscript Library" in Chennai, the Vice Presidency of the "Kuupuswamy Sastri Research Institute" in Chennai and was member of the "National Art Purchase Committee" of the National Museum of India. In 1981 Dr. R. Nagaswamy initiated the renowned Chidambaram Natyanjali Dance festival, along with Dr. Kapila Vatsyayan. Among other awards he has received the "Kalaimamani" by the Government of Tamilnadu. He gave lectures at the universities of Harvard, Chicago, Philadelphia, Austin, at the British Museum London, London University, Paris, Berlin, Uppsala, Berlin, Heidelberg etc. He has published several books in English, Sanskrit and Tamil and contributed more than 300 research articles. At present Visiting Professor, Jawaharlal Nehru University, New Delhi. [**address:** Tamil Arts Academy, 11, 22nd Cross Street, Besantnagar, Chennai-600 090, India, **E-mail:** <nagaswamy@msn.com>]

Selected publications: *The Art of Tamilnadu*, Chennai, 1972; *Studies in Ancient Tamil Law and Society*, Chennai, 1978; *Art and Culture of Tamil Nadu*, New Delhi, 1980; *Masterpieces of Early South Indian Bronzes*, New Delhi, 1983; *Shiva Bhakti*, New Delhi, 1989; (ed.) *Studies in South Indian History and Culture*, Chennai, 1997; (ed.) *Foundations of Indian Art. Proceedings of the Chidambaram Seminar on Art and Religion*, Chennai, 2002; *Facets of South Indian Art and Architecture*, New Delhi, 2003.

Dr. André Padoux: born in 1920 at Peking, where his father occupied a diplomatic post; he studied political science in Lyon and Paris. His diplomatic career started with a three years' service as a member of the French delegation to the UNESCO. In November 1949 he was appointed cultural attaché at the French Embassy in Norway, from 1953 to 1959 in a similar function in the French Embassy at New Delhi. In 1946 he commenced the study of Sanskrit and Indian culture at the Institut de Civilization Indienne, University of Paris, under the guidance of Louis Renou. In New Delhi where his Sanskrit studies were further pursued, he met Lilian Silburn who encouraged him to study Abhinavagupta's oeuvre. Padoux read

Abhinavagupta's commentary on the *Parātriṁśikā Tantra* with Swami Lakshman Joo at Srinagar in 1958 and 1959. In 1959 he was appointed 'attaché de recherché' at the National Centre of Scientific Research (CNRS) in Paris. Since 1957 he worked under the supervision of Olivier Lacombe and Louis Renou on his doctoral thesis *'Recherches sur la symbolique et l'énergie de la parole dans certains textes tantriques'* (published Paris, 1963, 2nd rev. edn. 1975; English tr.: *Vāc: The Concept of the World in Selected Hindu Tantras*, Albany, 1990), one of the most important studies in the field of 'Hindu Tantrism.' After being appointed cultural advisor at the French Embassy in Laos, he became director of the French Institute at Frankfurt a.M. (Germany) in 1964. His last diplomatic function was fulfilled at the French Embassy in Hungary from 1969 until 1972. He continued his academic career at the CNRS ('directeur de recherche' from 1984 to his retirement in 1989), and directed the research team of the CNRS on Hinduism (1982-89). Since 1982 he was elected a member of the Comité National de la Recherche Scientifique (section Languages et Civilisations Orientales). Since 1975 he also has been a member of the Scientific Council of the National Institute of Oriental Languages and Civilizations. [**address**: 15, rue Seguier, 75006 Paris, France, **E-mail**: <andre.padoux@noos.fr>]

Selected publications: *La Parātrīśikālaghuvṛtti d'Abhinavagupta*, Paris, 1975 [translation, notes]; ed.: *Mantras et diagrammes rituels dans l'hindouisme*, Paris, 1986; ed.: *L'Image Divine. Culte et méditation dans l'hindouisme*, Paris, 1990; *Le Cœur de la Yoginī. Yoginīhṛdaya avec le commentaire Dīpikā d'Amṛtānanda*, Paris, 1994 [translation, notes]; (with L. Silburn) *Abhinavagupta: La Lumière sur les Tantras. Chapitres 1 à 5 du Tantrāloka*, Paris, 1998 [translation, commentary].

DR. RAIMON PANIKKAR: born in 1918 in Barcelona (Spain) as the son of a Hindu father and a Spanish Roman Catholic mother. PhD. in Philosophy dealing with the concept of nature (University of Madrid 1946), in Chemistry with a thesis on the philosophy of science (Madrid 1958) and in theology (Lateran University Rome 1961). Ordained as a Catholic priest in 1946. In 1953 he left Spain to live in India, from 1964-76 in Varanasi. From 1967-71 Professor of Comparative Religion at Harvard Divinity School, afterwards Professor of Comparative Religion and Philosophy at University of California Santa Barbara, Religious Studies Department; retired in the 1990s. 1988/89 Gifford Lectures at the University of Edinburgh with the title "Trinity and Atheism. The Housing of the Divine in Contemporary World." He is one of the leading figures in interreligious dialogue over the past half-century, till now committed for an authentic cross-cultural and interdisciplinary exchange and for a fundamental transformation in our attitude towards environment, social relations, relation of cultures and religions, etc. In 1999 awarded Premio Espiritualidad in Spain for his book *El mundanal silencio* (Madrid 1999), in 2002 with the Medal of the Italian Republic. In February 2002 he was honoured with an international symposium "The Intercultural Philosophy of Raimon Panikkar" organized by UNESCO Catalunya, in September 2003 with an international symposium at University of Tübingen to his cosmotheandric view of reality (published in fall 2004). He is President of the Center for Intercultural Studies *Vivarium*, Consultant for Interreligious Dialogue of the UNESCO. Lives in Tavertet (Spain). [**address**: "Vivarium," Can Felo, 08511 Tavertet, Catalunya, Spain, **E-mail**: <r.panikkar@wanadoo.es>]

Selected publications in English: *The Unknown Christ of Hinduism. Towards an Ecumenical Christophany*, London, 1964, rev. and enl. edn. Maryknoll, 1981; *The Trinity and the Religious*

Experience of Man. Icon — Person — Mystery, New York/London, 1973; *The Vedic Experience. Mantramañjarī*, Berkeley/Los Angeles, 1977; *The Intrareligious Dialogue*, New York, 1978, rev. edn. 1999; *Myth, Faith, and Hermeneutics*, New York, 1979; *The Silence of God. The Answer of the Buddha*, Maryknoll, N.Y., 1989; *The Cosmotheandric Experience. Emerging Religious Consciousness*, Maryknoll, N.Y., 1993; *A Dwelling Place for Wisdom*, 1993; *Invisible Harmony. Essays on Contemplation and Responsibility*, Minneapolis, 1995; *Cultural Disarmament. The Way to Peace*, tr. Robert R. Barr, Louisville, KY, 1995.

DR. DINANATH PATHY: born in 1942 in Digapahandi in south Orissa. His father, Shyama Sundar Pathy, was a priest, poet and puppeteer who introduced him into the world of visual art, theatre, etc. In 1956 participation in the All India Child Art Exhibition (Gold medal for painting). In 1959 he joined the Government School of Art and Crafts at Khallikote; 1972 M.A. in History, 1982 PhD. from Utkal University (dissertation on the history of Orissan paintings). He is a painter, art historian and creative writer, especially in Oriyā. Having extensively researched on the pictorial art traditions in Orissa and initiated the research on Orissan painting in the late 1970s, he is the foremost expert in the field of painting traditions in Orissa. He received the Jawaharlal Nehru Fellowship to work on Renewal Art and in 1986 the A.L. Basham Memorial Award for fundamental research in Orissan art and culture by the Institute of Oriental and Orissan Studies, Cuttack. In 1991 appointed member of the State Council of Culture, Bhubaneswar. Since 2000 he is Director of the Alice Boner Institute for Research on Fundamental Principles in Indian Art in Varanasi. Exhibitions of his own paintings in India, Malaysia and Europe. Lives in Bhubaneswar. [**address:** Avanti, E - 49/1386 (Pvt. Plot), Bhimatangi, Bhubaneswar - 751020, India, **E-mail:** <gunjar@satyam.net.in>]

Selected publications: ed. (with E. Fischer/S. Mahapatra) *Orissa. Kunst und Kultur in Nordost-Indien*, Zurich, 1980; *Mural Paintings in Orissa*, Bhubaneswar, 1981; *Traditional Paintings of Orissa*, Bhubaneswar, 1990; (with E. Fischer) *Murals for Goddesses and Gods. The Tradition of Osakothi Ritual Paintings in Orissa*, New Delhi/Zurich, 1996; *Essence of Orissan Paintings*, Delhi, 2001; *Art: Regional Traditions. The Temple of Jagannātha. Architecture, Sculpture, Painting, Ritual*, Delhi, 2001.

DR. DEBI PRASANNA PATTANAYAK: born in 1931; founder-director of the first national institute for Indian languages, the Central Institute of Indian Languages (CIIL) in Mysore, which was set-up in 1969, established to coordinate the development of Indian languages (especially minor, minority and tribal languages) and to focus the research on linguistics and the literary out-put in India. Related with Ivan Illich and his thoughts, he is one of the leading thinkers in the field of multilingualism and human rights, minority education, tribal education and languages. He is especially engaged for the diversity of languages, against the "monolingual myopia," for the recognition of the tribals and their contribution to Indian life and culture and for education in the mother tongue as an expression of personal identity and group solidarity. He is founder, now member of the Academic Body of Centre for Advanced Research on Indigenous Knowledge Systems in Mysore, and of the General Body of National Council for Teacher Education (NCTE). Awarded Nehru Literacy Award in 1998 and

Padmashri. Lives in Bhubaneshwar (Orissa). [**address:** B-188, Baramunda Duplex Colony, Bhubaneswar - 751003, India]

Selected publications: *A controlled historical reconstruction of Oriya, Assamese, Bengali, and Hindi*, The Hague, Mouton, 1966; *Aspects of Applied Linguistics*, Bombay, 1969; *Education for the Minority Children*, Mysore, 1976; (with M.S. Thirumalai) *An Introduction to Tamil Script, Reading and Writing*, Mysore, 1980; *Language and Social Issues*, Mysore, 1981; *Multilingualism and Mother-Tongue Education*, Delhi, 1981; *Multilingualism and Multiculturalism: Britain and India*, London, 1987; ed. (with P. Claus/J. Handoo) *Indian Folklore II*, Mysore, 1987; ed.: *Multilingualism in India*, Clevendon, UK, 1990; *Language, Education and Culture*, Mysore, 1991.

DR. JOSEPH PRABHU: completed his B.A. (1966) and M.A. (1968) in Economics from Delhi University, his B.A. (1973) and M.A. (1975) in Philosophy from Cambridge University, England. He took his doctorate from Boston University (PhD. in Philosophy 1982). Since 1978 he teaches at California State University, Los Angeles; currently he is Professor at the College of Arts and Letters (courses on Indian/Asian philosophy, nineteenth and twentieth-century European philosophy, ethics, philosophy of religion, social and political theory). In that time he was also Visiting Professor at UC Berkeley, Harvard, Boston and at universities in India and Germany. He is co-editor of the journal *ReVision*, a quarterly dealing with issues of philosophy, spirituality and psychology (www.heldref.org). He is active in peace, human rights and interreligious movements. Currently he is working on following book projects: *Gandhi, Globalization and a Culture of Peace; Hegel, India, and the Dark Face of Modernity; Human Rights in Cross-Cultural Perspective; Globalization and the Encounter of Religions*. [**address:** 123 Marathon Road, Altadena, CA 91001, **E-mail:** <jprabhu@calstatela.edu>]

Selected publications: ed.: *The Intercultural Challenge of Raimon Panikkar*, Maryknoll, NY, 1996; ed. (with P. Bilimoria/R.M. Sharma): *Companion for Indian Ethics: An Anthology on Classical, Contemporary and Applied Moral Thinking in and from India*, London, 2005.

DR. ALEXIS SANDERSON: born in 1948; 1967-71 Open Classical Scholar, Balliol College, University of Oxford; 1969 awarded First Class Honours in Classical Moderations, University of Oxford, in 1971 awarded Congratulatory First Class Honours in Oriental Studies (Sanskrit and Prakrit), University of Oxford. 1971-74 Domus Senior Scholar, Merton College, University of Oxford; 1974-77 Holder of the Junior Research Fellowship in the Humanities at Brasenose College, University of Oxford. 1972-77 Research in Kashmir; 1977-92 University Lecturer in Sanskrit (Associate Professor), University of Oxford. 1977-92 Fellow of Wolfson College, Oxford. 1985-91 Member of Équipe de Recherche 249, Centre National de la Recherche Scientifique, Paris. 1991 Visiting Professor (Directeur d'Études Invité), École Pratiques des Hautes Études, 5° Section (Sciences Religieuses). Since 1992 he is Fellow of All Souls College and Spalding Professor of Eastern Religions and Ethics, University of Oxford. [**address:** University of Oxford, All Souls College, Oriental Institute, Pusey Lane, Oxford OX1 2LE, Great Britain, **E-mail:** <alexis.sanderson@orinst.ox.ac.uk>]

Selected publications: 'Purity and Power among the Brahmans of Kashmir,' in: M. Carrithers, S. Collins, and S. Lukes (ed.), *The Category of the Person. Anthropology, Philosophy, History,*

Cambridge 1985, pp. 190-216; 'Maṇḍala and Āgamic Identity in the Trika of Kashmir,' in: A. Padoux (ed.), *Mantras et Diagrammes Rituelles dans l'Hindouisme*, Paris, 1986, pp. 169-214; 'Śaivism and the Tantric Traditions,' in: S. Sutherland, L. Houlden, P. Clarke and F. Hardy (eds.), *The World's Religions*, London, 1988, pp. 660-704; reprinted in F. Hardy (ed.): *The World's Religions. The Religions of Asia*, London, 1990, pp. 128-72; 'The Visualization of the Deities of the Trika,' in: A. Padoux (ed.), *L'Image Divine: Culte et Méditation dans l'Hindouisme*, Paris, 1990, pp. 31-88; 'The Doctrine of Mālinīvijayottaratantra,' in: T. Goudriaan (ed.), *Ritual and Speculation in Early Tantrism. Studies in Honour of André Padoux*, Albany, 1992, pp. 281-312; 'Meaning in Tantric Ritual,' in: A.-M. Blondeau, K. Schipper (eds.), *Essais sur le Rituel III: Colloque du Centenaire de la Section des Sciences religieuses de l'École Pratique des Hautes Études*, Louvain/Paris, 1995, pp. 15-95; 'Vajrayāna: Origin and Function,' in: *Buddhism Into the Year 2000. International Conference Proceedings*, Bangkok/Los Angeles, 1995, pp. 89-102; 'History Through Textual Criticism in the Study of Śaivism, the Pañcarātra and the Buddhist Yogīnītantras,' in: *Les sources et le temps. Sources and Time. A Colloquium, Pondicherry, 11-13 January 1997*, edited by F. Grimal, Pondicherry, 2001, pp. 1-47; 'The Śaiva Religion Among the Khmers, Part I': Bulletin de l'École française d'Extrême-Orient 90 (2003), pp. 352-464; 'Religion and the State: Śaiva Officiants in the Teritory of the Brahmanical Royal Chaplain': Indo-Iranian Journal 47 (2005), pp. 1-69; 'Religion and the State: Initiating the Monarch in Śaivism and the Buddhist Way of Mantras.' Part 2 of *Rituals in South Asia: Text and Context* (Ethno-Indological Series I-II), edited by J. Gengnagel, U. Hüsken, and S. Raman, Heidelberg, 2005 (forthcoming).

Dr. Baidyanath Saraswati: born in 1932 in Mithila (Bihar); M.A. from Ranchi University in 1954, PhD. 1960. He worked as a researcher in the Anthropological Survey of India for ten years and as a scholar at Indian Institute of Advanced Study in Shimla for ten years. He was Visiting Professor at Ranchi University for one year, at Vishva Bharati in Shantiniketan for one year. He is an anthropologist, concentrating on traditional thought and modern science. For five years professor of Anthropology at the North-Eastern Hill University in Shillong (India). Since 1995 he holds the UNESCO Chair in Cultural Development at the Indira Gandhi National Centre (IGNCA) in Delhi. Currently associated with the N.K. Bose Memorial Foundation in Varanasi; editor of *Sacred Science Review*. Lives in Varanasi. [**address**: N.K. Bose Foundation, B 8/9, Bara Gambhir, Sonarpura, Varanasi - 221001, India, **E-mail**: <nkbfoundation@yahoo.com>]

Selected publications: *Kashi — Myth and Reality*, Shimla, 1975; *Brahmanic Ritual Tradition*, Shimla 1977; ed.: *Man in Nature* (Prakṛti, vol. 5, 1995); *Primal Elements ṁ the Oral Tradition* (Prakṛti, vol. 1, 1995); *Cross-Cultural Lifestyle Studies* (1995); *Interface of Cultural Identity Development* (1996); ed. of the series *Culture and development* (1996ff); ed.: *The Cultural Dimension of Education* (3 vols., 1996); *The Nature of Man and Culture: Alternative Paradigms in Anthropology* (2001); *The Nature of Living Tradition: Distinctive Features of Indian Parampara* (2001). Publisher: IGNCA, Delhi. *Cultures and Cosmos*, Delhi, 2004: ed. *Voice of Death*, Delhi, 2005.

Manju Sundaram: born in 1944 in Varanasi. After her education at Rajghat School and Vasant College for Women, run by the Krishnamurti Foundation, she studied music, Sanskrit and English at Banaras Hindu University (M.A. in Sanskrit). 'Sangit Visharad' from Bhatkhande

Sangit Vidyapeeth in Lucknow, 'Sangit Pravin' from Prayag Sangit Samiti in Allahabad. Musical training by her father, M.K. Samant, later by Pt. S.N. Ratanjankar, K.G. Ginde, and since 1965 by Girija Devi in light classical music. Since 1979 head of the Vocal Music Department, Vasant Kanya Mahavidyalaya in Varanasi. Concerts in many major cities of India and Austria. Since her childhood she is learning and working in the background of Jiddu Krishnamurti's teaching and institutions as well as of the Theosophical Society. Lives in Varanasi. [**address:** Theosophical Society, Kamaccha, Varanasi - 221010, India]

Recordings: 'Udgiti' and 'Śiva-Śakti' (Vedic chants and Sanskrit Stotras, two cassettes), 'Stuti-Mañjari' (cassette), published by Jñāna Pravāha, Centre for Cultural Studies, Varanasi; 'Utpaladeva: Śivastotrāvalī' (CD), published by Trika Interreligious Trust, Varanasi (e-mail: trika@sify.com).

DR. KAPILA VATSYAYAN: born in 1928; early education in Delhi, afterwards the family moved to Calcutta. The home of her parents was a meeting point of freedom-fighters, poets, scholars, musicians and artists. Trained by her parents in dancing, she learned Kathak. At a young age of 16 she became the Vice-Principal of a School of Hindustani Music and Dance and later the founding Secretary of Sangeet Bharati, the premier institution of music and dance in Delhi. After her M.A. in English Literature (University of Delhi, 1948) she was awarded the Barbour Fellowship for Asian Women and pursued her studies in Ann Arbor, Michigan (USA), in the fields of art, education, modern dance, dance notation, Western art and English literature (M.A. in Education and English, 1949). After returning to India, she taught English literature at the University of Delhi (1949-54), and at the same time studied with V.S. Agrawal, Professor of the College of Indology in Varanasi (PhD. in Indology, Banaras Hindu University, 1982), as well as with Rai Krishnadasa, Hazari Prasad Dwivedi and Gopinath Kaviraj. Travelling extensively in India, she acquired a first hand knowledge of tribal and folk culture, supported for example the tribal forms of Teyyam, Tiryattam in Kerala and re-established the tradition of Nritya Seva in Chidambaram. As an Adviser in the Ministry of Education and in the Department of Culture (1954-82), she has been associated with the formulation of policy framework since the early fifties, with the focus on the support and development of India's cultural heritage. She has played an important role in organizing thematic art exhibitions in India and abroad. 1979-80 Visiting Professor at University of Columbia, 1981 University of Philadelphia, USA. 1977-82 Vice-Chairman of the Sangeet Natak Akademi; 1982-85 Additional Secretary, Dept. of Culture, Ministry of Education and Culture, Delhi; 1985-90 Secretary, Dept. of Arts, Ministry of Human Resource Development, Delhi. In 1990 awarded Padmaśrī by the Republic of India. She received many awards and degrees *honoris causa*, including D. Litt. by Banaras Hindu University (1982), Rabindra Bharati University Calcutta (1985), Mount Holyoke College, USA (1986) and Manipur University (1987). She has displayed a remarkable quality in institution building, including Nehru Memorial Museum and Library, the Central Institute for Higher Tibetan Studies in Sarnath, National Conservatory Laboratory for Cultural Heritage in Lucknow, the External Cultural Programmes of the Government of India and an unique institution called Centre for Cultural Resources and Training. The Dalai Lama acknowledged her inspiration for setting up his Foundation For Universal Responsibility. Her efforts and skills culminated in her conceptual plan and setting up (in 1985) of the Indira

Gandhi National Centre for the Arts in Delhi. From 1993 she was the Academic Director of this institution. In this function she was the general editor of following series: *Kalātattvakośa, Kalāmūlaśāstra, Concepts of Space*. Currently she is Chairperson of the India International Center-Asia Project. Lives in Delhi. [**address:** 85, SFS Flats, Gul Mohar Enclave, New Delhi - 110049, India, **E-mail:** <vatsyayan@vsnl.com>]

Selected publications: (with A. Danielou) *Kathakali*, Berlin, 1967; *Classical Indian Dance in Literature and Arts*, Delhi, 1968, 2nd edn. 1978; *The Theoretical Basis of Asian Aesthetic Traditions*, Paris (UNESCO), 1968; *Some Aspects of Cultural Policies in India*, Paris, (UNESCO), 1971; *Indian Classical Dance*, Delhi, 1972; *Traditions of Indian Folk Dance*, Delhi, 1975, 2nd edn. 1986, *Ramayana and the Arts of Asia*, Tehran, 1975; *The Juar Gita-Govinda*, Delhi, 1980; *The Square and the Circle of the Indian Art*, Delhi, 1983; *Bundi Gita-Govinda*, Varanasi, 1983; *Mewari Gita-Govinda*, Delhi, 1987.

DR. ANNETTE WILKE: studied Science of Religion, Theology, Philosophy and Indology at the Academy of Vedanta and Sanskrit, Piercy (USA), and at the universities of Fribourg, Zurich, Berne (Switzerland) and Varanasi (India). She obtained her doctorate in Religious Studies from Berne University in 1994, and pursued fieldwork in India (Varanasi, Tamil Nadu), Nepal and Sri Lanka. Since 1998 she is Professor for Religious Studies at the University of Münster (Germany). Her major fields of research are: Hinduism (devotional practices, Advaita Vedānta, Śāktism, Tamil Hindus in Germany), systematic and comparative studies in religion, mysticism and aesthetics, religious change, Islam in Germany and intercultural interactions. At present she is preparing a major publication on sonic communication in India. [**address:** Seminar für Allgemeine Religionswissenschaft, Hüfferstrasse 27, 48149 Münster, Germany, **E-mail:** <wilkeann@uni-muenster.de>]

Selected publications: *Ein Sein - Ein Erkennen. Meister Eckharts Christologie und Śaṅkaras Lehre vom Ātman: Zur (Un-)Vergleichbarkeit zweier Einheitslehren*, Bern, 1995; ed. (with A. Michaels/ C. Vogelsanger): *Wild Goddesses in India and Nepal*, Bern, 1996); ed. (with M. Baumann/B. Luchesi): *Tempel und Tamilen in zweiter Heimat. Hindus aus Sri Lanka im deutschsprachigen und skandinavischen Raum*, Würzburg, 2003.

DR. FRANZ WÖHRER (translator of the article of professor Alois M. Haas): born in 1950; studied English, philosophy and psychology at Vienna University (Austria). After teaching a year at the university of Lancaster (GB) and studying for a year as a postgraduate research student at Oxford, he took his PhD. in 1982 from the University of Vienna (thesis on *Thomas Traherne: The Growth of a Mystic's Mind*, Salzburg/ New York, 1982). He has specialized in the inter-disciplinary study of mystical literature in English. Has done interdisciplinary study on the religious lyrics of the 'Metaphysical Poets' as associate professorship. He has published several articles on the late Medieval English mystics, in particular on the author of the *Cloud of Unknowing*, on Julian of Norwich and Margery Kempe. He is currently associate professor of English Literature and Cultural Studies at the University of Vienna. [**address:** Institut für Anglistik und Amerikanistik, Universitätscampus, Hof Nr. 8, Spitalgasse 2-4, 1090 Wien, Austria, **E-mail:** <franz-karl.woehrer@univie.ac.at>]

Selected publications: *Phänomenologie mystischer Erfahrung in der englischen Lyrik des 17. Jahrhunderts*, Frankfurt a.M., 2003; *Introduction to Six Metaphysical Poets* (2005).

SRI TARALABALU JAGADGURU **DR. SHIVAMURTHY SHIVACHARYA** MAHASWAMIJI: born on 16th June, 1947. 1967 BA Degree (University of Mysore). 1969 MA in Sanskrit, 1972 Diploma in German, Ph. D in Sanskrit (Banaras Hindu University). 1977-79 Post-doctoral Studies at the Indological Institute, University of Vienna. For the field of Sanskrit studies he developed "Gaṇakāṣṭādhyāyī," a software on Sanskrit Grammar (www.taralabalu.org). He was the Honorary President of the 10th World Sanskrit Conference (Bangalore, 1997).

In 1979 he was installed as the Pontiff of Sri Taralabalu Jagadguru Brihanmath (Sirigere), a prominent Veerashaiva Math in Karnataka. He heads the Religious Seat "Saddhadharma Peetha," founded by the saint Marulasiddha in the twelfth century AD and is the 21st head in this lineage. The Math is running hundreds of educational institutions in 14 districts of Karnataka, mostly in the rural areas. In recognition of his environmental care (in particular the Medicinal Plants Conservation Centre) he received the "Certificate of Excellence" in 2002 from the Equator Initiative Technical Advisory Committee at the World Summit on Sustainable Development (Johannesburg). In 2003 he received the Award "Ambassador of Peace" from the International and Interreligious Federation for World Peace (New York). Dr. Shivamurthy Swamiji is committed to peace between all faiths. When the Babri Maszid was demolished, he gave a call "Demolish the walls of hatred and enmity, and not the Maszid or Mandir!" and led a Peace March in one of the major cities in Karnataka to avert communal clashes in the areas of his activities. He is the author of several books in English and Kannada (e.g. *Religion and Society at Cross Roads, Communal Conflicts in India, Hindu Visions of Global Peace, Hinduism and Harmony*). [**address:** Taralabalu Kendra, 3rd Main, 2nd Block, R.T. Nagar, Bangalore - 560 032, India, **E-mail**: <swamiji@vsnl.com>]

Index

Abaelard, Petrus, 505ff

Abhijñānaśākuntalam, 233, 347f, 365
 as an invocation to Mount Kailāsa, 342, 347f
 See, Kālidāsa

Abhinavagupta, xii, xxi, 4, 8, 11, 27-36, 42, 49-55, 65f, 114-148
 Aesthetic theory, 181
 Anubhavanivedana, 11
 Autobiographical information, 27, 114, 122f
 Commentary *Nāṭyaśāstra*, xi, 28, 34, 251 (fn. 32), 256 (fn. 74), 257 (fn. 75), 262 (fn. 108), 266 (fn. 139), 352
 conception of time (*Tantrāloka*, ch. 6), 50 (fn. 4)
 Dhvanyālokalocana, 94 (fn. 15)
 his philosophical stance is satkāryavāda, 51
 āśvarapratyabhijñāvivṛttivimarśinī, 27f, 30f, 33, 31, 90f, 106, 122, 126, 129
 Mālinīvijayavārttika, 33, 96f, 101, 105, 113, 124
 Parātriṁśikālaghuvṛtti - attribution to A. is doubtful, 142 (fn. 124)
 Paryanta-Pañcāśikā, 34
 Parātrīśika-Vivaraṇa, xi-xii, xxi, 27, 64, 124, 141f, 161
 Tantrāloka, 27f, 34, 49-55, 65, 90, 103, 105f, 106f
 Tantrasāra, 49, 54, 89-148 (opening verses), 103
 See, Ānanda
 See, Bhoga
 See, Bhūtirāja (teacher)
 See, Fullness
 See, Light, Pure
 See, Kaula
 See, Lakṣmaṇagupta (teacher)
 See, Narasiṁhagupta (father)
 See, Relation, Philosophy of
 See, Samāveśa
 See, Trika
 See, Vimalā (mother)

Abhishiktananda, Swami (Henri Le Saux), xii, xviii-xix, xxii, 559

Abyss of God
 Johannes Tauler, 525

St. Francis de Sales, 581

A-Dualism
 different from monism (or: monotheist/ trinitarian option), 571f

A-Duality (beyond duality), 349
 and Kashmir Śaivism, 352

Advaita experience, xi-xii, 493
 as a central motive in Hermann Hesses's novel *Siddharta*, 472
 See, Union with the One

Advaita Vedānta, 73, 492
 and Śrīvidyā, 150ff, 154f.
 as "religion itself in its most universal . . . significance" (S. Radhakrishnan), 553
 See, Śaṅkara

Aesthetic experience, 50f, 157, 158, 352
 'presentness' of art (Patañjali), 231f

Aesthetics, Indian
 See, Abhinavagupta
 See, *Nāṭyaśāstra*

Ahiṁsā ('non-violence'), 71f

Ajantā, 234

Anagarika Govinda, Lama, 464

Andhaka (blind demon; Śiva's son), 355

Aṇasarapaṭis, 330, 334f
 See, Jagannātha temple

Anuttara ('the Ultimate, Highest'), 96, 124, 141
 as a name for the supreme Goddess (Abhinavagupta, *Tantrāloka*), 98

Aparājitapṛcchā (Vāstu text, 12th century), 205f, 207, 209, 213f, 222
 See, Vāstu

Appār (Tamil saint), 58f

Aristotle
 theory of justice, 394, 404

Arunachala (sacred mountain), 367f

Atheism
 as a partner in the dialogue of religions, 466

Augustine, 487, 501f, 520, 522
 Enarrationes in Psalmos, 484f
 De vera religione, 494, 511
 Confessiones, 516

Aurobindo, Śrī, 475
 and Gandhi, 77
 See, Spirituality

Ābhāsa-vāda, 29
 See, Abhinavagupta

Āgama, 107, 135

Ādiyāga, 138

Āḷvars, 57

Āmardaka (Amrol), 294ff, 301

Ānanda ('bliss'), 154f, 157, 160, 165f, 225, 352
 and aesthetic experience, xi, 15, 51, 158
 of the Lord as "his repose in himself"
 (Abhinavagupta), 33
 and music, 15
 and alphabetic code (Abhinavagupta), 96
 the own form of the Goddess, 160, 162
 as ultimate awareness, 162
 Ānanda tāṇḍava (dance of eternal bliss of Śiva),
 352
 sensual contact as experience of "the subtlest
 energy of bliss", 63
 "all-embracing bliss" (jagadānanda), 97

Ānandamayī Mā, xxi, 600

Ārtavam ('menstrual blood'), 100 (fn. 34)

Ārya Samāj, 548
 See, Dayānanda Sarasvatī

Āśraya ('ground', 'basis')
 as equivalent to svarūpam ('nature', 'identity'),
 95 (fn. 18)

Ātman
 Buddhism did not deny the Upaniṣadic ātman
 in the beginning (K. Bhattacharya), 574

Ātman ('Self')-Brahman ('Absolute')-relation, 487ff,
 491f, 574

Bäumer, Bettina, xi-xiii, xvii-xxix, 11, 17, 20, 49 (fn. 1),
 67, 149, 205, 325, 411 (fn.), 457, 458 (fn. 1), 467
 (fn.), 492 (fn. 43), 493, 557, 567 (fn.)

Bahurūpagarbha Stotra, 37-47

Banerjea, J.N., 208

Bankei (Zen master), 386

Barth, Hans Martin, 374

Basavanna, 564
 See, Compassion

Batchelor, Stephen
 Buddhism Without Beliefs, 462

Baṭuka Bhairava (illustration), 197

Bāsava (Kannaḍa saint), 59

Beauty, 63

Bechert, Heinz, 463

Berger, Peter L., 399

Bernard of Clairvaux, 507, 522

Beryl, 253

Bhagavad-Gītā, 3, 57, 59, 419f, 425, 552
 commentary of Abhinavagupta, 4
 commentary of Gandhi, 74, 77

Bhāgavata Purāṇa, 59f

Bhājā (Maharashtra), rock-cut twin panels, 232

Bhairava, 37ff, 43, 54, 95 (and fn. 19), 102, 111, 139,
 321f
 five faces of iconic Bhairava (Tatpuruṣa,
 Sadyojāta, Vāmadeva, Aghora, Īśāna), 95
 (fn. 20)

Bhairavī, 37

Bhairavī Aghoreśvarī (illustration), 223

Bhakti movement, 57-61
 See, Santa poets

Bhakti-Yoga, 421f, 426

Bharata
 See, *Nāṭyaśāstra*

Bharhut
 railings (2nd century BC), 232f
 and Yakṣa, 343

Bhaṭṭa Rāmakaṇṭha, 106 (fn. 49), 127

Bhāskararāya, 152f, 154f, 161f, 163

Bhedābheda (dualism-cum-nondualism), 127

Bhikṣāṭana, Legend of Śiva as, 317f

Bhīmabhoi (mystic and poet, Orissa), 60

Bhoga ('enjoyment', 'experience', 'delight'), 41f, 51
 as a name of the Śakti (Abhinavagupta,
 Tantrasāra), 97 (fn. 23)
 See, Mokṣa

Bhojadeva (scholar and emperor), 199

Bhojpur, Śiva temple at, 199

Bhūtirāja (teacher of Abhinavagupta), 125f

Bhuvanaprakāśa, 326

Bible, 13, 379f
 See, Existential Interpretation (Rudolf Bultmann)

Blake, William, 538

Blavatsky, Helena Petrowna, 12

Body
 "the body is the temple" (Bāsava), 59
 as the whole earth, 59
 delusive identification of the self with the body (Abhinavagupta), 91
 as the mere frame or vessel for the soul (early Christian thinking), 497
 as an armour, the self as the warrior dressed by the armour (Origen), 497
 is, according Christian faith, not merely temporal, 498
 composes, together with soul and spirit, the perfect man (Ireneus), 498
 as an integral part of resurrection, 498
 cannot be excluded from the definition of man (church fathers), 498

Boner, Alice, xix, 205, 325

Borobudur, 353
 See, Mount Meru
 See, Śūnyatā
 See, Maṇḍala

Brahman (the Absolute), xi, 44, 83, 152, 157, 159f, 161f, 163 (fn. 57), 164, 166f, 580
 death reveals the Brahman that we are, 575
 See, Ātman-Brahman-relation

Bṛhadāraṇyaka Upaniṣad, 60, 490, 546 (fn. 21)

Bṛhadīśvara temple (Tamil Nadu), 365f, 367

Brown, W. Norman, 224, 226
 See, *Saundaryalaharī*

Buber, Martin, 72, 466, 571 (fn. 19)

Buddha, 12, 232ff, 390
 his sense of urgency that we have to work out our salvation in this life, 74
 emphasizes the connection between compassion and spiritual integrity, 77
 as incarnation of Viṣṇu (Kharujāho), 210
 and Mount Kailāsa, 368
 portrayed in *Buddhist Catechism* by F. Zimmermann (Germany, 1888), 460

Hermann Hesse (*Siddharta*) as an admirer of the Buddha, 471f
 his last words ("work out your salvation with diligence"), 578

Buddhism, 60, 384
 Abhinavagupta on B., 105
 and Mount Kailāsa, 340
 and 'de-mythification', 385, 387, 390f
 Maitrī ('loving kindness') and karuṇā ('compassion'), 397f
 in the West, 457-466
 as a "scientific religion of cognition" (K. Seidenstücker), 461
 and the question of immortality / persistence after death, 579
 See, Ātman
 See, Kyôto School
 See, Objectivization, Critics of
 See, Piyadassi, Mahathera
 See, Pratītyasamutpāda
 See, Reincarnation
 See, Seidenstücker, Karl
 See, Śūnyatā
 See, Zen
 See, Zimmermann, Friedrich

Buddhist art, 205, 232

Buddhist-Christian Dialogue
 in the west, 457-466

Bultmann, Rudolf, 379ff
 See, Existential Interpretation
 See, Hermeneutics, Modern

Burnet, Edward, 337

Byron, George Gordon, 11

Caitanya, 129
 See, Consciousness

Cakrayāga (or, mūrtiyāga, anuyāga), 50f, 52ff
 See, Parvan rites

Cakrodaya, 50

Cambodia, 307-323

Caṇḍikā, 195

Caṇḍī ('the Furious')
 as a name of the Śakti (Abhinavagupta, *Tantrasāra*), 97 (fn. 23)

Candramaulī, 42

Cassianus, John, 500f

Castes, 83, 120, 250ff, 259f, 326, 424 (fn. 9)

the "sacrament of breaking of bread" is realized
 in communities without restrictions
 of caste, creed, race (F. D'Sa), 418

Catuṣpāda ('four-footed'), Śiva (Khajurāho), 217

Cave
 cave form of the inner shrine of Kailāsanātha
 temple, Kanchipuram, 354
 cave shrines (western coast of India), 354
 Kailāsa temple, Ellora, 354ff
 Śiva as the "Lord of the cave" (Kandarīya
 Mahādeva), 364, 366
 See, Elephanta Cave
 See, Temple, Hindu

Chakravarty, Pt. Hemendra Nath, xxi, 149 (fn.1), 156
 (fn. 32)

Chāndogya Upaniṣad, 152

Chandra, Pramod, 205

Chenu, Marie-Dominique, 505

Christ, 67, 78, 414, 416ff, 495, 502f, 505, 514, 526, 572
 (fn. 23)
 as the "true inward man" of man, 496
 imitation of Christ, 516
 as the centre of meditation (Johannes Tauler),
 524
 as Life, 569 (fn. 17)
 "the first dweller, the real Ādivāsī" (F. X. D'Sa),
 415

'Christian' and 'christic' experiences, 414

Cid-ānanda, 37, 95, 160, 163, 166
 the highest human aim, 162
 the form of the Goddess (*Saundaryalaharī*), 225

Citrakāra workshops (Orissa), 325-335

Clement of Alexandria, 496

Colours
 use of primary colours in the *Nāṭyaśāstra*, 245-
 273
 theory of colours (*Nāṭyaśāstra*, ch. 21), 247f

Comparative theology, 373, 375

Comparison
 in Interreligious Debates, 541-555

Compassion
 is "the root of all religions" (Basavanna, 12th
 cent., Karnataka), 564

Coomaraswamy, Ananda K., 181, 205, 217, 343, 365f

Consciousness, 32f, 34, 42, 52, 90, 92f, 95ff, 129, 134,
 158f, 162f
 the Lord, "of the nature of consciousness", 42

and perception, 401f
divine consciousness, 49f
the universe is projected on the screen of the c.
 of the Lord, 65
the ultimate as the undifferentiated essence of
 c. (Trika school), 90
non-dual consciousness, 93
"The Highest Lord is all-containing
 consciousness (pūrṇasaṃvit)" (Abhinava-
 gupta, *Tantrasāra*), 97 (fn. 23)
the universe is a reflection in the void of
 Bhairava's c., 98
c. as one of the three dimension of
 'cosmotheandric' reality, 412
See, 'I'-consciousness
See, Self

Contact, 52, 63f, 113
 See, Saṃparka
 See, Touch

Corpus Hermeticum, 482, 484

Cosmic Axis (Axis Mundi; skambha), 219, 221, 255,
 339
 See, Mount Meru
 See, Temple art, Indian

'Cosmotheandric' vision of reality (R. Panikkar), 412,
 424, 428

Creatio ex nihilo ('Creation from nothing')
 interpreted by K. Nishitani, *Religion and
 Nothingness*, 388
 Johannes Tauler, *Sermon*, 61, 526

Creation
 is preceded by water (see Veda, Bible, etc), 567

Cross-cultural ethics, 393ff, 407ff
 and language, 398f, 400

'Cultural Disarmament' (R. Panikkar), xiii

Dagens, Bruno, 207

Dakṣiṇāmūrti, 312

Dalai Lama, xxvii, 368, 457

Davis, Richard, 219

Death, 573
 different from non-life, 570f
 in the monist view of reality (d. as a mere
 appearance), 571
 modern preoccupation with death, 583

'Death of God', 465f
 See, Nietzsche, Friedrich

Demchog Tantra
　description of Mount Kailāsa, 340

Desai, Devangana, 366

Descartes, René, 491 (fn. 38), 492
　Discours de la Méthode, 517f

Deshpande, Nirmala, xx

Detachment
　"Gelassenheit" (Johannes Tauler, Meister Eckhart), 526 (and fn. 2)

Deva, Krishna, 206, 210

Devarāja-worship (Cambodia), 319ff

Devī
　See, Goddess

Devī Māhātmya (illustrations), 194f

Devībhāgavata Purāṇa Brahman, 258

Devyāyāmala, 101f (and fn. 38)

Dhaky, M.A., 206

Dharma
　as the root cause of justice, 393f
　and *mokṣa*, 73

Dharmadāsa (saint-poet), 13

Dialogue
　works out the parameter of 'justice', 394
　See, Hindu-Christian Dialogue
　See, Interreligious Dialogue

Dionysius Areopagita, 521, 523, 525

Dīkṣā ('initiation'), 55 (fn. 13), 104, 110, 113, 120, 126f, 141

Donne, John, 74

Dṛg-Dṛśya-Viveka, 165

Dṛk ('vision', 'apperception')
　as a name for the Śakti, 97 (and fn. 23)

Dumoulin, Heinrich, 391

Durvāsā, sage, 195

Eckhart, Meister, 510ff, 521, 523 (and fn. 1), 606
　Sermon On noble man, 511

'Eco-sophy' (R. Panikkar), 419

Ekanātha, 59

Ekavīra, 124

Elements, Five, 86f, 368

Elephanta Cave, 218
　as a replication of Mount Kailāsa, 363f

Ellora
　See, Kailāsa temple, Ellora

Enlightenment, 90, 94, 99 (and fn. 32)
　and acts of immersion (samāveśaḥ), 93
　prayer for e. (Abhinavagupta), 90, 93 (fn. 14)

Enomyia-Lassalle, Hugo, xii

'Eriugena', John Scottus, 501ff
　See, Evil
　See, Paradise
　See, Senses

Ethics
　and religion (Mahatma Gandhi), 68-79
　its place in Indian philosophy, 76
　Ethics of Justice (cross-cultural context), 393-410
　a community as the basis for ethical values, 402f
　cross-cultural process of value-creation, 400
　and interreligious discourse, 406f
　See, Cross-cultural ethics
　See, Indian philosophy
　See, 'World-ethos'

Evil
　neither substance nor proceeding from any natural cause, therefore "nothing but an irrational and perverse and imperfect motion of nature" (Eriugena), 503

Existential Interpretation (Rudolf Bultmann), 379ff

Faber, Roland, 376
　See, Trans-religious processes

Fischer, Eberhard, 327

Fish (matsya)
　as a form of Viṣṇu, 339

'Five jewels', 110f (fn. 63), 112

Formless, Icons as form of the, 221

Formlessness
　"Weiselosigkeit" (Johannes Tauler), 523

Formlessness/Form (of Śiva), 218f
　See, Elephanta Cave
　See, Nirguṇa/Saguṇa

Foucault, Michel, 495

Francis of Assisi, Saint, xxi, 67

Francis de Sales, Saint, 581
　See, Immersion

Freedom, 34

Friendship
　and academic work and interreligious dialogue,

xiii

Fullness, 49f, 93, 166
 the mere contact of jñānins and yoginīs as a
 "source of f." (Abhinavagupta), 52f
 and aesthetic delight, 158

Fundamentalism, 79

Gadamer, Hans-Georg
 'fusion of horizons', xi

Gandhi, Indira, 9

Gandhi, Mohandas K. 'Mahātmā', xvii, 67-79, 551,
 563
 See, *Bhagavad-Gītā*
 See, Satyāgraha

Garbhagṛha-maṇḍala (sanctum in the form of the
 maṇḍala), 216

Gnoli, Raniero, 103 (fn. 42), 106

Goddess, 38, 40, 157f, 167f
 names, 155
 bliss as her essence, 157, 159, 161, 163
 as the *rasa* of nonduality, 157
 'uniflavouredness' (sāmarasya) as her
 characteristic, 159
 as "the form of one single bliss-consciousness",
 159f.
 as Brahman, 164, 168
 is with and without attributes, 164, 169f
 is becoming dual in the form of man and
 woman, 168
 Śivadūtī (śakti of the Great Goddess), 194f
 Indian paintings, 223ff
 Goddess on the Island of Gems (Rājasthānī
 painting), 223-228
 "a flood of consciousness and bliss", 225
 graceful (saumya) aspect, 227
 See, Bhairavī
 See, Bhairavī Aghoreśvarī
 See, Kālī
 See, Maṅgalā
 See, Nirguṇa/ Saguṇa
 See, *Saundaryalaharī*
 See, Śrīvidyā Lalitā
 See, Svanibhadevī
 See, Tripurasundarī

Goethe, Johann Wolfgang von, 342, 470f, 533-537

Goswamy, B.N., 224

Goudriaan, Teun, 320, 322

Grace
 and nature (Eckhart, *On noble man*), 511
 The soul becomes like God by grace (Johannes
 Tauler), 516
 Everybody wants to be 'something', therefore
 we are without grace (Tauler), 525
 See, Śaktipāta

Grimm, Georg, 464

Guru, 51f, 53f, 94

Gwalior, 301f, 305

Ha, Letter, 161f.

Hacker, Paul, 553

Haṁsa ('swan')
 Śiva, "the great Haṁsa", 43

Hanumānbāhuka (illustrations to), 183f, 196 (fn. 39)
 See, Tulasīdāsa

Hardy, Adam, 220

Harivaṁśa Purāṇa (illustration), 243

Hart, James, 69

Hayaśīrṣa-Pañcarātra (Pañcarātra text), 210, 213, 222

Heart
 ascent within the heart (Augustine), 485
 as the place of salvation, 500
 "Gemüt", in which all powers of the soul are
 collected (Johannes Tauler), 523
 "knot of the heart" (*Muṇḍakopaniṣad* II 2.8), 559
 we need a "dissolved and liquid heart" to
 receive the form of the Divine (St. Francis
 de Sales), 581
 my heart is "like wax, it is melted within my
 breasts" (Ps 21, 15), 581
 symbolism of the heart in many cultures and
 religions and death, 583 (fn. 66)
 See, Hṛt, hṛdayam

Heer, Friedrich, 505

Heidegger, Martin, 379f, 382 (fn. 32), 383f, 391

'Hellenization' of Jewish, Christian, and Muslim
 theology, 374

Hermeneutics of intercultural encounter, 582

Hermeneutics, Modern
 and Rudolf Bultmann, 379

Hesse, Hermann, 467-477
 See, Advaita experience

Hindu-Christian Dialogue, xviii, xxii
 See, Interreligious Dialogue

Hiraṇyagarbha (cosmic egg), 243
 as a name of Śiva, 316

History of religions
 as a discovery of the Enlightenment and
 Romanticism, 541
 See, Kippenberg, Hans G.

Hiuen Tsang, 302 (fn. 117), 303

Hölderlin, Friedrich, 539

Hrīṁ, Mantra, 155, 158, 161f, 163, 170f
 in Kashmir Śaivism, 161

Hṛt, hṛdayam ('heart'), 28, 34f, 50, 89, 93f, 96, 98,
 101f, 111, 122, 129, 134
 as a name for the Śakti, 97 (and fn. 23)

'I'-consciousness, 30, 32f, 93

Imagelessness
 "Bildlosigkeit" (Johannes Tauler), 523

Immersion (in the Divine/ the true Self)
 "The true diminution of oneself dives into the
 divine inner abyss of God" (Johannes
 Tauler, *Sermon* 51), 525; cf. 526 ("that we . . .
 dive into the divine being"); cf. 528 (". . . so
 that he may sink and melt into that ground")
 "immersion into God" (Johannes Tauler), 516
 the soul "comes out from this sacred flow . . . in
 order to merge entirely and be dissolved in
 Him" (St. Francis de Sales), 581
 "The soul that flows in God dies not, for how
 could it die after sinking into life?" (St.
 Francis de Sales), 581
 See, Samāveśa

Immortality
 of man, 572f
 of gods, 579

Inclusivism, 553

Indian philosophy
 and ethics, 76

Indra, 83 (and fn. 2), 228, 255

Initiation
 See, Dīkṣā

Intercultural hermeneutics, 582

'Interculturation' between Christian and Hindu
 traditions, 424ff

Interpretation
 See, Existential Interpretation

Interrelatedness of all phenomena

and 'cosmotheandric' constitution of reality,
 412f
See, Pratītyasamutpāda

Interreligious Dialogue, xii, 457f, 541-555
 Declaration of the World Council of Churches
 on I. D., 395ff
 See, Atheism
 See, Buddhist-Christian Dialogue
 See, Hindu-Christian Dialogue

'Inward man', 486f

India's contribution to the concept, 487ff

'Inner man' (Johannes Tauler), 523

Iyengar, H.R. Rangaswami, 224f

Iyer, Raghavan, 70

Īśvarapratyabhijñākārikā
 See, Utpaladeva

Īśvarapratyabhijñāvivṛttivimarśinī
 See, Abhinavagupta

Jagannātha, 60
 as the 'great void' (mahāśūnya), 60

Jagannātha temple, Purī, 327, 335

Jainism
 and Mount Kailāsa, 340, 353

Jayadrathayāmala, 113, 120

Jayākhyā-Saṁhitā, 209f

Jñāna-Yoga, 422f, 426f

John of the Cross (Juan de la Cruz), 466

Jungclaussen, Emmanuel, xxii

Justice, 393-410
 as an existential reality, 393
 dialogue as the framework for any theory of
 justice, 394
 as 'fairness' (John Rawls, *Theory of Justice*), 394
 and fn. 342
 cross-cultural dimension, 395f
 in the judeo-christian religious tradition, 397f
 incarnated in a religious counter-society, 414

Kabīr, 13f, 58, 351
 Kabīr-Raidās debate, 546

Kadambaguhā, 280, 283f

Kadambaguhādhivāsī, 280ff, 283f, 291f

Kadwaha, 289ff, 292, 301, 305

Kailāsa (sacred mountain), xxi, 17-22, 38, 337-369
 in the sense of 'top of the head'
 (brahmarandhra), 38 (fn. 4)
 in Indian poetry and drama, 342ff
 and Kālidāsa's *Abhijñānaśākuntalam*, 342
 See, *Demchog Tantra*
 See, *Mahābhārata*

Kailāsa temple, Ellora
 replication of Mount Kailāsa, 354f

Kailāsanātha temple, Kanchipuram, 353f

Kaivalya
 name for the highest stage of spiritual practice
 (Pāśupata system), 312

Kandarīya Mahādeva temple, Khajurāho, 209ff

Kant, Immanuel, 29, 69, 73f, 78, 394

Karma, 576

Karma-Yoga
 and Gandhi, 75, 77
 represents together with bhakti- and jñāna-
 yoga the fundamentals of an Indian
 religious experience, 419f
 "the yoga of renunciation" (saṁnyāsa), 421, 425

Kashmir, 72, 209, 367

Kashmir Śaivism, xi, xii, xxi, 352
 is not a religion (Swami Lakshman Joo), 7
 See, A-Duality
 See, Abhinavagupta
 See, Kaula
 See, Krama
 See, Kṣemarāja
 See, Lakshman Joo, Swami
 See, Lalleśvarī
 See, Madhya
 See, Sāmarasya
 See, Svatantraśivādvayavāda
 See, Trika
 See, Utpaladeva

Kaṭha Upaniṣad, 30, 490, 567 (fn. 1)
 "He is or he is not" (I.20), 574 (and Fns. 30, 33)

Kaula, 110, 113f, 133, 138
 pre-eminence of the Kaula form of Trika
 (Abhinavagupta), 99f, 102
 dynamics of Kaula Krama system as the
 dynamics of Trika at its highest level, 102
 and the cult of Tripurasundarī, 150ff.

Kaula ritual, 110 (fn. 63)

Kauṇḍinya (commentator to *Pāśupata-Sūtras*), 309ff

Kaviraj, Gopinath, xviii, 605

Kālasaṁkarṣiṇī ('the destroyer of time'), 101f, 114,
 134
 as a name for the Śakti (Abhinavagupta,
 Tantrasāra), 97 (fn. 23)

Kālānala, 275

Kālī, 112, 555
 as one of the names of the Śakti, 97 (fn. 23)
 illustration, 193f
 painted standards depicting K. in processions,
 328
 Dakṣiṇakālī and the cult of Jagannātha, 329, 334
 K. as the denominator of time, 329
 as a motif of oṣakoṭi mural, 333
 twelve Kālīs, 134

Kālidāsa, 231, 342, 354f
 See, *Abhijñānaśākuntalam*
 See, *Meghadūta*
 See, *Kumārasambhavam*

Kālikā, 329

Kālīkula, 107

Kāma, 346

Kāmadhenu, 50, 82

Kāmākṣī of Kanchi (local goddess), 151

Kāmeśvarī (goddess of love magic), 151 (fn. 11)

Kāpālika, 275

Kāraṇas, 38, 44, 46

Kenosis (self-emptying), 415

Keynes, John Maynard, 74

Kha ('sky'), xi

Khajurāho, Temples of, 209ff, 366
 and Yakṣa, 343

Khecarī-samatā, xii

Kimball, Charles
 When Religion Becomes Evil, 78f

Kippenberg, Hans G.
 Discovering Religious History in the Modern
 Age, 541

King Jr., Martin Luther, 75

Knowledge
 false and unreal knowledge as a cause of
 bondage, 65

Kramrisch, Stella, 206, 208, 210, 215ff, 364, 366

Krama, 105, 113, 117, 125, 127, 134, 137, 140
 and Śrīvidyā, 151 (fn. 11)
 as the core of Trika (Abhinavagupta), 102

Kṛṣṇa, 58, 60, 343

Krishna, Ananda, 183 (fn. 18), 193

Krishnamurti, Jiddu, xvii, xxi

Krishnaswami Sastri, R., 153

Kṣemarāja, 37, 52, 99, 120
 Śivasūtra-Vimarśinī, 64
 Pratyabhijñāhṛdayam, 65, 103

Kṣetrapāla, 321f

Kubera (Lord of the Treasures), 47, 338, 342f, 356

Kulacūḍāmaṇi, 148 (fn. 4)

Kunze, Agnes, xx

Kuṇḍalinī, 44

Kumārasambhavam (poem), 346f, 349
 See, Kālidāsa

Kuvempu (Kannaḍa poet), 562

Kyôto School, 373, 378
 reception of Existential Interpretation, 383ff

Lakshman Joo, Swami, v, xxi, xxix, 3-9, 593, 601

Lakṣmaṇagupta (teacher of Abhinavagupta), 123ff, 128

Lalitasvacchanda, 37, 47
 See, *Svacchanda Tantra*

Lalitātriśatī, 149, 154f

Lalitātriśatibhāṣya, 149ff
 and 'Kashmir Śaivism', 156

Lalitā-Tripurasundarī, Goddess, 149, 151, 168

Lalleśvarī, 350f

Landor, Walter Savage, 14

Life
 as the product or the very center of reality, 569
 See, Death
 See, Thomas Aquinas

Light, Pure
 "the innate essence of Śiva" (Abhinavagupta), 51
 creation of light (*Taittirīya Brāhmaṇa*), 81
 See, Prakāśa

Līlā (éplay'), xxiii, xxvii, 533
 of Śiva and Pārvatī, 342, 346, 356

Liṅga
 Mālinīvijayottara on *liṅga* worship, 115
 symbol of followers of Pāśupata-Yoga, 311
 worship, Beginning of, 315f

 in the Kailāsa temple, Ellora, 355
 Elephanta Cave, 364

Liṅga Purāṇa, 312ff
 See, Pāśupata

Liṅgarāja temple, Bhubaneshwar, 367

Lithography (Banaras, 19th century), 179-197

Logical knowledge, 65

Love, 429
 Petrus Abaelard, 506
 Bernard of Clairvaux, 507f
 Wolfram of Eschenbach, *Titurel*, 508f
 Johannes Tauler, 524f, 528
 "the essence of Christic revelation", 416

Luther, Martin (mountains), 337

Madhumatī, 298f

Madhya ('centre'), 65f, 101
 and conception, 101 (fn. 34)

Mahābhārata
 and Mount Kailāsa, 340
 presentation in Kailāsa temple, Ellora, 355

Mahadevan, T.M.P., xviii

Mahāmṛtyuñjaya (illustration), 194 (fn. 29)

Mahānayaprakāśa, Trivandrum edition, 29, 113

Mahānayaprakāśa, Kashmir edition, 92, 113, 125

Maheśvarānanda, 92

Mālinīvijayottara, 106f, 109f, 115f, 119f
 See, Liṅga

Mamallapuram, 233, 363

Mantra, 39ff, 310, 315
 See, Hrīṁ

Maṇḍala, 207, 254, 259, 266, 320
 in Trika, 101
 the sanctum of temples in Kharujāho as a M., 216
 Mount Meru as a M., 339
 Mount Kailāsa as the center of an universal M., 340, 353, 368
 Borobudur as Mount Meru and M., 353
 See, Garbhagṛha-maṇḍala
 See, Vāstupuruṣa-maṇḍala

Maṅgalam (verse for success), 89ff

Maṅgalā, 329ff, 335

Matilal, Bimal K., 76

Matsya ('fish'), 54

Māṁsa ('meat'), 54

Māyā, 3, 53, 65, 73, 159, 162, 164f, 166, 167
 as the power of the Goddess, 41, 158, 167
 path to enlightenment leads from the world of
 m. to the inner ātman, 490

Mayamata (Vāstuśāstra), 207

Mālinīvijayavārttika
 See, Abhinavagupta

Mātṛsadbhāva, 101f

Mechthild of Magdeburg, 466

Meghadūta, 342ff, 352, 355
 See, Kālidāsa

Mehtab Kak, Swami, 4, 8

Meister, Michael W., 206f, 212

Melaka ('tantric, ritual assembly'), 49ff
 See, Cakrayāga

Merton, Thomas, xii

Meru
 See, Mount Meru

Metz, Johann Baptist, 465

Mewārī masters, 223-228

Miniature paintings, Indian, 223ff

Mīmāṁsā, 152f, 162

Mohammad, 337

Mokṣa ('liberation'), 41f, 51, 64f, 68, 73, 76
 See, Bhoga

Monchanin, Abbé Jules, xviii

Monism
 different from a-dualism, 571f, 578
 See, A-Dualism

'Monoculturalism', xiii
 danger of "monocultural assumptions", 572

'Mono-economism', xiii

'Monolingualism', xiii

Monotheism
 Goethe has freed himself from the doctrines of
 m., 534
 rigid monotheism (monism) or the trinitarian
 option (a-dualism), 571

Mount Abu
 and Yakṣa, 343

Mount Arafat, 337

Mount Hira, 337

Mount Kailāsa
 See, Kailāsa

Mount Meru (mythic mountain), 215, 258, 266, 338f,
 341, 343, 346, 353
 as a Maṇḍala, 339
 and Borobudur, 353
 and Kailāsa temple, Ellora, 355
 See, Cosmic Axis (Axis Mundi; skambha), 339
 See, Kailāsa
 See, Temple art, Indian

Mount Sinai, 482

Müller, Max, 535, 541

Mulchand, Ustad, 180f (and fn. 10), 193, 196 (fn. 39)

Mullen, Eva, 463

Muṇḍakopaniṣad, 559, 567

Mus, Paul, 353

Music, Spiritual dimension of, 11-15

Myth
 objectivizing thought in myth as an expression
 for the longing for security, 380ff

Nirnāma ('the nameless')
 as a name for the Śakti, 97, 137

Narasiṁhagupta (father of Abhinavagupta), 89, 99,
 123, 125, 141

Navakalevara-ritual, 327
 See, Jagannātha temple

Nāṭyaśāstra, 226, 311, 345, 352, 366
 use of primary colours, 245-273
 See, Abhinavagupta
 See, Colours

Neoplatonism, 522
 See, Plotinus

Nicholas of Cusa
 De pace fidei (1453), 544

Nietzsche, Friedrich, 405, 465
 The Antichrist (1888), 458
 his message of the 'Death of God', 466

Nirguṇa ('formlessness')/ Saguṇa ('formfulness') of
 the Goddess, 168ff

Nishida, Kitarô, 383, 386
 See, Kyôto School

Nishitani, Keiji, 384ff
 See, Kyôto School
 See, Reincarnation

Nityā ('the Eternal')

as a name for the Śakti (Abhinavagupta, *Tantrasāra*), 97 (fn. 23)

Nityaṣoḍaśīkārṇava, 150

Nohalā, Queen, 300f

Nondualism between the One and the Many, theories
See, Pratibimbavāda
See, Vivartavāda

'Non-duality, Ultimate' (parādvaitam), 95, 97, 115

Non-violence, 421
See, Gandhi
See, Satyāgraha

Nothing
man as nothing (Johannes Tauler), 513

Nothing, Phenomenology of the (Martin Heidegger), 384, 391f

'Nothing', Absolute (jap. zettai mu), 386 (and fn. 52)

Nothingness, 573
Johannes Tauler, 521-529

Nṛtta-Bhairava, 308, 316

Objectivization, Critics of
Rudolf Bultmann, 380f
Kitarô Nishida, 383f
of the Buddha's message (Yoshinori Takeuchi), 390f

Olcott, H.S., 460

Oja ('vital essence'), 100 (fn. 34)

Opening Verse, 89f, 92
See, Maṅgalam

Origen, 497, 512

Ovallī (lineage), 122

Paddhati ('guide'), 106, 109
definition by Bhaṭṭa Rāmakaṇṭha, 106 (fn. 49)

Padoux, André, xx, xxvi, 149

Pañcadaśī, 165ff, 170

Pañcarātra
See, *Hayaśīrṣa-Pañcarātra*

Panikkar, Raimon, xii, xviii, xix, xxii, xxv, xxvii, 60, 67, 339, 379 (fn. 13), 412, 416 (fn. 5), 419, 466

Pantham, Thomas, 71

Paradise
allegorical interpretation by Eriugena, 501f

Paraśurāmakalpasūtra, 153 (and fn. 17)

Parā/Parāparā/Aparā (the three goddesses of Trika), 101, 102 (fn. 39)

Parādvaita (éultimate non-duality'), 95, 115
See, Non-duality, Ultimate

Parātrīśika-Vivaraṇa
See, Abhinavagupta

Paronomasia, 136, 139f

Parvan rites, 49-55
See, Cakrayāga

Paryanta-Pañcāśikā
See, Abhinavagupta

Pascal, Blaise, 518f

Patañjali, xviii, 231

Paul, Saint (apostle), 581
opposition between 'inward' and 'outward man', 496

Pāśupata, 104 (fn. 45), 105, 275
in Cambodia, 307ff
See, Saṁvit
See, Yoga, definition of

*Pāśupata-Sūtra*s, 307, 309ff, 315, 317

Periphyseon (by Eriugena, 9th cent.), 501

Pilgrimage, xvii ff, xxi, 17-22
life as a p. (H. Hesse, *Siddharta*), 472

Piyadassi, Mahathera, 461, 463

Plotinus, 481f, 487, 496, 515, 522
'threefold man' (sensual, intellectual, interior godlike man), 523
See, Tauler, Johannes (threefold man)

Ploutarchos, 568

Polarity
as the basic principle in Goethe's appreciation of nature, 536

Poverty
understanding of p. in the Indian sense of renunciation, 425
See, 'Interculturation' of Christian and Hindu traditions

Prabha Devi, xxi, 8

Prakāśa
direct perception of the Goddess in the form of prakāśānanda, 164
in the sense of 'undifferentiated manifestation', 96
and vimarśa, 93f, 96, 129, 152, 160
cf. āvaraṇa/ vikṣepa in post-Śaṅkara Vedānta, 162

See, Light, Pure

Pratibhā ('the light of creative intuition or omniscience', 'creativity'), 28, 96
 as a name for "the supreme Goddess" (Abhinavagupta, *Tantrāloka*), 98
 the ability of the Lord to embody himself as the universe without drawing on anything outside is the supreme goddess, called p. (*Tantrāloka* 3), 98

Pratibimbavāda ('reflection theory'), 163 (and fn. 56)

Pratītyasamutpāda ('interdependent co-arising', 'interrelatedness'), 402 (fn. 6)
 not to be understood as a chain of causes in an objectivized way, 390
 interpreted as a "theory of conversion" by Y. Takeuchi, 390, fn. 69
 justice as being in tune with P., 398
 the question of persistence after death and the doctrine of radical relativity in Buddhism, 579f

Pratyabhijñā ('recognition'), 28, 128
 See, Utpaladeva

Pratyabhijñāhṛdayam
 See, Kṣemarāja

Prāṇa ('life, life force, vital energy, breath', 50, 66

'Presentness' of art (Patañjali), 231f

Proklos (Proclus), 521f, 527

Purandara, 282ff, 291, 296, 304

Puruṣa, 81ff, 488
 Bṛhadāraṇyaka Upaniṣad, 490

Pūjā, 531-539

Radhakrishnan, Sarvepalli, 417, 476f, 553
 See, Advaita Vedānta

Raghuvaṁśam, 231
 See, Kālidāsa

Rahner, Karl, xviii

Ramaṇa Maharṣi, Śrī, xviii, xxi, 9, 367f

Ramanujam, A.K., 349

Ranod, 296f, 301, 304

Rājput art, 181, 234f

Rāma Joo, Swami, v, 3f

Rāmacaritamānasa, 184
 See, Tulasīdāsa

Rāmāyaṇa

and Mount Kailāsa, 340f
 presentation in Kailāsa temple, Ellora, 355

Rasa, xi, 157f, 159, 169
 of peace, discussed by Abhinavagupta (*Abhinavabhāratī*), 34
 See, Sāmarasya

Rasa theories, 155, 157 (fn. 35), 226

Rāvaṇa, 338, 356
 shaking Mount Kailāsa, 345, 356
 as a devotee of Śiva (Kailāsa temple, Ellora), 356, 364

Rawls, John, 394

Realization of the Divine
 ". . .where no perception of time exists, that very thing is your realization" (Utpaladeva, *Śivastotrāvalī*), 66

Reincarnation, 392, 464
 and de-mythification (K. Nishitani), 387
 and agnosticism (St. Batchelor), 462

Relation, Philosophy of (Abhinavagupta), 31

Religion, 558f
 and politics (Gandhi), 67ff
 four signals of the debasement of religion (Ch. Kimball), 78
 religious violence, 79
 philological approach to r., 149
 exchange of religions as a characteristic of religious strength, 374f
 and social identity, 399
 as the search for ultimate meaning, 413
 as "the search for the sacred in the real" (F. X. D'Sa), 413
 etymology of the Latin word 'religio', 480
 harmony and conflicts of religions, 561ff
 religious fanaticism, 565
 beauty of religious plurality, 565
 as a way to struggle with the tragedy of death, 576
 the need for revising the understanding of religious life in India, 424
 See, History of religions
 See, Trans-religious processes
 See, Spirituality

'Religionsgeschichtliche Schule', 373f, 375
 See, Josef Wei"

Reps, Paul, *Zen Flesh Zen Bones*, 7

Ṛgveda, 81f, 83, 568 (fn. 9)
 Puruṣasūkta

Nāsadīya Sūkta (X.129), 81, 338f, 569 (fn. 13)
Truth is one, sages call it by various names (Ṛ̥V
I.164.46), 552

Riedl, Peter, 462

Rūpamaṇḍana (Vāstu text), 217
Saccidānanda, 154f, 156f, 158, 160f, 165 (and fn.
65)
as a name of the Goddess, 155, 167
definition, 160 (fn. 47)
the ultimate human aim, 162
as the real characteristic of the divine Absolute,
163
formula not used by Śaṅkara, 166
Brahman is saccidānanda (*Pañcadaśī*), 167

Sacred geography, 337, 340, 352
See, Kailāsa

Samādhi, 8, 46
nirvikalpa samādhi, 64

Samāveśa ('immersion', 'absorption'), 93, 95, 99, 135
Abhinavagupta (*Īśvarapratyabhijñāvivṛtti-
vimarśinī*) on S., 90ff
See, Immersion

Samarāṅgaṇa-sūtradhāra (Vāstu text, 11ᵗʰ century), 199,
206f, 208f, 210, 222
See, Vāstu
See, Bhojadeva

Sambandha (Tamil saint), 58f

Saṃghaṭṭa ('passionate embrace, fusion'), 96, 98

Saṃparka ('contact'), 53
See, Contact

Saṃvidadvayavāda, 51

Saṃvit, 30
defined as deep intellectual analysis (Pāśupata
system), 311
See, Consciousness

Sandhi ('conjunction'), 211f
See, Khajurāho (figures in conjunction)

Santa poets, 57ff

Santāna ('lineage'), 54

Santati, 276

Sarasvatī, Dayānanda, 547-552
on Christianity, 550f

Sarvadarśana-saṃgraha, 217

Sarvaṃ sarvātmakam ('all is in all'), 25, 51

Sat, 152, 160

Satī (myth), 344, 346f

Satkāryavāda, 51

Satyāgraha (Gandhi), 70ff

Saundaryalaharī, Illustration of, 223-228

Saura tradition, 327f, 335

Sāmarasya/ samarasa ('single flavouredness', 'equal
essence'), xi, 41, 157f, 159f, 163, 166, 171
See, Śiva and Śakti

Sāra ('essence')
as a name for the Śakti, 97, 129

Schöne, Albrecht, 534

Secularism
secular conditions of Buddhist-Christian
dialogue, 464ff

Seidenstücker, Karl, 461

Self
experience of the self in any state, 63
". . . nothing in its ultimate reality but undivided
and autonomous consciousness"
(Abhinavagupta), 92
knowledge of the identity between self and
God, 485f

Self-awareness / self-knowledge, 479-520
and emergence of the modern concept of the
'subject', 495

'Self-identity, Absolutely contradictory' (K. Nishida),
386
and christological doctrine of the two natures
(divine, human) of Christ, 387
See, Kyôto School
See, Śūnyatā

Senses, 118, 420
as the means of self-realization according
Tāntric scriptures, 63
regarded as mere instruments of sense-
perception (vedic philosophy), 489
"The Creator made the senses outward-going.
. ." (*Kaṭha Upaniṣad* 4,1), 490
inner sense and outer sense (Eriugena), 502
corporal senses as the "place of falseness",
where the evil has its place (Eriugena), 503
the experience of God "transcends all sensible
experience" (Tauler, *Sermon* 29), 529
See, Self
See, Tanmātras

Service
as the manifestation of love, the "essence of
Christic revelation", 416f
the "sacrament of service", 417

Seuse, Heinrich, 510, 517, 521

Sharma, Prem Lata, xx, xxix, 245 (fn. 3)

Siddha, 49f, 100, 131, 139

Siddhayogeśvarīmatatantra, 53 (fn. 7), 110

Siddhis, 7

Silburn, Lilian, xi, 9, 601

Singh, Karan, 9

Singh, Thakur Jaideva, xviii, xxi, xxix, 15

Sloterdijk, Peter
 Weltfremdheit (1993), 499

Smith, Jonathan Z., 541

Somānanda
 See, *Śivadṛṣṭi*

Spanda ('subtle vibration', 'subtle motion'), 28, 43,
 96, 130
 as a name of the Śakti, 97 (and fn. 23)
 and self-realization, 63f
 See, Self

Sphaṭika, 253f

Sphurattā ('radiating, shining, sparkling, vibrating'),
 28, 130

Spirituality
 "wider than any particular religion"
 (Aurobindo), 475

Srinivasan, Doris, 218

Stavacintāmaṇi, 43

Stānu/Sthāṇeśvara, 41

Stoler Miller, Barbara, 348

Subject
 See, Self-awareness/self-knowledge

Sundaram, Manju, xx

Sundaram, S., xx

Suṣumnā, 101 (fn. 34)

Sūtradhāra, 200f, 209, 257 (fn. 80), 263 (fn. 114)

Svacchanda, 37

Svacchanda Bhairava, 37ff

Svacchanda Tantra, 37, 66, 109, 120

Svanibhadevī, 37

Svatantraśivādvayavāda ('doctrine of nonduality of
 the free Śiva'), xii
 See, Kashmir Śaivism

Syncretism, 376
 See, Trans-religious processes

Sāñcī, 232ff

Śaiva-Siddhānta, 275-306

Śaivism
 in Cambodia, 307-323

Śakti ('energy', 'power' of the Divine), 152, 166f
 experienced in practical life, 63
 See, Bhoga
 See, Caṇḍī
 See, Dṛk
 See, Goddess
 See, Hṛt
 See, Kālasaṁkarṣiṇī
 See, Kālī
 See, Kuṇḍalinī
 See, Nirnāma
 See, Nityā
 See, Pratibhā
 See. Sāra
 See, Spanda
 See, Śiva
 See, Trīśika
 See, Ūrmi
 See, Vāṇī

Śaktipāta, 64, 66

Śaktipīṭhas (legend of), 344

Śambhu, 41, 43, 54

Śaṅkara, 149ff., 160 (fn. 47), 163, 165, 172, 174, 224f,
 606
 on the unity of transmigrating soul and the Lord
 (*Brahma-Sūtra-Bhāṣya*), 580

Śarikādevī, 4f, 8, 593

Śilpa Prakāśa (Vāstu text), 213f, 222

Śilpa-Ratnākara, 211

Śilparatnakośa, 205, 208

Śilpaśāstras, 199ff

Śiva
 his "innate essence" is "pure light"
 (Abhinavagupta), 51
 'five faces' as the five powers of Ś., 95
 represented in Nineteenth Century Banaras
 Lithographs, 179-197
 Śiva Ardhanārīśvara, 43 (fn. 26), 182, 347, 364
 and Śakti, xi, 38, 152, 157, 160f, 166, 346, 348
 the world as the creation of the love play of
 Śiva and Śakti, 163
 as Mahāmṛtyuñjaya, 194 (fn. 29)
 unique images of Śiva in Khajurāho with four
 legs and six heads, 217

represented in a Mewar painting (18th century), 227ff

Śiva Tryambaka, 45 (fn. 39), 263 (fn. 113)

legend of Śiva as Bhikṣāṭana (Pāśupata system), 317f

Śiva Nīlakaṇṭha, 339, 348

as the vanquisher of the three cities (Tripurāntaka), 345, 355

Kalyāṇasundaram, 346, 364

eight-fold form (aṣṭamūrti), 342, 347ff, 364f

as Mahāyogī (Kailāsa temple, Ellora), 355

Gaṅgādhara ('who holds the Gaṅgā'), 356, 364

as the "Lord of the cave", 364

sculpture with five faces (Elephanta Cave), 364f

Śiva Dakṣiṇāmūrti, 365

dancing in 108 modes (Bṛhadīśvara temple), 366

and Kālī, 536

See, Bhairava

See, Cid-ānanda

See, Catuṣpāda

See, Dakṣiṇāmūrti

See, Elephanta Cave

See, Haṃsa

See, Kailāsa

See, Līlā

See, Prakāśa/ vimarśa

See, Tumburu

Śivadṛṣṭi (of Somānanda), 64, 96f, 121, 129f

Śivadūtī, 194f

Śivamahimna Stava (illustration), 196

Śivastotrāvalī
See, Utpaladeva

Śivasūtra, 52

Śrīcakra, 150f, 174, 226, 228
See, Yantra

Śrīvidyā, 149-175
and 'Kashmir Śaivism', 149ff.

Śrīvidya Lalitā, Goddess (painting, 19th century), 223

Śūnyatā ('formless void', 'emptiness', 'nothingness', 'absolute void'), 353, 386 and fn. 52, 388

ascension to Śūnyatā (expressed in the architecture of Borobudur), 353

existential interpretation of Śūnyatā. (K. Nishitani), 388

See, Nothing

Tagore, Rabindranath, xvii, 14f, 58

critical of Gandhi's moralism, 77

about Gandhi's influence, 78

Taittirīya Brāhmaṇa, 81

Taittirīya Upaniṣad, 13

Tao
as the root cause of justice, 394

Takeuchi, Yoshinori, 389ff

Tanmātras ('subtle elements')
as a support to achieve God consciousness, 63
See, Senses

Tantra
Tantric Spirituality, xi

Christian encounter with Hindu Tantrism, xxii

judged as debased and a deviation into magic, 149

and Veda, 150

and *Lalitātriśatibhāṣya*, 156

and Śrīvidya, 174

paintings (Ustad Mulchand, 19th century), 193f

new interpretation of tantric traditions today in the west, 463

See, Senses

Tantrāloka
See, Abhinavagupta

Tantrasadbhāva, 120

Tantrasāra
See, Abhinavagupta

Tantric ritual
See, Cakrayāga

See, 'Five jewels'

See, Kaula ritual

See, Matsya

See, Māṃsa

See, Melaka

See, Parvan rites

Tantric spirituality
See, Women

Tauler, Johannes, 510, 513f, 521-529

concept of threefold man (sensual, rational, highest part of soul), 515

See, Creatio ex nihilo

See, Detachment

See, Immersion

See, Nothingness

See, Plotinus (threefold man)

Temple, Hindu, 199-222

and Maṇḍala, 207

Fractal elements, 207

Orissan school, 213

Viśvakarmā school, 209, 222

Jaina temples, 213

Study of Temple art and textual sources, 199-222

temple as a model of the cosmos (Kramrisch, Coomaraswamy), 217f

Kandarīya Mahādeva temple (Khajurāho) as the expression of the essence of Indian philosophy at this time, 221

Renewal of images, 325-335

as mountains and caves, 346

See, Bṛhadīśvara temple

See, Cave

See, Khajurāho

See, Sūtradhāra

Terambi, 293f

Thakurji Kashmiri (artist), 181ff

Thankfulness, 531-539

Theology of Religions, xii

Thomas Aquinas, 522, 580

definition of truth, 404

Johannes Tauler, *Sermon*, 33, 527

"The life of living beings is their being", 569

Tijung (sacred mountain), 353

Time,

represented in Indian visual art, 231-243

Kālī as the denominator of time, 329

transcendence of time during parvan rites, 49

and prāṇa, 50, 66

Abhinavagupta's conception of time (*Tantrāloka*, ch. 6), 50 (fn. 4)

experience of the 'now' without durational dimension, 570

See, Kālasaṁkarṣiṇī

See, Realization of the Divine

Timelessness, 66, 95

Torella, Raffaele, 32

Törzsök, Judit, 53

Touch, 63f, 112

See, Contact

Tradition

as a process of construction in the present, 406

different from traditionalism or authoritarianism, 414

is the ground of all reason, 415

Trans-religious processes, 373-392

trans-religious development of Christianity, 375

definition of the category 'trans-religious', 375f

and transformation of religious traditions, 376

should be divided from syncretism, 376

and creative reception, 376f

and trans-religious studies, 377

'religion transfer analysis' and 'trans-religious theology', 377

Zen meditation as a trans-religious medium, 378

between existentially interpreted Buddhism and Christianity, 391

Triad

of man, Śakti, Śiva, 54

of the powers of will, knowledge and action, 97

'ultimate triad', 137

of 'God, World, Man' ('cosmotheandric' structure of reality), 411ff

Trika (a school of the non-dualistic Kashmir Śaivism), 89

pre-eminence of the Kaula form of Trika (Abhinavagupta), 99, 102

"the highest system of all" (Abhinavagupta, *Tantrāloka* 1), 105f

"the ultimate goal" (*Tantrāloka* 35), 106f

See, Abhinavagupta

See, Kaula

See, Parā/Parāparā/Aparā

Trinitarian constitution of reality, 412f

See, 'Cosmotheandric' vision of reality (R. Panikkar)

Tripurasundarī (name of the Goddess), 150ff, 226

Triśirobhairavatantra, 109

Trivedi, Kirti, 208

Trīśikā ('ruler of the three' [goddesses])

name of the Śakti, 97 (fn. 23)

Truth, 81, 403f

and practice (Gandhi), 68

"God is Truth. . ." (Gandhi), 69

eternal truth as "Absolute Truth" (Gandhi), 70

subjective and objective aspects of truth, 70

Buddhist concept of satyadvaya (two levels of being or truth), 403f

based on an intersubjective process of communication, 406

and language, 406

'intellectual truth' / 'living truth' (Johannes Tauler), 525

Tulasīdāsa (poet), 58, 183f

Tukarama, 59f

Tumburu, god (a four-headed form of Śiva), 320ff

Tuṭi ('fraction of breath'), 66

Uberoi, J.P.S., 537

Umānandanātha (disciple of Bhāskararāya), 153 (and fn. 17)

Union with the One
 Meister Eckhart, 512
 Johannes Tauler, 525
 See, Advaita experience

Untouchability, 417

Upādhi ('limiting adjunct'), 152 (fn. 15), 153 (fn. 18), 155f, 159

Utpaladeva, 11, 29f, 32, 90, 92f, 120, 124, 129
 Īśvarapratyabhijñākārikā, 91 (fn. 8), 103, 128
 Śivastotrāvalī, xvii, 4, 11, 66, 99

Ūrdhvāmnāya ('supreme transmission'), 152

Ūrmi ('wave')
 as a name of the Śakti ('divine energy'), 97 (and fn. 23)

Vaikuṇṭha-Viṣṇu (image of the god in Khajurāho), 209, 215

Vaiṣṇavism, 105

Vaiśeṣika-Sūtra, 564

Vaktram ('face')
 emergence of Śaiva revelation from the five faces of Sadāśiva, 97 (fn. 22)

Varāha ('cosmic boar'), icon of, 215
 See, Khajurāho

Vatsyayan, Kapila, xix, xxii (fn. 13), xxvii, 535

Varivasyārahasya, 152, 154, 157, 161f, 163f, 171
 See, Bhāskararāya

Vāṇī ('the word')
 as a name of the Śakti (Abhinavagupta, *Tantrasāra*), 97 (fn. 23)

Vāstu (canons of architecture and allied arts), 199f

Viśvakarmā Vāstu School, 209
 See, *Aparājitapṛcchā*
 See, *Rūpamaṇḍana*
 See, *Samarāṅgaṇa-sūtradhāra*
 See, *Śilpa Prakāśa*

Vāstukaustubha, 200

Vāstupuruṣa-maṇḍala, 206

Vāstuśāstras, 199f

Vāstutilaka, 200

Vāsukī (serpent), 339

Vetāla, 47

Vighnā (hindering powers), 90f

Vihaṅgama Yoga, 43

Vijñāna ('realization'), 52

Vijñānabhairava (Tantra), xxi, 35, 64, 66, 126

Vimalā (mother of Abhinavagupta), 89, 99

Vimarśa, 28, 152
 'innermost awareness', 93
 'representation', 94
 the nature of any manifestation, 129

Vīṇāśikhā Tantra, 319f

Visarga ('absolute potential'), 98f, 101, 140

Viṣṇu, 339, 344, 353
 depiction of (Lakṣmaṇa temple, Khajurāho), 213
 See, Fish (matsya)
 See, Vaikuṇṭha-Viṣṇu

Viṣṇu Purāṇa
 first major description of Mount Kailāsa, 341

Viṣṇudharmottara Purāṇa, 209f

Viśrānti ('resting', 'repose'), xi, 27-36

Viśvakarmā Vāstu School, 209, 222
 See, Khajurāho

Vitānas ('ceilings'), 206
 See, Temple art, Indian
 See, Dhaky, M.A.

Vivartavāda, 163 (and fn. 56)

Vīra, 37, 53

Void, 4, 40, 42, 457f
 See, Śūnyatā
 See, Jagannātha
 See, Formlessness
 See, Nothingness

Wangu, Madhu B., 223

Water
 metaphor "drop of water in the infinite ocean", 573-585
 cosmology, 343
 precedes creation (Veda, Bible etc.), 567
 lies at the source of everything, 567

Waters, Primordial, 339, 348, 353

Wei", Josef, 373

Wilke, Annette, 223

Wittgenstein, Ludwig, *On Certainty*, 29

Women
 quicker success in Tantric spirituality than men,
 101 (fn. 34)
World
 as a "reflection in the Lord" (Abhinavagupta,
 Tantrāloka), 98
 as unreal adjunct (Śaṅkara), 152 (fn. 15)
 as an accidental, indirect attribute of the
 Absolute (Advaita Vedānta), 163
 only made up of "names and forms"
 (*Pañcadaśī*), 167
 as the creation of the love play of God and
 Goddess, 163
 as manifestation of the Goddess, 157
'World-ethos', 407f

Yajña ('sacrifice'), 8, 416 (and fn. 5)

Yakṣa, 343f, 347, 352

Yantra, 219, 228
 Kāmakalā Yantra, 213
 See, Śrīcakra

Yāmala, 53, 96, 98

Yātudhāna, 47

Yoga, 39

Yoga, definition of, 423f
 Pāśupata-Sūtra, 310
 Liṅga Purāṇa, 315

Yogasiddhāntacandrikā, 258 (fn. 86)

Yoginīs, 46, 49f, 54, 100, 139
 eight Yoginīs, 52
 cult of the sixty-four Yoginīs, 208f

Yoginībhū ('born of a Yoginī'), 100, 139

Yoginīhṛdaya, 150f, 152 (and fn. 12 and 16), 154, 159,
 161, 166
 Wolfram of Eschenbach
 Titurel, 508f
 See, Love

Zen, 386, 389, 459, 522

Zen meditation as an example of a trans-religious
 medium, 378
 See, Bankei (Zen master)
 See, Kyôto School

Zimmermann, Friedrich
 A Buddhist Catechism (1888), 460